RESPONDING to ART

COVER ARTISTS

Roy Lichtenstein's painting *Artist's Studio: The Dance* (front cover) and Henri Matisse's painting *The Dance* (back cover) embody different ways of seeing. Viewers' reactions to these paintings likewise embody distinct ways of seeing based on their own unique life experiences and points of view. For example, feminist art historian Carol Duncan critiques early twentieth-century avant-garde paintings like *The Dance* as male fantasies in which "women simply exist as sensual beings or abandon themselves to spontaneous and artless self-expression." In comparison, art historian Jack Flam responds most positively to Matisse's 1909 painting. He writes that Matisse associated the theme of dance with vitality and rejuvenation. Dance for the artist was something extraordinary—life and rhythm—"and throughout his life he associated the dance with a kind of primitive potency."

A wide range of response has likewise greeted Roy Lichtenstein's "pop art" paintings since their rise to public attention in the 1960s. But their ability to stir up controversy aside, *The Artist's Studio* and *The Dance* are worlds apart and yet intimately connected. Within the setting of Lichtenstein's artist's studio—note the paintbrushes, tube of paint, and still-life objects on the table—we observe his own version of Matisse's *The Dance*. What you might note right away about the Lichtenstein painting is its cartoonlike appearance, and with good reason. The artist found the visual language of the cartoon strip "forceful and vital" and applied it to his own paintings, sculptures, and ceramics. A mass-media cartoon style of clean lines, clearcut shapes, areas of solid black and white and flat primary colors, and shorthand shading techniques characterize *The Artist's Studio*. For his use of a popular, cartoon-based artistic language and for his witty play upon masterworks of the past like Matisse's *The Dance*, Lichtenstein is considered an artistic founder of the contemporary direction known as "postmodernism." His way of seeing and representing is at one with our age of mechanical reproduction, commercial culture, and mass media.

Henri Matisse, in contrast, was a leader of "modernism," the art movement that dominated the first half of the twentieth century. Modernism emphasized a humanistic and individualistic abstract art. Far less comfortable with the mass media, mechanical reproduction, and the industrial age, Matisse's paintings, drawings, and sculptures pulse with modernist values such as personal self-expression and creativity. His painting *The Dance* looks a bit childlike, even primitive, a combination of clumsiness, innocence, and grace. The five nude female figures are highly simplified, flattened, and abstracted as are the green ground and blue background—all stylized in his own special way. But the women are drawn from life, not from Lichtenstein's world of mass-media cartoon language and style. Matisse carefully studied actual dancers and human models in these poses to capture the essence of their movements. One senses his trial-and-error struggle to delineate the circling women, dancers of an idyllic, imagined realm, a kind of Arcadia or Garden of Eden far from the industrial present. The final results is a work that has a very subjective and handmade quality—one can see Matisse's brushstrokes and erasures—based on an artist's direct observation and creative transformation of his human models.

To learn more about Henri Matisse and Roy Lichtenstein, modernism and postmodernism, and their sociocultural contexts, consult Chapters 17 and 19.

RESPONDING to ART
Form, Content, and Context

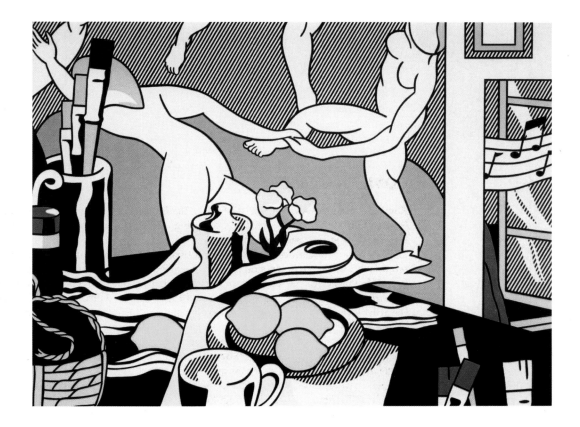

ROBERT BERSSON
James Madison University

McGraw Hill

Boston Burr Ridge, IL Dubuque, IA Madison, WI New York San Francisco St. Louis
Bangkok Bogotá Caracas Kuala Lumpur Lisbon London Madrid Mexico City
Milan Montreal New Delhi Santiago Seoul Singapore Sydney Taipei Toronto

In honor of my wife, Dolores Shoup, and my stepsons, Jordan and Silas

The **McGraw·Hill** Companies

McGraw Hill **Higher Education**

Responding to Art: Form, Content, and Context

Published by McGraw-Hill, an imprint of The McGraw-Hill Companies, Inc., 1221 Avenue of the Americas, New York, NY 10020. Copyright © 2004 by McGraw-Hill. All rights reserved. No part of this publication may be reproduced or distributed in any form or by any means, or stored in a database or retrieval system, without the prior written consent of The McGraw-Hill Companies, Inc., including, but not limited to, in any network or other electronic storage or transmission, or broadcast for distance learning.

This book is printed on acid-free paper.

1 2 3 4 5 6 7 8 9 0 DOW/DOW 0 9 8 7 6 5 4 3
ISBN 0-697-25819-X

Publisher: Chris Freitag
Senior sponsoring editor: Joe Hanson
Editorial assistant: Torrii Yamada
Marketing manager: Lisa Berry
Field publisher: Zina Craft
Senior project manager: Christina Gimlin
Senior production supervisor: Richard DeVitto
Development editor: Margaret Manos
Media producer: Shannon Gattens
Design coordinator: Jean Mailander
Art editor: Emma Ghiselli
Interior designer: Susan Breitbard
Cover designer: Joan Greenfield
Senior photo research coordinator: Nora Agbayani
Photo researcher: Robin Sand
Senior supplement producer: Louis Swaim
Compositor: GTS Graphics
Printer: RR Donnelley-Willard

Library of Congress Cataloging-in-Publication Data

Bersson, Robert.
 Responding to art: form, content, and context / Robert Bersson—1st ed.
 p. cm.
 Includes index.
 ISBN 0-697-25819-X (alk. paper)
 1. Art appreciation—Study and teaching (Higher)—United States. I. Title.

N346.A1B47 2003
701'.18—dc21
 2002045211

www.mhhe.com

Preface

Art surrounds us. If we take the trouble to look, we see the hand and mind of the artist in the architectural and interior design of the rooms we sit in as well as the design of the chairs we sit on. Paintings, prints, posters, photographs, video, and computer images fill our fields of vision. Artistic masterpieces from other times and cultures come to us through museum exhibitions and through films, television programs, textbooks, and even magazine advertisements. All of these art forms, in subtle or overt ways, influence our lives. Wherever we look—or don't look—in a world dominated by the eye, thousands of visual experiences affect us. To an extent that most of us would be hesitant to acknowledge, we *are* what we see.

Responding to Art focuses on significant components of our visual culture, from the objects of functional and mass-media art that pervade our daily lives to the creations of painters, sculptors, craftspersons, and designers whose work has earned the prestigious label of fine art. Like most introductory texts, *Responding to Art* focuses principally on fine art but treats it in a more "real life" way. Fine art is seen as a living force that influences and is influenced by the applied and mass-media arts. The form and content of modern advertising, for example, are viewed in *Responding to Art* as directly related to the five-hundred-year-old European tradition of oil painting; at the same time, the influence of advertising and commercial culture is noted in the work of contemporary pop and new realist artists.

EDUCATIONAL PHILOSOPHY AND PEDAGOGY

Responding to Art is specifically designed to excite and interest undergraduate students with minimal knowledge of art and limited confidence in responding to it. To this end, the book starts at the students' introductory level and sets out to stimulate their active participation. From the onset, *Responding to Art* introduces art and design forms that the students are already familiar with and have some interest in. These forms include campus architecture, CD album covers, magazine advertisements, Internet Web sites, fashion styles, crafts, and product design. In addition, *Responding* engages students and builds their confidence by incorporating into the chapters reactions and responses to art by introductory-level students like themselves. This sends an immediate message that their own thoughts and feelings are valid, valued, and diverse. With expanded interest, confidence, and knowledge, students are prepared for more challenging art forms, information, and concepts.

A COMPREHENSIVE APPROACH TO RESPONDING TO ART

Central to *Responding to Art* is its thoroughgoing application of a "comprehensive" process of appreciating art that combines formalist and contextualist approaches. The formalist way of responding emphasizes the formal or intrinsic

visual qualities—the line, color, shape, and composition—of a work. The contextual way of responding, in complementary relationship, sees the form and subject matter of art in terms of its sociocultural background—the creation of a particular artist, group, culture, and society. We respond to works of art as both visual form *and* sociocultural meaning, as befits their rich complexity.

ORGANIZATION OF THE TEXT

Laying down a solid foundation on which to build, the book's first four chapters are devoted to learning the process of appreciation and becoming aware of form and meaning in a wide range of artistic works. After becoming acquainted in Part One with the process of appreciation, concepts of art, the visual art elements, and principles of composition, the reader is introduced to the multifaceted worlds of art that are the subject of Parts Two, Three, and Four. Part Two features the two-dimensional arts: drawing and painting, graphic art and design, photography and moving pictures. Part Three examines the three-dimensional arts: sculpture, crafts and product design, architecture and the constructed environment. The text then proceeds in Part Four to an art historical survey, a chronological overview that begins with our prehistoric hunter-gatherer ancestors and concludes in our own computer age.

CULTURAL DIVERSITY AND INCLUSIVENESS IN CONTENT

Responding to Art covers well-known artworks by women and men of the Western tradition while, at the same time, giving significant attention to the creative production of artists of diverse cultural backgrounds and worldwide heritage. Coverage of a broad range of visual art and culture is a distinguishing feature of the book.

EDUCATIONAL FEATURES

In keeping with the text's general goals of diversity, inclusiveness, and active learning, a number of special features play a key role.

Appreciation Essays

Written by artists, designers, historians, critics, educators, and others, the Appreciation Essays are one to two pages in length and appear throughout the book, two per chapter. Their focus is generally a single work of art. These "Appreciations" help the reader focus on a given work and, perhaps more importantly, to experience other voices and viewpoints and ways of responding that often differ from those of the author. The essays support the central pedagogical principle that there are multiple ways to respond meaningfully to works of art.

Critical Thinking Captions

One to two sentences long and incorporated into illustration captions, the Critical Thinking Captions provoke reflective thought and questioning by posing questions and reinforcing ideas about formal and/or contextual matters from the main text itself.

The Visual Elements **25**

2.6 GIOTTO. *The Lamentation.* 1305–6. Fresco. 91 × 93 in. Arena Chapel, Padua. *To our eyes, Giotto's paintings do not look very realistic or true to life, but in his day Giotto was considered to be a groundbreaking master of realistic imitation. His contemporaries were astonished by how accurately he drew and painted people and their surroundings. Later masters of realistic depiction such as Leonardo da Vinci (2.18) honored Giotto as a forefather. To fully appreciate artists, is it important to know how their contemporaries viewed them?*

Types of Line A line that describes the outline, borders, or edges of an object is called a **contour line.** To draw or paint such a line requires very careful observation, because it must capture the thickness as well as the height and width of the form it surrounds. Contour lines in *The All-Night Café* (2.1) delineate the boundaries of chairs and tables, people, and the room itself. Their descriptive function aside, each artist's contour line is distinct. Van Gogh's contour lines in *The All-Night Café* are thick, heavy, and strong. Those of Ellsworth Kelly (born 1923) in *Apples* (2.4) are uniformly thin, simple, and direct. In contrast to Kelly's spare, understated lines, those of Katsushika Hokusai (1760–1849) are active and exciting (2.5). Hokusai's flamboyant, gracefully curving contour lines, varying from light to dark and thick to thin, capture the appearance and the energetic movement of a young Japanese woman.

While contour lines are usually associated with drawings or paintings, we can perceive them in sculptures, buildings, and other three-dimensional objects. When we speak of a city's "skyline," we are creating in our mind a kind of contour line formed by the edges of the buildings against the background of the sky. When we say that a dress, a suit, a sculpture, or an automobile has a certain "line," we are envisioning the overall shape of that object in terms of its contours.

Lines that we ourselves project are called **implied lines.** In works of art, implied lines are not drawn or painted by the artist but are created by the viewer's own perception. In *The Lamentation* (2.6) by the Italian artist Giotto (ca. 1266–1337), we observe an implied line where the sky meets the rocky ridge. We are the ones projecting this "horizon line" where atmosphere meets earth. In works of art, implied

When a dot begins to move and becomes a line, this requires time. —Paul Klee, artist, "Creative Credo," 1920

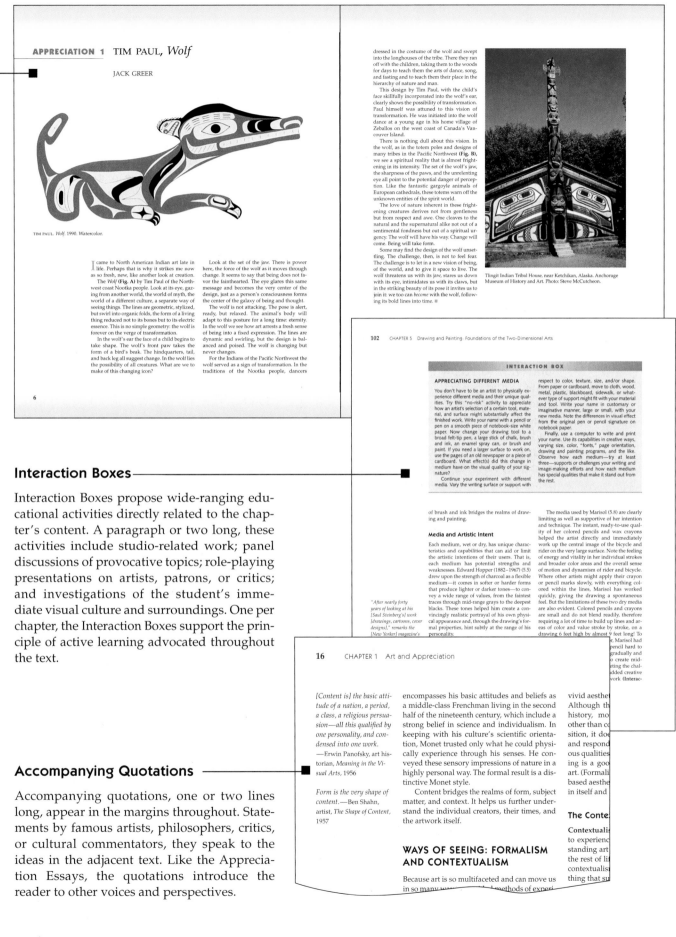

APPRECIATION 1 TIM PAUL, *Wolf*

JACK GREER

TIM PAUL. *Wolf.* 1990. Watercolor.

I came to North American Indian art late in life. Perhaps that is why it strikes me now as so fresh, new, like another look at creation.

The *Wolf* (**Fig. A**) by Tim Paul of the Northwest coast Nootka people. Look at its eye, gazing from another world, the world of myth, the world of a different culture, a separate way of seeing things. The lines are geometric, stylized, but swirl into organic folds, the form of a living thing reduced not to its bones but to its electric essence. This is no simple geometry: the wolf is forever on the verge of transformation.

In the wolf's ear the face of a child begins to take shape. The wolf's front paw takes the form of a bird's beak. The hindquarters, tail, and back leg all suggest change. In the wolf lies the possibility of all creatures. What are we to make of this changing icon?

Look at the set of the jaw. There is power here, the force of the wolf as it moves through change. It seems to say that being does not favor the fainthearted. The eye glares this same message and becomes the very center of the design, just as a person's consciousness forms the center of the galaxy of being and thought.

The wolf is not attacking. The pose is alert, ready, but relaxed. The animal's body will adapt to this posture for a long time: eternity. In the wolf we see how art arrests a fresh sense of being into a fixed moment. The lines are dynamic and swirling, but the design is balanced and poised. The wolf is changing but never changes.

For the Indians of the Pacific Northwest the wolf served as a sign of transformation. In the traditions of the Nootka people, dancers

dressed in the costume of the wolf and swept into the longhouses of the tribe. There they ran off with the children, taking them to the woods for days to teach them the arts of dance, song, and fasting and to teach them their place in the hierarchy of nature and man.

This design by Tim Paul, with the child's face skillfully incorporated into the wolf's ear, clearly shows the possibility of transformation. Paul himself was attuned to this vision of transformation. He was initiated into the wolf dance at a young age in his home village of Zeballos on the west coast of Canada's Vancouver Island.

There is nothing dull about this vision. In the wolf, as in the totem poles and designs of many tribes in the Pacific Northwest (**Fig. B**), we see a spiritual reality that is almost frightening in its intensity. The set of the wolf's jaw, the sharpness of the paws, and the unrelenting eye all point to the potential danger of perception. Like the fantastic gargoyle animals of European cathedrals, these totems warn off the unknown entities of the spirit world.

The love of nature inherent in these frightening creatures derives not from gentleness but from respect and awe. One cleaves to the natural and the supernatural alike not out of a sentimental fondness but out of a spiritual urgency. The wolf will have its way. Change will come. Being will take form.

Some may find the design of the wolf unsettling. The challenge, then, is not to feel fear. The challenge is to let in a new vision of being, of the world, and to give it space to live. The wolf threatens us with its jaw, stares us down with its eye, intimidates us with its claws, but in the striking beauty of its pose it invites us to join in: we too can *become* with the wolf, following its bold lines into time.

Tlingit Indian Tribal House, near Ketchikan, Alaska. Anchorage Museum of History and Art. Photo: Steve McCutcheon.

6

102 CHAPTER 5 Drawing and Painting: Foundations of the Two-Dimensional Arts

INTERACTION BOX

APPRECIATING DIFFERENT MEDIA

You don't have to be an artist to physically experience different media and their unique qualities. Try this "no-risk" activity to appreciate how an artist's selection of a certain tool, material, and surface might substantially affect the finished work. Write your name with a pencil or pen on a smooth piece of notebook-size white paper. Now change your drawing tool to a broad felt-tip pen, a large stick of chalk, brush and ink, an enamel spray can, or brush and paint. If you need a larger surface to work on, use the pages of an old newspaper or a piece of cardboard. What effect(s) did this change in medium have on the visual quality of your signature?

Continue your experiment with different media. Vary the writing surface or support with

respect to color, texture, size, and/or shape. From paper or cardboard, move to cloth, wood, metal, plastic, blackboard, sidewalk, or whatever type of support might fit with your material and tool. Write your name in customary or imaginative manner, large or small, with your new media. Note the differences in visual effect from the original pen or pencil signature on notebook paper.

Finally, use a computer to write and print your name. Use its capabilities in creative ways, varying size, color, "fonts," page orientation, drawing and painting programs, and the like. Observe how each medium—try at least three—supports or challenges your writing and image-making efforts and how each medium has special qualities that make it stand out from the rest.

of brush and ink bridges the realms of drawing and painting.

Media and Artistic Intent

Each medium, wet or dry, has unique characteristics and capabilities that can aid or limit the artistic intentions of their users. That is, each medium has potential strengths and weaknesses. Edward Hopper (1882–1967) (5.5) drew upon the strength of charcoal as a flexible medium—it comes in softer or harder forms that produce lighter or darker tones—to convey a wide range of values, from the faintest traces through mid-range grays to the deepest blacks. These tones helped him create a convincingly realistic portrayal of his own physical appearance and, through the drawing's formal properties, hint subtly at the range of his personality.

"After nearly forty years of looking at his [Saul Steinberg's] work [drawings, cartoons, cover designs]," remarks the [New Yorker] magazine's

The media used by Marisol (5.8) are clearly limiting as well as supportive of her intention and technique. The instant, ready-to-use quality of her colored pencils and wax crayons helped the artist directly and immediately work up the central image of the bicycle and rider on the very large surface. Note the feeling of energy and vitality her individual strokes and broader color areas and the overall sense of motion and dynamism of rider and bicycle. Where other artists might apply their crayon or pencil marks slowly, with everything colored within the lines, Marisol has worked quickly, giving the drawing a spontaneous feel. But the limitations of these two dry media are also evident. Colored pencils and crayons are small and do not blend readily, therefore requiring a lot of time to build up lines and areas of color and value stroke by stroke, on a drawing 6 feet high by almost 9 feet long! To [...], Marisol had [...] pencil hard to [...] gradually and [...] create mid-[...]ting the chal-[...]dded creative [...] work (**Interac-**

16 CHAPTER 1 Art and Appreciation

[Content is] the basic attitude of a nation, a period, a class, a religious persuasion—all this qualified by one personality, and condensed into one work.
—Erwin Panofsky, art historian, *Meaning in the Visual Arts*, 1956

Form is the very shape of content.—Ben Shahn, artist, *The Shape of Content*, 1957

encompasses his basic attitudes and beliefs as a middle-class Frenchman living in the second half of the nineteenth century, which include a strong belief in science and individualism. In keeping with his culture's scientific orientation, Monet trusted only what he could physically experience through his senses. He conveyed these sensory impressions of nature in a highly personal way. The formal result is a distinctive Monet style.

Content bridges the realms of form, subject matter, and context. It helps us further understand the individual creators, their times, and the artwork itself.

WAYS OF SEEING: FORMALISM AND CONTEXTUALISM

Because art is so multifaceted and can move us in so many [...]

vivid aesthe[...]
Although th[...]
history, mo[...]
other than c[...]
sition, it doe[...]
and respond[...]
ous qualities[...]
ing is a goo[...]
art. (Formali[...]
based aesthe[...]
in itself and [...]

The Conte[...]

Contextuali[...]
to experience[...]
standing art[...]
the rest of li[...]
contextualis[...]
thing that su[...]

Interaction Boxes

Interaction Boxes propose wide-ranging educational activities directly related to the chapter's content. A paragraph or two long, these activities include studio-related work; panel discussions of provocative topics; role-playing presentations on artists, patrons, or critics; and investigations of the student's immediate visual culture and surroundings. One per chapter, the Interaction Boxes support the principle of active learning advocated throughout the text.

Accompanying Quotations

Accompanying quotations, one or two lines long, appear in the margins throughout. Statements by famous artists, philosophers, critics, or cultural commentators, they speak to the ideas in the adjacent text. Like the Appreciation Essays, the quotations introduce the reader to other voices and perspectives.

Technique Boxes

Technique Boxes introduce technical information on specific artmaking processes from woodblock printing to digital photography. These boxes are used in chapters where additional technical explanation is necessary to clarify and amplify the main text.

Writing Appendix

The writing appendix guides students through the writing and research process, both how to write an interpretive art criticism essay and an art history research paper. Examples from the body of the text are examined, and students are provided with models of effective writing.

Maps, Timelines, Glossary, Index

As the art historical narrative in Part Four guides readers across continents and millennia, accurate maps become an essential educational aid, enabling the reader to locate the social, cultural, and artistic realms of which we speak. Equally important in the art history chapters, well-designed timelines help readers to situate artistic masterworks and their sociocultural worlds in the chronological progression of millennia, centuries, and decades. In the final pages of the text, a substantial glossary features clear definitions of key terms which appear in **bold** when they are first introduced. A comprehensive index provides an invaluable reference tool, quickly steering readers to the page references for the particular artist, artwork, or topic they are seeking.

Illustrations

The educational value of high-quality color and black-and-white illustrations cannot be overestimated. *Responding to Art* contains over 700 images, most of them in color. Every effort has been made to obtain the best possible transparencies, and we have reviewed and color-corrected each image during the production process to ensure that the reproductions are as faithful to the originals as human perception and contemporary printing technologies allow.

The Modern Period: The Rise of the Mass Media **133**

TECHNIQUE BOX 6-D

AQUATINT

According to *The Dictionary of Art Terms and Techniques*, the name *aquatint* derives from the resemblance of prints made by this method to drawings brushed over with watercolor washes. In **aquatint**, a copper or zinc plate is dusted with a fine layer of powdered rosin (a resin obtained from certain species of pine trees). The plate is carefully warmed to fuse the rosin to the metal so that when the plate is placed in an acid bath the acid eats around each minute spot of acid-resistant dust. This produces in the plate a series of fine pits that, when inked, print as a uniformly translucent, grainy tone. Varied tones are produced by **stopping out**, that is, resisting the corrosive effect of the acid that naturally bites away the metal from the plate.

In black-and-white printmaking, the technique of aquatint is rarely used alone. It is more commonly mixed with one or more other methods. Usually, the plate is first given a grained surface with aquatint. Then it may be either incised by line engraving or drypoint or covered again with an etching ground and etched. The majority of Goya's graphics (6.5) are made in aquatint with etched and/or drypoint lines.

TECHNIQUE BOX 6-E

LITHOGRAPHY

Invented in the late eighteenth century, by the mid-nineteenth century lithography was the most widely used method of reproducing imagery in journals, newspapers, books, and posters. Daumier's *The Legislative Paunch* (6.6) and *Murder in the Rue Transnonain* (6.7) and Kollwitz's *Hamm* (Appreciation 12) have the quality of crayon drawings, with great richness in the blacks and grays. Examples of posters done in color through lithography are posters by Toulouse-Lautrec (6.9), Mucha (6.15), and Bradley (6.16).

Lithography (*lith* means "stone"; *graph* means "writing" or "drawing") differs from the other printmaking techniques in that the printing is done from a flat surface. Lithography depends not on differences in surface elevation, that is, raised or indented surfaces, but on the simple principle that grease and water do not mix. The artist draws the images with a greasy crayon, or paints with a greasy solution, the image areas on a lithographic stone. The images on the lithographic stone (or a metal plate) are chemically treated to accept ink and repel water; the "nonimage" areas are treated to repel ink and retain water. The stone and paper are then pressed together, producing the lithograph. Because the stone does not wear away during the printing process, an almost unlimited number of prints can be taken from it. A later variation on the process is **photolithography**, a technique for producing an image on a lithographic stone or plate by photographic means.

THE MODERN PERIOD: THE RISE OF THE MASS MEDIA

The modern world was born in the late eighteenth and early nineteenth centuries, with the Industrial Revolution and political revolutions seeking democracy in Europe and America. The quest for life, liberty, and property was accompanied by the equally revolutionary ascent of capitalist free-market economics, with the commercial middle class rising forcefully to the head of society. Factories proliferated, and cities swelled in population. A new industrial laboring class, the proletariat, rallied for decent living and working conditions and adequate wages. For members of this class, socialist working-class ideals became the order of the day.

The modern mass media emerged in the mid-1800s out of this context of dynamic change and class conflict. They arose to meet the needs of—and cash in on—an increasingly large urban population hungry for information and entertainment. Daily and weekly

Any understanding of social and cultural change is impossible without a knowledge of the way media work as [total] environments. —Marshall McLuhan, communications theorist, *The Medium Is the Massage*, 1967

5 Drawing and Painting

FOUNDATIONS OF THE
TWO-DIMENSIONAL ARTS

40 CHAPTER 2 The Language of Form: The Visual Elements

2.22 LEONARDO DA VINCI. *Ginevra de' Benci*. ca. 1474. Oil on panel. 15 × 14⅜ in. Ailsa Mellon Bruce Fund. Photograph © 2002 Board of Trustees, National Gallery of Art, Washington, D.C. 1967.6.1 a(2326)/PA.

2.23 *Mwash a mbooy* mask. Kuba, Zaïre. Cloth, cowries, beads, feathers, fibre. 15¾ in. Musée Royal de l'Afrique Centrale, Tervuren. Photo courtesy Musée Royal de l'Afrique Centrale, Tervuren. The Kuba (or BaKuba) use a variety of masks for dances in religious and initiation ceremonies, burials, and other rituals. This helmet mask, called mwash a mbooy, is worn at initiation ceremonies... the cultural hero Woot, who originated Kuba...

STUDENT RESOURCES

Please note that the supplements listed here and below in **Support for Instructors** may accompany the text. Please contact your local McGraw-Hill representative for details concerning policies, prices, and availability as some restrictions may apply. If you are not sure of the name and address of your representative, you can find him or her by using the Rep Locator at www.mhhe.com.

The Basic Student Package

Free to students with every new text:
Responding to Art's Core Concepts in Art CD-ROM—offers students valuable study material on the key art elements and techniques. Elements such as line and color are visually illustrated and educationally reinforced through interactive exercises. Techniques are demonstrated and explained in substantial video segments.

Online Learning Center

www.mhhe.com/respondingtoart
McGraw-Hill offers extensive Web resources for students with Internet access. Students will find the Online Learning Center (OLC) of particular use with *Responding to Art*. For each chapter, the OLC provides chapter objectives, discussion questions, online quizzing, and interactive timelines. In addition, the OLC features links to promote further involvement in art experiences and in conducting Web research.

SUPPORT FOR INSTRUCTORS

Instructor's Resource Manual

McGraw-Hill offers an Instructor's Manual to all instructors who adopt *Responding to Art* for their courses. Practical and stimulating, the Instructor's Manual parallels *Responding to Art's* organization. It proceeds sequentially through the twenty chapters of the book. For each chapter, the Instructor's Manual offers:

1. The Leading Ideas
2. An Overview in Outline Form

3. Lecture and Discussion Topics
4. Teaching Ideas
5. Exam Questions (multiple choice, true/false, fill-in-the-blank, essay)
6. Educational and Multimedia Support Materials

Finally, the Instructor's Manual discusses the Writing Appendix, the Glossary, and the Index. Whether you are a new or veteran instructor, this particular Instructor's Manual might serve you well.

ACKNOWLEDGMENTS

Responding to Art is the collaborative product of hundreds of individuals and groups, all of whom deserve abundant praise. Without their substantial contributions this book would not be possible. First thanks go to the twenty-six writers whose original "appreciation essays" are featured in the book. Their names along with a brief biographical caption accompany their essays. Special appreciation likewise goes to four distinguished authors—Lucy Lippard, Josephine Withers, Wendy Slatkin, and Frima Fox Hofrichter—who allowed me to fashion appreciation essays from previously published materials. Other important writers whose contributions are quoted at length in the text are Steven Whitney, Eliot Cohen, M. E. Warlick, Sally Hagaman, Tom Anderson, Lavely Miller, Tricia Laughlin Bloom, William E. Harris, Margot Bergman, Mark Simon, Hal McWhinnie, Dorothy H. Ellis, and Marilyn Williams. Finally, deep appreciation goes to those students—Jessica Wright, Emily Horan, Andrew Bush, Jeff Lupardo, Liz Monseur, Sally Nash, Ge Baas, George Morris, Leah Berkowitz, Jay Menapace, Shannon LeGros, Devon Filas, Colleen Yancey, and Heidi Hartman—whose journal or essay excerpts appear throughout the text. All of these women and men, young and old, are truly co-authors of *Responding to Art.*

The unsung heroes of this book, the people behind the scenes, begin with the McGraw-Hill staff members who worked so hard day in and day out to make this a text of the highest quality. Joe Hanson, Torrii Yamada, Margaret Manos, Christina Gimlin, Robin Sand, Nora Agbayani, Jean Mailander, Emma Ghiselli, Lisa Berry, and Chris Freitag, you've been great! The same heartfelt appreciation goes to my ever supportive colleagues at James Madison University, and the members of those local and national groups who have served as my ongoing educators and motivators: Citizens for Downtown, CHANGE, Common Ground, the Alliance for Cultural Democracy, and the Caucus on Social Theory and Art Education.

A number of photographers created original images especially for *Responding to Art.* I offer Vada Kelley, Molly Chassman, Nathan Combs, and especially Patrick Horst my sincerest gratitude. This book is truly a tapestry, the creation of many minds, eyes, voices, and hands.

Last but certainly not least, there are the reviewers, including classics scholar Michael Allain, whose thoughtful criticism served to consistently improve the conceptual, factual, and literary dimensions of the text. My deep appreciation extends to them.

A. D. Macklin, Jackson State University
Carlos Gomez, University of Texas, Brownsville
David R. Kamm, Luther College
David E. Pactor, Visual and Performing Arts
Deborah Cibelli, Nicholls State University
Diane H. Elmeer, University of South Florida
George S. Anderson, Miami-Dade Community College
Gina Moore, Benedict College
Gregory Reimen, Southeastern Oklahoma State University
Helaine McLain, Northern Arizona University
H. J. Wassell, Colorado State University
Ivy Schroeder, Southern Illinois University
James G. Farrow, Macomb Community College
M. Jason Knapp, Anderson University
Jenny C. McIntosh, Elizabeth City State University
Marleen Hoover, San Antonio College
Michael Stone, Cuyahoga Community College
Nancy Hemmingson, Central Michigan University
Patrizia Fritsch Provenzano, University of Wisconsin, Oshkosh
Paul Solomon, Western Michigan University
Roderic A. Taylor, Norfolk State University
Ruth Pettigrew, Colorado State University
Susan Smallwood Herold, University of Northern Colorado
Thomas Patin, Ohio University
Meredith Rode, University of the District of Columbia
Kathryn E. Kramer, Purdue University
Ann Marie Malloy, Tulsa Junior College
April Claggett, SUNY-Cortland
Larry Schwarm, Emporia State University
Elizabeth Tebow, Northern Virginia Community College
Jeanne Hokin, Arizona State University
Suzanne Duvall Zurinsky, University of Northern Arizona

Contents in Brief

Contents

PART TWO

THE TWO-DIMENSIONAL ARTS 95

PART THREE

THE THREE-DIMENSIONAL ARTS 197

PART FOUR

A HISTORY OF ART 311

THE PROCESS OF APPRECIATION

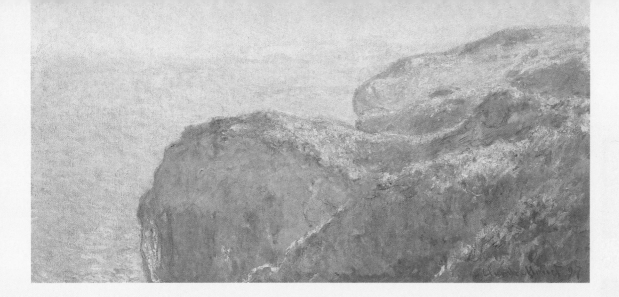

1

Art and Appreciation

L ook around you. Do you see art in your immediate surroundings? What qualities determine that certain things are art? Definitions of art vary widely, but most tend to fall within general notions developed over the centuries.

WHAT IS ART?

The technical ability of an ancient Egyptian potter to produce a well-made clay vessel defined his "art" **(1.1).** By extension, the ceramic pot itself, the product of such skillful execution, also qualified as art. In Europe 600 years ago, all the trade and professional associations, from shoemaking to banking, still held to this broad definition of art as skill or craft in a particular field. In Italy these organizations were actually called "arts," in German lands "craft" guilds. Builders of furniture, weavers of cloth, and workers in stone **(1.2)** were called artisans or craftsmen. They mastered traditional skills and followed professional rules set down by their trade associations. The current popular notion of the artist as the creator and definer of art—put simply, "Art is what artists create"—is a relatively recent concept. The social and professional role of the artist, and the identification of his or her works as art, began to develop about six centuries ago out of the ancient artisan

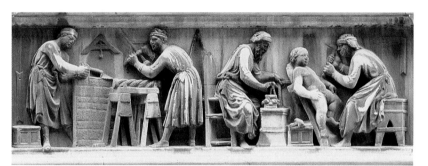

1.1 *Egyptian Potter,* from Giza. Ca. 3000 B.C.E. Limestone carving. Courtesy of the Oriental Institute of the University of Chicago. *The work of an Egyptian artisan from 5000 years ago exemplifies the definition of art as skill or craft. The unknown craftsman employs a mechanical device, the potter's wheel, to form a useful, durable ceramic pot. Would you consider this potter an artist?*

1.2 NANNI DI BANCO. *Sculptor's Workshop.* 1408–14. Marble relief. Or San Michele, Florence, predella. *This Italian stone carver's or sculptor's* bottega *of the beginning of the fifteenth century shows various types of stonework done at the workshop. From left to right, the artisans build a wall, carve a column or molding, and create a statue. They are largely anonymous workers who follow trade association rules and regulations in the production of well-made, useful products. But some, like Nanni Di Banco, the sculptor who completed this work in 1414, are considered to be the first artists. Their work is more self-guided and shows a more pronounced personal style than that of the typical artisan. To the present, we associate individualism and creativity with the production of artists.*

tradition. Today, an *artist* denotes a person whose creations embody technical skill as well as intellectual knowledge, inventiveness, and personal vision.

According to the ancient, encompassing definition of art as products and activities skillfully done, the finely made clothes you are wearing, the well-crafted chair you are sitting on, and the masterful athletic performance you watched the other day are considered art. So are mass-media forms such as compact disc covers, posters, magazine advertisements, music videos, and Internet Web sites **(1.3),** because all of these show human skill and technical ability. Paintings and sculptures in museums, churches, and palaces, those objects we commonly identify as art in our culture, likewise qualify under this broad definition.

Some items and activities in our environment, however, stand out from the rest. They are somehow more artistic, more "art" than other buildings, chairs, album covers, and athletic performances. Their appearance or **form,** that is, the way their line, color, shape, texture, and other visual elements combine to please the senses, is so satisfying or perfect that we call them beautiful. We apply this notion when we call a graceful bridge or majestic skyscraper "a beauty," a stellar basketball play

1.3 Qualcomm Web Site. www. qualcomm. com. *The visually appealing Qualcomm Web site required technical skill to create. Do you consider it a work of art? Why or why not?*

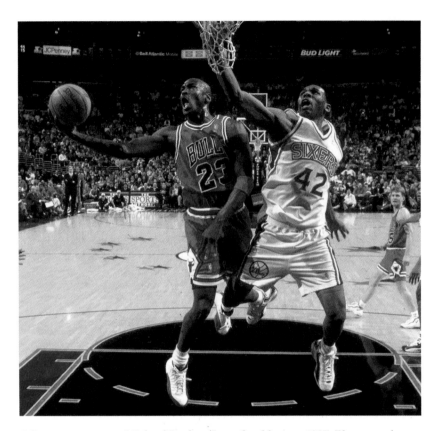

1.4 AL TIELEMANS. Michael Jordan/Jerry Stackhouse. 1997. Photograph. *Michael Jordan is one of the greatest basketball players of all time. Jerry Stackhouse is a current superstar. Their performances exhibit grace and beauty in addition to technical skill. Al Tielemans' photograph of the two in action shows technical mastery along with a dramatic composition that centers and highlights the pair against a colorful background. Do you think of Jordan, Stackhouse, and Tielemans as artists? Any of them? All of them?*

To define beauty . . . is the aim of the true student of aesthetics.—Walter Pater, writer, *The Renaissance*, 1873

Aesthetic theory is a theory not of beauty but of art.—R. G. Collingwood, aesthetician, *Principles of Art*, 1938

"beautiful," and the stunning photograph of the player "a work of art" **(1.4).**

Prior to the twentieth century, most aestheticians, or philosophers of art, believed that beauty was the central defining feature of art. **Aesthetics,** the philosophy of art, centered on the study of the nature of art and beauty. By the turn of the twentieth century, however, some aestheticians had begun to find this identification of beauty with art insufficient. Some called the expression of emotion art's defining characteristic; others argued that the effective communication of feelings and ideas to the viewer defined art. One group of influential aesthetic theorists, the formalists, emphasized the unique effect of artistic form on the viewer. They hypothesized that an object or activity qualifies as art if its visual form is sufficiently compelling or inspiring or beauti-

ful to provoke an intensely felt, sensory-based response or aesthetic experience. This conception echoed the ancient Greek definition of aesthetic, meaning "of or pertaining to the senses" or "sensuous perception." (*Aesthetic's* opposite, *anaesthetic*—a term you probably know if you've ever been given a tranquilizer prior to dental work—means "without feeling or sensation.") You might think that aesthetic experiences are extremely rare. They are not. If you have ever felt yourself swept away in the sensuous experience of a sports event, a musical performance, a film, a sunset, or a painting of a sunset, you have had an aesthetic experience.

Look around again. How much of your surroundings do you consider visually captivating or beautiful, expressive or communicative? Do any objects in your field of vision provoke an aesthetic experience? Do you consider these things art? Is it skill, beauty, expression, communication, compelling form, aesthetic experience, or all of the above that make these art for you? Or is it some quality not mentioned here, such as originality or creativity, that makes these objects or activities stand out as art? Might a change in setting or context more fully establish your selections as art? If it were moved into the impressive surroundings of an art museum, would a sports photo or CD cover become more fully art in your eyes? According to aesthetician George Dickie's "institutional theory of art," major art institutions such as museums determine what is and is not art in a given culture.

As you can see, art has been defined in a variety of ways. Given this diversity of definitions, many contemporary aestheticians conclude that there can be no single, fixed definition of art. Instead, they subscribe to the notion of art as a concept that evolves as we and the artwork of our period change. Your own concept of art might build upon the definitions of the past, but it will also be influenced by those of the present and changed by the art and ideas of the future. From this array of possibilities, you yourself will ultimately determine, like an aesthetician, your definition or concept of art.

While aestheticians are concerned with the general nature of art, critics tend to focus on specific artworks. A **critic** analyzes the qualities of specific artworks, interprets their mean-

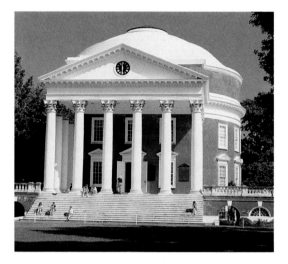

1.5 THOMAS JEFFERSON. Rotunda, University of Virginia, Charlottesville. 1817–26.

ing, and judges their artistic success or failure. When you and your friends discuss what you think a movie is about, why a poster makes you feel a certain way, or why you prefer one musical performance or CD cover to another, you are engaged in a basic form of criticism. Look at the buildings on your college campus **(1.5)**. What makes one more beautiful, aesthetically moving, or meaningful than another? Is it the building's exciting visual design, or its historical character? What does the building mean to the campus community? Does it communicate power and authority, or a welcoming warmth? Note how quickly observations, interpretations, and judgments on our visual surroundings transport us to the world of art, aesthetics, and criticism!

Art historians add to our understanding of the nature of art. Art history studies works of art in relation to the individuals, groups, societies, and cultures that created them. It also examines works of art in relation to other works of art across time and history. Art historians often begin their fact-finding inquiry with a work's **subject,** or what it depicts, whether it's an Egyptian artisan (1.1), a professional basketball game (1.4), a North American corporation (1.3), or a state-sponsored university (1.5). Who was this person? What was this institution? They also ask questions such as when and where, how and why, and by whom and for whom the work was created. What was the

artwork's function or intention? How did it express or reflect the beliefs and values of its particular culture and society?

EXPERIENCING ART

A Range of Possibilities

Just as there have been divergent conceptions of art across time periods, cultures, and disciplines, so have there been different experiences of art. We might experience art from the specialized vantage point of the art historian, aesthetician, art critic, artist, or artisan. Adopting the art historian's perspective, we might look for factual information and intellectual knowledge through art historical study. Like a formalist aesthetician, we might choose enlivening aesthetic experience by responding primarily through our senses and feelings to a given artwork's formal properties. Following the artisan's lead, we might focus our attention and enjoyment on evidence of refined skill or tradition-based technical mastery. Or, like most educated viewers, we might blend these specialized modes of experiencing art into an individualized approach in keeping with our personality, background, and interests. In mining the richness and complexity of artworks, various ways of seeing are essential. Your own enjoyment and understanding—your appreciation of art—will steadily expand and deepen as you learn to experience works of art in a multiplicity of ways.

The contributors to this book, whether artists or historians, professionals or laypersons, respond to and experience art in distinctive ways. Some of their experiences are primarily sensory and emotional; others are intellectual. Some interlace emotion, intellect, and sense. This diversity of experience stems from differences in area of specialization, way of seeing, cultural background, and individual personality. Furthermore, the particular artwork being considered—an idyllic college campus (1.5), a dynamic photograph (1.4), a well-designed advertisement (1.3), or a Native American painting of a wolf (**Appreciation 1**)—might inspire a particular response. Where and how we experience a work, that is, its setting (home, classroom, or museum), and format (the object itself or its presentation as a

What I am arguing, then, is that the very expansive, adventurous character of art, its ever present changes and novel creations, make it logically impossible to ensure any [fixed] set of defining properties.—Morris Weitz, aesthetician, "The Role of Theory in Aesthetics," 1956

JACK GREER

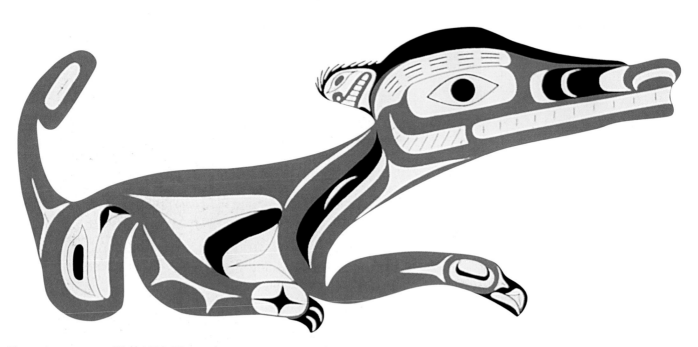

Figure A TIM PAUL. *Wolf*. 1990. Watercolor.

I came to North American Indian art late in life. Perhaps that is why it strikes me now as so fresh, new, like another look at creation.

The *Wolf* **(Fig. A)** by Tim Paul of the Northwest coast Nootka people. Look at its eye, gazing from another world, the world of myth, the world of a different culture, a separate way of seeing things. The lines are geometric, stylized, but swirl into organic folds, the form of a living thing reduced not to its bones but to its electric essence. This is no simple geometry: the wolf is forever on the verge of transformation.

In the wolf's ear the face of a child begins to take shape. The wolf's front paw takes the form of a bird's beak. The hindquarters, tail, and back leg all suggest change. In the wolf lies the possibility of all creatures. What are we to make of this changing icon?

Look at the set of the jaw. There is power here, the force of the wolf as it moves through change. It seems to say that being does not favor the fainthearted. The eye glares this same message and becomes the very center of the design, just as a person's consciousness forms the center of the galaxy of being and thought.

The wolf is not attacking. The pose is alert, ready, but relaxed. The animal's body will adapt to this posture for a long time: eternity. In the wolf we see how art arrests a fresh sense of being into a fixed expression. The lines are dynamic and swirling, but the design is balanced and poised. The wolf is changing but never changes.

For the Indians of the Pacific Northwest the wolf served as a sign of transformation. In the traditions of the Nootka people, dancers

dressed in the costume of the wolf and swept into the longhouses of the tribe. There they ran off with the children, taking them to the woods for days to teach them the arts of dance, song, and fasting and to teach them their place in the hierarchy of nature and man.

This design by Tim Paul, with the child's face skillfully incorporated into the wolf's ear, clearly shows the possibility of transformation. Paul himself was attuned to this vision of transformation. He was initiated into the wolf dance at a young age in his home village of Zeballos on the west coast of Canada's Vancouver Island.

There is nothing dull about this vision. In the wolf, as in the totem poles and designs of many tribes in the Pacific Northwest **(Fig. B),** we see a spiritual reality that is almost frightening in its intensity. The set of the wolf's jaw, the sharpness of the paws, and the unrelenting eye all point to the potential danger of perception. Like the fantastic gargoyle animals of European cathedrals, these totems warn off the unknown entities of the spirit world.

The love of nature inherent in these frightening creatures derives not from gentleness but from respect and awe. One cleaves to the natural and the supernatural alike not out of a sentimental fondness but out of a spiritual urgency. The wolf will have his way. Change will come. Being will take form.

Some may find the design of the wolf unsettling. The challenge, then, is not to feel fear. The challenge is to let in a new vision of being, of the world, and to give it space to live. The wolf threatens us with its jaw, stares us down with its eye, intimidates us with its claws, but in the striking beauty of its pose it invites us to join it: we too can *become* with the wolf, following its bold lines into time. ▬

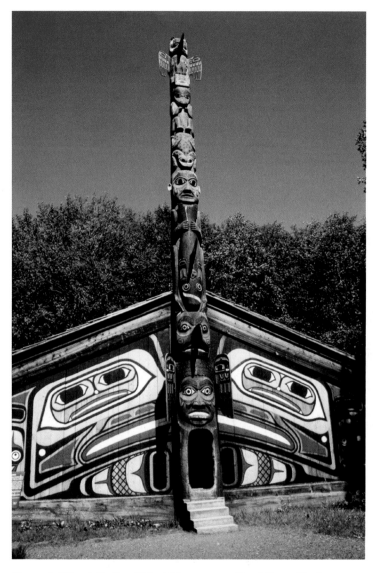

Figure B Tlingit Indian Tribal House, near Ketchikan, Alaska. Anchorage Museum of History and Art. Photo: Steve McCutcheon.

Jack Greer is a poet, fiction writer, and writer on environmental issues. He works for the Maryland Sea Grant College, a joint state and federal program concerned with the ecological well-being of the Chesapeake Bay.

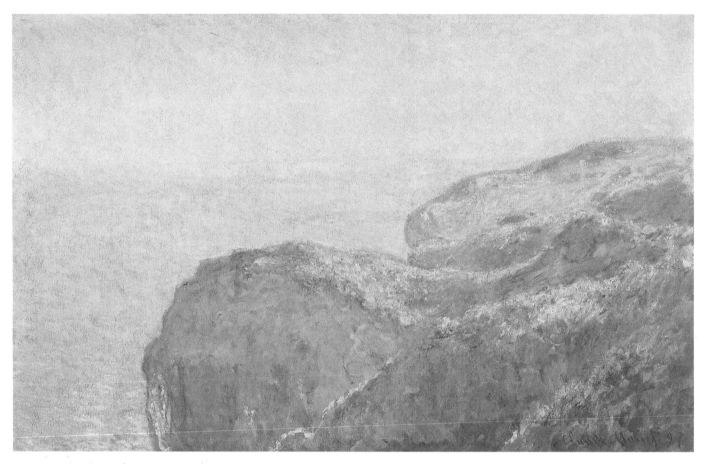

1.6 CLAUDE MONET.
On the Cliffs, Dieppe.
1897. Oil on canvas.
25½ × 39⅜ in.
Acquired 1959. The
Phillips Collection,
Washington, D.C.

*[A work of art is] a corner
of nature seen through a
temperament.*—Émile
Zola (1840–1902), art critic
and writer

print reproduction, slide or video projection, or computer image) further influence this experience. Certain artworks may transport us spiritually, fill us with cultural pride, or impel us into arenas of conflict and debate. The experience of art is an encounter marked by human variability. It joins a work of art, the product of a particular time and place, with a viewer unique in background, personality, values, and point of view. For these reasons, the possible range of art experiences is truly extraordinary.

Two Student Responses

Let us look at the reaction of two persons to two works of art. The first, an undergraduate student in an introduction to art course, wrote about her experience of *On the Cliffs, Dieppe* **(1.6)** by French artist Claude Monet (1840–1926). Her response shows a romantic sensibility and a poetic writing style.

> When my glance fell upon the painting I was suddenly transformed into the mist and cool-

ness and silent secret that is the sea. The ocean is calm; blue and green with touches of pink and purple. The sky is pale, paler than the ocean, and there is a hint of pink and yellow on the horizon. Perhaps in an hour the sky will be ablaze with sunset.

> There is a oneness, a unity among sky, rocks, and ocean. There are so many different colors and tiny, graceful brushstrokes that they cannot always be separated or distinguished. The cliffs in the background have almost merged with the ocean. Only at their summit is a contrast between earth and sky discernable.

> The artist has transported us to a world devoid of people or their influence. All we see is water, earth, and sky. And even these seem to want to merge with each other, share each other's identity, filling the eye of the beholder with the light which suffuses land, sea, and air.

Through the sunlit art of Monet, this student was transported and transformed. Drawn into a world distant in time and place, yet as vibrant as the day the artist painted it, the young woman experienced the seemingly

INTERACTION BOX

WRITING ABOUT ART

Writing just a paragraph or a page about a painting, photograph, or sculpture can significantly deepen one's experience of that work of art. Writing is to the viewer what sketching is to the artist: It gets us to look closely, think seriously, and focus our feelings on the art object. The process of writing can engage the imagination, emotions, thoughts, memories, and senses and concentrate all of these powers of thought and feeling in a singular act of appreciation. The undergraduate students' responses to the Monet painting (1.6) and the Reiss photograph (1.7) do just this. Whether you simply jot down observations in a journal or compose fully developed "reaction papers" as did the two students, writing can always enrich your experiences of works of art.

Careful observation is crucial to writing about any work of art. With artworks that immediately attract or repel you, writing down visual details about the subject matter and the appearance or form of the work will help you appreciate how and why these art objects stirred such a strong response. With artworks that do not interest you or that you cannot figure out, taking a closer look may illuminate the mystery or draw you into the drama of the work. Like a good detective, you should note how the various aspects of the work interact. Check out all the visual components of form and subject and see how they add up. The more you look at any artwork and write about it, the more you will appreciate and understand it.

To learn more about describing, analyzing, and interpreting works of art, consult the Appendix, Writing about Art.

timeless power of great art to move us. Her aesthetic experience of *On the Cliffs, Dieppe,* a heightened blend of sense, emotion, and thought, carried her to a more vital sense of nature and of herself. Her interaction with the painting led her to become, for a significant moment, more fully and vividly alive. Such experiences of art invariably become part of us, enriching our lives well into the future.

In an essay charged with social conscience, a second student wrote forcefully about an exhibition of photographs by award-winning artist Peter Reiss (born 1953). Reiss, an epileptic who suffered a stroke that paralyzed his right side, photographs the severely retarded and physically malformed, so often hidden from our view **(1.7).** In the conclusion of her paper, this deeply affected student wrote:

> Imagine a toothpaste commercial showing a child with overcrowded teeth and a hydrocephalic head as Reiss has done unabashedly. Imagine an advertisement with something other than beautiful, comfortable, or "normal" people. The kind of human beings Reiss celebrates will rarely be celebrated in pictures. It is easy to forget them as they spend their lives in beds or in institutions. Reiss is not repelled by their features or fragility; rather, he is attracted by their strength. Perhaps we should follow his example **[Interaction Box].**

1.7 PETER REISS. *Untitled.* 1982. Chromogenic color print, type C process. 14½ × 14½ in. © Peter Reiss.

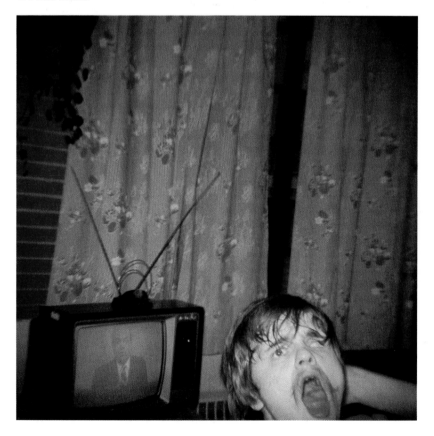

1.8 DIEGO RIVERA. *The Night of the Poor.* 1923–28. Mural. 81⅛ × 62⅝ in. Top floor, Secretariat of Education Building, Mexico City. *If you define art in terms of communication, is Diego Rivera's painting a successful work of art? Does it effectively communicate its story about the people and forces involved in the Mexican Revolution?*

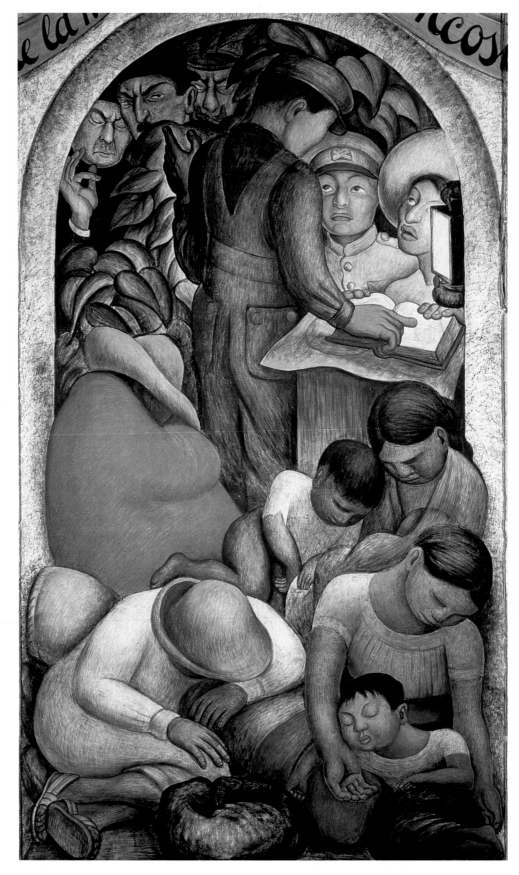

THE POWER OF ART

Expanding Our Awareness

One of art's most positive functions is the expansion of our awareness—personally, socially, politically, and culturally. *The Night of the Poor* **(1.8),** a mural by Mexican artist Diego Rivera (1886–1957), belongs to an artistic tradition that seeks to make visible the lives of those who are usually invisible: the "abnormal," the poor, the oppressed. Painted with a loving brush, Rivera's poor are penniless but noble, tired yet not without hope. A committed leftist in his politics, the artist bathes the sleeping poor in a warm light. Bent over her barefoot child, a mother holds out her hand for a bit of charity. In the shadows, men with bitter expressions, representing the upper-class forces of oppression, are kept at bay by a working-class partisan of the Mexican Revolution. Commanding the center, he helps the poor to rest, gather their strength, and progress. The poor are brought out of the darkness and into the light. The painting's message is clear: Mexico must check the oppressor and raise up the downtrodden.

Little-known experiences can reach the public consciousness through the forceful images of art. Artists working from an ethnic or a feminist perspective make us deeply aware of the diverse cultures that make up our world. African-American artist Hale Woodruff (1900–1980) painted a majestic mural series, *The Art of the Negro* **(Appreciation 2).** The first panel, *Native Forms* **(1.9),** presents a generalized selection from the wide-ranging art forms of ancient and traditional African cultures. Clockwise from the bottom right corner, we see ancient North African and South African rock paintings. Next we see a man using the sharp edge of a rock to draw on a stone surface. In the upper left corner are people (possibly members of the West African Igbo people) in ceremonial masks and costumes, then a sculpture of an orisha (a spirit) of the Yoruba people, and finally figures wearing masks from mixed traditions, including the Dogon of West Africa. These African spirit figures, masks, costumes, and rock drawings, which are used in community and family rituals, are examples of art tightly interwoven with everyday life. Such art forms speak to the range and varied purposes of art across cultures.

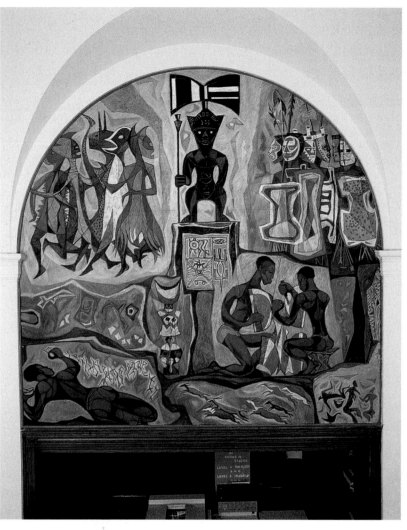

1.9 HALE WOODRUFF. *Native Forms* mural, panel one from *The Art of the Negro.* 1950–51. Oil on canvas. 12 × 12 ft. Courtesy Clark Atlanta University art galleries, Atlanta, Georgia.

The Dinner Party, an epic work by Judy Chicago (born 1934), includes a triangular table, a tiled floor, and thirty-nine place settings in praise of great, often underacknowledged women in history. The ceramic plate **(1.10)** dedicated to Sojourner Truth (1797–1883), the African-American abolitionist and feminist, emphasizes Truth's proud African heritage and her painful life in slavery. A highly decorated mask, symbolic of Africa, dominates the center of the plate. It joins the woman on the left, who weeps for the suffering of the slaves, with the bold, stylized figure on the right, who calls out powerfully for freedom and equality. The runner beneath, of strip-woven African patterns and triangular sections of printed fabric, honors the southern slave women who proudly pieced scraps of

APPRECIATION 2 HALE WOODRUFF, *Interchange* and *Dissipation* from *The Art of the Negro* Mural Series

EUGENE GRIGSBY, JR.

Hale Woodruff, although not widely known to the general public, was recognized by colleagues as a major artist, by students as a master teacher, and by friends and associates as a warm, friendly person with a ready smile and a willing handshake. Born in Cairo, Illinois, in 1900, Woodruff overcame poverty and racial discrimination to become a prominent figure in America's artistic and intellectual communities. The initial support of his mother, a domestic servant, and his own hard work and desire to become an artist boosted him in his climb to success as a painter and professor at Atlanta University and at New York University.

A man with a deep sense of humanity, Woodruff was one of those rare individuals everyone seems to like. Yet in spite of his calm, easy-going manner, he was an intense person, and this intensity is reflected in the dynamic quality of his work.

One of the best examples of his work is the six-panel mural, *The Art of the Negro*, created between 1950 and 1952 for Atlanta University's Trevor Arnette Library. Painted in oil on canvas, two of the panels, *Interchange* **(Fig. A)**

Eugene Grigsby, Jr., is professor emeritus of art and art education at Arizona State University and a founder of the Committee on Minority Concerns of the National Art Education Association. He is also a professional artist and author of Art and Ethnics (2000).

and *Dissipation* **(Fig. B),** show the range of design and feeling in Woodruff's work: from the cool, solid, and classically structured, to the hot, frenzied, and rhythmically dynamic. They also show his concern for understanding cultures and his particular love for African art. *Interchange* depicts the sharing of knowledge between Greek, African, Roman, and Egyptian scholars and artisans in ancient times. In contrast, *Dissipation* shows Europeans attempting to destroy African culture by destroying its sculpture. Author Gylbert Coker makes this comparison:

> *Interchange* offers Woodruff's feelings about the exchange . . . that has taken place over the centuries between . . . culture[s]. In the center top area of this panel, Woodruff has created a symbolic image of what he considers to be the four major cultural influences on Western art . . . —Greek, Roman, Nigerian, and Egyptian. . . . [Note the symbolic architectural columns of the four different cultures and related sculptural forms.] Around this symbol he places all the artisans of antiquity exchanging new concepts and ideas.
>
> *Dissipation* . . . begins the attack on the culture of Africa. By dramatically using the burning of Benin, the capital of Nigeria, by the British, Woodruff . . . focus[es] on the waste and loss of a people's culture through the blind looting and destruction of their art.

In *Interchange* the artist plays contrasting shapes and colors against one another to make a telling visual and symbolic statement: Different people and cultures (like different colors and shapes) might contrast but still interact

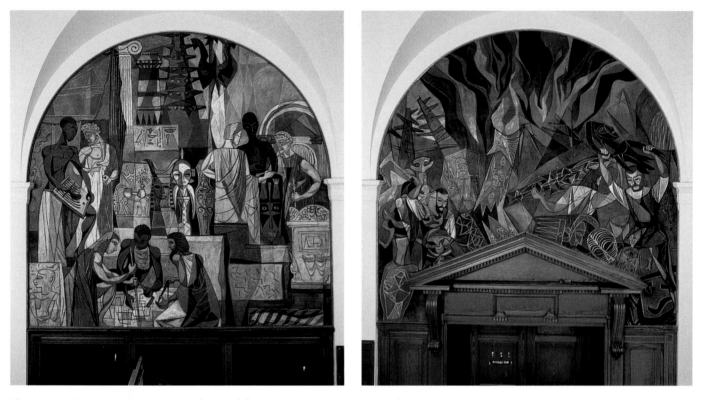

Figure A and B HALE WOODRUFF. *The art of the Negro: Native Forms,* interchange panels, panels two and three of six. 1952. Oil on canvas. 12 ft. × 12 ft. 1 in. Courtesy Clark Atlanta University Art Galleries.

harmoniously. Woodruff conveys a sense of solidity and harmony by the balancing of straight lines, strong verticals and horizontals. Adding to the sense of orderly interchange between peoples, colors, and shapes, Woodruff uses the composition of the painting to lead the eye, step by step, through the three groups of artisans and scholars to the African masks and Greek horse in the center and then to the columns above. The overall composition is pyramidal; the eye moves upward and inward from the broad base to a point just above the center columns. Adding to the quiet dynamism of the picture, the gentle curve of the architecture that forms the top of each panel contrasts with the straight lines and square shapes of the modules that overlap and intersect in the painting.

Visually, *Dissipation* gains strength and tension from dynamic diagonals, rippling with rhythmic movements. African masks and sculptures crisscross in and above the hands of the European destroyers. Rich colors animate the patterns of design. Whereas the quiet and composure of *Interchange* evoke calm reflection, the composition and content of *Dissipation* angrily admonish the Europeans for trying to destroy a culture, suggesting that the masks and sculpture of Africa will survive the looting and outlive the flames. ▪

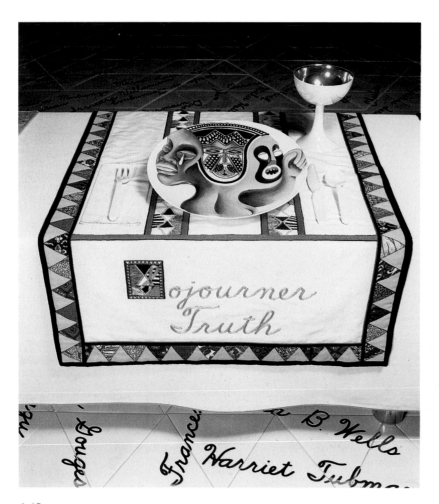

1.10 JUDY CHICAGO. *Sojourner Truth*, plate and place setting from *The Dinner Party*. 1979. Multimedia, china painting on porcelain, needlework. 48 × 42 × 36 in. installed. © Judy Chicago 1979. Photo: Donald Woodman. *Judy Chicago's art is strongly feminist in orientation. How can you tell this? Beyond the fact that Sojourner Truth, the subject of the work, campaigned for women's rights, is there anything else about the ceramic plate and its dinner-party setting that might reveal the artist's feminist point of view?*

weaving from their homelands into beautiful quilts (15.29). Central to both Woodruff's and Chicago's work is the theme of recovering one's cultural past in order to affirm and build one's present identity.

In a period when the need for interpersonal and multicultural understanding is greater than ever, art experiences that expand our consciousness are essential.

Restricting Our Awareness

Unfortunately, not all works of art enlarge our horizons and sensibilities. Some masterful works can restrict our awareness and debase our humanity. It is essential that we understand those artistic creations that limit or even enslave the human spirit.

Artworks that stereotype ethnic, religious, racial, social, or national groups are examples

of art used in a harmful way. Stereotypes encourage a narrow, limited view of complex groups and the diverse individuals who make them up. At their worst, stereotypes can be used to promote violence against a group or a people.

All Their Worldly Goods (1940) **(1.11),** by Adolf Reich, appears to be a realistic portrayal of an event from everyday life. The story it tells is filled with emotion and tension. A white-haired man sits, pen in hand, at a desk. He is being encouraged to sign a document by a portly man, whose face is hidden from us, and by the man's colleague, whose face is partly shielded by a black hat. From their body language and facial expressions, we sense that the intentions of the two men are sinister. A well-dressed government bureaucrat stands beside the desk, a passive witness to the proceedings. Heightening the drama, the old man's wife sits in agitated silence in the corner. The largest figure in the room and the one closest to us, she looks on anxiously as her husband prepares to sign away "all their worldly goods." Our sympathy naturally goes out to the couple.

In terms of realistic rendering and effective storytelling, *All Their Worldly Goods* is an accomplished work of art. To the Nazi regime for whom Reich created this work, the identity of the scheming beneficiaries was clear: They were greedy and evil Jews, a deviant race bent on destroying the German people. The German public, whether they agreed with this "official" view or not, instantly recognized Reich's stereotypic presentation of the Jews as obsessed with money, darkly clad, dark-skinned, emerging from the shadows, and devilish in expression and gesture.

All Their Worldly Goods was among thousands of state-sponsored artworks—paintings, prints, posters, films—that stirred anti-Semitic hatred in Nazi Germany and Nazi-controlled countries (including Austria, the setting of the painting) and helped foster a supportive climate for Hitler's demonic campaign to suppress and then destroy an entire people. As art, the painting retains the power to inspire fascists and racists while aesthetically seducing the rest of us into enjoying its artistic form and suspenseful storytelling.

Thoughtful viewers have come to understand that experiencing art is not simply a mat-

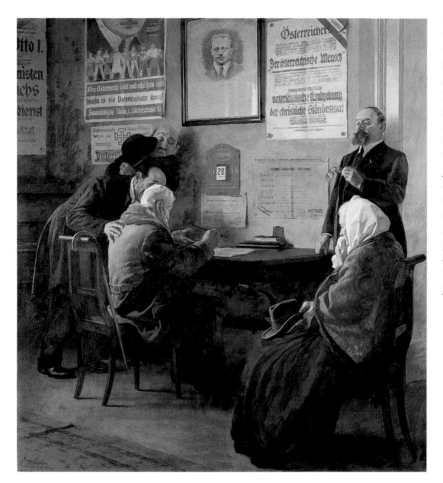

1.11 ADOLF REICH. *All Their Worldly Goods.* 1940. 51³/₁₆ × 42¼ in. Oil painting. Eigentum der Bundesrepublik Deutschland, Oberfinanzdirektion Munich. *Stereotypes of different racial or ethnic groups always simplify and often falsify the complex nature of these groups. The negative stereotyping of Jews in Nazi art supported Hitler's violent racist policies. Is stereotyping always bad? Can stereotypes ever serve a positive function?*

ter of aesthetic enjoyment. Surely *All Their Worldly Goods* and other political propaganda artworks throughout history and across cultures might be appreciated for their enduring aesthetic qualities, irrespective of their social or political meaning. But such works of art must also be appreciated contextually for what their form, subject matter, and content can teach us, both good and bad, about ourselves and about our history.

CONTENT: A BRIDGE CONNECTING FORM, SUBJECT, AND CONTEXT

An artwork's **content** includes the feelings, thoughts, and meanings embodied in the work. It is the driving force and reason behind an artwork's form and subject matter. The content of an artist's life—his or her emotions and

ideas, values and beliefs—shapes every aspect of the work, from the selection and application of colors to the choice and treatment of subjects. Because a work's content encompasses the artist's attitudes, values, and beliefs as well as those of the larger society and culture, it is closely connected to **context,** the work's social and cultural background.

Reich's *All Their Worldly Goods* (1.11) embodies Nazi beliefs and ideals in Germany and Austria in the late 1930s and early 1940s. This content clearly influences the formal presentation of the two Jewish subjects as dark, looming figures who threaten society. The content in Monet's *On the Cliffs, Dieppe* (1.6) is less obvious. What we first notice about Monet's painting are the unique brushstrokes, textures, colors, and composition of this seaside scene. What is the content? It includes Monet's personal fascination with light and atmospheric effects and his deep love of nature. It also

The regime of Hitler, now that it has rid Germany of all those artists whose work expressed the slightest sympathy for liberty, . . . has reduced those who still consent to take up the pen or brush to the status of domestic servants of the regime. . . .—Andre Bréton and Leon Trotsky, leftist cultural and political leaders, "Manifesto: Towards a Free Revolutionary Art," 1938

[Content is] the basic attitude of a nation, a period, a class, a religious persuasion—all this qualified by one personality, and condensed into one work.
—Erwin Panofsky, art historian, *Meaning in the Visual Arts*, 1956

Form is the very shape of content.—Ben Shahn, artist, *The Shape of Content*, 1957

encompasses his basic attitudes and beliefs as a middle-class Frenchman living in the second half of the nineteenth century, which include a strong belief in science and individualism. In keeping with his culture's scientific orientation, Monet trusted only what he could physically experience through his senses. He conveyed these sensory impressions of nature in a highly personal way. The formal result is a distinctive Monet style.

Content bridges the realms of form, subject matter, and context. It helps us further understand the individual creators, their times, and the artwork itself.

WAYS OF SEEING: FORMALISM AND CONTEXTUALISM

Because art is so multifaceted and can move us in so many ways, one-sided methods of experiencing art are insufficient. A more inclusive approach balances aesthetic enjoyment with intellectual understanding. Such a comprehensive approach combines two traditionally distinct ways of seeing art: formalism and contextualism.

The Formalist Way of Seeing

Formalism is an approach to viewing art that focuses on a work's artistic form—its visual elements (line, color, shape, space, texture) and their **composition** or arrangement. (Chapters 2 and 3 discuss in detail the formal properties of the elements and principles of composition.) The formalist writer Clive Bell defines art as "significant form," that is, a particular combination of lines, colors, and shapes that inspires a thrilling aesthetic experience. The formalist values art for its artistic qualities, for how it looks, not for its connections to the larger world. The subject matter, whether seaside cliffs, an African-American abolitionist, or a financial transaction, is of secondary importance.

In the case of *All Their Worldly Goods*, a formalist would concentrate on the work's visual appearance and ignore the painting's contextual relationship to Nazism and anti-Semitic stereotypes. Such "nonartistic" considerations, the formalist argues, only detract from the

vivid aesthetic experience of a fine work of art. Although the formalist approach pares away history, morality, and virtually everything other than color, shape, technique, and composition, it does help the viewer look closely at and respond with feeling to an object's sensuous qualities. As such, the formalist way of seeing is a good starting point for experiencing art. (Formalists, to be sure, argue that the form-based aesthetic experience is an invaluable end in itself and the highest reward of art.)

The Contextualist Way of Seeing

Contextualism, the other traditional approach to experiencing art, is concerned with understanding art "in context," that is, in relation to the rest of life. Like a wide-angle camera shot, contextualism takes in the big picture. Everything that surrounds and relates to the work of art is relevant: the viewer, the artist, the physical setting and format of the work, and the culture and society that gave birth to it. Contextualists insist that the particular sociocultural context defines the nature of art itself and explains the varying definitions of art throughout history.

For the contextualist, fully experiencing *All Their Worldly Goods* requires information about the artist and his other work as well as knowledge about Nazism, anti-Semitic stereotyping, and Germany in the 1930s. Contextualism expands our understanding of the work in relation to the larger world. The research and ideas of art critics and historians, psychologists, sociologists, the viewer, and others also contribute to our understanding. In contrast to the subjective "close-up" focus of formalism, contextualism offers many ways of looking at and giving meaning to a work of art. However, contextualists can sometimes emphasize fact finding and intellectual theorizing to the exclusion of any sensuous, intuitive response to a work of art.

TOWARD A COMPREHENSIVE EXPERIENCE OF ART

Formalism and contextualism both have a good deal to contribute to a holistic approach to experiencing art. A primarily formal aes-

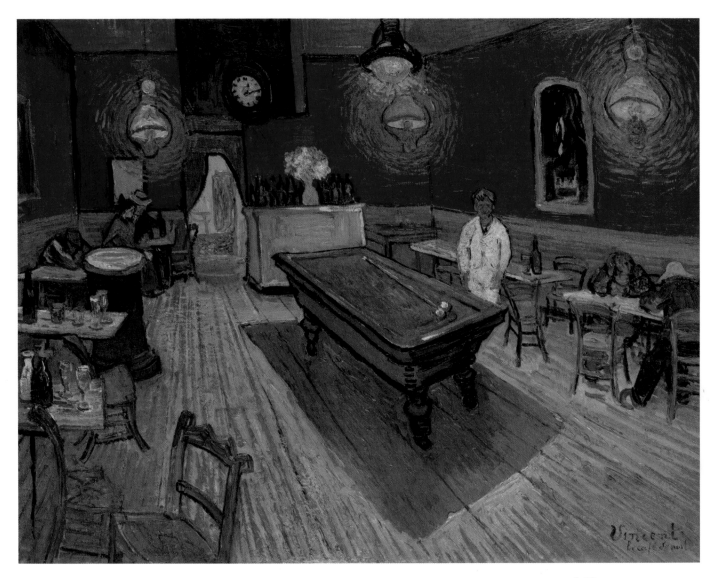

1.12 VINCENT VAN GOGH. *The Night Café*. 1888. Oil on canvas. 28½ × 36¼ in. Yale University Art Gallery. Bequest of Stephen Carlton Clark, B.A. 1903.

thetic approach, like the undergraduate student's response to Monet's *On the Cliffs, Dieppe* (1.6), is a natural starting place for experiencing art. With little or no knowledge of Monet or his style of painting, the student achieved a deeply personal experience of the work based on her own perceptions, thoughts, and feelings. A broader contextual understanding of the work, based on commentary by the artist, art historians, and social scientists, would help her build on that initial personal experience and achieve a richer and more complex appreciation.

We can apply both ways of seeing to Vincent van Gogh's *The Night Café* (1.12) for a comprehensive experience of the work. Although our discussion of *The Night Café* begins with the formalist approach, no rule dictates that the two ways of seeing must be applied sequentially. We separate them into two clearly distinct entities mainly for the sake of introducing the two modes of experience. After mastering the formal and contextual approaches, the majority of experienced viewers interweave the two, mixing feeling with fact, sensuous response with intellectual insight and understanding. Ultimately, the viewer's personal temperament and purpose, the cultural background, and the specific work of art determine the nature of each art experience.

a

b

c

d

1.13 VINCENT VAN
GOGH. *The Night Café*.
1888. Oil on canvas.
Yale University Art
Gallery. Bequest of
Stephen Carlton Clark,
B.A. 1903. (a) Detail of
billiard table leg.
(b) Detail of overhead
lamp. (c) Detail of table
with wine glasses. (d)
Detail with chair and
man's leg.

VAN GOGH'S *NIGHT CAFÉ:* AN APPRECIATION

A Formalist Response

"From a formalist point of view," artist Jerry
Coulter explains, "all that is necessary is that
we look at the work of art. Knowing who did it
or where it came from might be interesting but
it is not necessary to our responding to the
work." Instead, according to Coulter, we must
respond directly to the formal properties of the
artwork, because it is in the visual elements
and the composition that the feeling of the
work is contained. Coulter's experience of *The
Night Café* (1.12) is primarily formalist.

The most powerful element in this small paint-
ing is color. The color is acidic. It has a kind of
strength and intensity that's unpleasant. The
light and color that emanate from the room
convey tension and unease. One doesn't have
to know about van Gogh's personal life or his
artistic intentions to feel these emotions. They
are embodied in the color relationships. The
value [light-dark] contrasts in *The Night Café*—
from light yellows to dark reds and blue-
greens—are very strong. Then there are the
discordant contrasts of the reds against the

greens. All of these contrasts create a tension and excitement.

When one looks at the material itself—the way the paint is put on in rough, heavy textures—there's a kind of anxiety in it. There's a scratching, almost flailing in some places as opposed to a fluid, tender touching of brush to canvas. And although there is control, there seems to be a psychotic intensity behind it. It's all put down so excitably, scratched into or thrust onto the picture surface.

After sensitively probing the elements of color and texture and describing his response to them, Coulter turns his attention to the element of space **(1.13).**

Animated by the intense, unpleasant color, the space in the painting feels almost claustrophobic. The perspective of the interior leads the eye to a little yellow opening in the back of the room which appears to be electrically hot. It's not the kind of place one would enter in order to calm down. It has an electric anxiety. The cool blue-green vibrating against that blistering hot yellow in the opening, they're just incompatible. And that yellow is the brightest, hottest spot in the entire picture. It moves towards the eye although, in terms of a realistic spatial representation, it's supposed to be the area most distant from us. Yet another incompatibility and source of tension.

In keeping with these distortions of space and color, the lines in the back of the painting are as thick and strong as the lines in the foreground. That doesn't make sense. So again one gets the feeling that the space is not right. There's something wrong with the space, and although the discrepancies are relatively subtle from a realistic point of view, one feels a tension in it.

Sloping downward at an impossibly sharp angle, the pitch of the floor makes our sense of balance precarious. The shadow under the billiard table extends this feeling of unease. It's an oozing, weighty kind of thing. Van Gogh is clearly not trying to depict the actual space of *The Night Café.* He's trying to convey the feeling of the café, the kind of tension and remoteness human beings can actually feel even when in close proximity to each other.

The shapes of the figures displayed in the café convey a weightiness; the stiff vertical figure; the hunched drinkers; the lumps of humanity sitting at the tables. They all seem immobilized but filled with tension. Their gestures are not friendly but rather standoffish ones. They lack in ease and naturalness.

Coulter focuses so strongly on the work's formal properties that he views all the figures and objects in terms of color, texture, and other visual elements. His formalist way of seeing transforms the human subjects into shapes. He perceives the man in the center of the room as "the stiff vertical figure" and the hunched drinkers as "lumps . . . filled with tension." After intensive analysis and interpretation of each element, Coulter proceeds to a brief analysis of the work's formal organization.

> The painting's overall composition, characterized as it is by contrast, variety, and a dynamic asymmetrical balance, strengthens the feeling that is generated by the individual elements.
>
> What is really so interesting about *The Night Café* is that it is so small in size [28½ by 36¼ inches] and yet so powerful. I think that's one of the charms of van Gogh's paintings. They're so small and intimate, yet when one is drawn into them, their intensity sends you reeling. That's the kind of tension and psychological power that characterizes van Gogh's art.[1]

Responding to the painting's visual elements and composition, Coulter shows how formal properties convey feeling: The work's clashing color relationships communicate tension and unease; rough, heavy textures transmit anxiety; distortions of space create a claustrophobic sensation. By looking carefully at and reacting with feeling to *The Night Café*'s visual elements and their arrangement, Coulter has brought the painting alive aesthetically.

A Contextualist Response

The formalist approach gives us an intimate close-up of the artwork itself. The contextualist approach, in contrast, widens the focus so we can see the work in relation to its surroundings—every person, place, or thing connected to it. We begin our contextualist experience of *The Night Café* with the words of the person most intimately linked with the painting.

Lonely and isolated from most of his fellow human beings, Dutch artist Vincent van Gogh (1853–1890) **(1.14)** poured out his most intimate thoughts and feelings in hundreds of

There must be some one quality without which a work of art cannot exist. . . . What is this quality? . . . significant form . . . lines and colors combined in a particular way, certain forms and relations of forms [that] stir our aesthetic emotions.—Clive Bell, art critic, *Art,* 1913

1.14 VINCENT VAN GOGH. *Self-Portrait with Gray Hat.* 1887–88. Oil on canvas. 17¼ × 13¾ in. Vincent van Gogh Foundation, National Museum Vincent van Gogh, Amsterdam.

letters to family and friends. His self-portraits and other works reveal much about his psychological state. In a September 1888 letter to Theo van Gogh, his brother and supportive friend, van Gogh tells of his financial problems and of a new painting he has recently completed. It is called *The Night Café*, and he hopes that his landlord, who is also the café's owner and the central figure in the work, will buy it and thus ease his financial burden. In the letter to his brother, van Gogh relates the circumstances surrounding the creation of the work, describes the painting in formal detail, and touches on his artistic intentions.

> Then to the great joy of the landlord, of the postman who I had already painted, of the vis-
> iting night prowlers and myself, for three nights running I sat up to paint and went to bed during the day. I often think that the night is more alive and more richly colored than the day.
>
> Now, as for getting back the money I have paid to the landlord by means of my painting, I do not dwell on that, for the picture is one of the ugliest I have done. It is the equivalent, though different, of the "Potato Eaters" [van Gogh's dark, powerfully expressive portrayal of poor peasants eating a meal].
>
> I have tried to express the terrible passions of humanity by means of red and green.
>
> The room is blood red and dark yellow with a green billiard table in the middle; there are four citron-yellow lamps with a glow of orange and green. Everywhere there is the clash and contrast of the most disparate reds and greens in the figures of little sleeping hooligans, in the empty, dreary room, in violet and blue. The blood-red and the yellow-green of the billiard table, for instance, contrast with the soft tender Louis XV green of the counter, on which there is a pink nosegay. The white coat of the landlord, awake in a corner of that furnace, turns citron-yellow, or pale luminous green.[2]

As we read van Gogh's letter, the painting takes on additional levels of meaning for us. The more we learn about the artist and his world—the context of the work—the more we appreciate *The Night Café*.

> In my picture of the "Night Café" I have tried to express the idea that the café is a place where one can ruin oneself, go mad or commit a crime. So I have tried to express, as it were, the powers of darkness in a low public house, by soft Louis XV green and malachite, contrasting with yellow-green and harsh blue-greens, and all this in an atmosphere like a devil's furnace, of pale sulfur.[3]

Our intellectual and emotional intimacy with van Gogh increases with exposure to the words of art historian Werner Haftmann, who locates the artist and his work in a larger social and historical context.

> In February, 1886, Vincent van Gogh came to his brother Theo's shop [a Paris art dealership]. Gaunt, awkward, red-headed, highly-strung, he took everyone but himself for a genius. Given to dreams of universal brotherhood and love he met with indifference everywhere.

What brought him to painting in the first place was his overflowing love of things and his fellow men. He had been an unsuccessful salesman in an art gallery, and then a lay preacher in the Belgian coal mining area. He had always been drawn to men. He was a great Christian; though a religious dilettante, he was one of the "poor in spirit" mentioned in the Gospels. Throwing himself wholeheartedly into his mission, he had lived with the wretched miners of the Borinage as one of them. For that reason, the religious authorities had forbidden him to preach. But a man of his stamp had to do something to express his love. And so van Gogh took up drawing.[4]

By 1886 van Gogh's journey into art had brought him to Paris and, through his brother, into contact with the most innovative artists of the day. He adopted the free, bright palette of Monet (1.6) and the impressionists, a group of artists who painted colorful impressions of nature and everyday scenes with the intent of capturing a fleeting moment in time. But his nature forced him to dive deeper into the expression of personal emotions than Monet and the impressionists. He struggled to get beyond surface appearances and reveal psychological depths and spiritual realities.

What world produced this great, troubled artist, Vincent van Gogh? In what society did this nocturnal café, its inhabitants, and van Gogh's painting of them exist? How has our own mass-media society shaped the popular view of van Gogh as a romantic, tragic artist in numerous books, songs, films, videos, and television and computer programs? We could learn much more about the artist and the artwork, about their past and present lives. Psychologists, sociologists, cultural critics, and others could add their perspectives. The appreciative experience can always be enlarged. The point is this: We enhance our appreciation of works of art by employing the formal and contextual modes of responding to complement each other. The resulting experience is rich and complex. In the chapters that follow, we will emphasize both the formal and the contextual—the visual form and the sociocultural meaning—of works of art.

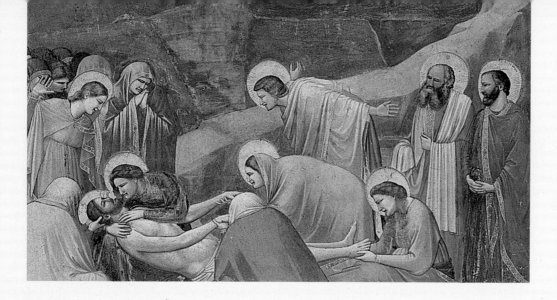

2 The Language of Form

THE VISUAL ELEMENTS

Artist Maurice Denis wrote, "It is well to remember that a picture—before being a battle horse, a nude woman, or some anecdote—is essentially a plane surface covered with colors assembled in a certain order." From Denis's formalist perspective, a painting is first and foremost a flat, two-dimensional surface covered with colors that have been applied in a certain way. His implication is that form (the assembled colors on a flat surface) is of prime importance and subject matter (the horse, the nude figure) is secondary to the appreciation of a picture. While one might rebut his position, arguing that subject matter is of equal (or greater) importance in the appreciation of art, Denis's emphasis on the aesthetic significance of form is valid.

THE VISUAL ELEMENTS

What tends to make an artwork compelling is the uniqueness of its visual elements and their arrangement. What makes a painting, sculpture, or photograph of a particular subject—whether an Egyptian artisan (1.1), a famous athlete (1.4), or seaside cliffs (1.6)—special is the way it is executed in formal terms. Let's consider two paintings of the same subject, in this case by the same artist. Van Gogh's watercolor painting *The All-Night Café* **(2.1)** was probably done in preparation for his oil painting *The*

Night Café (1.12). Do its colors, textures, lines, shapes, and composition differ markedly from those of the oil painting? If so, how? In your opinion, is one work artistically superior to the other? If so, why? The answers to these questions lie in the way the visual elements have been manipulated to create a particular effect.

The elements and their organization are the foundation of any work of art. This chapter focuses on the visual elements. The next chapter will focus on their organization or composition.

Line

The visual element **line** refers to marks—straight or curved, bold or faint, thick or thin, long or short—made by pencil, chalk, brush, or other implements or techniques. Capable of almost endless variety, lines might be delicate and gentle, or forceful and energetic like the bold red and black lines that define the chair in the left foreground of *The All-Night Café* (2.1). One senses in van Gogh's lines the speed and intensity with which he executed them. *Poppy Petals* (**2.2**) by British artist Andy Goldsworthy (born 1956) consists of red poppy flower petals that were each licked underneath by the artist and pressed to the next to make a 7-foot red line. The colorful, gently cascading line flows down the green leaves of a large tree, descending to the ground like the thinnest of waterfalls. Goldsworthy's *Broken Pebbles* (**2.3**) features a series of small split stones, arranged in a spiral with a narrow crack down the middle. The dark open space between the light gray stones creates a dramatically curving line that is exceedingly narrow at the spiral's center and grows steadily in width and force as it moves outward with a kind of centrifugal energy.

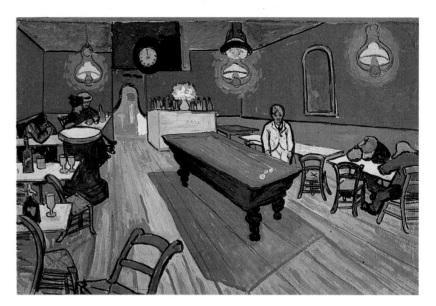

2.1 VINCENT VAN GOGH. *The All-Night Café.* 1888. Watercolor. Private Collection.

2.2 ANDY GOLDSWORTHY. *Poppy Petals.* 27 August 1994. *"Andy Goldsworthy has democratized art more than any other contemporary artist," a landscape designer asserts. He means that Goldsworthy has made all materials of equal worth in the creation of art. He has given all of us permission and encouragement to create art from the stones, sticks, or leaves in our natural surroundings. We no longer must be masters of drawing or painting to create art. Do you agree with this argument about the democratization of art?*

2.3 ANDY GOLDSWORTHY. *Broken Pebbles* (spiral). 1985. Pebbles scratched white with another stone.

2.4 ELLSWORTH KELLY. *Apples.* 1949. Charcoal pencil. 17 × 22⅛ in. The Museum of Modern Art, New York. Gift of John S. Newberry (by exchange). © Ellsworth Kelly.

2.5 KATSUSHIKA HOKUSAI. *A Maid Preparing to Dust.* Edo period, 1615–1868. Ink on paper. 12½ × 9 in. Courtesy of the Freer Gallery of Art, Smithsonian Institution, Washington, D.C. Gift of Charles Lang Freer, F1904.248.

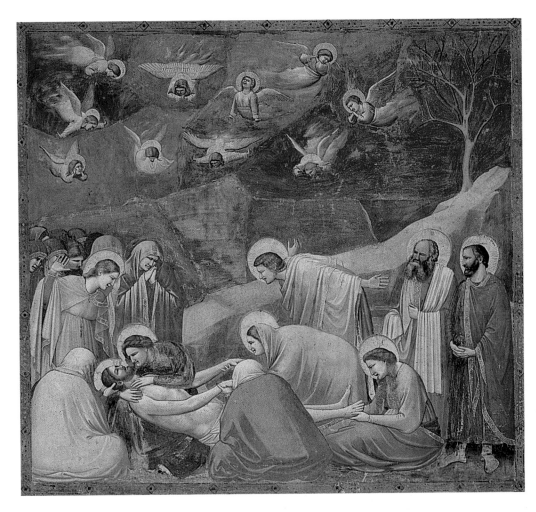

2.6 GIOTTO. *The Lamentation.* 1305–6. Fresco. 91 × 93 in. Arena Chapel, Padua. *To our eyes, Giotto's paintings do not look very realistic or true to life, but in his day Giotto was considered to be a groundbreaking master of realistic imitation. His contemporaries were astonished by how accurately he drew and painted people and their surroundings. Later masters of realistic depiction such as Leonardo da Vinci (2.18) honored Giotto as a forefather. To fully appreciate artists, is it important to know how their contemporaries viewed them?*

Types of Line A line that describes the outline, borders, or edges of an object is called a **contour line.** To draw or paint such a line requires very careful observation, because it must capture the thickness as well as the height and width of the form it surrounds. Contour lines in *The All-Night Café* (2.1) delineate the boundaries of chairs and tables, people, and the room itself. Their descriptive function aside, each artist's contour line is distinct. Van Gogh's contour lines in *The All-Night Café* are thick, heavy, and strong. Those of Ellsworth Kelly (born 1923) in *Apples* **(2.4)** are uniformly thin, simple, and direct. In contrast to Kelly's spare, understated lines, those of Katsushika Hokusai (1760–1849) are active and exciting **(2.5)**. Hokusai's flamboyant, gracefully curving contour lines, varying from light to dark and thick to thin, capture the appearance and the energetic movement of a young Japanese woman.

While contour lines are usually associated with drawings or paintings, we can perceive them in sculptures, buildings, and other three-dimensional objects. When we speak of a city's "skyline," we are creating in our mind a kind of contour line formed by the edges of the buildings against the background of the sky. When we say that a dress, a suit, a sculpture, or an automobile has a certain "line," we are envisioning the overall shape of that object in terms of its contours.

Lines that we ourselves project are called **implied lines.** In works of art, implied lines are not drawn or painted by the artist but are created by the viewer's own perception. In *The Lamentation* **(2.6)** by the Italian artist Giotto (ca. 1266–1337), we observe an implied line where the sky meets the rocky ridge. We are the ones projecting this "horizon line" where atmosphere meets earth. In works of art, implied

When a dot begins to move and becomes a line, this requires time.—Paul Klee, artist, "Creative Credo," 1920

2.7 MU-CH'I (FA-CH'ANG). *Six Persimmons.* Southern Sung Dynasty, thirteenth century. Ink on paper. Width: 14¼ in. Daitoku-ji, Kyoto.

2.8 RENÉ MAGRITTE. *The Listening Room.* 1952. Oil on canvas 17¾ × 21⅝ in. © Photothèque R. Magritte—ADAGP/Art Resource, N.Y.

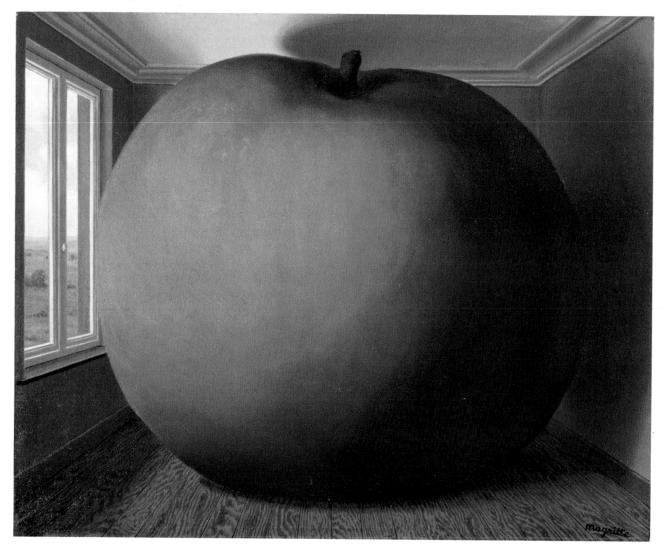

lines can also function in the movement or gestures of figures and in eye contact between figures. For example, *directional lines* direct our gaze even though no line physically exists. In *The Lamentation*, the eyes and gestures of most of the figures focus on the dead Christ. Their gazes create directional sightlines, imaginary paths of vision that we follow to the central figure.

Shape

The visual element shape refers to physical or spatial forms. (Here *form* denotes the individual shapes or masses or their groupings in works of art or everyday objects.) Like lines, shapes are remarkably diverse. They can be big or small, massive or slight, light or dark or any color. Shapes might be solid, or they might have large openings through them. Their contours or surfaces might be jagged or smooth.

Shapes are either **two-dimensional,** possessing height and width, or **three-dimensional,** possessing height, width, and depth. Both Mu-Ch'i's small ink painting *Six Persimmons* **(2.7)** and Ellsworth Kelly's *Apples* (2.4) present their fruit subjects as primarily flat, two-dimensional shapes. Both artists emphasize the fruits' height and width but do not attempt to create an illusion of three-dimensional depth. If they had, the fruits would appear fully round and weighty. In contrast, the painted "apple shape" in *The Listening Room* **(2.8)** by Belgian artist René Magritte (1898–1967) conveys a convincing illusion of depth. Magritte's coloration and shading make the apple appear so full-bodied that it evokes a sense of solidity or mass. The fruit's enormous size—it literally fills a room—adds to this sense of massiveness.

In contrast to such illusionism, three-dimensional shapes possess actual depth and physical bulk. We say that they have **mass** or **volume.** Three-dimensional shapes can be solid, heavy, and enclosed like each of the massive heads carved from a single huge stone by the Olmec culture of ancient Mexico **(2.9),** or they can be small like the stones in Goldsworthy's *Broken Pebbles* (2.3). They can be of any color or configuration, such as the pyramidal black mass of the contemporary sculpture *The Spirit of the Haida Gwaii* **(Appreciation 3).**

2.9 Colossal head from La Venta, Mexico. Olmec, 1500–300 B.C.E. Basalt. Height: ca. 96 in. Anthropology Museum, Veracruz, Mexico. *The Olmec culture, America's first civilization, developed along the eastern coastal lowlands of Mexico between 1500 and 400 B.C.E. It featured large ceremonial centers, villages, and a hierarchical class system ruled by an aristocratic elite in which priests played a major role. The colossal Olmec heads were carved at basaltic rock deposits and then transported overland to the main ceremonial centers. These heads and remnants of the religious centers remain. Ruins of Olmec palaces and homes have not been found. Does this tell you something about the Olmec culture and what it valued most?*

APPRECIATION 3 BILL REID, *The Spirit of the Haida Gwaii*, 1991

ROBERT BERSSON

It is shortly after nine o'clock on a spring morning. The government workers have reached their desks at the Canadian Embassy in Washington, D.C. In the far corner of the embassy's large entrance courtyard, the dark three-dimensional volume of a bronze sculpture rises up **(Fig. A).** From fifty yards away, the sculpture of a figure-laden boat emerges from the morning shadows, a dense, black presence. "The Black Canoe," as it is popularly known, is a compact, concentrated mass. It is comprised of a crew of mythical human and animal beings, tightly packed on a canoe of the Native American Haida people of the Pacific Northwest coast. (The sculpture's official name is *The Spirit of the Haida Gwaii*, Haida Gwaii meaning "The Islands of the [Haida] People.")

In the center, rising above the others, is a majestic Haida chief or shaman. Compositionally, this shaman-chief figure forms the apex of a triangular shape that is symmetrical and balanced overall but seething with human and animal activity within. It is a stable and solid shape, this vessel filled to the brim with interwoven travelers.

The commanding chief figure looks out, a potent presence, toward the horizon, to the journey before him. Small bursts of light ripple across the shiny, black metal surface of the sculpture. The low morning sun creates intense white highlights, areas of brightest light, on the chief's smooth black skin. The flickering sunlight also animates the textured, geometric patterns of the chief's hat and hair and the intricate Haida totem symbols on his cape and spear.

Throughout the day, the patterns of light and dark will change on the sculpture's surface. The rising and setting sun will cast an ever-moving shadow around the perimeter of the Haida Gwaii. Public sculpture in the out-of-doors is ever active and alive, changing as the light and environmental conditions change. This is one of its challenges and joys. Viewing the sculpture from 9:00 to 10:00 A.M., and then again in the early afternoon, one witnesses a metamorphosis in visual appearance and expressive quality, from dark morning mystery to the bold clarity of midday. In its daily cycles, The Black Canoe truly undergoes a voyage through time and changing conditions.

The subject of the work is a voyage. The canoe, heavy with life, is a kind of Noah's Ark filled with human and animal figures. Both humans and animals paddle, with three oars propelling the craft on the left side and four on the right. The leader stands impassive in the center. Not all is order and harmony on the boat, however. The paws of the creature in the bow are bitten by the large bird next to it, which in turn is bitten on the wing by a horselike creature. Other figures interlock tightly with their neighbors. It is a crowded, turbulent world where some fight and others work together to survive. All of the crew members—humans and animals, males and females, adults and children—participate in the life-and-death struggle on board. Some might interpret this journey of the Haida Gwaii as a metaphor for our earthly voyage of life.

In our experience of The Black Canoe, past and present blend. In the midday sun, the

Figure A BILL REID. *The Spirit of the Haida Gwaii (The Black Canoe)*. 1991. Bronze. Canadian Embassy, Washington, D.C.

ancient personages and the boat pick up dashes of blue-green color reflected from the Canadian Embassy's tinted glass windows. Showcased within the embassy's late-twentieth-century plaza [10.58], in visual proximity to the United States Capitol and the National Gallery of Art, The Black Canoe is a participant in our contemporary world. At the same time, it asserts the ancient heritage and ongoing existence of the Haida people, original settlers of Canada's Pacific Northwest coast.

A note on the sculptor. Like his sculptural creation, Bill Reid (born 1920) is of two worlds. A Canadian citizen of Haida and European extraction, Reid moves fluidly between contemporary industrial civilization and the ancient realm of his Haida forebears. Deeply conversant with Haida mythology, spiritual practice, and woodcarving traditions, Reid also is a master of contemporary sculptural materials and technologies. ■

2.10 NANCY HOLT. *Sun Tunnels.* Great Basin Desert, Utah, 1973–76. View through northwest tunnel; holes cut in the pipe project the pattern. Total length 86 ft.; each tunnel 18 ft.

Masses or volumes might also feature open areas like those in the four concrete pipes, each 18 feet long and 9½ feet in diameter, that make up *Sun Tunnels,* an astronomically oriented work by Nancy Holt (born 1938). The tunnels, aligned in pairs, are oriented to the summer and winter solstices. The dramatic view through the northwest tunnel **(2.10)** reveals a cylindrical inner space that frames both the next tunnel and the surrounding landscape. Holes cut through the walls of the northwest tunnel allow the brilliant desert sunlight to project the pattern of the star constellation Draco the Dragon on the darkened interior.

Types of Shape **Geometric** shapes are formed by straight or curved lines and tend to progress regularly according to mathematical laws. They include two-dimensional shapes such as squares, rectangles, triangles, and circles and three-dimensional shapes or volumes such as cubes, boxes, pyramids, cylinders, and spheres. *Sun Tunnels* (2.10) employs four identical industrially made cylindrical shapes. A 1930s cotton quilt in the "tumbling blocks" pattern **(2.11)** creates the startling optical illusion of three-dimensional cubes or blocks balancing one on top of the other. The final product of material cut, pieced, and sewn together, the quilt combines beauty and practicality—originally, it provided warmth and comfort as a bedcover.

In contrast to the *Tumbling Blocks* quilt, the CD cover *Compass Points* **(2.12)** features **organic** or **biomorphic** shapes, that is, shapes derived from natural forms such as flowers, birds, fish, and underwater life. Such shapes, whether of specifically natural origin or naturelike in a generalized sense, tend to be

2.11 Amish quilt, *Tumbling Blocks*. ca. 1930. Cotton. 74 × 64 in. Ohio. *The Amish are an extremely traditional Protestant group of German and Swiss ancestry. In their small agricultural communities in the United States and Canada, they do not drive cars or use electricity in their homes. The patterns of their handmade quilts have specific names (tumbling blocks, baskets, log cabin, fan, bow tie) but focus on abstract geometric shapes and patterns—not realistic representations—suggested by these names. Realistic depictions are considered idolatrous and against the Amish religion. Can you see how the form of the Amish quilts follows the content of Amish lives?*

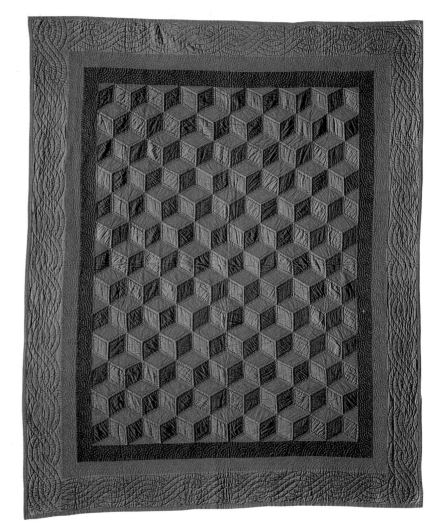

curvilinear and irregular in form. The particular biomorphic shapes in the CD cover, inspired by the art of Henri Matisse **(Appreciation 4),** are reminiscent of warm waters and ocean life, the setting for this Jamaican reggae music CD.

The biomorphic shapes on the *Compass Points* cover are also called **abstract** because they move away from or "abstract" the actual appearance of sea life. Both Kelly's radically simplified apples (2.4) and Mu-Ch'i's persimmons (2.7) are likewise abstract shapes, but they are more recognizable in terms of the actual natural objects from which they were drawn.

Their abstract qualities notwithstanding, these organic shapes—apples, persimmons, and sea life—qualify as **representational** in that they are based on and thus represent recognizable things. Shapes that seem to cut all ties with recognizable real-life sources are

2.12 DESMOND DEKKER. *Compass Points.* 1981. Desmond Dekker album cover. Barney Bubbles, designer. © 1981 Stiff Records Ltd.

HENRI MATISSE, *The Flowing Hair (La Chevelure)*, 1952

REBECCA HUMPHREY

Henri Matisse wrote in a 1948 letter:

> I have always tried to hide my own efforts and wished my work to have the lightness and joyousness of a springtime which never lets anyone know the labors it has cost. So I am afraid the young, seeing in my work only the apparent facility and negligence in the drawing, will use this as an excuse for dispensing with certain efforts I believe necessary.

Matisse's *The Flowing Hair* **(Fig. A),** made of cut and pasted paper, appears so unlabored that one might misunderstand all that is behind and went before it. Few would guess that a work as lively and energetic as *The Flowing Hair* was executed by a man eighty-three years old. Moreover, *The Flowing Hair* is just one work in an entire cut paper series of joyous, colorful pieces suggesting dance and music.

The Flowing Hair shows no three-dimensional modeling of the forms or shadows. The female form is depicted as an intense blue shape of flowing curves, a graceful rhythmic arabesque. The whole figure—arms, legs, torso, even the hair—seems to be in motion. The footless legs have strength, and the arms have almost become wings. One feels that at any moment the figure might dance off the paper.

How did Matisse, as an old man, come to create such vital works? One answer is his development of a new art form: cut paper, or, as it is called in French, *papier collé, papier découpé,* or *découpage.* Partly crippled by illness and repeated surgery in 1941, Matisse came to rely on the less strenuous medium of cut paper, rather than oil painting, as his major art form. He could work in the new art form lying down in his bed or from his chair. He had studio assistants paint expanses of paper in brilliant hues of gouache, an opaque watercolor paint, to his requirements. The old master then cut shapes directly out of the paper without any preparatory drawings. He felt he was drawing with scissors. He loved the directness of the process of cutting. After the shapes were cut, Matisse instructed his assistants to pin the pieces onto his studio wall. The many tiny pinholes in the paper show that Matisse had his helpers adjust the arrangement of the cutouts numerous times until the most expressive spatial relationship had been achieved.

Out of the painted, cut, and pasted papers arose a self-sufficient medium of great pictorial strength. Cutting paper with scissors gave him a very strong feeling for line and enabled him to develop forms of great simplicity and economy. Yet Matisse did not use his scissors to declare war on drawing and painting. Rather, his scissors were an extension of pencil, charcoal stick, and paintbrush. "My découpages," he stated, "do not break away from my former pictures. It is only that I have achieved more completely and abstractly a form reduced to the essential, and have retained the object, no longer in the complexity of its space, but as the symbol which is both sufficient and necessary to make the object exist in its own right, as well as for the composition in which I have conceived it."

Old and crippled, Matisse could have rested on the laurels of his past accomplishments. But not Matisse. He truly enjoyed the challenge, the directness, the intimacy of his new approach to collage. He relished the opportunity to select, place, and reposition the cut paper shapes. His habit of hard work in the studio was so deeply rooted and his creative vitality was so strong that he let nothing, not even bad health, interrupt his art. In the end, Matisse came to esteem his cut paper works as the high point of his creative career.

Rebecca Humphrey is a professor emerita of art at James Madison University, Harrisonburg, Virginia, and a professional artist who works in the medium of paper.

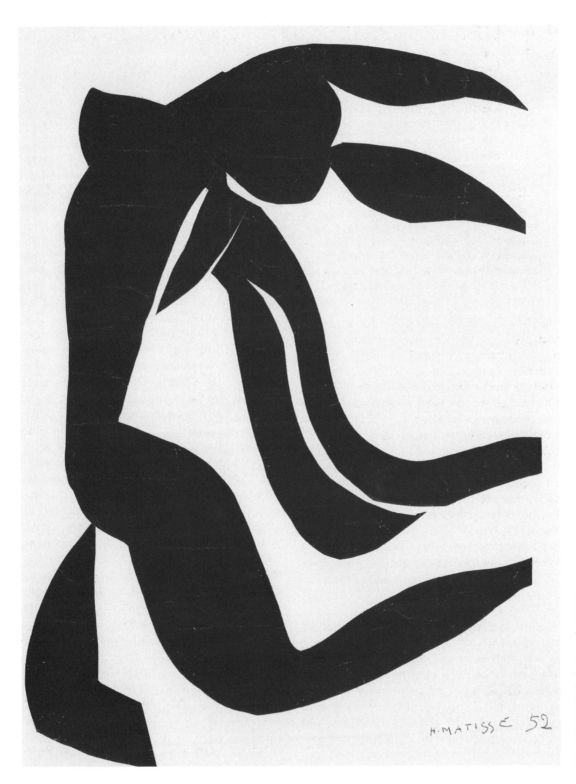

H·MATISSE 52

In addition to enjoying the color in Matisse's paintings, and the celebration of life in all of his art, I particularly respond to the directness and economy of the paper cutouts. I feel these late works have an inspiring sense of immediacy. They have certainly inspired me in my work in handmade paper and mixed media. ■

2.13 JOSÉ DE RIVERA. *Construction, no. 2.* 1954. Developed stainless steel sheet. 19 × 23 × 16 in. Photo courtesy of the artist and Richard Gray Gallery, Chicago.

2.14 FRANK LLOYD WRIGHT. The Solomon R. Guggenheim Museum, New York. 1956–59. View of interior from dome.

referred to as **nonrepresentational** or nonobjective. Artists who wish viewers to see their work as nonrepresentational, to appreciate the purely abstract qualities of their forms, frequently give their works a title such as *Abstraction, Composition, Construction,* or *Untitled* to emphasize their independence from recognizable forms. *Construction, no. 2* **(2.13),** a sculpture of stainless steel by American artist José de Rivera (1904–1982), invites the viewer to enjoy its nonobjective curvilinear shape, open spaces, and energetic movement.

The [nonrepresentational] shapes we are creating are not abstract, they are absolute. They are released from any already existent thing in nature and their content lies in themselves.—Naum Gabo, sculptor, *Circle,* 1937

Space

Space is the area that surrounds or is framed by shapes. Spaces can be two- or three-dimensional, large or small, geometric or organic. The interior of the Guggenheim Museum of Art **(2.14),** designed by architect Frank Lloyd Wright (1867–1959), is one of the most dramatic spaces in the world. It is framed and given airy, active form by the spiraling shapes that make up the building's floors and galleries. Combining the geometric and the organic, the cylindrical space of the Guggenheim interior swells and breathes like a living being. In this architectural masterpiece, space and shape are ever interactive.

Spaces can be enormous and awe-inspiring, as in the Guggenheim, or they can be only inches long and intimate, like the narrow space that forms a line between the split stones in Goldsworthy's *Broken Pebbles* (2.3). (Individual visual elements can take on the identity of other visual elements; for example, a space in the Goldsworthy piece can function simultaneously as a line or a shape.)

In both two- and three-dimensional artworks, the term *positive* is often attached to solid shapes, while the term *negative* is attached to the adjacent open spaces or voids. The concept of **positive shape** and **negative space** teaches us about the intimate relationship between the two elements. Note the negative areas surrounding the shapes that make up Kelly's apples (2.4), Hokusai's maid (2.5), and Mu-Ch'i's persimmons (2.7), as well as the open space in three-dimensional creations such as Wright's Guggenheim Museum interior (2.14), Rivera's metal sculpture (2.13), and Holt's *Sun Tunnels* (2.10). The negative areas in each artwork, the supposed voids, have distinctive shapes of their own. We might call them "negative shapes."

Like the other visual elements, space is capable of conveying psychological states. For example, we might experience the central space of the Guggenheim as energetic and exciting, and the open area around Mu-Ch'i's six persimmons as peaceful and quietly supportive of the little family of fruits. In contrast, the

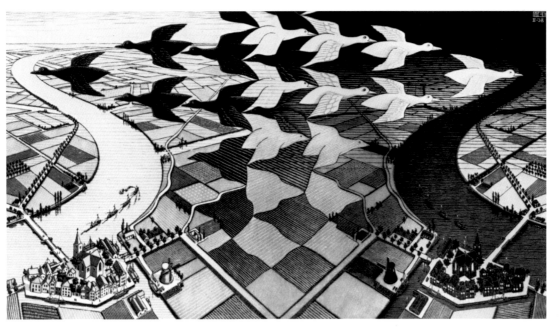

2.15 M. C. ESCHER. *Day and Night*. 1938. Woodcut. 15½ × 26¾ in.

2.16 ALEXANDER CALDER. *The Hostess*. 1928. The Museum of Modern Art, New York. Gift of Edward M. Warburg.

space surrounding and separating the isolated human figures in *The All-Night Café* (2.1) adds to the unsettling feeling of estrangement in this "place where one can ruin oneself, go mad, or commit a crime."

Closely associated with the concept of positive shape and negative space is that of **figure and ground.** The young woman, the positive shape in the Hokusai work (2.5), can be perceived as the "figure" and the surrounding space as the background or "ground." The same figure-ground relationship pertains to the fruits and their backgrounds in the works by Kelly and Mu-Ch'i (2.4, 2.7). Twentieth-century artists such as M. C. Escher (1898–1972) played provocatively upon the interactive relationship between figure and ground. Escher's *Day and Night* **(2.15)** shows shape and space, and figure and ground, melding into and then becoming the other. Moving from right to left, observe how the artist transforms the dark, airy background areas between the white birds into the solid figures of black birds. Reversing direction, note how the light background between the black birds fluidly changes into full-bodied figures of white birds. In *Day and Night*, figure and ground are in a continual state of role reversal.

Artists like Escher, Kelly, Wright, and Alexander Calder (1898–1976) are especially attuned to the interaction of shape and space,

figure and ground. The open space within and outside Calder's wire sculpture *The Hostess* **(2.16)** is as vibrant and palpable as the line and shape that comprise the solid areas of the work. Creating his sculpture literally out of thin air, Calder used playful lines and exaggerated shapes to gently spoof the hostess's somewhat snobbish attitude. Space, as much as

Up to now, the sculptors have preferred the mass and neglected or paid very little attention to . . . space. Space interested them only in so far as it was a spot in which volumes could be placed or projected. We consider space as an absolutely sculptural element . . . and we represent it from inside with its own specific properties.—Naum Gabo, sculptor, *Circle,* 1937

2.17 *Darbar of Jahangir.* Indian, Mogul. Opaque watercolor and gold on paper. 13¹³⁄₁₆ × 7⅞ in. Francis Barttlett Donation of 1912 and Picture Fund. Courtesy of Museum of Fine Arts, Boston.

shape and line, creates the figure of the matron as we fill in her form with our eyes.

Representing Space in the Two-Dimensional Arts Since prehistoric times, individuals have tried to create an illusion of three-dimensional space or depth on a flat surface. We call this two-dimensional surface the **picture plane.** This area on which the picture is created might be perfectly level, rounded, or irregular and undulating, but it is always defined by the two dimensions of height and width. On the picture plane surface of bumpy cave walls, curving ceramic vessels, and flat pieces of paper, makers of images have used various means to convey depth.

One of the most basic methods is **overlapping,** in which one figure or form is placed in front of another, partially blocking the view of the forms behind. Overlapping enables certain figures to seem close to us, in the foreground,

while others appear progressively more distant in the middle ground and background. In the small Indian painting *Darbar of Jahangir* **(2.17),** created by one or more artists of the royal workshop, a crowd of Indians (and one European priest in black dress) assembles at a Darbar, or public audience, before Emperor Jahangir (reign 1605–1627). Certain figures, such as the elephant and horse and their attendants, are in the foreground. In the middle ground are the European priest and the main body of the crowd, with its numerous overlapped figures. Above and in the background are the emperor and his retinue.

The painter employs a second, frequently used approach to representing space: He stacks the figures from bottom to top in accordance with a time-honored convention called **vertical placement.** Vertical placement equates figures lower in the picture with nearness to us and those higher up with distance from us. (Giotto's *Lamentation* (2.6) also employs vertical placement and overlapping, with similar spatial effects.)

In *Darbar of Jahangir,* the stacking and overlapping give an overall impression of foreground, middle ground, and background but do not really create an illusion of deep space. In fact, the picture appears quite flat or shallow. Our eye does not travel deeply into the painting but instead stays close to the actual flat surface of the picture plane. Perspective systems, perfected by European artists in the fifteenth century, radically pierced the picture plane to create the illusion of deep space. In Latin, **perspective** means "to look through." It is an apt definition, capturing the idea that a drawing or painting functions like a window that we "look through" into an illusionary space beyond the flat surface of the picture plane. Perspective systems can create a space that seems to stretch for miles, from foreground to middle ground to distant background. Compared to the shallow illusionistic space and tightly knit surface of the painting *Darbar of Jahangir* **(2.17),** *The Last Supper* **(2.18)** by Leonardo da Vinci (1452–1519) opens up a vast space. The monastery wall on which *The Last Supper* is painted seems to dissolve, and we come face to face with Christ and his disciples in a spacious room whose windows reveal green hills and sky in the faraway background.

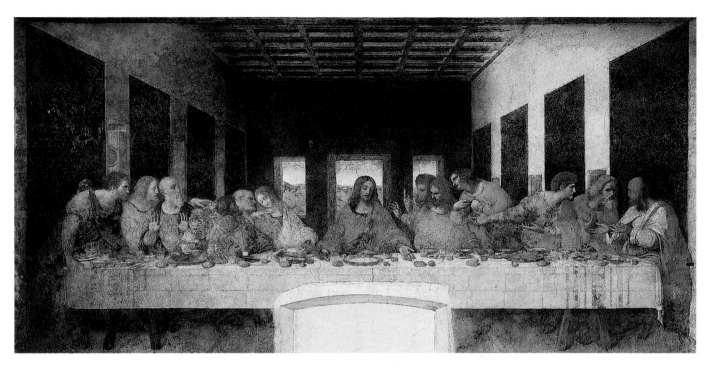

2.18 LEONARDO DA VINCI. *The Last Supper* (after restoration). Ca. 1495–97. Fresco. 15 ft. 1⅛ in. × 28 ft. 10½ in. Refectory of Santa Maria delle Grazie, Milan.

Leonardo accomplished this feat of spatial illusionism by combining various perspective systems. Applying **atmospheric** or aerial **perspective,** he muted and lightened the colors of the distant sky and landscape. (Figure 2.22 shows the artist's application of atmospheric perspective to land and sky even more clearly.) The physical nature of the atmosphere or air causes colors to fade and details to diminish as objects (for example, mountains and sky) recede into the distance.

Leonardo also employed **one-point linear perspective (2.19),** a mathematically based spatial system perfected by the Italian architect Filippo Brunelleschi (1377–1446) in the early fifteenth century. In one-point linear perspective, parallel lines appear to meet in the faraway distance. These parallel sightlines or guidelines converge in a single **vanishing point** on the horizon. In *The Last Supper,* the system of linear perspective guides us into the deep illusionistic space of the room and out the rear windows to the distant landscape beyond. The room, table, and figures subsequently undergo **foreshortening,** or the diminishing in size of forms, as they move away from the viewer (a concept we will discuss further in Chapter 5). At the same time, the sightlines formed by the table ends, walls, and ceiling

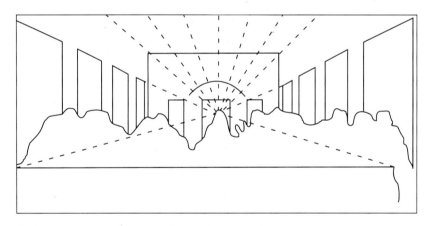

2.19 LEONARDO DA VINCI. *The Last Supper* with overlay one-point perspective drawing.

2.20 Two- and three-point perspective drawings.

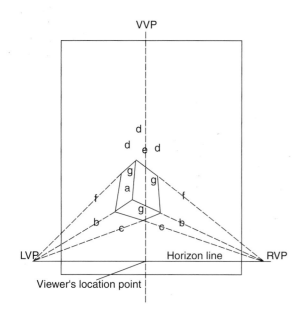

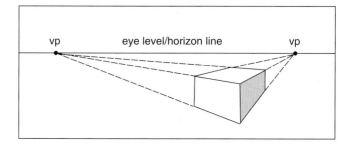

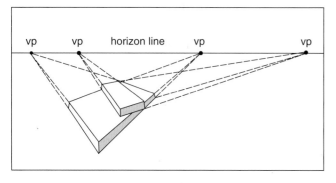

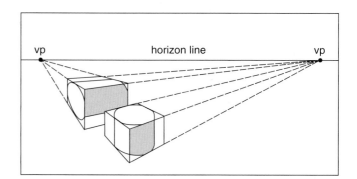

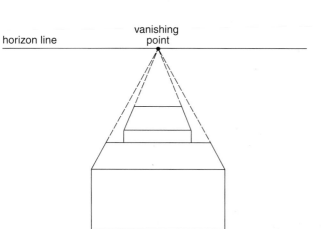

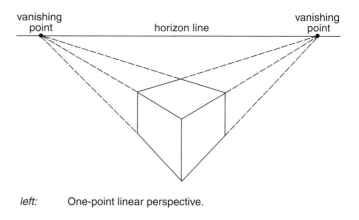

left: One-point linear perspective.

above: Two-point linear perspective.

2.21 GENE BODIO. *New City.* 1992. Computer graphic created using Autodesk 3D Studio, Release 2. Courtesy of the artist, © Gene Bodio.

beams angle our vision toward the central figure of Christ. He sits at the vanishing point, which is also the focal point of the entire work. The perspective system leads our gaze to him.

One-point perspective has been put to powerful use in a wide range of works. Some artists have employed it for psychological impact as well as spatial effect. In *The All-Night Café* (2.1), the single vanishing point is located behind the door at the back of the room. The location of van Gogh's vanishing point, off center and high up, causes the café room and billiard table to be dramatically foreshortened and the space to rush back and upward to the vanishing point. At the same time, the viewer feels that the floor tilts downward at a steep angle. It appears as if the billiard table could slide out of the room! This perspectival effect produces a sense of both physical imbalance and psychological instability.

Artists have employed two- and three-point perspective systems **(2.20)** to create increasingly complex spatial arrangements. Escher's *Day and Night* (2.15) uses a three-point perspective system to organize sightlines around vanishing points at the center and on the far left and right sides of the horizon line. (Follow the lines of the roads and fields to locate these three vanishing points.) Contemporary creators of video animation and computer-generated images frequently employ sophisticated one- and multi-point perspective systems to develop their stunning spatial illusions. Gene Bodio's *New City* **(2.21)** offers an exhilarating bird's-eye variant of three-point perspective.

2.22 LEONARDO DA VINCI. *Ginevra de' Benci.* ca. 1474. Oil on panel. 15 × 14⁹/₁₆ in. Ailsa Mellon Bruce Fund. Photograph © 2002 Board of Trustees, National Gallery of Art, Washington, D.C. 1967.6.1 a(2326)/PA.

2.23 *Mwash a mbooy* mask. Kuba, Zaïre. Cloth, cowries, beads, feathers, fibre. 15¾ in. Musée Royal de l'Afrique Centrale, Tervuren. Photo courtesy Musée Royal de l'Afrique Centrale, Tervuren. *The Kuba (or BaKuba) use a variety of masks for dances in religious and initiation ceremonies, burials, and other rituals. This helmet mask, called* mwash a mbooy, *is worn at initiation ceremonies to symbolize the cultural hero Woot, who originated Kuba royalty, political structure, and most arts and crafts. The mask is worn only by men of royal descent. How are masks used in your culture? What do they symbolize?*

Texture

Texture is an important component of atmospheric perspective. **Texture** refers to the actual or simulated surface of an object—whether it is rough or smooth, soft or hard. When we speak of the **texture gradient** relative to atmospheric perspective, we mean the progressive loss in textural detail as an object recedes into the distance. Up close, we perceive the roughness and detailed complexity of a rocky or tree-filled mountainside. At a distance of ten or twenty miles, we lose those textural qualities. The mountain appears as a smooth mass, and details take on a uniform surface appearance. Note the hills and mountains in Leonardo's *Last Supper* (2.18) and in the background of his portrait of the beautiful, young Ginevra de' Benci **(2.22).** A pioneer in capturing the effects of distance on vision, Leonardo created the

pictorial effect known as *sfumato* (Italian for "hazy," "smoky," or "shaded"), in which the edges and surfaces of distant objects are softened or blurred, just as we perceive them with our own eyes in the real world.

Actual and Implied Textures A work of art can have a rough or a smooth surface texture. These are actual textures that you might feel if you touched the work. The textures of an African helmet mask of Zaire's Kuba people **(2.23)** have a wide range. Worn at ceremonial dances, the mask features the touchable or tactile stimulation of beads, seashells, fibers, feathers, and cloth. The stone surface of the ancient, weathered Olmec head (2.9) is slightly rough and grainy, while the modern walls of the Guggenheim Museum (2.14) are uniform and smooth to the touch.

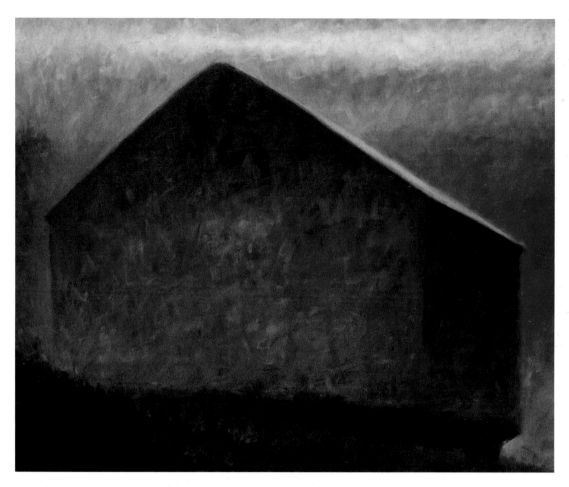

2.24 RYAN RUSSELL. *Barn at Dawn*. 1998. Oil on canvas. 46 × 54 in. Photo: Ellen M. Martin.

Actual textures can likewise be pronounced in two-dimensional works. Van Gogh applied thick layers of oil paint in his final version of *The Night Café* (1.12) for a heavily textured, built-up picture surface, a technique called **impasto** (the Italian word for "paste" or "dough"). Monet's *On the Cliffs, Dieppe* (1.6) has a similarly dense, impastoed surface, created by hundreds of dabs of thick oil paint. On the other hand, the surfaces of the Indian painting *Darbar of Jahangir* (2.17) and Leonardo's *Ginevra de' Benci* (2.22) are texturally smooth. We can barely observe a single brushstroke. Nevertheless, both artists have created many simulated or implied textures through keen, detailed depiction and illusionistic rendering. In *Ginevra de' Benci*, the diverse textures of skin, hair, and clothing have such a pronounced tactility and tangibility that we can sense the smoothness of the skin and the oily silkiness of the hair. In the surrounding trees, we perceive a firm, sharp-edged quality in some leaves and a soft, feathery quality in others.

Light and Color

An hour before sunrise in most communities, the darkness of night prevails. Except for limited areas of artificial illumination, the nighttime world is largely without color. Slowly, the light begins to change. Clouds begin to take on a pink or an orange coloration. The trees and leaves, houses and yards begin to assume their daytime colors of brown, yellow, blue, red, green. As the sun rises above the horizon, the colors increase in brilliance. The light of day has given birth to a world of color, a phenomenon captured in the oil painting *Barn at Dawn* **(2.24),** by Ryan Russell (born 1960).

We speak of light and color in the same breath because they are so closely related.

We recognize visual form only by means of light, and light only by means of form, and we further recognize that color is an effect of light in relation to form and its inherent texture. In nature, light creates color; in painting color creates light.—Hans Hofmann, painter, *Search for the Real and Other Essays,* 1948

Intensity

Value

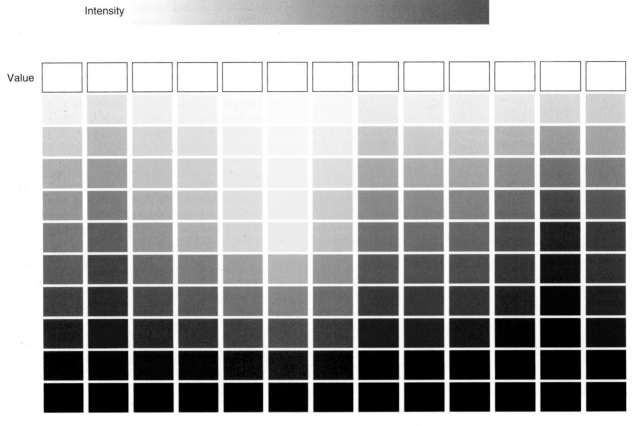

2.25 Values chart.

2.26 Film still from *The Blair Witch Project*.

An increase in light gives an increase in darkness . . .—Sam Francis (1923–1994), painter

What we see as light is a form of radiant energy (a narrow band of the electromagnetic energy range) that our eyes and brains process into visual images. The sun is our natural source of this radiant energy. Candles, oil lamps, incandescent light bulbs, and fluorescent lights are among our artificial, human-made sources that bring color to life. As artist Johannes Itten puts it, "Color is life; a world without colors appears to us as dead. . . . Light, that first phenomenon of the world, reveals to us the spirit and living soul of the world through colors."

Light and Values Day and night. Light and darkness. In works of art, we speak of the range of light to dark as **values** or **chiaroscuro** (literally "light-dark" in Italian). A values chart or values scale **(2.25)** shows the range of lightest through darkest values in terms of both the individual colors and the scale of grays between white and black. Note how the various gray and color values align: lighter grays with lighter colors, darker grays with darker hues.

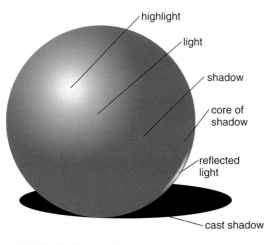

highlight

light

shadow

core of
shadow

reflected
light

cast shadow

2.27 Highlighted sphere.

Analyzing Russell's *Barn at Dawn* (2.24) in terms of the values scale, we see that the lighter whitish yellows and pinks of the sky correspond with the lighter grays while most other colors in the picture, from the darker sky blues to the dusky reddish purples of the barn, align with darker grays. The areas in deepest shadow, the brownish black vegetation in the foreground and the undersides of the barn, match up with blackish grays or even black on the values scale. The term **key** is used to describe the prevailing range of color values in such artworks. A painting in a high key is characterized by light, bright, or pale colors, while one in a low key features dark or subdued hues. *Barn at Dawn,* with its predominance of subdued darker values, is in a low key. (So is Rembrandt's *Man in a Golden Helmet* (2.35), a work noteworthy for its arresting chiaroscuro effect.)

Black-and-white films, photographs, drawings, and paintings show values in abundance and in diverse application. Escher's *Day and Night* (2.15), befitting its title, moves through every subtle gradation of white, gray, and black on the values chart. In comparison, an image from the riveting horror film *The Blair Witch Project* (2.26) creates high drama through an extreme value contrast of ghostly facial close-up and sky against the deep nocturnal blacks of forest and trees. Intermediate grays are largely excluded so as to generate a disturbing tension.

Descriptive and Expressive Use of Value
Light and shadow are form givers. They bring out the fullness of objects, "giving form" both in everyday perception and in works of art. We observe this phenomenon in *Barn at Dawn* (2.24), in which the contrasts of early morning light and dark shadow on and around the farm building evoke its three-dimensional structure. Without gradations of light to dark, we would not readily perceive distinctions between the barn's sides, between the building and its roof, or between the foreground and the background. In a standard values study drawing of cast light on a sphere **(2.27),** we see how this impact of light and shadow evokes a sense of three-dimensionality. The study sensitizes us to a variety of optical effects and illustrates terminology such as **highlight,** the area of highest reflected light, and **cast shadow,** the shadow cast by the illuminated object. A masterful photographic still life, *Parrot Tulip in a Black Vase* **(2.28)** by Robert Mapplethorpe (1946–1989), takes advantage of these optical effects—highlight, light, shadow, core of the shadow, reflected light,

2.28 ROBERT MAP-PLETHORPE. *Parrot Tulip in a Black Vase.* 1985. © Copyright the Estate of Robert Mapplethorpe. Used with permission.

Of the original phenomena, light is the most enthralling.—Leonardo da Vinci (1452–1519), artist and scientist

2.29 LEONARDO DA VINCI. *Ginevra de' Benci.* ca. 1474. Oil on panel. 15 × 14⁹⁄₁₆ in. Ailsa Mellon Bruce Fund. Photograph © 2002 Board of Trustees, National Gallery of Art, Washington, D.C. 1967.6.1 a(2326)/PA. Detail of face.

2.30 ROBERT WIENE. *The Cabinet of Dr. Caligari.* Dr. Caligari and his sleepwalking assistant, Cesare, film still showing shadow of figure on wall. 1919. Deda-Bioslp/Erich Pommer. The Museum of Modern Art, Film Stills Archive. *Certain writers believe that film is the dominant visual art form of our time. Do you think that film masterpieces should be studied in art appreciation and art history courses and featured in art museums?*

cast shadow—to elicit the smooth, crystalline roundness of the vase and the soft, feathery fullness of the flower.

Like Mapplethorpe, numerous artists have utilized light and shadow to "model" or give three-dimensional form to their subjects. We call such use of values descriptive because its primary purpose is to describe or represent the appearance of an object. As an artist and scientist, Leonardo da Vinci was concerned with accurate representation of his portrait sitters in terms of anatomical correctness, physical likeness, and naturalistic lighting effects. In the portrait *Ginevra de' Benci* **(2.29),** he employed values that would simulate the effect of the actual light cast on his young subject. Blocked from the light above by her chin, Ginevra de' Benci's neck is in shadow. Leonardo has darkened or "shaded" this and other areas (the hair at the back of the head, the skin under the lip) that are shielded from the light source. Conversely, he has highlighted, or strongly lightened and brightened, those areas most directly exposed to and reflective of the light. The young woman's reddish orange curls are highlighted to an almost yellow-white. Her upper brow is similarly lightened. These lighting effects simultaneously bring out the textural detail and the tactile qualities of hair, flesh, and fabric.

Many artists have employed light and dark for expressive effects that convey feeling or mood. You may have noticed how hidden "off-camera" light sources in films and theater productions cast shadows and create chiaroscuro effects that produce certain moods or emotions. The creators of the artistically innovative 1919 film *The Cabinet of Dr. Caligari* employed a variety of formal means, including lighting, to make two of the main characters (the doctor and his sleepwalking assistant) especially ominous. In a still photograph from the film **(2.30),** we observe how a brilliant unseen lighting source above and slightly behind Dr. Caligari has cast a monstrous shadow that reaches threateningly across the picture frame. The light also splits Caligari himself in half. He is literally light on one side and dark on the other, an intimation of a split or double personality. Extreme light-dark contrast and an exaggerated shadow are also evident in *The Night Café* (2.33), a work similarly expressive of

a troubled mind. The shadow looms under the billiard table, in part the product of the strong gaslight above.

The Science of Light and Color British scientist Sir Isaac Newton (1642–1727) discovered the secrets of light and color in the second half of the seventeenth century. Newton found that sunlight was made up of an orderly range of rays of different lengths and coloration. Analyzing the "white light" of the sun as it was filtered through a glass prism **(2.31),** Newton noted a spectrum or series of colors in bands arranged in order of their respective wave lengths. These bands proceeded from red, the longest wave, through orange, yellow, green, and blue to violet, the shortest. This spectrum of color is identical with the colors of the rainbow and other phenomena created when natural sunlight is refracted, or bent, through a clear substance such as glass, water, or water vapor.

What then is color, and how is it related to light? Color is the sensation resulting from the stimulation of the retina of the eye by light rays reflected from a given object. We perceive a red piece of paper as red because the chemical structure of the paper absorbs all the rays of light of the spectrum except red, which it reflects back to our eyes. Likewise, a piece of paper or an area of a painting that is perceived as green absorbs all the light rays from the spectrum except green, which it reflects back to us.

The Color Wheel From the bands of colored light refracted through his glass prism, Newton formulated a "circle of colors." Maintaining the fixed sequence of the six bands of the light spectrum, he brought together the red and violet colors on the far ends and arranged the entire group in a circular form. The **color wheel (2.32),** a circular chart of colors, is a contemporary version of Newton's circle. We call the individual colors of the color wheel **hues.** The term *hue* is both a scientific designation based on Newton's spectrum of light and the common name or designation for the colors on the wheel, such as red or violet (also called purple or indigo). Manufacturers of crayons, inks, and paints create numerous hues, many of which originate from the hues on the color wheel.

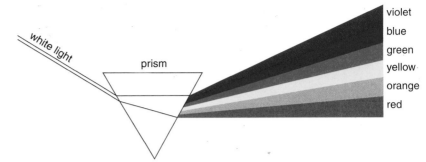

2.31 Prism and spectrum of colors.

2.32 Color wheel.

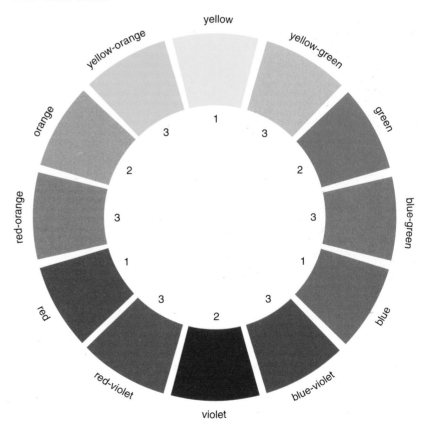

Mixing hues gives us new colors. The color wheel helps us understand basic color mixing and also introduces us to the essential relationships of color interaction.

PRIMARY, SECONDARY, AND TERTIARY COLORS
The **primary colors** or hues (yellow, red, and blue) are the basic, irreducible units that cannot be produced by mixing other colors. The **secondary colors** (orange, violet, and green) are made by mixing a different pair of primary colors: orange by mixing red and yellow, violet by mixing blue and red, green by mixing yellow and blue. The **tertiary** or intermediate **colors** are created by mixing adjacent primary and secondary hues on the color wheel. For example, the tertiary hue red-orange is created by mixing the primary color red and the adjacent secondary color orange. Blue-green, as its name indicates, is produced by mixing blue and green. There are six tertiary colors in all. Additional hues can be created by mixing tertiaries and secondaries and so on.

COLOR PROPERTIES AND RELATIONSHIPS Like people, colors operate both as individuals and in relationships. The relationships between colors (called *color groups, schemes,* or *harmonies*) are either harmonious or contrasting. Harmonious relationships between the hues tend to be agreeable or concordant and low in tension, with little contrast or conflict between the colors. Contrasting relationships, between colors of strongly divergent properties, are more tension-filled. They are also called *discordant* or *dissonant* color harmonies. Observe the color schemes in Russell's *Barn at Dawn* (2.24), Leonardo's *Ginevra de' Benci* (2.29), and van Gogh's *The Night Café* **(2.33)**. Which appear harmonious? Which are contrasting?

Color relationships also can be defined by position on the color wheel. Closely related in hue, **analogous colors** are those adjacent to each other on the color wheel. Hues such as red, red-orange, and orange are analogous because they share common color elements; red-orange, for example, contains the colors of its neighbors, red and orange. Because of their proximity in hue, analogous colors readily blend or harmonize. They display minimal contrast. Observe the analogous color har-

monies in Leonardo's *Ginevra de' Benci* (2.29). The red of the lady's dress harmonizes with the red-oranges of her hair and the reddish oranges of the large tree to the right. These are closely related colors of the same general family. The analogous reddish purples, purples, and bluish purples that pervade Russell's *Barn at Dawn* (2.24) also produce a serene, harmonious color scheme. Opposite in hue and maximum in contrast, **complementary colors** are those directly across from each other on the color wheel, such as red and green or yellow and violet. These color pairs are called complementary because, when placed adjacent to or near each other, each of the two strongly contrasting hues intensifies or complements the other. This **simultaneous contrast** brings out the full brilliance of each hue.

Such simultaneous contrasts are so strong that they induce a perceptual phenomenon known as an **afterimage:** The viewer's eyes see a complementary color's opposite on any nearby white surface. This so-called **optical color** effect induces the perception of colors that are not physically present, whether in the artwork or in the exterior world. Rather, optical colors are projections of the visual apparatus of our eyes and mind. Van Gogh shows awareness of these phenomena when he notes that "the white coat of the landlord, awake in a corner of that furnace [of blood-red color] . . . turns pale, luminous green [the complement of red]." You can experiment with the power of complementary colors, simultaneous contrast, and afterimage by focusing for a minute on any red, blue, or green color and then looking at a white piece of paper or a white wall. Like magic, your eyes will project that color's complement on the white surface.

Complementary color contrasts, brimming with vitality and tension, can energize an artwork. Goldsworthy's placement of a cascade of red leaves against a leafy green background creates a vibrant contrast (2.2), though it is moderated by the softness of the leafy textures. In comparison, the complementary contrasts (red-green, orange-blue, yellowish orange–bluish purple) in *The Night Café* (2.33) shout out. Note specifically how the intense red-orange of the café walls contrasts with the vivid blue-green of the ceiling. Van Gogh notes that he consciously employed "the clash and

. . . color directly influences the soul. Color is the keyboard, the eyes are the hammers, the soul is the piano with many strings. The artist is the hand that plays, touching one key or another purposively, to cause vibrations in the soul.—Wassily Kandinsky, painter, *Concerning the Spiritual in Art,* 1911

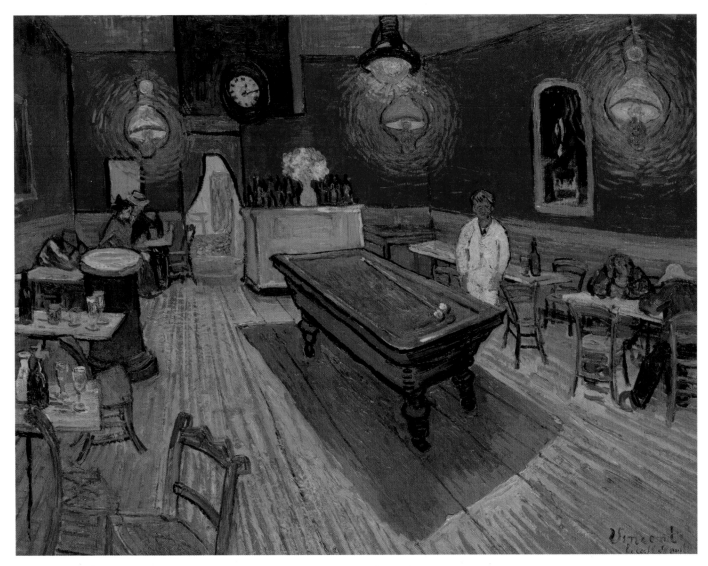

2.33 VINCENT VAN GOGH. *The Night Café*. 1888. Oil on canvas. Yale University Art Gallery. Bequest of Stephen Carlton Clark, B.A. 1903.

contrast of the most disparate reds and greens" to create a disturbing psychological effect.

Interestingly, complementary relationships always involve a pairing of contrasting warm and cool colors. **Warm colors,** those in which yellow, orange, and red predominate, make us feel warmer and excite our senses, probably because we link them with the heat and light of sun and fire. Perceptually, warm colors project forward. Hot reds, oranges, and yellows jump out at us. Stop lights and cautionary signs employ red, orange, or yellow-orange to grab our attention. The hot yellow beyond the rear door in *The Night Café* (2.33) makes that distant area project toward us, thus working against the depth-creating thrust of the one-point perspec-

tive system and creating spatial and psychological tension. Note that in the color wheel the warm colors—from the yellows to the reds—occupy one half of the circle.

Cool colors are those in which blue, green, and purple hold sway. Recall *Barn at Dawn* (2.24) with its cool hues of blue, purple, and reddish purple. The color wheel shows these cooler colors—from the greens to the purples—on the other half of the circle. These colors have a cooling and soothing effect; muted versions are often used in hospitals, libraries, and classrooms. Perceptually, cool colors seem to recede or move away from us. The depths of cool blues and greens lure us like cooling waters or faraway sky. In Leonardo's

Ginevra de' Benci (2.29), the soft blues and blue-greens of the sky and the distant landscape likewise beckon us to gaze into the depths of the picture. Bringing the entire color wheel into action, the potent warm-cool, complementary contrasts of *The Night Café* project a bold tug-of-war of colors. In comparison, the serene *Ginevra de' Benci* displays a harmonious warm-cool balance of colors.

Colors also vary in **intensity,** that is, in their degree of purity or "saturation." The closer a color is to its pure primary, secondary, or tertiary hue (for example, red, orange, or reddish orange), the more intense and saturated it is. Pure, brilliant colors are muted or toned down (made less intense) by mixing them with white, gray, black, or certain other colors. Mixing complementary hues, for example, causes a reduction in intensity. Mixing red with a bit of green tones down the red. Adding yet more green moves the red in the direction of gray. Like pouring water on a fire, adding a complementary color ultimately extinguishes or neutralizes the intensity of the original hue.

Adding white, light gray, or any hue that lightens a given color creates a **tint** of that color. Adding black, dark gray, or any hue that darkens a given color produces a **shade** of that color. Shading, like tinting, reduces the purity and intensity of any hue. The values chart (2.25) shows how a pure primary, secondary, or tertiary color becomes less vivid as it is made lighter or darker. Many of the colors in *The Night Café* (2.33) are pure, intense, and highly saturated, from the blue-greens of the ceiling and the red-oranges of the walls to the yellows and yellow-oranges of the floor, but the tabletops and the bar area are tinted with white or whitish gray, making them paler and softer in effect than the pure, intense surrounding colors. Van Gogh himself refers to these colors as "soft" and "tender." We often call such softened, tinted colors **pastels.** The lightest whitish yellow and tinted pink colors in Russell's dawn sky (2.24) are pastels, whereas the darker colors of the barn and the ground below are largely shades. The term **tone** is applied broadly to the prevailing quality of a tint (for example, a light pink tone), shade (a dark red tone), or saturated hue (a pure blue tone). An artwork with a variety of tones, such as *The Night Café*, is called *polytonal.*

If one says 'Red' . . . and there are fifty people listening, it can be expected that there will be fifty reds in their minds. And one can be sure that all these reds will be very different. —Josef Albers (1888–1976), artist and color theorist

Descriptive and Expressive Use of Color
Color, like value and all the other visual elements, can function both descriptively and expressively. We say that color is descriptive when its primary purpose is to describe the appearance of an object. For example, a painting, photograph, video, or film representation that captures a person's actual skin tones is descriptive. The paintings *Darbar of Jahangir* (2.17) and *Ginevra de' Benci* (2.29) sensitively record the colors of skin tones, clothing, and physical surroundings using **local color,** the color found in that particular locale or setting. Local color is also called *naturalistic color,* meaning that the color is natural or normal for that setting.

Artists sometimes move away from local, naturally occurring colors in order to use color in an expressive way, that is, to express a feeling or a psychological state. Van Gogh uses color expressively—and arbitrarily—in *The Night Café* (2.33). He made arbitrary decisions based on strictly personal preference to achieve his expressive ends; for example, the landlord's hair and eyes are a bold bluish green. This and other coloristic distortions intensify the psychological tension in the room. In his *Self-Portrait* (1.14), the artist adds green, blue-green, yellow, orange, and reddish orange to his natural skin tones to express an excitable state of mind.

Artists might also integrate descriptive and expressive qualities in a single work. Rembrandt's *Man in a Golden Helmet* (2.35), for example, combines naturalistic depiction with chiaroscuro effects that convey a mood of mystery and drama.

TWO WORKS OF ART: FOCUS ON VISUAL ELEMENTS

To summarize and reinforce what we have learned about the visual elements—line, shape, space, texture, value, and color—let us consider the responses of a young college student and a famous art teacher to two different works of art. Both qualify as "analytic descriptions" (see Appendix) in that they describe and analyze the properties of the two artworks. In each case, the writing reveals a formalist

2.34 *Four-ram Wine Vessel*. Ningziang Xian, Hunan Province, China. Shang Dynasty, ca. 1300–1030 B.C.E. Historical Museum, Beijing. The Metropolitan Museum of Art, New York. Department of Asian Art: Objects in "The Great Bronze Age of China," a loan exhibition from The People's Republic of China.

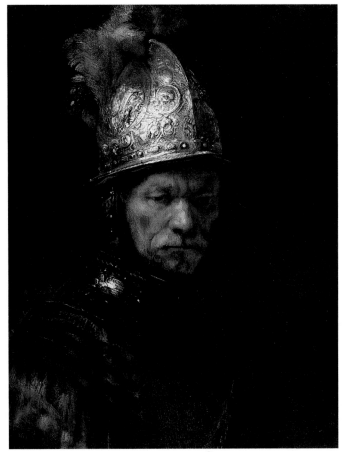

2.35 REMBRANDT VAN RIJN. *Man in a Golden Helmet*. 1652. Staatliche Museen zu Berlin, Preussischer Kulturbesitz, Gemäldegalerie.

orientation, with the focus being on the visual elements.

The student describes an ancient bronze wine vessel **(2.34)**, the creation of an anonymous Chinese artist of the Shang Dynasty (1300–1030 B.C.E.).

> I am most impressed with the *Four-ram Wine Vessel*. It is a large, solid, heavy vessel, 23 inches high and weighing 75 pounds, 14 ounces. The vessel is a bright greenish hue. There appears to be a gradation from light to dark green values throughout the piece. The shape is aesthetically pleasing. It is narrow at the bottom, swells in the center with the prominence of the rams' heads, and then narrows again before it flairs out at the top. The thin vertical shapes, made by the rams' legs and adjacent dragon tails, define and accentuate the form of the vessel from top to bottom. These linear shapes create a strong upward thrust. Horizontals made by the lip at the top and the swelling projection of the rams' heads balance the verticals and give a feeling of stability and harmonious order.

The student turns to the texture and linear patterns on the vessel's surface before making a brief concluding statement.

> The surface is textured with a complex range of curving and curling lines that repeat to make a variety of spiral and rectilinear patterns. These multitudinous lines are etched into the surface at a shallow depth. They cover the surface completely and energize it with a flowing motion that leads the viewer's eye up, down, and around the vessel.
>
> The *Four-ram Wine Vessel* commands attention, combining stylized elegance with energetic activity. It conveys a sense of perfection and a true understanding of beauty.

Johannes Itten, one of the twentieth century's most influential art educators, eloquently describes and analyzes the formal properties of the oil painting *Man in a Golden Helmet* **(2.35)** by the Dutch artist Rembrandt (1606–1669). He begins with the observation that Rembrandt "constructed his paintings in

LEARNING THE VISUAL ELEMENTS

To learn all there is to know about one visual element is tough enough. To try to remember what this chapter had to say about six elements (line, shape, space, texture, value, and color) is that much harder! Here's an idea to help you master the visual elements we've presented. Select an artwork of your choice—a painting, sculpture, mask, building, magazine advertisement, television commercial, comic strip, Web site design, film still, or photograph—and analyze its use of a single element. For example, isolate your attention on shape in a sculpture, texture in a mask, color in a painting, or space in a photograph. After you've mastered one ele-

ment, try focusing on two in a given work, then three, and on up to six.

Finally, analyze all six elements in a visual work you are very familiar with. This work might be your house or room, your car or fashion style. It might be a special CD cover or poster, an original work of art or a reproduction of one. My introductory art students always enjoy describing and analyzing student fashion styles, CD covers, and campus buildings in terms of the visual elements. Visual works you know well and are already interested in are ideal places to start. After describing and analyzing them in visual terms, you might even find you're not quite as familiar with them as you thought!

light-dark contrast" to bring out the three-dimensional "plastic" qualities of his subjects and the full "polytonal" possibilities of the colors.

> In this example, the golden helmet is painted in light, warm, yellow-orange tones. The shadows of the embossing are picked out in dark green-gray. The lighted side of the helmet gives an effect of sharp and hard molded texture. The plume, on the other hand, is done in a dull but luminous red, and its dark tone relates the shaded side of the helmet to the background. The man's face as a whole is as dark as the medium tone of the helmet, only the highlights having a brighter value. The face is a wonderful fabric of light and dark, warm and cold, dull and bright hues, vibrant in the shadowy half-darkness. The flesh appears as if painted in depth, pulsating with life. Broad, linear light-dark rhythms solidly suggest the shoulder, while the torso is lost in the dark background. A very important factor in the depth effect of

the head is the small highlight on the shoulder. When the beholder half-closes his eyes, he perceives this implicit depth treatment very clearly. Light-dark contrast becomes an arresting medium of expression in this painting.[1]

These two analytic descriptions show how the masterful use of the visual elements **(Interaction Box)** can endow works of art with compelling form and expressive power. They also touch on ways that artists combine or compose the elements into harmonious and expressive wholes, that is, into successful works of art. Itten, for example, speaks of how Rembrandt organized or "constructed" his painting around light-dark contrasts. The student writes of how the wine vessel balances verticals and horizontals to create a harmonious order. Such overarching ways of organizing the visual elements, "the principles of composition," are the subject of the next chapter.

The Language of Form

COMPOSITION TO STYLE

Every artistic creation involves organizational decisions. The creators of a magazine advertisement, cartoon strip, office building, piece of furniture, painting, or video must decide how to visually organize—that is, compose or design—the elements that make up the work. Compositional choices need to be made about the types of line, shape, space, texture, value, and color to be used and their arrangement.

THE IMPORTANCE OF GOOD COMPOSITION

If the visual elements of an artwork are poorly or haphazardly arranged, the result will be a disorganized mess. If the overall composition or design is of only average quality, the work will be nondescript and without aesthetic interest. In comparison, a well-designed artwork is far more visually appealing.

Consider two photographs by Patrick Horst (born 1974) of a man playing ping-pong in a streetside park in Beijing, China. Each is well-designed and has its respective strengths. The first photograph **(3.1)** provides more visual information than the second in that we see more of the ping-pong table, man, bicycle, and background. This photograph is Horst's original version of the scene. In a subsequent version **(3.2)**, the photographer has cut down, or "cropped," the image, creating a more intimate, close-up

Composition comprises choice of surface, division of the surface, co-modulation [or unification of forms], relationships of density, color scheme.
—Le Corbusier, architect, and Amédée Ozenfant, painter, *The New Spirit*, 1920

3.2 PATRICK HORST. *Ping-Pong Park, No. 2*. 2002. Color photograph.

3.1 PATRICK HORST. *Ping-Pong Park*. 2002. Color photograph.

view of the player. Cropping out much of the table and background dramatically shifts the compositional focus to the enlarged ping-pong player, his facial expression and bodily action. The new, tighter framing also creates a horizontal rather than a vertical orientation for the overall work. Horst observes that "these shots show how composition determines the 'direction' of a picture, in that the placement of the subject can influence the way the picture moves." The cropped, horizontal version promotes a more sideways movement and intensifies the action in the right side of the photo. Note how the captivating negative space around the player along with the intersecting lines of bicycle and fence produce a lively figure-ground relationship and a dynamically

balanced design. When pressed as to which of the two images he prefers, Horst chooses the second as "the stronger work of art." Do you agree?

THE PRINCIPLES OF COMPOSITION

As shown by the analysis of the two photographs, compositional decisions are absolutely central to the quality and success of a work. To better understand these decisions, let us turn to basic strategies or principles that artists traditionally employ in the organization of their works. These so-called "principles of composition" include unity, variety,

balance, emphasis, rhythm, and proportion. Understanding these principles helps us appreciate works of art in terms of both form and content.

Unity

Unity refers to the integration of all the elements or aspects of the work into a single, indivisible whole. A unified work conveys a sense of wholeness and coherence. It speaks of integrity and completion. An analogy from the world of sports will help reinforce this concept. A team with unity operates like a tightly knit unit, with all the individual players or parts melding together in an organic whole. A team that lacks unity is characterized by lack of cohesion, disorganization, or dissension. It fails to hold together or achieve wholeness. Each player is going his or her own way.

In works of art, "the players" are the visual elements, subjects, techniques, and materials. As a basic principle, the simpler, more similar, or fewer in number the players or parts, the easier it is to unify or integrate them. The Beatles' *White Album* CD cover **(3.3)** by Richard Hamilton (born 1922) employs a single, uniform white color on a flat, square surface. The texture of the paper surface is smooth and uniform. With so few elements to organize, the *White Album* is a shockingly simple, totally unified package. Like all Beatles album covers, it was artistically groundbreaking and influential in the world of popular culture. With well-known artists and photographers as their designers, Beatles covers injected ideas from "the art world" of museums and galleries into the culture at large. In recent decades, such vital popular art has in turn influenced "fine art" (that is, art-world art) worldwide.

In art historical terms, the 1968 *White Album*, with its emphasis on the most basic formal elements and composition, fits with the 1960s art movement known as **minimalism.** A fine art example of minimalism is a painted 6-by-6-by-6-foot steel sculpture **(3.4)** created by Tony Smith (1912–1980) in 1962. It is uniform in color, texture, height, width, and depth. Like the *White Album*, the all-black cube (or die) fea-

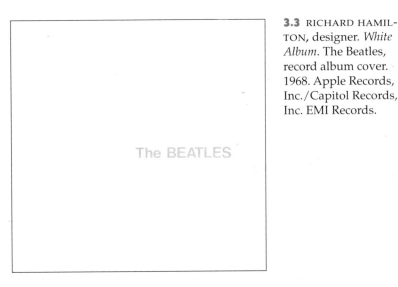

The BEATLES

3.3 RICHARD HAMILTON, designer. *White Album*. The Beatles, record album cover. 1968. Apple Records, Inc./Capitol Records, Inc. EMI Records.

tures a minimum of art elements joined together in the simplest of arrangements. The result in both works is maximum unity with minimal variety.

Variety

The more different, contrasting, or numerous the elements or components in a work—that is, the more variety—the more challenging it is for the work to attain unity. (Returning to the sports analogy, it's harder to organize and unify an eleven-person squad than a two-person team.) Yet variety adds interest and excitement to an artwork. The more variety, the more there is to look at and experience. In total contrast to the *White Album,* the Beatles' *Sgt. Pepper's Lonely Hearts Club Band* album cover **(3.5)** features maximal variety in terms of subject matter, materials, and artistic techniques. Components of the composition include real persons, life-size wax figures, photographic portraits, actual musical instruments, dolls, a miniature television set, fake foliage, and a painted blue sky back-

I shall define Beauty [what modern aestheticians call 'organic unity'] to be a harmony of all the parts in whatsoever subject it appears, fitted together with such proportion and connection that nothing could be added, diminished, altered, but for the worse.—Leon Battista Alberti, Italian Renaissance architect and writer

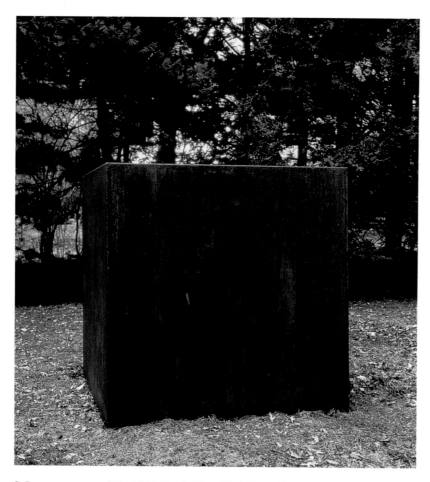

3.4 TONY SMITH. *Die*. 1962. Steel. 72 × 72 × 72 in. Collection of Samuel J. Wagstaff, Jr., Hartford, Connecticut.

3.5 PETER BLAKE and JANN HAWORTH, designers. *Sgt. Pepper's Lonely Hearts Club Band*. The Beatles, record album cover. 1967. © Apple Records, Inc./Capitol Records, Inc. EMI Records.

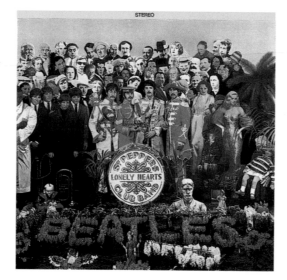

ground. Formally, the cover contains a rainbow of colors and a myriad of textures. Helping to unify all this variety is the frontal orientation of the many figures and their arrangement in a basic rectangular shape. Note how the foreground and background sections repeat this same basic rectilinear shape within the rectilinear format of the album cover. In addition, artists Peter Blake and Jann Haworth effectively employed the principle of symmetrical balance (discussed below) to further unify the composition.

Another work of substantial variety is a late-nineteenth-century dance robe **(3.6)** created by a Native American artist of the Clayoquot tribe from the Pacific Northwest. Used in spiritual ceremonies, the dance robe bears the colorful image of a large mythical thunderbird, with two undulating lightning serpents face to face at the lower edge. Numerous and diverse shapes, spaces, and colors make up the animals and the overall design. Helping to bind all of this variety together is the analogous color harmony of warm reds, oranges, and brownish yellows that pervades the composition. A consistent abstract stylization of the animals and surrounding forms also fosters unity among the parts. Melding the natural and the geometric, the artist has made each figure and form a member of the same stylistic family. In addition, all the shapes and spaces are uniformly flattened, making for a tight integration of positive and negative, figure and ground on the robe's surface. Finally, a relatively equal distribution, or balancing, of the figures and parts between the left and right halves and the top and bottom of the garment helps bring unity from diversity.

Artworks might also push unity and variety to the edge or beyond, as we will see in two works (3.15, 3.16) later in this chapter.

Balance

Balance is the sense of equilibrium between different or opposing forces. Artists might create equilibrium both within a given element (for example, balancing warm and cool colors) and between the separate elements (for example, balancing bold, loud colors with soft, subtle textures). They might also

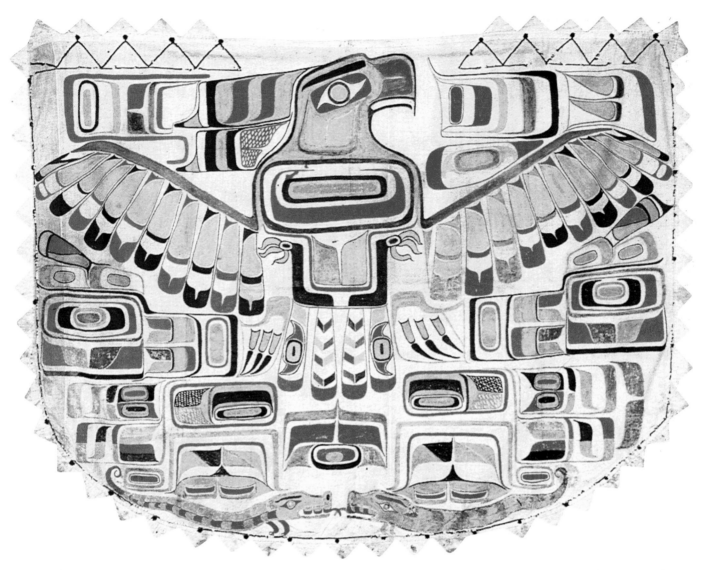

forsake conventional types of balance for challenging states of equilibrium that incorporate varying degrees of imbalance or tension. In a painting, this might mean using clashing color combinations that seem painfully out of balance. Or it might mean that the foremost "weights" of the work—the major subjects or objects or most stimulating elements—are off-center and spatially arranged in a tension-filled way. Such boundary-pushing equilibrium notwithstanding, almost all successful artworks achieve some sense of compositional balance. Indeed, achieving balance is one of the most basic human and ecological needs.

Symmetrical Balance One of the most common strategies artists use to organize their compositions is **symmetrical balance.** Symmetrical balance refers to exact correspondence in shape, size, and arrangement of the parts on both sides of the central axis of a work. The fantastical entrance of an old Italian palace in Rome **(3.7)** shows such exact symmetry in the service of a dynamic composition. The decorative architectural elements and the grimacing face of the giant surrounding the door are identical on each side of the central vertical axis. (Go in that door, and you will literally be swallowed alive!) Tony Smith's *Die*

3.6 Clayoquot artist from Pacific Northwest. Dance robe. Late 19th century. Muslin, with image of a thunderbird. Courtesy of the Burke Museum of Natural History and Culture, cat. no. 1178. Photo: Eduardo Calderon. *In your opinion, when does an article of clothing become a work of art?*

3.7 FEDERICO ZUCCARI. Palazzo Zuccari, doorway, Rome. Ca. 1600.

Art tends toward balance, order, judgment of relative values, the laws of growth, the economy of living— very good things for anyone to be interested in.—Robert Henri, artist, *The Art Spirit*, 1923

(3.4) is another three-dimensional work that is perfectly symmetrical. The Beatles' *White Album* (3.3) and Escher's *Day and Night* (2.15) are examples of completely symmetrical two-dimensional works with equal parts or "weights" on both sides of the central vertical axis. Strongly (though not exactly) symmetrical in spatial arrangement are the Native American dance robe (3.6), the *Sgt. Pepper's* album cover (3.5), and Leonardo's *Last Supper* (2.18). Also strongly symmetrical is the *Frida Kahlo Altar* **(3.8).** Amalia Mesa-Bains (born 1943) and members of San Francisco's Hispanic community created the altar to honor Mexican artist Frida Kahlo (Appreciation 34), whose framed photographic portrait resides proudly at the center axis of this three-dimensional piece. The pronounced symmetry in these latter artworks helps unify their diverse figures and forms.

Asymmetrical Balance Asymmetrical balance (*a-* means "not" or "non-") refers to a nonexact or inexact correspondence between the shape, size, and arrangement of parts on both sides of a work. Asymmetrical compositions like that of *The Haneda Ferry and Benten Shrine* **(3.9)** by Japanese artist Ando Hiroshige (1797–1858) make creating equilibrium a challenge, but the balance that is achieved is invariably lively. It's similar to the process of balancing on a playground seesaw with unequal weights on either side of the center. Hiroshige places enough weight on the right side— strong color and value contrasts, a panoramic landscape, three key shapes along the right edge—to balance the major weight of the ferryman, rope, and tiller on the left. Such adjustments keep the visual seesaw from tilting in one direction and throwing the composition out of balance.

As an architectural example, Frank Lloyd Wright's Guggenheim Museum **(3.10)** is asymmetrically balanced, with the building's signature feature, its large, expanding spiral tower, boldly situated on one side. On the museum's other side is a smaller, glass-enclosed, round structure or "rotunda." This smaller rotunda, coupled with a longer lower section of the building beneath it, balances the dominant spiral tower in a dynamic equilibrium. In contrast, the rectilinear high-rise buildings surrounding the museum are strongly symmetrical. If we divided them down the middle, they would split into roughly equal halves. Yet, within their symmetries, a number of these high-rises incorporate asymmetrical touches, such as the interest-generating, off-center windows and entranceway of the museum's own tall, slablike annex. Built behind the museum several decades after the completion of the original structure, the similarly colored annex brings more visual weight to the side of the Guggenheim that houses the smaller rotunda, moderating the dominance of the spiral tower.

Radial Balance **Radial balance,** a third type of arrangement of visual parts or weights, is in most cases a type of symmetrical balance. In radial balance, the constituent parts radiate outward from and are balanced around a common center. The design on the bass drum in the

3.8 AMALIA MESA-BAINS (collaboration with CARMEN LOMAS GARZA). *Frida Kahlo Altar.* 1979. Altar and mixed-media installation at Galeria de la Raza, San Francisco, 1979. Courtesy of the artist. *Amalia Mesa-Bains turned to the Mexican and Chicano traditional home altar for the form of this artwork. With her collaborator, Mesa-Bains transformed the small, private religious altar form into a public, participatory artwork. Community artists contributed offerings to the altarpiece, which honored a secular figure, artist Frida Kahlo. Was Mesa-Bains, who claimed that her intentions were strongly spiritual, violating the home altar tradition or expanding it?*

3.9 ANDO HIROSHIGE. *The Haneda Ferry and Benten Shrine.* 1858–59. Woodblock print from *One Hundred Views of Edo.* The British Museum, London.

3.10 FRANK LLOYD WRIGHT. Solomon R. Guggenheim Museum, New York City. 1956–59. Exterior view from opposite (NW) corner.

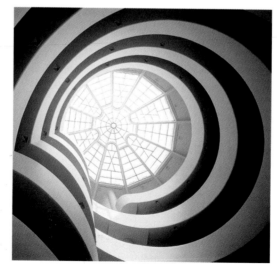

3.11 FRANK LLOYD WRIGHT. Solomon R. Guggenheim Museum, New York City. 1956–59. Interior of the dome.

Sgt. Pepper album cover (3.5) is an example of radial balance, with the outer letters and interior decoration radiating from and composed around the circle's center. Circle-based architectural domes across cultures and time periods likewise feature radial balance, with decorative embellishment, visual scenes, or structural elements organized around the central point. Completed in New York City in 1959, the interior of the Guggenheim Museum's spiral tower dome **(3.11)** employs glass and metal structural elements in a lively radiating pattern around its center. The Great Mosque in Córdoba, Spain, built twelve centuries earlier, features eight golden and eight blue-toned sections of abstract floral and

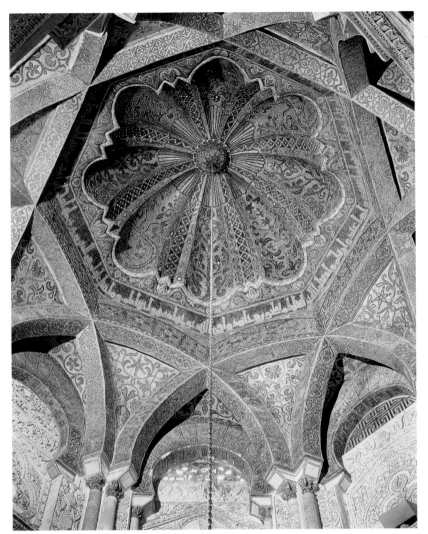

3.12 Dome above the Great Mosque, Córdoba. Ca. 961–66.

geometric decoration **(3.12)**. They radiate symmetrically from the center of the dome, which rises high above the building's holiest site. Half circles and a variety of other shapes might also serve as the bases of a radial composition. For example, Nancy Holt's four sun tunnels (2.10, 8.7) are arranged in an "X" configuration around a common center. A veritable sunburst, *Barcelona Fan* **(3.13)** by Miriam Schapiro (born 1923) combines painting and fabric sewn to a flat canvas surface. The mixed-media work was inspired by the shape of a woman's small hand fan in open position. All the elements and parts of Schapiro's very large work, 6 feet high by 12 feet long, radiate from and are balanced around a common point.

3.13 MIRIAM SCHAPIRO. *Barcelona Fan*. 1979. Acrylic and fabric on canvas. 6 × 12 ft. Collection The Metropolitan Museum of Art, New York. Gift of Steven M. Jacobson and Howard A. Kalka, 1993 (1993.408).

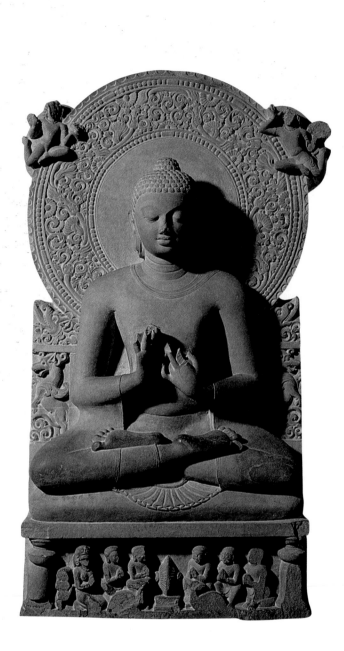

3.14 *Buddha Preaching the First Sermon.* From Sarnath, ca. 465–85 C.E. Sandstone. Height: 63 in. Archaeological Museum, Sarnath.

Emphasis

Emphasis (also called *focus* or *dominance*) refers to the principle of visual organization in which certain elements or parts assume more importance than others in the same composition or design. The focal point or dominant feature in the Guggenheim Museum (3.10) is the spiral tower; in *The Haneda Ferry* (3.9), the ferryman; and in the *Frida Kahlo Altar* (3.8), the framed photograph of the artist Frida Kahlo. The three compositions are organized around these magnetic attractions.

Preeminent religious figures such as Jesus Christ or the Buddha are always given maximum emphasis in any artworks in which they appear. Symmetrically centered on an impressive throne and backed by a huge decorated halo, the founder of the Buddhist religion is a serene but commanding presence **(3.14).** Frontally posed in this Indian sculpture carved from sandstone, the Buddha dwarfs the six tiny devotees below him and the two heavenly winged beings above. He is the primary focus. The other figures are secondary, or **subordinate,** to the Buddha. This same primary-secondary, dominant-subordinate relationship holds in Leonardo's *Last Supper* (2.18) and Giotto's *Lamentation* (2.6). Christ is the center of attention, and the disciples and others are the supporting cast.

In contrast, no single feature or element is clearly dominant in either the dome of Córdoba's Great Mosque (3.12) or Miriam Schapiro's *Barcelona Fan* (3.13). The decorative sections and center of the dome, for example, seem of relatively equal importance. Many twentieth-century artists, like Schapiro, have created artworks in which all sections or areas of the piece receive equal emphasis. There is no single center of attention and no subordinate or secondary parts. The radial center of the *Barcelona Fan,* which would ordinarily be the focal point of the composition, is deemphasized through the use of muted color. The radiating sections are brighter and more intense in color than the central core and expand in size as they move outward. The result is an overall emphasis on all the parts, or an **all-over composition.** The Beatles' *White Album* (3.3) and Tony Smith's *Die* (3.4) take this a step further with an all-over composition that allots uniform emphasis to every square inch of surface.

Rhythm, Repetition, and Pattern

Rhythm refers to the ordering of time. Regular rhythms involve a repeating or repetition of moments of time. **Pattern** refers to an ordered repetition of line, space, shape, or texture on a visual surface. Schapiro's *Barcelona Fan* (3.13), the interiors and domes of Córdoba's Great Mosque (3.12) and the Guggenheim Museum (3.11), Escher's *Day and Night* (2.15), and the Amish *Tumbling Blocks* quilt (2.11) exhibit orderly patterns and regular rhythms based on repeating shapes, spaces, colors, and textures. Note how your eye rotates with a rhythm of smooth regularity around the halo of the seated Buddha (3.14). The consistency of the halo's decorative detail creates a flowing pattern and circular path around the master's head.

Whereas regular rhythms are based on strict repetition, irregular rhythms play upon or defy repetition. A work with a very irregular, herky-jerky rhythm is the collage *Head* **(3.15)** by Raoul Hausmann (1886–1971). Nothing repeats in this potpourri of pasted-down images and text fragments in wide-ranging sizes, fonts, and spacings. Numbers, letters, words, and images are placed upside down, rightside up, and at various angles. If Hausmann's collage expanded and exploded into the realm of three dimensions (and the fourth dimension, if one counts actual movement), it might resemble Jonathan Borofsky's *Paula Cooper Gallery Installation* **(3.16)**. Installation artists like Borofsky (born 1942) utilize entire rooms and other spaces to create their works. For the period of a month, Borofsky filled this New York City art gallery with his two- and three-dimensional drawings, paintings, sculptures, and writings. The works were leaned on or against the walls, hung from the ceiling or wall, stuffed in a trash can, or scattered across the floor. To further animate the space, he installed a commercially manufactured Ping-Pong table, which was put to use by certain visitors as others walked through the space viewing the artist's multifarious productions. As with Hausmann's collage (3.15), the rhythm of Borofsky's installation is uneven, nervous, start and stop. The eye bounces erratically around the far-flung attractions. With so little orderly repetition, focus, or balance, the beholder might experience a kind of free-for-all

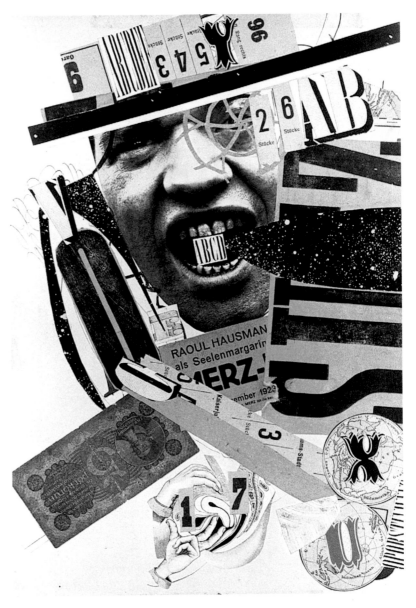

3.15 RAOUL HAUSMANN. *Head (ABCD)*. 1923. Photomontage. 15⅜ × 10½ in. Musée National d'Art Moderne, Paris.

randomness or even chaos. But the force of the artist's energetic forms and of the purposeful location of his numerous creations throughout the gallery brings a degree of coherence to the interior, as does the defining nature of the rectilinear gallery space itself. Like a picture frame, the gallery encompasses and gives clearly marked parameters to the wide-ranging works within. In both Borofsky's *Paula Cooper Gallery Installation* and Hausmann's *Head* collage, variety and irregularity reign, while traditional notions of unity, balance, dominance, and order are challenged.

Movement is the expression of life. All movements are of a spatial nature. The continuation of movement throughout space is rhythm. Thereby rhythm is the expression of life in space. —Hans Hofmann, painter, *Search for the Real and Other Essays,* 1948

3.16 JONATHAN BOROFSKY. *Paula Cooper Gallery Installation.* 1980. Mixed media. Courtesy Paula Cooper Gallery, New York. Photo: eeva-inkeri.

Proportion and Scale

Proportion is the relation of art elements or subjects to one another in terms of their size, quantity, or degree of emphasis. In terms of size, the figures, musical instruments, and toy dolls in the *Sgt. Pepper's* album cover (3.5) for the most part are in correct human proportion to one another. We would find the same comparative size relationships in everyday life, though in proportional terms we probably wouldn't find such a quantity of people densely packed together.

Scale refers to proportional size relationships relative to a standard or normal size. Looking a bit more closely at the *Sgt. Pepper* cover, the four "live" Beatles, the featured performers, are just a bit larger in scale than the multitude of people around them. Yet because the difference in scale is so slight they seem in proportional relationship to the others. In contrast, consider artworks in which figures or forms are "out of proportion." The enormous green apple filling the room in René Magritte's *The Listening Room* (2.8) is outsize in scale. A sculptural counterpart is the 45-foot-high steel *Clothespin* **(3.17)** by Claes Oldenburg (born 1929). Oldenburg has vastly expanded a small object normally about 3 inches long to huge size and outlandish scale. Enlarged to 180 times its usual size, the little household object now boldly measures itself against the surrounding high-rise buildings in downtown Philadelphia. Such bizarre inflation of the clothespin's scale provokes wonder and smiles of disbelief on the part of passersby.

At the other extreme, artists sometimes wildly diminish the scale and transform normally large subjects or objects to diminutive size. A good example is *The Cruel Discussion*

3.17 CLAES OLDENBURG. *Clothespin*. 1976. Coreten and stainless steel. 45 ft. × 12 ft. 3¼ in. × 4 ft. 6 in. Central Square Plaza, Fifteenth and Market Streets, Philadelphia. © 2001 Claes Oldenburg. Photo: Attilio Maranzano. *One noted art critic has called Oldenburg "the thinking man's Walt Disney." What did the critic mean by his linking of the artist to Disney, Disneyland, and the productions of the Disney corporation?*

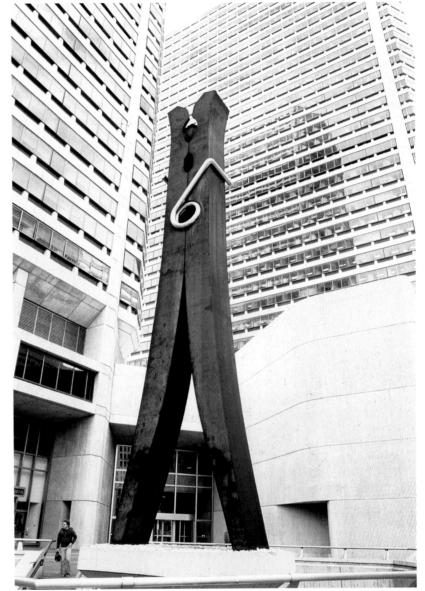

(3.18), a painting by Nicholas Africano (born 1948), in which a silent man and a woman leaning forward with her hands over her ears sit facing each other. In a conventional painting, the central figures are much larger in size in relation to both the picture surface and the space around them. The two protagonists in Africano's painting, facing each other at a distance, are dwarfed by the vast scale of the surrounding blank space. This clashing of scales—tiny for the figures and vast for the picture space—effectively produces a sense of uneasy tension in keeping with "the cruel discussion" under way.

Appreciation 5 explores the use of proportion and scale and the other principles of composition in album cover design. The essay also employs the art critical skills of analytic description and interpretation discussed in the Writing about Art Appendix.

3.18 NICHOLAS AFRICANO. *The Cruel Discussion*. 1976–77. Acrylic, wax, oil on canvas. 6 ft. × 15 ft. 10 in. Courtesy of the artist.

APPRECIATION 5 *The Art of Album Cover Design*

ROBERT BERSSON

Figure A JOHN JAGEL, designer. *Ornette!* Ornette Coleman Quartet, album cover. 1962. © Atlantic Records.

Figure B REID MILES, illustrator. *Right Now!* Jackie McLean, album cover. 1966. © Blue Note/Capitol Records, Inc. EMI Records.

The jazz album covers *Ornette!* **(Fig. A)** and *right now!* **(Fig. B)** are two bold attempts at achieving equivalence between musical and visual forms. Shape, typography, color, and composition seek correspondence with sounds, rhythms, and melodic lines.

In the early 1960s, the revolutionary playing of Ornette Coleman (born 1930) shattered the traditional boundaries of jazz harmony and rhythm. By bursting these musical bounds, the Coleman quartet unleashed the freest, most unrestricted—and to some, the most ear-splitting—jazz ever heard. The *Ornette!* album cover succeeds admirably in capturing the explosive originality of the saxophonist's music. The musician's first name dominates the square format. A lean, modern typeface is employed. But there is nothing traditional about the size or placement of the letters on the cover.

Large in scale, they are fractured into an irregular configuration, each one seemingly in motion, up or down, forward or back, expressive of a quirky, restless rhythm. Following the line or shape of the combined letters, the eye bounces along a taut, jagged passageway. Adding to these effects, the letters stand out in extreme chromatic contrast, cool-tinted bluish purple against bright, hot yellow, an uneasy but vibrant complementary color relationship. Spatially, the letters and surrounding nonrepresentational shapes interpenetrate, exploding distinctions between foreground and background, figure and ground. This integration of shapes, spaces, and type into a flattened picture plane, along with an arrangement that is strongly symmetrical, brings forth a compositional unity from all the creative variety and contrast on the surface.

The album *right now!* by Jackie McLean (born 1932) contains bold music by another major jazz saxophonist, but its break with tradition is less radical. McLean has been described by jazz critics as a "strongman" and his playing called "hard and raw," "muscular." Coleman broke the rules; McLean bent and stretched them to the limit. The words "right now!" and "Jackie McLean," which fill the cover, are noticeably more readable than the fragmented letters of *Ornette!* But that and the cover's symmetrical balance are about the only traditional aspects of the composition. Like the music, the cover is bursting with power, contrast, and boundary-stretching variety. Large jet-black letters stand out against a brilliant white ground. As if set down with the hard, metallic immediacy of a giant typewriter, the letters dominate the cover, jumping out at the viewer. They reassert, with an aggressive urgency, the exclamatory message of the title. Stretching beyond the conventional, several letters are a little thicker and heavier than the others. Some are slightly above, several below, their expected positions. Parts of others move off the cover. Standard notions of alignment and spacing are defied. The visual design virtually shouts forth the boldness and rebellious power of McLean's music.

The hip, knowing sophistication of jazz cover design of the 1950s and 1960s linked avant-garde painting, photography, typography, and illustration with a form of music and a musical audience that was self-consciously "progressive." The racially mixed, vanguard jazz audience, primarily intellectuals, artists, and bohemians, wanted information from the covers, but they also wanted art and style. They got both, as avant-garde sounds were transformed into cutting-edge imagery. The quality and invention of these pioneering covers were not to be matched until rock music gained a sense of its own relevance in the 1960s. ■

3.19 MIRIAM SCHAPIRO. Lerner-Heller Gallery installation, *First Fan.* 1976–77; *Paisley/Leaf Vestituro.* 1979. Installation shot. Courtesy of the artist. *Why would feminist artists like Miriam Schapiro have been drawn to decorative patterns as a basis for their art?*

In life, sometimes the spirit has been overemphasized at the expense of the body; sometimes one has been preoccupied with the body and neglected the spirit; similarly in art content and form have alternately been overemphasized or neglected because their inseparable unity has not been realized.

—Piet Mondrian, painter, *Circle,* 1937

FORM AND CONTENT: AN INSEPARABLE PAIR

The way artists employ and organize the visual elements, the form of the work, is always tied to the artists' unique personalities and backgrounds, values, attitudes, ideas, and intentions; that is, the form is tied inextricably to the content.

Nicholas Africano asserted, "I want my paintings to be about something [of social significance] . . . to mean something in a cogent and revealing way." The concern of *The Cruel Discussion* (3.18) is the difficulty or breakdown of communication between people. For Africano, the underlying social significance influences the painting's visual form, with its vast spaces and tiny figures placed uneasily left of center.

Raoul Hausmann's philosophy and lifestyle were countercultural and strongly critical of the status quo in Germany and his native Austria. As members of the Dadaist art movement, he and his fellows followed a credo of freedom, nonrational creativity, and rebellious nonconformity. The Dadaists despised the German leaders, ruling social classes, and political groups that they believed brought ruination to the country through World War I and its turbulent aftermath. Hausmann's *Head* collage (3.15), with its clashes and violent contrasts, embodies this rebel attitude and outlook in formal terms. Its multitudinous severed figures and its torn and cut text fragments, crashing into each other from skewed angles, defy the traditional values of order, balance, unity, and propriety so dear to the mainstream society the artist hated.

Miriam Schapiro's work is based on deep personal commitments to feminism and multiculturalism. This is the content that shapes its form. Her art honors women's worldwide cultural heritage, their everyday work and lives, which she perceives as undervalued. Schapiro's *Barcelona Fan* (3.13), for example, is based on the shape and formal properties of a practical and decorative art form, much used by women in times past and across cultures,

from Spain to Japan. Fans in general and the *Barcelona Fan* in particular feature repeating patterns arranged for decorative pleasure and expression, hence the name Pattern and Decoration (or P&D) for the larger 1970s art movement that the artist helped pioneer and to which this work belongs.

Form, Content, and Context

A note on the highly important relationship of form and content to exhibition context is essential: Each artist thinks about the physical place in which his or her work will be exhibited and the audience that will view it there. The previously cited Buddhist sculpture (3.14) was created for a specific religious setting, and its form and content mirror this. Nicholas Africano's framed and portable paintings were created with the art world of museums and commercial galleries in mind; their form and content likewise reflect the influence of this secular art world setting. The intended destination of Miriam Schapiro's Pattern and Decoration artworks was likewise the world of galleries and museums, and their form and content embody this and other meanings. The feminist Schapiro wanted her mixed-media creations, combinations of sewn fabric and painting, to be accepted as significant fine art ("high art") in the male-dominated art world of the 1970s. For this reason, she made the works very large, incorporated painting along with cut and sewn fabric as her media, and utilized a repeating geometric grid arrangement as basic elements in her own style **(3.19).** These qualities, basic to men's artworks of the period, were bent by Schapiro to her own feminist and multicultural purposes. As art historian Ruth Appelhof relates:

> The grid was . . . important to Schapiro because it signified "high" art. So did paint, which she combined with diverse [fabric] materials. The "big" size of her pictures was a sign of ambitious painting—at a time when the art world equated small with minor. But size had another function. Schapiro said that "the fan is a trivial, insignificant aspect of women's culture. I heroicize it. I make the fan twelve feet long."[1]

The influence of exhibition context and intended audience on the form and content of any given work cannot be underestimated.

FROM FORM AND CONTENT TO STYLE

Miriam Schapiro (3.19), Nicholas Africano (3.18), Jonathan Borofsky (3.16), Raoul Hausmann (3.15), Frank Lloyd Wright (3.11), Ando Hiroshige (3.9), and the anonymous Pacific Northwest robe maker (3.6) each have his or her own unique artistic style. **Style** is the constant form, manifested in recurring elements, compositional approaches, and content, in an individual's or a group's art. We become aware of a style when we repeatedly experience continuities of form and content over time.

Personal Style

We note **personal styles** of specific artists— "That's a Schapiro," "That's an Africano"— after we have seen a range of their works. In Miriam Schapiro's *First Fan*, 1976–77 (3.19), and *Barcelona Fan*, 1979 (3.13), we observe a constellation of common qualities: half-circle fan shape, large size, mixed-media integration of sewn fabric and painted areas, repeating patterns, radial symmetry, and integration of abundant visual variety and detail into a geometrically organized all-over composition. Such constant form, combined with the feminist, multicultural, and art world content underlying and shaping that form, defines a personal style that we can subsequently identify as that of Miriam Schapiro.

In van Gogh's *The Night Café* (2.33) and *Self-Portrait* (1.14), we note recurrent forms that point to his personal style: reappearing elements (bold color contrasts, rough impasto texture) and compositions (unified but with much variety). We also detect a common underlying content. Embodied in the form of van Gogh's art is a highly individualistic and emotional way of seeing, an outlook influenced by the most advanced artistic ideas of late-nineteenth-century European culture.

Examination of Leonardo's *Last Supper* (2.18) and *Ginevra de' Benci* (2.22) likewise reveals a personal style. In both works, we can discern common visual elements (subtle use of values, naturalistic color and shape, sfumato, aerial perspective, clear figure-ground distinction), compositional qualities (dominance of a single figure, symmetrical balance), and content

But the style is, above all, a system of forms with a quality and meaningful expression through which the personality of the artist and the broad outlook of a group are visible. It is also a vehicle of expression within the group, communicating and fixing certain values of religious, social, and moral life through the emotional suggestiveness of forms.
—Meyer Schapiro, art historian, *Anthropology Today*, 1953

Personal style, be it that of Michelangelo, or that of Tintoretto . . . has always been that peculiar personal rapport between an artist and his medium.
—Ben Shahn, artist, *The Shape of Content*, 1957

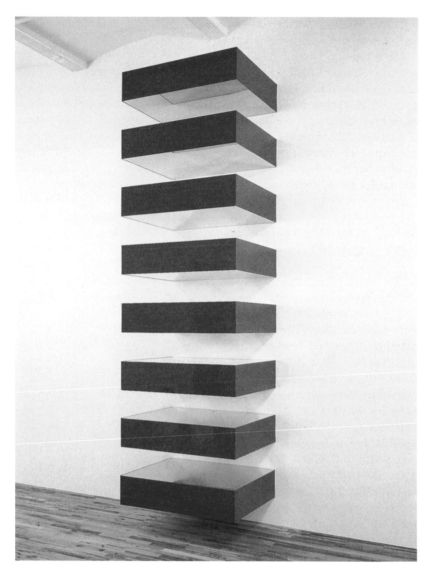

3.20 DONALD JUDD. *Untitled.* 1989. Installation view in gallery. Copper, red plexiglass. Each 9 × 40 × 31 in. (8 of 10 units). © Donald Judd Foundation/ Licensed by VAGA, New York, NY. *Do you consider minimalist sculpture to be art? Why or why not?*

Group Style

We can detect **group styles,** those of artists in specific organizations, political or artistic movements that share a general outlook or set of values. Artworks such as the Beatles' 1969 *White Album* (3.3) and Tony Smith's 1962 *Die* (3.4) fit within the minimalist art movement of the 1960s. The sculptures **(3.20)** of Donald Judd (1928–1994) likewise fit within the minimalist

style and its standard value system, or "canon." All these works share and affirm enough common properties (simple, pared-down shapes; uniformity of color, surface, and texture; minimal variety and maximal unity; composition that is absolutely symmetrical and all-over) to relate them to the group style minimalism, to which various artists and designers subscribed. When we speak of the art of the late-nineteenth-century French impressionists (1.6), the early-twentieth-century Dadaists (3.15), late-twentieth-century Pattern and Decoration artists (3.13, 3.19), or practitioners of Nazi art under Hitler's Third Reich (1.11), we are referring to works and artists associated with a group style. While artists within these groups have clear personal styles, commonalities in form and content among the various artists' works tend to affirm an identifiable group style. Adding final confirmation to group identities, art museums exhibit the works of impressionists, Dadaists, P&D artists, and others connected to group styles in the same rooms, and art historians discuss them on consecutive pages in their books.

Cultural Style

Cultural styles are distinctive styles associated with specific cultural or subcultural groups. So far we have viewed four quite different works by artists of Pacific Northwest Indian heritage. Two are more than a hundred years old: a dance robe (3.6) and a traditional totem pole (Appreciation 1, Fig. B). The other two are contemporary: a small watercolor painting (Appreciation 1, Fig. A) and a monumental outdoor sculpture (Appreciation 3). But all four works share constant qualities, notably a unique abstract stylization of mythical subjects, that stamp each with a firm Pacific Northwest Indian identity. The four works could not have been made by anyone other than a Native American artist from one of the many tribal groups of the Pacific Northwest culture or someone faithfully applying that cultural style.

We define *culture* as the attitudes, beliefs, and values of a given people in a given period, and we broadly apply the concept to groups large and small. We associate culture with entire societies (American culture), with social

(a concern for scientific accuracy, human beauty, and moral and spiritual perfection in keeping with late-fifteenth-century northern Italian humanist values).

classes or life-style-based groups within a given society (urban culture, suburban culture, commercial culture, youth culture), with ethnic or racial groups (Jewish, African-American, Native American), and with tribes (the Native American Clayoquot or Nootka) or tribal communities sharing the same geographical area and heritage (Native American culture of the Pacific Northwest). In the section on fashion design and style, we will speak of mainstream cultural groups (middle-class businesspersons) and subcultural groups (punks), each with unique values and visual styles (3.22, 3.23).

Period Style

Looking at cultures over long periods of time, we might also note **period styles** in which the works of a certain time period, age, or era manifest shared formal characteristics and content different from earlier or later styles within that culture.

Within Chinese art, for example, art historians have assigned period styles to the art created during specific royal dynasties such as the Shang, Sung, and Ming. These dynasties have discrete beginning and ending points during which a particular royal family held imperial power and a certain social structure and culture manifested itself. Such a sociocultural context cultivated a generally identifiable style in its arts. From a period style standpoint, Mu-Ch'i's ink painting *Six Persimmons* (2.7) is art of the Sung Dynasty (960–1279), while the *Four-ram Wine Vessel* (2.34) is a work of the earlier Shang Dynasty (1700–1050 B.C.E.). This same type of stylistic classification, blending period and dynasty, holds for much Indian art. For example, art historians describe the statue *Buddha Preaching the First Sermon* (3.14) as art of the Gupta Period or Gupta Dynasty (320–600). Dynasties serve to distinguish period styles in Western art as well. For example, we speak of Ottonian art from the period (936–1002) when the royal line of Otto (father, son, and grandson) reigned in Germany.

Time periods are another major way to classify a period style. Art historians define time periods on the basis of broad sociocultural identities and often link them to geographical areas. "Italian Renaissance" and "Northern European Renaissance" art of the fifteenth and sixteenth centuries are examples of such classifications. Art historians likewise speak of the "art of the modern period." They identify "modern art" with the time period of the nineteenth through later twentieth century and link it socially and culturally with the urban-industrial societies of Europe and North America. A wide range of works, from Hausmann's Dadaist *Head* (3.15) to Judd's minimalist sculptures (3.20), fits within this period style.

STYLE AND MEANING IN THE EVERYDAY WORLD

Styles surround us in our daily lives. Take a look at the practical or useful arts in your immediate environment. Combining artistic design with utilitarian function, these function-based or "applied" arts are ever present. We know them well and are familiar with their styles. We can readily identify specific styles of cars, fast-food eateries, chain stores, and brand-name consumer goods. The same is true for popular art and commercial culture across the board. We know GAP clothing from the Tommy Hilfiger line, and a Honda from a Ford. Such recognition is based primarily on stylistic differentiation. Examining these familiar art forms will further our understanding of the general concept of style, as well as its integrated components of form and content and its basis in a particular social and cultural context **(Interaction Box).**

Fashion: Case Studies in Style

Our clothes, accessories, hairstyles, and body language all tell the world who we think we are—or at least who we would like to become. The visual images we present in public—designed by ourselves in living color, texture, and shape—express the most eloquent of personal and social messages, from "please accept me" to "steer clear." As a form of moving sculpture, fashion is truly our second skin.

Punk Style: Form, Content, and Context
What an aggressive outer skin the punk style has been from the 1970s to the present! As a "revivalist" movement that continually "gestates

INTERACTION BOX

FORM, CONTENT, AND STYLE IN POPULAR ART

Analyzing popular forms of art and design—advertisements, automobiles, fashions, and chain restaurants and businesses—is an enjoyable way to learn about the concepts of form, content, and style. In McDonald's fast-food restaurants, Honda cars, and Nike ads, you will find the common repeating elements, qualities, and expression that define a style.

Choose a single example of popular art or design that you find interesting, such as a McDonald's restaurant. Describe and analyze it relative to formal qualities: visual elements (line, shape, color, texture) and principles of design (unity, balance, emphasis). Then interpret what these formal qualities express in terms of content: feelings, ideas, messages. What do the bright colors and lighting, smooth surfaces, and streamlined shapes of a McDonald's convey? What does this form embody and say content-wise? What defining constants in the style of McDonald's fast-food restaurants around the world make them immediately identifiable? Comparatively speaking, how is the style (and the form and content) of another fast-food chain such as Burger King or Hardees similar to or different from that of McDonald's?

and mutates," writes contemporary punk-rocker Jay Insult, punk first drew from tough-guy styles of the past. "When the Ramones [one of the first 1970s punk music groups] first donned leather motorcycle jackets," Insult explains, "they were emulating the outlaw styles of 1950s motorcycle gangs and rockabilly greasers. They then added their own interpretation and this was the genesis of the punk style."

What Insult calls the mainstream punk style is certainly compelling **(3.21)**. It demands attention. Sharp metal objects are pinned to or laid over rough, torn fabrics and black leather. Chains and metal-studded leather belts, bracelets, and collars wrap around waists, wrists, ankles, and necks. Knifelike earrings and pins pierce ears, nose, and lips. Hair is often cut severely short or worked up into a spiked style. Extreme value contrasts, such as white against dominant black, characterize the look. The metallic glint of silver stands out against pale skin or black leather. Hues and their contrasts are likewise glaring. Phosphorescent orange, purple, and red in hair, makeup, and accessories send out jolts of color—the colors of music concert lighting and urban neon in the night. The lines and shapes of punk style are angular and irregular, disrupted by pieces torn off or objects tacked on. The exciting diagonal holds sway over stabler horizontal and vertical lines. Asymmetry is the compositional rule: One sleeve is cut higher than the other; buttons, pins, and tufts of hair are arranged in conscious disregard for traditional order and balance. Completing the image, a specifically punk facial expression and body language—taut, bound up, coldly explosive—accompanies the clothing style.

Born in working-class England in the mid-1970s, the punk fashion style **(3.22)** is still going strong, subculturally speaking, after three decades. It is embraced as a second skin, with many variations, by young people around the world. Its hard, defiant look, born of the grim realities of unemployment and low-income life-styles, has become for more affluent youth an expression of alienation, a source of new personal identity, and a way to capture attention. One middle-class punk stylist put it this way: "Everyone is such a clone of everyone else, dressing the same, acting the same. I wanted to be unique. I had to break out, be expressive, different." According to Insult, turn-of-the-century variants of the original punk style include the "skate-punk" of the skate-board subculture; emotional or "emo pop-punk," which marries elements of punk to preppy styles; and spin-offs such as Hardcore, Straight Edge, and Oi, "a streetwise, working-class, often patriotic version of punk favored by skinheads."

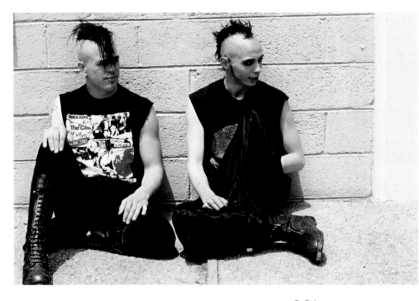

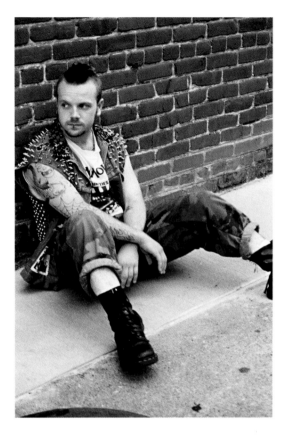

3.21 MOLLY CHASS-MAN. *Andy and Gopaul.* 2002. Color photograph. 8 × 12 in.

3.22 MOLLY CHASS-MAN. *Tony.* 2002. Color photograph. 8 × 12 in.

3.23 Contemporary business style. *Traditional business dress has a long history. Can you foresee any sociocultural changes that might radically transform or terminate this durable style?*

Business Dress: Style and Context Western business dress **(3.23)** embodies everything that punk and other countercultural styles are not. The latter are aggressively expressive styles suffused with imagination, feeling, and sensuousness. The business style, in contrast, is dignified and restrained, a tradition-bound style befitting the commercial middle class that has led Western society for over two centuries. With conscious purpose, the business world has identified itself with the style known as **classical.** This term describes the broad stylistic stream, with its roots in ancient Greece, that features formal and intellectual clarity, emotional restraint, and calm grandeur. Compositionally, classical art and dress tend to embrace principles of unity, symmetrical balance, harmony, and order. This style choice was moral as well as artistic. All visual designs embody and express a particular worldview, a specific system of values and beliefs. In the case of today's business outfit, image and form are perfectly matched to ideology and content.

Clean, crisp lines and an unambiguous contour characterize the business suit. Stable horizontals, commanding verticals, and a symmetrical balance communicate firmness and calm. Clear lines and precise geometric shapes are emphasized, while color and texture are kept under strict control. To the classical way of thinking, clearly articulated forms indicate

3.24 Contemporary political leaders in business dress. *What does the similarity of dress of these leaders from around the world say to you?*

intellectual clarity and depth, and color and texture are mere surface effects that appeal to the senses and the emotions, the most excitable and imprecise of the body's receptors. For the strict classicist of past centuries, writes art historian Walter Friedlaender, clear lines and shapes "embodied something moral, lawful, and universal, and every descent into the coloristic and irrational was a heresy that had to be strenuously combatted."

For over two centuries, the business dress of our economic and political leaders **(3.24)** has reflected a classical style and philosophy of art. Today's business outfit remains an idealized expression of smoothly functioning commercial or governmental operation: rational, impersonal, and rule-laden. No surprises or distractions are welcome in the way of bold colors, eye-catching shapes, sensuous textures, or dynamic asymmetrical balances. To preserve aesthetic and organizational unity,

strong contrasts are limited. Covering up most of the body, business attire for men and women alike transmits a nonsensual look of cool, "masculine" intelligence. Masking individual, class, gender, and ideological differences, the look is recognized worldwide as a symbol of power, professionalism, and respectability.

Style has been aptly described as a system of forms or compositions that embodies the broad outlook of a group **(Appreciation 6)** or the sensibility of an individual artist. The fashion styles of groups such as businesspersons and punks and the artistic styles of individuals such as Schapiro and van Gogh show us that form and content, style and context are forever intertwined. The next chapter deepens the connection between artistic styles and context, examining how distinct ways of seeing and representation emerge across different cultures and time periods.

APPRECIATION 6 *The French Revolution in Fashion*

PAM SCHUELKE JOHNSON AND ROBERT BERSSON

As a decorative art form, fashion expresses who we are, what we believe in, and where we stand in the social scheme of things. An article of clothing can give us a glimpse into the structure, technological accomplishment, and spirit of a society. Even more can be revealed through a study of the fashion styles of the day. A dramatic example is the fashion styles in the decades prior to the bloody French Revolution. These fashions reflect a sharply stratified society smoldering with class conflict. A small aristocratic minority, extravagantly attired from head to toe, held sway over a rising middle class and vast, impoverished working class. Threatened by the growing economic and political power of the bourgeoisie, worker discontent, and the cultural challenges of liberal European Enlightenment thinkers, many French aristocrats deepened their commitment to fashion as the clearest display of their social superiority. The excessive decoration and frivolity of aristocratic costume **(Fig. A)** spoke volumes about hereditary wealth, conspicuous consumption, and privileged leisure. Splendidly at odds with the demands of workshop and field, aristocratic fashion asserted that its wearers could hire others to toil for them.

Women of noble birth were willing to pursue monstrous extremes to keep up with the latest styles and to distinguish themselves from their affluent middle-class counterparts. Powdered hair, sculpted into a cornucopia of forms, rose to heights of up to three feet. Dresses, supported on elaborate metal frames called *paniers*, ballooned outward. Upon them were festooned every form of ruffle, pleat, button, and bow. While the dresses billowed outward, corsets brutally pinched in the waist and breasts to achieve the "perfect" silhouette. In what one contemporary costume designer called "an almost demented preoccupation with the sporting of wealth," ladies "of quality"

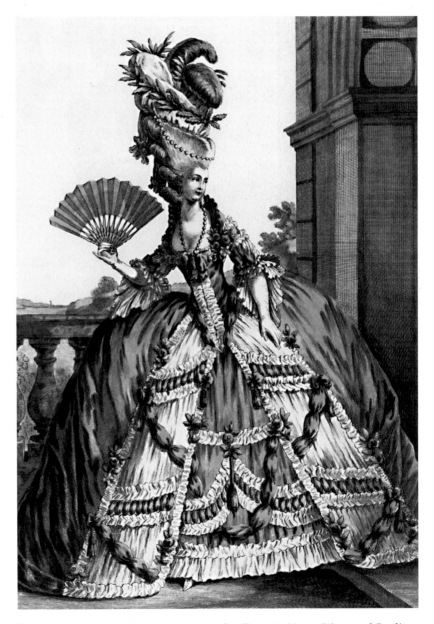

Figure A ETIENNE CLAUDE VOYSARD, after Desrais. *Young Woman of Quality Wearing Vicorur Headdress.* 1776. Etching, from Nicholas Dupin, *Les Costumes François... Paris.* Print Collection, Miriam & Ira D. Wallach Division of Art, Prints and Photographs, The New York Public Library, Astor, Lenox and Tilden Foundations.

73

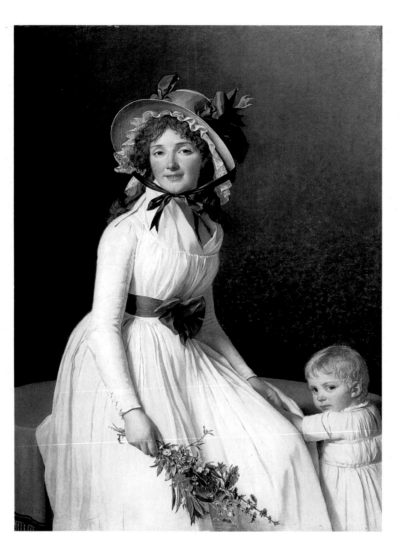

Figure B JACQUES LOUIS DAVID. *Madame Seriziat*. 1795. Oil on canvas. 51 × 36 in. Musée du Louvre, Paris.

came to look like oversize wedding cakes with all the pastry-tube trimmings.

With the violent overthrow of the old order, aristocratic fashion was radically exorcized. Rallying to the cry of "liberty, equality, and fraternity," the new society sought to integrate its revolutionary values into every sphere of activity, especially those in the public eye. Clothing, hairstyles, and even bodily movement in the Directory Period (1795–1799) would convey the spirit of the new order, bourgeois governed, worker supported, and modeled on the liberating cultural ideals of the European Enlightenment and the classical world of ancient Greece and Rome.

Revolutionary ideology had declared war on the fetters and chains imposed by the tyranny of aristocratic costume: corsets, *paniers*, wigs, high heels, powder, beauty spots, and ribbons. These stood as hated symbols of the old order and had to be expunged at all costs. A more uniform dress was adopted which, in accordance with the ideals of equality and fraternity, would draw little distinction between the classes: for the men, the sober bourgeois fashion; for women of means **(Fig. B),** extreme simplicity influenced by the naturalness of ancient Greek and contemporary English fashions. Enlightenment ideals of simplicity, industry,

Figure C FRANÇOIS GERARD. *Jean Baptiste Isabey and His Daughter Alexandrine.* Oil on canvas. 77 × 51¼ in. Musée du Louvre, Paris.

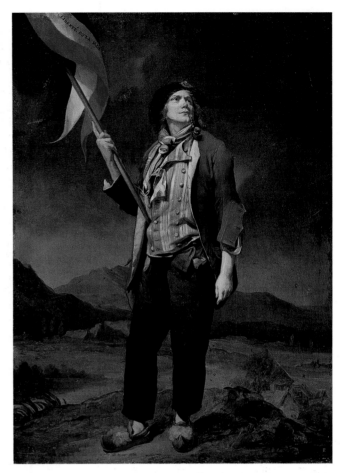

Figure D LOUIS-LÉOPOLD BOILLY. *The Actor Chenard as a Sans-Culotte.* 1792. Oil. Musée Carnavalet, Paris.

and rational seriousness were widely embraced in the culture and conveyed in the dress.

Male clothing of the Directory Period **(Fig. C)** settled into the convention of dark coat, light waistcoat, and skin-tight breeches or stockinet pantaloons. The modern business outfit of dark suit, vest, light shirt, and tie was not far from being born. Just as feminine dress displayed the natural figure and ease of movement for the first time in almost four hundred years, so too did masculine dress. In keeping with the ideal of naturalness, hairstyles became shorter and simpler, with locks falling over the ears.

Interestingly, a key article of the evolving bourgeois business outfit came from working class "fashion." The dress of the revolutionary French workers **(Fig. D)**, highly functional but filled with patriotic colors, made itself felt in the Directory Period in several ways, one of the most lasting being the adoption by a wider public of proletarian trousers or *sans-culottes.* For certain bourgeois intellectuals, the wearing of this obviously utilitarian garment stood as a bold, style-conscious symbol of identification with the oppressed, as well as a statement against the old feudal order and its exploitive life of leisure. ▪

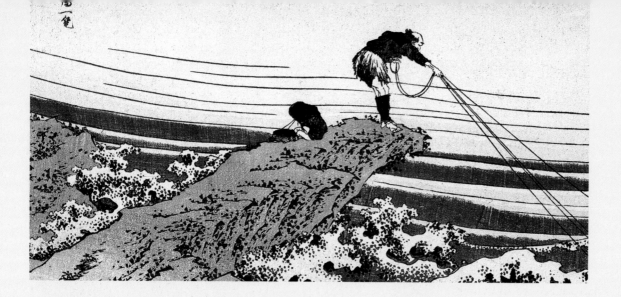

4

The Influence of Context

DIFFERENT WAYS OF SEEING

Every day we confront people with different viewpoints and outlooks. Each work of art likewise embodies a unique point of view, a distinct perspective. By looking closely at art, we gain access to a rich, complex tapestry of individual and cultural worldviews different from our own and develop a fuller appreciation of the worlds of art around us.

WAYS OF SEEING

The way we see things is affected by what we know or what we believe.—John Berger, art critic, *Ways of Seeing*, 1972

The way a person sees is colored by personality, shaped by education, and directed by individual interest and purpose. Consequently, no two people see the world in exactly the same way. A scientist viewing an oak tree may register a combination of biological facts: the tree's botanical classification, characteristic markings, and patterns of growth. A timber company executive may view the same tree in terms of the amount of lumber and profit it might produce. An artist might contemplate the oak from a pictorial perspective: as an interplay of line, color, shape, and texture, a worthy subject for a painting or photograph. A poet, a young child, and an ecologist will see the oak in other ways still.

Differences in ways of seeing—what we choose to look at and how we think and feel about what we see—become even more pronounced when the comparison is between people of highly distinct cultures, such as eleventh-century Chinese and twenty-first-century North Americans. Each culture has a worldview of its own based on a commonly held system of values and beliefs. Rather than "seeing is believing," we might say that "believing is seeing." What we believe and value, the result of living in a particular society, culture, and time, becomes the basis of how we see. The same is true for the famous artists and anonymous artisans who create works of art. They too are products of their sociocultural context and share its belief system and worldview. In diverse ways, their artworks mirror their world.

This chapter examines how people from different cultures and historical periods—that is, from different contexts—have seen and artistically represented the natural world. Putting these artistic representations of nature in context helps us learn about the richly complex societies and cultures that brought them into being. Reciprocally, contextual analysis and interpretation reveal the content and amplify the form and subject matter of the individual artworks.

WAYS OF SEEING NATURE ACROSS TIME: THE MIDDLE AGES AND THE RENAISSANCE

There is not one "Nature" but many natures, each the cultural product of different ways of seeing. For example, most men and women in Europe between 500 and 1100, the historical period we call the early Middle Ages, showed little aesthetic interest in the natural world. They did not look to nature as a source of visual or artistic pleasure. (The Middle Ages or medieval period refers to the era between the end of the Roman Empire in the fifth century and the beginning of the Italian Renaissance in the fifteenth.) In contrast to Italian Renaissance culture, images of nature are not prominent in early medieval art or literature.

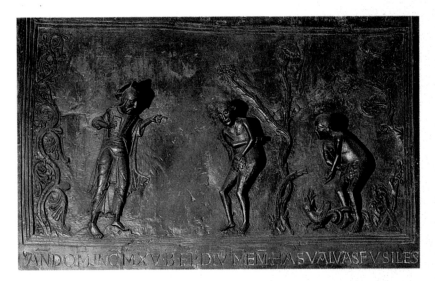

4.1 *Adam and Eve Reproached by the Lord.* Ca. 1015. Bronze door panel. Cathedral (Abbey Church of St. Michael), Hildesheim, Germany. Approx. 23 × 43 in. *Outside of churchmen and churchwomen, very few people during the early Middle Ages could read or write. Church libraries preserved religious writings and books from the past, and monks, nuns, and bishops studied these writings. How do you think the institutional concentration of formal education in the Church influenced the art and culture of this period?*

The Medieval Way of Seeing

The pervasive Christian teachings of the early Middle Ages held that this life was but a wretched interlude on the road to eternal bliss. On an earthly journey fraught with physical temptations, one must not allow one's surroundings to become the object of too much sensory pleasure. If the soul is divine and the body prone to sin, if ideas are godlike and sensations debased, then absorption in nature, which is perceived through the senses, is sinful.

The influence of the medieval view of nature on the general populace, and on creators of art in particular, was considerable. Most artists and artisans were either monks or nuns or private artisans hired by the Church aristocracy to execute projects. When we do find nature portrayed by book illustrators, painters, or sculptors of the early Middle Ages, it is almost always at a nonsensuous distance in the form of stereotypic symbols or abstract ornamentation—expressions of the intellect more than of the flesh. In the cathedral door panel *Adam and Eve Reproached by the Lord* **(4.1),** consider the fantastic trees and dragonlike serpent and

Parallel with this distrust of nature was the symbolizing faculty of the medieval mind. We who are heirs to three centuries of science can hardly realize a state of mind in which all material objects were thought of as symbols of spiritual truths or episodes of sacred history.—Kenneth Clark, art historian, *Landscape into Art,* 1949

4.2 AMBROGIO LORENZETTI. *The Effects of Good Government on the Countryside* from *The Allegory of Good Government*. 1338–39. Fresco. Palazzo Pubblico, Siena, Italy. *The physical and institutional setting of the painting* The Effects of Good Government *is the city hall building of Siena, one of the most important Italian cities of the Middle Ages. This context and the painting's subject speak to its political purpose: encouraging wise municipal governance. Have you seen works of art in government buildings? What are their subjects and purposes?*

The first surviving land-scapes, in a modern [artistic] sense, are in Ambrogio Lorenzetti's Good and Evil Govern-ment. *These are so factual that they hardly belong to the [medieval] landscape of symbol and remained unique for almost a cen-tury.*—Kenneth Clark, art historian, *Landscape into Art,* 1949

the decorative swirl of the vines along the left border. The thin, twisting tree between Adam and Eve, with its two tiny umbrella-like tops, is more a symbol than an accurate representation of a tree. The small devilish creature beneath Eve is likewise a creation that stems more from the sculptor's imagination than from observation of an actual animal.

Reinforcing this cultural outlook was the perception of nature as a discomforting and frightening place. A thousand years ago, sea-coasts represented violent storms, perilous currents, and bloodthirsty invaders; the hin-terlands meant dark forests and primeval swamps. Wild animals and outlaws lurked

beyond the city walls. Serfdom, the slavelike economic system that bound agricultural workers (called *serfs*) to the land of their aristo-cratic masters, demanded the backbreaking la-bor of millions. (Figure 13.18 shows a sad-eyed serf, worn and tattered, sowing winter wheat while the lord's foreman, astride a horse, over-sees and plows the field.) In such a context, the vast majority of the population viewed nature as anything but a source of refreshment and delight.

Not until the later Middle Ages, between approximately 1100 and 1400, did this sociocul-tural context begin to substantially change. Saint Francis of Assisi (1182–1226) (4.4) preached

that animals, earth, and sky were God's glorious handiwork. A developing society of market towns and cities began to regulate and safeguard the countryside, "civilizing" nature in the process (4.2). Land, sea, and sky thus could be seen as objects of down-to-earth human interest and enjoyment. An increasingly trade- and money-based economy brought merchants, bankers, and manufacturers to positions of urban power, and their "realist" business values of common sense, practical experience, and material success infused cultural and artistic life.

As the sociocultural context changed, a more secular or worldly mode of seeing resulted in paintings and sculptures that strove to be lifelike and factual (4.4, 2.18) as opposed to imaginatively symbolic and stereotypic (4.1, 4.3). In the fifteenth century, a transitional period that historians view as the end of the Middle Ages and the beginning of the Renaissance, we observe some artists who represent the world in the new "modern" way and others who hold to the earlier, compelling medieval vision.

Two Italian paintings illustrate the transition from the medieval to the Renaissance way of seeing and representing the natural world. *The Young Saint John Going Out into the Wilderness* (4.3), created around 1450 by Giovanni di Paolo (1403–1482/83), continues the worldview of the Middle Ages. Working on a small wooden panel, the artist retells a familiar New Testament story. Like spoken or written narrative, the action unfolds sequentially. Consecutive scenes are shown side by side as in a contemporary cartoon strip. Familiar with many of the symbols and stories, a largely illiterate public could "read" such visual narratives as easily as twenty-first-century people read wordless traffic signs and computer screen icons. Medieval and Renaissance viewers knew instantly that a person with a halo was a saint and that a saint with a rough, animal-skin coat was John the Baptist. In the first scene, the young Saint John, knapsack in hand, leaves the protection of a walled building, symbolizing the town. In front of him lies a schematic, cultivated countryside of orchards and fields. In the second scene, Saint John climbs a rough path into untamed mountain highlands, symbolizing the wilderness. Space and time, size

4.3 GIOVANNI DI PAOLO. *The Young Saint John Going Out into the Wilderness.* Ca. 1450. Tempera on wood. 12⅛ × 15⅛ in. The National Gallery, London. *Certain art historians have argued that the Italian aristocracy of the fourteenth and early fifteenth centuries, namely Church leaders and lords, preferred such abstract, other-worldly styles, which evoked spiritual states or chivalric ideals rather than the nitty-gritty of earthly life. In contrast, the art historians assert, middle-class art patrons—silk merchants, wool manufacturers, bankers—were receptive to worldly, realistic styles in keeping with their materialist, rationalist way of seeing the world (4.4). Do you think members of distinct social classes in our society see the world differently and patronize or prefer particular styles or types of art?*

and shape are rendered symbolically. The artist is concerned with retelling a familiar story and revealing a metaphysical truth about God's divine plan. Such "nonrealistic" imagery would have been exceedingly "real" to a community of devout Christian believers. As symbolic communication, religious paintings were indeed worth a thousand words.

The Renaissance Way of Seeing

In contrast to the di Paolo painting, *Saint Francis in the Wilderness* (4.4), executed by Giovanni Bellini (c. 1430–1516) ca. 1485, epitomizes the new way of seeing and representing nature. Bellini presents Saint Francis and his natural environs realistically, not symbolically. Atmospheric and linear perspective create the illusion of a real three-dimensional space. The saint is not an abstract symbol but a human

4.4 GIOVANNI BELLINI. *Saint Francis in the Wilderness.* Ca. 1485. Tempera and oil on poplar panel. 49 × 55⅞ in. The Frick Collection, New York. *Bellini represents Saint Francis without the divine halo that traditionally crowns the heads of all saints (4.3). Responding contextually, why do you think the artist excluded Saint Francis's halo?*

individual of flesh and blood. Trees, plants, and rocks are likewise individualized and scientifically accurate. On the arbor we see grapevines, and in the sky cumulus clouds. A foxglove blooms by Saint Francis's side, and ivy crawls over the face of the rock. Although Bellini is a man of religious belief, he manifests a profoundly sensuous as well as spiritual love for nature's sunlight, colors, and textures.

In the new age of Renaissance **humanism,** with its emphasis on the earthly life of the human individual, even the wilderness, or "wild

animal land," has been humanized. With a pleasant arbor of vines above and a comfortable chair and desk below, Bellini's Saint Francis lives in congenial harmony with nature. The cultivation and regulation of the countryside, already evident in the late Middle Ages (4.2), were greatly advanced in the Europe of the fifteenth century. The impressive fortified towns and productive agricultural fields in the painting's background emphasize this contextual change **(Interaction Box).** The view of nature from the early medieval period, which

Workers laboring in these "scenic" forests and fields, often appearing as background figures in picturesque landscape paintings, would have found the notion of nature as an artistic composition even more baffling. Long hours of arduous work, a rudimentary formal education (if any at all), and scant leisure time were not conducive to an artistic appreciation of nature. Rural laborers saw nature more bluntly and pragmatically. Nature was the source of their survival, not a picture gallery in the open air.

4.6 Mabry Mill, Blue Ridge Parkway, Virginia. 1986. Postcard. © Ron & Linda Card, Cards Unlimited, Inc., Keysville, Virginia.

The Picturesque in Contemporary Life

In our own more democratic society, many ways of seeing, embodied in the arts of past and present, are available to a broad public through museums, art reproductions, public school art education, films, television, and computer programs. As a way of seeing, the picturesque has become a fixture in our industrialized world. People now look to nature for lovely "scenery," charming "views," and captivating "landscapes," terms that derive originally from the world of art.

Picturesque images of nature are everywhere: on calendars and postcards **(4.6)**, in magazine and television advertisements, in feature films. Even our own yards bear the stamp of artistic vision. Grass is cut, hedges are shaped, trees are pruned, and flowers are planted, all for the sake of forming our surroundings into a pleasing picture. The pleasure we derive from nature's colors, shapes, and compositions is a legacy of centuries-old ways of artistic seeing.

SEEING NATURE ACROSS CULTURES: FAR EASTERN AND WESTERN WAYS OF SEEING

We have looked at different views of nature within Western culture over time and between social classes. Now we turn to differences in seeing nature across cultures. Historically, Chinese and Japanese artists have seen and depicted nature quite differently from European and American artists. We can begin to appreciate the artistic differences between cultures by comparing some Far Eastern and Western artworks.

Two Views of the English Countryside

In *Art and Illusion,* art historian Ernst Gombrich offers two views of Derwentwater, a large lake in the English Lake District. The first, a typical picturesque rendering from the early nineteenth century, is an idealized, "postcard-perfect" version of the actual scene **(4.7).** The second is a work by Chiang Yee (1903–1977), a writer and artist who shows the English countryside from a Chinese perspective **(4.8).** Chiang Yee's way of seeing is based on his schooling in a thousand-year-old Chinese tradition of landscape painting. Yee selects and represents those features for which his background has prepared him. He emphasizes the sights that are valued by his native culture and that can be matched with the techniques and conventions of a deeply rooted artistic tradition. The scene may be the English Lake District, but the stylized trees and mist-shrouded mountains make a Western viewer think more of the Orient than of the British Isles. Does this mean that Chiang Yee saw the English Lake District differently than his Western counterpart? It certainly does. As the artist himself noted, he was viewing the English countryside "through Chinese eyes," bringing a very different set of values, beliefs, and artistic conventions to the experience. The contextual heritage that shaped Chiang Yee's way of seeing and representing is examined next.

4.7 ANONYMOUS. *Derwentwater, Looking Toward Borrowdale* from *Ten Lithographic Drawings of Scenery.* 1826. Lithograph. Victoria and Albert Museum, London.

4.8 CHIANG YEE. *Cows in Derwentwater* from *The Silent Traveller.* 1937. Brush and ink. Courtesy Country Life, Ltd., London.

4.9 UNKNOWN ARTIST. *Autumn Landscape.* Southern Sung Dynasty, second half of 13th century. Round fan mounted as album leaf, ink and color on silk. 9½ × 10⅜ in. Marie Antoinette Evans Fund (28.849). Courtesy Museum of Fine Arts, Boston. *Nature is revered in later forms of Confucianism and in other dominant Asian philosophies such as Buddhism and Taoism. Responding contextually, why do you think nature was so highly valued in these Eastern religions but seen in a less favorable light (4.1) in the Judeo-Christian tradition?*

Nature as Central in Chinese and Japanese Culture

Prior to experiencing intensive industrialization in the twentieth century, China had been an agricultural society for thousands of years. People lived very close to nature and felt a deep respect for it. Chinese culture long regarded nature as vast and all-important and regarded humanity as insignificant in comparison. The visual evidence of this view of nature is Chinese landscape art: People, houses, boats, and animals are represented as infinitesimal compared to nature's grand proportions **(4.9).**

In contrast, nature has an ambivalent, secondary status in the Western world. Since the Renaissance, Western civilization has become ever more anthropocentric, with the human race taking the central place in the universe. Because humanity and the individual are so highly valued in our culture, we view nature almost strictly in terms of fulfilling human needs, only some of which are spiritual. We revere nature as a source of serenity, beauty, and poetic and aesthetic inspiration. But mostly we look at nature from a materialistic standpoint, as a domain to be commercially exploited for what it can produce. Nature represents territory to be conquered and exploited. Thus nature is experienced as separate and disconnected, something external or alien.

This Western attitude differs sharply from both the traditional Chinese view and the reverential view of indigenous or native peoples of the world—including Australian aborigines, Native Americans, and African tribal peoples—who worship the forces of nature and attempt to live in spiritual and ecological harmony with natural laws. In their sacred rituals (1.9), indigenous peoples honor and invoke the

powers of nature to bless their crops and en-
sure survival. Their masks and costumes sym-
bolically represent the attributes of natural
forces such as the moon, sun, wind, and rain.
Both indigenous peoples and traditional Chi-
nese value intimacy and connectedness with
nature, and their artworks show this.

As a subject, nature has been prominent in
Chinese art for well over a thousand years. Na-
ture for centuries served strictly as back-
ground in Western art (4.1), with the central fo-
cus invariably on human protagonists or on
pagan or Christian divinities who, in keeping
with Western humanism, were of distinctly hu-
man appearance. Nature did not play a domi-
nant role in European or North American art
until the nineteenth century.

In Chinese art, nature is rarely portrayed as
mere background but instead is the very
ground of existence, a cosmic tapestry in which
the human species is but one of innumerable
strands. In the words of the philosopher Confu-
cius (ca. 551–479 B.C.E.), "Nature is vast and
deep, high, intelligent, infinite, and eternal."
The celebrated Chinese poet Li Po (701–762)
(5.19) captures the idea: "To dream among the
clouds, to listen to the whisper of the pines, to
lose oneself in eternity." In such a worldview,
either act—painting a landscape or simply
observing one, real or painted—is a path to
spiritual enlightenment.

Let us look at a reproduction of Fan Kuan's
masterpiece, *Travelers amid Mountains and
Streams* **(4.10)**, created around 1000. Fan Kuan
(active ca. 990–1030) is sensitive to nature's
physical appearance but has idealized and
beautified the scene. "For Chinese people," a
Taiwanese commentator explains, "God lives
in this kind of mountain, high, with huge pine
trees and lots of clouds around. It's utopia.
Our goal. Peaceful, calm. Perfect." The ever-
changing terrain and atmosphere of actual
nature have been transformed in Fan Kuan's
painting into a timeless ideal landscape.

Travelers amid Mountains and Streams shows
us the "vast and deep, high, intelligent, infinite

4.10 FAN KUAN. *Travelers amid Mountains and
Streams.* Sung Dynasty, ca. 1000. Hanging scroll,
ink on silk. Height: 81¼ in. National Palace
Museum, Taipei, Taiwan.

4.11 KATSUSHIKA HOKUSAI. *Boy Viewing Mount Fuji.* Edo period, ca. 1839. Hanging scroll, ink and color on silk. 14¼ × 20¹/₁₆ in. The Freer Gallery of Art, Smithsonian Institution, Washington, D.C. Gift of Charles Lang Freer (F1898.110).

and eternal" nature described by Confucius. The human travelers are barely visible, no larger than ants, as they walk with their animals across an open cut of land in the lower right corner of the painting. Several Buddhist temples are seen nestled among the trees on the cliff immediately above the travelers. Nature is immense; people and the products of civilization are minuscule. The relationship between nature and humanity remains harmonious, however; the travelers and temples blend peacefully into their surroundings.

Westerners, conditioned in recent times to constant social and cultural change, are often surprised by the stability of Far Eastern views of nature over many centuries. The same physical immensity and spiritual serenity that characterize Fan Kuan's Chinese landscape painting from a millennium ago are evident in *Boy Viewing Mount Fuji* **(4.11)**, a work created 800 years later by the Japanese artist Katsushika Hokusai (1760–1849) **(Appreciation 7)**. A small boy sits on the trunk of a solitary tree, contemplating Mount Fuji as he plays a wooden flute. One imagines the sounds to be as serene and noble as the mountain, a holy

site for many Japanese. One can also imagine the meditative notes wafting over the vast space and subtly fading from hearing. Similarly, the mountain itself fades, in most delicate gradations of color, from the solid whites and tans of the snow-capped summit to the almost transparent bluish tans below. A subtle progression of tone and substance likewise occurs in Fan Kuan's much earlier painting, in which the darkness and solidity of the mountain's core lighten in value and weight as the eye moves downward toward the mist-shrouded base. Although the color scheme of the nineteenth-century Japanese work is far more varied than the restrained palette—limited in colors but rich in values—of the Chinese painting, an extraordinarily fine modulation of light to dark values is common to both. These value effects, in turn, create sensitive transitions between opacity, translucency, and transparency, qualities especially evident in the depiction of the mountains. Nature is revealed as simultaneously substantial and insubstantial, as solid matter and ethereal void. Form flows into formlessness, interweaving physical fact and metaphysical essence.

APPRECIATION 7 Hokusai's *View from Kajikazawa in Kai Province*

TAKUYA KANEDA

The Ukiyo-e prints of Katsushika Hokusai (1760–1849) are usually regarded in the West as masterpieces of fine art done in a traditional Japanese style. While the prints of Hokusai are indeed masterpieces, they were not created as fine art for the cultural elite; nor are they entirely traditional in style.

Ukiyo-e (pronounced oo-kee-yoe-ee) prints developed and gained popularity in Japan between the late seventeenth and mid-nineteenth century. They were not originally created as fine art. Rather, they were a kind of popular art and entertainment for the common people. The typical subjects—beautiful women, Kabuki actors, Sumo wrestlers, famous landscapes—reflected the tastes of the general public, not the aristocratic elite.

Ukiyo-e, meaning "a picture of the floating world," derived from the Buddhist philosophy of transiency, the negative view that the pleasures of this world are only transitory, never of lasting import. The general public, while aware of the transitory nature of such entertainments, tended to pursue all sorts of earthly pleasures. In this "live for today" culture, Ukiyo-e prints became extremely popular. Advances in multicolor woodblock print techniques [Chapter 6, Technique Box 6-A] enabled the general public to purchase inexpensive, mass-produced works of popular Ukiyo-e art. Especially in the New Year season, people enjoyed purchasing the latest Ukiyo-e prints. Employed in diverse formats, the prints were used to illustrate popular books, pornographic literature, game sheets, and paper toys. In addition, they might be purchased as separate, single-sheet prints. These various forms of Ukiyo-e were prominently displayed in shops and open-air stalls in the capital city of Edo (present-day Tokyo) and other cities in Japan.

Hokusai's prints of famous landscapes, such as his series *Thirty-six Views of Mt. Fuji*, were both typical and exceptional examples of this popular art form. Born in 1760, Hokusai learned woodblock carving by the age of fifteen. Shortly thereafter, he began his apprenticeship to an Ukiyo-e artist, Shunsho Katsukawa (1726–1792). Calling himself "art mad" because he was so passionate about art, Hokusai was always enthusiastic about learning different techniques and changing his style. He studied traditional Japanese painting, classical Chinese painting [4.9, 4.10], and Western techniques. The series *Thirty-six Views of Mt. Fuji* is the result of six decades of persistent artistic development. It is a masterpiece that integrates all of his wide-ranging approaches and methods.

In the print *View from Kajikazawa in Kai Province* (**Fig. A**) from this series, the contrasting styles of realism and abstraction are successfully harmonized. Note how the shape of Mount Fuji is extremely simplified—that is, abstracted—while the figure of the fisherman is depicted more realistically. Hokusai's combination of abstracted landscape with a realistic human figure [4.11, 4.12] represents a unique innovation in Japanese art. Through this original combination, Hokusai sought to express both the metaphysical and the physical qualities of nature and humanity in the same work. In light of this success, the series sold extremely well.

Works like *View from Kajikazawa in Kai Province* appealed to the general public for a number of reasons. Landscape art is close to the heart of the Japanese—our most ancient

Takuya Kaneda is an artist and lecturer in art education at Otsuma Women's University in Tokyo, Japan.

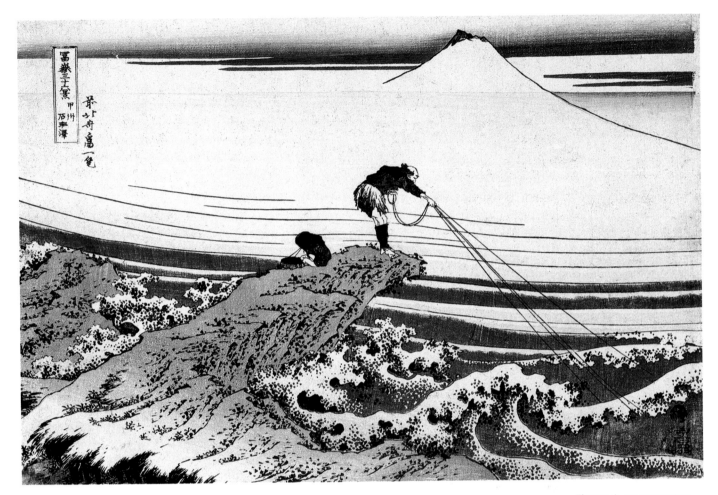

Figure A KATSUSHIKA HOKUSAI. *View from Kajikazawa in Kai Province*. Woodblock print.

traditions place nature in a revered position. In traditional Japanese culture, "religion" did not necessarily mean allegiance to a particular religious doctrine, but rather a way to pursue a kind of spirituality inseparable from nature. For this reason, many people sought to visit the holy Mount Fuji, whose glorious view could satisfy their religious and aesthetic feelings. Hokusai's views of Mount Fuji may well have appealed to those who could not afford a pilgrimage but could afford Ukiyo-e prints of the holy mountain.

In *View from Kajikazawa*, Hokusai evokes the spiritual, transcendent, timeless quality of nature. A style of abstraction and simplification helped him to achieve these metaphysical qualities characteristic of traditional Japanese and Chinese paintings. At the same time, he was able to convey the reality of nature that is transient and ever-changing. Deep observation of nature and a realistic treatment that emphasized significant details—learned, in part, from his study of European art—served him in this regard.

In the history of Japanese art, Hokusai can be seen as a modern type of artist. He developed a truly original and individualistic style that blended the abstract and the realistic. Moving across time and cultures, his grand "hybrid" art drew from sources that were contemporary and ancient, elite and popular, Eastern and Western. In the hybrid culture of the present, it is understandable that Hokusai's art still holds a fresh appeal for us. ■

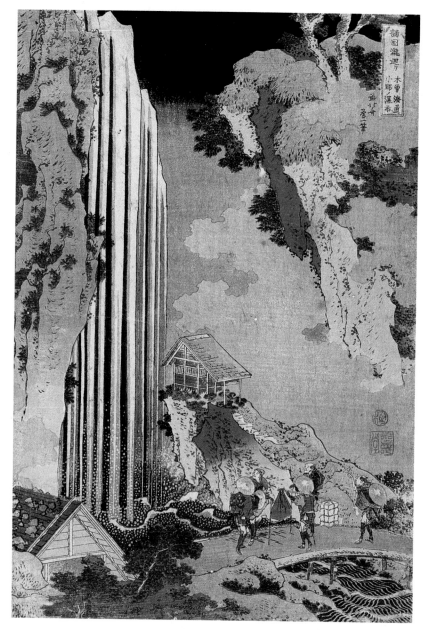

4.12 KATSUSHIKA HOKUSAI. *The Waterfall at Ono on the Kiso Koido Highway*, from *Famous Waterfalls in Various Provinces*. Edo period, 1833. Woodblock print, ink and color on paper. 14⅝ × 9⅞ in. The Freer Gallery of Art, Smithsonian Institution, Washington, D.C. Gift of the family of Eugene and Agnes E. Meyer (F1974.72).

Two Nineteenth-Century Views of the Sublime

It is instructive to compare the Far Eastern conception of nature as sublime—vast and imposing, yet peaceful and intelligent—with the Western way of seeing nature called the **Sublime.** This concept, prominent in Europe and North America in the nineteenth century, had strong connections with the cultural movement known as **romanticism.** Emphasizing feeling, imagination, and individualism in both life and art, romantics sought out nature at its most passionate, dramatic, and irrational. The romantic mind found tempestuous storms, threatening heights, and crashing ocean waves thrillingly Sublime. Nature in such earthshaking guises simultaneously frightened and exhilarated.

Two waterfall scenes, one by Hokusai and the other by the American romantic Frederic Edwin Church (1826–1900), emphasize the enormous difference between the Far Eastern and the Western conceptions of the Sublime. In Hokusai's work **(4.12),** from the series *Famous Waterfalls in Various Provinces,* the waterfall is depicted as immense and the onlookers as minute, but there is no sense of threat either to the tiny figures or to ourselves, the viewers. Rather, nature is imposing but friendly, and the figures blend harmoniously with their surroundings. Like the artist, we see the great falls from a secure, comfortable position on high ground.

In contrast to Hokusai's small print, Church's huge oil painting, *Niagara* **(4.13),** thrusts the viewer into perilous proximity to the churning waters. Many nineteenth-century viewers were initially unnerved by the convincing illusionism of this wall-size painting, feeling as if they were about to be swept over the falls. Inspiring reverential wonder and awe, Church's canvas is a tour de force of the romantic Sublime.

The Sublime emerged in the context of the Industrial Revolution, a tumultuous period in Europe and North America during which the rapid growth of cities, factory mass production, and technological invention (railroads, steamships, photography, electricity) transformed millions of lives. The romantic rebels and the new industrialists held divergent views of nature, but in one sense they were of like mind: Both sought to challenge and even conquer the forces of nature. The romantics differed from the industrialists in that their goal was to reunite with nature in those places where it was still most "natural," most untouched by humanity. By the twenty-first century, nature conservancies and wilderness areas had become havens from advanced industrial civilization, wildlife preserves where individuals might experience something of the Sublime in both nature and themselves **(Appreciation 8).**

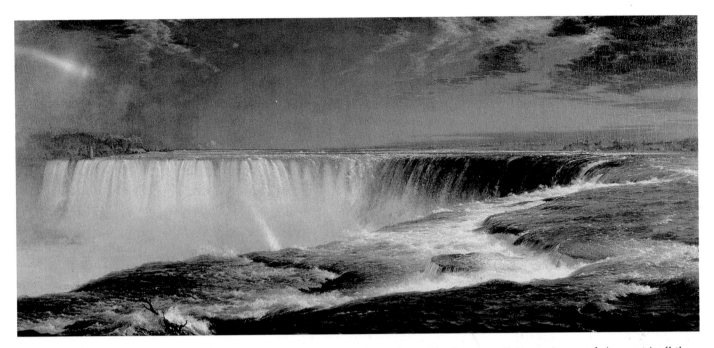

4.13 FREDERIC EDWIN CHURCH. *Niagara*. 1857. Oil on canvas. 42½ × 90½ in. The Corcoran Gallery of Art, Washington, D.C. Museum purchase, Gallery Fund. *Art historians say that Church's* Niagara, *painted in 1857, shows American patriotic pride in the young nation. New York State's Niagara Falls drew tourists from around the country and the world. Experts interpret the rainbow over the falls as a symbol of God's blessing of America and its bounteous land. However, this work was created during the period of turmoil between the Northern and Southern states that led to the Civil War (1861–1865). Can you see how this painting by Church, a Northerner, might have been a product of this sociocultural context?*

. . . their aspect is all the more attractive for its fearfulness; and we readily call objects sublime, because they raise the forces of the soul above the vulgar commonplace . . . to measure ourselves against the seeming omnipotence of nature.
—Immanuel Kant, philosopher, *Critique of Judgment*, 1790

SEEING NATURE IN THE TWENTY-FIRST CENTURY: SUBLIMITY AND TECHNOLOGY

Technological inventions have dramatically influenced our twenty-first-century way of seeing and representing nature. Contemporary transportation modes and artistic media show us nature in extraordinarily grand ways that our forebears could not have imagined. We have seen pictures of the entire earth taken from a space vehicle **(4.14).** We see awe-inspiring views of nature from airplanes and helicopters and ever-changing vistas from speeding automobiles, buses, and trains. Films, videos, television programs, books, magazines, CD-ROMs, and laser disks give an international audience sublime views in overwhelming numbers and with unprecedented technical brilliance. At the same time, these global media and forms of transport reveal environmental devastation and pollution

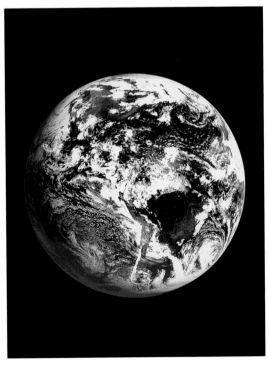

4.14 Photograph of the earth from *Voyager*, satellite view of North and South America and a little bit of Africa. 1977.

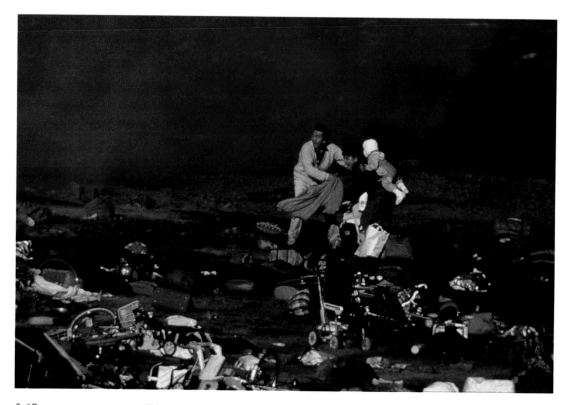

4.15 AKIRA KUROSAWA. Film still from *Dreams*. 1990. *Kurosawa's* Dreams *film segment "Mt. Fuji in Red" features a nuclear holocaust caused by human error in nearby power plants. Meltdowns and other malfunctions of nuclear power plants had occurred in various countries before Kurosawa made his film. In addition, the Japanese people had brutal firsthand experience with atomic fire storms and radiation from the bombing of the cities of Hiroshima and Nagasaki at the end of World War II (1941–1945). Does this contextual knowledge help the viewer to more fully appreciate the Japanese film director's way of seeing and representing Mount Fuji?*

What is beautiful in the landscape is what is healthy and sustainable. . . . Given the continued stress on natural, ecological beauty, we may yet be called to intercede and place restraints, not on nature, but on human actions in order that such beauty may continue on earth.—Alan Gussow, artist and environmentalist, "Beauty in the Landscape: An Ecological Viewpoint," 1995

of our planet on a vaster scale than ever before seen. *Dreams,* a 1990 film by Japanese film director Akira Kurosawa (1910–1999), addresses the potential destruction of nature and humanity by nuclear war and other types of ecological holocaust. In one segment, Kurosawa presents sublime Mount Fuji, the Japanese holy site, erupting in red flame from explosions at nearby nuclear power plants **(4.15).** Our choice, the film asserts, is between annihilation of life on earth and harmony between humanity and nature. Kurosawa's films and other works in diverse media by a growing number of artists worldwide urge us to choose a harmonious, respectful relationship with nature lest we destroy the ecology of the planet. In this regard, recall how the works of Andy Goldsworthy (2.2, 2.3) and Nancy Holt (2.10) respectfully

employ natural settings, materials, and forces. Aided by technological inventions and scientific and artistic insights, an international public now sees nature as both sublime and fragile, a complex ecosystem in need of human care, not abuse.

This chapter has introduced several examples of different ways of seeing and representing the subject of nature. Ways of seeing conditioned by unique sociocultural contexts undergird all artworks and influence the representation of all subjects: men and women, religious stories, everyday life. Contextual analysis and interpretation allow us to understand the fascinating relationship between art and its sociocultural background. In the process, they help us more fully appreciate both art and our multicultural world.

APPRECIATION 8 ANSEL ADAMS: *Photographer of the Landscape*

ELIOT COHEN

In the foreword to one of his most important books, *Yosemite and the Range of Light*, the twentieth-century photographer Ansel Adams writes that his photographs of nature served not as factual reproduction but as "equivalents of my experiences." There were, Adams noted, many fine books on California's Yosemite region if scientific analysis or history is your interest. The goal of his book, in contrast, was "to present visual evidences of memories and mysteries at a personal level of experience." "Most such experiences," Adams wrote, "cannot be photographed directly but are distilled as a synthesis of total personal significance; perhaps their spirit is captured by images visualized through the obedient eye of the camera."

Although he began his photography career working in the soft-focus mode of picturesque turn-of-the-century pictorialism, Adams converted quickly to the so-called straight approach that emerged during the 1920s. This approach was well suited to Adams's reverence for the natural qualities of wilderness and the forces of nature that could be observed there. In *Mount Williamson—Clearing Storm* (**Fig. A**), one can observe Adams's interest in the mysteries of nature as well as the concept of equivalence, a symbolic or metaphoric approach to subject matter articulated by the pioneering modernist photographer, Alfred Stieglitz. The drama created by the rays of light descending on a vast plain of huge boulders suggests an equivalent epic of creation from a biblical or scientific perspective. By backlighting the clouds, Adams creates an aura of energy which is opposed by the dark mountain forms beneath them. The power of this light can be seen in the foreground, where it directs us to several prominent boulders that presumably have broken off from the mountains in the background.

Like his predecessors in the nineteenth century (among them photographers such as Carleton Watkins, Eadward Muybridge, and Timothy O'Sullivan), Adams invokes a sublime sense of the landscape. The image creates feelings of intimidation and respect. In the sense of the word as used by Emerson, Thoreau, and other nineteenth-century New England transcendentalists, the image is also transcendent. We see it not only for what it is but also for the spirit associated with it.

To achieve his dramatic results, Ansel Adams made certain decisions about formal elements in the organization of his picture. First is the choice of a large-format camera, which, although bulky and slow, provides a negative whose size (4″ × 5″ or 8″ × 10″) allows much more detail than negatives obtained with conventional cameras do. The great clarity and wealth of detail give the sense of being present in the environment.

A second decision is the placement of the camera. In *Mount Williamson—Clearing Storm*, Adams chose a position close to the rocks in the foreground to exaggerate their size relative to the mountains in the background, making them seem perhaps even larger than they are. Another question is framing. The boundaries of this picture imply a vast plain of rocks. Although this may be the case in fact, it may also be that Adams has selected a point of view that creates this impression. Light is also very important to Adams's photography. Light becomes a force that creates drama and leads one's eye through the picture.

Adams began photographing at a time when natural resources and primitive areas were still fairly abundant. By the end of his long life (1902–1984), things had changed considerably. Destruction of the natural environment had

continued

Eliot Cohen is a photographer whose traditional and digital photographs have been exhibited widely.

93

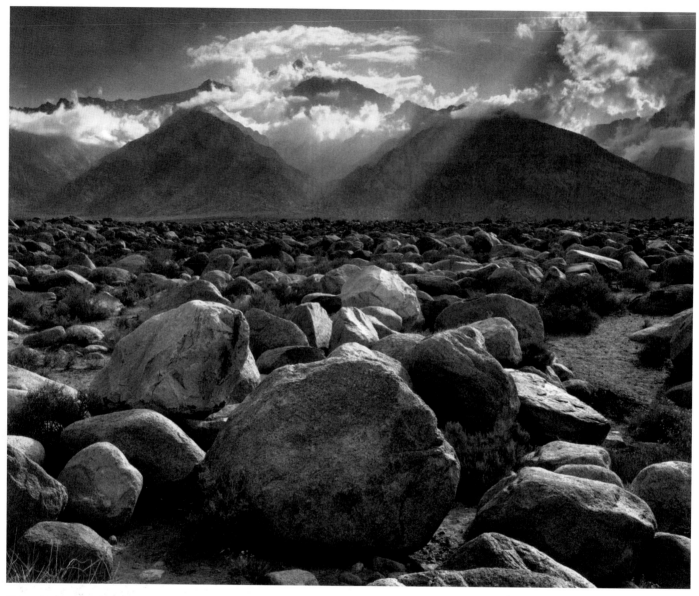

Figure A ANSEL ADAMS.
*Mount Williamson—
Clearing Storm.* 1945.
Gelatin silver print.
15⅝ × 18 1/16 in. © 2003
by the Trustees of the
Ansel Adams Publish-
ing Rights Trust.

become a national concern. Adams hoped that his photographs would increase public awareness of the need to protect our natural environments. In addition, he campaigned actively through public-interest organizations such as the Sierra Club for greater environmental awareness.

Since the turn of the century, Americans have lived most often in either urban or suburban settings. Nature, and certainly wilderness,

is no longer part of our daily routine. Our culture's knowledge of landscape comes increasingly through photographs rather than direct experience. In that sense, photographs such as those of Ansel Adams serve as a release from the pressure and pace of urban life. In so doing, they preserve and extend the romantic attitude toward American nature [4.13] that has informed landscape aesthetics from the mid-nineteenth century onward. ■

THE TWO-DIMENSIONAL ARTS

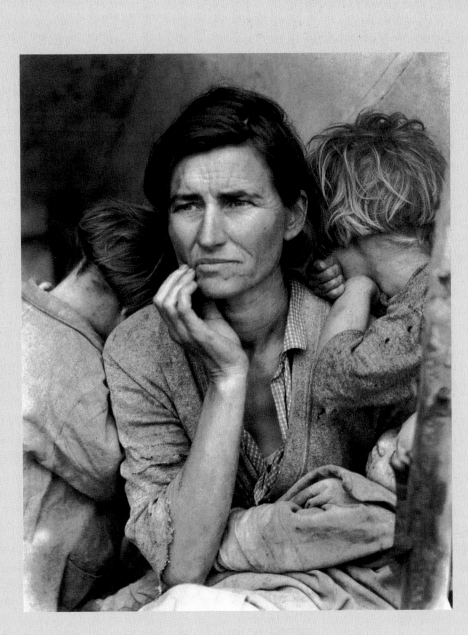

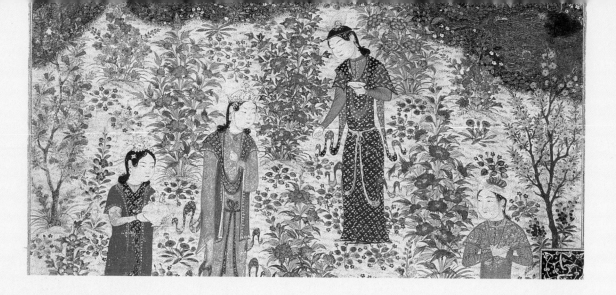

Drawing and Painting

FOUNDATIONS OF THE TWO-DIMENSIONAL ARTS

What do body paintings (5.1), mural paintings (5.2), photographs (5.3), drawings on rock surfaces (5.4), cartoons (5.6), and video images have in common? All are two-dimensional art forms. What does this mean?

THE TWO-DIMENSIONAL ARTS: A DEFINITION

Broadly speaking, the two-dimensional arts are those in which images are created or presented on a flat (that is, two-dimensional) surface or plane. That surface might be of any shape or size. It might curve like an eggshell or undulate like the human body, a receptacle for magical and decorative drawing and painting for millennia (5.1). What ultimately defines a two-dimensional surface is its planelike quality and the dimensions of height and width.

Drawing, painting, printmaking, photography, and types of graphic design such as publicity posters and magazine advertisements all qualify as two-dimensional art forms because they are created on flat, image-bearing surfaces such as paper, canvas cloth, and celluloid film. "Moving picture" art forms such as film, video, and computer animation also qualify as two-dimensional arts, because they are produced, projected, or presented on a planar surface: a television, cinema screen, or computer monitor.

5.1 Australian Aborigine painting a boy's body. Photograph. State Library of South Australia (Mountford-Sheard Collections). *Painting on the human body is one of the most ancient arts. Its functions have ranged from the magical and religious to the social and aesthetic. Do we still paint on or apply color to our bodies? For what purposes?*

5.2 WILLIAM COCHRAN. Mural painting, *Community Bridge*. 1995. Mural painting (detail). Carroll Creek Park, Frederick, Maryland. **Trompe l'oeil,** *or "fool-the-eye," paintings entrance us, as do all illusions that evoke "real" three-dimensional objects and life. We marvel at artist William Cochran's magical, almost godlike power to transform a blank concrete surface into a full-bodied angel who looks at us and emerges into our world. Why do you think our culture so admires trompe l'oeil illusionism? Why do other cultures show little interest in or even censor such fool-the-eye, "realistic" images?*

5.3 Children fingerpainting, drawing with crayons, and painting on an easel.

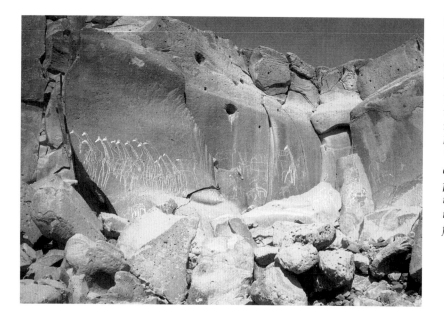

5.4 Rock shelter with giraffes and various other animals, Gonoa, Tibesti. Hunter period, 7th–6th millennium B.C.E. Engravings. Photo Dr. C. Staewen. 1972 expedition by Dr. C. Staewen to Tibesti sponsored by the Frobenius Institute at the Johann Wolfgang Goethe University. *There is no single answer as to why Stone Age people so often represented animals as their subjects. One theory is based on the magical power of the images: that by "fixing" representations of the animals to rock faces or cave walls, prehistoric peoples believed they gained power over the animals, thereby ensuring their capture during the hunt. Does this "sympathetic magic" theory seem plausible to you? How powerful and influential are images in the twenty-first century?*

5.5 EDWARD HOPPER. *Self-Portrait.* 1903. Charcoal on paper. 18½ × 12 in. National Portrait Gallery, Smithsonian Institution, Washington, D.C.

This central feature of two-dimensionality does not mean that these art forms forsake the third dimension and illusions of volume and depth. Quite the contrary. The ability of a painting or drawing to conjure the third dimension has a magical quality and perennial appeal. From the strokes of a paintbrush, a face, a flower, or an entire landscape emerges. You might think that the stones you see in the photograph of *Community Bridge* **(5.2)** are actual stones, but they are not. What you are seeing is a "fool-the-eye" mural painting on a smooth-surfaced, concrete bridge in Frederick, Maryland. William Cochran (born 1955), the artist at work in the photograph, produced each illusionistic stone with paint and brush, just as you see him creating the angel who seems to be emerging through an oval frame into our own three-dimensional world. Across centuries and cultures, paintings, photographs, films, and drawings offer us images that pulse with life. They evoke a sense of "real," three-dimensional volume and vitality on a flat picture plane.

Whether they evoke illusions of a stone bridge or an actual person (5.5), invent imaginary "abstract" characters (5.6), or paint magical patterns and symbols on a human

body, what binds the two-dimensional arts is their common creation on a flat surface. Which of these arts, then, should we study first? Drawing and painting are so ancient and so fundamental to all the other two-dimensional arts that beginning with them is absolutely essential.

DRAWING AND PAINTING: FUNDAMENTAL MEDIA

Medium The specific tool and material used by an artist, e.g., brush and oil paint, chisel and stone. (Ralph Mayer, *A Dictionary of Art Terms and Techniques, 1969*)

What was the first visual art medium you ever used? It might have been fingerpaint at age two or three **(5.3).** Covered with oozing, thick colors, your fingers were your tools and the large, glossy white paper on the table or floor your support. Your every movement mirrored and expressed aesthetic instincts and expressive energies. The finished painting was a tactile extension of yourself, art at its most direct and immediate.

Or your first media might have been simple graphite "lead" pencils or colorful wax crayons. Out of your early scribbles, human figures gradually emerged. By age four or five the artist in you was creating sticklike representations, first of yourself and then of family members: mother, father, sister, brother. These representations of family were far more than symbols. They were alive. You spoke to them, and they spoke to you. The same intense involvement with youthful artmaking held true for other media: finger in wet sand, stick in dirt, sharp stone on rock surface, chalk on sidewalk.

In preschool or kindergarten you might have had the good fortune to work with tempera "poster" paint. Your teacher created these paints by mixing fine, colored tempera powder with tap water. Each color—red, yellow, or blue—had its own metal, plastic, or glass container. Applying the liquid colors with big brushes onto a large paper clipped to an easel, you painted people and houses in bold strokes. Some of the paint dripped down the surface— pencil and crayon didn't drip like this!—but

5.6 SAUL STEINBERG. *Untitled.* 1944. Ink on paper. 14½ × 11 in. Published in *All in Line*, New York, 1945. © The Saul Steinberg Foundation/Artists Rights Society (ARS), New York.

you kept at it and breathed life into your stick figures and human dramas. Occasionally the work came out a mess and you threw it away, but most of the time you enjoyed the creative process and the final artistic product and felt proud of its exhibition on the school wall and home refrigerator. In all this, you were a true artist whose early creative work in diverse drawing and painting media, each with its own unique qualities, anticipated everything we are going to talk about in this chapter.

The fundamental media of young children, drawing and painting were also basic to the image-making processes of our ancient ancestors. Drawings and paintings many thousands of years old cover the surfaces of cave walls and rock faces. A rock cliff in Africa's Sahara desert is covered with 4-foot-high figures of giraffes and other animals **(5.4).** Prehistoric hunter-gatherers using sharp stones cut or engraved these "rock drawings" into the hard surfaces. (The twentieth-century painting *Native Forms* (1.9) shows an African man in the lower left corner intently cutting such sticklike figures into the face of a large rock.) For the earliest image makers and viewers, such rock drawings of animals, people, and spiritual symbols must have been as mesmerizing as any action drama in our contemporary media of photography, film, and video. (We will explore their magic-laden meanings in Chapter 11.)

When the Paleolithic [Stone Age] artist painted an animal on the rock, he produced a real animal. For him the world of fiction and pictures, the sphere of art and imitation, was not yet a special province of its own, different and separate from empirical reality; he . . . saw in one the direct, undifferentiated continuation of the other.—Arnold Hauser, art historian, *The Social History of Art*, 1951

5.7 M. C. ESCHER. *Drawing Hands.* 1948. Lithograph. Gementemuseum, The Hague. © 2002 Cordon Art B. V.-Baarn-Holland. All rights reserved.

5.8 MARISOL (Marisol Escobar). *Licking the Tire of My Bicycle.* 1974. Colored pencils and crayons. 6 ft. × 8 ft. 10 in.

DRAWING: FOCUS ON LINE, SHAPE, AND VALUE

At their most essential, drawing and painting center on the making of marks on a surface, or support. While the two media can and do overlap, different materials and technical processes and the resultant formal qualities have, over time, made these art forms somewhat distinct. Almost everyone has created drawings on paper using pencil, pen, crayon, chalk, charcoal, or felt-tip marker. These marking devices are adept at making lines and clearly delineated shapes. Most drawings, in fact, possess a "linear" quality, in which lines and shapes are prominent elements. To vary the visual quality of these lines and shapes or to evoke a sense of three-dimensionality, artists often add light-dark value contrasts. The subtle variation of values in M. C. Escher's *Drawing Hands* **(5.7)** gives lifelike volume to the linear shapes that make up the two hands. Technically, such light-dark modulation is known as *chiaroscuro* (literally "light-dark" in Italian).

Though the elements of line, shape, and value are central in the Escher drawing and many others, this is not to say that drawings must limit or exclude color. In *Licking the Tire of My Bicycle* **(5.8),** the Venezuelan artist Marisol (born 1930) creates a huge drawing (6 feet by 8 feet 10 inches) with colored pencils and crayons. A wide range of colors can indeed be employed in drawings, with colored inks, pencils, crayons, and pastel chalks supplying the coloration. But color is not considered essential to the art of drawing, whereas line, shape, and value are. In painting, however, color is central.

Dry and Wet Media

Edward Hopper's *Self-Portrait* **(5.5)** was executed in a "dry" medium, charcoal, while the Saul Steinberg drawing **(5.6)** was rendered in the "wet" medium of ink. What does this mean? Dry media are simply those materials—charcoal sticks, chalks, wax crayons, graphite pencils—that are applied in a solid, dry form to a surface **(5.9).** These media consist of coloring agents or **pigments** sometimes mixed with **binders,** substances that hold the pigments together in a solid form. In a wax crayon, for

5.9 Dry media, clockwise from top: crayon box, hard pastel set, soft pastels, kneaded eraser, drawing pencils, charcoal sticks, conté crayon set, tortillions (paper blending tools), chalk set; inside: gum eraser, felt-tip pens. Photo: J. P. Langlands.

5.10 Wet media, clockwise from top: watercolor set, bottles of ink, tubes of acrylic paint, paintbrushes, tubes of gouache, calligraphic pen, tubes of oil paint. Photo: J. P. Langlands.

example, wax is the binder that holds the colored pigment together. In a pastel chalk, the pigment is mixed with just enough water-based binder, such as glue and gum arabic (a tree resin), to hold it together. A charcoal stick, on the other hand, requires no binder. Made from burning vine or willow wood at high temperatures until only carbon charcoal remains, a charcoal stick is pigment in pure, solid stick form, ready for direct application. Graphite, a carbon-based product used in the modern writing pencil and in drawing pencils of lighter and darker mark-making capability, likewise requires no binder.

Wet media, in contrast, are applied in liquid form to the support, usually a paper of heavier density or "weight" capable of absorbing and holding the liquefied pigment without buckling, warping, or falling apart. The most commonly used wet drawing media **(5.10)** are pen and ink (5.6), felt-tip marking pens, and brush and ink (Appreciation 9, Fig. A). Wide-ranging in type and quality, inks are made from a variety of pigment substances finely dispersed in a water-based binder. Ink-based media encompass traditional black and a variety of hues, from the primaries red, yellow, and blue to a host of phosphorescent tones. When applied with a soft brush, the liquid ink is capable of flowing lines and **washes** or broad areas of thin, diluted color, both typical of the painter's art. The medium

A feeling for media, sensitivity to their intrinsic beauty and expressive potential, a delight in manipulating them, are part of the make-up of most artists. . . . The velvety blackness of India ink or compressed charcoal, the pale silvery gray of hard pencil . . . all these add to the pleasure of drawing, and this is reflected in the full and sensitive exploitation of each medium.—Daniel M. Mendelowitz, artist, *A Guide to Drawing,* 1976

INTERACTION BOX

APPRECIATING DIFFERENT MEDIA

You don't have to be an artist to physically experience different media and their unique qualities. Try this "no-risk" activity to appreciate how an artist's selection of a certain tool, material, and surface might substantially affect the finished work. Write your name with a pencil or pen on a smooth piece of notebook-size white paper. Now change your drawing tool to a broad felt-tip pen, a large stick of chalk, brush and ink, an enamel spray can, or brush and paint. If you need a larger surface to work on, use the pages of an old newspaper or a piece of cardboard. What effect(s) did this change in medium have on the visual quality of your signature?

Continue your experiment with different media. Vary the writing surface or support with respect to color, texture, size, and/or shape. From paper or cardboard, move to cloth, wood, metal, plastic, blackboard, sidewalk, or whatever type of support might fit with your material and tool. Write your name in customary or imaginative manner, large or small, with your new media. Note the differences in visual effect from the original pen or pencil signature on notebook paper.

Finally, use a computer to write and print your name. Use its capabilities in creative ways, varying size, color, "fonts," page orientation, drawing and painting programs, and the like. Observe how each medium—try at least three—supports or challenges your writing and image-making efforts and how each medium has special qualities that make it stand out from the rest.

of brush and ink bridges the realms of drawing and painting.

Media and Artistic Intent

Each medium, wet or dry, has unique characteristics and capabilities that can aid or limit the artistic intentions of their users. That is, each medium has potential strengths and weaknesses. Edward Hopper (1882–1967) (5.5) drew upon the strength of charcoal as a flexible medium—it comes in softer or harder forms that produce lighter or darker tones—to convey a wide range of values, from the faintest traces through mid-range grays to the deepest blacks. These tones helped him create a convincingly realistic portrayal of his own physical appearance and, through the drawing's formal properties, hint subtly at the range of his personality.

In a similarly harmonious match of medium, artistic intent, and manner of technical execution, American artist Saul Steinberg (1914–1999) employed a sharp-pointed pen and ink (5.6) to create the finely drawn, mobile lines—uniform in width—that characterize his signature style: obsessively linear, cerebral, and witty.

"After nearly forty years of looking at his [Saul Steinberg's] work [drawings, cartoons, cover designs]," remarks the [New Yorker] magazine's present editor, William Shawn, "I am still dazzled and astounded by it. His playfulness and elegance are of a sublime order."
—quoted in art review by Robert Hughes, *Time,* 1978

The media used by Marisol (5.8) are clearly limiting as well as supportive of her intention and technique. The instant, ready-to-use quality of her colored pencils and wax crayons helped the artist directly and immediately work up the central image of the bicycle and rider on the very large surface. Note the feeling of energy and vitality in her individual strokes and broader color areas and the overall sense of motion and dynamism of rider and bicycle. Where other artists might apply their crayon or pencil marks slowly, with everything colored within the lines, Marisol has worked quickly, giving the drawing a spontaneous feel. But the limitations of these two dry media are also evident. Colored pencils and crayons are small and do not blend readily, therefore requiring a lot of time to build up lines and areas of color and value stroke by stroke, on a drawing 6 feet high by almost 9 feet long! To create values within a given color, Marisol had to press her crayon or colored pencil hard to obtain a deep, opaque tone and gradually and carefully reduce the pressure to create midrange and lighter values. By meeting the challenges of these media, Marisol added creative tension and excitement to her work **(Interaction Box).**

APPRECIATING DRAWINGS: FORM AND CONTEXT

In this section, we respond in depth to three drawings by artists working in the United States in the twentieth century. We begin with a comparison of two drawings. By comparing the form, technique, medium, subject, and expressive content of these drawings, we gain greater appreciation of each work's uniqueness. We will then focus on a single work to show how the artist's cultural background and life experiences influenced his drawing.

Two Drawings: A Comparison

Native Son No. 2 **(5.11)** by Charles White (1918–1979) features a crisp, taut, linear quality and bold value contrasts extending from deep black to bright white. The dark figure—a pulsating pattern of white, black, and gray—is sharply distinguished from its stark, empty light background. White's "native son" is a pictorial interpretation of Bigger Thomas, the tormented main character in Richard Wright's famous 1940 novel *Native Son*. Confused and tortured in spirit, Bigger Thomas moves toward us. His massive hand, radically foreshortened, offers us a broken piece of wood, an item connected to a tragic event in the story. He is convulsed by a fearful energy.

White used dark ink and a pen with a sharp tip to create this dynamic image of striking line, piercing shape, and extreme value contrast. The artist painstakingly applied hundreds of tiny lines or strokes ("hatches") in parallel or criss-cross ("cross-hatched") configurations to define the overall figure and build up its volumes, textures, and values. Note the parallel **hatching** that evokes the three-dimensional contours of the immense fingers, neck, and chest muscles and the intricate web of cross-hatching that delineates the texture and shape of the pants. An intricate pattern of separate small dots or circular marks, made by the marking technique known as **stippling,** builds in a subtle crescendo of values to become a shirt sleeve swelling with bicep and forearm. White's strong definition of line and shape functions like an aesthetic pressure cooker, containing in its iron grip the

5.11 CHARLES WHITE. *Native Son No. 2.* 1942. Ink on paper. 27¼ × 17¾ in. Howard University. The Gallery of Art, Washington, D.C.

compressed emotions about to burst forth from Bigger Thomas.

In comparison to the tightly bound, explosive quality of *Native Son*, *Love* **(5.12)** by Charles Alston (1907–1977) communicates serenity, stillness, and quiet strength. A gentle, compassionate person himself, Alston employs long, gently curving contour lines that come together to produce the interlocked shapes of the young man and woman. These

5.12 CHARLES ALSTON. *Love.* Ca. 1947. Pastel and charcoal on paper. 29 × 24½ in. Collection of Alitash Kebede. *After reading the comparison of White's* Native Son *(5.11) and Alston's* Love, *a thoughtful person might ask, "Can a soft chalk ever be used to make the sort of taut, linear drawing White made, or is it better suited to soft, tender works?" Alternately, "Can an inkpen with a sharp tip be used to create gentle pictures like Alston's?" Can artists produce wide-ranging results from any given medium, or do media have their formal and expressive limits?*

curvilinear shapes overlap throughout the drawing. The effect is to formally and psychologically unite the two figures. Male and female and background—note the light, torso-like shape and hand—are effectively interwoven. Using both the tip and the side of a chalk stick, Alston further unifies his shapes and overall composition with broad, tender strokes of the chalk. Compared to the extreme light-dark contrasts of *Native Son*, the value range of Alston's *Love* is far more moderate,

centering on a middle range of closely related grays. Alston's figures are also more simplified, flat, and softly curving in their abstract form. This formal strategy suits his desire to somewhat generalize and universalize his subjects. At the same time, we should note that these subjects are rooted in specific sources, including the artist's study of African sculptures and their abstract, generalized qualities.

A Contemporary Drawing: Form in Context

Our analytic description and interpretation of *Native Son* and *Love* focused substantially on the formal and technical qualities of the two works. Now we shift gears and respond to a drawing from a strongly contextual as well as a formal standpoint. At first glance, the pen and ink drawing *Endurer's Tale* **(5.13)** seems to be a very abstract or even nonrepresentational artwork. We observe a large, somewhat curvilinear central form comprised of smaller geometrical and biomorphic shapes. These constituent shapes, each distinct, pulsate with patterns formed from repeating circles, ovals, squares, rectangles, and parallel lines, the latter short and straight or flowing in long, gentle curves. The artist renders these elements in either deep black or bright white, the colors of the ink and paper, respectively. To the left and especially to the right of the central figure, tentacle-like appendages rise and descend. Positive shapes interweave with negative spaces within and around the highly abstract main form. Like a flattened pancake pressed to its griddle, the big black figure meshes with its white ground. Brimming with detailed parts, with abundant contrast and variety, *Endurer's Tale* is a cornucopia. There is much to see, investigate, and unfold.

Created by Nigerian artist Barthosa Nkurumeh (born 1961), *Endurer's Tale* is a window into the artist's personal life. An introspective, autobiographical story, it tells us about both the artist himself and his cultural roots. The drawing builds upon the traditional Uli wall painting **(5.14)** and body art of his West African country, art forms that rely heavily on the use of diverse lines, textures, patterns, and elongated shapes. Like Uli art, *Endurer's Tale* employs "parent shapes" and "panel

composition," that is, a dominant form built from subsidiary forms and patterns—all for narrative purpose.

Nkurumeh states that the parent figure, birdlike in shape, represents the artist himself. "We notice that the figure is in solitude, self-directed, like Rodin's *Walking Man* [16.40], forward bound with thoughts bared for viewers' possible speculation." The artist parent figure, with eyes closed, is marching to the left, "pulling everything in the work along its path of movement." Does this journey mirror Nkurumeh's own migration as a young man from Nigeria to the United States, where he has lived since 1982? He says that there are two circles of illumination at the figure's head, perhaps halos, suggestive of his faith. For Nkurumeh, each shape and panel symbolizes something (friendship, struggle, control) or tells a story (about masquerade festivals, marching forward, being the sum of one's parts). The smaller, secondary figures, behind and to the far right of the artist figure, are elongated, in keeping with traditional Uli art. Other figures, small and peoplelike, adjoin the parent figure on the left. Nkurumeh depicts these anthropomorphic figures right side up or upside down, from the front, the side, and above. Is the artist saying that we see and are seen from many angles? Is he stating in visual terms that we are made up of and swollen with a multiplicity of experiences, sometimes nurturant and harmonious, and at other times clashing or confusing? The story and subplots of *Endurer's Tale* work on many levels, befitting Nkurumeh himself. A hybrid African and American artist, Nkurumeh melds Nigerian roots and traditions, American life experiences, and cross-cultural artistic learning in one enduring tale.

PAINTING: FOCUS ON COLOR AND TEXTURE

Just as line, shape, and value are basic to the art of drawing, color is fundamental to painting. This identification of color with painting is so strong that even works in dry media customarily associated with drawing—crayon, colored pencil, pastel—are often regarded as a type of painting or a hybrid form of drawing and

5.13 BARTHOSA NKURUMEH. *Endurer's Tale*. 1994. Ink on paper. 8½ × 11 in.

5.14 ANONYMOUS ARTIST. Uli painting on house exterior. Nigeria, late twentieth century.

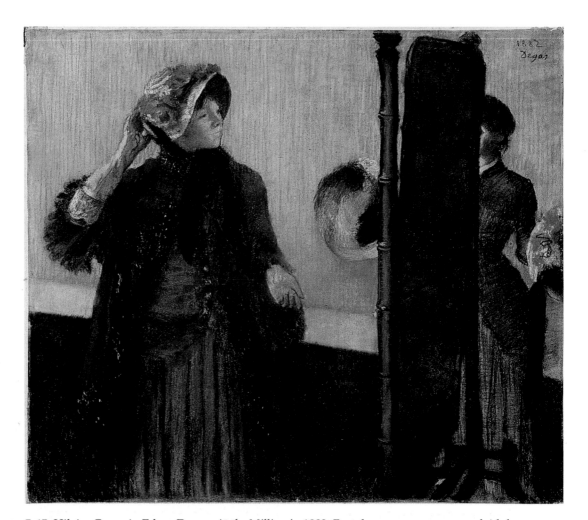

5.15 Hilaire Germain Edgar Degas. *At the Milliner's.* 1882. Pastel on gray wove paper, laid down on silk bolting. 30 × 34 in. The Metropolitan Museum of Art, New York, H. O. Havemeyer Collection. Bequest of Mrs. H. O. Havemeyer, 1929 (29.100.38). Photo © 1987 The Metropolitan Museum of Art. *Degas's works, which look like they are done almost spontaneously, are actually the result of arduous labor and ceaseless innovation with materials and techniques. Degas's pastels are usually "mixed-media" works with strokes or layers of watercolor or oil paint applied beside or over his dry chalk strokes. Ever the experimenter, sometimes he sprayed the pastel paintings with hot water so that he might work on the moistened pictures with a brush. On occasion, the artist soaked his pastel sticks in steam so that they would be softened enough to produce an impasto quality. Some artists, like Saul Steinberg (5.6), accept a medium for what it is, while others, such as Degas, forever push a material's limits in pursuit of expanded possibilities. Which type of artist would you be?*

After having done portraits from above, I will do them seen from below—sitting very close to a woman and looking at her from a low viewpoint, I will see her head in the chandelier, surrounded by crystals, etc.; do simple things like draw a profile which would not move, [the painter] himself moving, going up or down, the same for full face—a piece of furniture, a whole living room . . . —Edgar Degas, artist, Notebooks: 1878–1884

painting. Marisol's large drawing in color, *Licking the Tire of My Bicycle* (5.8), exemplifies such a crossover work. Major art museums traditionally place large, colorful works such as Edgar Degas's *At the Milliner's* **(5.15)** in rooms with paintings rather than in rooms with other drawings. (Drawing rooms in museums are traditionally filled with works that are limited in color but expansive in values; figures 5.12 and 5.13 are typical. The majority of these drawings, small in size and executed on paper, are created in the value range between black and white or within a single color such as red or brown.)

Note the overall coloristic brilliance of the pastel *At the Milliner's* (5.15) and the way Degas

5.16a Painting materials and tools, (clockwise from top): cans of enamel and acrylic housepaint, paint thinner, assorted brushes, broom and piece of wrought iron fence (used as tools to apply paint), paint roller on extension pole, large yellow sponge.

(1834–1917) has blended the dry powder to a smooth finish in certain areas and left the more roughly textured marks of his pastel sticks visible in others. Pastel sticks in a rainbow of ready-to-use hues allowed Degas to work with physical directness to convey a sense of immediate perception of everyday Paris life. In this "slice of life" scene, a woman (actually Degas's friend and fellow artist, Mary Cassatt) is trying on a hat while a store employee, cut in half by the frame of a mirror, offers her another selection. Upon completion of this large pastel work, Degas would have applied a protective varnish spray or fixative to "fix" and seal the powdery chalk marks to the surface. Although executed without paint, the centrality of color in pastel works like *At the Milliner's* has caused many a viewer to associate them with the painter's art.

Color and Paint

As we have noted, when we think of paintings, we almost immediately think of color, an element whose expansive possibilities encompass the hues of the rainbow and beyond. This miraculous spectrum or keyboard of hues and their seemingly infinite variations and combi-

5.16b (clockwise from top): spray paint cans, feather, tubes of oil and acrylic paint, palette knife resting on small ceramic palette, pair of scissors, comb, small and large airbrushes, piece of plastic used as a large palette.

nations have caused many artists to fall under color's spell. They have thought of it as a spiritually moving force that appeals directly through the senses to the viewer's soul.

On the down-to-earth, physical level, the miracle of color is provided through the liquid or pastelike medium of paint. There are many types of paints **(5.16),** each made from pigment combined with a **vehicle,** that is, the liquid material in which the pigment is dispersed. As the carrier of the color, the all-important vehicle serves one or more functions: to put the color

5.17 ANONYMOUS. Portrait of an artist in Turkish costume. Persian, late 15th century. Opaque watercolor and gold on paper. 7⅜ × 5 in. Freer Gallery of Art, Smithsonian Institution, Washington, D.C., purchase (F1932.28).

If you let your eye stray over a palette of colors, you experience two things. In the first place you receive a purely physical effect, namely the eye is enchanted by the beauty and other qualities of color. . . . But to a more sensitive soul the effect of colors is deeper and intensely moving. And so we come to the second result of looking at colors: their psychological effect. They produce a correspondent spiritual vibration, and it is only as a step to this spiritual vibration that the physical impression is of importance. —Wassily Kandinsky, artist, *Concerning the Spiritual in Art,* 1911

into liquid form so it can be spread and manipulated; to bind the pigments together in a cohesive mass or film; to act as a glue or cement to attach the colors to a ground or surface; to bring out the depth and intensity of the pigment colors. Water is the vehicle for watercolor paints; an oil such as linseed is the vehicle for oil paints. For professional-quality "egg tempera" paints, egg yolk is the vehicle's primary ingredient. But whatever the pigment-vehicle combination, artists commonly refer to paints as belonging to one of two categories: water-based media (for example, watercolor and tempera) and oil-based media (for example, oil paint and enamel housepaint). Water-based paints are thinned or diluted with water; oil-based paints are thinned with a solvent of turpentine or mineral spirits. Such paint thinners also serve as the primary agents for cleaning hands and brushes.

Some artists or cultures use mainly water-based paints. The famous Persian miniature painters of the fifteenth and sixteenth centuries employed opaque watercolor paints (also known as **gouache**), which they brushed onto

small sheets of vellum, a fine form of parchment prepared from calfskin, lambskin, or kidskin. In *Portrait of a Painter in Turkish Costume* **(5.17),** a Persian painter who might have lived in the Ottoman Turkish empire and worked for a Turkish lord applies his colors to a thin sheet of parchment, with a small, fine-tipped brush with animal-hair bristles. The paint is absorbed into the parchment and becomes one with its surface. The artist creates the miniature painting on his lap, and viewers likewise would have examined the work at close range. These detailed, jewel-like "miniature paintings" were not hung on walls like framed paintings. Originally, the great majority filled richly bound and decorated books, illustrating famous Persian stories (5.24).

In the fifteenth and sixteenth centuries, artists in Europe were perfecting the use of oil paint made from pigments mixed with a vehicle of oil, usually linseed oil from flaxseed. These artists initially painted directly on wooden panels (4.3), later switching to a canvas cloth stretched taut over a wooden frame. *Las Meninas* **(5.18)** shows the Spanish artist Velázquez (1599–1660), paintbrush and palette in hand, preparing to paint on a large canvas stretched tightly over and nailed to wooden "stretcher strips." Dabs of oil paint in different colors cover Velázquez's wooden palette. The painting in progress is supported by a stand or easel, one of whose diagonal wooden legs and horizontal cross-brace is visible in the bottom left foreground. From the fifteenth to the middle of the twentieth century, almost all oil paintings, large or small, were created on an easel in an upright position, with the artists looking out and observing the subjects—people, landscapes, still lifes—they were representing on their canvases. The thick, adhesive nature of oil paint supports this orientation because the paint holds firmly to the vertical picture surface. In addition, the physical qualities of the paint promote a particular type of surface appearance or finish. After oil paintings have dried to their final solid, dry state, their finish exhibits a lustrous, luminous quality. Observe how the surface appearance of *Las Meninas* glistens. It appears naturally shiny or glossy, especially compared to an opaque watercolor (5.17), whose finish is more dull or mat (or matte).

Throughout his life, Velázquez had sought respect and acclaim for himself and the art of painting. Here, dressed as a courtier, the Order of Santiago on his chest and the keys of the palace in his sash, Velásquez proclaimed the dignity and importance of painting as one of the liberal arts. —Marilyn Stokstad, art historian, *Art History,* 2002

What distinguishes oil painting from any other form of painting is its special ability to render the tangibility, the texture, the lustre, the solidity of what it depicts. It defines the real as that which you can put your hands on. Although its painted images are two-dimensional, its potential of illusionism is far greater than sculpture, for it can suggest objects possessing colour, texture and temperature, filling a space and, by implication, filling the entire world. —John Berger, art critic, *Ways of Seeing,* 1972

5.18 DIEGO VELÁZQUEZ. *Las Meninas (The Maids of Honor).* 1656. Oil on canvas. 10 ft. 5 in. × 9 ft. Museo del Prado, Madrid. Postcleaning. *On first glance, the painter Velázquez and the little Princess Margarita, attended by her maids of honor ("las meninas"), appear to be the painting's principal subjects. But who are Velázquez and Margarita looking at? Are they looking at the work's patrons, the king and queen, whose reflections appear in the mirror on the back wall? Might yet another major subject be the power of light (reflected light, natural light, artificial light, painted light)?*

Texture and Consistency

Usually applied with a brush, both oil- and water-based paints are capable of great variation in texture and physical consistency. Water-based paints and inks can be so diluted, or "thinned down," with water that they create transparent or translucent washes of color. You can literally see through them to the surface beneath. A masterful example of the use of diluted ink is *Li Po Chanting a Poem* **(5.19)** by the Chinese artist Liang Kai (ca. 1160–1246). The transparent and translucent brushstrokes of ink that make up the clothing and body of the poet (compare these to the dense blackness of eyes, lips, and hair) create a remarkable effect: a synthesis of solid and void, material body and immaterial spirit. See **Appreciation 9** for a contemporary example of Chinese ink painting. *St. John's River, Florida* **(5.20)** by

5.19 LIANG KAI. *Li Po Chanting a Poem.* Southern Song Dynasty, late 12th–13th century. Ink on paper. 32 × 12 in. National Commission for the Protection of Cultural Properties, Tokyo. Photo: M. Sakamoro. *In China, calligraphy, or the art of beautiful writing, in brushed ink on paper or silk was long considered the most important art. Writing and literature were so highly valued that the particular scholar-artists known as* **literati**—*they often combined painting, poetry, and calligraphy in their work—were particularly acclaimed. Do you think that the artist, Liang Kai, qualifies as a literati painter? Was he knowledgeable in poetry and skilled in calligraphy? How can you tell?*

5.20 WINSLOW HOMER. *St. John's River, Florida.* 1890. Watercolor on paper. 14 × 20 in. Private collection. *Museum exhibitions and art history survey books emphasize large-scale oil and acrylic paintings over small, intimate watercolor works. Given the beauty and undisputed excellence of watercolors by Homer and other prominent artists, why do you think this medium has received less attention?*

The purity of black ink on white paper or silk had a definite metaphysical attraction for painters [like Liang Kai] inspired by Chan [Chinese Buddhism]. . . . His painting of the celebrated Tang [Dynasty] poet Li Po seems a condensation out of nothingness into the physical form and spiritual concentration of Li's personality.—John D. La Plante, art historian, *Asian Art,* 1992

Winslow Homer (1836–1910) also features these qualities of water-based paint. Vaporous washes and flowing, watery forms balance more opaque shapes, including a profusion of solidly defined stones and dense shadows. The painting achieves an effect both palpable and evanescent. We sensuously perceive nature's light and color, wind and water through the magic of Homer's brush. At the same time, this master orchestrator and choreographer of opaque colors and transparent washes makes the distant shore appear to vanish into the air.

As a comparison to the thinned ink and watercolor washes of Liang Kai and Winslow Homer, observe Lee Krasner's use of *impasto,* that is, thickly and heavily textured surfaces. In

her nonrepresentational oil painting *Noon* **(5.21),** Krasner (1908–1984) has built up the paint into a thick, rough consistency. Recall a similarly bold use of impastoed surfaces in Vincent van Gogh's oil painting *The Night Café* (1.12). Oil paint, one of the most flexible of painting media, can be built up to substantial thicknesses or diluted to extreme degrees of thinness with paint thinners such as turpentine or mineral spirits. In Helen Frankenthaler's *Mountains and Sea* (18.24), the oil paint is so thinned down that you can actually see through the colors to the surface beneath. Frankenthaler has succeeded in capturing in oils the transparent and translucent qualities usually associated with water-based paints and inks.

5.21 LEE KRASNER. *Noon.* 1946. Oil on linen. 24 × 30 in. Private collection. Courtesy of the Robert Miller Gallery, New York. *Artist Lee Krasner was a big fan of oil paint but didn't like acrylic paint at all. About acrylic paint she said flatly, "I find it opaque, dead as a door nail, and about as unsensuous as you can get. The one quality that I respond to highly is the sensuousness of the paint." Krasner loved oil paint for sensuous physical qualities and malleability. If you were a painter, what qualities would you like in your chosen type of paint?*

In the past fifty years, water-based acrylic paints have come to rival oils, the premier painting medium in the Western tradition for 500 years. Acrylics are made from pigments mixed with plastic-based, synthetic binding materials. With the help of an array of additives, acrylic paints can now equal the degrees of thickness and thinness and the chromatic power of oil paints. An acrylic painting with an even heavier impasto texture than Krasner's oil painting *Noon* (5.21) is Anselm Kiefer's *Nuremberg* **(5.22).** Applied to a huge canvas, the paint, combined with pieces of straw and other foreign substances, takes on a rough, physically aggressive quality. The somewhat ominous quality of this work—in its technique, color, and texture as well as its composition and subject—speaks to one of Kiefer's central themes: a postwar Germany troubled by memories of its Nazi past. (For the artist, the city of Nuremberg was alternately a revered center of German culture and a center of Nazi activity leading up to World War II.) In a match of media properties, form, and content, weighty issues are embodied in some of the densest, heaviest paint surfaces ever produced.

Untitled **(5.23)** by Sam Gilliam (born 1933) demonstrates the capacity of acrylics to function like vaporous watercolors. Gilliam transforms his acrylics, heavily diluted with water,

5.22 ANSELM KIEFER. *Nuremburg.* 1982. Acrylic, oil, straw, and mixed media on canvas. 9 ft. 2¼ in. × 12 ft. × 5⅞ in. The Eli and Edythe L. Broad Collection. Photo: Douglas M. Parker Studio.

Kiefer's work is made (to list only the main substances other than paint) of tar, paper, staples, canvas, a rough foil formed by throwing a bucket of molten lead on the canvas and letting it cool there, sand, epoxy, gold leaf, copper wire, woodcuts and lumps of busted ceramic. It is highly unlikely that these paintings will survive for another fifty, or seventy-five years—Kiefer carries a disregard for the permanence of his materials to such an extreme that the lead will not stay in place and the straw is rotting already, although this does not seem to discourage collectors.—Robert Hughes, art critic, Time, 1987

water, into flowing, blending layers of brilliant color. Soaking into the surface and seams of the absorbent paper, the watery colors blend so totally that the hues of purple, blue, pink, and orange literally bleed together.

For artists, like Gilliam, who like to work quickly, loosely, and improvisationally, acrylic paints have a definite appeal. Acrylics dry to a finished state in minutes or hours, in contrast to the days, weeks, or even months that oils take to dry. For those artists who want to work more deliberately, the drying time of acrylics can be slowed down by adding a retardant material to the paint. Water-based acrylic paints are far easier to clean off brushes and palettes than are oil paints, which require strong turpentine or mineral spirit thinners. Because of its flexibility, ease, and versatility, a fair number of artists have turned to the acrylic medium. The advantages of acrylics notwithstanding, many artists continue to paint in oils, preferring their unique coloristic and textural qualities. These artists swear by the creamy, full-bodied texture, sensuous feel, and luster of oil paint. Numerous artists, including the

aforementioned Kiefer (5.22), paint in both media, creating separate acrylic or oil paintings or mixing the two media in "mixed-media" works.

TWO PAINTINGS: FORM AND CONTEXT

In this section we compare two paintings with a similar theme: a couple in love. The two works were created within a few decades of each other but continents and cultures apart. Comparing them brings out their special qualities with respect to media, form, content, and context.

The first painting, *The Persian Prince Humay Meets the Chinese Princess Humayun in Her Garden* **(5.24),** is done in opaque watercolor, or gouache, on a sheet of parchment, a finely made paper. Created around 1450 for aristocratic patrons, this Persian miniature was originally a page from an illustrated manuscript, a small handmade book with pictures that illustrate the stories. The visual scene is based on a

poem written the previous century. The text is written in an elegant calligraphy (literally, "the art of beautiful writing") on the rectangular panels at the top and bottom of the page. A renowned calligrapher, not the painter, would have executed these written words. Persian miniature painting is a collective art form, the creation of a highly coordinated group that includes the painter, the calligrapher, the maker of the paper, the binder of the pages, and the overall project director, a librarian or literary expert. In terms of the painting and calligraphy processes, both artists would have bent over the horizontal work, placed perhaps on a small table on their lap (5.17).

To create this story illustration, the painter applied his paint in broad, flat areas, a specific strength of gouache. Soaking into the parchment, the opaque watercolor leaves little or no physical trace on the smooth surface. Little attempt is made at shading or modulating values to create an illusion of three-dimensional volume. The resulting figures and objects thus are simplified and flattened in appearance. Foreground and background—people, flowers, trees, sky—interweave in a single decorative plane, much like the flat, abstract design of the interlocking letters of the accompanying text. Painted in pure hues, with primary and secondary colors leading the way, the royal couple, their attendants, and the surroundings resonate with complementary colors. The gold-crested red and orange wall and the deep purple-blue sky with golden moon and stars shine like gems in the night. Abstracted and stylized, the royal personages and their surroundings take on an insubstantial, dreamlike appearance in keeping with the poetical quality of this romantic tale.

A thousand miles or more to the west, European painters would pursue a different goal with a different medium. Through the subtle effects made possible by oil paints and oil paint **glazes** (coats of transparent or semitransparent color laid over a dried layer of paint), European artists, especially in Germany and the Netherlands, were beginning to reproduce the full range of colors and textures of actual life. The oil painting on wooden panel *The Arnolfini Wedding Portrait* **(5.25),** by Jan van Eyck (ca. 1390–1441), is a case in point. Executed in 1434, the painting was commissioned

5.23 SAM GILLIAM. *Untitled*. 1972. Acrylic and watercolor on rice paper. 24 × 36 in. Courtesy of the artist.

5.24 *The Persian Prince Humay Meets the Chinese Princess Humayun in Her Garden*, from a Persian manuscript. Ca. 1450. Gouache. Musée des Arts Décoratifs, Paris.

While the physical properties of gouache and transparent watercolor paints are nearly alike, their handling characteristics and surface textures are very different. The opaque nature of gouache [5.22], its easy application in hatched strokes that produce optical impressions of color blendings, its restrictions on actual, physical blendings and fusions of strokes, and its overall surface appearance in a completed painting . . . [differentiate it from] transparent watercolor [5.18], where splashes and fusions of color washes and the absence of white paint as a means of adjusting color and value set it apart from other media.—Nathan Goldstein, author, *Painting: Visual and Technical Fundamentals*, 1999

5.25 JAN VAN EYCK. *The Arnolfini Wedding Portrait.* 1434. Oil on wood. 33 × 22½ in. National Gallery, London. *Some scholars believe that beneath the oil-painted surface of this work lies a detailed preliminary version of the two figures and their surroundings done in a prominent water-based medium of the day, egg tempera. If this is the case, we have before us in a single work a historic example of an older, established medium being built upon and then eclipsed by a newer one. Do you think computer-based drawing and painting programs are building upon and replacing handmade paintings as the dominant artistic medium of the future, or will "low-tech" handmade paintings and "high-tech" electronically generated pictures continue side by side?*

by and commemorates the marriage of Giovanna Cenami to Giovanni Arnolfini, a wealthy young Italian businessman in the international wool trade. Weaving together Christian symbolism (for example, the single candle, burning in broad daylight, standing for the all-seeing Christ) and scientific realism (the accurate reproduction of physical objects and everyday life), the painting was revolutionary in its illusionism. It creates an extraordinary likeness of the couple, their belongings, and the interior of their home. Van Eyck's very subtle use of values and shading, along with the related representation of real daylight and shadows, gives the figures and objects the illusion of three-dimensional volume. While hardly a brushstroke can be seen, the oil paint itself sits on top of and smoothly covers the wooden panel surface, communicating a further sense of solidity or "body." Compared to the two-dimensional fantasy world of Prince Humay and Princess Humayun (5.24), van Eyck's oil painting endows the Arnolfini couple and their surroundings with realistic weight. A simple corner of the world had suddenly been captured on a flat surface as never before. Here it all is in living color and texture: the carpet and the slippers, the chandelier, the mirror and chain of beads on the wall. It is a world of cherished objects and activities. Where the flat, pure colors of gouache served the ends of Persian poetic imagination and decorative flair in many a miniature, oil paint supported the development of a realistic style in keeping with the values of a European culture ever more secular, materialistic, scientific, and individualistic. Recall Velázquez's *Las Meninas* (5.18).

Note also that van Eyck and Velázquez were the exclusive or primary creators of their paintings, in contrast to the group creation of Persian miniature paintings. Each man viewed and represented his subjects from a personal vantage point. Velázquez looks out at us and at his patrons, the king and queen, whose bright reflections are seen in the tall, rectangular mirror on the center of the back wall amid darkly lit oil paintings. Van Eyck's presence is not immediately apparent, but we discover him in the small mirror on the rear wall of the bridal chamber **(5.26)**, legally witnessing the couple's marriage vows and affirming in written words

5.26 JAN VAN EYCK. *The Arnolfini Wedding Portrait.* 1434. Oil on wood. National Gallery, London. Detail of convex mirror.

above the round glass that *Johannes de Eyck fuit hic, 1434* ("Jan van Eyck was here, 1434"). In comparison, the presence of the Persian painter, illustrator, and calligrapher is much more understated. They leave their imprint in brushwork and style, not in an overtly individual point of view.

DRAWING AND PAINTING: DIFFERENT FUNCTIONS AND STATUS

Formal differences aside, paintings—especially in the Western tradition—have been differentiated from drawings by status and function. Until relatively recent times, paintings have been accorded a higher status than drawings. Paintings have usually been created and valued as final products: as altarpieces, ceiling and wall paintings, framed portraits and landscapes. As such, they tend to be larger, physically stronger, more costly and labor intensive than drawings. Drawings, for the most part, have not been accorded this same status as a final product, although in our own period, their status—figures 5.11–13 are examples—has risen steadily; like paintings, they are now often created and appreciated as ends in themselves. And some, like Marisol's *Licking the Tire of My Bicycle* (5.8), six feet high by almost nine feet long, are comparable in dimension to very large oil or acrylic paintings.

[W]e must not forget, when we are dealing with Renaissance painting, that it was only possible because of the immense fortunes which were being amassed in Florence and elsewhere, and that rich Italian merchants [like Arnolfini] looked upon painters [like van Eyck] as agents, who allowed them to confirm their possession of all that was beautiful and desirable in the world. The pictures . . . represented a kind of microcosm in which the proprietor, thanks to his artists, had re-created within easy reach and in as real a form as possible, all those features of the world to which he was attached.—Anthropologist Claude Lévi-Strauss, quoted in John Berger, Ways of Seeing, 1972

5.27 ANGELICA KAUFFMANN. Design in the ceiling of the Central Hall of the Royal Academy. 1780. Oil on canvas. 52 × 59 in. © The Royal Academy of Arts, London, 2000. *An instructive footnote to this painting concerns gender restrictions. Right up to the twentieth century, art academies and schools did not permit women to draw from the naked live model, in particular the male model, because it was considered morally inappropriate. Women had to work exclusively from sculptures or plaster casts of famous nude sculptures in order to master the anatomical understanding necessary to draw convincing male and female figures. How do you think limits on their training affected women's choices relative to media and subject matter in centuries past?*

5.28 GEORGES SEURAT. *Sketch of Trees*, study for trees in *La Grande Jatte* painting. 1884–85. Conté crayon drawing. The Art Institute of Chicago. *Note how Seurat has subtly modified these trees in the later study [5.29]. Why do artists take creative liberties as they develop their sketches and studies into a final work?*

Drawing as Sketch or Study

Over the centuries, drawings have most often served as means to various ends; that is, they have functioned as preparatory sketches, studies, or plans for final products. A **sketch** tends to be a quick, fragmentary drawing that generates broad ideas either for the overall product or for parts of it. It usually precedes and leads to a detailed **study** that more specifically delineates the final work. Each drawing might in turn prepare the artist for execution of a larger-scale painting, the end product. An eighteenth-century painting **(5.27)** by Angelica Kauffmann (1741–1807) shows a young woman doing a drawing study of a sculpture so she can learn to realistically render the human body. Later she might create a painting based on the anatomical knowledge gained from her drawing studies and sketches.

A good example of the progression from sketch to detailed study to finished painting is found in the work of French artist Georges Seurat (1859–1891). A Seurat pencil sketch of trees **(5.28)** captures the overall look and feel of their contours, focusing on the shapes of the tree trunks. This type of sketch is often referred to as a "contour drawing." A more developed landscape study **(5.29)**, executed in Conté crayon (a semihard chalk with an oily binder), includes the group of trees from the sketch in the upper right section of the scene. The addition of shading and value contrasts creates a further sense of three-dimensional space and volume. Areas of sunlight and shadow are elaborated, and a dog and two boats enter the scene. Seurat has set the stage for the people who will be the main actors in his well-known oil painting *A Sunday Afternoon on the Island of la Grande Jatte* **(5.30).** The

5.29 GEORGES SEURAT. *Landscape with Dog*, study for *La Grande Jatte* painting. 1884–85. 16 × 24 in. British Museum. (Cesar M. de Hauke Bequest.)

5.30 GEORGES SEURAT. *A Sunday Afternoon on the Island of La Grande Jatte*. 1884–86. Oil on canvas. 6 ft. 9¾ in. × 10 ft. 1⅜ in. The Art Institute of Chicago. Helen Birch Bartlett Memorial Collection, 1926.224. © The Art Institute of Chicago. All rights reserved. *Seurat created a bold, new style, known as "pointillist" or "divisionist," based on tiny points or dots of divided color placed next to each other. Yet his overall preparation for the finished oil painting was quite traditional in that he worked from numerous preliminary drawings before executing the final work in the studio. In contrast, some of his contemporaries, such as Monet (1.6) and van Gogh (1.14), created their final paintings directly, with few or no preparatory drawings. What do you see as the advantages and disadvantages of each approach?*

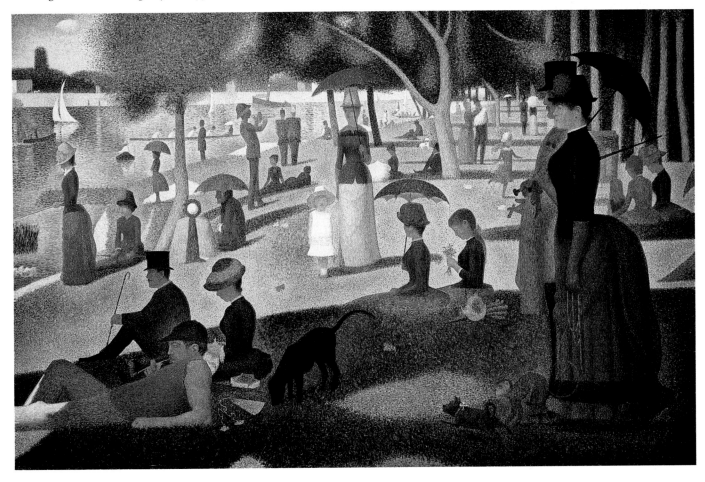

landscape locale established in the preliminary drawing has formed the basis of the landscape in the painting. Seurat similarly employed preliminary drawings as the basis for most of the figures in the final painting.

Drawing and Painting: Fundamental to the Other Arts

Although there is no such thing as "a" computer, the principles in learning how to use the machine as an art tool remain similar to traditional precepts. We must still learn the basics of drawing.—Lilian F. Schwartz, artist, *The Computer Artist's Handbook,* 1992

Advertising designers, product designers, architects, and sculptors also use drawings as studies or plans for their finished, three-dimensional works. These preparatory drawings, whether executed in pen or pencil or with the aid of computer programs, function like the drawings of Seurat. Movie directors and video artists sketch out on paper the basic setups for their camera shots. Many types of printmaking, as well as computer-generated imagery **(Appreciation 10),** employ time-honored drawing techniques such as stippling, parallel hatching, cross-hatching, and contour lines to evoke texture, value, and volume. Escher's print *Drawing Hands* (5.7) is an example. No art form is more basic or fundamental to the other visual arts than drawing.

Painting has also been basic to diverse art forms. Earlier in the chapter we saw how a painting style (5.14) served as the formal basis for Barthosa Nkurumeh's *Endurer's Tale* (5.13). Both black-and-white and color photography and cinema owe much to the painter's art. Many twentieth-century films—*The Cabinet of Dr. Caligari* (2.30, 7.25) is a celebrated example—were actually conceived by their directors or designers as "paintings brought to life." While Caligari's designer drew inspiration from a contemporary painting style (7.24), other films (7.22) have drawn ideas from famous paintings of the past (7.23). The influence of painting on photography has been equally great. In reactive response to this influence, the noted photographer Edward Weston (1886–1958) (7.39) scolded his colleagues for producing "photo-paintings," photographs that too slavishly imitated the formal qualities and styles of the fashionable paintings of the day. While present-day photographers and film-makers (7.32, 7.49) do not imitate painting styles as closely as did earlier practitioners, they remain keenly receptive to the influence of painters and painting movements both past and present.

In the Tradition of the Chinese Masters: I-Hsiung Ju Paints a Picture

CHOW-SOON JU, GAYLE JOHNSON STECK, AND ROBERT BERSSON

Figure A I-Hsiung Ju doing calligraphy. Washington and Lee University, du Pont Gallery. Photo: Hinley. Photo courtesy of Washington and Lee University.

I-Hsiung Ju (pronounced Yee-Shiong Jue) was born in Kiangsu, a province in southeastern China, in 1923. After receiving his degree in Chinese art and literature from the National University of Amoy in 1947, he taught art at the college level in the Philippines and the United States. In the tradition of the Chinese masters, Professor Ju is accomplished in calligraphy, poetry, and philosophy as well as painting. An internationally known artist and educator, Professor Ju has had one-man shows in China, Hong Kong, Japan, the Philippines, Australia, England, Canada, and the United States.

In a brief essay, author Chow-Soon Ju describes her husband's traditional Chinese approach to painting.

> In a Chinese artist-scholar's studio there are the so-called "four treasures," namely the brush, the ink, the paper and the inkstone for grinding ink. These are the most important materials and tools for both writing and painting. Chinese artist-scholars must be calligraphers first. When they paint, the brushwork techniques of calligraphy —beautiful writing—are still used.

We call the paper from Asia "rice paper" as a general term. But there are hundreds of different types of paper, also soft and absorbant, which are not all made from the rice stalk. Oriental paper contains no acid and lasts long.

It is not only the way of making the brush [a bamboo shaft capped with a head of soft sable or goat hair] but also the way of using the brush that makes the Oriental painting technique. Writing and painting in Asia are kinds of performing arts and need a long time of training and practicing.

The ink used is always permanent. The black ink has to be freshly ground. There are only five colors of ink: indigo blue, cambogia yellow, crimson red, vermillion and sienna brown. Professor Ju is a painter of the Southern School, so he does not use stone green or stone blue, colored inks that are not organic and also not transparent.

When Professor Ju paints, he says that he always lets his brush "dance" and his ink "sing." Working quickly and spontaneously, he brushes the ink onto the paper with a flourish **(Fig. A).** He never makes pencil sketches to start his painting and never retouches it. Like magic, the subject matter emerges on the paper in a very short period of time.

The background wash is added at the back of the painting. [Because the rice paper is so thin, the colors of the wash show through to create waterfalls, clouds and mists.] All the ink used here needs a long time of exposure [to the air for purposes of drying] to assure permanency. After Professor Ju finishes his painting **(Fig. B),** he writes either a poem or an inscription as part of the composition. Lastly, he puts his personal name chop [a stamp of his name] on the work. It is done in red ink. He may put more chops on the painting which are called "decorative chops."

With great care, he mounts his painting on another sheet of paper or silk. He does this after

the painting has dried for many days. This process of mounting is also an aged art form. To paste a painting onto a scroll is a complicated and effective process that insures longevity. This is one of the reasons why Oriental paintings of the ancient days remain in such good shape.

Inspired by his artistic process, one of Professor Ju's former students, Gayle Johnson Steck, wrote a poem that sensitively evokes the artist's preparation and painting method. Here is an excerpt from the poem, titled "Listening to I-Hsiung Ju Paint":

The ritual preparation begins: mud forms from grinding the ink stick on black, weighty inkstone . . .

Ink now viscous, the artist's bamboo brush, stripped of black felt wrapper, is full and poised; its shadow is long on the ricepaper taped to an easel against the wind.

The brush barely touches, then flattens to blend all shades of black, gray, white. Strokes are long lives on the expanse of ricepaper. He dips a sable's hair-point to the inkstone; I-Hsiung's brush skims its space: sweeps dye ricepaper. The last stroke: an arc. Two fish appear.

I-Hsiung dips his brush for cleaning: excess ink is a suspended spiral in the clear glass of water. On his black felt wrapper the artist rests his brush. His inkstick dries its edge; in red I-Hsiung seals his poem. ▧

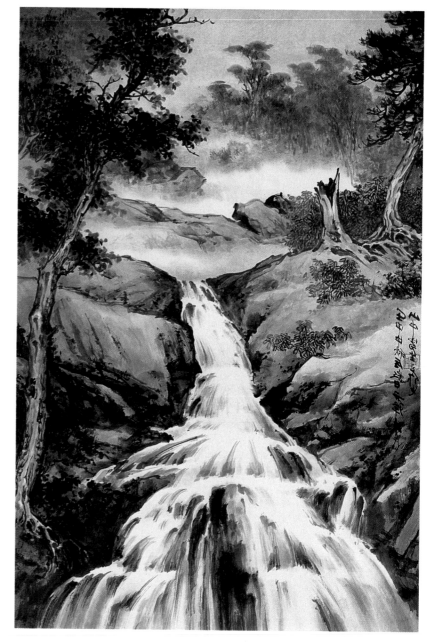

Figure B I-HSIUNG JU. *Crabtree Falls.* 1992. 29 × 18 in. Ink on rice paper, pasted on silk.

Chow-Soon Ju is a writer and scholar who lives in Princeton, New Jersey. Gayle Johnson Steck is a poet and writer who lives in California.

APPRECIATION 10 *An Interview with Artist Peter Ratner on Computer-Generated Art*

ROBERT BERSSON

Figure A Peter Ratner at the computer. Photo: Diane Elliot.

Robert Bersson: We previously discussed how computer-generated art is a high-tech extension of traditional drawing and painting. How is it different from drawing and painting in form and process?

PETE RATNER: One of the first things that many of us working in this new digital medium discovered was that creating art on the computer was mostly a cerebral experience. It was different from the more physical, "hands-on" art-making approaches such as drawing, painting, and sculpture. The artistic process that my computer animation students and I dealt with was now situated in the realm of visual perception. It was devoid of any of the sensuous considerations and tactile qualities associated with traditional art media.

BERSSON: Is the idea that computer-generated art is more mechanical than traditional art true or false?

RATNER: Because the experience of making art on a computer is more cerebral than physical, the artist is removed from any direct contact with his or her work. The artist is forced to

Peter Ratner is a computer artist and painter. His book Mastering 3D Animation *(Allworth Press, 2000) is an instructional text for aspiring computer artists.*

view and work through devices such as monitors, central processing units, a mouse or digital pen **(Fig. A).** The use of these mechanical devices creates a barrier between the artist and the work, leading to a kind of emotional detachment from the creative product. Thus computer art has often been labeled as cold and impersonal. This, however, is a misconception since the computer artist can still infuse the work with emotional content while keeping a more detached viewpoint during its development. The artist and viewer can and often do derive emotional satisfaction from the work even though it may dwell in the intellectual rather than sensory realm. In other words, the actual artmaking process may be more mechanical and less physical, but the final product can be as emotionally satisfying as any traditional art form.

BERSSON: As someone who both paints in oils and does computer-generated art, what do you see as the unique qualities of each medium?

RATNER: Traditional art forms such as oil painting have a strength of physical presence unequaled by digital images except for those employed in the movie industry. Over the past half century, movies have probably influenced people to a greater degree than any other form of expression. The use of digital media in movies has elevated this influence to an even greater degree. Computer-generated special effects have transported the human consciousness to areas unimagined in any previous time. Computer-generated three-dimensional modeling and animation present the artist with an almost unlimited source of creative freedom. The artist now has control over lighting, textures, camera angles and movements as well as the various expressions of his or her digital figures. Working in a virtual 3-D space allows the artist to manipulate everything in any manner he or she chooses. One can truly be a master of illusion.

121

Figure B PETER RATNER. *The Artist*. Still from computer-generated video.

BERSSON: Has your computer work influenced your oil painting and vice versa?

RATNER: Yes. Three-dimensional animation and illustration allow me the means to approach artmaking from an analytical point of view, while painting with oils gives me the option to create imagery from a sensory position. My background as a painter enables me to give physical body and texture to the images that I create on the computer. Conversely, my computer background allows me to plot out images for my paintings on the computer instead of sketching them in pencil, ink, or paint. I find it much easier to explore ideas using the computer. The computer is a wonderful tool for the exploration of lighting, textures, and camera angles. Such wide-ranging exploration and discovery could never be duplicated through the use of simple thumbnail pencil or pen sketches.

Prior to the computer, painting a picture in oils was a lengthy, arduous, and haphazard process. I never knew until the painting was finished whether it would be a success or failure. With the computer, I am able to overcome most of the obstacles before committing myself to the final print or animation. I can go back at any time to revise, perfect, or otherwise manipulate the work.

BERSSON: Tell us about *The Artist* (**Fig. B**).

RATNER: The figures and forms in *The Artist* were built in a virtual 3-D space and thus can also be used in computer animations. After the modeling of all the objects in the scene, over thirty lighting effects and many textures were applied to the models. This image was used on the cover of my book *Mastering 3D Animation*. It is also a scene from my two-minute, forty-second animation titled *The Dreamer*. Here's the story. An artist places an advertisement for a model. When someone phones him about the ad, his overactive imagination takes over. He dreams that Venus (Fig. B) and Diana, famous goddesses from mythology, are his models. [See Botticelli's *Birth of Venus* (14.16), the Renaissance painting that Ratner references in his artist's dream.] But each dream ends in disaster. Finally, the real model shows up and doesn't quite meet his expectations. The artist makes a hasty retreat into one of his paintings, hiding behind a painted tree on his canvas. ▪

Graphic Art and Design

6

FROM PRINT MEDIA TO MASS MEDIA

Graphic art and graphic design share the common adjective *graphic*, meaning "drawing or writing," but the two disciplines are usually considered to be worlds apart. At most colleges, the graphic design major prepares students for jobs in the mass-market fields of advertising design and public relations. Graphic design students consequently see themselves as "popular" or "commercial" artists. Far fewer undergraduates pursue a major in printmaking, the contemporary name for graphic art. Student printmakers view themselves as future "fine artists" and aspire to exhibit their work in the elite "art world" of gallery and museum exhibition. These differences notwithstanding, graphic design students flock to printmaking courses and even minor or double-major in this graphic art form, because graphic design and graphic art share much in common. This chapter examines the two art forms, their separate and overlapping histories, and the processes and techniques they employ.

GRAPHIC ART AND DESIGN: DIFFERENCES AND COMMONALITIES

Graphic art refers to the medium of **printmaking,** a general term for a number of processes through which two-dimensional images are produced in limited editions or in sets of identical or nearly identical **prints.** These

6.1 NASSER OVISSI. *Omar Khayyam.* 1979. Etching. 20 × 24 in. Courtesy of the artist.

According to the artist, the figure at the lower right is Omar Khayyam himself. He shines a candle up to the lovers above him. The light symbolizes the advice and guidance that the poet's words provide. The *Omar Khayyam* image was produced in a limited edition of 120 prints for a select art world audience. Ovissi pulled each individual print by hand and then signed and numbered each print. His personal creation of each print gives the *Omar Khayyam* edition a uniqueness and originality traditionally associated with fine art.

Graphic design is customarily associated with the commercial art of the business world. Magazine covers and advertisements, CD covers (3.5), Web site layouts (1.3), corporate brochures, and publicity posters are all examples of graphic design. Reproduced in numbers sufficient to reach an entire community, nation, or worldwide audience, works of graphic design readily qualify as mass media. Whereas a single artist such as Nasser Ovissi creates a work of graphic art, an entire team of specialists—artistic directors, illustrators, photographers, printers, writers, market research analysts—combines to create a work of graphic design.

These differences aside, graphic art and graphic design have intersected throughout their history. They share artmaking techniques and methods and the basic printmaking processes of reproduction. Both are primarily two-dimensional art forms, with the final graphic image usually printed on a piece of paper or a flat panel.

THE GRAPHIC ART OF PRINTMAKING: A BRIEF HISTORY

The various printmaking methods, such as woodcut, engraving, etching, aquatint, lithography, and screenprinting (see Technique Boxes 6-A through 6-F), have developed over the centuries. This brief historical survey explores these printmaking methods and the work of some of the artists who helped make the processes famous. It also points out ongoing connections between the graphic art of the past and today's graphic design.

What distinguishes a fine print from, say, a painting, is that the artist creates an image on a surface (matrix), perhaps wood, metal, or silkscreen, and this image is then transferred, often by a manual printing press, onto paper. —Washington Printmakers Gallery brochure, 2001

prints are made by pressing paper or other materials against an inked surface on which an image has been carved, drawn, painted, or stenciled. Usually, individual artists create these graphic art images and make or "pull" each print by themselves. This gives each print a handmade quality: Each work is different, even if ever so slightly. Some artists work with professional printers who manually execute multiple prints of the original image.

Iranian-born artist Nasser Ovissi (born 1934) created *Omar Khayyam* **(6.1)** through the printmaking process of *etching* (see Technique Box 6-C). The work was inspired by the verses of Omar Khayyam, a famous twelfth-century Persian poet, astronomer, and mathematician.

TECHNIQUE BOX 6-A

WOODBLOCK PRINTING

The **woodblock print,** or woodcut, used in China from the fifth century C.E., was one of the first methods of printmaking to be developed. The artist first draws an image on a block of wood and then carves ("woodcuts") away the background, leaving the image slightly raised in **relief.** The raised surfaces of the woodblock—those standing out in relief—are inked. Paper or another material is pressed against the woodblock by hand or printing press, and the ink on the raised image is transferred to the paper. In a woodblock print such as Albrecht Dürer's *Four Horsemen of the Apocalypse* (6.2), the dark lines and areas are the result of the transfer of ink from the raised sections of the carved woodblock. In formal terms, this process promotes a bold use of line and strong light-dark or color contrast. The resulting images can be vigorous and emotionally charged.

In addition to wood, surfaces such as linoleum ("lino") and hardboard, a wallboard made of wooden composition, have enriched the domain of relief printmaking. Colored inks can also be used in the printing process, as evidenced, for example, in Japanese woodblock prints (3.9, 4.12).

TECHNIQUE BOX 6-B

ENGRAVING

Engraving, the process used in Dürer's *Knight, Death, and the Devil* (6.3), grew out of the art of the armorer and goldsmith (the profession of Dürer's father). It originated in Germany and northern Italy in the mid-fifteenth century and is referred to as an **intaglio** process (from the Italian *intagliare,* "to cut in"). The image is cut or incised into a highly polished metal plate, usually of copper, with a sharply pointed cutting instrument called a **burin** (or graver). The lines made by the burin on the plate and subsequently on the print are fine and clean. In contrast, the lines made by another common tool, the **drypoint** needle, have a subtly ragged edge and are consequently softer in appearance in the final print. After cutting in the lines and marks for the figures and forms, the artist inks the metal plate and wipes it clean so that the ink remains only in the thin, incised grooves. When a printing press squeezes the paper tightly against the incised metal plate, the paper picks up the ink in the grooves.

Because an engraved image is created from fine, incised lines cut into a metal plate, the resulting image can be highly realistic. Dürer's engraving *Knight, Death, and the Devil* shows a remarkable degree of detail and the subtlest range of light-to-dark values, all built up from the interaction of finely drawn lines. Dürer's lifelike horse and knight are the result of the painstaking engraving process.

Albrecht Dürer: Graphic Art for the Public

Characteristics of both graphic art and graphic design are evident in the work of German artist Albrecht Dürer (1471–1528), the first great printmaker in the European-based "Western" tradition. The son of a goldsmith, Dürer created original, one-of-a-kind paintings and altarpieces as other eminent artists did, but he is most famous for his *woodblock prints* and *engravings* (**Technique Boxes 6-A and** 6-B). Through his prints—truly a "popular" art form in their time—he became the first major artist of mass communication. With the development in fifteenth-century Germany of a printing press with movable type, inexpensive paper, and artistic print media such as the woodblock and engraving, illustrated pamphlets, books, and religious stories became for the first time widely available and affordable. Printing as we know it in the West was born, resulting in a far more democratic distribution of knowledge, opinion, and imagery—a truly

With the woodcut, graphic art became mechanically reproducible for the first time, long before script became reproducible by print.—Walter Benjamin, culture critic, "The Work of Art in the Age of Mechanical Reproduction," *Illuminations,* 1936

6.2 ALBRECHT DÜRER. *The Four Horsemen of the Apocalypse.* Ca. 1497–98. Woodcut. 15�5/16 × 10⅞ in. *Some theorists argue that the dominant communications medium of any given time—whether the handwritten word, still photography, television, or the Internet—is the greatest shaper of people's lives. They further claim that it is the form rather than the content of the particular medium that is most influential, that "the medium is the message." What was most revolutionary about printmaking: its capacity for mass reproduction of text and imagery, or the specific messages conveyed?*

revolutionary development. The entrance of rudimentary "mass media" into the everyday world resulted in reading and viewing publics made up of individuals who read the same information and viewed the same images.

Individuals in England, Spain, and Germany might read the same printed essays of Dürer's contemporary, Erasmus of Rotterdam, a well-known Dutch priest and scholar who sought to reform corruption and dogmatism in the Catholic Church. Erasmus's essays took to task popes, kings, monks, scholars, war, and religion. Literate persons across Europe who read these essays came to think new thoughts completely at odds with the laws and teachings of local religious and political authorities. Such changes encouraged not only the rise of Christian reformist thinking but also reflective, individualistic thought in general. In a similar way, the wide distribution of the contemporary printed tracts of Martin Luther and other "protestant" theologians, combined with expanding ownership of printed Bibles, spurred the development of religions of individual conscience. In short, the impact of printed words and images on European civilization was rapid, widespread, and substantial.

Within this revolutionary context, Dürer gained renown as a master of woodblock prints and copperplate engravings. His mechanically reproduced imagery reached persons of both wealth and modest means across Europe, selling at fairs for as little as "one penny plain, two penny colored," that is, one penny for the print in black and white or two pennies if color was added. The fifteen prints of his woodblock series *The Apocalypse*, illustrating the apocalyptic revelation of Saint John, were among his most famous. Created in 1498, these woodblocks heralded the coming of a cosmic holocaust that would consume all evil. Their tumultuous themes and fervent spirit reflected the era's troubled period of war, plague, and social and religious unrest. Stirred by such visions, many people believed that the world would come to an end in the year 1500.

In the fourth print of the series, *The Four Horsemen of the Apocalypse* **(6.2)**, four figures ride roughshod over Europe. Under the approving eyes of an angel, Famine, Pestilence, and War trample on the sinful, while Death's

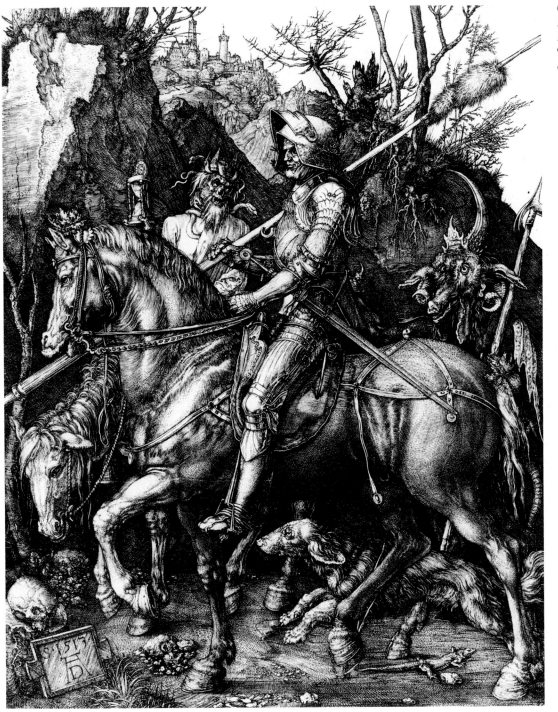

6.3 ALBRECHT DÜRER. *Knight, Death, and the Devil.* 1513. Engraving. 9¾ × 7½ in. Musée du Petit-Palais, Paris.

bony nag treads on a corrupt bishop who falls into the gaping jaws of the dragon of hell. Fifteen years later, Dürer would create a somber but hopeful response to *The Four Horsemen.* His engraving *Knight, Death, and the Devil* **(6.3),** based on Erasmus's *Manual of the Christian Soldier,* expresses the belief that a pious humanity can forge its way past mortal temptations to everlasting salvation. Neither the swine-snouted Devil nor grim Death, holding the

Print technology created the public.—Marshall McLuhan, communications theorist, *The Medium Is the Massage,* 1967

TECHNIQUE BOX 6-C

ETCHING

Like engraving, **etching** involves cutting an image into the surface of a metal plate. Unlike engraving (6.3), however, etching uses chemicals, not tools, to etch or "bite" the image into the plate. The plate is first coated with an acid-resistant substance, or etching ground, to protect those areas that are not to be bitten. Such grounds, made in varying proportions from a combination of rosin (pine tree resin), beeswax, and soft asphalt, are characterized as either hard grounds or soft grounds, depending on the amount of tallow or other greasy material that is added to the mixture. The artist uses an etching needle to make the drawing (and remove the coating). The plate is then immersed in an acid bath. The acid bites the open lines and marks of the plate, leaving indentations that will later hold the ink for printing. Formally, a firm, durable hard ground supports fine linear work, while a soft ground, because of its more pliable consistency, promotes greater fluidity in the drawing.

One advantage of etching is that it requires less of the artist in terms of actual physical labor in marking the plate's surface. Because chemicals do much of the work, an etching can be made much more quickly than a woodblock or an engraving. Some disadvantages of the process are the need to work with dangerous acids and a lack of control over manipulating the mark on the plate. Used effectively by masters like Rembrandt (6.4) and Ovissi (6.1), however, etching can create beautiful values and marks.

A final note: Many prints are "mixed-method" creations that combine different techniques. Rembrandt utilized burin and drypoint engraving techniques as well as etching in *Christ Healing the Sick* (6.4) to achieve a broader range of visual effects.

hourglass, can halt humanity's progress. Dürer's argument is clear: Humankind, with puritan determination, must follow the lead of the incorruptible knight of Christ.

Rembrandt van Rijn: Prints for the People

In seventeenth-century Holland, the painter Rembrandt van Rijn (1606–1669) was best known to the general public through his popular, widely available *etchings* (**Technique Box 6-C**). These small works were reproduced in sufficient numbers to keep the price fairly moderate. Persons of modest finances could conceivably afford a small Rembrandt etching, whereas a large painting would be far beyond their means. In keeping with the democratic and capitalistic life of seventeenth-century Holland, prints became a way for Dutch artists to commercially expand their market beyond the wealthy cultural elite.

Rembrandt's etching *Christ Healing the Sick* **(6.4),** one of his best-known and most commercially popular etchings, shows diverse strata of society. Men of wealth and stature on the far left appear oblivious to Christ's presence. Next to them, a rich young man, seated with his hand across his face, ponders Jesus' instruction to give one's money to the poor. On the right, the sick and downtrodden, more clearly delineated, press forward. Hands clasped or outstretched, they pray to be healed. But more than facial expression and bodily gesture tells the tale. As an undergraduate student, a double major in printmaking and graphic design, writes:

> Rembrandt's ability to tell a story with chiaroscuro is sometimes awe inspiring. This dramatic use of light and shade is the source of the print's power. Note that the light does not come from above or from the side, as is customary, but from Christ. The central group of figures is bathed in this light, as bright as day. The background, especially on the right, is cloaked in a murky darkness from which the pious newcomers emerge and timidly approach the main group. Dark, looming shapes complete the backdrop for the spotlit central group. This juxtaposition of virtual daylight with deep shadow is startling until one realizes its

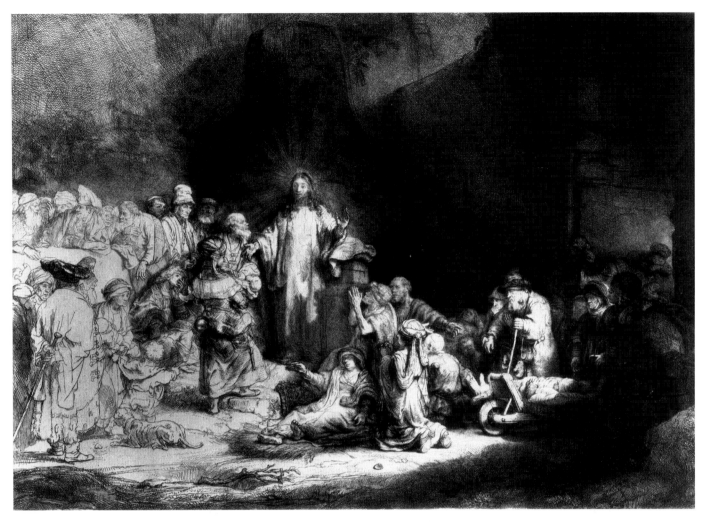

significance to the story being told. The bold chiaroscuro directs the eye to the part of the print that holds the most meaning. The artist meant for the viewer to notice that the source of light is not the sun in the sky, but Christ the son of God; otherwise he would not have made it so obvious. Rembrandt's message is that Christ enlightens all those who listen to him and heals all those who accept him as Lord.

Other areas of light and dark also have allegorical significance. The shadows can be seen as representing the everyday mortal world that one must leave to "see the light." The figures on the left fringe of the crowd are not as brightly lit or sharply drawn; they are the ones who ignore or question Christ's capacity to enlighten. Those closest to Christ, bathed in his radiance, are most attentive, thus less of this world and more of the next.

Francisco Goya: Dark Views of a Mad World

Spanish artist Francisco José de Goya y Lucientes (1746–1828) believed fervently in the eighteenth-century European cultural movement known as the Enlightenment. Proponents of the Enlightenment emphasized education and critical inquiry and sought rational and scientific solutions to society's problems. Yet Goya looked around him and saw a country beset by corruption, ignorance, and superstition. This disturbing situation impelled the artist to create a series of eighty bitterly satirical prints that lampooned both Spain's rulers and its people. Published and advertised for sale as *Los Caprichos (The Caprices)* in 1799, the set provoked instant controversy among the

6.4 REMBRANDT VAN RIJN. *Christ Healing the Sick* (The Hundred Guilder Print). Ca. 1642–49. Etching, drypoint, and burin. 11 × 15⅝ in. The Metropolitan Museum of Art, New York. Bequest of Mrs. H. O. Havemeyer, 1929 (29.107.35).

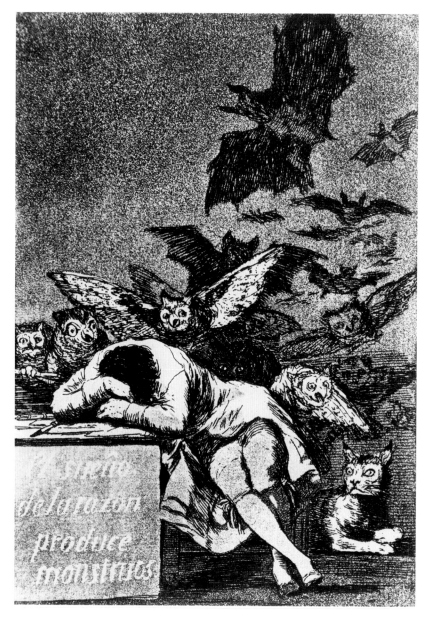

6.5 FRANCISCO DE GOYA Y LUCIENTES. *The Sleep of Reason Produces Monsters.* 1799. Etching and aquatint. 84⅝ × 59 in. Museum of Fine Arts, Boston. Gift of Mr. and Mrs. Burton S. Stern, Mr. and Mrs. Bernard Shapiro, and the M. and M. Karolik Fund.

reason and imagination, the rational and irrational faculties. This interpretation is confirmed by Goya's own accompanying caption beneath the print. It reads, "Imagination abandoned by reason produces monsters; united with her, she is the mother of the arts, and the source of their wonders."

Extending the print's meaning from the individual to the social level, we can say that the print is an indictment of Spanish society for its failure to make reason its guiding light. As reason sleeps, Goya asserts, Spain has been transformed into a dark realm ruled by the monstrous follies of political corruption, religious superstition, lechery, prostitution, stupidity, and greed. In print after print, Goya hammers home this message. The sunlit goals of the Enlightenment—reason, justice, order, harmony—have been eclipsed. The artist, as rebel, cries out for their return.

Goya used the printmaking techniques of drypoint engraving, etching, and *aquatint* **(Technique Box 6-D)** in the *Caprichos* series. His print *The Sleep of Reason* employs both etching (for the detailed drawing of the figures) and aquatint (for the broadly applied value areas). In *The Sleep of Reason,* we observe three basic aquatint values: a dark gray, a light gray, and a white. Yet the viewer experiences a wide variety of lights and darks as tones combine with lines. The aquatint values suggest mood and atmosphere. The indefinite, shapeless nature of the grainy, dark background, for example, evokes a sense of timeless unreality befitting the fantastical subjects.

Influenced by past masters such as Rembrandt (6.4) and Velázquez (5.18), Goya the printmaker stands on the threshold of the modern era, beckoning the graphic artist to explore the darker recesses of the human psyche and champion that which is reasonable and humane. His work in the graphic arts, so expressive, imaginative, and socially concerned, set the stage for Daumier (6.6), Käthe Kollwitz (17.5), Edvard Munch (17.4), and numerous others. Late in life, the forward-thinking Goya took up the newly invented print medium of lithography (see Technique Box 6-E). To the present time, artists employ lithography, often combined with other printmaking methods and art forms, to create unique, mixed-media artworks **(Appreciation 11).**

authorities. Goya was forced to withdraw the series from the public arena.

The print *The Sleep of Reason Produces Monsters* **(6.5)** is representative of the series. A sleeping figure is beset by a nightmare. On one level, the print shows that irrational, frightening dreams can fly up and overcome the individual while the conscious mind sleeps. But on a deeper level, the artist is pointing to the necessary partnership between

APPRECIATION 11 KARYN YOUNG, *The Making of a Print*

CHARLOTTE RICHARDSON

Muted blues and mauves wash across rough-edged, handmade paper **(Fig. A).** An out-of-scale *kimono* [a traditional Japanese garment] shape is overlaid with vibrant calligraphy, and over it, a formal gold-stenciled crest splashes exuberantly out of its borders. Below the crest, the calligraphy disappears and re-emerges from behind a fragment of a traditional Japanese woodblock print. My first impression: a riot of energy, a quiet of color.

The six women in the woodblock print are themselves engaged in making prints: carving the woodblock, sharpening the knife, preparing the wood, serving tea, checking proofs. Two pages of old Japanese newsprint float transparent over the background on the lower right, angles dancing with the angles of the *kimono*. A more disorderly profusion of Japanese writing on the upper left loses legibility, obscured by the large calligraphy across the center of the piece. The mysterious writing evokes something ancient but resonant, a text I can read only with feelings.

Thin gold lines mark the outline of the *kimono*. The figured triangle atop it represents an oversized collar, but it suggests Mount Fuji to me, rising above the vitality tumbling out of this *kimono* form just as the sacred mountain itself seems to oversee the life of Japan.

Positive and negative space in the print keeps shifting. The swaths of blue and mauve are positive to the paper's neutral ground, then negative to the zigzagging calligraphy, itself negative in its blackness. Layers of contrast enliven my awareness: the sensuality of so much life held within the embrace of the *kimono* form; the alluring strangeness of those classic woodblock faces in a work with such a contemporary feeling; the quirky resonance of old and new, image and text, illusion and allusion. There are prints within prints in this print.

Already an accomplished weaver, fabric artist, and Aikido student, when Karyn Young arrived in Japan in 1980 she spent five years learning to make *kimono*. Karyn studied Japanese arts such as papermaking and flower arranging diligently, then began breaking their rigid rules with aplomb. Her earlier training in painting and collage figure in her work here, incorporating the stencil, printed paper, part of a late eighteenth-century Utamaro woodblock print, and pages from old song, prayer, and theater books. She found the crest stencil, traditionally applied to formal black *kimono*, in a flea market. Her large calligraphy doesn't actually "mean" anything; it's more *sumi-e*, a picture, as all Japanese characters were, originally. One morning, I saw it as a figure speeding off-stage to the right! In her composition, even the black *kimono* of the printmakers suggest calligraphy, pulling my eye down and across to the bottom left.

Serendipitous events have led Karyn's artistic path. She ended up spending fourteen years in Japan, though she only meant to stop by for a few months en route to Nepal. After seven years, she began to experiment with calligraphy. She couldn't get every character correct in one assignment she was practicing, so "I looked at all my papers and cut out the best characters from each one and glued the whole thing together." Her teacher thought this was hysterical. But that return to collage was the beginning of Karyn's finding her form. She started combining calligraphy with textiles, and did a series of large collages on the *kimono* theme, which became her signature. When someone suggested that her work would translate well into lithography, she began learning printmaking.

Charlotte Richardson writes about the arts. Currently based in San Francisco, she lived in Japan for eleven years.

Figure A KARYN YOUNG. *Making a Print.* 1994. Mixed media.

The layers of work and layers of images in Karyn's print transmit a sense of the oscillating depths and subtleties of Japanese culture. Its explosive, breaking-out quality demonstrates how her imagination takes flight from a broad base of technical expertise. The print captures the balance—of energy and precision, whole-heartedness and irony, respect for tradition and intrepid originality—which characterizes her witty, adventurous art. ■

TECHNIQUE BOX 6-D

AQUATINT

According to *The Dictionary of Art Terms and Techniques*, the name *aquatint* derives from the resemblance of prints made by this method to drawings brushed over with watercolor washes. In **aquatint,** a copper or zinc plate is dusted with a fine layer of powdered rosin (a resin obtained from certain species of pine trees). The plate is carefully warmed to fuse the rosin to the metal so that when the plate is placed in an acid bath the acid eats around each minute spot of acid-resistant dust. This produces in the plate a series of fine pits that, when inked, print as a uni-formly translucent, grainy tone. Varied tones are produced by **stopping out,** that is, resisting the corrosive effect of the acid that naturally bites away the metal from the plate.

In black-and-white printmaking, the technique of aquatint is rarely used alone. It is more commonly mixed with one or more other methods. Usually, the plate is first given a grained surface with aquatint. Then it may be either incised by line engraving or drypoint or covered again with an etching ground and etched. The majority of Goya's graphics (6.5) are made in aquatint with etched and/or drypoint lines.

TECHNIQUE BOX 6-E

LITHOGRAPHY

Invented in the late eighteenth century, by the mid-nineteenth century lithography was the most widely used method of reproducing imagery in journals, newspapers, books, and posters. Daumier's *The Legislative Paunch* (6.6) and *Murder in the Rue Transnonain* (6.7) and Kollwitz's *Hamm* (Appreciation 12) have the quality of crayon drawings, with great richness in the blacks and grays. Examples of posters done in color through lithography are posters by Toulouse-Lautrec (6.9), Mucha (6.15), and Bradley (6.16).

Lithography (*lith* means "stone"; *graph* means "writing" or "drawing") differs from the other printmaking techniques in that the printing is done from a flat surface. Lithography de-pends not on differences in surface elevation, that is, raised or indented surfaces, but on the simple principle that grease and water do not mix. The artist draws the images with a greasy crayon, or paints with a greasy solution, the image areas on a lithographic stone. The images on the lithographic stone (or a metal plate) are chemically treated to accept ink and repel water; the "nonimage" areas are treated to repel ink and retain water. The stone and paper are then pressed together, producing the lithograph. Because the stone does not wear away during the printing process, an almost unlimited number of prints can be taken from it. A later variation on the process is **photolithography,** a technique for producing an image on a lithographic stone or plate by photographic means.

THE MODERN PERIOD: THE RISE OF THE MASS MEDIA

The modern world was born in the late eighteenth and early nineteenth centuries, with the Industrial Revolution and political revolutions seeking democracy in Europe and America. The quest for life, liberty, and property was accompanied by the equally revolutionary ascent of capitalist free-market economics, with the commercial middle class rising forcefully to the head of society. Factories proliferated, and cities swelled in population. A new industrial laboring class, the proletariat, rallied for decent living and working conditions and adequate wages. For members of this class, socialist working-class ideals became the order of the day.

The modern mass media emerged in the mid-1800s out of this context of dynamic change and class conflict. They arose to meet the needs of—and cash in on—an increasingly large urban population hungry for information and entertainment. Daily and weekly

Any understanding of social and cultural change is impossible without a knowledge of the way media work as [total] environments.—Marshall McLuhan, communications theorist, *The Medium Is the Massage,* 1967

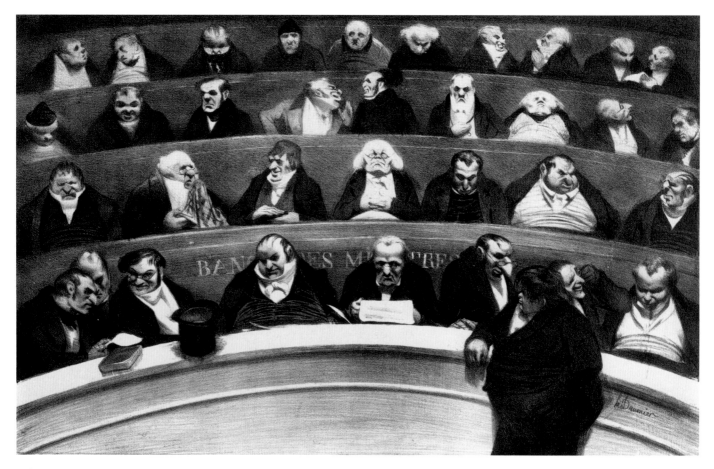

6.6 HONORÉ DAUMIER. *The Legislative Paunch.* 1834. Lithograph. 11 × 17 in. Museum of Fine Arts, Boston. Bequest of William P. Babcock (B4299).

Lithography . . . permitted graphic art for the first time to put its products on the market, not only in large numbers as hitherto, but also in daily changing forms. Lithography enabled graphic art to illustrate daily life. . . .
—Walter Benjamin, culture critic, "The Work of Art in the Age of Mechanical Reproduction," *Illuminations*, 1936

newspapers offered pages of opinion pieces, news items, and human interest stories. Dürer's woodblock prints and copperplate engravings and Rembrandt's etchings might have been seen by a few thousand Europeans over the course of many years. By contrast, in the nineteenth-century graphic illustrations in newspapers and magazines, executed through wood engravings and the rapid new print medium of *lithography* (Technique Box 6-E), reached tens of thousands of people in a single city on a daily or weekly basis.

Honoré Daumier and His "Public Easel"

Inspired by the new spirit of freedom and individualism and compelled by the free-market economy to fend for themselves, certain artists began to portray life with a critical eye. Honoré Daumier (1808–1879), a political cartoonist, illustrator, and ardent supporter of democracy, took advantage of the picture magazine and newspaper—what he called his "public easel"—to address the new urban

middle classes and the industrial working-class proletariat in France.

Firing barbs at the alliance of royalty and upper middle class that ruled mid-century France—a rogue's gallery of arrogant lawyers, avaricious entrepreneurs, and pompous administrators **(6.6)**—Daumier's lithographic drawings are little stories packed with information and invective. Far more sober in tone than his biting caricatures, but just as passionate, is Daumier's pictorial journalism. His lithograph *Murder in the Rue Transnonain* **(6.7)** is based on the true story of the murder of an innocent worker, his family, and his proletarian neighbors by government troops. The graphic severity of Daumier's lithograph made all of Paris witness to the gruesome event. In the drawing, silence and death reign. The troops of law and order have withdrawn, leaving behind the corpses, which sprawl where they have fallen. The drawing, which took three months to create, drew excited crowds to the publisher's shop window. Individual copies were sold until the government confiscated the

original lithographic stone and all remaining copies. Imprisoned once for his biting caricatures of the state, Daumier represented a new breed of artist, one willing to publicly challenge the authorities rather than simply do their bidding.

Winslow Homer: Visual Reporter

A young illustrator and visual reporter for *Harper's Weekly,* the greatest pictorial newspaper of nineteenth-century America, Winslow Homer (1836–1910) was not a hard-hitting reformer in the style of Daumier. In his newspaper assignments, Homer drew the news as he witnessed it. Yet his own liberal values—including support of African-American emancipation—subtly influenced his reportage. First as a popular artist and later as a painter, Homer was one of the first American artists to place substantial African-American figures at the center of his work.

A Bivouac Fire on the Potomac **(6.8),** an 1861 wood engraving for *Harper's Weekly,* depicts a Civil War campfire scene. A black dancer and a fiddler, probably recent escapees from slavery

6.7 HONORÉ DAUMIER. *Murder in the Rue Transnonain*, from L'Association Mensuelle. 1834. Lithograph. 11 1/4 × 17⅜ in. Boston Public Library, Print Department.

6.8 WINSLOW HOMER. *A Bivouac Fire on the Potomac*, in *Harper's Weekly.* 1861. Wood engraving. 13¹³⁄₁₆ × 20³⁄₁₆ in. The Museum of Fine Arts, Houston. The Mavis P. and Mary Wilson Kelsey Collection of Winslow Homer Graphics.

6.9 HENRI DE TOULOUSE-LAUTREC. *La Goulue au Moulin Rouge.* 1891. Poster, color lithograph. 74½ × 45⅝ in. The Mr. and Mrs. Carter H. Harrison Collection (1954.1193). © The Art Institute of Chicago. All rights reserved. *How many posters on the street today do you think will eventually be seen and valued as works of fine art? Have you ever considered seeking out "a future Toulouse-Lautrec" amid the glut of poster reproductions, taking it off a wall or bulletin board, framing it, and hanging it as a work of art in your room or home?*

in the South, are entertaining the Union troops. At the very center of the composition, in dramatic contrast to the bright firelight, the dancer holds most of the troops spellbound. He commands their interest and, from some, their respect. Homer's composition draws our eye first to the dancer and then around the campfire circle in a fluid motion. Powerful values contrast, from velvety blacks to gleaming whites; looming shadows and a cloud-strewn, moonlit night further enliven the scene. The war, and campfires in particular, fostered an initial interaction between men from different regional and ethnic backgrounds. Out of such interchanges would emerge an increasingly hybrid culture. At the beginning of the Civil War, this interchange was particularly intense and captivating to all involved, including Homer and the *Harper's Weekly* subscribers.

Posters and Publications: "The Art Gallery in the Street"

By the second half of the nineteenth century, the range of mass-produced graphic illustration had expanded to include posters, literary journals, soft-covered books, advertisements, and political leaflets. The posters of Henri de Toulouse-Lautrec (1864–1901), which today hang in museums, were mounted on Paris walls and kiosks as commercial advertisements for café nightlife. Consider his poster *La Goulue au Moulin Rouge* **(6.9).** The main subject is "La Goulue," a popular dancer and star performer at the Moulin Rouge dance hall in Paris. Toulouse-Lautrec portrays her in a style that was on the cutting edge for its time. The figures are radically simplified and abstract, almost cartoonlike. Figures, shapes, and surrounding spaces are flattened out. Toulouse-Lautrec's style was influenced by the daring contemporary art of Edgar Degas (5.15) and Vincent van Gogh (1.12) and by the abstract qualities of Japanese prints (4.12, 3.9). In the 1890s, avant-garde artists such as Toulouse-Lautrec, excited by the possibility of having their fine art seen by a large public, pursued and helped establish the new genre of poster art. Not surprisingly, turn-of-the-century cultural observers would call the poster "the art gallery in the street."

In literary illustration, the sinuously linear fantasies of Aubrey Beardsley (1872–1898) brought to life characters and scenes from the works of Omar Khayyam, Shakespeare, and Beardsley's own controversial friend, writer Oscar Wilde (1854–1900). In Beardsley's illustrations for Wilde's 1894 play *Salome* **(6.10),** the princess Salome triumphantly raises the bloody decapitated head of the prophet Jokanaan (John the Baptist) before her vengeful eyes. She had just danced seductively before her husband, the king, to secure John the Baptist's execution. Beardsley's literary illustrations, with their sinister perfume of eroticism and decadence, made him the most famous graphic artist in Victorian England.

Far different in purpose and tone are the socially concerned works of Käthe Kollwitz (1867–1945). The artist's emotionally gripping images of the poor and the oppressed were seen by her fellow German citizens between 1890 and 1930 in the form of political leaflets handed out in the street, posters hung on building walls, and drawings published in a weekly newspaper **(Appreciation 12).** Only later would her images, too, find their way into art museums for permanent preservation and exhibition.

Posters and Publications to the Present

In the present age of mechanical reproduction, hundreds or thousands of images of every artistic category and cultural lineage appear daily before our eyes. This is not to say that much of this mass-reproduced imagery is of enduring artistic quality. In fact, the vast majority of it, especially the crassly commercial variety, is not. But amid the glut of printed graphics are artworks of distinction by artists from around the world. These include the book illustrations of North American Leonard Baskin (1922–2000), the *Atomkreig Nein (Atom War No)* poster by Swiss artist Hans Erni (born 1909), and the *Water Waters Life* poster series by Korean-born designer Sang Yoon (born 1958).

Baskin's illustrations **(6.11)** grace a widely used *Passover Haggadah,* the Jewish book of narrative, prayer, and ritual for the Passover holiday, which commemorates the exodus of the Jews from bondage in ancient Egypt. The

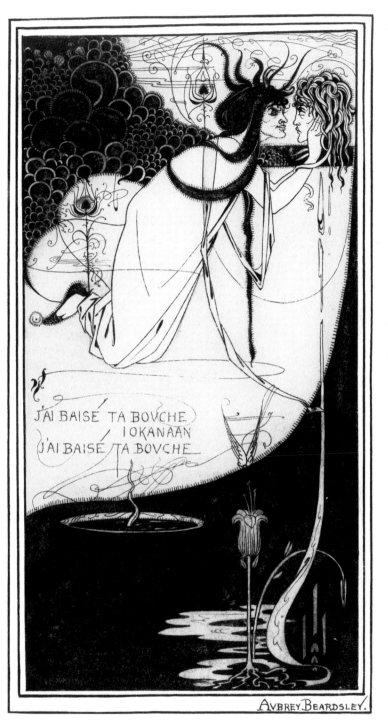

6.10 AUBREY BEARDSLEY. *Salome with the Head of John the Baptist.* 1893. Pen drawing. 10⅞ × 5¾ in. Manuscripts Division, Department of Rare Books and Special Collections, Princeton University Library. Aubrey Beardsley Collection. *Sexual activity and violence are frequent subjects in Beardsley's prints. How do the line, shape, chiaroscuro, and composition of* Salome *relate to its subject matter and content?*

APPRECIATION 12 KÄTHE KOLLWITZ, *Hamm*

RENATE HINZ AND LUCY R. LIPPARD, COMPILED BY ROBERT BERSSON*

In the years 1908 to 1911 Kollwitz's drawings appeared in *Simplicissimus*, a satirical [Berlin] weekly newspaper with a liberal political orientation. That *Simplicissimus* published her drawings—works of social criticism that stood in sharp contrast to the satirical and humorous illustrations that dominated the weekly—for four years attests to the reputation Kollwitz had attained. . . . Kollwitz made fourteen drawings for *Simplicissimus* [including *Hamm* **(Fig. A)**], all illustrating "the many sung and unsung tragedies of urban life." Eight of these drawings depict general aspects of the urban proletariat's social situation, e.g., widowhood, unemployment, hunger and despair, antisociality, unwanted pregnancy. The series *Scenes of Poverty* shows [in Kollwitz's words] the "typical misfortunes of working-class families. If a man drinks or is sick or unemployed, the same things always happen. Either he is a dead weight on his family and lets them support him . . . or he kills himself. And the fate of the wife is always the same. She is left with children she has to support. . . ."

Unlike many contemporary illustrators of the urban environment, Kollwitz largely avoided any sentimental, pamphleteering elements. Her protest is truly effective because it "so convincingly links social comment to the reality depicted."

Kollwitz's work for *Simplicissimus* forced her to conceptualize key themes quickly and to express them in a pictorial language that was accessible to a broad public. This brought about a major change in her mode of work. In the past she had carefully developed her pictorial ideas using live models, painstakingly working out every movement and detail. Now she shifted to a freer drafting style, dispensing with detail in order to focus on essential elements. The result was a compressed pictorial idiom. . . . Her earlier prints and drawings had either suggested or concretely depicted the worker's world. Now she focused exclusively on the human figure, using it alone to convey the social problems she envisioned. In this phase of her artistic development, she had such a large store of studies on hand and was so practiced in her draftsmanship that she could work without models. [From the Introduction by Renate Hinz, p. xxi.]

[Her] politics [and art] emerged from her social life, her gut, her heart, her historical awareness, and merged with the forms of the human bodies that were the vehicles for her beliefs. She dealt with tragedy, not pathos, though [the heroic notion of] tragedy was not usually associated with the lives of working-class people. . . . Her formal strategies were integrated with her content. There are no weak spots in her shapes or compositions; like her figures, they are compact and earthbound, held together by a suggested solidity/solidarity. In the person of each weary woman, bowed under oppression she is helpless to affect directly, are the hidden courage and endurance that permit her to survive and will eventually permit her to fight back.

There was also an evangelical component to Kollwitz's responses that can be traced to her attachment to her father, a committed social democrat, and her grandfather, a reform preacher. She often mentioned "a duty to serve" through her art. As a child she was

Renate Hinz of Germany and Lucy R. Lippard of the United States are internationally known writers on art. Each has a special interest in twentieth-century art that is socially responsive.

Compiled with the authors' permission from their book, Käthe Kollwitz: Graphics, Posters, Drawings, *New York: Pantheon Books, 1981.*

fascinated by the bodies and faces of water-front laborers in her hometown, by their "native rugged simplicity . . . a grandness of manner, a breadth to their lives." . . . In addition, she felt a level of intolerance for her own class that these days would probably be chalked up to "middle-class guilt." "Middle-class people held no appeal for me at all," she recalled. "Bourgeois life as a whole seemed to me pedantic." And as for the "upper-class educated person," "he's not natural or true; he's not honest, and he's not a human being in every sense of the word."

With age, however, Kollwitz learned to become more tolerant. Living with her doctor husband in Berlin's poorest district, she was "gripped by the full force of the proletarian's fate. Unsolved problems such as prostitution and unemployment grieved and tormented me, and contributed to my feeling that I must keep on with my studies of the lower classes. And portraying them again and again opened a safety valve for me; it made life bearable." Life in Berlin offered the practice to fuse with the theories of her Konigsberg girlhood. One of the most moving aspects of Kollwitz's biography is the evolution of her intimate and utterly natural relationships with the women whose lives and sorrows she came to share, depict, objectify into searing symbols of injustice. . . .

"The working-class woman," she wrote, "shows me much more than the ladies who are totally limited by conventional behavior. The working-class woman shows me her hands, her feet, and her hair. She lets me see the shape and form of her body through her clothes. She presents herself and the expression of her feelings openly, without disguises."

. . . Kollwitz had stated in the early 1920s her desire to "exert influence in these times when human beings are so perplexed and in need of help," and to "be the direct mediator between people and something they are not conscious of, something transcendent, primal." She succeeded then, and her art continues to succeed as an example for those who care enough about their art to want it to function in society. [From the foreword by Lucy R. Lippard, pp. viii–xi.] ■

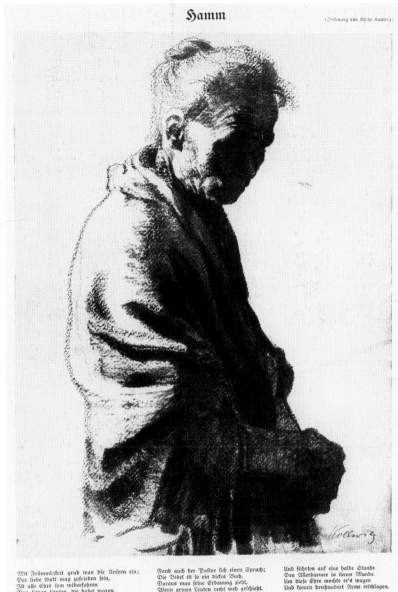

Figure A KÄTHE KOLLWITZ. *Hamm (Standing Working-Class Woman).* From *Simplicissimus,* November 30, 1908. Kunstbibliothek, Staatliche Museen Preussischer Kulturbesitz, Berlin.

6.11 LEONARD BASKIN. *A Passover Haggadah* illustration, from *A Passover Haggadah*, Viking Press, 1982. Watercolor. *Books of prayer or religious ritual have frequently employed visual imagery. Have your religious ideas and beliefs been influenced by such imagery? If so, how?*

6.12 HANS ERNI. *Atomkreig Nein (Atom War No).* 1954. Offset lithograph, printed in black. 50 × 35 in. The Museum of Modern Art, New York. Gift of the designer.

Hebrew text and the figurative imagery of this particular Haggadah page refer to the patriarch Abraham, the biblical father of the Jewish people. Abraham's powerful presence emerges, awesome and mysterious, from an intense, yellow-orange ground, evocative of desert heat and sun as well as divine blessing and illumination.

In contrast to the multiple levels of meaning and interpretation of the Haggadah illustration, the contemporary social messages in the works of Erni and Yoon are decisive. Created during the Cold War arms race between the United States and the Soviet Union, Erni's *Atomkreig Nein* **(6.12)** issues a grim, exclama-

tory warning: Atomic war will destroy the earth. Yoon's work is likewise a call, albeit a more positive one, to save the planet. *Water Waters Life* **(6.13)** offers an ecological argument for clean, nonpolluted water for all living things on earth: Given healthful drinking water, animals, plants, and humans thrive; without clean water, all species die, as indicated by the lifeless black silhouette outside the water droplet.

Keith Haring (1958–1990) is another artist who created powerful graphic artworks on social themes. Haring's posters, T-shirts **(6.14)**, and buttons, produced by the *screenprinting* process (see **Technique Box 6-F**), encompassed

6.13 SANG YOON. *Water Waters Life*. 1986. Poster series created for the Third International Design Competition held in Osaka, Japan, in 1987. Each 22 × 15½ in. *Jae Yoon, a specialist in mass-media culture, writes that graphic designer Sang Yoon "adopted a positive approach that emphasizes the ecological importance of water. A positive approach operates by sympathy and consensus, whereas a negative one functions mostly by fear and repression." If Sang Yoon had adopted a "negative approach" to the issue of water, what subjects and formal strategies might she have employed?*

TECHNIQUE BOX 6-F

SCREENPRINTING

Alternately known as **silkscreen** or **serigraphy,** from *seri* meaning "silk" and *graph* meaning "drawing," **screenprinting** is one of the newest printmaking media. The technology, based on the principle of a stencil, is relatively simple. A screen made of silk, organdy, or a simple open-meshed material is stretched over a frame. An image or design, created by drawing, painting, photography, or a mixture of media, is made by blocking out parts of the screen with a paper or plastic stencil, glue, or photographic emulsion (a light-sensitive gelatin coating). This leaves the remainder of the screen open for black or col-ored inks to pass through. The screen is placed over the surface—paper, plastic, metal, tile, and so forth—and the ink is pushed through with a squeegee.

Screenprinting is well suited to images of uniform color and linear definition, such as the works of Keith Haring (6.14) and Andy Warhol (19.11), but more painterly effects (19.5) can also be attained. Combining ease of personal handling and moderate cost, screenprinting has proved to have widespread appeal. As Haring and Warhol have demonstrated, it is an ideal crossover medium for the production of fine and popular art.

As [Keith] Haring's short but intensely active career showed, it was possible for fine artists to reach a broader public provided they were willing to adopt a popular style [in Haring's case, graffiti] . . . , to organize their own exhibitions in non-art venues [including retail outlet stores where Haring sold his mechanically reproduced posters, T-shirts, and cards at low prices], and to step outside the art world in order to involve themselves with the lives of ethnic minorities, subcultures and local communities.—John A. Walker, critic, *Art in the Age of Mass Media,* 1994

6.14 KEITH HARING. Stop AIDS t-shirt design. Silkscreen print.

many issues: political repression and racial discrimination in South Africa, illiteracy, drug abuse, lesbian and gay pride, and AIDS (from which he died in 1990). Like his one-of-a-kind paintings and murals, Haring's screenprinted works combine the design sensibility of modern abstract art and the gestural boldness of urban graffiti, the street art form he loved.

These graphic works, in their captivating form and significant content, all have a human and aesthetic significance that will continue to affect viewers centuries from now. In the jungle of publicity and advertising images that surround and accost us each day, such art waits to be discovered and appreciated.

THE EVOLUTION OF MODERN ADVERTISING

Advertising, as a pervasive and powerful art form, is a little over a hundred years old. Shop signs that advertised services or products existed even in ancient Rome, but modern advertising is a beast of an entirely different nature. Mass-market advertising, as we know it, is the product of the modern period of mass-produced products and mechanically reproduced images.

Turn-of-the-Century Graphics

To meet the needs of rapidly expanding capitalist commerce, increasing numbers of artists from the end of the nineteenth century to the present were enlisted to create advertising publicity for consumer goods, services, and institutions. At first, some of the resulting advertisement graphics followed the fine-art styles

of the day. This stylistic connection to fine art—a successful strategy that continues to the present—added a sense of sophistication to turn-of-the-century ads plugging everything from Job cigarettes to Victor bicycles. The posters *Job* **(6.15)** by Czech artist Alphonse Mucha (1860–1939) and *Victor Bicycles* **(6.16)** by Will Bradley (1868–1962) echo the curvilinear fantasies, abstracted organic forms, and flat patterning of Toulouse-Lautrec's posters (6.9), Beardsley's book illustrations (6.10), and the international artistic style that after 1895 became known as **art nouveau,** or "new art." Mucha's *Job* advertisement features a beautiful, barefoot young woman in a sinuous S-shaped pose. Her body-length, jet-black hair, adorned with brilliant red flowers, swirls around her, as do the dark letters behind her head. The letters *J, O, B*—creative trademark repetition at its best—are everywhere: in monogram combination on the broach on the woman's dress, in the star-shaped design that makes up the background pattern, and in vertical orientation on the cigarette package, slightly obscured by a carefully placed index finger. The unfastened cigarette package dangles from the model's left hand. She gazes at a cigarette in her uplifted right hand. Further attracting our attention to the uplifted hand and featured product, the cigarette appears to metamorphose into both a plume of smoke and a long, curving tobacco leaf. Even in this early, highly artistic cigarette ad from 1897, smoking is being associated with the healthful realm of nature (leaves and flowers) and portrayed as a sensual activity.

Like his well-known European colleague Mucha, the American Will Bradley thought of himself as an artist. He was responsible for the overall creation and execution of his advertisements, and he was proud of the fact that the public could discern a Bradley ad from others. Some of these turn-of-the-century advertising posters were even signed by the artist, like paintings or sculptures. Bradley's *Victor Bicycles* advertisement (6.16) employs the vanguard art nouveau style and seeks to appeal to young, well-to-do men and liberated women. The poster seems to be saying that those who appreciate the "new art" should also enjoy the new, turn-of-the-century recreational activity of bicycling and a freer, more mobile life-style.

6.15 ALPHONSE MUCHA. *Job.* 1897. Lithograph, printed in color. 61³/₁₆ × 40¾ in. The Museum of Modern Art, New York. Gift of Lillian Nassau. *In 1999, advertising critic Jean Kilbourne wrote that many contemporary ads "offer cigarettes to women as a symbol of emancipation and freedom." What do you think this ad from a century ago is saying to the women and men of its time? Is it associating cigarette smoking with liberation and freedom? With other values or goals?*

6.16 WILL BRADLEY. *Victor Bicycles* poster in purple and white. 1896. Commercial lithography, printed in color. 27 × 40¾ in. The Metropolitan Museum of Art. Gift of Leonard A. Lauder, 1986 (1986.1207). *This graphic was made in the same era as the previous cigarette ad (6.15), but it presents a very different image of a liberated woman. What qualities does the man in the foreground observe in the woman riding the bicycle? What social class or market do you think the ad is addressed to?*

She is the Queen of the Bicycle Girls! Cool as an icicle when on her bicycle, She down the boulevard whirls. . . . Come now with me and you shall see My little bicycle girl.—W. H. Gardner, song writer, "Queen of the Bicycle Girls," song lyric, 1897

I shop therefore I am. —Barbara Kruger, artist, text from her photomontage *Untitled (I shop therefore I am),* 1987

Although most of today's advertisements are no longer the creation of individual artists bent on creating fine art for the masses, the relationship between mass-market advertisements and fine art remains strong, as we will see.

Advertising for the Masses

As the twentieth century progressed and capitalist industry in Europe and America grew to vast proportions, the public had to be stimulated to desire the endless array of products coming off the assembly lines. Need and desire had to keep up with industrial output. How to accomplish this? The answer was advertising. As President Calvin Coolidge (1872–1933) stated in a major address in 1926, the desire for more and better things was the crucial element separating a civilized from an uncivilized people. It was advertising's role, Coolidge said, to educate the people of the United States to the need for ". . . new thoughts, new desires, new actions."

The 1928 soap advertisement *Heart's Desire* **(6.17)** translates Coolidge's speech into visual form. Aimed at the largely immigrant working class, this "American Dream" ad promises that hard work, courage, common sense, and, above all, cleanliness will lead the laborer up in the world. Stimulating the worker's desire for "health and wealth," the advertisement promotes, in President Coolidge's words, "new wants in all directions." The end result is an increase in worker production, consumption, and civility.

By the early twentieth century, advertising had indeed become a great leader, a "captain of consciousness," according to sociologist Stuart Ewen. It was capable of motivating the new worker-consumers, winning their allegiance and shaping their desires. Impressed by advertising's power to persuade, the major corporations quickly began to employ advertising to undercut the appeal of communism and socialism, especially to industrial workers. Successful advertising possessed the power to convince the masses that the good life was available to all citizens in a capitalist society.

By the middle of the twentieth century, the preparation of ads had become increasingly scientific. The advertising industry took advantage of scientific research on perception and human behavior to produce "effective information packages" that would generate sales, such as a 1983 automobile advertisement, shown here in "takeoff" form **(6.18).** The strangely compelling "automobile man" image reinforces the ad's message that the car is a direct extension of its well-dressed, classy, and knowledgeable owner. Drawing upon the most advanced scientific and artistic knowledge bases, the production of such advertisements required an entire team: market research analysts, copywriters, illustrators, photographers, printers, and artistic directors. Graphic design grew out of this focus on the systematic organization of visual information. The day of the singular advertising artist such as Will Bradley or Alphonse Mucha was over. Ad production had become scientific, advertising had become an industry, and the individual artist had been replaced by a design team.

Did the change from graphic art to graphic design and from individualistic expression to the collective organization of information

signify, as many might assume, an automatic reduction in aesthetic quality and cultural importance? Eminent graphic designers like Milton Glaser (born 1929) answer with a resounding No! Glaser, who often works as part of a large design team, argues that the collective design of information is basic to many art masterpieces. He asserts, for example, that the magnificent cathedrals of the Middle Ages (10.28) were the creation of teams of anonymous artisans that organized objective information (church liturgy and law) for the instruction of the entire populace. Like contemporary advertising, early Christian religious art (4.1) was "designed" to provide information and propagate particular ideas, beliefs, and practices; its dual purpose was to inform and persuade. Although one might argue that Christianity and consumer materialism have little in common, many aspects of commercial graphic design clearly have precedents in the great art of the past.

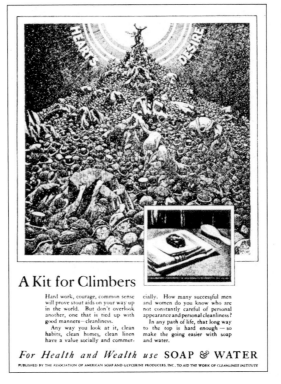

6.17 Heart's Desire advertisement. 1928. Published by the Association of American Soap and Glycerine Producers, Inc.

6.18 After a 1983 automobile magazine advertisement. Photo: Vada Kelley, 2002. *Many individuals are threatened by the notion that people are increasingly controlled by the machines that populate our world. Does the fact that an automobile company produced this ad twenty years ago show that human beings are now fully accepting of the machine presence in our lives? Have we, like the "automobile man," become full-fledged extensions of our machines?*

6.19 WILLEM KALF. *Still Life*. Ca. 1660. Oil on canvas. 25⅜ × 21³⁄₁₆ in. Chester Dale Collection. Photograph © 2002 Board of Trustees, National Gallery of Art, Washington, D.C. 1943.7.8(745)/PA.

6.20 After a contemporary magazine advertisement for fine wines. Photo: Patrick Horst, 2002.

Advertising and the Oil Painting Tradition

The style and subject matter of much contemporary advertising in fact originate in the realm of oil painting, a centuries-old art form. Both oil painting and advertising attempt to render reality as it appears to the senses. The artist or designer makes physical objects look so real that one gets the sense of actually being able to touch and possess them. As anthropologist Claude Lévi-Strauss observes, "It is this avid and ambitious desire to take possession of the object for the benefit of the owner or spectator which seems to me to constitute one of the outstandingly original features of the art of Western civilization." This way of seeing and representing, critic John Berger argues, is rooted in the experience of acquisition and is

the natural outgrowth of a commercial, consumer-oriented society in which the possession of material things has become a dominant value. Such a society has shaped Western culture for the past five hundred years or so and has made first oil painting and then modern advertising its primary visual art form. From the fifteenth through the nineteenth century, Berger relates, oil paint, better than any other medium, created convincing illusions of the texture, color, and weight of material objects. Through their masterful illusions, oil paintings served as a means by which wealthy patrons and collectors could affirm all that was beautiful and desirable in the world. Thanks to the artists, owners of such paintings (5.18, 5.25) could re-create within easy reach and in as real a form as possible those features of the world to which they were attached. In this sense, oil

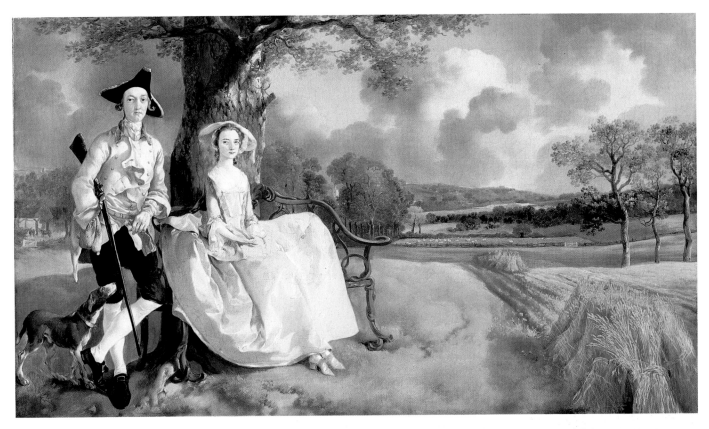

6.21 THOMAS GAINS-BOROUGH. *Mr. and Mrs. Andrews.* 1748. Oil on canvas. 27½ × 47 in. The National Gallery, London.

paintings introduced the basic language of modern advertising.

A comparison of a seventeenth-century Dutch oil painting **(6.19)** by Willem Kalf (1619–1693) and a takeoff of a contemporary advertisement for fine wine **(6.20)** brings the argument home. Each work is a highly realistic still life featuring food and drink. Each employs the medium that in its time best created the illusion of reality: The extreme verisimilitude of the color photograph is simply an extension of the painstaking realism of the oil painting. Both media evoke similar, highly tactile qualities—reflections, textures, subtle gradations of value—that convince the viewer that he or she can actually touch and possess the real things portrayed in the image. Each work is also a visual eulogy in that objects, warmly lit and carefully composed, serve to praise a life-style of material abundance characterized by the proud, pleasurable possession of physical things.

Yet despite the continuity of language between the two works, the function of the advertisement is decidedly different from that of the oil painting representation. The spectator-buyer viewing an advertisement stands in a very different relationship to the world from that of the spectator-owner who commissioned a painting or bought it on the open market. Most often, the spectator-owner actually owned the objects represented in the purchased painting. These possessions might include prize animals (a bull, horse, or dog) or expensive objects of art (beautifully crafted furnishings, plates, vessels). The oil painting might even show the collectors standing proudly in front of their home or land, as does the portrait *Mr. and Mrs. Andrews* **(6.21)** by English painter Thomas Gainsborough (1727–1788). An oil painting of this type generally showed the possessions or way of life its owners were already enjoying. It confirmed their sense of their own value and enhanced their view of themselves as they already were. These paintings began with facts and hung proudly

6.22 Lincoln Navigator car advertisement, 2001.

ware, rare antiques, and an expensive clock that doesn't even work; you will be a person with money to burn.

For almost five hundred years, artists created oil paintings for the small elite who led Western society, the aristocrats and members of the middle class. These paintings represented the objects, values, and life-style already possessed by this elite. In contrast, the mass-market advertisement is an insubstantial promise, beckoning the spectator-buyer to future fulfillment.

TOWARD A CRITICAL APPRECIATION OF ADVERTISING DESIGN

Like all works of art, advertisements can be appreciated from either a formal or a contextual perspective. From a formal point of view, certain product advertisements and corporate posters, book and album covers, and television, film, and Internet commercials possess an aesthetic power that can move present-day viewers and will continue to move viewers of the future. When their original purpose of plugging products, services, or events has faded, the best advertising designs will be perceived as works of fine art, just as turn-of-the-twentieth-century posters like those of Mucha (6.15) and Bradley (6.16) are today. Yet advertisements, because of their power to effect social conditioning, must be appreciated from more than a formal artistic standpoint. They must also be understood in terms of content and context. We must look closely at what advertisements are saying to us, because they can expand or restrict our potentialities.

Advertisements That Empower

The compact disc cover *Still on the Journey* **(6.23)** presents an image of African-American women who are empowered by their cultural heritage and who are not only creative and expressive as individuals but also successful as a singing group. Vibrant in its graphic design, this ad for the group Sweet Honey in the Rock sells CDs while promoting expansive role models. The contextual roots of the image are

in the homes in which their owners actually resided.

The purpose of an advertisement, in contrast, is to make the spectator-buyers somewhat dissatisfied with their present life-style—not with the materialism of consumer society, but with their own lives within it. An ad suggests that life will become better if the consumer buys what the advertisement is offering. Wash with Heart's Desire soap (6.17) and you will climb the social ladder. Drink fine wine (6.20) and you will enjoy a sophisticated, upper-class life-style. Drive the 2001 Lincoln Navigator **(6.22)** and you will attain a life-style of luxury, adorned with sterling silver table-

6.23 Sweet Honey in the Rock. *Still on the Journey, the 20th Anniversary Album.* CD cover. Photo: Joe Grant. Ann Reid Reynolds, designer. Courtesy of EarthBeat! *According to writer Joanne V. Gabbin, "the banner heading* Still on the Journey *boldly occupying the upper portion of the cover, functions as more than the title of the album. Its strength of typography (reverse lettering on a black background) carries the message of perseverance, survival, insistence, persistence, and years given over to struggle—fighting racism, sexism, political and economic exploitation . . ." In what other ways do formal qualities like color, space, pattern, and composition embody the musical group's values and message?*

6.24 Barbara Kruger. "Whose Values?" Cover of *Newsweek* magazine, 8 June 1992.

the contemporary historical movements for civil rights, ethnic pride, multiculturalism, and women's liberation. Another advertisement that aims to expand our possibilities is the 1992 *Newsweek* cover "Whose Values?" **(6.24)** by artist Barbara Kruger (born 1945). Featuring jolting contrasts of shape, hue, and value and the patriotic colors red, white, and blue, the hard-hitting cover challenges us, visually and textually, to think about power figures and groups that influence our values. It asks us to question rather than simply accept traditional notions of justice, morality, community, and family. By posing such weighty questions, it fosters critical thought, discussion, and possible dissent, qualities essential to a healthy democracy.

Advertisements That Restrict

Most advertisements, however, do not encourage thought or expand possibilities. Rather, they seek our automatic agreement with messages that are limiting and not very laudable: Social climbing is good; smoking makes one sexually attractive; drinking brings success and sophistication. While we can appreciate the alluring artistry of such ads, we must also learn to understand their meanings. This is especially true for those that might restrict or even harm us, as in the case of products and images that are physically addicting and unhealthy.

One of the most damaging and pervasive of advertising's messages concerns physical beauty. Both women and men are bombarded

A democratic civilization will save itself only if it makes the language of the image into a stimulus for critical reflection—not an invitation for hypnosis.
—Umberto Eco, novelist and communications theorist, Media Education Foundation 1996 Catalogue

6.25 After a June 2000 magazine cover. Model: Mia Wilson. Photo: Patrick Horst and Nathan Combs, 2002. *Is there an ideal of physical beauty set by the dominant culture? Do most mass-media models and celebrities adhere to this ideal? Who determines cultural ideals of beauty? Why?*

6.26 *Detroit Style.* Ford Focus 2001 advertisement. *The Ford Focus ad is similar to and different from the earlier "automobile man" ad (6.18). Both man and woman are joined with their automobiles; but the presentation of the "Ford woman" is quite different from that of the "Automobile man." How would you describe the differences?*

Beauty is defined cosmetically in this society. It's defined by the cosmetics industry, the fashion industry, the movie industry. That's very skin-deep, so to speak.—Ralph Nader, consumer advocate and 2000 Green Party presidential candidate, *Esquire,* April 2001

with images of how they are supposed to look, but women are the primary targets of such ads. The effects, especially on young and middle-aged women, can be harmful or even life-threatening. A takeoff of a June 2000 magazine cover **(6.25)** lays out the problem in bold terms. Physical beauty has become "deadly," not in the sense of killing expenditures of time, energy, and dollars on beauty products and services, but to the extent of women injuring themselves or even dying through extremes of dieting and exercise, plastic surgery, and other invasive measures. The goal of achieving an unattainable cultural ideal of female beauty is reinforced endlessly in magazines and news-

papers, on posters and billboards, and on television and computer screens. The ideal takes the form of the professional model or celebrity, who is young and gorgeous, fit as an athlete, and incredibly thin yet full-breasted. Making the ideal even more unattainable is the fact that the model's appearance in an advertisement is enhanced by optimal lighting, photographic touch-ups, or computer manipulation. Rationally, this ideal is not one to hurt or kill oneself for. But the power of advertising and mass-media images is such that critical consciousness-raising is in order.

Advertising critic Jean Kilbourne, in her lectures, *Killing Us Softly* videos, and 1999 book

6.27 TITIAN. *Venus of Urbino*. Ca. 1538. Oil on canvas. 25⅝ × 46⅞ in. Galleria degli Uffizi, Florence.

Deadly Persuasion, asserts that advertisements cannot be brushed off as inconsequential. In fact, they are most dangerous because the vast majority of viewers believe themselves immune to their influence. But businesses are not spending billions annually on ad campaigns for nothing. They achieve maximum results by selling both products and life-styles. Advertising, Kilbourne emphasizes, "sells a great deal more than products. It sells values, images, and concepts of love and sexuality, romance, success, and perhaps most important, normalcy." Paradoxically, the beautiful women who dominate the mass media—the sexy sellers of every type of product—are truly abnormal exceptions who represent a minuscule proportion of the population. Yet through advertising imagery they become the norm or the ideal that many strive to emulate, sometimes to the death.

The mass-media fixation with physical beauty becomes even more dangerous when it is exploited to sexually attract and excite the male viewer—which is almost all the time. Consider an artistically arresting ad for the 2001 Ford Focus **(6.26),** clearly targeted to a male audience. The powerful engine that powers your car and beckons you to buy is nothing less than a beautiful, sexy young woman. Car and woman are one, and you can be in the driver's seat. In visual terms, the presentation of women as sexy visions is not new, although their exploitation to sell products is. In Western art of the past five hundred years, printmakers, draftsmen, painters, and sculptors have presented the female nude in a generalizable way as ever beautiful, young, and erotically posed for the pleasure of male viewers. Titian's sixteenth-century *Venus of Urbino* **(6.27)** is one of the earliest and most esteemed

6.29 After a contemporary high-fashion magazine advertisement. Models: Sara Tomko, Autum Riddle. Photo: Patrick Horst and Nathan Combs, 2002. *A series of ads featuring a young model, made up to appear dirty and bruised, ran for several months in popular fashion-oriented magazines in 2001. The ad is selling a well-known high-fashion line. What is the company saying with this type of ad, and what audience is the company trying to reach?*

6.28 After a 2001 cereal magazine advertisement. Model: Mia Wilson. Photo: Patrick Horst and Nathan Combs, 2002. *Create advertising "takeoffs" of your own. You will discover how amazingly manipulative the ads can be in terms of subject matter and visual strategies. Does any art from the past compare with advertising in respect to persuasive power?*

of such representations; Cabanel's acclaimed nineteenth-century *The Birth of Venus* (16.26) carries the tradition into modern times. Extending the fine-art tradition of the nude, advertisements (6.25, 6.26) carefully position their enticing young women, with or without clothes, posing for or gazing seductively at a male viewer. Such images clearly objectify women, transforming individuals into sex objects designed and displayed for the male gaze.

A corollary to this, Kilbourne points out, is the slicing of women's bodies into parts in numerous ads. If women's bodies are simply objects, she asserts, then they can be readily cut up and exploited piecemeal. In a seemingly lighthearted advertisement takeoff of a breakfast product **(6.28),** a sexy, bikini-clad body—

we can hardly call her a person—sells the cereal portrayed beneath her. Red and white strawberries match pink and red bikini, and warm flesh tones correspond to cereal colors. The attention-grabbing ad may sell more cereal to men and women, but it also reinforces what Kilbourne calls "a stereotype that harms." Kilbourne convincingly makes the case that rape is one likely result when men are conditioned to look upon women as objects, and particularly as sex objects. Certain ads, mainly in women's fashion magazines and men's magazines, even show images of women who appear violated or battered, adding weight to Kilbourne's argument. What can the viewer assume about the image of a bruised, dirtied young woman **(6.29)** other than that she has been raped?

HOW ARE MEN AND WOMEN REPRESENTED IN GRAPHIC ART AND DESIGN?

In Chapter 4, we looked at the way different cultures and artists saw and represented nature. Here we will examine how different graphic artists and designers have viewed and depicted men and women. Men are the exclusive subjects of Dürer's *Knight, Death, and the Devil,* Goya's *The Sleep of Reason Produces Monsters,* Daumier's *The Legislative Paunch* and *Murder in the Rue Transnonain,* Homer's *A Bivouac Fire on the Potomac,* Baskin's Haggadah book illustration, and the "automobile man" advertisement. They are the central subjects of Ovissi's *Omar Khayyam* etching, Dürer's *The Four Horsemen of the Apocalypse* woodcut, and the Heart's Desire soap advertisement. In these artworks, what kind of actions are the subjects engaged in? Do you consider these activities typically male-oriented? Are the men shown in active or passive roles? Are they presented positively, negatively, or a mixture of both?

Women are the exclusive subjects of the *Job* cigarette ad, the *Hamm* print, the Sweet Honey in the Rock CD cover, the *James* magazine cover, and the Ford Focus, cereal, and high-fashion ads. A woman dancer, "La Goulue," is the central figure in Toulouse-Lautrec's poster. What actions are the subjects involved in? Do you deem these typically female activities? Are the women shown in a positive light, a negative light, or both?

Men and women appear together—in relationship—in Ovissi's *Omar Khayyam,* Beardsley's *Salome* book illustration, Bradley's *Victor Bicycles* poster, and Gainsborough's *Mr. and Mrs. Andrews.* What roles do they play? Are they represented as equal in status or power? Is one sex more active and the other more passive? How would you describe the male-female relationships in the four distinct works?

Do the answers to these various questions allow you to generalize about how men and women are represented, singly and in relationship, in the works of graphic art and design discussed in this chapter? Extend the questioning process to the contextual level: What in the artists' lives or in their sociocultural contexts might have prompted such representations?

"Advertising," Kilbourne concludes, "is our *environment.* We swim in it as fish swim in water. We cannot escape it. . . . Advertising's messages are inside our intimate relationships, our homes, our hearts, our heads." Because of their enormous cumulative impact, ads need to be looked at critically and with deadly seriousness.

SOCIETY'S MIRROR

Graphic art and design have always been revealing social mirrors, accurate reflections of the status quo **(Interaction Box).** The prints of Dürer, Rembrandt, Goya, Daumier, and Homer powerfully reflect their times (6.2–6.8).

Modern advertisements play much the same role. By critically examining the world of advertisements, we can learn a great deal about ourselves, our society, and our culture. Consider an example from the recent past. When American society was racially segregated, African Americans, Hispanics, and Asian Americans appeared in ads, if at all, only as servants or cooks. After the legal and social integration of restaurants, schools, and neighborhoods, these same minorities gradually entered ads (6.26) on a more equal footing with white Americans. Very quickly, they too became a valued market to capture. From Dürer's fifteenth-century woodblock prints to contemporary advertisements, graphic art and design both mirror and help shape our lives. They deserve our full attention.

Advertising in its . . . new dimension invades everything, as public space (the street, monument, market, scene) disappears. . . . It monopolizes public life in its exhibition.—Jean Baudrillard, culture critic, "The Ecstasy of Communication," from *The Anti-Aesthetic: Essays on Postmodern Culture,* 1983

Photography and Moving Pictures

FROM PREHISTORY TO THE PRESENT

A story about Apelles, court painter to Alexander the Great (356–323 B.C.E.), celebrates an early instance of extreme *mimesis*, a Greek term for the imitation of reality. According to legend, Apelles painted a portrait of the conqueror's horse, Bucephalus, so accurately that Bucephalus whinnied at the portrait as if it were a real horse. The portrait bust of the third-century Roman emperor Phillipus the Arab **(7.1)** similarly is so particularized and accurate that it seems a photograph of the man in stone. Inspired by such Greco-Roman illusionism, innumerable Western artists since the Renaissance have sought to faithfully reproduce reality in portraits, landscapes, still lifes, and depictions of religious stories. Consider the realism of van Eyck's *Arnolfini Wedding Portrait* (5.25), Leonardo's *Ginevra de' Benci* (2.29), Bellini's *Saint Francis in the Wilderness* (4.4), and Velázquez's *Las Meninas* (5.18). The ambitious desire to achieve lifelike illusions, a peculiarly Western phenomenon, laid the groundwork for photography, film, and video. Initially valued for their wondrous mimetic powers, these art forms soon moved beyond reproduction to creations of the most imaginative diversity.

PHOTOGRAPHY'S HISTORICAL BACKGROUND

The efforts by artists to reproduce the external world with objective accuracy, in "a photographic likeness," constitute photography's background or prehistory. But artists weren't the only ones striving for mimesis. The illusionistic reproduction of reality was a passionate interest of scientists in fields ranging from botany to astronomy.

Science, Art, and the Camera Obscura

Since the Renaissance, a science based on sensory observation and analysis of the physical world has dominated Western thought. To chart and reproduce physical reality, scientists developed various mechanical devices. One of these devices, a favorite of astronomers, was the **camera obscura** ("dark room"). Invented by the Arab scholar Ali Hazen in the eleventh century, the camera obscura was initially used to observe solar eclipses and sunspots. Light from an object (in this case the sun) passed through a small opening, which might be covered by a glass focusing lens, and produced an exact upside-down image at the back of a darkened room or box. Later camera obscuras **(7.2)** used internal mirrors to reorient the image to a rightside-up position. From these images, whether of sunspots or of trees, a person might make exact drawings or even paintings. By the seventeenth century, the use of improved lenses and mirrors made the camera obscura resemble a modern photographic camera **(Technique Box 7-A)** in every major respect except one: It did not use film to fix the image. Users of the camera obscura still had to copy the representation of nature onto paper or another surface to permanently capture it. Artists were able to acquire books on how to operate this "machine for drawing," and the device began to be used to varying degrees by painters.

Naturalism and the Birth of Photography

Among the painters who used the camera obscura was British landscapist Paul Sandby (4.5). Seeking greater scientific naturalism, Sandby aimed at giving his drawings the appearance of nature as seen in the camera obscura, with truth in the reflected lights, clearness in shadows, and accurate coloration in the distances and the skies. By viewing the world through the eye of the camera, painters like Sandby attempted to see and represent the world more "photographically."

This same desire to record reality more photographically is evident in the landscape paintings **(7.3)** of Englishman John Constable (1776–1837). Looking like a moment frozen in time, *Water Meadows near Salisbury* accurately captures the motion of trees and clouds and

Both the camera obscura and the Renaissance system of perspective have the effect of focusing vision, of creating a visual field in which "single vision" becomes fixed in a space distinct from the flow of time, so that one visual element follows another in linear sequence.
—Jose Arguelles, author, *The Transformative Vision,* 1975

7.1 Unidentified sculptor. *Phillipus the Arab.* 224–49 B.C.E. Marble bust. Vatican Museum, Rome.

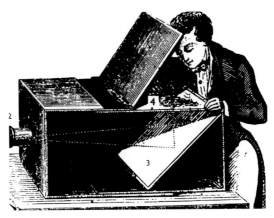

7.2 Camera obscura. *If our inventions reflect our cultural values, why do you think Europeans perfected the camera obscura? Why didn't the Chinese, who were at least as technologically advanced at the time?*

7.3 JOHN CONSTABLE. *Water Meadows near Salisbury.* 1829. Oil on canvas. 18 × 21¾ in. Victoria and Albert Museum, London.

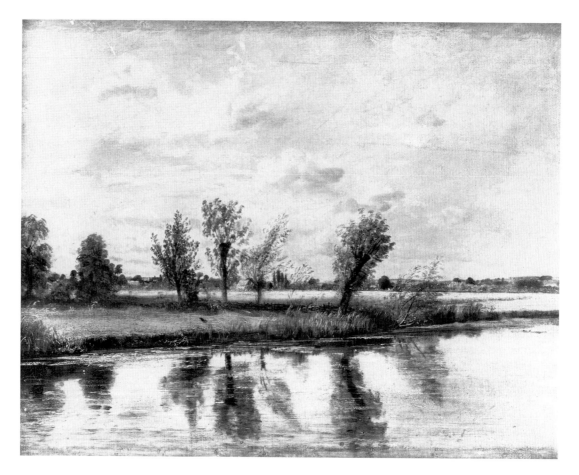

reflections on the water. Though he probably did not use the camera obscura in his work, Constable firmly believed that painting should be looked on as a pursuit "scientific and mechanical." His so-called "natural painting" and the camera obscura–aided landscapes of his compatriot Sandby were precursors to a full-fledged **naturalist** art movement that arose in mid-nineteenth-century England and France. In addition to striving for an objectively accurate representation of nature, naturalism, like early photography, emphasized a democratic range of subject matter, from commonplace landscape views to scenes of everyday lives.

Within this cultural context of artistic and scientific naturalism in the 1830s, during the rise of the Industrial Revolution, Frenchman Louis Daguerre (1789–1851) and Englishman William Fox Talbot (1800–1877) almost simultaneously invented photography. Their crucial innovation was the development of light-sensitive surfaces that reproduced and fixed the images produced by the advanced camera obscuras of

the day. Sunlight inscribed the images on these surfaces, giving the new invention its lasting name: photography ("drawing with light"). Because photography is a way of seeing and representing that marries science and art, it is not surprising that both inventors were actively involved in the visual arts. Daguerre was a realistic painter and creator of illusionistic trompe l'oeil ("fool the eye") theater effects and dioramas, while Talbot, a scientist, was an amateur artist who had used the camera obscura as an aid in his landscape drawings.

PHOTOGRAPHY: THE NINETEENTH CENTURY

Formally introduced to the world in 1839 by the French Academy of Science, the photographs of Daguerre amazed with their documentary truthfulness **(7.4)**. Talbot's photographs **(7.5)**, produced by a different chemical process and

BASIC PHOTOGRAPHY: CAMERA, FILM, AND DEVELOPMENT

The modern film-based camera (**Fig. A,** 7.9) operates in a manner similar to that of its camera obscura predecessor (7.2) in the most basic optical sense. Light passes through a small lens-covered opening into a light-tight chamber (or "camera") and forms an upside-down image. From this point, the unique qualities that distinguish the film-based modern camera take over. First, the image is recorded or fixed on film or some other photosensitive (that is, light-sensitive) material within the completely dark interior. Second, adjustable mechanical parts—aperture, shutter control—control the exposure of light on the film while a focusing device moves the lens in or out to bring the subject into clear view or focus. The photographer "shoots" each frame or unit of film by mechanically opening the shutter by means of a knob, lever, or ring. After shooting an entire roll of film (usually twenty-four or thirty-six frames), the photographer removes the film from the camera, making certain it is not exposed to light.

The exposed film is called the **negative** because the light and shade recorded on it are the reverse, in terms of light-dark values, of the actual photographed image. The negative image is converted to a positive image and final print by placing it in contact with a second sheet of photochemically sensitized paper and exposing it to light in a process called "contact printing." The photochemical processing, or "developing," of the film from negative to positive final print takes place in a light-sealed workspace or darkroom. The entire process might be repeated to produce numerous duplicate prints from the original negative.

Englishman William Fox Talbot invented the negative film process that formed the basis of modern photography (7.5) because it permitted reproduceability. In contrast, Frenchman Louis Daguerre's photographic process, developed at the same time, produced one-of-a-kind pictures. To create his singular images, Daguerre inserted a silver-plated copper sheet coated with chemicals into a camera obscura and focused on a subject through a lens. For fifteen minutes, the silver-plated surface was exposed to the light that entered the dark camera interior. The plate was then removed from the camera, exposed to chemical fumes, and placed in a chemical solution or "bath." Immersion in the bath fixed the image onto the surface of the plate. The result was a unique photographic image. Commercially popular because of its sharp focus, such images became known as **daguerreotypes** (7.4, 7.6).

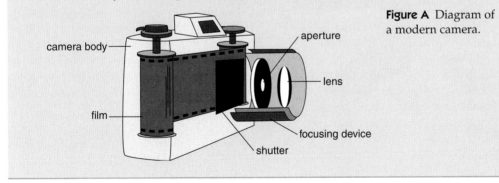

Figure A Diagram of a modern camera.

camera body — aperture — lens — film — focusing device — shutter

characterized by a softer, grainier appearance, were made public the same year. An eager public bought multitudes of photographic images, from panoramic city views to portraits. The daguerreotype of Frederick Douglass (1817–1895) is an example of an early photographic portrait **(7.6).** With striking realism, it captures the dignity and power of the famous African-American political leader and jour-nalist. The image is sharp in definition and stands forth boldly on its metallic ground. The instant popularity of photographic portraiture and scenic views spurred technical developments in the field. Improvements in chemical processing steadily reduced the time needed to take a photograph, and by the 1850s increasingly "instantaneous" reproductions were possible.

The true culmination of the mechanistic mode of visual perception and mental ordering was the perfection of drawing with light, *the literal meaning of photography. . . . Just as a mechanistic mode of consciousness had to precede full-scale industrialization, so a naturalistic mode of visual perception had to precede the invention of photography.* —Jose Arguelles, author, *The Transformative Vision,* 1975

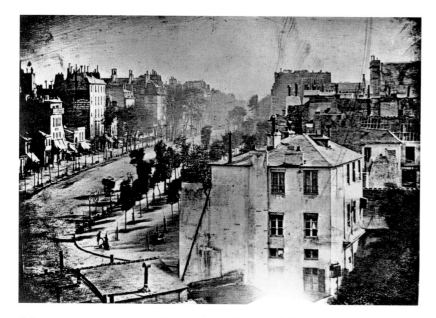

7.4 LOUIS-JACQUES-MANDÉ DAGUERRE. *Boulevard du Temple.* 1839. Photograph. Bayerisches Nationalmuseum, Munich, Germany. *It is broad daylight, but there don't seem to be any people in this daguerreotype of a normally busy Paris street. Where are they? Hint: Look at the small, solitary figure standing still, knee bent, on the sidewalk in the lower left foreground. Remember the long exposure time required to shoot early photographs. Why do we see only the one figure and no others?*

7.5 WILLIAM FOX TALBOT. Calotype of trees. Ca. 1842. Calotype. Photo: Science Museum/ Science and Society Picture Library, London.

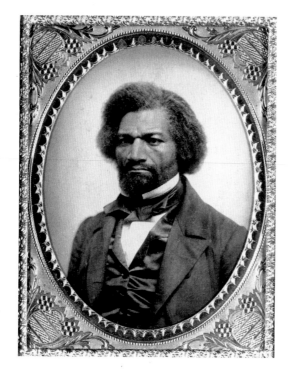

7.6 Unidentified photographer. Portrait of Frederick Douglass. 1856. Daguerreotype. 4³⁄₁₆ × 3³⁄₈ in. National Portrait Gallery, Smithsonian Institution, Washington, D.C. *In spite of the solemn formality of the pose, this daguerreotype portrait of Frederick Douglass (1817–1895) captures the dignity and power of the journalist and statesman. A militant spokesman for Negro freedom and civil rights, Douglass was perhaps the most influential African-American abolitionist of the nineteenth century. How might daguerreotypes and other early photographs have aided the abolitionists' cause?*

7.7 GASPARD-FÉLIX TOURNACHON (NADAR). ▶ Satire on Daubigny's *Les bords de l'Oise (The Banks of the Oise).* Exhibited in the Salon of 1859. Caricature shows man trying to dive into the canvas. *According to a mid-nineteenth-century commentator, "One can guess from the crispness of the details, from the mathematically correct placing of the shadows, that he [the painter] has taken the daguerreotype as a collaborator." How can you distinguish a painting that was based on a photograph from one based on the artist's "naked-eye" view of the subject or scene?*

The New Machine Art: Triumphs and Trials

The response to the revolutionary invention of photography was almost universally enthusiastic. No image-making procedure had ever received such widespread public acclaim. Scientists from anthropologists to biologists applauded photography's documentary capabilities. Artists, portraitists in particular, praised photography as a valuable aid to drawing and painting. No group, however, was more excited by the introduction of photography than the general public. Historians claim that in 1849 (a scant ten years after the introduction of Daguerre's invention by the Academy of Science) 100,000 daguerreotype portraits were taken in Paris alone. (A lithograph (7.9) shows the city of Paris crammed with photography advertisements and businesses.) As a method of mechanical documentation, photography had clearly won over the masses.

By the 1850s, excited by photography's mimetic capabilities, increasing numbers of artists (7.23) strove to simulate the detailed accuracy of the new "drawings with light." Contemporary cartoons capture the fever. One mocks a group of battle paintings, showing them to be so realistic that actual smoke billows from their surfaces. Another shows a swimmer about to dive into an oil painting of a river (7.7); a security guard has to prevent the confused man from jumping into the picture.

At the same time that artworks were becoming more photographic, artistically minded photographers, many with backgrounds in painting or printmaking, sought to have their photographic battle scenes, nudes, still lifes, landscapes, religious subjects, and portraits **(Appreciation 13)** judged as art. They claimed that theirs was not merely a mechanical skill, as some artists and critics contended, but an aesthetically informed activity involving thought, feeling, and individuality. *Head of John the Baptist* **(7.8)** by Oscar Rejlander (1813–1875) is a consciously artistic example. It is the inventive product of a painter turned photographer. In his photographic works, Rejlander generally took his cue from the subjects, poses, and compositions found in traditional historical and religious paintings. But no painting could be quite as lifelike and strangely disturbing as this representation of the decapitated John the Baptist. Created by a **photomontage** technique, in which images of two

60. Nadar: Satire on Daubigny's *Les bords de l'Oise* exhibited in the Salon of 1859

7.8 OSCAR G. REJLANDER. *Head of John the Baptist.* Ca. 1860. 14 × 18 in. Albumen print. George Eastman House, Rochester, New York. *A painter who turned to photography, Oscar Rejlander pioneered composite pictures or photomontages. Taking his cue from the subjects, poses, and compositions found in traditional historical and religious paintings, Rejlander hoped to have his composite pictures accepted as art. Why do you think many critics in his own time judged his work harshly, whereas experts of the present respect and prize it?*

LIANG SHITAI, *Chinese Court Photographer from Hong Kong*

EDWIN K. LAI

Chinese-owned photographic studios emerged in the British colony of Hong Kong from the middle of the 1860s. Many of the practitioners were previously commercial oil painters who had painted portraits, port views, ship portraits, and pictures of local Chinese customs and trades. Their paintings were created for a diverse public. Europeans living and working in Hong Kong and visiting foreign traders and sailors were their major patrons. But some wealthy Chinese merchants also sat before their painting easels. These painters saw commercial potential in the newly imported Western medium and proceeded to learn the craft from certain Western photographers who had come to photograph China and its people. Some, however, continued their earlier painting trade even after they had taken up the camera. Liang Shitai (pronounced *liang see-tay*) was one of them, advertising himself as "Photographer and Painter."

In the face of growing competition in the 1870s, some of the early Hong Kong photographers went north to Mainland China to try their luck in regions where the camera was still a novelty. Liang Shitai went to Shanghai in 1876 and advertised his "Shitai Photographic Studio" in the daily newspaper. Later he moved farther north to Tianjin in order to receive commissioned assignments from the local government. When Ulysses S. Grant, former president of the United States, visited China in 1879, Liang was hired to take the official photograph of his meeting with the famous Chinese statesman Li Hongzhang. During this period, Liang photographically documented numerous governmental reform programs, notably the construction of railway lines, the building of fortresses, and the training of the North Sea Navy.

Liang Shitai's association with the Imperial Court dated from 1886. In April of that year, Prince Chun, who also held the post of Grand Minister Supervisor of the Naval Affairs Office, made an inspection tour of the North Sea Navy. Liang was responsible for the photographic documentation of this tour and from then onwards made portraits of the Prince and high-ranking officials. When Prince Chun celebrated his fiftieth birthday in 1889, Liang Shitai was summoned to take photographs of him and his sons.

Because of the long exposure time (several seconds or more) required to take each picture, these photographs were carefully posed and staged. The requirements of staging and posing apparently suited the tastes of the Chinese people, since traditionally they had understood portraiture as an assertion of meaning and power rather than an objective record of reality. In these regards, one photograph of the Prince **(Fig. A)** is particularly interesting. Taken in 1889, possibly on his fiftieth birthday, the Prince is shown in casual clothes and appears full-length directly in front of the camera. Following Chinese aesthetic preferences, Liang Shitai has illuminated the Prince from the top and front, thereby revealing his features and gestures clearly, almost without any shadows. In his left hand, Prince Chun holds a branch of a pine tree; to his right is a small pet deer. The meaning of this photograph was

Edwin K. Lai is an art historian whose area of specialization is nineteenth-century Hong Kong photographers. Of Chinese heritage, he lives and teaches in Hong Kong.

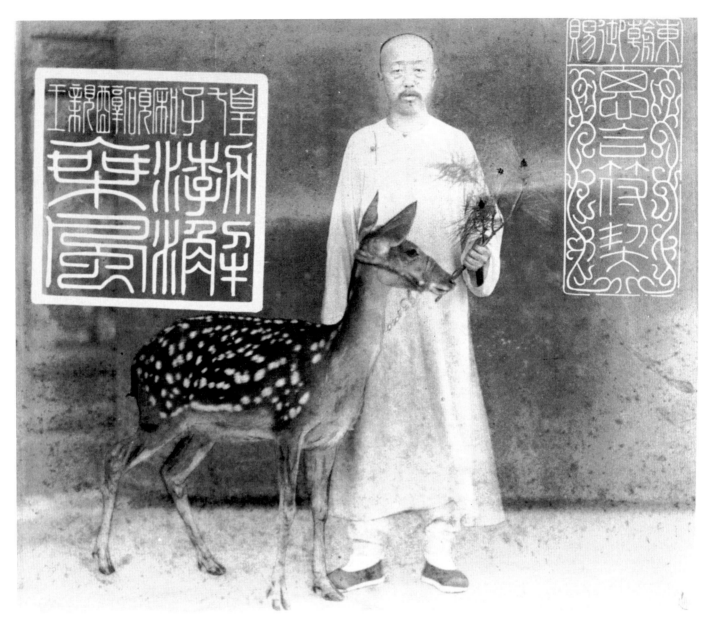

Figure A LIANG SHITAI. The Chinese Emperor Yi Huan in the villa at Miao Gao Peak of the Western Mountain. 1887. Palace Museum, Beijing.

unambivalent: Both the pine tree and deer are classical Chinese symbols for longevity, indicating the Prince's wish for a long life. (Unfortunately, he died shortly afterwards at the age of fifty-one.) In the upper half of the photograph, two large official seals of the Prince are prominently affixed, a practice that was rare in photography and obviously borrowed from the traditions of court paintings.

Clearly, the Prince attached artistic and cultural importance to Liang Shitai's photographic portraits. ■

161

7.9 HONORÉ DAUMIER. *Nadar Elevating Photography to the Height of Art.* 1862. Lithograph. *Nadar was one of the first photographers to take pictures underground. Employing artificial lighting and dummies (because of exposure times as long as 18 minutes), Nadar created scenes that simulated the subterranean activities of workers in the ancient burial grounds of Paris. Between the netherworlds of the catacombs and sewers and the heavens above, Nadar and other photographers explored widely. They didn't necessarily have to range so widely. What about photography and its sociocultural context might have promoted such exploration?*

7.10 GASPARD-FÉLIX TOURNACHON (NADAR). *Photography Asking for Just a Little Place in the Exhibition of Fine Arts.* 1855. Engraving from *Petit Journal pour Rire*. Library of Congress.

or more negatives are combined and developed into a final print, Rejlander's pictures laid the groundwork for twentieth-century photographic innovations (7.28, 7.30).

In mid-nineteenth-century France, artistically minded photographers like Rejlander sought to have their pictures shown in the prestigious annual Salon, the government-sponsored national exhibition. Exhibition in the very same Paris building previously reserved for painting, sculpture, drawing, and

printmaking would certify the arrival of photography as a full-fledged art form. But as photographic submissions to the Salon increased, cultural resistance stiffened. The heated debate between the upstart photographers and the protectors of fine art reached the boiling point. In his review of the Salon of 1859, the prominent art critic and poet Charles Baudelaire (1821–1867) thundered against the popular "new industry," which he branded a malignant cancer infecting the public and threatening the very existence of art ("the divine in the French genius"). His argument against photography's artistic aspirations and admission to the Salon centered on its mechanical, documentary nature (7.4–7.6) and on what he saw as the equation, on the part of the public and certain artists, of exact reproduction with art. For Baudelaire and other defenders of high culture, art was a painting or sculpture made by hand, not an imitation of nature made by machine. Art was suffused with feeling and filled with dreams, the creation of an imaginative individual and not a mechanical copying machine. Baudelaire wrote:

7.11 GASPARD-FÉLIX TOURNACHON (NADAR). *The Ingratitude of Painting, Refusing the Smallest Place in Its Exhibition, to Photography to Whom It Owes So Much.* 1857. Engraving from *Le Journal Amusant.* Library of Congress.

7.12 GASPARD-FÉLIX TOURNACHON (NADAR). *Painting Offering Photography a Place in the Exhibition of Fine Arts.* 1859. Engraving. Library of Congress.

If photography is allowed to stand in for art in some of its functions it will soon supplant or corrupt it completely thanks to the natural support it will find in the stupidity of the multitude. It must return to its real task, which is to be the servant of the sciences and of the arts, but a very humble servant, like printing and shorthand which have neither created nor supplanted literature.[1]

Caricaturists immediately joined the fray. The pioneering photographer Nadar (1820–1910), who took the first aerial shots of Paris from a hot air balloon, found himself lampooned by the popular artist Daumier (6.6, 6.7). In a caricature with double meaning **(7.9)**, Daumier poked fun at Nadar for attempting "to raise photography to the height of art." A caricaturist himself, Nadar summarized the topsy-turvy relationship between fine art and photography in three cartoons **(7.10–7.12)** executed between 1855 and 1859, the year in which photography was officially granted space in the prestigious Salon.

Rapid-Exposure "Instantaneous" Photography

During the years of struggle to achieve fine-art status, photography's technical development continued. In 1858, rapid-exposure photography made its sensational debut. The human eye records motion at intervals of $\frac{1}{12}$ of a second. Rapid-exposure photography recorded motion at intervals of as little as $\frac{1}{50}$ of a second. The public's desire for these "instantaneous" views **(7.13)** that literally stopped action was boundless. Sales of instantaneous photographs in Paris alone totaled in the millions. Stirred by the precision in detail of stop-action views taken in Paris in 1861, American writer Oliver Wendell Holmes (1809–1894) wondered at the "walking figures, running figures, falling figures, equestrian figures and vehicles, all caught in their acts without the slightest appearance of movement or imperfect definition."

Like the general public, artists were naturally influenced by the new way of seeing and

7.13 FERRIER AND
SULIER. *Paris Boulevard.*
1860. Instantaneous
photograph. Courtesy
George Eastman House,
Rochester, New York.

Degas loved and appreciated photography at a time when artists despised it or did not dare admit that they made use of it. He was among the first artists to see what photography could teach the painter—and what the painter must be careful not to learn from it.
—Paul Valery, writer,
"Degas, Dance, Drawing,"
1935

picturing. Rapid-exposure photographs, which were immensely popular throughout Europe and North America, exhibited characteristics that increasingly appeared in the works of avant-garde artists: arbitrary framing, asymmetrical composition, unusual angles of vision, real-life variety and unexpectedness. In these photographs (7.13, **7.14**), as in certain vanguard paintings (5.15) and posters (6.9), figures, carriages, and buildings were often "cut off" at the edges. An accomplished amateur photographer, the impressionist painter Edgar Degas (1834–1917) captures his friend Count Lepic, his daughters, and their dog in a fleeting, seemingly unposed moment **(7.15)**. Degas called this slice-of-life work a "modern portrait." As in a candid snapshot, major parts of the girls, their father, and a stranger on the left are cut out of the picture. In photographic terms, the figures have been cropped from the frame. Mocking the "ridiculous" cut-off forms and figures in such instantaneous views, the caricaturist Cham shows us a horse-drawn

carriage slashed in half, with the passengers, their legs severed at the kneecaps, riding on top **(7.16)**. Yet what was initially perceived as odd and even hilarious soon became second nature to both artists and the public—such was the influence of the new industry and its millions of documentary images on the way the public sees.

One lesson artists learned from instantaneous photography was how horses really galloped. The famous sequential photographs of galloping horses **(7.17)** by American Eadweard Muybridge (1830–1904), circulated in France from 1878, taught artists like Degas to correct previous errors in drawings and paintings of racehorses, including the incorrect representation of the traditional "flying gallop" position in which the speeding horse's four outstretched legs—the two front legs thrust forward, the two rear legs back—are simultaneously off the ground. Muybridge's sequential photographs proved that such a position does not exist. Only when the racing horse's legs are

7.15 HILAIRE-GERMAIN-EDGAR DEGAS. *Place de la Concorde* (Viscount Lepic and His Daughters). Ca. 1875. Oil on canvas. 31¾ × 47⅜ in. Document Archives Durand-Ruel, Paris. *Certain writers argue that the unusual cropping and placement of figures in Edgar Degas's pictures were influenced primarily by the creative framing and asymmetrical compositions found in Japanese prints (3.9, 4.12, Appreciation 7), an art form Degas much admired. Others assert that the instantaneous photograph, with its slice-of-life informality, was the greater influence. What do you think?*

7.16 CHAM (AMÉDÉE-CHARLES-HENRI COMTE DE NOÉ). Detail from page of caricatures and satire on Disderi. 1861. From *Le Charivari*. Bibliothèque Nationale, Paris.

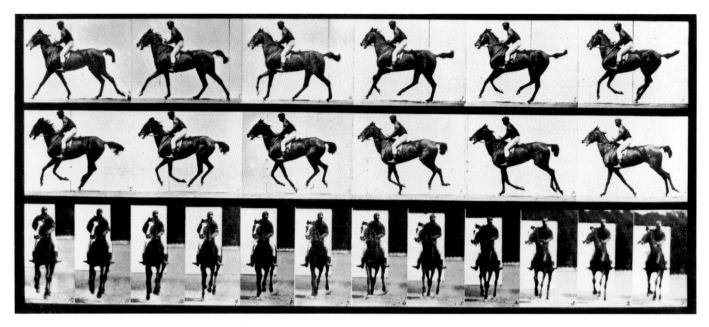

7.17 EADWEARD MUYBRIDGE. *Annie G. with Jockey.* Sequential photograph from *Animal Locomotion.* 1887. Collotype print. Courtesy George Eastman House, Rochester, New York.

7.18 ETIENNE-JULES MAREY. Chronophotograph of the flight of a bird. 1887. Archives de Cinémathèque Français, Paris.

underneath the body, the photographs revealed, can all four legs leave the ground.

From Still Photography to Cinematography

The nineteenth century's desire to reproduce life ever more accurately and completely made inevitable the progression from the single still photograph to Muybridge's sequential photographs to a sequence of shots that, when projected, simulated the movement of life itself. The "chronophotographs," or time photographs, of Frenchman Etienne-Jules Marey (1830–1904) followed logically from Muybridge's sequential instantaneous photographs. Invented in the 1880s, Marey's chronophotography **(7.18)** showed each minute phase of a movement in its correct spatial position.

From these simulations of motion, it was but a stone's throw to cinematography, the art of making pictures that actually moved. The mid-1890s brought the public release of motion picture shorts by American inventor Thomas Alva Edison (1847–1931) and the French Lumière brothers, Auguste (1862–1954) and Louis (1864–1948). The age of film was under way. Audiences screamed and recoiled in fear as a train hurtled toward them in the Lumières' minute-long 1895 film *The Arrival of a Train* **(7.19)**. By the late 1920s, sound was added to the previously silent films; "living color" entered the realms of motion pictures and photographs shortly thereafter. The public appetite for increasingly convincing illusions of reality, soon to include the televised images of electronic video, laser-generated holography, and computer-generated "virtual reality," was insatiable, spawning vast new industries and billions of dollars in profits.

PHOTOGRAPHY AND MOVING PICTURES: THE TWENTIETH CENTURY

Photography, film, and, after World War II, television rapidly became the twentieth century's most influential visual media in terms of information, persuasion, and entertainment. Today, the average person experiences millions, if not billions, of photographic images in a lifetime—in newspapers and magazines; on computer screens, posters, billboards, and products; in home albums. Film is a multibillion-dollar industry, and commercial television, a communication form and industry we will only tangentially explore here, consumes viewers to the tune of hours of viewing time per day. By featuring film channels and serving as a monitor for films in videocassette recording (VCR) and digital video disc (DVD) format, television assumes the hybrid role of home movie theater. These new media have become "mass media," and their impact has been nothing less than incredible in all areas of life. But, an avant-garde painter or sculptor might have retorted, is anything in this vast media landscape worthy of being called "art"? At the beginning of the twentieth century, the debate over whether photography and film were valid art forms continued. Over the course of the century, the art

world would gradually embrace photography, film, and artist-made videos as full-fledged works of fine art. The stylistic range of these photographic and cinematic works mirrored that of the paintings and sculptures of the day.

The New "Art Photography"

At the turn of the twentieth century, only a small minority in the art world would have claimed that the new mechanical media were capable of producing fine art. But making contemporary fine art became the steadfast goal of select groups of men and women equipped with cameras. These photographers called themselves **pictorialists,** by which they meant artistic picture-makers. At his Gallery 291 in New York City, photographer Alfred Stieglitz (1864–1946) exhibited both the work of avant-garde painters and sculptors and that of vanguard pictorialist photographers. Pictorialists shared the aesthetic concerns of the avant-garde painters and sculptors and worked in closely related styles. They included Stieglitz himself, Gertrude Kasebier (1852–1934), and Edward Steichen (1879–1973).

Steichen's *Rodin—The Thinker* **(7.20)** exemplifies the union of vanguard art and photography that Stieglitz's Gallery 291 espoused. The great sculptor Rodin (1840–1917) is shown

7.20 EDWARD STEICHEN. *Rodin—The Thinker*. 1902. Gravure print. 15⅞ × 19¹³⁄₁₆ in. The Metropolitan Museum of Art, Alfred Stieglitz Collection, 1933 (33.43.420-469).

. . . the photographer's most important and likewise most difficult task is not learning to manage his camera, or to develop, or to print. It is learning to see photographically—that is, learning to see his subject matter in terms of the capacities of his tools and processes, so that he can instantaneously translate the elements and values in a scene before him into the photograph he wants to take. —Edward Weston, photographer, *The Complete Photographer*, 1943

with two of his famous works: *The Thinker* and, in the background, his portrait of the Romantic writer Victor Hugo. Light flickers moodily on the dark silhouetted foreground figures and floods the whitened sculpture behind. Both the gestures of the figures and the overall **symbolist** quality suggest deep meditation. (Symbolism, a movement in the arts that flourished at the turn of the century, sought to suggest or evoke subjective thoughts and spiritual states, often by means of abstraction from natural appearances.) The photographer's manipulation of artificial lighting, camera focus, and darkroom effects gives the finished print a paintinglike quality typical of many pictorialist photographs. Compare the blurry "soft focus" of the brilliantly lit Victor Hugo sculpture to the crisper "sharp focus" delineation of Rodin's head and the upper torso of *The Thinker*. Note the reduction of details and the abstraction of forms, and the way the composition of the figures leads the eye around the work in a circular path. Steichen was happily surprised to find that such photographic works, with their pronounced aesthetic and symbolist qualities, were well received. Writing from Paris in 1901, Steichen related to his

friend Stieglitz in America that "even big painters and artists here . . . up to Rodin himself" praised his creations as "remarkable works of art."

Another sensitive—but quite different—artistic vision is evident in Alfred Stieglitz's famous 1907 photograph *The Steerage* **(7.21)**. At first glance, *The Steerage* appears to be straightforward documentation, or **straight photography.** In contrast to Steichen's carefully orchestrated *Rodin—The Thinker* (7.20), Stieglitz did not pose his subjects, add artificial lighting, or employ darkroom techniques to alter the actual scene. *The Steerage* is essentially a slice-of-life snapshot. Yet what makes the subject matter so compelling is Stieglitz's selective way of seeing and framing, the way he framed the scene within the rectangular boundaries of the camera's viewfinder to create the final composition at this initial point of contact.

Stieglitz's own account of the genesis of *The Steerage* sheds light on the picture's composition and its interrelationship of form and content. On a trip to Europe aboard a luxurious ocean liner, Stieglitz found himself surrounded by newly rich people he did not like. On the third day out, longing to escape the atmosphere of the fashionable first-class section, he went as far forward on the ship as he could, coming upon the steerage section reserved for the poorest passengers. What met his eyes was remarkable: a ready-made work of art waiting to be photographed. His words convey the excitement he felt:

> A round straw hat, the funnel leaning left, the stairway leaning right, the white drawbridge with its railings made of circular chains—white suspenders crossing on the back of a man in the steerage below, round shapes of iron machinery, a mast cutting into the sky, making a triangular shape. I stood spellbound for a while, looking and looking. Could I photograph what I felt, looking and looking and still looking? I saw the shapes related to each other. I saw a picture of shapes and underlying that the feeling I had about life. And as I was deciding, should I try to put down this seemingly new vision that held me—people, the common people, the feeling of ship and ocean and sky and the feeling of release that I was away from the mob called the rich—Rembrandt came into my mind and I wondered would he have felt as I was feeling.[2]

7.21 ALFRED STIEGLITZ. *The Steerage*. 1907. Photogravure. 18⅛ × 12½ in. The Los Angeles County Museum of Art. Museum Library Purchase, 1965. From "291" Journal (issue no. 7–8, published 1915).

Stieglitz ran to his cabin for his camera. Racing back again, out of breath, he discovered that his passionate hope had been miraculously fulfilled: "Seemingly no one had moved." If anyone had substantially changed position, Stieglitz wrote, "the relationship of shapes as I wanted them would have been disturbed and the picture lost." Amazed and with heart thumping, he snapped the photograph, an artistic masterpiece "based on related shapes and on the deepest human feeling."

With Stieglitz and his friends leading the charge, pictorial photography—also called "art photography"—seemed to be making its

7.22 D. W. GRIFFITH. *The Birth of a Nation*, Storming of the Union Line. 1915. Film still. The Museum of Modern Art Film Stills Archive. *D. W. Griffith's The Birth of a Nation has been both critically acclaimed and socially criticized since its premiere in 1915. A commanding work of cinematic art, it has also been continually denounced as a racist distortion of history. In 1993, protests over its screening at the Library of Congress in Washington, D.C., almost led to the showing's cancellation. The film was finally shown, but with an accompanying seminar to discuss its particular view of history. Can you aesthetically appreciate a film whose social content you find repugnant? How do you do this?*

way to art-world acceptance. (Ansel Adams, featured in Appreciation 8, would emerge from this background.) In addition to creating photographs and running Gallery 291, Stieglitz was editor of *Camera Work,* an influential art photography journal published between 1903 and 1917. Among its contributors were the contemporary modernist writers Gertrude Stein, Maurice Maeterlink, H. G. Wells, and George Bernard Shaw. These modernists felt that the camera and darkroom were but tools that, like the painter's brush and the sculptor's chisel, could be employed to convey the sensibility of the individual artist.

Toward an Art of Cinema

Cinematography, as a still younger medium, had to wait until the second and third decades of the twentieth century before anyone thought it capable of creating great art. With the films of D. W. Griffith and Erich von Stroheim in America, Sergei Eisenstein and Vsevolod Pudovkin in Russia, and F. W. Murnau and Leni Riefenstahl in Germany, directors of artistic power (or *auteurs,* "authors," as the French later called them) began to be recognized for their personal vision and indelible style. In the hands of creative artists, even films based on historical facts or actual events—supposed objective reality—were transformed into artistic tours de force of personal interpretation and imagination.

In the 1915 silent film classic *The Birth of a Nation,* D. W. Griffith (1875–1948) re-created the Civil War and Reconstruction from a white southern gentleman's point of view **(7.22).** Simultaneously acclaimed as great art and denounced for its racist perspective, *The Birth of a Nation* continues to be both controversial and compelling. Griffith's epic production brought the Civil War and its aftermath to heart-throbbing life—"history written in lightning," marveled President Woodrow Wilson. A convincing "historical facsimile" to Wilson and millions of viewers, Griffith's film appropriated for the cinema what had been one of the most revered traditions in Western art, that of history painting. With its basis in literature, its realistic settings and style, and its larger-than-life scenes, *The Birth of a Nation* seems a natural outgrowth of the grand-scale history paintings immensely popular in nineteenth-century Europe and North America, such as Leutze's *Washington Crossing the Delaware* **(7.23).** Pioneering silent films like *The Birth of a Nation,* with roots stretching deep into the most elevated fine-art traditions, were eventually recognized as masterpieces of visual art. Numerous art museums now own and show such classic films as part of their regular offerings.

PHOTOGRAPHY, MOVING PICTURES, AND ART: SELECTIVE VIEWS

Throughout the twentieth century, the relationship among painting, sculpture, photography, film, and video has been dynamic. To chart this vast and varied artistic landscape, we will use four broad interpretive categories: expressionism, surrealism, social realism, and

7.23 EMANUEL LEUTZE. *Washington Crossing the Delaware.* 1851. Oil on canvas. 12 ft. 5 in. × 21 ft. 3 in. The Metropolitan Museum of Art, New York. Gift of John S. Kennedy, 1897 (97.34).

formalism. These four categories are part philosophical (concerned with artistic intention), part historical (referring to official art movements), and part stylistic (based on recurring formal qualities and content). Used appropriately, they can help us understand diverse art forms. At the same time, it is important to remember that the best art, particularly in the modern era, often defies or transcends categories.

Expressionism: Unleashing the Emotions

As an approach to creating art, **expressionism** focuses on the exaggeration or distortion of natural forms for the purpose of expressing subjective feelings or psychological states. It is as prevalent in photography and film as it is in painting and sculpture. Vincent van Gogh was one of its originators. Recall how his *The Night Café* (1.12) and other works (1.14) exaggerate or distort the natural appearances of people and things for the purpose of emotional or psychological expression.

In the first decades of the twentieth century, the expressionist way of seeing and representing deeply affected Northern European artists, most centered in Germany, who collectively came to be called **German expressionists.** One of the earliest German expressionist groups, *Die Brücke* ("The Bridge"), originated in Dresden in 1905. Its leader, Ernst Ludwig Kirchner (1880–1938), used distortion and abstraction to convey his inner apprehension of life rather than his optical perception of it. *Die Brücke* artists pursued honesty of personal expression, especially with respect to life's darker and repressed sides, with missionary zeal. They declared that optical imitation of the physical world was insufficient to capture the "internal" truth of reality. In Kirchner's *The Red Cocotte* **(7.24),** begun in the first bloody year of World War I, a sexually alluring woman in glaring red is surrounded by faceless men in evening attire. Like a vortex, they whirl around her. The form of the work, even more than the subject matter, conveys its inner expression: a feeling of jittery glamour. Elongated, sharply angular shapes crash together.

7.24 ERNST LUDWIG KIRCHNER. *The Red Cocotte.* 1914. Pastel. 16⅛ × 12 in. Graphische Sammlung, Staatsgalerie, Stuttgart.

the science of the inner being. Northern European artists would be influenced by the theories of Sigmund Freud (1856–1939), Carl Gustav Jung (1875–1961), and other psychoanalytic practitioners. Expressionistic artworks representing the artist's internal perception of reality grew naturally in such soil.

Expressionism in Film The goals and methods of *Die Brücke* painters, printmakers, sculptors, and their colleagues were readily translated by expressionists who used film and photography as their media. The most notorious masterpiece of the German expressionist cinema, *The Cabinet of Dr. Caligari* **(7.25),** looks like a Kirchner painting come to life. (Many called it the first art film.) Its designer, Hermann Warm (1889–1976), a painter himself, actually conceived of the film as "a drawing brought to life." The sets, lighting, costumes, and makeup all adhere to the conventions of *Die Brücke* expressionism. Knifelike shapes pierce or cover the walls. Windows are asymmetric openings leading nowhere. Dramatic, artificial lighting creates shrill, dark-light contrasts and ominous shadows. Diagonal lines and zigzag patterns foster a feeling of unease. Space is alternately compressed or elongated, boxed in or elliptically stretched out. The design causes the eye to be ever moving and restless. The cinematography reinforces the nightmarish quality of set and story through the use of tilted camera angles, off-center circularly framed shots, and continuous movement. The editing style is jumpy, with scenes crashing into each other without smooth transition. Everything is askew, out of balance, insane.

The film's plot is as distorted and disturbing as the appearances of its characters and settings: The evil Dr. Caligari hypnotizes his innocent sleepwalking assistant, Cesare, to commit a series of brutal murders. Originally, the writers intended *The Cabinet of Dr. Caligari* to be a metaphor for Germany itself, a country in which power-mad leaders had cast a spell over the unsuspecting masses, leading them into the horrors of World War I and the doing of the society's dirty work. In keeping with leftist political theory and the cultural radicalism of the German expressionist art movement, the scriptwriters wanted to show poor Cesare forced to commit criminal acts under

The color is shrill, dashed down in anxious strokes. Pictorial space is shallow and flattened, with the blue-white ground beneath the figures tilted downward at a precarious angle. It is an unnatural mix that feels claustrophobic and dangerously unstable.

The social context out of which such works grew was big-city life, increasingly anonymous, nervous, and morally unrestrained, an unsettling world denounced by its critics as "a devourer of souls." As if to address this modern problem of unsettled souls, the scientific study of psychology emerged during this period. Developed largely by Austrian, German, and Swiss-German researchers, psychology is

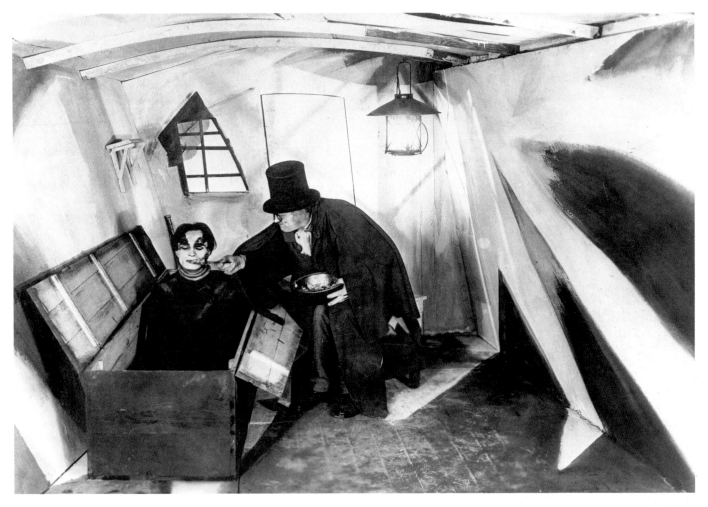

7.25 ROBERT WIENE. *The Cabinet of Dr. Caligari*, Dr. Caligari and his sleepwalking assistant, Cesare. 1919. Film still. Deda-Bioskop/ Erich Pommer. The Museum of Modern Art Film Stills Archive.

the demonic and corrupt figure of authority. Although the story was ultimately changed by the movie's profit-minded producer to eliminate any political sting, the style of the film nonetheless conveys the feeling of a world gone mad.

In *The Last Laugh* **(7.26)** by F. W. Murnau (1888–1931), completed in Germany in 1924, the theatrical set design of *The Cabinet of Dr. Caligari* is replaced by more naturalistic settings, but the probing of the inner being is just as acute. In the original story (again changed by a producer seeking profit, not controversy), a hotel doorman is stripped of the uniform of which he is so proud and demoted to the lowly rank of lavatory attendant. We are made to feel all of the doorman's inner turmoil. His humiliation, despair, and subsequent drunkenness are communicated through innovative camera work as well as masterly acting. So unusual

was the movement of the camera in *The Last Laugh* that the film was initially regarded by reviewers as a "cinematic curio." *The Last Laugh* pioneered the cinematographic approach that became known as **subjective camera,** the shooting of a scene as if it were seen through the eyes of a character in the film. In scenes in which the doorman reels drunkenly, the camera also wobbles and dives, and the surroundings spin in and out of focus. We literally see through the eyes of the doorman, becoming part of his inner world.

Expressionism in Photography Several decades later, the subjective camera of Sally Mann (born 1951) likewise illumined a psychological world, though in a different manner. Whereas the cinema tends to deal with fiction, Mann's photographs are grounded in facts, which she and her subjects bring to emotive

7.26 F. W. MURNAU. Two scenes from *The Last Laugh*, the drunken vision of the doorman. 1924. Film stills. UFA Films. Courtesy Filmmuseum, Munich.

cated story and sometimes we try to take on grand themes: anger, love, death, sensuality, and beauty. But we tell it all, without fear and without shame.[3]

Writing about *Candy Cigarette* **(7.27),** a favorite Mann photograph from the *Immediate Family* collection, artist Lavely Miller observes that, from a formal standpoint, the image moves lyrically from rich blacks to stark whites. This value contrast is what first captures her eye. From there the experience of the photograph evolves, as a slow narrative involving each of Mann's three children begins to spin. Miller writes:

> Jessie, around the age of seven, is in the middle looking directly at the camera in an unsmiling, almost worldly way that some very young people are able to convey, or at least have someone misconstrue. The white stick that she is holding between her fingers gives Jessie a kind of truant air, one that instantly becomes more complicated, sensual, and psychologically compelling once the photograph's title is revealed. Her sister Virginia stands beside with her back to the camera and her hands on her hips, looking at their brother Emmett on stilts, who is heavily blurred in the background. The scene being played out evokes the complexity of their youthful world: child's play coupled with seriousness, the sense of things innocent and casual commingled with the sensual and the worldly. "Thus the paradox," Mann notes. "We see the beauty and we see the dark side of things . . . like beauty tinged with sadness." This conflict produces an odd kind of vitality, just as the madman's despair reveals a beguiling discovery.[4]

As both collaborator and caregiver to her subjects, Miller concludes, Sally Mann has woven artistic intrigue into a relationship whose poignancy seems briefly captured in the moment her images reveal.

Surrealism: Visualizing Dreams and Fantasy

Surrealism emerged in the 1920s as an art movement committed to realizing the irrational world of the unconscious in literature and the visual arts. Its focus was on the imagination, dreams, hallucinations, and fantasies. For two decades, the surrealists formed an

life. Willing to explore darker undercurrents in the lives of her subjects (often the members of her immediate family), Mann brings emotional intensity and a narrative quality to each photograph she takes. As she relates in her book *Immediate Family*:

> When the good pictures come, we hope they tell truths, but truths "told slant," just as [poet] Emily Dickinson commanded. We are spinning a story of what it is to grow up. It is a compli-

7.27 SALLY MANN. *Candy Cigarette*. 1989. From *Immediate Family* collection. Photograph. © Sally Mann. Courtesy Edwynn Houk Gallery, New York.

identifiable group that often published and exhibited together. The wide range of their visual work encompassed diverse media and styles. Spanish painter Salvador Dalí (1904–1989) called his dreamscapes "hand-colored photographs" of the unconscious (17.25). Photographers and filmmakers, for their part, made equally important contributions to the surrealist movement.

Surrealist Photography Born in New York but spending much of his life in Paris, painter and photographer Man Ray (1890–1976) was the primary American in the surrealists' international circle. His association with the avant-

garde was lifelong. His close friendship with photographer Alfred Stieglitz (7.21) and frequent visits to Stieglitz's Gallery 291 in the early teens led to his active association, from the 1920s onward, with the European surrealists. His photomontages are surrealist flights of fantasy, combining parts of images from two or more negatives for development into a single final print. In *Le Violon d'Ingres (The Violin of Ingres)* **(7.28),** created in 1924, a nude woman, beautiful and exotically attired, is turned into a violin. The impossible in reality becomes possible in surreality, the world of dreams, fantasy, and the imagination. Like dreams themselves, this visual representation is pregnant with

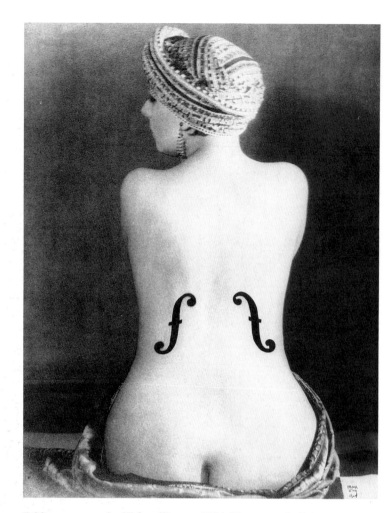

7.28 MAN RAY. *Le Violon d'Ingres*. 1924. Photograph. Private collection.

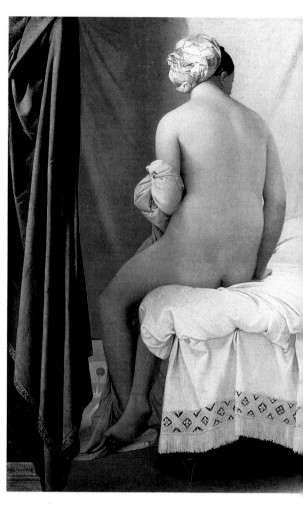

7.29 JEAN-AUGUSTE-DOMINIQUE INGRES. *The Bather of Valpinçon*. 1808. Oil on canvas. 56¾ × 38¼ in. Musée du Louvre, Paris.

multiple meanings. Cooly erotic, the woman maintains a degree of distance. With her back turned, she gazes slightly away from the viewer yet appears seductively aware of being viewed. She is indeed a sensual woman, but she is more. She is a violin—the violin of Ingres according to the title. Is she an enigma within a mystery?

The work's title refers to the nineteenth-century artist Ingres (1780–1867), renowned as a painter of exotic courtesans and sensual bathers. His paintings were much enjoyed by the bourgeois male public of his day. Is the woman in Man Ray's montage an instrument, like a sweet-toned violin, to be played upon by men of affairs? It would seem so. The turban the woman wears and the pose she assumes

are certainly references to paintings by Ingres, such as *The Bather of Valpinçon* (**7.29**). Ingres, a rather proper gentleman in the public domain, was reputed to be a good classical violinist. Ever irreverent, *Le Violon d'Ingres* simultaneously pokes fun at Ingres, his music, and his art. A second meaning of the work relates to Man Ray himself. The model for the work was the celebrated Kiki de Montparnasse, Ray's mistress in Paris for six tempestuous years. Was Kiki also Man Ray's violin, the instrument of his own life's song and art? Or was the exotic image conveyed by Kiki an unattainable fantasy, realizable only in art or dreams? Surrealist images can rarely be pinned down. Like dreams and fantasies, they inspire and are open to interpretation.

Lonely Metropolitan **(7.30)** is such an enigmatic image. It is a photomontage by Herbert Bayer (1900–1985), an Austrian who was a principal instructor at Germany's progressive Bauhaus school of art and design during the 1920s. Fleeing the Nazis in the 1930s, Bayer went on to become a famous graphic designer in the United States. In *Lonely Metropolitan,* two eyes, one light and one dark, with eyebrow-like forms above them, are superimposed on the palms of a pair of hands, one of which is dark and the other light. The sleeve beneath the lighter hand (containing the darker eye) is darker than its mate, one more irrational relationship in an image that nonetheless has an unsettling unity. Proportionally larger than the windows of the building on which they cast their shadows (proof of their reality?), the hands reach upward with their palms facing the picture plane. As we look at the image for a while, the hands become a face, a startling double image whose precise meaning eludes us.

The title of the montage refers to the general condition of urban loneliness, but the photo may also convey some of Bayer's own sense of alienation and foreboding. When the Bauhaus was closed by pro-Nazi authorities in 1933, Bayer's close-knit artistic community scattered. Perhaps echoing his experience, the setting in *Lonely Metropolitan* is desolate: two adjacent apartment buildings with no people in sight. The "lonely metropolitan" floats disconnected and rootless in space. The eyes seem to stare with a look that is hard and cold. And while no one rational meaning is possible, the image haunts the viewer. The static singular viewpoint of reproductive photography has given way to a dynamic multiplicity of views and meanings. The medium of photomontage, the artist notes, ". . . makes images of a surreal character, of the impossible and the invisible possible." The photomontage, Bayer says, "has been compared to a conquest of the irrational, it can express the hallucinations of dreams."

The great power of the photomontage to connect with the subliminal self has not gone unexploited. We see its general application everywhere: in contemporary photographs (7.43, Technique Box 7-B), attention-grabbing advertisements (6.18, 6.26), and music videos and feature films.

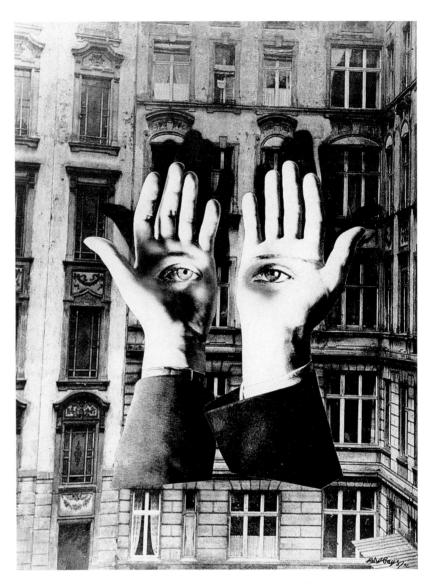

7.30 HERBERT BAYER. *Lonely Metropolitan.* 1932. Gelatin silver print. 13⅜ × 10½ in. Museum Folkwang, Essen, Germany.

Surreal Cinema In 1929, Salvador Dalí and Spanish film director Luis Buñuel (1900–1983) premiered the most famous surrealist film, *An Andalusian Dog (Un Chien Andalou)* **(7.31).** Like an extended dream, *An Andalusian Dog* is governed by non sequiturs, scenes that seem to be related but don't follow in any logical order from what preceded them. As in dreams, repressed content—sexual desires, tensions, and violence—rises to the fore. Film historian Gerald Mast describes the film:

> Despite the whiffs of consistent meaning, *An Andalusian Dog* is pure dream, irrational, a series of daring and imaginative vignettes with no rational paste between them. From the

7.31 LUIS BUÑUEL AND SALVADOR DALÍ. *An Andalusian Dog (Un Chien Andalou)*, slicing of a girl's eye with a razor. 1928. Film still. The Museum of Modern Art Film Stills Archive.

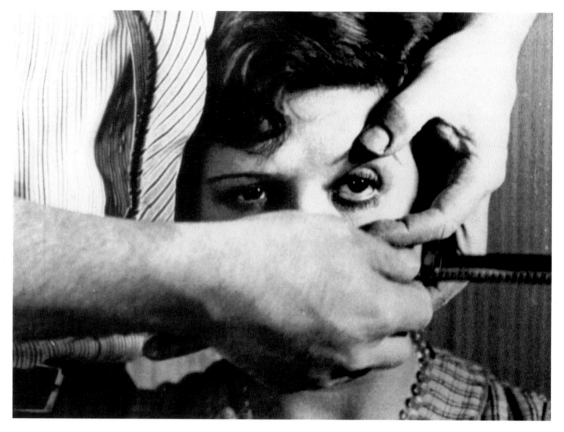

I want to look at any kind of reality: not just social reality, but also spiritual reality, metaphysical reality, anything man has inside of him. —Federico Fellini, film director, transcript of a radio interview, 1959

opening sequence in which Buñuel slits a lady's eyeball with a razor (in intentionally gruesome close-up) to the final one in which the man and woman wander inexplicably on a rocky beach "in the springtime," the film's goal is to excite, to shock, to tickle, to surprise, to make us "see" differently rather than to preach or explain.[5]

Learning from the surrealist legacy, noted directors such as Federico Fellini (1921–1993) of Italy, Ingmar Bergman (born 1918) of Sweden, and Akira Kurosawa (1910–1998) of Japan (4.15) transport viewers beyond external reality to the inner worlds of their protagonists— into their memories, dreams, fantasies, and spiritual realities.

Fellini's 1963 masterpiece *8½* **(7.32)**, a loosely autobiographical story of his private and professional life, centers on the making of a film. In *8½* we glimpse Fellini's world through the eyes of the movie's central character, the film director Guido. We experience Guido's world fully, both the objective social reality of his public life and the hidden subjective reality. We see this inner world through Guido's flashbacks, daydreams, and nocturnal dreams. The viewer comes face to face with an internal universe that is every bit as real as the film director's physical and social reality. As Guido shoots the film within the film, memories and dreams flood his consciousness— memories of his guilt-ridden socialization in a repressive Catholic school, recollections of his childhood sins and of his disappointed mother and absent father, dream visions of stern saints and voluptuous prostitutes and of his present wife and his former girlfriend. Because dreams and memories permeate Guido's life (as they do our own lives), *8½* interweaves "surreality" and "reality" so tightly that it is often difficult for the viewer to know where psychic reality ends and waking reality begins.

Social Realism: The Documentation of Society

Expressionism and surrealism make subjective inner reality visible. **Realism** represents external reality in all its diverse forms, and **social**

7.32 FEDERICO FELLINI. *8½*, the film director Guido among his memories and fantasies. 1963. Film still. Angelo Rizzoli.

realism focuses on the social dimension of reality. Social realists aim to illuminate the human and physical dimension of daily existence. In India, photographer Raghu Rai (born 1942) documented the lives of everyday people. His photographic book on the Taj Mahal combines social realism with potent symbolism to capture the life of this world-famous tomb (13.33) and the common people who live in its environs. Writing about the book's photos, Indian artist Asit Poddar observes that the timeless quality of the Taj Mahal has been subtly hinted at and contrasted with the mortality of man. "Rai's photograph shows the Taj to be a famous silent witness to generation after generation of nameless Indians living, working, and dying in its vicinity." Building on the legacy of Raghu Rai, photographer Ian Berry (born 1934) focuses his camera on the contrast between the sweaty worklife of an anonymous Indian boatman and the transcendent vision of heaven on earth that the Taj Mahal presents to the world **(7.33).**

Ian Berry and Raghu Rai clearly empathize with the poor and implicitly hope for their social betterment. While not an overt call for political reform, Berry's photograph is a social mirror that brings to light the lives of nameless Indians we might never know about or, as tourists or art lovers focusing on the Taj, might consciously ignore.

Social realist photographers, filmmakers, creators of video documentaries, painters, and sculptors share the broad goal of helping humanity and society see itself, but with a political twist. Social realism has always had an ideological orientation toward the goals of the political left. Its goal is to document the trials and triumphs of the common people, the underprivileged, and the oppressed.

In Western society, the imagery of social realists has tended to honor working-class people and expose social injustice in order to promote political reform. It comes as no surprise, therefore, that social realism evolved into a full-scale art movement in the United States during the catastrophic years of the Great Depression of the 1930s. Socially concerned artists, working in a variety of styles and media—the paintings of Jacob Lawrence are one example (18.6)—sought to bear witness to

7.33 IAN BERRY. *Boatman on the River Jumma across from the Taj Mahal at Dawn.* 1992. Photograph. Ian Berry/Magnum Photos.

poverty, unemployment, drought, hunger, and homelessness. These artists were often financially supported in their task by the federal government.

Social-Realist Photography It was in this context that the Historical Section of the Farm Securities Administration, known popularly as the F.S.A. project, got under way. Headed by Roy Stryker (1893–1976), a former teacher in the Department of Economics at Columbia University, the project brought together a gifted group of photographers, including Dorothea Lange (1895–1965) and Arthur Rothstein (born 1915). Their immediate job was to document the working and living conditions of displaced farmers who had suffered the double disaster of economic depression and drought and, when possible, to portray the more positive aspects of rural life. Their photographs have given us a lasting image of the

Depression and its great underclass. These photographers, more than any other group of artists, made visible the suffering and injustice experienced by the displaced and unemployed, stirring government legislators and the more affluent public to relieve their plight.

Although the F.S.A. photographers used different approaches to produce their portraits of the period, all the images, in the end, shared one crucial quality: documentary truthfulness. Some of the portraits were posed—"fakery in the service of truth," as a documentary filmmaker put it. Others, like Rothstein's *Fleeing a Dust Storm, Cimarron County, Oklahoma* **(7.34)**, were candid snapshots of unposed immediacy.

Of all the many compelling images recorded, some 270,000 in all, one of the most famous is Dorothea Lange's *Migrant Mother* **(7.35)**, taken in 1936. The F.S.A. project head called Dorothea Lange "the supreme humanist"

7.34 ARTHUR ROTHSTEIN. *Fleeing a Dust Storm, Cimarron County, Oklahoma.* 1937. Gelatin silver print. Library of Congress, Washington, D.C.

7.35 DOROTHEA LANGE. *Migrant Mother, Nipomo, California.* 1936. Library of Congress, Washington, D.C. *Why do you think the government no longer sponsors photo-documentary projects like the F.S.A., which chronicled the lives of the unemployed, homeless, and oppressed during the Depression? Is the government simply not interested in such documentary photography, or have other media and institutions taken over this function?*

and considered her *Migrant Mother* to be the single picture that best symbolized the concern of the Roosevelt administration for displaced farmers and their families. This is how Lange recalls meeting Florence Thompson and her young daughters, the subjects of the photograph:

It was raining, the camera bags were packed, and I had on the seat beside me in the car the results of my long trip, the box containing all those rolls and packs of exposed film ready to mail back to Washington. It was a time of relief. Sixty-five miles an hour for seven hours would get me home to my family that night, and my eyes were glued to the wet and gleaming highway that stretched out ahead. I felt freed, for I could lift my mind off my job and think of home.

I was on my way and barely saw a crude sign with pointing arrow which flashed by at the side of the road, saying PEA-PICKERS CAMP. But out of the corner of my eye, I *did* see it.

Having well convinced myself for 20 miles that I could continue on, I did the opposite. Almost without realizing what I was doing, I made a U-turn on the empty highway. I went back those 20 miles and turned off the highway at that sign, PEA-PICKERS CAMP.

I was following instinct, not reason; I drove into that wet soggy camp and parked my car like a homing pigeon.

I saw and approached the hungry and desperate mother, as if drawn by a magnet. I do not remember how I explained my presence or my camera to her, but I do remember she asked me no questions. . . . She told me her age, that she was 32. She said that they had been living on frozen vegetables from the surrounding fields, and birds that the children killed. She had just sold the tires from her car to buy food. There she sat in that lean-to tent with her children huddled around her, and seemed to know that my pictures might help her, and so she helped me. . . .[6]

In recent decades, artists have built upon the legacy of the Depression Era social realists to focus more fully on the natural environment and its abuse by humanity. Ansel Adams (1902–1984) campaigned for the safeguarding of the natural world and contributed his photographs to the Sierra Club, an international environmental organization, for their use in calendars, publicity, and fundraising (Appreci-

ation 8). Since 1999, photographer Scott Jost (born 1962) has centered his work on a small stream that passes through Harrisonburg, Virginia, a city of 40,000 in the rural Shenandoah Valley. Blacks Run winds through the central business district, industrial zones, and outlying farmlands, eventually joining a system of rivers that empties into the Chesapeake Bay. Organized in both art exhibit and book formats—each visual accompanied by extensive text—Jost's photo essay "Blacks Run: An American Stream" **(7.36)** directs our attention to environmental damage and the complex interface of humanity and nature. Leaking sewer lines, street runoff, and human dumping and littering have poisoned the water and destroyed marine life. Documenting such damaged ecologies often leads environmentally conscious artists to activism. Jost, for instance, has been working with a local citizens' group to create a greenway park along the stream.

Social Realism in Film Hard times, whether the result of depression, war, political oppression, or ecological devastation, seem to elicit in certain artists a social-realist response. In cinema, this impulse has been the impetus for masterpieces worldwide. Some of these films may even have helped improve the health of people's lives and the environment (4.15).

The award-winning film *Yol* (*The Way*) (1982), written and directed by Turkey's Yilmaz Guney (1937–1984), is one such masterpiece **(7.37)**. *Yol* recounts the heart-rending experiences of a handful of inmates in a Turkish prison. We travel with them from prison on a week's leave to their homes in different parts of the country. Experiencing reality from the inmates' point of view, we come to empathize with their plight. As individuals, the prisoners are as culturally diverse as Turkey itself, but all are victimized by common conditions of social injustice. Guney wrote the film during his own imprisonment for his antigovernment political views. Upon release from prison, he fled abroad to France to make yet another film and to communicate his insights to the world. As a wrenching social portrait of the country, *Yol* was condemned by the authorities and banned from all Turkish movie theaters. However, the film played in small movie houses around the world, stirring individuals, groups, and governments

As an artist, I work as a modern-day explorer, traveling through damaged landscapes close to my home, collecting images and stories and creating art work to be exhibited in my community. The art work is meant to provide a place to begin serious discussion about revitalizing these local landscapes. —Scott Jost, photographer, *Blacks Run: An American Stream*, 1999

a b

7.36 a & b. SCOTT JOST. *Blacks Run: An American Stream.* 1999. Gelatin silver prints. Each 9 × 13¼ in.

7.37 YILMAZ GUNEY. *Yol (The Way).* The prisoners receive a week's leave to visit their families. 1982. Film still. Cactus/Maran/Triumph Films. The Museum of Modern Art Film Stills Archive.

7.38 STEVEN SPIEL-BERG. *Schindler's List.* 1993. Film still. Working desperately to save his workers' daughters from Auschwitz-Birkenau death camp, German industrialist Oskar Schindler (Liam Neeson, left) convinces an SS guard that the children's small hands are needed to polish the inside of artillery shell casings.

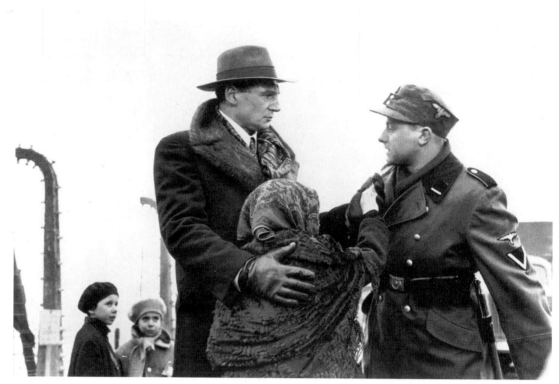

. . . the camera's innate honesty . . . provides the photographer with a means of looking deeply into the nature of things, and presenting his subjects in terms of their basic reality. It enables him to reveal the essence of what lies before his lens with such clear insight that the beholder may find the re-created image more real and comprehensible than the actual object.
—Edward Weston, photographer, *The Complete Photographer,* 1943

to pressure Turkish leaders to improve human rights and social conditions.

In 1993, *Schindler's List* **(7.38),** by American director Steven Spielberg (born 1947), dispelled the stereotypic film image of World War II Germany as absolute, anti-Semitic evil. Spielberg's film etched in viewers' minds the horrors of the Holocaust while portraying a courageous German who, against tremendous odds, saved Jewish lives. The revelation of such hard, complex truths is an achievement of social-realist cinema.

Formalism: Emphasis on Visual Form

All photographs, films, and video works are really "formalist" to a substantial degree in that, above and beyond the choice of subject matter, each work requires innumerable formal decisions: about lighting (natural, artificial, high or low contrast), definition ("soft" or "sharp" focus), texture ("smooth" or "grainy"), framing (close-up, medium shot, wide angle), editing (fast-paced, leisurely or accelerating rhythms), and so forth. A film classic like *Citizen Kane,* for example, is the product of innumerable formal decisions made by a host of individuals working on their own and in

collaboration **(Appreciation 14).** Most of the finest media creations of social realism, expressionism, and surrealism are expressive, evocative, or communicative because they are effective from a formal standpoint. Only through articulate use of the language of visual form does the artist's subject (for instance, an everyday event, an emotional state, or a fantasy) come alive.

Most often in works of art, a balance is struck between the concerns of form and subject. However, in certain works, especially in the modern period, formal concerns outweigh or even eclipse social or psychological ones. An artist of strong formalist persuasion does not view or portray a subject—a person, a factory, or a flower—in terms of its social or psychological meanings but rather in terms of its abstract visual qualities. Drawing on the formalist sensibility, photographers like Edward Weston (1886–1958), Charles Sheeler (1883–1965), Aaron Siskind (1903–1991), Margaret Bourke-White (1904–1971) and, more recently, Robert Mapplethorpe (1946–1989) came to love and look for significant form in the world around them. Controversial for his blatantly sadomasochistic "sex pictures,"

7.39 EDWARD WESTON. *Artichoke, Halved.* 1930. Gelatin silver print. © 1981 Center for Creative Photography, Arizona Board of Regents, Tucson, Arizona.

whose intention was to shock, Mapplethorpe was a formalist in the refined abstraction of his flower still lifes (2.28) and of many of his nudes. In Weston's photographs, all forms of physical reality—a nude, the California seacoast, a vegetable—take on an extraordinary, highly abstract, quality. Commonplace subject matter undergoes an aesthetic transformation. A halved artichoke, in extreme close-up view, ceases to be an artichoke and becomes instead a fascinating play of light, texture, and shape **(7.39)**. The same holds true for Siskind's close-up views, in which fragments of a building or sandy beach become wondrous abstract compositions **(7.40)**. On a far larger scale, Sheeler's paintings and photo-graphs strip industrial architecture and design of their usual economic, social, and psychological associations. In his impressive images of machinery, Sheeler emphasizes the artistic interplay of smooth surfaces, clean lines, geometric shapes, and light-dark value contrasts. Much the same holds true for Margaret Bourke-White's pictures of a commanding industrial landscape **(7.41),** many featured in *Life* magazine, which emphasize monumental, boldly simplified shapes and compositions of abstract beauty.

Bourke-White's and Sheeler's abstract, formalist vision of industry stands in sharp contrast to that of a social-realist or an expressionist artist dealing with the same subject. In *Smoky*

7.40 AARON SISKIND. *Untitled*. New York. 1944. Gelatin silver print. © Aaron Siskind Foundation. Courtesy Robert Mann Gallery. *Many artists use the title* Untitled *if they want the viewer to focus primarily on the artwork's form instead of its subject. If Siskind had called his photograph "Crumbling City Wall," might viewers have interpreted the work from a social-realist as opposed to a formalist perspective? Might they have created stories about the wall or interpreted it in symbolic or metaphoric terms?*

7.41 MARGARET BOURKE-WHITE. *Fort Peck Dam on the Missouri River*. 1936. Photograph. *Note the tiny human figures at the bottom of the photo. Analyze how the photographer manipulates formal means such as scale, camera angle, positive shape and negative space, repetition, light and dark to convey her content and message.*

City **(7.42),** for instance, social realist W. Eugene Smith (1918–1978) conveys his message about harmful industrial pollution loud and clear. Clouds of smoke overwhelm the factory and the city beyond. Bourke-White's impressive industrial surfaces, clean lines, and attractive shapes have disappeared under a dirty veil we know to be pollution. The social statement of *Smoky City* is so strong that it renders a purely formalist appreciation almost impossible **(Interaction Box).**

NEW MEDIA AND MASS MEDIA: RELATIONSHIPS IN FORM AND CONTENT

Since the second half of the twentieth century, both traditional art media such as painting and sculpture and the newer media of photography, film, and video have developed a dynamic relationship with the commercial mass media. Just as numerous painters, printmakers, collagists, and sculptors now draw upon mass-media images and styles, new-media artists such as Barbara Kruger, Michael Brodsky, Nam June Paik, and Cindy Sherman mine the form and content of popular mass-media culture. Others, such as Bill Viola and Eliot Cohen, produce highly individualistic

7.42 W. EUGENE SMITH. *Smoky City* (*Untitled*, from *Pittsburgh* series). 1955–56. © The Estate of W. Eugene Smith/Black Star.

7.43 BARBARA KRUGER. (Untitled). We Won't Play Nature to Your Culture. 1983. Photomontage. 73 × 49 in. Courtesy the Institute of Contemporary Arts, London; the Kunsthalle, Basel; and Mary Boone Gallery, New York.

woman, her eyes covered by leaves, fills three-quarters of the picture frame. The background appears to be a blurred natural landscape. The woman's head is upside down and tilted diagonally. The viewer towers above her in a dominating position of power. Dramatically posed and lit, this image works in the same way that a perfume advertisement or a traditional oil painting of an alluring nude (7.29, 6.27) might: by employing the stereotype of a beautiful, mysterious, sensual woman who attracts and then fulfills a man's desires. The addition of text makes the work more specifically a feminist critique. Women are stereotypically associated with nature (for instance, with fertility, sensuality, the irrational, mystery), whereas men are stereotypically associated with culture (for instance, with concepts, skills, instruments, institutions, ideologies). Men conquer and employ nature for their own uses. In total, Kruger's work is a defiant statement: Women, long governed by the restrictive stereotype of "nature," will no longer "play nature to your culture."

Whereas Kruger reworks newspaper and magazine imagery, California-born photographer Michael Brodsky (born 1953) records images directly from the television screen, transferring TV images to a computer graphics program that converts the images into a digital dot-matrix format. Brodsky then employs the endless possibilities for computerized image manipulation to create his final pictures **(Technique Box 7-B).** Looking like a cross between a traditional photograph and a digital computer image, Brodsky's "digital photographs" comment wryly on the form and content of the media he explores. Images such as *Power/Poise* **(7.44)** prompt us to think about our relationship to the mass media that portray, distort, and condition us. They also encourage us to consider our role as individuals in a world shaped by mechanical and electronic media.

From engaging in intimate inner journeys to tackling vast social and cultural issues, video artists are on the cutting edge of a revolution in artistic form and content. In the 1960s, Korean-born Nam June Paik (born 1932) helped launch the growing field of video art with all its diverse applications. A video artist of extraordinary range, he often incorporates scores of television sets and

artworks through video and computer technologies usually associated with mass-media applications.

New York City–based Barbara Kruger (born 1945) appropriates images from newspapers and magazines. She then takes apart and transforms the original meaning of the images, adding text, to make forceful comments on media and cultural stereotypes. On a strictly visual level, Kruger's large black-and-white photomontage *We Won't Play Nature to Your Culture* **(7.43)** is startling and surreal. Like successful mass-media advertisements, it grabs our attention. The head of an attractive young

TECHNIQUE BOX 7-B

DIGITAL IMAGE CREATION

Three basic stages are involved in digital or electronic image creation: picture capture, editing, and printing. Picture capture can be done directly with digital cameras that record the image in digitized "pixel" (point) form. Scanners can also convert existing images in print or on film into pixels for computer use.

Editing digital image files requires a computer software program such as Adobe® Photoshop, which offers a wide range of tools and features. It allows pieces of a photograph to be selected and treated as unique elements. It also uses transparency, allowing images to be superimposed, layered, and merged in unique ways. Image elements can be freely moved around the picture and can be positioned either in front of or behind other elements. The final digital picture can be printed on any printer connected to a computer.

Artist Eliot Cohen (born 1947) describes the process by which he created the electronic photo collage *Muybridge Fantasy*:

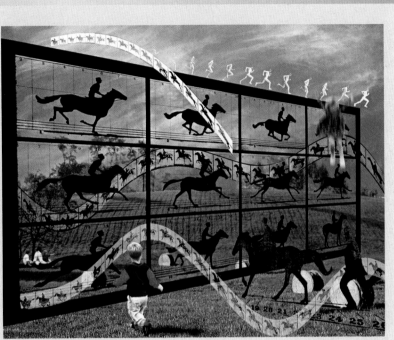

This piece **[Fig. A]** *is made from ten separate elements. There are three landscape components including the foreground with hay bales, the middle ground or hillside, and the sky. They were chosen to make a unified space for the composite picture. There are three separate horse and rider sequences derived from the classic photographic studies of animal and human locomotion by Eadweard Muybridge [7.17] and one Muybridge photo in the foreground. And there are three contemporary pictures of children or families.*

I wanted a foreground with identifiable objects and the round haystacks seemed appropriate. Using a Photoshop paintbrush tool I blended that foreground with the small hillside in the middle of the scene until they "fit" nicely together. The sky above the hill in the

original image was actually very plain and almost gray. I replaced it with a bluer one through more of Photoshop's blending options. All the Muybridge photographs have been dramatically altered. I removed the original solid white background behind each horse and rider on the large Muybridge panel and replaced it with transparent areas that reveal the landscape behind. The narrower ribbon-like sequences come from a grid of twenty photographs like the large panel. The contemporary figures were selected from other photographs and placed in their new locations in the digital composite.

This picture took many hours to create. As an artist, I am excited by the potential of electronic technology to enhance and expand the way that I work. The process is one that combines attention to fine details with a playful approach to creating the work.

video images in a single piece. Yet one of his most powerful and evocative works, *TV Buddha* **(7.45),** is also one of his simplest. In a kind of three-dimensional mini-environment, a video camera captures and records a traditional statue of the seated Buddha. The revered religious figure silently observes himself on the television monitor. In ancient times, sculptures of Buddha were carved out of mountainsides or cliffs, or placed in shrines (3.14), and pilgrims meditated before the religious figure. Here the television has become the shrine, and the Buddha gazes upon it—a stereotypic TV viewer, transfixed, mesmerized, lost to the world. Television, the piece seems to be saying, is our new form of meditation and

Since the early 1960s, Paik has manipulated television—its images and its physical apparatus—in almost every imaginable way: reconfiguring its electronic signal, emptying it of its circuitry, filling it with different artifacts, and fashioning it into sculptural arrangements. . . . His performances and video works are characterized by satire and an almost reckless will to defy convention. . . . —Matthew Drutt, writer, Mediascape, 1996

7.44 MICHAEL BRODSKY. *Power/Poise*. 1990. Laser digital silver print. Courtesy of the artist.

7.45 NAM JUNE PAIK. *TV Buddha*. 1974. Mixed media. 55 × 115 × 36 in. Stedelijik Museum, Amsterdam.

worship, divorcing us from the everyday world and hypnotizing us into a mindless, "mediated" state. TV's influence is so great, Paik's installation implies, that it has even made a convert of the Buddha.

Video artist Bill Viola (born 1951) is often the central participant in his own works. Viola's wide-ranging videos deal with personal, social, and metaphysical themes: the loss of a loved one; existence in a fragmented, technocratic society; death and rebirth. In a nineteen-minute piece, *Reasons for Knocking at an Empty House*, created in 1983, Viola records his attempt to stay awake continuously for three days while confined to a single upstairs room in an empty house. Recordings, made regularly day and night from a fixed camera position, chronicled the artist's responses to the relentless passage of time. Viola's 1996 *The Crossing* **(7.46)** is surreal, visually complex, and dependent on sophisticated special effects. A large, double-sided projection screen stands in the middle of a darkened room. On one screen a man (Viola) slowly approaches from a great distance through a dark space. Stopping immediately before us, the man stands still and is gradually consumed by a roaring fire that rises

a

b

7.46 BILL VIOLA. *The Crossing.* 1996. Video/sound installation; consists of two pictures, one of fire **(a)** and one of water **(b)**. Collection: Edition 1, Collection of the Solomon R. Guggenheim Museum, New York, gift of The Bohen Foundation. Edition 2, Collection of Pamela and Richard Kramlich, San Francisco. Edition 3, Dallas Museum of Art, Texas. Photo: Kira Perov.

from the ground. He disappears without a trace as the conflagration slowly dies away. On the other side of the screen, the same man is deluged by a cascade of blue water and likewise disappears as the falling water recedes. Nothing but silent darkness remains on either screen. The video then recycles, and the scenes, in perfect synchronization, repeat. Viola speaks of *The Crossing* as combining or "crossing" the ideas of destruction and annihilation with purification, liberation, and transcendence. Whatever the viewer determines to be the final meaning of the piece, the two sequences astonish with their visual imagery and sound effects of fire and water.

Finally, let us look at an artist who has been strongly influenced by both commercial television and film. In the late 1970s, Cindy Sherman (born 1954) created an extensive series of black-and-white 8-by-10-inch "untitled film stills." To create *Untitled Film Still #35* **(7.47)**, Sherman became a one-woman movie crew: She scripted the part, produced the set and lighting, costumed and posed herself, directed the photographic process, and then saw to the development and editing of the final print. Her "film still" photographs portray and question many of the stereotypical roles, from housewife to sex goddess, to which women have been subjected in mass-market films and television programs and commercials.

THE CHANGING MEANING OF ART IN AN AGE OF MASS MEDIA

In the age of mass media, the meaning and function of fine art itself have changed. Photography, film, and television have taken over centuries-old functions previously performed by painting and sculpture. Simultaneously, the fine art in our galleries and museums has taken on new functions. As art critic Robert Hughes writes, there seems to be general recognition that, in a showdown between fine art and mass media, fine art cannot compete on equal terms. Museum art "cannot be as vivid, as far-reaching, as powerfully iconic as TV or print [newspapers, magazines, posters]." The hope that painting (7.23) and sculpture (7.1) might recover their pre-twentieth-century stature as dominant cultural forms, educating large portions of the public in moral, political, historical, religious, and intellectual matters, has been washed away by tidal waves of photographs, films, and video programs. "People," writes Hughes, "believe what they see in photos, on the movie screen, or perhaps on the TV set, but few would even claim to extract the moral and factual information for the conduct of their lives from looking at works of art [as was the case prior to the twentieth century]." This does not mean that

Viola's images absorb the viewer in the "logic" of their associative combinations. . . . His works demand the viewer's immersion into their process of flux, invoking continuous change with hypnotic intensity.
—Ursule Frohne, writer, *Mediascape, 1996*

7.47 CINDY SHERMAN. *Untitled Film Still #35.* 1979. Photograph. 10 × 8 in. Courtesy the artist and Metro Pictures.

tion in the way we experience art. This is the premise of Benjamin's influential essay "The Work of Art in the Age of Mechanical Reproduction." The new media, Benjamin writes, have made the reproduction—as opposed to the original—the dominant form of art experience in our time. Our primary experience of art is increasingly through copies we see in books, prints, slides, posters, and postcards, as well as in film, television, and computer programs on art and artists. We have reached the point at which the copy has gained de facto supremacy over the original and "mediated" experience has won out over direct, "immediate" experience of original artworks. Some even argue that contemporary viewers have actually grown to prefer photographed, filmed, televised, or computerized images of art to the art object itself.

There are both advantages and disadvantages to living in an age of mass reproduction. One advantage is that rare works are made available to millions of people at affordable cost in their homes. In this sense, the experience of fine art has been democratized. On the negative side of the ledger, the sheer glut of reproduced images tends to create sensory overload and information overdose, conditions that short-circuit the active thought and concentrated feeling essential to meaningful appreciation. Add to this the distortion factor: Reproductions alter the scale, physical sense, and context of the work and, all too often, trivialize its authority. For example, Michelangelo's tortured, larger-than-life *Pietà* (8.40) is squeezed within the printed titles on a compact disc cover with "*MESSIAH* HIGHLIGHTS" above and "HANDEL" (the composer's name) below. Or the figure of Christ might be extracted from the gathering of the twelve apostles in Leonardo da Vinci's *The Last Supper* (2.18), a wall painting 15 feet high and almost 29 feet long, and then converted into the central image on an 8-by-11-inch color print, a 4-by-6-inch greeting card, or a 3-by-5-inch postcard. It might metamorphose into a 21-inch digitized television image or assume vast proportions on a huge movie screen. Leonardo da Vinci's renowned *Mona Lisa* might become the main image on an album cover, book cover, or newspaper advertisement **(7.48)**. It might even walk down the street as a photo-silkscreened T-shirt image on

traditional fine art is without cultural importance. In fact, Hughes affirms the increasingly crucial role of art as "an arena of free thought and unregimented feeling." But it does mean that the status, meaning, and influence of the older media in our society have changed forever.

Besides having an impact on the creators of all forms of art, the new media have exercised enormous influence on the way the viewing public appreciates art. Photographic reproductive processes, argues theorist Walter Benjamin (1892–1940), have wrought a full-scale revolu-

somebody's chest—certainly a far cry from the experience of the original.

In our mass-mediated culture, video, cinematic, and photographic reproductions (including this book) have become the principal way we experience art. Our art history and appreciation classes are based almost exclusively on the experience of reproductions. Even our art museums, which house the originals, are becoming dominated by reproductions; visitors often spend as much or more time browsing in the museum's bookstore and gift shop than viewing the original works. These commercial outlets have become increasingly popular as mini-museums of collectible art reproductions in the form of posters, prints, stationery, postcards, calendars, date books, wrapping paper, shopping bags, and clothing. Museum auditoriums are filled with visitors watching films or videos about artists and artworks featured in the museum's collection. Some of these films, with screen stars in the leading roles, also show in the major movie houses with mass-market consequences. Replacing the very artists they simulate **(7.49)**, actor Jeffrey Wright becomes our image of Jean-Michel Basquiat and David Bowie our image of Andy Warhol.

In an age in which photography, film, and video have burst the walls of once exclusive museum and private collections, art has lost its traditional preserve. "For the first time ever," writes critic John Berger, "images of art have become ephemeral, ubiquitous, insubstantial, available, valueless, free. . . . They surround us in the same way language surrounds us. They have entered the mainstream of life over which they no longer, in themselves, have power."

From cave to cathedral to country estate to, most recently, the public museum, the visual arts have always existed within and been created for a certain physical and cultural context. Now the images of original paintings and sculptures, as well as the images of fine-art photographs, films, and videos, float freely, like atoms in space, waiting to find a home and meaning. The proliferation of mass-mediated imagery might represent the ultimate in the distortion or overproduction of art, or it could represent a high point in cultural democracy: art available to all. It all depends on the seriousness with which we attend to our present

7.48 Mona Lisa advertisement. 1989. Stephen Hawley Martin & Company.

7.49 JULIAN SCHNABEL, director. *Basquiat*. 1996. Film still. *Artists Jean-Michel Basquiat (Jeffrey Wright), Andy Warhol (David Bowie), and Julian Schnabel (Gary Oldman), and art dealer Bruno Bischof berger (Dennis Hopper) pose for the camera.*

world(s) of art. It is up to us, through our thoughts, feelings, and study, to give context and meaning to the free-flowing art images that surround us.

In evolutionary terms, the "new media" of photography, film, and video have been a long time in coming. Along the way, and in their current forms, these new media have changed the course of art, the process of art appreciation, and the viewers of art themselves.

Who Made *Citizen Kane?*

WENDELL FUQUA

*C*itizen Kane (RKO, 1941) is one of those "ten" films: Ten Most Influential, World's Ten Best, Top Ten American Films, Critics' Top Ten Picks, and so forth. It's an "important" film.

Now, ask any film buff this question: "Who made *Citizen Kane?*" You'll get a condescending stare and the reply, "Orson Welles, of course." Not to denigrate Welles (who ranks in a lot of "ten" lists himself and was an "important" director), but wait a minute. Wait a minute! Film is a collaborative medium.

I repeat, *film is a collaborative medium.* Michelangelo may have painted the Sistine Chapel all by himself, but *Citizen Kane*—the story of the rise and fall of a power-obsessed newspaper publisher—did not leap full blown form the head and hands of Orson Welles.

First of all, Welles had a screenwriter: Hermann J. Mankiewicz. It's not clear whether Mankiewicz or Welles came up with the original idea for *Kane,* but it is clear that Mankiewicz, a veteran Hollywood writer, wrote the first drafts and gave the story its basic shape. For instance, Mankiewicz is credited with the wonderfully gothic beginning **(Fig. A)** as well as the newsreel segment that introduces Charles Foster Kane to the viewer. Welles, on the other hand, penciled in much of the visual glitter. To Welles belongs the "breakfast montage" in which we see Kane age nine years and destroy his first marriage **(Figs. B, C, D, E).** The whole sequence, showing Kane and his wife at a breakfast table, takes about a minute of screen time. It's nifty, but it's not the entire script.

In addition to a screenwriter, Welles also had a cinematographer, a brilliant one: Gregg Toland. A great deal of the inspiration for the deep-focus photography in *Kane* came from Toland, who had experimented with the effect in his last two films. In the expressionistic *The Longest Voyage* and in the brooding *Wuthering Heights* (for which Toland won an Academy

Figure A Film still from *Citizen Kane* movie. The gothic view of Kane's mansion, Xanadu, in opening of the movie.

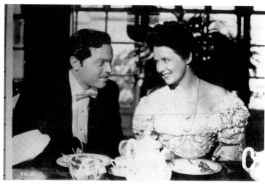

Figure B Breakfast montage. Kane and young bride.

Wendell Fuqua is a freelance writer specializing in film and audiovisual productions. He is based in San Antonio, Texas.

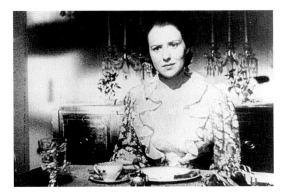

Figure C Midmarriage, the romance has faded.

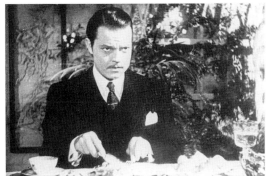

Figure D Kane no longer sits with his wife.

Figure E End of breakfast montage. Longer view of breakfast table, the Kanes at each end of the table.

Figure F Kane's symbolic walk into solitude in his mansion.

Figure G Kane's obsession with power.

Award), we can see many of the stylistic elements Toland brought to *Kane*. So when Kane takes his famous walk to reclusion, getting smaller and smaller as he retreats down a vast hall of mirrors **(Fig. F),** we have to wonder: how much credit goes to Welles; how much to Toland? Or, after Kane loses the gubernatorial election and argues heatedly with his friend, Leland, whose idea was it—Welles's or Toland's?—to place the camera in a hole in the floor so that Kane would look huge, dominating, inflated **(Fig. G)?**

continued

Figure H Kane with Teddy Roosevelt in the newsreel footage.

Figure I The opera set—huge spectacle.

Like the cinematography, the editing of *Kane* is exceptional, in large part due to the efforts of the film's editor, Robert Wise. Wise manipulated the opening "newsreel" footage to simulate actual news film footage gathered over many years from many sources **(Fig. H).** Wise even scratched some of the footage to make it look authentic. Wise also put together the montage depicting the opera tour of Kane's weak-voiced mistress and second wife, Susan Alexander **(Fig. I).** Wise cleverly ended the sequence with the image of a stage light as it fades out, a visual metaphor for Susan's career. Wise also inserted the sound transitions—which Welles called "lightning mixes"—that allowed for the rapid depiction of the passage of time. In one brief sequence, Kane grows from childhood to adulthood: In the first scene, his guardian tells Kane, "Merry Christmas"; in the second scene, the same man completes the sentence fifteen years later, saying, ". . . and a Happy New Year." Welles's idea? Perhaps. Welles did have an extensive background in radio, but he was away on a speaking tour for much of the editing period.

Two other people contributed greatly to *Citizen Kane*: the composer, Bernard Herrmann, and the art director, Van Nest Polglase. What would the movie be like without the funereal opening music or the band music that punctuates Kane's blindly ambitious political campaign? What would the movie be like without the imposing sets for Kane's gargantuan pleasure palace, Xanadu? How much credit for the music and sets belongs to Welles? How much to Hermann and Polglase?

All this commentary is not meant to take away from Welles's genius as a filmmaker. But it does dispute the *auteur* theory: that movies are made by one person, the director. Movie making is a group effort. Everyone contributes. *Jaws* may be a Steven Spielberg movie, but Peter Benchley wrote the story, and John Williams, the composer, gave us the unforgettable music that we hear in our heads every time we swim in the ocean. *Fanny and Alexander* may be Ingmar Bergman's most beautiful film, but would it even have been "Bergman" without the cinematography of Sven Nykvist?

When the credits roll, let's give credit where credit is due. ■

PART
THREE

THE THREE-DIMENSIONAL ARTS

8

Sculpture

A FOUNDATION OF THE THREE-DIMENSIONAL ARTS

What do the statue in the city square, the building you reside in, the chair you sit on, the computer you work at, and the cup you drink from have in common? All are three-dimensional forms. They all have height, width, and depth. Created by individual artists or by design teams, they are examples of the three-dimensional arts.

The formal and conceptual relationship between sculpture and the other three-dimensional arts is fundamental. Popularly, we apply the terms *sculpture*, *sculptural*, or *sculptural form* to buildings, products, and craft items we wish to compliment for their artistic distinction. We marvel at architect Frank Lloyd Wright's Guggenheim Museum (3.10, 3.11) because of its sculptural form. We can appreciate the striking coffee table **(8.1)** by artist-designer Isamu Noguchi (1904–1988) as a sculpture. Its captivating abstract shapes and negative spaces make the table a sculptural object as well as a functional piece of furniture. Noguchi's sense of sculptural form infuses all of his diverse creations in the three-dimensional arts—his home furnishings, public fountains, playgrounds, parks, gardens, and sets for dance and theater productions—as well as his sculptures themselves (8.4). Whether they take up residence in a museum, a living room, or a public plaza, Noguchi's creations are sculptural. By the same token, we can admire

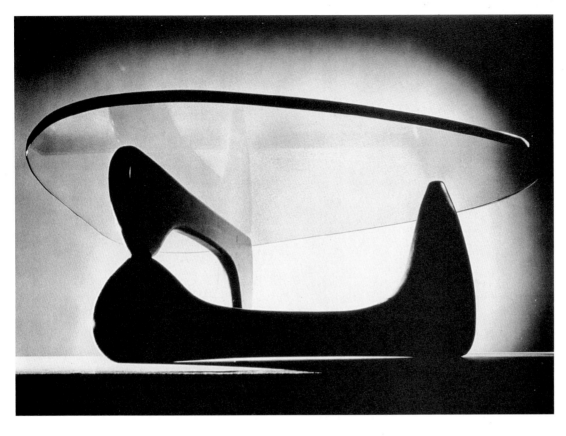

8.1 ISAMU NOGUCHI. *Coffee Table (803).* 1944. Wood and glass. Courtesy of Isamu Noguchi Foundation, Inc.

the sculptural form of a beautiful automobile (6.22), airplane, handwoven basket, or ceramic pot. The tall black ceramic vessel **(8.2)** by potter Maria Martinez (1887–1980) blends geometric regularity with organic form. Perfectly symmetrical, it swells like a rounded gourd, then rises like a tree trunk to blossom at the top like a gently opening flower. Its aesthetic power beckons, and we respond to its sculptural properties.

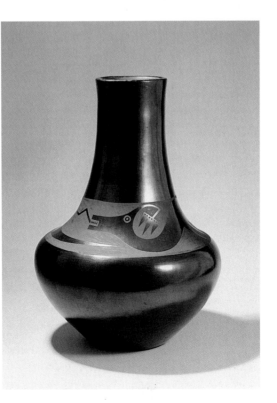

8.2 MARIA and JULIAN MARTINEZ. Vessel. 1927. 14½ in high. Courtesy Dennis and Janis Lyon Collection. *Black polished pots decorated with dull or mat designs were first made at San Ildefonso Pueblo by Julian and Maria Martinez in 1919. Earlier Native American potters had employed black along with red and cream colors, but Maria and her husband were the first to perfect and totally commit themselves to all-black ceramic vessels. What might have prompted their innovation?*

8.3 ISAMU NOGUCHI at work in Pietrasanta, Italy. Ca. 1970. Courtesy of Isamu Noguchi Foundation, Inc.

8.4 ISAMU NOGUCHI at work in Pietrasanta, Italy. Ca. 1970. Courtesy of Isamu Noguchi Foundation, Inc.

Noguchi is not simply an artist who makes sculpture: The impulse that motivates decisions . . . proceeds from the same single unifying sensibility that animates his work [in all the three-dimensional arts].—Henry Geldzahler, curator, Metropolitan Museum of Art, 1986

Do you remember playing with clay as a child, rolling it into thin snakes or coils, shaping it into thick balls or cubes, and joining the pieces together into representations of yourself, family members, or a house or car? You tore parts out of the malleable material, cut pieces to make them fit, and joined sections together. Whenever you made people from clay or playdough, built castles out of wet sand, whittled wood, or carved soap, you were engaged in some of the same sculpting processes we will explore in this chapter.

Figure 8.3 shows the Japanese-American sculptor Isamu Noguchi chipping away at a block of stone with a hammer and chisel. Here, at a very early stage of his artmaking process, Noguchi is creating a sculptural work in the original sense of the word *sculpture* (from *sculpere*, meaning "to carve in stone"). We witness much the same stone-carving process in

Nanni di Banco's fifteenth-century sculpture *Sculptor's Workshop* (1.2), in which sculptors with hammers, chisels, and other tools are busily carving statues and columns in a typical Italian Renaissance workshop setting. Both the carved stone panel and the photographs of Noguchi working present classic images of "the sculptor." However, the contemporary conception of sculpture has evolved far beyond the original definition of carving in stone to encompass a wide range of materials and artmaking processes: carving in wood or ivory, modeling clay, assembling and joining pieces of paper or metal, and bulldozing earth and stones into three-dimensional art forms. This chapter offers a brief introduction to the ever-expanding world of sculpture, so diverse in its forms and functions, so wide ranging in its artmaking methods and technical processes.

SCULPTURE: FOCUS ON SHAPE, SURFACE QUALITY, AND SPACE

At its most essential, sculpture centers on the creation of three-dimensional shapes or volumes. These shapes encompass geometric and organic forms, representational and nonrepresentational forms, and every possible combination of these. In terms of size, they might fit in your hand or rival tall buildings. The physical and formal properties of sculptural shapes—light or heavy, dense or hollow—are seemingly endless in variety.

Shape: Formal Variety

The stone block that we see Isamu Noguchi just beginning to carve (8.3) will evolve into a highly abstract organic shape **(8.4)**. Almost finished, the latter sculpture represents no recognizable person or animal but does suggest a life-form, a product of the artist's imagination that invites our own imaginative interpretation. You might interpret it to be a mysterious underwater animal or a fantastical plant. Can you detect an affinity between this organic shape and those in Noguchi's table (8.1)?

One of Noguchi's teachers and major stylistic influences was the pioneering Romanian sculptor Constantin Brancusi (1876–1957). Noguchi became Brancusi's assistant in 1927, the year of a well-publicized legal battle involving one of the Romanian master's highly abstract bronze sculptures. The nonrealistic nature of *Bird in Space* **(8.5)** initially baffled a U.S. customs official. In the official's judgment, *Bird in Space* was simply "manufactured metal." With no beak, wings, or tailfeathers, it didn't resemble any bird the official had ever seen. Therefore, the customs official refused to admit it into the United States as a work of art—but he did accept it under the category of "Kitchen Utensils and Hospital Supplies"! The owner of the work, American photographer Edward Steichen, was charged a corresponding import duty for his unusual $600 purchase.

The U.S. customs official's confusion is understandable. *Bird in Space* is an extremely simplified form that soars upward from its narrow base. What the innovative Brancusi sought to

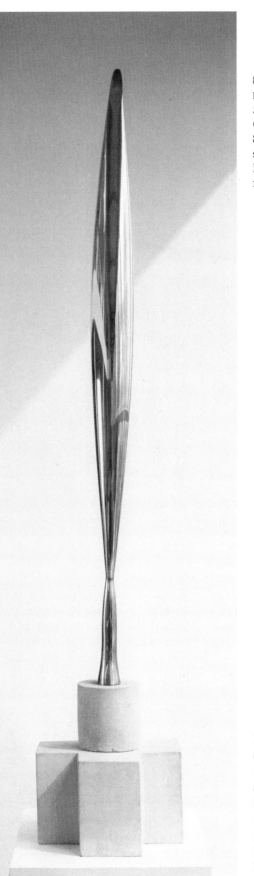

8.5 CONSTANTIN BRANCUSI. *Bird in Space*. 1928. Bronze, (unique cast). 54 × 8½ × 6½ in. The Museum of Modern Art, New York. Given anonymously (153.1934).

They are imbeciles who call my work abstract; that which they call abstract is the most realist, because what is real is not the exterior form but the idea, the essence of things.—Constantin Brancusi, sculptor, 1957 statement

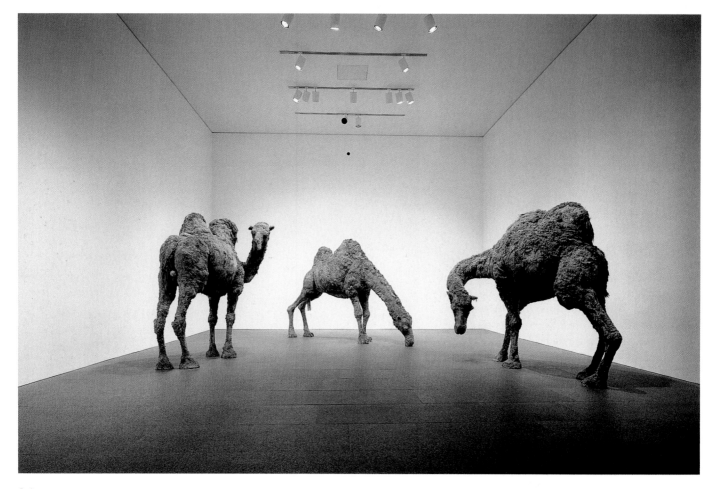

8.6 NANCY GRAVES. *Camels*, VI, VII, VIII. 1968–69. Wood, steel, burlap, polyurethane, animal skin, wax, acrylic, oil paint, and fiberglass. National Gallery of Canada, Ottawa.

capture was not the actual appearance of a bird but rather its essence. Excerpts from three student papers speak to the artist's intention:

> The Brancusi sculpture *Bird in Space* is an abstraction that gives a definite feeling . . . of a bird in space. The sculpture displays gracefulness, weightlessness, and flowing movement, all qualities one would associate with a bird.

> Free from the limitations of realism, *Bird in Space* is a fluid representation of a species and its action.

> In its own way it is a golden idol. An idol to the ideals of freedom, movement, and elegance.

If naturalistic depiction was the U.S. customs official's major criterion for accepting a sculpture of an animal as a work of art, then *Camels* **(8.6)** by Nancy Graves (1940–1995) would have passed his test with flying colors. Laboriously constructed with scientific accu-

racy, the life-size camels are created from a mixture of materials: burlap, animal skin, wax, fiberglass, and polyurethane (a synthetic, rubberlike compound). Inside each camel is a framework or armature of wood and metal to hold up the large but hollow creature. The artist applied acrylic and oil colors to the exterior to evoke a "true to life" effect. Throughout her career, as one critic notes, "all Nancy Graves's sculpture is about nature." Her broad vocabulary of organic forms, realistic or abstract, derives directly from nature, the source of all of Brancusi's varied work as well.

In contrast to sculptures derived from natural forms are those that feature geometric shapes. These sculptures range from single, straightforward geometric shapes to complex multipart configurations. Tony Smith's *Die* (3.4) is a perfect black cube, and Nancy Holt's

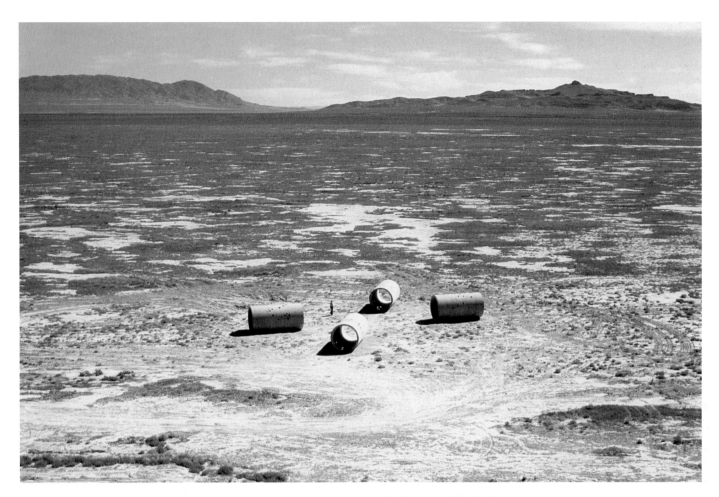

8.7 NANCY HOLT. *Sun Tunnels*. Near Lucin, Utah, in the Great Salt Lake Desert. 1973–76. Four concrete pipes, each 18 ft. long, 9½ ft. in diameter. Total configuration 86 ft. Aligned with sunrises and sunsets on solstices. *Describing the framing effect of* Sun Tunnels, *Holt wrote that the tunnels frame the overwhelming desert landscape so that it might come into focus. "I chose the diameter, length, and distance between the tunnels based on the proportions of what could be seen of the sky and land, and how long the sun could be seen rising and setting on the solstices [8.44]." While the concrete cylinders themselves are not particularly appealing, would you agree that the views and experiences they produce are?*

Sun Tunnels (**8.7**, 2.10) employs four identical, industrially fabricated concrete cylinders. Donald Judd's minimalist sculptures (3.20) are likewise based on simple geometric shapes arranged with mathematical regularity. Mathematically based but far more complex in formal variety and configuration is *ABCD 5* (**8.8**) by Sol LeWitt (born 1928). A variation on the theme of a cube as a module, it is nonrepresentational yet nonetheless evokes a mini-city with its host of cubic forms within a grid layout. Compared to LeWitt's art, in which creative permutations occur within the parameters of mathematical logic and order, the giant out-

door sculpture *Iliad* (**8.9**) by Alexander Liberman (born 1912) appears almost "free-form" even though it consists entirely of cylindrical steel shapes. Painted bright red-orange, the metal cylinders are of different lengths and diameters and are cut and shaped in many ways. In contrast to the simple radial composition of the four identical cylinders in *Sun Tunnels* (8.7), the composition of *Iliad*, with its energetic interplay of diagonals, verticals, and horizontals, is complicated and dynamic.

Beyond conventional geometry exists an expansive realm of shapes that blend geometric and organic qualities. Examples are Maria

When an artist uses a multiple modular method he usually chooses a simple and readily available form. The form itself is of very limited importance; it becomes the grammar for the total work.—Sol LeWitt, artist, "Paragraphs on Conceptual Art," 1967

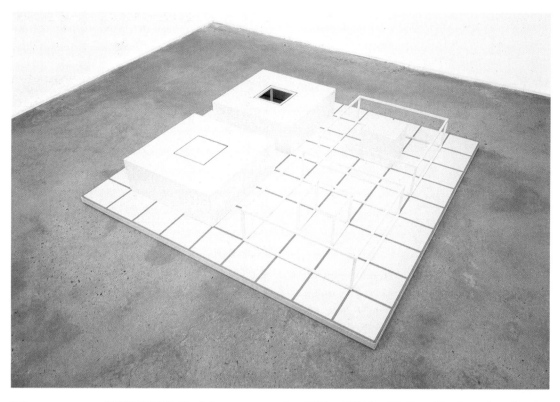

8.8 SOL LEWITT. *ABCD 5*. 1968. Steel, lacquer, tape. 8 × 57¼ × 57¼ in. (SL/P = 52). *A number of sculptors discussed in this chapter do not physically create their works. Like Sol LeWitt, they come up with the idea, concept, or model. Because they elevate the creative idea over the artmaking process, these artists hire others to physically make the final piece. What do you think of this approach?*

8.9 ALEXANDER LIBERMAN. *Iliad*. Storm King Art Center, NY. Photo: David Finn. *The title* Iliad *references an ancient Greek epic poem that recounts the larger-than-life events of the Trojan War, a heroic struggle between the armies of Greece and Troy. Do the sculpture's formal qualities fit well with this title?*

Cohabiting at Storm King [the sculpture-park home to Liberman's Iliad *and numerous other outdoor sculptures] are two of the most potent myths of the American imagination: the machine and the natural paradise. . . . Their joint appearance at Storm King may be unsettling, but it is provocatively appropriate.*—John Beardsley, author, *A Landscape for Modern Sculpture: Storm King Art Center*, 1985

Martinez's black ceramic pot (8.2) and Claes Oldenburg's four-story steel *Clothespin* (3.17). Martinez's vessel expresses geometric regularity and symmetry within a plantlike form. Oldenburg's work magnifies the shape of an upright clothespin in such a way as to wittily suggest a human figure with two legs while still having the appearance of a mass-produced home product.

Surface Quality

The surface of a sculptural shape might highlight the physical properties of the material from which it is made—stone, metal, wood, concrete—or it might be covered with paint, decorated with figures or patterns, or otherwise altered. In *Three Forms (Porthmeor)* **(8.10)**, English sculptor Barbara Hepworth (1903–1975) has lovingly brought out the natural whitish-orange, translucent, fine-grained qualities of the alabaster stone. Similarly, Brancusi lovingly polished the bronze surface of his *Bird in Space* (8.5) to bring out the deep warmth and reflective luster of the bronze. The Staff God **(8.11)**, a sculpture from Oceania (the islands of the Pacific Ocean region), demonstrates a love of wood in its natural state. Carved by an anonymous artist of the Polynesian Cook Islands, the sculpture showcases the deep reddish brown color and the grain of the wood from which it was made.

In contrast to sculptures that emphasize the "pure and natural" quality of their materials, a West African Grebo mask **(8.12)**, also made of wood, is painted and adorned. For symbolic and magical purposes, the natural physical qualities of the wood are covered with color, and strands of fiber hang beardlike from the chin. Altering surface quality and shape, both paint and fiber add to the dramatic impact of the Grebo mask, enhancing its ritual function. Many twentieth-century and contemporary sculptors have likewise chosen to work in a mixture of materials and methods ("mixed media") and readily apply paint or other covering materials to their creations. Inspired by the art and life of Africa, Oceania, and indigenous cultures worldwide, *Spirit Catcher* **(8.13)** by Betye Saar (born 1926) is a mixed-media assemblage of wood, grasses, rattan, beads, and feathers in which certain

8.10 BARBARA HEPWORTH. *Three Forms (Porthmeor)*. 1963. Alabaster. Height: 10 in. New Art Centre, Sculpture Park and Gallery.

8.11 Head of a Staff God. 18th–early 19th century, Rarotonga, Cook Islands, Polynesia. Wood. 31¼ in. University of East Anglia, Norwich, England. Robert and Lisa Sainsbury Collection.

8.12 Mask, Grebo, Ivory Coast. Wood, paint, vegetable fibers. 14½ in. high. Musée Picasso, Paris.

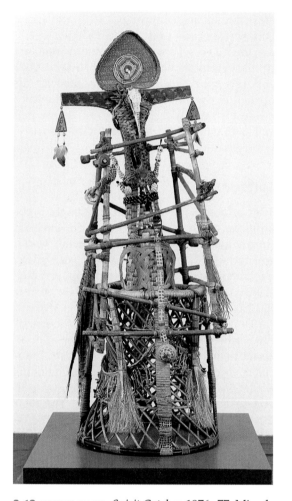

8.13 BETYE SAAR. *Spirit Catcher*. 1976–77. Mixed media and assemblage. 45 × 18 × 18 in. Private collection.

8.14 HELEN CORDERO. *Creche*. 1970. Ceramic figures. Heard Museum, Phoenix, AZ.

organic materials wrap around and cover others. At the work's center is a tall, thin, abstract figure, the "spirit catcher," that rises up within a towerlike framework and stands upon an inverted basket, as if upon an altar.

Likewise altering natural surface quality—in this case clay—Helen Cordero (ca. 1915– 1994) has added diverse hues, patterns, and textures and a degree of realism to the whimsical figures that comprise *Creche* **(8.14).** Representing people of Pueblo Indian heritage, the diminutive figures are oriented in a

circle around the Christ child. Rooted in the ancient clay figurative work and oral narrative tradition of her people, Cordero's "storyteller" figures took twentieth-century Native American ceramics beyond pottery vessels (8.2) to figuration.

Shape and Space

Many sculptures feature a shape or "mass" whose surface is solid and unbroken, with no open areas or spaces piercing the shape. *Composition* **(8.15),** a figurative sculpture by English artist Henry Moore (1898–1986), is a solid, unbroken mass suggesting the human female form. On the other hand, a later Moore piece, *Reclining Mother and Child* **(8.16),** has openings that penetrate the solid shape and create expansive spaces within the sculptural form. Moore, along with colleague Barbara Hepworth (8.10), was an innovator in the use of open spaces, or voids. *Reclining Mother and Child* creates a dynamic interaction between areas of solid mass and open space that are comparable in size. Not only does the horizontal void arrest our attention by creating a cradling, protective space for the child figure,

8.15 HENRY MOORE. *Composition*. 1931.

8.16 HENRY MOORE. *Reclining Mother and Child*. 1960–61.

What draws many younger sculptors to Puryear's sculptures is their fine craftsmanship wedded to a gentle abstraction that conveys a quiet spirituality.—John Havercamp, sculptor, statement, 2002

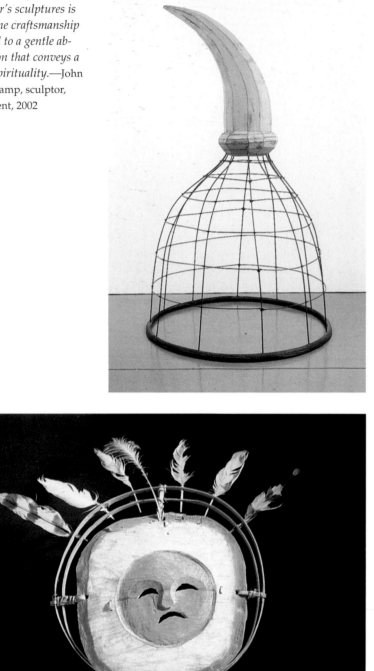

8.17 MARTIN PURYEAR. *Seer*. 1984. Water-based paint on wood and wire. 78 × 52½ × 45 in. Solomon R. Guggenheim Museum, New York. Purchase with funds contributed by the Louis and Bessie Adler Foundation, Seymour M. Klein, President. Photo: Douglas M. Park. *Puryear subscribes to the handmade tradition of sculpture. He respects his materials and their innate sensuous qualities. If, like certain other sculptors (8.8, 8.9), Puryear contracted a skilled artisan to execute his plans (sketches, small models), what might be lost or gained?*

but it also allows the surrounding environment to enter into and literally become part of the work. Positive shape and negative space are equally important to the overall effect of the sculpture.

From the early twentieth century to the present, sculptors have increasingly taken advantage of open space as a central feature in their work. *Seer* **(8.17)**, a sculpture by contemporary artist Martin Puryear (born 1941), is a good example. While the wooden, tusklike form at the top emphasizes mass and solidity, the lower half of *Seer* is open and airy. A framework of thin metal wires (the positive shape) outlines and activates an expansive volume of space. Because this large negative space and the smaller sectional spaces within it are so clearly delineated, we might exclaim that clear-cut shapes have been created out of the air! "Most of Puryear's positive and negative shapes," wrote an undergraduate student, "have an organic feeling. The sculptures are all pretty abstract, but if there are references to the outside world they are to forms like beehives, nests, and other natural containers."

The art of various indigenous or aboriginal peoples worldwide, which inspires the work of so many twentieth-century and contemporary sculptors, often makes similar use of negative space. In an Inuit (Eskimo) mask representing the potent spirit of the moon **(8.18)**, both the face and especially the area around the head are dramatically opened up and defined in spatial terms. Created for ritualistic ceremonial

8.18 Mask with representation of the spirit of the moon. Eskimo, Western Alaska. Smithsonian Institution, Washington, D.C. *The Inuit maskmaker and carver, writes anthropologist Edmund Carpenter, is "indifferent to the demands of the eye" when he makes formal choices. "Size and shape, proportions and selection, these are set by the object itself [its ritual function and symbolism], not forced from without." How can this be, given the fact that the final result has such visual power?*

use, the mask has open spaces that serve symbolic functions. The concentric outer bands of circular space symbolize the different levels of the Inuit universe. The outer ring represents the world above, while the inner ring represents the earth, ice, sea, and underworld.

Tantra I **(8.19),** a contemporary work by Barbara Chase-Riboud (born 1939), works in a related vein in terms of both space and mixture of materials. (It is not used in actual rituals as was the Inuit mask, but it references ancient Hindu rituals.) An unusual combination of polished bronze and knotted and hanging silk twine attached to an armature, the sculpture resembles a standing figure with head, hair, body, and legs. According to art historian Peter Selz, the term *Tantra* refers to the female energy and generative power of Shakti, a consort to Siva, the powerful Hindu god of destruction, and to occult rituals that lead to a sense of oneness with the universe. Formally, Selz describes and analyzes *Tantra I* as

> . . . a stately sculpture of lustrous appearance . . . almost seven feet high and more than four feet across. The interlocking and tangled fall of the silk lends complexity to a work that is otherwise characterized by geometric simplicity of form and line. The elaborate skeins of silk respond to the fall of gravity and act as visual pedestals supporting the massive fan that makes us think of a head or, rather, a mask.[1]

As evidenced in *Tantra I* and the Inuit mask, open space is a dynamic, almost magical element in numerous contemporary and indigenous artworks. Its presence is palpable even though it is no more than air.

Spatial Orientation

In spatial or perceptual terms, every sculpture is designed to be seen in a certain way. The works by Hepworth, Cordero, Liberman, LeWitt, Graves, Noguchi, and Brancusi are all created for viewing from all sides, or "in the round." These pieces invite a multiplicity of perceptual experiences as we move through the space around them. Looking at a sculpture in the round, the beholder becomes a creative participant in the unfolding drama of an ever-changing work. Other sculptures are made to be seen primarily from the front. Ancient

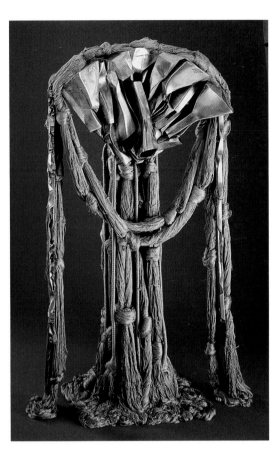

8.19 BARBARA CHASE-RIBOUD. *Tantra I.* 1994. Polished bronze and silk. Courtesy Jacqueline Rothchild Fine Art, New York, NY.

Egyptian and Roman sculptural portraits of imperial rulers (7.1) and holy figures from Buddha (3.14) to Christ are traditionally designed to be seen from a commanding "frontal" position. A frontal orientation has been used throughout time and across cultures to promote feelings of formality and respect on the part of the viewer.

An ancient figure from the Huastec culture of Mexico fits within this tradition of frontal presentation but adds a compelling twist. On one side, meant to be seen head-on, is a "life figure" of a youthful male wearing a conical hat **(8.20).** On the other side, compressed within the youth's broad back and sharing the same arms and conical hat, is a skeletal "death figure" **(8.21).** Curators at the Brooklyn Museum, where the statue is housed, think that the life-death figure might be a cult statue to the famous Mexican plumed serpent god Quetzalcoatl or a representation of the conversion of a Huastec ruler into a god.

8.20 Life-Death Figure, Life image, Mexico, Vera Cruz, Huastec. 900–1250. Stone. Brooklyn Museum of Art, Henry L. Batterman and Frank S. Benson Funds.

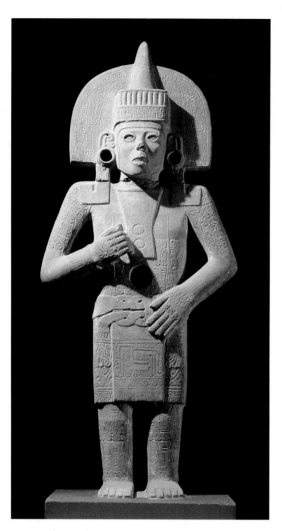

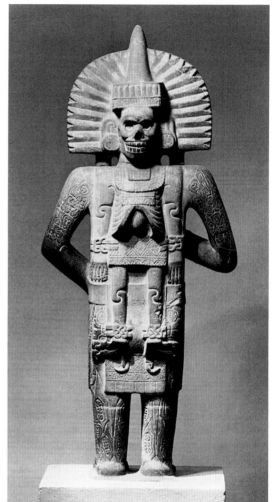

8.21 Life-Death Figure, Death image, Mexico, Vera Cruz, Huastec. 900–1250. Stone. Brooklyn Museum of Art, Henry L. Batterman and Frank S. Benson Funds. *Artworks of the indigenous Mexican cultures often encompass dualities such as life and death with a single form or subject. The plumed-serpent god Quetzalcoatl, the probable subject of this sculpture, is himself dualistic, being both bird and snake with symbolic associations to sky and earth, spirit and flesh, creation and destruction. Are you aware of other dualisms (light and dark, male and female, solid and void) in sculptures? In visual terms, how do sculptors resolve these dualisms?*

Also designed for frontal viewing are **relief sculptures**, in which the figures and forms stand out "in relief" from a flat surface. Some relief sculptures honor a single central dignitary such as a god, king, high-ranking government official, or national hero. Such honorific sculptures might be very large or extremely small. (Take out a quarter and examine George Washington in mass-reproduced relief; the tail sides of American coins have reliefs of national symbols, monuments, and mottoes.) Other relief sculptures are dense with narrative, commemorating historical events or telling mythical or religious stories. The cathedral door panel representing *Adam and Eve Reproached by the Lord* (4.1) is an example. An ancient Indian relief sculpture representing the descent of the Ganges **(8.22),** carved directly out of a wall of

8.22 *Descent of the Ganges*, central section, with cleft in rock down which water descends, Mamallapuram. Pallava (630–68). Carved granite. Photo: Archaeological Survey of India. *One writer compares* Descent of the Ganges, *with its periodic cascade of water, to water-based sculptures such as fountains. He argues that the flowing water highlights the focus of the work on the river Ganges and formally "reinforces the suggested movement in the stone itself." Can you think of other sculptures that blend the kinetic and the static, with one or more moving elements (water, wind, light) animating a still form?*

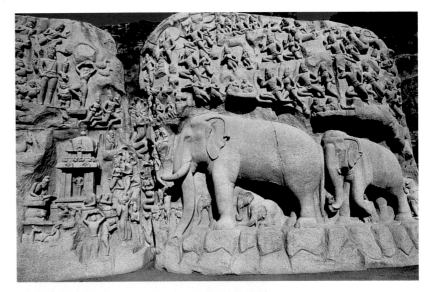

very hard granite, is huge (35 by 90 feet) and complex. The combination of frontality, immense size, dominating position, and abundant detail overawes the viewer. With the sacred river Ganges as its symbolic centerpiece—an actual stream of water flows down its cleft during the rainy season—the sculpture is populated by a multitude of Hindu religious figures (deities of the river, gods, and angels, as well as humans and animals) who stand out in high, or "deep," relief a considerable distance from the stone.

In contrast, figures and decorative patterns in low relief, also called "bas-relief," barely rise above the planar surface. Examples of bas-relief include coins, medals, and the delicate decorative work on the recorder-like musical instrument in **figure 8.23**. This intricate creation is by an anonymous sixteenth-century West African Bini (or Benin) artist, a member of the king's ivory carvers' guild directly attached to the court and palace. The figures, emblems, and patterns on the "oliphant" (carved elephant tusk) are drawn from both the Bini and Portuguese cultures (hence the term "Bini-Portuguese" to describe this hybrid style). Note the European hunter with dog above, and the strips of geometric Bini decorations, some derived from basket-weaving patterns. The royal carver might have created this oliphant for the Bini king and added European motifs for their prestige and exotic nature, or

8.23 Oliphant, Bini-Portugese style, Nigeria. 16th century. Ivory. 22½ in. Rautenstrauch-Joest Museum für Völkerkunde der Stadt Köln. Cologne, Germany.

8.24 Benin *Memorial Head*. Late 17th century. 10¾ in. high. British Museum, Cat. No. 97.12–17.2.

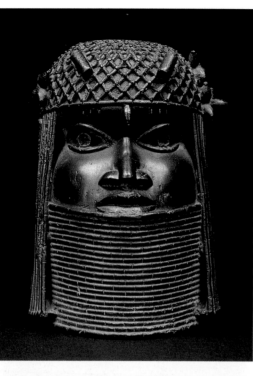

The pride and power of Benin royalty is portrayed through the commanding gaze of the eyes. The individual face is generalized to represent the dignity of the entire kingdom. The riches of the king are memorialized in what he wears, from high coral collar (the odigba*) to beaded cap (the* erhu ivie*) with coral clusters.*—William E. Harris, artist-educator, essay, 2000

8.25 JAMES TATUM. *Oba*. 1982. Earthenware. 38 in. high. *Tatum's sculpture is called* Oba, *and the Benin* Memorial Head *(8.24) represents an actual Bini oba. Do you note any formal connections between the two works? How does the Tatum sculpture evoke the presence of a kingly figure?*

for a Portuguese collector or trader. Rising to prominence by the mid-1400s, the kingdom of Benin became world-renowned for its ivory carvings and cast brass sculptures.

FUNCTIONS OF SCULPTURE

Across time and cultures, sculpture has served a wide variety of functions: magical, religious, commemorative, aesthetic, practical, and a mixture of these. Originally, the Inuit (8.18) and Grebo masks (8.12) were worn in communal religious ceremonies. The Mexican figure honoring a revered god or the apotheosis of a Huastec ruler (8.20) also would have been an integral part of the spiritual life of its society. A West African brass *Memorial Head* **(8.24)** commemorates the life of a late-seventeenth-century Benin king, or oba. Members of the culture would have worshiped this oba figure in ritual ceremonies to honor and cultivate favor with the spirits of royal ancestors. All of these sculptures once played a central role in the communal and cultural life of their societies.

Most modern and contemporary sculptures, in contrast, are designed for personal experiences: aesthetic, psychological, and/or intellectual. Their intention and function are geared to the individual. The contemporary ceramic sculpture *Oba* **(8.25),** while honoring the idea of West African kingship, is not used in community rituals. Created by James Tatum (born 1954) within the context of an advanced industrial society, *Oba's* abstract forms, coloration, and decorative patterning are designed to elicit subjective responses from individual art lovers. Similarly, sculptures such as Brancusi's *Bird in Space* (8.5), Graves's *Camel* (8.6), Hepworth's *Three Forms (Porthmeor)* (8.10), and Puryear's *Seer* (8.17) were created primarily for personal viewing experiences. (These personal experiences might be shared, as we are doing in this book and you are doing with your teacher and classmates, resulting in participation in a kind of sociocultural "art world" community.)

Numerous three-dimensional artworks, made by hand or machine, combine aesthetic, utilitarian, and social functions: the Noguchi table (8.1), the Martinez vessel (8.2), the Cook

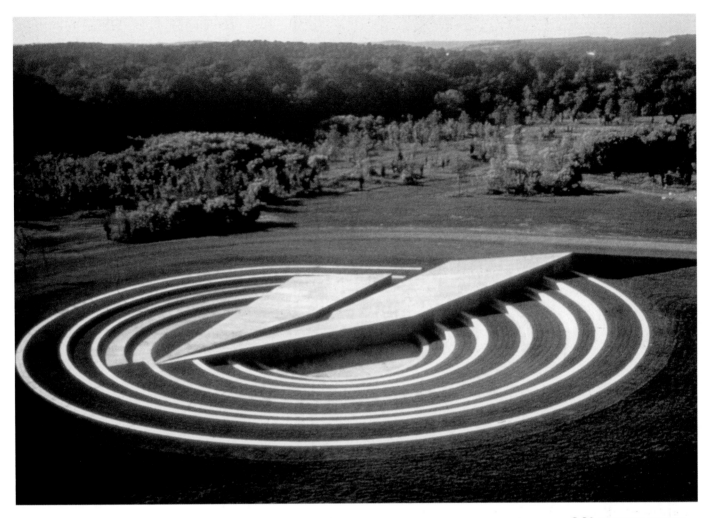

8.26 BEVERLY PEPPER. *Amphisculpture.* 1977. Bedminster, New Jersey. Photo: Gianfranco Gorgoni.

Island staff (8.11), a handsome automobile (6.22). Some would say that such practical or applied art forms are doubly successful in that they elevate a useful product (vessel, container, support) into an object of visual distinction. A large, impressive work that functions in a practical, aesthetic, and communal way is *Amphisculpture* **(8.26),** by sculptor Beverly Pepper (born 1924). Built into the grounds of the AT&T headquarters in Bedminster, New Jersey, *Amphisculpture* can function as a traditional amphitheater, accommodating an audience for a cultural or social event, or it can be enjoyed purely for its striking visual form. As is true for art in general, the functions of sculpture are diverse and often overlap.

ADDITIVE METHODS OF SCULPTING

Sculpture processes or methods might be broadly categorized as additive or subtractive. Many sculptures and three-dimensional art forms use both processes. In an **additive** process, materials are added or joined together to create the finished form. If you have ever joined pieces of clay to form a figure or glued or nailed together scraps of wood, you have engaged in an additive process. In a **subtractive** process, material is removed, as in the stone carving of Isamu Noguchi (8.3). Additive methods, the subject of this section, include constructing, modeling, and casting.

8.27 Sculptor Ed Dolinger welding at his Monroe, Virginia, studio. 2002. Photo: Lavely Miller.

8.28 MELVIN EDWARDS. *Homage to the Mentor.* 1979. Welded steel. 24 × 30 × 24 in. Courtesy of the artist. *Some interpret the expressive forms in this and other welded sculptures by Edwards as dealing with the artist's personal response to the issues of slavery and violence against African Americans. From your visual reading of the work, does this interpretation make sense? Do you have a different interpretation?*

Construction or Assemblage

Construction or **assemblage** refers to the combining or assembling of separate pieces of material—wood, metal, stone, and so forth—to create a final sculpture. Over the past century, throwaway and found objects such as old furniture, burnt-out light bulbs, empty bottles, and aluminum foil have become common materials in sculptural constructions **(Appreciation 15).** Glue, nails, bolts, wires, ropes, fibers, and other materials might be used to join these separate pieces. In the Inuit mask (8.18), separate pieces of wood (along with feathers) were assembled to make up the final work. The parts were tightly fitted or tied together with various natural materials. Sections in the Puryear sculpture *Seer* (8.17) are joined by wire, wood, and glue. In *Spirit Catcher* (8.13) by Betye Saar, parts are glued, tied, tacked, nailed, screwed, and even sewn together. The range of materials and techniques used in additive processes is almost endless.

New sculpture-making processes are always emerging. Welding became prominent in the second half of the twentieth century. In the welding process, pieces of iron, steel, or aluminum are fused through the intense heat of a gas-based blowtorch, an electricity-based arc welding tool, or related implements and processes. **Figure 8.27** shows sculptor Ed Dolinger (born 1948) welding with GMAW (gas metal arc welding) equipment, which combines features of both gas-based and electricity-based arc welding. The edges of two adjoining metal parts are heated to such a high temperature that they temporarily melt and fuse together. After the heat source is removed, the metal cools down and solidifies, and the two pieces hold together as one. In *Homage to the Mentor* **(8.28)** by Melvin Edwards (born 1937), heavy steel forms and chains have been welded together to produce a dynamically balanced, somewhat forbidding abstract sculpture. Although Edwards's *Homage* is only 24 by 30 by 24 inches, its tension-filled presence and monumental scale make it feel much larger.

Alexander Calder: Constructor in Metal Sculptors adept at welding, such as Melvin Edwards and Alexander Calder (1898–1976), can create small to human-size works on their

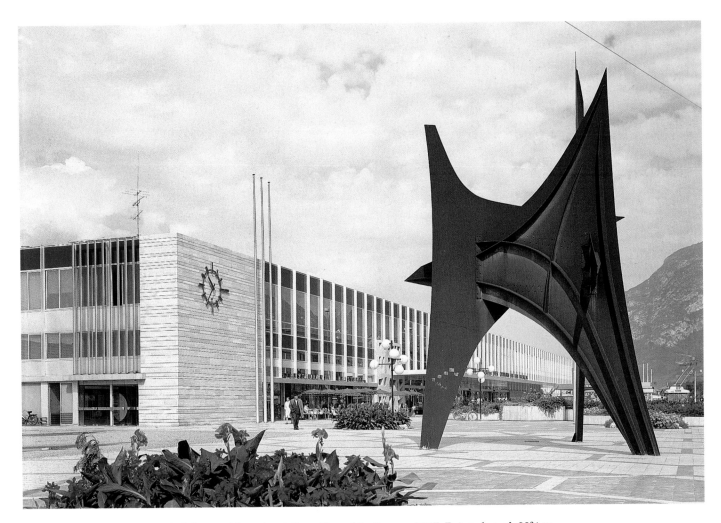

8.29 ALEXANDER CALDER. Stabile outside train station, Grenoble, France. 1967. Painted steel. 23¾ × 15¼ × 15¾ in. Gift of the artist. (392.1966). The Museum of Modern Art, New York. *Sculptures created for outdoor viewing (8.7, 8.9) offer an experience very different from indoor museum or gallery settings. Outdoor sculptures are influenced by ever-changing natural lighting and weather conditions and by a direct relationship with daily life and architectural or natural surroundings. Oftentimes, they can be touched. What is appealing or unappealing about the experience of outdoor sculpture?*

own. To fabricate works of architectural scale, that is, works that relate to buildings in size, sculptors must collaborate with industrial metalwork companies. The artist develops the drawings, specifications, and small models (called *maquettes*) for metalworkers who then carry out the project. These skilled craftspersons actually fabricate the final work, cutting, shaping, bolting, and welding together the parts. Often the artist is not even present during the construction, as was the case with the fabrication of Calder's huge sculpture for the train station square of the French city of Grenoble

(8.29). Calder sent his drawings, basic instructions, and maquette (8.30) to the metalwork company in France. The metalworkers took Calder's model, enlarged it to over twenty times its size, and created a "gateway" sculpture so grand that a car could comfortably drive under and through it.

Such sculptures by Calder, which animate public spaces worldwide, were accorded the name *stabiles* because they are "stably" rooted to the ground, static and unmoving. The term came about as a counterpoint to the artist's earlier invention, the **mobile,** or sculpture that

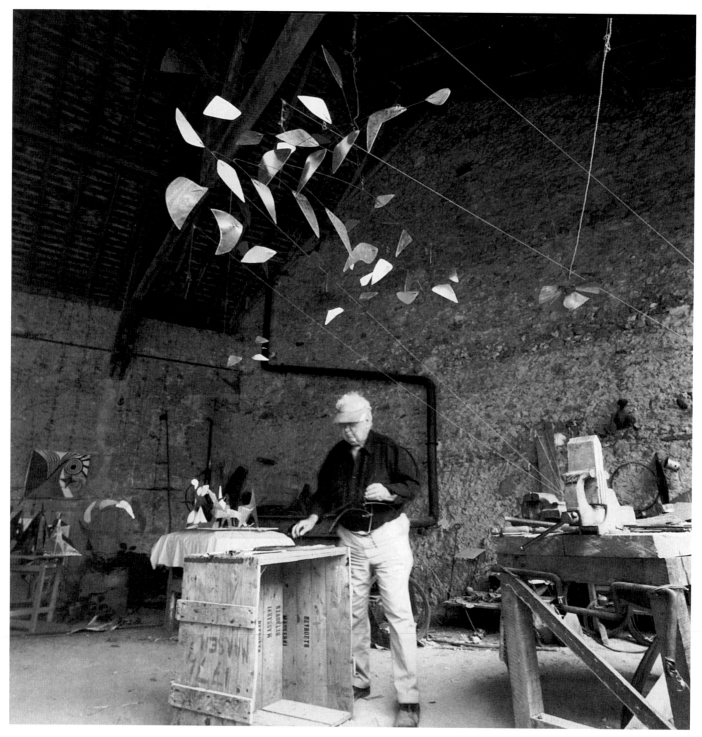

8.30 Alexander Calder working on
the small-scale model or maquette for
a sculpture that combines stabile and
mobile features. 1963. AKG
London/Paul Almasy. © 2002 Estate
of Alexander Calder/Artists Rights
Society (ARS), New York.

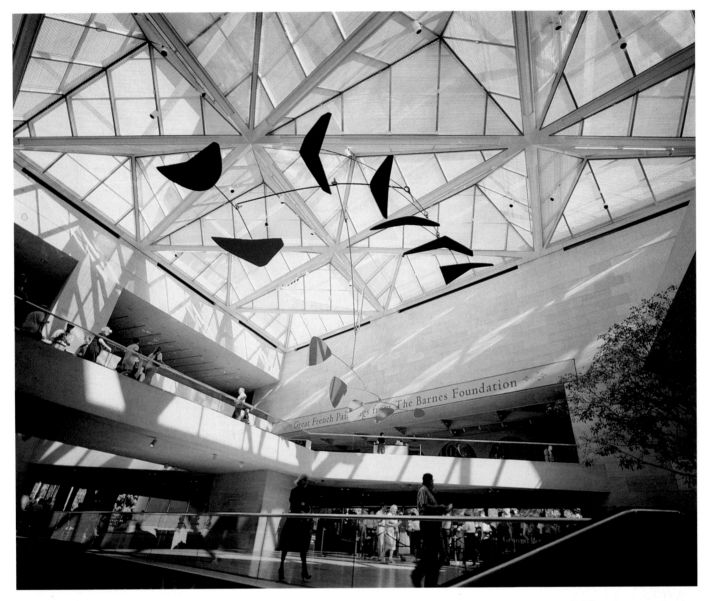

8.31 ALEXANDER CALDER. *Untitled*. 1976. Painted aluminum and tempered steel. 29 ft. 10 in. × 76 ft. Gift of the Collectors Committee. Photograph © 2002 Board of Trustees, National Gallery of Art, Washington. 1977.76.1 (A-1799)SC.

moves. Calder's first mobiles were propelled by machines. Later mobiles were set in motion by natural forces such as air currents. Many are small and delicate. Others, like the huge mobile of painted aluminum and steel hanging from the ceiling of Washington, D.C.'s National Gallery of Art **(8.31),** are commanding in their size and sweep. In all of them, a childlike sense of fun and fantasy conjoins with engineering brilliance. (Calder had training as both an engineer and an artist.) Philosopher Jean-Paul Sartre described Calder's mobiles as "pure play of movement [that] may be likened to water grasses in the changing currents, or to the petals of the sensitive plant, or to gossamer caught in an updraft." André Breton, founder of the Surrealist movement, observed that "through the use of pure nonfigurative rhythms, miraculously allied with real life, [a Calder mobile] recalls to us the movements of the heavenly bodies and rustling of leaves, as well as the memory of a caress."

APPRECIATION 15 *The Enigmatic, Wondrous Art of James Hampton*

NANCY BONDURANT JONES

An exhibit titled "Throne of the Third Heaven of the Nation's Millennium General Assembly" **(Fig. A)** fills one entire room in the National Museum of American Art with 180 objects created from gold and silver tinfoil, tacks, nails, straight pins, used furniture, old light bulbs, and purple paper—now faded to brown.

A *Washington Post* writer calls it "the most enigmatic work of art in Washington" and also terms it "splendid, bizarre, lavish, extravagant, hallowed, glorious, shimmering, triumphant." In 1976, *Time* magazine suggested it "may well be the finest work of visionary religious art produced by an American."

So who was this American artist with a single focus? At age nineteen, a black youth named James Hampton migrated from rural Elloree, South Carolina, in 1928 to join his older brother in Washington, D.C. During the Great Depression of the 1930s, the brothers probably struggled like countless other unskilled, uneducated men in the city bread lines, their poverty deepened by race. No record exists of those years. But from 1942 to 1945 Hampton served in the U.S. Army. After World War II, he returned to Washington and worked as a janitor for the General Services Administration until his death in 1964 at age fifty-five. His passing might have been unnoticed except for an amazing legacy in an unheated, poorly lit garage at 1133 N Street, NW, which he began renting in 1950.

Hampton claimed that beginning in 1931 God and his angels often visited him, instructing him to build a throne for Christ's Second Coming. He followed God's will, scavenged

Nancy Bondurant Jones is a writer and historian who lives in Rawley Springs, Virginia.

trash bins and alleyways for materials, for bits and pieces of discarded objects. He carried a sack wherever he went, a familiar figure in the neighborhood picking up bits of gold or aluminum foil from gum or cigarette wrappers and even paying vagrants for the foil on their wine bottles. From the government buildings where he worked, he gathered used light bulbs, desk blotters, sheets of plastic, insulation board, and craft paper. Whatever he found he melded into his vision, his creation of a monument to the return of Christ.

To all appearances, Hampton led an ordinary, quiet life. His secret project in the garage was created through long nights after he finished his janitorial duties at midnight and sculpted until dawn. Neighborhood children may have laughed at him as he plodded along the streets and alleys on his treasure hunt. Adults may have judged him harmless and looked the other way. Only three or four people saw his creation during his lifetime. But at his death, nationally known artists came to gaze upon the marvelous legacy.

Visitors to the National Museum of American Art stand in awe before this unexpected folk art masterpiece. Paleontologist Stephen Jay Gould wrote that the sight "stunned and delighted me . . . has never failed, upon many subsequent and purposeful visits, to elicit the same pleasure and awe." When I first saw it, there was a physical impact, a sensory overload. I couldn't take in all I wanted to see. It was the sudden realization of what "breathtaking" meant. I couldn't breathe. Since then I've read every article I could find on Hampton and his work. And I've recommended the display to every friend visiting Washington, D.C. No picture can do it justice. As *Washington Post* columnist John Pancake wrote, "If passion and obsession can be made into an object, this is what it looks like." ∎

Figure A JAMES HAMPTON. *Throne of the Third Heaven of the Nations' Millennium General Assembly.* Ca. 1950–64. Gold and silver aluminum foil, colored kraft paper, and plastic sheets over wood, paperboard, and glass. 105 × 27 × 14½ ft. Smithsonian American Art Museum, Washington, D.C.

8.32 Sculptor Brian Maughan modeling clay at his Manhattan studio, 2002. His fired and painted clay works are in the background. Photo: Caít Ní Duibhir. *Various clay sculptures in Brian Maughan's studio, including the piece he is modeling here, show his fascination with an ancient subject, the bull. Why has the bull been a powerful subject and symbol for artists across time and cultures?*

8.33 ELIZABETH CATLETT. *Tired.* 1946. Terra cotta. 15½ × 6 × 7½ in. Howard University Gallery of Art, Washington, D.C.

Modeling

In **modeling,** a pliable material such as clay or wax is manipulated by hand or with shaping and cutting tools. **Figure 8.32** shows sculptor Brian Maughan (born 1942) modeling the head of a bull in his New York studio. Creators of three-dimensional art often use modeling to generate ideas and refine forms—in much the same way two-dimensional artists employ drawing—in the service of larger or more permanent final products. At the same time, numerous artists, Maughan included, have modeled works, especially in clay, as final products.

In the modeling process, the sculptor alternately builds up, shapes, and cuts away material to create the final form. Consider a sculpture modeled from clay. *Tired* **(8.33),** a portrait of leaden physical exhaustion by Elizabeth Catlett (born 1919), is a small, brownish red terra cotta sculpture. Terra cotta (Italian for "baked earth") describes the process whereby the sculpture is first modeled in clay that came from the earth *(terra)* and then baked *(cotta)* or "fired" in a kiln to harden and strengthen the soft material. (A **kiln** is a specially designed oven for drying, baking, and hardening clay and other substances.) Terra cotta sculptures tend to be small—*Tired* is a little over a foot in height—because raw clay, even after it has been fired, is not a very durable material.

The addition of colorful **glazes,** glasslike coatings baked right into the clay, increases the durability and aesthetic range of ceramic sculpture or pottery. Think of how the hard glaze finish baked onto a common ceramic mug seals and strengthens the vessel's clay body, allowing you to handle it freely and drink hot beverages from it. A glazed ceramic sculpture such as *Oba* (8.25), fired in a kiln at a higher temperature than terra cotta, likewise gains in strength, though it still lacks the toughness and near indestructibility of metal. Sculptors whose intention is to make more permanent pieces, for outdoor display or to last centuries, therefore follow up a modeling process with a casting process in metal or some other hard material.

Casting

Across cultures and time, sculptors have employed this basic two-step approach: modeling a form in a soft, pliable material such as wax, plaster, or clay and then, through a mold (a hollow container) of the original form, **casting** it in a harder, more permanent substance such as bronze, brass, steel, or plastic. Created first in wax, the Benin *Memorial Head* (8.24) was cast in brass. Artist-educator William E. Harris describes the "lost wax" casting process that a Bini sculptor used to create the head:

> First, the caster models the work in wax. The wax is covered with coats of wet clay which cling to every intricate detail of the wax sculpture. The clay hardens and forms a durable mold around the wax. The mold is heated and the wax drains off, leaving a perfect impression of the original wax piece on the inside of the clay mold-container. Hot liquid brass is poured into the mold and fills the space once held by the wax. After the metal has cooled and solidified, the clay mold is broken. All rough edges on the brass sculpture are chiseled or filed away.[2]

The contemporary lost wax method **(8.34),** one of the most popular forms of casting, follows these same basic principles. Though materials and techniques may vary somewhat, the basic principles and the two-step sequence of modeling followed by casting remain the same. To create *Reclining Mother and Child* (8.16), Henry Moore first modeled the form in soft, pliable plaster. Assisted by skilled artisans from a foundry (a place where metal is cast), Moore constructed a hard plaster mold of the form and, from that mold, cast the original form in the hard, durable material bronze. Also the products of this modeling-casting "two-step" process are the ancient Chinese *Four-ram Wine Vessel* (2.34), the medieval Hildesheim Cathedral door panel (4.1), and the contemporary outdoor sculpture *The Black Canoe* in Washington, D.C. (Appreciation 3).

In recent decades, various figurative sculptors have pushed the boundaries of casting to extremes of realism by creating sculptures directly from plaster molds of actual people. Duane Hanson (born 1925), a pioneer of this approach, makes casts of people's arms, legs, torsos, and heads **(8.35).** Into each of these plaster molds he pours liquid plastic (polyvinyl acetate), which subsequently dries to a solid state. Breaking open the plaster molds for head, torso, legs, and other body parts, Hanson removes and assembles the hardened plastic pieces into a full figure. He then begins his painting process, painting the plastic form to articulate veins, bones, and wrinkles. He adds clothing and actual human hair, making his figures look so real that observers at first glance often mistake them for live people. This fool-the-eye realism is especially effective when the figures are fitted into real-life

8.34 Lost wax casting.

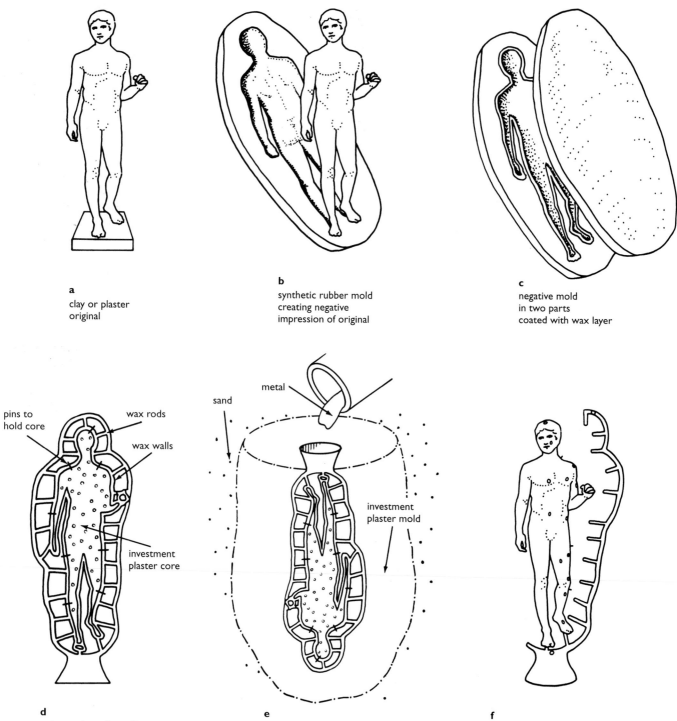

a
clay or plaster
original

b
synthetic rubber mold
creating negative
impression of original

c
negative mold
in two parts
coated with wax layer

d
cutaway view of wax figure
showing walls and plaster core

e
pouring molten metal into the mold
to replace the "lost" wax

f
completed figure as metal rods
are being removed

pins to
hold core

wax rods

wax walls

investment
plaster core

sand

metal

investment
plaster mold

surroundings. *Man on a Bench* **(8.36),** placed in a museum setting, might easily fool an unsuspecting museum-goer into initially believing the man was simply another visitor resting on a bench. Placed on the floor of a Fort Lauderdale, Florida, airport lounge, Hanson's reclining *Traveller*, dozing off while leaning against his luggage, appears to many passersby to be just another weary vacationer waiting for the plane home.

Utilizing the casting-from-life approach but taking it in an entirely different direction, Robert Gober (born 1954) makes the ordinary extraordinary in *Untitled* **(8.37).** Gober presents a convincingly pale, hairy lower leg in a natural reclining position. Wearing an upturned shoe, sock, and pants leg, the fragment provokes the surreal illusion of a real leg emerging from the gallery wall.

8.35 Duane Hanson creating—with model for his sculpture *Man on a Bench*, 1977–78.

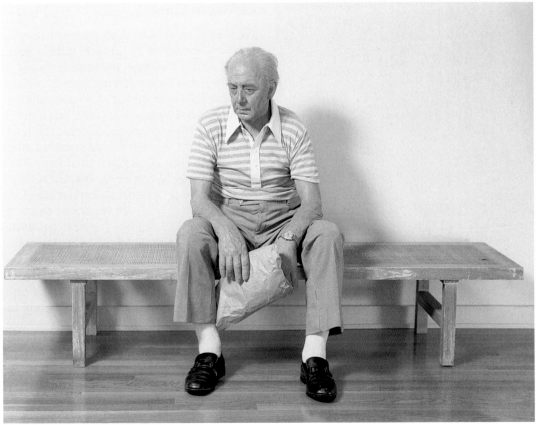

8.36 DUANE HANSON. *Man on a Bench.* 1977–78. Vinyl, polychromed in oil, with accessories, life size. The Saatchi Collection, London.

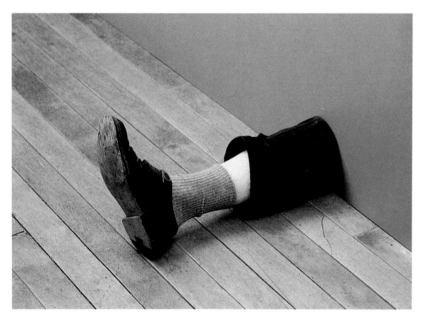

8.37 ROBERT GOBER. *Untitled.* 1989–92. Mixed media: wood, beeswax, leather, cotton, human hair. 12¼ × 20¼ × 6 in. Tate Gallery, London. Photo: D. James Dee. Courtesy of the artist. *Over the past century or so, fragments like this lower leg have become more common in works of fine and popular art (3.9, 3.15, 6.28, 7.14–7.16). Have our lives become more fragmented? Do we catch only glimpses or fragments of passing people and objects? Why do you think we are seeing more fragmented artistic forms today?*

SUBTRACTIVE METHODS OF SCULPTING

Subtractive processes, as stated earlier, involve the removal of material to create a form. In the subtractive process of **carving,** material is removed, cut, or carved away—that is, subtracted—from a solid block of material such as stone, ivory, or wood to produce the final form.

Carving in Stone

We began the chapter with a look at sculptor Isamu Noguchi (8.3) carving from a stone block with a hammer and chisel. Stones of every possible color, texture, density, weight, and size have been carved by a wide variety of artists. Most sculptors work with materials indigenous to their geographical area. The colossal head (2.9) created by anonymous stone carvers from one of Mexico's most ancient cultures, the Olmec, which flourished between about 1200 and 100 B.C.E., is carved out of the hard, dark, volcanic rock known as basalt. In contrast, a much smaller Aztec figure **(8.38)** from the area around Mexico City is created from a green, finely grained granite. This particular Aztec figurine represents the goddess Tlazoltéotl, the "Mother of God," giving birth to Centéotl, the all-important god of corn, the staple of the Mexican diet. Prior to its destruction by the Spanish conquistadors and their Native American allies, the Aztec empire dominated central and southern Mexico in the 1400s and early 1500s. Aztec artists selectively absorbed the subjects and styles of the various cultural groups the empire conquered and absorbed, including the Huastec (8.20).

8.38 Aztec Goddess Tlazoltéotl giving birth to Centéotl (Corn God). Figurine. Green aplite. Dumbarton Oaks, Washington, D.C. *Besides being the creator of corn, this mother goddess had the power to pardon, once in a lifetime, the sins of human beings. What is your reaction to this vigorous, expressionistic figure? Do you find her grotesque? Awe-inspiring?*

8.39 *Laocoön Group*. Roman copy of a Greek original, possibly by Agesander, Athenodorus, and Polydorus of Rhodes. 2nd century B.C.E.–1st century C.E. Marble. Height: 8 ft. Musei Vaticani, Rome. *Both the* Laocoön *and Liberman's* Iliad *(8.9) reference the ancient Greek epic poem* The Iliad, *which recounts the story of the ten-year war between the Greeks and the Trojans. Take a comparative look at the two works. How are they similar and different?*

The physical qualities of the stones used for carving are as diverse as the places in the world from which they come. From contemporary Zimbabwe, in southern Africa, come sculptures **(Appreciation 16)** of black serpentine, a hard, dense, and very heavy stone. Gleaming white are the numerous marble sculptures created in ancient Greece and Italy.

The dramatic *Laocoön Group* **(8.39)** is probably a Roman copy of the Greek original. It depicts an incident at the end of the Trojan War in which the Trojan priest Laocoön and his sons are destroyed by a pair of huge sea serpents sent by a god who favored the Greek side. Marble becomes flesh as muscles bulge, bodies strain, and faces cry out in pain.

8.40 MICHELANGELO. *Pietà*. Ca. 1555. Marble. Height: 92 in. Museo del Opera del Duomo, Florence.

Michelangelo: Carver of Marble The most famous statues by the Italian Renaissance master Michelangelo (1475–1564) are made of white Mediterranean marble. Both the materials and the forms of ancient Greek and Roman sculpture spoke to Michelangelo. The *Laocoön* group, which was excavated in Rome when Michelangelo was a youth, was one of the artist's favorite sculptures. Formally and expressively, the sculpture was a kindred spirit, its twisting shapes, propulsive energy, and emotional expression characteristic of many of Michelangelo's own creations.

The strain and torment of *Laocoön Group* infuse Michelangelo's late *Pietà* **(8.40),** a scene of grief over the dead Christ. Densely packed figures twist and strain within a narrow, triangular compositional shape. The central figure of Christ is violently contorted in an S-curve. Within and between the figures, roughly carved sections of marble clash with smoothly finished surfaces. These formal characteristics of the *Pietà* reflect the tension and unease felt by Michelangelo himself. A great heaviness and tiredness absorbed the artist as he neared the end of his long life. Distraught over the Protestant Reformation and other events that threatened the very existence of his Catholic faith, Michelangelo hoped for release from his earthly bonds. A religious man wracked by doubts, he longed for the peace of eternal life. His *Pietà*, executed between 1550 and 1555, expressed this state of mind. Carved for his own tomb, it is one of Michelangelo's most autobiographical statements. The immense weight of Christ as he is taken from the cross pulls the Son of God toward the grave. The Virgin Mary, Mary Magdalen, and Joseph of Arimathea are powerless to hold him up. But all is not lost. In the rough-hewn face of old Joseph of Arimathea, a likeness of Michelangelo himself, we see sadness but also a stoic calm and hopeful belief. Devotion to Christ, the sculpture seems to say, will bring the artist, in the guise of Joseph, ultimate redemption in the arms of his Savior.

Carving in Ivory

In appearance ivory resembles both light-colored stone and wood. Forming the tusks of elephants and walrus, among other animals, this hard substance is an important material for Inuit and African carvers (8.23). In color, it ranges from almost pure white to light yellow and orange. Its texture and surface quality might be perfectly smooth or might show cracks and grain. The impressive ivory sculpture depicting

a mother feeding her child **(8.41)** is from the ancient city-state of Owo in West Africa. The ivory's burnt-orangish hue and deeply cracked surface enrich the sculptural beauty and power of the interlocked figures. One expert notes a definite stylistic relationship between Owo art and art of the nearby kingdom of Benin (8.23, 8.24) but praises Owo art as "more vital and vigorous."

Carving in Wood

In the popular imagination, wood is the material most often associated with carving. As with stone, the varieties of wood that a carver might use are manifold. Wood might be dark or light, hard or soft. The pattern of its grain can vary enormously. The Cook Island staff (8.11) is carved from a dark, closely grained wood. Other types of wood have a more pronounced grain pattern that artists exploit in shaping or decorating their works.

Born of East Indian parents on the Caribbean island of Trinidad, Ralph Baney (born 1929) loves carving in wood **(8.42).** In an interview with artist Harold McWhinnie, Baney describes how he works with the grain and other intrinsic qualities of the wood:

> I start with the log of wood, turn it around, study it, and then determine what needs to be done to create a dynamic form. Instead of fighting against the wood, I cooperate with wood and bring out its hidden form and the beauty of the grain. If the wood has an interesting grain, then I carve, rasp, sand, and oil the wood to bring out its inherent beauty. If the grain is not very interesting, then I refrain from rasping and sanding and carve carefully with a very sharp gouge, leaving gouge marks to bring character to the form. I feel the sculpture should have some kind of vitality in its surface. To me the tactile quality is very important. I feel complimented when a viewer touches my work.[3]

Like the Zimbabwean sculptors discussed in Appreciation 16, Baney does not make preparatory drawings for his works. Rather, he visualizes the form within the material and allows the particular qualities of the piece of wood to dictate the formal direction he should follow.

8.41 Owo, Mother and Child. 16th century. Ivory. Height: 69 in. Private collection. *Make a cross-cultural comparison between this West African mother and child sculpture and the Aztec figurine of a mother goddess giving birth to the god of corn (8.38). Are the two sculptures worlds apart, or are they related in form, subject, and content?*

8.42 Ralph Baney, wood sculptor, carving a work in his studio.

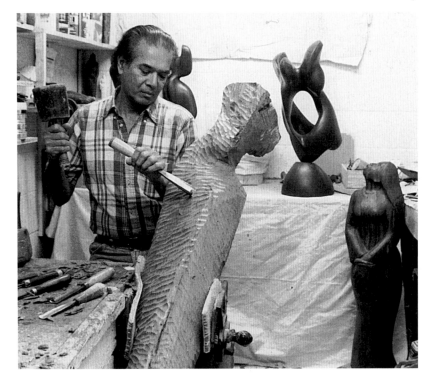

Zimbabwean Stone Sculpture

SHARON MAYES

"The sculpture is already inside the stone—my job is to remove what has been hiding in it." Henry Munyaradzi, a highly acclaimed, Zimbabwean sculptor, expresses the relationship between the spiritual motivation for his work and the hard substance of serpentine stone. This modern African art began some forty years ago when Frank McEwen, a contemporary of Picasso and Brancusi, left Paris to found the National Gallery of Rhodesia. McEwen started the Workshop School in 1956 to nurture the few carvers he had discovered when he arrived. He did not give these artists any formal instruction; he simply encouraged them to carve and began to display their work. A few sculptors gained international prominence rapidly after major exhibitions in New York, Paris, and London. Between 1973 and 1980, the growing war in Rhodesia, international sanctions, and isolation kept the sculptors from working and exhibiting, but since independence in 1980 they have once again burst onto the international art scene to considerable praise.

It is extraordinary to think that some of the finest figurative sculpture in the world today is being created by carvers from one single African tribe, the Shona. Westerners will recognize stylistic influences that appear to be European, such as cubism, expressionism, and abstract surrealism; however, we forget that many famous European modern artists owe their inspiration to the African figurative arts. Picasso, for instance, maintained that the artistic quality of "primitive sculpture" had never been surpassed. This sculpture is far from primitive, even though its subjects recognizably reflect the everyday life of the Shona.

Whether the sculptures depict a wise baboon or a mother and child, the form is universal in its communication. The content possesses an African soul and reaches to the soul of everyone.

The two pieces here are by very different, highly acclaimed Shona sculptors, Henry Munyaradzi (1933–1998) and Bernard Matamera (1949–2002). Out of my collection of over forty pieces of Shona sculpture, I chose these two because they evoke different appreciations in myself, and they represent the vast emotional range, from the elegant to the disturbing, of this work.

Munyaradzi's *Square Head* **(Fig. A)** was one of the first pieces I acquired. The purity of its restrained and lucid design, the abstract and spare beauty of its style, and the sense of human spirit almost transcending the stone riveted my attention. This work, reminiscent of certain works of Klee [17.8] or Picasso [Appreciation 33, Fig. A], is a classic example of Munyaradzi's work. Other artists often try to copy Munyaradzi but rarely achieve his particular magic. Although much can be said about the geometric configuration, the carving and polishing of the stone, and his skill in perfecting the form, none of this is immediately important to the appreciation of the work. What is important is the cool but commanding emotion of the face, the human-animal essence that stares back at the viewer and forces contemplation.

When I first saw the work of Matamera **(Fig. B)** I disliked it. The deliberately enormous and grotesque figures he created are primitive, sometimes monsterlike, and sometimes like a humorous creature out of Shakespeare's fantasy, *A Mid-Summer Night's Dream*. Yet, I kept returning to his work; the power of his creations haunted me. Most of his pieces are reminiscent of modern expressionist art [17.4] at its strongest. They feel alive. Perhaps being a newcomer to Zimbabwe exaggerated my reaction, but whatever the cause I was

Sharon Mayes is a sculptor and writer in San Gregorio, California. She lived in Zimbabwe from 1985 to 1987.

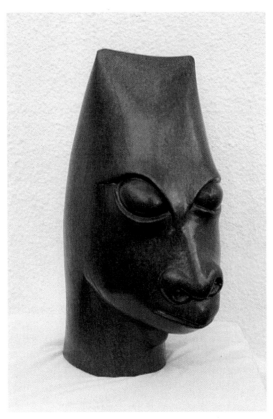

Figure A HENRY MUNYARADZI. *Square Head*. Ca. 1986. African serpentine. 14 × 6 × 2 in.

Figure B BERNARD MATAMERA. *Small Head*. Ca. 1986. African serpentine. 17 × 7 × 10 in.

drawn to this powerful, sensual piece. The intensity and vitality of the African continent speak with pride through Matamera. His pieces are never delicate like Munyaradzi's, but always strong and heavy, some weighing up to a ton. This work, called *Small Head,* is not really small. It weighs over 100 pounds. Now that I live with it every day, the spirit of the rock has come even more alive: it speaks, smiles, endures, admonishes, teases, encourages, and beckons back to Africa.

Whereas Munyaradzi's head is contained and controlled, Matamera's is aggressive and bold. The many other excellent sculptors of Zimbabwe convey the entire range of human emotions. Never bothering to sketch, these artists, fueled by nature, culture, and the spirit world, go directly to the stone with chisels and other hand tools. Although their popularity has soared in recent years, most Zimbabwean sculptors are relatively poor. Matamera lived in a sculptor's community called Tengenenge,

a village of thatched huts many hours down a dirt road from the capital city of Harare. Munyaradzi owned his own farm, where he grew vegetables when he wasn't sculpting. Both these sculptors live simple lives, prosperous by the standards of their own country. Their society's attitude toward money is much more communal and familial than in the Western world. Accumulating personal wealth is frowned on; thus, most Zimbabwean sculptors support large extended families and devote their time to artistic pursuits. In doing so, they have created a world-class art form that startles the imagination. Their dynamic, symbolic works bring together the old and the new, the animistic and modern, magic and cultural expression in timeless representations. More than exponents of most new art movements, these sculptors exemplify a fundamental process that makes their work great art: They explore the mysterious, reaching and expressing the universal in humanity without explanation. ■

8.43 NANCY HOLT. *Sun Tunnels*, Great Basin, NW Utah. Detail: Sunset, summer solstice. 1973–76. Four concrete tubes.

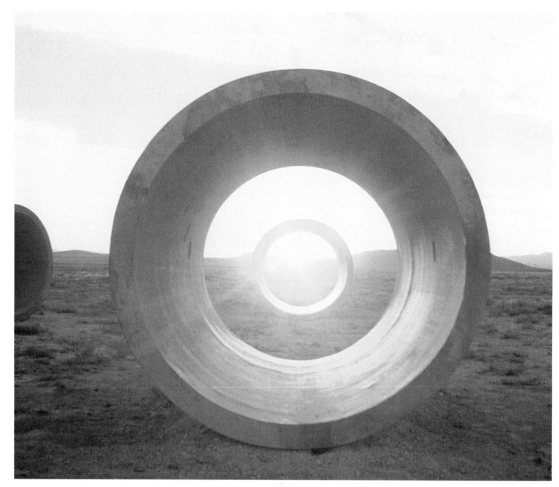

EXPANDING THE BOUNDARIES OF SCULPTURE: EARTHWORKS

"Time" is not just a mental concept of a mathematical concept in the desert. The rocks in the distance are ageless; . . . time takes on a physical presence. . . . Being part of that kind of landscape and walking on earth that has surely never been walked on before evokes a sense of being on this planet, rotating in space, in universal time.—Nancy Holt, sculptor of *Sun Tunnels*, 1988 statement

In the twentieth and twenty-first centuries, artists have introduced a wide range of nontraditional tools and materials for use in sculpting in subtractive, additive, and mixed-method ways. Earthworks are one of the most significant new directions taken in recent decades. In the late 1960s and early 1970s, a socially turbulent period when many challenged the status quo, a number of artists moved beyond the confines of studio walls and gallery exhibition spaces to work in the larger, natural environment. They went so far as to employ bulldozers and other heavy earth-moving equipment to remove or pile tons of rock and soil to make monumental "earthwork" sculptures. For his enormous earthwork *Double Negative*, Michael

Heizer (born 1944) directed earth-moving equipment operators in the excavation of 200,000 tons of earth and stone. Cut out of a rock wall in the Nevada desert, the two strips (50 feet wide, 500 feet long, and 30 feet deep) appear to be dark slits (negative spaces) on either side of the huge, open cliffside. Formalist in his intentions, the artist notes that all *Double Negative* is really about is "absence." The open space between the two cuts in the cliff "creates the double negative." For Heizer, the desert was a wide-open arena of huge shapes, vast spaces, and abundant materials to be visually manipulated.

Moving beyond primarily formal concerns like those of Heizer's *Double Negative* to the incorporation of larger "extra-artistic" considerations (symbolic, spiritual, ecological), the pioneering earthworks of Nancy Holt and her

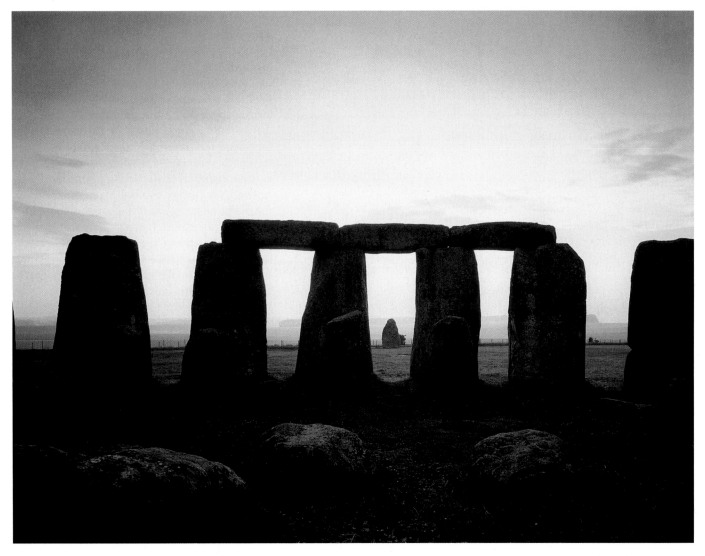

8.44 Stonehenge, Salisbury Plain, England. Ca. 2800–1500 B.C.E. © English Heritage Photographic Library.

husband, Robert Smithson (1938–1973), and the later works of Andy Goldsworthy (2.2, 2.3) relate to the earth as a living, changing environment. They share affinities with environmental works of aboriginal or indigenous peoples of the past and present. For example, Holt's astronomically oriented quartet *Sun Tunnels* (**8.43,** 8.7) in Utah's Great Basin Desert is a kind of industrially made, modern-day counterpart to ancient stone astronomical and ceremonial sites like England's Stonehenge (**8.44,** 10.12). Both structures are aligned to the movements of sun and moon and to seasonal solar events such as the solstices and equinoxes.

Oriented to the four compass directions, stone-based Native American healing circles called "medicine wheels" likewise fit within the tradition of seeking alignment and harmony between life on earth and universal forces. In contrast to Holt's work, which is a contemporary individual's artistic gesture and call to cosmological connection, the Native American medicine wheels were (and some still are) bases of community rituals designed to bring human activities into balance and order with the larger cosmos. Art historian and critic Lucy Lippard, whose book *Overlay* focuses on relationships between contemporary art and the environmental creations of indigenous

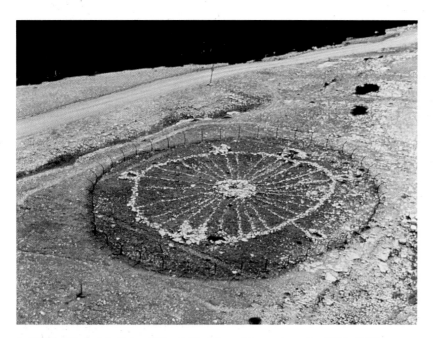

8.45 Big Horn Medicine Wheel, Big Horn Mountains. Ca. 1500–1765 C.E. Diam.: 80 ft.; circumference: 245 ft. *In his 1980 book* The Medicine Wheel, *Sun Bear, a Chippewa Indian medicine man, calls for the return of the medicine wheel and ceremonies that gather together "people of all clans, of all the directions, of all the totems" for the purpose of "healing of the Mother Earth." Do you think some or all artworks have a curative power? Should art concern itself with healing and ceremonial rituals?*

I saw a hilltop bare of trees, and there was a soft breeze blowing. The prairie grass was moving gently. Then I saw a circle of rocks that came out like the spokes of a wheel. I knew that here was the sacred circle, the sacred hoop of my people.—Sun Bear, Chippewa Indian medicine man, *The Medicine Wheel*, 1980

peoples, writes that a Native American medicine wheel in the Big Horn Mountains of Wyoming **(8.45)** "may represent the sun, though its twenty-eight spokes suggest lunar months." Its six conical heaps of stones might stand for the planets: "They are aligned to sunrise and sunset on the summer solstice and to the rising points of the stars Aldebaran, Rigel, and Sirius. The wheel may have signaled the proper day to begin the Sun Dance." While Native Americans created this Wyoming medicine wheel perhaps 500 years ago, artifacts at a prehistoric medicine wheel in Alberta, Canada, date back 5000 years.

Ancient peoples created their earthworks —stone circles, earthen mounds, barrows, and pyramids—for magical and spiritual reasons: to create balance and order between the human and spirit realms, between the earth and the universe, and among animals, plants, and "the two-legged ones." Around the world, these earthworks have taken on a wide variety

of shapes and patterns: spirals, circles, mazes, labyrinths. Some assume the shapes of human beings, plants, and animals. The Serpent Mound **(8.46)**, created in southern Ohio by Native Americans, is exemplary. No one knows the exact meaning or purpose of the 1,350-foot-long Serpent Mound. It may have represented the specific animal totem of the people who produced it, who might furthermore have designed the Serpent Mound to promote fertility and the survival of the society. Native American and prehistoric symbolism associates both the snake on an egg and the spiral on a mound with fertility. (Note the egg shape above the serpent's head and the spiral on the mound that defines the snake's tail.) To the Hopis the snake is the female symbol of Mother Earth, from which all life is born. Viewed from above—designed to be seen by sky gods?— the Serpent Mound is as stunning a sculptural form as has ever been created.

Robert Smithson's *Spiral Jetty* **(8.47)**, perhaps the most famous contemporary earthwork, shares deep links with creations like the Serpent Mound. To begin, it is an earthen mound and is of comparable size. Located in Utah's Great Salt Lake, the 1,500-foot-long *Spiral Jetty* was created by moving, dumping, and piling tons of earth with earth-moving machinery. Beyond the artistic triumph of creating a huge and compelling sculptural form, Smithson sought to work intimately with ancient symbolism and the earth's natural processes, accepting the fact that the jetty mound would decompose and disappear. (Within several years of its 1970 creation, *Spiral Jetty* had indeed vanished, submerged beneath the salt-laden water, its continuing existence made possible only through photographs and a film.) On the symbolic level, the clockwise or "creative" spiral in traditional cultures has been a universal symbol of growth, while the counterclockwise circle has been a symbol of destruction. (Observe that the spiral in the tail of the Native American Serpent Mound turns clockwise, to the right, while the spiral in Smithson's earthwork, in keeping with its destiny of devolution, turns to the left.) That Smithson's favorite form was the spiral and that he loved and collected snakes as a child further connect his earthwork to the Serpent

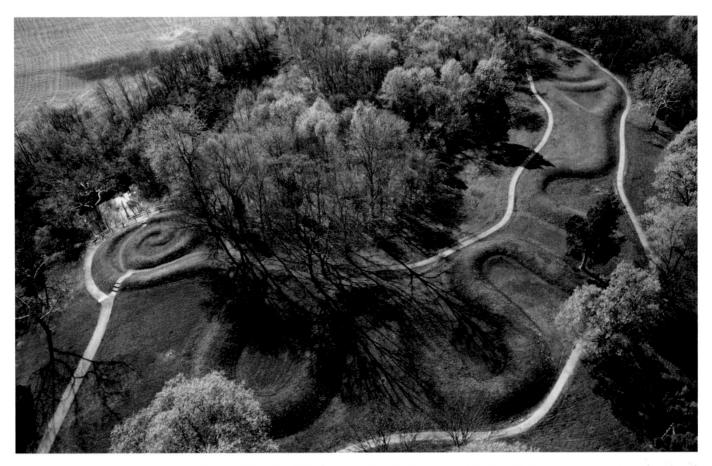

8.46 Serpent Mound, near Locust Grove, Ohio. Ca. 1000 C.E. or earlier. Sculpture, aerial view. *Quite a number of artworks in this chapter feature spiral, serpentine, and circular forms. Do these forms have symbolic, metaphorical, or spiritual significance for you? For people in general?*

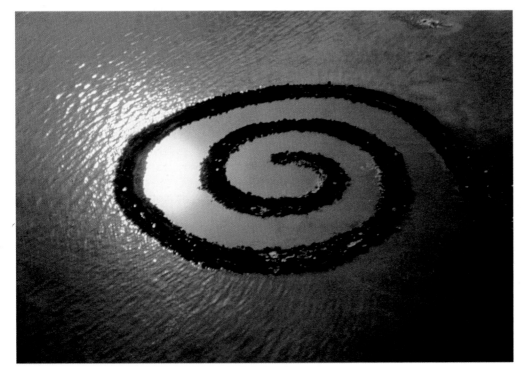

8.47 ROBERT SMITHSON. *Spiral Jetty.* 1970. Rock, salt crystals, earth, algae; coil length 1500 ft. Great Salt Lake, Utah. Photo: Robert Smithson. Courtesy James Cohan Gallery, New York.

INTERACTION BOX

MAKING A SCULPTURE

You might insist that you're not an artist, that you can't even draw a straight line. This simple exercise will prove you wrong while initiating you into the joys and challenges of creating sculptural shapes—and maybe even a sculpture.

Get some string, twine, or tape. Tie the string or tape to a piece of furniture or some other object indoors. Stretch the line tight to some other object or surface, and tie, tape, or otherwise secure it. You have created an initial straight line. Continue stretching, tying, and securing the same piece of cord, or separate pieces of cord, to create three-dimensional shapes: cubes, pyramids, and others. You can create these shapes and spatial volumes as small or as large as you like. Your creation will share qualities with the lower half of Martin Puryear's *Seer* (8.17) in its very thin positive shapes and airy negative shapes or spatial volumes.

This same type of sculptural activity can be done outside. Tie the cord to trees and secure it to the ground via long metal nails, plastic stakes, or wooden sticks. Tying the string around a brick or stone at ground level is also effective. In the out-of-doors, your sculptural shapes might greatly expand in size. They will move with the breeze and be affected by the changing light and weather. To expand your sculptural possibilities, consider readily available materials such as stones, sticks, leaves, bricks, playdough, clay, sand, snow, or soil—all possible materials to join or place together to create three-dimensional artworks. Recall the examples of earthworks (8.43–8.48, 2.2, 2.3) and the additive and subtractive processes used to make them.

Like self-taught artist James Hampton (Appreciation 15), you can create something unusual, perhaps even extraordinary, from the most ordinary materials and found objects.

Mound and other serpentine and spiral-based prehistoric art forms. Seen from above, in this case by humans in flying machines, *Spiral Jetty* joins its forebears as a catalyst for a deeply moving experience.

An ever expanding range of tools, materials, and methods has been used to create a cornucopia of sculptural forms and meanings

(Interaction Box). These same basic methods, materials, and tools have been used in countless creations in the other three-dimensional arts, as we will see in upcoming chapters. Like the bedrock from which a building rises, sculpture continues to be a foundation—conceptual, formal, and technical—of the three-dimensional arts.

Crafts and Product Design 9

For most of history, useful implements and objects of everyday life were created by hand rather than by machine. Today, we call the skilled persons who created these handcrafted objects "craftspersons" or "artisans." Over 4,000 years ago, craftspersons in ancient Egypt **(9.1)** employed their own hands and rudimentary stone **potter's wheels** to form useful vessels for all members of society. Unlike today's perfectly uniform mass-produced, machine-made products, each handcrafted product was unique. And each was considered a work of art because the maker's "craft" and "art"—his or her skill or technical mastery—was embodied in the product.

CRAFT AND FINE ART

Contemporary craftsmen Jim Hanger (born 1947) and Rob Barnard (born 1949) continue the craft tradition of forming or "throwing" pots on a potter's wheel **(9.2).** Hanger is what is known as a production potter. He creates a prototype bowl, mug, or dish and then produces numerous near-copies or variations of this prototype. For example, he might create twenty-five mugs of the same basic shape, coloration, and decoration. Each piece is well made, functional, unique, and identifiably "a Jim Hanger work." Hanger's artistic style is frequently described as earthy, solid,

9.1 EGYPTIAN POTTER. From Giza, Egypt, third millenium B.C.E. Limestone. Courtesy of the Oriental Institute of the University of Chicago.

9.2 Jim Hanger throwing a pot in his studio, Staunton, Virginia. *The four criteria that traditionally define a craft discipline are represented in this photograph of a potter at work. The clay vessel that he is shaping on a potter's wheel is characterized by skill, practical function, a traditional material, and a traditional forming technique. Clay pottery or ceramics is one longtime craft discipline. Can you think of several others that meet the four criteria mentioned here and have been practiced for millennia?*

For Barnard, the functional aspect of the pot is something to be acknowledged and used rather than something that diminishes its stature in the world of fine arts. The "crafts" label, with all its intimations of second-class art world citizenship, becomes irrelevant when you comprehend Barnard's pots because they are meant to be handled, to be understood not merely with the eye, but appreciated with the whole body. They add a level of communication that is generally denied to us when viewing painting and sculpture.—Alice Thorson, art critic, Kansas City Star, 1999

strong, and rugged. He sells his ceramic pieces at craft fairs, in specialty shops and galleries, and at his own studio. To earn a living from his craft, Hanger needs to produce large numbers of works. Yet quantity production does not mean that Hanger neglects the quality of his work. His ceramic pieces are consistently well crafted and visually appealing in their shape, decoration, and overall design. Many would call them works of art.

Rob Barnard produces many fewer pieces than do production potters like Jim Hanger. Trained in the United States and Japan (where pottery is held in the highest esteem), Barnard tends to create singular works **(9.3)** rather than sets or large numbers based on a prototype. Barnard does share Hanger's orientation toward making useful or functional pottery, however. A writer and lecturer as well as an award-winning potter, Barnard argues that craft is defined by its practical function and its "handmade" nature. If it's not handmade and functional, according to Barnard, then it's not craft. When ceramicists create work that is nonfunctional and exclusively concerned with aesthetic or intellectual response, Barnard asserts,

they and their works have moved away from craft and into the realm of the fine arts.

In historical terms, the honorific concept of fine art began in the Italian Renaissance when painters like Leonardo da Vinci and sculptors like Michelangelo (8.40) distinguished the intellectual, creative bases of their arts from the skill-based, utilitarian crafts. Compared to a craftsman's ceramic bowl, however skillfully done, Leonardo argued that a work of "true art" (or fine art) such as *The Last Supper* (2.18) performed higher, more intellectually and morally demanding functions: It told an important story about Christ and the apostles, created lifelike portrayals of people, taught religious truths, and promoted ethical behavior.

9.3 ROB BARNARD. Pitcher. 1997. Clay, 10 × 4 in.

Execution of such ambitious works required of the true artist not simply craft or technical mastery, but broad literary, mathematical, and scientific knowledge. Those who make the distinction between craft and fine art continue to do so along the lines of function versus nonfunction, skill versus intellect, physical activity versus mental creativity. While some might find da Vinci's and Barnard's definitions too decisive—numerous works blur the craft–fine art boundaries—the basic distinction is a valuable one.

Viewing Modern-Day Crafts as Fine Art

Early in his career, ceramic artist Peter Voulkos (born 1924) made utilitarian dishes and vessels. But in the 1950s he broke with the functionalist crafts tradition and began to create ceramic works in the bold, freewheeling spirit of the vanguard **abstract expressionist** (see Chapter 18) paintings and sculptures of the period (18.13–18.23). Intentionally fine art–oriented and nonfunctional, these works were conceived as ceramic sculptures and ceramic art, not as craft. In *Red River* **(9.4),** pots that are wheel-thrown or handbuilt are squeezed, torn,

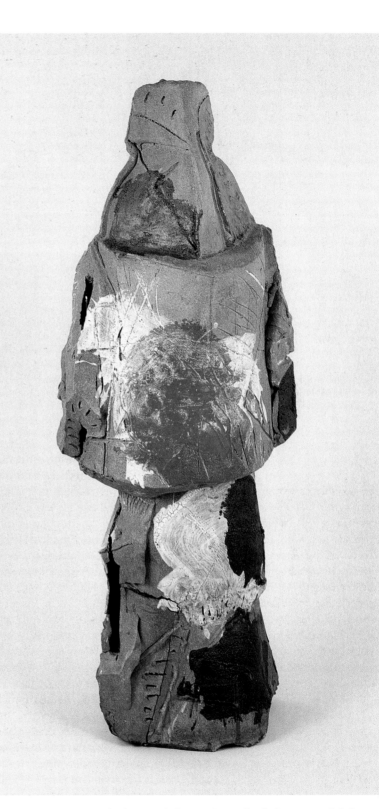

9.4 PETER VOULKOS. *Red River.* 1960. Stoneware, wheel-thrown and slab construction, paddled and scratched, white and black iron slips, red and orange low-fire glaze. Height: 37 in. Whitney Museum of American Art, New York; gift of the Howard and Jean Lipman Foundation, Inc. 66.42.

9.5 Vera Baney hand-building in clay.

9.6 HARLAN BUTT. *Wisteria Vase #8.* 1990–91. Copper, enamel, and steel. 16 × 16 × 32 in. tall.

[Voulkos] lifted the craft [of ceramics] from the minor niche it occupied and developed it into a field with full expression.
—Paul Hatgil, artist, quoted in *History of American Ceramics*, 1978

turned upside down, paddled, scratched, and mashed together to form what the artist calls a "pot sculpture." Practitioners like Voulkos, who take their lead from developments in the art world, clearly see themselves as fine artists and want their works' form and content to be viewed in terms of fine art. Practical function and traditional technical accomplishment, hallmarks of the crafts, are not of concern. To many appreciators of beautiful, well-made, and usable pottery—recall Maria Martinez's stately work (8.2)—Voulkos's clay pieces appear ugly and ill-made, a direct insult to the craft tradition. However, these same critics acknowledge the creativity and individuality of Voulkos's breakthrough ceramic art.

The ceramic work **(9.5)** of Vera Baney (born 1930) is likewise conceived as fine art. Baney, like Voulkos, once created skillfully made, functional works, but her interest soon turned to the creation of ceramic sculpture. Her nonfunctional pieces focus on concerns of abstract form and intellectual or emotional content. Born on the Caribbean island of Trinidad, Baney imbues many of her pieces with the organic shapes, natural colors, tropical rhythms, and feelings of her homeland. In the photo-

graph, Baney is handbuilding a biomorphic abstract form from bottom to top, coil by smoothed-over coil. Because she and Voulkos have created works in the basic form of vessels (an ancient tradition), use age-old craft material (clay), and at times employ traditional ceramic skills (handbuilding, wheel throwing), some might see their work as craft. But to do so would be to negate their intentions.

Other materials traditionally associated with ancient crafts traditions—glass, fiber, wood, metal—have likewise found fine art applications in recent times. Instructively, words like *art, painting,* and *sculpture* are frequently affixed to the medium—glass art, fiber art, wood sculpture, metal arts—if the creators intend their work to be fine art. The same is true for the titles of the practitioners themselves. Consider the distinction between the metalsmith and the metal artist. The former is a skilled craftsperson who creates useful items or "applied art" for everyday life: metal tools, utensils, implements. The metal artist pursues other aims. A graduate student explores this distinction between art and craft in an essay response to a gallery exhibit of jewelry, knives, vases, and candlesticks. Questioning whether

9.7 Jamestown glass mug. Colonial period. Photo: Patrick Horst, 2002.

these metal objects in their glass cases qualify as art, the student writes:

> When we think of metalsmithing, we may imagine a burly male figure before a blazing fire. We hear his hammer land blow after blow on the red hot metal. We smell his sweat, anticipate his thirst, feel the long grueling hours as he wrests a useful object from the material. It is hard for us to imagine this man as an artist.
>
> Harlan Butt does not fit the stereotype. A sensitive, soft-spoken poet, he transforms his metals into living gestures of grace. His pieces show no signs of battle with his materials. When Butt talks about his work, he does not mention the slow and tedious process. It is long forgotten. He has transformed sizzling metal into poetry.
>
> Butt spent a year in Japan and became deeply intrigued by its flower arrangements and tea ceremonies. He studied the traditional shapes of the tea pieces and learned their ritualistic functions. Japanese flower arrangements, embodying mystical and spiritual meaning, inspired his Wisteria Vase Series.
>
> *Wisteria Vase #8* [9.6] consists of a simple vessel of enamel over copper. Obviously, the vessel, like a tea kettle in shape, contains something: It has an opening at the top which lets

something in or out. From this opening, slithering vines of metal, animated and alive, protrude like reaching fingers into space. One vine pricks a curly finger into the side of the vessel, reentering the place from which it came. Clearly, one is looking at a metal sculpture.[1]

Similarly, glassblowers who create practical objects usually see themselves as craftspersons while those who aim primarily for aesthetic interest, intellectual conception, or emotional expression invariably view themselves as glass artists. The mug in figure **9.7,** an example of craft, is a re-creation of the glass vessels made and used in Jamestown, Virginia, the first permanent English settlement in North America. It was created by a glassblower **(9.8)** employing the same materials and techniques used in earliest colonial times. The vessel has a simple functional beauty enriched by a handle that swirls and tapers to a curlicue base. A small protuberance at the handle's top adds visual interest as well as a comfortable place to put one's thumb. A slightly lopsided shape, speckled imperfections in the glass, and walls of varying thickness engage us aesthetically. Visually appealing, well made, and functional, such glass vessels are generally conceived by their makers and users as craft, not fine art.

In contrast, the glassworks blown and assembled by contemporary master Dale Chihuly (born 1941) and his teams of skilled assistants are assertively fine art. Chihuly's large installation pieces **(9.9),** for example, are really floating or hanging sculptures made of glass. His stated concerns are primarily formal: organic and abstract shapes, brilliant color and light, environmental space and scale. The forms are up to 5 feet in diameter, huge for blown glassworks. Spotlights and backlighting create vibrant projections and rainbow-hued reflections on the surrounding museum walls. While Chihuly and his assistants may use a traditional craft material and employ some traditional craft techniques, they are inventing new technical processes and creating works that are essentially avant-garde sculptures made out of glass ("glass art").

The same distinction might be made relative to cloth and the sewing of quilts. The beautiful Illinois farm quilt cover discussed in **Appreciation 17** is an example of craft. The

I don't really care if they call it art or craft, it really doesn't make any difference to me, but I do like the fact that people want to see it.—Dale Chihuly, glass artist, 1993 statement

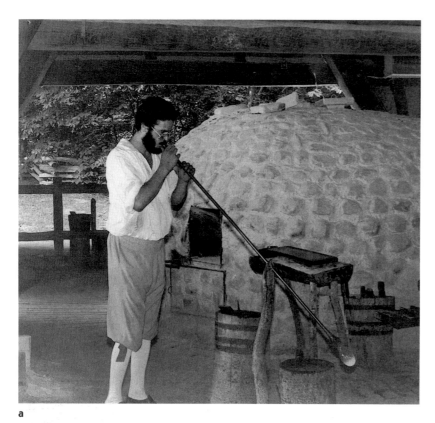

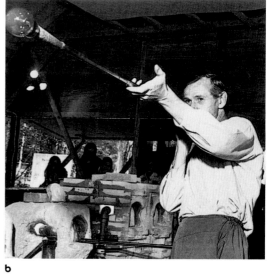

a

b

9.8 Glass bottle being blown and formed using 17th-century tools.
Jamestown Glasshouse, Jamestown, VA.

c

d

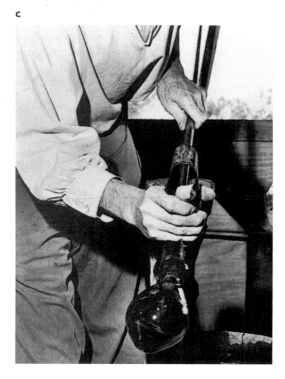

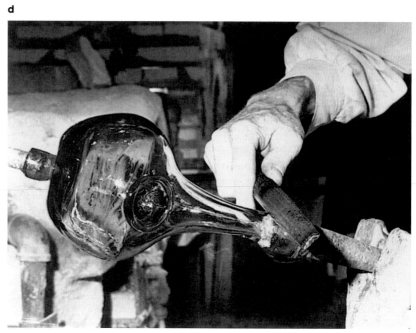

9.9 DALE CHIHULY. Victoria and Albert Chandelier. 1999. Handblown glass and steel. 16′ × 8 × 8 ft. Victoria and Albert Museum, London. Photo: Terry Rishel.

9.10 NATASHA MURADOVA. *Everyone Has Her Own City.* 1996. Painting, fabric manipulation, quilting, embellishment with silk, cotton, velvet, metallics. 82 × 70 in. Collection of Fred and Gail Berger.

rural woman who created it was thinking primarily about function (a warm quilt for the bed) and employed traditional sewing techniques to execute this impressive, meaning-laden object. She had no desire for the piece to be perceived or collected as fine art. In contrast, Russian "textile artist" Natasha Muradova (born 1946) received her training in an art school and creates works that are hung on gallery walls and are meant to be viewed like paintings. As Patricia Malarcher writes, "[Muradova] has developed an original way of combining silk painting, appliqué, manipulated fabric, stitching and weaving that allows a synthesis of complex ideas." While the Illinois farm quilt cover may, in its own way, be as

beautiful and rich in content as the Russian work, it is worlds apart from the experimental mixed-media form and self-consciously intellectual content of Muradova's *Everyone Has Her Own City* **(9.10).**

Exhibition context can collapse these separate worlds and bridge the customary divide separating fine art from craft. If, for example, the Illinois farm quilt were removed from its everyday use in a rural home and hung like a painting in an art museum, most viewers would probably respond to it as a work of fine art. Featuring it in an art book has a comparable effect. Such is the power of context in transforming, in our mind's eye, a traditional craft into fine art.

APPRECIATION 17 *An Illinois Farm Quilt Top*

CATHY MULLEN

I bought this quilt top **(Fig. A)** two decades ago, when I lived in Champaign, Illinois. I spotted it in an antique dealer's display in the concourse of my local shopping mall. The soft, faded blues, the neat lines, and the corners of the pattern caught my eye. The dealer told me that she had acquired the piece in a nearby farm town. She probably bought it at an estate auction.

Although it was meant to become the top layer of a useful bedcover, this unfinished patchwork now hangs on my bedroom wall. Displayed this way, it disengages from its identity as a practical object and becomes an image that I contemplate as I would a painting or drawing. In this way it tells me something important about the character of a place, of a farming way of life, and of a woman's domestic work.

The pattern reminds me of the farmland of east-central Illinois. The colors are the sky colors one sees during the growing season—harmonies of clear or cloudy blues and twilight mauves interjected with the muddy grays and greenish browns of thunderstorms and tornadoes.

Under that unpredictable sky, the flat, treeless earth is sectioned into precise rectangles and parallel rows for efficient agricultural production. It is a landscape of orderly, mind-numbing repetitions. The striped and checkered cloth shapes meet at straight edges and precise corners, much as the fields of corn and soybeans meet along roads and railroad tracks that run dead-straight to the horizon.

The stitches, both those sewed by hand and those done by machine, set a cadence of measured, steady repetitions. Stitch by stitch, piece by piece, a row forms and extends for as long as it needs to. Then a second row and a third are added, until a field of pattern grows to bed size. The pattern has no center; just edges and expanses, starts and stops.

This is also the rhythm of a farm woman's work: the back-and-forth cadence of housework—scrubbing, sweeping, ironing. Progress comes in measured steps. In due time she reaches the end of the row, turns, and begins the next one—equally considered, tidy, precisely constructed. The procession continues until the garden is weeded, the lawn is mowed, the floor is cleaned.

In this patchwork image I see one woman's skills and aesthetic sensibilities coming together in work sparked by purposefulness, endurance, adaptability—in a word, *gumption*. She worked carefully, meticulously, patiently. She got satisfaction in using her skills and knowledge to make something useful and pretty.

I imagine how she went about her work. She transformed worn-out clothing into a stock of fabric shapes. She selected colors that harmonize. She arranged the pieces according to her own design. She fitted and sewed each piece into the evolving pattern. She had to work piecemeal, interrupting this project with countless chores and distractions.

In the world of women's work, creative projects such as this are often casualties to the competing demands on a woman's abilities, energies, and time. Perhaps that explains why this patchwork top was not completed. It is

Cathy Mullen is a faculty member in the Department of Art Education at Concordia University in Montreal, Quebec, Canada. She is a teacher and researcher with interests in adult (especially women's) visual culture and learning in art, photography, and digital technologies.

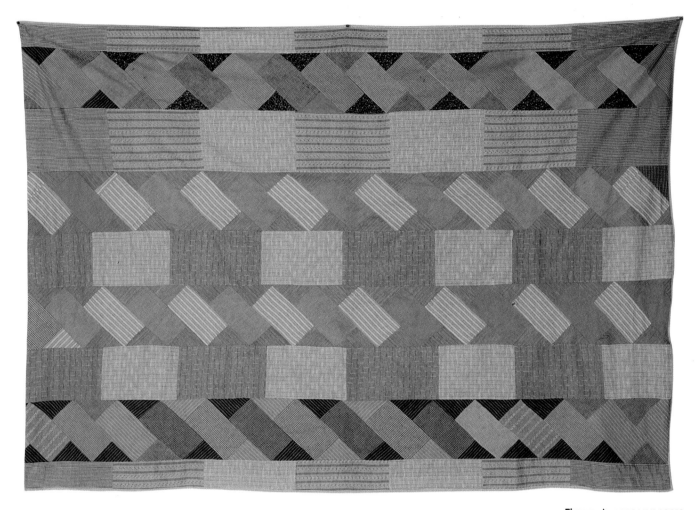

Figure A ANONYMOUS. Illinois farm family quilt top. Ca. 1940. Mixed fabric. 60 × 80 in. Owned by Cathy Mullen.

easy for me to speculate that its maker was drawn away from this project by any number of competing obligations and demands for her attention. Concentration dissipates, time passes, and a temporary interruption becomes permanent.

Although its intended use has not been fulfilled, this piece of patchwork gives valuable service in my daily life. From its place on the wall in my apartment, in a city hundreds of miles from those Illinois farmlands, it helps me to remember a place and way of life, and to acknowledge an unknown woman's work. Above all, it gives me a means to consider my own work and the rhythms of the life-pattern I am continually creating. ■

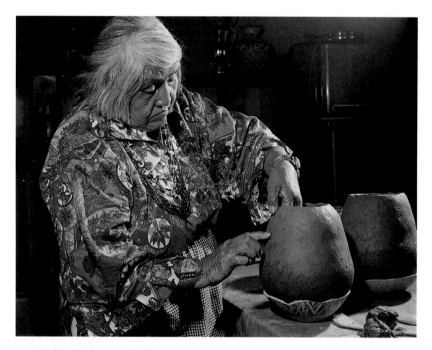

9.11 Lucy Lewis works on a coil pot. Photo: Jerry Jacka.

Viewing Traditional Crafts as Fine Art

Indigenous and rural peoples worldwide have always created useful crafts. They have produced works of functional or applied art that center on practical, social, or ceremonial use. These peoples never intended their hand-crafted work to be valued, in the modern fine art sense, for artistic qualities alone (the notion of "art for art's sake"). But that is precisely how much indigenous craft or useful art is now appreciated. Consider Native American pottery **(Appreciation 18),** kitchen implements (15.26), clothing (3.6), and African-American baskets (9.36) and quilts (15.29). Up to the twentieth century, the popular Western notion was that such items were examples of craft, however beautiful or artistically impressive. But as the modern formalist way of seeing (and interest in non-Western cultures) became deeply rooted, such works came to be viewed, collected, and exhibited by Westerners as fine art. In private and public collections, they were placed on sculpture pedestals or inside glass viewing cases instead of being used for storing grain, carrying water, or covering the body. (Their previous institutional home had been the ethnographic or history museum.) Such recognition by the Western and international art world notwithstanding, older Native American potters, so-called "matriarchs" like

Maria Martinez (ca. 1887–1980) and Lucy Martin Lewis (1900–1992), continued in the twentieth century to make pieces **(9.11)** in the ancient craft tradition that could be used as actual vessels or containers.

While the formalist way of seeing and honoring certain craft pieces as fine art objects has become prevalent in our society, increasing numbers of viewers and art professionals are seeking a more comprehensive appreciation. They believe that contextual understanding must be added to formal enjoyment. Consider the following example. Museum curator Salvatore Scalora purchased a Vodou (pronounced Voh-due) flag **(9.12)** in Haiti from flag maker Antoine Oleyant (died 1992). A highly respected artist, Antoine hired as many as six artisans to sew together the plastic sequins and beads that make up the flag's forms and colors. Traditionally, such flags were designed for use exclusively in Vodou religious ceremonies, but since the 1950s they have been available for purchase (if not already consecrated for religious use). In poverty-stricken Haiti, such sales, largely to foreigners, have provided precious income to their makers.

Scalora was moved by both the formal beauty and the cultural power of Haitian flags, which he displayed on gallery walls in a traveling exhibition, "Saluting the Spirits: Voodoo Flags of Haiti." According to Scalora,

> There are no more spectacularly beautiful objects in ceremonial use in the *houmforts* or Vodou temples than these sequined and beaded flags that picture various *loas* or spirits. Their vibrant designs, flashing in the light, are meant to be best appreciated while in motion, unfurled, swinging freely on a wooden or iron rod, and carried into the sanctuary space with ceremonial respect. These flags are earthly salutations to the living gods of Vodou, carrying a culturally encoded spiritual cargo. They act as heralds, invoking the loas to bless the ceremony and to bring their cosmic powers to bear in the lives of their devotees.[2]

As a museum curator, Scalora wants the viewing public to appreciate Haitian flags contextually as well as formally, to comprehend and respect their meaning in their own culture. Because of his belief in placing art in its context, Scalora provides educational materials on the artist and the cultural dimension of the works displayed in his shows.

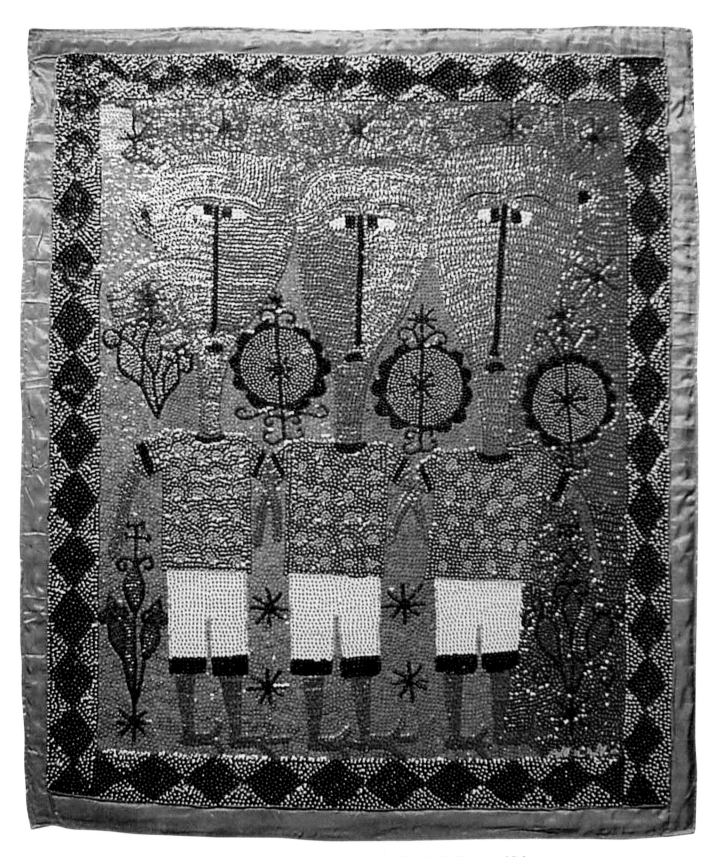

9.12 ANTOINE OLEYANT. *Marasah.* 1985. 43 × 36 in. Fabric, sequins, and beads. Collection of Salvatore Scalora. *The Marasah are divine entities who are endowed with supernatural powers of protection. They are believed to be the origin of all spirits and the ancestors of every family. Can you think of artworks from other cultures that function like Haitian Vodue flags?*

An Anasazi Indian "Kayenta Olla"

MOLLY F. WHITE

As I look at this pot **(Fig. A)** today, I think "what a strikingly handsome design!" And yet I know that it is almost one thousand years old and was made in the region of the southwestern United States where I now live.

This "olla" (the Spanish word for water jar) was found at Betatakin near Kayenta, Arizona, and is a product of the Anasazi culture. In this type of container the Anasazi stored water or grain. There is no reason to assume that it was made for ceremonial purposes. Rather, given all the many archaeological finds of similar objects throughout the Four Corners area, I assume that it was made for ordinary, everyday use.

The Anasazi lived either in apartmentlike cliff dwellings, as at Betatakin, or in pueblolike multistoried units, as at Chaco Canyon. At the height of their culture, pottery was developed technically to a high level of skill and craft.

Women shaped the pots by hand, building clay coil upon clay coil and then fusing the coils together into smooth walls. In the case of this Kayenta olla, the shaping had to be gauged carefully to build out diagonally to the wide shoulder and then tapered back to the small mouth.

Today the women at Zuni, Acoma, San Ildefonso, and other pueblos still build their pots by hand, using the same coil method. Mother teaches daughter, and the special polishing stones for smoothing the final surface are carefully passed down from generation to generation. The pot is set in the sun to dry before the design is added. The mineral black paint is applied with a brush cut from yucca roots. The brush is trimmed and then softened to the desired state of flexibility by chewing.

I am astounded by the skill of application of paint to create the dynamic black-on-white geometric design on this ancient olla. In this design the strong diagonals of the heavy black and white lines accentuate and complement the slanting contour lines of the body of the pot. Within these strong diagonal lines we find the more delicate shapes of triangles, stepped pyramids, and spirals. The narrow-patterned diagonal lines set up a complementary rhythm to the solid black shapes. The graceful curving line of the exterior shape of the olla is enhanced and made vibrant by the striking abstract design within.

We don't know exactly why this water jar for everyday use was decorated with its dynamically beautiful design. Perhaps it showed the high regard of its makers for its function, the storing of grain or water, precious commodities in the arid Southwest. What we can assume is that the design of the olla brought aesthetic pleasure to the one who made it and the ones who used it.

Viewing this Kayenta olla today creates in me a sense of wonder and excitement to realize the artistry of the people of this ancient civilization that flourished in the Southwest some five hundred years before the arrival of the white man. ■

Figure A ANASAZI KAYENTA OLLA. Tusayan black and white jar. Turkey Hill Pueblo, Arizona, ca. 1150–1300 A.D. 12¹¹⁄₁₆ × 12½ in. Courtesy Arizona State Museum, Tuscon.

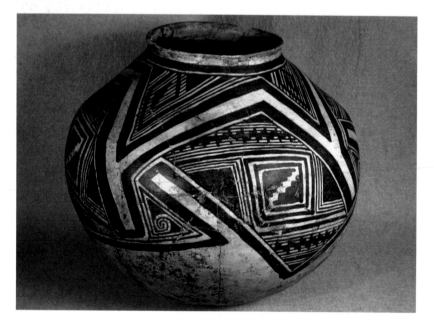

Molly F. White works as an artist. She is Former Chairperson, Division of Communications, Humanities, and Fine Arts, Navajo Community College, Shiprock Campus, Shiprock, New Mexico.

CRAFT AND PRODUCT DESIGN IN THE INDUSTRIAL AGE: THE NINETEENTH CENTURY

The world of handcrafted products, or "handicrafts," changed radically with the coming of the Industrial Revolution and machine-based mass production in the mid-nineteenth century. We turn now to some of the major movements, styles, and issues in the worlds of handcrafts and industrial-based product design. The year is 1851. The place is the Crystal Palace, the immense greenhouselike structure of glass and metal that housed "The Great Exhibition of the Works of Industry of All Nations," the first full-fledged world's fair **(9.13).** Situated in London's Hyde Park, it was, at the time, the largest single building ever created, covering eighteen acres. At 1,848 feet long (longer than six football fields) and 408 feet wide, it was a remarkable achievement of structural engineering and mesmerized almost all who experienced it. Writer William Makepeace Thackeray (1811–1863) exclaimed in his "Ode on the Opening" that the building was

> A Palace as for a fairy prince,
> A rare pavilion, such as man
> Saw never since mankind began
> And built and glazed.

The reigning Queen Victoria was moved to proclaim that she was "filled with devotion, more so than by any service I have ever heard."

Impressive and inspiring though the Crystal Palace was as a triumph of engineering and industry, it nonetheless appeared "styleless" or "artless" to many persons of cultivated taste. Focused as it was on its exhibition function, the grand pavilion lacked the customary artistic ornamentation and historical elements, such as Greek columns or Gothic arches, that endowed important works of architecture with style. "A greenhouse larger than ever greenhouse was built before," quipped a famous art critic, playing on the fact that its designer, Joseph Paxton (1803–1865), was a landscape gardener. (In actuality, the building's simple, streamlined, utilitarian design—what would be called **functionalist** or **machine style**—was years ahead of its time.) In contrast, many of the industrial products shown in the Crystal Palace's

9.13 JOSEPH PAXTON. Crystal Palace, London. 1850–51. Cast iron, wrought iron, and glass. Engraving (R. P. Cuff after W. B. Brounger). Victoria and Albert Museum, London. *Large-scale engineering projects (exhibition halls, railway sheds, suspension bridges) paved the way for the modern design approach to buildings and everyday commodities in the twentieth century. With effective practical function as its leading principle, the resulting design style was characterized by simple geometric shapes, precise and standardized, with a minimum of historical styling and ornamentation. The line or contour is direct and unbroken ("streamlined"), and surfaces are uniform in texture. At the present time, do engineering decisions exert a comparable aesthetic influence on the design of products such as cars, planes, trains, computers, stadiums?*

9.14 JOHN BELL. Hours Clock. 1851. Made by Elkington's. *How do you feel about highly decorated product designs like the Hours Clock? If you were going to make an argument for the positive contributions of product decoration, what would you say?*

The shapes arise!
Shapes of factories,
* arsenals, foundries,*
* markets,*
Shapes of the
* two-threaded tracks*
* of railroads,*
Shapes of the sleepers
* of bridges, vast*
* frameworks, girders,*
* arches.*
—Walt Whitman, poet, "Song of the Broad-Axe," ca. 1855

exhibition areas consciously strove for art status. In fact, their producers called them "art manufactures." In profusely decorated furniture, kitchen implements, and clocks, decorative and stylistic concerns prevailed over practical ones. In the Hours Clock **(9.14),** as in so much of the product design created for the affluent in the nineteenth century, the artistic components of ornamentation and styling disguised and overwhelmed the functional purpose. That the Hours Clock tells time seems almost an afterthought!

Nineteenth-Century Design: A Search for Cultural Identity

Highly decorated products such as the Hours Clock appealed to the increasingly prosperous and powerful middle class of the nineteenth century. The political and industrial revolutions of the eighteenth and nineteenth centuries had made the industrialist and the businessman the leaders of society, raising them above their former rulers, the clergy and nobility. Nineteenth-century product design in large part reflected their taste. It was the taste of a

"nouveau riche," a growing class of newly rich people. To a cultivated aristocrat or gentleman, most machine-made "art manufactures" represented a tasteless and dishonest display: ornamentation that was gaudy, forms that were illiterate distortions of earlier styles, and materials that strove to look like something they weren't (for example, zinc substituting for silver, or molded paper pulp for wood). By the standards of the cultural elite, the taste displayed by the nineteenth century's newly rich—more wealth, more show—seemed particularly low. In historical perspective, it was the taste of a class that was forging ahead vigorously on the economic and political fronts but was not entirely knowledgeable or sure of itself in the cultural sphere. This lack of a distinct cultural identity among the middle class was evidenced in their enthusiastic embrace of a freewheeling mix of the styles of earlier ruling elites (including that of the pharaohs of ancient Egypt), styles that too often were exaggerated imitations of the originals.

The Influence of Japanese Art and Design
Critical of the taste of the newly rich, the cultural elite looked in other directions for its applied arts. By the 1860s and 1870s, many among the aesthetically sophisticated had rejected machine-made products, instead seeking out fine handcrafted goods. Some of these were influenced by an exciting new Western discovery: the art and design of Japan. A painting **(9.15)** by London-based American artist James McNeill Whistler (1834–1903) shows this new "Japonisme," or love of Japanese things. Virtually every item in the room is of Japanese origin. A young European woman, dressed in Japanese clothing, holds a colorful Japanese print; others are scattered before her on the floor. (The woodblock prints of Hokusai (4.12) and especially Hiroshige (3.9) offer examples of what these prints might look like.) In the lower left corner are a dark brown lacquer box and a blue-and-white, porcelain "chinaware" vase (produced in Japan or China) holding an arrangement of flowers, itself a traditional Japanese art form. In the background is a large, folding golden screen, decorated with scenes from Japan. In front of the screen is a piece of furniture of very simple line and almost geometric shape.

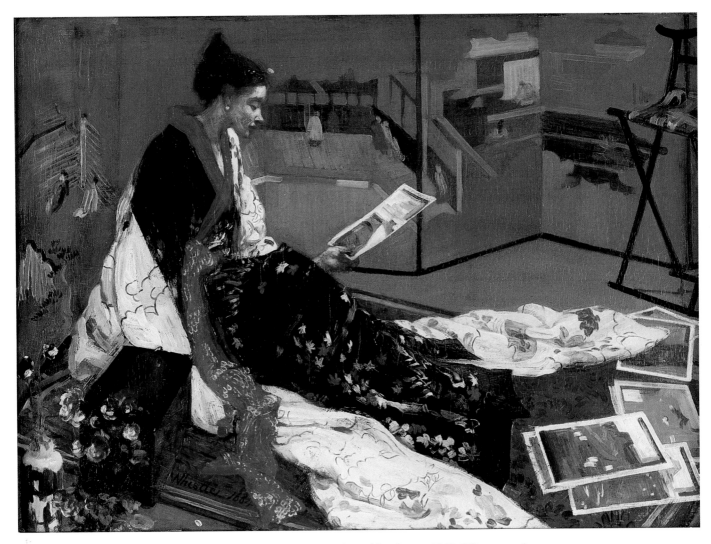

9.15 JAMES MCNEILL WHISTLER. *Caprice in Purple and Gold: The Golden Screen*. 1864. Oil on wood panel. 19¼ × 27 in. The Freer Gallery of Art, Smithsonian Institution, Washington, D.C. Gift of Charles Lang Freer, F1904.75. *Some think that reductive simplicity is the foremost Japanese aesthetic design principle, yet a second major principle centers on the inclination to decorate a surface completely. In which items in the painting is this aesthetic will to ornament seen? Explain.*

One of the guiding principles of Japanese design is an emphasis on elegant simplicity and decorative restraint. Note again the simplicity, lightness, and abstract elegance of the piece of Japanese furniture in Whistler's painting. This particular Japanese aesthetic was imaginatively adopted in the English furniture and interior designs of E. W. Godwin and others. Godwin's 1867 sideboard **(9.16)** is characterized by simple, clean lines and shapes and a minimum of decoration. Its thin vertical and horizontal elements and its spatial openness

convey a sense of lightness. These formal qualities, combined with the sideboard's commitment to effective function, anticipate the "modern" design of the twentieth century.

Looking to Japan or to the famous styles of their own past, such as the Gothic, different segments of society searched for works of practical art and design that affirmed their distinct values and taste. For the artistically discriminating, the so-called "aesthetes," these values and tastes most often centered on fine handcraftsmanship.

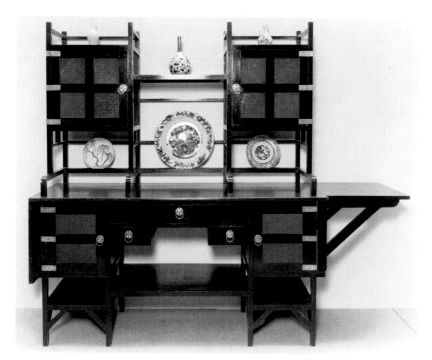

9.16 EDWARD WILLIAM GODWIN. Sideboard. Ca. 1867. Ebonized, silver plated, and inset panels of paper stamped in imitation of embossed leather. Victoria and Albert Museum, London. *During the second half of the nineteenth century, European aesthetes embraced Japan's expansive model of art appreciation, with its respect for artistic quality in the most diverse objects and activities: flower arranging, the tea ceremony, furnishings, ceramic vessels, clothing, woodblock prints. Can you accept this way of seeing and respond to Godwin's piece of furniture as a work of high art, equivalent in status to a fine painting or sculpture?*

9.17 CLAUDE MONET. *Unloading Coal.* 1875. Oil on canvas. 21¼ × 25½ in. Musée d'Orsay, Paris.

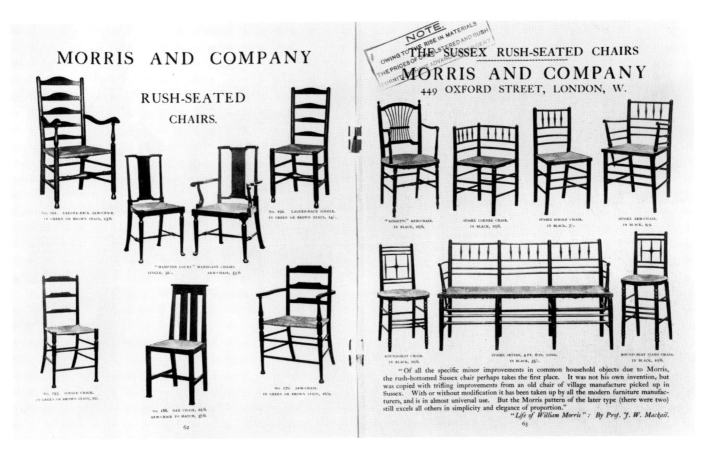

MORRIS AND COMPANY

RUSH-SEATED
CHAIRS.

THE SUSSEX RUSH-SEATED CHAIRS

MORRIS AND COMPANY

449 OXFORD STREET, LONDON, W.

NO. 191. LADDER-BACK ARM-CHAIR. IN GREEN OR BROWN STAIN, 23/6.

NO. 192. LADDER-BACK SINGLE. IN GREEN OR BROWN STAIN, 14/-.

"HAMPTON COURT" MAHOGANY CHAIRS. SINGLE, 32/-. ARM-CHAIR, 53/6.

NO. 193. SINGLE CHAIR. IN GREEN OR BROWN STAIN, 10/.

NO. 188. OAK CHAIR, 22/6. ARM-CHAIR TO MATCH, 37/6.

NO. 170. ARM-CHAIR. IN GREEN OR BROWN STAIN, 16/9.

62

"ROSSETTI" ARM-CHAIR. IN BLACK, 16/6.

SUSSEX CORNER CHAIR. IN BLACK, 10/6.

SUSSEX SINGLE CHAIR. IN BLACK, 7/-.

SUSSEX ARM-CHAIR. IN BLACK, 9/9.

ROUND-SEAT CHAIR. IN BLACK, 10/6.

SUSSEX SETTEE, 4 FT. 6 IN. LONG. IN BLACK, 35/-.

ROUND SEAT PIANO CHAIR. IN BLACK, 10/6.

" Of all the specific minor improvements in common household objects due to Morris, the rush-bottomed Sussex chair perhaps takes the first place. It was not his own invention, but was copied with trifling improvements from an old chair of village manufacture picked up in Sussex. With or without modification it has been taken up by all the modern furniture manufacturers, and is in almost universal use. But the Morris pattern of the later type (there were two) still excels all others in simplicity and elegance of proportion."

"*Life of William Morris*": By *Prof. J. W. Mackail.*

63

The Argument for Handcraftsmanship

The eminent critics John Ruskin (1819–1900) and Thomas Carlyle (1795–1888) believed that the Industrial Revolution had debased the status of the applied arts by employing masses of unskilled laborers toiling at machines at the expense of skilled craftspeople. Goods produced by the skillful individual, Ruskin observed, could not compete in price with the mass-produced goods coming off the assembly lines. High-quality products that were attractive in appearance, well made, and effective in function were being steadily lost, while machine manufactures—"cheap and nasty" according to Carlyle, and "cold and deadly" according to Ruskin—were flooding the market.

For these two widely read writers, work was the most sacred of activities, the chief source of human fulfillment. Monet's 1875 painting *Unloading Coal* (**9.17**) shows the dehumanization process they feared: rows of faceless laborers trudging back and forth, machinelike, tiny cogs in an endless assembly line. The industrialization of work, Ruskin and Carlyle asserted, was an incalculable sin against God, humankind, and high-quality production.

William Morris and the Arts and Crafts Movement

William Morris (1834–1896) and other English reformers of the **Arts and Crafts movement** not only criticized the effects and products of the Industrial Revolution but did something about them. Looking for furniture for his own lodgings, Morris, the son of a successful businessman, was utterly disheartened by the ugliness and vulgarity of the products available. Believing (as did Carlyle and Ruskin) that the combination of divided labor, machine production, and competitive commercialism was impoverishing products and work process alike, he determined to set an alternative example.

In 1861, at the age of twenty-seven, he opened a seven-member firm, Morris and Company, whose goal was to produce finely designed, handcrafted products (**9.18**) at reasonable cost. The firm included well-known painters, an architect, an engineer, and Morris himself, an artist-craftsman in diverse media. Skilled artisans assisted the master artist-craftsman on projects as in the guild workshops of the late Middle Ages and Renaissance (1.2). Within Morris's guild-workshop ideal,

9.18 William Morris and Company. The Sussex rush-seated chairs. Page from 1910 catalogue. The William Morris Gallery, London.

251

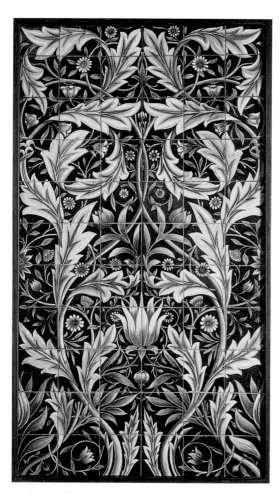

9.19 WILLIAM MORRIS, designer. Tile panel, made by William De Morgan for Membland Hall, Devon. 1876. 66 × 36 in. The William Morris Gallery, London.

9.20 PHILIP WEBB. Red House, interior showing view of staircase. 1859. Red House, Bexleyheath, England.

A time traveler, William Morris was a Renaissance artist in a Victorian age: Inspired by the range of Leonardo, he wrote poetry and prose; designed, painted, and decorated; spoke in public as a socialist activist and thinker; and manufactured patterns of flowers, leaf, stem, and pod.—Arlene Raven, art historian, *Designs by William Morris,* 1985

artists and craftspersons would cooperate to create decorative and functional art, well made and beautiful, for both private homes and public places. Arts and crafts were to have equal footing, with fine and applied artists working side by side for the greater good of art and society. In this setting, the work process itself would be pleasurable and gratifying, and the pride of the artist-craftsperson would be manifested in each work.

The range of decorative and useful art produced by Morris and Company was extraordinary: mural decoration, stained glass, decorative tiles, architectural carving, metalwork, jewelry, ceramics, weaving and embroidery, textiles, wallpaper and fabric design, furniture, and, by the 1890s, illustrated books. Though

advocating no single style, the group adhered to general imperatives that combined moral and aesthetic values. They emphasized respect for materials, simplicity and restraint, the humanizing effects of handcraftsmanship, and "fitness for purpose" (that is, form honestly following function). Within these broad parameters, the artist-craftsperson was encouraged to bring personal expression to his or her medium, whether stained glass, furniture, wallpaper, weaving, fabric, or tile design **(9.19)**. In this stimulating community of master artists, the individual, guided by personal integrity, was the ultimate arbiter of style.

Building on the idea of cooperative interplay among diverse artist-craftspersons, Morris urged the coming together of the various

9.21 Reconstruction of a Shaker Room. The American Museum in Britain, Bath, England.

arts in private homes and public buildings, on the street and in the workplace. Practicing what he preached, Morris made his own home, Red House, a complete aesthetic environment. Nearly every aspect of Red House, from the landscape gardening to the wall and floor coverings, furniture, and woodwork **(9.20),** was designed, decorated, and handcrafted by Morris and his friends. From staircase to lighting fixtures, the handcrafted products adhered to Morris's values of simplicity and fitness for purpose.

Shaker Products: An Arts and Crafts Ideal

People of means and cultivated taste could create a total domestic environment of beauty and function, but could modest working people, as the Arts and Crafts reformers hoped, do the same in their homes and communities? A group that came close to realizing this model was America's Shakers. Separating themselves from the urban industrial world, this idealistic Protestant sect established a handful of small rural communities in the United States in the late eighteenth and early nineteenth centuries.

Of modest means and totally devoted to their religious beliefs, the Shakers preached pacifism; sexual, racial, and economic equality; spiritual purity; and honest craftsmanship in the goods they made. In 1852, the Shakers founded a highly successful chair factory to make furniture for outside sale. The application of their theological beliefs such as "it is a gift to be simple" and "beauty rests on utility" to their handicraft work resulted in moral-aesthetic standards very much like those of Morris and Ruskin. Interweaving art and religion, Shaker furniture, baskets, and implements always had a simple, direct beauty, with no applied ornament or decoration **(9.21).** Crafted by caring hands, each object was made to last a lifetime or more. The Shaker approach could not have been further from the aesthetic embodied in the highly decorated, historically stylized furnishings (9.14), designed for machine mass-production, that dominated the Crystal Palace exhibition during this same time period. In their small, self-contained communities, the Shakers achieved in microcosm the Arts and Crafts ideal: nameless

Morris's vision of a new world arose from his optimistic understanding of the past—the coherent preindustrial society of the Middle Ages, which celebrated craftsmanship, pleasured in a simpler natural beauty, and delighted in work; in which the responsibilities of individuals to community were universally understood.—Arlene Raven, art historian, *Designs by William Morris,* 1985

9.22 LOUIS COMFORT TIFFANY. Four pieces of favrile glassware in the Art Nouveau style. Ca. 1900. The Metropolitan Museum of Art, New York.

craftsperson-citizens sharing their wealth and talents for the moral, aesthetic, and material good of society.

Arts and Crafts Influence in Europe and America In contrast to the Shakers, long-standing Arts and Crafts commercial firms such as Morris and Company (established in 1861) and the more socialist Art Workers, Craftsmen, and Handicraft Guilds that arose from the 1880s onward created products for a very limited audience. In a competitive free-market economy, their products proved too expensive or too unusual in style for the community at large. The Arts and Crafts firms and guilds survived primarily due to the commissions or purchases of a small elite of wealthy, sophisticated people.

Despite the slow growth of their commercial market, however, the passionate idealism of the Arts and Crafts movement spread rapidly. The movement's enthusiastic vision, coupled with the fine work of original Arts and

Crafts practitioners such as Morris, inspired and influenced several generations of artists, architects, product designers, and aesthetes in both Europe and America. Arts and Crafts ideals would strike a deep chord with Europe's "New Art" practitioners of the 1890s and the early twentieth century, as well as with North America's various Arts and Crafts societies, one of which included the young architect Frank Lloyd Wright (9.25, 3.10) as a charter member. All these organizations and movements promoted the equality of the fine and applied arts, the ideal of the artist-craftsperson as designer, and the goal of creating fine decorative and useful art for the larger public—"art for all," as Morris would say.

Art Nouveau: The New Art of the Turn of the Century

Sharing a great deal both ideologically and stylistically, the New Art movements of the late nineteenth and early twentieth centuries quickly took on an international character. Embracing the popular French title **Art Nouveau** ("New Art"), the various creations tended to find unity in their "underlying character of protest against the traditional and the commonplace," as an American critic wrote in 1902. To many, Art Nouveau seemed an anti-movement, consciously discarding the old, outworn styles and conventions for the new and experimental. Self-conscious modernists joined international art dealer Siegfried Bing (1838–1905) in his complaint that amid the scientific progress of the day so much art and decoration "continued to be copied from what was in vogue in previous centuries, when different habits and different masters were current. . . . What an astonishing anachronism!"

In fact, it was the German-born Bing who gave the movement its lasting title. Bing named his Paris shop "Maison de l'Art Nouveau" because it was "a meeting ground for all ardent young artists anxious to manifest the modernness of their tendencies." For his first Salon de l'Art Nouveau, which opened in 1895, Bing commissioned avant-garde artists to create designs for stained glass to be executed by Louis Comfort Tiffany (1848–1933) in the United States. The exhibition included vanguard paintings, Japanese woodblock prints,

and sculpture by French master Auguste Rodin (1840–1917) (7.20). Placing the applied arts on an equal footing with the fine arts, the show featured an array of handcrafted splendors: glassware by Tiffany **(9.22),** jewelry by René Lalique (1860–1945), book illustrations by graphic artist Aubrey Beardsley (1872–1898) (6.10), and advertising posters by the likes of Toulouse-Lautrec (6.9) and Bradley (6.16).

The New Art of the 1890s both reflected and contradicted its times. On the one hand, like the times, it was dynamic, interested in experimentation and progress, and oriented to new industrial materials and technologies. Architects such as Victor Horta (1861–1947) of Belgium extended the possibilities of iron as both building material and ornament, as seen in the fantastical interior design of his Tassel House **(9.23).** As theatrical set designer George Hillow observes, the iron staircase, grillwork, and posts, along with the floor and wall designs, "interweave with a serpentine beauty that seems spun by a spider rather than crafted by human hands." In the same vein, stained-glass artists such as Tiffany introduced new metals to join their pieces of glass together in innovative ways. Art Nouveau creators of glassware, metalwork, ceramics, and furniture, unlike their Arts and Crafts forebears, embraced the newest technologies as a means to expand the potential of their art.

On the other hand, Art Nouveau stood in bold contrast to its times, taking an antiestablishment stance in its art, clothing, manners, and values. To begin with, much of the style and subject matter of the new art, especially in the applied arts, came not from the urban, industrial world that dominated the times but rather from nature. In Art Nouveau jewelry, glassware, furniture, and interior decoration, we see forms abstracted from plant and underwater life, exotic birds like the peacock, and flowers like the sunflower and lily. Note how the shapes of flowers are abstracted and stylized in Tiffany's glassware (9.22) and in the graphic art of Beardsley (6.10) and Bradley (6.16). Consider the biomorphic shapes and snakelike lines that characterize the Tassel House interior (9.23) and the jewelry of Hector Guimard (1867–1942) **(9.24).** Unlike the geometric forms of the machine style (9.13, 9.26), Art Nouveau lines and shapes swirl, curling

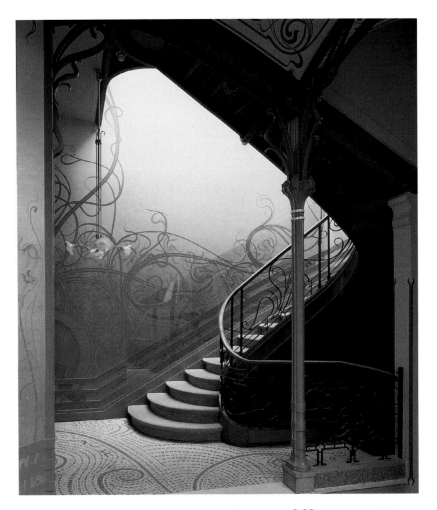

9.23 VICTOR HORTA. Staircase of the Tassel House. Ca. 1892–93. Brussels, Belgium. *What would it be like to live in the Tassel House? How might such an interior design affect your thoughts, feelings, behavior?*

organically like tendrils, vines, and roots. Given its close association with nature and female principles (organic fertility, the earth as a mother) and its focus on women as subject matter, Art Nouveau might be seen as a counterstatement to a male-dominated society in which the geometric shapes of machines, street grids, railroad lines, and bridges increasingly held sway.

MODERN DESIGN AND MASS PRODUCTION: INTO THE TWENTIETH CENTURY

In the early twentieth century, the Arts and Crafts emphasis on humanizing handicraft work gradually gave way to a new emphasis on finely designed products made by industrial

9.24 HECTOR GUIMARD. Hat Pin. Ca. 1910. Bronze. 1 × 1¼ in. Gift of Madame Hector Guimard. The Museum of Modern Art, New York. *Best known for his large-scale metal entranceways to the underground Paris metropolitan train system, Guimard worked in diverse materials, processes, and forms, from gem-studded jewelry to wooden furniture. How can an artist or a designer work in such a wide variety of art forms and not dilute the quality of his or her creations?*

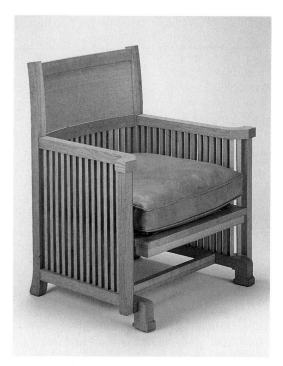

9.25 FRANK LLOYD WRIGHT. Armchair designed for the Ray W. Evans house in Chicago, Illinois. 1908. Oak. 34¼ × 23 × 22½ in. Gift of Mr. and Mrs. F. M. Fahrenwald, 1970.435. © The Art Institute of Chicago. All Rights Reserved.

processes. Taking the place of the humble artisan was "the creative artist," a master of exceptional abilities supported by the awesome powers of the machine. Such was the claim of North American architect-designer Frank Lloyd Wright (1869–1959). In 1900, Wright told his friend C. R. Ashbee, a major figure in the Arts and Crafts movement, that "the art of the future will be the expression of the individual artist through the thousand powers of the machine, the machine doing all those things that the individual workman cannot do, and the creative artist is the man that controls all this and understands it." In his own furniture, Wright employed organic materials such as wood but followed a pared-down, functionalist aesthetic; some consider his chairs to be the first truly modern furniture. Abstract and geometric in their styling, they were likened to "machines" to be sat in **(9.25).**

Like Wright, the most advanced European architects and designers were excited by the aesthetic of the machine and its capacity for mass production. But, unlike the individualistic Wright, many of the Europeans remained committed to the more collaborative model of product design put forward by the socialists of the Arts and Crafts movement. In 1897, German architect Alexander Koch (1860–1939) summed up this communitarian ideal in his call for "a complete integration of all artists, architects, sculptors, painters, and technical artists. They all belong intimately together in the same place, each thinking individually, yet working hand in hand for a larger whole." In 1907, the newly founded Deutscher Werkbund (German Work Confederation) declared its purpose to be to unite "artists, craftsmen, experts and patrons, intent on an improvement of production through collaboration of art, industry and the crafts, through training, publicity and the forming of a united front." In 1919, in answer to such calls, the **Bauhaus** (literally, "building house") was founded. In short order, it was to become the most influential school in twentieth-century art and design, bringing

9.29 MARCEL BREUER. B32 "Cesca" side chair. 1928. Chrome-plated tubular steel, wood, and cane. 31½ × 17½ × 18¾ in. Gebruder Thonet, Germany, manufacturers. The Museum of Modern Art, New York. Purchase.

9.30 GARY CHATELAIN. Fox Clinic, doctor's office. 1981. Harrisonburg, Virginia.

welcome, making Bauhaus product design look like streamlined machines to viewers. An example is the tubular metal furniture of Breuer and of the school's last director, architect Ludwig Mies van der Rohe (10.41). The furniture Breuer created between 1925 and 1928—his tubular chairs and tables, folding and swivel chairs, and cantilever chairs **(9.29)**—represents a minor revolution in design. Tubular metal posts, smooth and gleaming, are joined with natural materials such as fabric, leather, wood, and cane to create portable and comfortable lightweight chairs. These chairs were the first to use tubular metal, an innovation supposedly inspired by Breuer's meditations on the handlebars of his bicycle. For these true artists, the materials and processes developed by industry inspired formal-functional breakthroughs, leading to mass-produced articles that were practical, affordable, and beautiful. Numerous "take-offs" of Breuer's chairs and tables can still be found in homes, schools, and offices today.

The closing of the Bauhaus by the Nazis in 1933 (it was considered too progressive and iconoclastic, and it had Jews on its faculty) resulted in many of its most prominent members emigrating from Germany to the United States. The influence of these Bauhaus expatriates on North American designers, architects, and artists was substantial. A largely Bauhaus-inspired functionalist or machine style in the applied arts known as **international style** or simply **modern style** rose to renown beginning in the 1940s. The cool, refined minimalism of Gropius, Breuer, Mies van der Rohe, and their colleagues, as well as of the best work of several generations of students, epitomizes the functionalist machine aesthetic at its best. The furniture and interior design of Florence Knoll (born 1917), one of Mies van der Rohe's students, have had a worldwide influence on the form and function of the modern office building her firm, Knoll Associates, remains one of the foremost interior design firms and furniture manufacturers in the world. A

The industrial designer began by eliminating excess decoration, but his real job began when he insisted on dissecting the product, seeing what made it tick, and devising means of making it tick better—then making it look better.—Henry Dreyfuss, industrial designer, *Designing for People,* 1955

9.31 CHARLES and RAY EAMES, designers, and Herman Miller Furniture Company. 1953. Circular arrangement of various Eames chairs with display panels.

Baby boomers sat on Eames chairs when they were new. Now, half a century later, their children want them too. . . . Some designs are brilliant enough to transcend time—if they can survive the rigors of the assembly line.—Linda Hales, writer, "The Eames Show," *The Washington Post,* May 20, 1999

handsome, highly functional doctor's office, designed by Gary Chatelain (born 1949), epitomizes this tradition **(9.30)**. Expanding its base from a tiny avant-garde group of appreciators in the 1920s to widespread public acceptance today, the Bauhaus, with its integrated approach to art and industry, achieved a central place in the product, interior, and architectural design of the twentieth century.

Fine Product Design for the Masses: The Furniture of Saarinen and Eames

In the 1930s, an important community and school arose at Cranbrook, in the Michigan countryside near Detroit. The ideals of Cranbrook Academy grew from the Arts and Crafts movement, and its purpose paralleled that of the Bauhaus. Founded by Michigan businessman and aesthete George Booth and the internationally prominent Finnish architect Eliel Saarinen, Cranbrook became a North American version of Gropius's "building house" and a principal launch site for fine product design in America. Cranbrook designers took the cool, clear geometry of the Bauhaus and softened it, creating a more organic, sculptural style. In the area of furniture design, biomorphic forms derived from nature replaced the abstract machine geometry of Breuer and Mies van der Rohe. Eero Saarinen (1910–1961), son of Eliel, began his illustrious career as a product designer and architect at Cranbrook in the 1930s. He collaborated with the multitalented husband and wife team of Charles (1907–1978) and Ray Eames (1912–1988) in the creation of a new generation of well-designed furniture that was geared from the start for mass production **(9.31)**.

9.32 EERO SAARINEN. Pedestal (tulip) chair. 1957. Molded fiberglass shell, foam cushion, aluminum base. 32 × 20 × 21¼ in. Courtesy Knoll Inc., New York.

With Saarinen and the Eameses, the Arts and Crafts and Bauhaus ideals of art for the masses began to be fully realized. Some of the most popular chairs of the second half of the twentieth century are the result of their collaboration at Cranbrook and their subsequent independent work. The development of new materials and techniques (for instance, molded plywood and plastics) for furniture design, some actually pioneered by these three designers, opened the way for an expansion beyond the geometric Bauhaus style. As Saarinen was the first to admit, "New materials and techniques have given us great opportunities with structural shells of plywood, plastic and metal. . . ."

If the 1920s was the decade of breakthroughs in metal furniture, the 1940s and 1950s were certainly decades committed to the exploration of molded plywood and plastic, often used in combination with metal, wood, and various upholstery fabrics. In the skillful hands of North American designers, furniture forms became more gently rounded and

organic. The machine aesthetic became more "naturalized." The Eameses' molded plywood and plastic chairs welcomed sitters. Inexpensive to moderate in cost and light and practical, they were ubiquitous in homes, classrooms, and meeting rooms from the late 1940s.

One of Saarinen's crowning achievements was his pedestal series **(9.32)**, designed between 1955 and 1957. These tables and chairs, and "knock-off" variations of them, can be seen in airport and bus terminals and college classrooms worldwide. One of the designer's intentions had been to get rid of what he called "the slum of legs" in a room. In doing so, he achieved a most successful visual transition between the plastic shell of the chair and its base. Nicknamed the "tulip chair," the pedestal chair rises out of the floor on a single stem that flows into a sculptural shell of soft folds, almost flowerlike. To many, these pedestal chairs and tables have a space age look, perhaps because of their flowing line, sense of lightness, and suggestion of movement.

9.33 GAYLE MARIE WEITZ. Social Studies (Includes Personas #1–9: grandparents, businessman, housewife and baby, waitress, teenager, girl, and boy). 1986–1989. Assembled, carved, and painted basswood cabinets with collaged interiors; tallest figure 76 × 36 × 16 in., shortest figure 48 × 28 × 8 in. *Would you prefer to have Weitz's "Social Studies" cabinets in your home environment or regular, mass-produced cabinetry? Give your reasons.*

INTO THE TWENTY-FIRST CENTURY: NEW DESIGN DIRECTIONS

The substantial evolution of product design over the last 150 years leads us to pose a tantalizing question: In what directions will the applied arts evolve in the twenty-first century? One direction is products designed by **postmodernists,** who neither accept the principle that "form follows function" nor share the modernist's commitment to abstract, machine-like shapes. The other direction, **ergonomic** or "human factor" design, extends modern design's functionalism to the maximum degree.

Postmodern Design

Postmodern designers are interested in historical decoration and social references and welcome ornamentation that has no practical function. They appreciate premodern qualities such as symbolism, figurative representation, and even narrative; recall, for example, the organically suggestive shapes of Art Nouveau design (9.22–9.24) and the symbolic, storytelling features of the mid-nineteenth-century Hours Clock (9.14), where each figure represents a specific hour or time of day. Gayle Marie Weitz (born 1956), for example, goes so far as to transform a series of functional wooden cabinets into life-size human sculptures **(9.33)**

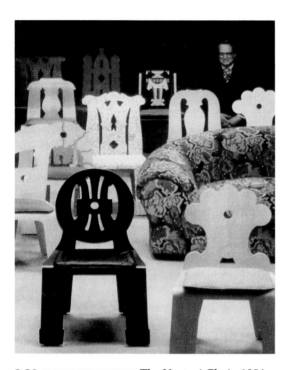

9.34 ROBERT VENTURI. The Venturi Chair. 1984. Courtesy Knoll Inc., New York. *Is Venturi's furniture collection an "eclectic mixture of traditions" and "the continuation of modernism and its transcendency," in keeping with one definition of postmodernism? Are the Venturi chairs and sofa "double-coded and ironic," as the definition further notes?*

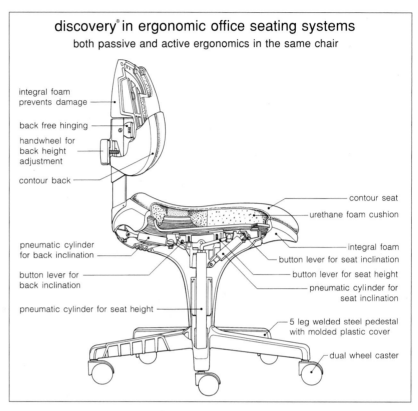

9.35 Ergonomic chair. Ca. 1981. Soft foam, aluminum mechanism, steel base. 29–38 in. Fröscher Sitform, Stüttgart, designers. Courtesy Fixtures Furniture.

that playfully depict stereotypes the artist held as a young girl.

Postmodernists, such as architect and designer Robert Venturi (born 1925), argue that modernist products' extreme focus on function leaves them abstract, cold, and without feeling. Venturi believes we need to rehumanize product design through forms and decoration filled with human associations and meanings. The furniture that he has designed **(9.34)** interweaves historical styles and decorative effects with contemporary materials and construction techniques, creating pieces that are playful and witty.

Ergonomic Design

Interior designer Chatelain, a confirmed functionalist (9.30), seems unconvinced by the claims of the postmodernists. Chatelain sees a more compelling direction in design, one that involves "ergonomics," or "the applied science of optimizing people's relationship with their immediate environment." Also known as human factor design, ergonomic product design is functionalist in the most complete sense of the word. Its foremost goals are worker efficiency and the health and comfort of the product's users. To accomplish these goals with office furniture, manufacturers have created completely adjustable "active" chairs **(9.35)** with a complete range of adjustability in seat height and tilt and backrest height and tilt, all operated by a gas cylinder within the chair that makes adjustments at the touch of a button. Just as the light, portable metal chairs of Breuer (9.29) expressed the values and met the needs of early-twentieth-century society, the scientifically researched and efficient ergonomic chairs of the last quarter of the twentieth century are appropriate machines for the present computer age.

Post-Modernism is fundamentally the eclectic mixture of any tradition with that of the immediate past: it is both the continuation of Modernism and its transcendancy. Its best works are characteristically double-coded and ironic, making a feature of the wide choice, conflict and discontinuity of traditions, because this heterogeneity most clearly captures our pluralism.
—Charles Jencks, writer, *What Is Post-Modernism?* 1989

9.36 Contemporary sweetgrass baskets for sale at a roadside stand in Mt. Pleasant, South Carolina. 1977. Photo: John Michael Vlach.

9.37 Woman weaving a seagrass basket. McKissick Museum, University of South Carolina.

CRITICAL RESPONSES TO INDUSTRIALLY BASED DESIGN

While the mechanization of production has made fine design widely available at affordable prices, the majority of our products are not well designed and are manufactured—and discarded—at alarming rates. Poorly designed, shoddily crafted products of little artistic merit are being mass-produced for quick profit and rapid turnover. Some of these products are actually designed to break down or go out of style after a relatively short period in accordance with the principle of "planned obsolescence." (One response to such shoddy mass-produced products has been the recent "crafts renaissance," which we will discuss shortly.)

Poorly Designed Products and Alienation

Richard Latham, a one-time member of the prestigious industrial design firm Raymond Lowey Associates, notes that most people today no longer look to products for beauty, excellence of craft, or lifelong use. Rather, we buy cleverly packaged commodities that are "here today and gone tomorrow." We have succumbed to the mentality of a "temporary" society and its principle of planned obsolescence, in which products are thrown out as soon as they are used up, fall apart, or go out of style.

Latham observes that most persons in industrial nations, unlike their preindustrial ancestors, do not feel an emotional reverence or love for the implements of everyday life. If anything, we feel emotionally disconnected or alienated from our tools and products. In contrast, Latham argues, "the artifacts of our original settlers, the art of the Indians who populated our country (Appreciation 18), and later the everyday objects our pioneer stock evolved, all share a high level of intrinsic quality and craftsmanship. Most important, they reflect the regard which the people who made and used them felt for the objects themselves." Native American pottery (8.2), African-American baskets **(9.36),** Shaker furniture (9.21), and farm family quilts (Appreciation 17) are only a few of the many beautifully conceived and executed artifacts designed, made, and used by Americans living outside the commercial and industrial mainstream.

9.38 Home office of Robert Bersson. 2002. Harrisonburg, Virginia. Photo: Patrick Horst.

The Crafts Renaissance

A crafts renaissance in the second half of the twentieth century has brought about a revival of handcrafts in the spirit of the high-quality products made by our native and early American forebears. Increasing numbers of craft artists—potters, weavers, woodcarvers, metalworkers—are making their living through production and sale of their work. Recalling the Arts and Crafts movement of the previous century, craft artists like Jim Hanger (9.2) and Rob Barnard (9.3) speak of both the human fulfillment they receive from the work process and the pride they take in creating a useful product to the very best of their abilities. Many people, appreciating the individuality and excellence of such products, now seek out handcrafted items rather than mass-produced goods for everyday use. This commercial and cultural support has led to the revitalization of various craft traditions and their development into profitable trades. For example, the basketmaking craft, long practiced by African Americans in coastal South

Carolina, has experienced a substantial commercial expansion over the past fifty years. Selling their wares at rural roadside stands (9.36) or on the city streets of Charleston, the women and men create coil-woven baskets of diverse shapes, most with aesthetic connections to earlier African and African-American traditions. Figure **9.37** shows a "basketsewer of fifty years plus" weaving a basket from coils of local "sea grass." In a world dominated by standardized factory production, an individually created basket, cabinet (9.33), or handmade glass drinking mug (9.7) has a human presence or "personality" that is deeply gratifying.

APPLIED ART IN THE IMMEDIATE ENVIRONMENT

Take a closer look at your everyday surroundings **(9.38).** Step outside the normal rush of daily life and spend some time looking, perceptively and thoughtfully, at the products

INTERACTION BOX

ART, CRAFT, AND PRODUCT DESIGN: A BREAKDOWN OF BOUNDARIES?

Put on your contextual thinking cap. Not many years ago, distinctions between the fine arts, crafts, and product design were fairly strong in our society. Terms such as "high art" and "low art," art and craft, fine art and applied (or useful) art clearly distinguished one category of art from another. Today, these categories seem to be breaking down. One could argue that the previous distinctions are blurring or hybridizing; terms such as "ceramic sculpture," "textile art," and "industrial art" blend or bridge the former art-craft and fine art–applied art divides. If such is the case, what has changed in the larger society and culture to make this happen? Does it have something to do with television, the Internet, social mobility, multiculturalism, changing artworld values? Make a convincing contextual case for the breakdown (or lack thereof) of traditional art categories or boundaries.

around you. Probe your rooms, home, school, workplace. Which objects of practical function or decoration in your living or working environment are handcrafted? Which are machine-made? Which are well designed and crafted **(Interaction Box)?** It is one thing to look at applied art in museums, books, films, or slide reproductions and have experts tell us about them. It is another to examine the products that surround us. Those products are an accurate reflection of ourselves. They reveal our socioeconomic status, our mode of work, our values and life-style. They reflect our taste for contemporary or historical styles, our orientation to permanence or mobility, and much more. They mirror our inclination for the forms, materials, and values of nature, the machine, or individualist fantasy. Our products, ever in active relationship with us, mirror and affirm our personalities and influence our lives.

Architecture and Community Design

10

According to the dictionary definition, architecture is the art, science, or profession of designing and constructing buildings. But even this broad definition is not comprehensive enough. The historical concerns of architecture go well beyond buildings, especially if we equate buildings (from the Anglo-Saxon *bold* for "house") with enclosed structures that house human beings, their activities, and possessions: houses of worship; houses for the dead; housing for commercial, governmental, and recreational activity; homes for everyday living; and even houses with undulating roofs but no walls for commuters awaiting mass rail transit **(10.1).** From ancient times, the domain of architecture has included fortified walls, military camps, bridges, aqueducts, and ceremonial sites open to the skies. What each of these structures has in common with traditional house-type buildings are the interwoven functions of enclosure and protection. What architecture is really about is built structures that serve the needs of society through enclosure and containment, through shelter and protection.

10.1 Sasaki Associates, landscape architects, and Anna Valentina Murch, artist. San Francisco Municipal Railway N-Line Shelter. 1998. Photo courtesy of Sasaki Associates. *The major goals guiding the design of the railway shelter were the creation of a signature urban project for the adjacent waterfront area, one that was highly transparent to preserve views of the San Francisco Bay and modular in construction to reduce costs. In addition, the shelter's sinuous form was conceived by artist Anna Valentina Murch to allude to the dynamic proportional rhythm of the waves in the Bay and to evoke the forms of the distant hills. Do you think the team of an artist and designers accomplished their goals?*

10.2 MAYA YING LIN. Vietnam Veterans Memorial. 1982. Black granite. Length: 500 in. The Mall, Washington, D.C.

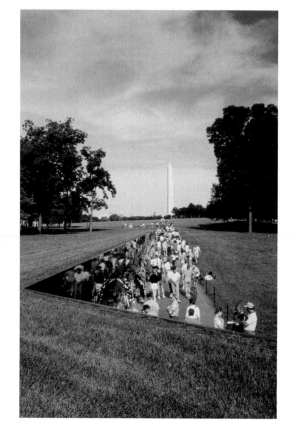

If we would know why certain things are as they are in architecture, we must look to the people: for our buildings as a whole are an image of our people as a whole. . . .
—Louis Sullivan, architect, speech to the Chicago Architectural Club, 1899

ARCHITECTURE: A SOCIAL AND INTERDISCIPLINARY ART

In addition to a wide range of enclosed buildings, contemporary architects (from the Latin *archi* meaning "chief" and *tekton* meaning "worker") create outdoor market complexes, plazas, parks, and open-air memorial sites. At the Vietnam Veterans Memorial **(10.2)**, designed by architect Maya Ying Lin (born 1960) and completed in 1982, relatives, friends, and daily visitors come to honor the dead and express their grief and love before the black stone walls, inscribed with the names of the over 50,000 men and women who gave their lives in the Vietnam War (1957–1975). On the Mall in Washington, D.C., the memorial's walls, walkways, and landscape design combine to create a circumscribed place, a roofless enclosure and container of special purpose.

Architecture has been described as "the most social of the arts" because its functions are so interwoven with those of society and because it visually embodies the image of a people so completely. Architecture is furthermore described as the "queen of the arts" because it is comprehensive and interdisciplinary, pulling into its creative process and final product many of the other arts. The creation of an architectural structure customarily incorporates interior, graphic, product, and landscape design. In addition, architects must relate their structure to its immediate and more distant surroundings, to the "community design" of the larger built, social, and natural environment. The Faneuil Hall Market Place project in Boston **(10.3)**, designed by Benjamin Thompson (born 1918), Jane Thompson (born ca. 1925), and their associates, required the exterior restoration, interior rehabilitation, and creative reuse of a number of buildings; the design and installation of pedestrian walking areas, benches, lamps, and other street furniture; the planting of carefully selected trees, bushes, and flowers; and the design of attractive, easy-to-follow signage. Prior to any of this, the Market Place project demanded years of retail planning (to convince clients that it would be a commercial success), urban planning (to integrate the market area into citywide social, economic, transportation, electrical, water, sewer, and police and fire safety systems), and meeting with scores of govern-

10.3 Benjamin Thompson Associates. Faneuil Hall Market Place, Boston, Mass. 1967–77.

mental officials and groups whose input and approval were necessary before any construction took place. A ten-year undertaking from beginning to end, the Faneuil Hall Market Place, as process and product, emphasizes the social and comprehensive nature of architectural practice.

ARCHITECTS AND BUILDERS

The people who create architectural structures are almost as diverse as their building projects. In our own urban-industrial, capitalist society, large buildings are the creation of professional architects. In preindustrial societies, the community members themselves create the structures that shelter and protect.

Architects as Designers

Master designers of buildings, professional architects **(10.4)** undergo a specialized higher education and earn official certification. Most have a staff of one or more assistants, with the biggest firms employing hundreds of persons: architects, draftspersons, project managers, interior designers, research librarians, computer

10.4 Architect Mark Simon working on three-dimensional model with Centerbrook colleagues. *Prehistoric peoples worldwide often arranged their homes, religious sites, and communities in sacred shapes like the circle or in the organic forms of an animal or a human being (with head, body, sexual parts). What type of shapes and patterns do we now base our buildings and community designs on? Why?*

10.5 Wesleyan Workshop #2: Participants work on floor plan, Clark Residence Hall Workshop, Wesleyan University, Middletown, Conn. Mark Simon, architect, Centerbrook Architects and Planners.

10.6 Three-dimensional model of Clark Residence Hall, Wesleyan University, Middletown, Conn. Showing entrance to building. Mark Simon, architect, Centerbrook Architects and Planners.

10.7 Clark Residence Hall, Wesleyan University, Middletown, Conn. Renovation with new entry porch and terrace additions. Mark Simon, architect, Centerbrook Architects and Planners. 2002.

technicians, and publicity, marketing, financial, maintenance, and secretarial staff. The architect, or rather his or her firm, is hired by a corporation, an organization, or an individual to design the building and make highly detailed architectural drawings (today executed on computer rather than by hand) that the construction crews faithfully follow. Usually, architects do not labor physically on the construction of their buildings. Their focus is not on hammering nails or installing electrical wires but rather on creating the plans for the building and overseeing the construction process from start to finish. With the most advanced engineering and technical expertise and equipment at their disposal, architects create such informationally accurate and complete diagrammatic plans ("blueprints") that construction workers can create the entire building from them.

Consider the collaborative design approach of the Centerbrook architectural and planning firm, eighty-five persons strong. Their process is highly interdisciplinary and interactive, soliciting extensive input from the future users and owners of the building being designed.

For the renovation and expansion of the Clark Residence Hall on the campus of Wesleyan University in Connecticut, architect-in-charge Mark Simon (born 1946) and project planner Margaret Lyons (born 1957) first asked the student residents and residential staff to show them on a giant floor map **(10.5)** how people move about the campus. This community planning exercise allowed them to analyze user relationships between the building and the larger campus community. In another exercise, related to the interior design of the residence hall, Simon and Lyons asked the students to rate aspects of the future building—single bedrooms, day lighting, furnishings, and so forth—in terms of importance. They then had the students try out different room arrangements and social spaces using small three-dimensional models. The two architects' evolving design plan **(10.6)** and the emerging building itself **(10.7)** reflected the students' feedback. It incorporated informal spaces for students to sit in the hallways, a special bicycle storage room near the front door, some lounges designed for quiet study, other lounges that welcome social noise, and a lounge next to the laundry where students can study or chat comfortably while washing clothes. Energy-saving materials and mechanical systems were incorporated as often as possible, based on students' ecological concerns. Add to this the planning Simon and Lyons did with members of the university administration, board of trustees, faculty, and staff—representing widely differentiated constituencies—and you can begin to realize how complicated and challenging the modern practice of architecture truly is.

Indigenous Builders

In an indigenous, preindustrial society, in contrast, the building occupations are neither professionalized nor very specialized. Buildings are created by the members of the community itself. As members of a deeply rooted community, the people have learned the ways and centuries-old traditions of building from their elders and from previous generations. None of these indigenous builders is the chief worker in the sense of a paid professional architect; rather, families construct their own homes or work together to construct dwellings. Nonetheless,

they succeed in creating architectural structures of effective function, pleasing form, and significant meaning.

Among Plains Indians, the women were responsible for the design, construction, and raising of the tent structures known as tipis (pronounced tee-pees), from the Sioux meaning an object "used to dwell in." They stripped the bark from the long wooden poles ("lodgepoles") that made up the framework of the tipi, scraped and tanned the buffalo-hide covers secured by the men through hunting, and chose the spot on which to raise the tent in the tribe's encampment.

Women of the Blackfeet tribe could assemble a tipi in a little more than an hour. Although the women usually worked in pairs, a group of friends and relatives might gather to help sew a new tipi cover or make major repairs. The sequential photographs of **figure 10.8** show a small group assembling a tipi. When the time came to strike camp, women dismantled and folded the tipis and lashed them to A-shaped skids fashioned from lodgepoles and pulled by a dog or a horse. This perfectly portable home then moved on to the next camp.

ARCHITECTURAL METHODS, FORMS, AND MEANINGS

As the construction method and conical form of the Plains tipi show, built structures reflect the societal and environmental conditions (available materials, weather, topography) that brought them into being. Whether the creation of nomadic hunter-gatherers or of an urban-industrial nation, a building's method of construction, form, and meaning reflect the particular sociocultural context that produced it. Societies throughout history have employed a variety of basic construction methods in their creation of fundamental building types (residence, house of worship, marketplace, tomb) of formal variety and diversified contextual meaning.

Load-Bearing Structures

The most basic form of construction, which has been used from earliest times, is known as load-bearing. The weight or load of the structure is

10.8 Tipi sequence. Shoshone Indians.

The tent was a sanctified place whose circular ground plan echoed the surrounding disk of the earth as it lay beneath the heavens. The tipi's floor represented the earth, its walls the sky. Its poles, as they stretched toward the firmament, were pathways that linked the earthbound people with the Great Spirit who lived on high. —Maggie Debellius and Stephanie Lewis, authors, *The Buffalo Hunters*, 1993

born by masses of solid material, usually stone or earth. Some of the most famous load-bearing structures are made of cut stone blocks fitted together without any mortar or adhesive material between them. They include the massive Egyptian pyramids (12.2) and the 4,000-mile-long Great Wall of China. The **masonry** (stonework or brickwork) of these two structures features repeating courses or rows of regular geometrical stone blocks. In South America in the fifteenth and early sixteenth centuries, the vast Inca Empire (stretching across modern-day Peru and much of the continent's western side) also employed dry masonry, with blocks cut regularly or irregularly, in extensive public projects: roads, stairways, farming terraces, plazas, buildings, and walls. A mighty wall in the Inca capital of Cuzco **(10.9)** shows stones of diverse sizes and irregular shapes fitted together with compositional flair. Such structures have withstood earthquakes that have leveled contemporary buildings.

In the West African Sahel, the vast savanna south of the Sahara desert, earth replaces stone as the load-bearing material in Islamic houses of worship. In the Great Mosque of Djenné **(10.10)**, in the nation of Mali, vertical earthen walls function as the load-bearing members. As in most sub-Saharan mosques, the walls are made of unbaked mud and mud bricks that harden under the hot West African sun. The mud has several advantages: It is in plentiful supply; it can be modeled (as in sculpture) into

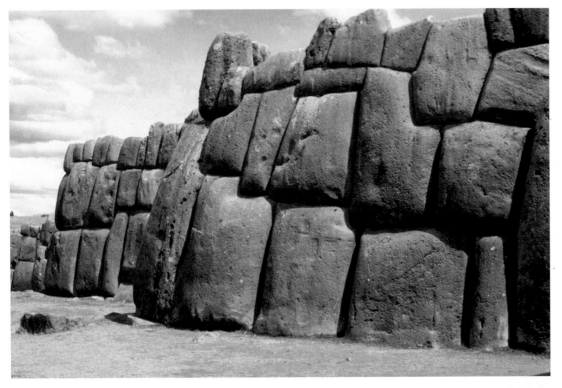

10.9 Cuzco, Peru, late Incan masonry wall. Ca. 1500. Photo: Tony Morrison, South American Pictures.

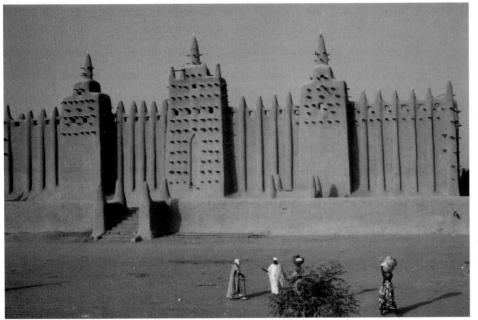

10.10 Great Mosque, Djenné, Mali. Rebuilt 1907 in the style of a 13th-century original.

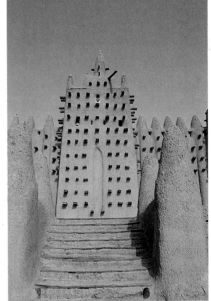

10.11 Great Mosque, Djenné, Mali. Rebuilt 1907 in the style of a 13th-century original. Stick and mud construction.

a variety of shapes, including curving ones; built up to a thick mass it can hold up a host of wooden cross-beams, which in turn lend further support to the walls and ceiling above them; and the mud's thickness can help keep the inside of the mosque cool in the hot climate. However, the hardened mud also has limitations. Because the walls must be very thick in order to support the structure, the interior space cannot be overly large. Also, the unbaked mud is prone to deteriorate in the harsh climate, especially during the brief but torrential rainy season. It requires continual repair, a process aided by the cross-beams, which are employed as scaffolding by workers restoring the structure **(10.11).** Also adding horizontal accents and ornamental pattern to the building, the cross-beams join aesthetic appeal with

10.12 Stonehenge, Salisbury, England. Ca. 2750–1500 B.C.E. Aerial view.

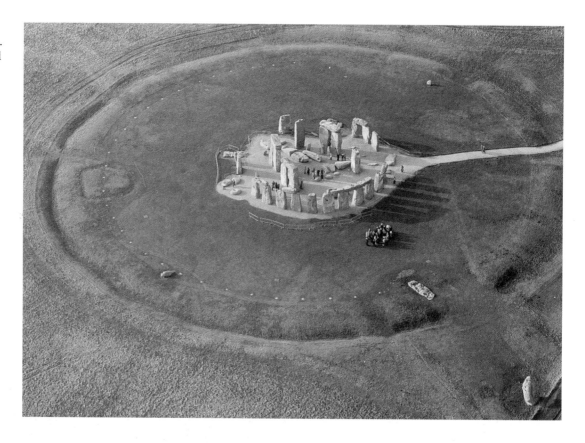

practical function. In Native American pueblos (communal villages) of the southwestern United States, this same method of construction—using load-bearing, sun-dried mud bricks—goes by the name adobe.

Post-and-Lintel Structures

Post-and-lintel construction developed with the first permanent-settlement cultures in villages and then cities. Permanent-settlement communities started to take root worldwide between 10,000 and 4000 B.C.E., when agriculture (and later commerce) began to replace hunting and gathering as the primary modes of subsistence for many peoples. As permanent residents, the populace of agricultural or agricultural-commercial communities required a different type of architecture than hunter-gatherers on the move—one possessing permanency, protective strength, and solidity. Whether built for residential, business, or religious purposes, such structures were designed to last for many lifetimes.

In the post-and-lintel system, horizontal lintels (often called beams) are supported by load-bearing vertical posts or walls. While the materials used might vary, the emphasis is on strength and durability. For this reason, the materials tend to be the heaviest, densest, and strongest available, able to bear up under compressive forces that push the lintel downward and inward on its supporting posts or wall. Until the industrial age, stone was the most common material of choice.

Built for eternity, England's Stonehenge **(10.12)** is perhaps the best-known prehistoric religious site constructed in post-and-lintel fashion. It was the creation of a complex, hierarchical society probably made up of a network of fortified villages and smaller agricultural settlements. The organizers and supervisors of its construction were likely a hereditary aristocracy of chiefs and priests. Many thousands of workers labored over the centuries, in four distinct phases of building between approximately 2800 and 1550 B.C.E., to complete the great stone circle. A marvel of engineering, its enormous posts hold up equally massive cross-beams or lintels. Weighing hundreds of tons, the immense stones had to be cut and

transported by land and water from sites as distant as 100 miles. Based on a traditional circular or oval ("henge") groundplan, Stonehenge shows the post-and-lintel system in "bare bones" form. No walls or ceilings were built around or on top of its simple elements. A spiritual and astronomical center—its stones align with the movement of the sun and moon, in particular the rising sun of the summer solstice—it needed no walls or ceilings, which would only have hindered its function.

On the African continent, the ancient temples of Egypt are powerful exemplars of the post-and-lintel system of building. At the Temple of Hatshepsut **(10.13)**, constructed as a tomb for the pharaoh Hatshepsut (12.8, 12.9), massive stone posts support equally massive horizontal stone beams. Note that the lengths of the horizontal stone slabs, as at Stonehenge, are not very great. While stone is very dense, heavy, and strong, its tensile strength (resistance to stress when stretched lengthwise) is quite limited. Without physical supports beneath it, a single horizontal stone slab is unable to span a sizable area without collapsing. Thus stone lintels must be relatively short and must rest on a pair of posts spaced close together, an example of how methods of construction and related building materials substantially determine the final appearance of an architectural structure.

In the Mediterranean world, with its temperate climate and quarries rich with glistening white marble, the stone temples of ancient Greece rose to become the most architecturally influential post-and-lintel structures **(10.14).** The entire Western building tradition has been affected by these temple forms, which have been adopted over millennia and across continents for diverse purposes. Innumerable buildings—monuments, museums, banks, government offices, homes, college buildings —employ the basic Greek temple form, or variations of it, in their designs.

Let us first consider the post supports (the columns) of the Greek temple. The early prototype of the simple, straightforward column (10.13) was elaborated in Greek temples into three distinctive column types. These column types became the central elements of the three basic Greek styles or "orders": Doric, Ionic,

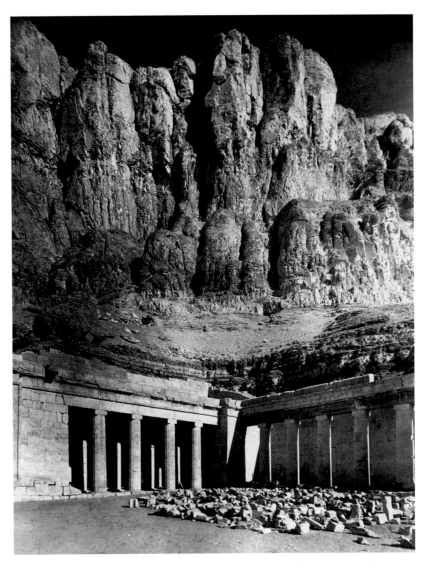

10.13 Deir el-Bahri, Hatshepsut Temple complex, lower terrace colonnade. 18th Dynasty, ca. 1480 B.C.E.

and Corinthian **(10.15).** (The names are derived from the peoples, somewhat distinct linguistically, ethnically, and geographically, who first developed them.) Subsequently used throughout Greek-speaking lands, these orders constituted a program or formula that architects might follow. Each order posited a different style for the temple's columns (posts) and entablatures (lintels). The Parthenon, for example, employs the Doric order in its exterior. The oldest, purest, and simplest of the Greek orders, the Doric communicates a sober, austere quality of seriousness and strength along with a calm grandeur. Developed shortly after the Doric, the Ionic, with its taller, thinner elements and curvilinear capitals (the "caps" or

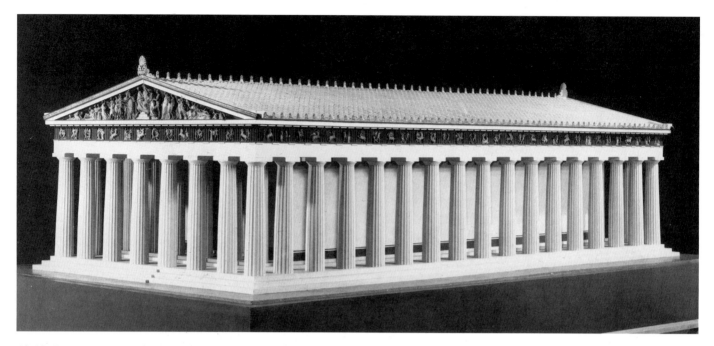

10.14 Reconstruction of the Parthenon. The Metropolitan Museum of Art, New York. Purchase, 1890, Levi Hale Willard Bequest (90.35.3).

10.15 Greek orders: 1. Base; 2. Shaft; 3. Capital; 4. Entablature; 5. Column; A. Cornice; B. Frieze; C. Architrave.

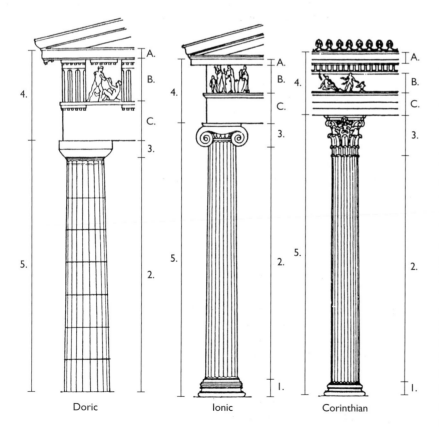

Doric Ionic Corinthian

heads of the columns), conveys lightness, grace, and elegance. The Corinthian, the final order (developed in the city-state of Corinth), is the most complex and decoratively detailed. It also employs the most overtly naturalistic imagery: The design of its capital is based on the leaves of the native acanthus plant. Tall and thin like the Ionic, the Corinthian is associated with sophistication and luxuriousness.

Focus on the Parthenon On the **Acropolis,** the fortified hill on which the Greek city-state of Athens built its spiritual center in the fifth century B.C.E., stands the Parthenon **(10.16),** the temple of Athena Parthenos (Athena the Virgin), the mythical founder and patron goddess of the city. The approach to the Parthenon is ever upward, from the crowded, bustling lower city of Athens—in ancient times an extraordinarily large city of 200,000—up through the gateways and courts of the Acropolis to the physical and spiritual top *(akros)* of the city *(polis)*. At the crest, the temple rises still higher into the sky. Viewing the Parthenon with the sea and mountains in the distance and the teeming metropolis below, one realizes how crucial the setting of a building is to its overall meaning.

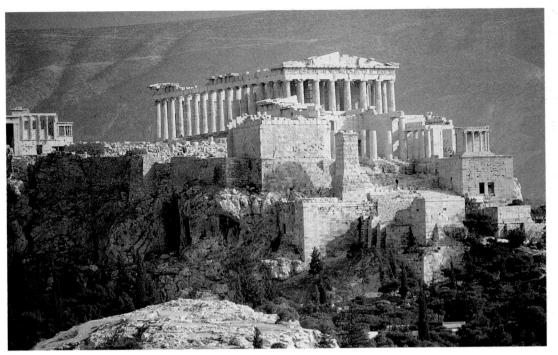

10.16 IKTINOS and KALLIKRATES. Parthenon and view of the Acropolis from the southwest. Ca. 447–439 B.C.E. Athens, Greece.

Crowning the heights of the city, communing with mountains, sea, and sky, the Parthenon evokes conscious or subliminal associations with higher things: uplifting moral values, transcendent spiritual beliefs, and exalted activities such as the ancient procession of the city's populace every four years up to the Acropolis to honor Athena in her temples. In the context of fifth-century Athenian democracy, the Acropolis, with the Parthenon at its crest, also fulfilled political functions. Built under the leadership of the statesman Perikles (ca. 500–429 B.C.E.), it inspired the democratic freemen of Athens to civic pride for the greater good of the polis while proclaiming the glory and power of Athens to friends and enemies alike.

Larger than the surrounding buildings and constructed of gleaming white marble, the most expensive of materials, the Parthenon could be seen by travelers on land and sea from many miles away. Directionally, the structure expands outward and upward: up a platform of steps, an indicator of elevated function, and up soaring vertical columns toward a triangular roof whose final crest points toward the heavens. But while the Parthenon is a giant, it is a giant whose power is ordered and controlled. It is power made reasonable.

Opposites—horizontality and verticality—have been balanced in careful proportion. A serene regularity presides in the repetitive spacing between the muscular Doric columns that taper subtly to their crowning capitals. The temple's symmetrical balance evokes a feeling of stability and permanence. The result of the design is a beauty that is at once dignified and potent, a fitting image for Athens itself, ruler of a tribute-paying confederacy of over 300 Greek cities.

The geometric lines and shapes of the Parthenon are pure, regular, and precise. These are the forms of reason and intellect, befitting a city famous for its philosophers, scientists, and mathematicians. We see positive shapes and negative spaces of rectangular variety, cylindrical columns with square Doric capitals, and two climactic triangular pediments—the one on the east showing the birth of Athena, the one on the west originally filled with a vast sculptural depiction of the triumph of Athena over rival god Poseidon in their battle for the rule of the city. A rational ordering, balance, and harmony of parts tie all the separate architectural and sculptural pieces together in a profound unity.

In the Parthenon, visual, emotional, and moral qualities are inseparable. Visual clarity,

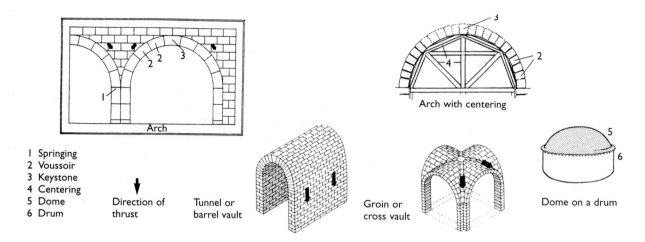

10.17 Arch/Vault/Dome diagrams.

1 Springing
2 Voussoir
3 Keystone
4 Centering
5 Dome
6 Drum

Direction of thrust

Tunnel or barrel vault

Groin or cross vault

Dome on a drum

Arch

Arch with centering

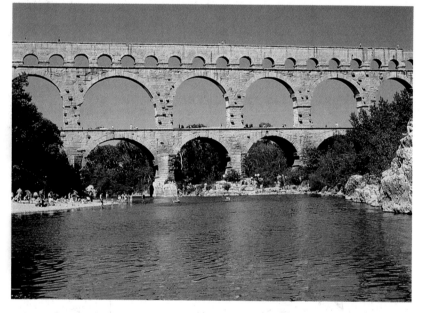

10.18 Pont du Gard, Nîmes, France. Late first century B.C.E.

harmony, and symmetry produce feelings and thoughts of order and calm. The ancient Greeks described what would later become known as the **classical style** with phrases such as "beauty without extravagance" and "all things arranged with sense and symmetry." All the individual elements, according to a character in an essay by Xenophon, appear "more beautiful when placed in order" and when so ordered, according to reason, "will then seem to form a choir." Twenty-five hundred years later, the rational order, symmetrical balance, unity, and beauty of the Parthenon—

with its post-and-lintel Doric columns and entablature, pediment, and stepped base vocabulary—still speak to us. The building, even as a ruin, continues to breathe with an immense vitality.

Arch, Vault, and Dome Construction

The Romans, conquerors of the Greeks by the mid-second century B.C.E., were in turn conquered by Greek culture. They fell in love with Greek buildings, adopting and creatively extending their post-and-lintel forms and vocabulary. The Romans developed, for example, their own version of the Doric (called Roman Doric) as well as a unique Composite order that combined the Greek Ionic and Corinthian styles. Their crowning achievements, however, involved entirely new types of buildings.

Brilliant architectural engineers—architect and engineer were the same person right up to the modern period—the Romans introduced new types of stone and concrete construction and perfected the structural forms we know as the **arch, vault,** and **dome (10.17).** Commissioned primarily by the central government in Rome, hundreds of well-trained architects fanned out across Roman lands in Europe, Asia, and Africa, applying arch, vault, and dome construction to all types of structures. Whereas straight lines and right angles in the form of vertical columns and horizontal crossbeams are predominant features of Greek and Egyptian architecture, Roman architecture

features the arch and other forms based on the circle and half circle.

As perfected by the Romans, arches, vaults, and domes became an integral part of the Greco-Roman or classical vocabulary of architecture. The Pont du Gard **(10.18)**, built by the ever practical and efficient Romans in the late first century B.C.E., combined two essential functions. Its lower level served as a bridge (*pont* in French) for pedestrian and military traffic, while its upper level functioned as an aqueduct that carried water some thirty miles across the French plain and the Gardon river valley to the city of Nîmes. Without a steady supply of water, the large cities—10,000 inhabitants to over 1 million in Rome—that administratively, militarily, and commercially held the Roman Empire together could not have existed. Structurally, the aqueduct shows the arch in a single plane stacked up into three stories. Not meant primarily as a work of art, this triumph of architectural engineering nonetheless possesses a functionalist beauty that takes one's breath away. The arches march across the river with the regularity, ordered efficiency, and irresistible force of Roman army columns.

In the Roman Empire, architects designed and supervised the construction of aqueducts and bridges, military camps and city plans, temples, civic centers, covered markets, and apartment houses. These master builders were esteemed in Roman society for their broad education, which encompassed both practical knowledge of all crafts (such as masonry and carpentry) and theoretical knowledge of all the liberal arts (such as mathematics, music, and poetry). This comprehensive background informed an architect's wide-ranging projects, helping architects produce structures that were functionally effective and aesthetically satisfying.

Consider a court of law and covered market in Rome. The impressive Basilica of Maxentius **(10.19)**, the Royal Hall of Justice built for the Emperor Maxentius, shows the arch stretched out in depth, thereby becoming an arched ceiling or roof known as a barrel vault. The nearby Markets of Trajan, a kind of three-story supermall, consisted of more than 150 shops and offices. The centerpiece of this complex was a covered market **(10.20)** composed of

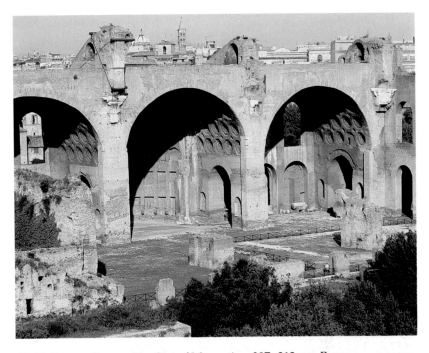

10.19 Roman Forum, Basilica of Maxentius. 307–312 C.E. Rome.

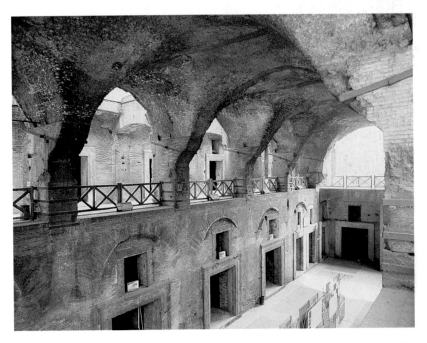

10.20 Apollodorus of Damascus. Markets of Trajan. 100–112 C.E. Rome.

two sets of intersecting barrel vaults called **cross** or **groin vaults.** The innovative application of vaulting produced a broad commercial space, well lit and well ventilated—a suitable creation for a populace engaged primarily in

10.21 The Pantheon, view from the north. Ca. 117–125 C.E. Rome.

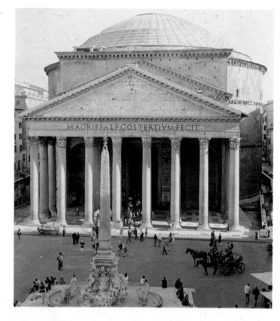

10.22 GIOVANNI PAOLO PANINI. The Interior of the Pantheon, Rome. Ca. 1734. Oil on canvas. 50½ × 39 in. Samuel H. Kress Collection. Photograph © 2002 Board of Trustees, National Gallery of Art, Washington, D.C.

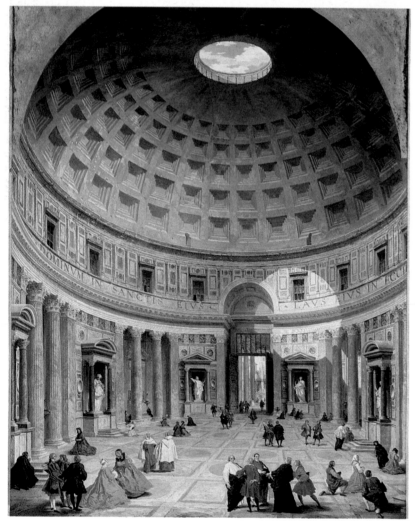

working for, buying from, and selling to one another.

This proliferation of arches and vaults of multiple forms was accelerated by the development of a slow-drying cement, just one of the many technological advancements made by Roman builders. The earlier architecture of ancient Egypt (10.13) and Greece (10.14) had been essentially an art of mass; space was simply what was left over or left between massive horizontals and verticals. In contrast, Roman building became an architecture of space, with the structure being conceived as a flexible shell molding space into whatever form was desired. Such spacious buildings not only facilitated urban life on the most practical level but also expressed cultural values and communicated political ideology.

Focus on the Pantheon All the technical innovations that had aided the creation of the new architecture of space were put to use in Rome's Pantheon **(10.21),** whose dome (a convex roof erected on a circular, square, or polygonal base) remains one of the wonders of the world. On the outside, this Roman temple dedicated to the "pantheon" (*pan* means "all," *theon* means "gods") combines a traditional Greek temple **portico** (porch entry) with an enormous domed **rotunda** (Latin for "round building") measuring 144 feet in both height and width.

Passing through the Greek portico with its confining angular forms, one enters a space of spherical boundlessness in which the darkness is penetrated by a column of light pouring through a circular, 30-foot-diameter eye, or *oculus*, at the top of the dome **(10.22).** Within, one is compelled to look up. On a bright day, the broad beam of light is so concentrated that the sky itself is blocked out by its brilliance. The onlooker experiences a magical light coming from some infinite place above, setting up a dramatic contrast as it revolves around the dark circular interior. An association is set up between the Pantheon's boundless hemispheric dome, with its illuminating shaft of light, and the metaphorical dome of heaven. Earlier domes had been decorated to symbolize the heavens, but no single building embodied this idea more effectively or on a grander scale than the Pantheon.

Like the Athenian Parthenon, Rome's Pantheon expressed political content. It held statues of earlier emperors in the entrance vestibule and a portrait of a deified Julius Caesar, the first emperor, within. The emperor Hadrian (76–138 C.E.), who had the Pantheon built (his many talents and fields of knowledge included architecture), held judicial court in the rotunda. Other imperial meanings were embodied in the structure. The Pantheon was built from materials supplied from subject lands: From Egypt came granite; from Africa, colored marbles; from Greece, white marbles. That the Pantheon was, in effect, the sum of its parts had a clear social meaning among the Empire's multicultural populace.

Arches, Vaults, and Medieval Churches The only architectural tradition to rival the Greco-Roman in ongoing influence in the West is that of medieval Christendom, almost a thousand years old. The European building styles of the Christian Middle Ages were themselves deeply indebted to the forms and techniques of the classical tradition. Building especially upon the arch and vault innovations of the Romans, the medieval Christian style called Romanesque (literally, Roman-like) features massive stone load-bearing walls and columns and expansive interior spaces covered by great barrel or groin vaults **(10.23).** These forms and construction techniques define the large eleventh- and twelfth-century churches that gathered in many thousands of Christian faithful during their pilgrimage journeys across southern France, northern Spain, and other parts of Europe. The huge spaces served to accommodate the streams of pilgrims coming to experience the holy relics housed in the churches: a lock of hair or a finger of a martyred saint, or a splinter from the supposed "true cross" on which Jesus was crucified. Such relics, the pilgrims believed, could heal illnesses and further spiritual progress toward heavenly salvation. Just as the sacred chants of the church choir might ascend and spread throughout the building, the souls of the supplicants might rise up to the vaulted heights of these soaring celestial spaces.

Building directly upon the achievements of the Romanesque, certain Roman Catholic church leaders set to work on a magnificent

new architectural style, later called the Gothic. Most prominent among these leaders was the French abbot Suger (1081–1151). Suger was a lover of precious and beautiful things, an aesthete who appreciated art and architecture for their sensuous appeal as well as their power to inspire and teach. In opposition to earlier Christian views that saw the body and the senses as prone to sin, Suger argued for a sensory-based, aesthetic approach to religion. Through the arts and their effect on the various senses, he argued, the mind might be lifted upward to experiences of joy, solemnity, and harmony, that is, to experiences of God. His position won out and became the public policy of the Catholic Church.

10.23 Romanesque Church of St. Sernin, Toulouse. Interior view looking down nave toward the apse. Ca. 1088–1120.

First we shape our buildings. Then our buildings shape us.—Winston Churchill, mid-twentieth-century prime minister of England, on the reconstruction of the Parliament Building

Suger put his revolutionary philosophy into practice with the new "modern" style of the abbey church of Saint-Denis **(10.24)**, on the outskirts of Paris. An anonymous architect, serving as structural engineer and supervisor of teams of workers, carried out the religious leader's vision. Together at Saint-Denis they innovated the characteristic pointed "Gothic" arches and the light-giving high window known as the **clerestory.** For Suger, it was crucial that the building be opened to new light. He believed in the idea of God as "superessential light" reflected in "harmony and radiance" here on earth. Characteristic of Suger's modern work on the church, the renovated choir and sanctuary were "pervaded by new light," a mystical metaphor for Christ, the light of the world. Brightly colored gems shone from the high altar, the great cross, and gleaming liturgical vessels. Architecture brought together all the parts—light, color, soaring space, the implements of church practice—in one all-embracing whole. In the apse of Saint-Denis, the semicircular space housing the choir, sanctuary, and altar at the eastern end of the church, Suger's ideal was realized.

10.24 Abbey Church of Saint-Denis. Ambulatory, interior view of Choir aisles. 1140–1144. Near Paris.

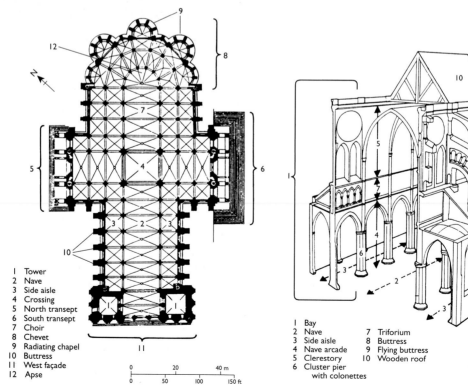

10.25 Chartres Cathedral. Floorplan and cross-sectional diagram.

1	Tower
2	Nave
3	Side aisle
4	Crossing
5	North transept
6	South transept
7	Choir
8	Chevet
9	Radiating chapel
10	Buttress
11	West façade
12	Apse

0 20 40 m
0 50 100 150 ft

1	Bay		
2	Nave	7	Triforium
3	Side aisle	8	Buttress
4	Nave arcade	9	Flying buttress
5	Clerestory	10	Wooden roof
6	Cluster pier with colonettes		

282

In addition to the promotion of high windows and arches that pointed heavenward, Suger contributed to the emergence of the rose window, the large, circular window usually situated above the main entrance of Gothic cathedrals. Symbolic, like virtually every other part of the cathedral, the rose window stood both for Christ, the new illuminating sun, the circle and light of God, and for Mary, the nurturing "rose without thorns." Suger also experimented with stained glass windows, whose colored pieces produce radiant lighting effects. These innovations, realized in the east end of Saint-Denis, inspired churchmen throughout France to create entire cathedrals in the new style **(10.25).** Ever taller and wider and filled with stained glass—with town competing against town to create the grandest cathedral—the churches' design necessitated the invention of a new exterior support system, the **flying buttress.** These buttresses consisted of an arch or half arch that transmitted the thrust of vault or roof from the upper part of the walls to an outer support.

To gain some sense of the astonishing effect this new "French" style must have had on the medieval mind, one should travel to Chartres, a small rural city one hour southwest of Paris by train. Here stands one of the best preserved of all Gothic cathedrals. As the main church housing the bishop's throne or "cathedra," the Chartres Cathedral **(10.26)** still dominates both town and countryside as it did eight centuries ago. With its soaring towers and roof, Chartres is visible from agricultural fields miles away. Early pilgrims traveling from all over France and Europe to see its holy relics—among them, reputedly, a piece of the Virgin's robe—would have experienced the cathedral as a grand vision rising from the earth. Arriving within the city's walls, the pilgrims would have made their way up the narrow streets to reach the impressive, sculpture-filled entranceways on the cathedral's north, south, and west sides **(10.27).** There they would have joined the ranks of townspeople on their way to the market outside the building's walls or to a service or town meeting within. The cathedral stood (and still stands) proudly at the center of the town and was central to every facet of town life.

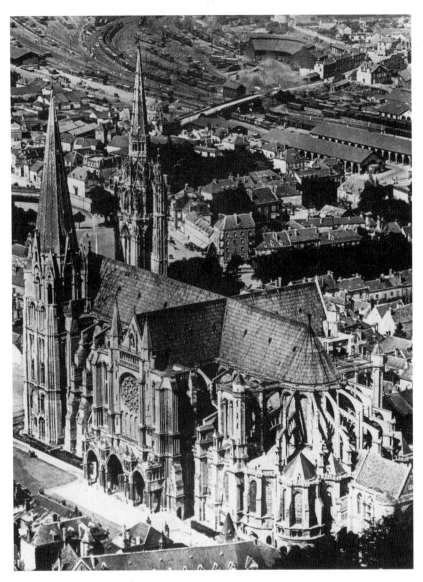

10.26 Chartres Cathedral. Ca. 1140–1260. Aerial view from the southeast.

We cannot fully comprehend how a medieval peasant, merchant, or lord might have experienced the cathedral, especially since first-person reports are virtually nonexistent. However, the impressions of an American college student, a modern-day pilgrim to this wonder of the world, offer some insight into the mystery and power of Chartres. The young man, a student of art, wrote in his diary:

In the vast space of the nave **[10.28]**, one feels like a tiny atom in the mysterious darkness. My immediate instinct is to look up. And with

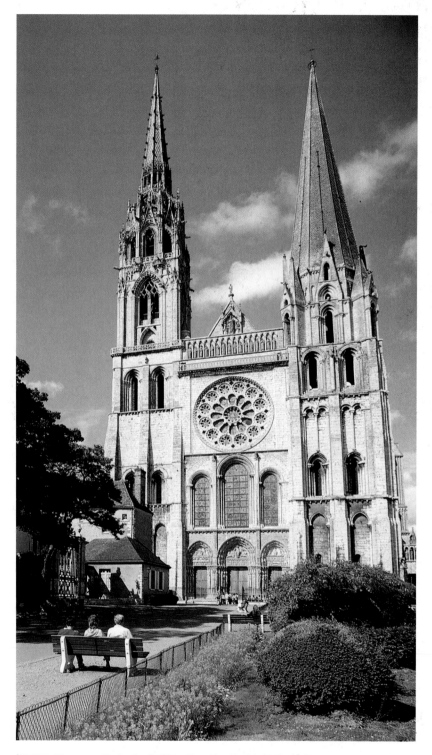

10.27 Chartres Cathedral. West Facade. *Gothic cathedrals might take decades or even centuries to complete. Note the distinct styles of the two towers. Which do you think is the earlier and which the later?*

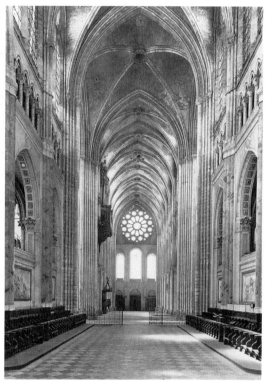

10.28 Chartres Cathedral. Interior view of the nave toward the rose window on the west front.

good reason. The entire focus of the interior is upward. Beams of colored light—red, blue, purple—filter through the darkness from the high stained glass windows **[10.29]**. The holy light leaves touches of color on the floor and wall and even dapples the tourists who sit or stand or walk slowly about. Moreover, it moves as the sun moves and changes as the sky changes. Truly sent from the heavens, it seems to live and breathe. The stained glass windows are filled with figures and scenes but most are too high up to be well seen or understood. No, it is the light itself, the magical light, animating the darkness from on high, that inspires a reverence.

I look up also because the ceiling itself is so high, with bundles of thin columns shooting skyward and coming to a point in the ribbed vaults of the ceiling. Everything points to the heavens: the arches, the vaulting, the high stained glass windows which allow entry of the heavenly light.

The message of the cathedral is clear: glory to God in the highest.[1]

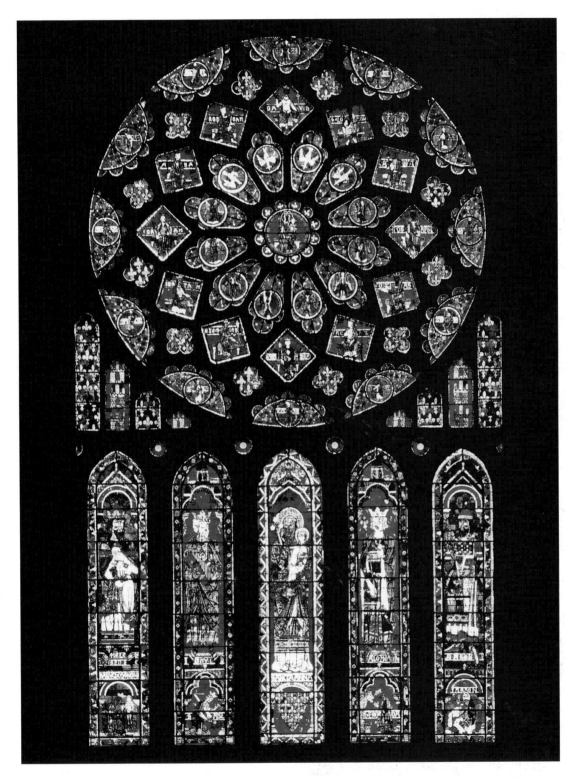

10.29 Chartres Cathedral. View of rose and lancet windows in north transept. Stained glass. Diam.: 42 ft. 8 in. *The immense circular rose window features a symmetrical design in which all the elements and subjects radiate out from the central orb that contains the figures of the Virgin Mary and baby Jesus. The five slender, vertical lancet windows feature Saint Anne holding the infant Mary surrounded by Old Testament figures, including the kings David and Solomon. The eight windows rising between the rose and lancet windows are decorated with royal coats of arms that proclaim the divine right of the French kings. Look closely. What else do you see?*

10.30 Entrance to the king's palace, Foumiban, Cameroon. 1906–7. Photo: Adolf Diehl.

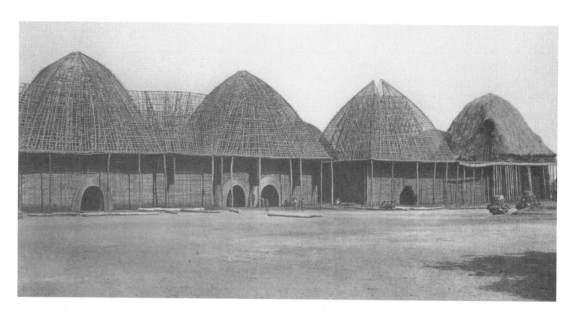

10.31 King Munza Hall. The King's Reception Room. 1850s. Drawing: Jan Vansima.

10.32 Lesotho domed house, Republic of South Africa. Traditional architecture.

Arch, Vault, and Dome in Worldwide Application While the medieval Christians and their Roman predecessors may have innovated large-scale arch, vault, and dome construction in stone and concrete, peoples worldwide have employed these basic forms, executed in a variety of materials and methods, across the centuries. In the king's palace in Cameroon, West Africa, the arch functions as an entranceway **(10.30).** Constructed from bendable bamboo shoots and palm fronds that have been bundled and tied together, the arched openings rise out of the earth with an organic vitality.

In central Africa, the form of a barrel vault defines the reception hall of nineteenth-century King Munza **(10.31).** Built around 1870, the communal structure employs native wood for its framework and other local materials such as raffia stems, leaves, and grass for coverings. In the hot climate of Zaire, it provided both shade and maximum air circulation. Its interior expanse (approximately 100 feet long by 40 feet high by 50 feet wide) must have impressed those who came before the king to transact business.

To build their domed houses, the Lesotho people of South Africa employ the wood, grasses, and earthen materials of their local environment **(10.32).** Other dome-shaped homes created by indigenous societies worldwide include the ice-block igloos of the Inuit peoples of the Arctic north and the baked mud "beehive" homes of Syrian descendants of the desert-dwelling Bedouin peoples.

Frame Structures

One of the oldest types of building methods, used by nomadic and seminomadic peoples from prehistory to the present, is frame construction. The frame operates as the skeletal structure that provides the basic shape for the final form. For hunter-gatherers frequently on the move to more plentiful hunting and gathering grounds, tents (10.8) or huts of frame construction were the perfect home. Their tents and huts were made of animal skins, tree bark, or other natural coverings stretched over rigid poles of wood (as in the tipi) or over thin, bendable wood saplings. The tent or hut might be set up or taken down in short order. It was

wood balloon-frame construction steel-frame construction

10.33 Skeleton frames.

light and relatively easy to transport yet durable and capable of offering effective shelter from rain or sun, heat or cold, and even wild animals. Modern portable, frame-based backpacking and mountaineering tents extend this tradition.

Beginning in the industrial age, factory-style production led to innovative frame construction methods in both wood and metal **(10.33).** The so-called balloon frame, introduced in 1833, features a lightweight but strong skeleton of standard-size pieces of lumber hammered together with mass-produced metal nails. Immediately popular for domestic home use, the wooden frame offered commercial builders a support for any type of skin or sheathing (wooden boards or shingles, metal roofing strips, stucco, glass). Taking this balloon-frame method to architectural heights is Thorncrown Chapel **(10.34),** designed by Fay Jones (born 1921) and completed in 1980. Soaring like a Gothic cathedral, the chapel's wooden-skeleton frame, sheathed with clear glass, totally opens the building to the heavens, to nature's light, and to the inspirational beauty of the surrounding Arkansas countryside.

For the construction of urban buildings of increasingly great size, metal became the

10.34 FAY JONES and Associates. Thorncrown Chapel, Eureka Springs, Arkansas. 1980. 60 × 24 ft. Height: 48 ft.

10.35 LOUIS SULLIVAN and DANKMAR ADLER. Guaranty Building, Buffalo, N.Y. 1895.

industrial-age material of choice. From the vast Crystal Palace exposition hall of 1851 (9.13) to the immense railroad stations (10.58) of late-nineteenth- and early-twentieth-century urban-industrial society, new "modern" buildings were created around a skeleton of iron or steel. The covering or skin of such buildings might consist entirely of glass, as in the Crystal Palace, or it might be a sheathing of metal, stone, brick, concrete, glass, or a combination of any of these. Whatever the covering, the metal skeleton provided the basic framework and defined the overall geometric shape. Possessing great tensile strength, it also bore almost all the weight and stresses of the ceiling, walls, floors, and physical contents of the building.

The modern skyscraper would be inconceivable without metal-frame construction (and a second technological breakthrough, the power elevator). With the necessary technology in place, buildings that housed hundreds or even thousands shot to the sky at the turn of the twentieth century. The development of these tall urban buildings was prompted by skyrocketing real estate costs and advertising appeal. Ascending heavenward, the new "cathedrals of commerce" served as both efficient corporate headquarters and visual monuments that broadcast the wealth and power of the particular business for all the world to see. Occupying relatively small plots of costly urban land, skyscrapers moved upward rather than outward, rising to as high as fifteen

stories by the turn of the century. For architectural historian Vincent Scully, Buffalo's Guaranty Building **(10.35)** by Louis Sullivan (1856–1924) and other early American skyscrapers represented "a new kind of giant [standing] high on his legs: mass man with steel [frame] muscles, tensile and springy."

By the mid-twentieth century, onetime giants like the twelve-story Guaranty Building were dwarfed by numerous skyscrapers thirty to sixty stories in height. One of the finest mid-century skyscrapers, built in 1956–58, is New York City's thirty-eight-story Seagram Building **(10.36).** It was designed by German architect Ludwig Mies van der Rohe (1886–1969) and his American student Philip Johnson (born 1906), today an internationally known architect in his own right. A monument to modernist form and function, the Seagram Building stands heroically, according to architectural historian Scully, "as a body on its legs much like Sullivan's Guaranty Building," albeit with thinner metal sections supporting its seemingly weightless skin of glass. But the being who stands so straight and tall is increasingly technological: "simplified, pure, clean, generalized, reasonable, abstract . . . the ideal fleshless skeleton of ringing steel." The structure is sheathed from top to bottom in gray-tinted glass and architectural bronze, making it one of the most richly textured skyscrapers ever built. Extending from the steel framework skeleton, vertical I-beams are welded to the exterior, where they act to separate the windows and give a lively vertical pattern, moderated by horizontals, to the building's outer form. Carried out in the most luxurious of materials, the tower is a study in precision, restraint, clarity, and dignity.

Compared to the Seagram Building, Hong Kong's Bank of China Tower by Chinese-American architect I. M. Pei (born 1917) is a supergiant, a full seventy stories in height **(Appreciation 19).** Aesthetically, it is more varied and complex in its shape than the rectilinear "glass box" minimalism of the Seagram Building. But, like the Seagram, the Bank of China Tower functions as a modern cathedral of commerce. In its commercially vibrant home in Hong Kong, the Bank of China Tower has become something of an icon, embodying a range of meanings for different publics.

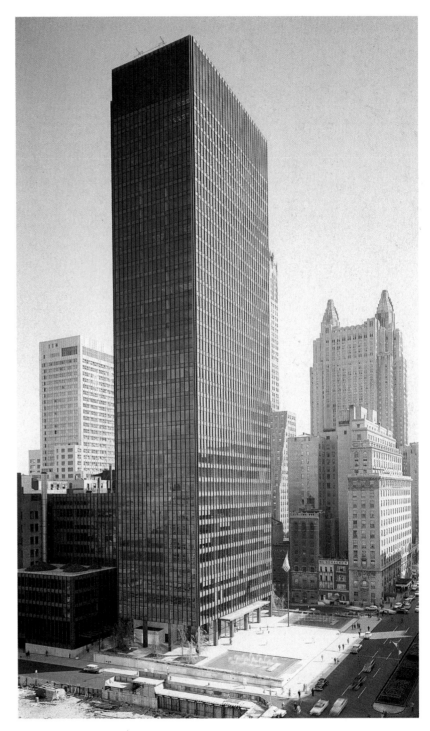

10.36 LUDWIG MIES VAN DER ROHE and PHILIP JOHNSON. Seagram Building, New York. 1956–58. Photo: Ezra Stoller, © Esto, 4IT.3. *The perception of buildings changes with the changing social context. For example, during the 1960s, a time of civil rights struggles and anti–Vietnam War protests, many perceived corporate skyscrapers as chilling, unfriendly fortresses, reflections of insensitivity to human values and resistance to social concerns. The decade of the 1980s, in contrast, was very pro-business, and skyscrapers conveyed the achievements of corporate capitalism. Can you see how the tenor of the times might strongly influence one's appreciation of a building?*

APPRECIATION 19 *The Bank of China Tower in Context*

SIU KING CHUNG

In May 1990, the Bank of China (BoC) completed its new seventy-story Tower **(Fig. A)** in the Central District of Hong Kong. As one of the tallest "mega-structures" in Asia to date, the BoC Tower presents itself formidably as a spectacular architectural event for Hong Kong, the small but prosperous former British crown colony on the southeastern border of mainland China. [In 1997 the British turned over political sovereignty of Hong Kong to the People's Republic of China.]

The Bank of China Tower was designed by the Chinese-American architect I. M. Pei (born 1917) and was built by his architect son, Sandi Pei (born 1949), along with other associates. Commissioned and financed by the People's Republic of China, the dominating presence of the BoC Tower communicates the substantial economic role that mainland China plays in Hong Kong, a former British colony populated largely by people of Chinese origin.

The crystalline tower rises disproportionately high above the city's skyline. Relative to the soaring height of his building, I. M. Pei explained that he attempted to architecturally translate a Chinese proverb that alludes to "rising section by section." This square-based geometrical tower consists of four obliquely truncated triangular shafts of different heights. The association is with a stalk of tapered bamboo propelling higher and higher—a Chinese metaphor for taking measured steps in a quest for strength and excellence. Among other cultural connections, a Chinese garden **(Fig. B)** decorated with cascades, stepped pools, and landscapes of rocks and trees is incorporated at the building's base. This garden is intended as an area of public amenity, according to Sandi Pei, to effect "a comforting subliminal

response to elements in their [the Chinese citizens'] memories or heritage," namely, auspicious interpretations of prosperity and longevity, and the like.

By bringing together traditional Chinese references, advanced technology, and a commanding skyscraper style, the BoC Tower communicates that the Bank of China is Hong Kong's premier corporation for modern international banking; that the BoC stands in full support of Hong Kong's up-to-date capitalist economy; and that the bank's owner, the People's Republic of China, has risen as the legitimate sovereign of Hong Kong.

Because of its power as an architectural symbol, the BoC quickly inscribed the image of the Tower on its newly issued bank notes, an unmistakable signifier for Hong Kong's lucrative future. In addition, the image has become more broadly popular throughout the nation and has been exploited in many mass-media commercial forms, ranging from comics and movies to Hong Kong Tourist Association promotions.

Such positive readings notwithstanding, this huge tower of reflective glass was initially received with much ambivalence, especially at the grassroots level. Figures on popular TV shows likened the triangular-edged skyscraper to a dagger and its twin antennae to a pair of incense sticks. The former was said to have metaphorically cut into the nearby Hong Kong Government House, adversely affecting the political wisdom and performance of the Governor; the latter signified burning candles to the dead. For many, the Tower came to resemble a tombstone to Hong Kong's successful past as a British colony.

Around the time of the 1997 British handover of the colony to the People's Republic of China, such negative perceptions could have been caused by lingering sentiments in local Chinese minds over the 1989 Tiananmen Square massacre of "pro-democracy" protestors in

Siu King Chung teaches at the School of Design, The Hong Kong Polytechnic University.

Beijing, the capital of mainland China. Maybe they had to do with a heightened sense of insecurity felt locally as the date of "Communist" China's resumption of governance over the city drew near.

Looking at it objectively, the way those with negative opinions attribute metaphorical meanings to such an artifact is not very different from the way the Peis ascribe positive architectural meanings to the building. All of its progressive architectural signification—"stylistic excellence," "postmodern cultural reference," "state-of-the-art technology"—aside, the Bank of China Tower is a complex and mixed metaphor. At the same time that some regard the Tower as a progressive socioeconomic indicator of Hong Kong's future, others see it as a damning symbol of political and economic interference from the People's Republic of China. Doubtless, the meanings attached to the building will change as Hong Kong society changes in the years ahead. ■

Figure A I. M. PEI. Bank of China building, Hong Kong. 1990.

Figure B I. M. PEI. Bank of China building, Hong Kong. View of the garden flanking the west side of the tower. Photo: Siu King Chung.

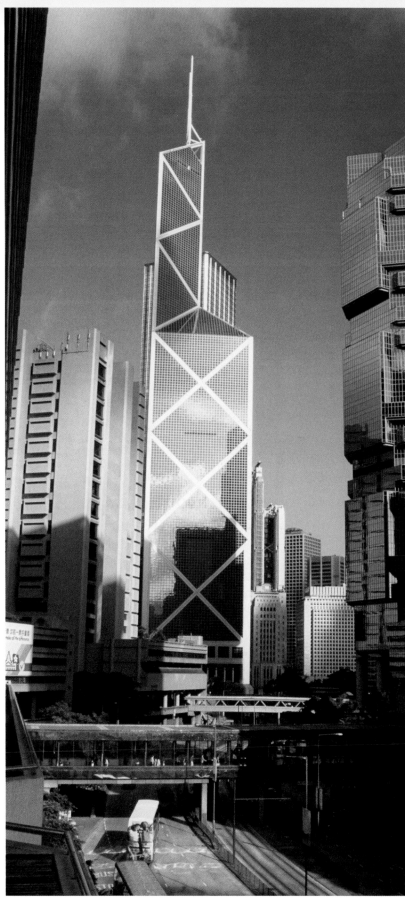

10.37 JÖRN UTZON.
Sydney Opera House,
Sydney, Australia.
1959–72.

Reinforced Concrete Structures

Reinforced concrete, or ferroconcrete (concrete with a framework of iron or steel embedded in it), combines the tensile strength of iron or steel with the plasticity and malleability of poured concrete. Because it can initially take on a semi-liquid form, concrete—a mixture of cement with coarse or fine pebbles or crushed stone or brick—can assume almost any shape.

To create reinforced concrete, rods or cables of iron or steel are placed as inner skeletal frames at the center of wooden molds. The rods or cables may be straight or curved, long or short, in grid or in parallel configurations depending on the shape of the mold, which might be virtually any shape, from geometric to organic. A pastelike concrete mixture is poured into the wooden molds and gradually solidifies into a rock-hard material. When the molds are removed, the section of solid reinforced concrete remains. The reinforcing rods or cables are completely hidden within the concrete but provide enormous tensile strength when the concrete section is set in place.

The curving reinforced-concrete vaults of Australia's Sydney Opera House **(10.37)**, designed by Danish architect Jörn Utzon (born 1918), show the wide-ranging forms made possible by this construction method. Reinforced concrete allows the architect to create like a sculptor, designing forms that have the malleability of soft materials such as clay and plaster. None of the hard, clear, boxlike geometry of the typical steel-frame skyscraper is in evidence in Utzon's Sydney Opera House. The finished building resembles a biomorphic abstract sculpture, an artwork inspired by biological or natural life-forms. Looking at this masterpiece of ferroconcrete construction, writer Jack Hobbs observes that "one is reminded of gull wings, swelling sails, or breaking waves, all of which are appropriate to the site—a peninsula jutting into the middle of Sydney's harbor. The repetition and varied axes of the vaults impart a sense of movement; the scale (the highest shell is nearly 200 feet) and unique design of the vaults provide drama." Such drama is certainly a fitting attribute for a building that has come to symbolize Sydney itself, the vibrant port city that hosted the 2000 Summer Olympics.

Suspension Structures

Close by the Sydney Opera House is a large modern bridge. In the industrial age, most major bridges—San Francisco's Golden Gate Bridge **(10.38)** is a particularly graceful example—have employed a **suspension system** in which a horizontal span is suspended from powerful steel cables or chains anchored at either end and supported by vertical towers at regular intervals. This general system is also used for suspending ceilings in a wide assortment of buildings, from indoor sports stadiums to airports to shopping malls. The vast open spaces of Tokyo's 1964 Olympic stadiums **(10.39)**, designed by architect Kenzo Tange (born 1913), were made possible by suspending the roof from steel cables strung from huge concrete structures, called abutments, at the far ends of the buildings. The suspension construction method provides long, sweeping shapes and spaces that are aesthetically pleasing as well as unobstructed views for thousands of spectators.

MODERN ARCHITECTURE AND COMMUNITY DESIGN: SELECTED VIEWS

If a vote were taken among the experts, the award for the most important architectural "form givers" of the twentieth century might well be shared by Mies van der Rohe, Le Corbusier, and Frank Lloyd Wright. Not only did each man create buildings that are artistic masterpieces, but their works became prototypes for popular types of buildings ranging from the steel-and-glass skyscraper to the commercial shopping center to the urban housing project. These building types and the modernist aesthetic they employed became so influential that they were adopted worldwide as the **international style.** Such global application notwithstanding, the international modern style was transformed by individual architects. **Appreciations 19 and 20** show how this style was "nationalized" or "localized" in the hands of a Chinese-American and a Nigerian designer.

10.38 JOSEPH B. STRAUSS, chief engineer. Golden Gate Bridge, San Francisco. 1937.

10.39 KENZO TANGE, Olympic stadium. Built for 1964 Olympic Games. Now known as Yoyogi National Stadium. Tokyo, Japan.

The Architecture of Oluwole Olumuyiwa

I. A. OJOMO AND ROBERT BERSSON

It is a truism that architecture must respond to the prevailing circumstances of its age. To appreciate the work of Nigerian architect Oluwole Olumuyiwa **(Fig. A)**, one must understand the evolution of contemporary Nigerian architecture from its origin in the colonial experience.

Before the British colonization of Nigeria, beginning in the nineteenth century, Nigeria's existing built environment derived purely from indigenous African construction methods and forms [10.10, 10.30–10.32], that is, the vernacular. The architect's role was not defined. Buildings were a product of the coordinated efforts of the total community. The resultant built forms were highly sensitive to the sociocultural peculiarities of the cultural groups and reflected to a high degree not only their life-style, but also their sociopolitical structure.

The situation changed rapidly with the intensification of colonialism in the late nineteenth century. The colonialists considered indigenous structures to be unsatisfactory for modern residential and administrative functions, and they hired British architects, thereby creating the first architect-designed buildings in Nigeria. These buildings, designed to satisfy contemporary British life-styles, overemphasized technology and "climate control" and deemphasized cultural factors such as extended family size and traditional religious rituals. The breakup, for example, of spaces into numerous private rooms militated against the more communal Nigerian living style. The undesirable consequences of such disregard for cultural factors were manifested in the architect-designed houses during the urban renewal projects in Nigeria beginning in the late

1940s. These consequences included household accidents, unsanitary conditions, and even civil unrest.

Western architecture, which became the model for contemporary Nigerian architecture, relies heavily on technological solutions (for instance, air-conditioning) to environmental problems in buildings. Given the lack of technical and organizational abilities in underdeveloped nations, such as Nigeria, controlling the environmental problems in Western-type buildings becomes a nearly impossible task. Thus, once the equipment breaks down, the artificial compatibility between buildings and users disappears.

After training and working as a young architect in Europe, Olumuyiwa started his professional practice in Nigeria in the late 1950s. He quickly identified the shortcomings of contemporary Nigerian architecture: It lacked physical comfort (due to the unsustainable technical solutions to environmental problems), and it lacked cultural comfort (due to the new architecture's failure to reflect the citizens' way of life). Using the capital city of Lagos as his laboratory, Olumuyiwa developed a new architectural idiom—an amalgamation of traditional vernacular architecture and local technology, colonial period and modern architecture. The result, from a physical and cultural standpoint, was some of the finest architect-designed buildings in Africa **(Fig. B).**

His buildings are distinguished by meaningful use of native materials and methods along with spatially open and flexible interiors. Instead of air-conditioning he introduces natural, traditional cross-ventilation through perforated "breathing walls" that allow air currents to pass through openings of different sizes. He tempers the effect of heat on the roof through high ceilings, window sizes and locations attuned to sun and wind direction, and related approaches that promote movement of air and moderation of temperature.

I. A. Ojomo is a certified architect who was born in Nigeria. He currently lives and teaches in Philadelphia, Pennsylvania.

Olumuyiwa's buildings are distinguished not only by economy and by use of the simplest possible indigenous materials but also by strong color contrasts. Such bold use of color, inspired by African vernacular traditions [5.14] and Latin American architecture [10.54], is rarely found in European architecture except in some southern countries. In addition to their free ground plans, typical of the newer West African architecture, Olumuyiwa's buildings are also noteworthy for their sensitive integration of outdoor space to the structures, as in past African times [10.32].

Combining local Nigerian building traditions and forms with European models and methods, Oluwole Olumuyiwa has been among the first to create a new African architecture for his country and continent. ▪

Figure A OLUWOLE OLUMUYIWA in his Crusaders House, Lagos, Nigeria. 1968.

Figure B OLUWOLE OLUMUYIWA. College of Engineering, exterior, Ibadan, Nigeria. Photo: Udo Kultermann.

10.40 LUDWIG MIES VAN DER ROHE. Crown Hall, Illinois Institute of Technology, Chicago. 1950–56. *Would you call Mies's style "classical"? Why? Why not?*

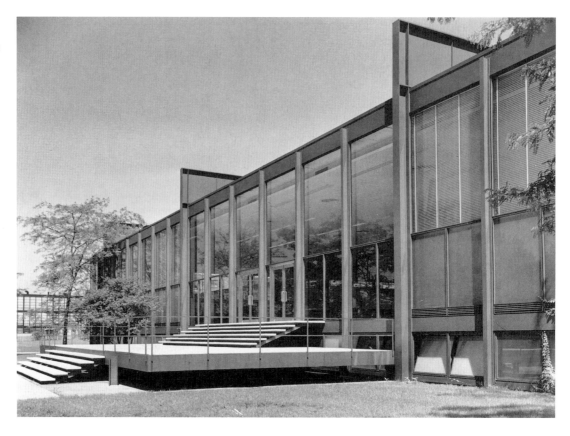

Ludwig Mies van der Rohe

Although Ludwig Mies van der Rohe (1886–1969) helped pioneer the prototype of the modern skyscraper of steel frame and glass (10.36), his construction method and aesthetic were equally applicable to frame structures that spread horizontally across the land, such as modern research centers, office parks, educational institutions, and commercial strip shopping centers. In his designs for the buildings of the Illinois Institute of Technology, Mies developed a few simple principles that he incorporated into a highly rationalized construction method with great appeal for the American building industry. At the core of this method was the use of a modular framework of steel in which all the vertical and horizontal beams were load-bearing. A non-load-bearing "curtain wall" of glass, stone, or any other sheathing material was attached to these weight-bearing steel elements.

Crown Hall **(10.40),** which houses the architecture school at the Illinois Institute of Technology, exhibits clarity, simplicity, and order in a modern functionalist design. Dark steel beams define and order the spaces and windows between them. The steel skeleton of these elegant frames exhibits a concern for clear proportionate relationships and for well-defined corners and joints. The vertical I-beams promenade at regular intervals around the building, much as columns march to a steady beat across the exterior of a Greek temple. We might even compare Crown Hall to the Parthenon (10.14); in both structures the vertical elements move and articulate the space, and both are lifted off the ground and mounted on platforms. Yet this comparison can be taken only so far. Crown Hall gives a sense of lightness, of thin stretched materials, of the transparency and reflectivity of glass, and of a machined geometry unrealizable in ancient stone buildings. In Mies's hands, the technology of the industrial age, the strength and rigor of steel, the crystal quality of glass, and the aesthetic of the machine were transformed into art.

In all his buildings—from Crown Hall to his skyscrapers, apartment houses, school buildings, private residences, and museums—Mies sought not variety but a single minimalist ideal. His stated goal was to subtract and distill until he had an architecture that was "almost nothing" and then polish what was left to perfection. From this rigorous pursuit came his now-famous maxim "Less is more."

Inside Mies's buildings, the same basic principles hold true. The interior of Crown Hall is completely open, unobstructed space—absolute simplicity. Some charge that Mies was interested only in the exterior form of his buildings, not in their specific functions, and thus left the interiors of his structures spatially empty. But he himself argued, like his Bauhaus colleagues, that open space was democratic space, the arena in which the users of the building might decide individually and communally how to arrange their working or domestic lives. "Closed" space was necessarily more directive and authoritarian in its influence on the users. The trend in interior design since the 1970s toward mobile "open plans" for the workplace—employing movable dividers, light portable furniture, and flexible configurations—seems to bear out Mies's original conception. Such an open plan supports a freedom of possibilities, whether the design is applied to community centers, to hospitals, or to office buildings.

In his interior and exterior design, Mies sought one ideal image of timeless consistency and refinement, but the enterprising developers of commercial strips, shopping centers, and malls who took up Mies's principles and forms had different goals in mind. On Mies's geometrical steel-frame skeletons, the developers and their builders, especially in the United States, threw up countless facilities, open containers waiting to be filled as the users saw fit. In their designs, they opted for variety and fashion. Their muse was not perfect geometric form but profit, and they pushed Mies's solutions for all they were worth in a spirit that thrives not on permanence or idealism but on novelty, trendiness, and advertising potential. In this regard, Mies's open, flexible spaces were perfect for a dynamic and ever-changing consumer-based society.

10.41 FRANK O. GEHRY, Santa Monica Place Mall. Interior view. Santa Monica, California. Photo: Esto/Tim Street-Porter. *In terms of architectural and community design, do you view malls as good, bad, or simply a fact of life? Compare and contrast the mall to other forms of community design such as the downtown business district and the college campus.*

Consider our suburban and urban shopping malls, for example, the lively one in downtown Santa Monica, California **(10.41),** designed by hometown architect Frank O. Gehry (born 1929). Many cultural critics view malls negatively, but they are enormously popular in their functions as the marketplace, town square, and social and entertainment center of many of our communities. Structurally, they are essentially horizontal Crown Hall–type frame structures, from one to several stories in height, that offer abundant flexible, open space for retail shops, eateries, movie theaters, and the like. In climate-controlled comfort, consumers are free to move from business to business, with each enterprise housed in a simple, boxlike space framed of steel. The steel framework is hidden behind walls and is part of the overall rectilinear grid that structures the mall. New businesses can be plugged into the open spaces, designed for maximum flexibility, whenever the need arises. The entire interior of the mall might even undergo a face-lift every decade or so to keep pace with changing marketing and architectural trends.

10.42 LE CORBUSIER. Notre-Dame-du-Haut, Ronchamp, France. Exterior view from southeast. 1950–55.

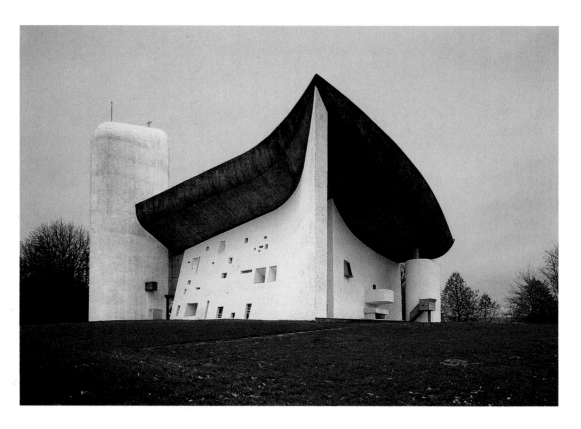

Le Corbusier

In the buildings of Swiss-French architect Le Corbusier (1887–1965), two attributes, sometimes separate but often combined, stand out: their monumentality and their sculptural quality. Some of his last and best buildings—for example, the Chapel at Ronchamp in France **(10.42)**, constructed between 1950 and 1955— are truly abstract sculptures in the round, molded and formed in the pliable medium of poured concrete. Architectural historian Spiro Kostof writes, "The building both engulfs and resonates, draws us into its hollows, and makes us go around it as we would around powerfully molded sculpture." It furthermore evokes figurative associations with sea crab and distant mountains, ship and cave, as "the dark roof slab bears down . . . but [also] lifts prowlike." The side chapels "send hooded funnels upward to catch the light." Taking inspiration from Le Corbusier's Chapel at Ronchamp, such powerful sculptural compositions as Utzon's Sydney Opera House (10.37), Wright's Guggenheim Museum in New York City (3.10), and Gehry's Guggenheim Museum

in Bilbao, Spain **(10.43),** are truly exceptions in the world of architecture. They stand out for their organic plasticity, which is so different from the expected rectilinear geometry.

All of Le Corbusier's buildings rise up from and seem to stand above the earth, making their existential mark. Many of his most monumental structures, such as the Marseilles apartment block the Unité d'Habitation **(10.44),** stand on *pilotis*, free-standing columns, posts, or piles that support the building and raise it above the ground. Rooted with certainty in the earth but rising above it, the building becomes, in Le Corbusier's terms, a "machine for living." But these are not elegant steel-and-glass machines in the style of Mies van der Rohe. Le Corbusier's machine-buildings often have an earthy ruggedness, beginning with their very substance. The surfaces of the poured concrete sections that compose many of them are rough-hewn and irregular, picking up the textural imprint of the wooden molds in which they were formed.

Aiming for social interaction and self-sufficiency, Le Corbusier incorporated shopping, recreation, and service facilities within the

10.43 FRANK O. GEHRY. Solomon R. Guggenheim Museum, Bilbao, Spain. 1993–97. © FMGH Guggenheim Bilbao Museo, 2001. Photo: David Heald. All rights reserved. Partial or total reproduction prohibited. © TAMCB, Guggenheim Bilbao Museoa, 2001.

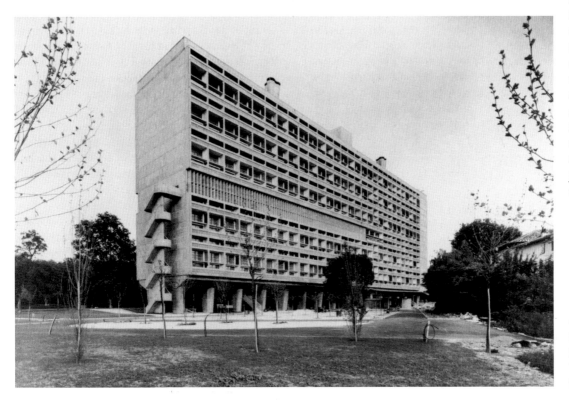

I have been fortunate to have had support from living painters and sculptors. I have never felt that what artists are doing is very different. I have always felt there is a moment of truth when you decide: what color, what size, what composition? How you get to that moment of truth is different and the end result is different.—Frank O. Gehry, architect, interview, 1993

10.44 LE CORBUSIER. Unité d'Habitation, Marseilles, France. 1945. Exterior. © Fondation Le Corbusier.

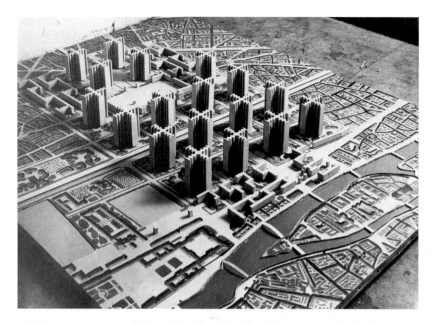

10.45 LE CORBUSIER. Voisin Plan for rebuilding Paris. 1925. Model. © Fondation Le Corbusier. *Most large cities feature a geometrical grid plan within which buildings rise ever higher and population density continually increases. Considering the Winston Churchill statement that we shape our community designs and then they shape us, what impacts—good or bad—might a Voisin-type urban design plan have on its inhabitants?*

10.46 Destruction of the Pruitt-Igoe apartment complex, St. Louis, Missouri. 1972. *One alternative to large-scale, Pruitt-Igoe-type public housing projects, where low-income renters are massed together, is the dispersal of smaller-scale, low-income rental units throughout the community. A second alternative involves financial planning that promotes ultimate tenant ownership of rental housing units. How do you think these options would impact quality of life in public housing for poor persons?*

huge Marseilles structure. The top floor contains a kindergarten and nursery. On the roof are playful sculptural forms, a children's swimming pool, a playground, a snack bar, a gymnasium, and a track. "Interior streets" or corridors run the length of the building on every third floor, and a broad shopping arcade resides halfway up the building. Designed to house 1,600 people, the Unité contained 337 independent living units in a wide variety of sizes and shapes, from single rooms to large family apartments opening onto both the front and the rear of the slab. The idea was to ensure a good social mix; Le Corbusier thought of the Unité as "unity" as well as "units," a complete neighborhood community.

Multiplied in kind, Unité-type structures might ultimately make up a "radiant city," a metropolis of spatially ordered megastructures "bathed in light and air." Le Corbusier's own 1925 Voisin plan for the urban renewal of Paris **(10.45)** gives one a sense of this vision. The plan called for the demolition of a very historic section of Paris that he saw as "particularly unhealthy and antiquated" and its replacement by a rational, modern city of high-rise Unité-type megastructures with superhighways running between them. In a city as historically minded as Paris, the plan naturally provoked fierce debate and was never executed. Yet versions of the plan are very much in evidence today in many major skyscraper cities; New York is one example (10.36). In addition, cities worldwide have adopted the Unité prototype as a principal alternative to the skyscraper tower for apartment, office, and institutional buildings. In Britain, Switzerland, and elsewhere, the high-rise block became a model, as the architect had hoped, for low- and moderate-income housing in the welfare state.

In the United States, Le Corbusier's prototype was used similarly in urban renewal projects. Its success in the sphere of public housing, however, was mixed. One highly instructive disaster, the Pruitt-Igoe housing project, employed Le Corbusier's basic scheme. A minicity complex consisting of high-rise Unité-type structures, the Pruitt-Igoe housing project was built by the city of Saint Louis based on the designs of Minuro Yamasaki (born 1912). The housing project, completed in 1955, was inhabited entirely by low-income inner-city residents. The buildings themselves received high

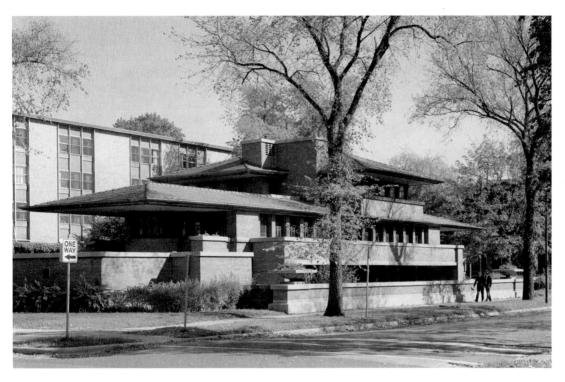

10.47 FRANK LLOYD WRIGHT. Robie House, Chicago. 1909. *In the photo we see two "modern" buildings. Compare the Robie House to the later international style modern building behind it. How are the two similar or different?*

marks for their design and won a variety of architectural awards, but living in the high-rise structures proved terrifying. The buildings became breeding grounds for drug abuse and crime. Residents feared using the common stairwells, elevators, or "interior street" corridors that led to their individual apartments. Forced to use these public passages because their apartments had no private outdoor entrances, residents felt endangered by the criminals lurking inside. The low-income project was dynamited in part by the city of Saint Louis in 1972 **(10.46)**. The megastructures had simply become too crime-ridden, garbage-strewn, and run-down to be workable as public rental housing.

Although Pruitt-Igoe lacked good management and the fundamental social mix that Le Corbusier so strongly recommended for urban living, factors that might have saved the community and the buildings, this tragedy and others like it taught idealistic architects a number of hard lessons. To begin, problems of housing are very complex, involving factors such as class, cultural background, employment and educational opportunities, social services, crime, and so on. Such problems, architects came to realize, are not amenable to architectural solutions alone, especially solutions that are not sufficiently sensitive to the complicated living-working patterns of the future occupants. From experiences such as Pruitt-Igoe, architects and city planners learned greater humility and realism. They learned that they could not create visionary designs in the isolation of their offices but instead needed to work closely with a difficult mix of government officials, social scientists, and social welfare professionals as well as future occupants. The last group represents the most important group to consult—and often the most easily forgotten.

Frank Lloyd Wright

One visionary architect-planner of the twentieth century who felt the pulse of the American masses was Frank Lloyd Wright. Low and sprawling, his so-called "prairie houses," built in the Midwest beginning in the early twentieth century, became a primary model for the now ubiquitous suburban ranch and split-level houses. Designed for affluent single families, the prairie houses **(10.47)** are detached homes that spread horizontally across their own rectangular plots of land—the ideal

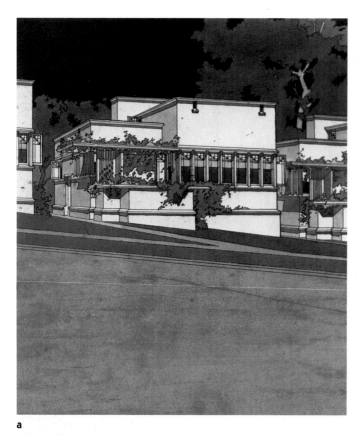

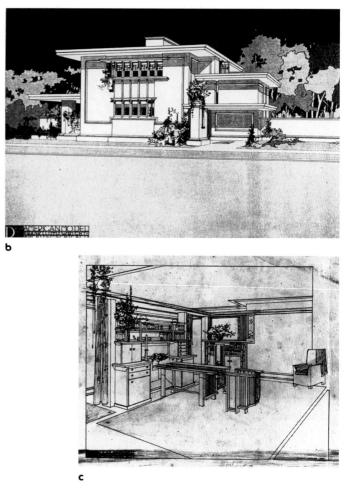

10.48 FRANK LLOYD WRIGHT. American System Ready-Cut Houses. 1913–15. Drawing. (a) Exterior view of the facade of the building. (b) Exterior view, back or side of the building. (c) Interior view.

model for American suburban living. In contrast with Le Corbusier's preference for urban living and emphasis on centralization and communal interaction, Wright's houses and community plans emphasized decidedly anti-urban qualities: spaciousness, decentralization, and personal privacy. Ideally, all families would own their own houses—of varying sizes according to income level—separated from their neighbors' houses by borders of shrubs or fences that defined their own yards.

Much of Wright's vision and work was in direct harmony with the American Dream, from his prairie houses in the first decade of the century to his later plans for "American System Ready-Cut" residences **(10.48)**, modestly priced, prefabricated structures that accommodated from one to four living units. All of these housing types would become constituent parts of his prophetic Broadacre City plan **(10.49),** a prototype of today's planned suburban communities, such as Columbia, Maryland, and Reston, Virginia **(10.50).** Broadacre City embodied the American dream come true, a community in which all citizens owned their own houses (or apartments) and private land for their lifetime. The citizens of Broadacre City (and, today, of Columbia and Reston) could cultivate their plots, gardening, mowing, and caring for trees and flowers, an experience Wright considered spiritually elevating. The citizens of Wright's ideal society would live away from the crowds, exorbitant rents, and centralized corruption he associated with the "big city." Commuting to the city, the bane of most contemporary suburbanites, would be reduced to a minimum because Broadacre City would be largely self-sufficient, providing enough industrial, agricultural, and service work for its citizens.

10.49 FRANK LLOYD WRIGHT. Broadacre City. Model. 1933–40.

10.50 CONKLIN and WITTLESEY. Reston, Virginia, aerial view. Late 1960s. *Reston is a planned community within the general suburban sprawl of northern Virginia just outside Washington, D.C. How would living in Reston or in Wright's Broadacre City (10.49) be different from living in suburban sprawl, the form of community design (or lack of design) that has dominated the rapidly growing outskirts of large and small cities from the end of World War II to the present? Do you observe any efforts within sprawling suburban areas to restore a visual sense of place and a psychological sense of community?*

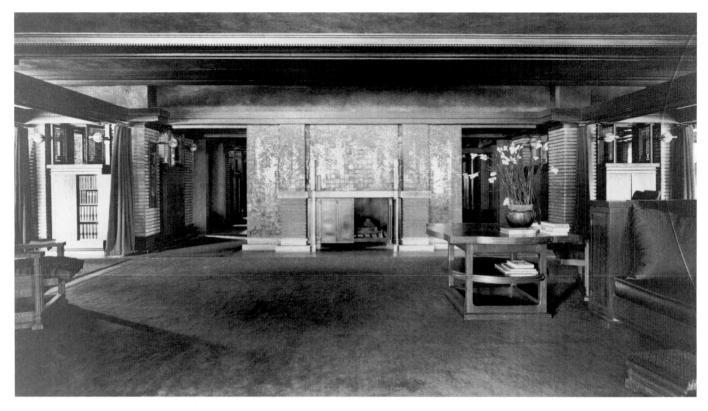

10.51 FRANK LLOYD WRIGHT. D. D. Martin House, Buffalo, New York. 1904. Interior view of living room.

10.52 Yoshijima House, Takayama, Japan. Ca. 1900. Interior view of reception room.

Such a planned, countrified city stands in stark contrast to the ever-expanding freewheeling sprawl of most contemporary suburban areas. In much suburban development, profit-driven commercial values, denounced by Wright as "insensate business greed," prevail over the "human" values he believed essential to wholesome life in a democracy.

Let us look once more at Wright's prototypical prairie house. These sprawling residences for the wealthy preview the shape of suburban homes to come. For example, in the Robie House (10.48), built in 1901 in what was the outskirts of Chicago, we find the basic form of many post–World War II suburban homes: long, rectilinear, horizontally sprawling, and low to the ground. The design of these prairie houses is characterized by a simple, unadorned geometry. In their day, Wright's streamlined prairie houses truly must have looked like "machines for living."

The interior of such suburban houses **(10.51)** exhibited a spacious horizontality, with

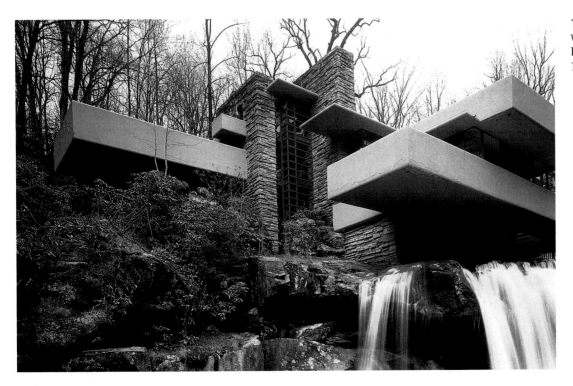

10.53 FRANK LLOYD WRIGHT. Fallingwater. Bear Run, Pennsylvania. 1936.

an open, continuous plan allowing the living, dining, and other common rooms on the first floor to flow into each other. This concept was inspired, in part, by the spatial openness and fluidity of traditional Japanese homes **(10.52).** Wright's design of flexible, open interior spaces, in turn, inspired the architectural and interior design of Mies van der Rohe (10.40), Gropius (9.26), and their Bauhaus followers (9.30). A basic component of the modernist international style, such open-space design would subsequently influence the living and working patterns of millions of people around the world.

Wright's prairie houses had a substantial influence on the shape of the American suburban house as well as the modernist architectural design of the Bauhaus and other modernist pioneers of the 1910s and 1920s. The wider influence of the Kaufmann house **(10.53),** the single-family home for which Wright is best known, would come decades later. Popularly known as "Falling Water" for the rural Pennsylvania waterfall over which it is built, it is perhaps Wright's crowning artistic achievement. He designed this "House on the Falls" as the weekend home of the wealthy Kaufmann family, who lived and worked in

Pittsburgh. The end result perfectly balanced the family's desire for outdoor pleasures and Wright's ideal of "organic architecture," in which the building embodies the human desires and values of its users, functions effectively, and relates harmoniously to its natural surroundings.

Whereas the machines for living of Le Corbusier and Mies van der Rohe maintained a distinct separateness from their immediate natural surroundings, even rising on *pilotis* above the ground in the case of Le Corbusier's Unité, Falling Water merges with its natural surroundings. Actually placed in the rushing stream, the steel-reinforced concrete slabs of Falling Water extend out, or "cantilever," over the water and echo the rock shelves beneath. The stone of the walls, floors, and chimney was quarried from the surrounding area. Within, the boulder on which the house is built functions as the base of the central fireplace. Like an anchor, the boulder connects the interior of the house to the bedrock beneath. The house is situated to allow a maximum of sunlight to enter all the rooms. At the same time, the rectilinear bands of the upstairs windows are located to frame surrounding nature much as a picture frame might.

Each structure we build is an integral statement on how we want or don't want the entire world to be. We either work on its construction or on its destruction. We complete or we fragment it. The first rule of ecology is that we cannot do one thing alone.—Leon Krier, architect, *Architecture, Urbanism, and History,* 1985

POSTMODERNISM: TOWARD A NEW PHILOSOPHY IN ARCHITECTURE

In retrospect, Falling Water contained a seed of the multifaceted architecture that since the 1970s has been referred to as postmodern. One major value associated with postmodernism, alternately referred to as "ecological" or "contextual," is an emphasis on buildings that relate sensitively to their natural or built surroundings. Falling Water certainly made the case for architecture that was well integrated with its natural surroundings. Postmodernism builds on this legacy, extending it—as modernism did not—to the surrounding built environment. Many postmodernists consciously seek to relate a building to its neighbors; most modern buildings, in contrast, such as those of Mies van der Rohe, Le Corbusier, and Wright himself, reflect little or no consideration of the built environment in their vicinity.

There is more to postmodernism, however, than its ecological orientation. What observers often note first about postmodern architecture and design—recall architect Robert Venturi's postmodern chairs (9.34)—is its eclectic historical character.

Emphasis on Context and Ecology

To be fair, numerous modernists did over time become more sensitive to their buildings' architectural and cultural surroundings. (The general rise of ecological, multicultural, and postmodern values from the 1960s onward deserves credit in this regard.) I. M. Pei's Bank of China Tower integrated ancient cultural symbols and an actual Chinese garden design at its base (Appreciation 19). Oluwole Olumuyiwa's buildings in Nigeria drew upon local or indigenous building styles and took into account everyday life-styles in a tropical climate (Appreciation 20). Mexican architect Ricardo Legoretta (born 1931) likewise introduces the vernacular into his modernist architecture **(10.54)**, employing local building materials (brick and stucco), popular eye-popping colors, and preindustrial "on-site" construction techniques. The result, writes architect William Tate, is "an architecture of emotion and celebration" in keeping with the Mexican and Latin-American heritage.

10.54 RICARDO LEGORETTA. Casa Zetuna, the architect's own house in Mexico City. 1988. *Architect William Tate writes that "a Legoretta house is a weaving of space. The spaces are playful, while at the same time powerful. One is also called to encounter color." Have you ever had a similarly vivid experience of architecture in a private home?*

Contextually sensitive postmodern architects, like the previously mentioned modernists, seek to design buildings that are in an ecological relationship with their environs. Built in 1985, the Baptist Student Center **(10.55)** in the small city of Harrisonburg, Virginia, is an exemplar of the postmodern orientation at its ecological best, seeking as it does a harmonious relationship with the older buildings adjacent to it. Its clean lines and clear-cut, unadorned geometry, combined with its use of advanced building techniques and materials, communicates its late-twentieth-century origins, yet its overall scale, shape, color, and composition show a respect for its neighbors and their early-twentieth-century appearance. Extending the concept of ecology even further, many architects now seek to make their buildings as energy efficient and environmentally friendly as possible.

Eclectic Historical Character

In postmodern buildings, the forms and symbolism of past styles of architectural design are welcome. With sensitivity and subtlety, the Baptist Student Center incorporates the basic forms—roof lines, colors, window shapes—of

10.55 RAWLINGS and WILSON. Baptist Student Center, Harrisonburg, Virginia. 1985.

the adjacent older buildings on the block. Far more extroverted, the Piazza d'Italia (Plaza of Italy) in New Orleans **(10.56)** literally explodes with boisterous humor. Designed by Charles Moore (1925–1995) and completed in 1980, this public square incorporates five orders of classical Greco-Roman columns (10.15) but with an irreverent twist. The columns are either rendered in shiny metal or neon or brightly painted. Tongue-in-cheek remakes of entablatures and arches, a central fountain in the shape of Italy, and theatrical nighttime lighting join in the fun. In postmodern works, history and humor might conjoin.

Postmodern buildings can just as readily employ historical references in formal, dignified ways. The Canadian Chancery (Embassy) in Washington, D.C. **(10.57),** by Canadian architect Arthur Erickson (born 1924), is an example. Completed in 1989, the Chancery respectfully integrates the classical revival and modern architectural styles of its District of Columbia surroundings with an eclectic but impressive design. Here simplicity and restraint characterize the handling of the historical elements. Tall columns, expansive entablatures, and an open-air domed rotunda tie the Chancery to nearby U.S. government buildings. Visually, the Chancery is a good neighbor, strong in its Canadian individuality but respectful of the Washington, D.C., built environment. Up close, the building reveals further evidences of its Canadian identity: a series of columns that look as if they're made of stone but are actually constructed of aluminum (one of the country's major products) and "The Black Canoe" sculpture (Appreciation 3) in the exterior courtyard honoring the land's original "First Nations" settlers. Such symbolism and national, regional, or multicultural characteristics are welcome within the postmodern value system.

Whether postmodern historical features are derived from the ancient Greco-Roman world or from older buildings next door, they communicate to us in a familiar language. They remind us of earlier meanings and kindle memories of the past. Looking toward a superior future, most modernists cast off the past and its language and values. Postmodernists accept the past and the imperfect present and freely work with them.

10.56 CHARLES MOORE with U. I. G. and Perez Associates, Inc. Piazza d'Italia, New Orleans, Louisiana. 1975–80.

10.57 ARTHUR ERICKSON. Canadian Chancery, Washington, D.C. Exterior view. 1989. *Observe the "classical revival" style National Gallery of Art in the distance. Does the Canadian chancery relate well to this older building?*

BUILDING COMMUNITY IN THE TWENTY-FIRST CENTURY

In keeping with key postmodern architectural values, innovative community design approaches collectively called "the new urbanism" have taken root in recent decades. The new urbanism emphasizes the preservation and restoration of historic buildings and the revitalization of older downtowns and neighborhoods. It is an approach that is worlds apart from the mid-twentieth-century planning approach of "urban renewal," which generally meant the sweeping away of the old and its replacement by the new (10.45), sometimes with catastrophic results (10.46). New urbanists likewise seek solutions to the challenges posed by the burgeoning suburbs, where a full 50 percent of the U.S. population now resides.

Preservation-Restoration and Downtown Revitalization

An award-winning example of historic preservation and creative restoration, what architects call "adaptive reuse," is the Musée d'Orsay **(10.58)**, an art museum in the center of Paris completed in 1987. Italian architect Gae Aulenti (born 1929) preserved the exterior and much of the interior structure of the Gare d'Orsay, a railroad station (finished in 1900) with a soaring barrel-vaulted, frame roof of iron and glass and intricate period decoration. Within the venerable building shell, Aulenti added stepped and ramp flooring, exhibition and divider walls, seating areas, and an array of display stands and cases. The so-called sculptural avenues that formally define the upper floor and provide for the exhibition of sculpture recall the rows of train cars that once lined the station's tracks. These functional additions combine an abstract geometric flair with subtle historical references to columns, capitals, and entablature, setting up a contrast and a connection between the railroad station and the art museum as well as a lively dialogue between inner and outer—a kind of architectural "play within a play."

The preservation and creative conversion of historic buildings—for cultural centers, stores, apartments—are cornerstones of downtown revitalization. This redevelopment strategy is employed in the United States and other nations to counter the economic, social, and cultural decline of downtowns caused by the rapid, ongoing suburbanization of the past fifty years. To bring people and business back to the city center, downtown revitalization organizations have built upon those qualities that once made it special. Programs at the local, state, and national levels have subsequently worked to make the city center an appealing "people place": pedestrian friendly, socially vibrant, culturally alive, and historically and architecturally memorable. To these ends, welcoming public spaces (squares, plazas, markets, parks, walking streets, benches, and other street furniture), restoration of the facades of historic buildings, attractive signage, and year-round cultural attractions (museum exhibitions, public art, concerts, plays, sporting events and festivals, and street performers and vendors) are essential ingredients. Boston's popular Faneuil Hall Market Place (10.3), New Orleans' pedestrian-friendly Piazza d'Italia (10.56), and Washington, D.C.'s Canadian Chancery plaza (10.57) with its public art feature *The Black Canoe* (Appreciation 3) are major successes of downtown revitalization.

On a still grander scale, the Baltimore Orioles' baseball stadium, Camden Yards **(10.59)**, is a propulsive engine of inner-city revitalization. Completed in 1992 in the style of ballparks of the early 1900s, the stadium deepened the sense of downtown Baltimore as a special place. It features a brick facade, steel beams, a raked upper deck, a spacious interior with views of the city skyline, and an eight-story 1898 warehouse, several blocks long, forming a historic architectural border behind the right-field seats. Architect-in-charge Joseph Spear and his associates sited the popular stadium in a contextually sensitive way that respects earlier urban patterns. Planner Todd Bressi notes with approval that the stadium fits snugly within the city's existing grid (reinforcing the public space of the street), connects to nearby light-rail and commuter rail lines (providing an option to auto travel), and is within a short walk of housing, retail, and office facilities (adding to the local diversity of activities).

Suburban Communities: Problems and Possibilities

Since World War II, millions of persons, mostly middle class, have moved to the suburbs. Eagerly exiting the cities, seeking an American dream of peace and quiet, open space, privacy, and ownership of a single-family home surrounded by a spacious yard, most people got the whole package—at least initially. But as the suburban population far outstripped that of city and rural countryside, newcomers also got suburban sprawl with its daily commuting and traffic bottlenecks and its ever-rising costs and taxes for new water, sewer, phone, and utility lines and roads. Sprawl has resulted in severe air pollution from auto emissions and a gobbling up of the natural landscape that first attracted city dwellers to the country. Within the sprawling suburbs themselves, single-family detached homes still provide a maximum of privacy, but at a cost: reduced social interaction with neighbors and the larger community. With the life of each person and family centered at home or in the automobile—almost all activities are driven to—the inevitable result, critics maintain, is a loss of community.

New urbanists have responded to these challenges by creating planned suburban cities, towns, and villages that seek to achieve a synthesis of the best of contemporary urban and suburban life. The new urbanist vision values suburban privacy and greenery but joins them with urban qualities: greater population density within a more concentrated area centered around a vital downtown. (An earlier generation of planned suburban "new towns" such as Reston, Virginia (10.50), and Rouse's Columbia, Maryland, established in the late

10.58 GAE AULENTI. Musée d'Orsay, Paris. Interior view of the sculpture hall. 1980–86.

1960s spread for miles across the land and are highly automobile-dependent.) Compact, new urbanist communities emphasize pedestrian-friendly spaces, the public life of the street, and social interaction. Begun in 1981, the village of Seaside, Florida **(10.60),** is a prototype for this new urban-suburban community mix. Its creators are the husband-and-wife architectural design and planning team of Andres Duany (born 1950) and Elizabeth Plater-Zyberk (born 1950). Working closely with their client, real estate developer Robert Davis, Duany and Plater-Zyberk introduced zoning laws that require Seaside's homes, mostly single-family, to be close to each other and intimate with the sidewalk and street. Front porches, a required feature, encourage residents to see and interact with their neighbors. Ubiquitous picket fences around small yards engender suburban privacy

10.59 JOSEPH SPEAR, architect-in-charge, and Helmuth, Obata, and Kassabaum and Associates. Oriole Park at Camden Yards, Baltimore, Maryland. 1992.

10.60 Seaside, Florida, view of town center. Slight aerial view. Photo: © Michael Moran. *Late-nineteenth- and early-twentieth-century suburban houses often had front porches. In suburban homes of the past fifty years, the front porch has been eliminated, replaced in the back by a patio or deck and in the front by a driveway and garage. What conditions and values led to the gradual elimination of the front porch by the 1950s?*

INTERACTION BOX

"ADOPT A BUILDING"

Choose a building in your neighborhood that you find particularly interesting or attractive, and find out as much as you can about the building. You might start your research by visiting the local library or historical society or by interviewing the current residents or users of the building. Even if these people don't know very much about the building, they might be able to give you some valuable leads. In doing this type of detective work—investigating primary and secondary sources—you are functioning like an architectural historian.

Get to the heart of the matter with your questions. When was the structure built? Who designed and built it? Was the designer a professional architect or a local builder? What was the building's original function? Who lived there or used it? What style or styles (classical revival, gothic revival, modern, postmodern) does the structure exhibit? Was it built all at one time, or over decades or centuries? How do its style, physical makeup (stone, brick, wood), construction approach (wood or steel frame, reinforced concrete), and additions and alterations reflect its context (social, cultural, environmental)?

By learning as much as you can about this one building, you will become more historically intimate with it and formally appreciative of it. In coming so much closer to the building in terms of knowledge and even affection, you might feel that you have a special relationship with the building, that you've personally "adopted" it.

The major issue surely has to do with reshaping that sprawl of automobile suburbia into communities that make sense, and that's what the New Urbanism is primarily about.—Vincent Scully, architectural historian, *The New Urbanism*, 1994

while at the same time fostering an architectural connection between the diverse building types. The social message for residents is "We're all unique but connected." Within neighborhoods, streets are narrow and lined with trees to tame the car and calm traffic, resulting in extensive in-town walking, bicycling, and person-to-person interaction.

In total contrast to suburban-sprawl development, new urbanist communities such as Seaside feature a center and an edge (providing a focus and a limit that contribute to the geographic and social identity of the community), a balance of activities (dwelling, shopping, working, school, worship, recreation) within an easy five-minute walk of one another, and an emphasis on public space and civic buildings.

A major shift in architectural and community design philosophy toward communities more firmly grounded in neighborhood interaction, respect for others, and the honoring of past traditions may be under way. If this is the case, then the design of our buildings and communities will show it **(Interaction Box).**

A HISTORY OF ART

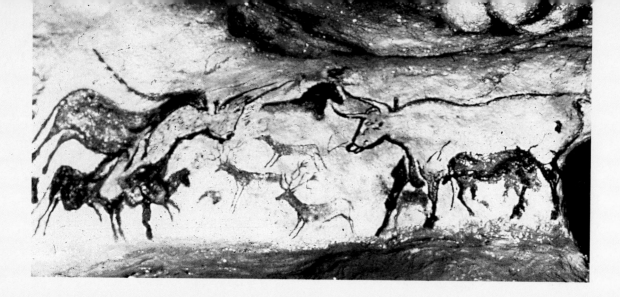

11 From the Paleolithic Era to the First Civilizations

"Try to imagine an art gallery," writes Robert Hughes, "that could be entered only by crawling on your belly through a hole in the earth; that ramified into dark tunnels, a fearful maze in the earth's bowels in which the gallery-goer could, at any moment, disturb one of the bears whose claw marks can still be seen on the walls; where light came from flickering torches, and the bones of animals littered the uneven floor." Robert Hughes, *Time* magazine's art critic, was writing in response to the 1995 discovery of a labyrinthine cave filled with painted images created 20,000 years ago. Cave paintings on the walls and ceilings of underground chambers—more than 200 such sites have been found in southwestern Europe alone **(11.1)**—were probably meant to be seen by a select few under conditions of extreme difficulty and dread. Covered with images of animals **(11.2)** sometimes accompanied by abstract signs, the chambers may have been centers for magical rites or places of initiation and trial in which human consciousness was tested to an extent we can only dimly imagine.

Whatever their meaning and purpose, the experience of these paintings of bison, wild horses, and woolly mammoths was completely different from our own contemplative experience of art in well-lit, climate-controlled museums in the company of hundreds of other viewers from all

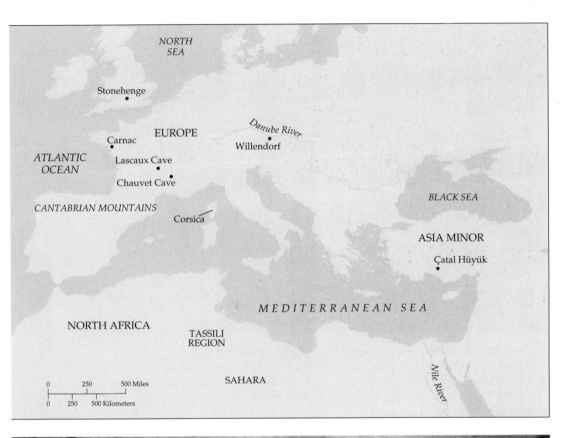

11.1 Map of prehistoric Europe, North Africa, and Asia Minor.

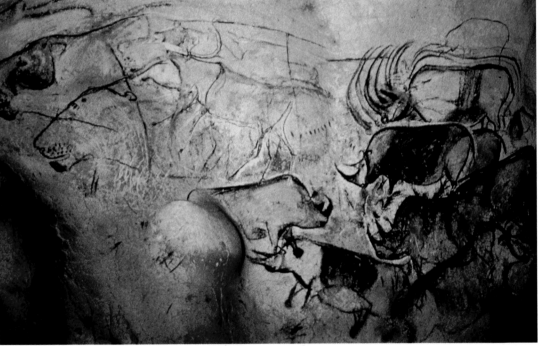

11.2 Lion panel, Chauvet, Ardèche Valley, France. Ca. 25,000–17,000 B.C.E. Courtesy of J. Clottes, the Regional Office of Cultural Affairs, and the Ministry of Culture and Communication. (Direction du Patrimoine, sous Direction de l'Archélogie.) *How could the animal paintings in caves be so realistic, so skillfully done, so aesthetically impressive? Why is there no evidence of the less accomplished works that must have preceded and prepared the way for the mature cave paintings?*

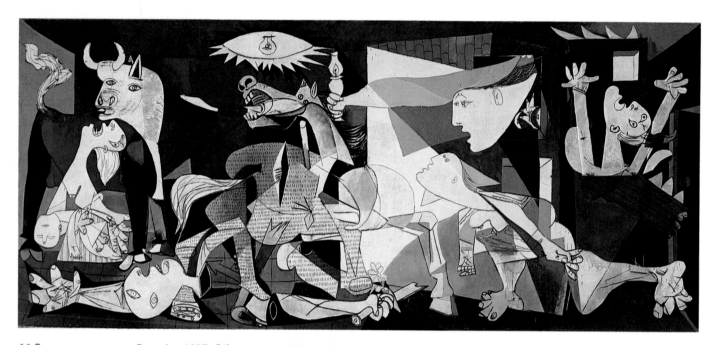

11.3 PABLO PICASSO. *Guernica.* 1937. Oil on canvas. MUSEO NACIONAL CENTRO DE ARTE REINA SOFIA, Madrid, Spain. © 2001 Estate of Pablo Picasso/Artists Rights Society (ARS), New York. *Pablo Picasso (1881–1973) was born in Spain, where the bullfight is a deeply rooted cultural institution. The bull became an important symbol in his art. What might the symbolic meanings of his bulls be? How might they relate to prehistoric peoples' interpretations of the male bovine?*

Today we know that the evolution of man, from early hominid [humanlike primate] forms, covers a period of at least 4 to 5 million years. Yet the invention of "art," that is, the intentional manufacture of recognizable images, began only at the very end of this long process, possibly with the appearance of modern types of man and the development of modern human languages.

—Alexander Marshack, archaeologist, *Ice Age Art,* 1979

walks of life and at odds with our ready access to art through courses, books, films, television, and the Internet. Art and the experience of art have certainly changed! And yet there are shared qualities between a cave painting of a bull in southwest France and the bull (upper left) in Pablo Picasso's *Guernica* **(11.3),** a famous twentieth-century oil painting on display in a Spanish museum a day's drive away. Stylistic differences notwithstanding, both works portray a wild bovine subject of commanding presence, and both works evoke a sense of mystery and primal life force. Across the millennia, such artistic representations of bulls continue to reach into deep places in our human psyche: to instincts of fight or flight, to sexual energy, to feelings of awe before untamed nature.

We are so different from our earliest ancestors, yet we have much in common with them at the most basic genetic, intellectual, psychological, and artistic levels. The history of art, ranging across societies and cultures from prehistory to the present, helps us comprehend the commonalities and differences.

Perhaps each adult 40,000 years ago was a maker of art. Each person may have been involved in "the intentional manufacture of recognizable images," to use archaeologist Alexander Marshack's definition of art. This creation of communicative images was most noticeable on people's bodies. Adornment with bracelets or necklaces, tattoos, body piercings, and painted marks identified a person as a member of a particular family, clan, or society or as a participant in a specific ceremony or rite of passage. (In widely diverse forms, this age-old "body art" tradition of personal and social identity continues to the present (5.1, 3.21–3.24).) But to paint large leaping bulls (11.2) or running horses on cave walls most likely required a specialist, a person both intimately familiar with wild animals and the hunt and having exceptional artistic skill and power of visualization that were revered by the group. From the creation of cave paintings to the artistic production of the first urban civilizations, the role of the artist would continue to evolve, becoming ever more specialized—and ultimately professionalized—to meet the requirements of a changing society.

THE UPPER PALEOLITHIC ERA

The place is southwestern Europe during the final or "upper" part of the Paleolithic (Old Stone Age) era, covering the period from roughly 40,000 to 10,000 years ago—the time of the last Ice Age, when a large part of the northern hemisphere was covered with glaciers. South of this frozen ice cap, limestone hills and cliffs within protected river valleys provided shelters and caves for the Franco-Cantabrian cultures inhabiting the region that today constitutes southern France and northern Spain. In this potent natural setting, the painter of animals moved through dank, pitch-black passageways to a faraway cave chamber. The artist was probably followed by one or more assistants who helped transport materials, held up a torch or an oil lamp to illuminate the painting surface, or perhaps assisted with the actual making of images. Who was this master artist?

The First Artists

Many scholars propose that the cave painter of animals and signs was a shaman (from the Manchurian word *saman* meaning "to know"), an individual with special status whose concerns included physical and spiritual healing, prophecy, problem solving, and magical rituals. From prehistoric times to the present, the shaman has been a respected member within diverse societies. Whether in the world of contemporary art (20.11) or politics, the shaman is still very much with us. A July 30, 2001, Associated Press news piece speaks to this fact:

> Returning to his Indian roots a day after being inaugurated as Peru's first democratically elected president of Indian descent, Alejandro Toledo was blessed Sunday in a traditional ceremony atop the ancient ruins of Machu Picchu, the "Lost City of the Incas." The ceremony performed by an Indian shaman on the mountaintop religious sanctuary is an ancient ritual which gives thanks to the Pachamama or the Earth Mother, and to the "apus," the spirits of the Andean heights.[1]

Emphasizing the connection between art and spirituality in the first shaman-artists, contemporary painter and fabric artist Margot Bergman hypothesizes:

11.4 *Shaman*, Trois-Frères cave painting, Ariège, France. 13,000–11,000 B.C.E. Below: Contemporary drawing based on cave painting.

. . . the first men and women spiritual leaders were also the most imaginative object-makers and storytellers of the group. They dramatized tales of everyday life. They fashioned objects to represent essentially invisible powers and forces: the wondrous processes of nourishment, growth, and reproduction; the fatefulness of the hunt.[2]

According to Swiss anthropologist Andreas Lommel, the Upper Paleolithic cave paintings (11.2, **Technique Box 11-A**) were created by artist-shamans who worked mainly in a self-induced trance. A contemporary drawing based directly on a prehistoric cave-wall image **(11.4)** shows a shaman at work, his mask perhaps that of a bison. Dressed in a ritual costume made of animal skins and horns or antlers, the shaman took on the vital powers

The way [cave] animals are drawn . . . is evidence of something sacred.
—Henry De Lumley, Director, Museum of Natural History, Paris, 1995

TECHNIQUE BOX 11-A

CAVE PAINTING

The main cave painting technique, according to archaeologist Michel Lorblanchet, director of France's National Center of Scientific Research, involved not brushes but a kind of oral spray painting—blowing pigment dissolved in saliva onto the wall and using the hand as a stencil. By turning himself into a human spray can, Lorblanchet **(Fig. A)** can produce clear lines on a rough stone surface much more easily than by using a brush. To create the line of a horse's back, with its clear upper edge and lower blurry one, he simply blew pigment below his hand; to capture the angular rump, he placed his hand vertically against the wall, holding it slightly curved. To produce the sharpest lines, such as those of the upper hind leg and tail, he placed his hands side by side and blew between them. In some places he chose to blow a thicker pigment through a reed; in others he applied the pigment with a brush made by chewing the end

Figure A Scientist simulating prehistoric cave painting technique.

of a twig. Lorblanchet, who has re-created cave paintings with uncanny accuracy, suggests that the primary method of applying paint, blowing it onto the wall, may have had a spiritual dimension: "Human breath, the most profound expression of a human being, literally breathes life onto a cave wall. Perhaps the shamans did this as a way of passing into the world beyond."

Animal images in other parts of Europe also seem to have been made more for symbolic use than as images of potential meals. Lions, for instance, were certainly not intended as a source of food, nor would the hunter have sought their increase. Lions and bears apparently played a symbolic role in Upper Paleolithic cultures.—Alexander Marshack, archaeologist, *Ice Age Art,* 1979

associated with a particular animal. In a trance state, the shaman received visions, usually of animals, that were the source of artistic activity: singing, reciting, drumming, dancing, miming, and image making. Such artistic activity served the shaman's role as a channeler of energy, solver of problems, and healer. As a painter or sculptor, the shaman connected this image making to hunting rites—perhaps to propitiate angry animal spirits, replace the bodies of killed animals, show respect for the souls of admired beasts, or depict desired events such as the migration of herds into the people's hunting lands.

Whoever made the art, shaman or hunter or someone else, the purpose of the representations was functional. To represent something was (and still is) to capture and master it, to understand and come to terms with it, to have power over it. According to the early-twentieth-century theory of sympathetic magic, one of the more persuasive and long-standing explanations of prehistoric art, Stone Age artists believed that by capturing a likeness of an animal on cave wall **(11.5),** horn, or stone they were taking magical possession of the animal so as

to lead it to the hunting grounds or capture it during a hunt. A more recent theory, emphasizing art's cognitive, knowledge-generating power, argues that the depiction of animals was a means of chronicling, counting, and charting animal life season to season and year to year. Whether bent on magical possession, objective documentation, a combination of the two, or something else entirely, the artists had intimate knowledge of all the animal species and were able to render them with convincing realism. They clearly admired and even revered these beasts. Consider a little 4-inch bison **(11.6)** carved with stone tools from a reindeer antler. Its turning, stretching head and hairy mane, etched in finely incised lines, display a detailed naturalism based on the specific type of animal the hunter might want to physically capture, honor, or understand. A close cousin to the cave paintings of the species, the sculpted bison is likewise great art, exhibiting the same acute perception, skillful execution, economy of means, and vitality. Some scholars postulate that these small animal sculptures might have served as models for the much larger cave paintings.

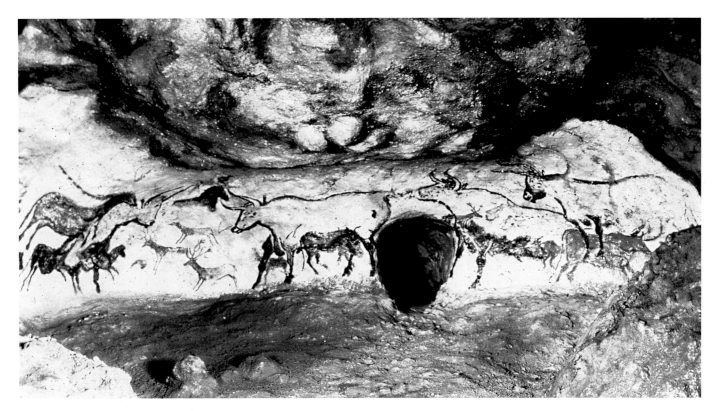

11.5 *Hall of Running Bulls*, Lascaux cave painting. Dordogne, France. 15,000–13,000 B.C.E. *Hunting wild animals is still a major activity today. What connection, if any, is there between the contemporary sport of hunting and the activity of Paleolithic hunters? Is there a sportsman-hunter's art just as there was a hunter-gatherer's art?*

Old Stone Age Art and Hunter-Gatherer Society

The worldwide creators of these first works of art on cave wall, bone, and human body were hunter-gatherers, Paleolithic peoples who moved from place to place hunting game, fishing, and gathering fruit, nuts, roots, and other naturally occurring edibles. A typical hunter-gatherer group probably consisted of two to six families, with ten to thirty members in all. Women are thought to have been the primary gatherers and men the hunters. A socioeconomic equality appears to have prevailed among the members of the small, tightly communal society. Food was shared according to need.

Paleolithic paintings and sculptures reflect the fact that raw survival was at the core of hunter-gatherer life, in which existence depended on adequate food supplies and a sufficiently high birthrate. Predictably, the subjects of cave paintings and sculpted figurines focus on two essential needs: fertility and food. Using stone tools, the hunter-gatherers created tiny portable sculptures that predate the cave

11.6 Bison with turned head. La Madeleine, France. Ca. 11,000–9000 B.C.E. Museum of National Antiquities, St.-Germain-en-Laye, France.

paintings by 10,000 years or more. Why the sculptures came first, between about 30,000 and 20,000 B.C.E, is unknown. What we do know is that full-bodied women are the predominant subjects of these earliest sculptures, with animal subjects a distant second. Old Stone Age people must have thought the

11.7 Venus of Willendorf, from Willendorf, Austria. Ca. 25,000–21,000 B.C.E. Limestone. Height: 4⅜ in. Naturhistorisches Museum, Vienna.

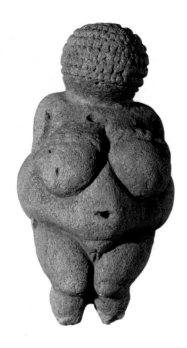

sculptures of women to be connected somehow to fostering the birth of new members of the species and thus essential. Applying the sympathetic magic theory, if a Paleolithic woman or man created a fertility figurine—a woman pregnant with new life—then that woman or the women of the small band would produce children. Not understanding the biological causes of conception, Old Stone Age people sought to capture the life force through representations of it. A fertility figurine found near Willendorf **(11.7)**, in Austria, might have been created for such a function. Only 4 inches high, the tiny sculpture depicts the female form as swollen with life, with full hips and belly, and breasts enlarged with life-giving milk. It is a powerful, generalized figure of procreative power. Its abstract style is highly appropriate as the formal embodiment of an invisible force or universal energy.

It seems clear that woman as mother, as life-giver, was venerated from earliest times among Paleolithic peoples. All of the 60–100 fertility figurines found in Europe are small and portable. "They wear no clothing or jewelry," writes art historian Linnea Dietrich, "but their appearance even now reveals traces of red paint, as if they were bathed in blood, bursting into flame, about to give birth, beginning." The main theme of Upper Paleolithic art, Dietrich emphasizes, is fertility or, viewed

broadly, the renewal of life, whether of humans, animals, plants, or stones. There is a concreteness and specificity to Paleolithic art that conveys a confidence in the physical world, in its existence and continuation. The art that follows the Paleolithic in subsequent prehistoric eras enlarges on this theme, just as a larger, enthroned Birth Goddess (11.11) from Çatal Hüyük in modern-day Turkey, created between ca. 6500 and 5700 B.C.E., builds upon the Willendorf fertility figurine.

THE MESOLITHIC ERA

The Mesolithic or Middle Stone Age era (ca. 10,000–6000 or 8000–4000 B.C.E., depending on location) was an important transitional period between the Old and New Stone Ages. Climate changes brought about technological and lifestyle changes. As the earth warmed and the Ice Age glaciers melted, the great herds of animals moved northward. New areas of land became usable. Naturally occurring grains such as wheat and barley began to be cultivated, dogs were tamed, and cattle were herded. Paintings in the Mesolithic period reveal humanity's expanded relationship to animal and plant life.

Painting the New Relationship of Human to Animal

Across southeastern Spain and in North African sites like Tassili, we find scenes of both hunting and herding depicted in a new style of quick, fluid marks in black and red on mainly outdoor rock shelter surfaces. The paintings, a blend of realism and substantial abstraction, show lithe men and women and wild or domesticated animals in diverse settings. What is as strikingly new as the innovative painterly style is the appearance of the human figure, not only singly but in large groups and in a variety of poses and subjects. Why the sudden prominence of human beings when hardly any appear in Paleolithic cave paintings? In the absence of written records, we can only speculate. The development of greater human confidence, based on increased control over the natural environment, is one probable reason. The movement away from a nature-centered

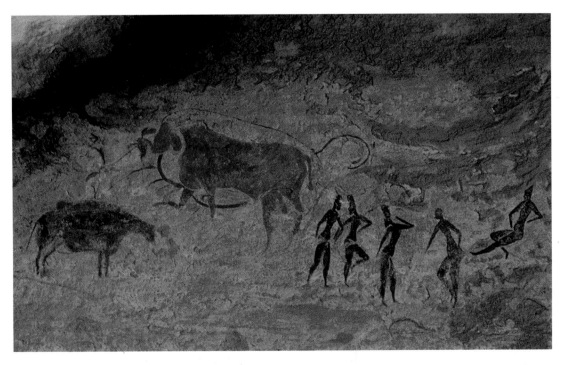

(or animal-centered) world to a human-centered world began in the Mesolithic era and continues to the present. This movement is reflected in art. Painted images on rock faces in Tassili in the Sahara desert region of North Africa (in modern Algeria) show a group of dark-skinned figures standing or reclining next to two peacefully grazing bovines **(11.8)**. The wild bull of Paleolithic cave paintings (11.5) and sculptures (11.6) has been domesticated. These descriptive images were probably created by Negroid peoples between approximately 5000 and 4000 B.C.E. in what was then a fertile land of rivers and lakes. Possibly of ritualistic importance, their primary purpose may have been documentary, serving as a kind of visual journal. Whatever their original function, they provide us with a revealing view of the Middle Stone Age transition from Paleolithic hunter-gatherer society to the more settled life of agricultural communities in the Neolithic era.

THE NEOLITHIC ERA

In the period identified as the Neolithic or New Stone Age (ca. 6000 or 4000–2000 B.C.E., depending on location), an ever more productive agricultural system steadily replaced hunting and gathering as the primary means of subsistence. Animal husbandry and plant cultivation enabled social groups to grow in size as food became more abundant. Compared to Paleolithic bands of ten to thirty members, Neolithic societal groups might easily have included fifty people, in the largest towns perhaps hundreds or thousands. Neolithic women acted primarily as keepers of the home and the agricultural fields. The men most likely served as hunters and herdsmen, assisting in the fields when time permitted. Both men and women might have worked in specialized arts and crafts when necessity called or leisure time allowed.

New Stone Age Art and Agricultural Society

As securing food became a less consuming task, residents of small villages and larger towns began to spend their newly available time on the creation of a wide range of useful objects—pottery, tools, clothing, ceremonial items—for their own use and for trading. Essentially living in one place, Neolithic settlement dwellers could make utilitarian products of greater size and weight than could their

Most surprising of all, the range of art styles in this early image-making is as wide as that which we find today within specialized "schools": It encompassed naturalism and realism, abstraction and schematization, exaggeration and modification of patterning, and caricature, portraiture, fantasy, exquisitely elaborate decoration, humor and a use of natural forms. There were also complex narrative compositions that told symbolic stories.
—Alexander Marshack, archaeologist, *Ice Age Art,* 1979

11.9 Chinese ceramics —Yang Shao pottery. Ca. 3000–1750 B.C.E. Earthenware. Iris and B. Gerald Cantor Center for Visual Arts at Stanford University. Bequest of Mr. and Mrs. Stewart M. Marshall (1960.139, 1965.112), Gift of Mr. Mortimer C. Leventritt (1941.56).

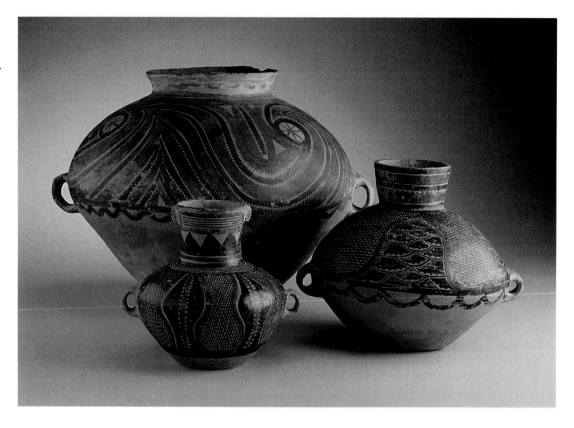

nomadic ancestors. The requirements of the new agricultural society, in fact, dictated such changes. The need to store surplus grain and protect it from rain and animals led to larger, stronger ceramic containers. The general direction of both art and life was toward greater size, permanence, and specialization. The stable food supply supported the development of more populous, fortified village settlements in which certain residents pursued specialized skills or "arts": soldier, trader, potter, weaver, and the like. (Recall our discussion of this early definition of art as skill (1.1, 1.2) at the beginning of the book.)

It is likely that a full-time potter created the elaborately shaped and finely decorated ceramic vessels **(11.9)** from Henan Province in Neolithic China. Their basic form, characteristic of the so-called painted-pottery culture, combines finger-size circular handles attached to wide, rounded shoulders with a small base below and a raised cylindrical lip above. The ceramic artist built the pots by fusing coils of raw clay into perfectly symmetrical containers without the aid of a potter's wheel. He or she

painted the surface with a variety of designs in mineral colors and then fired the pots, producing maximum durability, in bonfires or simple kilns. These particular painted pots, highly valued "cemetery vessels," held food to serve the needs of the dead in the afterlife. The largest and finest vessels were probably commissioned for military chiefs and priests, the aristocracy of advanced Neolithic societies. Art historian Sherman Lee writes that the interesting combinations of geometric and naturalistic designs on the pots symbolized death, birth, and fertility. He notes that the combination of the geometric, serrated-edge "death pattern" with a more naturalistically curvilinear pattern "of birth and fertility may be yet another expression of the desire for life after death or, at very least, for continuity in the social order."

If, as scholars argue, well-made, aesthetically pleasing pottery is one indication of a mature Neolithic society complete with arts and crafts specialists, impressive earthen and stone formations **(Appreciation 21)** and effective town planning are others. The large settlement of Çatal Hüyük in modern-day Turkey **(11.10)**

featured houses and shrines of mud brick and wooden frame built around courtyards and entered through rooftop openings that also served as vents for smoke from cooking and heating fires. Inside, the houses were outfitted with built-in beds and furniture. Perhaps for protection from enemies, the town was designed without streets, and the houses without doors or exterior windows. With a population of up to a thousand or more, Çatal Hüyük was, of necessity, a specialized, diversified community. It thrived between roughly 6500 and 5500 B.C.E. Its agricultural economy was supplemented by the manufacturing and long-distance trade of obsidian, a rare hard volcanic glass used to make sharp blades.

Sculptures and paintings excavated at the Çatal Hüyük site reveal both similarities to and differences from Paleolithic art and culture. Animal subject matter (especially bulls) and powerful female fertility figures still predominate. A big-breasted, wide-hipped Çatal Hüyük figure (11.11), believed to be a goddess giving birth, appears to be closely related to the hunter-gatherer fertility figurine from Willendorf, with similarities in style (abstract, simplified, generalized) as well as function (the promotion of fertility). Yet the differences between the two sculptures are significant. The Çatal Hüyük goddess, at 8 inches, is twice as tall as her predecessor. She is made not of limestone but of terra cotta (clay baked in an oven), a technology developed during the Neolithic era. She is also more anatomically detailed and therefore more human in appearance. She and other female figures found at the site are humanized divinities rather than abstract symbols of fertility. The Çatal Hüyük figure is seated on a leopard-armed throne, signifying not only her goddess status and her accompanying animal symbol, but also her contextual origins in a settled town society. She no longer is the portable fertility figurine carried in the hand of a nomadic hunter-gatherer but rather has become a seated goddess of a permanent place, residing in a special, protected shrine within the community. The figure was probably made by a specialist in ceramic art, a person skilled at finding, mixing, hand-building, and firing clay. A wealthy family or group of families or a shaman or priestess may have commissioned the work.

11.10 Reconstruction of Çatal Hüyük, Turkey. Ca. 6500–5500 B.C.E. *No streets. No doors. No exterior windows. What do you think motivated the people of Çatal Hüyük to come up with this type of architectural and community design?*

11.11 Anatolian Goddess giving birth, from Çatal Hüyük, Turkey. Ca. 6500–5700 B.C.E. Baked clay. Archaeologist Museum, Ankara, Turkey. *Is the legacy of the fertility goddess dead and gone? Do you know of any contemporary cultural practices designed to promote fertility? Can you think of any symbols, rituals, or works of art still connected to fertility?*

APPRECIATION 21 *Worldwide Megaliths*

LUCY R. LIPPARD

In 1977 I went to live for a year on an isolated farm in southern England. I thought I was escaping from art—from a complicated life of criticism, organizing, and activism. . . . Hiking on Dartmoor [a wild upland in Devonshire], with nothing further from my mind than modern sculpture, I tripped over a small upright stone. When I looked back over my shoulder, I realized it was one in a long row of stones. They disappeared in a curve over the crest of the hill. It took me a moment to understand that these stones had been placed there almost 4,000 years ago, and another to recognize their ties to much contemporary art.

The megalithic [literally, "large stone"] monuments, inseparable from their sites and from their unknown but suggestive histories [as possible centers of fertility ritual, astronomical observation, and much more], include a multitude of varied and many-leveled forms,

each ranging broadly in scale as well. A *menhir,* deriving from the Celtic word *men,* for stone, is a single standing stone. Menhirs come in an amazing range of stone type, shape, height, width, degree of worked surface, location, and association with other monuments. Menhirs are spires and stubs and massive blobs, as well as roughly anthropomorphized figures. . . .

Stone rows, or rows of menhirs, are found only in specific areas of Britain and in Brittany [the northeast coast of France]. They too are highly diverse. On Dartmoor alone, there are single, double, triple, and quadruple lines. . . . At Avebury the double stone rows form broad processional "avenues"; elsewhere, the stones are too close together to serve that function. Some rows seem to be connected to astronomical alignments. Near Carnac, in Brittany, there are immense fields of rows including over 3,000 stones, set in great fan-shapes **(Fig. A)**.

Figure A Alignment of menhirs, Carnac, France. Ca. 3000 B.C.E.

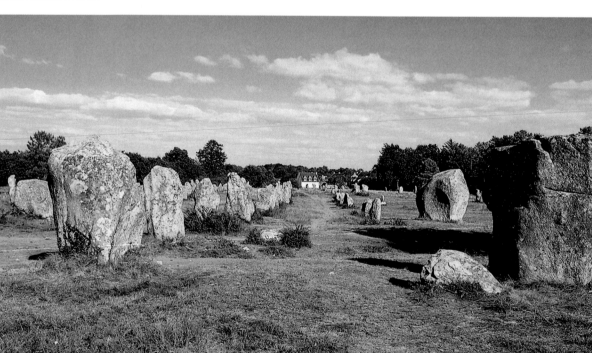

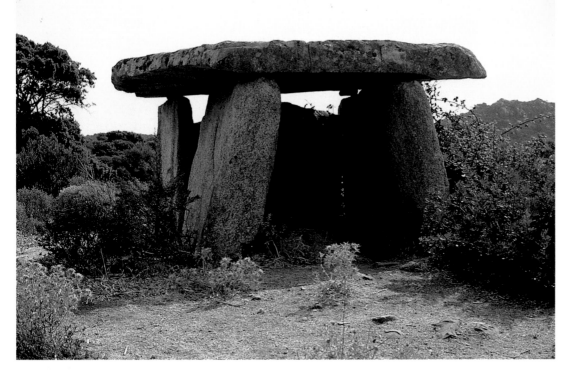

Figure B Megalithic dolmen tomb, Corsica, France. Early Bronze Age. Archaeological site, Fontanica, Corsica.

Stone circles are even more varied and more complex in form. . . . Some circles are paired together; one large, one small near each other, or adjacent equal-sized circles in a figure eight. . . . Complex sites like Stonehenge [10.12] may combine several of these features, and in western America and Canada there are the related spoked stone "medicine wheels [8.46]."

. . . Then there are the endless varieties of stone tombs and chambers . . . with different celestial orientations and intricate carved inscriptions, sometimes still covered by earth mounds. . . . The *dolmen* or *quoit* **(Fig. B)** is a tablelike form of two or four giant slabs of stone topped by a still larger "capstone"; dolmens may have been tombs once covered by earth.

. . . There are two main theories about how the megaliths came to be so omnipresent. The

Lucy R. Lippard is a cultural critic whose 1983 book Overlay: Contemporary Art and the Art of Prehistory (New Press) *is the source of this excerpt.*

first is the diffusionist theory. It posits the spreading influence over the millennia of a single very ancient culture, through direct contact. This theory is harder and harder to prove archaeologically but is often made credible by the presence of identical images, myths, and symbols in disparate parts of the world. The second theory might be called "the ideas-in-the-air school." It holds that similar forms arose at different times in different places due to the fundamentally similar nature of people and natural phenomena. Thus any culture, given certain conditions and materials, might imitate mountains [11.13, 12.2] and make processional rows, dance circles, ceremonial enclosures, and underground tombs. Comparative mythologists, especially the Jungians [followers of the psychological theories of Carl Jung], come up with some fascinating correspondences connecting, if not the actual objects, at least the underlying belief systems and psychologies of extremely diverse distant cultures. ■

11.12 Map of ancient
Mesopotamia, Egypt,
and surrounding areas.

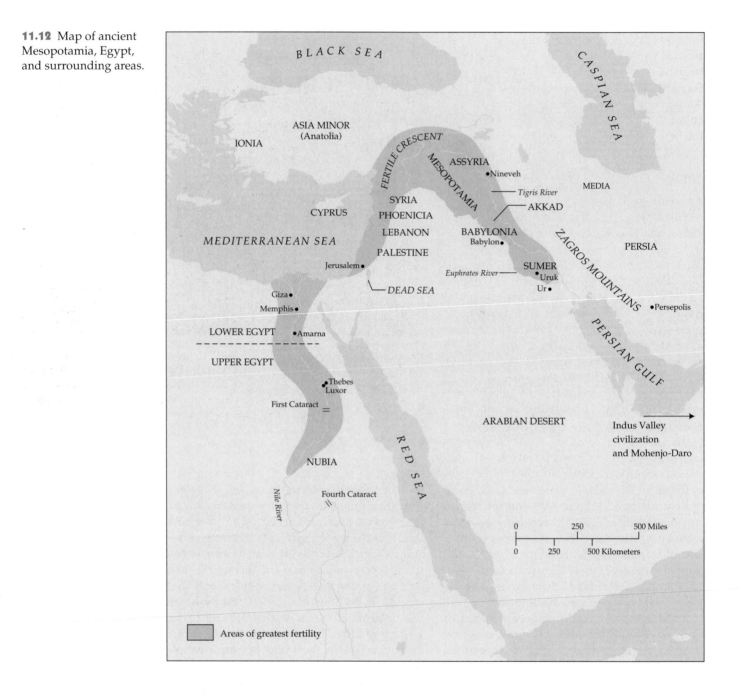

MESOPOTAMIAN CIVILIZATION

From the complex, hierarchical late Neolithic societies worldwide, it was but a small step to the first urban societies. The first urban civilizations (from the Latin *civitas* meaning "city") arose in ancient river valleys in present-day Iraq, Egypt, and India during the fourth and third millennia B.C.E. Increasingly effective agricultural production in these fertile river basins led to predictable yields and surpluses that could support ever larger populations. Increasing numbers turned from farming and animal husbandry to a wide range of city-based occupations: manufacture, long-distance trade, arts and crafts, bureaucratic administration, and the all-important new job of the scribe (12.4), keeper of written records. This evolution from Neolithic agricultural settlement to civilized or city-based society first took place

in Mesopotamia (Greek for "the land between the two rivers") in the region known as Sumer beginning around 3500 B.C.E. **(11.12).** Powerful Sumerian cities, such as Ur and Uruk and later Akkad and Babylon, came to rule broad agricultural lands and even other cities, creating the first city-states.

Sumer

The growing complexity of Sumerian society required systematic city and city-state organization, which ultimately took the form of centralized governance by an aristocracy of priests and kings. The invention of writing at this time fit with the need for systematic records of commerce and land ownership and usage. (As a record-keeping and communication medium, writing doubtless had an impact as great as or greater than our own recent computer and Internet revolution.) The first known symbolic script consisted of wedge-shaped forms or "cuneiform" inscribed in stone or clay tablets. Executed by scribes for the aristocratic and administrative elite, these inscriptions literally etched the laws of the land in stone (11.18) for effective royal governance of the various classes, occupations, and individuals of the city.

The **ziggurat** (ancient Assyrian for "raised up" or "high") **(11.13)** is especially fitting as a symbol of this new, urban society. Commissioned by the upper class of priests and military leaders and executed by a master builder (an architect) commanding an army of workers, the ziggurats of Sumerian cities were both religious centers and beacons of civic pride. Truly an embodiment of the community, these temples mounted on high platforms required the labor and economic support of the entire city. The ziggurat, an imitation mountain, functioned as a platform between heaven and earth where priests might commune with the city's protective god or gods. As symbolic mountain and sacred architecture in the same spirit as the later pyramids of Egypt (12.2) and Mesoamerica (ancient Mexico and Central America) **(Appreciation 22),** the ziggurat was a transitional space, a bridge between the people and their gods.

At Uruk, the oldest surviving ziggurat dates from between 3500 and 3000 B.C.E. A

11.13 White Temple Ziggurat, Uruk, Iraq. Ca. 3500–3000 B.C.E. *Architecturally speaking, the ziggurat may have been the first "sacred mountain." But other works of architecture, such as the pyramids of ancient Egypt and Mexico, also arose as transitional spaces and bridges between the gods and humans. What was it about these early civilizations that demanded such structures? Do we have any buildings today that fulfill a similar purpose?*

solid clay stepped structure reinforced with brick and asphalt, it supported a whitewashed shrine reached by a stairway. This so-called White Temple is believed to have been dedicated to the sky god Anu, supreme god of the heavens, associated with the all-important natural elements rain, wind, heat, and cold. The stepped ziggurat can also be seen as a metaphor for the new class-based society. From on high, a relative few (priests, king, court, royal family) ruled over the many—the temple mount was their actual cultural and political command center. From the ziggurat and spacious upper-class residences that surrounded it, the ever smaller, more densely packed homes and workplaces of the lower classes spread outward, ultimately pushing beyond the city's protective walls into the countryside.

One of Sumer's most striking works of art is a bull lyre **(11.14),** a kind of musical harp, with a head made of thin gold beaten around a wooden core. It was found in the tomb of Queen Puabi within Ur's royal cemetery, an excavation site filled with harps, chariots,

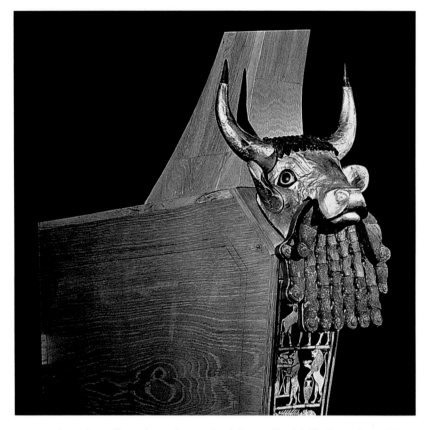

11.14a Lyre Soundbox, from the tomb of Queen Puabi, Ur, Iraq. Ca. 2685 B.C.E. Height of bull's head: 12 in. Wood with inlaid gold, lapis lazuli, and shell. University of Pennsylvania Museum of Archaeology and Anthropology, Philadelphia. *The animals on the soundbox move and act like humans. The figures in the top scene combine human and animal qualities. What do you make of this? Might such images show a desire on the part of Sumerian civilization to control or express humanity's animal side?*

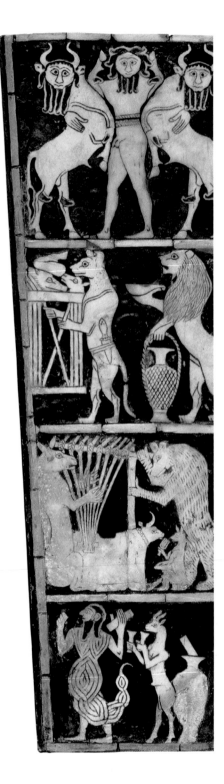

11.14b Lyre Soundbox, from the tomb of Queen Puabi, Ur, Iraq. Ca. 2685 B.C.E. Wood with inlaid gold, lapis lazuli, and shell. 12¼ × 4½ in. Detail of inlay. University of Pennsylvania Museum of Archaeology and Anthropology, Philadelphia.

sculptures, headdresses, and jewelry. In addition to such precious grave goods, the cemetery contains the bodies of people who may have been ritually killed in order to provide companions for the royal family in the afterlife. Continuing the burial tradition of the chieftains and priests of Neolithic times—but on a much grander scale—Sumerian royalty equipped themselves for life after death with their most valued possessions. Like the ziggurat, the bull lyre tells us a great deal about the first civilization. Sumer was commercially vibrant and technologically advanced, certainly in metalworking **(Technique Box 11-B).**

Precious materials—gold, silver, copper, shell, blue lapis lazuli stone—came into the hands of Sumerian craftsmen through thriving long-distance trade. The craftsmen who created the bull lyre employed the finest tools of the day—sharp, precise tools made of metal or

METALWORK

The first substantial use of metals (copper, bronze, gold, silver) in tools and in artworks coincides with the early period of civilization. The Sumerian discovery of how to mine, smelt (refine or extract), alloy (mix), and cast metals enabled them to make tools, weapons, and artworks of new formal and symbolic potentialities. While gold was considered the most precious metal, durable bronze, an alloy of copper and tin, took first place for its many everyday applications—thus the term Bronze Age to describe the first two or three millennia of city life. (Only after about 1000 B.C.E., with the development of even stronger iron tools and weapons, was the Bronze Age gradually eclipsed by the Iron Age; even then bronze remained the favorite material for metal sculptures and vessels.) Two Bronze Age masterpieces, created by casting the molten metal in molds (8.34), are the head of an Akkadian ruler (11.15) and the *Four-ram Wine Vessel* from China's Shang Dynasty (2.34).

obsidian—in the detailed carving of the stylized blue beard and in the etching of the inlaid shell sections that make up the front of the sound box underneath the golden bull's head. One of these shell inlay scenes, the second from the bottom, shows what the original harp complete with strings must have looked like. In this scene a seated donkey plucks the strings of the ancient instrument. Joining the music making, a standing bear braces the instrument's frame, and a seated jackal plays a small percussion instrument, perhaps a rattle. While the exact meaning of the scene is not certain, we can conclude that Sumer must have been a society that enjoyed its urban pleasures, one richly endowed with skilled musicians, instrument makers, and music lovers.

Analysis of the forms and subjects of the lyre reveal continuities and differences between the art of urban society and that of agrarian and hunter-gatherer societies. The soundbox figures recall the simplified, cartoonlike depictions of herdsmen and domesticated animals on Neolithic and Mesolithic rock walls (11.8) and, like those depictions, adeptly capture movement and gesture. With roots that go back to the Paleolithic shaman (11.4), animals are prevalent as subjects (11.5, 11.6) and mix with human beings in hybrid forms. In addition to the golden bull head with human beard, the bull lyre sports a scorpion-man in the bottom section and bull-men in the top one. In the other scenes, animals walk, play music, and carry vessels like human beings. In the third scene from the bottom, a wolf with a sharp metal knife in its belt carries a table piled high with pork and mutton. A lion follows with a large ornamented wine jug and a drinking bowl. But rather than humans metamorphosing into animals, like the Old Stone Age shamans of an animal-centered world, animals are here transformed into humans, mirroring a civilized world that is becoming more human-centered.

What is the overall meaning of the soundbox figures? One interpretation connects the four scenes to funeral rites: the playing of songs of mourning and the entry of the soul into the fantastic realm of the underworld, with its animal guardians. Another reading is more straightforward, joining festive music making—during life and after life—with related activities of eating, drinking, and being merry. Of course, the two readings might not be mutually exclusive.

Akkad

Between about 2340 and 2180 B.C.E., the Akkadians, a Semitic-speaking people who lived north of Sumer, gradually conquered Mesopotamia. From their capital of Akkad (near modern-day Baghdad), they ruled an empire made up of major city-states. A bronze head **(11.15),** created around 2250 B.C.E., represents one of their rulers, perhaps the famous Sargon I. The head is striking for several reasons. It introduces a new subject (the king) executed in a new material (bronze) by a new technique (casting). It presents us with the prototypical

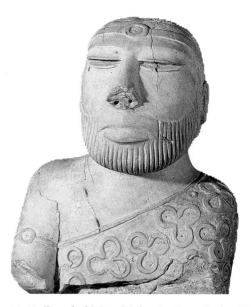

11.15 a&b Head of an Akkadian Ruler (Sargon I ?) from Nineveh (modern Kuyunjik Iraq). Ca. 2250 B.C.E. Bronze. Museum of Antiquities, Baghdad. *What emotions does this head provoke in you? What feelings do you think the original statue would have elicited from Akkadians?*

11.16 Bearded Man. Mohenjo-Daro, Indus Valley civilization. Ca. 2000 B.C.E. Limestone. Height: 6⅞ in. National Museum of Pakistan, Karachi.

image of kingship: powerful, formal, idealized. We recognize a human being, but he is more a lordly type than an individual. Everything about this head aspires to a geometric perfection, with all parts symmetrically balanced, defined, and in place and no human blemish or hint of vulnerability allowed. Near life size, the head, its eye sockets filled with precious stones, originally would have topped a full-length statue. The statue would probably have stood in the palace, the center of court and administrative life, adjacent to the ziggurat or principal temple. With divinely sanctioned kingships as early civilization's dominant form of political rule, this portrait type appears throughout the ancient world to express the power of the ruler.

The Indus Valley Civilization and Mohenjo-Daro

Where did the materials come from for the Akkadian bronze head, the Sumerian bull lyre, and other works of Mesopotamian art? The land between the two rivers possessed limited natural resources of its own. It traded its wool and woolen garments, cattle skins, barley,

dates, and oil to distant cities in exchange for wood, shell, precious metals, and semiprecious stones. One civilization with which Sumer and Akkad traded, probably through Persian Gulf sailors, was that of the Indus River Valley in modern-day Pakistan and India. The Indus Valley civilization, covering an area larger than Mesopotamia, flourished between approximately 2700 and 1500 B.C.E. Mohenjo-Daro, one of its main commercial centers, was laid out in an orderly geometric grid plan. The city featured large structures—a citadel, granary, and impressive public bath (180 by 108 feet)—near its center. Excavations so far have yielded only sculptures that are small in size, but these works show similarities to and differences from the Mesopotamian artistic styles. A 7-inch-high limestone carving **(11.16)**, believed to be a high priest or some other important figure, exemplifies the same formal style as the bronze head of the Akkadian ruler with its symmetrical balance, geometrical patterning (in the beard, hair, and clothing), and simplified and conventionalized features (ears, mouth, and eyes). Might aesthetic influences from Mesopotamia have come to the Indus Valley along with trade?

Again, the high priest or official is an ideal type more than a specific individual; his high rank is officially communicated by a more abstract, idealized style. In contrast, a 4-inch-high dancer cast from copper **(11.17)** is rendered more realistically, in the candid "slice of life" style applied in the ancient world to persons of lowly rank (9.1). Naked except for arm and neck decorations, the dancer stands casually, hand on hip. She looks outward, seeming to address an audience. Her twisting body and shifting weight speak of movement, a quality absent from the static presentations of both the imperious high priest and the Akkad ruler. Where the high-ranking aristocrats present an austere public face, to be approached on bended knee, the thin, young dancer is very down-to-earth, accessible, even erotic. Whether she is a representation of a human being or a deity—one scholar, emphasizing her open sexuality, interprets the figure as a fertility goddess—it is possible to feel that if someone called out to her the little dancer would respond.

Babylon

The official style for representing those of highest rank is evident in one of the most famous of all Mesopotamian sculptures, the 7-foot-high *Stele of Hammurabi* **(11.18)**. Semitic-speaking Amorites (or "Westerners") had united Mesopotamia under their rule and established their capital in Babylon. Hammurabi, the most famous king of the Amorite dynasty, reigned from about 1792 to 1750 B.C.E. and is best known for his law code, which comprises 300 statutes and is written in Akkadian in fifty-one cuneiform columns. At the crest of the black stone column is a deep sculptural relief of the king standing before the Akkadian sun god Shamash, who is enthroned on a symbolic mountain **(11.19)**. Rays of light emanate from the sun god's shoulder. Shamash wears the horned cap of divinity and holds the ring and rod of divine power. In a conventional pose for gods and royalty, Shamash's torso is placed frontally, while his head and legs are in profile, facing Hammurabi. The smaller, mortal king receives the sun god's blessing for both his kingship and his law code. In Hebrew, also an ancient Semitic language, the word *shamash*

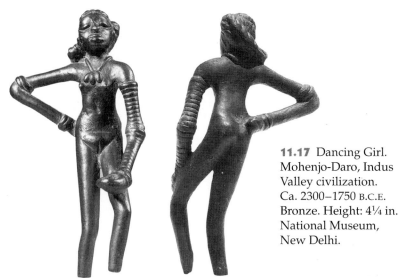

11.17 Dancing Girl. Mohenjo-Daro, Indus Valley civilization. Ca. 2300–1750 B.C.E. Bronze. Height: 4¼ in. National Museum, New Delhi.

11.18 Stele inscribed with the Law Code of Hammurabi. Ca. 1792–1750 B.C.E. Height of stele: approx. 7 ft. Basalt. Musée du Louvre, Paris. *Certain communication theorists argue that "the medium is the message," that how we communicate (for example, by writing) has a far greater impact than what we communicate. What are the essential characteristics of writing? How might these characteristics have influenced the people, life, and art of the first civilizations?*

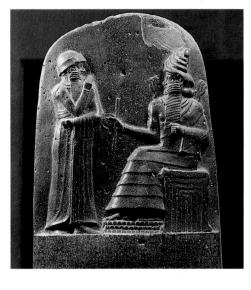

11.19 Stele inscribed with the Law Code of Hammurabi. Ca. 1792–1750 B.C.E. Detail of Shamash and Hammurabi. Basalt. Musée du Louvre, Paris. Height of relief: 28 in.

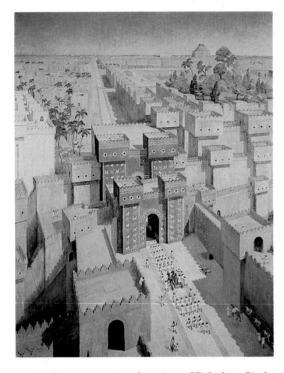

11.20 Reconstruction drawing of Babylon. Sixth century B.C.E. The Oriental Institute of the University of Chicago.

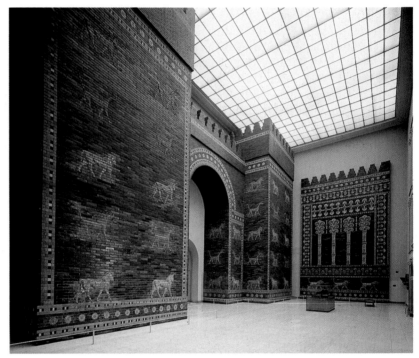

11.21 The Ishtar Gate and throne room wall (restored), from Babylon, Iraq. Ca. 575 B.C.E. Glazed brick. Staatliche Museen zu Berlin, Preussischer Kulturbesitz, Vorderasiatisches Museum.

I [Nebuchadnezzar] caused a mighty wall to circumscribe Babylon . . . so that the enemy who would do evil would not threaten . . . [and] of the city of Babylon made a fortress.—The Book of Daniel, The Hebrew Bible, ca. sixth to second century B.C.E.

designates the central candle on the candelabra that lights all the others—clearly a variation on the sun god's rays, which illuminate and bless Hammurabi and his laws.

Over the next thousand years, Babylon was invaded by different peoples. One, the Elamites, carried off the *Stele of Hammurabi*, literally stealing the city's god and laws. Babylon was finally restored to greatness under a new or Neo-Babylonian dynasty of its own in 612 B.C.E.

Neo-Babylonia

The most famous Neo-Babylonian ruler was Nebuchadnezzar II (ruled 604–562 B.C.E.). A great patron of architecture, he built temples dedicated to Babylonian gods throughout his realm, which stretched from modern-day Turkey to northern Arabia and from Mesopotamia to the Mediterranean Sea. He transformed Babylon into the greatest commercial center of its day and a city of architectural magnificence. A reconstruction drawing of the city in the sixth century B.C.E. **(11.20)** shows broad paved streets, high stone towers and

walls, and the famed Hanging Gardens. Built on terraces and topped with trees, the Hanging Gardens were renowned as one of the seven wonders of the ancient world. Beyond the gardens, looming up in the far distance on the east bank of the Euphrates River, is the Marduk Ziggurat, believed by some to be the biblical Tower of Babel (of Babylon). In the center, the great arched Ishtar Gate straddles the Processional Way and is surrounded by the king's palace complex. The gate is composed of brilliant, blue-glazed brick on which are depicted lions, bulls, and dragons. Formed from molded white- and yellow-glazed bricks in raised relief, the animals represent the gods most sacred to the city. Marduk, the city's patron deity, is represented by the long-necked dragon; Adad, the god of the sky and weather, by the bull; Ishtar, goddess of love, fertility, and war, by the lion. The figures present a stately heraldry proclaiming the gods of the temples to which the Processional Way leads. Now reconstructed inside a Berlin museum, the Ishtar Gate is installed next to a panel from the outer wall of the throne room in

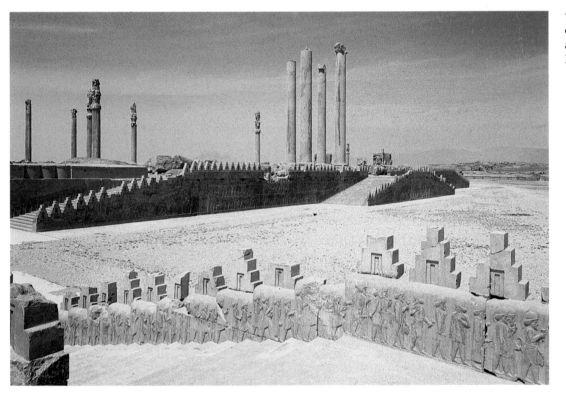

Nebuchadnezzar's palace **(11.21)**. In this palace panel, the lions of Ishtar and the king slowly stride in a ritual march beneath stylized palm trees, sacred and secular joined in artistic unity.

Persia

Conquerors of the Assyrians, Persian civilization is nowhere better expressed than in King Darius's own new capital city Persepolis ("city of the Persians" in ancient Greek). Its grandeur and its fusion of materials and styles fit well with its status as the largest of all empires, encompassing the entire Middle East and stretching from the north coast of Africa to India. Persepolis's most important structure was an enormous audience hall or Apadana **(11.22)**, where the king received foreign delegations. The Apadana and nearby palace were huge, square buildings of post-and-lintel construction in which rows of tall stone columns supported Lebanese cedar beams and a flat roof. Such **hypostyle** ("resting on pillars") hall structures were inspired by Egyptian architecture, which had impressed Darius (ruled 521–486 B.C.E.). The columns—only a handful

of the original thirty-six remain—are of great height (40 feet) but are proportionately thin in the elegant, fluted columnar style of the Ionian Greeks (10.15). It is probable that many craftsmen from Ionia, a populous Greek region in western Turkey, worked on the ceremonial complex. Decorations on the bases and capitals show Egyptian influence as well, but the crowning glory of the columns is uniquely Persian. The crests of the capitals **(11.23)** feature identical pairs of kneeling lions, bulls, or bull-man figures fused back to back. This imaginative design hearkens back to the abstract, fantastical "animal style" decorations of the Persians' nomadic Indo-European Aryan forebears, who were dependent on their animals **(Interaction Box)**. Did the Persepolis bull and lion capitals symbolize fertility, the power of the king, or a particular deity? We don't know, but we do know that each saddle, the low, flat area where the two animal bodies fuse, held up a great cedar ceiling beam in a magnificent synthesis of form and function.

Sculptural reliefs, originally painted in bright colors, line the audience hall's walls and stairways. They depict processions of royal

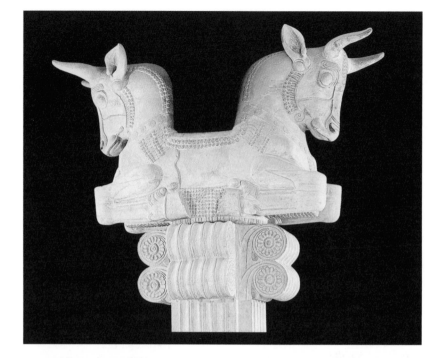

11.23 Bull Capital from ceremonial complex of Darius and Xerxes, Persepolis, Iran. Ca. 500 B.C.E.

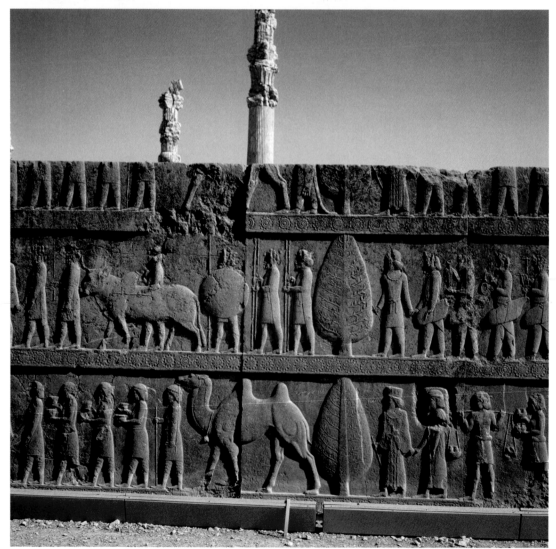

11.24 Subjects bringing gifts to the king. Detail, relief sculpture on the stairway to the Audience Hall of Darius, Persepolis, Iran. Ca. 500 B.C.E.

COMPARE AND CONTRAST

A subplot in this chapter concerns the bull and the female fertility figure. Over a 20,000–30,000-year period and across cultures from Paleolithic Europe to the civilizations of Mesopotamia and the Indus Valley, each subject's formal presentation and meaning change.

The bull develops from naturalistic Old Stone Age sculpture and cave painting to the golden head of a bull with a human beard on a Sumerian lyre. Is he the legendary Bull of Heaven? Stylized bull-men adorn the lyre's soundbox. The Mesopotamian sun god Shamash, carved in relief on the Hammurabi stele, wears a hat with bull-like horns. In Neo-Babylonia, the glazed brick Ishtar Gate features molded bull figures of Adad, god of the sky and weather. Finally, the Persian city of Persepolis features unique bull capitals atop the tall columns of the royal audience hall.

The female fertility figures move from abstraction to naturalism and from universal type to individual person. We meet a Paleolithic fertility figurine, a Neolithic goddess giving birth, and an Indus Valley dancer. All convey meanings of sexual fertility.

Your challenge is to compare and contrast two or more fertility figures or two or more bulls. Look for similarities and differences in terms of subject matter, form, and content. What clothing, if any, do the fertility figures wear? How does their style, abstract or naturalistic, fit with their meaning? Are they all full-bodied, with large breasts and swollen bellies? Do you think they are meant to promote human birth, or fertility—of crops, rainfall, animals—in a broader sense? How can you tell? Address comparable questions with regard to the bull figures. Take off and run with your comparisons. Focusing on one subject helps foster both learning and an appreciation of the continuity and uniqueness of artworks across history and culture.

guards, Persian nobles and dignitaries, and representatives of subject peoples bringing tribute and gifts to the king. In the relief detail titled *Subjects Bringing Gifts to the King* **(11.24),** two Bactrians deliver camels, a Babylonian leads a humped ox, and other tribute bearers bring horses, metalwork, ivory, incense, and gold. The artistic style likewise is derived from different cultures. Its emphasis on frontality, symmetrical balance, and hierarchical order (the direction of the entire composition leads to the king, who is the focal point) shows firm roots in the formal, idealized tradition of Mesopotamian and Egyptian royal art. The subjects are simplified, depicted as repeatable, general types (a Babylonian, a Bactrian, a humped ox, a tree) rather than as variable individuals. All the subjects assume one of two conventional poses—full profile or mixed design (torso front, head and feet sideways)—as they walk in stately procession to offer their gifts. Yet the roundness and softness of the carved figures and the way the bodies swell their garments are new, perhaps yet another influence of the Ionian Greeks and their contemporary figurative style (12.18).

Highly civilized and politically astute in the sense of embracing the best the peoples within the empire had to offer, the architects of Darius and his successors employed craftsmen from across the realm. In one inscription describing a royal building program, Darius relates: "The stone-cutters who wrought the stone were Ionians and Sardians. The goldsmiths who wrought the gold were Medes and Egyptians. The men who wrought the baked brick were Babylonians. The men who adorned the walls were Medes and Egyptians." That Egyptians played a major role in Persian artistic projects is not surprising. In the area known as the Fertile Crescent, the river valley lands stretching from the Nile to the Tigris and Euphrates, Egyptian civilization (see chapter 12) had been a cultural and political force longer than any other.

APPRECIATION 22 *Teotihuacán: Birthplace of the Gods*

MARC TAYLOR

Teotihuacán, Mexico, is an eternal city in ruins. However, its gods yet live.

In the farthest corner of northeast Mexico City, on the plain of the San Juan River, the ruins of Teotihuacán rise from the surrounding fields of maize. Its archaeological beginnings, around 500 B.C.E., probably resulted from the spread of the Olmec culture [2.9] from Mexico's central Caribbean coast. The city-state quickly became the first major urban center of Meso-America.

As old and studied as it is, many secrets remain. The culture that created it; the engineering marvel of the Pyramid of the Sun, the world's second largest; its sister Pyramid of the Moon; the meaning and use of the Avenue of the Dead that intersects the entire site **(Fig. A)**; the god cult of the Plumed Serpent Quetzalcóatl **(Fig. B)**; and the city's extensive influence are unplumbed. Most mysterious are the explosive advent of Meso-American mythology centered at Teotihuacán and the city's sudden collapse around 750 C.E.

In Nahuatl language, Teotihuacán means "Birthplace of the Gods." This designation gives the site spiritual dimension and timelessness. The city has always existed, not as brick and mortar, but as the ever expanding conscious manifestation of essential humanity and spiritual communion. This city told the Meso-American world who it was and who it will always be: the center of creation, ever indebted to the gods.

Teotihuacán's construction was a sacred ritual. Each stone, carried and placed by hand, was a prayer. Each sacred drawing was an offering. Each sculpture was a divine revelation. Every personal sacrifice was an ecstatic mystery play repaying eternal indebtedness that gave rise to the sun each day. These pyramids were no egocentric expressions of kings searching for immortality. Rather, they stand, as do the gods, immortal themselves.

Imagine yourself, climbing to a terrace high above the plain, a heavy basket of adobe brick on your back. Your pounding heart and heavy breath are joyful reminders of Omecteotl, god of all dualities; divine sons and daughters fighting for ascendency during the four epochs of creation; the sacrifices of the gods that became the sun and moon of the fifth and final creation. You and thousands of other citizens, from all stations in life, build a permanent earthly residency for the gods. Yours is at once a supreme creation and the source of your city's demise.

The pyramids' completion, around 150 C.E., was the culmination of a sacred process more important than the edifices themselves. Previously the gods were beings of mythic proportion who lived in realms only accessible by the most accomplished shaman. Now the artist/priest captured the gods in stone and paint and became himself imbued with divine transcendent powers. Donning the elaborate costumes and masks, the artist/priest actually became the god. History is littered with examples of those self-made gods who in tragic grandiosity fell to folly. Such may be the lesson of Teotihuacán.

Here is one version of the end. Over the course of 1,200 years the gods rise and diminish in their power. By 650 C.E. life at Teotihuacán is difficult. The gods seem unresponsive and powerless to help. Sacrifices become more demanding and less fulfilling. The city no longer supports its 250,000 residents. Wars of expansion replace the sacred rituals. The ideals of the culture are no longer within reach of its people. The gods escape the prison of their images and abandon the city. Anomie, a condition of deep cultural malaise and despair, sets in.

Marc Taylor, a psychologist, artist, and educator, lives in San Miguel de Allende, Mexico.

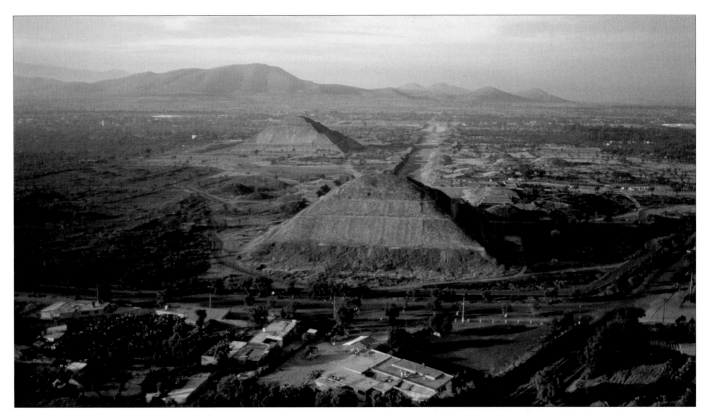

Figure A View of Teotihuacán. Temple of the moon (foreground), Temple of the Sun (middle ground), Avenue of the Dead. Temple of Quetzalcoatl (Figure B) located beyond the Temple of the Sun along the Avenue of the Dead.

Figure B Temple of Quetzalcoatl, Teotihuacán, facade, detail of jaguar heads. Before 300 C.E.

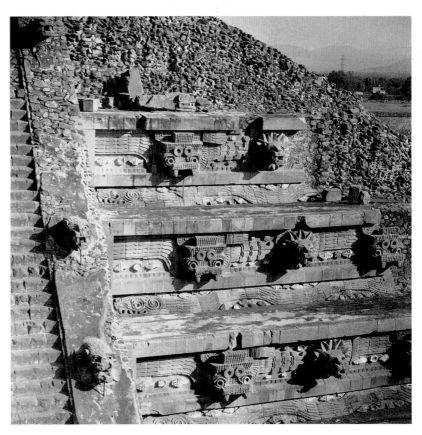

In this state of profound demoralization, edifice, artifact, statue, and timber are dismantled. The remains are scattered as shards of puzzle pieces in the now parched and barren fields that strangle the city. The people resume their wandering in central Mexico. Perhaps they reemerge several generations later to create the next city-empire in nearby Tula. We do not know.

The results we see now are lonely stone vigils to the sun and moon watching as archaeologists slowly and painstakingly unearth human history. In my view, that history is the Teotihuacán culture's attempt to see how it was created in the image of the gods to prove its own divinity. ■

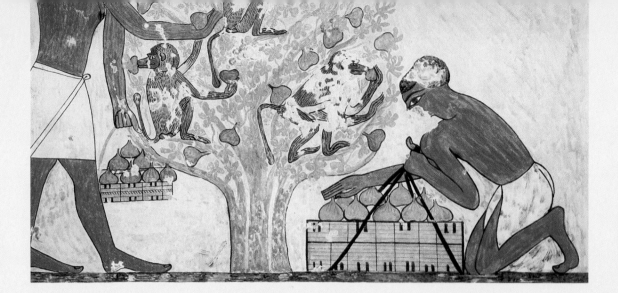

12 The Art of Ancient Egypt, Greece, and Rome

Of the ancient civilizations, none have been more influential on worldwide culture and art than those of Egypt, Greece, and Rome (12.1). Of these civilizations, Egypt was by far the oldest, growing up along the Nile River in the northeastern corner of Africa 5,000 years ago. Across the Mediterranean Sea on the European continent, Greek and Roman civilization would arise in the first millennium B.C.E.

EGYPT AND ITS ART

From columned temples to idealized statues of imperial rulers to lifelike sculptures and paintings of everyday people, a broad range of European, African, and Middle Eastern art forms, subjects, and styles has roots in ancient Egyptian art. Among these forms, none has etched itself more vividly in the popular imagination than the monumental pyramid.

The Old Kingdom: Social and Cultural Pyramid

The pyramid is both architectural wonder and visual metaphor for Egyptian society and its art. As a shape, the pyramid is highly stable, unified, hierarchic, and powerfully rooted. The largest Egyptian pyramids from the Old Kingdom—the Third through Sixth Dynasties, which ruled between

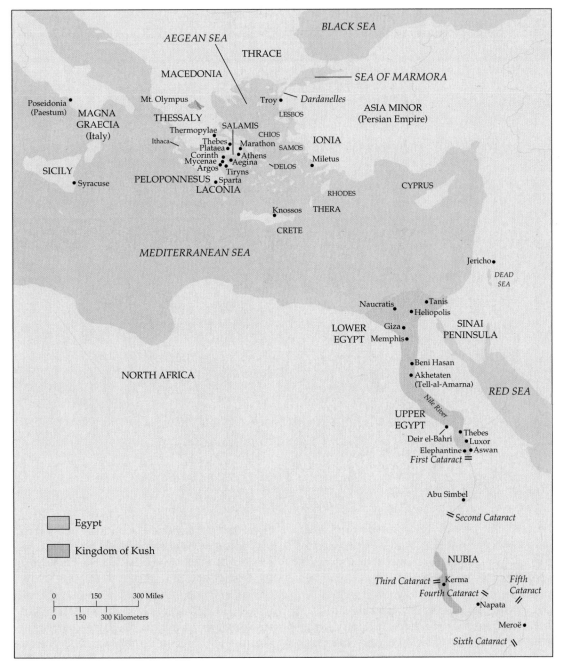

12.1 Map of ancient Egypt and the Mediterranean world.

ca. 2700 and 2190 B.C.E.—are those at Giza **(12.2).** They are extraordinary in height, volume, and weight. Made of granite and limestone, the largest is 450 feet tall! Built to last forever, these mighty giants tell us that stability and continuity were highly prized by the ancient Egyptians.

The pyramid soars upward and points to the heavens and the sun, the divine realms whose gods would take up the soul of the Egyptian god-king or pharaoh after death. The pharaoh's mortal remains were preserved, wrapped, and buried safely in a mummy case in a tomb deep inside the pyramid. Surrounded by magically potent funerary (burial) artworks and inscriptions and by his most valued earthly possessions, the king would live happily after death as long as a physical trace

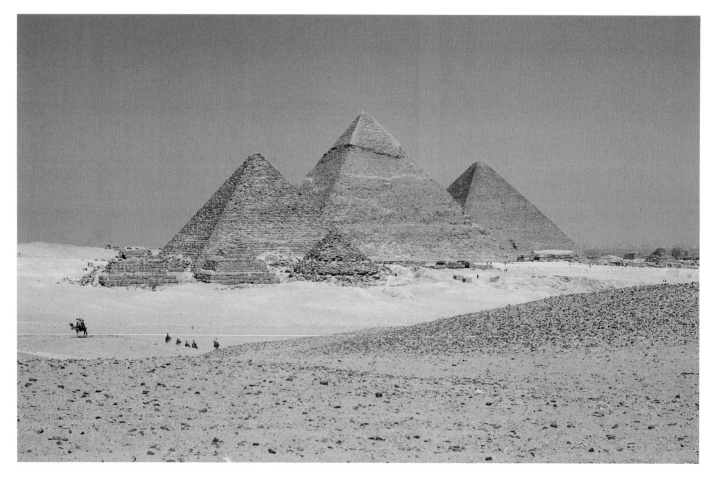

12.2 Pyramids, Giza, Egypt. Fourth Dynasty, 2723–2563 B.C.E. Limestone and granite. Erected by (from left) Menkaure (Mycerinus), Khufu, and Khafre.

We can recognize from many unfinished pieces that even in sculpture the final form is always determined by an underlying geometrical plan originally sketched on the surfaces of the block . . . that he [the Egyptian sculptor] then evolved the figure by working away the surplus mass of stone, so that the form was bounded by a system of planes meeting at right angles and connected by slopes.—Erwin Panofsky, art historian, *Meaning in the Visual Arts,* 1955

of him—preserved body, portrait art, or inscription of name and deeds—remained on earth. The lands of the living and of the dead were thus ever connected. If the king was happy in the afterlife, he would forever bless the lives of his people and the land of Egypt. All of society was therefore obligated to the king's eternal well-being (everyone, that is, except the numerous robbers who since ancient times have pillaged the extraordinary wealth of the pyramids' tombs).

Egyptian society itself was a pyramid. For almost 2,000 years, a tiny aristocratic minority at the top—king, high priests, top government officials—ruled with complete authority over the great masses below them. At the very crest of the societal pyramid was the king. His blood relatives, the members of his dynasty, surrounded and supported him: queens, wives, sons, daughters, brothers, cousins, nieces.

Consider the funerary sculpture of Pharaoh Mycerinus (or Menkaure) and Queen Khamerernebty II **(12.3)** from the Fourth Dynasty of the Old Kingdom (ca. 2615–2565 B.C.E.). Mycerinus and Khamerernebty are shown in a frontal, erect pose in which the left legs of both stride forward. Befitting his power and stature, the pharaoh is slightly taller and larger and stands a bit in front of the queen. While there is a moderate degree of detail and individuality in the faces, Egyptian sculpture, as a rule, generalizes, simplifies, and idealizes faces and bodies in conceptual types such as pharaoh, queen, scribe, or worker. As in Mesopotamian art, the higher the class or rank of the individual portrayed, the more formal, stereotypic, and standardized the presentation. Mycerinus and Khamerernebty are idealized as human-gods. Their facial expressions convey an eternal confidence and calm, while their poses

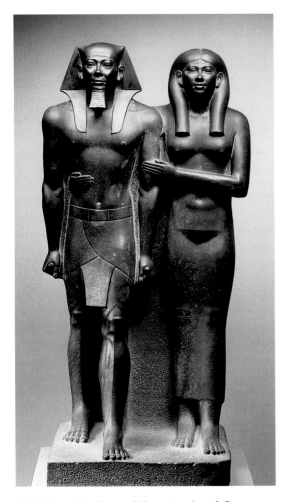

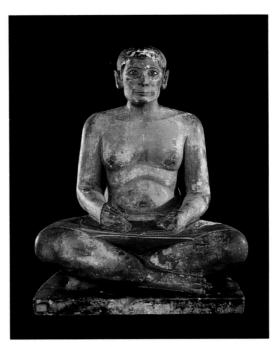

12.4 Seated Scribe from Saqqara. Fifth Dynasty, ca. 2400 B.C.E. Painted limestone. 21 in. Musée du Louvre, Paris. *Writing conditions the mind to think in linear, logical sequences. How might the rise of writing as a way of thinking and symbol making have impacted Egypt's culture and art?*

12.3 King Menkaure (Mycerinus) and Queen Khamerernebty II, from Giza. Fourth Dynasty, ca. 2515 B.C.E. Slate. Height: 54½ in. Harvard University–Museum of Fine Arts Expedition, 11.1738. Courtesy Museum of Fine Arts, Boston.

freeze their perfect, slim-waisted bodies in the noblest postures. So successful were early portraits like this one that the same basic poses, facial expressions, body types, and gestures continued virtually unchanged throughout 2,000 years of Egyptian art. In fact, a canon of standardized rules, formulas, and mathematical proportions was developed for Egyptian craftsmen to follow in the creation of statues and paintings of the ruling-class nobility.

Lower down the social pyramid were the members of the governmental bureaucracy, then the merchants, artisans, and menial laborers,

and at the bottom the slaves. As common workers, potters (9.1), painters, and sculptors—even the most talented—are portrayed with a straightforward, "true to life" realism (**Appreciation 23**, Figure A). Even scribes, who were prominent among professional bureaucrats for their ability to read and write, are presented with substantial realism. Carved from limestone and painted in lifelike colors, a statue **(12.4)** shows an Old Kingdom scribe sitting cross-legged, attentively awaiting his master's dictation. The front of his kilt is pulled taut across his knees, providing a sort of writing desk on which he unrolls his papyrus scroll. As Egyptologist Barbara Mertz observes, the scribe is "a middle-aged man, run to fat a trifle around the waistline, as scribes usually are; his face has the blank amiability of the trained bureaucrat of any age." Across the ancient world from Egypt to India (11.17), the lower one's social rank, the greater the degree of naturalism employed in artistic renderings.

[Apply yourself to this] noble profession. . . . You will find it useful. . . . You will be advanced by your superiors. You will be sent on a mission. . . . Love writing, shun dancing; then you become a worthy official. . . . By day write with your fingers; recite by night. Befriend the scroll, the palette. It pleases more than wine. Writing for him who knows it is better than all other professions.
—From a papyrus book; the beginning of the instruction in letter writing made by the royal scribe Nebmare-nakht to his apprentice, the scribe Wenemdiamun, after 1200 B.C.E.

The Egyptian Artist-Craftsman

BARBARA MERTZ

The praise that is due Egyptian artists **(Fig. A)** must be given as a group citation, and anonymously, for few names of individual painters and sculptors have come down to us, and even those few can rarely be connected with a given painting or statue. There is not a single signed work of art from ancient Egypt, unless we view the rough figures of Senmut, hidden behind the sanctuary doors of the temple [of Hatshepsut] he is thought to have designed [12.9], as equivalents of "Senmut made this." Tradition, or the circumstances of discovery, sometimes allow us to ascribe names to particular pieces; perhaps Thutmose of el Marna can claim the beautiful head of Nefertiti as his masterpiece **(Fig. B)**, but we cannot be sure. . . . Then there was Iritsen, who lived during the Middle Kingdom and who was, if we can believe his own words, a sculptor of no mean talent:

> I am a craftsman successful in his craft, one who comes out on top through that which he knows. . . . I know the movement of the figure, the stride of a woman . . . the cringing of the solitary captive, how one eye looks at another, how to make frightened the face of the outlaw, the pose of the man who harpoons the hippopotamus, the pace of the runner.

The word *craftsman*, which Iritsen uses, is important because it describes the status of sculptors and painters. Their trade lacked the semimystical sanctity of the "fine arts"; it was not even a profession, but a craft, on a level with carpentry and jewelry making. Within the general category of art there were specializations: the painter, the outline draftsman, the relief sculptor, and the sculptor in the round. In the workshops connected with the palace and the temples these craftsmen worked together under the supervision of the chief sculptor and the overseer of craftsmen. There was division of labor; one man might carve a statue and another man paint it [as we observe in figure A]. But perhaps there was not strict "union" separation of jobs. A single individual might learn all the aspects of his craft, and be outline draftsman, painter and sculptor in turn, with the hope of working up at last to the supervisory position of overseer of craftsmen. There are several indications that sculptors were regarded as superior to painters; for one thing, the tombs, stelae and other monuments left by successful sculptors far outnumber those left by painters, which implies that they were richer and more prominent.

Perhaps most artists, and certainly the best of them, worked for the state. Sometimes the king might order a statue or even a whole tomb to be made for a friend or good servant, as a mark of favor, but there were also artists whose services could be obtained by the private citizen. Were these the state artists, "moonlighting," or was there a class of privately employed artists? We don't know. The same mystery surrounds the training of artists. Since workshops existed it is not unreasonable to suppose that "likely" boys were sent to them for training. I imagine that the boys were chosen because of family connections rather than special talent. In many cases known to us son followed father in the trade, as he did in other trades and professions. It is the apprentice system in operation once again, with the father as the master. Yet some artists obviously took pride in their trade and enjoyed using their talents. Although the canon of art was limiting, there was room for the exercise of both skill and imagination; the great works of art surviving from Egypt show that, although genius may not have been recognized as such, some ancient Michelangelos did find their way into the trade which was, for them, a genuine calling. ■

Barbara Mertz, one of the world's leading authorities on ancient Egypt, is the author of Red Land: Daily Life in Ancient Egypt. *This appreciation is excerpted from her book* Red Land, Black Land: The World of the Ancient Egyptians. *New York: Coward-McCann, 1966, pp. 186–87.*

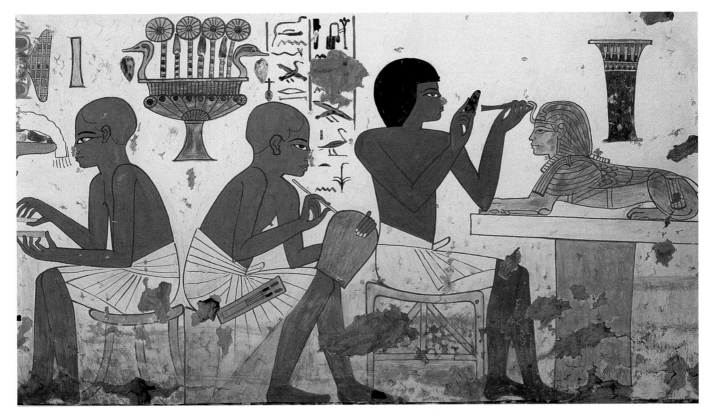

Figure A Egyptian craftsman at work on a golden sphinx with lion's body and human head. Wall painting from a tomb at Thebes. Ca. 1400 B.C.E. British Museum, London.

Figure B Bust of Nefertiti. Amarna Period. Painted limestone. Height: 19 in. Staatliche Museen zu Berlin, Preussischer Kulturbesitz, Ägyptisches Museum, Berlin.

341

12.5 Head of Sesostris III, from Temple of Medamud. Middle Kingdom, ca. 1862–43 B.C.E. Granite. Height: 11 in. Egyptian Museum, Cairo.

The Middle Kingdom: Transition

The art of the Middle Kingdom (ca. 2040–1674 B.C.E.), and of the Intermediate Periods (transitional periods between united kingdoms) that precede and follow it, reflected both continuity with and change from the Old Kingdom. These centuries were a tumultuous time during which the centralized power of the pharaoh was challenged, social and cultural disruptions were rife, and pessimism became a commonplace emotion. The rise of members of the aristocracy—priests, princes, governors—to positions of regional power weakened the institutional dominance of the pharaoh both politically and culturally. In what has been called "the democratization of the afterlife," local rulers even appropriated the pharaoh's divine right to immortality, which was further extended to all those who could afford to hold the funeral rituals previously reserved for the god-king. These lesser nobles commissioned tombs cut into rock faces or cliffs and outfitted and decorated their interiors in lordly style. The appropriation of pharaonic power and privilege certainly pleased large numbers of aristocrats, but it also meant that Egypt was a more divided land, weaker militarily and susceptible to outside invasion. Fostering further division, Egyptian princes and governors

battled and schemed among themselves. The result was an extended period of uncertainty and pain as the old ways and customary stability were tested. Only a few dynasties (eleventh to fourteenth), the twelfth in particular, were able through much trial and effort to unify the land; historians consequently have titled this period of hard-won unified reign the Middle Kingdom.

Middle Kingdom artworks give insight into and mirror the complex period. The carved stone head of a pharaoh, thought to be Sesostris III (ruled 1878–1843 B.C.E.) **(12.5)**, evokes a deepened sense of individual personality and mood. The stress and strain of the times may well have shaken up the standard idealized presentation of the king (12.3), modifying it to a somewhat more human—in this case, pessimistic—presentation. The sculpted head shows a determined ruler, but one who has also shared the cares of the world. Depicting a ruler sunk in brooding thought, the strong mouth turns downward, bags descend under bulging eyes, and lines furrow the brow. Compared to the serene majesty of an Old Kingdom pharaonic portrait, this face is emotionally expressive, almost intimate, revealing anxiety deep in the soul. During his thirty-five-year reign, Sesostris III may have remembered the foreboding words of his great-great-grandfather, founder of the Twelfth Dynasty:

> Fill not thy heart with a brother
> Know not a friend,
> Nor make for thyself intimates, . . .
> When thou sleepest, guard for thyself thine
> own heart;
> For a man has no people [supporters]
> In the day of evil.[1]

Transcending or escaping the anxious times, living for the day, Egyptians held a passion for the pleasures of the world as demonstrated in various Middle Kingdom rock-cut tomb paintings. A Twelfth Dynasty painting from the tomb of the local lord Khnumhotep conveys both light-hearted humor and satisfaction in a good harvest and its savory delights. In one scene **(12.6)**, two of the lord's farmhands, portrayed schematically, are picking figs. However, they are not the only ones actively harvesting. Three friendly baboons, who move with naturalistic ease, are enjoying

the sweet fruits. But the harvest is so plentiful—life is so good—that the farmhands' baskets are still stacked high with figs. The painting's lively color harmony of white with complementary reds and greens adds a warm, festive quality. A second Middle Kingdom tomb painting **(12.7)**, vibrant with color and decorative pattern, shows Western Asiatics bringing eye paint to trade during the reign of Sesostris II. Carefully ordered and well balanced, the composition conveys stability and hints at the Egyptian love for human beauty and its enhancement through cosmetic makeup. But the painting's form and subject matter also point to the fact that outsiders were making their way, in steady procession, into the land—first by trade, then by increasing migration, and finally, during times of weakness, by invasion.

Migrating from the north around 1670 B.C.E., the Hyksos, Semitic-speaking peoples from Palestine, Syria, and Mesopotamia, took control of much of Lower or Northern Egypt and, specifically, the low-lying delta region where the Nile flows into the Mediterranean Sea. Ancient Egyptian words describe these Western Asiatics as "shepherd kings" and "chieftains of foreigners." Black African Nubians, allied with the Hyksos, pushed across the country's southern borders. For the very first time, Egyptians were governed by foreigners; the Hyksos held actual dynastic power for over a century, between approximately 1670 and 1552 B.C.E. The benefits gained from the Hyksos invasion and occupation far outweighed the costs. The Hyksos introduced the Egyptians to new methods of warfare, including the horse-drawn chariot; advanced methods of bronze making; a vertical loom for weaving; an improved potter's wheel; the lyre and the lute; hump-backed cattle; and new vegetables and fruits. The previously cited wall painting of Western Asiatic traders speaks to this phenomenon. In contrast to an Egypt that was self-contained and isolated during the Old Kingdom, Western Asiatic trade, migration, and settlement had an expansive and empowering effect. In short order, powerful Egyptian rulers arose, cast out the Hyksos, and reunited the country, laying the groundwork for Egpyt's most glorious era: the New Kingdom.

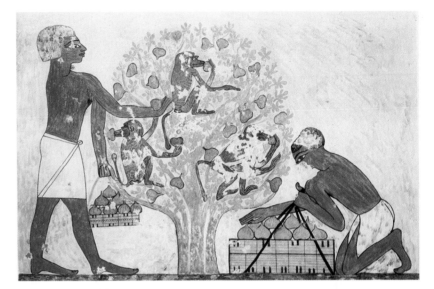

12.6 Harvest Scene, facsimile of wall painting in tomb of Khnumhotep, Beni Hasan. Twelfth Dynasty, ca. 1920–1900 B.C.E.

12.7 Painting of Western Asiatics, facsimile of wall painting, from Beni Hasan, reign of Sesostris II. Tomb of Khnumhotep. *Did the increase in foreign trade and immigration to Egypt, beginning with the Middle Kingdom, influence the form and content of Egyptian art? If so, how? If not, why not?*

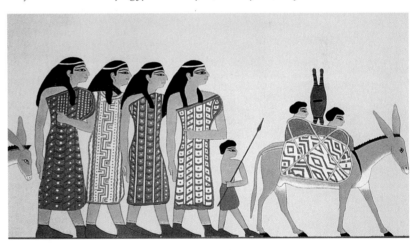

The New Kingdom: Restoration and Change

Taking advantage of all they had learned from the expelled Hyksos, Egypt emerged stronger than ever militarily, politically, and culturally to become the preeminent civilization, without serious rival for the next 500 years. Pharaohs of great ambition and ability ruled the Eighteenth

12.8 Hatshepsut statue, from Thebes, Deir el-Bahri. Temple of Hatshepsut. Nineteenth Dynasty, ca. 1503–1482 B.C.E. Painted indurated limestone. Height: ca. 77 in. The Metropolitan Museum of Art, New York, Rogers Fund and contribution from Edward S. Harkness, 1929 (29.3.2.).

to Twentieth Dynasties (ca. 1552–1069 B.C.E.), the era of the so-called New Kingdom. Among these rulers was Hatshepsut, the first female pharaoh. Her Eighteenth Dynasty reign lasted a full twenty-two years (1503–1482 B.C.E.). Hatshepsut was the first woman to ascend beyond queenship or regent (royal caretaker) status to full god-king status, becoming ruler when her husband died at a young age. Not content to remain simply queen or caretaker, she kept her young stepson Thutmose III, the male heir and a future pharaoh of greatness, from ruling until her own death. During Hatshepsut's reign the kingdom was peaceful, prosperous, and well governed.

We view Hatshepsut in one of her many royal portraits in stone **(12.8).** She is presented in the standard seated position for high royalty: frontal, stately, hands on thighs. Stylistically, her royal portrayal fits within the original Old Kingdom canon for the seated god-king. Following custom, she wears the traditional male headcloth of the divine king. In most portraits she is also depicted with the characteristic male body and beard, but in this portrait there is a difference: Hatshepsut wears the traditional long woman's robe and does not hide her gender behind the customary beard or within the stereotypic broad-shouldered torso of the male pharaoh. Her body is thin and fine-boned, with small hands and feet.

Hatshepsut was ably supported by a bold chief administrator, Senmut. Of common birth, Senmut rose to the highest governmental offices in the land, becoming royal architect. (Architects, with their knowledge of advanced mathematics and possibly of reading and writing, might ascend to the heights of society.) As the pharaoh's master builder, Senmut is credited with the design of Hatshepsut's funerary temple-complex, one of the most impressive in the ancient world **(12.9).** Replacing the old pyramid mausoleum with a new temple-tomb complex—an extension of the Middle Kingdom's rock-cut tombs—the pharaohs of the Eighteenth Dynasty of the New Kingdom built their structures by the high rock cliffs near the Nile and the present-day city of Luxor. The site of over sixty temple-complexes, this area of upper Egypt is aptly called the Valley of the Kings.

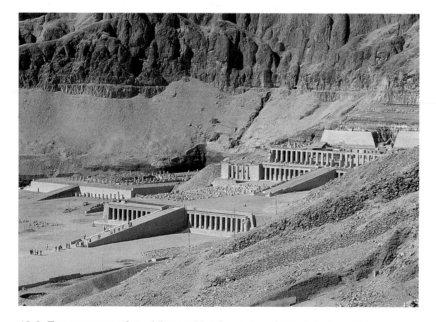

12.9 Funerary temples of Queen Hatshepsut and Mentuhotep, Deir el-Bahri, Egypt. Eighteenth Dynasty, ca. 1480 B.C.E.

Famous for its restoration of Egyptian unity and traditional culture, the New Kingdom is equally renowned for its breaks with the ancient traditions in terms of religious belief and artistic style. These breaks with the past were brought about with revolutionary suddenness by a single pharaoh, Akhenaten, who reigned from 1379 to 1362 B.C.E. His new royal city, Amarna, instantly became the center of a radically divergent art and culture (named the Amarna culture). During its brief two-decade life span, Amarna art introduced unprecedented degrees of naturalism within the basic conventions inherited from the past. The stiff, formal "at attention" poses of traditional portraiture (12.3) were banished. The new naturalness and naturalism represented in the art are a reflection of *ma'at*—loosely translated as "candor" or "sincerity"—the highest value of the Amarna culture. A sculptural relief **(12.10)** features both this greater naturalism and the ruler who instituted the new style. Pharaoh Akhenaten joins his wife, Queen Nefertiti, at play with their children. (The beautiful Nefertiti is featured in the portrait bust in Appreciation 23, Figure B.) Such slice-of-life informality in an aristocratic portrait must have astonished the tradition-oriented craftsmen who obediently followed the pharaoh's artistic orders. (All who witnessed the casual new poses must have been shocked, but they would have remained publicly respectful.)

Akhenaten is often referred to as the "great heretic" because of his departure from artistic canons and religiocultural laws thousands of years old. He was heretical with respect to the old gods, especially Amon-Ra, who had become the chief god. Replacing Amon-Ra and outlawing his worship, Akhenaten raised Aten, a sun god, to the position of supreme deity. To emphasize his change in allegiance, Akhenaten cast off his old name, Amenhotep (translated "Amon is satisfied") and took on the new name Akhenaten, which means "it is well with the Aten." In the relief (12.10), the circular sun disc, symbol of Aten, shines down upon the royal family, its rays illuminating and blessing their actions. So strong was Akhenaten's focus on Aten that he is credited with being the inventor of monotheism, or belief in one god. The movement to monotheism was truly revolutionary, because Egypt and other

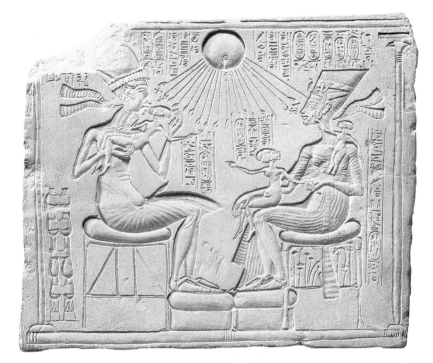

12.10 Akhenaten and His Family, from Akhetaten (modern Tell el-Amarna). Amarna Period, ca. 1345 B.C.E. Painted limestone relief, 12¼ × 15¼ in. Staatliche Museen zu Berlin, Preussischer Kulturbesitz, Ägyptisches Museum.

ancient cultures were thoroughly polytheistic, believing in and following a pantheon of many gods and goddesses. (As a little known, seminomadic people in contact with Egyptian culture, the ancient Hebrews may have been inspired to embrace monotheism by Akhenaten's example.)

The upheaval did not last long. The forces of tradition and the supporters of the established ways and old gods were too strong. Within a matter of decades, the old culture and its supporters returned to power. The fluid naturalism and individualism of the Amarna style were expunged, and the old "classical" style of Egypt returned full force. The massive temple sculptures of Ramses II (1304–1237 B.C.E.) at Abu Simbel **(12.11)** show the return of the classical Old Kingdom style with a vengeance. Formally posed and geometrically rigid, these behemoths speak of imperial control and the power and glory of the old ways. Biblical scholars often associate this specific Ramses with the pharaoh who wielded power over the ancient Hebrews—and other immigrants and subject peoples—during their time of labor or enslavement in Egypt.

Beautiful is your shining forth on the horizon, O living Aten, beginning of life! When you arise on the eastern horizon, you will fill every land with your beauty. You are bright and great and gleaming and are high above every land.—The Great Hymn to the Aten, New Kingdom

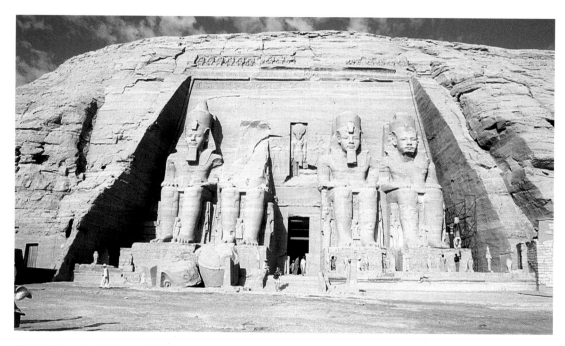

12.11 Temple of Ramses II, Abu Simbel, Nubia. Ca. 1237 B.C.E. *Some claim that tradition-based ancient Egyptian society and art were basically unchanging for over two millennia. In terms of style and subject matter, do you perceive ancient Egyptian art to be primarily static or dynamic? Explain the reasoning behind your answer.*

Egypt, Nubia, and Aegean Civilization: Artistic Interchange

Substantial interaction took place between Egypt and its neighbors, especially from the Middle Kingdom onward. Hale Woodruff's twentieth-century painting *Interchange* (Appreciation 2) shows Egyptian, Greek, and African Negro peoples (Nubians and others) in an intercultural exchange of art and ideas. From earliest times, Egypt traded with the Negro kingdom of Nubia (ancient Kush) to the southeast. Nubians fought in Egypt's army, and Egypt ruled the northern part of Nubia from 1400 to 1070 B.C.E. Nubia, in turn, reigned over Egypt from 712 to 657 B.C.E.

The interaction between the two lands was intense and ongoing over two millennia. For centuries, Nubian kings modeled themselves after the pharaohs, and much of their royal portraiture and burial practices shows definite Egyptian influence. The funerary figurine of Taharka (690–664 B.C.E.), ruler of Nubia and Egypt **(12.12),** comes from his pyramid tomb at Nuri in Upper Nubia. Taharka was a member of the Twenty-fifth Dynasty (780–656 B.C.E.), which ruled over Nubia and Egypt as one

enormous state. As pharaoh, Taharka is shown dressed and posed like his Egyptian predecessors. His features, however, show a distinctly Nubian cast. Other Nubian artworks display qualities more closely associated with the Negro art of Sub-Saharan Africa (the lands below the Sahara desert of Northern Africa) (8.41, 1.9). Nubian art, and attendant cultural values, might have subtly influenced Egyptian art throughout its 3,000-year history.

Economic and diplomatic interchanges between Eastern Mediterranean (or Aegean) civilization and Egyptian civilization were well established by 1200 B.C.E. and probably long before that. Given the ongoing contact between the two civilizations, certain scholars theorize that ancient Aegean art might even have influenced Egyptian art. They point in particular to the works of the Minoan civilization centered on the large island of Crete and neighboring smaller islands. (The name *Minoan* comes from the mythological King Minos of Crete.) Strategically located in the Aegean Sea between Egypt, Asia Minor, and the Greek mainland, Minoan civilization (ca. 3000–1400 B.C.E.) was famous for its cultivated urban life, dynamic commercial sea trade, and vital artistic

12.12 Shawabti (funerary figurine) of King Taharka. Nuri, Pyramid I. Napatan Period, 690–664 B.C.E. Syenite. 20¼ in. Harvard University–Boston Museum of Fine Arts Egyptian Expedition, 92-2-67. Courtesy Museum of Fine Arts, Boston.

12.13 Octopus Vase, from Palaikastro, Crete. Ca. 1500 B.C.E. Height: 11 in. Archaeological Museum, Herakleion, Crete. *Popular subject matter in works of art is usually an immediate tip-off in terms of what is valued in a given society and culture. What does the Octopus Vase tell you about Minoan civilization?*

production. Something of this cosmopolitan sophistication and dynamism can be seen in Minoan pottery and wall paintings. A vibrant octopus, its swirling tentacles radiating outward, spreads over the curved surface of a spherical vase **(12.13),** and little sea plants float and creatures swim in the active spaces in between—a perfect fit between two-dimensional figures and three-dimensional form and ground. Combining realistic observation and humor, the octopus's large eyes echo the two finger-grip openings atop the pot. Aesthetic play on the part of the creator(s) has produced a useful object of abundant visual pleasure. The slightly earlier wall painting *Boxing Children* **(12.14)** from the island of Thera, north of Crete, is likewise endearing, lively art. The slice-of-life naturalism and energetic curvilinear forms that characterize so much Minoan art may have inspired the radically new Amarna style of Pharaoh Akhenaten (12.10), so different from all Egyptian art that had come before it. Such a sudden, dramatic change in tradition-bound Egyptian art could well have been stimulated or furthered by the outside influence of Minoan art. Note the naturalistic candor and fluid movement characteristic of both Minoan and Egyptian Amarna art.

After the Minoan civilization disappeared suddenly and mysteriously around 1400 B.C.E.—cataclysmic volcanic eruptions and earthquakes coupled with military invasions have been cited as possible causes—Aegean foreigners of more warlike disposition made contact with Egypt. Called "the Sea Peoples" by the Egyptians, these traders, marauders, and sometime invaders of the Eastern Mediterranean and Egypt included the Philistines and the Mycenaeans, two peoples who probably shared cultural affinities. Repulsed by Pharaoh

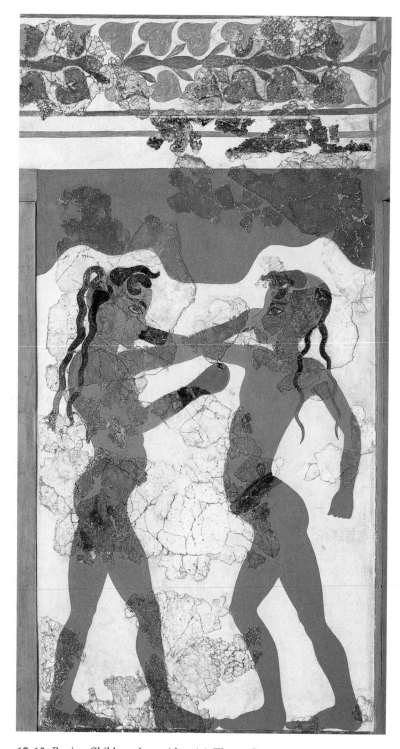

12.14 *Boxing Children*, from Akrotiri, Thera. Ca. 1650–1500 B.C.E. Fresco. 9 ft. × 3 ft. 1 in. National Archaeological Museum, Athens. *Minoans seem to have been peace-loving people—their cities are largely unfortified—who took up sports for enjoyment rather than as training for war, as was the case with the subsequent Mycenaeans and Spartans. How do you explain the Minoans' deemphasis of militaristic activity and prowess and their enjoyment of some physical contests purely for fun?*

Ramses II (12.11), some of the fearsome Sea Peoples, with their weapons of iron, settled in southern Palestine (present-day southwestern Israel and Egyptian Gaza). *Palestine* is in fact a derivative of *Philistine,* the name of this Iron-Age people who soon controlled the area. Among their subject peoples were the Hebrew tribes, which rose up around 1000 B.C.E. under the successive leadership of kings Saul and David—recall the young shepherd's legendary slaying of the Philistine military hero Goliath (14.40)—and established an independent Jewish kingdom of their own in central Palestine.

Contemporaneously, the warrior- and trade-based Mycenaean states on the Greek mainland controlled the sea lanes of the Aegean. The Greek-speaking Mycenaeans lived in heavily fortified cities with stone walls as thick as 24 feet. They achieved legendary status through two immortal epic poems, *The Iliad* and *The Odyssey,* attributed to Homer. These epics, recorded in writing in the eighth century B.C.E., were based on centuries-old oral traditions (Appreciation 24). *The Iliad*'s tales of the ten-year Trojan War appear to be a mythological version, grounded in general historical fact, of the Sea Peoples' battles with peoples in western Asia Minor. Under their supreme Mycenaean military commander King Agamemnon, the epic poem relates, the forces of Greece battled those of Troy, a city on the western coast of Turkey, around 1200 B.C.E. Archaeological excavations have verified the existence of a large ancient city on the site, and history reveals that large numbers of Greeks settled in and colonized this coastal area in subsequent centuries.

It is within this mythological and historical context that a gold burial mask **(12.15)**, the "Mask of Agamemnon," might best be appreciated. So named by the archaeologist who discovered it, the mask is the idealized likeness of an important figure, perhaps a Mycenaean warrior-prince or king. The features are stylized. The curlicue ears, almond-shaped eyes, serrated eyebrows, and handlebar moustache are identical on each side of the face, and the compositional balance is perfectly symmetrical. But other characteristics—thin lips, broad forehead, pointed nose, jutting jaw, abundant beard—evoke the physical identity of a particular individual, not just a conceptual type.

Attached to the face of a mummified prince, a death mask like this one was thought to guarantee the dead person's identity in the afterlife. This burial practice and the fact that the gold itself may have come by maritime trade with Egypt emphasize the influence of Egyptian civilization on Mycenaean life.

Taking over Crete and other depopulated Minoan islands by around 1400 B.C.E., the Mycenaeans reigned as the dominant power in Greece and the surrounding Aegean until the migratory or military invasion of Greek-speaking Dorian peoples from the north between 1200 and 1100 B.C.E. A so-called Dark Age followed the decline of the Mycenaeans, lasting three to four centuries. It was a period of poverty from which little in the way of architecture, art, or literature remains. But out of these supposedly dark times came light. Enterprising Aegean and Greek mainland peoples emigrated to places all around the Mediterranean seeking a better life (similar to the waves of immigrants to the Americas over the last four centuries, people bent on improving their lives in a new world). The Aegean emigrés created colonies in Asia Minor, establishing an eastern Greek or Ionian culture. They migrated to Spain, France, and Italy. Egypt invited them in as traders to live and work in the commercial outpost of Naucratis, near where the waters of the Nile flow into the Mediterranean Sea.

This period of historical migration finds a mythological parallel in the epic poem *The Odyssey*, a Homeric epic relating the ten-year journey or odyssey of a Greek hero on his way home with his men from the Trojan War. Wandering from island to island and coast to coast, the hero Odysseus, like the real-life Aegean emigrants, meets with all types of strange peoples and adventures. However difficult they might have been, the centuries of the Dark Age laid the groundwork for an expansive, commercially vibrant Greek culture spread around the entire Mediterranean and set the stage for the rise of famous city-states such as Athens (once a Mycenaean city) and Sparta on the Greek mainland in the eighth century B.C.E.

No longer the immense power it had once been, Egypt still had a substantial influence on the Mediterranean peoples in the first millennium B.C.E. As the area's preeminent civilization for millennia, Egypt naturally had an im-

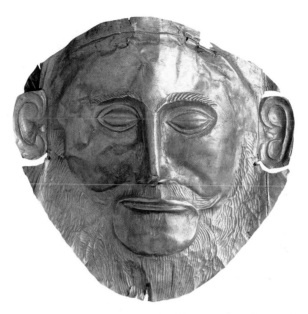

12.15 Funeral mask ("Mask of Agamemnon"), from the royal tombs of Mycenae. Ca. 1500 B.C.E. Beaten gold. Height: 12 in. National Archaeological Museum, Athens.

pact on surrounding cultures and their art. Just as the Nubian kings still portrayed themselves as pharaohs (12.12) in the eighth and seventh centuries B.C.E., the contemporary figurative sculpture of the emerging Greek mainland culture also showed decisive Egyptian influence.

GREEK CIVILIZATION AND ITS ART

For seven hundred years, from the eighth century B.C.E. to the rise of the Roman Empire in 31 B.C.E., the Greeks were the major cultural and artistic force in the Mediterranean world. Gradually asserting a unique identity during the eighth and seventh centuries, Greek art subsequently influenced the Egyptians, the Etruscans, the Romans, and all the contemporary cultures of the Mediterranean world.

The Archaic Period (ca. 700–480 B.C.E.)

Look at a Greek statue **(12.16)** from what is known as the Archaic Period. *Archaic* denotes that which is old or old-fashioned and refers, in art historical terms, to the first major period

So clan after clan poured out from the ships and huts onto the plain of Scamander [before Troy] . . . the Athenians . . . the citizens of Argos and Tiryns of the Great Walls . . . troops of the great stronghold of Mycenae, from wealthy Corinth . . . Knossos in Crete, Phaistos . . . and the other troops that had their homes in Crete of the Hundred Towns.
—Homer, *The Iliad*, on the Greek forces deployed for war against Troy

12.16 *Kroisos* (*Kouros* from Anavysos). Ca. 525 B.C.E. Marble. Height: 76 in. National Archaeological Museum, Athens.

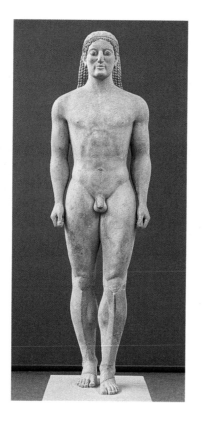

Man is the measure of all things.—Protagoras, Greek philosopher, late fifth century B.C.E.

of Greek art, from approximately 700–480 B.C.E. The *Kouros* (literally, "boy" or "youth") from ca. 525 B.C.E. is patterned after an ancient style. As in Egyptian royal portraiture (12.3), the pose is frontal and upright and the gaze is directly forward. The left leg advances. The statue appears cut from a single slab of stone, making for an overall shape that is rectilinear and blocklike. But formal differences from Egyptian art are evident, and more characteristically Hellenic (from *Hellenes*, "the Greeks") qualities make their presence felt. The Greek statue seems rounder, fuller, and more relaxed, less rigid and less rigorously geometric in its features and proportions. Rather than adhering completely to predetermined mathematical proportions, the sculptor appears to have observed an actual human model in the creation of his work. Consequently, the *Kouros* seems more anatomically detailed and accurate.

At the same time, underlying conventions are being followed. This is a perfect, "ideal" body with the strong, chiseled muscles of a world-class athlete. The Greeks adored the beautiful nude male bodies of their athletes and soldiers, and the popular kouroi (plural for *kouros*) sculptures are thought to be modeled after these muscular physical types. The kouroi, in fact, are the first true nudes in Western art—the human body presented and admired as a work of art for its own sake. (The first fully nude females would come two centuries later in the form of Aphrodite, the Greek goddess of love (12.23).)

There is a hint of movement in the Greek statue's pose. The *Kouros* is totally free of the stone, and his bodily weight has moved forward onto his toes. The statue may have had some religious purpose—perhaps serving as a votive offering to a god—but its function was probably more of this world. It may well have served as a memorial at a young nobleman's grave or as a monument to the glory of a triumphant athlete. It glorifies men in this life—their physical beauty, athleticism, and nobility. In keeping with these values, a general human-centeredness or humanism pervaded ancient Greek culture.

Relative to social context, large Egyptian sculpture in the round was reserved for the highest members of a centralized ruling class: the pharaoh, the queen, the chief administrator. The life-size Greek kouroi were created for a larger, widespread nobility. These aristocratic lords owned land and collected rents and produce from the peasantry. They fought in frequent wars and took home the spoils, from bounty to slaves. In life and art, these warlords modeled themselves after famous warrior heroes of Greek mythology such as Achilles (Appreciation 24). When they weren't fighting, they continued their competition at leisure: wrestling, racing, throwing the discus, playing at board games. The statues first of kouroi and later of athletes and warriors in action were created for an expanded leisure-class minority. Not as fabulously wealthy as the pharaoh or his governor, the Greek nobles were still wealthy enough to spend hours at physical training for sports and war. And they were rich enough to commission sculptors or painters to create models of human perfection in their own idealized image.

Paintings on Greek ceramic vessels from both the sixth and the fifth centuries B.C.E. depict the nobility and their mythological heroes at war, sport, and play. (Such ceramic vessels

were used for storing honey, olive oil, water, or wine—the good things of life.) It is hypothesized that the art was so emphatic in its portrayal of ancient warrior heroes and the glories of an aristocratic class because the hereditary, landed nobility was under political and economic attack. Exerting power through wealth, a growing urban middle class of merchants, tradesmen, and craftsmen was beginning to buy entry into the ruling elite. The vase paintings and their social context affirm that competition had become a central feature of Greek life. Competition was at the core of the wars, games, and sports of the aristocracy—the Olympic Games, showcasing Greek contestants from throughout the Mediterranean world, were founded in 776 B.C.E. and took place near Olympia in mainland Greece—and competition was equally important to the everyday world of middle-class business and artistic production.

In the arenas of commercial production and trade, competition was fierce. Shunned by leisure-class aristocrats, this was the domain of common-born "freemen" in the cities. At the top of the emerging middle class were wealthy merchants and traders. In the lower half were tradesmen and artisans, including individual artist-entrepeneurs. Propelled by artistic competition, the potter-painter Exekias (Appreciation 24) developed his own personal style, following no official canons or formulas. Rivaling the aristocratic heroes whose images and names he painted on his vessels, he even inscribed his own name on his pieces, a practice virtually unknown in the ancient world (Appreciation 23). Whether as personal advertisement or as a sign of personal pride, Greek artists signed works as their very own. Trading their wares across the Mediterranean, famous artist-craftsmen now competed with their peers for commissions and used their personal style as a selling point.

For the most successful potters, painters, and sculptors, large workshops became essential. A pottery workshop might employ as many as fifty freemen or slaves, a dozen of whom might be skilled craftspersons. Most of these workers in clay were men, but a small number of women—engaged primarily in weaving and textile manufacture—participated in the ceramic arts, as a painted fragments **(12.17)** from

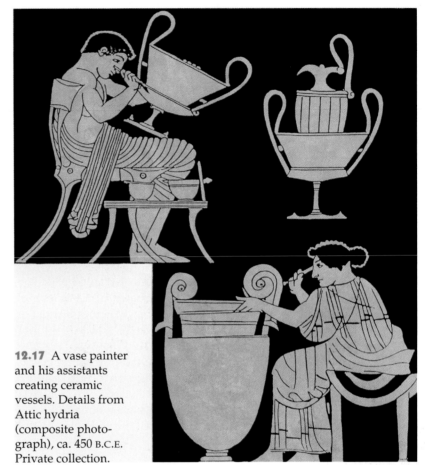

12.17 A vase painter and his assistants creating ceramic vessels. Details from Attic hydria (composite photograph), ca. 450 B.C.E. Private collection.

a large vase attests. The female and male ceramists are working on vessels of varying sizes and shapes whose functions range from drinking or mixing water and wine to storing oil and honey.

By the beginning of the fifth century B.C.E., much of northern Greece and the Greek coastal settlements and islands of Asia Minor was under the control of the mighty Persian Empire (centered in present-day Iran). The most far-flung empire to date, Persia, under kings such as Darius and Xerxes, ruled lands and peoples from Egypt to India. Recall the magnificent royal capital at Persepolis (11.22–11.24), constructed by artisans from all over the world, including Greek Ionia. Full-scale war between the Greeks and Persians broke out when Ionian revolts received support from mainland Greek city-states. Invasions of the Greek mainland by Persian forces were ultimately repulsed by 480 B.C.E., marking the end of the Archaic Period of Greek art.

. . . the beginning of Greek history appears to be the beginning of a new conception of the individual . . . the history of personality in Europe must start with the Greeks.—Werner Jaegar, author, *The Ideals of Greek Culture*, 1939

Exekias, Achilles Killing Penthesilea, *ca. 530* B.C.E.

CHARLES R. JANSEN

An amphora **(Fig. A),** a storage vessel, painted by a man who signed the foot of the pot as both potter and painter during the Archaic Period of ancient Greece when pottery manufacturing was a rapidly changing industry and a staple in a growing export market It seems an unlikely object to study as a way to understand something about the ancient Greeks. It would be like trying to say something about American culture by studying images of superheroes printed on the sides of drinking glasses you get as a premium in fast-food places when you purchase a drink. (But of course those drinking glasses *do* reveal significant aspects of U.S. culture; they show the United States as an industrial and capitalist country with a streak of idealism distilled in images of superheroes.) As an art historian I value what Exekias has made not only because his elegant work *does* reveal so much about ancient Greek culture and our debt to it, but also because this particular work haunts me in a way. Indeed, I find much to admire in Exekias's work.

Initially what I admire in Exekias's work is his skill of hand in those perfectly executed spirals (made all the more miraculous when we remember that they were laid down with a drawing instrument as clumsy as a syringe) and the decisive quality in the drawing of the figures. Technique (from the Greek *techne* for "skill") has long been a standard of quality in the arts, though it is certainly not the only or even the most important standard. Modern art, for example, is often treasured more for its revelation of inner character or personality, and in Exekias's image of the Greek hero Achilles killing Penthesilea, Queen of the Amazons, the figures seem too formalized and the faces too masked or masklike to reveal much about the feeling of these characters or of Exekias. But feelings—powerful conflicting emotions of loyalty, duty, love, fear, and regret—are here in the story Exekias represents.

This is a story in praise of the victors and their accomplishments, like so many other battle scenes that have always been produced throughout the history of art. Like similar subjects in Greek art of battles between the Greeks and the Trojans, between the Lapiths (early Greeks) and the Centaurs, and between the Greek gods and the Giants, the success of the Greeks in battle stood as a way of holding up Greek ways—their society, their beliefs, their customs—as better than those of others. (It's a form of xenophobia—fear or hatred of

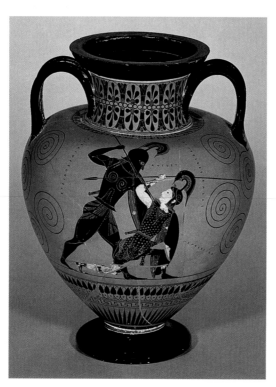

Figure A Exekias. Amphora showing Achilles and Penthesilea. Ca. 525 B.C.E. 16¼ in. British Museum, London.

Charles R. Jansen is a professor of art history at Middle Tennessee State University in Murfreesboro.

strangers or foreigners—to use another Greek word.) More specifically, the belief that is highlighted here is that one's social duty must take precedence over any individual interests. You see, even as the Greeks battle to the death with the Amazons because these women warriors have joined the Trojans against the Greeks, Achilles is falling in love with Penthesilea. But, as representative of their respective cultures, honor demands that only one return from the battleground. As Achilles strikes the death blow, he is deeply moved by Penthesilea's valor in battle, her youth and beauty. Although we cannot see much of Achilles' face through the mask of his helmet, it is easy for me to imagine the horribly mixed emotions he is experiencing as he slays Penthesilea.

The theme here, a theme revisited many times in ancient Greek art, is the proper balance between social responsibility and individual freedom. In Exekias's painting, social responsibility wins almost without question. Seventy years later, another artist strikes more of a balance, revealing the inner conflict more clearly **(Fig. B).** This is the balance struck in the Classical Period of ancient Greek art, and it echoes a similar balance established by the government of Athens at that time. It was in the fifth century B.C.E. that Athens developed a democratic political system, a system which proposes just the balance between social responsibility and individual freedom that we see being worked out in the evolution of Greek vase painting.

But I see more than this in Exekias's work. The powerful sense of aggression in the image jars me with its glorification of war and its metaphor of men's domination of women. While telling so much about fundamental values I admire, the work also reminds me that the ancient Greeks kept slaves and strongly subordinated women. Admirable and influential as the invention of democracy was, it served only a small portion of society. In the history of art, as we marvel at artworks for their skillful construction or the ways they reveal underlying and motivating cultural values, we must also remember that no society is perfect and that there are always hidden costs in an idealized art.

Moving beyond moralizing in and about the past, look at the image. It's so difficult these

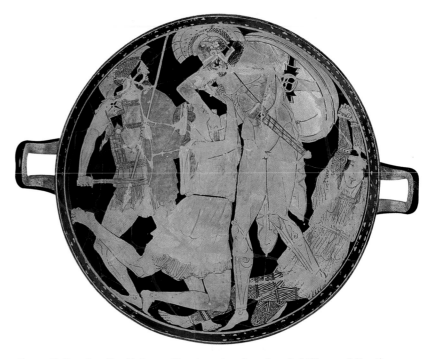

Figure B Penthesilea Painter. Cup interior showing Achilles and Penthesilea. Ca. 455 B.C.E. 17 in. Staatlische Antikensammlurgen und Glyptothek, Munich.

days to focus for very long on a still image. In our culture, most images *move* (film, video, computerized images), or we quickly move *them* (we turn the page, we drive by, we glance away). I am reminded of what colleague George Dimock said about still images, that their value consists precisely in requiring that the beholder's *mind* animate them. Look at the images; look for a while. Perhaps this time Penthesilea's arm raised in protest will be enough to stop Achilles; perhaps the empty field upon which they meet will shortly admit who? or what? What title would you give this image? How would you write a story to fit this image, this vessel? What would these figures represent to you? Of course, there are as many answers as there are readers of this essay, and your response—if you take the time to connect your imagination to this image—is finally an exploration of self-discovery. This above all is why many people see the arts (and study of the arts) as important. In our culture, unlike Exekias's where duty prevailed, it's the individual we prize, and this is what the still images of art tap out. ■

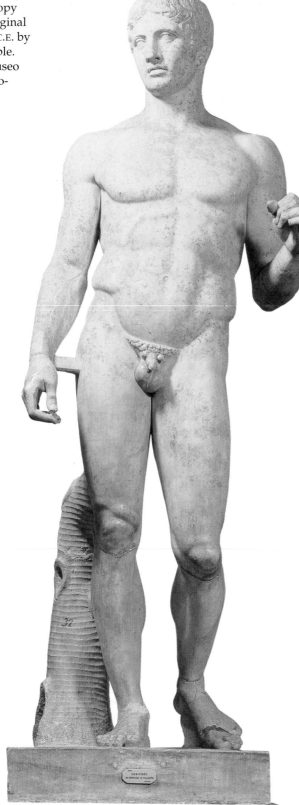

12.18 *Doryphoros (Spear Bearer)*. Roman copy after a bronze original of ca. 450–440 B.C.E. by Polykleitos. Marble. Height: 78 in. Museo Nazionale Archeologico, Naples.

The Classical Period (480–323 B.C.E.)

The Greeks' final expulsion of the foreign invaders in 480 B.C.E. is often cited as the beginning of the Classical Period of Greek culture. In historical terms, the Classical Period lasted until 323 B.C.E., the year in which the Macedonian-Greek Alexander the Great died and his vast empire, eclipsing even that of the Persians, began to break up. For most scholars, the Classical Period marks the high point of Greek civilization. It was characterized by unparalled cultural confidence and vitality—a kind of "golden age" of achievement in almost every sphere of life. Politically, the Classical Period saw a movement away from the rule of tyrants and kings to rudimentary forms of democracy (from the Greek words meaning "rule of the people"). In certain city-states, such as Athens, direct democratic governance through voting by property-holding male citizens took root. In the intellectual realm, the human being was examined from every angle: anatomical, medical, psychological, philosophical, political. Spurred by humanistic studies, democratic political practice, and free-market commerce, earlier Greek emphases on humanism and individualism deepened.

Artists reflected the values of the larger society. Formally, artworks became more differentiated by the artist's individual style. A viewer could readily tell a work by Polykleitos from one by his contemporary Phidias or Myron. Increasingly, artists signed their paintings or sculptures to affirm their individual accomplishment. As in the Archaic Period, the primary subject was the human being or gods created in the image of humans. The specific style, befitting the age, combined humanism, naturalism, and idealism. A sculptor might create a naturalistic, anatomically accurate rendering of an athlete or a god, but that was not enough. The representation had to be raised to a higher perfection in terms of Greek ideals of beauty. What ideals did the fifth-century Greeks associate with the beautiful? In formal terms, the works of art reveal ideals of clarity, order, unity, balance, and harmony. Relative to content, ideals of calm grandeur, noble simplicity, emotional restraint, and rational intelligence are evident. Collectively, these are the values that for centuries we have associated with the classical style and the ideal in the various arts.

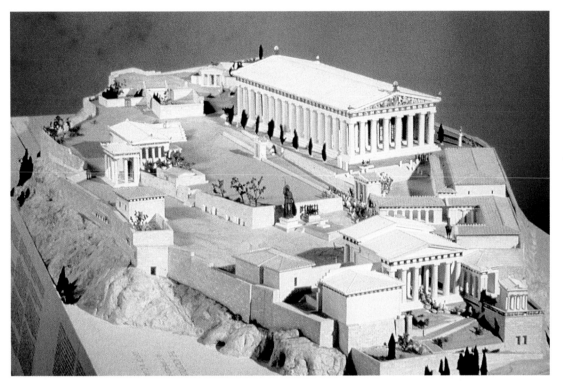

12.19 Model reconstruction of the Acropolis, Athens. Ca. 400 B.C.E. Royal Ontario Museum, Toronto, Canada. Parthenon (top), Propylaea (bottom), Erechtheum (left).

The *Doryphoros* (or *Spear Bearer*) by Polykleitos **(12.18),** from ca. 450–440 B.C.E., shows the nascent classical ideal of the earlier Archaic Period brought to full flower. (We experience it through a Roman marble copy after the bronze original.) With respect to humanism, naturalism, and idealism, the *Doryphoros* advances beyond the *Kouros* (12.16) of the century before, displaying more anatomical accuracy, naturalistic detail, and lifelike movement. The statue seems almost alive. It walks slowly toward us, weight confidently shifting onto its right foot. In the *Doryphoros*, ongoing emphases on the perfect nude male body, athletic and military fitness, and aristocratic bearing reach full fruition. The spear bearer has cast off any final traces of Egyptian influence. He is now proudly and quintessentially Greek. So rationally and aesthetically perfect are *Doryphoros*'s bodily proportions that this sculpture became the canon for the ideal male body for generations of Western artists.

If the *Doryphoros* embodies the classical ideal in sculpture, then the Parthenon, the Temple of Athena, patron goddess of Athens, is its counterpart in architecture (10.14, 10.16). The largest building on the Athenian Acropolis

(12.19), the Parthenon commands the fortified hill on which Athens built its spiritual center in the fifth century B.C.E. Surrounding it in this three-dimensional model of the restored Acropolis are smaller temple structures in distinct and mixed styles: The Erechtheum is Ionic, while the Propylaea is Doric with a touch of Ionic at the entranceway (10.15). The Parthenon itself features the Doric order on the outside but an Ionic-style sculptural frieze within. Such stylistic mixing and inclusiveness certainly befit Athens' far-flung empire. In addition, colossal standing statues of Athena within and outside the Parthenon, painted sculptures in the round in the east and west **pediments,** and painted relief sculptures on the interior Ionic and exterior Doric **friezes** broadcast the city's prowess to its inhabitants and the world. The interior sculptural frieze proudly represents the ancient Panathenaic procession of the city's populace every four years up to the Acropolis to honor Athena in her temples. The pediment sculptures center on two patriotic themes: the birth of Athena and her triumph over the rival god Poseidon in their battle for the rule of the city. Deeply carved relief sculptures featured in the Doric

Not long ago . . . the Hellenes [the Greeks] were of the opinion, which is still generally received among the barbarians, that the sight of a naked man was ridiculous and improper. . . . But experience showed that to let all things be uncovered was far better than to cover them up.
—Plato, Athenian philosopher, *The Republic*, early fourth century B.C.E.

12.20 Alexander the Great, coin issued by Lysimachos of Thrace. 306–281 B.C.E. Silver. Diam: 1⅛ in. The British Museum, London. *How might a money-based, as opposed to a barter-based, economy have affected the production of art and international trade in artworks?*

frieze (10.14) that rings the outside of the building depict hard-fought victories of Greek warriors over wide-ranging foes—Trojans, Amazons, and centaurs. The recent victories over the Persians and the ascendancy of Athens to superpower status had spurred the immense Acropolis building campaign under the statesman Pericles and architects Iktinos and Kallikrates. Of the city and its empire, the contemporary Athenian historian Thucydides would say: "Mighty indeed are the marks and monuments of our empire which we have left. Future ages will wonder at us, as the present age wonders at us now." This was Athens' shining moment, but, in political and military terms, it would not last long.

Perhaps guilty of *hubris* (Greek for "excessive pride"), Athens engaged the city-state of Sparta and its allies in the disastrous Peloponnesian War (431–404 B.C.E.), which tore asunder Greek unity and ended with Athens' abject surrender. For decades thereafter, the Greek city-states Sparta, Athens, Corinth, and Thebes would battle one another in ever-shifting alliances. Across this divided, weakened panHellenic realm, two military giants soon marched. Using advanced military tactics

learned from the Greeks, King Philip of Macedonia conquered much of mainland Greece and adjacent Aegean lands by 338 B.C.E. Assassinated two years later, his battle-tested twenty-year-old son Alexander (356–323 B.C.E.) took over the throne. With lightning speed, the ambitious, adventurous Alexander expanded Philip's conquests to encompass much of the known world from Egypt to India. Alexander, coming from a less advanced culture on the northern Greek perimeter, a kingdom as much like the ancient warrior-state of Mycenae (12.15) as contemporary Greece, quickly became an ardent admirer of Hellenic architecture and art, especially that of Athens with its wondrous Acropolis. His private tutor at King Philip's court had been none other than Aristotle (384–322 B.C.E.), the renowned philosopher of the Athenian school.

The head of a coin (12.20) shows Alexander in profile, a man of commanding presence in the full bloom of youth. As an art form, portraiture grew in popularity with the hero-cult of Alexander and the steady increase of Greek individualism in general. A type of portrait miniature, coins featuring different representations of the heroic conqueror or territorial governors were used as currency throughout Hellenic lands. Alexander wears the curled ram's-horn headdress that identifies him with the supreme Greek-Egyptian god Zeus-Amun, a symbolic embrace of the divine kingship tradition of Egyptian pharaohs and Mesopotamian and Persian kings and a departure from the more down-to-earth political practice of the Greek city-states. Issued within decades of Alexander's death by King Lysimachos of Thrace, this particular coin portrait combines naturalism with a substantial dose of idealism and beauty. The masterful designer of the coin has fully followed Aristotle's advice to artists regarding their "representation of people who are better than average." Creators of portraits, the philosopher wrote, should reproduce "the distinctive appearance of their sitters and [when] making likenesses paint them better-looking than they are." This fits with the Classical Greek ideal that physical beauty mirrors moral and spiritual greatness. Gesture and pose operate similarly. Alexander's eyes gaze with serene confidence toward the heavens, to higher values and inspired vision. Classical

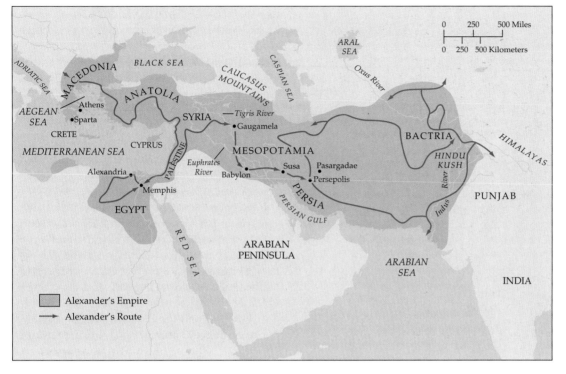

12.21 Map of Alexander the Great's Empire.

calm and grandeur emanate from the sensitively modeled, clearly defined face. Yet the upturned eyes and the combination of curling ram's horn and swirling locks of hair speak of energy, motion, and theatrical effect, qualities that were to become increasingly pronounced in Greek art of the third through first centuries B.C.E.

Imagine the cultural experiences of Alexander and his troops as they crushed the Persian Empire in 331 B.C.E., sacked Persepolis (11.22), and pushed into what today is western India **(12.21)**. They came face-to-face with the cosmopolitan Persian culture and its Zoroastrian religion, as well as with the Jainist and early Buddhist religions of the Indus Valley. It is possible that the Hellenes witnessed the first manifestations of Buddhist art in the form of symbols like the spoked wheel, the lion, and the lotus, subsequently fashioned in combination with a smaller, symbolic bull and horse on a column capital **(12.22)** of the third century B.C.E. This lion-headed capital and many other such symbolic columns were erected by order of the Mauryan Dynasty ruler Ashoka (reigned 273–232 B.C.E.), the first Buddhist emperor. Alexander and his men may have learned that

such symbols referred to the founder of a new spiritual path known as the Buddha (ca. 563–483 B.C.E.) (3.14). For their part, the peoples of present-day Afghanistan, Pakistan, and India came into contact with the humanistic Greek culture with its anthropomorphic gods and figurative art. Under Alexander's successors and the subsequent Roman Empire, Hellenic culture remained influential in the region, at least in pockets, for centuries. Hellenistic influences, as scholars propose, may have stimulated the Kushan and Gandhara peoples in the first centuries C.E. to give the first sculptural representations of the Buddha as an enlightened or divine man. Some of these first Buddha figures in fact show Hellenistic influence in their physical features, poses, or clothing. Alexander's sweeping march to the east was an intercultural watershed, promoting unprecedented crosscurrents in arts and ideas as well as intercontinental trade among Europeans, Asians, and Africans.

After Alexander's death on the long journey home—he died at age thirty-three in Babylon (11.20)—his generals put the conqueror's heirs to death and battled among themselves. Splitting the empire into three parts, they and

12.22 Lion capital, Ashoka pillar, Sarnath, Uttar Pradesh, India. Maurya period, mid-third century B.C.E. Polished sandstone. Height: 84 in. Museum of Archaeology, Sarnath. *Compare and contrast Ashoka's third-century B.C.E. lion capital with the fifth-century B.C.E. lion capital (11.23) from the Persian imperial city of Persepolis. Can you make the case that the style and subject matter of the Persian capital influenced the Indian Mauryan capital?*

their descendants established ruling dynasties: the Ptolemies in Egypt, the Seleucids in the Middle East, the family of Antigonus II Gonatus in Macedonia. For the next 300 years, ancient Greek culture, now a worldwide phenomenon, offered a command performance historians call the Hellenistic Period.

The Hellenistic Period (323–31 B.C.E.)

The Hellenistic world of the third through first centuries B.C.E. was much more international and intercultural than the Classical and Archaic Greek worlds that preceded it. Greek culture impacted India and Egypt, and the cultures of Asia and Africa in turn influenced Hellenism. The commercial dynamism and cross-cultural ferment, the diversity and expansiveness, along with the turmoil and instability of the times, are reflected in the art of the period. The wide-ranging works embody both the continuity of tradition and much change. Throughout the period, the classical style continued to evolve; the coin featuring Alexander the Great's profile is a good example. At the same time, interest in a broader range of human life, befitting a cosmopolitan empire made up of many peoples and cultures, emerged. More significant representations of female goddesses, women, and lower-class persons (a hardened boxer, an aged market vendor), along with more varied human psychological states, found their way into works of art.

In a Roman marble copy of a famous Greek sculpture of Aphrodite, the goddess of love, the classical style itself expands sensuously. The first love goddess nudes, created in the late fourth century B.C.E., were classically idealized, rather chaste and restrained in their sexuality; The *Aphrodite of Knidos* by Praxiteles, Alexander the Great's favorite sculptor, is an example. In contrast, the *Medici Venus* **(12.23)** is more sexually suggestive. (Venus is the Roman counterpart of Aphrodite.) It is also a later creation, probably from the third or second century B.C.E. Comparing the *Medici Venus* to the earlier *Aphrodite of Knidos*, art historians Hugh Honour and John Fleming write that "the rendering is less idealized—more fleshy and malleable—and there is a hint of self-conscious coquetry in the turn of the head and almost alluringly defensive gesture." Consider the gesture. Do the hands of Venus lead the viewer's eyes to the sexual areas of breast and genitals, or do they chastely cover them? Has the sculptor posed the love goddess for the pleasure of the male viewer? Whatever they signify, the pose and gestures of these

Hellenistic Aphrodites and Venuses became the love goddess archetype. Sculptors and painters would build upon these sculptures in their renditions of "the nude" for centuries to come (6.27).

In addition to the expansion of the classical style, the Hellenistic period gave rise to a new and quite different style. Some have called it anticlassical and have used terms such as expressionistic, romantic, and baroque to describe it **(Interaction Box).** Consider *Laocoön and His Sons* **(12.24),** a bold embodiment of this new style. The larger-than-life-size sculpture is believed to be a Roman marble copy of a Hellenistic original or an original Roman work based on the new Hellenistic style. What we first experience in the sculpture is struggle, gut-wrenching tension, and agony—decidedly unclassical emotions. What has happened to calm grandeur and noble restraint (12.18)? Faces grimace, muscles bulge and strain, torsos contort. These are still strong, athletic nude bodies, but we can no longer admire them dispassionately for their idealized beauty. Emotions overwhelm us, and we are forced to identify with these victims of a cruel fate: gods allied with the Greek side brutally murdering the Trojan priest for attempting to warn his countrymen of a surprise Greek attack. The sea serpents, the Roman poet Virgil (70–19 B.C.E.) tells us:

> . . . seize and bind in mighty folds; and now, twice encircling his waist, twice winding their scaly backs around his throat, they tower above with head and lofty necks. He the while strains his hands to burst the knots, his fillets steeped in blood and black venom; the while he lifts to heaven hideous cries, like the bellowings of a wounded bull. . . .[2]

War, death, and suffering, reflective of the tumultuous era, are often subjects of the dramatic and tragic Hellenistic style. The titles of some of the most famous works of this period—*The Dying Gaul*, *Gallic Chieftain Killing His Wife and Himself*, *Athena Attacking the Giants*—speak to this tumult. Certainly anticlassical, the expressive style of these works, like that of *Laocoön and His Sons*, features motion and emotion, exaggeration, and theatricality. These qualities parallel the dynamism and turmoil of the contemporary Mediterranean world.

12.23 *Medici Venus.* Third century B.C.E. to first century C.E. Marble. 60¼ in. Galleria degli Uffizi, Florence. *What, if any, connections do you perceive between the Venus/Aphrodite nude figure and worldwide fertility goddesses (11.17, 11.11, 11.7), including those stretching back thousands of years? How has the concept of fertility been modified or redirected in the Hellenistic female nude?*

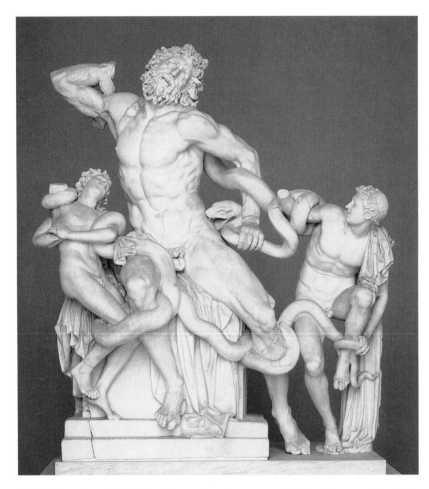

12.24 *Laocoön and His Sons.* Second century B.C.E.–first century C.E. Possibly Roman copy of a Greek original by Agesander, Athenodorus, and Polydorus of Rhodes. Marble. Height: 96 in. Musei Vaticani, Rome.

By the time the *Laocoön* sculpture was made, Roman armies had completely conquered Greece and the Roman Empire had been declared. By 31 B.C.E. the Hellenistic period had come to an end. Yet culturally Hellenism carried on, as the mixed Greek-Roman authorship of the *Laocoön* sculpture shows. Rome may have vanquished Greece, but Greek culture in turn had conquered Rome.

ROMAN ART AND ARCHITECTURE

Given the extraordinary achievements of the ancient Greeks, it is no wonder that the inhabitants of the nearby Italian peninsula, Etruscans

and Romans among them, came to embrace many elements of Greek culture and art as their own. But before Greek culture captured the Romans in the second and first centuries B.C.E., Etruscan civilization was their leading model.

The Etruscans and Their Art

Ultimately eclipsed by the rising star of Rome, the Etruscans for centuries shared the Italian peninsula with the Italic tribes (Latins, Romans, Sabines, and others) who, like themselves, would be absorbed into the Roman cultural and racial identity. Master builders and engineers, bronze casters, lovers of jewelry and sensual pleasures, the versatile Etruscans lived in well-fortified city-states in north-central Italy in a region called Etruria (12.25). The Etruscans were culturally advanced and influenced the early Romans in the areas of architecture and engineering, religion, representative government, the celebration of military victories with the processional march, and public games. A cosmopolitan people, they themselves were influenced by the dominant Greek culture, as well as the cultures of Egypt, Asia Minor, and the Near East. After 500 B.C.E., they would come increasingly under the influence of the rapidly developing Roman culture as well.

Because little of their written work has been found or translated, much of what we know about this mysterious people comes from their tomb sculptures and funerary art, which includes wall paintings and sculptures in the round and in relief. Subject and mood range from profuse party merriment to spare and poignant seriousness. One fifth-century wall painting in a room-size tomb (12.26) shows light-skinned women and dark-skinned men in mixed frontal-profile poses, Egyptian-style, engaged in energetic banqueting. Stylistically and culturally, the work also recalls Minoan (12.14) and Greek painting (12.17). Eating, drinking, conversing—a very good time is being had by all, a condition the patron clearly hoped would continue in the afterlife. In contrast, the sculpted lid of a later Etruscan stone coffin (12.27) from 300–280 B.C.E. presents a man and a woman asleep. In the ancient world, sleep and death were closely

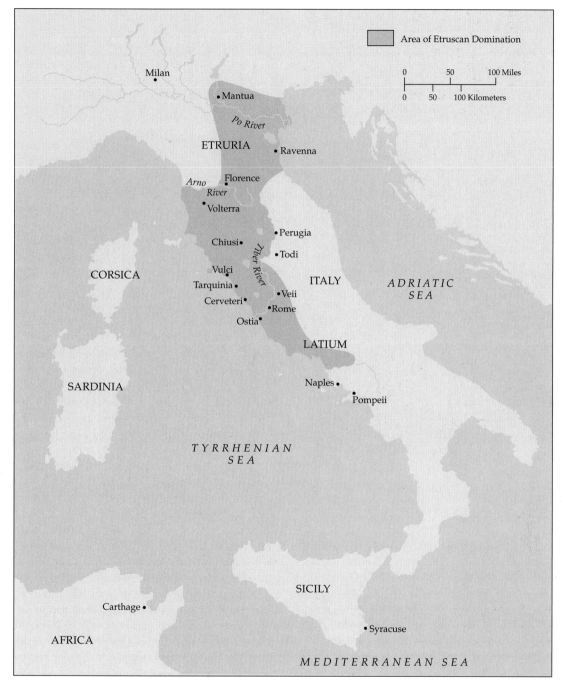

12.25 Map of ancient Italy.

associated; in Greek mythology, they are twins. The man and woman lie on the lid of the limestone coffin or sarcophagus. A thin blanket covers them. They embrace tenderly, resting on their bed, just as they might have done during years of life together. Do they appear asleep or awake? Are they whispering endearing words? Are they gazing into each other's eyes? People of middle age and in good health, the loving pair must have been wealthy aristocrats. The stone carver presents them as equals, a reflection of the fact that women enjoyed a high status in Etruscan society. The sculptor also presents the woman and man with a kind of documentary realism, as individual persons, a way of portraying people shared by later Etruscan and early Roman artists.

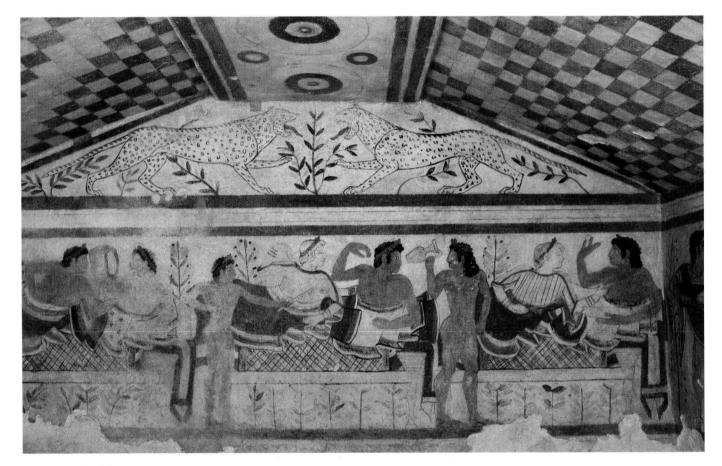

12.26 Tomb of the Leopards, Tarquinia, Italy. 480–470 B.C.E. Fresco.

Republican Portraiture (509–31 B.C.E.)

A Roman sculpture **(12.28)** made more than a century later, by an Etruscan artist for a Roman patron, has an even more true-to-life quality. A man is speaking to a crowd or assembly and trying to convince them with his arguments— no emotional theatrics as in the *Laocoön* sculpture (12.24), just simple, direct talk. This straightforward documentary style—reflecting the steadfast Roman virtues of honesty and seriousness—would be prominent in Roman portraiture for centuries. Such accurate rendering and faithful portrayals of individuals may have derived from Roman veneration of their ancestors and the practice of making death masks of deceased relatives. Standing erect, his left leg slightly bent and forward, the folds of his toga flowing downward toward his leather boots, the man beckons and salutes the crowd with his outstretched arm and hand. You can

And the very best deeds are those which serve your country.—Roman statesman Cicero, *On the Good Life,* mid-first century B.C.E.

almost hear him saying "Friends, Romans, countrymen, lend me your ears." The subject, in fact, is a Roman official during the Republican Period (509–27 B.C.E.), the centuries during which Rome was governed by an elected senate, a representative body of aristocratic citizens, and popular assemblies that included the common people. The original context of such large statues, the Roman writer Pliny the Elder relates, was at the tops of columns, with the whole structure functioning as a public memorial to the individuals portrayed. The speaker's name, Aulus Metellus (in Latin), is inscribed in Etruscan letters on the hem of his toga. Aulus Metellus might be addressing a mixed Roman-Etruscan audience, because by the early third century B.C.E.—the years during which the earlier limestone tomb sculpture (12.27) was made—Roman republican governance had been extended to the Etruscan city-states; by 90 B.C.E., around the time the *Aulus Metellus* statue was made, the Etruscans had

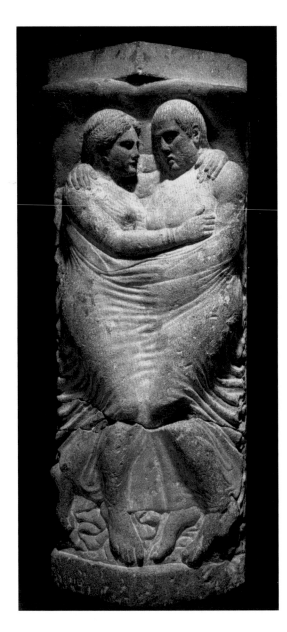

12.27 Sarcophagus and lid with representations of husband and wife, from Vulci, Italy. Late fourth or early third century B.C.E. Peperino (volcanic stone). 34⅝ × 28¾ × 82¹¹⁄₁₆ in. Gift of Mr. and Mrs. C. Cornelius Vermeule III, by exchange 1975.99. Museum of Fine Arts, Boston. *It is easy to stereotype the art of a given people. Many art historians today seek complexity and nuanced subtlety as opposed to clear-cut pronouncements and possible oversimplification. What do the form and content of this sarcophagus cover and the tomb painting (12.26) say about the complexity and range of Etruscan art and culture?*

12.28 *Aulus Metellus,* found near Perugia, Lake Trasimeno. Late second–early first century B.C.E. Etruscan. Bronze. 71 in. Museo Archeologico Nazionale, Florence. *Stylistically, how is the Roman orator similar to and different from the figures depicted on the Etruscan sarcophagus cover (12.27)? Does Aulus Metellus share any common ground at all with the almost contemporary Greco-Roman Laocoön figures (12.24)?*

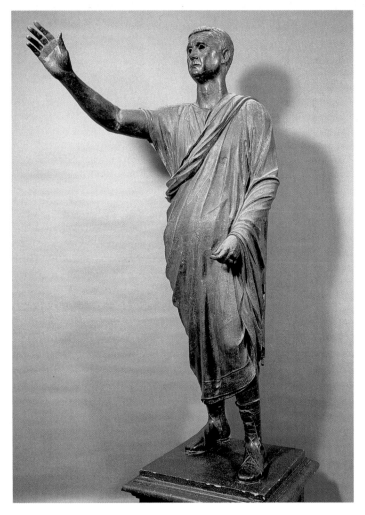

been absorbed into the Roman mainstream as full citizens.

As a companion to this typically realistic portraiture style, the Romans would soon offer their version of the Greek classical style. Two centuries of Roman political control over the Greek city-states and extended contact with Hellenic culture had had their effect. As the Romans swept across the Greek mainland and islands, Asia Minor, and the eastern reaches of the Hellenized empires, they were smitten by Greek culture. There would be no bigger fans of Hellenism than the first Roman emperors.

12.29 *Augustus of Prima Porta.* Early first century C.E. Marble. 80 in. Vatican Museums, Rome.

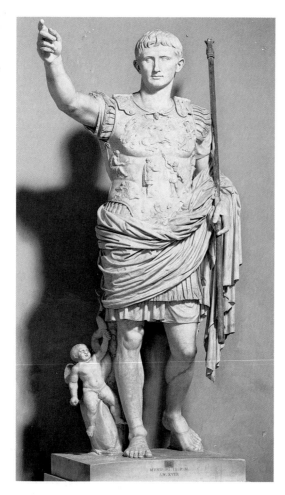

Captive Greece captured her savage conqueror and brought arts in rustic Latium [the territory of the Romans].—From a letter (*Epistles II*) by Roman author Horace to the Emperor Augustus, late first century B.C.E.

The Art of the Empire
(31 B.C.E–337 C.E.)

Earlier, we noted that the Romans created numerous marble copies of famous Greek sculptures, such as the *Doryphoros* (12.18). They went on to pattern many of their own sculptures after classical Greek models. A statue of Emperor Augustus (63 B.C.E.–14 C.E.) **(12.29)** appears to be an imperially clothed version of the *Doryphoros*. The face might be that of Augustus, but the overall pose, style, and ideal clearly derive from the *Doryphoros*. At the same time, this is very much a Roman statue, with its realistic portraiture and practical sense of purpose. Augustus gestures to his Roman audience in the traditional pose of a learned orator (12.28). His armor, filled with symbols and stories, speaks of his divinely sanctioned power and his achievements as a military commander. Augustus's features might be some-

what idealized, but he still comes across as a flesh-and-blood leader who both commands and reaches out to his people. A bit like the idealized sculptural portrayals of our own presidents George Washington (15.19) and Thomas Jefferson, *Augustus* is both a realistic portrait and an idealized patriotic presentation. Pragmatic public relations at its best, it presents a confident and noble commander-in-chief worthy of his subjects' loyalty.

In large sculptural friezes, the Roman emphases on realistic portraiture, historical narrative, and public relations are much in evidence. Witness a section from the relief sculpture on the side of the Ara Pacis **(12.30)**, or Altar of Peace, in Rome. The Ara Pacis was commissioned by Augustus as a war memorial to the military conquests that secured peace and stability for the empire. A great public monument, its purpose was to celebrate and commemorate the new Pax Romana (Roman Peace) that would ultimately last for almost two centuries. The scene of the Imperial Procession portrays royal family members so realistically that scholars have proposed specific identities. The woman in the center is probably Livia, the accomplished and highly influential wife of Augustus. Next to Livia on the right is her elder son Tiberius, the future emperor. Small children, also identifiable, hold on to their parents' arms, legs, or tunics and assume lifelike poses. The emphasis on mothers and children in such a famous public monument had a definite purpose. Livia and Augustus desired to promote private family life in the empire and enacted laws and commissioned public art to this end.

Portraiture likewise held an honored position in Roman painting. The love of portraiture is related to the Roman veneration of family line and a desire to capture or immortalize in likenesses the history of the family over the generations. It also reflects a worldly attitude that emphasizes the physical certainties of this life over the uncertainties of an afterlife. In a typical Roman portrait **(12.31)** from the first century C.E., a fashionable young woman looks out at us, stylus in hand. She appears to be thinking about the words she will write in her wax writing tablets. After perfecting her text on such tablets, the young woman would copy her words onto expensive papyrus or

12.30 South side of the Ara Pacis, detail of an imperial procession, Rome. 13–9 B.C.E. Marble relief. Height: approx. 63 in.

parchment. As her portrait and the frieze depicting Livia show, women of the privileged classes could attain both a high degree of education and participation in various sectors of Roman life. Lifelike and illusionistic—the three-dimensional modeling and shading are superb—the painting functions almost like a contemporary snapshot. It presents us with a thoughtful individual, a person who seems not all that different from ourselves. In both its official public portrayals and its intimate private portraits, Roman art, in paintings and sculptures, presents us with styles and subjects that seem remarkably "modern" and have much in common with our own world.

The same might be said of Roman architecture and engineering, whose creative forms are very much with us today. In chapter 10, we noted the remarkable originality of Roman builders in their structural innovations of the arch, vault, and dome. The Pont du Gard (late first century B.C.E.), the Markets of Trajan (100–112 C.E.), the Pantheon (ca. 120–127 C.E.), and the Basilica of Maxentius (307–312 C.E.) represented a completely new type of architecture (10.18, 10.19–10.22). The earlier architecture of ancient Egypt (12.9) and Greece (12.19)

12.31 *Young Woman with a Stylus*, detail of a wall painting, Pompeii. Late first century C.E. Diam.: 11⅜ in. Museo Nazionale Archeologico, Naples. *Many people find parallels between ancient Roman civilization, its rise and fall, and our own. Can you find parallels between Roman art and North American art (from the early years of democratic and republican self-rule to the present)?*

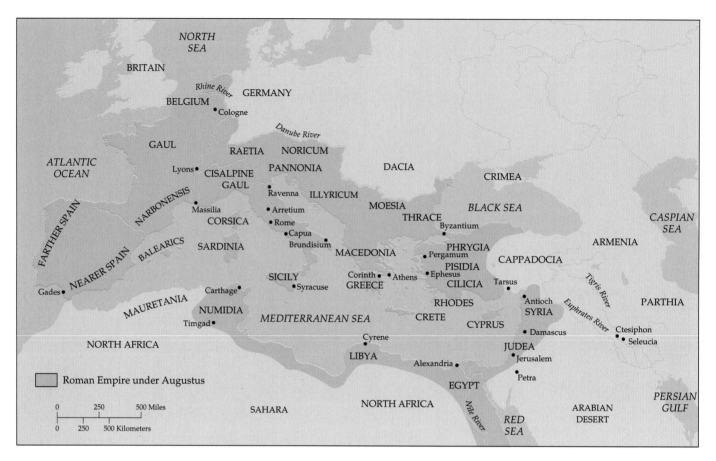

12.32 Map of the Roman Empire.

had been essentially an art of mass; space was simply what was left over or left between massive horizontals and verticals. By contrast, Roman building became an architecture of space, with structure conceived as a flexible shell molding the interior space into whatever form was desired. In this regard, it was primarily an urban architecture. The Romans constructed their well-planned, gridded cities across the empire **(12.32)**, from Western Europe to the Near East to North Africa **(12.33, 12.34)**. A municipality of 1 million, Rome itself **(12.35)** was the largest, most dynamic and cosmopolitan city of the time, a kind of New York City and Washington, D.C., combined. Like New York, Rome was an intercultural mixing bowl with big-time popular entertainments and the most sophisticated arts, extremes of wealth and poverty, and people of diverse race and language crossing paths daily. Rome was also the political capital of a worldwide empire, much like Washington, D.C., which in architectural and governmental terms saw itself as a new

Roman Republic being established in the woodlands of America.

Following the two centuries of the Pax Romana, what had been a very large, effectively administered empire began to decline. Rome in the third century experienced almost perpetual crisis. Rebellions of subject peoples from within and invasions of foreign invaders (so-called barbarians) from without threatened stability. Traditional spiritual beliefs were challenged by assorted religions—Christianity, popular among the poor; Persian Mithraism, favorite of soldiers; and Egyptian and Greek mystery cults (20.5), practiced among diverse sectors of society. Division on all fronts, cultural, political, and economic, began to dissolve the glue of Roman solidarity and undermine moral fiber. Retaining the throne became a matter of naked force, succession by murder a regular habit. The "soldier emperors," mercenaries from the outlying provinces, followed one after another at brief intervals. The portraits of some of these men, like Philippus the

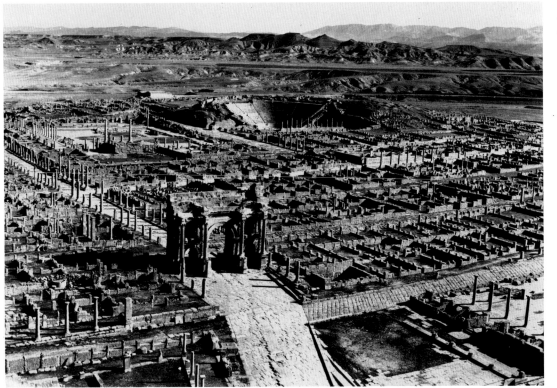

12.33 View from the west of the ruins of Timgad, Algeria. Early second century.

12.34 Plan of Timgad, Algeria. Early second century.

0 200 m
0 500 ft

Z

1 Forum
2 Theater
3 Arch

12.35 Reconstruction of the forums, Rome. Ca. 46–117 C.E., Museo della Città Romana, Rome.

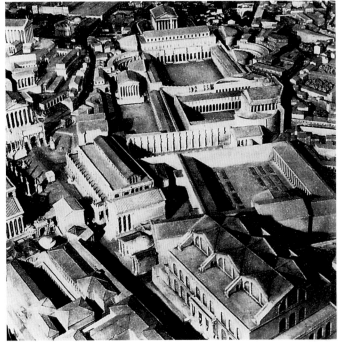

FORMALIST ART HISTORY IN ACTION

Different art historical approaches can be used to analyze and interpret any given work of art. One method is the formalist art historical approach, which focuses on the formal aspects of an artwork (line, color, shape, composition, technical execution) and the overarching concept of style in formal terms (that is, the recurrence of compositional and technical characteristics over time). With regard to style, a formalist art historian might emphasize the visual qualities that make the *Doryphoros* (12.18) classical and the *Laocoön* sculpture (12.24) anticlassical (or romantic, expressionistic, or baroque). Formalist art historians also like to look at specific styles across cultures or over

time, for example, how the early Greek classical style of the fifth century B.C.E. (of, say, the *Doryphoros*) is similar to or different from the late classical Hellenistic style of the Hellenistic period as embodied in the *Medici Venus* (12.23).

Looking at the subject of the married couple through the lens of formalism, compare and contrast the Old Kingdom style of the Pharaoh Mycerinus and Queen Khamerernebty statue (12.3), and the Amarna style of the Pharaoh Akhenaten and Queen Nefertiti sculptural relief (12.10). Compare and contrast these styles with the late Etruscan style of the husband and wife on a sarcophagus cover (12.27). What makes each style visually unique?

12.36 *Philippus the Arab*, 244–249 C.E. Marble. Height: 26 in. Vatican Museums, Rome.

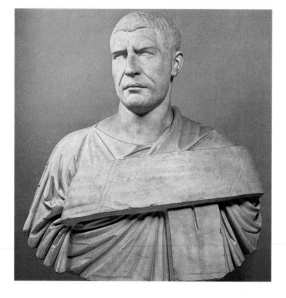

Arab **(12.36),** who reigned from 244 to 249 C.E., are psychological revelations—as they should be. Philippus murdered his predecessor and met his own end by assassination. Interpreting these troubled, brutally honest portrait busts, art historian H. W. Janson writes:

> Their facial realism is as uncompromising as that of Republican portraiture [12.28], but its

aim is expressive rather than documentary. All the dark passions of the human mind—fear, suspicion, cruelty—suddenly stand revealed here, with a directness that is almost unbelievable. The face of Philippus mirrors all the violence of the time. Yet in a strange way it also moves us to pity. There is a psychological nakedness about it that recalls a brute creature, doomed and cornered. Clearly, the agony of the Roman world was not only physical but spiritual. That Roman art should have been able to create an image of a man embodying this crisis is a tribute to its continued vitality.[3]

By the fourth century, even powerful and capable rulers could no longer hold together an overextended empire in decline. The most extraordinary of these rulers, Constantine (13.1), took the giant step of moving the capital from Rome to Byzantium, a city at the crossroads of Europe and Asia, which he would rename Constantinople after himself. In addition, Constantine embraced Christianity as the imperial faith, immediately transforming that once small, persecuted cult into a major worldwide religion. The development of a Christian art to accompany the newly institutionalized faith began within a Roman world in transition.

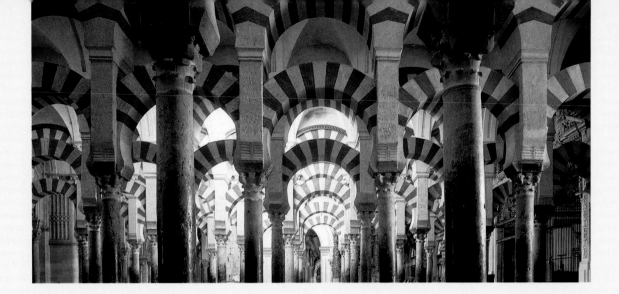

Early Christian, Medieval, and Islamic Art

13

THE RISE OF CHRISTIANITY AND CHRISTIAN ART

A Roman emperor, Constantine the Great (288–337 C.E.), paved the way for Christianity's rise as a major religion. In 313, his Edict of Milan legalized all religious practices in the Roman Empire, including that of the much-persecuted Christian sect. He himself adopted Christianity, and thereafter Constantine provided the former underground cult with substantial state backing. With his support and that of subsequent Roman emperors, Christian art—rudimentary, quickly executed, searching for an identity—left its hiding places and emerged into the light of day.

Constantine and Early Christian Art

An enormous stone head of Constantine **(13.1)** shows the first Christian emperor as a larger-than-life figure, a god-king like the pharaohs of ancient Egypt. Formal and frontal in presentation, like Ramses (12.11), the colossal idealized head became the standard for the representation of secular and divine rulers, including Christ himself, in early Christian art. Compared to the imposing portrait of Constantine—psychologically distant, almost "other worldly"—the portrayal of earlier Roman emperors, even idealized ones like that of Augustus (12.29), appears human and down-to-earth.

369

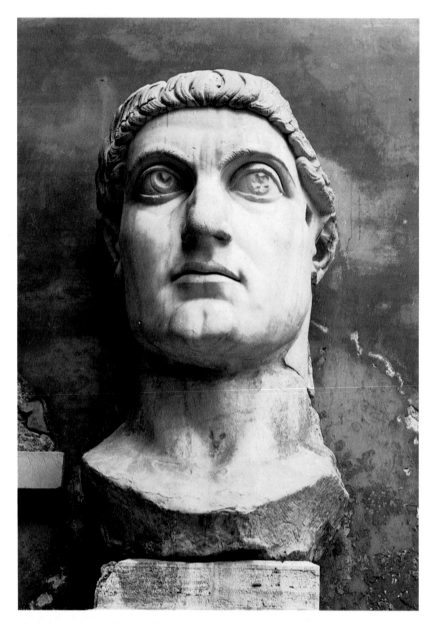

13.1 Monumental head of Constantine, from Basilica of Constantine, Rome. 313 C.E. Marble. 96 in. Palazzo dei Conservatori, Rome. *Can you think of instances in which huge statues of political leaders are sculpted for all the world to see? How are the meanings of these works similar to and different from the Constantine heads?*

The Christian emphasis on the afterlife notwithstanding, Constantine was very much a man of this world, an astute politician and master of public relations. To reinforce his worldwide decisions and authority, the emperor sent colossal imperial heads to his governors in various parts of Europe, Africa, and Asia, where they were attached to bodies that

were locally sculpted—effective Roman political communication in action. Once he had adopted Christianity himself, he sought to employ it as a unifying political and cultural force throughout the empire. Constantine apparently believed, correctly, that religion could unite diverse peoples, a fact Christianity, Judaism, and Islam have proved across nations and generations (though sometimes at the cost of religious intolerance and even violence toward others). His ambitious building projects involving Christian shrines and churches—which initially took the form of Roman basilicas or meeting halls such as the Basilica of Maxentius (10.19)—were meant to spur the practice of the religion. Through the agency of the emperor and his successors, Christianity soon took root in Rome and flourished from England to Africa.

A basic challenge for the fledgling religion was the establishment of an art appropriate for its rituals and mission. Prior to state legalization and support for Christianity, Christian art existed almost entirely in secret places. Early Christian visual symbols and roughly made paintings were executed in subterranean catacombs, where the sect buried its dead and held rituals **(Appreciation 25).** With Constantine's patronage, this renegade Christian art moved aboveground and took on a decidedly professional quality. For example, an affluent, high-ranking Roman official, Junius Bassus, commissioned an accomplished stonecarver to create a coffin, a sarcophagus richly adorned with Christian figures and stories, to carry him into the afterlife. In one of ten compartmentalized scenes on the sarcophagus's side **(13.2),** Christ, in the role of divine king, sits on a heavenly throne between richly decorated Roman Corinthian columns. He wears the pallium, a type of Greek robe associated in Italy with philosophers and teachers. He is not, however, bearded like a philosopher but has a fresh adolescent face. The sculptor seems to have taken a Greco-Roman deity such as Apollo, "the shining one," as his model. Christ is surrounded by robed disciples, teachers of the faith. The larger scroll in Christ's hand and the smaller one held by a disciple speak to their mission of educating and saving the masses. Naturally, the artist employed the popular Greco-Roman style—classical, idealizing,

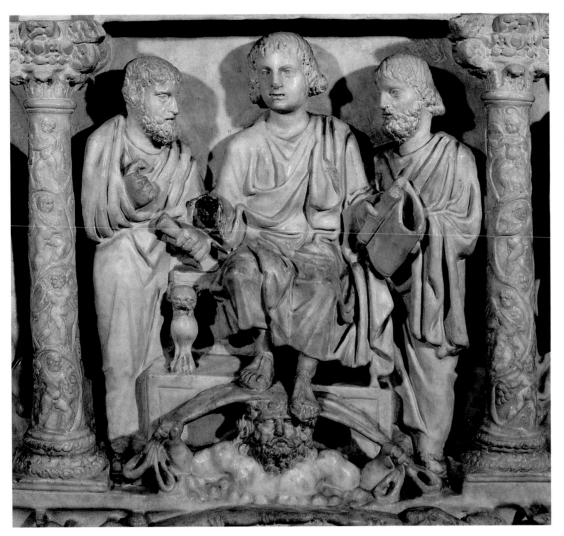

13.2 Sarcophagus of Junius Bassus, detail of Christ between two apostles. Ca. 359 C.E. Marble. Approx. 24 × 24 in. Vatican Grottoes, Rome.

humanistic in orientation—with which he was familiar. As art historian H. W. Janson writes, with a formalist focus:

> The figures in their deeply recessed niches betray a conscious attempt to recapture the statuesque dignity of the Greek tradition. Yet beneath this superimposed classicism we sense a basic kinship to the Constantinian style [13.1] in the doll-like bodies, the large heads, the oddly becalmed, passive air of scenes. . . .[1]

Because no official Christian visual language yet existed, early Christian art was a curious, even contradictory hybrid: Christian subjects and content presented through pagan styles. It would be some time before Christian art would develop a formal language and stylistic identity of its own.

With the political-military breakup of the Roman Empire by the early fourth century into eastern and western halves, Christianity itself underwent its first major cultural and artistic split. The Church of Rome and "Roman Catholicism" came to dominate central and western Europe, while the Greek-influenced Eastern Orthodox Church based in Constantinople (Constantine's capital city) reigned in Greece, eastern Europe, Asia Minor, and Russia. For over ten centuries, Constantinople (modern-day Istanbul in Turkey), located at the strategic crossroads of Europe and Asia, ruled as the central city of the eastern Roman or "Byzantine" Empire. (The term *Byzantine* is derived from Byzantium, the ancient Greek city that Constantine renamed Constantinople in 330 C.E.)

Constantine Augustus built the basilica of blessed Peter, the apostle [of Jesus and founder of the Christian church], . . . and laid there the coffin with the body of the holy Peter; the coffin itself he enclosed on all sides with bronze. . . . He made a vaulting apse in the basilica, gleaming with gold, and over the body of the blessed Peter, above the bronze which enclosed it, he set a cross of purest gold. . . .—The Book of Popes, official history of the Roman papacy from the first through the twelfth centuries

The Good Shepherd, *Ceiling Fresco, Catacomb of Saints Peter and Marcellinus, Early Fourth Century* C.E.

CHARLES R. JANSEN

Look at the image of the Good Shepherd, simply painted with thin, sketchy strokes **(Fig. A).** We see a man with a sheep over his shoulders standing between other sheep in a barely visible landscape. This is the central image in a ceiling divided to make a cruciform design. Around the ceiling's edges we also see other loosely defined figures: three images telling the story of Jonah and the whale as well as standing figures praying in an ancient fashion. Such images commonly decorated the labyrinthine, underground cemeteries dug principally from the late second through fifth centuries of the Common Era (C.E.) in many cities around the Mediterranean. Although the catacombs (as they are called) collapsed long ago in most cities, a quirk of geology in the form of volcanic soil called tufa has preserved some 60 miles of catacombs in the city of Rome where some three-quarters of a million Christians, Jews, and some pagans were buried by the end of the fifth century C.E.

Can an artist of evidently modest ability and perhaps limited training nevertheless produce artwork worthy of admiration? The artist surely worked hastily in dark, cold, damp places that smelled of death to paint oft-repeated images; some 120 images of the Good Shepherd survive in catacombs. Yet the imagery and its execution in this Early Christian tomb decoration nevertheless seem remarkably apt, and emotionally potent.

Jews and Christians found the Roman custom of cremation distasteful, in part because pagan practices reminded them of pagan op-

pression. But Christians especially preferred burial because of the promise of resurrection and eternal life at the time of the Second Coming when Jesus would return to judge all souls after first restoring them to life, just as Jonah was restored after three days in the belly of the whale. Both the Biblical story of Jonah and Biblical references to Jesus as a Shepherd caring for His flock pointed to this Christian promise of salvation from death.

Unlike Greeks and Romans, Early Christians did not embrace this earthly life. Especially during periodic Roman persecutions of Christians, this life was fraught with insecurity, fear, and suffering. As a result, Early Christians came to shun the world, seeing it as essentially evil, a devilishly cruel test of faith on the way to the promised heaven. Early Christian artists therefore cared much less about the details of physical reality than Greco-Roman artists had. A sketch would do since, after all, it was only a symbol of what really counted: the ideas of sacrifice and salvation, the root notions of the Christian faith.

Catacomb images like the Good Shepherd are among the few records of the early phases of the Christian faith and rare evidence of what Christians believed before there was a standard Bible or an agreed upon creed, an established institutional structure for the faith, or any image of Jesus. It is worth noting that the Good Shepherd image goes back many hundreds of years before Christianity. As a pagan image, the Good Shepherd conveyed associations of country life (so popular as a theme in decorating Roman houses) and symbolized philanthropy. When Christians adopted it and put it in the context of Christian burial sites, the idea of philanthropy expanded into the notion of a giving Christian God, offering grace in this life and salvation in the next.

Charles R. Jansen is a professor of art history at Middle Tennessee State University in Murfreesboro.

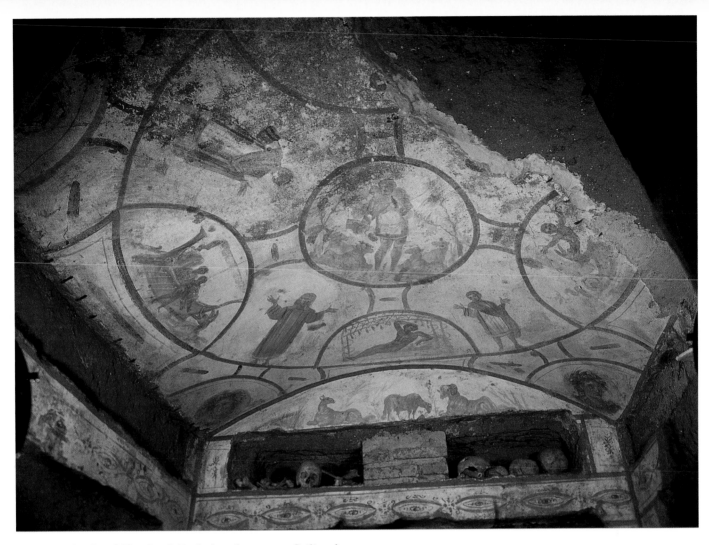

Figure A The Good Shepherd. Early fourth century. Ceiling fresco. Catacomb of Saints Peter and Marcellinus, Rome.

But perhaps more important to appreciation than these historical and doctrinal factors is the human determination to honor family and the rituals of life that these sites represent. Although relatively few of the tombs in the catacombs have any decoration, those that do exhibit loving inscriptions, sometimes a few cherished artifacts that belonged to the deceased, and perhaps images of comfort like the Good Shepherd representing the promises of faith—as much a comfort to the living in their farewell as to the dead. There is the story of a grave site in a Jewish catacomb where a father writes on the sealing stone of his son's grave how he wishes he could bury his boy in a gold coffin, calling him the sweetest child. Here, those whose significant personal moments were literally driven underground because of misunderstanding and persecution nevertheless express what is deeply human and shared by us all.

Even though the images and their execution seem crude, by assuming they had meanings for a larger community we still may find ways to open up the images and find what that community believed, experienced, and valued. In the process, we are opened to discovery and learning and connections at deeper levels that magnify an artwork's value, thereby enhancing appreciation. ▪

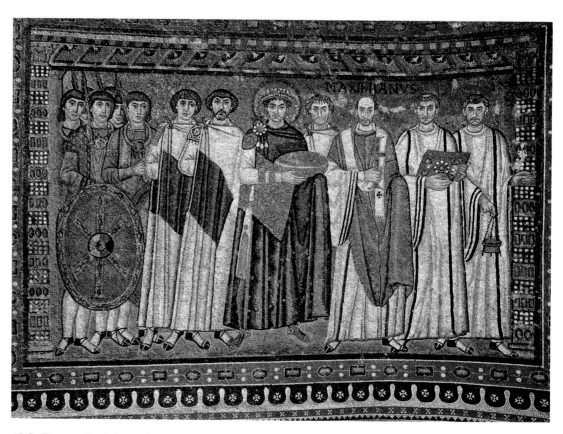

13.3 *Emperor Justinian and His Attendants*, apse mosaic, San Vitale, Ravenna, Italy. Ca. 547. *Compare and contrast Justinian's commissioning of mosaics of himself and Empress Theodora in a distant church with Constantine's shipping of colossal heads of himself around the empire. How might the difference in art form, mosaic versus carved stone head, foster a divergent meaning or effect?*

Byzantine Art

The all-powerful emperor of the first Byzantine golden age was Justinian (483–565 C.E.), who reigned long and supreme from 527 to 565. A tightly knit aristocracy of high-level church and state officials administered his earthly realm with authoritarian control. We observe Justinian at the center of a glittering mosaic **(13.3)** in the Church of San Vitale (Saint Vitalis) in Ravenna, on the northeast coast of Italy. The mosaic celebrates, in part, the triumph of Justinian over the forces of the Germanic Goths, who had conquered and ruled the Italian peninsula since 493. (The western Roman Empire had ceased to exist at this point, and the religious authority of Rome, as the center of western or Roman Christianity, was much weakened.) This and a companion mosaic of the Empress Theodora **(13.4)** across the sanctuary rededicate the church to the Eastern Orthodox faith of Constantinople. Flanked by soldiers, administrators, and high church officials, Justinian presents himself as a divine king sanctioned by Christ. To reinforce this politico-religious point, a halo of heavenly light circles the emperor's richly crowned head, associating him with Jesus and with divine light in general. He is flanked by twelve companions, the imperial equivalent of the twelve apostles or followers of Jesus. To Justinian's left are four high church officials, including Archbishop Maximian, whose name is inscribed over his head. To the emperor's right are two court officials and four members of his military guard grouped behind a shield bearing the monogram of Christ. The specific scene depicts the offertory procession, the part of the liturgy, or prescribed rituals, when the bread and wine of the Eucharist, the most holy Christian ceremony, are brought forward and presented. Justinian, in the role of priest-king,

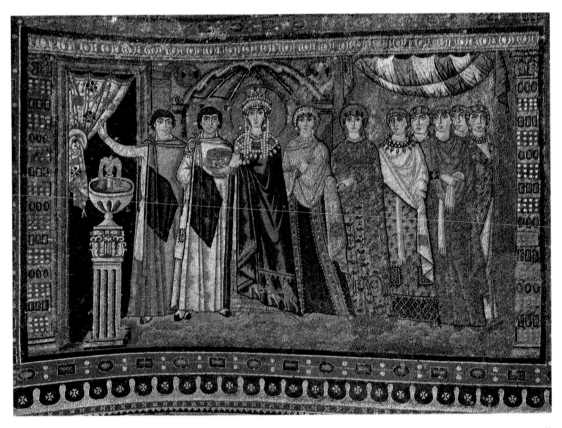

13.4 *Empress Theodora and Her Attendants,* apse mosaic, San Vitale, Ravenna, Italy. Ca. 547. *Can you tell anything about Theodora's personality from her portrayal in this work? If so, what? If not, why do you think the artist represented her in a way that reveals little about her as a person?*

carries a golden vessel containing the bread, sign of the body of Christ.

The figures and their arrangement are typically Byzantine in style: frontal, flat, and strongly outlined. The design is absolutely symmetrical, ordered, and hierarchical like the society itself. Justinian stands dead center, and all is oriented and unified around him. In this formal arrangement, the emperor is the clear authority. In a long tradition of royal portraiture reaching back to ancient Egypt (12.3), the bodies and poses are essentially ideal stereotypes created according to formulas. Yet a degree of Greco-Roman naturalism, observed in earlier portraits of Roman emperors (12.29), enters into the portrayal of the faces of the emperor and of the church and court officials.

Directly across from Justinian and his retinue is the mosaic featuring his coregent, the Empress Theodora, and her retinue. Whereas Justinian is presented as Christ's divine repre-

sentative on earth, Theodora is associated with his mother, the Virgin Mary. On the hem of Theodora's mantle is embroidery showing the three Magi carrying their gifts to Mary and the Christ child. Her gesture of offering the gold chalice in the offertory procession is echoed by the Magi offering their gifts to Mary and Jesus. The empress's chalice is filled with wine, sign of Christ's blood. She joins the emperor in completing the holy ritual of the Eucharist. Bread and wine, body and blood, are brought together in remembrance of the death and resurrection of Christ. As the mosaic indicates, Theodora functioned as a virtual equal to Justinian in administering the religious and political life of the empire.

As an art form, **mosaic** was ideally suited to portraying the imperial and heavenly courts. Byzantine mosaics are made up of small pieces of colored stone and glass (some containing gold leaf) carefully inlaid into moist

13.5 Anthemius of Tralles and Isidorus of Miletus. Church of the Hagia Sophia, Constantinople (modern Istanbul, Turkey). 532–537. The original church is now surrounded by later additions, including the four minarets built under the Ottoman Turks after 1453.

cement or plaster on a wall, ceiling, or floor. An art form of great permanence remains when the cement dries. The small pieces (or **tesserae**) combine like atoms of color to create a vision of the imperial couple and their retinue as simultaneously worldly personages and divine luminaries. The figures of Justinian, Theodora, and Christ (on the domed ceiling) emerge from a golden background glow, symbolic of heaven. Purposely tilted and irregularly placed, the tiny bits of color sparkle as light hits them. Justinian, Theodora, and Christ above them are "illuminated" by the play of reflected light.

Whereas the Church of San Vitale in Ravenna was a beautiful outpost of Christianity at the western edge of the empire—Justinian and Theodora never actually visited it—the Church of Hagia Sophia (Holy Wisdom) **(13.5)** was situated at its very center. The main church in the capital city of Constantinople, the Hagia Sophia was built by Justinian to

serve himself, the imperial court, and the religious leadership of the empire. After every Eucharist or Holy Communion service, the emperor and the patriarch, the supreme religious leader, exchanged the kiss of peace, affirming the theocratic nature of the Byzantine Empire, where the church and the state were one.

Scholar Margot Bergman notes that many features of the Hagia Sophia interior serve to "dematerialize" its physical weight and mass. A ring of windows around the base of the dome, set seamlessly on triangular **pendentives** over a square base, make it seem to hover weightlessly over the nave space. The light that enters, as divine illumination, falls in shafts across an atmosphere filled with incense and smoke to be reflected by walls on which gold mosaic tiles enchant the eye with their infinite shimmering **(13.6).**

Although only royalty were allowed to enter the sublime inner sanctum of the Hagia Sophia, all others could experience its external beauty and grandeur. Built on a high ridge, the enormous domed building could be seen throughout Constantinople and far out to sea. Such focus on the dome as a major external feature was new in Western architecture. Buildings such as Rome's Pantheon (10.21) did feature the dome on the inside but deemphasized or hid it on the outside. The Hagia Sophia changed all that. Impressive beyond all other buildings, the Hagia Sophia communicated the power and wealth of the theocracy to the populace. Architecturally, it commanded their loyalty. If the citizens of the empire were to prosper in this life and the next, they must follow the teachings and values of those who could erect such a magnificent structure. An eyewitness account of the grandeur of Constantinople and its churches comes from French nobleman Geoffroy de Villehardouin, a participant in the fourth and final Crusade to wrest Jerusalem and the Holy Land from the Turks. The year is 1202. The first sight of the city, de Villehardouin writes, took each soldier's breath away: "They noted the high walls and lofty towers encircling it and its rich palaces and tall churches of which there were so many that no one would have believed it to be true if he had not seen it with his own eyes and viewed the length and breadth of that city which reigned supreme above all others."

When the Ottoman Turks conquered Constantinople in 1453, they were so impressed with Hagia Sophia that they converted it into a place of worship to the glory of Allah, their name for God. The replacement of Christian mosaics with Islamic decoration and scripture and the addition of large circular shields to the walls, inscribed with the names of Allah and his prophets, are signs of this transformation.

Christian Art in Europe: The Early Middle Ages

The "Middle Ages" is a modern historical construct. Since the nineteenth century, scholars have defined the Middle Ages or medieval (middle age) period as the 1,000-year period in Europe between the fall of the western Roman Empire in the fifth century and the rise of the Italian Renaissance in the fifteenth. For much of the Middle Ages, Europe was dominated by feudal lords who followed Christianity. (*Feudalism* is defined as the economic, political, and social organization of medieval society in which land, worked by serfs attached to it, was held by lesser lords or vassals in exchange for military and other services given to overlords.) Feudal rule was fragmented among numerous kingdoms, dukedoms, principalities, and lesser lordly entities that often warred with one another. A multitude of distinct cultural and racial groups further divided the continent. Compared to the Byzantine Empire's highly unified theocratic state, governance in Europe was decentralized and often anarchic. Factions within church and state were forever shifting their allegiances. In England, France, and Germany, warlords frequently changed political-military-religious alliances for the sake of power and material gain.

Carolingian Art and Culture The first Christian king to unify the German and French nobility and provide a modicum of peace in Europe **(13.7)** was Charlemagne, or Charles the Great (742–814). In a ninth-century manuscript illumination **(13.8),** we see Charlemagne (or one of his line) surrounded by high churchmen who bless his office. In return for their blessing, he protects and supports their parish churches, monasteries, and nunneries. The leading defender of Western Christianity, Charlemagne

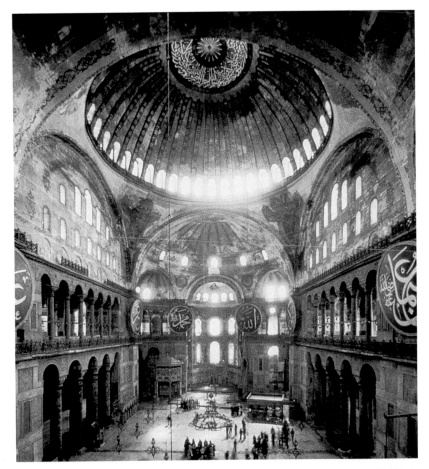

13.6 Interior, Hagia Sophia, Constantinople. 532–537.

employed diplomacy or military action to ensure that the polyglot Christian peoples from England to North Africa—those outside the control of the Byzantine Empire's Eastern Orthodox faith—followed the "Roman" creed.

Charlemagne became the closest thing to a theocratic emperor of the West. On Christmas Day 800, he had himself crowned "Holy Roman Emperor" in Rome. Note that in the manuscript illumination he is haloed and divinely crowned. The pope, highest official of the Western Christian Church, did the honors. A semblance of the old western Roman Empire was hereby restored, and Charlemagne became a kind of Constantine (13.1) or Justinian (13.3) of the Western Christian world. But the emerging European states were to prove far more difficult to unify and govern than the Byzantine Empire, and Charlemagne's empire, encompassing French, German, and Italian territories, quickly dissolved after his death. In

He paid the greatest attention to the liberal arts; and he had great respect for men who taught them, bestowing high honours upon them. . . . He learnt Latin so well that he spoke it as fluently as his own tongue; but he understood Greek better than he could speak it. . . . He also tried [unsuccessfully] to learn to write.—Einhard, author, The Life of Charlemagne, early ninth century

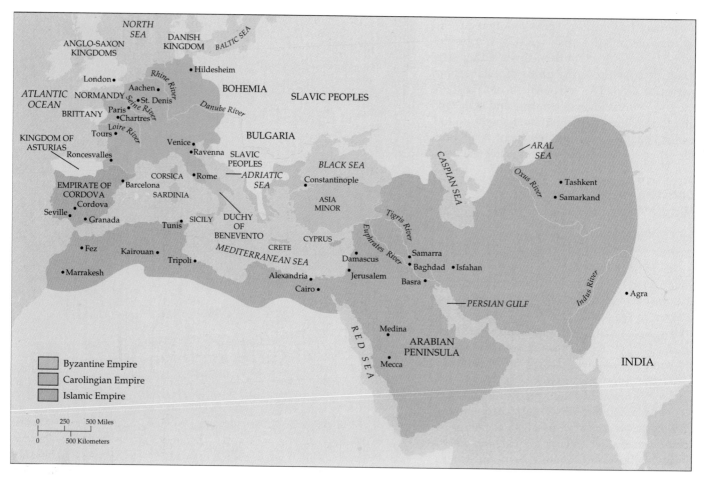

13.7 Map of the Byzantine, Carolingian, and Islamic Empires in 814, the year of Charlemagne's death.

13.8 Page with *Charlemagne between Pope Gelasius and Pope Gregory the Great* from the Metz Coronation Sacramentary of Charles the Bald. Bibliothèque Nationale, Paris, Ms. Lat. 1141, folio 2 verso.

short order, tumult and instability returned, exacerbated by sporadic attacks by Vikings from the Scandinavian northlands and Arab Islamic armies from the south.

During the Early Middle Ages (ca. 500–ca. 1100 C.E.), the most significant cultural achievements occurred during the reigns of strong rulers who could guarantee political and economic stability. The cultural and artistic achievements during the reign of Charlemagne and his relations, for example, were so substantial that this relatively brief period of a century or so has often been referred to as the "Carolingian Renaissance." (Carolingian, from Carolus or Charles, refers to the line of rulers—in particular Charlemagne—descended from Charles Martel.) The Carolingian cultural revival featured the development of schools throughout the empire to teach reading, writing, and other basic subjects to young people who would serve church or state (or both).

13.9 Page with *Saint Matthew* from the Coronation Gospels. Ca. 800. 13 × 10 in. Vienna, Schatzkammer, folio 15 verso.

13.10 Page with *Saint Matthew* from the Ebbo Gospels. Ca. 830. 10¼ × 8¾ in. Epernay, Municipal Library, Ms. 1, folio 18 verso.

These schools were most often headed by church officials and connected to a monastery, nunnery, parish church, or cathedral (the bishop's church). In addition to producing literate officials for the church and the state, the teaching of reading and writing enabled a small but growing army of copyists to preserve and pass on the texts of early Christian, Roman, Greek, and Hebrew authors—the so-called ancients. Executed in palace workshops or in scriptoriums (writing rooms) in monasteries and nunneries, these painstakingly written copies were carefully protected in church and state libraries. (How different from our contemporary world of copy machines and instant photomechanical reproduction!) Bibles, or sections of them, were copied in a fine Carolingian hand, the basis of our modern script. Artists illustrated or "illuminated" the manuscripts with miniature drawings or paintings.

Two depictions of Matthew, one of the twelve apostles of Christ, from New Testament "Gospel Books" show the range and richness of Carolingian art. Saint Matthew from the Gospel Book of Charlemagne (ca. 800–810 C.E.) **(13.9)** is based on early Christian or pre-Christian art from the ancient Roman world. The illustrator, probably from the palace workshop, modeled his Saint Matthew on earlier artwork(s) in the Greek (12.17, 12.18) or Greco-Roman classical style (12.30, 12.31). Combining naturalism with classical idealism, the illustrator presents Saint Matthew as serene, full-bodied, and dignified. Affirming the classical ideals of rational order and unity, emotional restraint and calm grandeur prevail. Created for Charlemagne and his imperial court, such a noble, classical portrayal would certainly have been in keeping with the overall image the emperor sought to project.

The second Saint Matthew **(13.10)**, from the Gospel Book of Archbishop Ebbo of Reims (ca. 816–835), presents a very different figure. Perhaps because it was made in a monastery workshop for a high church official, it was invested with a far more intense religious spirit. Descriptions such as nervous, agitated, excited, and inspired come to mind. Saint Matthew is engrossed in his writing, swept away by his recording of the words of the Lord. He bends his head and shoulders into his work. Draperies swirl. The landscape swells and bristles with energy. For the sake of

Craftsmen present in the monastery should practice their crafts with humility, as permitted by the abbot. But if anyone becomes proud of his skill and the profit he brings to the community, he should be taken from his craft and work at ordinary labor. This will continue until he humbles himself and the abbot is satisfied.
—St. Benedict of Nursia (ca. 480–550), *The Rule,* the regulations for the monks' daily lives

13.11 Bronze doors of Bishop Bernward, Hildesheim Cathedral, Germany. Completed 1015. Height: approx. 16 ft.

emotional expression, the artist has created a more abstract, antinaturalistic figure. Saint Matthew and his surroundings flatten out and meld together in a divine paroxysm. The Ebbo Gospel Saint Matthew introduces us to a northern European style and sensibility different from the two most influential artistic styles of the day, the Greco-Roman and the Byzantine. In the Ebbo Gospel, a new northern European spirit and style appear. Looking to their cultural and racial roots, twentieth-century northern European artists (7.24, 17.4–17.8) would find inspiration in the abstract, expressionistic, spiritually animated qualities of works like the Ebbo Gospels.

Ottonian Art and Aristocratic Culture
Something of this same northern spirit is seen in the art of the Ottonian Period (919–1024), named after the Saxon dynasty of King Otto I (the Great) and his two successors, Otto II and Otto III. Otto the Great, a ruler in the mold of Charlemagne, employed Christianity to unify the various German tribes under his theocratic dominion. Like Charlemagne, he had the pope crown him Holy Roman Emperor.

Strongly supported by the Ottonian dynasty, churches, cathedrals, and monasteries flourished, as did their art. Religious art in the West was clearly meant to be didactic; that is, its purpose was to teach and inspire the multitudes. For the great majority who could not read, a picture was indeed worth a thousand words. The bronze doors of Hildesheim Cathedral **(13.11)**, for one example, offer a most effective Christian education. In contrast to intimate manuscript illuminations for a small, privileged audience, these large public doors are a gigantic picture book for all to see. On the sixteen panels of the two doors, an entire biblical history is laid out. On the left-hand door, "reading" from top to bottom, the viewer experiences the creation and fall of man and woman. Sin has entered the world. But hope is not lost. Starting from the depths, from the bottom of the right-hand door, the viewer begins an upward journey toward salvation. Following the ascending narrative, humble peasant or mighty lord witnesses the birth of Christ, then His crucifixion and resurrection. The unfolding story educates the observer as to the possibility of redemption from sin.

The man who commissioned the doors and possibly designed and worked on them was Bishop Bernward of Hildesheim (ca. 960–1022), a former tutor of Otto III. According to one historian, Bernward was almost an embodiment of the culture of his age: a painter, calligrapher, metalworker, mosaicist, architect, administrator, saint. He was ideally suited to be overseer of the design and production of the large sculpted doors, the first sculpted metal doors cast in Europe since Roman times.

Note the panel *Adam and Eve Reproached by the Lord* (13.12). An angry God points the finger of guilt at a crestfallen Adam. Adam covers his nakedness with one hand and points accusingly toward Eve with the other. She, in turn, gestures to the dragonlike serpent at her feet. It is the snake, her body language tells us, that has seduced her into sin. Adam and Eve cringe in guilt and fear before the Lord. Tense bodies twist and turn. Agitated trees twirl, and foliage spirals. Even the background convulses with rough, crisscross textures. The same spiritual intensity and psychological expressiveness that animated the Ebbo Gospel Saint Matthew (13.10) have reappeared in three-dimensional relief form.

A century later, we find the same type of religious fervor, likewise communicated through abstract means, in the sculpted stone figures (13.13, 13.14) surrounding the main entrance doors to newly built Romanesque (Romanlike) churches (10.23) and cathedrals. What explains this continuity of content and style displayed by Bishop Ebbo's Carolingian Gospel Book (completed in 835), Bishop Bernward's Ottonian bronze doors (ca. 1015), and the Romanesque stone carvings on the Cathedral of Saint-Lazare, Autun (ca. 1135)? Contextually oriented art historians, especially those of Marxist persuasion (Interaction Box), argue that the three works show strong connections because they are the products of the same sociocultural order: a feudal society in which aristocratic church leaders—bishops, popes, abbots, abbesses—commissioned and directed artist-monks and nuns or laypersons under strict church guidance. "Feudal culture which is essentially anti-individualistic," writes art historian Arnold Hauser, "favors the general and the homogeneous in art as in other fields and strives for representation of the world in which

13.12 *Adam and Eve Reproached by the Lord*, and *Adam and Eve Expelled from the Garden of Eden*, panels from the Hildesheim Cathedral bronze doors, Germany. Completed 1015. Each panel approx. 23 × 43 in. *Various critics have argued that the Judeo-Christian placement of the responsibility for man's downfall primarily on Eve set the stage for the superior, leading role that men play and the inferior, secondary role that women play in western society and art. Is this biblically rooted inequality between the sexes evident in any of the artworks we've viewed so far? In answering this question, consider works that feature men and women alone and together.*

What Scripture is to the educated, images are to the ignorant, who see through them what they must accept; they read in them what they cannot read in books.—Pope Gregory 1 (reigned 590–604), from a letter to Serenus of Marseille

everything is stereotyped, the physiognomies as well as the draperies, the large gesticulating hands as well as the small trees [13.12]. . . ." The three works represent art of and by a learned clerical elite; whether the works are displayed on Ottonian church doors or Romanesque portals, it is clear that they are aristocratic church art.

Romanesque Art and Society: Pilgrimages and Crusades The message preached by the eleventh-century Hildesheim door panels (13.11, 13.12), to abstain from sin and place all one's faith in the Lord, intensifies in the twelfth-century Romanesque stone carvings (13.13, 13.14) that pound home the spine-chilling

The very sight of these costly but wonderful illusions inflames men more to give [money] than to pray. In this way wealth is derived from wealth. . . . O vanity of vanities . . . ! The Church is radiant in its walls and destitute in its poor. . . . It serves the eyes of the rich at the expense of the poor.—Saint Bernard of Clairvaux (1090–1153), *Apologia to Abbot William of Saint-Thierry*

13.13 GISLEBERTUS. *Last Judgment*, tympanum of west portal, Cathedral of Saint-Lazare, Autun, Burgundy, France. Ca. 1120–35. *Thinking in political and economic as well as religious terms, why did the Last Judgment become the dominant subject of Romanesque pilgrimage churches?*

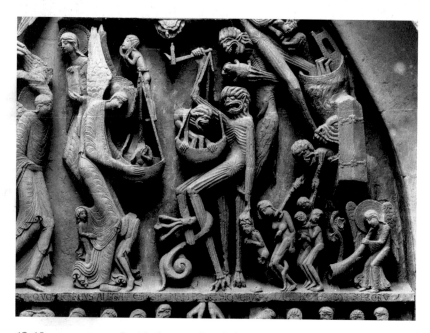

13.14 GISLEBERTUS. *Last Judgment*, detail showing the weighing of souls. Tympanum of west portal, Cathedral of Saint-Lazare, Autun, Burgundy, France. Ca. 1120–35.

consequences of sin and lack of faith: eternal damnation and hellfire. The deep relief carvings in the tympanum, the semicircular stone section over the main door of the Cathedral of Saint-Lazare, Autun, speak to this. An accompanying inscription reads "Let this terror appall all those bound by earthly sin." In a scene common to Romanesque church tympanums throughout France, the risen Christ sits in stern

judgment over all humankind. Such "Last Judgments" are the preeminent subject of Romanesque art. Elongated, flattened, and gigantic, Christ the imperious judge points with His right hand to the saved while His left hand indicates the damned. The blessed—including pilgrims to Autun and other churches (10.23) on the pilgrimage route—are assisted by angels and ascend to heaven. The damned, tormented by hideous demons, are thrust down to hell. As the dominant public art form in an age of faith, such sculptural programs on pilgrimage churches must have been frightening as well as awe-inspiring. As an undergraduate student wrote in her journal:

> The importance of the pilgrimage church during this period cannot be underestimated. Pilgrims went in droves to see the various holy relics housed in the churches. The buildings functioned as places of worship and meeting places for pilgrims. There they sought divine help, forgiveness, cures, salvation of the soul, and did penance. The pilgrimage itself transformed society, allowing for an exchange of goods and ideas, and money which helped to pay for the churches. As surrogate heads of power during the absence of large cities, the numerous pilgrimage churches across Europe became the intellectual seat of authority during this time.

Intertwined with the pilgrimage as a sociocultural force were the Crusades, a form of military pilgrimage to the "Holy Land" of Christ's

birth. Taking place between 1096 and 1270, the Crusades were a series of military expeditions, led by Europe's church-state aristocracy, to retake the city of Jerusalem and surrounding lands from the Muslims. Beyond their bloody military consequences and lack of permanent success—Jerusalem and the Holy Land were secured for only brief periods—the eight crusades promoted long-term commerce, intercultural alliances, and the spread of ideas across continents. New towns, markets, and long-distance trade, in complementary relationship, revived across Europe. The growth of towns and trade, along with the movements of hundreds of thousands on pilgrimages and Crusades, had an overall liberalizing effect that promoted a less restrained conception of art, one open to individual, humanistic, and secular values. The individually identifiable style of Gislebertus, the sculptor and signer of the Autun Cathedral stone carvings (13.13, 13.14), is an example. His Autun works, especially the sculpted religious scenes on column capitals, present an expanding range of expression, encompassing even more down-to-earth human emotions such as the love of a mother for her child. While the basic tendency of the Romanesque art style remained antinaturalistic and priestly, the society and culture that produced it were giving way. From within this transitional, late Romanesque society and culture would emerge the first forms of Gothic art.

Gothic Art and the Later Middle Ages

Rooted in Germany, England, and especially France, the Gothic style blossomed in the final triumphal centuries of the medieval period. (Extending from approximately 1150–1450, the Gothic originally overlapped and then dominated much of the period known as the Late or High Middle Ages.) Leaders of the church were again the principal creators of artistic form and content. Prominent among them was the French Abbot Suger (1081–1151), whose architectural innovations included the pointed arch, light-giving high windows, and stained-glass panels. Most of these earliest manifestations of the Gothic style can be seen in Suger's remodeled church choir at Saint Denis just outside Paris (10.24). Beginning in the twelfth

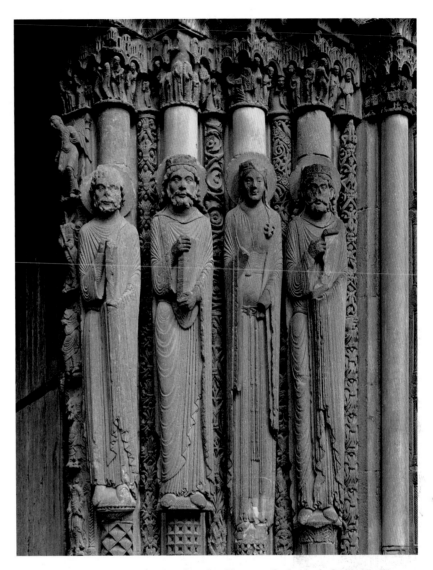

13.15 Door jamb statues, west facade, Chartres Cathedral. Ca. 1145–70. *What changes do you note between Romanesque and early Gothic statuary in terms of form, content, and subject matter? Are these differences in degree or in kind?*

century—late Romanesque and early Gothic art developed concurrently—the new "French" style reached its full development in soaring cathedrals such as Chartres (10.26–10.29). Moving close to Chartres' cathedral doors, let us gaze intently, like pilgrims or townsfolk, at the door jamb statues that rise around and above us.

The first set **(13.15)**, representing the early Gothic sculptural style, is from the main west facade and dates from approximately 1145 to 1170. Four thin, elongated figures, all haloed and three with royal crowns on their heads,

Dull minds rise to contemplation of the Divine through the senses.—Abbot Suger (1081–1151) of Saint-Denis, writings

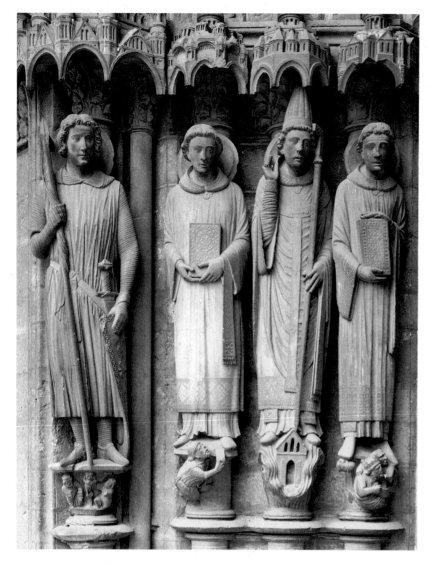

13.16 Saints Theodore, Stephen, Clement, and Lawrence, door jamb statues, south transept, Chartres Cathedral, France. Thirteenth century.

confront us. Art historians identify them as Hebrew Scripture figures, the ancient Jewish ancestors of Christ. Stylistically, the four figures are extensions of their immediate Romanesque forebears. Their bodies are rigid and geometrically stylized, holding tightly to the line of the column jambs. But their faces betray a change, a hint of humanistic naturalism. The queen or prophetess even appears gentle and welcoming, qualities elsewhere associated with the Virgin Mary, whose sympathetic human presence became ever present—a full-fledged "cult of the Virgin"—during the Gothic era.

The second set of door jamb statues **(13.16)**, from a south doorway entrance, typifies the beginning of the High or Late Gothic and dates from about 1210 to 1235. The quartet of saints is also vertically oriented to the door jambs, but much less so than the first set. The last of the figures to be completed, Saint Theodore on the far left, has become an almost freestanding sculpture in the round with feet solidly planted on the ground beneath. His arms swell with muscle, his lungs with breath. Blood seems to pulse in his veins. In comparison to the narrow, columnar shapes and abstract stylization of the west facade statues, Saint Theodore and, to a lesser degree, his three companions are physically breaking free, coming to life. Saint Theodore, in particular, must have startled onlookers with his naturalistic appearance. He seems a classically idealized knight, a Christian version of the ancient Greek *Doryphoros* (12.18), complete with spear, slight contrapposto weight shift, and relaxed but well-grounded pose.

The creators of these statues were most likely middle-class stonecarvers who lived and worked in the town. They represent a newly emergent commercial middle class, which Marxist art historians like Hauser (Interaction Box) view as the social class responsible for the most progressive and productive trends in art and culture as well as in economic life at this moment in history. The stonecarvers assuredly followed the general dictates of the church authorities in their cathedral statuary, but within these strictures they infused the artworks with qualities associated with down-to-earth middle-class life: materialism, naturalism, humanism, and individualism. These particular qualities must have been popular and basic to the spirit of the Gothic age, permeating all sectors of society, because aristocratic church leaders approved and paid for thousands of such works by middle-class artists.

All was not religious and holy in medieval society and culture, especially during the later Middle Ages. Two masterpieces of French miniature painting from the Late Gothic period focus on the secular side of life. In one revealing French manuscript from the early 1400s, *The Very Rich Hours of the Duke of Berry*, an illustrated calendar provides detailed insights, month by month, into the secular lives

13.17 LIMBOURG BROTHERS. *January,* from *The Very Rich Hours of the Duke of Berry.* 1413–16. 8½ × 5½ in. Musée Condé, Chantilly, France. *The Duke of Berry was a great patron and collector of the arts. At the same time, he was a vain, obstinate, pleasure-loving spendthrift who harshly taxed his subjects and died penniless. Does knowledge of the duke's personality and deeds affect your appreciation of this artistically magnificent manuscript illumination?*

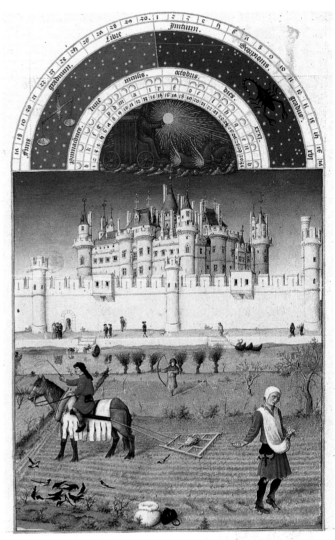

13.18 LIMBOURG BROTHERS. *October,* from *The Very Rich Hours of the Duke of Berry,* 1413–16. 8½ × 5½ in. Musée Condé, Chantilly, France. *The funds to gratify the Duke of Berry's very expensive tastes, historian Barbara Tuchman relates, "were wrung from the people . . . by the heaviest taxation in France of his time," sowing so much hatred and misery that the result was bloody insurrection. The patronage, production, and uses of art are often a mixed bag of the good and the bad. How does this picture tell that story?*

of the peasants and nobles. In the January illumination **(13.17)**, we witness the nobles engaged in pursuits of pleasure: hunting, feasting, jousting, and courting. It is the age of chivalry. Larger than life and luxuriously robed, the Duke of Berry commands attention. His chamberlain's words ring out, telling a suitor "Approach, approach." Meanwhile the joyless peasants, portrayed with an exacting realism, labor to make all this activity possible. According to apologists for the church and nobility, it was the God-given calling of the peasants to

faithfully serve their masters, who in turn would protect and provide for them always. (Several centuries later, plantation owners in the Americas would give much the same justification for slavery.) In the illumination for the month of October **(13.18)**, the lord's foreman, seated on a horse, plows the field while a sad-eyed serf, worn and tattered, sows the winter wheat. A scarecrow, with bow and arrow poised, stands guard. An impressive white castle, figurative head of the medieval "body social," looms over the peasantry, the

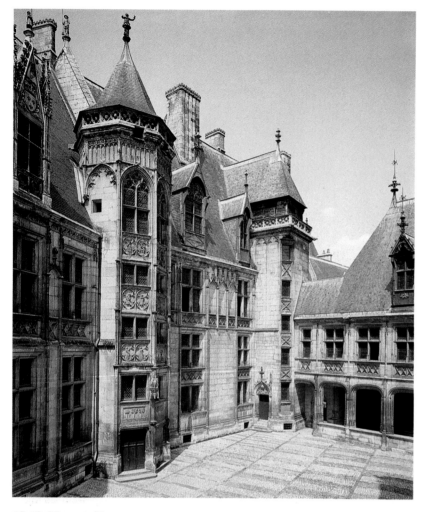

13.19 House of Jacques Coeur, courtyard, Bourges, France. 1443–51.

innumerable "feet" who, according to the twelfth-century writer John of Salisbury, "raise, sustain, and move forward the weight of the entire body." Above, encompassing all of nature and humanity, the heavenly bodies and zodiacal constellations, the divine presence made manifest, march in their eternal progression through the days, months, and years. Of the manuscript's illuminators and their style, art historian Kenneth Clark writes:

> Pol de Limbourg, and all the other artists who created this [late "International Gothic"] style, though they were employed by princes, came from the bourgeois Low Countries [of the Netherlands], from a land of work and fact. Of the months in the *Très Riches Heures,* more than half represent the work of the fields, and in these we are aware of an eye for fact so keen that the symbolical inheritance of the middle

ages is almost forgotten. The men sowing in front of the Louvre [royal palace] who illustrate the month of October, the scarecrow and the osiers [willow trees] by the bank of the Seine [River] and the little figures opposite, all are rendered with an objectivity and a truth of tone. . . .[2]

A group rarely featured in medieval art but essential to its creation was, as we have noted, the middle class or *bourgeoisie* (French for freemen of a medieval town or *bourg*). Commoners without hereditary property or privileges, these freemen and freewomen gained a modicum of stature and power through their personal membership in guilds, town-based organizations of skilled artisans or tradespeople. Bustling centers of production and market exchange and areas of growing population, the towns naturally became homes to cathedrals (10.26) and numerous churches. Working toward independence from the landed nobility of nearby castle and manor, some towns ("communes") even maintained their own military force and enacted their own laws. Between 1100 and 1400, fortified walls, a central town hall with bell tower, and a town charter and seal all came to symbolize this new communal entity and its independent government. A famous fourteenth-century mural in the town hall of Siena in northern Italy was painted in praise of the life of the town and good communal government (14.6, 4.2).

Money and town-based property, not rank or land, propelled an individual to the top of the middle class and social stature. An example of high bourgeois achievement was Frenchman Jacques Coeur. His palatial home **(13.19)** in the city of Bourges shows what middle-class wealth could attain. Created between 1443 and 1451, Coeur's house was built in the so-called "Flamboyant Style," a final ornate, imaginative version of the original Gothic style. A merchant and member of the guild of silversmiths, Coeur was a financier of the French king and one of the wealthiest men in France. His house is a carefully calculated public expression, a kind of politico-cultural statement. As a "bourgeois aristocrat," a man of the middle class who communed regularly with king and court, Coeur naturally looked to the French national style when building his home. Cathedrals like Chartres (10.26) and palaces of

the nobility such as the white turreted castle portrayed in the Duke of Berry's Book of Hours (13.18) were his most likely models. The rich merchant clearly desired to be looked upon as a noble. To this end, Coeur's house seeks to embody the chivalric values of the nobility: fanciful romance, extravagant flourish, and conspicuous display. The shapes and decorative trappings of the exterior and interior—teeming with coats of arms and legions of guardian angels—are executed with delicacy and fashioned of the finest materials in a fitting expression of Coeur's climb to the pinnacle of French society.

The painters and sculptors who decorated the homes of nobles and wealthy merchants like Jacques Coeur were members of the craft guilds of tradesmen and handicraft workers. A manuscript illumination **(13.20)** shows one man painting a wall while another executes a portrait, perhaps of a religious figure or of the master of the house. A young apprentice prepares paint for his superiors. As towns became centers of commerce, an expanding upper-middle-class joined the nobility and the church as patrons of the arts. Demand for skilled painters and sculptors increased. The most successful painters and sculptors in a town might own a workshop employing a small staff of assistants and apprentices (1.2). The craft guilds to which these master artisans belonged upheld quality standards and protected their members with respect to pay scale and working conditions. In a large town, each trade might build its own guild hall where its members could meet and make policy decisions.

Women of the late medieval period were particularly active in the craft of embroidery. Their creations served diverse purposes. The embroidered Bayeux Tapestry, only 20 inches in height but over 230 feet long, chronicled the eleventh-century conquest of Saxon England by the Norman king William the Conqueror. Commissioned by Bishop Odo, the king's half-brother, for display at special times in his cathedral and executed by teams of anonymous women (from a nunnery, royal estate, or town workshop), this monumental hand-stitched production is a kind of full-length Norman newsreel. It includes 50 scenes, with 623 human figures, 202 horses, 55 dogs, 505

13.20 *Artists Decorating a Nobleman's House.* Manuscript illumination, from a fifteenth-century Bible Historiale. The Pierpont Morgan Library, New York, ms. 394, folio 145. *How is the role of the painter in the late medieval period similar to and different from the role of the painter of pictures today? What profession in contemporary society is most like that of the men represented in this picture? Why?*

other creatures, 37 buildings, 41 ships and boats, 49 trees, and nearly 2,000 inch-high letters that describe the action. Art historian Laurie Schneider Adams analyzes one battle scene **(13.21):**

> Odo holds a mace, while the nobles carry banners, shields, and lances. The weapons, held on a diagonal, increase the illusion of forward movement, as Odo seems to clash with an enemy riding against him. The ground is indicated by a wavy line on a horizontal plane, but, aside from the overlapping of certain groups of figures, there is little attempt to depict three-dimensional space. Above and below the narrative events are borders containing human figures (note the decapitated figure below), natural and fantastic animals, and stylized plant forms.[3]

First in the hands of noblewomen of the convent or feudal manor and later in the hands of the freewomen of the towns, embroidery was held in the same level of esteem as painting

Regarding what you say about women expert in the art of painting, I know a woman today, named Anastasia, who is so skilled in painting manuscript borders and miniature backgrounds that one cannot find an artisan in all the city of Paris—where the best in the world are found—who can surpass her, nor who can paint flowers and details as delicately as she does, nor whose work is more highly esteemed, no matter how rich or precious the book is.
—Christine de Pisan (ca. 1363–1430), author, *The Book of the City of Ladies*

13.21 The Bayeux Tapestry, detail of battle scene showing Bishop Odo with a mace. Ca. 1070–80. Wool embroidery on linen. Height: 20 in. Tapisserie de Bayeux, Musée de l'Evêche, Bayeux, by special permission of the City of Bayeaux.

13.22 *The Syon Cope.* Gold, silver, and silk thread on linen. Early fourteenth century. Victoria and Albert Museum, London.

and sculpture. By the late Middle Ages, certain middle-class women became so renowned for their needlework talents that their names have come down to us. The early-fourteenth-century embroidery work of Rose of Burford, a London merchant, was so highly esteemed that she received a commission from Queen Isabella of Spain to decorate a vestment intended as a gift to the pope. An example of the impressive aesthetic quality of such English embroidery work, or *opus Anglicanum*, is the Syon Cope **(13.22),** created by one or more anonymous artists. Originally a priest's vestment, the Syon Cope integrates scenes from the New Testament and Christian lore—the crucifixion is at the center—into a symmetrical geometric design of interpenetrating sections of warm reds, oranges, yellows, and browns.

Queen Isabella, Rose of Burford's most famous patroness, provides a link between Christian and Islamic art. During the later Middle Ages, the Christian nobility of Spain steadily forced Islamic civilization from its last strongholds in Spain, a land the Muslims had conquered in the early eighth century. While this "Holy War" between the armies of Christianity and Islam wreaked much devastation, some masterpieces of Spanish Islamic art have survived.

INTERACTION BOX

TAKING A MARXIST APPROACH TO ART HISTORY

Marxist approaches to art history, inspired by the writings of Karl Marx (1818–1883), have become an important means of analysis and interpretation for contextually oriented art historians. Here we summarize some of the basic ideas. At the base of any given society is its economic system (for example, hunting-gathering, feudalism, capitalism). Tightly integrated with the economic base is a political system (tribal chiefdom, monarchy, oligarchy, democracy). Atop this foundation or substructure is a cultural "superstructure" (religion, philosophy, art, traditions, values, customs), simultaneously shaped by and shaping the politico-economic system. Art (in subject, form, and content) reflects the particular sociocultural world that produced it. Marxist art historians like Arnold Hauser typically focus on major changes at the base or root of society, especially the rise and

fall of socioeconomic classes, so-called "ruling classes" like the aristocracy and, since the later medieval period, the middle class. Such changes inevitably impact the world of art. For example, Hauser speaks of early medieval art (13.8–13.14) as being an "aristocratic art," the product of a feudal society in which secular and clerical aristocrats joined together as the ruling class. He notes that the rise of the commercial middle class of the towns in the later Middle Ages initiated a different type of art (13.15–13.20) reflective of this socioeconomic class (the bourgeoisie) and its particular cultural outlook.

Here's your challenge. Apply the Marxist perspective to early Gothic art. Looking at the art in terms of class-based politics and culture, explain how the door jamb statues of Chartres Cathedral (13.15, 13.16) are embodiments of middle-class culture, aristocratic culture, or a combination of the two. Interpret the growing naturalism in these works from a Marxist perspective.

ISLAMIC ART AND ARCHITECTURE: FROM WEST TO EAST

Islam closely followed the rise of Christianity. (Islam, in Arabic, means "submission to God's will.") In the generation following the death of Muhammad (570–632), the new religion's founder, Islam began its rapid growth as a politico-religious empire.

The Rise of Islam and Its Art

Sweeping out of Saudi Arabia, armies of Muslims ("true believers") conquered vast stretches of western and central Asia, North Africa, and southern Europe, including Spain **(13.23).** The conquest of Spain was complete by 718; the Muslim advance into Europe was finally stopped by the Frankish troops of Charles Martel (Charlemagne's grandfather) at Tours in central France. In later waves, Islam conquered or converted peoples in West Africa, India, and even the Far East.

In its charismatic appeal and imperial reach, Islam rivaled Christianity. Military con-

frontations between the two religions and cultures were inevitable. Islamic Arabs and European Christians battled for centuries, from Spain and the Balkans to North Africa and Palestine with its holy sites in and around Jerusalem sacred to Christians, Muslims, and Jews alike. In perhaps the greatest victory of Islam over Christendom, Constantinople, the final stronghold of the Byzantine Empire, fell to the Ottoman Turks in 1453. (Incorporating Byzantium and other states within its borders, the Ottoman Turkish Empire endured for over 600 years, ending in 1924 with the birth of the modern nation of Turkey.)

As a religion, Islam is monotheistic and claims Judaism and Christianity as its forebears. Its primary belief system requires devotion to the word of Allah (God), as revealed on earth by his prophet Muhammad. The words of Allah, communicated by Muhammad in the form of religious writings and ethical codes, make up the most holy book of Islam, the Koran ("The Book"). So central and powerful is the word of God in Islam that its religious art is based on Koranic words and sayings and the abstract designs that accompany them. Figurative

From being in awe of God, I [Muhammad] forgot everything that I had seen and known. Such unveiling, grandeur, and pleasure from proximity was produced that you would say that I was intoxicated.
—Ibn Sīnā (Avicenna) (980–1037), philosopher, *Mi'raj-namah,* a Persian account of the miraculous journey of Muhammad into God's presence

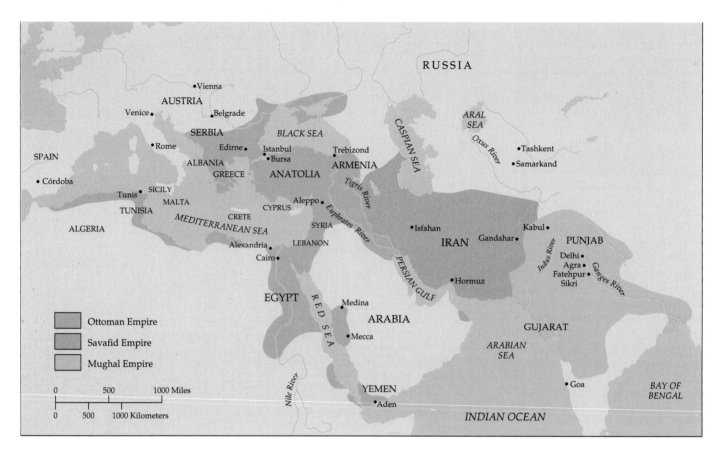

13.23 Map of Islamic lands.

13.24 Koran page in Kufic script, Iraq or Syria. Eighth or ninth century. 8½ × 13 in. Staatlische Museen zu Berlin, Preussischer Kulturbesitz, Museum für Islamische Kunst, Berlin.

depictions of Allah, Muhammad, and other prophets are generally prohibited from places of worship; following the ancient Hebrew tradition, such lifelike representations are seen negatively as idol worship. As a consequence, Islamic religious art turned to literary and decorative abstraction, with beautiful writing, or calligraphy, central. In a Koran page from

eighth- or ninth-century Syria or Iraq **(13.24)**, the letters and words become artistic forms. The incisive, dark brown letters in the upper part are striking in their spare but elegant abstract form. The golden letters below, framed within rectangular gold borders, interweave with a geometric pattern to become an integral part of the overall decorative design. After researching and attempting to replicate an elaborate cursive design, a student, impressed by the precision and artistry of the calligraphy, wrote about the technical requirements of the art, which is still practiced today:

> The calligrapher uses reeds, brush pens, inkpots, and sharpening tools. The main tool was a reed pen, called a Qalam, which was a very valuable object and was traded across the entire Muslim world. An accomplished calligrapher would need several different Qalams to achieve the various styles of calligraphy. The ink they used was made in several colors including black, brown, yellow, red, blue, white, silver, and gold. Some calligraphers gave instructions about how to prepare the ink, while

others claimed it was their secret. Although more attention was paid to the skillfulness of the calligrapher, rather than his artistic innovation, some original compositions were created and then painstakingly replicated by generations of masters.

Islamic Religious Art

Such calligraphy and surrounding designs cover many of Islam's mosques, or houses of worship. Adorning the exterior and interior walls of the mosque, the holy words of the Koran become literary and visual centerpieces of highly abstract designs. Consider the walls and horseshoe-shaped arch that frame the **mihrab (13.25)** in the Great Mosque of Córdoba in southern Spain. The mihrab is the recess or niche in a mosque oriented to the holy city of Mecca, birthplace of Muhammad. It indicates to all worshipers the direction of daily prayer. The density of interlacing lines, the complexity of organic and geometric forms, the kinetic rhythmic patterns, and the golden color harmonies are striking. The Islamic compositional principles of compartmentalization, mathematical proportion, and symmetrical balance give order and unity to the complex detail and immense diversity. The dome above the mihrab **(13.26),** with its starlike interlocking ribs, creates a fascinating array of geometrical configurations. The total effect is dazzling and mesmerizing, which fulfills the mosque's purpose. It is an art of "infinite pattern" that, according to Islamic scholar Lois Ibsen Al-Faruqi, communicates "a reality that reaches beyond the natural world." It inspires an intuition of transcendence, and the faithful observer can only exclaim "Allahu Akbar!" (God is great!)

The vast interior space of the Great Mosque **(13.27)** is equally impressive. It presents the observer with a seemingly endless forest of multicolored red and tan columns. Horseshoe-shaped arches rise up out of the columns, divide, and blossom into a second tier of larger arches above. Moved aesthetically and spiritually, the worshiper finds his place of prayer. He faces in the direction of the mihrab and prays directly to Allah. The Islamic conquest of Christian Visigothic Spain in the early eighth century prepared the way for the building of the mosque. The ground plan was laid out in

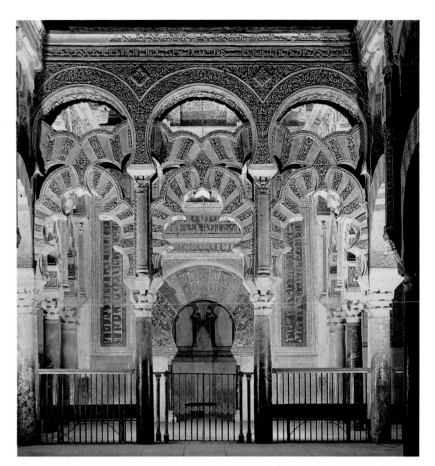

13.25 Mihrab bay, the Great Mosque, Córdoba, Spain. Ca. 961–966.

13.26 Dome above the Great Mosque, Córdoba. Ca. 961–966. Mosaic.
Observe the pointed arches near the base of the dome. Such Islamic pointed arches preceded the development of the pointed arch in Gothic cathedrals centuries later. Through what arenas of contact might Islamic architectural forms have reached European Christians and influenced their buildings?

391

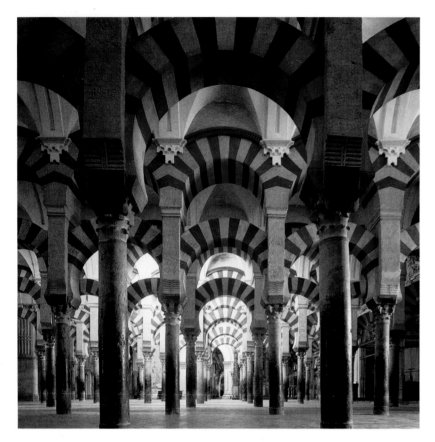

13.27 Arches of the Great Mosque, Córdoba, Spain. Ca. 961–966.

13.28 Synagogue, decorative archway, Córdoba, Spain. Fourteenth century.

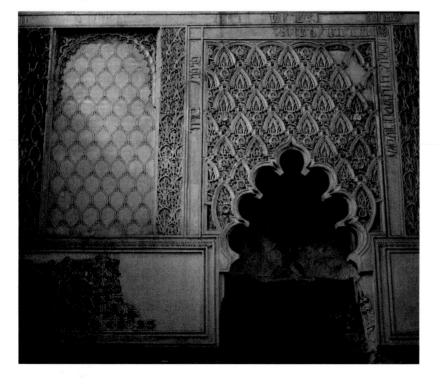

785 on or adjacent to the sites of former Roman and Visigothic buildings. (Columns and capitals from these buildings are integrated among the interior forest of columns.) Over the centuries, the original mosque was greatly expanded by successive Islamic rulers.

Most of these rulers accepted the religious practice of their Christian and Jewish subjects. The remains of a Jewish synagogue or house of worship **(13.28)** in Córdoba—a two-story building not far from the Great Mosque—testify to the Islamic policy of religious toleration. The synagogue's segmented arches and rich interior decoration were clearly inspired by the prevailing Islamic architecture and art. Especially noteworthy are the intricate abstract decoration and Hebrew lettering executed in stucco, a fine plaster material. Having mastered this high Islamic art, resident Hebrew and Christian artisans joined their Arab peers as carvers and molders of intricate plaster decoration. The walls, ceilings, and domes of medieval mosques, synagogues, churches, and palaces evidence their virtuoso work. The beauty of these buildings inspired such marvel, writes Solomon ibn Gabirol (1020–1070), a Jewish poet of Islamic Spain, that "the heart of the poor and burdened delights in this, the perishing forget their poverty and bitterness. . . . Yea, my body all but soared in my joy as upon wings of eagles." Islamic Spain was truly an advanced civilization for its time, a tolerant multicultural society with a flourishing intercultural life resplendent with architecture and art. The same cannot be said of the Christian kings and queens who reconquered Spain between the eleventh and fifteenth centuries. They outlawed Muslim and Jewish religious practice and closed their houses of worship. Following the reconquest of Córdoba in 1236, the Christian rulers immediately consecrated the Great Mosque as a church and built a soaring Gothic cathedral in its center.

Ranging across continents, Islamic religious architecture came to vary widely. Its forms and building materials changed with geographical location and local cultural traditions **(13.29).** Mosques in sub-Saharan West Africa, for instance, including those at important ancient cities such as Timbuktu and Djenne **(13.30),** were made of baked mud-brick (adobe). Like the Great Mosque in Córdoba, these mosques employ a hypostyle design, in

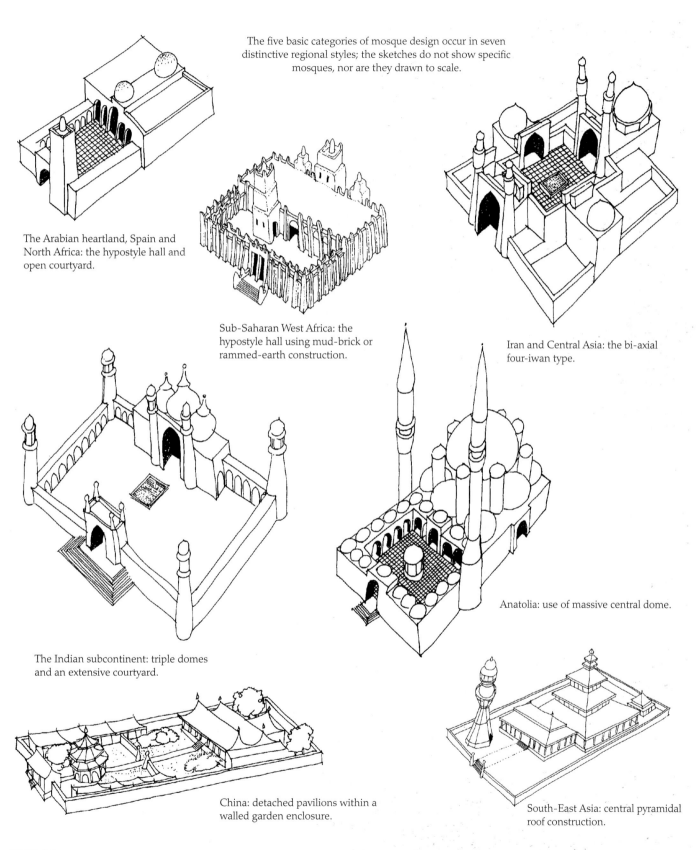

The five basic categories of mosque design occur in seven distinctive regional styles; the sketches do not show specific mosques, nor are they drawn to scale.

The Arabian heartland, Spain and North Africa: the hypostyle hall and open courtyard.

Sub-Saharan West Africa: the hypostyle hall using mud-brick or rammed-earth construction.

Iran and Central Asia: the bi-axial four-iwan type.

Anatolia: use of massive central dome.

The Indian subcontinent: triple domes and an extensive courtyard.

China: detached pavilions within a walled garden enclosure.

South-East Asia: central pyramidal roof construction.

13.29 Mosque types.

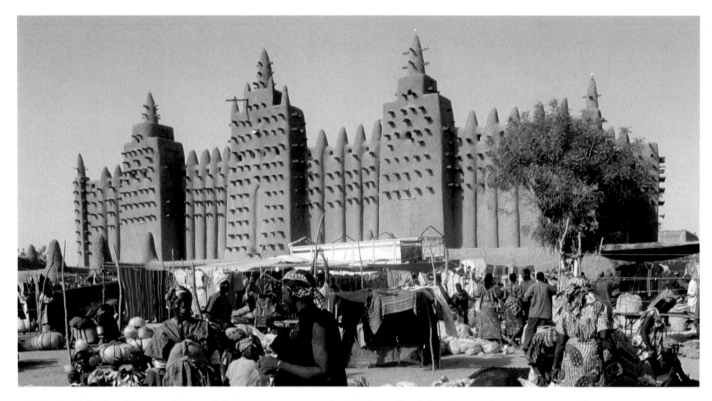

13.30 Good Friday Mosque, Djenne, Mali. 1907 reconstruction in the style of the thirteenth-century original.

which the roof is supported by rows of columns, giving a forestlike appearance. Like the Córdoba mosque, the mosques at Timbuktu and Djenne include an adjoining courtyard for purification rituals and a minaret (tower) from which the muezzin (crier) calls the faithful to prayer five times each day. The West African mosques were built after the Mali empire converted to Islam in the fourteenth century. Later Timbuktu and Djenne mosques are a synthesis of the basic Islamic hypostyle design and indigenous cultural traditions and building techniques. The Djenne mosque's thick load-bearing walls and sculpted shapes began with the physical capabilities of the commonly used mud material (10.11). Traditional Malian house forms also influenced the design. The result, as one scholar put it, is an Africanized Islamic architecture that has "rethought, rephrased, remoulded and rewoven" the form and fabric of Spanish and North African hypostyle mosques to local conditions and conventions.

In the century after the conversion of the Mali empire, Islam reached the capital city of the Christian Byzantine Empire. The Hagia Sophia (13.5, 13.6) was transformed by the victorious Ottoman Turks into a mosque in 1453, its massive central dome becoming the model for subsequent Turkish mosques throughout Asia Minor or "Anatolia." To complete their distinctive central-dome mosque design, the Ottoman Turks added two or more tall, pencil-thin minarets around the perimeter of the basic central-domed structure. (In converting the Hagia Sophia into a mosque, four minarets were added at the corners of the rectangular perimeter.) This format of central-dome structure and soaring minarets gave birth to numerous offspring. The Sultan Ahmet Mosque **(13.31),** with its six minarets, is an impressive example.

The design of the mosque was also used as a model for the glorious tombs or mausoleums of mighty Islamic rulers, such as India's Taj Mahal **(13.32,** 7.33), commissioned by the Mogul Emperor Shah Jahan (died 1666) upon the death of his beloved wife, Mumtaz Mahal (died 1631). Begun in 1631, the magnificent white marble mausoleum was completed in 1654. The roots of its form can be found in central and western Asian

mausoleums and mosques (13.31, 13.5), but its final design seems most closely related to the characteristic mosque form of the Indian subcontinent (13.29). Note the Taj Mahal's triple domes and extensive courtyard with minarets around the rectangular perimeter—all typical of the mosques of India. Abd al-Hamid Lahori, the emperor's court historian, speaks of the "heaven touching, guava-shaped" central dome, "the circumference of whose outer girth is 110 yards"; the four marble minarets "appearing, as it were, like ladders reaching toward the Heavens; . . . the Paradise-like garden, 368 square yards, abounding in aromatic herbs and different kinds of trees"; and, within the garden's walkways, the "water-channel, 6 yards wide, in which fountains jet up spouts of water. . . ." A slightly later Indian court historian, Bakhtawar Khan, marveled at the artistry of the calligrapher whose inscriptions from the Koran grace the building: "The sight of his calligraphy added the brightness of insight to the eye and sight of those of creative discernment. The inscriptions of the sky-high dome of the tomb of Her late Majesty . . . were written by his jewel-threaded pen."

Secular Art in Islam

While Islamic belief deems the depiction of figurative imagery in religious art idolatrous and sinful, it does not proscribe such representation in secular art. The figurative illustration of books reached a high point in the Persian Empire in the fifteenth century (**Appreciation 26**). Known as miniatures because of their small size, these book illustrations provided the model for book illustration from Turkey to India. Many of these illustrated books were "romances," based on contemporary poems or mythological tales. They were designed for wealthy, educated readers—usually aristocrats connected to the palace court.

The Persian dynasty that gave rise to this golden age of book illustration and general cultural achievement was the Timurid, named after Timur (Tamurlane), the fourteenth-century Mongol warrior-lord who was the son of Kublai Khan and a descendant of the famous conqueror Genghis Khan. Sweeping westward, Timur (ca. 1336–1405) overran

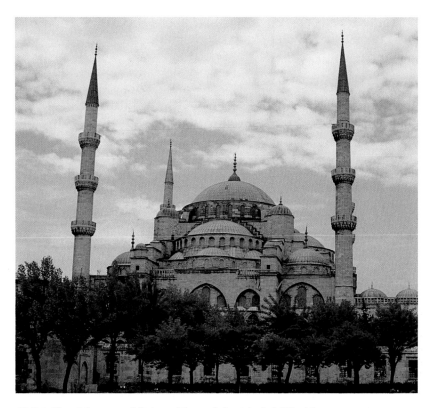

13.31 Blue Mosque of Sultan Ahmet I, Istanbul. 1609–16.

13.32 Taj Mahal, Agra, India. 1632–48.

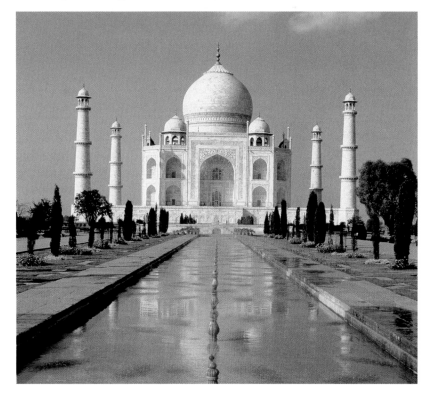

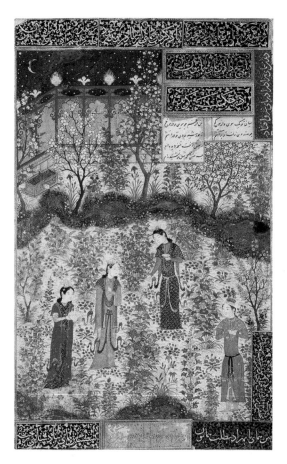

13.33 *The Persian Prince Humay Meets the Chinese Princess Humayun in the Garden,* detail from a Persian manuscript. Ca. 1450. Musée des Arts Décoratifs, Paris. *The intercultural influences on Persian life and art, from the earlier Greeks and Romans to the later Mongols and Chinese, were extensive. Is American art more or less intercultural than that of medieval Persia?*

much of Central Asia, including Persia. Reigning over Persia from the end of the fourteenth to the beginning of the sixteenth century, the descendants of Timur, the Timurids, developed extensive palace workshops and commissioned numerous artworks, from bronze vessels to manuscript illuminations. Coming originally from the Mongol empire that encompassed China and much of the Far East, Timur and his descendants brought a love of Chinese art and design to their new Central Asian home. Various manuscript illuminations reveal that the Timurid Dynasty engaged in a

vibrant commercial and intercultural exchange with China's Ming Dynasty (1368–1644). A previously discussed Persian manuscript illumination (5.24) depicts the arrival of the Persian Prince Humay and his reception by Princess Humayun in the garden of the Ming emperor of China. In the hands of one of Princess Humayun's attendants **(13.33)** is a gift for the Prince, a finely crafted Chinese vessel of the early Ming Dynasty. The epitome of multiculturalism and intercultural exchange, Persian Timurid art melds Islamic, Central Asian, Chinese, and Mongolian forms and subjects.

In addition to romances, manuscript illumination in the Islamic world also embellished histories of great rulers. An illustrated biography **(13.34)** documents the life and achievements of Süleyman (ca. 1496–1566), the emperor of the Ottoman Turks and perhaps the most powerful ruler of his time. Süleyman's empire stretched from eastern Europe and northern Africa to Central Asia. His reign lasted over four decades, from 1520 to 1566. European monarchs and business and religious leaders sought commercial and military alliances with the ruler they called "Süleyman the Magnificent" because of the military might and commercial wealth of his empire.

Like Timur before him, Süleyman was an art patron extraordinaire. Workshops in the royal palace and other parts of the empire produced manuscript illuminations, jewelry, weaving, and pottery of the finest quality. According to scholar Esin Atil:

> Süleyman personally oversaw the activities of the artists and rewarded them for outstanding achievements. He was himself a goldsmith, following the tradition of the Ottoman house that each sultan [Muslim ruler of Turkey] have a practical trade. . . .
>
> Under his discerning guidance the imperial studios produced splendid works of art that represented a unique blend of Islamic, European, and Turkish traditions. The styles developed in the palace spread throughout the empire and influenced the arts of neighboring states. The most innovative artists belonged to the *nakkashane,* the imperial studio that produced manuscripts for the sultan's libraries. They created two new and original styles that not only characterized the artistic vocabulary of the age, but also had a profound impact on the development of Turkish art.

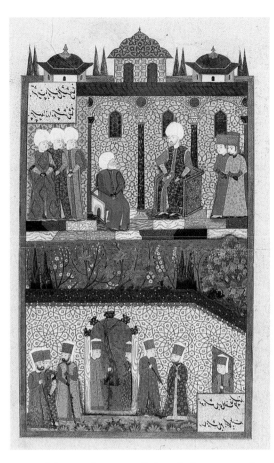

13.34 Meeting between Sultan Süleyman and the admiral of the Ottoman Fleet. Illustration from the *Süleymanname*. 1558. Istanbul, Topkapi Palace Museum, ms. Hazine, 1517, folio. 412a.

13.35 Folio (detail) from Süleyman the Magnificent manuscript, Divan-t Muhibbi, transcribed by Mehmed Serif and illuminated by Kara Memi. 1565–66. Istanbul University Library, T.5467.

The first style, called *saz*, meaning an enchanted forest, evolved from drawings of mythical creatures engulfed by foliage with fantastic flowers and long twisting leaves. . . .

The second style is distinguished by sprays of identifiable tulips, carnations, roses, hyacinths, and blossoming fruit trees. It also appeared first in manuscript illuminations and spread soon to other media.[4]

The second floral style finds exquisite application in a manuscript illumination of the poetry of Süleyman himself **(13.35).** Recognizable flowers accompany each line. Esin Atil describes the sultan's poetry as "a rare combination of lyricism and mysticism as well as humility and sincerity. He wrote about his love for his wife, Hurrem, and the loneliness of his office, displaying a profound acceptance of his destiny as a sultan in the servitude of the state."

The age of Süleyman was a magnificent one. A century earlier and several hundred miles to the west, Italy had initiated a golden age of its own, which today we call the Renaissance. For most historians, this new age marks the end of the medieval period in Europe.

APPRECIATION 26 *Persian Manuscript Painting of the School of Herat*

MARYAM OVISSI

In the golden age of the Persian Timurid Dynasty (1369–1469), painting reached its pinnacle during the reign of Baysunghur (1397–1433), grandson of Timur, the dynasty's founder. Baysunghur settled in his new capital of Herat (in present-day Afghanistan) and there developed one of the greatest schools of Persian painting. Painting first developed as a book art, specifically taking the form of "illuminated" (that is, illustrated) manuscripts. Small painted scenes—referred to today as "Persian miniatures"—were made to illustrate and accompany a text written in a beautiful calligraphic hand [13.24]. The success of the painted picture was judged according to its ability to reveal the story poetically and harmoniously.

Under Baysunghur's rule, the Herat royal workshop, or Kitab Khaneh, developed several visual characteristics that became standards for later Persian schools of art to follow. The illuminated manuscripts became larger, the sizes expanding from 5 by 7 inches to as much as 16 by 18 inches. Increased emphasis was placed on a central character, usually located in the center of the page, and the features of the human figures were more individualized. Stylistically, more intricate detail was incorporated in the architectural and landscape subjects and the decorative objects represented in the works. In formal design terms, unified composition was stressed.

During the Timurid Dynasty, various manuscript illuminations were derived from the national epic of Persia, the *Shahnameh* (Book of Kings), written in the eleventh century by the poet Ferdowsi. The *Shahnameh* was a standard text which the Kings of Persia and Near East-ern cultures would have illustrated for their courts. The epic relates the mythical history of the birth of Persia and her national heroes.

An image from a School of Herat *Shahnameh* illuminated manuscript of 1444 is titled "Simurgh Restores Zal to His Father Sam" **(Fig. A)**. The Simurgh is known as the mother of Persia. The mythological bird brings Zal back to his father Sam on earth. Zal later becomes the father of Rustam, the greatest hero of Persian mythology. The image features lavish color and painstaking detail in the faces, clouds, and landscape. Notice the rich red and blue hues, the small red flowers, and the detail in the feathers of the Simurgh. For the most detailed passages the artist might use a brush with only a single hair. The compositional design effectively integrates and balances the areas of calligraphic text and visual imagery. It also places the Simurgh and Zal at the center of the design, with the angles of the interlocking hills and the glances of Father Sam and his companion focusing attention upon them.

It is important to note that this one manuscript page was made by the hands of at least ten different artists of the Kitab Khaneh. Each artist possessed his own specialty. The workshop master, or Ustad, provided the overall plan for the page. One artist drew the landscape while another drew the figures. One mixed the paint while another applied the pigment to the thin sheet of highly absorbent vellum (a fine parchment made from animal skin). There are no signatures to be found on this manuscript created by so many hands. The workshop is noted, and the patronage of the work is inscribed.

This illuminated manuscript page and all others were products of collaborative interaction between the skillful and creative artists of the Kitab Khaneh. So great was their artistic achievement that it set the standard for manuscript illumination in Persia, the Near East, Turkey, and India for centuries to come. ▪

Maryam Ovissi is an independent curator specializing in contemporary Iranian art. She has worked at the Sackler and Freer Galleries of Art, the Boston Museum of Fine Art, and the Asian Art Museum of San Francisco.

Figure A The Simurgh restores the child Zal to his father Sam. 1444. Illumination. Cod. Persian 239, folio 16b. The Royal Asiatic Society, London.

Renaissance to Baroque Art in a Worldwide Context

14

The years between 1400 and 1700, the approximate historical span of Renaissance and baroque art in Europe, featured both great empires and empire building on a worldwide scale (14.1). We have viewed the art of Ottoman Turkey (13.34), Timurid Persia (Appreciation 26), Moghul India (13.32), and Ming China (4.9), great empires all. In the period between 1400 and 1700, increasing numbers of Europeans traveled to these established Asian cultures on diplomatic missions, commercial ventures, and proselytizing missions to win religious converts.

Europeans probed southward and westward seeking a sea route to the rich Asian lands to the east. Beginning in the mid-1400s, the seafaring Portuguese developed spheres of economic influence and even outright colonies in Africa, Asia, and South America. Hybrid Bini-Portuguese art, originating in the West African kingdom of Benin, was one result (8.23). From 1492, with Columbus's discovery of a "New World," Spanish conquistadors explored and conquered the Americas, creating the largest empire ever known. In the process, they destroyed the imperial cultures of the Aztecs (8.38) and the Incas (10.9) and killed and enslaved hundreds of thousands of local peoples. The ultimate result, however, was not annihilation but rather the rich multiracial, multiethnic mix of today's "mestizo" cultures of Mexico (1.8, Appreciation 34) and Central and South

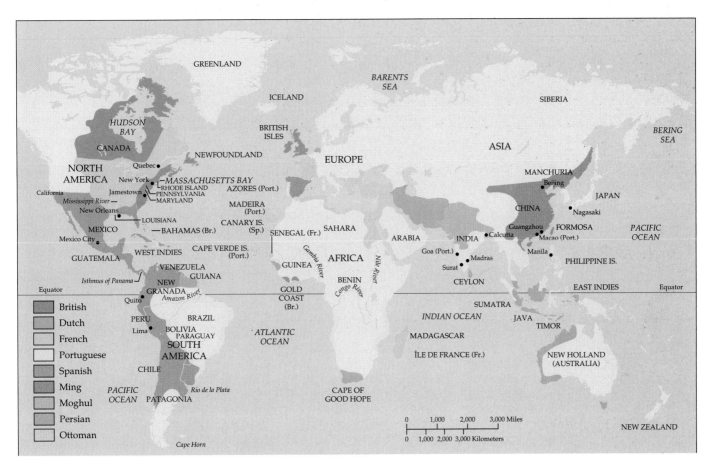

14.1 Map of world empires.

America (15.31, 20.2). In the sixteenth century, England, France, and Holland joined Spain and Portugal in a fierce, war-filled competition for overseas empires and trading partners.

In this context of exploration, empire building, cross-cultural contact, and conquest, European painters, sculptors, and architects likewise explored and conquered new realms. An oil painting (14.2) by an unknown Italian artist from the city of Venice, executed around the years of Columbus's voyages, speaks to these developments. Just below and to the left of the huge arched gateway stand six Venetian ambassadors, dressed in red and black. They are being received by the seated Syrian Mamluk governor, who is wearing a white horned turban, a shape with possible associations to ancient Near Eastern bull symbolism (11.14, 11.23, 11.24). The setting is Damascus, the Syrian capital, with high walls, mosques, and minarets. As a commercial, seafaring republic on Italy's northeast coast, Venice had long en-

joyed contact with the societies of the Middle East and was one of continental Europe's main intermediaries in long-distance trade with Asia and Africa. Like their fellow Italian Columbus, from the rival maritime city of Genoa, Venetian navigators learned to map and chart the world with mathematical accuracy. The anonymous Venetian painter has visually conquered and brought firm order to the extraordinary detail and variety of the seen world. Through the application of mathematically based spatial perspective, atmospheric perspective, and firsthand observation, the artist has composed an accurate, unified representation of the city of Damascus and its inhabitants. Beyond the possible picturesque addition of exotic animals in the foreground—camels, a trained monkey, two deer—*The Reception of the Ambassadors in Damascus* is a visual record of discovery for Europeans back home, a detailed scientific inventory of the appearance, customs, and costumes of a distant land.

The single epoch in human history that can be said to have made possible the idea of globalism is the Age of Exploration, an age that began in the fifteenth century with the voyages of Chinese admiral Zheng He, and, for the Western world, with the Portuguese voyages down the coast of Africa.—Circa 1492: Art in the Age of Exploration, National Gallery of Art Exhibition Catalogue, 1991

As this age of global discovery, cultural interchange, and scientific and artistic exploration unfolded, so did the medieval era fold itself into the historical period known as the Renaissance.

FROM THE MIDDLE AGES TO THE RENAISSANCE

A confluence of developments during the late medieval period (approximately 1200–1400) laid the groundwork for the Renaissance. They included a renaissance or "rebirth" of interest on the part of the intellectual elite in the literature, art, and philosophy of Greek and Roman antiquity, along with a growing focus on the human individual as "the measure of all things." This credo, from the ancient Greek philosopher Protagoras, was at the heart of the emerging cultural movement of the late Middle Ages and early Renaissance known as humanism. Humanism was based on the humanities, the pursuit of learning in language, literature, history, and philosophy in a secular rather than a religious framework. The humanist outlook and course of study were further advanced by the growing scientific examination of the physical world, manifested in activities ranging from the mapmaking of geographers to the documentary cityscape paintings of

artists like the Venetian who recorded the architectural features and life-style of faraway Damascus. All these cultural developments took place within a social context characterized by the decline of feudalism, the ascent of the commercial middle class through capitalist enterprise, and the subsequent rise of prosperous, self-governing cities. The Church, for its part, continued to be a powerful institution and influence over people's lives. The form, subject matter, and content of late medieval and early Renaissance paintings, sculptures, and buildings reflect this genesis of our modern Western world.

Fourteenth-Century Art: From Medieval to Renaissance

Consider two paintings executed around 1300, the work of Italian masters based in Florence, the leading city of the region of Tuscany **(14.3),** birthplace of the Renaissance. One painting embodies the spirit and style of the Middle Ages, while the other breaks ground in the development of the new "modern" style that would soon be identified with the Renaissance. Designed as an altarpiece, the large tempera and gold painting of the crucifixion of Christ on a wooden panel **(14.4)** by Coppo di Marcovaldo (1225–1274) is typical of much medieval painting in Italy before and during

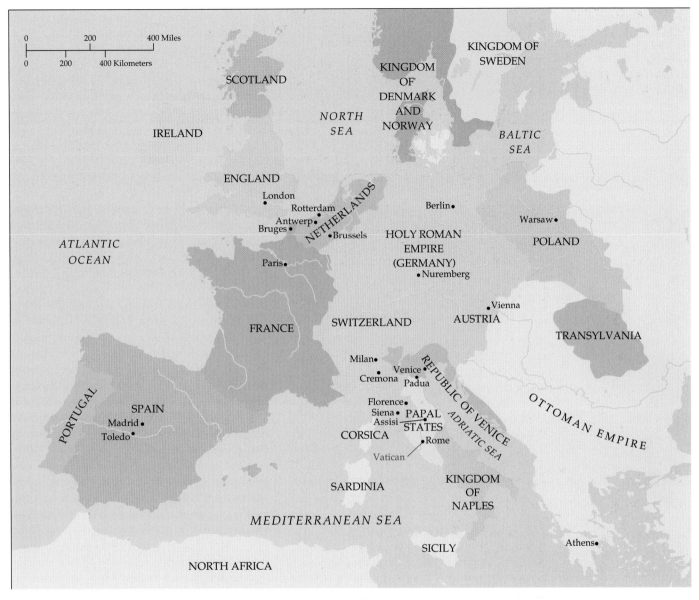

14.3 Map of Italy, Europe, and the Ottoman Empire.

the fourteenth century. The figure of Christ is schematically rendered and stylized in a manner indebted to earlier Byzantine (13.3) and Romanesque (13.13) styles. Posed in the reverse S-curve typical of Byzantine presentations of the crucified Christ, Jesus is a divine symbol rather than a flesh-and-blood human being. Distinctly outlined shapes and patterns are joined in a flat, two-dimensional portrayal of the suffering Jesus. Observe how Christ's abdomen and rib cage are patterned abstractions, visual schema or symbols of these body sections. The same stylized abstraction, based on traditional formulas, is seen in Christ's legs, arms, and stiff loincloth. Only in the face, with its furrowed brow and downcast eyes expressive of grief, does Christ become more a human being and less an intellectual symbol.

Coppo's fellow Tuscan artist Giotto di Bondone (ca. 1267–1337) created his fresco painting **(14.5)** on a chapel wall in Padua during the same general period **(Technique Box 14-A).** The basic **iconography** (subject matter and symbolism) of the two paintings and their central figures remains much the same. Note in both works the golden halo, symbolic of Christ's divinity, and the skull at the base of the cross representing the skull of Adam, the first man, and symbolizing Christ's redemption of humankind through His resurrection.

14.4 COPPO DI MAR-
COVALDO. *Crucifixion.*
Late 1250s. Panel.
74⁷⁄₁₆ × 97¼ in. Museo
Civico, San Gimignano,
Italy.

In formal terms, both works feature symmetrical compositions with Christ at the center, head hanging and torso and legs turned slightly to the right, the symbolic side of salvation. As viewers, we look up to the crucified Christ. What then differentiates the two crucifixion paintings and makes Giotto's painting a forerunner of the Renaissance?

Giotto's Christ is more realistic, full-bodied in its modeling, and weighty in volume. Muscles and bones are realistic rather than schematic in appearance. A shallow three-dimensional space has opened up between figure, cross, and blue sky. Christ's heavy body, more accurate than Coppo's in its anatomical representation, hangs as dead weight from pinioned hands; Coppo's Christ, in comparison, seems to stand upright in its active S-shaped pose, tacked to but not really hanging down from the cross. Whereas Coppo

employed a stereotypic way of representing the human form based on preexisting formulas, Giotto appears to have closely observed the body of an actual person in order to render the human form more faithfully. Contact with ancient and contemporary Roman painting and sculpture, more true to life in style, might have affirmed Giotto's basic interest in copying nature, the artistic goal that the ancient Greeks called *mimesis* or imitation. In summary, Giotto's crucified Christ shows greater naturalism, humanism, and individualism.

Giotto's fourteenth-century Italian contemporaries, including internationally famous writers Dante, Petrarch, and Boccaccio, immediately noted the difference between Giotto's work and that of his peers and predecessors. Dante wrote in *The Divine Comedy* that Giotto's fame as a painter eclipsed all others. Petrarch and Boccaccio, passionate admirers of the culture of ancient Greece and Rome, saw in Giotto's painting a rebirth of the greatness of the Greco-Roman artistic past. They asserted that Giotto's painting, compared to the art of the centuries since the fall of Rome, was new and true to life like the best illusionistic painting of classical antiquity (12.31, 20.5). Boccaccio compared Giotto with Apelles, court painter to Alexander the Great (12.20), as a master of illusionism and clarity. Petrarch, considered the first full-fledged humanist, wrote that Giotto's art was not for the ignorant but for the intellectually and aesthetically enlightened. At the turn of the fifteenth century, the Florentine humanist historian Villani insisted that Giotto "is not only celebrated enough to be compared with the painters of Antiquity, but is even to be preferred to them in skill and genius—[he] restored painting to its pristine dignity and high reputation. For pictures formed by his brush follow nature's outlines so closely that they seem to the observer to live and breathe." These judgments by humanist intellectuals of the fourteenth and early fifteenth centuries to a great extent define the criteria of Renaissance art: the revival of the illusionism and naturalism of Greek and Roman art; emphasis on the individual artist's genius, intellect, and fame; the sense of a breakthrough to a new, superior age. No wonder so many later modern art historians consider Giotto to be a "proto-Renaissance" artist, that is, a forerunner or pioneer of the Italian *rinascita* or rebirth to come.

14.5 GIOTTO. *Crucifixion*. Ca. 1305. Fresco. Arena Chapel, Padua. *Is Giotto the first Renaissance painter, or the last medieval one? Or is he a blend of the two? Justify your opinion.*

A man of humble origins, Giotto was catapulted to success by his modern style as he fulfilled commissions all over Italy for patrons at the highest levels of society. These patrons included aristocratic lords, middle-class businessmen, and the religious order of the Franciscans, followers of Saint Francis of Assisi (14.18), whose deep appreciation of the natural world influenced Church and laypersons alike. Through masterworks in major churches in Florence and Assisi and at the Scrovegni Chapel in Padua, site of the *Crucifixion* and the adjacent *Lamentation* fresco painting (2.6), Giotto substantially influenced painters to take up his modern style. While many continued to work in traditional medieval styles (4.3) through the next century, numerous artists of the upcoming generations strove to incorporate Giotto's achievements into their paintings.

One of the finest of these artists was Ambrogio Lorenzetti (active 1319–1347) of Siena, a philosopher, scientist, and brilliant mapmaker as well as a talented painter. His large fresco *The Allegory of Good Government* (**14.6**, 4.2) was commissioned by the governing council of merchants for the main meeting room of Siena's Palazzo Pubblico, or city hall. The painting attempts to realistically portray city life, at its healthful best under good republican government, with accurately scaled figures in an illusionistic three-dimensional urban space. Within high walls, Lorenzetti presents fortified homes, shops, churches, narrow streets, and market areas. The work is very much the proto-Renaissance forerunner of the full-fledged Renaissance cityscape painting, such as *The Reception of the Ambassadors in Damascus* (14.2). Lorenzetti's Sienese citizens are engaged

Of all the methods that painters employ, [fresco] painting on the wall is the most masterly and beautiful, because it consists in doing in a single day that which, in other methods, may be retouched day after day, over the work already done.—Giorgio Vasari, artist and writer, *The Lives of the Most Excellent Painters, Sculptors, and Architects*, 1550

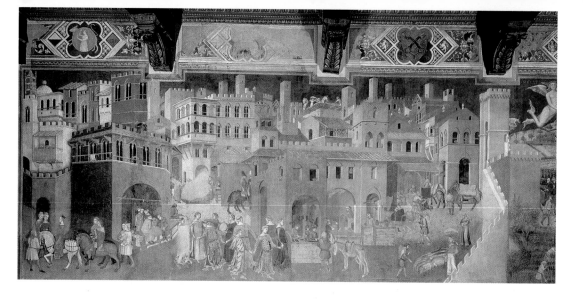

14.6 AMBROGIO LORENZETTI. *The Effects of Good Government on the City,* from *The Allegory of Good Government.* 1338–39. Fresco. Palazzo Pubblico, Siena, Italy.

FRESCO

The Italian word *fresco* means "fresh." It refers to the technique of applying water-based tempera paints to a wet coat of plaster on a wall or ceiling. Such application of wet paint to wet plaster also goes by the name *buon fresco* (literally, good or true fresco), in contrast to the technique of painting on a dry wall or ceiling surface. Artists have used this latter technique, known as *fresco secco* (dry fresco), to touch up or highlight areas of the true fresco.

The main challenge for fresco painters was (and is) rapid execution. (Note that artists have employed the technique in the ancient world (20.5) and in the medieval, Renaissance, Baroque, and modern periods (1.8).) The artist first blocked out the overall composition in

charcoal and made a brush drawing (or sinopia) on a rough layer of dry plaster in red ochre pigment mixed with water. The painter and a team of assistants then laid down a coat of wet plaster. The fresco painter had to work fast, section by section, to complete the figures and forms before the plaster dried, usually in less than a day's time. But once dry the fresco colors possessed a permanence, binding physically to the plastered wall or ceiling. Over the centuries, fresco color, mat in finish and chromatically rich, has resisted deterioration and shown itself receptive to cleaning and restoration. Recent restoration of Michelangelo's Sistine Chapel ceiling fresco (14.27) has revealed the brilliance and permanence of the artist's colors.

in everyday activities: attending school, working in their shops, carrying goods, constructing a roof. A noblewoman and her entourage exit left while beautiful maidens dressed in fashionable silks dance gracefully to the beat of a tambourine. Such bits of picturesque pageantry within the otherwise slice-of-life cityscape make it clear that the chivalrous Late Gothic style (13.17) also influenced artists and patrons in Siena and much of Europe. Sadly, this lively, bountiful city life came under the attack of a series of bubonic and pneumonic epidemics, the so-called "Black Death" that killed half the inhabitants of Siena and Florence and one out of three persons in Europe between 1348 and 1400. Many artists, Lorenzetti probably among them, died from these plagues. Giotto's modern, realistic style would wait over half a

century to be fully realized with the emergence of a generation of remarkable artists in Florence, the foremost center of Renaissance art and culture.

RENAISSANCE ART: THE FIRST HALF OF THE FIFTEENTH CENTURY

It was a fellow Florentine of humble origins who fully realized the illusionistic realism and humanism inherent in Giotto's modern painting style. Masaccio (1401–ca. 1428) had a tragically short life, but his influence on the art of painting was immense and longlasting. Along with his friends Donatello and Brunelleschi, the premier practitioners of sculpture and

14.7 MASACCIO. *The Holy Trinity*. Ca. 1425. Fresco. 21 ft. × 10 ft. 5 in. Church of Santa Maria Novella, Florence.

14.8 MASACCIO. *The Holy Trinity*, with perspective drawing lines marked. Ca. 1425.

architecture in the first half of the fifteenth century, Masaccio was a founding father of Renaissance art.

Early Renaissance Art in Florence

Painting Masaccio's fresco *The Holy Trinity* **(14.7),** painted on a nave wall of Florence's Gothic-style Church of Santa Maria Novella, shows a crucified Christ even more full-bodied, robust, and anatomically correct than Giotto's earlier figure (14.5). Whether painting spiritual beings—the "Trinity" of Christ, God the Father, and the Holy Spirit (the symbolic white dove above Christ's head), and the haloed Virgin Mary and St. John—or the life-size husband-and-wife donors of the painting, Masaccio represents individuals in the most convincing human form. Equally impressive is the lifelike space he creates for his figures. Moving beyond the shallow space surrounding

Giotto's figures and the more illusionistic three-dimensional space pioneered in Lorenzetti's *Good Government* cityscape, Masaccio's painting presents an entirely new type of space. A chamber of substantial depth appears to open up the solid wall, a veritable chapel for prayer.

If Giotto's and Lorenzetti's frescoes initially astonished onlookers as being true to life, Masaccio's painted scene must have appeared hyperrealistic. Through the application of a one-point mathematical perspective system, perfected by his architect-friend Brunelleschi, Masaccio has created a deep space within which his figures and forms reside. In addition, the spatial illusionism of *The Holy Trinity* is rationally and tightly ordered by a single, controlling vanishing point into which all the perspective lines, or orthogonals, recede **(14.8).** This point is located beneath Christ's feet at the viewer's eye level, and each figure or form is systematically organized around this

14.9 DONATELLO. *Saint George.* From Orsanmichele. 1415–17. Marble. Height: 82 in. Museo Nazionale del Bargello, Florence. *Anyone visiting Florence is immediately impressed with how much art is displayed in public places, either outdoors or in churches. Putting yourself in the place of Donatello, what physical and aesthetic considerations would you have had to take into account to create the* Saint George, *located above eye level on the building's exterior?*

mathematical framework. Even the halos conform to and align with the perspectival lines of spatial recession; they are no longer the flat, upright disks of Giotto's time. In a harmonious synthesis that characterizes Renaissance art, science (mathematical perspective, anatomical accuracy, portrayal of natural lighting and cast shadows) unites with religion. Reason and faith join together. A rationally constructed composition—note the triangular arrangement of the symmetrically balanced figures—leads the eye upward to Christ, the Holy Spirit, and God the Father. The artistic goal is the viewer's transport to a mystical experience of the Trinity.

The painted architectural surroundings of the figures also show the influence of Brunelleschi's architectural style. The barrel-vaulted chapel with its columns, pilasters, capitals, architrave, and proportions of Greco-Roman heritage, so different from the medieval style of the Church of Santa Maria Novella itself, clearly relates to the groundbreaking buildings that Brunelleschi was even then creating in Florence (14.10, 14.11).

Replacing Adam's skull at the base of Giotto's cross as the traditional medieval symbol of death and resurrection is a full-length skeleton lying atop a coffin. The words painted above it read "What you are, I once was; what I am, you will become." Inscription and image combine in a sobering warning to onlookers to lead a good life and put their faith in the Father, Son, and Holy Spirit. Then they too, like Adam and all other sinners, will be redeemed.

Sculpture Like Masaccio, leading Florentine sculptors such as Lorenzo Ghiberti (ca. 1378–1455), Nanni di Banco (ca. 1385/90–1421), and Donatello (ca. 1386–1466) created artistic figures in public places that, to passersby, seemed to live and breathe. The exterior wall of Orsanmichele, a Late Gothic–style church in the center of Florence, is a famous public setting for works by Ghiberti, Nanni, and Donatello. Each of twelve **niches,** or recesses in the walls of the building exterior, was assigned to a crafts guild, which then commissioned a large figure of its patron saint for the niche. For the guild of woodworkers and stonemasons, Nanni carved in marble relief the *Sculptor's Workshop* (1.2). He filled the niche above the relief with four life-size, standing marble saints, early Christian sculptors who had been executed for refusing to make pagan images. The members of the armorer's guild commissioned Donatello to sculpt a statue of their beloved Saint George **(14.9).** Naturally, Saint George is well armored and holds a large shield with a Latin cross embossed upon it. While legend associates Saint George with knighthood, the Crusades, and tales of chivalry, there is nothing medieval about Donatello's artistic interpretation, especially compared to a Gothic representation of another knight of Christ, Saint Theodore of Chartres Cathedral (13.16). How much more weighty, muscular, and active Donatello's Saint George is!

14.10 FILIPPO BRUNELLESCHI. Hospital of the Innocents, Piazza della Santissima Annunziata, Florence. Begun 1419.

Probably based on an actual human model, the bold knight comes across as a living, breathing person. Like his younger comrade Masaccio, Donatello achieves the naturalism of ancient classical sculpture (12.18) and weds it to the emotional intensity of Christian faith. The saint's body swells his finely crafted armor. Saint George's head and face are a curious combination of idealized physical beauty, bold expression, and glaring eyes. Likewise, one leg is tense and one relaxed; the same is true for the arms. By bringing together such counterposed opposites, Donatello has created a Saint George of classical contrapposto pose and dynamic unity. The statue prefigures that of another great defender of Florentine culture, the defiant *David* (14.26) of Michelangelo, executed almost a century later. In the decades to follow, Donatello created tremendously diverse sculptures. These include a sensual adolescent David in polished bronze, the first full-fledged nude since Roman times; an enormous bronze statue of an iron-willed Paduan military leader on horseback; and, very late in life, an emotionally expressive wood carving of the aged Mary Magdalen, emaciated but quietly majestic.

Architecture Probably accompanied by Donatello, Filippo Brunelleschi (1377–1446), architect, sculptor, and goldsmith, traveled south to Rome to study its ancient ruins. He had gone to Rome, his biographer Vasari tells us, to study "the way the ancients built and their proportions" and to observe "closely the supports and thrusts of the buildings, their forms, arches, and inventions . . . as also their ornamental detail." We see this classical legacy in thorough translation in Brunelleschi's Hospital of the Innocents **(14.10),** considered by many to be the first truly Renaissance-style building. In the graceful columned arcade of this public foundling home for abandoned children (or "innocents"), the complex, otherworldly medieval styles of the preceding centuries are nowhere to be found. In their place is an original "modern" architecture, classical in inspiration. Corinthian columns (10.15) rise into circular Roman arches that glide gracefully along under their straight entablature. The cornice, somewhat lifted, is the base for a row of "pedimented" windows, an evocation, in shape, of the triangular pediments of Greek temples such as the Parthenon (10.14). The vaulted arcade of the Hospital of the Innocents creates a welcoming space that is open, light-filled, and airy. The ancient classical attributes of simplicity, clarity, and order are manifested here in a building that does not merely copy but extends the achievements of the Greco-Roman past. Beauty without extravagance, a pleasing harmony among the parts, and a symmetrical, rhythmic arrangement greet the viewer. This is an architecture of humanism. Unlike the soaring God-centered

14.11 FILIPPO BRUNELLESCHI. Pazzi Chapel, Church of Santa Croce, Florence. Begun 1440.

Gothic cathedrals of the preceding centuries, such early Renaissance architecture is proportioned to the scale of humanity. One feels at home, not awed, walking under the hospital's gentle vaulted roof or resting on the welcoming steps in front of the building.

Much the same feeling is generated by the interior of the Pazzi Chapel **(14.11)**, designed by Brunelleschi for one of the powerful merchant families of Florence. Begun in 1440, the building was completed by others after the architect's death. Compared to the inner sanctum of the Late Gothic Cathedral of Saint Lorenz in Nuremberg, Germany **(14.12)**, built at almost the same time, the Pazzi Chapel appears plain and unassuming, even unimpressive. It is certainly worlds apart from the Gothic. It does not overwhelm so much as make one feel at peace. Simplicity, clarity, and gentle curves replace Gothic complexity, pointed arches, and upward thrust. In Brunelleschi's design, medieval mystery and aspiration toward the otherworldly give way to a more down-to-earth equilibrium of horizontals and verticals, a harmonious relationship of the parts to one another, and a humanistic orientation in which man is the measure of all things. In the Pazzi Chapel, Brunelleschi drew once again on the principles and elements of the Greco-Roman legacy—arches, vaults, domes, flattened **pilaster** columns with Corinthian capitals. But he forged them into an architectural beauty and a completely new meaning that spoke the language of the clear-headed, rational Florentines—scholars, craftspersons, businesspeople, artists—who were fashioning their city in the fertile hills of Tuscany into a new Athens or Rome.

The Renaissance in the North

Prominent among these clear-sighted Florentine merchants were members of the Medici family, leaders in the political, economic, and cultural life of the city. So successful were Medici manufacturing and banking enterprises that their agents, including Giovanni Arnolfini, criss-crossed Europe, often living for extended periods in thriving commercial cities of the north, which is where the Flemish artist Jan van Eyck painted *The Arnolfini Wedding Portrait* (14.14, 5.25).

The art of brothers Hubert (died 1426) and Jan van Eyck (ca. 1390–1441) of Flanders shows the modern style in its Northern European form. Much about the van Eycks' early Renaissance style mirrors its Italian counterpart in the south. Building upon the naturalism of Late Gothic art (13.17), the van Eycks' paintings, done singly or in partnership, show the same emphases as their Italian contemporaries on three-dimensional modeling and spatial illusionism. As a result, their convincingly human figures reside and move in a deep, lifelike pictorial space. Basic humanism, individualism, and realism characterize both Flemish and Tuscan art. We observe all of these qualities in the brothers' *Crucifixion* **(14.13).** Executed in tempera and oil on canvas attached to a small wooden panel, the *Crucifixion* is both similar to and different from Masaccio's *Holy Trinity* fresco, created in Florence at almost the same time. The Flemish painting features a deep space that rises dramatically upward, with the onlooker's point of view and organizing center of the composition around Christ's kneecaps, and then extends outward to the hazy blue peaks in the far distance. Aerial or atmospheric perspective, revived and perfected in the early fifteenth century by the Limbourg brothers (13.18) and the van Eycks, helped evoke this sense of spatial depth. Accurate diminution of the sizes of figures and objects furthers the illusion. The space recedes smoothly from foreground to middleground to background, but without the rigorous order imposed by a thoroughly mathematical perspective scheme like that employed in Masaccio's *The Holy Trinity* (14.8).

In contrast to *The Holy Trinity*, the van Eycks' *Crucifixion* features an abundance of intensely detailed figures and objects. Such microscopic attention to all aspects of physical reality appears basic to much Northern European art. Masaccio's and Giotto's crucifixion scenes are far more simplified, clearly ordered, and emphatically focused on the central protagonists. In the van Eycks' *Crucifixion*, we can readily locate Christ as the main figure in the picture's center, but where are the Virgin Mary and Jesus' followers? They are almost lost in the commotion and abundant detail. We locate them in the immediate foreground.

In formal terms, whereas Masaccio's figures are limited in color range and very sculptural

14.12 KONRAD HEINZELMANN and KONRAD RORICZER. Choir of Saint Lorenz, Nuremberg Cathedral, Nuremberg, Germany. Begun 1439. © Architectural Association/ A. Hamber.

in their weighty, simplified volumes, the van Eycks' personages emphasize painterly surface qualities. They glow in their red, green, and yellow hues, brilliant lights, and dark shadows. The brothers' perfection of the oil painting medium gave their works painterly possibilities far beyond those of fresco and tempera on wooden panel, the primary media of the Italian artists. Like alchemists magically transforming one material into another, the van Eycks evoke with remarkable veracity the textures of shiny metal, smooth or rough cloth, dry dirt or rough stone.

412

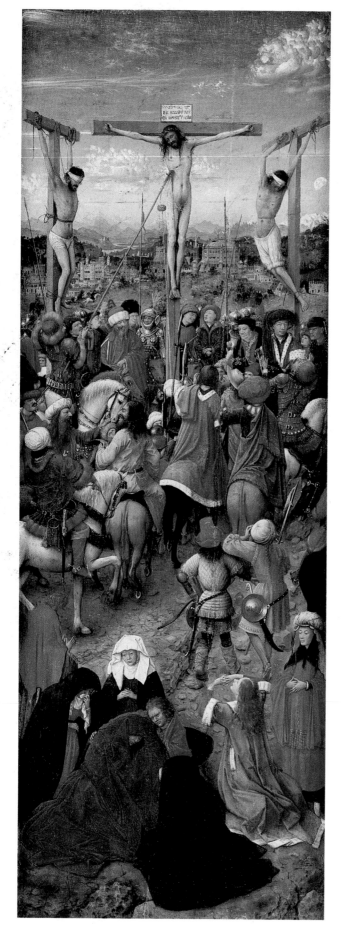

Drawing upon the spiritual intensity inherent in Northern European culture and art (13.10–13.14), the brothers infused their religious subjects with an emotional expressiveness: Christ suffers, Mary swoons, Christ's followers cry and call out. At the same time, sinful Europeans and turbaned Islamic warriors, both shown as threats to the Christian faith, laugh among themselves. It is a tumultuous, all too human scene—Christ and Mary even appear without the customary halos.

Jan van Eyck's *Arnolfini Wedding Portrait* **(14.14),** painted for an Italian client and friend, is something of a Flemish-Italian hybrid. It incorporates qualities of simplicity, dignity, and gravity found in Florentine early Renaissance art. The figures are statuesque and formally posed, and the composition appears perspectivally ordered. Perhaps inspired by an Italian work, such as Masaccio's *The Holy Trinity,* van Eyck employs a one-point perspective system that orders all spatial configuration around a vanishing point atop the small, round mirror on the back wall. In this convex glass we see the painter and another witness to the couple's marriage vows (figure 5.26 provides a close-up view). All the receding orthogonals, evidenced in the lines of the floorboards, bed, and window frames, angle back toward the mirror and van Eyck's personal vantage point. This specific way of seeing and representing, literally through the eyes of a single individual, is in harmony with the growing individualism of Renaissance society and culture.

At the same time, much separates the van Eyck wedding portrait from contemporary Italian painting. It is more luscious and vibrant in coloration. The complementary reds and greens enliven each other and sing out. The

14.14 JAN VAN EYCK. *The Arnolfini Wedding Portrait.* 1434. Oil on wood panel. 33 × 22½ in. National Gallery, London.

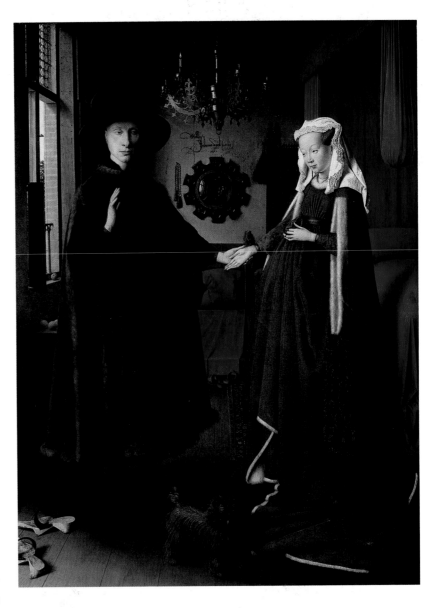

painting's simulation of the textures of the physical world—lace, fur, glass, shiny metal, polished wood—invites our touch. Like a color photograph in its mimetic power, the painting meticulously reproduces every square inch of the visual field. In addition, the painting is more densely packed with traditional religious symbols than most Italian portraits. Permeated by symbolism, the natural world and the world of the spirit meld into one. The single lit candle in the chandelier, burning in broad daylight, is not only material substance but the all-seeing Christ. The convex mirror, whose frame contains miniature scenes from the Passion of Christ, also references the ever-present eye of God. The shoes that the couple has taken off signify that they are standing on holy ground. The little dog between man and wife stands for marital fidelity, while the red-orange fruits ripening by the window connote fertility and abundance. The finial or ornamental crest of the bedpost is a tiny statue of Saint Margaret, patron saint of childbirth; from the finial hangs a whisk broom, symbolic of domestic care. On a more secular level, the man stands by the window and the out-of-doors, the external world in which men function, whereas the woman is silhouetted against the domestic interior, with its allusions to the roles of wife and mother.

Its many unique Northern European characteristics notwithstanding, *The Arnolfini Wedding Portrait* shows us that Italian artistic influence and patronage had moved northward. The oil painting techniques and illusionistic realism pioneered by the van Eycks in turn would soon head south.

RENAISSANCE ART: THE SECOND HALF OF THE FIFTEENTH CENTURY

Giovanni Arnolfini, a Tuscan merchant from the city of Lucca who had established himself in Bruges in Flanders, was in direct contact with the Florentine Medici family, the commercial powerhouse that, for all practical purposes, ruled that republic and city-state from

the 1430s to 1498. The Medici heads of family, always patrons of Florentine cultural life, became ever more passionate about humanist intellectual pursuits and the arts with each succeeding generation. In the century's final quarter, Lorenzo de' Medici, called "The Magnificent," became the most important patron of Florentine high culture.

Sculpture, Painting, and Printmaking Across Italy and Europe

We see the formidable Lorenzo the Magnificent **(14.15)** in a likeness long attributed to the wide-ranging artist, influential teacher, and

Greatly pleased by such invention [of oil painting], Giovanni [Jan van Eyck] quite understandably went to work on many pictures and filled the entire country with them, to the amazement and delight of the people and very great profit to himself.—Giorgio Vasari, artist and writer, *The Lives of the Most Excellent Painters, Sculptors, and Architects,* 1550

14.15 Portrait bust of Lorenzo de' Medici (probably after a model by Andrea Verrocchio and D. Benintendi). 1478 or 1521. Painted terra cotta. 25⅞ × 23¼ in. Samuel H. Kress Collection. Photograph © 2002 Board of Trustees, National Gallery of Art, Washington, D.C. 1943.4.92 (A-146/SC).

workshop owner Andrea Verrocchio (ca. 1435–1488), whose apprentices and assistants over the decades included Leonardo da Vinci and Sandro Botticelli. The sculpted head is reminiscent of the head and upper torso format of ancient Roman portrait busts of emperors (12.36) and other important figures. The handling by Verrocchio or one in his circle is generalized, his goal a forceful overall impression rather than a meticulously detailed reproduction. Administrator, poet, intellectual, and collector of rare books and art, Lorenzo was the sun around which numerous individuals revolved. He and the humanist circle of philosophers and scholars meeting in the various Medici palaces and villas substantially influenced numerous artists, including Botticelli, Leonardo, and Michelangelo.

The commission for Botticelli's *Birth of Venus* **(14.16)** came from a member of the Medici family, possibly Lorenzo di Pier Francesco de' Medici, who financed fellow Florentine merchant and navigator Amerigo Vespucci (namesake of America) on his 1497 voyage to the New World. Without the Medicis, there would have been no *Birth of Venus* and no continent named America— showing that the power of patrons can never be overemphasized. Botticelli apparently based the pose of his Venus directly on a Greco-Roman statue of the nude goddess, very likely one in a Medici collection (12.23). *Birth of Venus*, in fact, features the first full-fledged female nude since antiquity, a daring innovation. The protection of the Medicis against possible religious censure of the work for its pagan nudity was essential. With supporters in the highest rank of society, Botticelli was able to make visible the mythical story of Venus's birth.

The Roman goddess of love and beauty, Venus rises, born from the wind and sea. Blown by the west wind Zephyr accompanied by his love, the nymph Chloris, and welcomed by another nymph who offers a billowing flower-covered garment, Venus arrives at her earthly home, the Mediterranean island of Cyprus. The giant cockleshell from which she arises is echoed in shape by the shoreline. Flowers and sweet fragrances waft through the air. Almost 6 feet high by 9 feet long, the painting has all the grace, delicacy, and idealized beauty of Late Gothic manuscript illumination (13.17), tapestry wall hangings, or decorative painting. The shallow space and Botticelli's linear style, in which all the figures and objects are clearly delineated, also hearken back to the Late Gothic style. With its elements of artifice and fantasy, *Birth of Venus* recalls a theatrical tableau in which the characters perform before a flat backdrop. The miraculous event takes place on a green ocean with little, repeating V-shaped waves, next to a storybook island and in front of a fanciful light blue sky. Renaissance qualities appear in the sensitive modeling and anatomical accuracy of the human forms, learned from Verrocchio and other masters. Yet Botticelli's airborne protagonists, painted in soft, almost pastel colors, dematerialize the solidity of typical Renaissance

14.16 SANDRO BOTTICELLI. *Birth of Venus.* Ca. 1482. 5 ft. 9 in. × 9 ft. 1 in. Galleria degli Uffizi, Florence. *Works of art become more or less popular during different time periods. Botticelli's art has never been more popular than in the last hundred years. Why do you think this is the case?*

figures, and for good reason. The artist has sought to convey spiritual and poetic qualities in the visual retelling of the mythic birth. Within the Medici circle, where ancient Greek and Roman philosophy fused with Christian thought, Venus in her celestial or sacred guise was equated with notions of universal love, making her a classical equivalent of the Virgin Mary.

To the average devout person outside the elite Medici circle, such a painting would have been shocking. This was not art for the public realm, the domain of so much previous Florentine art (14.4–14.10), but rather art for a private residence and for appreciation by a select audience. What a strange brew it is, an enchanting fusion of seeming opposites: pagan and Christian, Gothic and Renaissance, unabashed nudity and virginal innocence. Botticelli's unique

art, emblematic of the complex Medici culture that ended with Lorenzo the Magnificent's death in 1492, would find fellow travelers in certain elegant and complicated aristocratic styles of the sixteenth century.

The art of Leonardo da Vinci (1452–1519), another Verrocchio workshop assistant, took a decidedly different direction. As a painter, Leonardo focused on Christian subject matter (2.18) and on portraiture, with truth to nature his guide. His portrait sitters, along with their apparel and backgrounds, as in the *Ginevra de' Benci* painting of ca. 1474 (2.22), are observed closely and rendered with three-dimensional illusionism through the new medium of oil paint. (Botticelli worked in the older medium of egg tempera.) Perfection of atmospheric and linear perspective (14.21) fostered the illusion of endless space. The viewer looked into a

14.17 LEONARDO DA VINCI. *Vitruvian Man*. Ca. 1485–90. Pen and ink. 13½ × 9⅝ in. Galleria dell'Accademia, Venice. *The writings of the ancient Roman architect Vitruvius were highly respected during the Renaissance. He believed that the symmetry and proportions of the human body were related to the geometric harmony and proportion of well-designed buildings. Do you think Leonardo's geometrically proportioned* Vitruvian Man *is fact or fiction, that is, reality or an ideal?*

to the perfect mathematical proportions he believed undergirded all the diverse entities of the material universe. In contrast to Botticelli, whose slender, elongated figures aspire to a chivalric concept of grace, Leonardo sought to firmly base his figures on scientific observation and a beloved theory of ideal mathematical proportions. His scientific nature notwithstanding, Leonardo inevitably invests his figures, from Christ to Ginevra de' Benci, with a poetic sensitivity and gracefulness.

Despite the occasional depiction of pagan nudes and mythological stories, most Italian artworks throughout the fifteenth-century remained either firmly religious in subject or—in the case of painted or sculpted portraiture—proper, formal, and straightforward in their fidelity to the sitter's appearance. A large painting of Saint Francis of Assisi by the leading Venetian artist, Giovanni Bellini (ca. 1430–1516), combines the best of both: true-to-life portraiture and a moving religious subject. The scene of Saint Francis receiving the stigmata **(14.18)**, or crucifixion wounds of Christ, demonstrates the synthesis of classically inspired humanism and Christian religiosity, of scientific vision and spiritual belief, that represents the triumph of the Renaissance. Saint Francis may be supernaturally receiving the wounds on his hands and body, but he is also a specific human being whose face and body were probably based on a live model. Note too that the medium employed by Giovanni Bellini, his remarkable student Giorgione (16.25), and the unknown Bellini circle painter of *The Reception of the Ambassadors* (14.2) is oil paint. Exploiting its flexible qualities and chromatic brilliance, the artists of the Veneto region became world renowned for their "Venetian color."

The influence of the Italian Renaissance—characterized by humanism, individualism, naturalism, and classicism—spread throughout Europe. German, French, Flemish, and Dutch artists who traveled to view the modern and ancient art of Italy returned to their homelands changed, or at the very least informed. Residing in Venice in 1497 and again between 1505 and 1507, the young German printmaker and painter Albrecht Dürer (1471–1528) absorbed the influences of the Italian Renaissance, became an admirer of Leonardo da Vinci, participated in a Bellini workshop, and

da Vinci work as if through a window into an extension of the natural world beyond the picture plane. Where Botticelli's works aspired to worlds above the physical, Leonardo sought the divine in material reality, probing nature and the human being for God's perfection here on earth. His drawing *Vitruvian Man* **(14.17)**, for example, seeks to relate the human figure

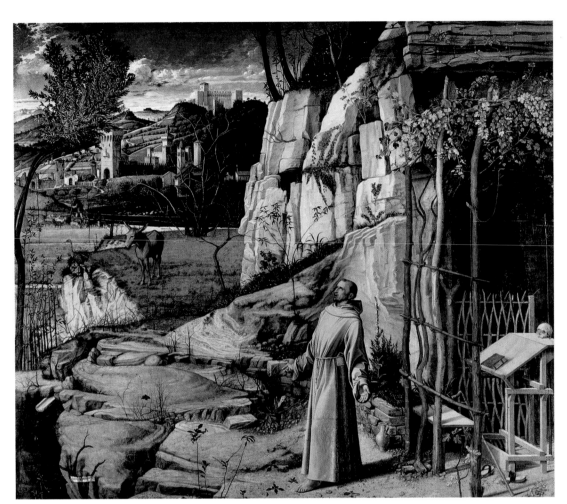

14.18 GIOVANNI BELLINI. *Saint Francis in the Wilderness.* Ca. 1485. Oil and tempera on panel. 48½ × 55 in. The Frick Collection, New York.

was a close friend of Giovanni Bellini himself. His black-and-white print engraving *Adam and Eve* **(14.19)** strives for a perfect beauty of the human male and female form, building upon the comeliness of Bellini's figures and the notion of the proportionally ideal body form visualized by Leonardo in his drawing *Vitruvian Man* (14.17). The valuation by Renaissance high culture of the beautiful nude body, gradually emerging in the works of artists in Venice, in Florence, and across Italy, clearly influenced Dürer. Medieval and early Renaissance paintings and sculptures depicting Adam and Eve's nakedness (13.12) had always associated their bodies with shame and sin. In Dürer's interpretation, Adam and Eve commune with each other in the Garden of Eden, unashamed of their nakedness. The moment is just prior to Eve's temptation by the serpent and the couple's

fall into sin. The pair are classically beautiful and display their bodies, leafy genital coverings notwithstanding, most openly. In his athletic build and contrapposto pose, Adam recalls Michelangelo's recently completed *David* (14.26) and the ancient Greek *Doryphoros* (12.18). Eve similarly appears to be a northern relative of Botticelli's *Venus* (14.16) and the ancient Greco-Roman *Medici Venus* (12.23). At the same time, much of Dürer's engraving is quintessentially Northern European in style and content. Like van Eyck's wedding portrait (14.14), man and woman reside in an illusionistic three-dimensional environment full of descriptive detail. Note the artist's microscopic rendering of each leaf, section of tree bark, and animal. And, as before, abundant symbolism characterizes the work. Flora and fauna, for example, embody both Christian

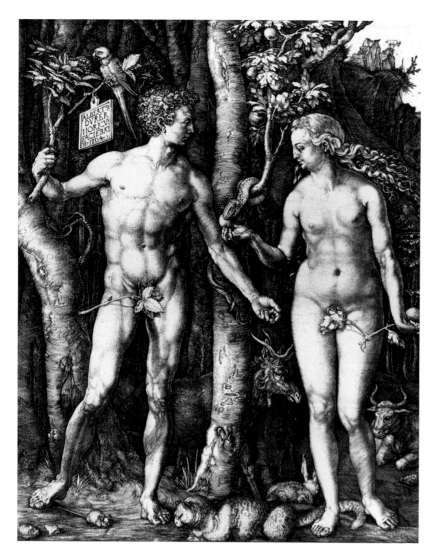

14.19 ALBRECHT
DÜRER. *Adam and Eve.*
1504. Engraving. 9¾
× 7⁷⁄₁₆ in. Bibliothèque
Nationale, Paris.

virtues and vices and contemporary medical theory. Art historian Marilyn Stokstad relates:

> Dürer embedded the landscape with symbolic content related to the medieval theory that after Adam and Eve disobeyed God, they and their descendants became vulnerable to imbalances in body fluids that altered human temperament: an excess of black bile from the liver produced melancholy, despair, and greed; yellow bile caused anger, pride, and impatience; phlegm in the lungs resulted in a lack of emotion, lethargy, and disinterest; and an excess of blood made a person unusually optimistic but also compulsively interested in pleasures of the flesh.

These four human temperaments, or personalities, are symbolized here by the melancholy elk, the choleric cat, the phlegmatic ox, and the sensual rabbit. The mouse is a symbol of Satan, whose earthly power, already manifest in the Garden of Eden, was capable of bringing perfect human beings to a life of woe through their own bad choices. The parrot may symbolize false wisdom, since it speaks but can only repeat mindlessly what is said to it.[1]

Dürer was so proud of this engraving, a true synthesis of northern European and Italian styles, that he signed his name in Latin on the placard that hangs from the Tree of Life.

From Dürer and Leonardo back to Donatello and Brunelleschi, printmakers, painters, sculptors, and architects were seeing themselves in new ways. Reflecting the advanced intellectual currents of their time and with their impressive creations deeply admired, these men began to publicly assert their desire for an improved social status, seeking recognition as artists in our contemporary sense of intellectually knowledgeable, creative individuals.

THE BIRTH OF FINE ART AND THE ARTIST

Our modern notions of the artist and of "fine art" as an exalted pursuit first developed in the fifteenth century, when sculptors and painters such as Lorenzo Ghiberti and Leonardo da Vinci began to seek a higher social and cultural stature for their professions. In their quest to distinguish themselves from handicraft workers and crafts guilds, various painters and sculptors argued that their arts required substantial intellectual knowledge, not simply technical skill. In 1440, the prominent Florentine goldsmith, painter, and sculptor Ghiberti promoted the idea of the intellectual artist, writing that sculptors and painters "should be trained in all these liberal arts: Grammar, Geometry, Philosophy, Medicine, Astronomy, Perspective, History, Anatomy, Theory of Design, and Arithmetic." Ghiberti used his knowledge of mathematical perspective (14.8), anatomy, the history of religion, and design theory to create his sculptural relief depicting the story of the Hebrew Scripture figures Jacob

and Esau, a panel **(14.20)** from the famous bronze doors of Florence's Baptistery.

A genius in the fields of science and engineering as well as painting, Leonardo da Vinci made the boldest case for the painter's art. He claimed that painting was equal and even superior to the scientific disciplines, all acknowledged from ancient times as respected liberal arts. Leonardo asserted that painting encompasses many sciences, requiring knowledge of anatomy, optics, and mathematics. Leonardo closely observed the live human model and dissected cadavers to learn how bones, muscles, and organs operate from the inside out. Created out of such anatomical knowledge, a figure by Leonardo lives and breathes. His study of optics, the branch of physics dealing with the nature and properties of light and vision, led to the use of the aerial or atmospheric perspective that endows his landscape backgrounds (2.29) with greater realism. Through the application of mathematics to spatial configuration, Leonardo's perspective systems produce illusions of deep, rationally ordered space **(14.21,** 2.19). Yet in the final analysis, the artist argued, painting was more than the sum total of all these applied sciences. Painting combined the different scientific disciplines in "an act of creation," therefore making it superior to science. Artists like Leonardo and Dürer spoke of painting as a godlike act. Like God creating the universe from the void, the artist invents a person or landscape out of nothing. Truly blessed, the artist is a participant in an essentially divine process of creation.

As prominent artists freed themselves from the protections and restraints of crafts guilds, they competed for artistic commissions in what might be described as a rudimentary "art market." As private entrepreneurs, artists might work for the highest bidder, whether a bourgeois or aristocratic patron, a city council or church order. Like Albrecht Dürer, they might print editions of their engravings and woodblocks and sell them through middlemen in city shops or county fairs across Europe. Or they might enter the paid service of a powerful ruler and develop artistic, architectural, and engineering projects, as Leonardo da Vinci did for the Duke of Milan and as Dürer did as court painter, draftsman, and printmaker to the Holy Roman Emperor Maximilian. What-

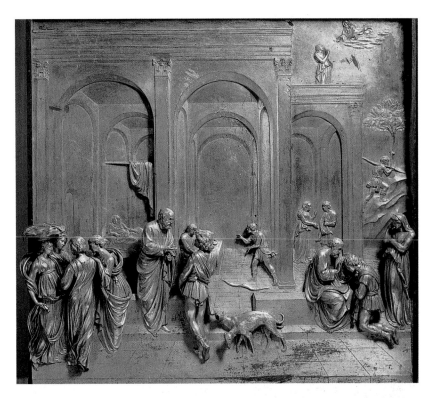

14.20 LORENZO GHIBERTI. *Jacob and Esau*, panel from the Baptistery doors. Ca. 1435. Gilt bronze (postrestoration). 31¼ in. square. Museo dell'Opera del Duomo, Florence.

ever route the artist took to secure his economic and social well-being, his—and soon her—star was rising.

By 1550, a handful of women artists had achieved comparably high social and cultural status as court painters. The Italian portraitist Sofonisba Anguissola (1528–1625) was employed by the king and queen of Spain, while Flemish portrait painter Caterina van Hemessen (1528–1587) served in the retinue of Mary of Hungary, the sister of the Holy Roman Emperor Charles V (also from Spain). Supported by humanists who praised the accomplishments of the female artists of the ancient world and recommended education in the arts as part of a gentlewoman's upbringing, Anguissola became the first professional female painter in Italy since ancient times. Raised in the city of Cremona in northern Italy, she and her five younger sisters received substantial art training from a professional painter hired by their father. Sofonisba's portraits combine a detailed, true-to-life realism with a warm, down-to-earth emotional expression that was ahead

It is nothing new to find famous artists in restricted circumstances. And yet the art of drawing was once counted among the liberal arts, and only outstanding men were allowed to teach them, and in any case only gentlemen; in fact it was forbidden to entrust this to slaves. It must be blamed on the princes, not on art, if it lacks its rewards.—Erasmus of Rotterdam, humanist intellectual, *On the Correct Delivery of Latin and Greek Speech*, 1528

14.21 LEONARDO DA VINCI. Architectural perspective study for *The Adoration of the Magi*. Ca. 1481. Pen and ink. 6½ × 11½ in. Gabinetto dei Disegni e Stampe, Uffizi, Florence.

Perspective is to painting what the bridle is to the horse, the rudder to the ship.—Leonardo da Vinci (1452–1519), from his notebooks

14.22 SOFONISBA ANGUISSOLA. *Husband and Wife*. 1580. Oil on canvas. Galleria Doria Pamphili, Rome. *Compare this picture with that of another married couple (14.14). How are the Anguissola and van Eyck paintings similar and different?*

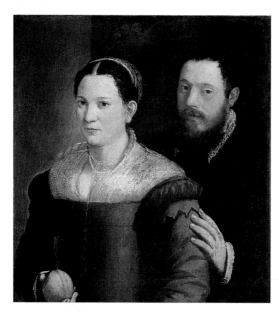

of its time. A double portrait of Sofonisba and her husband **(14.22)** by the artist captures not just their appearance but also a sense of each person's quiet strength and independence, as well as the intimate connectedness of the couple's marriage. Note how the figures meld together and how key features such as heads and hands are highlighted while other areas are painted in much darker hues. As court painter for the most powerful European monarchy, Anguissola achieved unprecedented status, combining the roles of intellectual, gentlewoman, and creator.

The Artist as Intellectual and Gentleman

In *The School of Athens* **(14.23),** a large wall painting by Raphael Sanzio (1483–1520), painters, sculptors, and architects have won the battle for higher status. They stand beside the most learned philosophers, scientists, and poets of ancient times. No work shows the connection between the Renaissance "moderns" and the Greco-Roman "ancients," between pagan and Christian culture, or between science and art more explicitly than this painting in the heart of the papal complex in Rome. Several of the great artist-intellectuals of the Renaissance—Leonardo, Michelangelo, the architect Bramante, and Raphael himself—are believed to have been the models for four of the learned personages portrayed in the work.

In the center of the painting stand the foremost philosophers of antiquity, Plato and Aristotle. They are situated within a grand classical structure thought to be derived from Bramante's contemporary plans for the rebuilding of the papal church, Saint Peter's (14.37), and reminiscent of the ancient Roman Basilica of

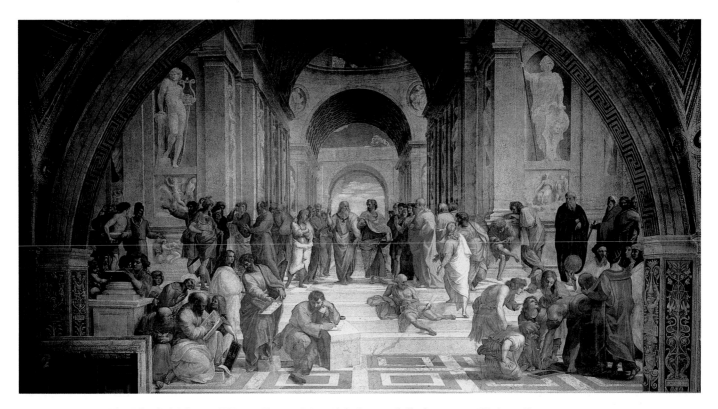

14.23 RAPHAEL. *The School of Athens.* 1509–11. Fresco. 26 × 18 ft. Stanza della Segnatura, Vatican, Rome. *Scholars assert that High Renaissance art moves away from the average citizen both in its location (for example, papal apartments) and in its learned subject matter. Do you see a split between early and later Renaissance art in these regards, for example, between Masaccio's* Holy Trinity *(14.7) and Raphael's* School of Athens?

Maxentius (10.19). Plato, the idealist, points upward to the realm of spirit, the source of metaphysical ideas and divine inspiration. In a niche above him and to his right is the commanding statue of Apollo, the god of high places, who is associated with poetry and transcendent thought. To Plato's right are famous poets and philosophers of ancient times, including the garlanded Epicurus, reading a book, and Pythagoras, writing about and demonstrating his theory of proportion. Other philosophers look on, among them the turbaned Arab mathematician Averroës. Many have proposed that the figure of Plato is an idealized portrait of Leonardo da Vinci, whose art and views on art Raphael clearly admired. Indeed, the younger painter may actually have drawn inspiration for his more complicated *The School of Athens* from Leonardo's own wall painting, *The Last Supper* (2.18). There certainly are some basic similarities: the placement of figures within an overarching architectural

setting, the employment of a one-point perspective system that focuses attention on the central figures, the representation of the protagonists in expressive poses and gestures that convey their innermost thoughts, the intertwining of participants and groups to produce a unified dramatic whole, and the combination of realism and idealism in the treatment of the subjects.

Walking beside Plato and sharing center stage in *The School of Athens* is Aristotle. Thirty years younger than his teacher, Aristotle is more interested in the practical functioning of the natural and political world. He holds out his hand with the palm facing downward, perhaps to bring his master's soaring idealism back to the earth and the realm of the possible. The statue to Aristotle's left represents Athena, goddess of reason. Physical scientists, who apply reason to worldly activity, occupy this half of the painting. The astronomer Ptolemy holds a celestial sphere, and Euclid holds a compass

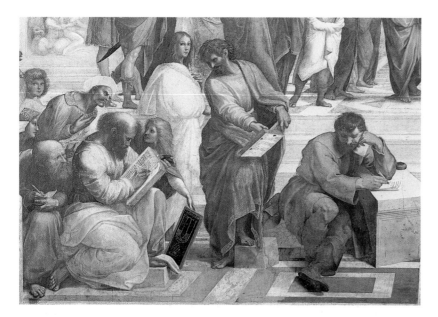

14.24 RAPHAEL. *The School of Athens*, detail of Pythagoras, Averroës, and Heraclitus (Michelangelo). 1509–11. Fresco. 26 × 18 ft. Stanza della Segnatura, Vatican, Rome.

and bends over a problem in geometry. The model for Euclid was Raphael's friend, the architect Bramante (ca. 1444–1514), for whom the science of geometry would have been essential. Behind the figure of Euclid on the painting's extreme right-hand side, the handsome face of the twenty-six-year-old Raphael looks out at us. In front and just to the left of center on the steps, another artist is a large, brooding, and solitary presence. Reputed to be the ancient "weeping philosopher" Heraclitus, this figure is a melancholic portrait of Michelangelo **(14.24).** (Contemporary humanist thinkers, following Aristotle, taught that "all men who excel in a great art have been melancholics.") Fittingly, he wears the short, hooded smock and soft boots of a sixteenth-century stonecutter. The greater bulk and tension embodied in this figure, and its last-minute integration into the work, are said to have been inspired by Raphael's clandestine visit to the nearby Sistine Chapel, where the moody and secretive Michelangelo was in the second year of labor on a vast ceiling fresco (14.27). Raphael must have been moved by the giant painted figures of the fresco, superhuman in size and power.

Like Raphael and the figures pictured in *The School of Athens,* the Venetian painter Titian (ca. 1487–1576) was a gentleman and an intel-

lectual. A student of Bellini (14.18) and a collaborator with Giorgione (16.25), Titian learned from the greatest Venetian artists of the late fifteenth century and went on to become his city's leading painter in the sixteenth century. In incredible demand, he worked wherever and for whomever he pleased: private patrons, religious orders, the government of Venice, the Spanish king, and the Holy Roman Emperor. Titian's *Assumption of the Virgin* **(14.25),** created for the religious order of the Frari (or Fathers) of his home church, rises in a visual crescendo behind the huge church's high altar. The subject is the assumption or rising of the Virgin Mary to heaven upon her death. A host of cherubic angels carry Mary slowly upward on a cushioning cradle of cloud into a circle of divine golden light. Radically foreshortened, a hovering God the Father awaits her. Mary, pure, young, and of idealized beauty, raises her gaze and hands in radiant expectation. Below her, on the earthly plane, the disciples, like the actual onlookers in the church, are awed and excited by the heavenly ascent. Moved aesthetically, an art student wrote:

> The vibrant complementary colors, especially reds and greens, hold our attention. I am aware of the artist's use of color as design element within the three levels of the composition. Areas of bright red are repeated in lessening amounts, leading our eye carefully from level to level, through the mass of swirling heavenly host to God himself draped in "Titian red." Movement is further created through billowing clothing, attentive gazes, the push and pull of gestures, pointing fingers, outstretched wings, angelic legs treading air, and apostles reaching upward. What a wonderful sensory experience!

Shifting gears from religious or "sacred" works, artists such as Titian might paint very worldly or "profane" works for other patrons. Like numerous sixteenth-century artists, Titian moved back and forth between sacred and profane subjects, creating a series of erotic nudes in the guise of pagan goddesses such as Venus, the Roman goddess of love. His famous *Venus of Urbino* (6.27) was painted as a "cabinet picture," a portable oil painting for the private chamber (or cabinet) of a northern Italian nobleman. The model, some suggest, was the lord's mistress, a beautiful young woman made even more beautiful by the artist.

The Artist as Embattled Genius

Unlike the well-mannered Titian and the sociable Raphael (whom he saw as a rival), Michelangelo Buonarroti (1475–1564) was far from a graceful cavalier. A melancholic loner who lived in shabby quarters and dressed like the poorest of workmen, Michelangelo possessed a volcanic pride and a most ungentlemanly temper; on occasion, he rebuked the popes themselves. Once he combatively broke off a papal commission from the warlike Julius II and went into hiding, risking the possibility of torture or imprisonment. The next pope, Leo X, was an art lover who showered commissions on the genial Raphael. He said of Michelangelo, "He is too intense; there is no getting on with him." But Michelangelo's genius was so universally acknowledged that commissions from society's rulers poured in, chaining the artist to scaffold or stone for years.

Over the course of a long life, Michelangelo worked mainly for the popes, but secular authorities also commissioned his work. One of the most famous works of his young manhood was created for his home city of Florence: the huge statue of *David* **(14.26),** about 14 feet high, carved at the request of the city government. A public outdoor sculpture, it represented the proud independence of the Florentine Republic, free from the control of Italian tyrants like the Duke of Milan or foreign imperialists like the king of France.

Outwardly, the nude body of the *David* evokes a classical beauty and calm grandeur. Yet inside the torso, especially in the young man's expression, swells a vigorous energy. Tension awaits release. David's brow is knit. His eyes glare, an early instance of the titanic power, *terribilità* in Italian, that filled Michelangelo's later works. This "terribleness" is already evident in David's glowering expression of fierce confidence. The eyes seem to emit thunderbolts shot out defiantly at any oncoming Goliath who might dare to threaten the republic. In its original setting on the square outside the Palazzo Signoria, the palace of the city's governors *(signorie),* the *David* for centuries served as political art to stir the Florentine public.

In the *David*, Michelangelo's *terribilità* is tempered by his passion for the beauty of the

14.25 TITIAN. *Assumption of the Virgin.* 1516–18. Oil on panel. 22 ft. 7 in. × 11 ft. 10 in. Santa Maria Gloriosa dei Frari, Venice.

It is to Titian that we must turn our eyes to find excellence with regard to color, and light and shade, in the highest degree. He was both the first and greatest master of this art. —Sir Joshua Reynolds (1723–1792), artist, *Discourses*

The Painter must always seek the essence of things, always represent the essential characteristics and emotions of the person he is Painting . . . —Titian (ca. 1487–1576), artist

nude male body. The same holds true for his powerful figures of God and Adam in the famous *Creation of Adam* **(14.27)** from the ceiling of the Sistine Chapel, the pope's personal chapel in Rome. In fact, Adam recalls a slumbering *David* just rising to life. Art historian William Wallace notes this contrast between the passive Adam, formed of the mud on which he reclines, and God, astonishing in His energy.

> With inclined head set upon a muscular torso and body, Adam looks longingly towards his creator, who is about to invest his physical perfection with soul. In the few centimeters that separate their fingertips is the greatest suspension of time and narrative in the history of art. That gesture is the focal point, with a magnetic intensity, of the entire ceiling, perhaps the most

14.26 MICHELANGELO. *David*. 1501–04. Marble. Height: 18 ft. Galleria dell'Accademia, Florence.

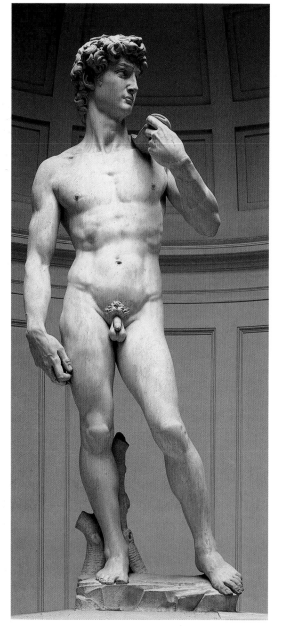

Manner [the style of the High Renaissance] then attained to the greatest beauty from the practice which arose of constantly copying the most beautiful objects, and joining together these most beautiful things, hands, heads, bodies, and legs, so as to make a figure of the greatest possible beauty.—Giorgio Vasari, artist and writer, *The Lives of the Most Excellent Painters, Sculptors, and Architects,* 1550

universally recognized and one of the most frequently imitated images of all time.[2]

In the half century to come, however, the physical beauty and optimism shown in Michelangelo's *David* and *Creation of Adam* steadily vanished. In a very late pietà sculpture for his own tomb in Florence's cathedral (8.40), the faces of the dead Christ and Joseph of Arimathea (a self-portrait) reveal the full heaviness, tiredness, and struggle that had besieged the artist and profoundly affected his works. A patriot at heart, Michelangelo was deeply saddened by the transformation of his beloved Florence from republic to dictatorial dukedom.

Even more disturbing for this devout Roman Catholic was the Protestant Reformation—which began in the German states in 1517—and the subsequent turning away of papal Catholicism from a humanistic spirituality to a far more dogmatic and puritanical practice. As he grew older, Michelangelo longed to be released from his earthly bonds to gain the realm of the spirit and the peaceful rest of eternal life. His *Pietà*'s expression of pity for and solidarity with the crucified Christ conveyed much about his later state of mind.

SIXTEENTH-CENTURY ARTISTIC DIRECTIONS

Some art historians have called the period of the late 1400s through the early 1500s the High Renaissance and have closely associated it with the masterpieces of Leonardo, Raphael, Michelangelo, and Titian. They have seen in the classically harmonious, heroically uplifting works of these four men a "grand manner" embodying the highest expression of Renaissance values. They judge the work of this brief period to be the stylistic and sociocultural culmination of a century-long period that began with the "Early Renaissance" works of Masaccio, Donatello, and Brunelleschi.

Around 1520, a variety of unsettling and highly idiosyncratic styles began to rival the Renaissance vision of confident humanism, ideal beauty, and perfect order. Many scholars attribute the change in style to profound crises in the larger society, including warfare between Italian states, foreign invasions, corruption in the Catholic Church, and the Protestant Reformation to the north. For the remainder of the sixteenth century, the resulting artistic "manners" or styles deviated from or interwove with classical Renaissance tendencies.

Mannerist Art

Mannerism, the modern term for these post-Renaissance styles, is broadly defined as an extreme emphasis on the personal manner or style of the artist. Already, in the case of High Renaissance artists such as Leonardo, Raphael, Titian, and especially Michelangelo, personal styles were pronounced. A first generation of

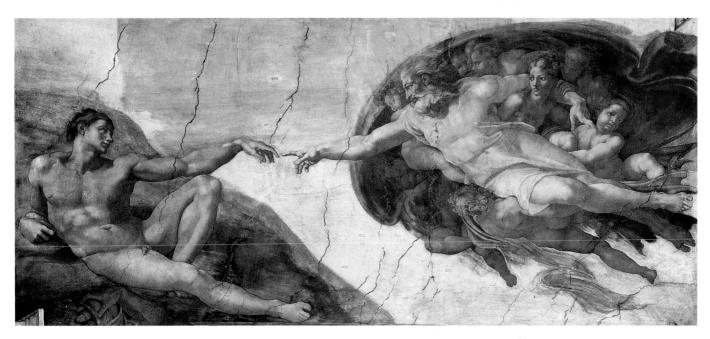

14.27 MICHELANGELO. *Creation of Adam*, detail of the ceiling of the Sistine Chapel. 1510. After cleaning.

mannerist artists, brought up in a world of spiritual and social crisis and inspired by these individualistic High Renaissance masters, simply pursued their own distinctive manners, with little regard for past rules or norms. Exercising their own inventiveness like Leonardo, seeking to realize their own creative genius like Michelangelo, and aspiring to aristocratic high culture like Raphael, young artists such as Rosso Fiorentino, Pontormo, and Parmigianino welcomed arbitrary distortions and exaggerations of the rational, classically idealized Renaissance forms and compositions of the day. Consider the exaggeration and the grotesque in a self-portrait **(14.28)** by Parmigianino (1503–1540). Taking advantage of the distortion wrought by looking at himself in a convex mirror, Parmigianino has invented a most unusual, nonclassical portrayal. An arm and a grotesquely large, elongated hand join curving walls and ceiling to swirl around the sensitive, realistically reproduced head of the artist, whose gaze is transfixed in dreamlike reverie on his own reflection. Certain mannerist works, including this one, speak of personal isolation, self-absorption, and troubling emotions, a development in keeping with the crises of the times and the growing emphasis on individualism in both art and society.

14.28 PARMIGIANINO. *Self-Portrait in a Convex Mirror*. 1524. Oil on panel. Diam.: 9⅝ in. Kunsthistoriches Museum, Vienna. *Do mannerism and a melancholic personality go hand in hand? In the sixteenth century, melancholy was medically and astrologically associated with the artistic personality (14.24). Does this mannerist self-portrait convey melancholy or a different kind of feeling?*

14.29 AGNOLO BRONZINO. Allegory called *Venus, Cupid, Folly, and Time*. Ca. 1545. Oil on wood. 61 × 56¾ in. © The National Gallery, London.

Maniera [manner], then, is a term of long standing in the literature of a way of life so stylized and cultured that it was, in effect, a work of art itself; hence the easy transference to the visual arts.—John Shearman, art historian, *Mannerism*, 1967

Writing about Michelangelo's artworks after 1520, sixteenth-century art historian Giorgio Vasari, himself a mannerist artist and architect, comments on the shift from realism and classical norms to a new manner of "determined grace" and unbridled imagination. Michelangelo's grand *maniera* (manner), Vasari writes, so novel and free, had broken "the bonds and chains" of classicism and given "license . . . and courage to imitate him to those who have seen his methods, and new fantasies have since been seen which give more of the grotesque than of reason or rule. . . ." These aesthetic qualities, which we now associate

with an encompassing mannerist style, characterized works of architecture, interior design, and decorative art as well as sculpture and painting. The delightfully grotesque doorway of the Palazzo Zuccari (3.7) in Rome is one architectural example.

An exotic, mysterious oil painting **(14.29)** by Florentine artist Agnolo Bronzino (1503–1572) brings Vasari's words to visual life. Its figures, especially the four in the center, are determinedly graceful, with gently curving, twisting poses; long, thin fingers; beautifully formed bodies; and elegant hairstyles and accessories. The artist's imaginative fantasy runs free, so much so that the viewer is puzzled. What is going on? The answer is some type of complex allegory, a symbolic story centered on the pagan deity Venus and her amorous son Cupid, whose arrows of love none can resist; note the pointed red shaft in the goddess's left hand. Symbolic figures crowd the scene and interlock in a convoluted narrative. One scholarly interpretation proceeds as follows: Old Father Time pulls back a curtain held by Fraud, in the upper left-hand corner, to reveal Venus and Cupid in incestuous embrace, to the delight of Folly, who brings passionate red roses, and to the dismay of grimacing Jealousy, who tears her hair as Pleasure, half woman, half snake, offers a sweet honeycomb. The moral is that folly blinds us to the jealousy and fraud of sensual love that time reveals. At the same time, the picture sends a contrary message, reveling in the very act it supposedly condemns.

A gift from Duke Cosimo de' Medici, royal ruler of Florence, to King Francis I of France, the painting portrays the Renaissance love of classical subjects and the beautiful nude body with three-dimensional fullness, but it distorts or transcends Renaissance practice in several other areas. The space within which the story takes place is no longer deep and rational, arranged according to mathematical law. Rather, it is shallow, claustrophobic, and ambiguous. Symmetrical balance and the stable triangular arrangement of figures are jettisoned for a dynamic asymmetry, with Venus and Cupid off-center to the left and the major figures linked literally arm to arm and leg to leg in an irregular rectangle. Finally, the chaste Venus of the Renaissance past (14.16) has given

way to a lascivious Venus of the mannerist present. Cooly refined yet sexually hot, with warm and cool coloration to match, Bronzino's allegory is as contradictory as the court life that formed its backdrop. Mannerist art, commissioned by ruling Catholic aristocrats across Europe, manifested, to paraphrase one scholar, a range of qualities, from exaggerated intellectualism with a tinge of the bizarre and abstruse to a fastidious and affected epicureanism that translated everything into subtlety and elegance. At the same time, other mannerist artworks achieved a deepening and spiritualizing of religious experience. Such an expression of heightened spiritual content through mannerist form is at the core of the late-sixteenth-, early-seventeenth-century art of El Greco.

Doménikos Theotokópoulos (1541–1614), called El Greco ("The Greek"), came from the Greek island of Crete, which was then under Venetian rule. Soon after 1560 he arrived in Venice and absorbed the lessons of Titian and other leading artists of that city. A decade later, in Rome, he came to know the art of Raphael, Michelangelo, and the Italian mannerists. Around 1576 he went to Toledo, Spain, where he lived for the rest of his life. Working mainly for patrons of the Church aristocracy in the most intensely religious Catholic country in Europe, El Greco evolved a late-mannerist style of otherworldly grace and spiritual beauty.

In El Greco's *Resurrection* **(14.30)**, elongated figures, windblown and dappled in flamelike tongues of light and shadow, either are tossed on their backs or gesture upward in inspired astonishment at Christ's rising to heaven after his crucifixion on earth. Serene and already distant from the tumult below, Christ ascends, seemingly walking on air, red cape billowing and white banner unfurled. In marked contrast to Titian's High Renaissance version of a divine ascension (14.25), El Greco's composition is a long, narrow ellipse in which contorted figures interweave in a shallow yet darkly indeterminate space. In keeping with the zeal of Spanish Catholic mysticism, El Greco's distortion and elongation of forms and his compression and confusion of spatial relations evoke an irrational, ecstatic spiritual dimension. In the earthly realm, El Greco's paintings served as potent expressions of deep

14.30 EL GRECO. *Resurrection*. Ca. 1597–1604. Oil on canvas. 9 ft. × 4 ft. 2 in. Museo del Prado, Madrid, Spain.

14.31 ALBRECHT DÜRER. *Four Horsemen of the Apocalypse.* Ca. 1497–98. Woodcut. 12 ft. 8 in. × 9 ft. 1⅝ in. (trimmed).

*The difference which, to my mind, exists between the pictures of this man [Hieronymus Bosch] and those of all others is that the others try to paint man as he appears on the outside, while he alone had the audacity to paint him as he is on the inside. . . .—*Fra José de Sigüenza, Catholic priest and historian, *History of the Order of St. Jerome,* 1603

Catholic faith amid the Church's desperate battle against challenges from protesting priests and laypersons across much of Northern Europe.

From Renaissance to Reformation: Art of a Critical Spirit

As the year 1500, the midpoint of the millennium, approached, many intensely religious Catholics began to have apocalyptic fears about the end of the world. These fears were spurred by a perception that most peo-

ple, including Church leaders, were sinners. Within Renaissance culture, certain devout Christians—artists among them—felt the need to protest the sinful state of earthly affairs.

Dürer's woodblock print series *The Apocalypse,* published in 1498, speaks to this critical "end of days" view of the world. The fourth print **(14.31)** of the fifteen in the series shows the four symbolic horsemen of the apocalypse— death, famine, disease, and war—riding roughshod over a sinful humankind. In the resulting tumult, a Roman Catholic bishop, his head crowned by a jeweled miter, is swallowed by the gaping jaws of the dragon of hell while an abbess, perhaps his partner in carnal sin, is trampled under the flying hooves of death's bony nag. As the first mass-media art form, prints such as *The Apocalypse* and *Adam and Eve* (14.19) spread across Europe, creating a public discourse based on shared visual messages, many of which dealt with the pressing religious issues of the day.

In the realm of painting, no artist visualized these religious concerns and apocalyptic fears more obsessively or imaginatively than Dutch artist Hieronymus Bosch (ca. 1450–1516). As reflected in the title of one of his moralizing panel paintings, *Ship of Fools,* Bosch saw humankind as bedeviled by temptations of the flesh, with men and women of all ranks wallowing in vice: gambling, drunkenness, gluttony, promiscuity, corruption, violence. In a scene from the panel representing hell in his renowned three-part painting or triptych *The Garden of Earthly Delights* **(14.32),** bizarre punishments are meted out to those whose lives were spent in wanton pursuit of earthly pleasures. Fiendish animals attack the gamblers, players at dice and backgammon. Lovers of music are strung up on a harp, racked on a lute, swallowed by a steaming horn, and anally pierced by a recorder. A huge satanic bird sitting on a high chair, a chamber pot perched on his head and vessels on his feet, swallows men whole and eliminates them into the ooze below. Into this same hole a greedy sinner defecates coins. In the lower-right corner, a pig dressed as an abbess embraces a doomed man and seeks to have him sign over his wealth to the Church. Grotesque combinations of animality and humanity, bodily piercings and eliminations, and flights of creative fantasy and hard-hitting moral

messages pack every inch of Bosch's panel. Some consider this work a final blast from the Middle Ages, an ultimate warning in the spirit of medieval last judgment paintings and sculptures (13.13, 13.14). Others see in it a prophetic call for reform of a corrupt Church. Psychoanalytically oriented scholars (Interaction Box) have focused on Bosch's attitude toward his subjects. Some perceive in his representations a mixture of pleasure and revulsion, attraction and repulsion. All would agree that Bosch's imaginative vision is wondrously surreal, 500 years before Dalí (17.25), Man Ray (7.28), Magritte (2.8), and the official birth of surrealism.

Pieter Bruegel (ca. 1525–1569) was much influenced by his countryman Bosch. Bruegel's narrative paintings were drawn from biblical and mythological stories whose moral was that sinful arrogance and overweening pride lead to disaster. With an unblinking eye that captures a slice of life of the everyday world, Bruegel's painting *The Peasant Dance* (**14.33**) shows us peasants, symbolic of all humankind, feasting and fighting, playing music and dancing. In their earthly delights, they ignore the church in the distance and the picture of the Virgin Mary tacked to the tree in the upper-right corner. Our view of the animated scene is at eye level, as bystanders just feet away from the activity. Like a film camera that zooms the audience into the action, Bruegel's art involves us in an up-close, visceral way matched by few previous paintings. He himself had been such a participant-observer, getting to know peasant life firsthand, in the company of a merchant friend, by attending (in disguise) peasant fairs and weddings and observing the way (the friend writes) "they ate, drank, danced, capered, or made love, all of which he was well able to reproduce cleverly and pleasantly in water colors or oils, being equally skilled in both processes."

Sharp of eye and sly of wit, Bruegel reveals the pressures of the contemporary commercial economy on the artist in his drawing *The Painter and the Connoisseur* (**14.34**). The painter,

14.32 HIERONYMUS BOSCH. *The Garden of Earthly Delights*, detail from Hell section, right panel. Ca. 1505–10. Oil on panel. 7 ft. 2⅝ in. × 6 ft. 4¾ in. Museo del Prado, Madrid. *Might the large human face be that of the artist? Why?*

14.36 CARLO MADERNO and GIAN-LORENZO BERNINI. Saint Peter's, Rome. Facade (ca. 1602–12) and colonnade (begun ca. 1656).

common people and reinforce their faith. The baroque was, in this sense, visual theater for the masses played out on a superhuman scale, with Saint Peter's becoming the grandiose model for Catholic churches being built throughout Europe and in colonies overseas. The papacy had consciously built on the legacy of ancient Rome and surpassed it in size and excitement. The more sober, restrained classicism of the Roman Pantheon (10.21) and of Renaissance buildings such as Brunelleschi's Hospital of the Innocents (14.10) and Pazzi Chapel (14.11) was left far behind.

In the church's facade by Maderno, which follows the pattern set by Michelangelo for the exterior of the church, another drama unfolds. A colossal order of columns and pilasters two stories in height interrelates dynamically to focus the viewer's attention on the entrance portals and the central temple-front form. A crescendo of energy gathers from the corners and builds toward the center. The vertical supports become more closely spaced, and

14.37 LOUIS HAGHE. *Interior View of Saint Peter's*, view of Nave, looking toward the apse and baldacchino. 1867. Oil painting. Victoria and Albert Museum, London.

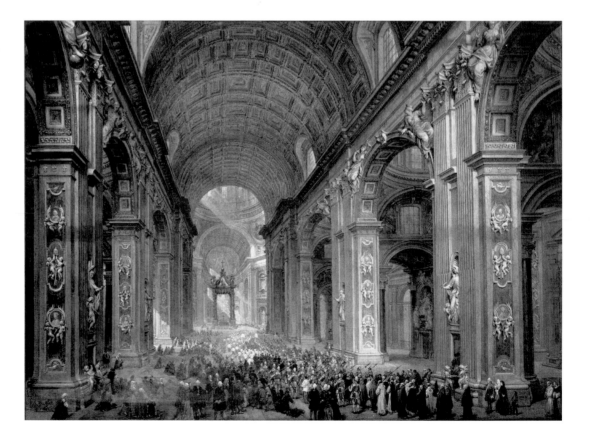

flat pilasters metamorphose into full-bodied columns. All the architectural elements project further outward toward the viewer. Step by step, in a quickening rhythm, the onlooker is pulled magnetically to the central entrance-ways.

Extending outward from the church's entrance portals and the main facade toward the elliptical plaza are Bernini's two enormous **colonnades**, series of columns at regular intervals supporting an entablature and roof. Visually and figuratively, the colonnades open their arms to embrace the spectator. Bernini, the greatest sculptor-architect of the seventeenth century, thought of them as the motherly arms of the Church "embracing Catholics in order to reinforce their belief, heretics to reunite them with [her], and agnostics to reveal to them the true faith." Such baroque spaces create an active yet totally controlled environment in which the viewer experiences a sense of freedom and excitement within a secure, symmetrically focused order.

Making one's way across Bernini's vast enclosed plaza, climbing the steps of the Basilica, and passing under the enormous facade, the viewer enters a nave (14.37) immense in height and breadth and over two football fields (695 feet) in length. All of the decoration of this colossal interior owes some debt to Bernini—the sculptures, mosaics, and ornamental details, created by innumerable artists over the centuries, were largely based on his original plans. It is here, within the Basilica, that the theater of baroque illusion truly begins. Billowing bishops, weightless angels, and trembling cherubs preside. Gold leaf glitters, and the floor is alive with a patterned array of multicolored stone. Walking toward the central crossing point of the church under the great dome, the onlooker approaches Bernini's giant *baldacchino*, or canopy, for the main altar of the church (14.38). Situated above the tomb believed to contain the remains of Saints Peter and Paul, the gigantic *baldacchino*, 95 feet high and made of bronze embellished with gold, rises majestically, like an irresistible force, to reaffirm the centrality of the spot not only for this church but for all of Christendom. Many of the elements, it should be noted, even the unusual twisted columns, had their roots in ancient times. But here they are recomposed and

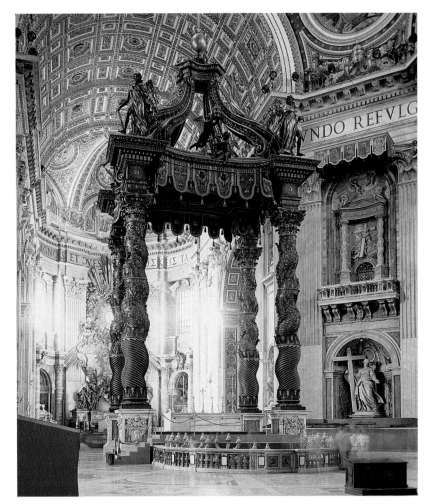

14.38 GIANLORENZO BERNINI. Baldacchino in Saint Peter's Basilica, Rome. 1624–38. Bronze embellished with gold. Height: approx. 95 ft.

animated by a baroque dynamism and a cinematic flourish that speak of the missionary grandeur and emotionalism of the Counter-Reformation.

It is all *un bel composto*, a beautiful whole, in which architecture, sculpture, and mosaics combine to carry one away on a magical journey. A student on a university art tour testified:

St. Peter's Basilica is one of the most amazing structures I have ever seen, almost beyond human comprehension, and even when you are standing inside, it is still too much! I kept readjusting to its size, believing in its hugeness, yet not believing. Every statue, column, painting or mosaic is actually gigantic, as is the building itself, but because of perfect proportions, it all falls into place and does not appear to be as big as it is. Every inch of the floors, walls, ceilings is covered with an enduring precious metal, marble or mosaic. The large mosaics were almost unbelievable, for they looked like huge oil paintings, but were actually small pieces of tile put together in endless values and shades of

If instead to the teaching of the scholar is added the confirmation of grandiose buildings, of monuments in a certain guise eternal . . . popular faith will be reinforced and stabilized.
—Pope Nicholas V, statement, 1455

14.39 GIOVANNI BATTISTA GAULLI. *Triumph of the Name of Jesus*, ceiling fresco with stucco figures. 1676–79. Church of Il Gesù, Rome.

commentators, in fact, often compare the interior design of baroque churches to the performing arts in their dramatic capacity to simulate movement, create spatial illusions, and pull the viewer into the action.

Baroque Painting and Sculpture

The baroque ceiling of Il Gesù ("The Jesus"), the main church of the Jesuits, confirms the comparison of baroque painting and sculpture to the performing arts. Created by Giovanni Battista Gaulli (1591–1666), the ceiling fresco *Triumph of the Name of Jesus* **(14.39)** is a true "aerial ballet." In accordance with the Roman baroque ideal, the Il Gesù ceiling functions as a joyously instructive and immensely popular imaginative realm in which the senses are stimulated at every corner; a giddy illusion of freedom exists within a carefully planned system of total control. Such illusionistic "fool-the-eye" ceiling artworks—from the distance one cannot tell what is painting, what is sculpture, and what is architecture—are literal dances in which two- and three-dimensional figures meld together, rise, fall, and float in the air. With other illusionistic Roman ceiling paintings as precedents—the ceilings of the Sistine Chapel and Saint Peter's are but two—the artist Gaulli, a protégé of Bernini, has marshaled all the forces of painting, stucco sculpture, and architectural decoration to create a sweeping total composition.

To achieve its populist ends, baroque religious painting and sculpture innovated visual effects still used today, including theatrical lighting, emotive close-ups, and action-packed drama. The *David* **(14.40)** of Gianlorenzo Bernini, Italy's most famous baroque artist, exemplifies these innovative qualities. We catch Bernini's *David* in action. His body twists and coils; he is just about to unleash his stone at the oncoming Goliath. Michelangelo's *David* (14.26) is far more classical: still and stable in his anticipatory stance, emotions intense but contained. In viewing Bernini's *David*, we are caught up in the throes of battle. Goliath is rushing forward. David has loaded his sling and is quickly readying it into position. Within seconds the stone will be hurled at the oncoming giant. We are catapulted into the action. The protagonist's expression, knitted brow

colors. . . . It was truly beautiful and very moving. . . . Some of the world's finest works of art, by Bernini, Michelangelo, Donatello, and others, were constantly before my eyes. I guess it is trite to say I was overwhelmed, but I was.

Compared to mannerist art (14.29) and much of the art of the High Renaissance (14.23–14.27), which was arrived at through intellectual means—geometry, perspective, knowledge of the philosophy and literature of antiquity—and subsequently appreciated by only a small group of learned humanists, baroque art appealed to the masses and was as popular as our prime-time television or commercial Broadway stage is today. Present-day

with mouth clenched and eyes afire—far more emotionally overt than the expression of Michelangelo's *David*—is likewise pure baroque. Bernini achieved this expression by making a fearsome face into a mirror held by his patron, Cardinal Scipione Borghese, for whose palatial Roman villa the sculpture was created.

Like Bernini, first artist to the papal royalty, and Diego Velázquez, court painter to the Spanish royal family (5.18), Peter Paul Rubens (1577–1640) was blessed in his social stature. The vast majority of artists, it must be emphasized, never became rich or famous. Of privileged birth, Rubens was the son of an Antwerp lawyer and alderman. He subsequently received much of his education, in both diplomacy and art, in the Catholic courts of Europe. Vigorous and learned, this handsome northerner became a painter-courtier in the mold of Raphael as well as an esteemed diplomat who carried state secrets and performed international negotiations at the highest level. His organizational abilities, in fact, carried over to his painting commissions. Coming from the courts and churches of Catholic Europe, his commissions were so numerous that Rubens developed a finely tuned "studio-factory" of talented painters to help him execute his projects.

To some contemporary viewers, Rubens's style may seem almost too energetic, overblown, and melodramatic. To the Catholic nobility and the Jesuit church leaders of his own day, it was dazzling. Again, comparison might be made to contemporary cinematic spectaculars. At their most extravagant, Rubens's grand-scale paintings are peopled by multitudes. Covering enormous walls, they are sometimes as large as movie-house screens. And what a show they provided! "I have never lacked courage to undertake any design, however vast in size or diversified in subject matter," the artist wrote in 1621. "I am by natural instinct better fitted to execute very large works than little curiosities." Appropriately, for the powerful and controversial Marie de' Medici (1573–1642), queen of France, Rubens painted twenty-one 12-foot-high canvases illustrating scenes from the monarch's life. In these scenes, Rubens portrayed his patron with a grandeur and heroic flourish usually

14.40 GIANLORENZO BERNINI. *David*. 1623. Marble. Height: 67 in. Galleria Borghese, Rome.

He [the sculptor Bernini] had some general advice for all who draw from nature. They should be on their guard and examine the model carefully. They should make the legs longer rather than shorter, for if you add a little bit to the length of the legs you increase the figure's beauty, but if you shorten them a little bit you render it heavy and clumsy. . . . Feet must be made small rather than big, in accordance with the handsomest models and antique statues.
—Comments of sculptor Gianlorenzo Bernini at the French Royal Academy, recorded by Paul Fréart, 1665

reserved for male rulers and heroes. Executed for the royal palace between 1621 and 1625, the large paintings currently hang in the galleries of the Louvre in Paris. In *The Arrival of Marie de' Medici in Marseilles* **(14.41),** the sea god Neptune rises from the waters, buxom sea nymphs show off their bodies and sing praises, and angelic Fame sounds his trumpets, all in joy over the mighty queen's safe arrival. On the earthly plane, a caped and helmeted figure symbolizing France greets her majesty, a true "hero heroine," while a knight of Christ looks on. Mythology and allegory intertwine with history, and heaven and earth rejoice in a unifying swirl of color and movement. The continuous motion, dynamic action, shifting lights, and dissolves that the cinema would appropriate three centuries later are foreshadowed in such baroque works.

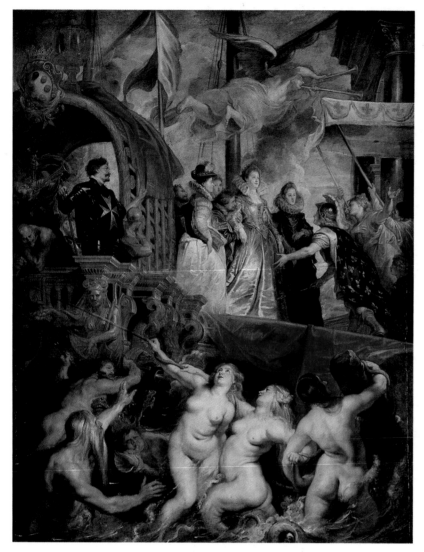

14.41 PETER PAUL RUBENS. *The Arrival of Marie de' Medici in Marseilles.* 1622–25. Oil on canvas. 12 ft. 11 in. × 9 ft. 8¼ in. Musée du Louvre, Paris.

The fame of Rubens notwithstanding, the art most eagerly sought by European collectors remained Italian. Even an artist with so difficult a personality as Michelangelo Merisi (1571–1610), called Caravaggio after his native northern Italian town, received commissions from the Catholic aristocracy of cardinals and lords. An impulsive and violent man, Caravaggio revolutionized Italian baroque oil painting. His grand synthesis combined a Northern European realism and focus on everyday life with an Italian sense of the dramatic and his own special type of chiaroscuro, called *tenebrism* or "dark manner." Like a single spotlight shining on the central characters in a blackened theater, a swath of Caravaggio's light in the darkness simultaneously focuses on the chief protagonists and tells the picture's story. *The Calling of Saint Matthew* **(14.42),** a large oil painting in the leading French church in Rome, is exemplary. Follow the light and you follow the story. A narrow band of light descends in a diagonal from the upper right to the lower left, picking up parts of faces and shoulders and then exploding into full brilliance on the face of the bearded man. Fully illuminated, he points to himself. The message is clear: He is being called. By whom is he called? Following the path of light back to its origin, we note that it crosses a faint halo above the gaunt, bearded face of a man who has just entered the room. It is Christ, and he is calling Matthew the tax collector—surrounded by his fancily dressed companions, who are counting coins—to come forth and serve a higher power. It is pure theater. The viewer feels like a front-row spectator or perhaps a drinker at the tavern's next table. Compared to the illusionistic deep space of baroque ceiling paintings (14.39), the picture space in *The Calling of Saint Matthew* is shallow, with the characters pushed up close to the picture plane, resulting in greater intimacy and intensity on the part of the audience. The strategically placed window with its subtly illuminated interior cross shape leads our eye to Christ's expressive pointing hand. This hand reverberates with the memory of a similar pointing gesture, recalling Michelangelo's unforgettable hand of God that brings life to an unawakened Adam (14.27)—a fitting parallel and subtext. Matthew and the disciple next to Christ both repeat the gesture. The tension builds but does not release, as the answer to the call remains to be uttered.

The painting made Caravaggio famous, but not with everyone. Critics who loved the grand manner of heroic Renaissance art judged the artist harshly for the ugly, commonplace setting, contemporary clothing, and candid poses, which they believed degraded such a noble event. A half century later, the writer Bellori summed up this negative reaction to Caravaggio's realism and growing influence: "Now began the depiction of worthless objects, a preference for filth and deformity . . . the clothes they paint are stockings, breeches,

14.42 CARAVAGGIO. *The Calling of Saint Matthew.* 1599–1600. Contarelli Chapel, San Luigi dei Francesi, Rome. *Caravaggio's art influenced the most important artists of the seventeenth century, from Rubens (14.41) and Velázquez (5.18) to Rembrandt (15.9) and Leyster (Appreciation 29). What was it about his work that was so affecting?*

and shaggy caps. . . ." Too close to real life for some, Caravaggio's impact on numerous artists across Italy, Spain, and Northern Europe was instant and profound. One of these artists was his countrywoman Artemisia Gentileschi (1593–1652).

We observe Gentileschi, paintbrush in one hand and palette and brushes in the other, in the act of creating an oil painting **(14.43).** She was that rare Italian woman who possessed both immense artistic talent and the possibility of realizing it. Her father, Orazio, was an accomplished painter who willingly taught her everything he could about the medium of oil

painting. Growing up in Rome, she was moreover in perfect position to absorb the pictorial language of early baroque painting, especially as embodied in the stirring religious scenes of Caravaggio, which she could study firsthand. Gentileschi's *Judith and Her Maidservant with the Head of Holofernes* **(14.44)** shows that she learned her lessons well and moved on quickly to the creation of original masterpieces. Based on the biblical story of Judith, the setting of *Judith and Her Maidservant* is the tent of King Holofernes, the Assyrian general who was about to attack and conquer the Hebrew people. Determined to save her people, Judith offered

14.43 ARTEMISIA GENTILESCHI. *Self-Portrait as the Allegory of Painting*. 1630. Oil on canvas. 38 × 29 in. The Royal Collection © 2002 Her Majesty Queen Elizabeth II.

14.44 ARTEMISIA GENTILESCHI. *Judith and Her Maidservant with the Head of Holofernes*. Ca. 1625. Oil on canvas. 72½ × 55¾ in. © The Detroit Institute of Arts (gift of Mr. Leslie H. Green).

her sexual favors to the general. After their third night of lovemaking, Judith, with the help of her serving woman Abra, cut off the sleeping general's head. In the painting, the maidservant is gathering up the severed head from the floor. Waking to find their leader decapitated, the shocked Assyrians retreated. The Hebrew people were saved.

In Gentileschi's visualization of the story, a windblown candle burns in the darkened tent, casting dramatic shadows on the faces and arms of the two protagonists. Light flickers on the ruby red drapery and green tablecloth and on the gold and purple dresses; these complementary colors sing in deep, resonant tones. A noise is heard outside. Judith motions for Abra

to be quiet and holds her sword in readiness. The deed has been done, but the two women still must escape through the Assyrian camp. This is wonderfully suspenseful theater, and our attention is riveted on the interlocked figures of Judith and Abra as they prepare for action. But it is far more than theater. It is a revolutionary pictorial drama in which women are portrayed as powerful, active leaders in a world dominated by men. Most Italian paintings up until this time had portrayed women stereotypically as softly beautiful and idealized, whether as chaste virgin, mythological love goddess, or dignified portrait likeness. Here was a far bolder, more realistic and down-to-earth image of women from a strong-willed

INTERACTION BOX

TAKING A PSYCHOANALYTIC APPROACH TO ART

Psychology is a social science that focuses on the personality, mental processes, and behavior of the individual. Art historians taking a psychoanalytic approach attempt to analyze and interpret the subject matter, form, and content of works of art in terms of an artist's psychological makeup. In this regard, they look closely at the formative experiences that shaped the artist's psyche. Psychological theorist Sigmund Freud (1856–1939) believed that early childhood experiences powerfully shape the individual both emotionally and intellectually. Freud argued that we repress our most disturbing experiences and force them into our unconscious minds, where they continue to modify behavior. He contended that dreams and works of art are two principal (and healthful) means by which such repressed ideas and feelings arise (or are sublimated) to consciousness.

Interpret Hieronymus Bosch's dreamlike visions from a psychoanalytic perspective. How might the style and subjects of *The Garden of Earthly Delights* (14.32) embody the Freudian principles of repression and sublimation? Consider Artemisia Gentileschi's continuous reworking of the subject of Judith's killing of Holofernes (14.44) in a series of often bloody pictures. What formative life experience, touched on in the text, might have promoted the artist's conscious or unconscious preoccupation with this theme?

female painter who had suffered much in her youth, including rape at the hands of a male artist **(Interaction Box)**.

Gentileschi's numerous paintings of courageous biblical heroines, such as Judith, are indeed rare images in the history of art. They present the viewer with emotionally complex, multidimensional female characters who are heroic in the elevated classical sense customarily reserved for male characters. Spanning the sexes, Gentileschi's strong women embody male as well as female qualities, an androgynous ideal. They are breakthrough images, not to be seen again until artists such as Eugene Delacroix in the nineteenth century and Käthe Kollwitz at the turn of the twentieth century reintroduced forceful images of women as heroic liberators (16.6, 17.5).

Baroque Culture and the New World

There was a dark, unseen side to the glory of Catholic baroque art. All but forgotten in the grandiose displays of Saint Peter's and Il Gesù, the religious dramas of Gentileschi and Caravaggio, and the intimate portraits of the Spanish royal family by Velázquez (5.18) were the sources of the wealth, largely ill-begotten, that financed these great buildings and artworks. Behind these visual masterworks lies the destruction of the Inca (10.9) and Aztec cultures **(Appreciation 27,** 8.38) along with many others. Forgotten are the untold numbers of Indians and Africans in the New World who slaved for their European lords to keep the papal families and the international Catholic aristocracy awash in cash and power. It was this foreign wealth, combined with the levying of harsh taxes at home, that made possible the fame and fortune of artists like Bernini, Velázquez, and Rubens.

Mexican author Carlos Fuentes writes that "the European destruction of the Indian civilizations of the Americas was a loss to the West . . . since they were not barbarous, heathen nations but nascent human societies with many lessons for Renaissance [and baroque] Europe." At the same time, Fuentes asserts, the European conquest of the Americas, in particular the Spanish colonization of the New World, gave rise to a richly complex "mestizo" culture **(Appreciation 28)** and an intercultural art (1.8, Appreciation 34) that continue to flourish to the present day (19.20, 20.2).

Xochipilli: Aztec God of the Spring

ROBERT BERSSON

The Aztecs dominated the lands and peoples of central Mexico from the fifteenth through the beginning of the sixteenth century. A warrior people, the Aztecs rapidly progressed from a collection of seminomadic tribes to the powerful rulers of a tightly organized empire. Their grand capital of Tenochtitlán **(Fig. A),** located on the site of present-day Mexico City and encompassing the ancient site of Teotihuacán [Appreciation 22], was one of the largest cities in the world.

Aztec society followed an animistic and polytheistic religion, worshiping many gods and goddesses. Numerous deities represented the forces of nature upon which the largely agricultural society depended for its survival.

In this context, the function of art was primarily religious, designed to honor and appeal to the gods. Xochipilli **(Fig. B)** was such a god. According to Frances Smyth and Michael D. Coe, Xochipilli was the "prince of flowers," a title defining him as supreme patron of the greenness of the fields, responsible for opening the flowers that bring butterflies and birds—in effect, the god of spring. Appropriately, flower and butterfly forms adorn the god's body and throne. Smyth and Coe note that "Xochipilli was also the god of dances, of games (including the important ball game), of gambling, and of love. He was the supernatural patron of pleasures and voluptuousness and of the arts, such as music, poetry, and song." One scholar

Figure A Reconstruction view of Tenochtitlán (Mexico), the Aztec capital, looking southwest, with the double temple to Huitzilopochtli and Tlaloc to the left.

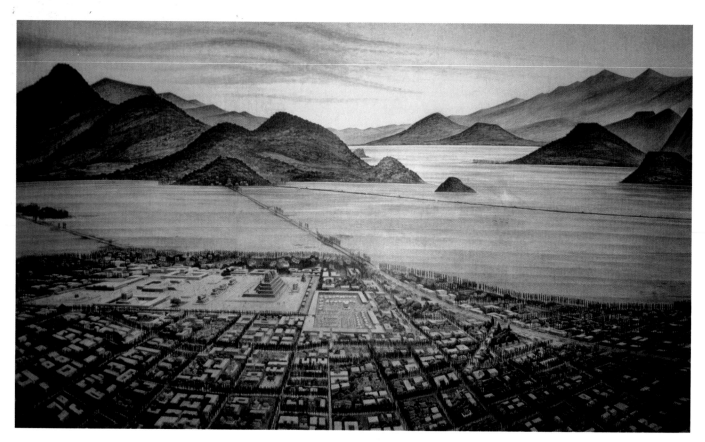

notes that the mask Xochipilli wears symbolizes his role as patron of theatrical performances and dances during which the performers were masked. The expression of the mask, with the curve of the mouth turning downward at the corners, conveys solemnity and perhaps a hint of the tragic.

The figure's life-size proportions, pose, and splendid throne speak to the exalted position of Xochipilli in Aztec religious practice. Sitting with torso erect and head tilted back, he seems to look down upon us from imperious heights. Though in repose, Xochipilli's strength is conveyed through flexed arms, crossed legs, and clenched fists. The fists may have held banners, bags of resin, or natural flowers in their grasp. He is dressed in a loincloth, typical of royal dress of the times. Around his neck the god wears a chest protector that simulates the head, eyes, and fangs of a catlike animal. Earrings, bracelets, and a headdress, all possessing religious symbolism, complete his costume.

In 1521, the Spaniards and their Native American allies under the conquistador Hernando Cortés captured and destroyed the Aztec capital of Tenochtitlán. On the site they founded their own capital of Mexico City and built a Catholic cathedral over the former sacred grounds of the Aztec priests. In the process of raising a new religion and culture over its predecessor, the Spaniards obliterated almost all of the religious art and architecture of the Aztecs. That the statue of Xochipilli survived, broken nose notwithstanding, is a miracle befitting the god of spring, the deity who presides yearly over nature's rebirth. In magnificent works like Xochipilli, Aztec culture has outlasted the Spanish conquerors. ■

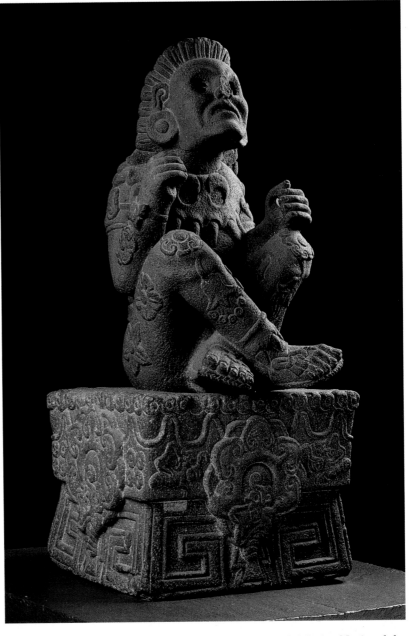

Figure B Xochipilli, Aztec statue. Basalt. CNCA-INAH–Mexico Nacional de Antropologie, Mexico City, Mexico.

The Baroque Culture of the New World

CARLOS FUENTES

Following the Renaissance, the response to the great divide between ideals and reality was a sensual one. The Protestant Reformation banned images from its churches, considering them to be proofs of papist idolatry. But this puritanism was overcome by a great form of sensual compensation in the glorious music of Johann Sebastian Bach. The rigid Catholic Counter-Reformation also had to make a concession to sensuality. This was the art of the baroque, the expanding, dynamic exception to a religious and political system that wanted to see itself as unified, immovable, eternal. The European baroque became the art of a changing society swirling behind the rigid mask of orthodoxy. But if this was true of Catholic Europe, how true was it of the nascent societies of the New World and the obstacles to change that *they* faced?

During the Renaissance, the discovery of America meant . . . that Europe had found a place for Utopia. Again and again, when the explorers set foot in the New World, they believed that they had regained paradise. And it was to these lands that the Europeans transferred their failed dreams, moving from paradise to despair. The New World became a nightmare as colonial power spread and its native peoples became the victims of colonialism, deprived of their ancient faith and their ancient lands and forced to accept a new civilization and a new religion. The Renaissance dream of a Christian Utopia in the New World was also destroyed by the harsh realities of colonialism: plunder, enslavement, genocide.

Carlos Fuentes is a world-renowned Mexican author and intellectual. His book The Buried Mirror: Reflections on Spain and the New World *(1992) is the source for this excerpt. Copyright © 1992 by Carlos Fuentes. Reprinted by permission of Houghton Mifflin Company. All rights reserved.*

Between the two was created the baroque of the New World, rushing to fill in the void between ideals and reality, as in Europe. But in America, the baroque also gave the conquered people a place . . . where they could mask and protect their faith. Above all, it gave us, the new population of the Americas, the mestizos, a manner in which to express our self-doubt, our ambiguity.

What was our place in the New World? To whom did we owe allegiance? Our European fathers? Our Quechua, Aztec, or Chibcha mothers? To whom should we now pray, the ancient gods [Appreciation 27] or the new ones? What language would we speak, the language of the conquered or that of the conquerors? The baroque of the New World addressed all of these questions. And nothing expressed this uncertainty better than the art of paradox, the art of abundance based on want and necessity, the art of proliferation based on insecurity, rapidly filling in the vacuums of our personal and social history after the conquest with anything that it found at hand. An art that practically drowned in its own burgeoning growth, it was also the art of those who had nothing else, the beggars at the steps of the church, the peasants who came to have their birds blessed or who invested the earnings of a whole year of hard work in the celebration of their saint's day. The baroque was a shifting art, akin to a mirror in which we see our constantly changing identity. It was an art dominated by the single, imposing fact that we were caught between the destroyed Indian world and a new universe that was both European and American.

In the Indian quarter of the great mining capital of Potosí [in Bolivia in South America], hearsay has it, there once lived an orphaned Indian from the tropical lowlands of the Chaco. According to myth, he went by the name of José Kondori, and in Potosí he learned to work

Figure A Warrior figure dressed in armor (detail of carving), Church of San Lorenzo, Potosi, Bolivia. Ca. 1728. Photo: Peter McFarren.

wood and the crafts of inlaying and furniture building. By 1728, this self-taught Indian was constructing the magnificent churches of Potosí, surely the greatest illustration of the meaning of the baroque in Latin America. Among the angels and the vines of the facade of San Lorenzo **(Fig. A),** an Indian princess appears, and all the symbols of the defeated Incan culture are given a new lease on life. The Indian half-moon disturbs the traditional serenity of the [classical] Corinthian vine. American jungle leaves and Mediterranean clover intertwine. The sirens of Ulysses [the ancient Greek mytho-logical hero] play the Peruvian guitar. And the flora, the fauna, the music, and even the sun of the ancient Indian world are forcefully asserted. There shall be no European culture in the New World unless all of these, our native symbols, are admitted on an equal footing.

Beyond the world of empire, of gold and power, of wars between the religions and dynasties, a brave new world was indeed forming itself in the Americas, with American hands and voices. A new society, with its own language, its own customs, and its own needs, was coming into being. ∎

The grand manner consists of four things: subject-matter or theme, thought, structure, and style. The first thing that, as the foundation of all the others, is required, is that the subject matter shall be grand, as are battles, heroic actions, and divine things.—Nicolas Poussin, seventeenth-century artist, *Observations on Painting*

15.2 HYACINTHE RIGAUD. Portrait of Louis XIV. 1701. Oil on canvas. 9 ft. 2 in. × 7 ft. 11 in. Musée du Louvre, Paris. *Do you think this is an accurate portrayal of the king, or do you think the artist has improved upon or idealized his actual appearance? Using just the visual information (for example, pose, lighting, color, composition) available in the work itself, justify your opinion.*

15.3 PIERRE PATEL. Perspective view of the Garden and Chateau of Versailles. Ca. 1685. Versailles, France.

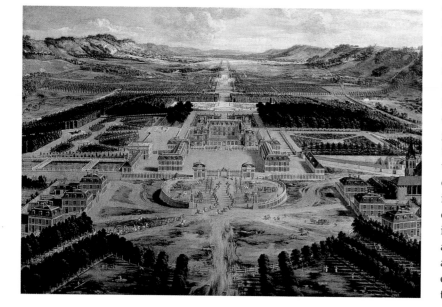

Italian peninsula and, thereafter, in France and England. Founded in 1648, the French Royal Academy of Painting and Sculpture helped French painters and sculptors raise their disciplines to the esteemed status of liberal arts by legally separating itself from the various guilds of artisans and craftspeople. Painting and sculpture were henceforth defined, in the law books and in the public mind, as liberal rather than mechanical arts. The French Royal Academy subsequently sought to guarantee that all painters and sculptors associated with it demonstrated the good taste of gentlemen-intellectuals in their work. It accomplished this task by educating professional artists and interested "amateurs" in what theorists called "the true art" and "the manner of the modern age." According to Vasari, this manner (later called "the grand manner") originated with Leonardo and reached perfection with Raphael and Michelangelo. Academic training, both practical and theoretical, elevated the artist above the artisan in technical capability and intellectual knowledge.

For its part, "academic art" aspired to be high art, seeking its home among the social and cultural elite. That the first national academies in France and England were directly sanctioned and supported by the king attests to the high culture connection. A painting **(15.4)** by Swiss-born artist Johann Zoffany (1733–1810) reveals much about these two national academies and their closely related educational approaches. It portrays the male members of the English Royal Academy, gentlemen-artists engaged in theoretical discussion, surrounded by plaster casts of modern and ancient masterworks that their students (not present here) would sketch or copy in their figure drawing classes. After achieving drawing mastery of these sculptural casts, the gentlemen-artists-in-training would proceed to drawing from the nude male model, two of whom are shown in the studio space. Mastery of drawing the male nude, as the basis of painting or sculpting the human figure, was the core of the curriculum, a fact that limited the participation of women as both academy members and students. In Zoffany's picture, two female academicians, founding members of the Academy, are indirectly present in the room in the two painted portraits hanging on the wall.

Contemporary moral standards did not permit women to view the nude male model. (This prohibition continued to apply to female art students until the early twentieth century.) Instead, the women members, including the internationally known Angelica Kauffmann (1741–1807), and the female students had to learn how to represent the human figure by drawing exclusively from plaster casts or by copying famous works of art. In her painting design in the Central Hall of the Royal Academy **(15.5)**, Kauffmann portrays a young female artist, framed by two classical columns, intently drawing a twisting, muscular torso in the style of Michelangelo.

Strongly influenced by the art and theory of French painter Nicolas Poussin (1594–1665), seventeenth-century academic philosophy was decidedly classicist, valuing an intellectual art of mythological and religious "history" subjects that was based on a linear style of precise contours and time-tested rules. These rules, it was argued, had been derived from the glorious art of the ancients and passed down to the present through masters such as Raphael and Poussin, a Frenchman based in Rome. Poussin's *Landscape with the Burial of Phocion* **(15.6)** is both a significant work of art and the embodiment of this academic philosophy. The subject concerns the burial of Phocion, a noble Greek leader of ancient Athens, whose white-shrouded body is being carried to burial on a stretcher by two men. The costumes of the men and the classical buildings speak of ancient Greece, though the landscape itself appears more like the countryside around Rome. A mood of intellectual reflection, gravity, serenity, and order prevails, a contrast to the emotional extroversion and theatricality of Bernini (14.40) and Gaulli (14.39), Poussin's Italian baroque contemporaries working in Rome in the same years.

An equally pronounced contrast exists between Poussin's landscape painting (15.6), with its elevated historical subjects, and a contemporary Dutch landscape **(15.7)**. When working from a sketch of an actual landscape, a classicizing academic painter like Poussin might add a tree here, remove a house there, or "improve upon" the colors of the scene to create a more properly ideal vision. Some landscapes, like the one pictured

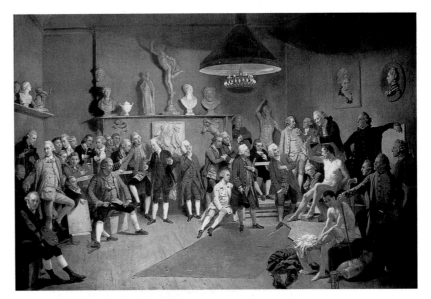

15.4 JOHANN ZOFFANY. *The Academicians of the Royal Academy.* Oil on canvas. 39¼ × 57½ in. The Royal Collection © 2002, Her Majesty Queen Elizabeth II.

15.5 ANGELICA KAUFFMANN. *Woman Drawing.* Design in the ceiling of the Entrance Hall of the Royal Academy, London. 1780. Oil on canvas. 52 × 59 in. © Royal Academy of Arts, London, 2000.

in *Landscape with the Burial of Phocion,* might be completely the product of the artist's imagination. Poussin has invented a main road that leads the eye through the painting by a series of calculated curves. As a vehicle of our vision, the road carries us through the pictorial space from foreground characters to middle-ground classical buildings to distant spring and groves. A carefully placed tree leans over, as if weeping, in a gentle curve above the main subjects. It guides our eye to the center of the work and to the central

15.6 NICOLAS POUSSIN. *Landscape with the Burial of Phocion*. 1648. Oil on canvas. Musée du Louvre, Paris.

. . . the Academy should possess the plaster casts of all the finest antique [that is, ancient Greek and Roman] statues, bas-reliefs, and busts, for the instruction of the students, so that they could learn to draw in those antique styles and from the outset familiarize their minds with beauty. . . . If one makes them draw from nature at the beginning, one ruins them. Nature is nearly always feeble and puny, so that if their imaginations are filled only with natural forms they never will be able to produce anything beautiful and grand, for these qualities are not to be found in nature.—Gian Lorenzo Bernini, sculptor, lecture to the French Royal Academy of Painting and Sculpture, 1665

characters. (Note how the cumulus clouds and another tree to the left echo its rounded leafy shape.) The spreading tree links foreground to distant sky and clouds in a well-knit composition.

Truthful representation, the naturalistic approach of Dutch landscape artists like Jacob van Ruysdael (1628–1682), appeared crude or dull to viewers of refined, studiously developed academic taste. One writer staunchly declared his preference for Poussin's classically ideal landscape (15.6) over its factually based, down-to-earth Dutch counterpart (15.7), preferring "the sacred grove where [mythological] fauns make their way, to the forest in which [actual] woodworkers are working; the Greek spring in which nymphs are bathing, to the Flemish pond in which ducks are paddling; and the half-naked shepherd who, with his Virgilian crook, drives his rams and she-goat along the Georgic paths of Poussin, to the peasant, pipe in mouth, who climbs Ruysdael's back road." Ruysdael's everyday subject matter and sensitively recorded landscape, with its local color lit by actual sunlight, lead us into a world divergent from that of both the French and Italian Baroque.

SEVENTEENTH-CENTURY ART IN PROTESTANT HOLLAND

Certain Protestant Dutch painters of the seventeenth century were influenced by Catholic baroque artists like Poussin (15.6), Rubens (14.41), and especially Caravaggio (14.42), but in general Dutch Protestant art of the 1600s differed substantially from contemporary art in Catholic Italy and France. To begin, it was shaped by different religious, political, and social traditions. It was also strongly affected by the dissimilar economic conditions under which artists worked. Catholicism emphasized the miraculous and mystical and the primacy of the Church in guiding the human flock to salvation. Protestantism, on the other hand, held that the individual, and not the Church hierarchy, was primarily responsible for his or her salvation. Eternal life was to be gained largely through personal prayer, reading one's Bible, and doing "good works." Interpreted broadly, good works might include working industriously and profiting financially from one's commercial activity. Material achievement in life, some believed, was a sign that the successful person was among the blessed, the "elect" destined for salvation. The modern

15.7 JACOB VAN RUYSDAEL. *Wheatfields*. Ca. 1670. Oil on canvas. 39⅜ × 51¼ in. The Metropolitan Museum of Art, New York, Bequest of Benjamin Altman, 1913 (14.40.623). *Can you tell the difference between a landscape painted partly or largely outdoors and one painted primarily in an indoor studio under artificial lighting? Consider this landscape and the previous one by Poussin (15.6) in answering this question.*

German sociologist Max Weber (1864–1920) made much of this notion in his classic study, *The Protestant Ethic and the Spirit of Capitalism,* claiming that the new Protestant religion provided the spiritual base for the vigorous development of capitalism in Northern Europe and colonial America. Whatever we might think of Weber's theory, the Protestant commitment to individual conscience and "the Protestant work ethic" certainly served to support Holland's rudimentary forms of capitalism and democracy. In turn, these factors influenced the character of Dutch art.

Having recently liberated themselves from the autocratic rule of Catholic Spain, the Dutch "United Netherlands" built up a vibrant middle-class commercial society with a thriving international trade that encompassed goods ranging from pictures to spices to tobacco to beaver pelts secured from the Native American Iroquois people. Dutch colonies and spheres of influence, all exploited for immense profits, ranged from North and South America to Asia and Africa. In this dynamic capitalistic society, the painters of the Dutch Netherlands were the first artists to fully participate in what we have come to know as the "art market." Whereas Bernini and Rubens created works primarily in response to commissions for specific works, producing particular religious, mythological, or historical paintings and sculptures for individual courtly or ecclesiastic patrons, Dutch artists increasingly created pictures for an anonymous art market. Producing artworks in quantity at relatively low prices, many Dutch artists tended to specialize, concentrating on landscapes (15.7), seascapes, still lifes (6.19), portraits, interiors, devotional pictures, or **genre** scenes of everyday life such as Judith Leyster's *The Proposition* **(Appreciation 29).** Such works might be marketed through art dealers who had previously purchased the work or who received a commission for the sale, or the pictures might be sold directly by the artist at markets or fairs **(15.8).**

The buying public encompassed all classes of society, ranging from upper-middle-class "burghers"—bankers, shippers, manufacturers, governing officials—to lower-middle-class artisans and extending to shopkeepers and

15.8 DAVID VINCK-BOOMS. *A Fair*, detail. 1608. Herzog-Anton-Ulrich-Museum, Braunschweig. Kunstmuseum des Landes Miedersachsen.

enterprising peasants. The many and varied portable oil paintings might be bought either for investment or for decoration of one's house or workplace. It was a situation very much like our own today, with art sold at fairs and auctions, in galleries and shops, and by private dealers of all kinds. An English traveler to Amsterdam in 1640 wrote of the singular affection of the Dutch people for pictures, "all in general striving to adorn their houses, especially the outer or street rooms, with costly pieces—butchers and bakers not much inferior in their shops, which are fairly set forth, yea many times blacksmiths, cobblers, etc. will have some picture or other in their forge and in their stalls."

The patronage system of court and church, so dominant in Catholic Italy, Spain, and Flanders, played a lesser role in the Dutch Netherlands. Opposed to the visual idols or "graven images" of Catholic churches, Protestant churches did not generally commission grand-scale paintings and sculptures of Jesus, Mary, and the disciples. The hereditary nobility, for its part, had been largely replaced by the commercial middle class as Dutch society's power brokers. For these reasons, an open art market came to dominate in the Dutch Republic, and large-scale commissions such as those showered on Bernini and Rubens by church and court were few. *The Night Watch* **(15.9)** by Rembrandt van Rijn (1606–1669) was one such commissioned work, but it was exceptional in

every way. It was not paid for by a cardinal or a prince; rather, its funding source was a company of civil guardsmen. In true democratic-capitalistic spirit, each guardsman decided what he would contribute to the artist's fee. Commensurately, those who paid the most were featured front and center, while those who contributed less found themselves on the sides or in the rear—Dutch capitalism and democracy made visible. And such a work was not hung in a royal palace or private chapel. The first place of residence of *The Night Watch* was the social hall of the guardsmen; its second was Amsterdam's Town Hall.

Rembrandt's *The Night Watch*

Rembrandt's *The Night Watch* (15.9) exhibits certain qualities of the Italian baroque: grand scale, dramatic lighting, energetic activity, and protagonists in substantial number. Some of the chiaroscuro handling and everyday realism and humanism of Caravaggio's *The Calling of Saint Matthew* (14.42) has entered this picture. But Rembrandt's large painting is much toned down in comparison to the supernormal spectacles of Rubens, Bernini, and Gaulli (14.38–14.41). The expressions and gestures of the eighteen paying members of the company and of the sixteen other figures Rembrandt added free of charge are more matter-of-fact than superhuman, more spontaneous than posed. Overall, it is a work more Dutch than Italian in inspiration, one in keeping with the pragmatic Netherlandish temperament and its penchant for realism. Compared to the larger-than-life spectacles of much Catholic baroque art, *The Night Watch* is, in fact, rather down-to-earth. The dog in the lower right barks as the men assemble. Soldiers converse informally as they load or check their weapons. A guardsman on the extreme right, cut by the picture frame, beats out the call to assembly. No one strikes the customary noble pose, even though this is a group portrait. Spontaneity and informality are the rule.

In formal terms, lights and darks predominate. We note values of blacks, browns, burnt yellows, and whites, emboldened by a few areas of red. This color scheme contrasts with the far more brilliant hues of Rubens and most Italian baroque painters. And while the painting has baroque energy and variety—men

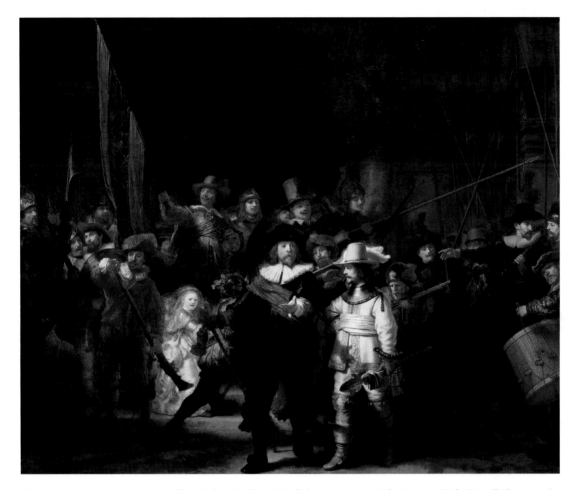

15.9 REMBRANDT VAN RIJN. *The Night Watch*. 1642. Oil on canvas. 12 ft. 2 in. × 17 ft. 7 in. Rijksmuseum, Amsterdam. The Night Watch *contains a little, highlighted angelic girl to the left of the main figures. Based on the visual data in the picture itself, do you think she is an actual person or an allegorical figure symbolic of some virtue?*

readying themselves in a diversity of activities, with flags, pikes, and guns pointing every which way—all the pieces hold together and are tempered by a classically balanced composition. A triangular formation, in which the two leading officers form the bottommost point, helps bring unity to the variety. Captain Cocq, in black, and his first lieutenant walk in the very front center, at the advance of their guard. They are the persons of highest prestige and the largest contributors to Rembrandt's fee. A triangular phalanx of soldiers, accompanied by a dwarf, a dog, and an angelic girl in golden tones, follows behind. The two commanders are clothed in rich black and white colors, making them stand out from the rest; the captain's bright red sash is the central coloristic feature.

The emphasis in *The Night Watch* on individualism, humanism, and realism carries over to Rembrandt's other works. We observe these same qualities in his portraits (2.35), which brought him respect as one of the leading painters of the day. In no other painted or sculpted portraits prior to these is the particularized inner life of the human being so keenly felt. They encompassed anonymous persons, surgeons, guild leaders, burgomasters (mayors), and members of Amsterdam's Jewish community. Portrait commissions for the well-to-do along with prints (6.4) in multiple editions for a broader public made Rembrandt a wealthy man, though in later years, his moneys depleted from excessive spending, he was forced to sell or auction artworks and belongings to save himself from paupery. Obstinate to the end, Rembrandt refused to resort to a second (or third) job to pay for food or rent, as did many more-pragmatic Dutch painters.

Rembrandt spared no pains to create as convincing an illusion of actuality as possible in this image of self-possessed and somewhat self-satisfied burghers walking out of the picture to meet us on their own terms.
—John Fleming and Hugh Honour, *The Visual Arts: A History, 1986*

APPRECIATION 29 *Judith Leyster's* The Proposition

FRIMA FOX HOFRICHTER

It has been three centuries since the death of the versatile Dutch genre, portrait, and still-life painter Judith Leyster (1609–1660) **(Fig. A),** but it was only during the last women's movement [Interaction Box] that the pioneer study [in 1927] of her works was finally made. . . .

Yet during her own lifetime, Leyster had been praised twice in the histories of the city of Haarlem (where she was born), once in 1627 by Samuel Ampzing . . . when she was only eighteen, and again in 1648 by Theodore Shrevel,

Figure A JUDITH LEYSTER. *Self-Portrait.* Ca. 1630. Oil on canvas. 20⅜ × 25⅝ in. Gift of Mr. and Mrs. Robert Woods Bliss. Photo © 2002. Board of Trustees, National Gallery of Art, Washington, D.C. 1949.6.1 (1050)/PA.

who, punning on her last name, called Leyster a "leading star in art." She was admitted to the St. Luke's Guild in Haarlem in 1633, and is known to have had several students (documents concerning at least three students exist). She married another Haarlem painter, Jan Miense Molenaer, in 1636, bore three children, and died in Heemstede, near Haarlem, in 1660.

The Proposition **(Fig. B)** is a small panel painting 12.2 inches high by 9.5 inches wide, bears her monogram, and is dated 1631. . . . The proposition is initiated by the man as he leans over the woman's shoulder, with one hand on her upper arm and his other extended forward full of coins. She, without noticeable reaction, or perhaps with determined disinterest, sits in a chair with her feet propped on a footwarmer, concentrating on the sewing which she holds in her lap. Leyster is openly and clearly depicting a sexual proposition (the man is not offering the woman payment for the sewing!). However, it is not the subject, but rather Leyster's attitude toward this popular theme, which is our main concern.

The theme of propositions, prostitution, procuresses, and brothels . . . was common in Northern art. . . . The popularity of the theme may be explained in part because the subject was common enough in life in seventeenth-century Holland. . . . Such paintings were probably appealing both as depictions of forbidden, but commonplace, pleasures and as works with moralizing intent.

. . . The procuress theme was particularly popular in seventeenth-century Utrecht and is well illustrated by Baburen's *Procuress* of 1622 [15.11]. The entire cast is present: the old procuress at the right, the customer in the center, and the prostitute on the left. Each is a stereotype for a clearly defined role, and all are shown as bold, jocular, and certainly willing participants in this exchange of services for money.

However, Leyster's attitude toward the subject and her treatment of it differ from those of the Utrecht masters and from those of her contemporaries in general. . . . Leyster's work may, in fact, be considered a critical response to the painting of her predecessors. Her depiction of the scene is contrary to the accepted role assigned women in the painting from the fifteenth to the seventeenth centuries, previously mentioned, in which they "fleece" men, pick their pockets, steal their money, seduce them, abuse them, and generally make fools of them. The theme of prostitution exploits the idea of women using their wiles to degrade men and lead them to sin. Leyster's painting does not foster this image.

In her *Proposition*, the mood is not one of carousing but of quiet intimacy. The woman, usually depicted as a willing participant in the adventure if not its instigator, is not shown that way here. She is not entertaining the leering cavalier who offers her money; she is neither playing a lute, nor drinking, nor wearing a low-cut dress—nor is she accepting his offer. The embodiment of domestic virtue, she continues her sewing. Rather than encouraging the man's intentions, she becomes the embarrassed victim. The room is silent as we wait for her response. Leyster's woman is no harlot: she is an ordinary woman being propositioned—not an extraordinary circumstance. The difference in approach is unprecedented: it surely represents, to some degree, Leyster's viewpoint as a woman in a world whose way of seeing and representing was dominated by men. ■

Figure B JUDITH LEYSTER. *The Proposition*. 1631. Oil on panel. 11¹¹⁄₁₆ × 9½ in. Mauritshuis, The Hague, The Netherlands.

Frima Fox Hofrichter, chair of the History of Art Department at Pratt Institute, has published extensively on Judith Leyster and seventeenth-century Dutch art. This essay is excerpted from her chapter, "Judith Leyster's Proposition—Between Virtue and Vice," *in* Feminism and Art History, *edited by Norma Broude and Mary Garrard, Harper & Row, New York, 1982, pp. 172–81.*

Vermeer and *The Concert*

Seventeenth-century Dutch artists whom we admire today earned much of their income from more lucrative sidelines such as trading in tulips, collecting taxes, or working as innkeepers. The case of Jan Vermeer (1632–1675), one of the great painters of all time, is illuminating in this regard. In spite of the fact that he was well known among his contemporaries, Vermeer never achieved sufficient financial success to support his family from his art alone. The Dutch art market was characterized by fluctuating prices, changing fashions, and an overabundance of artists, and like today's art world it was a very difficult venue in which to earn one's way. Most Dutch painters came to specialize, which helped them establish a personal identity in an overpopulated art world as well as increase their output. (If they came up with a successful formula, they'd use it again and again.) For his part, Vermeer specialized in indoor domestic scenes ("interiors"), many of which possessed moral overtones or secondary, symbolic meanings. *The Concert* **(15.10)** at first glance depicts a trio of privileged young people playing music together. But, like so many seventeenth-century Dutch paintings, it can be studied for further levels of meaning. Art historian Mary Ann Scott writes:

> Some scholars recognize subtle romantic undertones in works such as this. A clue to the possibly sensual secondary meaning might be read in the erotic painting on the back wall at the right, a procuress scene representing a lute-playing prostitute, her merry customer, and a madam. The arrangement of two women and a man parallels that of the trio in the room. It may be that Vermeer meant the picture as a reference to the sensual association enjoyed by the music makers, whose precise relationship the artist otherwise leaves ambiguous.

> Besides providing us with an object of exceptional beauty and rich meaning, *The Concert* further serves as an important visual document. The painting of *The Procuress* **[15.11]** on the wall is not a fantasy but a known work by Vermeer's near contemporary Dirck van Baburen (ca. 1595–1624). We know from surviving inventory of Vermeer's private collection that he owned this very painting. By incorporating it into his genre scene, Vermeer increased the sense of realism.[2]

Scholars hypothesize that the setting for *The Concert* and other Vermeer interiors may have been the rooms of his own house in the city of Delft, which may have served simultaneously as living quarters, inn, exhibition space, art dealer's shop, and artistic subject.

That Vermeer produced so few paintings in his lifetime—no more than thirty-five pictures can be attributed to him—probably stemmed from the limited time he could devote to his art, coupled with the fact that he worked very slowly and meticulously. In this regard, *The Concert* may reveal as much about Vermeer's socioeconomic status as about his artistic life. The paintings in the backgrounds of this and other works might have been part of an inventory he was willing to sell to supplement his income. Like the vast majority of fine artists today, who support themselves and their families through other jobs such as teaching, house painting, driving taxis, waiting on tables, or working in art galleries, Vermeer was a "hyphenated artist," in his case an artist-innkeeper and/or artist–art dealer. Because he valued his painting as a "liberal art"—a learned pursuit that combined art, science, morality, and poetry—Vermeer was willing to take up other occupations so as not to compromise the quality of his work. With other sources of income at hand, he could work as slowly and thoughtfully as he wished in order to capture the visual poetry of everyday life. Nonetheless, Vermeer would find himself at the end of his life the proverbial struggling artist, forced to sell off his pictures at auction to stay financially afloat.

If Vermeer had to struggle to make ends meet, he did not have to struggle when it came to artistic style. Vermeer's art fit comfortably within the mainstream of Dutch realism. His small pictures did not break new formal ground so much as expand or enrich the possibilities already present in the art of the Netherlands. "Characteristic of Vermeer," art historian Scott notes, "are the refined handling of the brush, realistic figural representation, subtle gradations of color and light, double cast shadows, masterful textural effects, and intricate compositional balance such as the spatial effect achieved [in *The Concert*] by the juxtaposition of the table detail at the left with the figural group at the right." Use of the camera

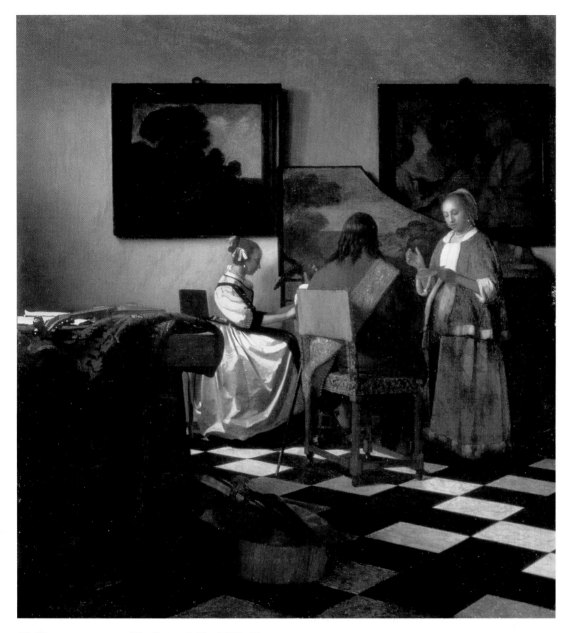

15.10 JAN VERMEER. *The Concert*. Ca. 1665–66. Oil on canvas. 28½ × 25½ in. The Isabella Stewart Gardner Museum, Boston. *Vermeer's paintings have a poetic stillness and a near-photographic quality. They seem like moments frozen in time. How do you think he created them?*

15.11 DIRCK VAN BABUREN. *The Procuress*. 1622. Oil on canvas. 40 × 42⅜ in. M. Theresa B. Hopkins Fund. Courtesy, Museum of Fine Arts, Boston.

obscura (7.2) or other optical devices probably
supported the artist's quest for accurate repro-
duction. His was "the art of describing" at its
best, an art that succeeded in creating the
smooth, transparent mirror of the world that
was the goal of so many Dutch painters.

EIGHTEENTH-CENTURY ART:
BAROQUE TO ROCOCO TO
NEOCLASSICAL

With the Dutch art of everyday life, theatrical
baroque art, and the French and Italian acad-
emies in the background, we enter the art
world of eighteenth-century France. Between
Rubens's seventeenth-century *The Garden of
Love* **(15.12)** and Watteau's *A Pilgrimage to
Cythera* **(15.13),** completed in Paris in 1717, we
move into both a new century and a new cul-
tural sensibility and artistic style. In art his-
torical terms, we leave the world of the
baroque and enter that of the **rococo,** a style
that emerged from the baroque but is
more delicate and intimate. After comparing

Rubens's baroque painting and Watteau's
rococo artwork, we examine two other
eighteenth-century directions, naturalism and
neoclassicism.

Baroque to Rococo: Two Paintings

Let us begin our comparison by noting what
the two painters of *The Garden of Love* and *A
Pilgrimage to Cythera* had in common. Peter
Paul Rubens (1577–1640) and Jean-Antoine
Watteau (1684–1721) were Flemish Catholics
who were closely connected to the French up-
per classes. Rubens, born of an Antwerp fam-
ily, spent much of his life working throughout
Catholic Europe, in Italy, France, and the Span-
ish Netherlands. Watteau, brought up until the
age of eighteen in an area of the Spanish
Netherlands newly annexed by France, spent
most of his adult years in Paris. Born forty-four
years after Rubens's death, Watteau was a
great admirer of Rubens, first coming to know
his works in Paris in the form of engraved
copies of original drawings or paintings. He
later made many copies after Rubens's vast
cycle of paintings on the life of the former

15.13 JEAN-ANTOINE
WATTEAU. *A Pilgrimage
to Cythera*. 1717. Oil on
canvas. 51 × 76½ in.
Musée du Louvre,
Paris.

French queen Marie de' Medici (14.41). He was
able to see these paintings in their original set-
ting in the Luxembourg Palace through the
mediation of a highly placed friend. Watteau, it
should be noted, was supported by a small cir-
cle of aristocrats and "bourgeois nobles" who
patronized his art and provided living quar-
ters for him in their palaces and apartments.
Like Rubens, he worked exclusively for soci-
ety's elite.

Watteau was inspired by the imaginative
designs, opulent coloring, and unabashed sen-
suousness of Rubens's paintings. In the ongo-
ing battle between those at the French Royal
Academy who supported the "Poussinist"
philosophy of classical line and composition
and morally elevated subject matter—recall
Poussin's *Burial of Phocion* (15.6)—and those
who followed the more intuitive, colorful,
painterly art of Rubens, Watteau's art and its
ultimate public success would be seen as a vic-
tory for the "Rubenists." The proponents of
Rubens's style would indeed rejoice when in
1717 Watteau's *Pilgrimage to Cythera* earned the
painter official entry into the French Royal
Academy of Painting and Sculpture. The
painting was further honored by having a new

artistic category, the *fête galante* ("elegant enter-
tainment"), invented for it. In the Academy's
hierarchy of artistic categories, the *fête galante*
gained an intermediate position, with history
painting (of elevated religious and mythologi-
cal subjects or prominent historical events) at
the top and genre and still life at the bottom.

In its way, Rubens's *Garden of Love* is a
baroque *fête galante*, an upper-class party in the
countryside, that sets the stage for Watteau's
rococo *Pilgrimage to Cythera*. Both depict ele-
gant open-air entertainments that share a com-
mon theme: the allegorical worship of love. The
island of Cythera, from which (or to which)
Watteau's gentlemen and ladies are traveling in
a gilded boat, was reputed to be the home of an
ancient cult that worshiped the mythological
love goddess. Rubens's gentlemen and ladies,
in contrast, are not at the beginning or end of
their revels but rather are fully engaged in the
pleasures of their love garden. The two paint-
ings involve a comparable number of lovers,
spurred along by airborne cupids. In both, a lit-
tle dog, symbolic of loyalty, resides at the foot
of a man in red. In addition, each work shows
us the various stages of the relationship
between lovers, from the inviting opening

457

conversations to the consummation of couples pairing off. Observation alone would certainly lead us to think that Watteau was inspired by Rubens's work, and a reading of the art historical record proves this to be the case.

For all their similarities, however, these are very different works, the result of both personal disparities between the two men and differences in the worlds in which they lived. Rubens's *Garden of Love* was improvised from the garden-park of the artist's own country estate, a setting dominated by hard, heavy stone; massive baroque architecture; and solid, full-bodied sculptures. Watteau's *Pilgrimage to Cythera* is likewise set in a garden-park, probably based loosely on the pastoral estate of one of his wealthy benefactors, but the light and airy surroundings are more informal and "natural," an environment later writers would describe as "picturesque." In Watteau's parkland of the privileged, we encounter a soft backdrop of trees and misty mountains and a type of statuary that is far more understated and attenuated than that in *The Garden of Love*. Witness the slender, garlanded figure of Venus, the goddess of love, on the right. Compared to the hefty baroque statues pictured in Rubens's painting, this rococo Venus appears tall and thin, a wistful spirit of nature.

With respect to overall conception, Rubens's *Garden of Love* is a place of grandeur and dynamism where love is being energetically pursued. The figures are big-bodied and dominate the foreground. Compositionally, they form a compact, physically interrelated group, evoking a sense of confidence and solidarity. These are people of weight, health, and strength. Watteau's figures, in contrast, are slender and elongated and appear to move with a slower, more calculated grace. They have been compared to actors and actresses, men and women who play their roles with consummate skill upon life's stage. (Watteau was in fact a great lover of theater.) Small in scale compared to their Arcadian surroundings, these rococo lovers seem to be in a more harmonious relationship with their natural setting rather than dominating it. They spread out languidly over a gently curving slope and proceed separately as couples or small groups. Figures split off from their fellows. Space opens between and around them.

In contrast to baroque art (15.6), which tends to direct one's attention to the objects of greatest concern, Watteau's painting offers an enlarged sense of openness, a greater degree of decentralization, and a more diffused focus. These spatial characteristics in *A Pilgrimage to Cythera* find interesting parallels in Watteau's own life and times. The life of the French court had recently been decentralized, with the nobility spreading out into townhouses ("hotels") throughout Paris. For the previous half century the French nobility had been subjected to the centralized control of Louis XIV (15.2), but with the gradual weakening of the king's hold on power and his death in 1715 the nobles chose once again to go their separate ways. Many moved to Paris, where they mixed with the wealthy bourgeoisie. Members of both groups served as supporters of Watteau's career. In the capital city, this social elite entertained in their townhouse hotels and pursued life freely and individualistically. The control and focus of Louis XIV's autocratic court, manifested in the sternly rational order and imperial feeling of his architecture (15.1) and landscape design (15.3), had given way to the less bounded flow of urban living and carefree *fête galante* entertaining.

Besides these larger sociocultural factors, personal differences promoted distinctions between Watteau's rococo art and that of his baroque predecessor Rubens. Rubens had been a vigorous participant—diplomat, artist, husband, and family man—on the stage of life. (He appears in the left foreground of *The Garden of Love*.) Watteau, in contrast, was an introspective outsider and a keen observer from a distance. He was a tender man, delicate and shy, a bachelor of solitary disposition. These qualities are captured in a sensitive portrait **(15.14)** by the internationally famous pastel artist Rosalba Carriera (1675–1757). In several of his paintings, Watteau pictures himself as the odd man out, the sad-eyed clown or background musician, never showing himself as the passionate merrymaker or life of the party. Weakened by tuberculosis and destined to die from it at the age of thirty-seven, Watteau necessarily sought love and life as pleasures alternately precious and transient, passing before his eyes just as the idyllic landscape in the background of his painting fades into the mists.

Carriera's loose, painterly technique with its subtle surface tonalities and dancing lights revolutionized the medium of pastel. Dragging the side of a piece of white chalk across and under drawing in darker tones, she was able to capture the shimmering textures of lace and satin, and highlight facial features and soft cascades of powdered hair. —Whitney Chadwick, art historian, *Women, Art, and Society,* 1990

In this respect, Watteau anticipates the impressionists (1.6, 7.15) and possesses a kind of modernist consciousness. He is a captor of fleeting words and glances, of moments of happiness and instances of anxiety that pass between individuals. His nervous sensibility revealed life much as it was, ultimately making for a view of the world far less idealized, grandiose, and melodramatic than that of his Catholic baroque predecessors. Cupids, statues of Venus, and Arcadian garden-parks might be the backdrops for Watteau's scenes of high society, but their primary subject is the real world, with its lovers, actors, musicians, and clowns. To his contemporaries, Watteau's art was considered to represent reality far more than fantasy. No artist, rococo or otherwise, had ever observed and pictured the life of French society more accurately.

In the formal characteristics of *A Pilgrimage to Cythera*, we discover key elements of the Style of Louis XV (the original period name for the rococo). Coloristically, Watteau's palette is a bit more delicate and muted than its vigorous baroque parent. Primary reds in Rubens's art become plums or pinks in Watteau's. Brilliant baroque blues are toned down to rococo pastels, and bright yellows turn toward yellow-browns and mellow golds. This softer, sweeter, more delicate coloration found its way into rococo interior design and other forms of decorative art.

Rococo Interior Design and Decoration

Watteau's vocabulary of shapes found counterparts in contemporary decorative and applied arts. Art historian Steven Jones observes that the pilgrimage bark that lies at the waterside of the island in *A Pilgrimage to Cythera* is elaborately ornamented. "Its stern," writes Jones, "is dominated by the shell, or *rocaille*, motif [from which the name "rococo" was derived]. The cherubs who hang in the air on their cloud are curling and decorative elements." The same ornamental flair and vocabulary of visual forms that appears in Watteau's painting—the *rocaille* shell motif, leaves, branches, flowers, clouds, and other natural forms—made themselves felt in the Style of Louis XV interiors of Paris townhouses, such

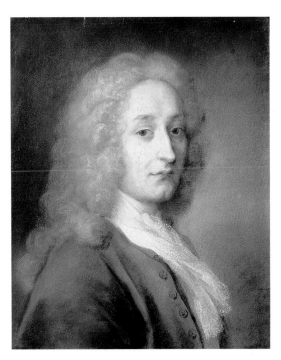

15.14 ROSALBA CARRIERA. *Antoine Watteau.* 1721. Pastel on paper. 21⅝ × 16⅞ in. Museo Civico di Treviso, Italy. *The talents of the Venetian Carriera, an inventor of the pastel portrait, were so admired that she was invited to become a member of France's Royal Academy of Painting and Sculpture. What do you think made portraits created from colored chalks, rather than the customary oil paints, so appealing to Europe's aristocracy during the rococo period?*

as the Princess's Salon of the Hotel Soubise **(15.15)**. Light plum in color with golden decorative effects (curling shells and clouds, curvaceous cherubs, stylized plant motifs) on walls and ceiling, the oval-shaped princess's room seems to have been conjured up rather than constructed. Its mirrors, light color, loosely curving shape, inset paintings, and tall arched windows that manipulate the natural lighting make the walls of the room seem almost insubstantial. Here and elsewhere, chairs, tables, fireplaces, clocks, chandeliers, silverware, porcelain figurines, and even the high-fashion apparel of the upper classes reflected this generalizable style. For several decades, the rococo would be the style of the French upper classes, pervading every visible aspect of their lives.

In the context of a total style, rococo paintings were seen as part of the overall decor, an essential ingredient in the interior decorator's composition. As such, paintings of a specific size and shape were often commissioned with a very particular interior space in mind. Created for such urban interiors, French rococo period paintings tended to be smaller and more intimate than their baroque counterparts. Unlike the large-scale paintings of the baroque, *A Pilgrimage to Cythera* measures a modest 4¼ by 6⅓ feet. Baroque power and grandeur

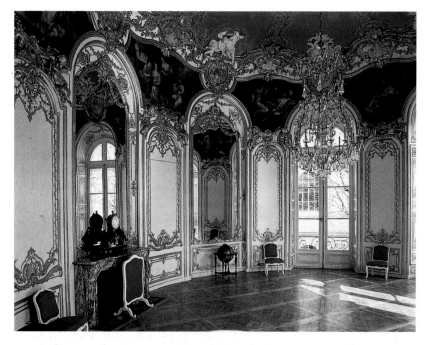

15.15 GABRIEL-GERMAIN BOFFRAND. Salon de la Princesse. Hotel de Soubise, Paris. Ca. 1740.

had given way to rococo intimacy and elegance. Though baroque in its lineage, the rococo style achieved an identity very much its own. Its influence would spread across Europe. In England, Gainsborough combined rococo gracefulness, ease, and elegant style with a realistic depiction of a wealthy couple, their estate, and natural surroundings in his outdoor portrait *Mr. and Mrs. Andrews* (6.21).

Middle-Class Naturalism and Idealism in the Art of Chardin

If Watteau is one of the premier painters of French high society, Jean-Baptiste-Siméon Chardin (1699–1779) must be declared one of France's preeminent painters of middle-class life. A contemporary commentator wrote about Chardin's painting *The Morning Toilet* **(15.16)**: "It is always the *Bourgeoisie* he brings into play. . . . There is not a single woman of the Third estate, who does not think it an image of her figure, who does not see there her own domestic establishment, her polished manners, her countenance, her daily occupations, her morals, the moods of her children, her furniture, her wardrobe." For the Parisian middle-class of his day, Chardin presented realistic images of daily life shown at its ideal best. Acting almost as a role model, his art presented the "real and ideal" image to which they aspired.

Chardin was born two months before the birth of the eighteenth century into the large family of a skilled cabinetmaker. Artistically, his inspiration came not from the elegant rococo but from the naturalistic genre and still-life art of seventeenth-century Holland and Flanders. In fact, he gained admittance to the French Royal Academy as a painter of "animals and fruit" (that is, still life). From this humblest of artistic categories, rated lowest in the academic hierarchy because it did not concern itself with human beings and their actions, Chardin proceeded to the painting of genre scenes, especially interiors, in the Flemish and Dutch tradition (15.10). Genre paintings were rated slightly higher than still lifes because they dealt with the human world,

15.16 JEAN-BAPTISTE-SIMÉON CHARDIN. *The Morning Toilet*. 1741. Oil on canvas. 19⅛ × 15³⁄₁₆ in. The National Museum of Fine Arts, Stockholm.

albeit the world of common people and activities. It was these early genre paintings, rather than the still lifes, that would dominate his later years, that brought Chardin success in the Salons, earning for him a solid if unspectacular reputation. (Named after the large room or salon in the Louvre (15.1) where it was first held, the **Salon,** juried and organized by the Royal Academy, was the most prestigious annual art exhibition in France.) In the art world of the eighteenth century, the highest honors were still reserved for those who painted history paintings of great religious, mythological, or historical events or idealizing portraits of distinguished persons.

Like the genre paintings of his Dutch and Flemish predecessors, Chardin's pictures portray reality and convey moral messages. With the French artist, these messages revolve around the highest ideals of middle-class morality: simplicity, honesty, and industry. Such moral idealism pervades the full range of middle-class life shown in Chardin's pictures: His subjects—in pictures with fitting titles such as *The Morning Toilet, Saying Grace, The Industrious Mother, The Governess*, and *The Young Schoolmistress*—deal with personal hygiene, food preparation, homemaking, and education of the young. Blending pictorial naturalism and ethical idealism, such representations of bourgeois life were appreciated and purchased by middle- and upper-class persons alike, perhaps reflecting the growing prominence of the bourgeois worldview in eighteenth-century French society.

Reflecting his own industrious and self-effacing nature, Chardin's unassuming little paintings represent a split from the more refined and elevated history (15.6) and portrait (15.2) paintings preferred by the upper classes. Whereas many of his more honored contemporaries flattered their sitters or beautified their subjects, Chardin painted subjects as he saw them, not as academic tradition or upper-class patrons would prefer. A discerning viewer of the day noted that Chardin's genre paintings and still lifes differed substantially from the more decorative, outwardly sophisticated work of most of his contemporaries, stating that they possessed values of "simplicity and truth, which are so rare, so difficult to grasp in a century when art of every kind is so close to mannerism and affectation."

15.17 FRANÇOIS BOUCHER. *The Toilet of Venus.* 1751. Oil on canvas. 42⅝ × 33½ in. The Metropolitan Museum of Art, New York. Bequest of William K. Vanderbilt, 1920. *In his negative evaluation of works like* The Toilet of Venus, *the critic Diderot could not separate the artist's frivolous subject matter from his technical excellence and painterly flair. As a critic, could you accept a work as a masterpiece if its subject and content were of little significance?*

A similar evaluation of Chardin's work was made by the eminent philosopher, social reformer, and art critic Denis Diderot (1713–1784) (15.20), the principal contributor to the first modern encyclopedia. For this genius-activist of the liberal French Enlightenment, Chardin's art embodied all the commendable values so lacking in the more elegant, ethically frivolous paintings of contemporary rococo masters. The son of an accomplished artisan, the morally upright Diderot leveled some of his harshest criticism on the fabulously successful rococo painter François Boucher (1703–1770), famous for his stylish portraits of the nobility and for playful mythological scenes that brim with sensual pleasure. Whether or not we agree with Diderot's harsh assessment of Boucher, the latter's *The Toilet of Venus* **(15.17)** is worlds apart from Chardin's matter-of-fact, morally proper *The Morning Toilet* (15.16).

15.18 JEAN-BAPTISTE-SIMÉON CHARDIN. *The Jar of Olives.* 1760. Oil on canvas. 28 × 38⅝ in. Musée du Louvre, Paris. *Dutch genre paintings (15.10) and still lifes (6.19) often have secondary, symbolic levels that center on moral messages. For example, a rotting fruit or a broken watch in a Dutch still life refers to the passing of earthly pleasures, the message being to live a good, moral life during one's brief time on earth. Is Chardin's still life more straightforward, simply a still life for its own sake, or do you perceive a secondary, symbolic message?*

Talent does not declare itself in an instant. . . . He who has not felt the difficulties of his art does nothing that counts.

—Jean-Baptiste-Siméon Chardin, painter, speech to the admission jury of the Salon, 1765

Especially sympathetic to Chardin's realism, Diderot wrote glowingly of the artist's still lifes **(15.18)** at the Salon of 1763. A materialist in his worldview, Diderot was impressed by Chardin's truthfulness to nature, the magical power of his illusionism, and the honest but dignified way he treated his humble subject matter. With the misguided, libertine talent of the rococo master Boucher in mind, Diderot exclaims of Chardin:

> Here is the real painter; here is the true colorist. . . . For the porcelain vase is truly of porcelain; those olives are really separated from the eye by the water in which they float; you have only to take those biscuits and eat them, to cut and squeeze that orange, to drink that glass of wine, peel those fruits and put the knife to the pie.
> . . . Here is the man who truly understands the harmony of colors and reflection. Oh, Chardin! What you mix on your palette is not white, red, or black pigment, but the very substance of things; it is the air and light itself which you take on the tip of your brush and place on the canvas. . . .[3]

The bourgeois worldview, soon to shake society to its roots in the form of the French and American Revolutions, finds a visual microcosm in the paintings of Chardin. Yet future French revolutionists did not discern the revolutionary qualities in Chardin's art, instead bestowing their praises on the classically inspired, grand-scale history paintings that overtly flamed the fires of revolution.

NEOCLASSICISM, DEMOCRACY, AND REVOLUTION

Chardin passed away in 1779 and Diderot in 1784, but the basic mix of naturalism and moral idealism valued by both men infused the artistic movement we have come to know as **neoclassicism.** For subject matter, the painters and sculptors of this "new classicism," including Angelica Kauffmann (15.5) and the many members of England's Royal Academy (15.4), initially looked to the history and mythology of ancient Greece and Rome. A wide variety of European and North American artists soon applied the naturalism, idealism, and classical inspiration of these artists to the interpretation of contemporary as well as "antique" subjects.

Sculpture and Architecture for a Democracy: Houdon and Jefferson

In creating sculpted portraits, Frenchman Jean-Antoine Houdon (1741–1828) was the greatest of the neoclassicists, an artist "without rivalship," wrote Thomas Jefferson in 1785. His full-length marble portrait of George Washington **(15.19)** presents the victorious general as a kind of modern-day Roman hero: a dignified country gentleman called away from his home to defend the honor and liberty of his country. In his sculptural portrait of Diderot **(15.20),** exhibited in the Salon of 1771, Houdon presents his famous subject "a la antique," with the torso abbreviated and undraped to the collarbone. The once customary wig, which Diderot hated to wear, is also removed. Houdon is thus able to present Diderot in accordance with the ancient formula for depicting a Roman philosopher or man of letters. Joined with this specific reference to Roman sculpture are the

15.19 JEAN-ANTOINE HOUDON. *George Washington*. 1788–92. Marble. 74 in. State Capitol, Richmond, VA. Photo courtesy of Virginia State Library and Archives, Richmond, VA.

15.20 JEAN-ANTOINE HOUDON. *Denis Diderot*. 1773. Marble. 20⁷⁄₁₆ in. The Metropolitan Museum of Art, New York. Gift of Mr. and Mrs. Charles Wrightsman, 1974. (1974.291).

time-honored characteristics of classical idealism: emotional restraint, calm grandeur, noble simplicity, and intellectual clarity. To this neoclassical mixture Houdon added a convincing naturalism that caused Diderot himself to admit that the bust was "very like" him.

This idealized naturalism certainly appealed to the great men and women of Houdon's age; his commissions came from across the political spectrum. Houdon's subjects were kings and queens as well as liberal reformers such as Diderot and democratic revolutionaries such as Washington, Jefferson, and Benjamin Franklin. The American War of Independence from England brought about a new order that was bourgeois and democratic. In Houdon's portraits of smooth white marble, the American founding fathers found a neoclassical style and an ideal befitting democracy's heroes and values.

Thomas Jefferson (1743–1826) was challenged as an architect by the problem of how to create the architecture of democracy. Acutely aware that architecture could symbolize political ideology, Jefferson sought to design buildings that spoke of democratic and republican ideals. In addition, he desired to create buildings that emphasized rationality, learning, and moral dignity, primary principles of the eighteenth-century European philosophical movement known as the Enlightenment, a movement that featured among its leaders England's liberal political theorist John Locke (1632–1704), Diderot, and Jefferson himself. Shunning the prevailing British architectural style in the colonies, Jefferson sought a building style independent of "King George's Tyranny." Having just fought a bloody war for independence, the former colonists needed an American style; the British Georgian style would not serve.

Where might an architecture appropriate for the young democratic republic be found? Jefferson and his compatriots, among them architect Benjamin Latrobe (1764–1820), looked to classical Greece and republican Rome.

15.21 THOMAS JEFFERSON. State Capitol, Richmond, VA. 1780–85. Aerial view. Photo courtesy of the Library of Virginia. *Neoclassical architecture is not always "the architecture of democracy." In the twentieth century, the Nazis in Germany and the Fascists in Italy adopted neoclassicism as a preferred style for their regimes. How could this style serve such opposite political purposes?*

Latrobe asserted that a new Greece was growing "in the woods of America." Like the United States, he noted, "Greece was free; in Greece every citizen felt himself an important . . . part of his republic." Classical Greek architecture, it was concluded, was well-suited for America. Jefferson, for his part, had the architecture and culture of republican Rome in mind, as did those Frenchmen who would lead the first phase of their country's bourgeois revolution. The leaders of the American War of Independence drew their moral inspiration from those self-denying Roman heroes (15.24) who loved country above all else and valued liberty more than their lives. Their planned senate on the Potomac would be a reincarnation of the Roman senate, a patrician precursor of American representative democracy. It is therefore not surprising that neoclassical architecture came to dominate the Federal Period, the years from approximately 1790 to 1830.

To Jefferson, the first order of business in bringing forth a national architecture was the transport of the Roman architectural style to America. The designs he sent from France for the new state capitol of Virginia reproduced, on a larger scale, a Roman temple (the so-called Maison Carrée) that he had seen in Nîmes, France. He wrote that he had gazed on the small temple for hours, "like a lover at his mistress." "It is very simple," he observed, "but it is noble beyond expression, and would have done honor to our country, as presenting to travellers a specimen of taste in our infancy, promising much for our maturer age." In Richmond, legislative, executive, and judicial functions were to be carried out within the walls of this harmonious structure **(15.21).** The moral-aesthetic qualities communicated by the exterior extended to both the building's interior design and the featured statue within: the full-length portrait of George Washington (15.19). In the fine and applied arts, as well as in architecture and in fashion (Appreciation 6), the neoclassical aesthetic would become synonymous with the political ideals of the new revolutionary republics in both the United States and France.

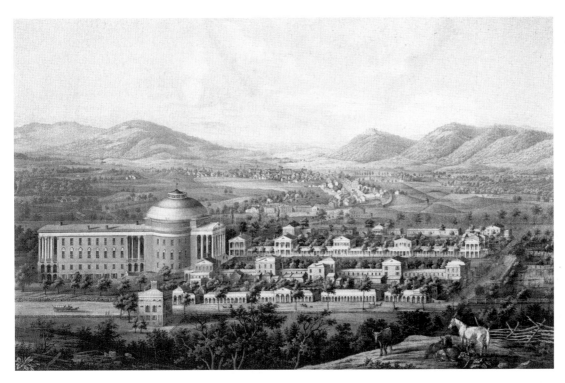

15.22 THOMAS JEFFERSON. Rotunda, University of Virginia, Charlottesville. 1817–26. Photo courtesy Albert and Shirley Small Special Collections Library, University of Virginia Library.

A strong believer in publicly funded education, Jefferson took great pride in founding the University of Virginia. For its library (**15.22,** 1.5), the core of his "academical village," Jefferson built a version of Rome's Pantheon (10.21) at two-thirds its scale. Situated at the head of a gently rising lawn, this pantheon of knowledge was flanked by ten pavilions for professors and, between them, behind a colonnade, the rooms of the students—all linked to the whole, yet each individual. The symbolism of this design should be appreciated. The library is the largest, most centrally located building on campus. In Jefferson's plan, the faculty and students, architecturally and factually, are at the core of the academic enterprise, physically linked to all the knowledge of the past. The original campus of the University of Virginia was open at one end, looking out and thereby linking with the mountains and larger world beyond, speaking to Jefferson's desire that academia be integrally related to nature (and natural law) as well as to evolving human civilization. The academical village was not to be an "ivory tower," walled in and cloistered from the rest of life.

From Jefferson's time through the first half of the twentieth century, the American government continued to forge an architecture of democracy from the classical vocabulary. In the particular sociocultural context of the United States, democracy and the classical style march hand in hand.

David and Revolutionary History Painting

In France, neoclassical style and revolutionary fervor came together in the grand-scale history paintings of Jacques-Louis David (1748–1825). Of comfortable middle-class background, David (**15.23**) had always been drawn to history painting, the Academy's most esteemed category. History painting, which encompassed biblical, mythological, and historical subject matter, was the domain in which artists could best convey moral and intellectual positions. For a man of revolutionary temperament like David, history painting was thus the most effective means by which to promote political change. Its goal was supposed to be humanistic, "to spread the progress of the human

. . . the columned ranges of the University of Virginia, the product of so many centuries of development in Western architecture since the time of Greece, were in fact erected on this continent not so many centuries after the time when Teotihuacán [Appreciation 22] was still in use as a sacred site [by Aztec kings]. . . . This is the curious syncopation that time wrought in the Americas.
—Vincent Scully, architectural historian, *Architecture,* 1991

15.23 JACQUES-LOUIS DAVID. *Self-Portrait.* 1794. Oil on canvas. 31⁹⁄₁₆ × 25 in. Musée du Louvre, Paris. *Compare David's middle-class fashion style—clothing, hairstyle, facial expression—with that of his aristocratic contemporaries (Appreciation 30) and predecessors (15.2). Can you see how each fashion statement and each visual image embodies a distinct worldview? See Appreciation 3 for an in-depth discussion of "The French Revolution in Fashion."*

spirit," as David put it. If history paintings of worthy men and women were brought before the masses, the artist asserted, "then will those marks of heroism and civic virtue offered the eyes of the people electrify its soul, and plant the seeds of glory and devotion to the fatherland." David made this statement in 1793 as the leading artist in the service of the French Revolution. Since David, perhaps only movie directors such as D. W. Griffith in *The Birth of a Nation* (7.22) and the great Russian film directors who immortalized their 1917 revolution have aspired to such ambitious social-artistic goals.

One of the highest goals of the liberal arts in the Western tradition had always been instruction in morality, and David took this goal to heart. As a branch of the liberal arts, history painting could put forward the progressive moral values of the day. David had been drawn to the teachings on art of Diderot and other French Enlightenment thinkers. The ideals to be pursued, especially in his history paintings, were central middle-class values: purposeful rationality and moral seriousness. Much rococo art, in contrast, projected courtly upper-class values such as sensuousness, grace, and playfulness. At first appealing to the young David for its visual and technical qualities, even the best rococo art soon came to seem

frivolous or decadent. The "Style of Louis XV" was not for a person committed to high-minded ideals. David must therefore have been pleased that the neoclassical style was increasingly taking hold throughout French culture. Even the new reigning monarchs—King Louis XVI, who came to the throne in 1774, and his queen, Marie Antoinette **(Appreciation 30)**—had shown support for the rising style, with its emphasis on history painting, moral betterment, and a pictorial approach of noble simplicity and calm grandeur.

Classical Revival and Enlightenment Values

In the middle of the eighteenth century, interest in classical art and Greek and Roman culture was stimulated by major archaeological excavations in Rome and in the southern Italian towns of Pompeii and Herculaneum. (Numerous Italian artists devoted themselves to capturing these ancient monuments in paintings (10.22) that young European aristocrats eagerly purchased and took home as mementos of their "grand tour" of the continent's cultural highlights.) Pompeii and Herculaneum had long been buried beneath the ancient eruptions of Mount Vesuvius. The impressive architecture and artworks that were excavated from the earth fired imaginations, sparking interest beyond the archaeological and antiquarian. In men committed to political change such as Diderot and David, the classical revival motivated passionate thoughts of a new society that might match the greatness of ancient Rome or Greece. David's growing embrace of the classical revival, in combination with the progressive values of the French Enlightenment, ultimately led him to take up a classicist style of painting. His principal goal was moral instruction, and he chose morally uplifting subjects from the ancient world for this purpose. Two key Enlightenment precepts of Diderot served him well: to think and act like an ancient Greek Spartan (heroically, selflessly, stoically) and to value most that art which is socially useful, morally instructive, and ethically elevating.

The Oath of the Horatii

David's *Oath of the Horatii* **(15.24)** was painted five years before the French Revolution, but it seems to prophesy it. Even without our knowing the specific

15.24 JACQUES-LOUIS DAVID. *The Oath of the Horatii*. 1784–85. Oil on canvas. 10 ft. 10 in. × 14 ft. Musée du Louvre, Paris.

story depicted in the painting, it stirs feelings of duty, sacrifice, and moral earnestness in us. An older man holds up three swords before three young soldiers in ancient Roman battle dress. The women respond to the situation with a sense of tragic expectation. The men's expressions are of the utmost seriousness. Their eyes are fixed upon the swords, fierce symbols of the bloody mission they are about to undertake. They are swearing to fight for a noble cause and, if necessary, die for it.

All the formal elements in this very large painting, approximately 11 feet high by 14 feet long, work to express these feelings and thoughts. The composition turns to the classically simple and emphatic one-point perspective of the Renaissance, with the crossed swords occupying the visual and psychological center of the design. Something of the pyramidal arrangement and one-point perspective system seen in Leonardo's *Last Supper* (2.18) and Raphael's *School of Athens* (14.23) is used here to dramatic effect, but in a more

rigorously simplified, concentrated way. The story is told with a vivid economy of means. The outstretched arms and parallel poses of the three men communicate human solidarity: "All for one and one for all." The young men will give their lives rather than fail.

Responding to the danger their men will soon face, two of the women swoon, while a third shields two small children in fearsome anticipation. David's men are dominant forces, powerful in body and stern and selfless in mind. They keep their feelings under tight control. The women, in their secondary, reactive roles, are emotional; their gestures convey their anguish and fear. To express their mental state, David has given them softer poses, transforming their bodies into wilting curves. The colors of the clothing they wear are muted, weakened in strength to reflect their physical and mental condition. In virile contrast, the men are clothed in stronger reds, whites, and blues. Their gestures are bold and straight-lined, their postures angular and erect.

Then, will those marks of heroism and civic virtue offered the eyes of the people electrify its soul, and plant the seeds of glory and devotion to the fatherland.
—Jacques-Louis David, artist, 1793

15.25 PIETRO ANTONIO MARTINI. *At the Salon of 1785.* Engraving. Print Collection, Miriam and Ira D. Wallach Division of Art, Prints and Photographs, The New York Public Library, Astor and Lenox and Tilden Foundations.

The way David draws, paints, and arranges his figures reinforces the effectiveness of the storytelling. The three classical architectural niches that frame the background neatly divide the three groups. The balance is symmetrical. All is clear, ordered, and unequivocal, like the unfolding action itself. No moral blurs, shadowy doubts, or mixed meanings intrude upon this tragic drama. The crisp precision of the drawing, especially in the finely cut outlines and contours of the figures, reinforces the clarity of story and composition. It is as if David has sculpted the figures rather than painted them.

The story of *The Oath of the Horatii* centers on the actions of the three Roman brothers. The threesome is set to battle three brothers from the neighboring city of Alba for the purpose of settling a political dispute. Commanded by their father, they are ready to give their lives for the honor of family and city. And they do. The Albans are defeated, but only one brother returns alive. Rome has triumphed over its foe. But the bloody tale is not yet over. In a fit of what today seems stoic and patriotic excess,

the one returning brother, with the ultimate approval of his father, kills his own sister. The reason: She had mourned the death of one of the Alban brothers, a young man to whom she was betrothed. Patriotic pride and duty to one's country, the painting harshly instructs, take precedence over all human bonds, even familial ones.

But our experience of *The Oath of the Horatii* cannot end here. A bit more contextual understanding will substantially broaden and deepen our appreciation. Probably proposed and certainly approved by Louis XVI's minister for the arts, the painting was commissioned for the Crown as one of several pictures whose express purpose was to improve public morality. David completed and first exhibited *The Oath of the Horatii* to huge public success in Rome in 1784 before transporting it to France and enjoying equal public success at the Salon of 1785 **(15.25).** All applauded it, especially the more antiestablishment literary figures. The painting rapidly became a favorite of liberal and radical writers, from Antoine-Joseph Gorsas to Jean-Paul Marat. Gorsas, for his part,

INTERACTION BOX

TAKING A FEMINIST ART HISTORICAL APPROACH

Feminist art historians are concerned with researching women's art and writing about women artists, topics long neglected in the field of art history. (As recently as 1970, certain major art appreciation and art history textbooks did not include a single work of art by a woman.) Feminist art historians are also concerned with the portrayal of women in artworks executed by men, especially in terms of representations of women that might stereotype, distort, or exploit. They believe that gender-specific differences in biology, upbringing, and social roles lead female and male artists to experience the world differently and consequently to represent it differently. Frima Fox Hofrichter argues that Judith Leyster's *The Proposition* (Appreciation 29) takes a very different position on the tradi-

tional subject of sexual propositioning from that of her male counterparts. Male artists had consistently pictured their women subjects as sinful temptresses (15.11), whereas Leyster represents her female subject as innocent and the man as the tempter.

Here's your challenge. Look at those artworks in this chapter (or others) in which women and men are represented together. Taking a feminist position, explore the respective roles and power relationships of the women and the men. (The contrast between the social roles of the men and women in David's *The Oath of the Horatii* (15.24) is particulary apparent.) Do you think these artworks accurately reflect gender relationships in that time and place? Do you think the social roles depicted empower or restrict each sex? How does each particular artwork reinforce or critique these roles? Argue your points.

praised it for "its truly dramatic emotion, nobility of form, appropriateness of style, purity of intention, and finally enthusiasm so fitting for returning the grand genre [that is, history painting] to its true purpose in the French school of painting." Gorsas defended the painting from those conservative critics, friends of the Academy and the Crown, who in their qualified praise pointed out *The Oath of the Horatii*'s "mistakes" or "faults."

The radical implications of David's powerful painting were quickly felt. Partisans lined up increasingly for and against David, and critical discussion escalated into fierce debate. Much of this debate was carried out along progressive versus conservative cultural-political lines, giving evidence that much more than one painting was at stake. The qualities of *The Oath of the Horatii*, along with David's subsequent paintings and anti-Academy statements and actions, had somehow meshed with broader antiestablishment attitudes: antimonarchy, anticonservative, anti–status quo. In David and his art, the liberal and radical writers and their publics had discovered their visual artist. In the content and especially in the form of his paintings they found their aspirations

represented. David ultimately associated himself with the radical Jacobin party, serving the French Revolution as its first painter and director of public art education, in which capacity he presided over propaganda, public festivals, and a reformed Academy.

History Painting for the New Social Order
During three tumultuous decades, from *The Oath of the Horatii*, painted in 1784 for the Crown, to his heroic paintings for the Revolution, such as *The Death of Marat* of 1793, to his works created as first painter to Emperor Napoleon, David raised the fine art of history painting to a state of unrivaled public importance and politico-cultural influence. To be sure, earlier artists had seen their fine art used prominently in the service of church and state. Their painting, sculpture, and architecture had served to affirm religions and glorify monarchs. The primary difference between David and these artists of the past was that he created not for the old order, but for the new one. His art operated as powerful propaganda for liberal reformers and radical revolutionaries, men and women whose ideals became the building blocks of the modern world.

Marie Antoinette and Her Children *by Elisabeth Vigée-Lebrun*

WENDY SLATKIN

Elisabeth Vigée-Lebrun (1755–1842) was among the most talented and successful aristocratic portrait painters of the late eighteenth and early nineteenth centuries. As official portraitist for the Queen of France, Marie Antoinette, she achieved one of the highest positions in her society. After the French Revolution, as she traveled around Europe, she continued to experience a series of international triumphs. Her output was prodigious: she produced about 800 paintings during her lifetime. Like [early-eighteenth-century Italian portraitist Rosalba] Carriera [15.14], to whom she was frequently compared by her contemporaries, Vigée-Lebrun had the capacity both to reflect and to formulate the esthetic tastes of her aristocratic clientele.

The daughter of a pastel portrait painter, Vigée-Lebrun recalled in her memoirs that her father and his colleagues gave her instruction and encouraged her talents. She also studied the paintings in the Louvre [15.1], especially Rubens's Marie de Medici cycle [14.41]. In this active, supportive environment, her talents developed precociously. When she was twenty, she commanded higher prices for her portraits than any of her contemporaries.

In 1778, Vigée-Lebrun was summoned to court to paint her first portrait of Marie Antoinette. Thus began a relationship that would dominate the career and reputation of the artist. An ardent royalist until her death at the age of 87, Vigée-Lebrun was called upon to create the official image of the queen. The painting that best exemplifies Vigée-Lebrun's role as

Wendy Slatkin is an art historian and the author of Women Artists in History *(Prentice-Hall, 1990), from which this essay is taken.*

political propagandist is the monumental and complex *Marie Antoinette and Her Children* **(Fig. A)**. This work was commissioned directly from the funds of the state to defuse the violent attacks on the queen's moral character then circulating in France. It was painted only two years before the cataclysm of the French Revolution, the imprisonment of the royal family, and their subsequent execution. This official image was designed as an aggressive, if ultimately ineffective, counterattack to the political opponents of the monarchy. Vigée-Lebrun placed the queen in the imposing and easily recognizable setting of the Salon de la Paix at Versailles. The famous Hall of Mirrors is visible on the left side of the painting. The royal crown sits on top of the cabinet on the right, the ultimate symbol of the power and authority of the kings. The figure of the queen herself dominates the composition. Her features have been enobled and beautified, while the enormous hat and full, voluminous skirts create an impression of superhuman monumentality. Her luxuriant costume, the immense blue velvet robe and hat convey . . . the grandeur of the French monarchy [Appreciation 6]. Vigée-Lebrun wanted her painting to express not only the sanctity of divine right monarchy but also the bourgeois, Enlightenment concept of "Maternal Love." The triangular composition is derived from High Renaissance images of the Madonna and Child by Leonardo and Raphael. . . . Marie Antoinette displays her children as her jewels. The Dauphin stands on the right, slightly apart from the group, as is only appropriate for the future king of France (although events were to alter the dynastic succession). The eldest daughter gazes up at the queen with filial adolescent adoration. The empty cradle to which the young Dauphin points originally contained the queen's fourth child, an infant girl, who died two months before the painting was to be exhibited at the Salon opening. On that day, August 25, 1787,

470

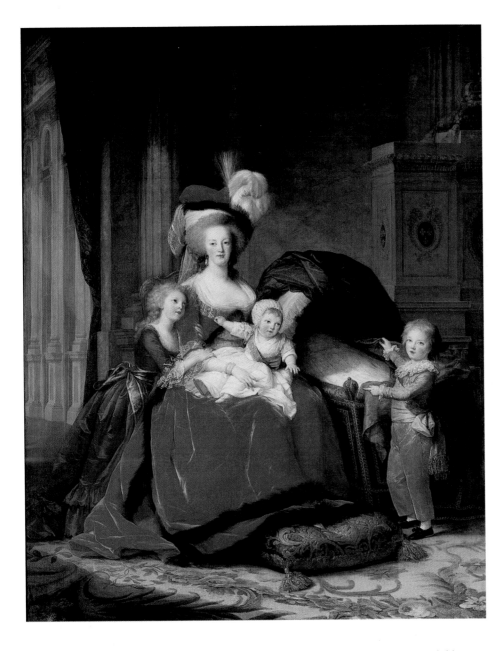

Figure A MARIE-LOUISE-ELISABETH VIGEÉ-LEBRUN. *Marie Antoinette and Her Children.* 1788. Oil on canvas. 8 ft. 10¾ in. × 6 ft. 4¾ in. Musée National du Château de Versailles, France.

antimonarchist feelings were running so high that Vigée-Lebrun refused to display the painting for fear that it might be damaged.

. . . Her close association with the queen made it dangerous for Vigée-Lebrun to remain in France after the imprisonment of the royal family. In 1789 she travelled first to Italy, then Vienna, eventually arriving in St. Petersburg, Russia. There, no political revolution had dis-persed the aristocratic clientele upon whom she depended for commissions.

. . . While the portrait of *Marie Antoinette and Her Children* found a sympathetic audience during the restoration of the Bourbons [French monarchy] at the Salon of 1817, its creator never regained the preeminent position she had held before Marie Antoinette was guillotined. ▪

15.26 Spoon with squirrel carved on handle. Seneca Iroquois, Tonawanda, N.Y., mid-nineteenth century. Wood. Lewis Henry Morgan Collection. New York State Museum, Albany. Catalogue no. 36818. Photo: Greg Troup. *Do distinctions between "high art" and "minor art" make any sense? Admittedly, an oil painting is very different from a spoon used for eating. When are such distinctions useful? When are they damaging?*

IN THE SHADOW OF THE FINE ARTS: THE "MINOR ARTS"

As fine art and the fine artist rose higher in status in Western society, the cultural value of the crafts and applied (functional and practical) arts fell. Accordingly, these arts came to be known as the "minor" or "lesser" arts, a status reflected in the fact that the crafts and applied arts received little emphasis in art museums and art history books until quite recently. In the New World, the creative production of Americans of European extraction (9.7, 9.8), Native Americans, and African Americans of the seventeenth through early nineteenth centuries (the period we have covered in this chapter) was rarely found in art museums or art history surveys because of its craft-based nature and utilitarian function. The discussion that follows joins many other recent attempts to expand the art historical story to include these previously neglected art forms and the cultures that produced them.

Native American Arts

When, in the seventeenth century, Rembrandt in Holland and Rigaud in France were creating their portraits of burghers (15.9) and kings (15.2), the tribes of the Iroquois confederacy (based in New York State) and their rivals, the Hurons and the Algonquins (based in eastern

Canada), were creating ceremonial masks, implements, and weapons of maximum utility and aesthetic quality. We do not know the names of those who made these masks or practical implements—they were not celebrated, individualist artists in the sense of Rembrandt or Rigaud—but their work was essential to their societies, and they were respected for their creations. An Iroquois spoon **(15.26)** displays an aesthetic of streamlined abstract beauty. The forms are simple and direct and employ long, subtle curves. Spoons like this one might serve ceremonial functions, but they were used primarily for everyday eating and food preparation. The back of the handle was shaped to fit over the edge of a bowl or kettle, preventing the spoon from slipping in. The squirrel at the crest of the handle might have been a personal favorite or a clan emblem. Its upright position projects a sense of dignity, which the owner of such an impressive object would likely hope to convey. After being carved, the spoon was boiled in an infusion of hemlock bark or roots to produce its rich dark color.

In the 1780s, when Houdon was sculpting his *George Washington* (15.19) and David was painting his *Oath of the Horatii* (15.24), Native Americans of the Pacific Northwest, scattered in villages along the western coast of Canada, were experiencing their first contacts with British explorers and traders. These native peoples of the northwestern Canadian coast—the Haida, Nootka, Tlingits, and many others—were highly skilled in the art of woodcarving. Contemporary sculptor Bill Reid (Appreciation 3) writes eloquently of the woodcarving art of his Pacific Northwest ancestors, describing its origins and its central place in their lives.

> With a few bits of sharpened stone and antler, with some beaver teeth and a lot of time, with later on a bit of iron, you can build from the cedar tree the exterior trappings of one of the

15.27 EDWARD S. CURTIS. *Masked dancers, Qaagyul* (*the North American Indian,* vol. 10). 1915. Photogravure, brown ink. 12¹⁄₁₆ × 16¾ in. Courtesy of Northwestern University Library.

world's great cultures. Above all, you can build totem poles **[15.27]**, and the people of the Northwest Coast built them in profusion: forests of sculpted columns between their houses and the sea, proudly announcing to all the heraldic past of those who dwelt there. . . .[4]

Like heraldic crests, these poles told of the mythological beginnings of the great families, at a time before time, when animals and mythic beasts and men lived as equals, and all that was to be was established by the play of raven and eagle, bear and wolf, frog and beaver, thunderbird and whale. The poles were many things. The house pole told of the lineage of the chief who presided within. The memorial pole commemorated some great event. The grave pole contained the body and displayed the crest of a leading noble. . . .[5]

These monuments were the work of master carvers and apprentices who brought to final perfection an art style whose origins lay deep in the past and partly in Asia [the people's original home]. It was an austere, sophisticated art. Its prevailing mood was classical control, yet it characterized even the simplest objects of daily life.[6]

African-American Arts

While Jefferson was at work designing his major buildings, between 1770 and 1817, the black slaves on his and other plantations were weaving and dyeing cloth, quilting and embroidering, making pottery, designing musical instruments, fashioning tools, and constructing houses. Their art embodied creativity and aesthetic excellence and often showed either subtle or overt African influence. A Virginia slave drum **(15.28)**, for example, made during the late seventeenth or early eighteenth century, shows clear African influence. According to John Michael Vlach, the cedar drum's form, size, and markings exactly match those of a specific type of drum used by the African Ashanti people and must certainly have been made by an Akan/Ashanti person from or descended from the area of West Africa today known as Ghana.

In the late seventeenth and early eighteenth centuries, Vlach notes, the black population of North America had a strong African focus. As recent arrivals on American soil, they practiced an art and craft strongly shaped by memories of their African cultures. By the second half of the eighteenth century—the period of Washington and Jefferson—a more mixed, intercultural "African-American" quality had begun to characterize the arts and culture of the slaves. By this time, several generations of blacks had been born on American soil and were influenced by Euro-American ways.

15.28 Slave drum. Virginia. Late seventeenth–early eighteenth century. Cedar and deerskin. Photo courtesy National Museum of American History.

By the late eighteenth and early nineteenth centuries, most African-American quilts, made for the mistresses of the great houses or for the slaves themselves, showed distinctly European or American influence in their techniques and patterns, but African influence can still be detected. According to Gladys-Marie Fry, the slaves' preference for the color red in both their quilts and their clothing was linked to traditional West African color symbolism. Red was identified with life and fertility. It was associated with blood, symbolic of the birth process and of the male roles of warrior and hunter. A crib quilt **(15.29)** created in the period from 1840 to 1860 was made in an original pattern that shows strong African influence. Fry writes:

> [T]he three motifs on the quilt—coffins, crosses, and suns—suggest that the quilt was made as a memorial for a dead child or as an amulet to ensure renewed health for a sick child. Red and white are also the colors of Shango, a religious cult that originated in Nigeria and spread to the New World. The crosses and suns on this quilt are symbols directly related to the Bakongo [people] of [West] Africa.[7]

The quilts of slave women and of other anonymous women quilters (Appreciation 17) are eloquent historical records literally stitched from the soul.

Hispanic Arts

At the same time the Spanish painter Velázquez was creating his seventeenth-century portrait of the royal family of Philip IV (5.18), a heterogeneous "Hispanic" culture with European, American, and African roots was forming in the Spanish territories of the Americas. In the Hispanic culture of "New Spain," Native Americans of diverse cultural backgrounds—Inca, Aztec, Mayan, and hundreds more—served as the principal artists and craftspersons for their Spanish overlords. Even

15.29 Crib quilt. 1840–60. Collection of Gladys-Marie Fry, College Park, Maryland.

when they were commissioned to follow European patterns and styles, their native genius shone through (Appreciation 28). Forced by the Spaniards to renounce their old dress styles, native peoples managed to adapt and retain something essential of their heritage. The handwoven Mexican sarape **(15.30)** is an example. Before the Spanish conquest of Mexico, native men, scantily clad by European standards, wore flowing capes of varying lengths (called *tilmas* in Aztec) tied in front or over the right shoulder. Their subsequent invention, the sarape, covered more of the body but also turned out to be a more versatile garment. Worn by men and boys only, sarapes served, and still serve, for adornment, as overcoats, as wedding cloaks, and as funeral shrouds. The same sarape might be used for a cover at night, as a spread for displaying marketplace wares, and as a cover stretched over poles to provide shelter in the open. Large sarapes are the size and shape of an ordinary blanket and are generally made of wool, usually of two pieces sewn together in the middle with wool of the same color masking the seam. An opening for the head in the center is called the *bocamanga*, a term that also refers to the diamond-shaped design around the opening. Sarapes continue to be woven in all parts of Mexico today. They are generally created on upright looms (a Spanish contribution) by men of Indian or "mestizo" (mixed) Indian-European background. The sarapes are different everywhere, reflecting diverse ethnic traditions and the style of the individual master weaver.

In the Andean region of "post-conquest" South America (the century or so after the mid-sixteenth-century conquest of the Inca empire by the Spanish conquistador Pizarro and his followers), native silversmiths were in high demand. A silver basin **(15.31)** exemplifies the high craftsmanship and creativity of this period. Four circular medallions interrupt the procession of human beings and animals impressively embossed on the broad rim. Designed in the Spanish silversmith ("plateresque") tradition, the four round medallions show two men and two women who seem to have been copied from contemporary European prints. Between the medallions, however, the subject matter and style turn distinctly Native American—specifically, Incan. A scene on

15.30 Esteban and Enzo Nieto wearing sarapes and flanked by hanging sarapes. 2002. Photo: Patrick Horst.

the left half of the detail **(15.32),** for example, shows a llama, an animal native to the area, kneeling with its load. An Indian man, wearing a headband, seems to urge the llama forward while a woman, also in Indian dress, bends to help the animal rise. Behind her lie articles for the journey—a gourd, a jug, and a typically Incan ceramic double vessel. Other scenes also show Inca clothing and articles. Only an Indian dweller of those regions, scholar Pal Kelemen concludes, could have rendered with such accuracy the native costumes and poses depicted in the various scenes. The overall style, he adds, is reminiscent of the pre-Columbian art of the silversmith.

15.31 Colonial silver bowl, Peru. 1586.
Reformierte Gemeinde, Siegen.

15.32 Colonial silver bowl, Peru. Detail.

Art historian Kelemen relates the amazing (and disturbing) story of how this silver bowl traveled as a valued gift from South America to Africa to Europe. The bowl's travels reveal much about the slave trade by which the Spanish and Portuguese ruling class exchanged goods for African slaves to work in their mines and plantations in South America. A wealthy Catholic bishop from South America secured his slaves through a powerful African king, a ruler of present-day Angola, whose warriors captured men and women from weaker inland tribes. The captives were brought to the bishop's commercial representatives at a European trading port on the African coast, where they were exchanged for goods and gifts, including the silver bowl. Packed into the innards of European vessels, the slaves were transported, in brutal fashion, to South America. In 1643, the African king presented the silver basin to the European governor of the nearby trading port. This gift-giving process, from bishop to king to governor, reflected the favorable and favor-seeking relations among these high-level participants in the slave trade. The governor of the port, a Protestant, added his coat of arms to the center of the plate and later presented the basin to a Protestant church in Germany, where it served as a baptismal font over the centuries. Thus did the much-traveled vessel, Incan and Spanish Catholic in origin, become a revered work of German Protestant religious art.

The more one studies art, the greater the appreciation of how interwoven and "mestizo" much of art is or becomes over time. Fine art and applied art, and the art of subject peoples and that of their rulers, continually interact and evolve in dynamic, multilayered combinations.

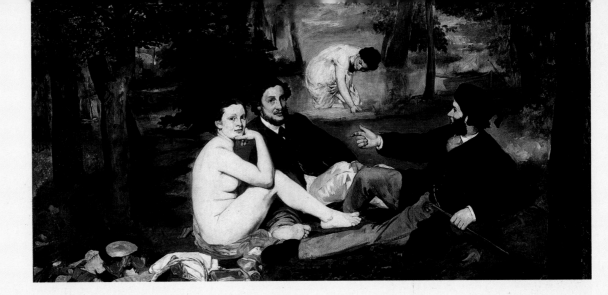

Art in the Nineteenth Century

16

ROMANTICISM TO POSTIMPRESSIONISM

In the seven decades between 1776 when Americans declared their independence from Great Britain and 1848, when almost fifty revolutions erupted throughout Europe, the modern world was born. It was a world born of radical change in every area of life. Revolutionaries in North America and France sought political freedoms, democratic governance, and property rights. Spain began its bloody struggle for national liberation from Napoleon's occupying French forces, Greece rose up against the Ottoman Turks, and the various Italian states rebelled against their Austrian rulers in pursuit of independence and ultimate nationhood. The art of the period reflected the revolutionary times.

INTO THE MODERN ERA

The birth of the modern period included the Industrial Revolution, which led to one of the most complete transformations of human and social relationships in history. The Industrial Revolution, together with the accompanying political revolutions, catapulted middle-class capitalists and politicians to power over the landed gentry and hereditary aristocracy in what historians have termed "the triumph of the bourgeoisie." An urban, industrial world of cities and factory towns (16.1) arose to surpass in importance

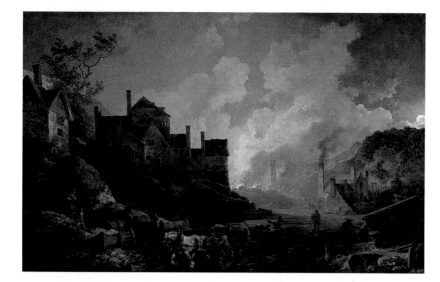

16.1 PHILLIPPE JACQUES DE LOUTHERBOURG. *Coalbrookdale by Night.* 1801. Oil on canvas. 26¾ × 42 in. The Science Museum, London/Science & Society Picture Library. *For the first generation of factory workers, the new technocratic mode of production (fragmented, impersonal, mechanical) was horrific. Consider how later artists like Monet (9.17), Bourke-White (7.41), and Smith (7.42) have represented industry. How do these depictions compare with De Loutherbourg's Coalbrookdale?*

the agricultural, rural world that had preceded it. The Industrial Revolution required an urban working class, which soon organized itself into a militant force fighting the owners of industry for better living and working conditions and higher pay. A technocratic approach, based on the values of science, capitalism, and bureaucracy, came to dominate society and the working world.

Amid all of these changes, yet another major transition was taking place. A static corporate world governed by legally constituted groups—fixed social classes, powerful professional and crafts guilds, hereditary orders, tradition-bound communities—was giving way to a world of freely moving individuals. Propelled by the emphases of the rising democratic and capitalistic systems on individual rights and self-interest, the centuries-old social fabric of Western society was unraveling. In the new, more fluid social order, the class, occupation, and life-style of individuals could change over the course of a lifetime. A new world was emerging whose primary shapers were democracy and capitalism, industrialism, science, and urbanism. Freedom and individualism were its rallying cries.

In this revolutionary sociocultural context, **romanticism,** the first certifiably modern art movement, was born. Like all revolutions, the so-called romantic rebellion both built on and reacted against the world that produced it. It grew from earlier art movements and schools,

but it infused these with unprecedented doses of freedom, individuality, and originality. It maintained ties with the past while striving idealistically to usher in a brave new future.

ROMANTICISM

As an artistic direction that emerged at the end of the eighteenth and the beginning of the nineteenth centuries, romanticism was a hybrid, initially incorporating elements of earlier styles: baroque, rococo, neoclassicism, naturalism. Although romantic art was of mixed parentage, it soon developed into a unique offspring. Romantic art at its foundations was characterized by a more intense expression of the artist's individuality—his or her personal feeling, thought, imagination—than any previous artistic movement. According to the contemporary German philosopher Georg Wilhelm Friedrich Hegel (1770–1831), the ruling principle in society and art was fast becoming "free subjectivity," the unlimited right of each person to make personal development and interest the key motive of his or her activity. Consider an early-nineteenth-century portrait of a young romantic painter **(16.2).** If any one quality impresses us, it is the subject's self-absorption. He is lost in his own thoughts and feelings. The outer world fades away like the nebulous background on which the young man hangs his palette. The viewer feels in this dreamy bohemian a mixture of sensitivity and world-weariness that might be overcome only by exceptional effort. Rightly called "the archetypal image of the romantic artist," the youth is compelled to take on the role of the great-souled person, the genius, the individual who expresses personal thoughts and feelings and makes his or her own rules. The individualistic spirit witnessed in the stylistic innovations of certain artists of previous centuries was fully unleashed by groundbreaking romantic artists such as Goya and Géricault.

Romantic Rebels: Goya, Géricault, and Delacroix

Goya The first five decades of Francisco Goya's long life were spent in a steady climb toward social and economic success as well as

critical acclaim. The son of an artisan father and a mother descended from minor nobility, Goya lived from 1746 to 1828, making him an almost exact contemporary of the French neo-classical painter David, whose grand-scale history paintings (15.24) anticipated and later served the French Revolution and the subsequent reign of Napoleon Bonaparte. But whereas David from quite early in his career went hard against the grain, denouncing both the monarchy and the Royal Art Academy, Goya began his career by sticking to the status quo. For the first forty years of his life, Goya sought success through the Spanish Academy and through commissions awarded by the royal court of Spain. Like the vast majority of his fellow artists, he desired the patronage of the upper classes. He made his way to the top, gaining appointment as court painter to Charles IV in 1799.

As a painter of high society, Goya was a huge success, but we probably would not recognize him as one of history's greatest artists had not two traumatic events redirected his life. The first was the permanent loss of his hearing after a life-threatening illness in 1792. This trauma seems to have transformed Goya, making him bolder and more willing to take risks. An unflinching realism increasingly came to characterize his portraits of the aristocracy. Even his group portrait of the Spanish royal family in 1800 abstained from the customary idealization. At the same time, Goya began to unleash a surreal imagination in self-expressive drawings and etchings. This direction, a prelude to modern expressionism and surrealism, is evident in Goya's print series *Los Caprichos*, or "The Caprices," first seen in public in the final year of the eighteenth century. (A caprice is a flight of the imagination.) *The Sleep of Reason Produces Monsters* (**16.3**, 6.5) and its accompanying text criticize a folly-ridden Spanish society for having abandoned the rational principles of the eighteenth-century European Enlightenment. Goya writes, "Imagination abandoned by reason produces impossible monsters; united with her, she is the mother of the arts and the sources of their wonders." (Note the art tools of brush and pencil and the sheets of paper under the arms of the sleeping man.) Nightmarish monsters beset the slumbering figure, who is symbolic of

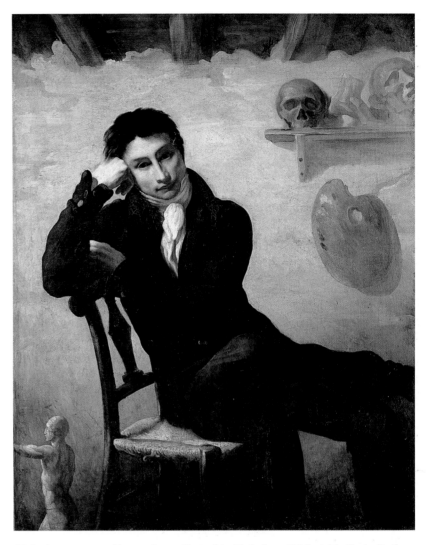

16.2 Anonymous (formerly attributed to Théodore Géricault). *Portrait of an Artist in His Studio*. 1818. Oil on canvas. 4 ft. 9⅛ in. × 3 ft. 8⅛ in. Musée du Louvre, Paris. *Compare this image of the romantic artist to Parmigianino's image of the mannerist artist (14.28) and Raphael's image of Michelangelo as the melancholic artist (14.24). How are they similar? How are they different?*

Spain, the individual Spaniard, and Goya himself. The romantic imagination must be harnessed to reason if it is to produce wonders and not disasters.

The second traumatic event that shook Goya's life was the occupation of Spain by the forces of Napoleon in 1808. The occupation would bring further follies and horrors. Many Spanish intellectuals, Goya included, initially had much sympathy with Napoleon's general program, which promised a shift toward the liberal Enlightenment values that the French

16.3 FRANCISCO GOYA. *The Sleep of Reason Produces Monsters.* 1799. Etching and aquatint. 8⅜ × 5⅞ in. Museum of Fine Arts, Boston. Gift of Mr. and Mrs. S. Stern, Mr. and Mrs. Bernard Shapiro, and the M. and M. Karolik Fund.

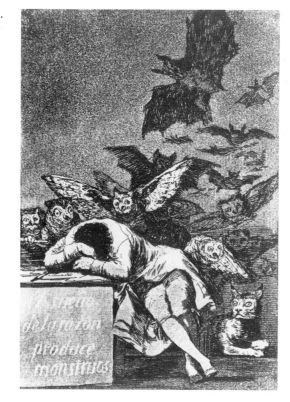

and American Revolutions had tried to put into effect. Spanish intellectuals were more than ready to do away with the corrupt, reactionary monarchy that had censored or imprisoned those who stood for reform. But, instead of bringing reform, the occupation of their country by Napoleon's armies led to disaster. Inspired by patriotic nationalism, the citizens of Madrid revolted against their foreign rulers. In response to the revolt, on May 3, 1808, French firing squads executed scores of Madrid's citizens. Six years later, Goya portrayed the event with chilling realism **(16.4).** Reason has disappeared altogether, to be replaced by the forces of death and destruction. The modern military machine lines up the motley resisters and mows them down. The mighty gesture of David's Roman Horatii (15.24), unified and heroic, has here gone astray. The three Horatii have turned into a French firing squad, faceless troops simply following orders. Only the hopeless Spaniards, about to die, respond with individualized expressions of bewilderment and fright. With

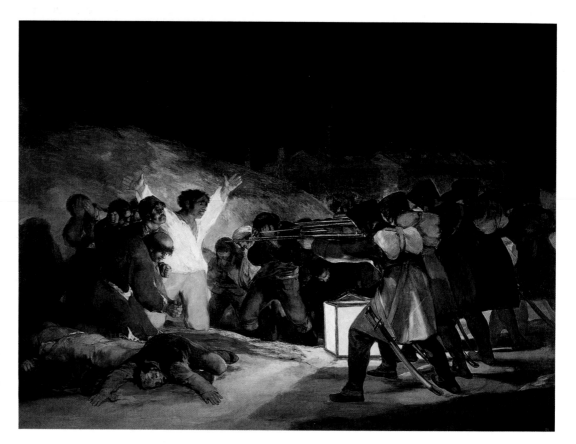

16.4 FRANCISCO GOYA. *The Third of May, 1808.* 1814–15. Oil on canvas. 8 ft. 9 in. × 13 ft. 4 in. Museo del Prado, Madrid.

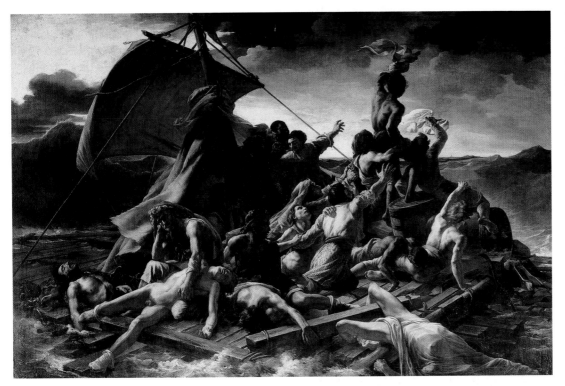

16.5 THÉODORE GÉRI-CAULT. *The Raft of the Medusa.* 1818–19. Oil on canvas. 16 ft. 1⅜ in. × 23 ft. 9 in. Musée du Louvre, Paris.

arms spread outward and upward, face and body ablaze with light, the principal figure is like a dying Christ. Intense clashes of light and dark and vigorous brushwork, most evident in the blood-spattered foreground, heighten the thematic conflict. The distortion of reason by a monstrous reality, the theme of Goya's prophetic print from fifteen years before, has wrought the most horrifying of nightmares.

Géricault Like Goya, Théodore Géricault (1791–1824) was committed to portraying life's victims, those victimized by injustice and by physical and psychological affliction. His subjects included the torn and tattered street people of the British underclass and mentally disturbed persons confined in French asylums, subject matter frowned upon by conservative government censors and the state-sponsored art academies. Yet Géricault didn't care about pleasing the establishment. He was a new type of artist, a rebel who pursued an independent and original vision, whatever the cost. Financial support from his affluent bourgeois family made independence all the more possible. Géricault did not have to starve in order to maintain his artistic freedom, nor did he have to seek commissions or hold an outside job.

Bourgeois wealth made it much easier for Géricault, as well as other well-to-do nineteenth-century innovators, to pursue an independent, personally chosen course. The artists themselves, not a particular patron or the academies, in most cases determined the subject matter and style of an artwork.

Perhaps with David's history painting *The Oath of the Horatii* (15.24) in mind, Géricault chose a stirring subject for the painting he hoped would make his public reputation. (Recall that the art academies and experts across Europe valued the "history painting" of a notable subject from mythology, religion, or human history as the highest category of painting, far above still lifes, landscapes, genre, and even portraits of dignitaries.) Like David, Géricault sought his major triumph at the government-sponsored Paris Salon (15.25), the most prestigious art exhibition in the world. And, like the work of the history-painting master he so admired, the historically based work **(16.5)** he submitted had strong political and moral overtones. Its subject was the controversial shipwreck of *The Medusa.* A government vessel captained by an incompetent aristocratic official appointed by the restored Bourbon monarchy, the ship had sunk off the western coast of

He [Géricault] painted directly on the white canvas, without a rough sketch or preparation of any sort, except for a firmly traced contour. . . . I noted also with what intense attention he examined the model before touching the brush to canvas, seeming to advance slowly, when in reality he executed very rapidly, putting one touch after another in its place, rarely having to go over his work twice.
—Antoine Alphonse Montfort, painter, observations on Géricault at work on *The Raft of the Medusa,* 1818–19

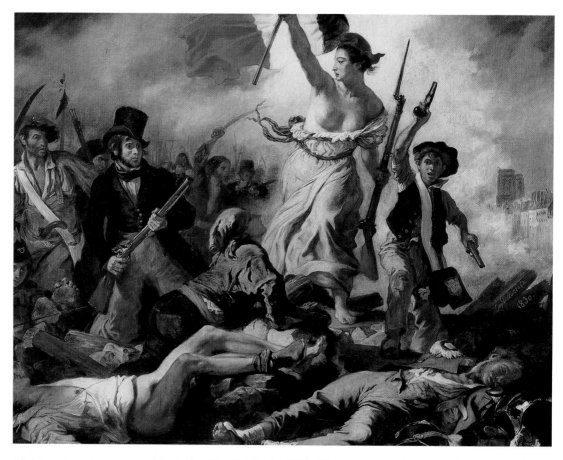

16.6 EUGÈNE DELACROIX. *Liberty Leading the People.* 1830. Oil on canvas. 8 ft. 6 in. × 10 ft. 10 in. Musée du Louvre, Paris. *The famous Statue of Liberty in New York harbor was a gift of France to the United States. Compare and contrast these two allegorical figures of liberty in terms of their visual form and symbolism.*

There is no picture in the Salon in which colour is so sunk in as in the July Revolution of Delacroix. But just this absence of varnish and sheen, with the powder-smoke and dust which covers the figures as with a grey cobweb, and the sun-dried hue which seems to be thirsting for a drop of water, all gives to the picture a truth, a reality, an originality in which we find the real physiognomy of the days of July.
—Heinrich Heine, poet and art critic, review of the Salon of 1831 and Delacroix's *Liberty Leading the People*

Africa in 1816. Provisions for the passengers' safety seem to have been minimal. One hundred forty-nine passengers were assigned to a hastily assembled raft that was to be towed by the ship's lifeboats. Shortly thereafter, the ropes between the vessels broke—or were purposely cut—and the raft drifted off. The result for those on the raft was devastation. Tortured by hunger and thirst and fighting among themselves, only fifteen passengers survived, many near death when rescued. The disaster inflamed the liberal opposition, of which Géricault was part, against the conservative monarchy. In the spirit of protest, Géricault first created a series of drawings to accompany a pamphlet, written by two of the survivors, that accused the government of criminal negligence. The artist then committed himself heart and mind to illustrating the disaster for all the world to see by creating a modern history painting of a contemporary tragedy.

In his personal life, Géricault was impetuous and given to a freewheeling, even violent life-style. He loved to ride the wildest horses and ultimately died at age thirty-three from a riding-induced injury. But in the creation of art Géricault was the most painstaking seeker of truth. In portraying the shipwreck, no artist could have been more methodically committed to the facts. Working like an investigative journalist, he interviewed the survivors of *The Medusa*. He studied dead and dying persons in hospitals. He had the ship's carpenter build a facsimile of the original raft and examined its response to rolling waves at sea. He observed the type of clouds that formed over the ocean. To Géricault's intense romantic sympathy with suffering, cruelty, and death was joined a rigorous commitment to scientific truth. The molding of feeling and fact by genius would bring forth a masterpiece.

In the spirit of high romantic drama, Géricault chose to portray the most impassioned moment, the one that combined the greatest anguish and hope. He also chose to work on a huge scale. Sixteen feet high by twenty-three feet wide, the "larger-than-life" dimensions of the painting amplify its emotional impact. On the horizon appears a tiny sail. Those survivors with remaining strength struggle

forward and upward. A crescendo builds, coursing through the dead and dying to those above, who surge toward their potential rescuers. Formally, we feel the stress of intersecting diagonals: The men, for example, surge one way, the mast another. We experience the upward thrust of the triangular formation of central figures, with the black sailor at the top waving his shirt, crying out for salvation. (As a subtext, the European emancipation movement to end slavery had begun, and the liberal Géricault was a supporter.) Stylistically, elements of Michelangelo (the writhing, powerful nude male bodies) (8.40), Caravaggio and Rembrandt (the dramatic light-dark contrasts) (14.42, 15.9), and Rubens (the propulsive energy and theatricality of the "baroque" composition) (14.41) can be found in *The Raft of the Medusa*. But most striking to Géricault's contemporaries was the emotional and empirical truth of the painting. So convincing was the work that most viewers overlooked its defiance of the traditional subject matter of history painting. An ignoble contemporary event had become the subject of a type of painting previously reserved for the noblest and most elevated subjects. No gods, saints, emperors, or Horatii are pictured here, only the nameless, brutalized survivors of a disaster. History painting was on its way to being democratized, with its subject matter opened up to a fuller range of human experience.

Delacroix Empathizing with the suffering, the cruelly treated, and those battling for liberty, many of the romantics were drawn to the various national movements for freedom and independence. Eugène Delacroix (1798–1863), France's romantic painter par excellence, created a stirring anthem for his own nation in *Liberty Leading the People* **(16.6).** The painting eulogizes the successful uprising of middle- and working-class French citizens against a repressive, reactionary monarchy in the Revolution of 1830. Dominated by the patriotic French "tricolors" of red, white, and blue, the work revolves around the allegorical figure of Liberty, "this strong woman with powerful breasts, rough voice, and robust charm," as a contemporary ode described her. Hand upraised with the French flag waving, a towering Liberty strides forward at the crest of a compositional triangle whose horizontal base is formed

16.7 HENRI FANTIN-LATOUR. *Homage to Delacroix.* 1864. (Seated: Fantin-Latour, Coatless; Baudelaire, far right. Standing: Whistler, left side of portrait; Manet, right side of portrait. Oil on canvas. 63½ × 98½ in. Musée d'Orsay, Paris.

by the dying defenders of the autocratic regime. In the distance the city of Paris watches. Closely tied to Liberty's cause, a prayerful working-class woman and a pistol-wielding street urchin complete the central triangle. Literally and symbolically, these poor and outcast are at the center of the revolution. Advancing from the left in staunch support are the liberal bourgeois intellectual in his top hat and a black "second-class" citizen from the colonies. They too thirst for liberty and are prepared to die in its cause.

No battle scene ever looked quite like this. Like Goya and Géricault before him, Delacroix has created a romantic, emotionally amplified image of reality. Universalized character types—the worker, the street urchin, the bourgeois—have been heroically posed in carefully choreographed groupings around an imaginary, allegorical figure. The result is an inspiring theatrical tableau, a stirring creation drawn from the imagination rather than a grisly scene recorded from the battle itself. So strong was the painting's impact on the larger public that the new government, which purchased the piece, soon removed it from public exhibition. Such a work, the officials feared, might foment yet more clamor for social change.

Delacroix's expressive subject matter, interactive color, energetic brushwork, and harmonious compositions combined to inspire many of the young lions of the coming generation. In Fantin-Latour's 1864 *Homage to Delacroix* **(16.7),** created a year after the master's death, we find the painters Whistler, Manet, and

If, to a composition that is already interesting by virtue of the choice of subject, you add an arrangement of lines that reinforce the impression, a chiaroscuro that arrests the imagination, and color that fits the character of the work . . . the result is harmony, with all its combinations, adapted to a single song. . . .
—Delacroix on his painting, ca. 1853

16.8 JEAN-AUGUSTE-DOMINIQUE INGRES. *Grande Odalisque*. 1814. Oil on canvas. 35¼ × 63¾ in. Musée du Louvre, Paris.

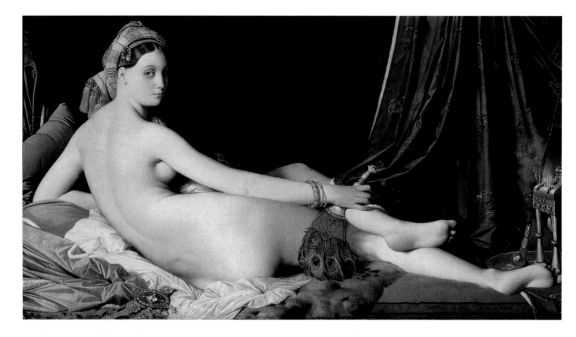

Fantin-Latour and the critic and poet Baudelaire grouped around a portrait of Delacroix. These groundbreaking artists, along with many others, appreciated Delacroix for his emphasis on form as well as subject. They also respected his artistic independence and originality, his great audacity in daring to be himself, and his commitment to developing an absolutely personal way of seeing and representing. Yet his was not the most favored art of the day. That honor was accorded to the major figure of French academic art, Ingres, and his neoclassical colleagues.

CLASSICAL ART

Ingres and the French Academy

While Delacroix's romanticism and individualism fired the minds of many of his younger artistic contemporaries, the more tradition-bound, classicizing art of Jean-Auguste-Dominique Ingres (1780–1867) and other academicians continued to dominate in the most prestigious art schools and public exhibitions. Taking his inspiration from the "grand manner" tradition of earlier masters such as Raphael (14.23), Poussin (15.6), and his own teacher, David (15.24), Ingres stood against the romantic rebellion as the nineteenth century's

protector of classical idealism. Classical line and intellect, he firmly maintained, should forever reign over romantic color and emotion.

For Ingres, those who admired his arch-enemy Delacroix or the "romantic" colorists of earlier times, such as the seventeenth-century Flemish painter Rubens (14.41), were outright enemies of art and society. To a fervent classicist like Ingres, the battle between classicism and romanticism was a life-and-death struggle for the very soul of the French nation. Classicism embodied discipline and morality, while romanticism stood for an amoral slackening of the rules and for subjective irrationality. For the committed classicist, art historian Walter Friedlaender writes, "line and linear abstraction embodied something moral, lawful, and universal, and every descent into the coloristic and irrational was a heresy and a moral aberration that had to be strenuously combatted." Because aesthetics and ethics were inseparable, anticlassical art was judged to be sinful and seditious. Seeing himself as the virtuous protector of classical line and moral order, Ingres fulminated that the violent subjects and colorful, boldly brushed style of his individualistic rival Delacroix were the work of the devil himself. "It smells of brimstone," he said. Whereas Delacroix takes an Arab courtesan and shows his subject in a supine state of sexual abandon, Ingres transforms his courtesans

He alone represents in our time the high traditions of history painting, of the ideal, and of style. . . . It is to Monsieur Ingres' honor that he carried the torch which Antiquity passed to the Renaissance, and that he did not allow it to be extinguished by the many mouths that blew on it. . . .—Theophile Gautier, poet and art critic, *The Fine Arts in Europe*, 1855

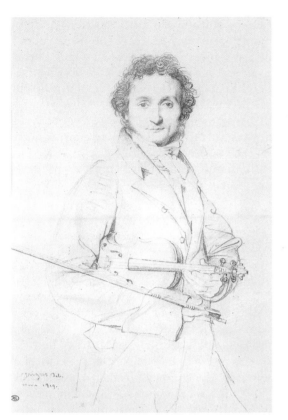

16.9 JEAN-AUGUSTE-DOMINIQUE INGRES. *Portrait of Nicolo Paganini.* 1819. Graphite Pencil. 11¾ × 8⅝ in. Musée du Louvre, Paris.

16.10 EUGÈNE DELACROIX. *Paganini.* 1831. Oil on cardboard on wood panel. 17⅝ × 11⅞ in. The Phillips Collection, Washington, D.C.

and bathers (7.29) into graceful beauties of cool, stylized perfection, their sexuality contained and their nudity idealized for the male gaze. The artist's elongation of his model's back in *Grande Odalisque* **(16.8)** to create a more pleasing line and shape is typical of his style. Their classical and romantic differences aside, Ingres's and Delacroix's portrayals of Arab or "Oriental" courtesans embody French male fantasies of a North African and Turkish world largely unknown but deemed highly exotic among many Europeans, the artists included.

The two artists' respective portraits of the renowned violinist Paganini likewise emphasize the enormous differences between their ways of seeing and representing. Like *Grande Odalisque*, Ingres's Paganini portrait **(16.9)** is characterized by clarity of line and shape, an appealing pose, and emotional restraint. It also beautifies the sitter and morally elevates him to fit Ingres's own classical ideal. A supposedly homely man with a very large nose, Paganini

is rendered remarkably handsome in Ingres's drawing. (The frontal pose and subtle shading diminish his long nose.) Morally, the violinist looks to be a paragon of virtue. With respect to form and subject, all is under control, ordered and balanced. The long tradition of classical idealism resonates in the sitter's dignified, formal pose. Clearly and confidently defined, Paganini shines like a nineteenth-century Greek god. Delacroix's romantic portrait **(16.10),** in contrast, is rough-hewn and heavily textured, a painterly rendering filled with motion and unrestrained emotion. Note how broadly and boldly Delacroix brushes the hands, face, and cravat of Paganini compared to Ingres's clear and detailed definition of the same features. The violinist is depicted in the passionate act of musical creation. Contemporaries considered Paganini to be a performer of almost supernatural ability, and Delacroix shows him in this vein: mysterious, spectral, emerging from the darkness, face and hands aglow in impastoed

16.11 BERTALL (Charles-Albert d'Arnoux). *Duel to the Death between Ingres and Delacroix.* Engraving from *Journal pour Rive.* Bibliothèque Nationale de France, Paris.

16.12 EDMONIA LEWIS. *Forever Free.* 1867. Marble. 40½ in. high. Howard University Gallery of Art, Washington, D.C.

hues of whitish yellow. In keeping with his romantic persona, Delacroix shows Paganini's hair as tousled, his body moving in a sensual S-curve. The overall look is one of flowing freedom: Lines meander and blur, and irregular shapes meld together.

Two different moral-aesthetic outlooks are indeed embodied in the two portraits that, for Ingres, could not peacefully coexist. A famous caricature of the day **(16.11)** brings the resultant "Duel to the Death" between the two schools to darkly comic life. Symbols of classicism and romanticism, respectively, Ingres and Delacroix joust in deadly combat. The battle takes place in front of the Institute of France, the parent body of the Academy of Fine Arts, which under Ingres's influence had denied Delacroix honorary admission for twenty years. Fittingly, Ingres's lance is a sharply pointed pencil, and his shield reads "Color is a utopia. Long live line!" Ingres rides into the fray from the right, symbolic of the conservative side. The words on his horse's skirt taunt "Rubens is a red" (that is, is a communist as well as a colorist!). Delacroix, in contrast, wields a paintbrush with a soft, malleable tip. Riding in from the left, Delacroix is associated with the forces of progress. His shield is a palette full of colors, and he displays the slogans "Line is a color" and "Only at night are all cats gray." The witty caption accompanying the caricature states "No hope of quarter being given, if Monsieur Ingres wins, color will be proscribed all down the line."

Classicism and American Art

Between 1835 and 1841, Ingres served as director of the French Academy in Rome, a city whose unmatched classical heritage influenced art and architecture across continents. In America, Jefferson's architecture for the University of Virginia (15.22) and the Virginia state capitol (15.21) and Houdon's statue of George Washington (15.19) for the Richmond capitol patriotically embody the neoclassical tradition. By the mid-nineteenth century, a handful of American sculptors had established themselves in Rome and Florence in order to partake of the classical tradition. In Italy these pioneering men and women could study the great sculptures of the past (14.9, 14.26, 14.40), obtain the finest

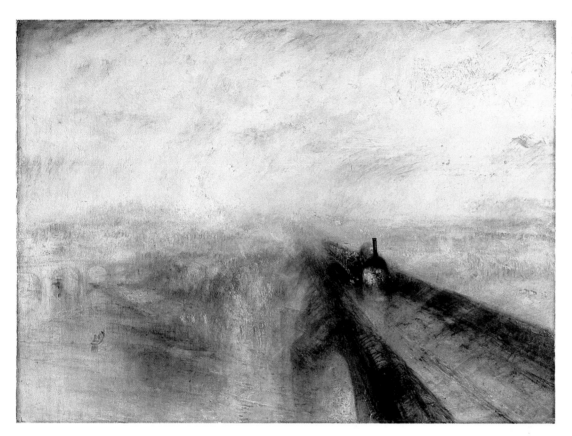

16.13 JOSEPH MALLORD WILLIAM TURNER. *Rain, Steam, and Speed.* 1844. Oil on canvas. 35⁷⁄₁₆ × 47½ in. The National Gallery, London.

white marble from nearby quarries, and engage skilled Italian artisans to assist them in the heavy, laborious work of carving. They could also learn from the finest teachers and gain a degree of critical success and international patronage unavailable to them in the United States.

Among these emigré artists was Edmonia Lewis (born 1843 or 1845), a young woman of mixed African-American and Chippewa heritage. Supported by liberal patrons in the United States, including the famous abolitionist William Lloyd Garrison, Lewis arrived in Rome in 1867 to pursue the life of a professional artist. She quickly succeeded in becoming the first internationally known artist of either African-American or Native American heritage. Embracing the classical manner of ancient Greek (12.18) and Roman (12.29) art and recent neoclassical sculpture (15.19), Lewis created works based on both traditional and modern subjects. She is famous for her portrayal of Hagar, the Egyptian mistress of the biblical Hebrew patriarch Abraham. In Hagar, the African-born heroine who, according to Hebrew Scripture, bore the Arab race, Lewis

found an ancestral spirit with whom she could identify. But she could identify more immediately with modern subjects related to her Native American and African-American background. Her 1867 marble sculpture *Forever Free* **(16.12)** shows a black woman in thankful prayer for the freedom her people have gained. In 1865, the bloody Civil War had ended, freeing millions of African-American slaves. Personified by the male figure, the Negro race—strong, beautiful, and free—breaks the bonds of slavery and rises to meet a new day. The clarity of form and composition, coupled with a dignified restraint of emotion in gesture and facial expression, creates feelings of calm grandeur and virtuous triumph.

ROMANTIC ART, ARCHITECTURE, AND DESIGN IN AN INDUSTRIAL AGE

The use of the railway as a subject of Turner's painting *Rain, Steam, and Speed* **(16.13)** bears witness to the fact that romanticism developed

Flashes of lightning, wings like great fire-birds, towering columns of cloud collapsing under the thunderbolts, rain whipped into vapour by the wind. You would have said it was the setting for the end of the world. Through all this writhed the engine, like the Beast of the Apocalypse, opening its red glass eyes in the shadow, and dragging after it, in a huge tail, its vertebrae of carriages.

—Theophile Gautier, poet and art critic, on Turner's *Rain, Steam, and Speed*, 1844

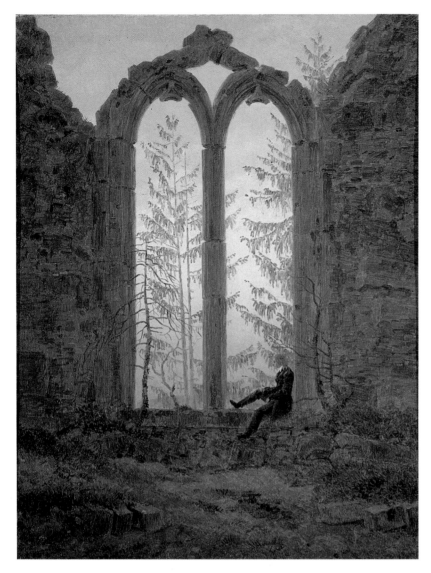

16.14 CASPAR DAVID FRIEDRICH. *The Dreamer (Cloister Ruin Oybin)*. After 1834 (?). Oil on panel. 10½ × 9 in. Hermitage Museum, St. Petersburg.

Close your eye, so that your picture will first appear before your mind's eye. Then bring to the light of day what you first saw in the inner darkness, and let it be reflected back into the minds of others.

—Caspar David Friedrich, artist, *Observations*, 1830

in an increasingly urban industrial world in which awesome feats of industrial engineering challenged both nature and traditional lifestyles. In Turner's painting we can discern several of these industrial achievements: a far-reaching span-design bridge and a powerful steam locomotive moving at seemingly breakneck speed (up to fifty miles per hour). Unseen but implied was a rapidly proliferating railway system that required immense tunnels through mountains and vast glass-covered, iron-ribbed train station sheds and stations (10.58). The great exhibition halls of the period, such as London's Crystal Palace (9.13), were also testaments to industrial production and design. Unrecognized as art in their own period, these buildings would serve as inspiring models for the functionalist "machine aesthetic" architecture and industrial design of the twentieth century.

Romantic Landscape Painting in Context

Compared to the clearly delineated, serene, orderly classical compositions of Lewis, Ingres, and Poussin, the Romantic landscape paintings of Englishman Joseph Mallord William Turner (1775–1851) must have seemed incomprehensible. For Ingres, a swirling Turner painting representing untamed nature—such as *Snowstorm, Avalanche, and Inundation, Steamer in a Snowstorm*, or *Rain, Steam, and Speed*— would have been aesthetic blasphemy and a moral threat.

In *Rain, Steam, and Speed* broad, bold brushwork and a torrent of gold, yellow, and white hues overwhelm the linear outline and obscure the shapes of bridge, train, and background landscape. To the classicist, Turner's image would have been an utter blur, an anarchic representation produced by muddled perceptions. Based on a personal experience of sticking his head out of a train window during a rainstorm, Turner's evocation of the distorting effects of rain, steam, and violent movement would, for the classicist, have been translated as the evil triumph of the confused senses over the ordering powers of the intellect, of irrational feelings over the rational mind. Yet for the romantically inclined the work would have been emotionally thrilling. A *London Times* review of the Royal Academy Exhibition noted the usual diversity of opinion with regard to Turner's work:

> The railways have furnished Turner with a new field for the exhibition of his eccentric style. His *Rain, Steam, and Speed* shows the Great Western in a very sudden perspective, and the dark atmosphere, the bright sparking fire of the engine, and the dusky smoke form a very striking combination. Whether Turner's pictures are dazzling unrealities, or whether they are realities seized upon a moment's glance, we leave his detractors and admirers to settle between them.[1]

This is certainly not a painting that the classical mind, with its love of order and balance, clarity and calm, would appreciate. For his admirers, however, Turner's passionate expression and earth-shaking imagery combine in the type of awe-inspiring experience that romantics like American painter Frederic Edwin Church venerated as "sublime." In their own

16.15 FREDERIC CHURCH and CALVERT VAUX. *Olana*. View of the exterior, showing tower. 1870–74. Hudson, New York.

vast continent, Americans found the sublime in mighty mountains, crashing waterfalls, and other natural wonders. Church's own close-up view of Niagara Falls (4.13) thrilled crowds with its powerfully churning waters and perilous perspective.

Architecture and Landscape Design for the Romantic Mind

Romantic artists preferred to portray exceptional, exotic, passionate, and inspiring subjects, whether from nature or from humanity. When they included buildings in their works, they chose ones that stimulated the senses and the imagination. In the paintings and drawings of Turner, his compatriot Constable, and the German romantic artist Caspar David Friedrich (1774–1840), for example, we find ruins of ancient structures, often Gothic **(16.14)**, upon which the viewer might meditate. Such meditations might soar from anguish to joy, recall times past, or ponder the cycle of life and death. Medieval castles and Gothic churches, rural cottages, and "Oriental" Middle Eastern and Asian architecture might be chosen for their respective association with poetic spirituality, naturalness and sensuousness, and mystery and fantasy. Actual nineteenth-century

architecture, in the romantic mode, was created from these diverse sources.

The romantic landscape painter Frederic Edwin Church (4.13), who had traveled extensively outside his native North America, designed his own house **(16.15)** in a quintessentially romantic way—idiosyncratically and individualistically—from a potpourri of Middle Eastern styles. Called Olana, meaning "Our Place on High" in Arabic, and built largely between 1870 and 1874, the Church residence and its surrounding lands resemble a romantic landscape painting come to life. Crowning a mountain palisade along the Hudson River in rural upstate New York, a view of romantic sublimity opens from the house: a 360-degree panorama of river, mountain ranges, and sky. The choice of the site fulfilled the need of the Romantic soul to rise above the commonplace. As Church wrote, "I think it better to reside on a mountain which overlooks the world than to be a mere creeping thing trying to see it as a mass of details." At the crest, the building uses decorative motifs and architectural features culled from a number of Middle Eastern sources, combined in a completely unique way by Church himself. A maze of color, detailed patterning, energetic movement, and dynamic asymmetry, the house

16.16 ANDREW JACKSON DOWNING. *Treatise on . . . Landscape Gardening.* New York, 1844, p. 54. Two drawings of gardens, one showing Graceful School, the other Picturesque School. *Examine the landscaping at your campus, around your house, and in a local park. What aesthetic philosophy (for example, picturesque or graceful, romantic or classical) underlies each landscape design?*

calls forth the romantic's love of motion and emotion, individuality and imagination.

The natural landscape surrounding the house was likewise cultivated to embody romantic values. Curving paths lead one on a kind of adventure from the main road below to the house perched far above. From the bottom entry point and along most of the journey, the residence is nowhere to be seen. A succession of surprises greets the traveler on the upward journey to Olana—a small lake, forests and meadowlands—all carefully planned and planted by Church. In the tradition of English picturesque landscape painting (4.5) and design, which originated in the previous century, no area looks human-made; rather, all areas retain the informal, varied, uncultivated (that is, "natural") look of nature itself. As one passes through these scenic lower lands, the house itself remains mysteriously invisible, appearing to full, dramatic impact only as one arrives at the very crest of the small mountain.

For many a romantic, the picturesque was something of a complement to the sublime, and at Olana the two find their respective places in the lower and upper sections of Church's landscape composition. In this regard, the famous American landscape architect and writer Andrew Jackson Downing (1815–1852) was a direct influence. Consider Downing's words, and two illustrations **(16.16)** from his well-known book *Treatise on . . . Landscape Gardening*, with respect to both Olana and the romantics' love of the natural and wild. Compared to the more classical landscape and

architectural design of what he calls "the Graceful School of Landscape Gardening," with its emphasis on clarity, smoothness, order, and neatness, "the Picturesque School" features typically romantic forms. Relative to ground, trees, thickets, glades, and paths, the picturesque school of landscape gardening favors "spirited irregularity," "intricacy and variety," and "somewhat wild and bold character." With respect to the element of water, for example, Church's man-made lake, "all the wildness of romantic spots in nature, is to be imitated or preserved. . . ." Finally, given that the house is an integral feature of the scene, Downing recommends that the architecture of the Picturesque School be "the Gothic mansion and old English cottage, or the Swiss, or some other bracketed form, with bold projection, deep shadows, and irregular outline."

Downing's description makes one realize that many a Victorian-style home built in the second half of the nineteenth century continued this tradition. Built in 1888, the Joshua Wilton House **(16.17)** in rural Virginia combines a profuse variety of forms with an inventive asymmetrical balance and a wealth of decorative detail: gingerbread trim, brackets, scrollwork, and leaded glass panels around the front door. The variety of line, shape, and texture keeps the eye moving nimbly and the imagination engaged. Then there are the characteristically Gothic elements: the conical turret; the sharply triangular gables; the central windows with their pointed arches; and the steeply angled roofs at their different

levels, a medley of tall, narrow shapes pointing skyward. A variant of what he called "the Gothic mansion," the Joshua Wilton House—and much of Victorian-period architecture (9.20)—would have struck Andrew Jackson Downing as romantically picturesque.

FROM ROMANTICISM TO NATURALISM

Romanticism encompassed a variety of orientations ranging from the picturesque and Sublime to the naturalistic.

The "Natural Painting" of Constable

English painter John Constable (1776–1837) thoroughly merged his romanticism with a scientific naturalism. His subjects and treatments of rural cottages and mills, country streams and waterways (7.3), and Gothic cathedrals and medieval ruins fit within the romantic love of the picturesque and nostalgic. His feeling of love and veneration for nature is also characteristic of the romantic landscape artists. Yet a distinction needs to be made. Constable was not a "high romantic" of peak emotional states or vivid imagination in the sense of Turner, Church, Goya, or Géricault. His romantic qualities are tempered by characteristics that link him, as a founding father, to the more objectivist, scientifically oriented "naturalist" movement that rose to prominence by the middle part of the nineteenth century. Perhaps "romantic-naturalist" is the best way to describe Constable's outlook and art.

Born a year after Turner, Constable would become a pioneer of early-nineteenth-century "natural" painting. Admittedly, *The Haywain* (literally, "the hay wagon") **(16.18),** Constable's most famous work, does not appear very ground-breaking today. It looks only mildly realistic to our twenty-first-century eyes, conditioned as we are to the extreme realism of the camera. But to art lovers of a prephotographic era, accustomed to intentionally beautified or stylized portrayals of nature, Constable's naturalism was jarring. To many of his fellow countrymen, his art appeared too plain and too blunt in its truthfulness. Critic John Ruskin found paintings like *The Haywain* "artless," that is, without charm or imagination. Ruskin

16.17 Joshua Wilton House, Harrisonburg, VA. 1888.

preferred the romantically sublime landscapes and seascapes of Turner (16.13), with their more passionate, imaginative portrayal of nature at its most untamed and dramatic.

Passions as profound as Turner's but far less tumultuous resonate in Constable's art. He may not have chosen violent storms, swiftly moving trains, mountain heights, or spectacular sunsets for his subjects. He may not have employed his contemporary's swirling brushwork or brilliant color in his treatment. His modest, down-to-earth temperament was incompatible with what he saw as high romantic "bravura" and "attempts to go beyond the truth." Yet a romantic emotion, quieter in tone, pulses in his sensitive renderings of gentle lowland scenes. "Painting," Constable wrote, "is but another word for feeling." To commonplace scenes he brought a profound sensuous love. Nature, straightforward and unadorned —in the actual color of trees and clouds, the texture of wood and stone, the motion of wind and water—offered more than enough to engage his artistic energies.

Constable's landscape paintings are animated by the mobile sunlight and rustling breezes present on the days on which he painted. In *The Haywain*, one senses that Constable actually felt and saw the rippling reflections on the water and the alternating patterns of light and shadow that color the fields. He knew those fleeting clouds, so particularized in their shape, value, and texture. It has been

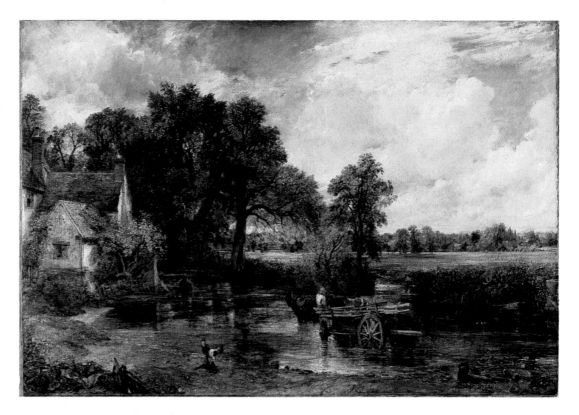

16.18 JOHN CONSTA-BLE. *The Haywain.* 1821. Oil on canvas. 50¾ × 72⁵⁄₁₆ in. The National Gallery, London.

. . . the sound of water escaping from milldams . . . willows, old rotten planks, slimy posts, and brickwork. Those scenes made me a painter and I am grateful.—Painter John Constable on his art, 1821

said that Constable went so far as to "bottle" clouds to study their true appearance. We know that he made hundreds of cloud studies, noting on the back of each picture the type of cloud, the month, the time of day, and sometimes even the direction of the wind. For this artist, landscape painting was the result of firsthand viewing and long study. When he entered his studio to elaborate a more "finished," academically polished painting from his full-size, out-of-doors oil sketch, both the freshness of the original impression and his years of careful observation served to keep his vision truthful.

The social context that gave rise to Constable's naturalistic landscape painting also saw the disappearance of large portions of the rural landscape. Factories, mines, railroads, and an expanding population would soon overrun the quiet, largely agricultural countryside. A centuries-old way of life centered on nature's rhythms would soon give way to the mechanical operations and accelerated pace of an urban, industrial society. Facing this disturbing prospect, Constable, the son of a wealthy rural miller, set out to paint—and thereby preserve —what he knew and loved best.

Although Constable's painting did not find immediate popular acceptance in England, it did receive a very warm welcome in France.

French society was just beginning to move toward an industrial and urban revolution of its own. Exhibited in the French national Salon of 1824, *The Haywain* was honored with a prestigious gold medal. More important, it influenced younger French romantic and naturalist artists alike. An admiring Delacroix was moved by its shimmering color, unifying light, and vibrant brushwork. Future French "open air" painters also appreciated these qualities as well as the rare combination of truth and feeling for nature found in Constable's art.

French "Open Air" Painting

In France, the naturalist landscape art movement coalesced between the 1830s and 1850s. A loosely knit group of painters in pursuit of the landscape of fact came together around the rural village of Barbizon on the edge of the Foutainebleau forest, southeast of Paris. Because they completed a substantial portion of their work out-of-doors, a totally new approach, they became known as *plein air* or "open-air" painters. Jean-Baptiste-Camille Corot (1796–1875), Théodore Rousseau (1812–1867), Charles Daubigny (1817–1878), and Jean-François Millet (1814–1875) were probably the foremost artists initially associated with *pleinairisme*, but many artists in the

16.19 CHARLES DAUBIGNY. *The Banks of the Oise.* 1859. Oil on canvas. 35⁷⁄₁₆ × 71½ in. Musée des Beaux-Arts, Bordeaux.

century's second half, including America's Winslow Homer (5.20, 6.8), embraced their general methods. The term *plein air* was applied to these artists not because they completed their entire painting out-of-doors. Few, if any, of them did. Rather, they earned their name because their concern with the momentary effects of nature, the play of light and changing atmospheric conditions, exceeded that of any previous landscape artists. They conveyed these fleeting, open-air sensations or "impressions" with a freer, sketchier, and more open and responsive brushwork than that used either by earlier landscape artists or by contemporary academic artists such as Ingres, whose laborious finishes and "touching up" required many hours in the studio away from the original motif. The development of small, portable tubes of oil paint in the first half of the nineteenth century greatly facilitated such direct, "on location" sketching and painting. Technological and cultural innovation marched hand in hand with *plein air* landscape art.

For the painter Daubigny to capture that one unique moment in time when the light and color were of a particular cast, he had to work rapidly, using broad, energetic strokes of paint. Adding to the painterly immediacy of the work, the color in pictures like *The Banks of the Oise* (16.19) was brighter and more scientifically truthful than that of any previous landscape painting, because Daubigny and his fellows executed a substantial amount of the work while painting in the light of the countryside.

16.20 GASPARD-FÉLIX TOURNACHON (Nadar). Satire on *Daubigny's Les bords de l'Oise*, which was exhibited in the Salon of 1859.

The resulting image, for many, captured an absolute truthfulness to nature. Poking fun at this capacity of naturalist artists to accurately reproduce nature, a caricature (16.20) pictures a swimmer about to dive into the waters of Daubigny's *The Banks of the Oise.*

The same desire to accurately record a dynamic, ever-changing reality through direct sensory perception that is at the heart of naturalism was realized most powerfully, and almost contemporaneously, by photography. The mid-century decades that saw the rapid rise of photography (7.4–7.14) and *plein air* painting pointed to a widespread cultural readiness for the naturalist way of seeing and representing. By the 1850s, naturalism—also called realism—was competing for prominence with the dominant classical and romantic schools. The case of Gustave Courbet highlights the struggle and ultimate success of this more empirically based art.

I do not know of anyone who has a more intimate feeling for nature, and who can better make it felt. But why does he only produce rough sketches. . . . Is M. Daubigny afraid of ruining his work by finishing it?
—French art critic on Daubigny's painting, 1852

REALISM AND THE PAINTING OF MODERN LIFE

The place is Paris. It is 1855, the year of the Universal Exposition, the French answer to England's Great Exhibition of 1851, the first world's fair (9.13). Ingres and Delacroix (16.11), identified with the rival movements of academic classicism and romanticism, respectively, are the two most widely acclaimed artists in France. In the Palace of Fine Arts at the Universal Exposition, they have the most space reserved for their works. Ingres shows over forty paintings, Delacroix thirty-five. Having had two of his major paintings, *The Burial at Ornans* and *The Painter's Studio*, rejected by the Exposition jury, an infuriated Gustave Courbet (1819–1877) takes these two works, along with eleven others accepted by the jury, and sets up his own "Pavilion of Realism" near the official Palace of Fine Arts. He has an exhibition space constructed and hangs a full fifty of his paintings in direct competition with the official international exhibition. The artist, assisted by a writer friend, then releases a "Realist Manifesto," aggressively asserting his views for all the world to read.

Courbet and Contemporary Subject Matter

Courbet's exhibit was, in effect, the first one-man show and the first official declaration of independence from the art establishment by a major artist. Courbet's defiance in the face of authority and tradition heralded the birth of the **avant-garde** (literally, "advanced guard"), those individuals or groups committed to the most advanced social, cultural, or artistic tendencies of the day. His rebellious thoughts, expressed in his Realist Manifesto, defined in bold terms the conception of the modern artist. Following in the footsteps of Géricault and Delacroix, self-taught artists whom he much admired, Courbet sought to develop his own artistic consciousness and approach, in short, to be his own man. Through his own self-conscious individuality, Courbet believed he would "be in a position to translate the customs, the ideas, the appearance of my epoch, according to my own estimation." Representing the "real and visible" world around him, according to his own interpretation, he aspired to be a "painter of modern life."

Committed to the revolutionary doctrines of socialism and democracy, Courbet infuriated supporters of the status quo with both his art and his attitudes. His painting *The Stone Breakers* **(16.21)**, innocent enough to twenty-first-century eyes, was denounced by most contemporary critics. The majority saw its subject matter as vulgar and degrading, its visual style as plain and unrefined. Their basic prejudice was that art should treat noble subjects and themes and that the artist's manner of execution should be pleasant and tasteful. If common persons or everyday scenes were to be treated, they should be beautified or sentimentalized. Because Courbet saw in a documentary way and represented life realistically, he was accused of being an apostle of ugliness, a degrader of art. He maintained, however, that his crime was simply that he portrayed objective truth. A well-known Daumier caricature **(16.22)** spoofs the unfolding battle between rough-hewn realists like Courbet, representatives of "the people," and the dominant academic classicists of Ingres's stripe, represented by a bespectacled warrior in stately classical pose, head thrown back, haughtily naked except for his Greco-Roman helmet and large palette-shield.

Courbet's passionate defenders—and they were a determined minority—commended his realism and his selection of "modern" subject matter. His supporters considered him an honest and heroic painter of modern life. One supporter wrote that in the eyes of the art establishment his "mistake [was] perhaps to show nature with too much reality." Courbet's friend the socialist philosopher Proudhon wrote of *The Stone Breakers*:

> That old man, kneeling, bent over his hard task, who breaks the stone by the side of the road with a long-handled hammer, certainly invites your compassion. His motionless face is heartbreakingly melancholy. His stiff arms rise and fall with the regularity of a lever. Here indeed is the mechanical or mechanized man, in the state of ruin . . . while that deplorable boy who carries the stones will never be acquainted with any of the joys of life; chained before his time to day labor, he is already falling apart; his shoulder is out of joint, his step is enfeebled, his trousers are falling down; uncaring poverty has made him lose the pride of appearance and the nimbleness of his eighteen years. Ground down in his adolescence, he will not live.[2]

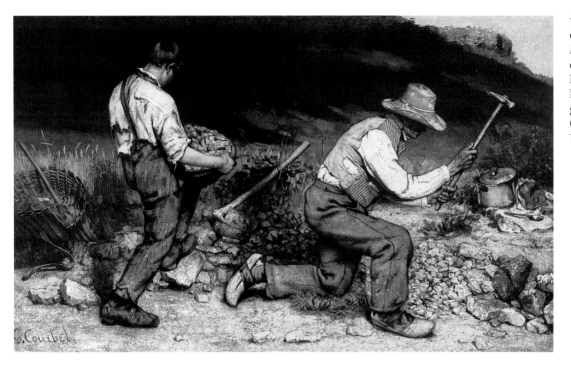

16.21 GUSTAVE COURBET. *The Stone Breakers*. 1849. Oil on canvas. Staatliche Kunstsammlungen Dresden. Gemälde-galerie Neue Meister. (Original destroyed in 1948.)

The Stone Breakers, Proudhon concluded, is "worth a parable from the bible"; it is "morality in action."

Boldly executed with broad, vigorous strokes that match the artist's personal temperament, the work exudes a power and physicality, a sensuous forcefulness. Extolling Courbet's handling of brush and palette knife, a supporter commended his "broad, easy, vigorous brushwork" that "envelops with a single stroke and gives form and movement at the same time." Another applauded the unaffected directness and amplitude of his execution. But the artist's formal style, his supporters asserted, was never to be valued as an end in itself. Its role was to support and harmonize with his chosen subject matter.

By mid-century, avant-garde defiance of the status quo was manifested in two decisive trends. The first was the opening up or "democratization" of subject matter; the second was the ascendance of the artwork's formal properties—color, light, brushwork, shape, space, composition—to a position of primary importance. Artists like Courbet and Géricault had been the shock troops of a whole new range of subject matter, bringing modern subjects, sometimes very disturbing, to the public eye. They devoted many feet of canvas to nameless stone breakers or shipwrecked sailors,

whereas before only a famous admiral or saint had been granted such space. A commercial horse fair, painted with vivid realism on an enormous scale **(Appreciation 31),** could be awarded honors once accorded only to painters of elevated history.

Manet: Modern Subjects and Style

The younger naturalist and realist artists, especially those soon to be dubbed "impressionists," were affected by both Courbet's manner of execution and his modern subject matter. But it was the painting of a man scarcely their senior who would influence them most. In the

16.22 HONORÉ DAUMIER. *Battle of the Schools—Classicism versus Realism.* Drawing from *Le Charivari*. 1855. Bibliothèque Nationale, Paris. *Daumier places the taller figure closer to us on the right and the shorter one further away on the left. What political symbolism is embodied in these compositional choices? See figure 16.11 for a caricature that uses a similar design to convey somewhat related political meanings.*

APPRECIATION 31 ROSA BONHEUR, *The Horse Fair*

ROBERT BERSSON

The artist Rosa Bonheur (1822–1899) and her large, enormously popular painting of 1853, *The Horse Fair* **(Fig. A),** are provocative subjects for contemporary scholars. Art historians, especially those of feminist commitment, find the most important issues of life and art embodied in Bonheur's biography and paintings.

Women artists from the sixteenth through the nineteenth centuries were compelled to enter fields such as animal, portrait, landscape, and still life painting because academic practice forbade them from studying the nude. Because history painting (15.24), the most esteemed of the academic categories, was based on the accurate representation of human beings, women found it difficult to enter this field. In such a sociocultural setting, it was natural that an aspiring young artist like Rosa Bonheur turned to landscape and animal painting.

To Bonheur's good fortune, the "lesser" artistic categories, those beneath history painting in prestige, were gaining in importance during the first part of the nineteenth century due to the rise of democratic and socialist values, the impact of contemporary romantic (16.18) and naturalist (16.19) landscape painting, and the subsequent revaluation of seventeenth-century naturalistic Dutch landscape art (15.7) and genre art (Appreciation 29). This larger shift in artistic ideology gave legitimacy to those subjects that women artists were already pursuing. Moreover, the newly dominant middle class, gaining in influence in the art world as elsewhere, tended to purchase paintings of everyday subjects for their homes rather than grandiose mythological or religious scenes. The moment was right for a talented woman animal painter like Bonheur to step onto the world stage. Her unique family background and personal sensibility paved the way for her artistic development and ultimate success.

Like most female artists who had achieved success in the previous centuries, Bonheur was born into an artist's family, receiving her initial training from her father. Her father was a painter, her mother had been his pupil, and all four children pursued artistic careers, each specializing in animal subjects. Following a thorough education in drawing and painting, Bonheur proved to be so excellent an artist that in 1849 she took over her father's post as director of a drawing school. Art historians Rozsika Parker and Griselda Pollock write that Rosa adopted her father's politics in addition to his position.

> [Raymond Bonheur] was a Utopian socialist of the school of Saint-Simon whose doctrines not only espoused equal rights for women but placed a special social responsibility upon the artist as part of the elite that would lead society to a new world. . . . Saint-Simonism thus provided Bonheur with a model of activity both as a woman and as an artist. Bonheur won considerable success as a professional artist—she was made a member of the coveted Legion of Honor. The award was given for her paintings, drawings and sculptures of animals, whose anatomy, unlike that of the human figure, she was able to study. She dissected carcasses in slaughterhouses and observed animals at work in the fields and in her own private menagerie.[3]

In art historical terms, Bonheur's work as an animal and landscape painter fit broadly within the development of naturalism and realism in French painting in the first half of the nineteenth century. Realist-naturalist artists such as Courbet (16.21) and Daubigny (16.19) might be considered her ideological and stylistic relatives, though Courbet's working-class stone breakers gave his work a radical political content absent from Bonheur's realistically portrayed beasts of burden.

But this is not to say that a work like *The Horse Fair* was without its revolutionary aspects. For one thing, *The Horse Fair* was

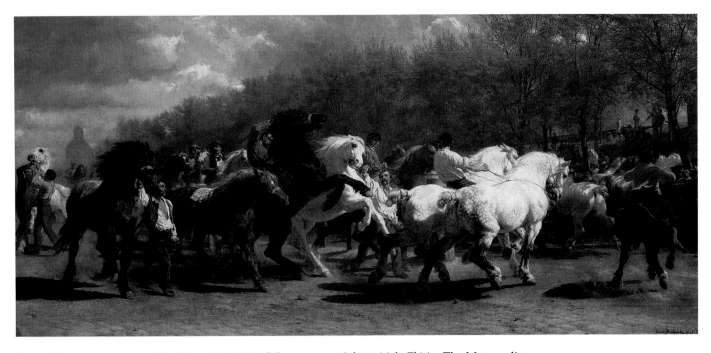

Figure A ROSA BONHEUR. *The Horse Fair.* 1853. Oil on canvas. 8 ft. × 16 ft. 7½ in. The Metropolitan Museum of Art, New York, Gift of Cornelius Vanderbilt, 1887 (87.25).

enormous, 8 feet in height and over 16 feet in width, the largest animal painting yet created. Here was a painting of work animals, a humble subject matter in a minor academic category, being presented on the same grand, heroic scale customarily reserved for prestigious history paintings of mythological or religious scenes. In addition, the horses themselves are the powerful, central characters; the human beings, their supposed masters, are but part of this dynamic world.

As a woman artist, Bonheur had to employ subterfuge in order to study and sketch the animals that were the subjects of the work. To visit Paris horse markets without harassment or danger, she was forced to disguise her gender. In order to sketch at the markets and slaughterhouses where she studied animal anatomy, Bonheur had to dress like a man, a complicated state of affairs that required legal permission from the authorities. Yet escaping

or transcending restrictive sexual boundaries was not entirely new to Bonheur. A wide-ranging maverick in her personal life, Bonheur often wore male clothing. At the same time, she made her deepest emotional commitments to women; for over forty years, her traveling and living companion was the artist Natalie Micas.

Although Bonheur's personal life was radical by bourgeois standards, her artworks were nonetheless loved by the bourgeoisie in both France and England and fetched the highest honors and prices. Bonheur was considered by the British to be the most famous woman artist of the nineteenth century and one of the greatest animal painters of all time. Both "natural" animal subjects and Bonheur's realistically detailed, accessible style appealed to middle-class audiences. Numerous prints based on *The Horse Fair* and other works were made and sold throughout the British Isles, France, and the United States. ■

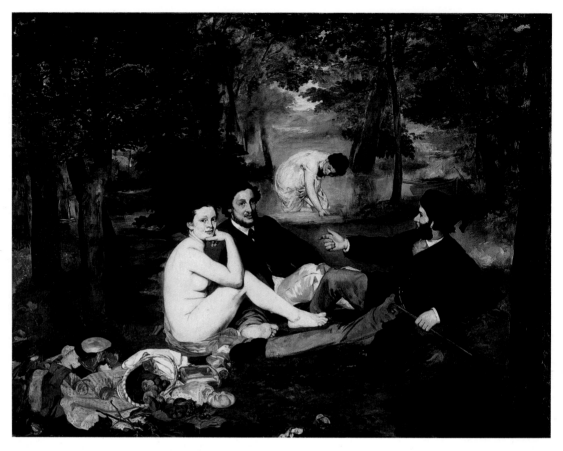

16.23 EDOUARD MANET. *Luncheon on the Grass.* 1863. Oil on canvas. 7 ft. × 8 ft. 10 in. Musée du Louvre, Paris. *Manet's nude model in* Luncheon on the Grass *and* Olympia *(16.27) is the same person, Victorine Meurent. The appearance, personality, and creativity of an artist's model can strongly impact the final work. How do you think Victorine Meurent might have influenced the final results in these two works?*

painting of Edouard Manet (1832–1883), the younger vanguard artists observed that the traditional relationship between form and subject matter had undergone a radical change. Form had begun to attain equal status with subject matter, at times seeming to become an independent concern, an end in itself. An aesthetic revolution was in the making, one to which they could give themselves wholeheartedly.

Controversial for both his subject matter and his manner of execution, Manet was hotly denounced by conservative critics for "the inconceivable vulgarity" of his subjects and "the absolute impotence" of his painterly style. Yet unlike the rebellious Courbet, who relished his role as a cultural and political outsider, the well-to-do Manet did not seek controversy or notoriety. Initially, he strove for acceptance from the French Academy and coveted prizes at the annual Salon. His friend Degas admitted that Manet constantly hoped "to become famous and earn money." Relative to these goals, Manet started off well. His *Spanish Guitar Player,* accepted by the Salon of 1861, was awarded an honorable mention by the jury. But works like *Luncheon on the Grass (Dejeuner sur l'herbe),* painted in 1863, quickly and unintentionally got him into trouble.

Although *Luncheon on the Grass* **(16.23)** was based upon earlier works of Renaissance art—as if Manet had tried to create a modern version of Raphael **(16.24)** and Giorgione **(16.25)** or Titian all in one work—the majority perceived the painting as an insult rather than an homage to tradition. Here was a woman, all too recognizable as a contemporary figure, sitting stark naked at a picnic with two men in modern middle-class dress. And if her brazen nakedness were not enough, the woman had the gall to stare at the viewer with a distinctly unfeminine boldness. It is true that, three centuries before, the Venetian Renaissance master Giorgione (or Titian) had placed two nude nymphs in a pastoral setting along with two clothed men playing musical instruments. But the two female figures were symbolic mythological figures, and *Fete Champêtre (Pastoral Concert)* was a poetic allegory, not a threatening, oddball translation of contemporary life.

Simply too modern and realistic for the public and too unconventional for the conservative jurors of the Salon of 1863, Manet's *Luncheon on the Grass* was relegated, along with other works rejected by the jury, to a *Salon des Refusés,* a special "Salon of the Rejected." So great was the outcry against the severe

decisions of the jury that year—three-fifths of the approximately five thousand paintings and sculptures had been rejected—that the government conceded alternative exhibition space in the Palace of Industry to the refused artists. Prominent critics unleashed their scorn on this "picture of the realist school," describing it as indecent, vulgar, and immoral. Emperor Napoleon III himself joined the critical chorus, pronouncing Manet's *Luncheon* "immodest." The emperor's preference at the Salon of 1863 was Alexandre Cabanel's *The Birth of Venus* **(16.26).** The Academy awarded the painting and artist the highest honors, and the emperor himself purchased the work. Considered not in the least indecent by the mainstream press and public, Cabanel's *The Birth of Venus* charmed all onlookers, according to one reviewer, because the subject is "cleverly rhythmical in pose, offers curves that are agreeable and in good taste, the bosom is young and alive, the hips have perfect roundness, the general line is revealed as harmonious and pure." How standards of decency and indecency have changed!

Coming to Manet's defense, the writer Émile Zola (1840–1902) directed viewers away from the unusual subject matter of *Luncheon,* urging them instead to consider its formal brilliance, which, he argued, was Manet's central concern.

> Painters, especially Manet who is an analytical painter, do not share this preoccupation with subject matter which frets the public above everything else; for them the subject is only a pretext for painting, but for the public it is all there is. So, undoubtedly, the nude woman in the *Dejeuner sur l'herbe* is only there to provide the artist with an opportunity to paint a bit of flesh. What should be noticed in this painting is not the picnic but the landscape as a whole, its strength and delicacy, the broad, solid foreground and the light, delicate distance, the firm flesh modeled in large areas of light, the supple and strong materials, and especially the delightful silhouette of the woman in her chemise in the background, a charming white spot in the midst of the green leaves. Finally the whole effect, full of atmosphere, this fragment of nature treated with a simplicity so exactly right, is all an admirable page upon which an artist has put the elements unique and peculiar to him.[4]

Like Courbet's defiant Pavilion of Realism the decade before, the *Salon des Refusés* of 1863 unleashed furious debate, this time on a far

16.24 MARCANTONIO RAIMONDI. *The Judgment of Paris,* detail. Ca. 1520. Engraving after Raphael. The Metropolitan Museum of Art, New York, Rogers Fund, 1919 (19.74.).

16.25 GIORGIONE or TITIAN. *Fete Champêtre (Pastoral Concert).* Ca. 1510. Oil on canvas. 43¼ × 54⅜ in. Musée du Louvre, Paris.

wider scale. Ideological battle lines were drawn: traditionalists versus modernists, those who looked to the honored past versus those who embraced the exciting present. The talk and ink flowed in torrents. The younger rebels of the avant-garde—Manet, Whistler (9.15), and other independents—had begun to rumble against the establishment. Their fight was for both exhibition space and cultural acceptance.

16.26 ALEXANDRE CABANEL. *The Birth of Venus.* 1865. Oil on canvas. 31½ × 53 in. Musée du Louvre, Paris.

Conciseness in art is a necessity and an elegance. . . . In a figure, always look for the greatest light and the greatest shadow; the rest will follow naturally.
—Edouard Manet, painter, on his art, ca. 1865

Manet's position in this debate was a curious one. Financially, as a gentleman-intellect of the upper middle class, he was in the enviable position of being able to paint what and how he wanted. Yet he longed for public approval almost as much as he valued his artistic independence. The denunciations hurled at his paintings sorely hurt him, but they did not discourage him. He determined to pursue his own course, at the same time hoping that both art experts and the public would come to appreciate and honor his work. With this goal in mind, in 1865 Manet presented his *Olympia* **(16.27)** to the art world. To his chagrin, the work prompted further blasts of ridicule. Like the earlier *Luncheon on the Grass, Olympia* was based on an esteemed work from the past, in this case, *Venus of Urbino* by Titian (**16.28,** 6.27), the grand master of the Venetian Renaissance. Once again, however, the artist's portrayal of his subject in accordance with particularly modernist sensibility—painting the appearances and manners of his time in his own idiosyncratic way—did him in. The critics charged that this "Olympia" was indecently naked and exhibited none of the elevating qualities of traditional love goddesses. Manet's modern *Olympia* was no coyly charming, sensually alluring beauty like Titian's *Venus of Urbino.* Nor was she a coolly exotic odalisque (16.8) in the refined classical style of Ingres. Nor was she a stylishly formed, erotic love goddess in the popularly and academically acclaimed manner of Cabanel (16.26). Rather, Manet's *Olympia,* a famous critic asserted, was a vile challenge hurled at the public. It was either mockery or

parody. "What is this odalisque with a yellow stomach, a base model picked up I know not where, who represents Olympia? Olympia?" he asked. "What Olympia? A courtesan no doubt. Manet," the critic concluded, "cannot be accused of idealizing the foolish virgins, he who makes them vulgar virgins." What seems to have deeply disturbed the critics was the artist's public portrayal of a successful prostitute in high heels receiving flowers from an admirer. The young woman looks down at the viewer with an unflinching directness, secure in her profession, her personal strength, and her independence (further symbolized by the black cat on the edge of the bed).

Responding to such insults, Zola once again came to his friend's defense. He argued that Manet's portrayal was not base but truthful, that here was a common girl of sixteen whom the artist "quietly copied just as she was."

> And everyone exclaimed that this nude body was indecent. That's as it should be since here in the flesh is a girl whom the artist has put on canvas in her youthful, slightly tarnished nakedness. When other artists correct nature by painting Venus, they lie. Manet asked himself why he should lie. Why not tell the truth? He has introduced us to Olympia, a girl of our own times, whom we have met in the streets pulling a thin shawl of faded wool over her narrow shoulders.[5]

Manet's truthfulness aside, the art establishment, in Zola's view, had once more missed the main point. What was most important about *Olympia* was not the character of its subject but the properties of its form, those abstract visual qualities that so wonderfully expressed the artist's particular temperament. What the painting was about was primarily color, with the white tones of Olympia, reclining on her sheets, contrasting with the black background.

> In this black background are the head of a Negress carrying a bouquet and the famous cat which has entertained the public so much. Thus at first glance you distinguish only two tones in the painting, two strong tones played off against each other. Moreover, details have disappeared. Look at the head of the young girl. The lips are two narrow pink lines, the eyes are reduced to a few black strokes. Now look closely at the bouquet. Some patches of pink,

blue, and green. Everything is simplified and if you wish to reconstruct reality you must step back a bit. . . . The painter worked as nature works, in simple masses and large areas of light, and his work has the somewhat rude and austere appearance of nature itself. In addition there is a personal quality . . . found in just that elegant austerity, that violence of transitions which I have pointed out. This is the personal accent, the particular savor of his work.[6]

For Manet and many of the finest figure painters of the modern period, formal concerns have been equally important as or more important than human concerns. The humanist tradition, extending from the Renaissance through the Enlightenment and honoring the human being in the work of art above all else, was no longer of primary import for artists such as Manet and critics such as Zola. By the 1860s, formalist notions such as "art for art's sake" were beginning to take root. The new doctrine emphasizing the abstract elements of the work and the equal treatment of all visual parts, with Manet as its prophet, inspired future generations. From the impressionists and postimpressionists of the late nineteenth century to the abstract artists of the twentieth, Manet's impact on the future development of modern art would be enormous.

The influence of Manet was especially great upon those younger artists who came to be lumped together as the **impressionists.** Young painters such as Claude Monet, Berthe Morisot, Pierre-Auguste Renoir, and their slightly older friend Edgar Degas admired Manet for his independent stance in the face of official denunciation, his commitment to modern subject matter, and his emphatic formalism (that is, his love of color, bold and lively brushwork, and equal treatment of all parts of the painting). These young artists also found inspiration in Courbet's realism (16.21), naturalist "open air" landscape painting (16.19), instantaneous photography (7.13, 7.14), and the colorful abstract style of Japanese prints (3.9, 4.12). But among all these formative influences, it was probably Manet's star that burned brightest. The young impressionists-to-be might meet with the embattled artist at his studio in Paris's Batignolles District or, on Thursday nights, at his favorite bar, the barnlike Café Guerbois. If they felt discouraged by their hard struggle, poverty, and lack of recognition, the

16.27 EDOUARD MANET. *Olympia.* 1865. Oil on canvas. 51 × 75 in. Musée d'Orsay, Paris. *Compare Manet's* Olympia *to Titian's* Venus of Urbino *(16.28) relative to each woman's location (higher up, lower down) in the picture, pose, the angle of the viewer's gaze, and the way each woman looks at the viewer. How do the differences affect the meaning of the work and your perception of each woman?*

16.28 TITIAN. *Venus of Urbino.* 1538. Oil on canvas. 25⅝ × 46⅞ in. Galleria degli Uffizi, Florence.

future impressionists might say "Let's go see Manet; he will stand up for us." They rallied themselves around Manet, talking art and raising their spirits. For reasons such as these, Fantin-Latour, the creator of the earlier *Homage to Delacroix* (16.7), honored Manet and his group with a comparable painting of homage. Titled *A Studio in the Batignolles Quarter* **(16.29),** the painting pictures Manet at work in

16.29 HENRI FANTIN-LATOUR. *A Studio in the Batignolles Quarter.* 1870. (From left to right: Scholderer, Manet, Renoir, Austruc, Zola, Maître, Bazille, Monet.) Oil on canvas. 68½ × 82 in. Musée d'Orsay, Paris.

Modernity is the transitory, the fugitive, the contingent. —Charles Baudelaire, poet and art critic, *The Painter of Modern Life,* 1863

his studio with his admirers and friends gathered around him. The date of the work is 1870. Standing behind Manet is Renoir, with his head framed by a picture on the wall; to Renoir's immediate left is the critic Zola, Manet's passionate advocate in the press. Monet stands on the far right, along with other artists and writers associated with realism and other progressive causes. (Because of an interpersonal squabble, Fantin-Latour did not include former group member Degas in the picture; because bourgeois propriety forbade women from attending such male gatherings, Berthe Morisot was also excluded.) From the group around Manet emerged a true avant-garde.

IMPRESSIONISM

The informal alliance of antiestablishment artists in the Café Guerbois group spawned something of an identifiable movement. With the paintings they submitted often rejected by the jury of the annual Salon, these young people resolved to put on their own "independent" shows. Between 1874 and 1886, they managed to stage eight such shows, with the first being held in the vacated studios of the pioneering photographer Nadar (7.9). These shows came to be known as the exhibitions of "the impressionists," a term inspired by the title of Monet's painting *Impression, Sunrise*

and thereafter applied as a slur to all exhibition participants.

Renoir and Monet: Capturing Fleeting Impressions

Of the young impressionist artists, no individual was more concerned with capturing the ever-changing face of nature (1.6) than Claude Monet (1840–1926), and no painter was better at capturing persons in action in outdoor settings than Pierre-Auguste Renoir (1841–1919). The two often worked together, painting the same village, city, or riverside scene. In the 1870s both men worked with a frenetic, on-the-spot intensity to seize the "fleeting impressions" that passed before their eyes. In the slice-of-life work *Monet Painting in His Garden at Argenteuil* **(16.30),** Renoir captures the artist at his easel in a brilliantly colored garden scene in the rural suburbs of Paris. Working in a similarly active way, with his own easel aimed at Monet, Renoir rapidly applied the oil paint in thick dabs and dashes of color that simulate the sunlit, multicolored scene at a particular moment in time. The writer Guy de Maupassant (1850–1893), while vacationing at the seashore in 1885, had the opportunity to observe Monet "hunting" for his impressions. De Maupassant wrote that Monet was followed by children who carried "five or six canvases representing the same subject at different times of day with different [atmospheric] effects."

> He took them up and put them aside in turn, following the change in the sky. And the painter, before his subject, lay in wait for the sun and shadows, capturing in a few brush strokes the ray that fell or the cloud that passed. . . . I have seen him thus seize a glittering shower of light on the white cliff and fix it in a flood of yellow tone that, strangely, rendered the surprising and fugitive effect of that unseizable and dazzling brilliance. On another occasion he took in his hands a downpour beating on the sea and dashed it on the canvas—and indeed it was the rain he had thus painted. . . .[7]

Not all of Monet's contemporaries viewed such impressions of nature with the same excitement as de Maupassant. To most critics and art lovers of the day, the paintings of the younger "impressionist" artists such as Monet, Renoir, and Morisot looked even more sketchy and unfinished than those of their naturalist

elders. For most viewers, the rapid-fire brush-work, divided patches of brilliant color, and blurred outlines of objects served to distort landscapes, seascapes, and cityscapes almost beyond recognition. One satiric reviewer quipped that the broadly brushed figures of people in Monet's 1873 cityscape *Boulevard des Capucines* **(16.31)** looked like "black tongue-lickings." The figures were simply unrecognizable. Quivering with indignation, the critic blasted Monet's "slap-dash" painting method as "unheard-of, appalling. . . . I'll get a stroke from it, for sure." Impressionist paintings were so upsetting, a caricature **(16.32)** quipped, that policemen had to prevent pregnant women from viewing them for fear of their inducing miscarriage. Other reviewers lambasted the young *plein air* painters for being everything from "criminals" and "communists" to malicious "enemies of beauty." It was joked that their method of painting consisted of loading a pistol with several tubes of paint and firing at a canvas, then finishing off the work with a signature.

Certain perceptive critics, however, appear to have understood the controversial way of seeing and representing from the beginning. Writing about the first impressionist group show in 1874, a number of reviewers commented on the intense concern of the younger *plein air* painters with capturing the fleeting effects of light and atmosphere on the color of objects and the consequent forgoing of careful modeling of three-dimensional form in favor of a painterly recording of an object and its coloristic "tone." Such painters, one critic noted, were concerned not with a detailed, objectively accurate representation of reality but with "a certain general aspect," an overall coloristic impression of a motif at one very particular moment of time. Impressionism became distinguishable from its parent, naturalism (16.18, 16.19), as truth to nature's actual appearance began to surrender to each artist's particular vision and unique way of representing.

Morisot and Cassatt: Women in the Vanguard

Among the painters who exhibited in the controversial shows of the impressionists were French woman Berthe Morisot (1841–1895) and Mary Cassatt (1845–1926), a wealthy

16.30 PIERRE-AUGUSTE RENOIR. *Monet Painting in His Garden at Argenteuil.* 1873. Oil on canvas. 18⅜ × 23½ in. The Wadsworth Atheneum, Hartford, CT. Bequest of Anne Parrish Titzell.

and independent-minded Pennsylvanian. The women's emancipation movement, just beginning in the nineteenth century, led women, especially those of the privileged classes, to begin to think about pursuing activities long dominated by men. But the barriers to such pursuits, including painting on a professional level, remained substantial if not insurmountable. The first barriers were erected at home. On hearing of her plans to study art in Paris, Cassatt's father is reported to have said "I would rather see you dead." Well-bred young women of the middle class were expected to be pleasing companions, courteous hostesses, faithful wives, and loving mothers, not independent, freewheeling, "homeless" artists. Morisot and Cassatt persisted in the face of familial and societal barriers and made their way to success in the avant-garde circles of late-nineteenth-century art.

Morisot, a painter of sensitive temperament, quickly earned the respect of Manet, her future brother-in-law, and the young artists of the Batignolles group: Monet, Renoir, Fantin-Latour, and Degas. As an exhibitor in the controversial impressionist group shows, she stood with her male colleagues from the embattled beginning, a brave commitment

. . . the two basic feelings which life in such an [urban] environment produces, the feeling of being alone and unobserved, on the one hand, and the impression of roaring traffic, incessant movement and constant variety, on the other, breed the impressionist outlook on life in which the most subtle moods are combined with the most rapid alternation of sensations.—Arnold Hauser, art historian, *A Social History of Art,* 1951

16.31 CLAUDE MONET. *Boulevard des Capucines.* 1873. Oil on canvas. 31¾ × 23¹³/₁₆ in. The Nelson-Atkins Museum of Art, Kansas City. Acquired through the Kenneth A. and Helen F. Spencer Foundation Acquisition Fund.

Policeman: "Lady, it would be unwise to enter!"

16.32 CHAM. Caricature of impressionist exhibition, published in *Le Charivari.* 1877.

16.33 BERTHE MORISOT. *The Cradle.* 1872. Oil on canvas. 18 × 21½ in. Musée d'Orsay, Paris.

indeed. Among her nine paintings in the first impressionist show in 1874 was the deftly painted *The Cradle* **(16.33).** The small picture depicts her sister Edma gazing tenderly at her newborn child. Art historian Wendy Slatkin writes:

> Formally, the image is a beautiful study in tonalities. . . . The translucent pearly-gray of the fabric covering the cradle is highlighted with a few touches of pink. The drapery covering the window is suffused with a blue hue indicating filtering daylight. The overall touch is quite painterly and the baby is indicated with the barest economy.[8]

Of such impressionist works by Morisot and her friends Renoir and Monet, a partisan critic of the period exclaimed: "Here is . . . much talent . . . and a way of understanding nature that is neither boring nor banal. It is lively, sharp, light; it is delightful. What a quick intelligence of the object and what amusing brushwork." Other admirers commented on the "fresh" and "graceful" quality of Morisot's work.

Most critics, however, were not supportive but hostile. Louis Leroy ranted about the lack of accurate drawing, detail, and finish in Morisot's pieces. "That young lady," Leroy sarcastically wrote, "is not interested in reproducing trifling details. When she has a hand to paint, she makes exactly as many brushstrokes lengthwise as there are fingers, and the business is done." To the discomfort of Morisot and her impressionist colleagues, harsh voices like that of Leroy initially were in the majority. Family members and friends, alarmed by the negative reviews, implored Morisot to break with "the so-called school of the future."

Morisot, however, continued painting, expanding the emotional range and subject matter of the impressionist group. The intimate scenes of family life and of women engaged in work or play by Morisot and Mary Cassatt, seen from the unique perspective of mother, aunt, sister, or friend, broadened and deepened the impressionist cultural landscape. Some of their representations of mothers and children are among the most humanly touching ever created, in spite of the growing emphasis of most impressionists on form over subject matter—"treating a subject in terms of the tone and not the subject itself," as one partisan put it.

Among the impressionists, Cassatt and her friend Degas perhaps struck the most equal balance between form and subject matter. Recall Degas's candid pastel portrayal of Cassatt trying on a hat (5.15) and his similarly informal "modern portrait" of Count Lepic and his young daughters (7.15). We can admire the color, line, and composition of works by Cassatt and Degas for their own sake while at the same time appreciating the inner life of their particular human subjects. Cassatt's *The Bath* (16.34) can be savored for its formal qualities: its bold use of flat color and design, reflecting the influence of Japanese prints (3.9, 4.12); its unusual tilted, "seen-from-above" perspective; its strong contours; and the rich decorative patterns in the rug, flowered wallpaper, painted chest, and striped dress. But *The Bath* must also be appreciated for the especially close human relationship it portrays between mother and child. In "close-up" depictions, which have been interpreted as reflecting the restricted social spaces of bourgeois femininity, a Cassatt mother and child hold and touch and glance as one. They are

16.34 MARY CASSATT. *The Bath.* 1891–92. Oil on canvas. 39½ × 26 in. © The Art Institute of Chicago, Robert A. Woller Fund, 1910.2. *The works of Cassatt and her friend Degas (5.15, 7.15) are both similar and different in form and subject matter. How might the divergent life-styles of women and men at the time have fostered some of the differences?*

never two separate beings but rather interconnect in a profound unity. Furthermore, they neither look out at nor are posed for the viewer outside the picture frame, the traditional way artists of the past had seen and represented the mother-and-child subject. We, the viewers, simply do not exist for them. The attention of mother and child is exclusively devoted to the other, promoting a feeling of maximum intimacy. Like the work of Morisot, Monet, and Renoir, Cassatt's paintings and pastels possess

16.35 VINCENT VAN GOGH. *The Starry Night.* 1889. Oil on canvas. 28¾ × 36½ in. The Museum of Modern Art, New York. Acquired through the Lillie P. Bliss Bequest. *The large cypress tree in the foreground is a traditional symbol of death. The church in the center, more Dutch in style than French, may also be symbolic. Do you think van Gogh had a moral or secondary meaning in mind when he painted this expressive work?*

an impressionist delicacy and charm, but they also express a very real female force: the vast power contained in the physical and spiritual bond between mother and child.

Within the larger context of the women's emancipation movement—which Cassatt, an outspoken political progressive, actively supported—the specific successes of artists such as Morisot and Cassatt were inspirational. Their public achievements helped bring increasing numbers of women to careers in painting and sculpture, especially in the independent circles of the avant-garde. And, although the fine arts were still very much a man's world, with women artists remaining in secondary positions in terms of leadership and public recognition, many women artists contributed significantly to the emergence of the avant-garde at the end of the nineteenth and beginning of the twentieth century.

POSTIMPRESSIONISM

Direct links connect the impressionists to the vanguard artists we now call **postimpressionists.** Three of the most influential postimpressionist artists, Vincent van Gogh (1853–1890), Paul Gauguin (1848–1903), and Paul Cézanne

(1839–1906), originally identified themselves with the impressionists; Gauguin and Cézanne exhibited in the group's shows. The influential painter Georges Seurat (1859–1891) likewise originated his own variant of postimpressionist art, called neoimpressionism (5.30), from impressionist roots. Their distinct approaches notwithstanding, each man's art was born of impressionism's formal breakthroughs, especially in the area of color.

Van Gogh and the Avant-garde Artist

In the first chapter of this book we saw how the emotionally expressive paintings of Vincent van Gogh's final years, works such as *The Night Café* (1.12) and *The Starry Night* **(16.35),** were born from the brilliant, liberated palette and bold brushwork of the impressionists. In *The Starry Night,* van Gogh energetically applies complementary contrasts of purple and yellow, orange and blue and their derivatives in swirling circular paths and coiling arabesques to express an ecstatic vision of a night sky above a small French town. The artist's intense feelings have burst the traditional bounds of naturalism, impressionism, and rationality to such an extent that Cézanne was led to comment that the Dutchman painted "like a madman." Beginning with nature's colors and shapes, van Gogh exaggerated or distorted for the sake of personal expression. Consequently, *Starry Night* rolls over us with the infinite power of the nocturnal cosmos, the primeval earth, and a human psyche on fire.

The paintings of van Gogh and the other postimpressionists also bear witness to the changing relationship between the avant-garde artist and society in the last quarter of the nineteenth century. Differences in temperament, artistic outlook, and life-style aside, van Gogh, Gauguin, and Cézanne shared a potent experience: that of estrangement from mainstream society. No longer an integrated member of society, as was the medieval artisan or court painter, the avant-garde artist of the late nineteenth century had become an outsider—if not an outcast. The great majority of people could not fathom artists and art that had become so individualistic and nontraditional. That van Gogh in his entire lifetime could sell but a single work, and that for a pittance, is the

result of the alienation of the vanguard artist from society.

The affluent art-buying public much preferred traditional academic art, which was easy to understand and showered with official honors, to avant-garde art. Academic art of the century's second half tended to be literary in content and stylishly executed with a meticulous, near-photographic verisimilitude. Created by accomplished painters such as Jean-Léon Gérôme (1824–1904), this academic art has been described by art historian Linda Nochlin as technically slick and showy, specializing in titillating nudes and saccharine religious scenes. It was the painting preferred by the newly rich. Such work, writes Nochlin, fulfilled "the secret dreams and more overt demands for moral probity and a recognizable story" of these *nouveau riche* citizens. Gérôme's attention-grabbing stories, with their exotic settings and frequent overtones of sex, violence, and power struggle, stylishly anticipate the popular films, television programs, and commercials of the future. In the setting of an Arab slave market **(16.36)**, a beautiful young woman is physically examined by her potential buyers while posing gracefully and passively for the male viewer outside the picture frame. Vanguard artists and critics might denounce such "bourgeois art" as "callous" or "philistine," but they could not dispute the fact that such painting sold well, garnered the major awards, and possessed popular mass appeal.

A painting, *Self-Portrait with Emile Bernard (Les Misérables)* **(16.37)**, and letter by Paul Gauguin speak to the contradictory and paradoxical condition of the avant-garde artist, who is both free and shackled to the world. Hard times are balanced by the exciting, spiritually uplifting journey to the frontiers of art. A groundbreaking "symbolic" and "abstract" art is being realized, paintings and sculptures that, in turn, would confound and alienate the average viewer of the day. For the artist's efforts, respectable society damns him as a disreputable bandit. The year is 1888. Gauguin writes:

> I have this year sacrificed everything—execution, color—for style, wishing to impose upon myself nothing except what I can do. It is, I think, a transformation which has not yet borne fruit but which will. I have done the self-portrait which Vincent [van Gogh] asked for. I believe it

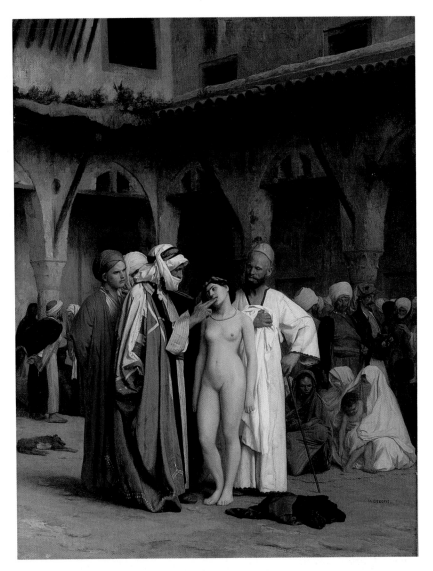

16.36 JEAN-LÉON GÉRÔME. *The Slave Market.* Ca. 1867. Oil on canvas. 33³/₁₆ × 24¹³/₁₆ in. Sterling and Francine Clark Art Institute, Williamstown, MA. *Influenced by the worldview of their particular cultures, art historians and critics are subject to changing tastes. With the rise to prominence of impressionism and postimpressionism in the eyes of twentieth-century art historians, the once-heralded position of nineteenth-century academic art took a nose dive. Certain contemporary art historians have been reevaluating the quality of academic art. Do you think academic art is of comparable value to impressionist and postimpressionist art? What might induce art historians and critics of the future to judge a work by Gérôme to be equal to one by Monet or van Gogh?*

is one of my best things: absolutely incomprehensible (for example) it is so abstract. Head of a bandit in the foreground, a Jean Valjean (*Les Misérables*) personifying also a disreputable Impressionist painter, shackled always to this world. The design is absolutely special, a complete abstraction. The eyes, mouth, and nose are like the flowers of a Persian carpet,

16.37 PAUL GAUGUIN. *Self-Portrait with Emile Bernard (Les Misérables).* 1888. Oil on canvas. 28⅛ × 35⅝ in. Amsterdam, Van Gogh Museum (Vincent van Gogh Foundation).

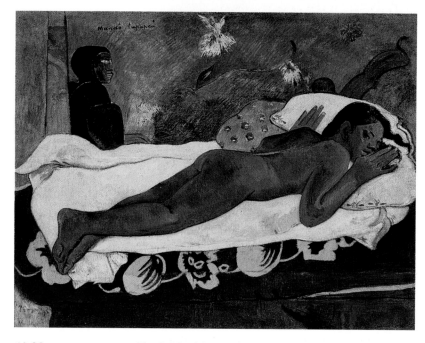

16.38 PAUL GAUGUIN. *The Spirit of the Dead Watching.* 1892. Oil on burlap mounted on canvas. 28½ × 36⅜ in. The Albright-Knox Art Gallery, Buffalo, NY. A Conger Goodyear Collection, 1965. *Gauguin presents his teenage model in a pose that reverses that of Manet's* Olympia *(16.27), one of the inspirations for the work. In what other ways does* The Spirit of the Dead Watching *turn Manet's picture on its head?*

likeness, you have an image of myself as well as a portrait of all of us, poor victims of society, who retaliate only by doing good."

Gauguin: Toward an Art of Imagination and Abstraction

Gauguin's numerous self-portraits of the late 1880s and early 1890s show us a man who is a willful, independent seeker of intuitive sensations, imaginative fantasies, and higher spiritual states. The artist saw himself alternately as a Christlike figure and as a "noble savage," defiant of industrial society with its scientific rationalism and bourgeois materialism. Searching for the purity of feeling and spirituality that he believed European commercial society had expunged, Gauguin traveled to the rural peasant culture of coastal Brittany and the tribal cultures of the South Seas. His subsequent self-portraits show us the struggling bohemian artist pursuing an existential quest. A successful bank official until 1883, Gauguin came to denounce his epoch as "the kingdom of gold." Disturbed by "our exaggeratedly civilized society," the noble savage determined to give it all up. Painfully, he left his wife and children to go off in search of his artistic and human destiny. His journey brought him in 1891 to the Pacific island of Tahiti in French Polynesia (**Appreciation 32**).

Gauguin's *Manao tupapau (The Spirit of the Dead Watching)* **(16.38)**, painted in Tahiti, exemplifies the imaginative and abstract art of the artist's final years. In a letter to his family in Europe, he sheds light on his invention of imaginary forms and figures in this painting, noting an abstract or "musical" use of color, line, and composition to convey mysterious moods.

> A young Tahitian girl is lying on her stomach, showing part of her frightened face. She rests on a bed covered by a blue *pareu* and a light chrome yellow sheet. A violet purple background, sown with flowers glowing like electric sparks; a strange figure sits beside the bed. . . .
>
> The *pareu* being intimately connected with the life of a Tahitian, I use it as a bedspread. The bark cloth sheet must be yellow, because in this color it arouses something unexpected for the spectator. . . . I need a background of terror; purple is clearly indicated. And now the musical part of the picture is laid out.
>
> . . . I see here only fear. What kind of fear?

thus personifying the symbolic aspect. The color is far from nature; imagine a vague suggestion of pottery contorted by a great fire! All the reds, violets, striped by flashes of fire like a furnace radiating from the eyes, seat of the struggles of the painter's thought. . . .⁹

The vanguard artist, for Gauguin, was a "Jean Valjean": the unfairly accused, outcast hero of Victor Hugo's classic novel, *Les Misérables.* In a subsequent letter to van Gogh, Gauguin added that "by painting him [Jean Valjean] in my own

INTERACTION BOX

RAISING CROSS-CULTURAL ISSUES IN THE ARTS

Did the American romantic landscape painter Frederic Church show respect or disrespect for Middle Eastern cultures by borrowing their forms and motifs and integrating them into his mountaintop house Olana (16.15)? Did the French painter Gérôme honor or dishonor an Arab culture by presenting a slave market scene (16.36) in an exoticized and academically idealized way? Was the French artist Gauguin, who claimed deep respect for his Tahitian and Marquesan hosts, a trespasser or violator of their culture and art? Was his use of a Marquesan paddle handle (Appreciation 32, Fig. B) as a visual basis for the spirit of the dead figure in

Manao tupapau (16.38) disrespectful appropriation and exploitation of the native culture and its art? Was his use of the traditional Western medium of oil painting as his means of representation a slap in the face to local peoples whose primary artistic medium was wood carving? Or was his personal interpretation of the culture and art of Oceanic peoples an affirmation and honoring of these cultures?

Imagine that you have traveled to a culture very different from your own. You find the life and the art of that culture fascinating and want to capture it in visual terms. You have a camera and a sketchpad with you. What cross-cultural issues would you take into account before proceeding?

... The *tupapau* (Spirit of the Dead) is clearly indicated. For the natives it is a constant dread.

... My decorative sense leads me to strew the background with flowers. These flowers are the phosphorescent flowers of the *tupapau*; they are the sign that the spirit nears you. Tahitian beliefs.

... To sum up: The musical part: undulating horizontal lines; harmonies of orange and blue, united by the yellows and purples (their derivatives) lit by greenish sparks. The literary part: the spirit of a living person linked to the spirit of the dead. Night and day ...[10]

In these paragraphs, Gauguin lays out some of the central tenets of **symbolism,** the formalist philosophy that underlay the broad stream of turn-of-the-century fine and applied art known as art nouveau or "new art." (The paintings and posters of Toulouse-Lautrec (6.9), the book illustrations of Aubrey Beardsley (6.10), the glassware of Louis Comfort Tiffany (9.22), the interior design and architecture of Victor Horta (9.23), and the jewelry (9.24), furniture design, and Paris Metro entranceways of Hector Guimard are all part of this extended family.) Gauguin speaks of the power of color and line, "the musical part of the picture," to evoke feelings. Independent of the literary or descriptive aspects of the painting, undulating lines and color harmonies, like melody lines and chordal harmonies in music, arouse our emotions. Line, shape, and color,

arranged according to the artist's "decorative sense," possess a mysterious, abstract force. The emotion or idea of fear is elicited by means of forms as much as by the figure of the *tupapau*. Such formal power was looked upon as magical and was honored as spiritual by Gauguin and the symbolists.

Focusing on the artist's style and subject matter from another perspective, that of contemporary feminism, two undergraduate students assert that Gauguin treats his Tahitian women—the model for his *Manao tupapau* was his teenage mistress—as objects rather than as individuals. The first student writes, "I do not think Gauguin cared very much about who these women were, just that they gave him a different subject matter to fit his avantgarde style. I think it is ironic that while he is trying to break from the mainstream society, he falls back into the traditional mode of painting nudes with the woman as submissive as we look down on her." According to the second student, "Gauguin's portrayal of the nude Tahitian woman is simply an exoticized version of Titian [16.28], which still denies the dignity and individualism of the subject. Although the technique and conceptual goal demonstrated within Gauguin's work may deny all past tradition, the overall image that is portrayed falls short of any progress concerning the artist's treatment of the female model."

Oceanic Art and Gauguin: Influences and Issues

LINNEA S. DIETRICH

The Pacific Ocean is the world's largest geographical feature **(Fig. A).** It is dotted with islands where hundreds of groups of peoples have lived since Neolithic times (ca. 1000 B.C.E. onward). Oceania is the collective name given to this vast region; within that term are three areas named by Western anthropologists: Melanesia (northeast of Australia and south of the equator); Micronesia (generally north of the equator and east of the Philippines); and Polynesia (roughly a triangle from Hawaii east to Easter Island to New Zealand). Paul Gauguin traveled and lived in the Polynesian group—on Tahiti in the Society Islands, near the Cook Islands [8.11] and Western and American Samoa, and in the Marquesas Islands. The rich cultural, linguistic, spiritual, and earthy power of Oceania cannot be captured in words, much as Gauguin would like to have captured it in both words and images.

Paul Gauguin had been living in Tahiti for almost a year when he painted *Manao tupapau* [16.38], typical in its mixture of Western and non-Western sources. The pose of the nude woman is a reversal of Manet's *Olympia* [16.27]. Gauguin had copied Manet's painting in 1890 and had brought with him to Tahiti a

Figure A Map of Oceania.

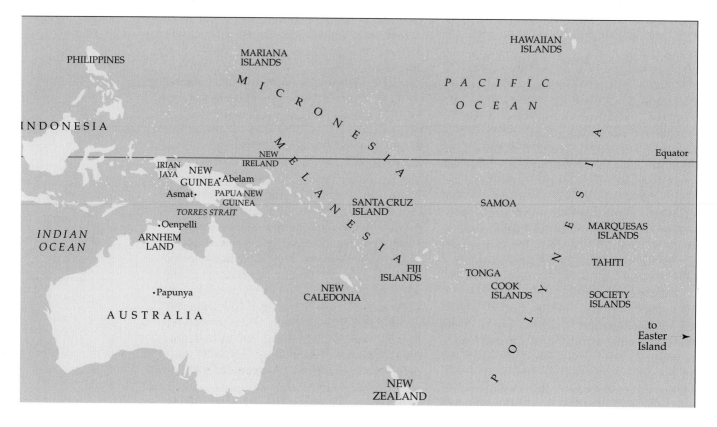

reproduction of that work, along with a collection of photographs of Egyptian and Javanese art and a "book of travels full of illustrations—India, China, the Philippines, Tahiti, etc.," as he wrote in his book *Avant et Après* (later published as *Intimate Journals*). The tupapau (or spirit of the dead) and the totemic post she sits by in the painting are vaguely Marquesan in form—the Marquesas being Polynesian islands about 400 miles northeast of Tahiti, where Gauguin spent the last two years of his life, and where he died and was buried.

A Marquesan paddle handle **(Fig. B)** served as a source for many figures in Gauguin's paintings and sculptures from 1892 on, the simplified form, profile head, and frontal eye suggesting a spiritual and not earthly being.

As a Symbolist, Gauguin's artistic and personal philosophical goal was to understand the links (the connections, *symbolon* in Greek) between the spiritual and human realms, and he structured his thinking about these connections into dualistic pairs: matter/spirit, female/male, East/West, "savage"/"sensitive" as he called himself, Buddha/Christ, and in *Manao tupapau*, Night/Day. He claimed to reconcile all these opposites in his art and writing and for himself personally.

So his travels were a way for him to complete himself and create a monumental global system which integrated all opposites, and specifically the arts and religions of the world. Scholars have claimed that Gauguin was in this sense one of the first European artists to embrace multicultural issues that opened Western eyes to the wonders of non-Western art, with all the ensuing perils and complications of studying and entering into a culture not one's own.

Gauguin had some legitimate claim to international status. His maternal relatives came from Peru, and he lived in Lima for four or five years as a young child. He traveled around the world twice during a six-year period in the French Merchant Marine and Navy, lived in Panama and Martinique, in the most "remote" part of France, the province of Brittany, spent two years in Tahiti and ten days in Auckland,

New Zealand in August 1895. (The sketchbook and discussion of his Oceanic sources can be found in *Gauguin and Maori Art* by Bronwen Nicholson, Auckland City Art Gallery, 1995.) There he visited the museums and cultural centers and sketched some of what he saw of indigenous Maori art. He resettled in Tahiti and moved to the Marquesas Islands in 1901, dying there in 1903. His reading and visiting universal expositions and museums in Paris added to his knowledge of Oceanic art.

Nonetheless, Gauguin brought Western colonizing and sexist ideas and behaviors with him on his travels. No matter how self-serving or how appreciative his motives were, he used Tahitian women, the landscape, what he could glean of its traditions, religion, and art in his work and life, all documented in the European medium of oil painting (although he made wooden sculptures, architectural carvings, and household items more in the native idiom). That his work pays homage to the Tahitian body and spirit may not be enough to excuse him from his intrusion into another's culture, the appropriation of its work, his apparent willingness to risk the degradation of indigenous culture through outside influence. Jonathan Mane-Wheoki, an art historian in New Zealand and a specialist in the Gauguin-Maori connection, asks these questions in an essay in the book cited above. Further he asks, "Does the recontextualization of Maori art into Gauguin's European *oeuvre* compromise or endanger the meaning and significance of that art?"

The answers to these questions may lie not in further debates about Gauguin's motives, failings, and accomplishments, but in recognizing these issues **[Interaction Box]** and in what we as contemporary and future citizens *do* about the increasing globalization and internationalization of the world and its peoples.

Tahiti itself was no longer the island paradise Westerners dreamed of even in 1891 when Gauguin arrived there because European colonization had severely damaged the social and cultural fabric of life. Gauguin's work was an attempt to reinvent in part what he could no longer see or fully experience. If a study of his work leads to an understanding of and a respect for the culture and peoples of Oceania, then Gauguin's debt can begin to be repaid. ▪

Figure B Marquesan paddle handle. British Museum, London.

Linnea S. Dietrich is a Gauguin scholar and teaches the history of art at Miami University in Oxford, Ohio.

16.39 PAUL CÉZANNE. *The Blue Vase.* 1883–87. Oil on canvas. 24 × 19⅝ in. Musée d'Orsay, Paris.

For if the strong experience of nature—and assuredly I have it—is the necessary basis for all conception of art on which rests the grandeur and beauty of all future work, the knowledge of the [formal and technical] means of expressing our emotion is no less essential, and is only to be acquired through very long experience.—Paul Cézanne on his art, 1904

Cézanne and Formalist Abstraction

As with the other postimpressionists, formalist concerns were prominent in the work of Paul Cézanne. The least successful of the original impressionist group in terms of public recognition or sales, Cézanne retired to his native city of Aix-en-Provence in the rural south of France. For the final twenty years of his life, supported by a family inheritance, he led the most solitary of existences. His closest companions were humble still life objects and the rugged Mount St. Victoire near his home. In nature and in his art, the aging man sought the grandeur, beauty, calm, and perfection that he was not able to find either in his personal life or in the larger social world. "Treat nature," Cézanne wrote, "by the cylinder, the sphere, the cone," advice that the

early-twentieth-century "cubist" artists took to heart (17.9, 17.10). In this way, according to Cézanne, the artist's intellectual, "geometrical" concept of nature would be perfectly integrated with his perceptual experience of it. The artist, Cézanne insisted, must experience the sensations of nature first so that the subject can be rendered with intensity. The artist's intellect can then join in to create the finished work of art. Perception and conception must proceed hand in hand.

The Blue Vase (16.39), artist Robert Stuart observes, shows this balance of perception and conception and "bears traces of Cézanne's search for form."

> We see in the two apples on the right his stray or floating contour lines. A Louvre Museum master such as Chardin [15.18] would never have allowed such drawing lines to remain visible in his still lifes. The tracks of Cézanne's struggle for balance and order remain for us to see. Behind the blue vase, the two split halves of the dish don't quite connect. The right half is slightly higher, and the same is true of the back horizon line of the table edge. These discrepancies, along with the tilt of the table's front edge, the upward-pointing ink bottle resting on the top edge of the table, and the long yellow ochre vertical on the right side of the canvas give a distinct upward movement to the right side of the vase and a counterbalancing downward push to the left side.
>
> It's quite a balancing act between weights and counterweights, movements and countermovements; a brilliant, stirring translation of the still life objects perceived through the senses and rendered by the intellect into a classically ordered aesthetic composition. This "redoing of Poussin according to nature," which Cézanne described as his task, represents not only a bridge between impressionism and the classicism of Poussin [15.6] but also a direction for painting into the modern world.
>
> . . . By himself Cézanne carved out a path for twentieth-century art, a path that leaves room for realism and abstraction, for direct observation of nature as well as the intuited order of the mind.[11]

Rodin and Vanguard Sculpture

The innovative sculptor Auguste Rodin (1840–1917), born within a year of Cézanne, Monet, Morisot, and Renoir, forged a personal

style that encompassed both naturalism and antinaturalism and paved the way for the free interpretation of the human figure in twentieth-century sculpture. Earlier we viewed an Edward Steichen photograph of Rodin with his famous bronze sculpture *The Thinker* and larger-than-life portrait of the French romantic writer Victor Hugo (7.20). Conceived about 1878, during the controversial heyday of impressionism, but not cast in bronze until 1905, the time of Cézanne's final works, Rodin's *Walking Man* **(16.40)** is one of the artist's most radical innovations. For no clear thematic reason, the sculptor imaginatively fractured the human figure. The contradictory result is a headless but powerfully striding man.

As art historian Stephen Whitney notes, "The *Walking Man* combines energetic realism and bizarre fantasy . . . authentic humanity, savage power, and ugliness." It is a paradoxical mix of anatomical accuracy and physical decapitation, a creative distortion of nature that "surprises the viewer so as to liberate the mind from its everyday habits of perception." In his *Walking Man,* Rodin arbitrarily decided to present the public with a fragment, a headless body, rather than the customary entire figure. Whitney observes that Rodin's use of such a bold technique required a leap of the imagination but is not entirely surprising.

> He spent virtually his entire adult life surrounded by sculptural fragments, both of older statues and of his own works in progress. Furthermore, he knew ancient statuary as we know it today, primarily in reconstructed and fragmentary form, often lacking the head or arms, often both. Rodin was obviously sensitive to the evocativeness of fragmentary objects, especially old ones, and can be assumed to have noticed that fragments sometimes stimulate the imagination in ways that whole objects cannot.[12]

16.40 AUGUSTE RODIN. *Walking Man.* 1900–1905. Bronze. 83 in. Hirshhorn Museum and Sculpture Garden, Smithsonian Institution, Washington, D.C. Gift of Joseph H. Hirshhorn, 1966.

A headless walker, realistic in form and movement, surges through space. A synthesis of naturalism and abstraction, *Walking Man* strides like a human locomotive between the more objective realism of the nineteenth century and the more subjective abstraction of the twentieth—an aesthetic position mirroring that of the impressionist and postimpressionist painters.

There is nothing ugly in art except that which is without character, that is to say, that which offers no outer or inner truth. —Auguste Rodin, Sculptor, on ugliness in art, ca. 1902

Completeness is conveyed in the armless statues of Rodin: nothing necessary is lacking. One stands before them as before something whole. —Rainier Maria Rilke, poet and art critic, *Rodin,* 1903

17 Early-Twentieth-Century Art

No three artists provided more inspiration for the coming generations of artists than Gauguin, van Gogh, and Cézanne. So great was their influence that they might even be called founders of three directions in twentieth-century art. Gauguin, working from interior memory, intuition, and imagination—the deep, mysterious centers of thought—served as a model for those artists whose art sprang from nonrational or irrational sources. This wide and complex stream, identified as irrationalist, fantasist, or surrealist, included the new century's Dada and Surrealist movements as well as diverse artists and movements concerned with an art of imagination and fantasy.

Building on the legacy of Cézanne's carefully constructed, architectonically structured paintings arose artists committed to the general direction of formalist abstraction. In Cézanne's work they found an inspirational formal order and abstract geometry. Abstractionists of diverse aesthetic outlooks—cubists, constructivists, and De Stijl and Bauhaus artists—expanded on Cézanne's artistic achievement, creating from it a multiplicity of movements, schools, and styles.

From van Gogh's emotionally self-expressive work issued a movement that centered on subjectivist expression of feeling. This broad direction became known as expressionism. Our journey into the twentieth century

begins with this expressionist stream as we focus on two very distinct artists: the Frenchman Henri Matisse and the Norwegian Edvard Munch, whose work shows that the world of feeling encompassed by modern expressionism was vast and varied.

EXPRESSIONISM: UNLEASHING THE EMOTIONS

The year 1903 saw the establishment of the *Salon d'Automne* in Paris, an annual autumn exhibition completely independent of the official French Academy and its centuries-old Salon. The express purpose of the *Salon d'Automne* was the championing of new, experimental art. Indeed, independent vanguard art was beginning to vie with academic painting and sculpture for the heart of the art public and had already captured its progressive wing.

Yet vanguard art, ever committed to exploring new ground, continued to frustrate and infuriate mainstream critics. At the 1905 *Salon d'Automne,* the young avant-garde painters grouped around Henri Matisse (1869–1954), including future artists of note such as Georges Rouault, Maurice de Vlaminck, and André Derain (1880–1954), were described as the *fauves* ("the wild beasts") by prominent critic Louis Vauxcelles. The critic found the violent coloration and unnatural distortion of the real-life subjects treated by Matisse and Derain and their circle of friends mind-boggling. Derain liked to recall those days, saying "It was the era of photography. That may have influenced us and contributed to our reaction against anything that resembled a photographic plate taken from life."

Matisse and Fauvism

The contemporary artist and writer Maurice Denis (1870–1943) responded with enthusiasm to the work of these "wild beasts." Denis, a leading member of the avant-garde, stated that "the Matisse tendency" had broken through to art more pure, autonomous, and free from the constraints of realism than any before. Here

was the most "abstract" painting yet created, powerfully liberated from the appearances of the natural world. Here was "pure painting," wrote Denis, based on each artist's "personal emotion."

Matisse, the leading Fauve, had absorbed the influences of van Gogh, Gauguin, and Cézanne. What made his approach truly unique was that his personal feeling focused primarily on artistic form and secondarily on subject matter. This was a substantial departure from the art of the three postimpressionist masters, which, however personal or abstract, had always been rooted strongly in the subject matter, be it a literary idea, a feeling state, or a physical object. For the postimpressionists, form and subject matter were accorded relatively equal weight. In Matisse's work, in contrast, form came to predominate. Observe the differences between Gauguin's 1901 painting of two nude Polynesian women (**17.1**) and Matisse's 1909 *Pink Nude* (**17.2**). The subject of Matisse's piece has undergone a radical metamorphosis: She has been transformed from a particular human being into a flat, abstract design of arbitrary color and decorative pattern. What the woman truly looks like, or the nature of her personality or life, is of little concern to the artist. Matisse's ever more "pure painting," increasingly independent or "autonomous" from the constraints of subject matter, shows how far Matisse and the Fauves had liberated form from subject matter. In comparison, Gauguin's painting of two Polynesian women looks almost realistic!

Matisse's goal, in this case, was to make the female nude an abstract equivalent for the human body that would be more expressive and true to life than any painstaking representation from daily life. Such a work would be more accurate and meaningful for capturing what Matisse called the nude's "enduring character and content" and for being a pure product of the artist's creativity (see back cover). Paradoxical as it might seem to create an equivalent for the human body that would be more an embodiment of the essence of life than any detailed realistic portrayal, Matisse often attained such true-to-life quality in highly abstract works of art. His *Flowing Hair* (**17.3,** Appreciation 4) of 1952, created with cut and pasted pieces of

17.1 PAUL GAUGUIN. *And the Gold of Their Bodies.* 1901. Oil on canvas. 26½ × 30 in. Musée d'Orsay, Paris.

Expression to my way of thinking does not consist of the passion mirrored upon a human face or betrayed by a violent gesture. The whole arrangement of my picture is expressive. —Henri Matisse, artist, "Notes of a Painter," 1908

handpainted paper, embodies this joint pictorial and human expressiveness. *The Flowing Hair* conveys the human essence, though not the naturalistic appearance, of the nude female body in joyous motion. Turning to cut paper at the end of his long career, Matisse believed that this new medium continued the evolution of his paintings, achieving even more "completely and abstractly a form reduced to the essential." (The Romanian artist Brancusi applied this same basic goal of reduction to the essential to his highly abstract sculpture *Bird in Space* (8.5).)

For his entire life, Matisse strove to create a life-affirming abstract art. His commitment was to an "art of balance, of purity and serenity," and to the depiction of uplifting subject matter that was never "troubling or depressing." There can be no doubt that works like *The Flowing Hair* have brought enduring

pleasure into an often troubled world. For such a significant accomplishment, Matisse well deserves his position as a giant of the "art of expression."

Munch and German Expressionism

Pain as well as pleasure dwells in the world, however, and many artists came forth to portray the darker aspects of modern life. Of these, none was more expressive than the Norwegian Edvard Munch (1863–1944). The source of expression of Northern European artists was the highly emotional experience of daily living itself. The swirling shapes, unnatural colors, and distorted figures of so-called expressionist art derived from the intensified way these artists experienced the world. Their pictorial form was inseparable from the storm

17.2 HENRI MATISSE.
Pink Nude (Seated Nude).
1909. Oil on canvas.
12⅞ × 16 in. Musée de
Grenoble, France.

and stress of life itself and dealt precisely with
the depressing subjects and troubling states of
mind Matisse so studiously avoided. If Matisse
stands at one end of the spectrum of modern
expressionist art, then assuredly the works of
Norway's Munch stand at the other.

The titles of some of Munch's greatest
paintings from the final decade of the nine-
teenth century—*Death in the Sick Room, Anxi-
ety, Melancholy, Jealousy*—imply a journey
into a dark realm where Matissean balance,
serenity, and pleasure could not possibly ex-
ist. Consider the frightening *Scream* **(17.4),**
painted in 1893. A shriek wells up inside a
ghostlike figure on a bridge. The scream is in-
ternal, crashing back and forth within the
walls of a paranoiac mind. The two persons
walking off into the distance are oblivious to
the silent cry. Unthreatened by the world,
they have no sense of what the protagonist,
Munch himself, is experiencing. Munch's
scream goes unheard, making the whole situ-
ation even more upsetting.

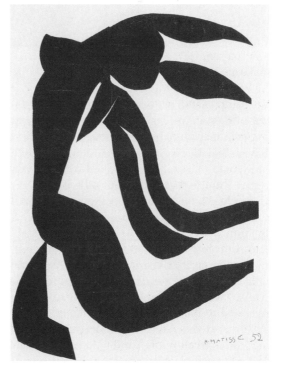

17.3 HENRI MATISSE.
*The Flowing Hair
(La Chevelure).* 1952.
Gouache on cut and
pasted paper. 42½ ×
31½ in. Private Collec-
tion. © 2002 Succession
H. Matisse, Paris/
Artists Rights Society
(ARS), New York.
Photo Archive Matisse.

17.4 EDVARD MUNCH. *The Scream.* 1893. Oil tempera and casein on cardboard. 36 × 29 in. Nasjonalgalleriet, Oslo, Norway.

Anyone who has ever experienced phobias or witnessed an attack of anxiety or panic knows what Munch is expressing. The world has suddenly become a frightening place, a nightmare. All that once seemed solid has become fragile. Stability and self-control are threatened by a sense of "losing one's mind." Out of fear that he is spinning out of control, the horror-stricken figure cries out in anguish. Facial expression and bodily gesture communicate part of the experience. The background tells the rest: the swirling, blood red sky; the water, land, and atmosphere undulating in a dizzying rhythm; the bridge, in unnerving perspective, rushing off at an impossible speed and tilt. Extremes of hot and cold colors—reds and red-oranges, blues and bluish purples—

jar against each other. Munch tells us why he painted *The Scream* the way he did:

> I was tired and ill—I stood looking out across the fjord—the sun was setting—the clouds were coloured red—like blood—I felt as though a scream went through nature—I thought I heard a scream—I painted this picture—painted the clouds like real blood. The colours were screaming.[1]

Matisse painted his subjects at a calm aesthetic and psychic distance with the goal of achieving a tranquil, harmonious art that might bring comfort and relief to the modern viewer. Munch, working from his inner turmoil, couldn't possibly have created his art at such a serene, intellectual remove. The fire of the moment brought forth his form and suffused every aspect of his work. He had suffered terribly as a child, the victim of a gloomy father who was a ranting religious bigot, a mother who was a submissive wreck, and the death by tuberculosis of a beloved sister as well as his mother. "Disease and insanity," as he later put it, "were the black angels on guard at my cradle. In my childhood I felt always that I was treated in an unjust way, without a mother, sick, and with threatened punishment in Hell hanging over my head." The pain of this unsettling upbringing was exacerbated by the alienation of the avant-garde artist from bourgeois society and the general sense of estrangement that many sensitive souls of the time felt in an increasingly urban, industrial society. For many, the city had become a place of lonely crowds and destructive allurements, a "devourer of souls." Both *The Scream* and van Gogh's *Night Café* (1.12) were visual manifestations of this lonely despair. Looking at Munch's painting in even larger societal terms, a student majoring in sociology wrote that increased specialization, surplus wealth, and leisure time enabled "a growing number of people to look inside themselves. . . . Munch's boldly emotional, introverted, and alienated art could not have come from a small, communally based agricultural society."

By the turn of the century, many avant-garde artists had rejected all aspects of bourgeois society, including its moral system and style of life. Many pursued "bohemian" or otherwise countercultural life-styles. Munch, like

the bohemian Gauguin before him, struggled to free himself from what he saw as repressive middle-class behavior. In art and etiquette shocking to the bourgeoisie, he sought open expression of his sexual drives and the irrational forces of his mind. The inner psychological life of the person was fast becoming a central concern in the world of medical practice, and many of the most prominent psychological theorists and practitioners of the early twentieth century were men, like Munch, of Northern European background. Sigmund Freud's first studies of hysteria and his pioneering *Interpretation of Dreams* (1899), for example, were published at the turn of the century. At the grassroots level, troubled individuals, Munch among them, could not see fit to enlist the help of psychotherapists to uncover and heal their internal wounds.

Many young German artists in the early twentieth century responded with psychic intensity to reality's more disturbing aspects. Like Munch, van Gogh, and Gauguin, these Germans employed distortions of natural appearances in order to convey emotional depths. With realistic detail pared away to intensify facial expression and gesture, the artworks of Käthe Kollwitz (1867–1945) literally cry out against communal pain and social injustice. Society's dark side—poverty, unemployment, and war—rather than inner neuroses motivated her personal turmoil and powerful artistic forms (Appreciation 12). *Outbreak* **(17.5),** part of her print series *Peasants' War,* conveys an explosive communal eruption of frustration and anger, a social counterpart to Munch's individual psychological outpouring in *The Scream* (17.4). The darkly clad, leaning woman in the foreground shakes with rage as the phalanx of peasants, gripping makeshift weapons, shoots forward like an arrow.

Kirchner and **Die Brücke** In the first decades of the twentieth century, the new goal of self-expression reached deep into the souls of diverse Northern European artists who collectively came to be grouped under the historical banner of German expressionism. One of the earliest German expressionist groups, **Die Brücke** (The Bridge), originated in Dresden in 1905. Expressing belief in their group as a liberating "bridge to the future," the manifesto of

17.5 KÄTHE KOLLWITZ. *Outbreak* (from *Bauern Krieg*), 1903. Mixed media, 20 × 23¼ in. Library of Congress, Washington, D.C., Coll. no. NE654 K6 ME fol. *Compare the gestures of the main figure in* Outbreak *with Munch's screamer (17.4) and consider what each expresses. How are they similar? How are they different?*

Die Brücke states, "He who renders his inner convictions as he knows he must, and does so with sincerity and spontaneity, is one of us." Ernst Ludwig Kirchner (1880–1938), *Die Brücke*'s leader, conveyed his inner apprehension of life rather than his optical perception of it. Kirchner's street scenes (7.24), with their acidic color, sharply pointed shapes, and claustrophobic space, convey a feeling of unease and urban dis-ease. Influenced by Kirchner and other northern expressionist artists, German filmmakers of the late teens and twenties directed their cameramen, editors, and designers to distort natural appearances to convey states of mental turbulence and even madness (7.25, 7.26). Rooted in the potent expression of psychological states of mind, expressionism became a major direction within German theater, dance, music, and literature as well as painting and sculpture.

That German expressionism came to exist as an art historical construct and a major cultural phenomenon was due largely to the writings of

Wilhelm Worringer. In the early twentieth century, this young German art historian proposed that an expressionist "drive to abstraction" was a central tendency in Germanic art, both of the past and of the present. The soul and art of Northern European people, he argued, were formed by the discomfort and alienation they felt toward the world around them. This condition of alienation began with the harsh physical surroundings of the north: a cold, dark, and storm-filled climate and a grudging landscape resistant to human attempts to secure food and shelter. Such an environment promoted not empathy but estrangement. Other thinkers added that the disrupting aspects of modern society and culture further contributed to the estrangement of the individual.

Because alienation was the basic condition of northern artists, Worringer contended, their natural tendency was to distance themselves from a discomforting world. Rejecting the outer world, they increasingly turned to face their inner selves. For motive and inspiration, they relied on their own heightened subjectivity and introspection. Incapable of an empathic relationship with nature and society, German artists felt compelled to forsake naturalness and tranquility for a personal "play of fantasy" and "drive to abstraction."

> Actuality, which Gothic [that is, Germanic] man could not transform into naturalness by means of clear-sighted knowledge, was overpowered by this intensified play of fantasy and transformed into a spectrally heightened and distorted actuality. Everything becomes weird and fantastic. Behind the visible appearance of a thing lurks its caricature, behind the lifelessness of a thing an uncanny, ghostly life, and so all actual things become grotesque. . . .[2]

This passage might well be describing many of the paintings of van Gogh, Munch, and Kirchner; German expressionist films such as *The Cabinet of Dr. Caligari* (7.25) and *The Last Laugh* (7.26); and the work of some of the most powerful early-twentieth-century Germanic modernist painters and sculptors. The large 1918–19 painting *Night* **(17.6)** by Max Beckmann (1884–1950), for example, an emotional by-product of the horrors of World War I and its aftermath, has as its theme the nocturnal invasion of a slum dwelling by a gang of thugs. In a claustrophobically shallow space, a

nightmarish scene of torture and violation is taking place. The mind and body of the artist have assimilated real-life wartime and postwar experiences and reinterpreted them as the "distorted actuality," "weird and fantastic" caricature, and "spectrally heightened" expression of which Worringer spoke. To be sure, psychic anxiety and its various manifestations in art—abstraction, expressionism, fantasy—have never been solely the property of the Northern European countries. Today, more than ever, anxiety and anxious abstract art are worldwide phenomena. But, these qualifications aside, Worringer's general theory of abstraction and alienation remains provocative and potent. In the early twentieth century, it was especially exciting and influential, offering Northern European artists a stirring explanation and rationale for their controversial new work.

***Kandinsky and* Der Blaue Reiter** Estrangement from the world led other artists to create works of imaginative fantasy or complete abstraction that transcended the natural world altogether. Artists who pursued such directions almost always attached a "higher" spiritual or religious significance to their abstract art. The chief proponent of this general tendency was Wassily Kandinsky (1866–1944), an artist who was born in Russia but lived much of his life in Germany. Kandinsky played a substantial role in pioneering twentieth-century abstraction. He created a transcendental abstract art, wrote influential books and essays, and founded a major movement known as **Der Blaue Reiter** (The Blue Rider) movement. Living in Munich between 1908 and 1914, Kandinsky met art historian Worringer and found that they shared many ideas. Each believed not only that alienation prompted the tendency to abstraction but that the resultant abstract art was the most spiritual type of art. In his own widely read treatise *Concerning the Spiritual in Art*, Kandinsky wrote that in a world "choked by materialist lack of belief" the mission of abstract art, which pierces through the dense outer surface of things, is to direct "the development and refinement of the human soul." Such beautiful, spiritualizing abstract art was a direct expression of the artist's inner spirit and need,

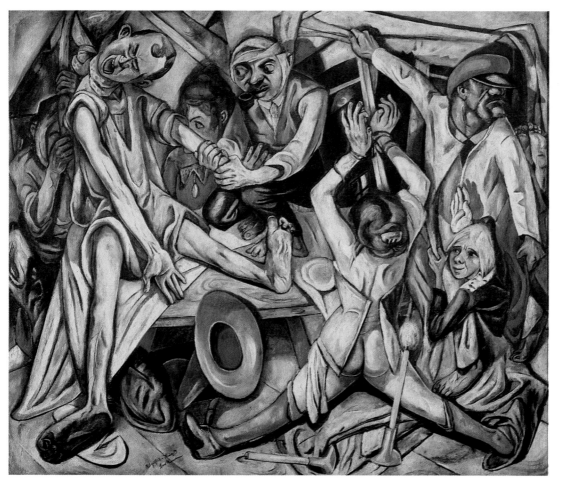

17.6 MAX BECKMANN. *Night*. 1918–19. Oil on canvas. 51⅞ × 60¹⁄₁₆ in. Kunstsammlung Nordrhein-Westfalen, Dusseldorf.

"produced by internal necessity, which springs from the soul."

In 1912, the year in which Kandinsky published *Concerning the Spiritual in Art* and helped found *Der Blaue Reiter* movement, he had not yet arrived at the modern "geometrical abstraction" he and Worringer had envisioned. But his art was still highly abstract and involved several exploratory approaches, one of which the artist called his "impressions." He described these as fauvist-type interpretations of natural subjects, ranging from mountains and buildings to horses with riders. More abstract, and at times entirely nonfigurative, was the approach Kandinsky categorized as "improvisations," which the artist defined as "largely unconscious, spontaneous expression[s] of inner character, of non-material [i.e., spiritual] nature." Created in 1912, *Improvisation 28* **(17.7)** pulsates with the ecstatic energy that characterized so many of the artist's

paintings from the pre–World War I period. If this is "painting of the soul," as Kandinsky maintained, it expresses a passionate soul vibrating with excitement. Black lines, straight or curving, dash and crisscross here and there. A cornucopia of primary and secondary hues—red, yellow, blue, green, brown, orange, purple—pulsates within and around the lines. Some shapes vaguely resemble mountains and tops of buildings, but they have all but left the material world behind. Space has become flattened, with foreground and background melding together in a swirling mix. Transformed by the artist's "largely unconscious, spontaneous expression of inner character," lines, colors, and shapes intertwine dynamically in an outpouring of Kandinsky's highly charged soul. Such painting anticipated by thirty years the improvisational "abstract expressionist" action painting that began in full force after World War II.

17.7 WASSILY KANDINSKY. *Improvisation 28 (Second Version).* 1912. Oil on canvas. 43⅞ × 63⅞ in. The Solomon R. Guggenheim Museum, New York. *Works like this one might appear chaotic or messy at first. The painting's spontaneous, abstract appearance grows out of many earlier Kandinsky works, some of which were quite representational. Look closely. What recognizable objects has the artist energetically abstracted?*

[Abstract art is] produced by inner necessity, which springs from the soul.
—Wassily Kandinsky, artist, *Concerning the Spiritual in Art*, 1912

Kandinsky's three closest friends in *Der Blaue Reiter* movement were the painters Franz Marc (1880–1916), August Macke (1887–1914), and Paul Klee (1879–1940). Like Kandinsky, each man was committed to search for the spiritual behind the material, for a higher reality within or above the physical plane. These artists looked to the imaginative art of tribal peoples and children, naive folk art, and the innocent lives of animals and plants for soulful, wise imagery that would break the conventional bonds of the academic painting of the day. Macke framed the issue: "Are not the children who construct directly from the secrets of their emotions more creative than the imitators of Greek form? Are not the savage artists, who have their own form, strong as the form of thunder?"

Klee and Psychic Improvisation The Swiss-German Paul Klee held children's art in especially high esteem. He loved its spontaneous expressiveness and uninhibited inventiveness. He longed to see and represent like a child or a primitive, to paint "as though newborn, knowing absolutely nothing about Europe; ignoring facts and fashions, to be almost primitive." Yet no child or tribal person could have created Klee's work. His little pieces combine whimsical fantasy with continental sophistication and studious technique.

In three decades of painting, Klee gave ever greater sway to freely creative expression, what he called "psychic improvisation." Recognizable figures and objects inhabit his little worlds, but physical reality is left ever farther behind. Nature, Klee wrote, was to be

17.8 PAUL KLEE. *The Battle Scene from the Fantastic Comic Opera "Sinbad the Sailor."* 1923. Watercolor. 15 × 20⅛ in. Privatbesitz Dürst, Muttenz, Switzerland.

abstracted or "deformed" so that a second, higher nature might be born. How did this transformation, this begetting of a more profound "nature reborn," take place? To answer this question, let us consider his work *The Battle Scene from the Fantastic Comic Opera "Sinbad the Sailor"* **(17.8),** painted during Klee's tenure at the Bauhaus. The transformative process began with actual nature, the objective reality we know through our senses. The raw material for *Sinbad* came initially from real life. The artist had seen fish and fishermen and had read stories of ocean voyages and sea battles. He had certainly read the fantastical adventures of Sinbad in the collection of Middle Eastern folk stories *A Thousand and One Nights.* Klee absorbed this "objective reality" into the "subjective reality" of his inner being. Over time, both story and life experiences were invested with emotional feeling, instinctual stimuli, and imaginative and dream imagery. Activated by some passing thought, memory, or observation or by the initial improvisatory strokes of brush on paper, this rich, complex brew of objective and subjective reality finally pushed upward, like sap rising through a tree. (Klee's chosen

metaphor for artistic creativity was the tree.) A marvelous crown of leaves and flowers—the work of art—soon blossomed for all to see.

Such psychic expression of impulse and imagery from deep within possessed a magical, spiritual quality for Klee and many other modern artists. Klee followed up this "inner need" to express himself with conscious mastery of line, color, and composition to capture the psychic content that had risen to the surface. The picture, "nature reborn," was made visible. From this grand synthesis of inner and outer nature, "of penetrating vision and intense depth of feeling," Klee believed, transcendent realities arose, "realities of art which help to lift life out of its mediocrity," artistic realities that "add more spirit to the seen" and "make secret visions visible."

In the amazing tale of Sinbad, three sea creatures with eyes of blazing red confront the intrepid mariner. A dark night of black multicolored squares frames the battle arena, stage center in this "fantastic comic opera," where all is lit up in a dramatic grid of phosphorescent blue. One creature has arched his back to attack. Calmly, Sinbad has thrust with his

The more horrifying this world becomes (as it is these days), the more art becomes abstract; while a world at peace produces realistic art.—Paul Klee, artist, statement on his art

17.9 PAUL CÉZANNE. *The House of the Hanged Man.* 1873. Oil on canvas. 32 × 25⅛ in. Musée d'Orsay, Paris. *In later works, Cézanne's landscapes became even more abstract. Does this painting look abstract or realistic to you? Or a combination of both?*

spear of brilliant reddish pink. Drops of blood fall from the cavernous mouth. The other two creatures, armored in pink, purple, and blue scales, look shocked. Before them, costumed in warm oranges with a fabulous hat on his head, our adventurer stands poised to strike again. What an extraordinary "deformation" of original nature has taken place!

FORMALIST ABSTRACTION: TOWARD AN ART OF SIGNIFICANT FORM

By the turn of the twentieth century, numerous avant-garde artists and theorists were arguing for "the independence" and "the autonomy" of art. What they meant was the independence and autonomy of art from the centuries-old Renaissance tradition of imitating external reality. Photography, many of them claimed, now fulfilled the imitative function perfectly, and it was time for painters and sculptors to move on to other challenges. Klee perhaps put it best: "Art does not reproduce the visible; rather, it makes visible." The purpose of modern art was no longer imitation but creation. Whatever their purpose or style—and the range was extraordinary—vanguard painters and sculptors across the board sought an art "pure" and "free" from the constraints of *mimesis*. Illustrating stories or reproducing the look of external reality was considered a thing of the past. Modern art would instead devote itself to making visible subjective expression or imaginative thought or to bringing into being "significant form."

The concept of significant form had grown out of the modernist shift in focus from subject matter to the "abstract" properties of line, color, shape, and composition. By concentrating on the work's formal qualities, some artists believed, an excitingly autonomous world of

color, shape, and design could be revealed. There was a marvelous pristine freshness in the process of lifting everything above the real, fauvist André Derain declared. This was heady stuff indeed. In a world in which traditional religions had lost their hold on the intelligentsia, the pursuit of an abstract realm of significant form "above the real" began to take on the character of a religious quest. For many vanguard artists, modern art took on the purposes and language of religion. Artists and writers spoke of an "aesthetic experience" beyond ordinary, daily experience that awaited those sensitive souls receptive to the power of abstract form.

In the years around 1905, Matisse and the Fauves had forcefully liberated art from the bounds of realism, pushing painting toward formal purity and abstraction. But it would remain for the **cubists,** centered in Paris, to complete the breakthrough into formalist abstraction. This they did in the seven bountiful years between 1907 and 1914.

Cubism: Braque and Picasso

At the heart of the cubist enterprise were two artists, Spaniard Pablo Picasso (1881–1973) and Frenchman Georges Braque (1882–1963). Inspired by Cézanne's emphasis on the formal architecture of each painting and his conceptual attempt "to treat nature by the cylinder, the sphere, the cone," Picasso and Braque moved steadily in their art from perceptual to conceptual concerns. An art of the senses was replaced by an art of the mind. As Picasso put it, "I paint forms as I think them, not as I see them." As conception superseded perception as the basis of cubist paintings, the entire 500-year-old Renaissance tradition was undermined.

Comparing Cézanne's precubist *House of the Hanged Man* **(17.9)** with Braque's more thoroughly cubist *Houses at L'Estaque* **(17.10)** shows how far the movement toward abstraction had come in several decades. While the houses and trees in Cézanne's painting are mildly realistic, those in Braque's painting have been simplified into schematic geometric shapes. The illusion of deep, realistic space, already reduced in Cézanne's painting, has given way in Braque's work to a shallow "cubist" space in which only

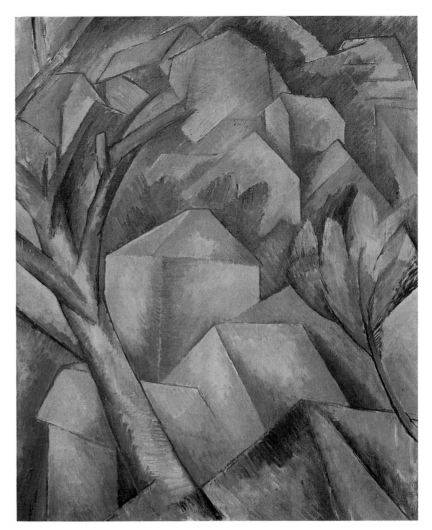

17.10 GEORGES BRAQUE. *Houses at L'Estaque.* 1908. Oil on canvas. 28½ × 23 in. Kunstmuseum, Bern. Hermann and Margrit Rupf Foundation.

the overlapping of forms conveys any sense of depth. Such antinaturalistic flatness reflected the evolving cubist idea of space as abstract and autonomous: Artistic space had a life of its own independent of the actual space of the real world. The colors of Braque's houses and trees still bear a vague resemblance to those of nature—Cézanne's colors are somewhat more naturalistic—but they are beginning to move from natural hues and values to ones created in the artist's mind. Braque's shading, for example, follows no perceptually based order; it is impossible to tell where the source of light is located. In *Houses at L'Estaque,* all the formal elements—color, shape, and space—begin to have an aesthetic life of their own, one independent of the physical world. Viewing Braque's paintings of

this period, the contemporary critic Louis Vauxcelles commented:

> The upsetting example of Picasso and Derain has hardened him. Perhaps also, the style of Cézanne and the remembrances of the static art of the Egyptians have obsessed him excessively.
>
> He constructs deformed metallic men of a terrible simplification. He is contemptuous of form, reduces everything, sites and figures and houses, to geometric schemas, to cubes.[3]

Perceptive in his views but conservative in his judgment, the distinguished Vauxcelles thus helped "cubism" to its lasting name. (Recall that several years earlier the same critic had given "fauvism" its title.)

Analytic Cubism The "terrible simplification" and geometric deformation that Vauxcelles decried was not to stop. Spurred on by works of traditional African and Oceanic art, newly arrived in Europe, Braque and Picasso pushed toward ever greater degrees of abstraction. Far more radically "cubistic" still lifes and portraits would be created by Braque and Picasso in the period between 1910 and 1912. Some of these so-called **analytic cubist** paintings were so abstract that they seemingly were totally nonfigurative or nonobjective; that is, they appeared to go beyond the representation of recognizable figures or objects altogether. Yet if we look closely at Braque's *The Portuguese* **(17.11)**, a classic example of analytic cubism, bits and pieces of objects meet the eye. It is as if the objects, geometrized and abstracted from life, have been taken apart, "analyzed," and creatively reassembled according to the artist's imagination. In *The Portuguese*, a highly abstracted musician stands or sits before us, a guitar under his arm. "Where is the guitar?" a confused viewer might ask. Looking hard, we locate the guitar's sound hole, crossed by four strings, in the center of the painting about three-quarters of the way down. Curving black lines that do not meet suggest the guitar's body, while a barely discernible rectangular shape to the left hints at the instrument's neck. Additional curving lines and forms around this central image seem to echo the basic guitar shape. Is Braque showing us the instrument as seen from different angles, as many writers maintain? Is he presenting us with a multiplicity or simultaneity of views? Such a painting

[The finest minds] are concerned only with lines and colors, their relations and quantities and qualities; but from these they win an [aesthetic] emotion more profound and far more sublime than any that can be given by the [realistic] depiction of facts and ideas. . . .

—Clive Bell, art critic, *Art*, 1913

makes demands of the viewer. We are required to put the pieces together, to bring closure to a multifaceted image. We must also search for the head and body of the Portuguese guitarist, because they too are composed of geometrical fragments. After some effort, we discover the head and torso centrally located in the upper half of the painting. The face of the musician appears in silhouette looking left. It fits neatly within the borders of a larger, triangular form that expands outward and downward from the painting's top edge.

An analytic cubist painting like *The Portuguese*, with its fractured shapes, flattened space, and monochrome color, leaves perceptual reality far behind. While still greater abstraction—total abstraction—might have been attained, Braque and Picasso were not interested in going that far. They desired to remain in touch, even if barely, with the real world. To this end they used words, numbers, letters, and signs in their paintings as anchors to reality. In *The Portuguese*, the stenciled word *Bal* ("the dance") and the numbers "10.40," the total of a bar bill, connect us to the reality of the dance hall where the Portuguese musician played and where customers danced, drank, and paid their tabs. The inclusion of such signs and symbols was an original contribution of Braque to the cubist movement.

Synthetic Cubism Braque and Picasso completed their most abstract paintings by 1912. From that year on, the fragmented forms of analytic cubism began to combine and coalesce—to "synthesize"—into objects that were more clearly delineated and recognizable. The analyzed fragments were reassembled into a synthetic whole. The basic objective was to "rehumanize" the picture by synthesizing the abstract and the real into a visual poetry. The resulting **synthetic cubist** style, with its more unified representations, was the second great phase of the cubist movement. Ultimately, it would become the dominant cubist style of the twentieth century, and its influence would extend throughout the fine and popular arts. A detail from Picasso's large political protest painting *Guernica* (11.3) and the works of Americans Aaron Douglas (18.7), Jacob Lawrence (18.8), and Romare Bearden (Appreciation 35) employ the synthetic cubist language.

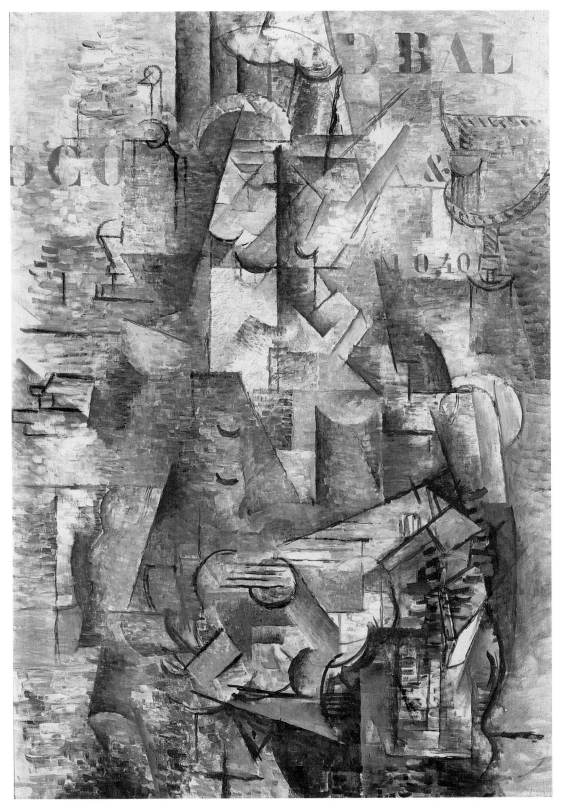

17.11 GEORGES BRAQUE. *The Portuguese*. 1911–12. Oil on canvas. 46 × 32 in. Kunstmuseum Basel, Gift of Raoul La Roche, 1952.

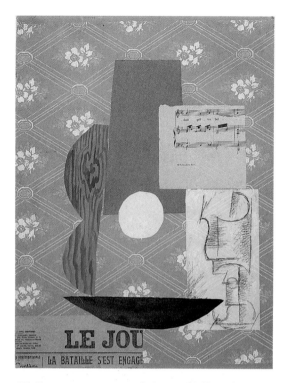

17.12 PABLO PICASSO. *Guitar and Wine Glass.* 1912. Collage and charcoal. 18⅞ × 14¾ in. Collection of the McNay Art Museum, Bequest of Marion Koogler McNay. © 2001 Estate of Pablo Picasso/Artists Rights Society (ARS), New York.

The introduction of **collage** into Braque's and Picasso's easel paintings around 1912, an innovation credited to Picasso, helped bring about the synthetic style by returning identifiable imagery to the artworks. Picasso's engaging *Guitar and Wineglass* **(17.12),** made mainly of pasted paper, shows how the technique of collage was initially employed and provides an early example of synthetic cubism. With the exception of the wineglass in the lower right, drawn in charcoal in the earlier analytic cubist style, this work exemplifies the greater integrity and wholeness now granted to objects. The guitar, easily seen, is composed of four cut pieces of paper, with the wallpaper pattern of the background serving to complete the body. Compared to the highly abstract paintings of the analytic cubist period, so difficult to comprehend and enjoy, *Guitar and Wineglass* is charming in its simplicity. It is a lighthearted, sensuous work, with Picasso playing the jester. A torn piece of sheet music is comically attached to the neck of the guitar as if to say

"This pasted-down guitar makes, and is made of, music!" A piece of handpainted paper simulating commercial, mass-produced woodgrain veneer ironically makes up part of the instrument's body. "Ah," the viewer might think, "here is an imaginary guitar made of imaginary wood that is supposed to suggest the real material." It is visual tongue-in-cheek humor in action. Picasso has created from his fertile imagination a world that synthesizes the abstract and the real, a world that does not imitate but rather, with human warmth, evokes the shapes, textures, words, melodies, and collagelike character of daily life. Collage would become a tremendously popular medium in the twentieth century, serving diverse artists in numerous ways.

Cubist Sculpture Collage was not Picasso's only major innovation from the period around 1912, however. Ceaselessly creative, Picasso made a revolutionary breakthrough in the art form of sculpture, opening up immense realms of possibility. Picasso's 1912 *Guitar* **(17.13)** advanced the art form in three important ways. In one fell swoop, the Spaniard's sculpture pointed the way to new materials, new methods of construction, and a whole new conceptual definition of sculpture.

Picasso's use of "industrial" sheet metal and wire in *Guitar,* as opposed to traditional artistic materials such as marble, bronze, clay, and wood, directed artists to the materials most reflective of their time. Metal, iron, glass, and plastic were materials better suited for modern men and women living in the machine age. The making of *Guitar* was equally revolutionary. Picasso assembled or "constructed" his sculpture from separate pieces of cut metal. He did not use the customary methods of execution of past centuries, neither carving his subject from stone or wood nor modeling it in clay or wax and then casting it into bronze. He invented a new way of bringing sculpture into being, one that was taken up in short order by the Russian constructivists, the dadaists, and many others. Finally, *Guitar* proclaimed a new conception of what sculpture could be. By emphasizing open spaces within its thin metal walls, *Guitar* promoted "space" or "spatiality" as a new basis for modern sculpture. Sculpture in the Western tradition had customarily been defined by the convention of solid form or

"mass." All sculptures prior to Picasso's *Guitar*, from those of the ancient Egyptians and Greeks to those of the twentieth century, had been based on the concept of mass. Artists now began to give space, both within and around the object, principal consideration, a perspective aided by growing contact with non-Western art forms.

African and Oceanic Art in a European Context Picasso and Braque, Matisse and the Fauves, and the German expressionists were all influenced by African, Oceanic, and other non-Western art forms at the start of the twentieth century. (Recall that Oceanic art, from European colonies in the Pacific, had already influenced Gauguin (Appreciation 32) and the symbolists.) Picasso's boundary-breaking sculpture *Guitar* may well have been inspired by spatially open African masks (8.12), reliquary figures, or statuary. **Appreciation 33** discusses the specific influence of traditional African art on Picasso's 1907 breakthrough painting, *Les Demoiselles d'Avignon*. By the late nineteenth century, works of African art had begun to arrive in Europe and to be displayed in ethnography and art museums and in private collections, including those of vanguard artists. European colonization of Africa had put England, France, Germany, Belgium, Italy, and Portugal in control of most of the vast continent. Europeans subsequently traded for or seized African works of art and other products they deemed desirable. The largest single transfer of African art to Europe occurred in 1897, when a British punitive expeditionary force sacked and looted the capital city of Benin in West Africa. (Figure B in Appreciation 2 is a visualization of the event.) Masterworks of royal Benin art from across the centuries (8.24) were removed to England, where they became the centerpiece of the British Museum collection of African art. This European accumulation of African art, by both illegal and lawful means, influenced the course of Western modern art. Artists seeking new, nonconventional ways of seeing and creating, including Picasso, Braque, and Matisse, were inspired by the artworks of Africa and other non-Western cultures. Braque declared, "Negro masks . . . opened a new horizon for me." The European artists, to be sure, did not understand the cultural significance of the "Negro art" they so admired. They were moved by the formal abstract quality of the work and its conceptual way of representing reality. Numerous artists in Europe and the United States, including pioneering African-American artists such as Aaron Douglas (18.7), were influenced simultaneously by traditional African art and by the African-influenced abstraction of the major European modernists. Art throughout the world would become increasingly intercultural and hybrid in both its form and its content.

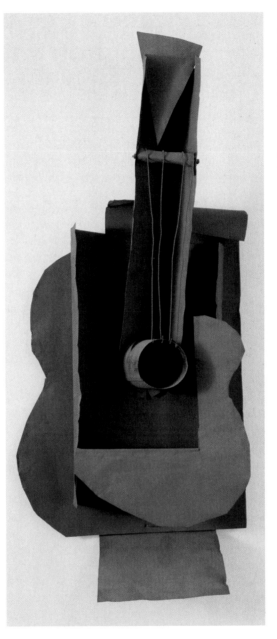

17.13 PABLO PICASSO. *Guitar*. Paris, 1912–13. Sheet metal and wire. 30½ × 13¾ × 7⅝ in. The Museum of Modern Art, New York. Gift of the artist (94.1971). *Compare this sculpture to the artist's collage of a guitar (17.12) from the same period. What is similar and what is different?*

[The young cubist artists] contemplate Egyptian, Negro, and Oceanic sculptures, meditate on various scientific works, and live in anticipation of a sublime art.
—Guillaume Apollinaire, French poet and writer, *The Cubist Painters*, 1913

Picasso's Les Demoiselles d'Avignon *and African Art*

JAY WILLIAMS

Just as Pablo Picasso is inevitably linked with cubism, so African art has been connected with Picasso's masterwork, *Les Demoiselles d'Avignon (The Women of Avignon)* **(Fig. A).** The completion of this canvas marked a turning point in the artist's career, after which he felt free to pursue more radical forms of abstraction. In the minds of many earlier scholars, Picasso was clearly influenced by "Negro art" *(l'art negre)*, a category invented in the colonial era, under which a great variety of "primitive" African [8.12] and Oceanic [8.11] art objects were often grouped. Picasso seems to have had little interest in the meaning of tribal art in its original context—knowing how a mask, for example, might have provided protection against witchcraft, sent a soul on its spiritual journey, or honored a deity.

Figure A PABLO PICASSO. *Les Demoiselles d'Avignon.* 1907. Oil on canvas. 96 × 92 in. The Museum of Modern Art, New York, acquired through the Lillie P. Bliss Bequest (333.1939). © 2002 Estate of Pablo Picasso/ Artists Rights Society (ARS), New York.

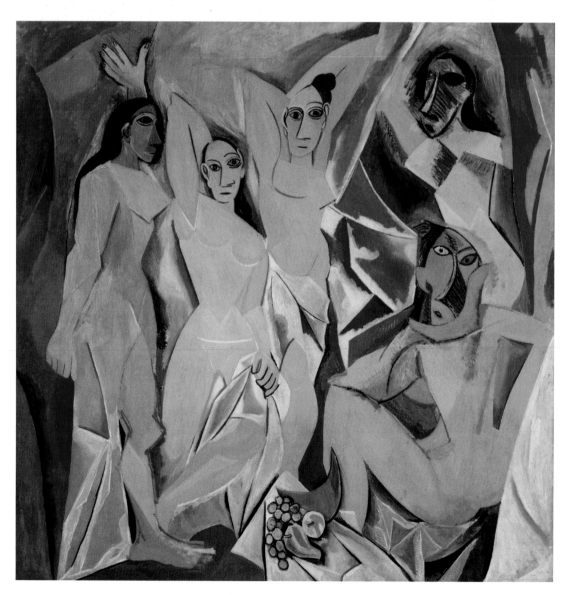

William Rubin, former curator of New York's Museum of Modern Art, considered the relationship of tribal art to the work of pioneering modern artists such as Picasso, Brancusi [8.5], and Matisse [17.2] in his 1984 exhibition "Primitivism in Twentieth-Century Art." Rubin wrote that he wanted to clear away "a variety of wrongheaded clichés" that "often overstated the direct influence of the tribal sculptors" on modern art. By the 1950s most scholars agreed that the two female figures in the right foreground of *Les Demoiselles* were formed under the influence of African masks. For example, Sam Hunter, professor of art and archaeology at Princeton University, wrote in 1956, "Their faces are painted in the style of garish and rather frightening African masks," adding a "raucous and barbaric note" to the painting.

While William Rubin claimed to be taking a fresh approach to this topic, he made curatorial decisions that detracted from the exhibition's effectiveness. European works by artists ranging from Gauguin and Matisse to Picasso and Giacometti [17.27] were installed alongside tribal art objects from Africa, Oceania, and North America, for the sake of comparison and discussion. Unfortunately, the implied relationship of the modern art to the "primitive" objects seemed condescending. As critic Marianna Torgovnick wrote, the exhibition said, essentially, "Here is the primitive instance; here is the masterwork, with the primitive absorbed and transcended."

Rubin's research actually succeeded in countering the fallacious view of *Les Demoiselles* perpetuated by some modernist art historians. After an astoundingly thorough investigation of the four types of African masks most frequently proposed as Picasso's prototypes, Rubin and his colleagues found that none of these masks were imported to French collections as early as 1907, the date of *Les Demoiselles*.

One of the few African objects known to have been available to Picasso was a kind of guardian figure **(Fig. B)** from the Ogowe River region in Gabon and the Congo. Produced by a group of closely related peoples collectively

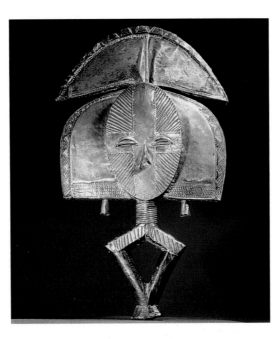

Figure B Kota reliquary figure. Nineteenth–twentieth century, Gabon. Wood, copper, and brass. Courtesy Entwistle Gallery, London.

known as the Kota, these copper or brass-clad wooden figures were attached to the lids of containers which housed the skulls of deceased ancestors. Picasso himself owned two of these reliquary figures. He might have also seen a fine Kota reliquary figure in the Trocadero ethnographic museum, forerunner of France's famous Musée de l'Homme.

Interested primarily in defying the Renaissance traditions of artistic representation upheld by the French academy, Picasso apparently never had a grasp of African culture. Picasso saw African objects as "magic things" like "weapons." He assumed that the African artists "were against everything—against unknown threatening spirits. . . . I too am against everything." The artist's attitude contrasts sharply with the traditions of African culture which address the emotional, social, and religious well-being of the community.

Ironically, these Kota reliquary figures are valued by contemporary African artists as part of a shared, pan-African cultural heritage, not because of their tribal function. Three of these powerful guardians were included in the Extinct Art section of the 1991 exhibition "Africa Explores," organized by the Center for African Art in New York City. Examining the impact of historical art on contemporary African artists, this exhibition showed that traditional art now inspires painters and sculptors across tribal and national boundaries as it once influenced Picasso. ■

Jay Williams is Chief Curator for Exhibitions at the McKissick Museum, the University of South Carolina, Columbia.

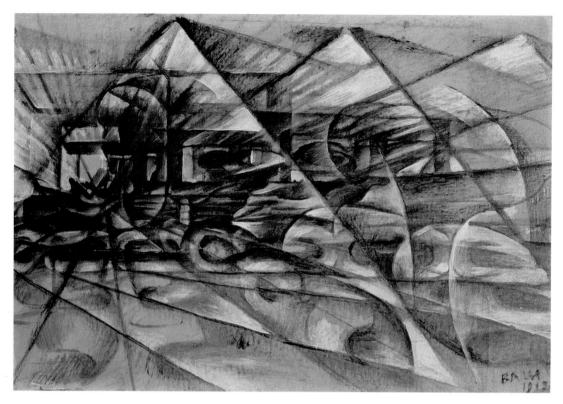

17.14 GIACOMO BALLA. *Speeding Automobile (or The Speed of an Automobile).* 1913. Oil on canvas. 23½ × 38¼ in. Civica Galleria d'Arte Moderna, Milan. © 2001 Artists Rights Society (ARS), New York/SIAE, Rome.

Varieties of Formalist Abstraction

Excited by the formal breakthroughs of Picasso and Braque, groups of vanguard artists across Europe employed the cubist language to capture the spirit of the industrial age. In countries from Holland to Russia, painters, sculptors, designers, and architects created distinct national styles within the broad stream of cubist-inspired formalist abstraction.

Italian Futurism In Italy, the artists known as **futurists** gave themselves, body and soul, to the brave new world of technological innovation. Violent in their likes and dislikes, the militant young futurists hated what they saw as Italy's stagnant social and cultural past. They longed to destroy all those obsolete paintings and sculptures that reeked of nature and of classical calm and order, all those museum "cemeteries" that housed worthless, outdated, "dead" art. In their view, the past only imprisoned. In their many writings, they associated it with "poison," "weariness," "decay," and "death." Past values and beliefs "exhausted, lessened, and trampled" the potentiality of modern, "living" humanity. The old books, artworks, and museums, the vessels and repositories of past culture, had to be burned. The ancient slate must be wiped clean. Only in

this way might a new world "nourished on fire, hatred, and speed" be born.

Poet F. T. Marinetti (1876–1944), the futurist leader and propagandist extraordinaire, called for a world of dynamism and fearless technological adventure with a vibrant modern art to match. "We declare," wrote Marinetti in the "Futurist Manifesto" of 1909, "that the splendor of the world has been enriched with a new form of beauty, the beauty of speed. A race-automobile adorned with great pipes like serpents with explosive breath . . . a race-automobile which seems to rush over exploding powder is more beautiful than the Victory of Samothrace [one of the most revered Greco-Roman sculptures]."

Speeding Automobile (**17.14**) by Giacomo Balla (1871–1958) makes Marinetti's exultant words visible. The immediate feeling is one of dynamism and speed. The powerful automobile is moving so fast that it has become a blur. Propulsive lines of force and energetic triangular shapes radiate from its center as the vehicle flies at high velocity toward and beyond the picture's left edge. The limited palette of burnt orange, black, and white and the fragmented imagery are reminiscent of analytic cubist paintings like Braque's *Portuguese*, but cubist paintings were never so fast-moving. Rather, the quality of blurred motion in *Speeding Automobile* is probably rooted in early cinema and,

more specifically, in sequential stop-action photographs (7.18) that capture in superimposed stages the movement of people or objects through space.

Of particular interest to contemporary viewers are Balla's perception and representation of speed circa 1913. He was obviously impressed with the speeds that automobiles, only recently mass-marketed, were capable of. Even to those who have watched modern race cars travel at 150 miles per hour or faster, Balla's car looks fast. It literally shoots across the picture. It is a car that hurls driver and spectator through the streets, tires scorching, at a death-defying clip, as Marinetti exclaimed, "break[ing] away from rationality as out of a horrible husk" so that "we give ourselves up" to the furious ecstasies of the mechanical "unknown." Yet if we look closely at Balla's automobile on the far left side of the painting, we see a square, boxlike affair with wooden-spoked wheels and big, bug-eyed headlights. It probably went no faster than 40 miles per hour! This irony aside, the futurists were prophetically in touch with the essential nature of the new urban, industrial society in which "all things move, all things run, all things are rapidly changing." As artists, they succeeded admirably in making the formal breakthroughs necessary to convey this technological world.

For Marinetti and his compatriots, the man fitting for the times—futurist man—must be fearless, violent, and, in today's terms, "macho." He had to be ready to destroy all that was old, weak, feminine, and conventional in order to clear the way for the new. With destruction seen in such a positive light, it was only natural that Marinetti glorified "war—the only true hygiene of the world—militarism, patriotism, the destructive gesture of the anarchist" (wild words from futurism's founder, but words that did not entirely overstate his real-life position, as he later became Minister of Culture to the Fascist dictator Mussolini). Futurist man must embody the power, force, and dynamism of the present. He was now a driver or a passenger in speeding automobiles and planes. On foot, he was a fast-moving pedestrian energized by the sights, smells, and sounds of the street. Futurist man—young, strong, and unstoppable—marched only forward, the embodiment of "our whirling life of steel, of pride,

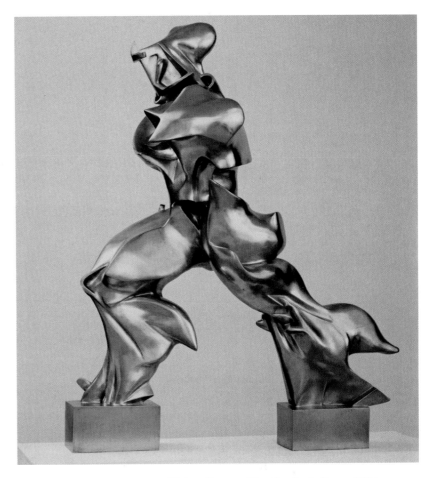

17.15 UMBERTO BOCCIONI. *Unique Forms of Continuity in Space.* 1913. Bronze. Height 43⅞ in. The Museum of Modern Art, New York. Acquired through the Lillie P. Bliss Bequest (231.1948). *At first glance, what type of social context do you think produced Italian futurist art: a strong, industrially advanced society or a weak, technologically backward one? Consider how sociocultural context impacts even artworks that are highly individualistic in style.*

of fever and of speed." So wrote the futurist painters, led by Umberto Boccioni (1882–1916), in their "Technical Manifesto" of 1910.

While speeding cyclists and motorists, dynamic soccer players and laborers, and violent soldiers and rioters served as the subjects of abstract futurist paintings, a sculpture by Boccioni provided the most memorable image of futurist man. *Unique Forms of Continuity in Space* **(17.15)** shows us a powerfully striding figure: part man, part machine, all energy. It makes an instructive comparison with Rodin's equally powerful but slower-moving *Walking Man* (16.40), conceived several decades earlier. The figure's right leg and left arm surge forward, their mighty sinews pushing through and opening out into the surrounding space.

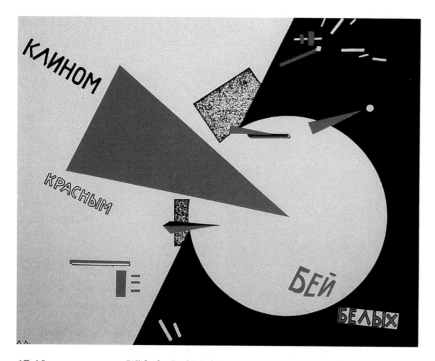

17.16 EL LISSITZKY. *With the Red Wedge Beat the Whites.* 1919. Poster/Colored lithograph. 24⁹⁄₁₆ × 20¼ in. Library of Congress, Gift of Gary Yanker.

The blur of motion seen in futurist paintings like *Speeding Automobile* is here replaced by winglike forms that seem to grow out of and flow behind the figure. Atop the massive, mobile torso is the control center of these "unique forms": the cranial lobe of the head, swept back but still organic in shape. The rest is all machine. The face of futurist man evokes the visage of a steam locomotive, armored car, or tank. The features are enginelike, with geometrical spaces opening into or out of the core. The "marvelous mathematical and geometrical elements that make up the objects of our time," Boccioni wrote, must characterize futurist sculpture. Futurist man would increasingly be required to give up human personality (face) for mechanical impersonality (force), thereby appropriating for himself the abstract essences of the machine age: energy, dynamism, exhilarating movement through space. Responding to the inhuman side of futurism, a student wrote:

> The gleam and glitter of the futurists' art is really scary when I look at it in context. Boccioni's *Unique Forms of Continuity in Space* bears absolutely no resemblance to any individual; it

is a faceless, voiceless figure whose primary purpose in life is to *move!* The Italian Fascists thought that was a pretty good model citizen. It fit with their desire to maintain a powerful state of faceless workers and soldiers in battle for world domination.

In 1914, a year after the creation of *Unique Forms of Continuity in Space*, Boccioni's joyous vision of futurist sculpture and futurist "machine-man" was dashed by the crushing devastation of World War I. Machines operated by men killed combatants and civilians in the millions. Europe was devastated. The sculptor, fighting with the Italian forces, was killed. But the influence of Boccioni's tradition-smashing sculptures, paintings, and writings outlasted the catastrophe. His works and those of his futurist colleagues inspired many others, among them the artists of revolutionary Russia.

Russian Constructivism Russian avant-garde artists, in alliance with the Communist vanguard led by political leaders Lenin and Trotsky, sought to build from the ruins of World War I and their own 1917 Bolshevik revolution an ideal classless society based on the marriage of humanity and industry. Many Russian artists in graphic design, painting, sculpture, architecture, and film were as excited as their futurist predecessors about creating an art appropriate to the industrial age, one befitting their cutting-edge society. Against artworks isolated in museums or private collections they championed an art that was present throughout society, "in the squares and on the streets . . . at the bench, at the table, at work, at rest, at play; on working days and holidays . . . at home and on the road. . . ."

The Russian **constructivist** artists of the teens and early twenties looked with much favor on the abstract language of the futurists and the cubists. Beyond its antibourgeois flavor, they also saw in abstraction a kind of universal language. Employing a vocabulary of nonrepresentational shapes, symbolic colors, and simple, spare text, a 1919 poster **(17.16)** by El Lissitzky (1890–1941) urges the revolutionary Communist forces ("the Reds") to beat their counterrevolutionary foes ("the Whites"). Appropriately, a dynamic red triangle pierces a white circle to the core, with smaller red triangles joining the successful attack. Unfortunately

for Lissitzky and the Russian avant-garde, abstract graphic design, painting, and sculpture were soon discouraged by revolutionary political councils who favored artworks that were more conventional in style and subject matter (for instance, realistic portraits of idealized worker-heroes and Communist leaders). Lacking jobs or commissions, prominent members of the Russian avant-garde, Lissitzky and Kandinsky (17.7) among them, began to leave Russia for the freer, more supportive environment of Central and Western Europe. Some went on to teach or lecture at the Bauhaus and at other major art schools.

In sculpture, the boundary-breaking works and ideas of futurism and cubism found a receptive audience in two young Russian brothers, Naum Gabo (1890–1977) and Anton Pevsner (1886–1962). In his futurist "Sculpture Manifesto," Boccioni had called for the use of modern materials: "transparent planes, glass, sheets of metal, wires . . . , cardboard, iron, cement . . . , cloth, mirrors, electric lights, etc., etc." Picasso had fashioned his cubist *Guitar* (17.13) from sheet metal and wire. Gabo and Pevsner assembled or "constructed" their works from the materials of industry—plastics, glass, steel, nylon thread—and used these materials more extensively than any had before them. Boccioni had written defiantly that the traditional criteria defining sculpture, notably enclosed form (mass) and stillness (stasis), were to be thrown on the garbage heap of the past. The Italian imagined a sculpture of open space, of "atmospheric planes that link and intersect things." Picasso's *Guitar* had moved in this direction of spatiality, but Gabo's *Column* **(17.17)** was truly a sculpture of transparent planes and open space.

Made of transparent plastic, wood, and metal, *Column* has the lightness, transparency, and geometrical lucidity admired by cubists, futurists, and Bauhaus architects and designers. About *Column*, created in 1923, Gabo said: "My works of this time, up to 1924 . . . are all in the search for an image which would fuse the sculptural element and the architectural element into one unit. I consider the *Column* the culmination of that search." Gabo's sculpture somewhat resembles an early model of a glass skyscraper **(17.18)** by the pioneering German Bauhaus architect Mies van der Rohe (10.36).

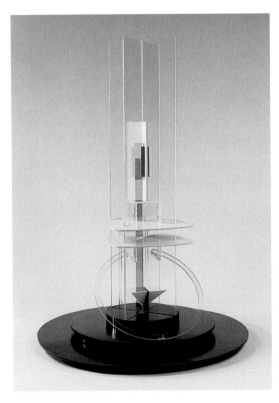

17.17 NAUM GABO. *Column.* Ca. 1923 (reconstructed 1937). Perspex, wood, metal, and glass. 41½ × 29 × 29 in. The Solomon R. Guggenheim Museum, New York.

This is not surprising, because Gabo indeed thought like an architect and engineer. Echoing Bauhaus director Walter Gropius, who saw architecture as the leading art in which all others could be synthesized, Gabo wrote that his constructive sculpture should keep pace with modern architecture, "the queen of all the arts," and guide it. He found it encouraging that modern architecture and product design, as evidenced in the creations of Mies, Gropius, and Breuer at the Bauhaus (9.26, 9.29), were following principles parallel to his own. Constructivist forms and ideas were finding a receptive home in what would become known in architecture and design circles as "international style," a worldwide movement that Gabo believed would powerfully energize "the whole edifice of our everyday existence."

Gabo left a rich legacy. Any sculptor who works in the newest industrial materials, who emphasizes space over mass, who works nonobjectively or architectonically, or who creates large-scale outdoor sculptures for public spaces owes a substantial debt to Gabo's pioneering efforts and to Russian constructivism in general.

17.18 LUDWIG MIES VAN DER ROHE. Model of a glass skyscaper. 1922. Photograph courtesy of Mies van der Rohe Archive, The Museum of Modern Art, New York.

Dutch **De Stijl** The intimate interplay between fine and applied art desired by Gabo and the constructivists was also central to the Dutch *De Stijl* movement. Founded in neutral Holland in 1917, the *De Stijl* ("the style") movement grew out of despair over World War I and idealistic hopes for a more enlightened future. Sickened by destruction and the societies that produced it, "believing themselves to be at the end of capitalist individualism and on the edge of a new, spiritualized world order," writes critic-historian Robert Hughes, the members of the *De Stijl* movement wanted to be international men, universalists unbound by personal ego and modernists unrestrained by the past. They hoped their paintings **(17.19)**, buildings, and graphic and product designs—all created in "the style" of rigorous geometric abstraction—would serve as models for the perfect harmony they believed possible both for individuals and for society as a whole. Through the international language of geometric form, their work would communicate across national boundaries. Truth, not beauty, wrote their leader, Theo van Doesburg (1883–1931), was their central concern. They would rise above the divisions in the world through adherence to universal truths. For a world in need, they would pioneer an art of ethical and spiritual mission.

Their charismatic ideas and their imagery—a pristine geometry of right angles with all nonessentials (for example, naturalistic references and decoration) cleared away—affected many, including the influential Bauhaus architects and designers. Together with the German Bauhaus and Russian constructivism, the Dutch *De Stijl* movement left a lasting imprint on the international modern style of architecture and design (9.26–9.29) that has so dominated the twentieth century.

For all its impact on the applied arts, however, the quintessential images of *De Stijl* came from a painter, Piet Mondrian (1872–1944). In his early development, Mondrian passed through fauvist and cubist stages before arriving, gradually and systematically, at the geometrical abstractions for which he is best known. His move from abstract versions of naturalistic forms—trees, piers, sea, and sky—to pure abstract forms was inspired as much by moral and spiritual concerns as by aesthetic ones. Coming from a devout Protestant background, Mondrian converted in 1909 to Theosophy, a mystical religion born in the last quarter of the nineteenth century. The basic thrust of Theosophy, which also influenced the symbolists and Kandinsky, was transcendence of the individual ego and worldly empirical knowledge as a means to promote spiritual insight into universal principles. This moral-spiritual goal of Theosophy became the generating center of Mondrian's artistic philosophy. The painter's numerous writings about his art are filled with phrases that emphasize his spiritual quest. He sought to experience and make visible "universal beauty," "universal expression," "universal laws," "eternal truths," and "the fundamental law of dynamic equilibrium."

How was the modern, nonfigurative artist to give physical or "plastic" form to these spiritual truths? To begin, the purest, most ideal forms were necessary. For these the artist turned to the abstract shapes of geometry: the rectangle and the square. What Mondrian sought was "the clarity and simplicity of neutral forms," forms that could rise above the limitations of particularity and individuality. For color he reduced his palette to the basics—the three primaries plus black, white, and gray—in order to bypass references to the natural world. He applied these colors to the

canvas in flat, uniform areas to avoid any hint of three-dimensional depth. A nonnaturalistic, "spiritual" space was thus achieved. Black horizontal and vertical lines divide the colored rectangles and squares from each other. Compositionally, the several elements are organized in asymmetrical configurations that simultaneously convey vitality and balance, creating a "dynamic equilibrium."

Of Mondrian's 1928 *Composition* (17.19), Bauhaus instructor Johannes Itten (1888–1967) wrote:

> Mondrian can create a stable equilibrium with a small blue area and a large white area, or intensify the whole with a slender horizontal yellow area at the bottom. Great stability and clarity are achieved by dividing the field with broad black lines. The separating black causes each color to appear isolated and concrete. . . . His feeling for clean design leads him to an unadorned, visually strong, geometrical, elemental realism of form and color.[4]

The final image of "pure plastic form," Itten concludes, rises beyond the natural world to the spirit of the abstract.

ART OF THE IRRATIONAL: DADA AND SURREALISM

Just as diverse streams are present within expressionism and formalist abstraction, so too are a variety of directions apparent within **dada,** the anarchic international movement that arose in response to World War I. By 1924, many of dada's ideas, approaches, and participants had been absorbed into a new countercultural movement, **surrealism.** The leader of the surrealist movement, French poet André Breton, was himself a former dadaist. Like dadaism, surrealism's appeal and influence were worldwide and longlasting.

Dada Directions

With a name fittingly derived from a nonsense word, dada was a countercultural movement that stood for freedom, "nonrational" creativity, and rebellious nonconformity. Committed to absolute freedom and everything that was antibourgeois, dada art and activities tended to follow discrete tendencies in different countries

17.19 PIET MONDRIAN. *Composition in Red, Yellow, and Blue.* 1928. Oil on wood. 17⁹⁄₁₆ × 17⁹⁄₁₆ in. Wilhelm-Hack Museum, Ludwigshafen, Germany. *Many once-controversial artworks or styles are later absorbed into mainstream society through applied-art versions in fashion, graphic, product, and interior design. Mondrian-like, De Stijl art was popular in the fashion world in the 1960s, almost half a century after its inception. Cite examples of specific vanguard artworks or styles that are now a fixture in mainstream culture, from shopping bags to T-shirts.*

and cities. For example, the creations of Marcel Duchamp (1887–1968), the premier figure of Paris and New York dada, emphasized the movement's intellectual and aesthetic side. In contrast, the output of the Berlin dadaists like Hannah Hoch (1889–1978) and John Heartfield (1891–1968) was emotional in tone and political in intent.

Duchamp and Intellectual Dada By 1917, Duchamp, a successful vanguard painter in the cubist and futurist styles (18.4), had begun to devote much of his energy to acts of aesthetic rebellion and provocation of the art establishment. One of the most infamous of these acts was his showing of a common urinal in a public art exhibition. He titled the fixture *Fountain* and signed it "R. Mutt" **(17.20).**

17.20 MARCEL DUCHAMP. *Fountain* (second version). 1917. Readymade: glazed sanitary china and black paint. 12 × 15 × 18 in. The Philadelphia Museum of Art. Gift (by exchange) of Mrs. Herbert Cameron Morris. © 2002 Artists Rights Society (ARS), New York/ADAGP, Paris/Estate of Marcel Duchamp.

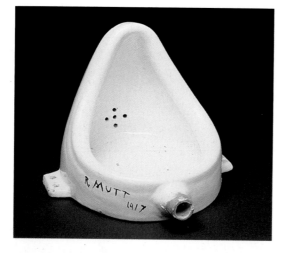

Intellectually, Duchamp was challenging the art establishment to battle. Placing a ready-made object in the art exhibition raised a variety of aesthetic issues. Viewers were aghast. Nothing like Duchamp's *Fountain* had ever been shown in an art exhibit! Was the urinal to be taken seriously and considered "art" because of its visual form, or was R. Mutt's urinal nonart? Antiart? All a big joke? Duchamp had everybody guessing—or riled up. Duchamp's work, intellectual Dada at its best, continues to provoke debate. Is *Fountain* "art" simply because Duchamp, an established artist, selected it and put it in the show? Does it continue to be art because art historians and museum curators say it's art? Is it the bold originality of Duchamp's thinking that makes *Fountain* art? Was Duchamp saying that mass-produced industrial products possessed a beauty equal or superior to works of fine art? Was he saying that the distinction between fine and applied art should be dispensed with? Ever enigmatic, Duchamp refused to supply specific answers to these questions.

We do know that Duchamp espoused an art that provoked and made viewers think, an art in the "service of the mind," as he said. He called for art to turn to "an intellectual expression, rather than to an animal [that is, physical or sensuous] expression." The idea that artists were simply instinctual, emotional creators disturbed him. He stood for the artist as aesthetic challenger and cultural provocateur, preferring art that functioned as a "cerebral pistol shot." Of Duchamp, a student wrote in his journal:

> Duchamp had obviously become disillusioned with the world and sought its destruction, throwing down everything the West held dear except pure existence. His art makes sense when viewed in the context of the First World War. In the wake of the blazing technological and economic development of Western nations, many Westerners were ablaze with pride and hope. But between 1914 and 1918, WWI brought their expectations down to ground zero, and people were confused. Although they might not have realized it, Duchamp's work was the logical conclusion of such frustration. Duchamp's work was bold in that it defied barriers, fallbacks, and universal truths. Art was valuable because it existed—that's it. Like the existential philosophers who could be assured of nothing except the fact that they existed,

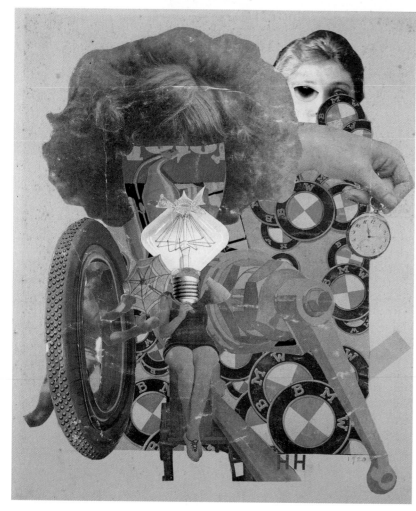

17.21 HANNAH HÖCH. *Pretty Girl* (Das Schöne Mädchen). 1920. Photocollage. 13½ × 11½ in. Private Collection, Hamburg, Germany. *Some writers believe that collage might be the art medium that best captures the complexity and multiplicity of our contemporary culture. Can you see how collage—the bringing together of disparate subjects, materials, and forms in a single composition—is commonly employed in photomontage (17.22), advertisements, film, and television?*

Duchamp's work was sure of nothing except that it existed, and was to be embraced as art solely for that reason.

With Duchamp and his American friend Man Ray in the forefront, Paris and New York dada was characterized by intellectual iconoclasm and irreverent wit, as seen in Man Ray's photomontage in which his nude model's shapely back and hips take on the appearance of a violin (7.28).

Berlin's Political Dada Berlin dada, in contrast, was hotly emotional and political. Its anticultural nihilism was more desperate, its anarchy more urgent. By the end of World War I, its intentions were socially activist, even revolutionary. Berlin dada was more a bitter cry in the wilderness than a playful protest against art establishment conventions. "Dada," as one of its founders, Romanian poet Tristan Tzara, asserted, was born not "of art, but of disgust."

The German dadaists were disgusted with the bourgeois society whose nationalism, materialism, and misguided rationalism had brought the countries of the world into a brutal, senseless war. Millions had been killed or maimed by the machines of industry and the military men who wielded them. In this bloodiest of wars, the once great hopes of the Industrial Revolution and scientific progress had been smashed. Hundreds of thousands of civilians were homeless or starving. For these reasons, Berlin dadaists felt compelled to make dada more socially relevant. To them dada had to consist of more than free experimentation and anarchic gestures, more than modern artworks hanging on gallery walls. The devastating conditions of postwar Germany demanded that Berlin dada change its course. Art, wrote Richard Huelsenbeck, must provoke, incite, and serve the revolutionary working-class proletariat in "the voluntary destruction of the bourgeois world of ideas." Despite the fact that a large-scale Communist revolt had been brutally suppressed in Germany in 1919, the Berlin dadaists were not silenced. They continued to hope for and work toward future revolution.

Through their paintings, collages (3.15), photomontages, objects, and actions, John Heartfield, Hannah Höch, Raoul Hausmann (1886–1971), and George Grosz (1893–1959)

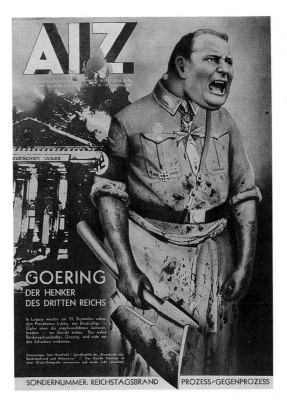

17.22 JOHN HEART-FIELD. *Goering the Executioner of the Third Reich.* From AIZ. XII.36. 1933. Rotogravure on newsprint from original photomontage. 15¼ × 11⅛ in. Published by the German Workers Party, 9/14/1933, The Museum of Fine Arts, Houston. Museum purchase with funds provided by Isabel and Max Herzstein.

sought to bring down the ruling order. Höch's 1920 photocollage *Pretty Girl* **(17.21)** challenged both capitalism and patriarchy and set the stage for all subsequent feminist photo art critiques (7.43, 7.47) of the social order. With biting humor, it shows a sexy, scantily clad machine-woman, a construction of patriarchal society, advertising German consumer products and keeping the economy running like clockwork. John Heartfield created photomontages that also hit hard at both militarists and capitalists. A decade later, these photomontages reached their shrieking peak in reviling and dissecting the Fascist beast of Nazism **(17.22).** An ex-soldier, Heartfield continued to wear his uniform, in a wretchedly dirty and disgusting state, so as to dishonor it. The climax of the Berlin dada movement came at the International Dada Fair of 1920, where the group's works were spread about the room and the main object of attention was a dummy of a German officer, fitted with the head of a pig, hanging absurdly from the ceiling **(17.23).** Although the dada movement disintegrated during the early 1920s, the dada spirit, in both its political and its intellectual forms, resurfaced throughout the twentieth century in various guises (7.45, 8.37, 19.1–19.7).

Revolted by the butchery of the 1914 World War, we in Zurich devoted ourselves to the arts. While the guns rumbled in the distance, we sang, painted, made collages and wrote poems with all our might. We were seeking an art based on fundamentals, to cure the madness of the age, and a new order of things that would restore the balance of heaven and hell.
—Artist Jean Arp, artist, statement on Zurich dada, 1948

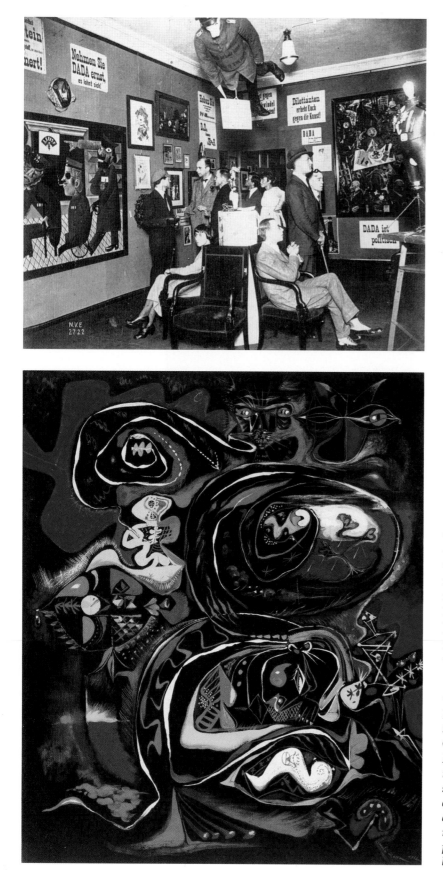

17.23 First International Dada Fair, Berlin. 1920. Photograph of dada artists taken in the gallery of Dr. Otto Burchard. Bildarchiv Preussischer Kulturbesitz, Berlin.

Surrealism and the Unconscious Mind

Much influenced by the pioneering psychological theories of Sigmund Freud, André Breton (1896–1966) called for a liberating "surrender to the Unconscious" and made it the central principle of the new countercultural surrealist movement. By integrating the unconscious and conscious life-worlds, Breton believed, a wondrous superreality or "surreality" might be attained. All of the arts—literary, visual, dramatic, and cinematic—might serve as instruments of exploration and revelation in this grand quest. In his 1924 "Surrealist Manifesto," Breton wrote, "I believe in the future transformation of those two seemingly contradictory states, dream and reality, into a sort of absolute reality, or surreality, so to speak." He officially defined surrealism as "the belief in the superior reality of certain forms of association neglected heretofore; in the omnipotence of the dream and in the disinterested play of thought."

The pursuit of the dream and the free play of thought, rather than any specific aesthetic considerations, were the primary goals of the surrealist movement and preconditions for all artmaking activities. Freed from preconceived aesthetic strictures, surrealist artists created an outpouring of work so diverse in style and media as to defy categorization. Some paintings, for example, those by Frenchman André Masson (1896–1987), were highly abstract. Masson's art was spurred by what the surrealists called "psychic automatism," a kind of unchecked stream of consciousness wherein

17.24 ANDRÉ MASSON. *Meditation on an Oak Leaf.* 1942. Tempera, pastel, sand on canvas. 40 × 33 in. The Museum of Modern Art, New York. Given anonymously (84.1950). *In the spirit of Masson's* Meditation, *allow words, phrases, and extended sentences to spontaneously rise to your consciousness. Immediately write these down on a sheet of paper and keep writing, without any censoring or editing, until you have filled the entire page. The surrealists called this exercise "automatic writing." Its purpose was to liberate the unconscious mind and bring up creative material for their artworks.*

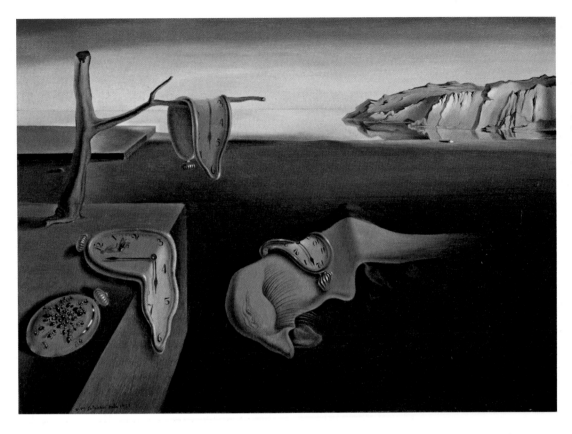

17.25 SALVADOR DALI. *The Persistence of Memory.* 1931. Oil on canvas. 9½ × 13 in. The Museum of Modern Art, New York. Given anonymously. Photograph © 2001 The Museum of Modern Art, New York. © 2001 Kingdom of Spain, Gala-Salvador Dalí Foundation/Artists Rights Society (ARS), New York.

the artist allowed dream imagery, instinctual impulses, and spontaneous thoughts to guide the initial creative process. The creative process in Masson's *Meditation on an Oak Leaf* **(17.24)** might be likened to the unfolding of a chain of associations around the theme of nature. Masson allowed the deepest impulses of his psyche—"subterranean forces," as he called them—to inspire his imagery. In *Meditation on an Oak Leaf,* we see a representation of nature in ceaseless metamorphosis. At the top left is a blue oak leaf, the supposed stimulus for the swirl of animal and plant life that fills the picture: a cat's head (top center), oak leaves of many sizes and colors, a miniature tree, cocoons, larvae, and other organic forms. Nature multiplies and divides before our eyes in a mix of freewheeling images given abstract shape and unity by the artist.

In contrast to the work of the "abstract surrealists," the art of certain surrealists was highly illusionistic and even employed the techniques of academic realism. The Spaniard Salvador Dalí (1904–1989), for example, defined his own extremely illusionistic paintings as "hand-done color 'photography' of 'concrete irrationality' and of the imaginative world in general." In *The Persistence of Memory* **(17.25),** watches melt or are eaten by hungry ants; time and memory are not "persistent"

but rather are rendered limp and lifeless by the forces of irrationality. Nor is Dalí himself—represented as the central fleshy form, with nose downward, tongue out, watch draped over his neck—in any way persistent. He lies expired, on his side, in the desert landscape. Similar to Dalí's art in form if not subject matter, the enigmatic paintings (2.8) of Belgian René Magritte (1898–1967) likewise employ traditional academic techniques to create illusionistic scenes drawn from the nonrational realms of imagination and dream. Mexican artist Frida Kahlo (1910–1954), creating a realist-surrealist style all her own, painted gripping self-portraits that bridge the gap between inner and outer reality **(Appreciation 34).**

Moving beyond traditional easel paintings and conventional sculpture, surrealist artists worked in a host of new media and "mixed media" forms that encompassed collage, "frottage" (rubbings), photomontage (7.28, 7.30), cinema (7.31), and much more. Three-dimensional surrealist work included "objects," found or manipulated; environmental works; fashion; theater; and demonstrations. Probably the most infamous surrealist "object" is *Luncheon in Fur* **(17.26)** by Swiss-German artist Meret Oppenheim (born 1913). Popularly known as the "Fur Cup," this simple wrapping

SURREALISM, n. Pure psychic automatism, by which it is intended to express, verbally, in writing, or by other means, the real process of thought. Thought's dictation, in the absence of all control exercised by the reason and outside of all aesthetic and moral preoccupations.
—André Breton, founder of surrealism, 1924

17.26 MERET OPPENHEIM. *Luncheon in Fur* (Le Déjeuner en Fourrure). 1936. Fur-covered cup, saucer, and spoon. Cup 4⅜ in. diam., saucer, 9⅜ in. diam.; spoon 8 in. long; overall height 2⅞ in. The Museum of Modern Art, New York. Purchase. Photograph © 2001 The Museum of Modern Art. © 2001 Artists Rights Society (ARS), New York/ProLitteris, Zürich.

17.27 ALBERTO GIACOMETTI. *The Palace at 4 A.M.* 1922–33. Construction in wood, glass, wire, and string. 25 × 28¼ × 15¾ in. The Museum of Modern Art, New York. Purchase.

We [the artist and his lover] used to construct a fantastic palace at night—days and nights had the same color, as if everything happened just before daybreak; throughout the whole time I never saw the sun—a very fragile palace of matchsticks.
—Alberto Giacometti, artist, statement on *The Palace at 4 A.M.*, 1932

numerous writers on art have appended wide-ranging sexual meanings to *Luncheon in Fur.* Art historians Hugh Honour and John Fleming note that Freudian symbolism (for example, a phallic spoon, a vaginal cup, fetishistic hair) pervades Oppenheim's object, fusing subliminally with the contradictory textures in an unforgettably libidinous way. Whether *Luncheon in Fur* can be interpreted in specific psychoanalytic ways is for the viewer to decide. However, it is fair to say that surrealist object-makers from Oppenheim to Man Ray to Salvador Dalí epitomize the movement's belief in "the marvelous," that state of almost sexual excitement that Breton called "convulsive beauty," which was available everywhere, lurking just below the skin of reality.

Pushing beyond sculpture's conventions of mass and solidity, Italian-Swiss artist Alberto Giacometti (1901–1966) communicates a sense of astonishment and the marvelous in his small construction of wood, glass, wire, and string titled *The Palace at 4 A.M.* **(17.27).** A houselike structure of radically open space, it evokes an airy lightness. Spatially and environmentally oriented sculptors of the future would be indebted to Giacometti's surrealist work. It points the way to the now popular environmental art forms that range in size from miniworlds like *The Palace at 4 A.M.* to large-scale structures or spaces that people can sit in or walk through (10.56, 8.43, 8.26, 3.16). As to the meaning of *The Palace at 4 A.M.*, Giacometti relates that the piece is a kind of nocturnal palace of the imagination, or dreamscape, that arose largely from his unconscious mind over an extended period of time.

> In the middle there rises the scaffolding of a tower, perhaps unfinished or, since its top has collapsed, perhaps also broken. On the other side there appeared the statue of a woman, in which I recognized my mother, just as she appeared in my earliest memories. . . . I can't say anything about the red [phallic] object in front of the board [with the ball near the bottom]; I identify it with myself.[5]

Surrealism as a public, unified movement thrived in the 1920s and 1930s, with numerous exhibits, publications, and public manifestations worldwide. Guest artists such as Picasso (17.12), Klee (17.8), and Calder (8.31, 2.16), whom the surrealists considered kindred spirits, exhibited in the surrealists' influential

of a porcelain cup, saucer, and spoon in animal fur radically transforms the normal meanings and sensations we associate with these "luncheon" implements. At the level of texture, hard industrial surfaces have been replaced by the softness and sensuality of fur. Yet even those who relish the feel of fur find the thought of eating or sipping from a soft, hairy spoon or drinking from a fur-covered cup unsettling. The viewer is simultaneously attracted and repelled. On one hand, we might desire to touch the soft, furry object; on the other, we reject its unsavory oral implications.

Given surrealism's preoccupation with Freud's psychoanalytic theory and its commitment to breaking bourgeois sexual taboos,

CREATE EXPRESSIONIST, ABSTRACT FORMALIST, AND SURREALIST VERSIONS OF THE SAME SUBJECT

Choose a single subject (for instance, a chair, box, book or CD cover, tree, mountain) and create expressionist, abstract formalist, and surrealist versions or "takeoffs" of it. Don't worry about technique. You don't have to be an experienced artist to successfully role-play one. Use whatever media and materials (pencil, chalk, paint, paper, cardboard, clay, found objects) you prefer. In your takeoff, focus on capturing the thoughts and feelings of an artist working within each of these three major movements. In the expressionist version, emphasize your personal emotions—such as joy, fear, or anger—and allow these to shape the work. In the formalist abstraction takeoff, reduce your subject to its visual essentials in terms of line, shape, color, and composition; at the same time, come up with a formally interesting creation. Finally, in your surrealist version, allow images from your imagination or dreams to transform your subject. A chair might sprout treelike roots or claws and grow a face reminiscent of a family member, a friend, or a foe. Do not censor your unconscious. Allow it to freely enter and animate your work.

shows. However, by 1940 the end of the movement was near. Driven out of Europe by the Nazis, many of the most important surrealists took refuge in America. Branded by the Nazis as "degenerates," "Bolsheviks," or "Jews," the surrealists, along with other "modern" artists, were forced into hiding or scattered abroad. A famous 1942 photograph of the group called "Artists in Exile" **(17.28),** taken on the occasion of an exhibition of their work in New York City, documents the flight of prominent surrealists (Breton and Ernst), cubists (Léger and Lipshitz), and nonobjective artists (Mondrian) to the United States.

Even though World War II brought the official surrealist movement to its conclusion, the surrealist spirit lives on. Beyond the realm of fine art, surrealism has been readily embraced by the cinema (7.32) as well as by the worlds of commercial and applied art. The strange, dramatic juxtapositions that astonished viewers of surrealist masterworks are now employed to grab the attention of consumers. Surrealist-inspired imagery is prevalent in pop music videos and on MTV; on album, cassette, and compact disc covers; and in television and magazine advertisements (6.18, 6.26). Surreal qualities can even be found in certain fashion, product, interior, and architectural designs. Ironically, Breton and the surrealist movement of the 1920s and 1930s did not succeed in sweeping away bourgeois society; rather, middle-class society, ever resilient and voracious, successfully appropriated surrealist

17.28 GEORGE PLATT. *Artists in Exile.* 1942. Photograph taken at the Pierre Matisse Gallery, New York. From left to right, first row: Matta Echaurren, Ossip Zadkine, Yves Tanguy, Max Ernst, Marc Chagall, Fernand Léger; second row: André Breton, Piet Mondrian, André Masson, Amédée Ozenfant, Jacques Lipchitz, Pavel Tchelitchew, Kurt Seligmann, Eugene Berman. The Museum of Modern Art, New York.

techniques and imagery and bent them to its own ends. Originally on the outside, surrealism and much of modern art **(Interaction Box)** have come to occupy center stage.

APPRECIATION 34 FRIDA KAHLO, *The Broken Column*

GEORGINA VALVERDE

I was introduced to the work of Frida Kahlo by one of my art teachers in college. It is a bit embarrassing to admit this, but in spite of my Mexican roots, I had not paid much attention to her before. Since then I have read her biography several times and pored over catalogues of her paintings. Through all this I feel I have learned much about my own self and my origins.

Given a penchant for the grotesque and shocking, I was powerfully drawn to Kahlo. Her biography seems to have been lifted out of one of those morbid, sensationalistic tabloids, the title reading something like this: "Woman impaled by metal railing in bus accident spends the rest of her life painting strange self-portraits." But there is more than plain goriness to her story, and, although Kahlo speaks for herself through her life and deeds, I hope I can convey some of the ways in which I have been touched by her personality and work.

The most impressive and inspiring aspect about her was her endurance in the face of tragedy. In a 1925 bus accident she was actually skewered by a rod which went through her upper spine and out through her vagina, crushing and tearing her right leg and foot as well. A triple fracture of the pelvis wrecked her dreams of ever having children. She began painting during the month she spent recovering at the Red Cross Hospital in Mexico City. It must have been a form of therapy, certainly one of the few things she could do while bedridden, and eventually a powerful reason to carry on.

A strong-willed individualist in a society that taught women to be passive, Kahlo was also somewhat of a daredevil in her art, as the following story illustrates. As soon as she was able to walk, she decided to consult with the renowned Mexican muralist Diego Rivera [1.8] to see "whether her paintings were worth

anything." She went to the site where he was working on a mural, summoned him down from the scaffolding, and asked him point-blank to judge her work. His response: "Go home, paint a painting, and next Sunday I will come and see it and tell you what I think." Three years later, in 1929, they were married.

Kahlo's paintings are small, jewel-like, meticulously rendered, and mostly shocking because of the intimate subject matter she chose to represent. She adopted the style of Mexican *retablos*, small narrative paintings which tell of hardships and misfortunes and are offered in gratitude to Christ, the Virgin, or a patron saint thought to have intervened mercifully in curing an illness or effecting miracles to overcome a tragedy. Her treatment and themes, although secular, make her paintings into personal *retablos*. They represent her personal martyrdom as she records her hospital stays, numerous operations, an abortion, and an amputation. She portrays herself in pain, but with such dignity and inner strength that the result is uplifting.

One of the most poignant examples of her work is *The Broken Column* **(Fig. A),** painted in 1944 following spinal surgery. (She underwent over thirty operations during the course of her life.) In this painting we see a suffering Frida standing in the center of the canvas. The figure is cropped at the groin area, which is covered by a white cloth held delicately by her fingers. A deep, bloody open wound starts under the chin and runs down the length of her naked body, revealing inside it a crumbling Ionic column. Nails of different sizes stud her flesh from head to toe, a feeble attempt to fix the tortured body. A cracked landscape of dusty green earth spreads out behind her, echoing Frida's own desolation. The only thing seemingly holding all this despair together is the white strap corset, but like the nails it too looks more like a Band-Aid applied too late to a body beyond repair. But Frida is not asking for pity. Her painting describes pain, and we want to grieve with her, but at the same time we are made aware of a powerful sense of balance

Georgina Valverde is an artist and language instructor who teaches English as a second language to Hispanic-Americans. She lives and works in Chicago.

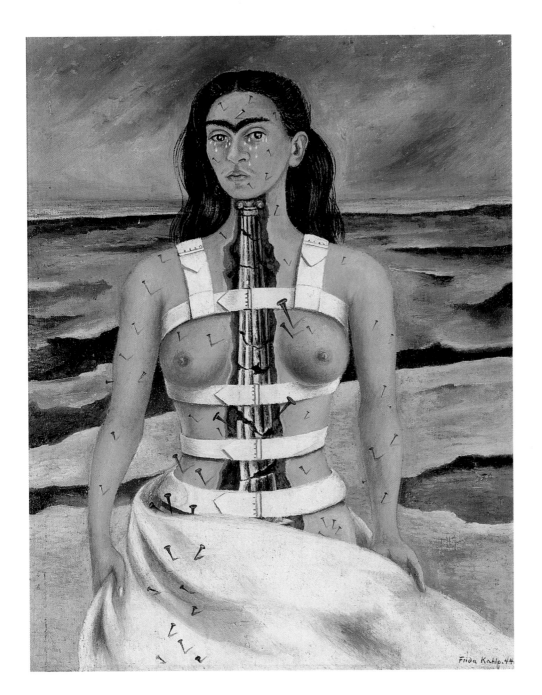

Figure A FRIDA KAHLO. *The Broken Column.* 1944. Oil on masonite. 15¾ × 12¼ in. Fundación Dolores Olmedo, Mexico City, Mexico.

and self-composure that transcends bodily sensations. The martyr-Frida stands erect and stoic, commanding the picture plane and the horizon beyond. Her tears stream down freely, but her expression remains unmoved. She seems to be saying, "I am this suffering body, but I am something more, something enduring and strong."

Not all of Kahlo's work deals with suffering. In fact, there is much celebration of life and its gifts as she mesmerizes the viewer with lovingly painted details of the natural world: flowers that radiate out into many fine tendrils, clinging vines that twist and twirl, ripe open fruits, mysterious monkeys, suns, moons, stars, leaves, and rain. When I see a Frida Kahlo painting I am reminded that to be alive consists of many experiences and that all have their worth whether sweet or bitter, tender or harsh, joyful or sad. Frida Kahlo knew this. By scrutinizing her pain, she lived courageously not in spite of it but because of it. ▪

545

18 Twentieth-Century American Art

REALISM TO ABSTRACTION

In our previous study of expressionism, formalist abstraction, and surrealism, our focus was on Europe, the birthplace of these major artistic directions. We now shift our attention to turn-of-the-century North America and a significant realist movement founded in the United States by Robert Henri, John Sloan, and their friends. As painters of modern life in the tradition of Courbet, Manet, Degas, and Cassatt, the circle of artists around Robert Henri found themselves at the cutting edge of American art. The straightforward realism to which they aspired had by now been well accepted in Europe. But North America was not Europe, and their own homegrown product met much resistance from a highly conservative art establishment.

ART IN AMERICA AT THE BEGINNING OF THE CENTURY

Though far behind the Europeans in terms of modernist developments, the art scene in the United States at the turn of the twentieth century was nonetheless pregnant with change. Certain American artists, including James McNeill Whistler (9.15) and Mary Cassatt (16.34), had emigrated to Europe decades before and had become leading participants in the vanguard movements. Along with others who had lived or studied in France,

England, and Germany, they shared advanced European ideas with a receptive, if small, group of forward-thinking North American artists. As the new century began, the pioneer American photographers Edward Steichen (7.20) and Alfred Stieglitz (7.21), with their close ties to the European vanguard, were a conduit for the most progressive thinking. Stieglitz's tiny Gallery 291 in New York, the *City of Ambition* **(18.1),** and his magazine *Camera Notes* brought the most up-to-date European artistic movements—cubism, futurism, and expressionism—to the attention of a small but enthusiastic public. This eager audience included future American modernists of note such as painter Georgia O'Keeffe (18.10) and dadaist-surrealist Man Ray (7.28). The first full-scale revolt against academic convention, however, came not from Americans looking to the European avant-garde for inspiration but from a handful of artistic realists proudly oriented to North American culture and society.

The Rise of American Realism

In the first decade of the century, the small group of American realists issued an aesthetic declaration of independence from the conservative Academies of Art and Design in Philadelphia, Chicago, and New York. Their modern-life realism emerged from a patriotic allegiance to the melting-pot cities and democratic ideals of the United States. Most of the contentious young painters, including Sloan, William Glackens, George Luks, and Everett Shinn, got their start as pictorial reporters for newspapers. From the beginning, they were artists of the street. If as young artists they turned their gaze to Europe, it was not to the subjectivist abstractions of the postimpressionists. Such formalist deviations from reality did not interest them. They looked instead to Europe's realist artists of modern life—that honored line stretching from Courbet (16.21) to Manet (16.27) and Degas (5.15). They considered these renowned European realists their comrades.

The leader of the American realist movement was the academically trained painter Robert Henri (1865–1929), who returned home from Europe in 1891 imbued with the ideas of realism and social reform. He ardently

18.1 ALFRED STIEGLITZ. *City of Ambition.* 1910. Photogravure. 13¼ × 10³⁄₁₆ in. © The Art Institute of Chicago. All Rights Reserved. *With the city's ferryboats and skyscrapers smoking away, this photograph conveys the raw energy and power of Manhattan Island, the commercial and cultural center of New York City. Through Manhattan passed the varied immigrant groups that settled the city and much of the nation. Notice the names and backgrounds of the artists in this chapter, and you will get a sense of the ethnic diversity that makes up America and its art.*

believed that art sprang from life and could in turn influence people's lives for the better. A humanitarian anarchist, Henri asserted that painting had an ethical and social mission, and young idealistic artists flocked to take classes in his studio, where independent, personal development was stressed. Henri's individual-centered approach represented a radical break with the educational approach

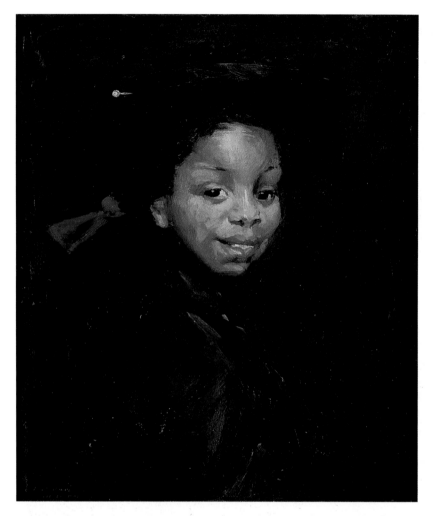

18.2 ROBERT HENRI. *Eva Green.* 1907. Oil on canvas. 24⅛ × 20¼ in. The Wichita Art Museum, Wichita, Kansas. The Roland P. Murdock Collection. *Observe how Henri applies his oil paint in very broad strokes, how the picture surface is vibrant with creamy texture, and how the bold chiaroscuro adds drama to the subject. In what ways is the artist's realism traditional or nontraditional in style?*

America's individuals: old and young, rich and poor, Native American, Hispanic, Asian-American, and African-American **(18.2).** As he put it, "[W]herever they may exist, the people through whom dignity of life is manifest . . . my interest is awakened and my impulse immediately is to tell about them through my own language—drawing and painting in color."

John Sloan (1871–1951), a member of Henri's circle, was also committed to democracy in both his art and his politics. Born in Pennsylvania, Sloan worked as a newspaper illustrator in Philadelphia and New York City before becoming a painter, thus continuing in the print media tradition of his great nineteenth-century predecessors Daumier (6.7) and Homer (6.8). Some of Sloan's finest drawings, created for the prominent socialist magazine *The Masses,* are lively, hard-hitting political commentaries. In his paintings, however, Sloan's overt protest gave way to seemingly straightforward pictures of modern life. Yet there was more to these paintings than simply documentation. In Sloan's pictures the commonplace is made notable and invested with warmth and poetic tenderness, with the lower classes and their environs accorded the same high respect earlier painters had showered upon mythological figures and regal subjects. It was in his love of everyday subject matter that Sloan's democratic and socialist principles shone through. His friend Henri put it best, observing that in Sloan's paintings of tenements, street scenes, and dusky saloons one experienced the artist's "demand for the rights of man, and his love of the people; his keen observation of the people's folly, his knowledge of their virtues. . . ."

Formally, many of Sloan's works, like Henri's, employ the broad, summarizing brushwork of Manet and the impressionists, with the paint applied with spontaneity and gusto. Yet, unlike the French artists, Sloan uses dark and smoky colors in his city scenes. His palette reflects the actual colors of American big-city life as well as the influence of Rembrandt, Daumier, and Courbet, the realist-humanist artists he so admired. Compositionally, Sloan's scenes tend to be informal and asymmetrical, actual slices from life. While he bristled against the camera, which eventually

of the Academies of Art and Design, which promoted narrow aesthetic standards based on "old masters" like Raphael (14.23) and Poussin (15.6) and practiced dogmatic methods of teaching that led to aesthetic conformism. To Henri's students, the teaching methods of the academies were dictatorial, in contrast to Henri's democratic approach. An influential artist, teacher, and promoter of exhibits independent of the academies, Henri was to American realism what Courbet had been to French realism fifty years earlier. Like the democratic socialist Courbet, Henri was an artist of the people, committed to telling the stories of all of

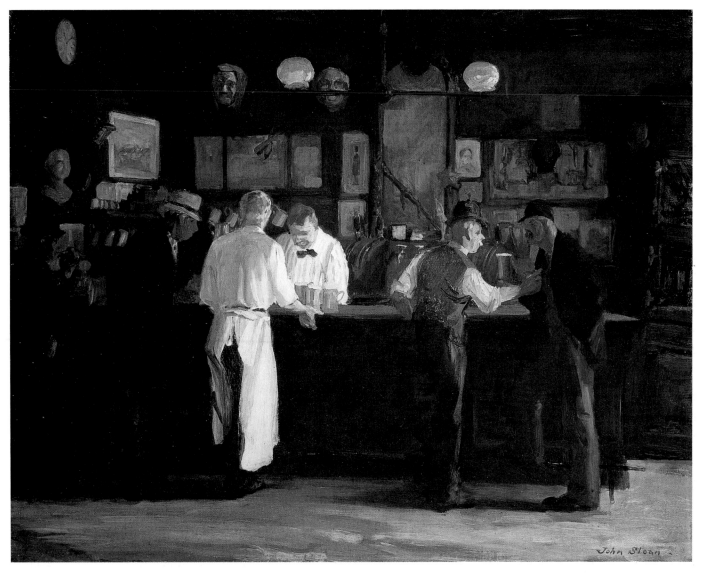

18.3 JOHN SLOAN. *McSorley's Bar.* 1912. Oil on canvas. 26 × 32 in. The Detroit Institute of Arts, Founders Society Purchase.

put newspaper illustrators like himself out of work, Sloan was probably influenced by photography's instantaneous images of city life. *McSorley's Bar* **(18.3),** which he called a "favorite out-of-the-way retreat for appreciative ale drinkers," captures a fleeting second in the life of the bar. Having taken visual notes like a good newspaper reporter, Sloan returned to his studio to record his vivid memories with painterly flourish. The result was the kind of rough-hewn painting conservative jurors of the New York Academy of Design tended to reject for inclusion in their annual exhibition on the grounds of ugliness or indecency. Hostile critics dubbed the painters of these works

"the Ashcan School" on account of their dingy subject matter and gritty realistic style.

Determined to reach the larger public on their own terms, Sloan, Henri, and their friends originated the idea of a group show of their own, a North American first. In the best democratic tradition, Sloan and Henri stood for "the giving of an opportunity for greater freedom in exhibitions." It was unfair, they maintained, for the academies with their conservative juries to decide for the entire public which art was praiseworthy and which unacceptable. Out of this modernist stance of artistic independence came the independent New York City exhibitions of "the Eight" (Henri,

Sloan, Glackens, Luks, Shinn, Arthur B. Davies, Ernest Lawson, and Maurice Prendergast) in 1908 and the New York Exhibition of Independent Artists in 1910. Coordinated by the artists of Henri's circle, both shows represented aesthetic democracy in action. For the first time, artists of diverse styles, from realism to impressionism to postimpressionism, exhibited together in the same room. The shows proved so popular with both artists and the public that the power of the academies was broken. Henceforth "anarchic individualism," what today we call pluralism, would reign. The two independent shows had created a new cultural climate supportive of experimentation. Both realists and abstractionists were the benefactors. The stage had been set for the so-called "ultramodern" art of Europe—postimpressionism, fauvism, cubism, futurism—to explode upon the North American scene. The contributions of Henri, Sloan, "the Eight," and the "Independent Artists" expanded U.S. culture by opening it to both the subject matter of modern life and the possibilities of modernist form.

The Armory Show

The "modern art" of the American realists, their independent exhibitions, and the missionary work of the avant-garde Stieglitz circle paved the way for the International Exhibition of Modern Art of 1913. The exhibition was organized by the painters Arthur Davies (an original member of "the Eight"), Walt Kuhn, and Walter Pach, a former student of Henri. Named for posterity by its New York City exhibition space, the Armory Show subsequently traveled to Chicago and Boston. It was a smashing success in terms of both controversy and attendance. The 1,600 works of painting and sculpture exhibited in the show were seen by more than 200,000 people on the three-city tour.

The Armory Show had been organized to teach the American public the historical development of European modernism. The show employed a sequential "historical" approach to exhibition organization that was ahead of its time, later to be appropriated by almost all museums of modern art. Upon entering the Armory building, visitors saw first early-nineteenth-century line portraits by Ingres (16.9), then canvases by the romantic master

Delacroix. They proceeded to the realism of Courbet and Manet and the colorful works of the impressionists. Works by the giants of postimpressionism—van Gogh, Gauguin, and Cézanne (16.35, 16.38, 16.39)—and the symbolist Redon followed. The visitor was thus prepared for the most modern works of all, those of the fauves, cubists, and futurists. In line with the expectations of the show's organizers, the most modern works bewildered almost everyone.

No work was more challenging than Marcel Duchamp's *Nude Descending a Staircase, No. 2* **(18.4)**, a painting in a cubist-futurist style. "Where is the nude?" many a shocked viewer asked. To aid the puzzled public, one newspaper printed a diagram locating the nude on the stairs. An art magazine offered ten dollars to anyone who could explain the picture. A major critic described the painting as "an explosion in a shingle factory." An astounded ex-President Theodore Roosevelt (1858–1919), writing sarcastically about "this naked man going downstairs," asserted, "There is in my bathroom a really good Navajo rug which, on any proper interpretation of the cubist theory, is a far more satisfactory and decorative picture." The cubists and other modernists would have agreed with Roosevelt's high regard for the formal qualities of his Navajo rug. They admired Native American (3.6) and other non-Western art forms (Appreciation 32, Figure B, Appreciation 33, Figure B) for their compelling abstract qualities.

Even sympathetic American artists such as Henri and Sloan were bowled over by the hundreds of avant-garde works in the Armory Show. Their own homegrown realism seemed very tame and even old-fashioned compared to the "ultramoderns," Sloan's term for the avant-gardists. His own *McSorley's Bar* certainly couldn't hold a candle to *Nude Descending a Staircase* in terms of innovation and abstraction. But to their credit Henri and Sloan accepted the achievements of the European vanguard, exposed their many students to the new directions, and encouraged their young charges to develop their own artistic directions from the full realm of possibilities. Many great artists, including the young Alexander Calder (8.31, 2.16), would be stimulated by Henri's and Sloan's classes.

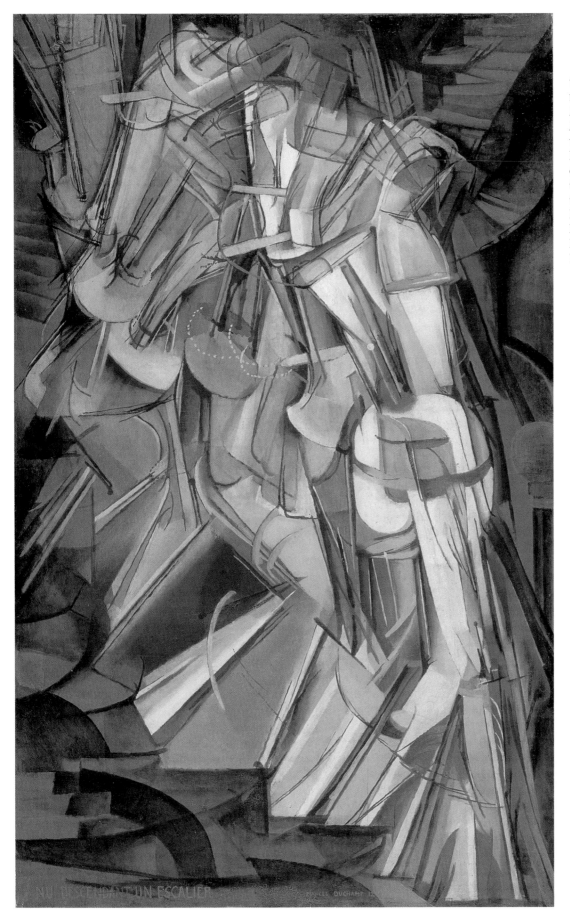

NU DESCENDANT UN ESCALIER

18.4 MARCEL DUCHAMP. *Nude Descending a Staircase, No. 2.* 1912. Oil on canvas. 58 × 35 in. The Philadelphia Museum of Art, Louise and Walter Arensberg Collection. © 2002 Artists Rights Society (ARS), New York/ADAGP, Paris/Estate of Marcel Duchamp.

THE GROWTH OF AN ORIGINAL AMERICAN ART: HOPPER TO O'KEEFFE

The substantial contributions of the Henri and Stieglitz circles and of the Armory Show laid a powerful cultural foundation for the rapid growth of American art. At the same time, the United States was emerging as a leading world power. With growing confidence, many Americans were now eager to push forward to the achievement of cultural as well as political and economic greatness. Learning from Europe's masters but also building on indigenous traditions, some of the finest North American artists who emerged in the first half of the century— Edward Hopper, Georgia O'Keeffe, Aaron Douglas, Jacob Lawrence, Romare Bearden, and Diego Rivera (1.8)—produced original syntheses of realism, expressionism, formalist abstraction, and surrealism. Artists were ready to move beyond a provincial "colonial" mentality, to break the tradition of looking to European culture for their models.

Edward Hopper

Edward Hopper (1882–1967), who had been educated both in the Henri circle and in Paris, emphasized the need for American artists to declare their independence from European artistic influence. Never denying the importance of European art, Hopper nonetheless believed in the value of an honest "native art" rooted in the rich soil of the American landscape and soul. Hopper's own stone-silent townscapes and cityscapes feature a sensitivity to a peculiarly northeast American light, shape, texture, and subject matter. At the same time, his formal compositional sense would have pleased Degas and Cézanne, two of his favorite painters. European influences notwithstanding, Hopper's paintings possess a distinctly American look and feel stemming, in part, from the artist's choice of subjects. Hopper's favorite subject, northeast American architecture, came already stamped, he noted, with "something native and distinct." His aim was to bring out those distinctive qualities. He did this by conveying a personal interpretation of his "most intimate impressions of nature." It was a grave mistake, Hopper asserted, to go too far in the European modernist direction of "invention of arbitrary and stylized design." Doing so would negate what made the scene truly "American," its realistic look and feel. In this sense, Hopper stood as a proud proponent of the realist tradition that had begun with Henri and "the Eight."

This is not to say that Hopper's realistic paintings are without their modernist side. A pronounced subjective element of personality always colors his work. Whereas Sloan's city scenes bustle with people and hum with social relationships (in part a reflection of Sloan's own outgoing personality and socialist political philosophy), Hopper's urban places are filled with silence. Even when he includes a figure or two, the mood remains one of solitude. The person remains isolated in his or her thoughts and feelings. The loneliness expressed in Hopper's paintings may be, in large part, a reflection of the artist's own reclusive nature. While he might not have consciously intended what he called "the loneliness thing," it was definitely there, and he admitted it.

Early Sunday Morning **(18.5)** combines Hopper's realist commitment with a modernist expressiveness and feeling for abstract design in an intimate portrayal of downtown storefronts. The result is a masterpiece with international appeal that at the same time communicates "something native and distinct" about North America. In the early 1980s the painting became a cultural icon. Reproduced on the cover of telephone directories throughout the United States, it became part of the collective consciousness of millions of Americans. The stores are closed; the people in the upstairs apartments are asleep. The street is deserted, a favorite Hopper state of affairs. But with the humans removed, the building, flooded in early morning sunlight, comes to life. The striped barber's poll and squat fire hydrant assert themselves as main characters. Areas of light and shade converse. Vibrant in the silence are Hopper's beloved "surprise[s] and accidents of nature": long morning shadows that streak across the pavement and building, sections of awnings that warm to the light while others recede into shade. Like musical variations on a theme, the large and small, vertical and horizontal rectangles of windows, doorways, buildings, and sky play off one another

If an apprenticeship to a master has been necessary, I think we have served it. . . . After all, we are not French and never can be and any attempt to be so is to deny our inheritance and to try to impose upon ourselves a character that can be nothing but a veneer upon the surface.

—Edward Hopper, artist, 1945

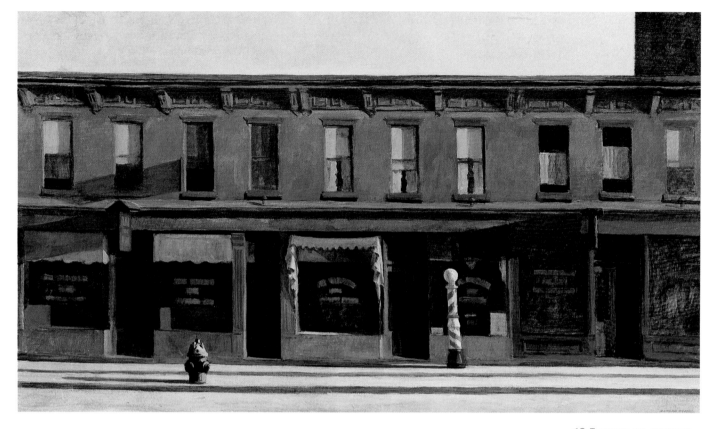

18.5 EDWARD HOPPER. *Early Sunday Morning.* 1930. Oil on canvas. 35³⁄₁₆ × 60¼ in. Whitney Museum of American Art, New York, Purchase, with funds from Gertrude Vanderbilt Whitney (31.426).

in a formalist "dynamic equilibrium." Here is a painting with roots in the New and Old Worlds but whose identity is uniquely American. Here is "nature seen through a temperament," a realism as complex and modern as the individual who created it.

Jacob Lawrence

The art of Jacob Lawrence (1917–2000) shows this same rich complexity. His personality and cultural heritage determine both his subject matter and his artistic style. Lawrence grew up during the Depression in New York City's Harlem, the Black cultural center of America. Like Hopper, he was committed to portraying meaningful American subject matter. In Lawrence's case, this meant the streets and tenements of the Black ghetto as well as scenes from African-American history. A man of progressive humanist sentiments, Lawrence portrayed African-American life with unflinching directness. His stories about slavery and the struggle for freedom, the recent Black migra-

tion from the South, and the experience of daily life in the big cities of the North **(18.6)** aligned him with the powerful art movement of "social realism" that swept the United States during the bitter Depression years of the 1930s and early 1940s. His early paintings depicting ghetto poverty and oppression made him something of an urban biographer, a big-city counterpart to the Farm Securities Association painters, graphic artists, and photographers—artists such as Arthur Rothstein (7.34) and Dorothea Lange (7.35)—who documented the harsh experience of rural poverty.

For all the social realism of Lawrence's subject matter, however, his formal style was exceptionally original. His paintings shun optical imitation in favor of flat, abstract forms that tell true stories. These schematic, stylized forms seem to have arisen from Lawrence's immediate visual world—the simplified figures and shapes and bold colors of African-American folk art and American popular illustration. As writer Jack Hobbs relates, Lawrence "intentionally adopted some of the characteristics of

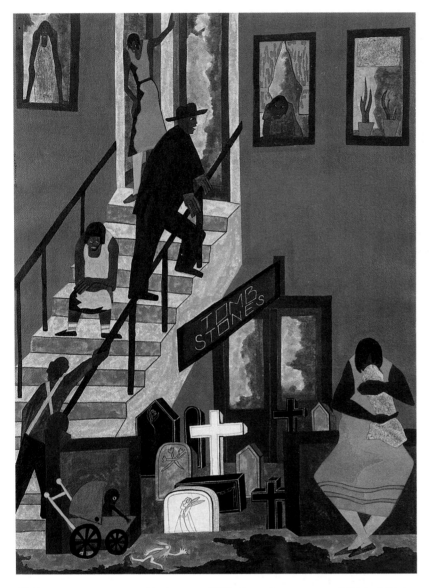

18.6 JACOB LAWRENCE. *Tombstones*. 1942. Gouache on paper. 28¾ × 20½ in. Whitney Museum of American Art, New York. Purchase (43.14).

folk art and comic strips in order to endow his own art with a greater power and directness" to comment on the Black experience.

A third stylistic influence on Lawrence was the art of the "New Negro Movement," today known as "the Harlem Renaissance." In full swing in the twenties, the Harlem Renaissance saw a great flourishing of Black consciousness ("the New Negro") accompanied by an emphasis on Black cultural heritage ("Negritude"), African as well as American. Rising young Black artists like Lawrence, Hale Woodruff (Appreciation 2), and Romare Bearden **(Appreciation 35)**

looked up to New Negro painters such as Aaron Douglas (1899–1979), whose grand-scale mural series *Aspects of Negro Life* **(18.7)** dramatically told the story of Black Americans, from their African origins to the Depression era. Douglas's mural, painted on the walls of a Harlem public library, was executed in stylized abstract forms and flat, hard-edged colors that reflect both European modernist and African art influences. To be sure, Douglas had been inspired by both West African art and the African-influenced abstract paintings of modernists such as Picasso and Matisse. Lawrence's realistic art, with its two-dimensional patterning, flat areas of emotive color, and pared-down geometric forms, is the product of a full-bodied multicultural heritage, reflecting North American, European, and African influences.

In synthesizing cultures, Lawrence also managed a synthesis of formalist abstraction and realism. Paintings such as his 1946 *Cabinet Makers* **(18.8)** are true "fusion art": a blend of social realism, synthetic cubism, and brilliant fauvelike color, in this case centered around the patriotic hues of red, white, and blue plus yellow and black. In terms of social content, *Cabinet Makers* presents us with five African-American artisans, skilled workers who measure, drill, and plane their boards with energy and confidence. They are model workers thoroughly committed to making the best product for the public. The artist, who has long believed that equal opportunity, integration, and hard work were the keys to Black success in America, was also implying that the future of Black Americans lay in education and constructive creative labor. From a formal standpoint, the overall design of the work was of paramount importance to Lawrence, a design valued not only for the sake of effective storytelling but also for its own sake. For Lawrence, the modernist beauty of significant form was not to be overlooked. Commenting on *Cabinet Makers*, the artist said: "The tools that MAN has developed over the centuries are, to me, most beautiful and exciting in their forms and shapes. In developing their forms in a painting, I try to arrange them in a dynamic and plastic composition." Formalistic and humanistic, North American, African-American, and European, Lawrence's art attests to the complexity and originality of realism in twentieth-century America.

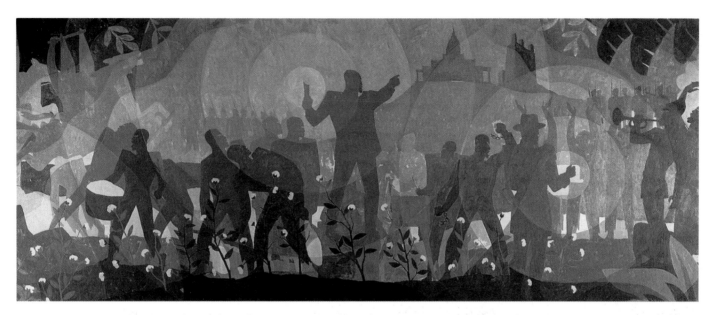

18.7 AARON DOUGLAS. *From Slavery through Reconstruction* (from the series *Aspects of Negro Life*). 1934. Art and Artifacts Division, Schomburg Center for Research in Black Culture, The New York Public Library, Astor, Lenox and Tilden Foundation. *Based on a formal analysis of the style of this work (for example, color, shape, space), what European artists or art movements do you think influenced Douglas? Compare and contrast this painting with earlier works by those European artists.*

18.8 JACOB LAWRENCE. *Cabinet Makers.* 1946. Gouache with pencil underdrawing on paper. 21¾ × 30 in. The Hirshhorn Museum and Sculpture Garden. Smithsonian Institution, Washington, D.C. Gift of Joseph H. Hirshhorn, 1966.

Romare Bearden's Patchwork Quilt

JOANNE GABBIN

Romare Bearden will be remembered as the American artist who revealed the rich cultural heritage and the jubilant and painful past of Black people. Born in 1914, Romare Bearden grew up in Harlem in the midst of the Harlem Renaissance. The sights, sounds, and colors of Harlem later emerged in his paintings. Jazz musicians Duke Ellington, Fats Waller, Earl Hines, Count Basie, Ella Fitzgerald, and Cab Calloway strongly influenced the stylistic rhythms and improvisation in several of his works, which are visual representations of remembered performances. In his collages, he distilled the writings of contemporary poets and novelists—Garcia Lorca, T. S. Eliot, Ernest Hemingway, Langston Hughes, Richard Wright, and Ralph Ellison—in response to their humanistic vision. Childhood sojourns to Charlotte, North Carolina, and his connections with the people of surrounding Mecklenburg County firmly rooted him in a culture ripe for revelation. There he learned the rituals and mysteries that informed and transformed southern Black culture.

By 1961 Bearden began to experiment with collage, which became his signature medium. His method reflected the catholicity and spirited originality of a man who studied with the German-born dadaist-expressionist George Grosz at New York's Art Students League and formed associations with the Romanian sculptor Constantin Brancusi [8.5] and the Frenchman Georges Braque [17.11] while he studied at the Sorbonne, the University of Paris. Eclectic in his study, he explored French impressionism,

traditional Chinese painting, and seventeenth-century Dutch genre painting, from which he learned about the representation of interior space. He studied African tribal sculpture, from which he learned the freedom to conceptualize his figures as abstract forms. Bearden was also in turn influenced by cubism, surrealism, and the social realism of contemporary Mexican painters such as Diego Rivera [1.8]. The catholicity of his artistic influences was echoed in the range of materials he used in his collages. These included photostated pictures, cutouts, photographs, pieces of cloth, and anything else that could enhance the reality of his work. In *Patchwork Quilt* **(Fig. A),** the quilt is actually fashioned of strips of fabric to create the textural reality. The woman's body is composed of paper cutouts adorned by cloth remnants.

Visually, *Patchwork Quilt* is a superb study of structure, what Bearden calls the "anatomy of space." His figure of a black woman dominates the space, rivaled only to a degree by the strength of the patches of cloth draped over a couch that bears her weight. His technique draws us in. His use of flat, opaque paper, his way of giving the bare outline of the form, his sparseness of detail make demands upon us as viewers. In distilling the very essence of the woman, he demands that we fill in the details. We add texture, we add complexity, we make her human by our prolonged interest.

Patchwork Quilt is strikingly simple visually yet revelatory of many human undercurrents and nuances. The variegated colors and textures of the quilt bespeak the familiarity of the heavy quilt stored in the closet, roughly patched together by a grandmother's arthritic fingers and meant "for comfort and not for show." Against the backdrop of the quilt is the woman, strangely regal and expectant. This figure is emphatically abstract, yet she has a complexity that defies the static nature of her outline. She represents continuity. Her figure

Joanne Gabbin is a professor of English and director of the Honors Program at James Madison University, Harrisonburg, Virginia. She is a scholar of African-American literature and is the author of Sterling A. Brown: Building the Black Aesthetic Tradition.

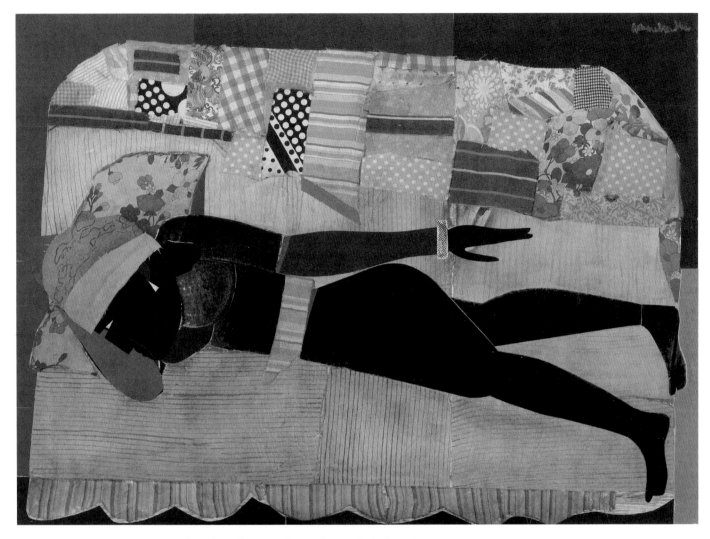

Figure A ROMARE BEARDEN. *Patchwork Quilt.* 1970. Cut and pasted cloth and paper with synthetic polymer paint on composition board. 35¾ × 47⅞ in. The Museum of Modern Art, New York. Blanchette Rockefeller Fund (573.1970).

dominates the collage with bold darkness. Shades of black, brown, tan, and red suggest her diverse heritage and her beauty. She is Africa, rooted in the fertile soil of Egypt and Ethiopia, her feet replicating those that graced the burial vaults of the great pyramids. Her torso is stiff and shapely like the Ghanaian fertility doll. She is Antilles [the Caribbean] with her breast ripe to suckle generations of slaves who would endure ocean passage, slavery, and repressive conditions. She is the intense, blues-

tinged elegance of America, bowed yet unbent. Her face resembles an African mask in its angularity, softened only by the rose bandanna that circles her head. She is the past and the present.

The collage says a great deal to me about survival, continuity, dignity, and diversity. In it, as in much of Bearden's work, the artist reaches for the heroic that resides even in the ordinary and the uncommon elegance that emerges from the familiar. ■

18.9 GRANT WOOD. *American Gothic.* 1930. Oil on beaverboard. 29¼ × 24½ in. Friends of American Art Collection. All rights reserved by The Art Institute of Chicago and VAGA, New York, 1930.934 © The Art Institute of Chicago. All Rights Reserved.

Grant Wood

In contrast to the urban, modernist art of Lawrence and Bearden, the paintings of Grant Wood (1892–1942) and the popular school of artists known as regionalists aspired to a pure and proudly native art reflective of America's rural regions. Decrying the European-influenced modernism of "American pseudo-Parisians" like Bearden, Lawrence, and Aaron Douglas, Wood's aesthetic philosophy paralleled the political philosophy of isolationism, which argued that America should avoid any involvement with Europe's growing troubles in the 1930s, such as the rise of Nazism and Fascism. It also mirrored a kind of conservative "nativism" that feared the churning cauldron of American city life, with its

teeming ethnic groups of worldwide heritage. Wood, born in Iowa and employed as an art professor at the state university, viewed himself as a patriot whose mission was to realistically represent the people and places of America's agricultural heartland. In a 1935 pamphlet titled "Revolt Against the City," Wood wrote that regionalist painting had declared its independence from Europe and was now beating a much-needed retreat "from the cities to the more American village and country life."

> The American public, which used to be interested solely in foreign and imitative work, has readily acquired a strong interest in the distinctly indigenous art of its own land; . . . This is no mere chauvinism. If it is patriotic, it is so because a feeling for one's own milieu and for the validity of one's own life and its surroundings is patriotic.
>
> Because of this new emphasis upon native materials [that is, subjects], the artist no longer finds it necessary to migrate even to New York, or to seek any great metropolis. No longer is it necessary for him to suffer the confusing cosmopolitanism, the noise, the too intimate gregariousness of the large city.[1]

The goal of each regionalist artist, Wood asserted, was to analyze, interpret, and convey the personality, physical characteristics, industry, and psychology of his or her region. His painting *American Gothic* **(18.9)** attempts to do just that. Using his sister and his dentist as models, Wood fashioned a picture of morally upright rural Americans in a meticulously realistic style reminiscent of Late Gothic and early Northern European Renaissance painting (14.14). The couple's mostly black and white clothing is clean and neat, plainspoken and traditional like their personalities and respective social roles. Proud farmer, honest breadwinner, and defender of the homestead, the man is the dominant figure. He looks us straight in the eye. Able and supportive, his serious-looking wife stands just behind her husband but does not return our glance. The rural Iowa setting features a red barn and a nineteenth-century wooden clapboard house with a Gothic-style second-story window, a domestic style called Carpenter's Gothic. This physical context combined with the upward vertical thrust of forms and subjects—erect figures, pitchfork, triangular roof lines, arched

18.10 GEORGIA O'KEEFFE. *The White Trumpet Flower.* 1932. Oil on canvas. 29¾ × 39¾ in. The San Diego Museum of Art. Gift of Mrs. Inez Grant Parker in memory of Earle W. Grant.

window—endows the small picture with a visual and iconographic sense of the Gothic, a style Wood associated with wholesome Christian and regional values.

Georgia O'Keeffe

Raised in rural Wisconsin and Virginia, Georgia O'Keeffe (1887–1986) could not have been more different in outlook from her country counterpart, Grant Wood. Antitraditional, individualistic, and a synthesizer of styles, O'Keeffe believed that she had to march to her own drummer, beginning with her education as an artist. "School and things that painters have taught me," she said, "keep me from painting as I want to do." She sought to originate a style of her own to capture her unique vision of the world. This does not mean that O'Keeffe was unaware of the most advanced European and North American art of the day. A member since 1916 of the vanguard circle around photographer Alfred Stieglitz, whom she would later marry, O'Keeffe was

exposed to the revolutionary innovations of Picasso, Matisse, Kandinsky, and the photographic avant-garde. Yet by that time her own sense of personal and artistic identity was so well developed that she was able to integrate cubist, expressionist, and surrealist influences seamlessly into her own distinctive style.

O'Keeffe's work covers a lot of territory. Her subject matter ranges from cityscapes to landscapes, from glittering skyscrapers to pastoral sunrises. Her focus extends from broad vistas of mountains, desert, and sky to intense close-ups of cow skulls and flowers **(18.10),** the latter possibly stimulated by the still life close-ups of vanguard photographers. Formally, she moves fluidly between realism, semiabstraction, and almost complete abstraction. At times her work stems from physical reality, while at other times it comes from her imagination. On still other occasions, it is a mixture of both **(Appreciation 36).** Uniting all these variables is a sensibility of subtlety and strength. Art historian Lloyd Goodrich has captured some of

APPRECIATION 36 *GEORGIA O'KEEFFE'S* Cow's Skull with Calico Roses

BARBARA WOLANIN

Georgia O'Keeffe created a compelling image from a surprising combination of objects: an animal skull and two fabric roses **(Fig. A)**. The composition is symmetrical, with the crack down the skull corresponding to the center of the canvas. The horns, which almost touch the edges, create an opposing horizontal line. The vertical axis is accentuated by the dark crevice that runs behind the skull and by two parallel wavy vertical edges to the right. Part of the skull is broken, revealing the jagged interior forms. The angular contours of the skull contrast with the rounded petals of the roses, which are also shown frontally. The stem on the lower flower points to the right, opposing the placement of the upper flower and the movement of the dark crevice to the left and thus creating a balance of forces.

The palette is limited to neutral shades, ranging from black to white, with subtle variations. The skull is creamy, the calico roses silvery gray against the black stripe. The warm golden tone inside the skull provides a focal point. There is some shading to define contours but no real illusion of light falling on the forms, since there are no cast shadows. The space and the gray shapes in the background are ambiguous. The objects seem frozen in time and space. They are smoothly painted, and the colors carefully blended. One imagines the artist painting slowly, with deep concentration, almost as if in a trance.

The objects are enlarged from life size, enhancing the viewer's concentration on their forms. This painting, with its almost cruciform design, attracts us almost like a religious icon; it is something on which to meditate. O'Keeffe often presented objects this way. The main object is presented frontally and centrally, often with a crevice or passageway running verti-

cally through the center of the composition, suggesting that something lies beyond the facade.

Although the artist denied the morbid implications of the skull and flowers, through them she created a personal iconography. Her choice of objects was directly related to the summers she spent in New Mexico, starting in 1929, two years before she created this painting. She would bring back barrels of bones to New York to paint. She loved the colors and shapes of the desert, and to her the bones were more beautiful and in a strange way more alive than the animals had been. They offered her endless possibilities of forms to paint. One day, she happened to put the cloth flowers in her studio, with the skull.

Many of the important influences on O'Keeffe can be traced in this painting. Her early study with Arthur Wesley Dow taught her to appreciate Japanese design, to experiment with "filling space in a beautiful way," and to balance light and dark. O'Keeffe was an important member of the circle of artists, writers, and photographers around Alfred Stieglitz, who first showed her work at his Gallery 291 in 1917. They later married, and he showed her work every year at his galleries. Several of his photographer friends created close-up views of flowers or fruit that may have unconsciously molded her vision. Stieglitz championed a number of painters who, like O'Keeffe, created abstract statements of their experience of nature. When O'Keeffe first showed paintings of skulls, critics called her a surrealist, despite her lack of connection with the official surrealist movement. For her own part, she saw herself and her paintings as unique.

The spareness of color in *Cow's Skull with Calico Roses* reflects O'Keeffe's personality and her almost monastic way of living. She usually dressed in black and lived in rooms with bare white or gray walls, often in solitude. After Stieglitz's death in 1946, she lived in the stark

Barbara Wolanin is an art historian whose area of expertise is early-twentieth-century American modernism. She lives and works in Washington, D.C.

landscape of New Mexico, which inspired her art until her own death at ninety-nine in 1986. O'Keeffe was a strong-willed person who had clear ideas about her art and who disliked being asked to explain her paintings with words. Her intensity of concentration on her art is reflected in this painting. She would become so absorbed in the subjects she painted that her painting process seemed to become a kind of mystical or spiritual experience. Through her art, she was able to convey a sense of the spiritual in nature to her viewers. ▪

the essential characteristics of O'Keeffe's sensibility and of her varied and inclusive art:

> Absolute clarity marks her style; there is nothing vague about it. The element of mystery which does exist in some works is due not to obscurity but to their clear-cut but enigmatic images and forms. Her lucidity never becomes a mannerism; it is an innate characteristic of her personal vision. Edges are precise but not hard; they round the forms into depth. Her art has an essential refinement that involves no loss of strength; it is capable of both delicacy and power. There is often a degree of severity in her style. Everything is simplified to essentials; there are no unnecessary details. This simplification sometimes produces works of minimal forms and colors, but of maximum impact. Again there can be a profusion of elements, but always selective. Her art presents a rare combination of austerity and a deep sensuousness.[2]

Like the art of Hopper and Lawrence, O'Keeffe's art asserted an independence from Europe. Great modern art, realistic and abstract, was now being freely produced on North American soil, no longer looking across the ocean for its models.

THE RISE OF THE AMERICAN ART WORLD

The decimation of continental Europe in World War II and the rise of the United States to the position of world leader helped shift the center of modern art activity to North America. Having fled the Nazis and the war, many of Europe's most important artists (17.28), designers, and architects resettled in the United States, Canada, and Mexico. Through their creative work and teaching activities, they substantially enriched the artistic life of their new homelands. The United States, having risen to the forefront militarily, politically, and economically, now proceeded to do the same on the cultural front. National wealth and power, coupled with quality artistic production and persuasive art writing, soon led to American cultural dominance. In the realm of vanguard art, New York City steadily took on the role previously played by Paris. Homegrown avant-garde artists looked beyond both European-inspired geometric abstraction

American artists are very much aware of a change in atmosphere since the war: they feel more self-reliant and often say that the center of art has shifted from Paris to New York, not simply because New York has become the chief market for modern art, but because they believe that the newest ideas and energies are there and that America shows the way.
—Meyer Schapiro, art historian, ca. 1950

(17.17, 17.19), promoted by the American Abstract Artists organization, and American realism, even its most original forms, in their search for new avenues of expression.

New York City: The New Center of International Art

With increasing numbers of gallery and museum exhibitions and magazine and newspaper articles devoted to North American modern art, New York City (18.11) soon became the capital of the international art world. Spurred on by polemical critics, wealthy collectors, and enterprising dealers centered in the New York area, the first internationally prominent art movements to originate outside Europe wrote themselves into Western art history books. Rising to prominence in the late 1940s and early 1950s, the so-called **abstract expressionists** of the New York School made a name for themselves around the world. Even those in the European vanguard acknowledged the strength of the new American art—so "powerful, serious, and disturbing," as one young artist in Paris put it.

Densely populated and fast-moving, growing upward and outward, New York City energized its varied cast of artists. Furthermore, "the City" provided the young modernists with relative anonymity and independence. During the 1940s, the American art marketplace was certainly not very interested in homegrown vanguard artworks. The young American modernists, poor but free, were left alone to develop their art. A fertile, independent space was opened up to them for genuine self-expression and creative experimentation.

American Art in a Global Context

The contextual picture extends beyond Manhattan Island and its art world, however. These young modern artists were also powerfully affected in the 1940s and early 1950s by some of the most momentous global developments of the twentieth century: World War II and the death camps, the first atom bomb explosions, the Cold War, anticommunist fever and the subsequent House Un-American Activities Committee witchhunts. As young men and

women, they had lived through the Depression years of the 1930s. For progressive American artists and their intellectual supporters, many of whom had been associated with the political left in the thirties and early forties, it was an "age of anxiety" politically as well as psychologically.

Almost all New York School abstract expressionists had been steeped in the leftist social and political art of the Depression era (7.35). According to critic Harold Rosenberg: "[Jackson] Pollock had been influenced by left-wing Mexican mural painting (1.8); [Mark] Rothko had composed tableaux of the city poor; [Willem] de Kooning had executed constructions for Artists Union demonstrations; [AD] Reinhardt and [Robert] Motherwell had dabbled in Marxism. . . ." But by the 1940s these artists had become dismayed by the inhuman autocracy of Stalinist Russia and the rigidity of old-fashioned socialist-realist aesthetics. At the same time, the commercialized mass culture spawned by industrial capitalism disgusted them. Having lost their social idealism, they tended to drop out, rejecting both communism and capitalism and turning inward in their search for personal and artistic meaning. In art, they believed, humanizing values might still be found.

This same period saw the rise of existential philosophy and Freudian and Jungian psychological theory in the intellectual and artistic communities. These streams of humanistic thought centered on the essential alienation of the individual from society, on the necessity of authentic choice and genuine risk taking, and on the supremacy of personal integrity and self-realization as the highest human goals. It is not surprising that the conflicts and heroic struggles of the free individual became the central concerns of the cultural vanguard in this "age of anxiety" and during the subsequent Cold War era of tension between the United States and the Soviet Union.

From this contextual pressure cooker, the New York School of abstract expressionism arose. Its legacy for several generations of artists in the United States and around the world was almost comparable in magnitude to the legacy of cubism and surrealism in the first half of the century. Powerful and original in its methods, materials, forms, concepts, and

18.11 BERENICE ABBOTT. *Nightview.* New York, 1932. Gelatin-silver print. © Berenice Abbott/Commerce Graphics Ltd., Inc.

content, the New York School influenced much of the modern art, and even postmodern art, of the coming half century.

ABSTRACT EXPRESSIONISM: THE FIRST-GENERATION PIONEERS

There they are, featured in the January 15, 1951, issue of *Life* magazine: the so-called "Irascibles," the defiant core group of the New York School **(18.12),** hard-bitten rebels seeking to express their inner depths and the soul of their age. Nervous energy or anxiety simmers

To photograph New York City means to seek to catch in the sensitive and delicate photographic emulsion the spirit of the metropolis, while remaining true to its essential fact, its hurrying tempo, its congested streets, the past jostling the present. . . .
—Berenice Abbott
(1898–1991), photographer

18.12 "THE IRASCIBLES." Painters of the New York School. 1951. Back row, left to right: Willem de Kooning, Adolph Gottlieb, Ad Reinhardt, Hedda Sterne; middle row: Richard Pousette-Dart, William Baziotes, Jackson Pollock, Clyfford Still, Robert Motherwell, Bradley Walker Tomlin; seated: Theodore Stamos, Jimmy Ernst, Barnett Newman, James Brooks, Mark Rothko. Nina Leen/TimePix. *What impact do the mass media have on artists and their art? If* Life *and* Time *magazine articles hadn't made the abstract expressionists so notorious—just as newspapers and magazines made Manet and the impressionists infamous—would their movement have succeeded? Without media exposure, might art history have taken a different course?*

. . . few of them over forty, [they] live in cold-water flats and exist from hand to mouth. Now they all paint in the abstract vein, show rarely on 57th Street [the fashionable uptown gallery district], and have no reputations that extend beyond a small circle of fanatics, art-fixated misfits who are as isolated in the United States as if they were living in Paleolithic Europe.—Clement Greenberg, art critic, 1947

just below the surface—in Jackson Pollock's hard stare, Willem de Kooning's leer, Mark Rothko's edgy glance. With Rothko, this inner turmoil found expression in huge expanses of enveloping color; with de Kooning and Pollock, internal necessity surged outward in violent strokes or swirling drips. Two distinct tendencies, in fact, coexisted in the New York School from the beginning. One group of painters, featuring Rothko, Barnett Newman, and Clyfford Still, worked in broad **color fields,** giant areas of interactive color. The other group, including Pollock, de Kooning, and Lee Krasner, expressed themselves through an energetic painterly style that came to be known as **gesture** or **action painting.** We turn first to the gestural or action painters.

Action Painting: Pollock, Krasner, and de Kooning

If any single artist can be said to symbolize the New York School, it is Jackson Pollock (1912–1956). In the late 1930s and early 1940s, Pollock was creating vigorous synthetic cubist-surrealist abstractions like *Moon Woman Cuts the Circle* **(18.13).** These paintings, done primarily in oils, were executed with rapid brushwork and revealed a quasi-figurative imagery that arose from the impulses and imagery of the unconscious mind. *Moon Woman Cuts the Circle* presents a dreamlike evocation of an American Indian figure and a sharp cutting knife. While the overall meaning is not entirely clear, certain subjects—the person, the knife—are recognizable. Around 1947, however, a major change took place in Pollock's art. Pollock broke through to a radical new way of creating pictures by dripping paint onto the canvas **(18.14).** The new approach grabbed the attention of both the art world and the person on the street and almost instantly became the subject of loud debate. The drip method enabled Pollock to work with an unprecedented improvisatory freedom, a quantum leap forward in the eyes of his fellow vanguardists. Pollock's large painting *Number 1, 1948* **(18.15)** was one of these breakthrough works. As de Kooning put it, "Pollock broke the ice" for an art of unlimited self-expression and spontaneity. Vanguard poets and novelists such as the Beat writers Allen Ginsburg and Jack Kerouac and jazz musicians such as saxophonist Ornette Coleman (Appreciation 5, Figure A), along with numerous painters and sculptors worldwide, were stimulated by the freedom and spontaneity of expression they felt in Pollock's work. Meanwhile, the mainstream press just laughed, lampooning Pollock as a madman clown. "Jack the Dripper," *Time* called him.

For his own part, Pollock explained his revolutionary "drip paintings" with characteristic seriousness:

My painting does not come from the easel. . . . I prefer to tack the unstretched canvas to the hard wall or the floor. I need the resistance of a hard surface. On the floor I am more at ease. I feel nearer, more a part of the painting, since this way I can walk around it, work from the four sides and literally be in the painting. This

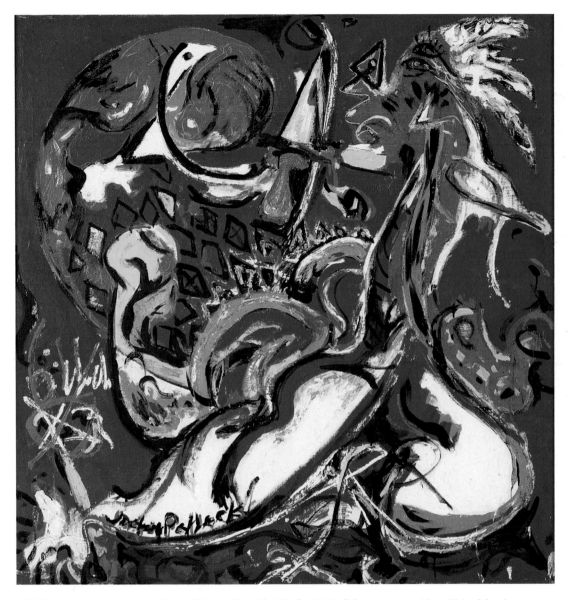

18.13 JACKSON POLLOCK. *Moon Woman Cuts the Circle.* 1943. Oil on canvas. 42 × 40 in. Musée National d'Art Moderne, Centre Georges Pompidou, Paris. Gift of Frank Lloyd. *Raised in Wyoming and California, Pollock had some contact with Native Americans and admired Navajo sand paintings made by medicine men with colored powders on the flat ground. Develop an interpretation for the painting's subjects: the red man or woman with feather headdress on the right, the yellow knife blade in the center, and the crescent-shaped black cut in the upper left-center.*

is akin to the method of the Indian sand painters of the West.

I continue to get further away from the usual painter's tools such as easel, palette, brushes, etc. I prefer sticks, trowels, knives and dripping fluid paint or a heavy impasto with sand, broken glass and other foreign matter added.

When I am in my painting, I'm not aware of what I'm doing. It is only after a sort of "get acquainted" period that I see what I have been about. I have no fears about making changes, destroying the image, etc., because the painting has a life of its own. I try to let it come through. It is only when I lose contact with the painting that the result is a mess. Otherwise there is pure harmony, an easy give and take, and the painting comes out well.[3]

Pollock added, importantly, that such painting came largely "from within." For almost all the abstract expressionists, the impulses and

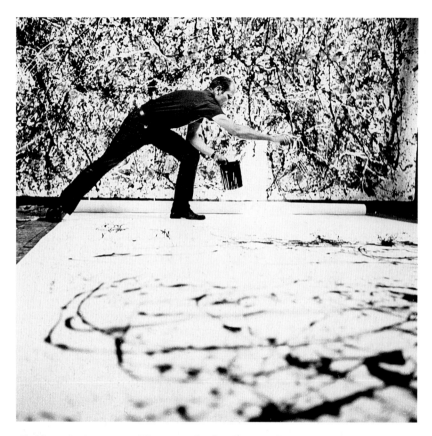

18.14 HANS NAMUTH. Photograph of Jackson Pollock painting in East Hampton, NY. 1950. In the background part of *Number 31, 1950.* © 1991 Hans Namuth Estate. Courtesy, Center for Creative Photography, University of Arizona.

imagery of the unconscious played a prominent role. Surrealist artists who practiced "psychic automatism" (17.24), the spontaneous release from the unconscious of representational and nonrepresentational imagery, were especially important influences on Pollock and his colleagues. So seminal was the influence of this branch of surrealism on the artists of the New York School that their early work (18.13) during the war years was actually referred to as "abstract surrealism." Pushing surrealist psychic automatism to the limit, the figurative imagery was gradually replaced by spontaneous linear outpourings, first painted and later dripped. Through such "action paintings," Pollock appeared to release the unconscious more directly and completely than had anyone before him.

Focusing formalistically on the artist's final product rather than on his creative process,

critic and historian Michael Fried praises *Number 1, 1948* as a breakthrough work in the history of Western painting in that each visual element—line, color, shape, space—is totally interwoven into a single overall "homogeneous visual fabric."

> The skeins of paint appear on the canvas as a continuous, all-over line which loops and snarls time and again upon itself until almost the entire surface of the canvas is covered by it. It is a kind of space-filling curve of immense complexity. . . . There are hovering spots of bright color, which provide momentary focus for one's attention, and in this and other paintings made during these years there are even handprints put there by the artist in the course of his work. But all of these are woven together, chiefly by Pollock's line. . . .[4]

Agreeing with Fried's formalist assessment, Marxist critic John Berger writes that "the continuous surface patterns" of Pollock's large drip paintings are "perfectly unified without the use of any obvious repeating motif . . . and their colour, their consistency of gesture, the balance of tonal weights all testify to a natural painter's talent. . . ." Yet, Berger concludes, Pollock's creative process was far too isolated and self-centered and paintings like *Number 1, 1948* eloquently show it. The British critic laments that such extreme psychological isolation, the product of a society that emphasizes excessive and destructive levels of freedom and individualism, was bad for Pollock and his paintings, tragic "pictures painted on the inside walls of his mind. . . ."

In a far more positive contextualizing view, German art historian Will Grohmann writes that Pollock's drip paintings called forth the vastness and unbounded energy of the American continent. In words recalling the nineteenth-century romantic's awe-inspiring experience of the sublime in nature and art (4.13), Grohmann exclaims: "Here is reality . . . an exuberance of the continent, the ocean and the forest, the conceiving of an undiscovered world comparable to the time 300 years ago when pioneers came to this country."

Focusing on the existential artmaking process, critic Harold Rosenberg asserted that Pollock and other abstract expressionists had gone so far beyond the boundaries of traditional Western painting that what they were

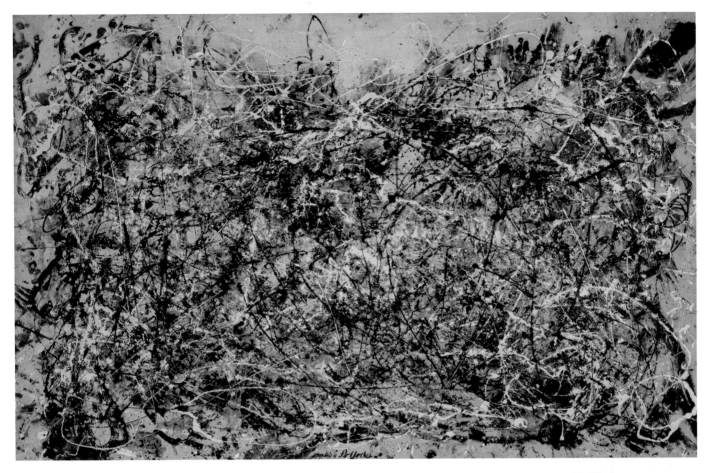

18.15 JACKSON POLLOCK. *Number 1, 1948*. 1948. Oil and enamel on unprimed canvas. 5 ft. 8 in. × 8 ft. 8 in. The Museum of Modern Art, New York. Purchase (77.1950).

engaged in was an "event," "act," or "encounter," in some ways related more closely to dance, theater, and autobiography than to traditional easel painting. Many saw the abstract expressionists as overthrowing the easel-painting tradition altogether. The term "action painting," coined by Rosenberg, soon took hold in referring to gestural artists like Pollock.

Both Pollock's paintings and his methods had immense implications for contemporary and future artists. To young vanguard artists and intellectuals around the globe in the 1950s and after, the works of action painters such as Pollock possessed a freedom, a power, and a towering individuality that were positively inspiring. According to art historian Tricia Laughlin Bloom, painter Lee Krasner (1908–1984) admitted to being thrown initially into a period of artistic crisis by the dramatic impact of encountering Pollock's drip paintings, which were so strikingly free and nonobjective compared to the highly structured

cubist mode in which she had been working. Laughlin Bloom writes that Krasner's *Noon* **(18.16),** painted in 1947, is a strong statement of her subsequent exuberant liberation from traditional painting.

> The canvas is vigorously covered with an all-over pattern of color, applied liberally and with flourish. Krasner worked the surface with brush, palette knife, and at times applied the paint directly from the tube to the canvas. The all-over treatment keeps the eye moving over the entire canvas; foreground and background merge, creating an energetic field of color and texture. Perhaps most essential to the success of *Noon* is the sense we get that the canvas breathes—that is to say, it conveys a feeling of lightness, despite the many layers of paint, and a feeling of vitality and expansiveness beyond its physical shape.[5]

True to the independent, oppositional tradition of avant-garde art, however, Krasner and Pollock (who were married in 1945) and

18.16 LEE KRASNER. *Noon.* 1946. Oil on linen. 24 × 30 in. Private Collection. Courtesy Robert Miller Gallery, New York. *Noon is a small but intensely layered, thickly impastoed painting, measuring 24 by 30 inches. After Pollock's death, Krasner moved her studio to the small barn where her husband had worked. Over the course of a long career, she produced increasingly large works. How important is physical size to the success of an abstract expressionist work?*

their action-painting colleagues received more criticism than praise. Mainstream opinion, as expressed in *Time* magazine articles, derided Pollock's paintings as a "nonobjective snarl of tar and confetti," wild and woolly "chaos," and "the slosh-and-spatter school of postwar art." The art columns of major newspapers at home and abroad chimed in, comparing the paintings to "a meaningless tangle of cordage and smears," "baked macaroni," "wallpaper," and "a mop of tangled hair"—slurs reminiscent of the criticism heaped upon the impressionists and postimpressionists in the nineteenth century.

The most notorious of the action painters, Pollock really hit a nerve. His art was fiercely admired or hated. There was no middle ground. In a true irony, even bitter enemies united in their dislike of Pollock's paintings. Hard-line communist critics denounced abstract expressionist art as "bourgeois decadence," evidence of the final disintegration of capitalist culture. American right-wing politicians, equally

upset, branded the works "creeping communism" in disguise, an evil that would gradually rot American society from the inside out. Defending Pollock and the New York School, the liberal intelligentsia argued that abstract expressionist painting exemplified the American democratic tradition at its best—freedom of thought and expression in action—in an age of totalitarianism and social conformity. With the support of liberal intellectuals, politicians, museum directors, and corporation heads—the Rockefellers, for example, were founders and board members of New York's tremendously influential Museum of Modern Art—the New York School eventually carried the day and was embraced by the international world of high culture. What a bubbling cauldron of response Pollock and the abstract expressionists had stirred up!

Tragically, Pollock died young, at age forty-four. The life of this most provocative painter ended in 1956 in what may have been a suicidal automobile crash. Pollock's many demons, among them depression, alcoholism, and the fear that he had little more to say as an artist, had come to haunt and perhaps overwhelm him. In a passage that might serve as an epitaph, critic-historian Sam Hunter wrote that "Pollock's sudden passing only served to make him more of a heroic figure for a younger generation of artists, and dramatized his impressive role as an innovator." His influence on art worldwide continues to be enormous.

Fellow painter Willem de Kooning (1904–1997) had once praised Pollock for breaking through to the freest art ever created. If Pollock was the most spontaneous painter, de Kooning was a close second. Arriving in the United States in 1926, this academically trained Dutchman, who could draw a still life with realistic ease, turned out to be one of the wildest of "the wild ones," a freewheeling gesture painter of Promethean energy. His black-and-white *Dark Pond* (18.17), painted in 1946, reveals much about the action painter and his art. The picture surface or ground of *Dark Pond* is entirely black, with white marks, dots, and lines of differing length and thickness. Almost every white line interconnects in some way to form an irregular shape—along with a few geometric ones—against the black ground. Although de Kooning has sketchily painted in several of these shapes

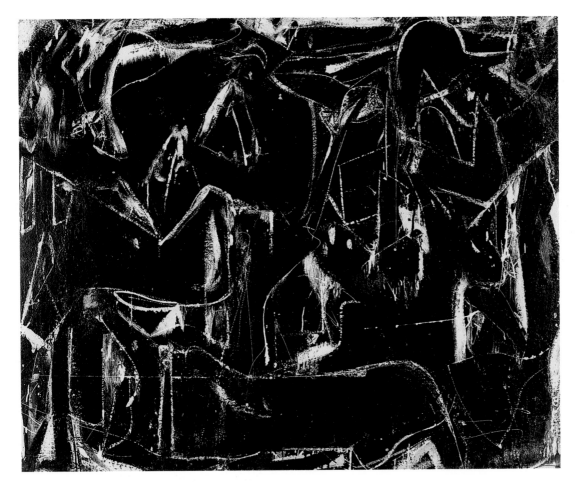

18.17 WILLEM DE KOONING. *Dark Pond.* 1948. Enamel on composition board. 46¾ × 55¾ in. Frederick R. Weisman Art Foundation, Los Angeles, CA. *Before and after his black-and-white paintings, de Kooning created expressionistic figures of men and especially women. Most of the shapes in this painting have an organic quality. Do you discern abstract fragments of body parts; or does* Dark Pond *suggest naturelike shapes as opposed to human forms? Or is it completely nonrepresentational?*

with white at the picture's upper edge, the others remain white outlines against the black ground. Shading is not attempted, and a flat, friezelike effect is produced. Figure-ground distinctions are blurred, although one might perceive the white markings to be up against or slightly raised above the black ground. Given more or less equal emphasis, these many varied shapes interweave to create an "all-over" effect, with no single focal point.

These same formal qualities reveal the artist's fiery method of putting paint on canvas. De Kooning's line is intense, highly charged, and emotional, much like the pulsating, electrical lines of a rock guitarist. Such lines are not the precise contours of a classicist but rather the passionate outpourings of a

romantic. The artist is powerfully involved in the actual physical process of creation. We feel the speed, the force, the gesture of each brushstroke. Every line, shape, and mark is infused with de Kooning's manic excitement, his urgent desire to paint, to get it all said. It is easy to envision de Kooning struggling, wrestling with the canvas, stepping back, looking with fixed concentration at the evolving work, making sure all is right and in place. Setting passionately back to work, painting over lines and shapes, he ceaselessly destroys hard-won images in order to create an image of ever greater vitality, painting boldly on until the painting seems to have a life of its own.

Like Pollock, de Kooning did not adhere to a consistent form or content. Both artists

18.18 WILLEM de KOONING. *Gotham News.* 1955. Oil on canvas. 69 × 79 in. The Albright-Knox Art Gallery, Buffalo, NY. Gift of Seymour H. Knox, 1955.

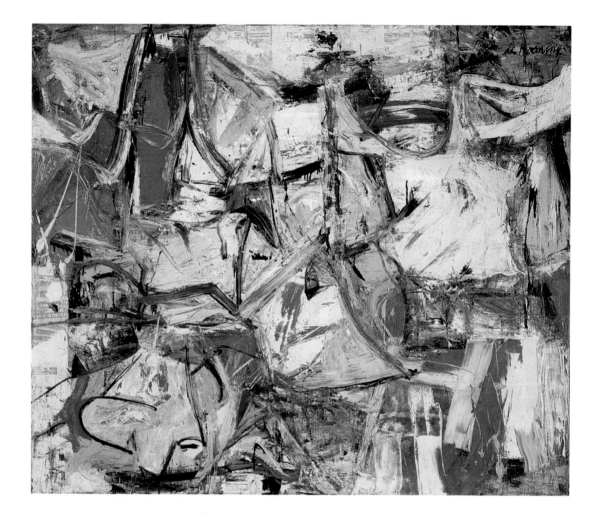

moved fluidly between complete abstraction and full-scale figuration. De Kooning produced moderate-sized paintings in spare black and white, like *Dark Pond,* as well as huge canvases, abstract or figurative, with immense swaths of singing color. Following the series of black-and-white paintings of 1946–51, which included *Dark Pond,* the expressionistic *Women* series burst forth. Known for their presentation of monstrous, distorted women of colossal size, these paintings showed that abstract expressionism was not closed to figurative representation. Following the *Women* series, de Kooning returned to seemingly nonfigurative abstractions such as *Gotham News* **(18.18).** But these abstractions, like many of the artist's works, maintained a relation to the outside world, and their titles reflect particular places or things. *Gotham News,* for example, incorporates pages torn from a New York City ("Gotham") newspaper. Almost seamlessly integrated into the painting, these torn pages ap-

pear as ragged white shapes along the picture's top and lower-left edges.

De Kooning was strongly affected by his surroundings, and *Gotham News* illustrates how the real world indirectly entered his nonrepresentational work. Such "crowded cityscapes of the mid-fifties," Harold Rosenberg observes, "belong, as their titles indicate, to news . . . and the flow of events in time, rather than to [actual] objects situated in space." That is, the paintings are connected to the artist's day-to-day experience of New York City, his general "abstract" feelings about urban life, and not to any specific object, event, or place. "The compressed composition," Rosenberg writes, "thick, ragged edges, gritty surfaces, and uncertain, nondescript colors of *Gotham News* are siphoned from de Kooning's grim years in his Fourth Avenue and East Tenth Street lofts, from the decaying doors of the buildings, the rubbish-piled areaways, the Bowery cafeteria, the drunks on the stoops."

Confirming the effect of place on de Kooning's more abstract works, Rosenberg notes that after the artist left New York City to live in "the Springs," on rural eastern Long Island (New York), "his compositions open out as if with a sigh into lyrical panoramas keyed to drives in the countryside."

Color Field Painting: Rothko and Newman

By the early 1950s, it had become clear that abstract expressionism consisted of not one but two types (and their variations). Art historian Meyer Schapiro quickly detected and wrote about these contrasting tendencies. After describing the action painting of Pollock and de Kooning as "an art of impulse and chance," Schapiro proceeded to delineate the "opposite approach." He identified this approach with the paintings **(18.19)** of Mark Rothko (1903–1970), but the tendency applied equally to the work of Barnett Newman (1905–1970) and their mutual friend Clyfford Still (1904–1980). In 1956 Schapiro wrote:

> [Rothko] builds large canvases of a few big areas of color in solemn contrast; his bands or rectangles are finely softened at the edges and have the air of filmy spectres, or after-effects of color; generally three or four tones make up the scheme of the whole, so that beside the restless complexity of Pollock or de Kooning, Rothko's painting seems inert and bare. Each seeks an absolute in which the receptive viewer can lose himself, the one in compulsive movement, the other in an all-pervading, as if internalised, sensation of a dominant color.[6]

Particularly drawn to the Rothko-Newman-Still stream of abstract expressionism, formalist critic Clement Greenberg reserved his highest praise for its accomplishments. Here was painting that truly pushed beyond the bounds of French cubism, painting prepared to make the next essential leap forward in the historical march of artistic styles. Here, Greenberg exclaimed, was painting that moved beyond all of cubism's by-now old-fashioned naturalistic tendencies, for example, its figurative shapes (abstractions of bottles, guitars, etc.) and figure-ground distinctions (foreground objects standing out from shallow backgrounds). Greenberg wrote in delight that "a new kind of flatness, one that breathes and

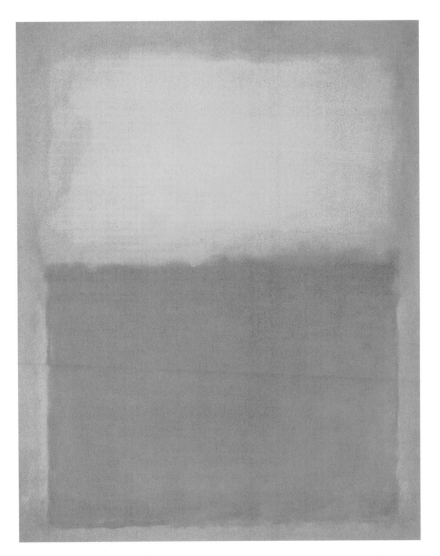

18.19 MARK ROTHKO. *Orange and Yellow.* 1956. Oil on canvas. 91 × 71 in. The Albright-Knox Art Gallery, Buffalo, (gift of Seymour H. Knox, 1956), © 1998 Kate Rothko Prizel & Christopher Rothko/Artists Rights Society (ARS), New York.

pulsates," inhabited "the darkened, value-muffling warmth of color of Newman, Rothko, and Still." In addition, here was painting that, like action painting, seemed to push beyond easel painting itself. Featuring enormous areas of color, these works functioned more like environments or fields than like pictures within confining frames. "Broken by relatively few incidents of drawing or design," Greenberg wrote, "their surfaces exhale color with an enveloping effect that is enhanced by size itself. One reacts to an environment as much as to a picture hung on a wall." Such works, he concluded, "have to be called, finally, 'fields.'"

And possessing an extraordinary tangibility and force, often being so large that it covers the space of a wall and therefore competing boldly with the environment, the canvas can command our attention fully like monumental painting in the past.—Meyer Schapiro, art historian, 1956

18.20 MARK ROTHKO. North, northeast, and east wall paintings from the Rothko Chapel, 1964–65. Oil on canvas. The Rothko Chapel, Houston. Photo: Hickey & Robertson.

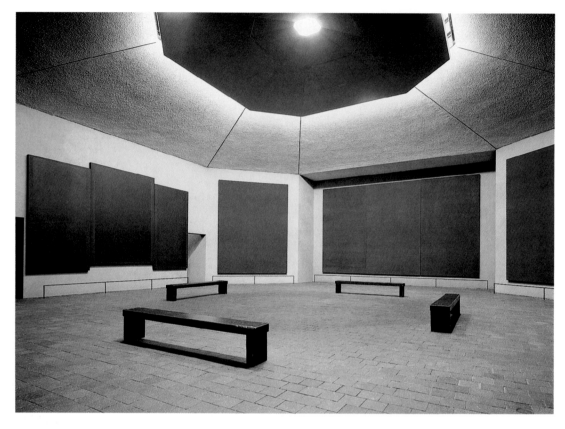

I am not interested in relationships of color or form. . . . I am only interested in expressing the basic human emotions—tragedy, ecstasy, doom, and so on—and the fact that people break down and cry when confronted with my pictures shows that I communicate with those basic human emotions. The people who weep before my pictures are having the same religious experience I had when I painted them. And if you, as you say, are moved only by their color relationships, then you miss the point.—Mark Rothko, painter, 1957

Soon "color field painting" became the name most frequently associated with this general approach.

With respect to method and intention, gesture (or action) and color field painting exhibit differences but also certain similarities. Color field painting replaced immediacy of gesture with a painting process that was relatively slow-moving yet nonetheless employed a kind of intuitive "action" in which enormous color areas were brought together in elemental encounters. Improvisational fervor was banished, to be replaced by a kind of impassioned meditation. In the end, however, each work was considered successful only if it directly expressed the individual artist's most profound feelings. A high moral seriousness characterized the tone of all abstract expressionist art.

So great was the moral seriousness of the color field artists—and so elevated the visions of Rothko, Newman, and Still—that they came to be recognized as the "theological" faction of the abstract expressionist movement. Such a religious connotation is, in fact, appropriately applied to these men and their work. Each

wanted his images to express and communicate content on a grand, universal scale. The form that shaped this content had to be sublime, tragic, and timeless. Not surprisingly, their paintings became gigantic in size, abandoning any reference to the everyday world in favor of vast spaces and elemental colors **(Interaction Box)**.

Two private patrons were so impressed by the spiritual power of Rothko's and Newman's art that they financed the building of a house of worship, currently a nondenominational chapel at Rice University in Houston, Texas, at which the two men's works are featured as objects of religious contemplation. For the interior walls of the chapel, Rothko created a series of enormous, darkly mysterious monochromatic paintings **(18.20)**. Individuals of diverse faiths—Christian, Jewish, Zen Buddhist, Islamic—have come to meditate or pray before them. Writing about her experience of being thus surrounded by Rothko paintings, a student related, "I was in awe of how they could just bring me into them. I felt like it was not even about color anymore, as the gradations of

color seemed to melt, and then it became about meditation and just pure thought."

Newman's contribution to the so-called Rothko Chapel was a large metal outdoor sculpture, a formal and spiritual counterpart to the paintings within. Twenty-six feet high, his *Broken Obelisk* **(18.21)** is a pillar balanced on the point of a pyramid. These heaven-ascending abstract forms are fertile with religious symbolism. According to one common interpretation, the obelisk, broken at its crest, represents imperfect humankind standing erect and striving upward for spiritual completion. Of his *Broken Obelisk*, Newman wrote, "[I]t is concerned with life and I hope I have transformed its tragic content into a glimpse of the sublime."

Abstract Expressionist Sculpture: David Smith

Although it is possible to speak of the New York School of abstract expressionist painting, it is less easy to identify a "New York School" of abstract expressionist sculpture. Yet certain sculptors did share strong affinities in background, influences, methods, and intentions with their painter counterparts. Some, such as Barnett Newman and David Smith (1906–1965), started out as painters. Like the abstract expressionist painters, with whom he was friendly, Smith initially was influenced by the major European art movements of the day: cubism, constructivism, and

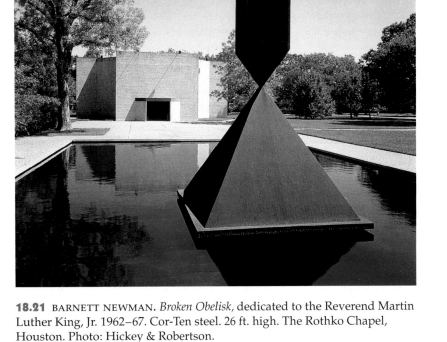

18.21 BARNETT NEWMAN. *Broken Obelisk,* dedicated to the Reverend Martin Luther King, Jr. 1962–67. Cor-Ten steel. 26 ft. high. The Rothko Chapel, Houston. Photo: Hickey & Robertson.

18.22 DAVID SMITH. *Hudson River Landscape.* 1951. Welded steel. 49½ × 75 × 16¼ in. Whitney Museum of American Art, New York. Purchase (54.14). *Interpreting this abstract work in terms of the actual Hudson Valley landscape that Smith viewed on frequent commuter train trips, a critic writes that the artist "took note of the rocky banks, the staircaselike steps of land that led down to the river when its level was low . . . and the slow circling of the huge clouds above." Was the critic "seeing things," or do you observe such identifiable forms in Smith's sculpture?*

When I begin a sculpture I am not always sure how it is going to end. . . . Sometimes when I start a sculpture, I begin with only a realized part, the rest is travel to be unfolded much in the order of a dream.—David Smith, sculptor, ca. 1950

surrealism. A 1945 work, fittingly titled *Reliquary House,* is a miniature surrealist world, an open house–like structure whose shelves or floors contain voluptuous forms suggestive of childhood memories and adult sexual fantasies. Like the psychologically motivated work of Rothko, Pollock (18.13) and other New York School painters during this same period, much of David Smith's early work might be called abstract surrealism. But Smith was not to be tied to any single movement, style, or subject matter. In the spirit of Pollock's statement "Every good artist paints what he is," Smith bent all styles and subjects to his own individualistic vision, creating a diversity of works as wide-ranging as his sensibilities. Over three decades, his subject matter and sources of inspiration stretched from surrealist fantasy to political protest to landscapes and geometric shapes. His style ranged from linear "drawings in space" composed of thin scrap-metal rods, shafts, and fragments to dynamic arrangements of large geometric volumes, including stainless steel cubes, cylinders, and slabs.

Smith's 1951 *Hudson River Landscape* **(18.22)** represents the former. A "drawing in space," it is also a landscape albeit a highly abstract one. As critic John Russell observes:

> [The artist] took note of the rocky banks, the staircaselike steps of land that led down to the water, the meandering movement of the river when its level was low toward the end of winter, and the slow circling of the huge clouds above. [The sculptor then] synthesized all these things in two-dimensional form [the sculpture being conceived in a frontal, planar way] with the effect of a man drawing in the air, bending the steel to his will as freely as a landscape draftsman bends the penciled line, and calling upon the memory of natural phenomena to help him to articulate space.[7]

The result was a piece reflective of modern sculpture's emphasis on open space and

modernist drawing and painting's emphasis on antinaturalistic flatness.

Ever the explorer, Smith soon moved beyond the frontal, horizontal landscape format of the early 1950s. His finest sculptures over the next fifteen years moved fluidly between solid mass and open space, vertical and horizontal alignments, and frontal and "in the round" orientations. His works incorporated found objects and invented shapes, abstract and representational forms, sometimes all welded together in the same piece. In his final years, geometric forms largely took over. A long series of stainless-steel sculptures, the *Cubi* **(18.23),** created between 1961 and 1965, were built from combinations of cubes, cylinders, elliptical lozenges, circles, and flat rectangular or square slabs. Earlier connections to surrealist fantasy or landscape imagery were exorcised, making way for a kind of freely geometrical abstract expressionism that could be read—and "completed" by the viewer—in diverse ways.

Critic John Russell was impressed by the anthropomorphic and "American" qualities of Smith's late works. To begin, he saw them as abstract metaphors of "vertical man." Russell writes: "Though not organized in expressly human terms, they stand for a certain idea of American manhood: one that is free, open, outgoing, erect and not overly complicated. . . . The glint and sparkle of the stainless steel are fundamental to them. So is their [human] scale, which dominates but does not dwarf us." For Russell, Smith's work was a powerful statement of humanism and optimism, art that "stands for a large-heartedness [and] a freedom from corruption and a breadth of ambition which have largely ceased to characterize the world of art." Others saw the *Cubi* more formalistically, as works to be appreciated entirely for their abstract and architectonic qualities. Art historically, they might link the *Cubi* to Gabo's constructivist *Column* (17.17) and other works of formalist abstraction.

Smith's own statements on the *Cubi* tend to support both critical positions. On one hand, he spoke of the mass and power of the stainless steel: "[S]ometimes you make it appear with all its force in whatever shape it is." On the other hand, he often roughly ground and polished the surfaces of the *Cubi*, giving them a

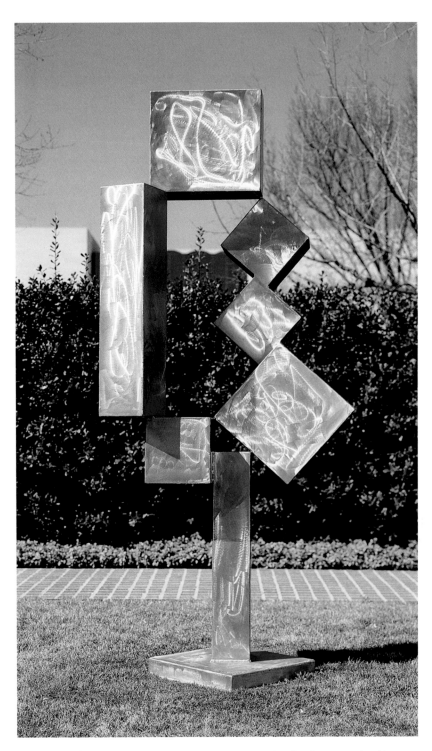

18.23 DAVID SMITH. *Cubi XII.* 1963. Stainless steel. 9 ft. 1⅜ in. × 4 ft. 1¼ in. × 2 ft. 8¼ in. The Hirshhorn Museum and Sculpture Garden. Smithsonian Institution, Washington, D.C. Gift of The Joseph H. Hirshhorn Foundation, 1972. *Certain artists (Smith, Pollock, de Kooning) work with a wide range of forms and subjects and with different series over time. Others (Rothko) find a certain form or subject and concentrate on it for a lifetime. If you were an artist, which type do you think you'd be or would want to be? Why?*

I feel no tradition. I feel great spaces. I feel my time. I am disconnected. I belong to no mores—no party—no religion—no school of thought—no institution. I feel raw freedom and my own identity.—David Smith, sculptor, ca. 1963

coloristic, "painterly" quality. Gestural, high-energy strokes reminiscent of those of Pollock and de Kooning that have been scored into the steel surfaces make us feel the artist's presence in the work as well as making the surfaces more reflective. "I make them and I polish them in such a way," Smith noted, "that on a dull day, they take on the dull blue, or the color of the sky in the late afternoon sun, the glow, golden like the rays, the colors of nature. And in a particular sense, I have used atmosphere in a reflective way on the surfaces." The sculptures, intended for the outdoors, take on the coloristic qualities of their surroundings—whether blue sky or green grass, bright sun or city lights. In delicious paradox, the solidity of steel merges with the weightlessness of atmosphere.

Modern Art and Mainstream Society

For the first-generation New York School artists, the making of art had been much more than a purely aesthetic exercise. It was totally autobiographical, involving every aspect of their lives: personal, social, political, and spiritual. Art was self-affirmation, catharsis, and, as Smith grimly saw it, "my only security." The generations to follow, both in New York and elsewhere in America, would be, on the whole, less alienated, less belligerent toward the establishment, and less demanding of art. In fact, with the passing of the first-generation New York School, a major historical period seemed to come to an end. As longtime *New York Times* art critic Hilton Kramer put it, the "age of the avant-garde" was over. Numerous new art trends and movements would arise, in accelerating fashion, but the great majority weren't really avant-garde in the original sense of the word. Most of them were not independent of the mainstream art world, nor were they anti-bourgeois or antiestablishment. Abstract expressionism, Kramer wrote, was the last of the "unpopular" art movements. To be sure, individual artists and a handful of movements continued to challenge the larger status quo. But as a whole the art movements and directions of the last half of the twentieth century ceased to be independent of and antagonistic toward the art establishment and middle-class society. Over the decades, "modern art" has

become steadily more popular with all social classes, especially the more privileged ones, and has become a well-accepted feature of American life. Attendance at modern-art museums has risen dramatically. By the late 1960s even previously antagonistic mainstream magazines such as *Time, Life,* and *Newsweek* were giving modern artists—even the old, hotly criticized abstract expressionists—positive, deferential reviews.

Modern art has, in fact, become the mainstream art of our times, achieving an honored place in museums and galleries, college classrooms, and corporate boardrooms. The year 2001 saw the release of the critically acclaimed, mass-market film *Pollock,* based on the life of the controversial artist (18.14). Widespread exposure and education have certainly helped foster understanding and popular acceptance of the twentieth century's vanguard art. In fact, modern and contemporary art has penetrated to the heart of academia itself, with most practicing artists now having college degrees in "studio art" and earning their livelihood by teaching art at colleges and universities. We might conclude that fine art has achieved its longtime cultural goal of becoming an honored discipline on an equal footing with the other liberal arts of the academy. Twentieth-century artists succeeded in achieving the cultural ideal expressed in Raphael's *School of Athens* (14.23). Into this rapidly changing cultural and social situation stepped the next generations of artists.

FROM ABSTRACT EXPRESSIONISM TO FORMALIST ABSTRACTION

As the North American art establishment and the world at large changed, so did the concerns of younger American artists. One major shift was from "extra-artistic" psychological, social, or spiritual concerns, so important to the first-generation New York School, to more strictly "artistic," art-centered concerns. The almost overwhelming abstract expressionist preoccupation with self—self-expression, self-discovery, self-transcendence—gave way to more impersonal, self-less, and media-based

concerns. One group of younger artists in the 1950s and 1960s focused on formal concerns: new ways of working with color, surface, shape, and composition. What the artistic pioneers of the next generations seemed to be seeking were ways to extend the boundaries or pass beyond the strictures of the triumphant abstract expressionist movement. Many felt it was necessary to consciously break loose from abstract expressionism's vise grip in order to realize an original art of their own.

Post-Painterly Abstraction

Formal innovation in color, the handling of paint, and surface design was one way to break the influential hold of the first generation. Clement Greenberg, partisan critic of formalist invention, wrote magazine articles, organized gallery and museum shows, and ultimately named the new movement he had helped build. He called it **post-painterly abstraction,** meaning painting that had evolved past the gestural abstraction typified by the work of de Kooning (18.18) and the hundreds of enthusiastic younger painters who, perhaps too slavishly, had taken up de Kooning's general style. All such "painterly" work was based on the hand-driven gesture of painted strokes. Greenberg did not like the fact that "the stroke left by the loaded brush or knife . . . frays out, when the stroke is long enough, into streaks, ripples, and specks of paint." Instead, the critic favored a nongestural, postcubist approach, with roots in the broad color fields of Rothko, Newman, and Still, that tended toward clearly defined, flat areas of color. Little or no personal gesture or "autobiographical" brushwork was to be discerned in such paintings. The artists Greenberg praised as "post-painterly" tended to be concerned with "the high keying, as well as lucidity, of their color . . . contrasts of pure hue rather than contrasts of light and dark . . . relatively anonymous execution."

The journey from gestural abstract expressionism to post-painterly abstraction was not made overnight, but it did not take long for the new formally oriented post-painterly abstraction to make its public and art historical presence felt.

Frankenthaler At the forefront of the new direction in the early 1950s was Helen Frankenthaler (born 1928). With her roots in gestural abstraction but her sensibility oriented to color and space, this young artist was a pioneer for her generation, freeing the field of painting to explore new possibilities. Of liberal upper-middle-class background, Frankenthaler was raised in New York City and educated in progressive private schools. At the end of the 1940s, she was studying at arts-oriented Bennington College, where she received a strong grounding in cubism. In 1950 she became a friend of Clement Greenberg, and, as she says, "Through Clem I met everybody, the whole cast. I was terrified. I was just coming out of a cubist academe. But seeing the pictures of de Kooning . . . Gorky . . . Pollock . . . it was thrilling." In 1951, aided by Greenberg, Frankenthaler had her first one-person show, at a New York City gallery. That same year she visited Pollock's studio in rural eastern Long Island and saw fifteen of his drip paintings up close. Key links between painterly and post-painterly abstraction were about to be forged.

Frankenthaler's 1952 painting *Mountains and Sea* **(18.24)** was the breakthrough work, a transitional piece between the painterly works of Pollock, de Kooning, and the early abstract expressionist Arshile Gorky and formalist post-painterly abstraction. (Frankenthaler's own work for the next five decades would be a successful synthesis of the two directions.) Justly honored as a seminal work, *Mountains and Sea* was for post-painterly abstractionists such as Morris Louis and Kenneth Noland what Pollock's drip paintings had been for the gestural action painters: It liberated them, opening up new possibilities to explore. It specifically helped Louis and Noland, both based in Washington, D.C., to break the potent grip of their immediate abstract expressionist heritage. At the insistence of Greenberg, the two men paid a visit in 1953 to Frankenthaler's New York City studio to see *Mountains and Sea.* "It was," Noland later noted, "as if Morris [Louis] had been waiting all his life for this information." What they saw was a unique painting that employed Pollock's revolutionary methods, the dripping and staining of paint into raw canvas tacked to the floor, to achieve formal as

The focus in recent painting has been on the lateral—a flat and frontal view of the surface. This has tended toward the use of flat color areas bound by and tied inevitably to a structure composed of edges.—Jules Olitski, post-painterly abstractionist, Venice Biennale catalogue statement, 1966

18.24 HELEN FRANKENTHALER. *Mountains and Sea.* 1952. Oil on canvas. 7 ft. 2⅝ in. × 9 ft. 9¼ in. Collection of the artist. On loan to the National Gallery of Art, Washington, D.C. Photograph © 2002 Board of Trustees, National Gallery of Art, Washington, © Helen Frankenthaler.

opposed to expressionist or surrealist ends. In the words of one writer, Louis and Noland saw in *Mountains and Sea* "a way to convey the weightless bloom of color without any apparent thickness of paint: light without texture." Here was an art that grew from but pointed beyond the emotive personal gestures of the abstract expressionist action painters, an "action-oriented" painting that emphasized the "abstract" rather than the "expressionist" side of the movement. Weighty existential concerns were replaced by concerns with formal innovation in color, light, and space. *Mountains and Sea* showed a way beyond the storm-tossed content of the first-generation painters. It heralded an art of largely visual or optical considerations.

Frankenthaler's own statements make clear this change in focus and intention from one generation of artists to the next. She saw her best paintings not as an expression of psychological forces but as "an intense play and drama of space, movements, light, illusion, different perspectives, elements in space." The expression of personal feelings, myths, or spir-

itual states mattered far less than the physical manipulation of paint and canvas. The primary goal for Frankenthaler was the creation of "successful," "aesthetically meaningful" pictures. In the life-affirming spirit of Matisse, Frankenthaler believed that good paintings embody that deeply satisfying moment when certain elements of space, light, and scale come together in harmony. With a sense of relief at escaping the powerful sway of the first-generation New York School, Louis, Noland, and others acknowledged Frankenthaler's work, especially *Mountains and Sky,* as a bright star pointing the way to ever more exciting possibilities.

Let us examine Frankenthaler's most influential painting through the insights of *Time* art critic Robert Hughes. Hughes praises *Mountains and Sea* as an "exquisite painting" of "rapid blots and veil-like washes . . . dashed down as though the canvas were a page in a sketchbook." Of ambitious abstract expressionist proportions, a full 7 feet high by 10 feet wide, the work was painted by the twenty-four-year-old Frankenthaler "after a trip to

Nova Scotia, whose coast is plainly visible in it: the pine-forested mountains and humpy boulder, the dramatic horizontal blue." As to method, "it was made flat on the floor, like a Pollock, and records the influence of Cézanne's [late, semiabstract] watercolors, as well as abstract expressionist painters whom Frankenthaler had studied. . . ." Despite its great size, writes Hughes, Frankenthaler succeeded in making *Mountains and Sea* "an agreeably spontaneous image (and was painted in one day), pale and subtle, with a surprising snap to its trails and vaporous blots of blue, pink and malachite green." With the thin pigment soaked into the weave of the canvas, the painting is, "in effect, a very large watercolor."

Paintings such as *Mountains and Sea,* based on the spontaneous gesture of action painting, show Frankenthaler to be, in one sense, an heir to the abstract expressionist tradition of Pollock and de Kooning. For decades she has remained enthralled by the spontaneous gesture and the kind of unforeseen imagery that emerges from improvised action. In her work, Hughes writes, "one sees traces of the surrealist ideas that had formed Pollock—an openness to the kind of unsought private image that was generally barred from [post-painterly] color-field painting." But if she is partly an abstract expressionist of painterly gesture, she is also partly a post-painterly abstractionist in the Greenbergian sense. Her main focus has always been color and the pleasurable sensations that can arise from it.

Louis and Noland Inspired by their 1953 visit to Frankenthaler's studio, Morris Louis (1912–1962) and Kenneth Noland (born 1924) began to explore the potentialities they felt were inherent in *Mountains and Sea.* Their journeys took them in the direction of an impersonal, optically oriented art in which personal gesture was jettisoned for the triumphal expansion of pure fields of color. Both men had been excited by the method and appearance of Frankenthaler's painting with its "light without texture." Stimulated by Frankenthaler's technique of staining thinned pigment—at first diluted oil paint, later water-based acrylic—into large expanses of unprimed canvas, Louis began to experiment in earnest. He unrolled huge stretches of canvas on the floor and then lifted or lowered different sections of the canvas while pouring, scrubbing, or blotting paint into the raw cloth. As the paint quickly soaked into the folds and pleats he had made, a number of basic configurations emerged. Working in series based on a single pictorial idea, Louis created numerous variations on the basic formal themes. His major themes or visual configurations, in their sequential order of development, have been categorized as "veils," "unfurleds" **(18.25),** and "stripes" **(18.26).** Over the course of eight years, from the first "veils" in 1954 to the final "stripes" in 1962, Louis progressed from first-generation abstract expressionism, especially its gestural, painterly side, to a post-painterly abstraction that has been called by names such as "color field," "color" painting, and "Washington Color School." (Washington, D.C., it should be noted, was the base of operations for Louis, Noland, and a group of similar-minded colleagues, including Sam Gilliam (5.23).)

As Greenberg saw it, Louis's work was proceeding in the right direction. It evolved gradually from the veils (interpenetrating fields of color that create a somewhat misty, atmospheric effect) to the unfurleds (rivulets of separate and distinct colors that flow diagonally down toward the center of the canvas from the sides) to the stripes (bands of pure, unsaturated color placed adjacent to each other in parallel vertical, horizontal, or diagonal arrangement). Supported by Greenberg, now a close friend, Louis had reduced the "expressionist" side of abstract expressionism in order to allow the "abstract" side of color and surface to breathe with a resplendent life of its own. An unfurled such as *Alpha-Pi* (18.25) helps us see the gradual movement from expressive to formal ends. In *Alpha-Pi* there still appears to be a degree of open-ended spontaneity in the flow of the paint. But in working the same basic format over and over again— the more spontaneous Frankenthaler never worked in such series—Louis exerted ever more conscious control over the painting process, making the end results more predictable. He also pushed Frankenthaler's staining method and emphasis on color into new directions. In the evolution from the veil

18.25 MORRIS LOUIS. *Alpha-Pi.* 1961. Acrylic on canvas. 8 ft. 6½ in. × 14 ft. 9 in. The Metropolitan Museum of Art, New York. Arthur Hoppock Hearn Fund, 1967 (67.232).

paintings to an unfurled like *Alpha-Pi* to a stripe painting like *I-68* (18.26), traces of the "painterly," hand-driven stroke have been steadily eliminated. Signs of the personal "character" of the artist, such as directional brushstroke, wrist-driven gesture, or textural shifts of weight, have been banished. The paintings appear to have been painted, almost magically, by color flowing of its own accord. All that the viewer sees in the unfurleds is brilliant, flat color running downward in rivulets from the sides of the canvas toward the bottom center. The expansive areas of brilliant white canvas that open up in the center themselves function as color fields, vying with the positive color areas for the viewer's attention. Many of these mural-size paintings are indeed stunningly beautiful, profound pleasures to the eye.

In Louis's final stripe series of 1961–62, we note that the artist has straightened the organically flowing rivulets of his unfurleds into narrow vertical, horizontal, or diagonal stripes. In doing so, Louis appears to have been consciously attempting to cast off any remaining associations with the external world. He was pushing the Greenbergian post-painterly direction to the limit. Associations with nature or the self are now almost completely absent. The paintings appear loosely geometric, composed simply of parallel bands of contrasting colors that seemingly "burn" in intensity. From a Greenbergian vanguard perspective, an important new absolute, not spiritual or personal but "optical," has been attained.

Reading more than optical effects in the repeating bands of color in the paintings of Kenneth Noland (born 1924) **(18.27),** art critic–historian Leo Steinberg wrote that the works "embody, beyond the subtlety of their color, principles of efficiency, speed, and machine-tooled precision which, in the imagination to which they appeal, tend to associate themselves with the output of industry more

than art." Perhaps because industry and corporations appreciated clean lines, a smooth finish, and streamlined design, post-painterly art was eagerly bought up by corporate collectors in the 1960s and 1970s.

The works of Noland and the post-painterly abstractionists, asserts Robert Hughes, "bloom and pulsate with light. They offer a pure, uncluttered hedonism to the eye." But such art, however optically appealing, must also be seen for its limits, that is, for what it leaves out. As Hughes observed, "The paintings Frankenthaler, Noland, Louis, and Jules Olitski did in the 1960s were, as a whole, the

most openly decorative, anxiety-free, socially indifferent canvases in the history of American art"—and this was the decade of civil rights struggles, the Vietnam War, the antiwar movement, the pop culture explosion, and widespread countercultural revolt. Responding in his journal to Noland's art, an undergraduate student echoes these sentiments, calling the paintings "silence without pain":

> I think all art is about people asking and answering questions about life: who we are, what we're doing, how we know what we know, what does it mean, God, etc. . . . It seems that in the Renaissance, art was made to confidently

The thing is color, the thing in painting is to find a way to get color down, to float it without bogging the painting down in Surrealism, Cubism or systems of structure. . . . No graphs, no systems; no modules. . . . It's all color and surface. That's all.—Kenneth Noland, painter, 1968

18.26 MORRIS LOUIS. *I-68*. 1962. Acrylic resin on canvas. 83¾ × 42 in. The Solomon R. Guggenheim Museum, New York.

18.27 KENNETH NOLAND. *Turnsole*. 1961. Synthetic polymer paint on unprimed canvas. 94⅛ × 94⅛ in. The Museum of Modern Art, New York. Blanchette Rockefeller Fund.

answer questions. With modern art, artists' questions and answers were increasingly more unique, more individualistic. I think abstract expressionism was an art that said "I don't know the answer" yet confronted the pain and despair of not knowing. But Noland doesn't ask any questions or offer any answers about life. He just doesn't care. His work is simply bands of color. There is no sign of spiritual struggle in his color bands because they are only optical statements. . . . I hate that because I need answers desperately.

Excluding the tumultuous external world from their work, post-painterly abstractionists and formally minded colleagues (2.4) created a style that was cool and refined, pleasant to the eye, and, at times, very beautiful. For some viewers this was not enough. The subsequent development of an increasingly minimalist art would disconcert such individuals even further.

Minimalist Art: Judd and Stella

Like its post-painterly relative and forebear, minimalist art tended to be cool and conceptually refined, but it also tended to upset viewers. It was just too simple. Its radical simplicity, lack of human feeling, and absence of conventional artistic qualities made minimalist works disturbing to many. Beginning around 1960, minimalism seemed to push the values of post-painterly abstraction to their logical reductive limit. A 1964 interview with two pioneers of minimalism, Donald Judd (1928–1994) and Frank Stella (born 1936), makes this connection between minimalist and post-painterly abstraction clear. In the interview, Judd and Stella frequently mention and praise Morris Louis and Kenneth Noland, specifying their attraction to the simpler, more pared down works such as Louis's "stripes" (18.26) and Noland's "targets" (18.27).

Instead of striving for the variety, asymmetrical balance, complexity, and handmade quality that characterized earlier geometric abstract art (17.19), Judd opted for absolute simplicity, unity, repetition, and mechanical finish. A good example of Judd's sculpture, his 1969 *Untitled* **(18.28),** features ten quadrangular boxes of brass and colored plexiglass, each identical in size (6⅛ by 24 by 27 inches), and spaced 6 inches apart. In addition, *Untitled* and

other Judd sculptures are made of industrial materials such as brass, plexiglass, aluminum, and galvanized iron and are fabricated by factory craftspersons according to the artist's design and exact specifications. The final product, much to the sculptor's satisfaction, exhibits an impersonal, machine-made quality reminiscent of the clean, rectilinear geometry of the modern-style skyscrapers that dominate urban American skylines (18.11). The famous saying by modernist architect Mies van der Rohe about his buildings (10.36), that "less is more," fits perfectly with Judd's goals. With its surfaces and shape finished to mechanical perfection, *Untitled* seems "untouched by human hands." Judd himself didn't touch a piece until it was delivered to his home or gallery. Even then, he might supervise others in its placement. Working in this way, the sculptor cast off yet another value he considered obsolete and imprisoning: the centuries-old tradition in European and American art that emphasized the presence of the artist's hand and personality in the work. Hard and repetitive, exuding an austere power, Judd's structures (3.20) communicate the same qualities of efficiency, impersonality, and mathematical predictability that drive advanced industrial production not only in America but worldwide.

Less doctrinaire in his views than Judd, Frank Stella was nonetheless driven by the same passionate desire to free himself from the clutches of past traditions. He wished to leave European geometric abstraction and abstract expressionism behind. (In actuality, he built upon certain elements from both movements while going off in fresh directions of his own.) To the first viewers of his art in the late 1950s and early 1960s, Stella's paintings appeared very different from typical abstract expressionist paintings, especially those done in the popular gestural style of de Kooning. Consisting of just a simple symmetrical geometric pattern of repeating white lines on a surface painted uniformly in one color, such as black, silver, or copper, Stella's paintings were so simple and spare that many didn't even think of them as art. Serious reviewers accustomed to the highly emotional, often busy, improvised canvases of gestural abstract expressionism were puzzled. Was Stella "trying to destroy painting?" a reviewer asked during an interview.

Replying that he wasn't out to destroy anything, the artist asserted, "It's just that you can't go back. . . . If something's used up, something's done, something's over with, what's the point of getting involved with it?" In effect, Stella didn't want to get involved with what he called "the old values in painting—the humanistic values," by which he meant sentiment, painterly brushwork, and detail. Rather, he sought to create art so visually "lean" and "accurate" that the viewer would want to look at his work simply as a visual "object." His goal was an art pared down to pure visibility, with no references to the artist's hand or personality or to the outside world. "All I want anyone to get out of my paintings, and all I ever get out of them, is the fact that you can see the whole idea without any confusion. . . . What you see is what you see."

What do we see in the Stella piece titled *Ileana Sonnabend* **(18.29)?** (Ileana Sonnabend was a famous art gallery director in New York City.) To begin, we see a very large monochromatic work, almost 6½ feet high by 11 feet long. (From their abstract expressionist forebears, Stella and most minimalists adopted grandeur of scale along with the idea of "allover" composition.) The work is purple, with darker lines spaced at equal intervals echoing the inner and outer shape of the canvas. The overall configuration is symmetrical. Stella liked such symmetrical composition because it was nonrelational, that is, beyond the need to "balance . . . to jockey everything around." As he put it, "In the newer American painting we strive to get the thing in the middle, and symmetrical, but just to get a kind of force, just to get the thing on the canvas." Paring away troublesome extras (for instance, the need for balance, detail, painterliness) allowed Stella to concentrate on and realize the potential of particular formal concerns. In *Ileana Sonnabend* we are aware of Stella's concern with shape. The "shaped canvas," in fact, would be one of Stella's principal contributions to the art of painting and object making. Stella sought to generate a painting from the "idea" of a certain shape or configuration. That shape or configuration would then provide the defining structure for the entire work. In a work like *Ileana Sonnabend*, the defining structure dictates the

18.28 DONALD JUDD. *Untitled.* 1969. Brass and red florescent plexiglass on steel brackets, ten pieces. Each 6⅛ × 24 × 27 in., each with 6 in. intervals. Hirshhorn Museum and Sculpture Garden, Smithsonian Institution, Washington, D.C. Gift of Joseph H. Hirshhorn, 1972. *Sometimes artistic styles that seem quite specialized or remote find their way into the everyday world. The Beatles' 1968* White Album *(3.3) introduced minimalism to a mass audience. Is such an album cover somehow more artistically accessible and acceptable than a minimalist sculpture or painting? Explain.*

18.29 FRANK STELLA. *Ileana Sonnabend.* 1963. Metallic paint on canvas. 6 ft. ¾ in. × 10 ft. 8 in. Courtesy Gagosian Gallery, New York.

"positive" shape of the canvas, the repeating linear pattern on the surface of the canvas, and also the inner, open-space "negative" shape. True to the idea of absolute symmetry and balance, the inner negative shape in *Ileana Sonnabend* and the outer positive structure possess the same basic proportions.

Such works obviously were not created by improvisation or chance. They look almost mathematical or scientific compared to most abstract expressionist works. Like an architect or a product designer, Stella carefully developed his visual ideas on paper or through the use of small three-dimensional models. But, like a traditional artist, he then executed these plans by his own hand. Because he valued control over chance, and deliberation over spontaneity, Stella, like most post-painterly and minimalist artists, worked in thematic series (for example, targets, stripes, grids, polygons) in more or less systematic ways. He developed visual ideas over a period of a year or more, with the kind of rigorous devotion that characterizes scientific research. In this respect, works like *Ileana Sonnabend* are cerebral and

conceptual ("idea art") as well as visual and optical. The names of the series of Stella's early shaped canvases, such as "Irregular Polygon Series" and "Protractor Series," give a sense of both the serial and the systematic nature of his art.

In *Ileana Sonnabend,* the principal visual idea certainly comes across with clarity and force. Stella affirmed that he "wanted something direct—right to your eye . . . something that you didn't have to look around—you got the whole thing right away." But, as one interviewer asked, were clarity and immediacy of a visual idea enough? Shouldn't there be more to see in the work than that? Stella's reply was that the enjoyment of seeing visual form, or ideas in visual form, should be enough. If he could invest in his works enough rightness of form and "presence," he said, then viewers would hopefully find them "worth looking at, or enjoyable"; they would receive "a visual sensation that is pleasurable." After four decades of inventive object making, Stella has found a substantial audience that finds his works well "worth looking at."

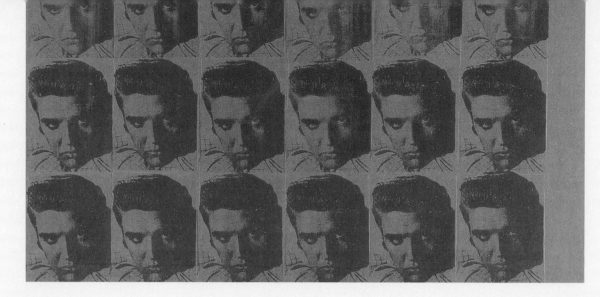

The Second Half
of the Twentieth Century

19

A MULTIPLICITY OF DIRECTIONS

From the possibilities inherent in abstract expressionism, two almost diametrically opposed artistic directions emerged in the 1950s. One, epitomized by post-painterly and minimalist art, embraced formalist abstraction (18.26–18.29) and a reductive process that led to simple, pure abstract forms. This stream has informed the work of diverse nonrepresentational and abstract artists from Sol LeWitt (8.8) and Martin Puryear (8.17) to Maya Ying Lin (Appreciation 39, figure A) and Richard Serra (Appreciation 39, figure B).

The other major direction, the focus of this chapter and the next, has been wildly expansive and has led to innovations in subject matter, media, and art forms. The new subject matter draws on sources as diverse as the American mass media, Tibetan Buddhism, and African popular culture. The new media include airbrush painting and sculptures made of poured plastic, as well as "mixed-media" combinations of every kind. Original art forms include happenings, installations, performances, and environments.

NEW SUBJECTS, MEDIA, AND ART FORMS

In the 1950s and 1960s, when post-painterly and minimalist artists were paring away "extraneous" form and content (realistic subject matter, naturalistic associations, psychological or spiritual meanings, painterly detail, and so on) in order to amplify the power of two or three formal elements (for example, color, surface, shape), other artists were violently expanding both the range of subject matter and the number of formal elements a work might contain. While the formalists concerned themselves with reducing painting and sculpture to their essentials by purging all unnecessary extras, so-called **neo-dadaists** such as Robert Rauschenberg (born 1925), Jasper Johns (born 1930), and Allan Kaprow (born 1927) pushed their work in the extreme opposite direction.

Between Art and Life: Mixed Media and Happenings

In the true spirit of dada and surrealism, Rauschenberg, Johns, and Kaprow, among others, were bursting the boundaries separating art and life. They pulled more and more of the world into their work until the demarcation between art and life became truly blurred. In 1955, the thirty-year-old Rauschenberg took his own pillow, bedsheet, and quilt, boldly painted on them in a gestural abstract expressionist style, and then hung the finished "combine"—part painting, part real-life object—on the wall. Titled *Bed* **(19.1),** the work was notorious in the art world for years. Was *Bed* a serious painting or a dada gesture? Was it art or life? Or was it something in between, a synthesis of all these? If the formalist tendency could be called "minimalist"

19.1 ROBERT RAUSCHENBERG. *Bed*. 1955. Combine painting. Oil and pencil on pillow, quilt, sheet, on wood supports. 39¼ × 31½ × 8 in. The Museum of Modern Art, New York. Gift of Leo Castelli in honor of Alfred H. Barr, Jr. (79.1989). *In an earlier work titled* Automobile Tire Print, *Rauschenberg and composer John Cage inked a car tire and drove the car over a twenty-two foot length of paper. Both* Automobile Tire Print *and* Bed *are in the permanent collections of major art museums. Do you consider them "art"? Why? Why not?*

in its reductive pursuit of pure form and clear definition, the Rauschenberg-Johns-Kaprow tendency was its "maximalist" antithesis: impure, messy, expansive, and all-encompassing. Confining definitions and all limitations on form or subject matter were thrown out the window.

The formalist artists and critics argued that the best modern art was always concerned with solving strictly visual problems—art in dialogue with itself, a closed system. Artists like Rauschenberg, Johns, and Kaprow, in contrast, stood for an open-ended art—art in dialogue with all of life, all of art, all of form and subject matter, and all at the same time. They admitted to no distinctions or separations, creating just one big bubbling stew in which the different art forms, subjects, styles, media, and elements might swim together in the same pot. Naturally, viewers were puzzled. They couldn't understand what the works of these artists were. Were they painting? Sculpture? Art? Anti-art? A battery of new names—combines, assemblages, mixed media, events, actions, performances, happenings—was invented to describe these novel works.

Neo-Dadaism in Art Historical Context For all their radicalism, such boundary-breaking works were not without a significant lineage. The primary artistic grandparents of Rauschenberg and Johns were the dadaists of the early twentieth century, with their two-dimensional collages (17.21) and photomontages (17.22), found-object readymades, and three-dimensional assemblages constructed from the throwaway items and refuse of everyday life **(19.2)**. Like their American "neo-dada" grandchildren, the original dadaists sought to blow apart all distinctions between high art and daily life. Marcel Duchamp's infamous *Fountain* (17.20), essentially a urinal exhibited in an art gallery, is a prime example. The debate continues as to whether Duchamp's "readymade" is art or life, nonart or anti-art.

If dada was the grandparent of the art of Rauschenberg and Johns, then abstract expressionism was its immediate parent. Abstract expressionism's painterly brushwork, its commitment to unbounded freedom and individualistic choice, and its sense of open-ended experimentation and "action" all found their way into the neo-dadaists' artmaking. Even

19.2 KURT SCHWITTERS. *Construction for Noble Ladies.* 1919. Cardboard, wood, metal, and paint. 40½ × 33 in. The Los Angeles County Museum of Art. Purchased with funds provided by Mr. and Mrs. Norton Simon, the Junior Arts Council, Mr. and Mrs. Fredrick R. Weisman, Mr. and Mrs. Taft Schreiber, Hans de Schulthess, Mr. and Mrs. Edwin Janss, and Mr. and Mrs. Gifford Phillips.

the incorporation of common matter from daily life had roots in abstract expressionism: for example, Pollock's use of sand, small pieces of glass, and his own handprints in certain drip paintings (18.15) and de Kooning's incorporation of newspaper or magazine fragments into a number of pictures (18.18).

Critical Responses While art historical background might help the reader intellectually understand these unusual works, it doesn't necessarily bring about appreciation. These are difficult works. When art critic–historian Leo Steinberg examined the pieces in Jasper

Painting relates to both art and life. . . . I try to act in the gap between the two.
—Robert Rauschenberg, artist, 1961

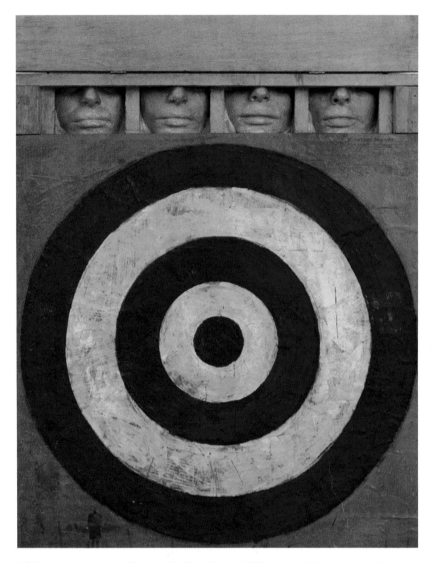

19.3 JASPER JOHNS. *Target with Four Faces.* 1955. Assemblage: encaustic on newspaper and collage on canvas with objects, 26 in. square, surmounted by four tinted plaster faces in wood box with hinged front; overall dimensions with box open 33⅝ × 26 × 3 in. The Museum of Modern Art, New York. Gift of Mr. and Mrs. Robert C. Scull (8.1958). © Jasper Johns/Licensed by VAGA, New York, NY.

Johns's first one-man show, in a New York City gallery in 1958, he was admittedly flabbergasted. He left the show unsettled, but, as he wrote:

> The pictures remained with me—working on me and depressing me. The thought of them gave me a distinct sense of threatening loss or privation. One in particular there was called *Target with Four Faces* [19.3]. It was a fairly large canvas consisting of nothing but one three-colored target—red, yellow, and blue; and

above it, boxed behind a hinged wooden flap, four life casts of one face—or rather, of the lower part of a face, since the upper portion, including the eyes, had been sheared away. The picture seemed strangely rigid for a work of art. . . . The pictures, then, kept me pondering, and I kept going back to them. And gradually something came through to me, a solitude more intense than anything I had seen in pictures of mere desolation. In *Target with Four Faces*, I became aware of an uncanny inversion of values. With mindless inhumanity or indifference, the organic and the inorganic had been leveled. A dismembered face, multiplied, blinded, repeats four times above the impersonal stare of a bull's-eye. Bull's-eye and blind faces—but juxtaposed as if by habit or accident, without any expressive intent.[1]

Writing in 2001 about Johns's target and flag paintings **(19.4),** two perceptive undergraduate students related the artist's works to the larger world of mass culture and the construction of cultural meanings. The first student wrote:

> [Johns] extensively examined the differences between signs (mass culture) and art. This is an important distinction because it doesn't seem that his contemporaries were dealing with "sign systems" as carefully as Johns. His targets are a good example for they question the purpose (which is taken for granted) of a target. In his works, all the parts are equally important, not just the center of the target, or the stars on the flag, or whatever. He focuses on the "paradox" of switching paradigms and looking as an artist rather than a marksman. Also his flag paintings confront the viewer, passively and quietly, but forcefully nonetheless, with a statement like "this is not a flag, nor three flags, but a painting."

The second student wrote in her journal:

> [Johns's] *Three Flags* shows that the flag is only a symbol constructed by society, and a painting and the American flag can be the same thing. I think he makes us question not only what art is but where our other meanings come from. When Johns shows that the meaning of the flag is constructed by collective society and it can be stripped of its meaning and turned into a painting, he is also pointing to the fact that all meaning is constructed by society.

Johns and Rauschenberg: A Study in Opposites
Learning a bit about Jasper Johns's personality and that of his colleague Rauschenberg further

enriches our experience of their works. At one time, the two men were intimate friends and struggling young artists sharing the same studio space. Like some of the great artists who, for a period of time, worked closely and productively together—such as Monet and Renoir, van Gogh and Gauguin, Picasso and Braque—Johns and Rauschenberg influenced each other, but never to the point of disguising their potent differences in personality and approach. Whereas Johns is reclusive, meditative, and introverted, Rauschenberg is amiable, impulsive, and extroverted. In working method, Johns is painstaking and deliberate, Rauschenberg freewheeling and spontaneous. Where Johns is all control and contraction, Rauschenberg is anarchic and expansive. Where Johns breathes in, wrote one critic, Rauschenberg breathes out. Their artworks reflect these differences in temperament and method. Johns's works are cool and terse, as critic Steinberg observed of *Target with Four Faces.* The piece seems resonant with meaning but tells very little. Compared to Johns's introspective and almost silent works, Rauschenberg's artworks (19.1) are passionate and verbose.

For Rauschenberg, all the world represents subject matter to act upon. Everything delights or fascinates him: beds, automobile tire prints, stuffed animals, electric clocks. Like a sponge, he drinks it all up, ready to throw together anything in an art of endless combinations. In the early 1960s, Rauschenberg began to collect and mix together the images of the mass media, appropriating his subjects and forms from print, photographic, and television images. As he put it, "I was bombarded with TV sets and magazines, by the refuse, by the excess of the world. . . . I thought that if I could paint or make an honest work, it should incorporate all of these elements, which were and are a reality."

Rauschenberg had come to recognize that the most influential reality of the present is one not of physical objects but of media images. He had realized that the mass-media environment was gradually eclipsing both the natural and the built environment in its power over us. In the 1964 silkscreen print *Retroactive I* **(19.5),** print and television images crash together much the way images, related and unrelated, smash up against each other in magazines and

19.4 JASPER JOHNS. *Three Flags.* 1958. Encaustic on canvas. 30⅞ × 45½ in. Whitney Museum of American Art, New York. 50th Anniversary Gift of Gilman Foundation, Lauder Foundation, A. Alfred Taubman, anonymous donor, purchase (80.32).

in TV shows and commercials. This collision of images echoes the quick editing cuts we experience when we change television channels or glance from page to page in a magazine. In *Retroactive I,* the image of President John F. Kennedy stands dead center with the other images butting into or revolving around it. Kennedy's pointing hand is repeated as a painted-over fragment. Above this second hand appears a box of oranges viewed at an odd angle. An astronaut descends through space. Hanging over Kennedy like a mournful halo of gray, black, and brown is a circular swirl painted in a gestural abstract expressionist manner. It overlays a photograph of men working and drips down on both President Kennedy and a glass of milk. Below the small glass is a photographic image from *Life* magazine that parodies Marcel Duchamp's *Nude Descending a Staircase* (18.4). (At one level of meaning, Rauschenberg, an admirer of both Duchamp and Kennedy, seems to be "retroactively" honoring both men.) It is these kinds of images, related and unrelated, that both artist and viewer experience simultaneously or in close succession on any given day of our lives. First through his combines of everyday objects and thereafter through his collagelike compositions of media images, which were cut up,

. . . Beginning with the flag, a painting was made. Beginning that is, with structure, the division of the whole into parts corresponding to the parts of a flag, a painting was made which both obscures and clarifies the underlying structure.—Jasper Johns, artist, 1964

19.5 ROBERT RAUSCHENBERG. *Retroactive I.* 1964. Silkscreen ink on canvas, 84 × 60 in. The Wadsworth Atheneum, Hartford, Connecticut, Gift of Susan Morse Hilles.

at the forefront of the development of a "new realism" expressive of the second half of the twentieth century.

Into Real Space and Time: Happenings and Kaprow Attracted to collaboration and to the idea of extending art into real space and time, Rauschenberg eagerly participated with other avant-garde artists in dance performances, theater pieces, and dadalike improvisatory events. These vanguard collaborations were staged by friends such as composer John Cage and modern-dance choreographer Merce Cunningham. Emphasizing chance, spontaneity, and a free-form synthesis of art and life, the pieces shared affinities with the **happenings** that visual artists such as Allan Kaprow and Claes Oldenburg were experimenting with in the late 1950s and early 1960s. Kaprow, a student of John Cage at New York City's New School in the mid-fifties, became the chief theoretician of the happenings movement. He also became its official historian, tracing the visual-arts roots of happenings back through contemporary painting and mixed-media (artists such as Rauschenberg, Johns, and himself) to the seminal action painting of Pollock and back further to the artworks and theaterlike "manifestations" and demonstrations of the surrealists, dadaists, and futurists.

As Kaprow saw it, the happening **(19.6)** was a synthesis of advanced painting, theater, and life. He began a 1961 essay, "Happenings in the New York Art Scene," by describing some "great moments" from different happenings:

> Slides and movies, projected over walls and people, depict hamburgers: big ones, huge ones, red ones, skinny ones, flat ones, etc. You come in as a spectator and maybe you discover you're caught in it after all, as you push things around like so much furniture. Words rumble past, whispering, dee-daaa, lawnmowers screech just like the I.R.T. [subway] at Union Square. Tin cans rattle and you stand up to see or change your seat or answer questions shouted at you by shoeshine boys and old ladies. Long silences, when nothing happens, and you're sore because you paid $1.50 contribution, when bang! There you are facing yourself in a mirror jammed at you. . . .[2]

pieced together, painted on, and ultimately printed by silkscreen process, Rauschenberg developed a truly different kind of realism. It was worlds apart from the straightforward social realism of earlier artists such as John Sloan (18.3) and Edward Hopper (18.5). Incorporating the traditions and imagery of dada, abstract expressionism, and the post–World War II mass media, Rauschenberg and Johns were

19.6 ALLAN KAPROW. *A Spring Happening.* 1961. Happening in rehearsal. *A mentor of Kaprow, John Cage composed a "musical" piece consisting of four minutes and thirty-three seconds of silence during which the chance sounds of the audience—creaking of chairs, coughs, rustling of clothing—constituted the work. How is this piece, entitled 4'33", similar to or different from a happening?*

Happenings came in all types: sophisticated and witty; ritualistic and Zen-like; and "crude, lyrical, and very spontaneous" like Kaprow's own. They were like theater pieces, but they differed from the conventional stage in important ways. First, they could be staged anywhere, but the closer to real life—in natural settings, grimy alleyways, or grungy work spaces **(19.7)**—the better. In these locations, the audience and actors were thrown together as one, with everyone ideally taking part in the action, no bystanders. Everyone was in the action, as Pollock was "in the painting." In addition, all things (for example, trees, catsup bottles, easels) in the setting might be spontaneously involved in the unfolding activity. For these reasons, official theaters where audience and performers were physically separated or immaculate galleries or museums where participants might feel restrained from spontaneous activity were less desirable "contexts." A second contrast from conventional theatrical plays, Kaprow noted, was that happenings had no plot and no obvious philosophy; they were brought to life in an improvisatory manner, like jazz and much contemporary painting, with viewers not knowing exactly what was going to happen next.

For both their creators and their participants, happenings offered an opportunity for intense creative interaction with the immediate surroundings. Kaprow observed that artists such as Pollock and Cage, Rauschenberg and Johns had "left us at a point where we must become preoccupied with and even dazzled by the space and objects of our everyday life, either our bodies, clothes, rooms, or, if need be, the vastness of [New York City's] Forty-Second Street." Feeling much the same imperative to join art and life, "environmental" and "earth" artists would soon be making city streets, desert landscapes, and seaside cliffs the bases of their art. Still other artists, called "performance artists," would build from the happening artists' emphasis on our bodies and the space and objects around us, choreographing their actions more tightly and focusing them on their individual thoughts and feelings.

Artists of the future, Kaprow predicted, would be intersensory and intermedia creators who drew upon the stuff of everyday life and popular culture. He could not have been more

Not satisfied with the suggestion through paint of the other senses, we shall utilize the specific substances of sight, sound, movements, people, odors, touch. Objects of every sort are materials for the new art: paint, chairs, food, electric and neon lights, smoke, water, old socks, a dog, movies. . . .
—Allan Kaprow, happenings artist and historian, 1958

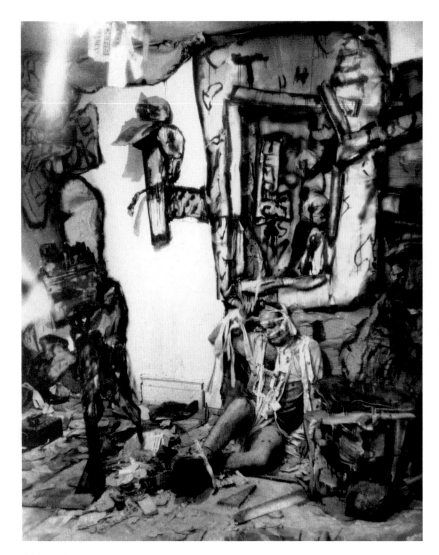

19.7 CLAES OLDEN-
BURG. *Snapshots from the
City.* 1960. Performance
at Judson Gallery, Jud-
son Memorial Church,
1960. Photo: Martha
Holmes. Courtesy of
Time Life.

on target. The pop artists and other new real-
ists who rose to prominence in the early 1960s
took as their subject matter the everyday
world in its entirety, from canned foods and
comic strips to humble store windows.

VARIETIES OF NEW REALISM

*I am for an art that takes
its form from the lines of
life itself . . . and is heavy
and coarse and blunt and
sweet as life itself.*
—Claes Oldenburg,
artist, 1961

The combine paintings of Rauschenberg and
Johns, along with the happenings, writing, and
teaching of Kaprow, provided a foundation
upon which numerous artists would build.
Prominent among these were the pop artists,
some of whom were major figures in the hap-
penings movement itself.

Pop Art

Oldenburg Claes Oldenburg (born 1929)
noted that what he did in his happenings (19.7)
was part of his general concern with using
"more or less altered 'real' materials." "This
has to do," he said, "with objects, such as type-
writers, Ping-Pong tables, articles of clothing,
ice cream cones, hamburgers, cakes, etc., etc."
After using such commonplace objects "in mo-
tion" in his happenings, Oldenburg proceeded
to make a brilliant career of creating witty ver-
sions of popular everyday objects, which he
exhibited in a variety of settings as **pop art**
sculptures. His first one-person show in a com-
mercial gallery **(19.8),** in New York City in
1962, shows his preoccupation with the alter-
ation of the things of everyday life. Working
midway between the real and the surreal—one
critic called him "the thinking man's Walt
Disney"—Oldenburg presented the common-
place in extraordinary ways that would have
been right at home in Alice's Wonderland. The
normal size, texture, and material of everyday
things underwent strange and amusing trans-
formations. An ice-cream cone and a slice of
cake became huge. A pair of pants expanded to
gigantic proportions. Soft items turned hard.
The humongous ice-cream cone, made of
painted plaster, was as resistant as a rock. The
cake was a weird mixture of hardness, soft-
ness, and heaviness; pliable to the touch, it was
made of stuffed, painted fabric. Normally hard
objects (toilets, saws, drums) metamorphosed
into soft, floppy ones. Over the next decades,
alterations of texture, scale, and material
makeup would characterize Oldenburg's play
on reality.

The Green Gallery show in New York City
revealed much about Oldenburg's art histori-
cal roots while predicting the future direction
of his art. Many of the objects were executed
with the rough, painterly finish typical of ab-
stract expressionist gesture painting. The gritty
urban quality associated with the work of
Pollock, de Kooning, and the happenings char-
acterizes Oldenburg's early style. We see this
in the Green Gallery photograph that in-
cludes the twin hamburgers (right foreground)
and the erect shirt with blue tie (left back-
ground), both painted in a rapid, aggressive
gestural style. The "environmental" nature of

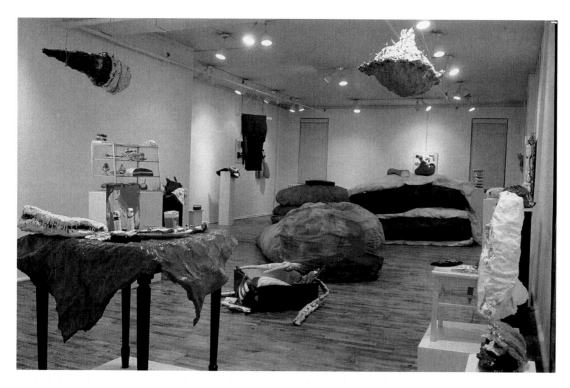

19.8 CLAES OLDEN-BURG. Installation view of solo exhibition at Green Gallery. Fall 1962. Large-scale sculptures, including works from *The Store*.

the exhibit—a total environment that surrounds the viewer with the commodities of American home life—grows out of the legacy of the happenings movement. But more present-oriented developments are also to be noted. For his one-person show in an expensive uptown gallery, Oldenburg was motivated to create pieces that were larger, costlier, and more refined in execution than his previous work. The result was his first large-scale "soft sculptures," notably the colossal *Floor-Cake* and *Giant Blue Men's Pants*. These two works, along with the *Giant Ice-Cream Cone*, foreshadow the inflation in scale and more refined, immaculate finish that Oldenburg sculptures, both soft and hard, would receive in the future. Some of the artist's works became so large in scale that they had to be moved out of galleries and museums and into the public domain. Two examples among many are Oldenburg's *Clothespin* in the heart of Philadelphia (3.17) and his 100-foot-high, 20-ton upright steel baseball bat, called *Batcolumn*, in downtown Chicago. These two public art monuments compete, with a wink of the eye, with the modern skyscrapers around them.

The huge commercial success of Oldenburg's 1962 Green Gallery show was one of the first indicators of pop art's appeal. It predicted the meteoric rise of "pop" to international acclaim. No longer an underground downtown movement of artists involved in happenings and rough-hewn object making, the new realist art quickly became a chic uptown commodity eagerly bought and sold by dealers and collectors and consumed by the affluent "jet set" crowd and the mass media. For its quick success, among other reasons, various established critics railed against the pop art incursion. They heartily disliked Oldenburg's soft sculptures for their bigness, brashness, and vulgarity. Clement Greenberg, pushing "post-painterly" art at the time, scorned the movement as merely fashionable, "a new episode in the history of taste." Harold Rosenberg denounced pop art, with its fetish for consumer commodities, as a sinister product of a materialistic, philistine culture. With the success of pop art, the century-long tradition of the avant-garde as committed to independence from and opposition to the status quo seemed to have caved in to the bourgeois mainstream. At least, that is how senior vanguard writers saw the pop art phenomenon. "A critical examination of ourselves and the world we inhabit," wrote art historian Peter Selz, "is no

[Pop art] is as easy to consume as it is to produce and, better yet, is easy to market, because it is loud, it is clean, and you can be fashionable and at the same time know what you're looking at. Eager collectors, shrewd dealers, clever publicists, and jazzy museum curators, fearful of being left with the rear guard, have introduced the great American device of obsolescence into the art world.—Peter Selz, art historian and critic, 1963

19.9 ROY LICHTENSTEIN. *Whaam!* 1963. Acrylic on canvas. 5 ft. 7⅜ in. × 13 ft. 2½ in. Tate Gallery, London. © Estate of Roy Lichtenstein. *The artist argued that works like this were not simply blown-up cartoons but rather unique creations carefully composed into aesthetically satisfying works of art, something cartoonists, with their primary interest in character depiction and narrative, were little concerned with. Do you agree with these points?*

longer hip: let us, rather, rejoice in the Great American Dream." Key avant-garde values—independence and criticality—were being surrendered.

Lichtenstein Of the new pop realists, Oldenburg was the master jester, playing with the overlooked everyday forms and drawing fun from them by blowing them up to vast sizes, deflating hard surfaces into softness, mining the gap between art and the everyday, and bringing forth astonishing gems of comic and aesthetic delight. In comparison, Roy Lichtenstein (1923–1997) appeared at first to be the cool stylist. He worked in a straightforward commercial mode that was clean, precise, and to the point. But soon he too established himself as something of a wit. Around 1961, Lichtenstein, who had been painting in both abstract expressionist and figurative styles, turned to the graphic art of the cartoon strip for his basic form and subject matter **(19.9).** This does not mean that he liked everything about comic strips. He personally found many of the subjects of cartoons disturbing (for instance, violence, militaristic and fascist-type

characters), noting that the subjects of pop art in general were among the "most brazen and threatening characteristics of our culture, things we hate, but which are also powerful in their impingement upon us." Such disagreeable subjects, he believed, were not to be shunned, as much modern abstract art had done, but should be met head-on. Art since Cézanne, Lichtenstein affirmed, had "become extremely romantic and unrealistic, feeding on art. . . . It has had less and less to do with the world, it looks inward. . . . Pop art looks out into the world; it appears to accept its environment, which is not good or bad but different—another state of mind." Anticipated in the work of Rauschenberg, Johns, and Kaprow, this divergent "state of mind"—outward looking, accepting of the environment, realistic—seemed to herald the coming of an "antimodern" or "anti–avant garde" direction. In this sense, pop artists such as Lichtenstein and Oldenburg may have been the first full-fledged "postmodernists."

Their subject matter notwithstanding, what had most attracted Lichtenstein to cartoons and commercial art was its form, a

universal "industrial" style he found "forceful and vital." (He had actually worked in earlier years as an engineering draftsman for Republic Steel and other engineering corporations.) He liked the simple dynamic forms of the commercial and industrial design styles, with their crisp, bold contours, dramatic color contrasts, and immediacy of visual impact. Transforming commercial styles in their different ways, pop artists created works that, according to Lichtenstein, broadcast a "brassy courage, competition with the visual objects of modern life, naive American freshness, and so on."

With his strong background in art history and theory, Lichtenstein saw himself as infusing fine-art values into the formal content of the popular commercial art style. He quickly proved that the form, not the subject matter, of cartoons was his primary interest. From as early as 1962, subject matter from the history of fine art (see front cover) steadily began to rival subjects drawn from the comic strips in his works. Over the course of a decade, Lichtenstein created ingenious cartoon-style takeoffs of a classical Greek temple, Monet's impressionist painting of Rouen Cathedral, cubist portraits and still lifes, and even abstract expressionist action paintings. In creating his personal cartoon-style versions of de Kooning–type gesture paintings, Lichtenstein altered the original abstract expressionist subjects in an ironic, comic way. Postmodern humor, irony, wit, and takeoffs from past artworks now entered the art world full force. In the 1965 *Little Big Painting* **(19.10),** Lichtenstein blows up several of de Kooning's characteristic brushstrokes to huge size and transforms the overall image into a newspaper-style cartoon complete with a background of small newsprint dots. The passionate brushstrokes that inspired thousands of aspiring action painters are transformed by the pop artist into a cool, crisp media image. Recast as pop art, de Kooning's gestural strokes have entered a twilight zone somewhere between the popular art of the cartoon and a sophisticated discourse of the art-world elite. Abstract expressionism has been appropriated from its intensely human, autobiographical style and re-formed into a synthetic pop art style, half commercial and half fine art. At the time, it should be noted, abstract expressionism had itself become a popular topic, a commodity in the commercial mass media.

19.10 ROY LICHTENSTEIN. *Little Big Painting.* 1965. Oil and synthetic polymer on canvas. 68 × 80 in. Collection of Whitney Museum of American Art, New York. Purchase with funds from the Friends of the Whitney Museum of American Art (66.2). © Estate of Roy Lichtenstein.

In *Little Big Painting,* irony abounds. The painting is as big as many of the large abstract expressionist works of the past, but it focuses on only a little area—just a few brushstrokes. In a seeming confrontation of comedy and tragedy, *Little Big Painting* also pokes irreverent fun at the high moral and emotional seriousness of abstract expressionist painting. Perhaps most ironically, Lichtenstein has managed, through his "industrial" style, to create an image of immediacy and forcefulness, qualities that the gestural abstract expressionists admired. Comparison of a de Kooning gesture painting such as *Gotham News* of 1955 (18.18) with Lichtenstein's *Little Big Painting* of 1965—with their divergent values, methods, form, and content—makes for a fascinating cross-referencing of the modern and postmodern worlds of artmaking.

Warhol In contrast to the sophisticated jests and ironies of Lichtenstein's and Oldenburg's

Lichtenstein's muse is the printing press and his inspiration the modern processes and conventions allied to it. . . . In Lichtenstein's painting, [commercial art] technique is transformed into [fine art] style.—Gene Baro, art critic, 1968

19.11 ANDY WARHOL. *Two Hundred Campbell's Soup Cans.* 1962. Synthetic polymer paint on canvas. 6 ft. × 8 ft. 4 in. © The Andy Warhol Foundation for the Visual Arts.

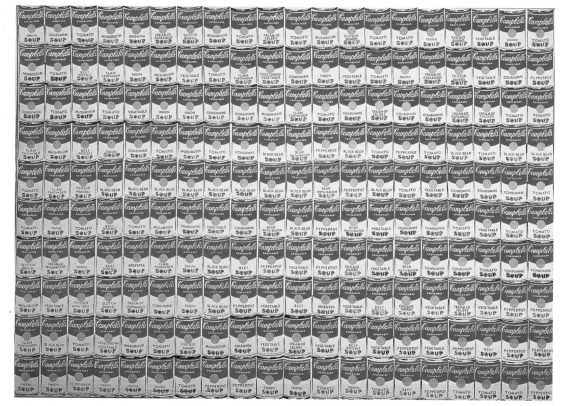

works, the paintings, silkscreen prints, sculptures, and films of Andy Warhol (1928–1987) seem utterly detached and deadpan. As a personality, Warhol himself came across as cool and neutral. The most noncommittal of the pop artists, he was perfectly suited for the role of walking mirror. In his works, Warhol reflected back the world of mass-media images and commercial products in almost exact reproduction but with several crucial alterations. First, he often repeated his chosen image—for example, a head shot of Marilyn Monroe, a Coca-Cola bottle, a Campbell's soup can **(19.11)**—many times over. He actually spoke of himself as a "machine," saying he loved mass production because "you do the same thing every time. You do it over and over again." Accordingly, Warhol used mechanically and chemically reproductive media—photography and silkscreen printmaking—so that he could repeat his given image rapidly and endlessly with relative ease.

Warhol's particular obsession with reproduction and repetition motivated his choice of subject matter as well as method. He selected for his subjects items or scenes that, by choice or chance, he had experienced over and over again. These centered on mass-media images such as pictures of famous personalities and mass-produced commodities such as Campbell's soup cans. When asked why he started painting soup cans, the artist responded matter-of-factly: "Because I used to drink it. I used to have the same lunch every day, for twenty years, I guess, the same thing over and over again. . . ." It was almost as if the Andy Warhol the public knew was himself a product or commodity, shaped by Western society's deepest industrial technocratic values: predictability, replicability, efficiency, and impersonality. Uniformity, repetition, and minor variations on a theme likewise played major parts in Warhol's art. Warhol created a single Campbell's soup can commercial-art style: simple, bold, direct. Accurate in form and color, it was a schematic facsimile of the actual product. At first, he handpainted each Campbell's soup can in paintings that contained as many as 200 cans. Later, he employed a photo-silkscreen process whereby he could mechanically repeat

I think everybody should be a machine.—Andy Warhol, artist, 1963

the soup can image, in grid formation, in whatever denominations he desired. Here was a quintessential visual expression of mass reproduction, just as the shopper would find it on the shelves of the local supermarket—soup can after soup can, row after row. Shifting his attention between mass-produced products and mass-produced media images—were the two interchangeable?—Warhol selected well-known photographs of celebrities such as Marilyn Monroe and Elvis Presley, modified them, and then printed them, in a grid pattern, over and over again. His 1962 *Elvis* **(19.12),** for example, features thirty-six repeated head shots of music and movie star Elvis Presley.

What all this repetition did was overload the viewer's mental circuits. Excessive repetition reduced the meaning of the person or product depicted to the lowest common denominator. A famous celebrity such as Elvis Presley ceased to be a unique person. Converted by endless repetition to a superficial media image, the once soulful rock 'n' roll singer was turned into little more than an instantly recognizable sign. Warhol's potent use of repetition makes us only too conscious of how the unending stream of media images blunts our sensibilities. Were such works simply mirroring society, or were they implicitly criticizing it? Warhol never said.

The pop art movement was soon accompanied by the vast "pop music explosion" that hit its full stride in Europe and America around 1964. Of all the pop artists, Warhol had the most influence on the pop music scene. Artistically, his grid format directly influenced the cover design of the Beatles' 1964 breakthrough album *A Hard Day's Night* **(19.13),** just as minimalist art later influenced the group's 1968 *White Album* (3.3). Like a whirlwind, the sixties pop music explosion carried Warhol into pop countercultural activities ranging from rock group management to album cover design for the Velvet Underground, the Rolling Stones, and Diana Ross. Fluidly crossing media boundaries, the artist became involved with other collaborative projects, most notably alternative filmmaking. His arts pursuits and his numerous appearances before a mass media insatiable for pop culture and counterculture news and gossip sealed Warhol's position as an artist and a celebrity.

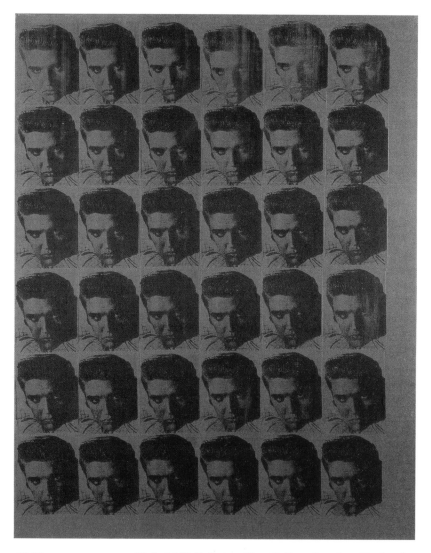

19.12 ANDY WARHOL. *Elvis.* 1962. Painting. Tate Gallery, London, England, © 2001 Andy Warhol Foundation for the Visual Arts/ARS, New York.

Pop Art in Art Historical Perspective In the 1960s, fine art and popular art were blending as they never had before. The old modernist avant-garde notion of the artist as lonely creator, working in the solitude of the studio, was under all-out attack. The whole direction of the new movement seemed outward, with fine art and the fine artist partaking in the nitty-gritty of the everyday world. New roles, previously taboo, now became acceptable: the artist as documenter of external reality; the artist as "commercial" in subject matter, style, and business goals; the artist as media star. To most artists and critics of the old avant-garde, from

19.13 THE BEATLES. *A Hard Day's Night.* 1964. Robert Freeman, designer. Parlophone. © Apple Records, Inc./Capitol Records, Inc. EMI Records. *Album cover design is often influenced by contemporary art world styles, and artists themselves (for example, Andy Warhol, Robert Rauschenberg) sometimes create album covers. Look at your own CDs and cassettes and see if you can detect the influence of pop art, minimalism, or other art styles in their covers.*

Rothko to Rosenberg, pop art—and new realist art in general—looked like a sellout. The pop artists had been co-opted by the system. Pop artists like Warhol and Lichtenstein, however, considered the emphasis of the older modernist vanguard art on subjective emotion, individuality, and personal creativity overdone. These younger artists were looking around and appropriating things for their art that their abstract expressionist elders had scorned: media images, mass-market products, commercial and industrial art styles. They were men and women from different worlds. Whereas the abstract expressionists had been shaped by the turbulent decades of economic depression and world war, the pop artists were largely products of an affluent, materialistic, and relatively peaceful society and the mass-media, mass-market culture of the 1950s and early 1960s. Given that their backgrounds were so different from those of their abstract expressionist predecessors, it is perhaps not surprising that the new realists broke with the values of the old, antiestablishment

vanguard. If, in retrospect, abstract expressionism can be seen as the last major modernist avant-garde movement in North America and Europe, then pop art, more mainstream, popular, and contextual, might well qualify as the first full-fledged postmodern one.

From Modernism to Postmodernism With pop art, American painting and sculpture reached a dividing line between modern and postmodern art, that is, between the long-standing, adversarial avant-garde that was concerned with the critical examination of self, art, and the world and a postmodernism more accepting of the artistic past and the societal status quo, from more traditional representational and realistic styles to commonplace commercial subject matter and form. Older art critics such as Selz, Greenberg, and Rosenberg clearly bemoaned this shift in artistic attitude and direction. But, one might ask these critics, what was the new generation of artists to do? Should they avoid representing the commodities, celebrities, and commercial images that glutted daily life, that is, avoid the all-pervasive imagery of the mass media? In postwar America, the world of popular culture was ever present. Nature, once the dominant setting of human activity, had been almost completely replaced by mass culture. The landscape of the present was no longer one of rural fields and village greens but rather one of skyscrapers, billboards, supermarket aisles, and television screens. True to the credo of the nineteenth-century realist Gustave Courbet (16.21), the "new realists" were interpreting the appearances and customs of their time in their own individual ways. Like Courbet and his colleagues, they were representing only that which was "real and existing"—actual, concrete reality. Of these new realists, none represented their subjects more accurately than did those artists called superrealists and photorealists.

Superrealism and Photo-realism

Two forms of the new realism that shared many of the values of pop art but soon became distinguishable from it were **superrealism** and **photo-realism.** So strong were some of the connections between pop art and the two new

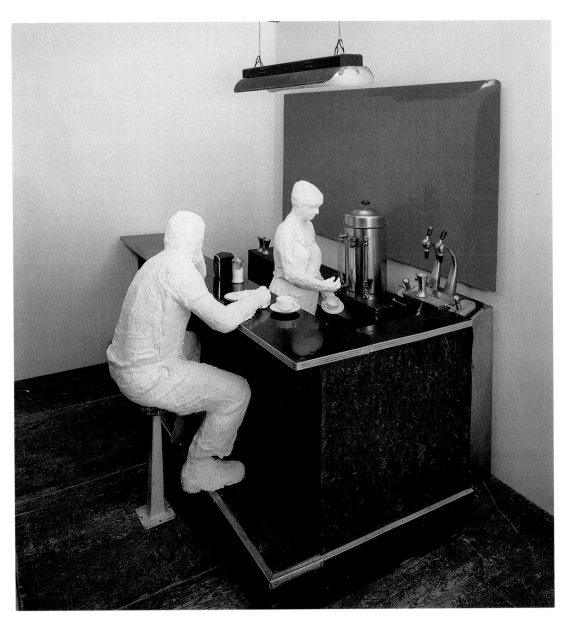

19.14 GEORGE SEGAL. *The Diner.* 1964–66. Plaster, wood, chrome, laminated plastic, masonite, fluorescent lamp, glass, paper. 8 ft. 6 in. × 9 ft. × 7 ft. 3 in. Collection Walker Art Center, Minneapolis. Gift of the T. B. Walker Foundation, 1966.

currents that one superrealist sculptor, George Segal (born 1924), was and often still is identified as a pop artist.

Segal: Between Pop Art and Superrealism Segal's friendship in the late 1950s and early 1960s with artists concerned with the stuff of everyday life, including Kaprow, Oldenburg, and Lichtenstein, linked him personally with those who helped to found pop art. More to the point, Segal's plaster-cast sculptures in their environmental settings, which he showed in New York from 1960 onward, were linked to pop art in their direct, impersonal representation of everyday reality. Segal's early environmental works even contained props from real life that fit closely with pop art iconography: a movie marquee, common kitchen and bath-room furnishings, a counter and cooking equipment from an actual diner **(19.14).** A confirmed people-watcher, Segal often saw his human subjects "against garish light, illuminated signs . . . visually vivid objects that were considered low class, anti-art, un-art, kitsch, disreputable. . . ." It was essential to include these "pop" objects in his work. Moreover, he was trying to look as bluntly as he could at these objects and the people involved with them. His was very much a pop way of seeing.

Yet as we pay more attention to Segal's art, its differences from pop art become more apparent. To begin, Segal represented real people and things, not media images of people or things. His plaster sculptures were cast from human beings, and the settings he built for them were constructed from the actual objects

of daily life. The work thus had a human immediacy lacking in the mediated images of pop art. Viewing a Warhol portrait was like viewing a person through the filtering device of television or photography. Seeing a Segal portrait was almost like encountering the person in the flesh, though with several crucial exceptions. In Segal's people, naturalistic color was left out, radically simplifying each person's appearance. The figures either were stark white, the color of their plaster material, or were painted in a particular monochrome, such as blue, black, or red, that evoked a mood. Segal's situational figures always conjured a feeling of aloneness, isolation, or self-absorption, not unlike the feeling found in Edward Hopper's earlier paintings of American people and places (18.5). But other feelings also come through in Segal's work—not the artist's personal emotions, but rather the feelings communicated by the individuals enmeshed in their specific situations.

The sculptor's situational sculpture *The Diner* (19.14), for example, might bring to mind another late-night spot, one we experienced through van Gogh's *Night Café* (1.12). Some of the feelings embodied in van Gogh's *Night Café* are similar, though the tone of Segal's work is cooler and more impersonal. Segal noted that the piece "is the essence of every New Jersey diner." The sculptor frequently returned to his New Jersey home from New York late at night, taking a much needed coffee break during the 40-mile trip. He observed:

> Walking into a diner after midnight when you're the only customer, there's both fatigue and electricity. The waitress behind the counter is always sizing you up, either wondering if you're going to rob her or rape her, if you're going to be dangerous or sexually attracted. There is a careful avoidance of eye contact with two people alone in a diner after midnight, but there's electricity—it's always present. My figures seem to be standing still, but I am interested in some kind of electricity or tension or ferment that's implied in the stillness.[3]

To capture this feeling of inner tension, Segal carefully chose the people and poses, organized the props, and manipulated the spatial relations between figure and figure, figure and prop. For all the literal or psychological content of their art, the new realist artists always made certain to emphasize its formal content.

In *The Diner*, Segal noted, "the white figure, the waitress, is against the pure intense red of a wall; the bottom half of the seated man is against the dark, black/green linoleum of the counter. And they are austere, abstract, dark, light, vivid—every kind of thing."

Hanson: Superrealist Sculpture The sculptures of Duane Hanson (born 1925), warmer in tone and far more naturalistic, qualify as full-fledged superrealism **(19.15).** Like Segal, Hanson places his figures in commonplace, lifelike situations, but unlike Segal he strives for extreme naturalism in his figures as well as his settings. He starts his figures by pouring a synthetic liquid plastic into plaster life-molds cast from actual persons (8.35). He then paints the hardened plastic figures in infinite detail, dresses them in actual clothing, and even implants real hair, strand by strand, into their scalps. The final product can be so lifelike in appearance that viewers have been known to go up to Hanson's sculptures and ask them questions.

By the 1970s Hanson's works became portraits of individual people, mostly of the working class: art museum and security guards, tourists, cleaning women, waitresses, construction workers, tired shoppers, struggling old people, and even a few paint-spattered artists. This focus on ordinary people (8.36) in their ordinary surroundings joined Hanson to the larger new realist movement, but it soon became clear that his aims were quite different from those of his pop art predecessors. Hanson, like Segal, was concerned with actual life versus media versions of it. Also like Segal, he was a determined social realist, but more than any other new realist he was an explicit social critic. A politically motivated artist concerned with "lost causes, revolutions," and society's forgotten people, he championed an art that expressed his "feelings of dissatisfaction" with the world.

Over the years, Hanson's figures have become more complex in their meanings, exuding what the artist calls "the bittersweet mixture of life." Relative to his sculpture *Dishwasher* (19.15), the artist asks us to put ourselves

> . . . in the place of a guy who washes dishes day in and day out, one who doesn't have many aspirations except to have a color television set.

That was one of the things the model was planning to save his money for. . . . He does his job well. He could wash dishes faster than any guy I ever saw.[4]

Such a man's life is indeed bittersweet. His work is esteemed by very few, yet he does it well and probably with some pride. The less pleasant aspect is that he is overweight and tired. Eyes downcast, shoulders sagging, he is beginning to look old and misshapen before his time. High blood pressure and a heart attack may be on the way. Is this dishwasher not a late-twentieth-century counterpart of the faltering young man in Courbet's *The Stone Breakers* (16.21)? Is he not an inevitable victim of a commercial-industrial society in which only some can really succeed? These are questions Hanson's sculptures ask us. His art is meant to jog our social consciences.

Close and Estes: Photo-realist Painting The superrealist sculpture of artists such as Hanson is usually seen as the three-dimensional counterpart to the work of photo-realist painters such as Chuck Close (born 1940) and Richard Estes (born 1936). The painted images of these artists **(Interaction Box)** look so real that viewers often mistake them for large-scale photographs rather than oil or acrylic paintings. Working from photographic prints or slide projections, photo-realist artists meticulously select from and imitate the visual reality that comes to us through the camera. Their reasons for turning to photographs are essentially twofold. First, in practical terms, it is far easier to work from photographs in the controlled comfort of the studio. Second, in a culture dominated by photographic images, painters are in tune with a photographic way of seeing and representing. The pop artists, after all, were already mining magazine and newspaper photographs for their subject matter and style. The photo-realists use photography in creating the most illusionistic paintings of commonplace scenes and people ever seen by twentieth-century eyes.

Like Hanson's superrealist sculptures, the photo-realist paintings received mixed reviews when they made their art world debut in the early 1970s. A fair number of viewers and critics saw in such art little more than copying. All who beheld them admitted that the paintings were extraordinary accomplishments from a

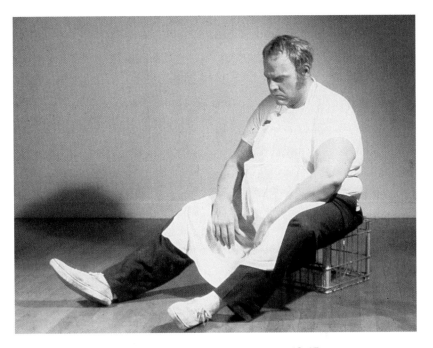

19.15 DUANE HANSON. *Dishwasher.* 1973. Polyester and fiberglass polychromed in oil. Lifesize. Courtesy Mr. Ed Cauduro, Portland, OR.

technical standpoint. Chuck Close's large portraits were particularly impressive. *Phil* **(19.16),** a black-and-white portrait of composer Philip Glass, is 9 feet high by 7 feet long. "How was that done?" nearly everyone asked in astonishment. But in the end viewers and reviewers often judged photo-realism's technical tours de force to be more imitation than art. Modern art had long ago cast off imitation and copying for expression, imagination, and abstract form. Were superrealist sculpture and photo-realist painting dramatically turning back the clock of art history? In the absolute mimesis of photo-realist paintings, the originality, individuality, and passion that had characterized so much earlier modernist art—abstract expressionism, surrealism, cubism—were utterly absent.

Even when photo-realist paintings were compared to their nearest neighbors, the pictures of earlier twentieth-century realists like Grant Wood (18.9) and Edward Hopper, the initial responses were not favorable. Compared to a Hopper streetscape (18.5), one by Richard Estes **(19.17)** looked strangely mechanical, impersonal, and absent of feeling. To be sure, photo-realism was all of these things. Without apology, photo-realist painting was as cool, exacting, and revealing as the all-seeing machine eye of the camera. Therein lay its exciting strengths and, for certain critics, its serious limitations. Harold Rosenberg, while

If art can't reflect life and tell us more about life, I don't think it's an art that will be very lasting and durable.—Duane Hanson, sculptor, 1972

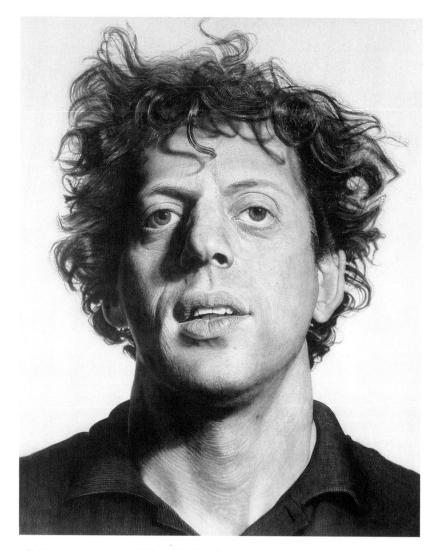

19.16 CHUCK CLOSE. *Phil.* 1969. Synthetic polymer on canvas. 9 × 7 ft. Whitney Museum of American Art, New York. Purchase with funds from Mrs. Robert M. Benjamin (69.102). *The subject of this painting, Philip Glass, is a composer of "minimalist" music. While the portrait shows a maximum of detail, does it relate to the minimalist art movement (18.26–18.29) in any way?*

It's funny, all the things I was trained to paint—people and trees, landscapes and all that—I can't paint. We're living in an urban culture that never existed even fifty years ago.—Richard Estes, photo-realist painter, 1972

admitting the illusionistic prowess of these new "sharp-focus realists," lamented that they, like their pop art predecessors, had cast off the modern movement's "avant-garde principle of transforming the self and society." For Rosenberg, new realist art did not challenge society but rather reflected it, just like the photographic, cinematic, and video images of the mass media. Yet even its opponents agreed that photo-realism's reflection of the world was a stunning one.

"We see things photographically," says painter Richard Estes. "We accept the photograph as real." Like the photographs from which he selects his visual "information," an Estes painting is characterized by immense detail, infinitely subtle values, fleeting reflections, and the lighting of the moment. Formally, they feature precision, a smooth surface, and clarity of shape and color. Only up close can the viewer discern the human touch through brushstrokes. (As in Close's portrait *Phil,* certain photo-realist painters pushing for even greater photo-reality and impersonality employ airbrush tools that spray the paint onto the canvas, thus eliminating all traces of the human hand in the work.) Their meticulous realism notwithstanding, Estes and his photo-realist colleagues are more interested in formal than human concerns. What they care most about is "making a painting" as opposed to making social comments on the places or people they record. They speak, for the most part, of surface and depth, clarity and sparkle, order and balance, and compositional organization. They also frequently discuss materials and techniques, including underpainting, overpainting, refinement, and "finish." Given such strong formal concerns, it is understandable that storytelling, narrative, and emotion have been excluded from their work. In many ways, they treat their scenes or people as still lifes, frozen objects to be rendered in paint. Estes, for example, examines buildings as abstract objects of color, shape, and texture rather than as containers that reflect and shape the lives of their human occupants. People are rarely presented. The urban environment, as visual structure, is both the subject and the object of the work.

THE RETURN OF FIGURATIVE ART

By the 1980s, art of a primarily representational or figurative character had returned to a place of dominance in the world of fine art. Abstract art, which had been such a powerful force for most of the century, no longer reigned supreme, though it continued as a significant area of creativity in the hands of numerous sculptors (8.17, 8.19), architects (10.43), printmakers (Appreciation 12), craft artists (9.9), and painters (**Appreciation 37**). The new figurative art took many forms, from idiosyncratic imagery to a variety of expressionist styles.

INTERACTION BOX

ROLE-PLAYING AN ARTIST: FIRST-PERSON NARRATIVES

"My name is Charles Thomas Close, but everyone calls me Chuck. My father was a plumber, sheet metal worker, and inventor. He moved us all over the country looking for civil service jobs with health benefits because he was always ill. . . ." These opening sentences from a student paper on the life of Chuck Close (19.16) combine research into the facts of the artist's life with a first-person narrative approach that students say makes them feel closer to the subject they are exploring.

Taking the narrative approach in another direction, students might invent an artist who works within a particular style or movement of art. Role playing a young feminist performance artist at the end of the twentieth century, a student wrote, "Happenings and performance art had great influence on me. I like the idea of the artists themselves becoming the work of art. The ideas for my work often come from feminist Body Artists. These artists focus on the female form, as I do, since the wearable art I create molds to me. Sometimes I'll wear my work for a week straight. . . ." In this type of fictional prose narrative, the student writer creates an entire history, complete with artworks and artistic intentions. While requiring more creativity, this type of paper is also based on factual art historical developments.

Here's another idea. Instead of or in addition to the written papers described above, make a first-person presentation to the class. Dress up, speak, and act like your chosen or invented artist to deepen the experience.

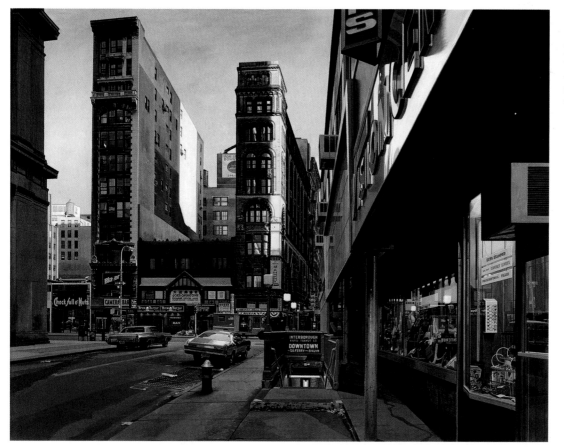

19.17 RICHARD ESTES. *Downtown.* 1978. Oil on canvas. 47⁹⁄₁₆ × 59¼ in. Museum of Modern Art, Vienna. On loan from Ludwig Foundation, Aachen.

APPRECIATION 37 *The Abstract Painting of Sylvia Lark*

DAN NADANER

Abstract painting has been one of the great experiments of the twentieth century. As an alternative to the supposed scenario where abstract painting loses its credibility after the 1960s, the works of artists such as Elizabeth Murray, Susan Rothenberg, Louisa Chase, Gregory Amenoff, and Sylvia Lark demonstrate the extension of abstraction to a wider range of human experience.

The abstract pictures of Sylvia Lark (1947–1990) exemplify several kinds of extensions that have occurred in recent decades: She alludes to the icons of diverse cultures; she challenges the dominant male formal structures of painting; and she is self-aware of the dangers of co-optation. Richard Wollheim has said of her work:

> Critics, rightly, have stressed Lark's visits to Africa and the Far East and her experience with alien shrines and cults. But what impresses me most about these paintings is the return journey they record. Amulets, archaic rocks, scraps of veil and silk, passages of half-erased script, lie side by side with her father's bric-a-brac, with vestiges of the body, and now, most recently with lumps of paint exploding onto the palette. . . . Lark's art is, amongst other things, an art of equivalences. It equates, by means visible to us, affections and feelings we would have thought irreconcilable.

The painterly means of the work keep pace with the extension of content. In *Chanting* **(Fig. A),** a painting ostensibly about a Tibetan prayer ceremony, thin pastel glazes give the work a structure that depends neither on Renaissance illusions of depth nor on the dynamics of the flat "picture plane." Instead, the space floods off the canvas and exists in a vibrant atmosphere between viewer and canvas. Lark borrows the freedom of abstract expressionism but extends it. For Lark, paint is pain and sexuality, a sense of touch and a sense of what cannot be touched. The work extends painting's expression of spirituality both by its inner motives and by the painterly inventiveness on the surface of the canvas.

In Lark's work paint precedes concept, and the painting is less receptive to quick historical categorization than are conceptual, minimal, or neo-expressionist genres.

By one view, abstract painting "died" for this very reason. But from another, all art is dying because its deeper levels are lost through facile art historical interpretation and by co-optation to art market commodity or pop-cultural status. We are approaching a situation where many avant-garde works are not totally distinguishable from MTV; they are fast, pulsating, shallow. The deeper levels of human experience still need subtle and ambiguous means to be expressed fully. Ann Gibson has written of the abstract expressionists' refusal to make their artistic intentions explicit. Donald Kuspit calls abstraction the final taboo, the refusal to make complex meanings clear in precise verbal terms. In Lark, and other contemporary abstract painters, meaning is taken seriously, but the form of its conveyance is kept beyond the range of any simplistic or reductive translation. Abstract painting defeats its own communicative power in small ways so that it can survive in larger ways, and with that survival preserves the chance to speak to the broadest range of human emotions. ■

Dan Nadaner is a painter, writer, and Professor of Art at California State University, Fresno.

Figure A SYLVIA LARK. *Chanting.* 1987. Oil on canvas. 76 × 96 in. University of California, Berkeley Art Museum. Gift of Jeremy Stone.

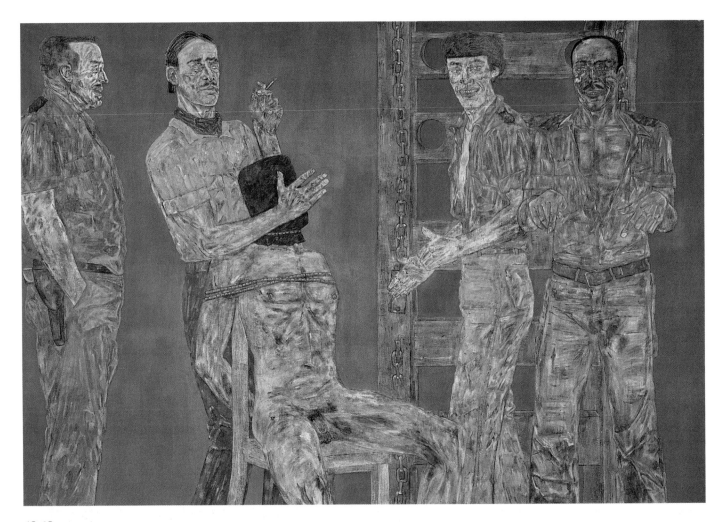

19.18 LEON GOLUB. *Interrogation II.* 1981. Acrylic on canvas. 9 ft. 10⅞ in. × 13 ft. 10⁷⁄₁₆ in. Gift of the Society for Contemporary Art, 1983.264. © The Art Institute of Chicago. All Rights Reserved.

New Image and Neo-Expressionist Art

With the tremendous popular success of pop art, photo-realist painting, and superrealist sculpture in the art world and in the public arena, the floodgates seemed to open for figurative artists of all kinds. From the early 1970s, feminist (1.10) and Pattern and Decoration artists (3.13, 3.19) had mixed figuration and abstraction. Later in the decade, Nicholas Africano's *Cruel Discussion* (3.18) and Jonathan Borofsky's large installation drawings and paintings (3.16) introduced an expressive, quirky type of representational art called "New Image" in the art world. Critics and historians began to discuss—and galleries and museums to show—numerous artists whose focus was the human figure, the architectural or natural landscape, and the still life. The traditional centuries-old subjects—history (1.10), portraiture (7.27),

genre (7.33), the nude (19.22), still life (2.28), and landscape (2.24)—experienced a remarkable rebirth of popularity, something of a renaissance.

"Cooler" approaches to realism such as those of Warhol, Estes, and Segal were joined by "hotter" forms of expressionistic figuration, which often simmered with psychological or social content. The broad title **neo-expressionism** was applied to many of these works of the 1980s. European vanguard artists such as German Anselm Kiefer (5.22) were among the leaders of this neo-expressionist direction. Contemporaneously, American artists such as Keith Haring (6.14) and Jean-Michel Basquiat (7.49) employed a raw, graffiti-based language in their artworks. Haring's large paintings, street murals, and posters often tackled a wide range of social issues (AIDS, gay rights, drug abuse) with a linear, streetwise flair. Basquiat's childlike figuration, snippets of text, and

emotive color, rapidly applied to city walls or large canvases, conveyed more subjective experiences often in a collage-like way.

Older artists who probed psyche and society—individuals such as Leon Golub (born 1922); Lucien Freud (born 1922), grandson of psychoanalytic theorist Sigmund Freud; and May Stevens (born 1924) (**Appreciation 38**)—were "discovered" by the art world establishment in the 1980s. Touched by the Depression, the Holocaust, the Cold War, the Vietnam War, and subsequent worldwide conflicts, the Chicago-born Golub shared something of the alienated sensibility of the first-generation abstract expressionists. But instead of shifting his aim away from a disturbing world and toward subjective or metaphysical concerns, Golub focused on the most unsettling aspects of contemporary civilization. Beginning in the mid-1970s, the artist focused on the civil wars raging in the third world, especially in Central America and Africa. Huge, boldly brushed, gritty in their textures, and disturbing in their color harmonies, paintings like *Interrogation II* (**19.18**) bring us face-to-face with prisoners and torturers, with third-world death squad killers and their victims. Intentionally ugly and painted with a "brutal brush," according to critic Donald Kuspit, such "activist pictures are not simply war pictures but concern the sadomasochistic interaction between alien groups of people. . . . These groups experience each other as foreign, almost nonhuman, and so feel free to victimize each other, treat each other inhumanly." Placing the artist in historical context, Kuspit sees Golub as continuing the critical tradition of the avant-garde, sharing Gauguin's and van Gogh's "tragic view" of life while at the same time, like Courbet, facing up to the tragedy through an activist social commitment.

Multicultural and Intercultural Expressions

In the 1980s, a society-wide movement to value **multiculturalism** or cultural diversity led to greater study and appreciation of artists from outside the European–North American mainstream: Native Americans, Mexican Americans, African Americans, Asian Americans, and artists from non-Western cultures worldwide. Veteran artists of diverse cultural background—such as

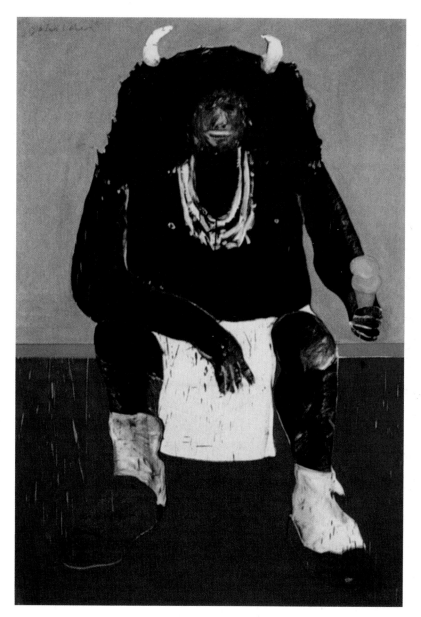

19.19 FRITZ SCHOLDER. *Super Indian #2 (with ice cream cone).* 1971. Oil on canvas. 90 × 60 in. Private collection.

Native Americans Fritz Scholder and Bill Reid and Mexican American Luis Jimenez—began to receive the recognition they deserved.

In his large paintings of the 1970s, Fritz Scholder (born 1937) forcefully expressed the conflict and challenge of being Native American in an all-consuming "Anglo" (European-American) culture. (Scholder is of mixed Anglo and Luseino tribal heritage.) His *Super Indian #2* (**19.19**) is a tragicomic figure. Dressed in the ceremonial costume of bygone days, the once powerful warrior holds a tiny ice-cream cone in his hand, a symbol of the culture that

19.20 LUIS JIMENEZ.
Progress, Part I. 1973.
Fiberglass and epoxy.
7 ft. 7 in. × 8 ft. 8 in. ×
9 ft. 9 in. Collection
the artist. © 2002 Luis
Jimenez/ARS.

*The myth [of the Old
West] only starts when
the reality ends.*—Luis
Jimenez, artist, 1985

has overwhelmed his own. *Super Indian #2* presents a large, brooding figure in a boldly frontal way. He seems uncomfortable, out of place. Behind him resides not a Native American village or tribal hunting ground—the places where he was once at home—but an abstract-art background of contrasting color, gestural brushwork, and an assertively flat surface. It is a space that feels both very modern and claustrophobic. In this space, "Super Indian" appears simultaneously bulky and flat, a Native American transformed by contemporary Western culture, torn between two worlds but not fully comfortable in either.

The art of Luis Jimenez (born 1940) likewise builds on the intercultural complexities of his heritage. Raised in El Paso, Texas, Jimenez has deep Mexican roots and affinities with Native American culture. In addition, he studied art in Rome and lived and worked in New York City for several years in the 1960s. More recently a professor of art at the University of Arizona, he sees himself as a traditional artist who gives form to the icons of his multicultural Southwest world. "I work with folk sources, the popular culture, and mythology," Jimenez says, "using a popular material—fiberglass—shiny finishes, metal flake and at times illumination." Some of his larger-than-life works tackle the history and myths of the Old West. His imposing *Progress, Part I* **(19.20),** is one of these works. A Plains Indian

warrior-hunter, bow in hand, lies expired upon his horse, all lying atop an enormous, red-eyed buffalo. The noble warrior appears to be dead. Writer Jack Hobbs observes that *Progress, Part I,* "is both heroic and satiric, a work that nudges our emotions in two directions at once." A huge pyramid of a sculpture, it joins Native American, horse, buffalo, rattlesnake, and dog in a single convulsive swirl of mass, color, and archetypal Western subjects. It is the Old West convulsing with life and death, animals of explosive energy carrying a Native American, tragic symbol of a vanishing race. As with Scholder's *Super Indian #2,* the content of Jimenez's sculpture and its title appear to be saying that the forces of "progress" have destroyed a vital way of life. In contrast, the large bronze sculpture by Bill Reid (born 1920) in the main courtyard of the Canadian Embassy in Washington, D.C., presents proud, indigenous "First Nation" protagonists—people, spirit guides, animals—engaged in an allegorical voyage of life in their "Black Canoe" (Appreciation 3). While cooperation and struggle coexist on the Black Canoe as in life's journey, the destiny of the vessel is clearly in First Nation hands.

The same message might be said to reside in the 1979 community mural *Ascension* **(19.21),** which exhorts the young African Americans of West Athens, Georgia, to ascend to their full potential as graduates, artists, and intellectuals. A product of the contemporary street mural tradition, which got its start in the activist years of the late 1960s with further inspiration coming from the early-twentieth-century Mexican mural movement (1.8), the huge wall painting uses the concept of ascension not only thematically but also stylistically. It demands that the audience stretch a bit to appreciate a style more abstract and expressionist than that of many community murals, whose messages tend to be conveyed in a naturalistic, straightforward way. And it is in the mural's style, writes art educator Tom Anderson, that the African roots of Black American culture are most clearly defined.

The patterns come from African masks and Nigerian and Senufo carvings. The mortarboard hats of the school graduates on the lower left appear first as pure decorative pattern. The music section on the lower right swings and

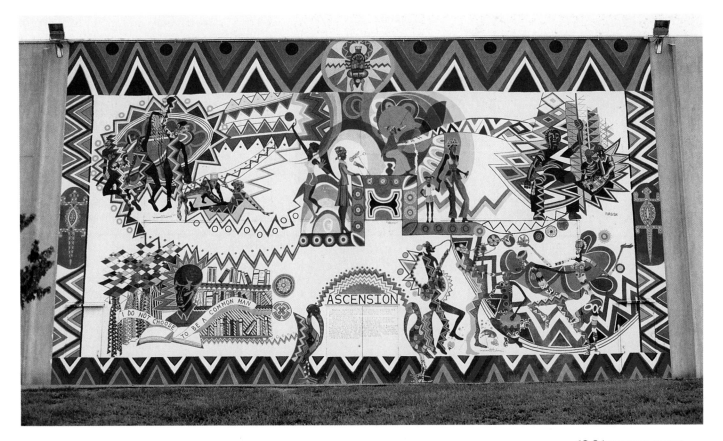

moves like the jazz it obviously depicts. Ironically, this music section, which is most removed from naturalistic imagery, is one of the most expressive of the human qualities it depicts. The liberties taken with the human form exude a sensuality visually expressive of the music's form. The gestures, elongation, implied movement, and fluidly connective pattern make for an inspired passage. This looks like the sounds great saxophonists have made. . . .

. . . Overall, it is significant that this mural uses the abstract language of the African tradition . . . to exhort black people to be proud of their heritage and to use it as a platform to rise to their full potential.[5]

Back in the art-gallery world, two painters of modern life whose works center on emotional narrative and frequently wrestle with intercultural themes are Eric Fischl (born 1948) and Cheri Samba (born 1956). Like Scholder and Jimenez, they create art whose content is significant (morally, psychologically, socially) in divergent styles that are a compelling mix of realism and expressionism.

Fischl's 1985 painting *A Brief History of North Africa* **(19.22)** is filled with cross-cultural tensions and sexual ambivalence. A clothed, dark-skinned North African, with a boy on his shoulders, walks toward a group of Western tourists on a sandy ocean beach. The hot, high-pitched yellows of the sand shout with intensity against the brilliant complementary purple-blues of the sky. The man has come to sell the Westerners "tourist art" to make his living. A young white-skinned boy runs eagerly toward the North Africans. Broad, bold brushwork animates his body and the entire scene. Excited by the sight of the exotic objects—especially the strange, many-armed, white-faced doll—the white boy's body melds into that of the African who walks toward him. At the same time, a bored jet-setter looks away; she appears in the same reclining nude pose in other Fischl paintings with vacation-spot titles (*The Black Sea, Costa del Sol*). Her dark glasses, hard look, and body language tell us she couldn't care less about native culture or tourist art, yet her leg lies between the eager

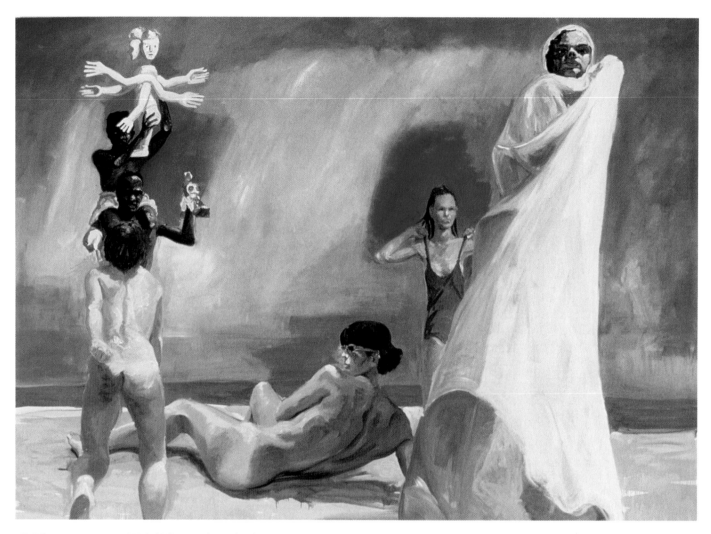

19.22 ERIC FISCHL. *A Brief History of North Africa.* 1985. Oil on linen. 7 ft. 4 in. × 10 ft. Private collection. Courtesy Mary Boone Gallery, New York. *In addition to exposing potential cross-cultural conflicts, the painting also touches on contrasts with respect to male and female roles. How does Fischl address these gender differences in compositional terms?*

One is forever on such brinks with Fischl, gazing into deep waters and debating whether to take a plunge. He is witness, giving testimony that must be taken . . . point by point and word by word.—Peter Schjeldahl, art critic, 1988

boy and the North Africans. Will she stop the boy from making contact with the Africans, or will she simply ignore their interaction? Is she the boy's mother, or is she a stranger? The artist leaves this—and other little stories within his paintings—open to our imagination.

On the right half of Fischl's painting another story is unfolding. Made up of revealing little incidents, a "brief history of North Africa" passes before our eyes. A North African woman, primly covered from head to foot in traditional garb, appears to walk steadfastly past us. She is the old Africa. We look up at her

from beach level. She does not look back. She will soon pass beyond our sight. As viewers, we see her as the other Western tourists, reclining nude on the brilliant sunlit beach, see her. Is Fischl implying that we and Fischl's tourists are one and the same? Are we like the central figure, fixated on our own thoughts or sights, or are we like the brown-skinned young woman in the black bathing suit who gazes at the tradition-bound African woman? Do we take off our suits and join in the nude sunbathing, or do we respect the ways of those North Africans, who still hold to their traditional ways and keep our swimsuits on? Do we

buy tourist art and trinkets from the native person who is dependent on our wealth for his livelihood? What do we do? How do we act? What is right? Fischl poses the questions but provides no easy answers.

Cheri Samba, from the south-central African nation of Congo (formerly Zaire and before that a French colony), is Fischl's opposite: an African insider with outsider ties to the West. Starting out in 1972 as a sign painter's apprentice in the capital city of Kinshasa, Samba also worked as a comic strip artist. In 1989 his paintings were acclaimed at a major show of worldwide postmodern art in Paris. Yet his work shows little Western high-art influence or pretension. His artistic storytelling brings something to the West rather than borrowing from it. His attention-grabbing style derives from Third World popular culture: billboards, comic strips, movie posters, and packaging. Its intention is communication with everyday people on the street. In 1990 critic Kim Levin wrote:

> Samba's narrative paintings critique the social habits, economics, and sexuality of his countrymen. His thoroughly socialized and highly graphic pictures aim straight for the superego [moral conscience]. They're about school, work, and home, about AIDS, about relations between men and women, about traveling to Europe and going home again. The paintings have white borders, sly combinations of earthy and Day-Glo colors, modulated "volumetric" shading, limpid mountains in the distance, and all kinds of loving details. They also have an occasional application of glitter so subtle that you can easily miss it. Their extensive texts are lettered in colors in an idiosyncratic punning of French, phonetic patois [street slang], and his native language, Lingala. Sometimes the artist narrates, other times his characters' thoughts float in the air like balloonless cartoons. Titles are emblazoned like slogans on signs. . . . These modern African morality tales intend to educate. . . .
>
> [In the painting] *Lutte Contre les Moustiques* [*Fight Against the Mosquitoes* **[19.23]**] a quartet of

19.23 CHERI SAMBA (Samba Wa Nbimba). *Fight Against the Mosquitoes*. 1989–90. Acrylic on canvas. 32 × 25½ in.

domestic warriors do comic battle against an enemy that appears at first to be the wallpaper pattern. But the evenly spaced starry design of stenciled mosquitoes continues across the open window too. "It seems mosquitoes with virus malaria kill more than AIDS in Africa, mostly children," the lettering informs. . . .[6]

Samba is a social moralist and a brave reformer, Levin concludes, in a country where it has been risky to express an opinion critical of the status quo.

By the 1980s, the art world was becoming steadily more internationalized, multiculturalized, and regionally dispersed. As shown by the success of Samba and numerous others, important art no longer had to originate in New York or Paris. Although the final seal of approval usually came from major museums and galleries in these cultural capitals, critically acclaimed art might now come from almost anywhere—from inner-city West Athens, Georgia, the African Congo, the Black Forest of Germany, or Canada's Pacific Northwest. A more pluralistic and egalitarian art world was in rapid formation.

The "Ordinary. Extraordinary" Art of May Stevens

JOSEPHINE WITHERS

May Stevens's odyssey with Rosa Luxemburg, "Polish/German revolutionary leader and theoretician, murder victim [1871–1919]," and her mother, Alice Stevens [1895–1985], "housewife, mother, washer and ironer, inmate of hospitals and nursing homes," began modestly with a two-page spread of collages in the first issue of *Heresies* magazine. This 1976 "Tribute to Rosa Luxemburg" and "Two Women" fitted well with *Heresies'* avowed goal of examining art and politics from a feminist perspective.

. . . This was the beginning of a complex exploration of the relationships between herself and Rosa Luxemburg—her adopted "ideal" mother—and her own mother, Alice Stevens, and ultimately between Rosa Luxemburg and Alice Stevens. . . . In 1978 she had been reading Adrienne Rich's *Of Woman Born: Motherhood as Experience and Institution* (1976), one of the early books to reevaluate the institution of motherhood from a feminist perspective. *Of Woman Born* clearly influenced the development of Stevens's own thinking. In fact, she appears to have responded directly to some of Rich's observations, as when Rich writes: "Many women have been caught—have split themselves—between two mothers: one usually the biological one, who represents the culture of domesticity, of male-centeredness, of conventional expectations, and another, perhaps a woman artist or teacher, who becomes a countervailing figure." Rich argued that "this splitting may allow the young woman to fantasize alternately living as one or the other

'mother,' But it can also lead to a life in which she never consciously resolves the choices. . . ."

Stevens first used the title "Ordinary. Extraordinary" in her artist's book, published in 1980; at the time she began to explore a way through or around this splitting that Rich described. The photo and Xerox collages in the book [featuring images of Rosa Luxemburg and her mother] were "written on, painted on, added to, subtracted from, desiccated and destroyed by repeated reproduction and loss of intermediate values and detail." The intention was to erode, break apart, and confound the divisive and polarized notion that the one woman's life was special, exemplary, extraordinary, and the other was banal, forgettable, and ordinary. Stevens's particular treatment of her theme responds to and challenges Rich's implicit argument that one must choose the one or the other. She does not, however, seek to flatten out the extreme contrasts and differences implicit in these women's lives with an easy resolution. "I don't want a false resolution, in my work or in my theory. I will rather have it not fit than force it, or cut off something, or deny something I believe in."

The painting *Forming the Fifth International* **(Fig. A),** in the "Ordinary. Extraordinary" series, was completed in 1985. Here Rosa Luxemburg and Alice Stevens are conversing in a garden, presumably speaking of the revolution which will "be once again," and which, Stevens implies in the title, must include women's voices if it is to succeed. Pictorially, however, the painting is more problematic than this description indicates. Although the depicted space is unified, the figures are not. Alice Stevens is both palpable and luminous, her body boldly modeled. Rosa Luxemburg, however, is flatly painted . . . and so appears to sink back into the painting and to remain just

Josephine Withers is Professor of Art History and has served as Director of the Women's Studies Program at the University of Maryland, College Park.

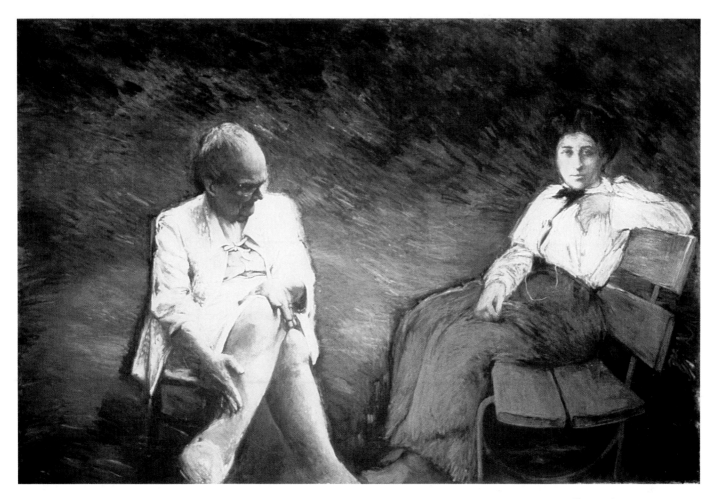

Figure A MAY STEVENS. *Forming the Fifth International.* 1985. Acrylic on canvas. 6 ft. 6 in. × 9 ft. 7 in. Collection of the artist.

beyond our touch. The incongruities and the dis-ease of this picture are not unintentional, and can be understood as part of Stevens's strategy to deepen her understanding of her own mental mapping by giving visual form to the fluctuating, uneven, and imperfectly remembered way in which she—and we—apprehend the world.

. . . At first view, the oppositional character of the "ordinary/extraordinary" conjunction seems paramount; both the words themselves and our dichotomous habits of thought easily prompt such a reading. But on longer reflection, it appears that Stevens has used this tension to explore and question what our relationships are, will, and can be to our mothers, to our foremothers, and to our past. The generative tension embedded in Stevens's "ordinary/extraordinary" theme echoes other, more familiar oppositions—the private and public, the personal and political. The notion that the personal is political has long been central to Stevens's own work, as it has been to feminist thinking of the past thirty years. Stevens has made an important and complex contribution to this discourse. The issue and oppositions she presents are clarified but not resolved; the work raises as many questions as it answers. It is not easy to look at these paintings. But, then, neither is it easy to live in the social and political situation in which we find ourselves today. ▪

20 Beyond Painting and Sculpture

EXPANDING THE BOUNDARIES OF ART

In the past five decades, artistic subject matter has expanded to include more of "life," both in terms of physical, moral, spiritual, psychological, sociological, and political content and in terms of multicultural and global experience. As part of this expansionistic "maximalist" tendency, many artists have seen fit to move beyond art forms such as traditional painting and sculpture as well as beyond the traditional venues for bringing art before the public.

A HOST OF NEW ART FORMS

To realize goals that were enormously wide ranging, artists in the second half of the twentieth century created totally new forms, beginning with the mixed-media works and combines of the 1950s and the happenings and situational sculptures of the 1960s. The installation, environmental, and performance art of the 1970s and 1980s and the digital and Internet-based art of the 1990s and early twenty-first century continues this expansion into "new media."

Mixed Media, Craft Media, and Narrative Art

In 1985, the mixed-media "story quilts" **(20.1)** of Faith Ringgold (born 1934) broke boundaries in several important ways. To begin, they reintroduced narrative or storytelling to the realm of fine art. As if breaking the modern art

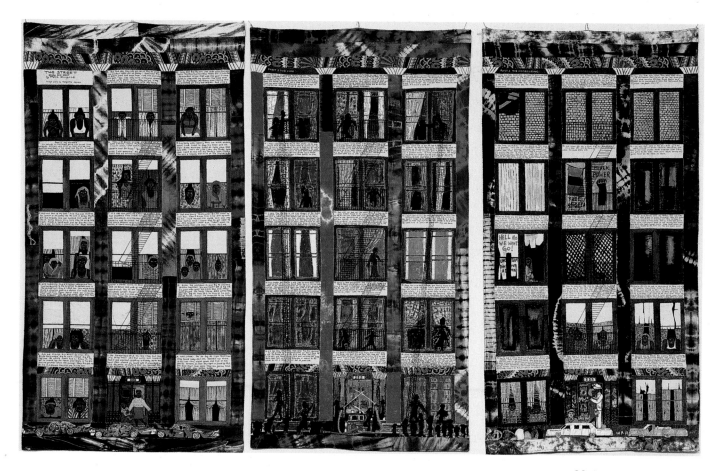

20.1 FAITH RINGGOLD. *The Street Story Quilt, Part I: The Accident; Part II: The Fire; Part III: The Homecoming.* 1985. Oil, felt-tipped pen, dyed fabric and sequins sewn on canvas, sewn to quilted fabric. 7 ft. 6 in. × 12 ft. The Metropolitan Museum of Art, New York, Purchase, Arthur Hoppock Hearn Fund and funds from various donors, 1990.

taboo against storytelling were not enough, Ringgold and others also began integrating traditional women's handicrafts into their work. Feminist artist Judy Chicago, for example, included needlework, china painting, and ceramics in her grand-scale work *The Dinner Party* (20.3). Ringgold, whose mother was an accomplished seamstress, included quilting and tie-dyeing in her art. Moreover, both artists' emphasis on collaboration challenged the engrained myth of the artist as isolated, individualist genius. Collaboration, as we will see, is central to a variety of post-modern art forms. Ringgold always gives public credit to the individual who dyes or sews the fabric on which she paints, and Chicago likewise acknowledges and honors the numerous artists and craftspersons who make epic works like *The Dinner Party* possible.

Spurred on by feminist and multiculturalist values and supported by the worldwide crafts renaissance, a wide range of practitioners employed traditional crafts media (glass, fiber, metal, clay, wood) for fine-art ends (9.6, 9.9, 9.10, 9.33). For Ringgold, Chicago, and artists like Miriam Schapiro (3.19) and Amalia Mesa-Bains (3.8), the vision of the artist (and of her or his collaborators) was what counted. They did not accept the centuries-old value system that placed crafts on a cultural rung far below painting and sculpture. If quilting, ceramics, or a collection of readymade objects works better than painting or sculpture as a means to accomplish artistic ends, then those should be the materials and techniques of choice. No medium is a priori better than any other. If an artist has important ideas, stories, or feelings to share and can do so with formal power, then whether the medium is sewn fabric or oil on canvas matters little.

As arts reviewer Phyllis Quillen tells it:

For artist Faith Ringgold, the outrage of social injustice and the beauty of the human spirit can't be captured with mere paint and canvas.

She began as a painter in the 1950s, but by the early 1960s Ms. Ringgold was feeling

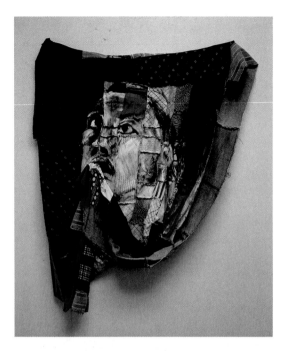

20.2 BEATRIZ MEJIA-KRUMBEIN. *Mute Muse.* 1999. Mixed media on fabric (quilt). 55 × 42 in. Courtesy of the artist. *The art form of collage, in this case sewing diverse fabric pieces together, seems a fitting metaphor or model for the way we patch or cobble together all the separate pieces of our lives in an increasingly multifaceted world. Can you think of other art forms that provide metaphors or models for life today?*

cramped. The stretched, prepared canvas was "too European, too intellectual" for this American black, feminist painter.

Painting gave way to masks, then to soft sculptures and, finally, to her story quilts, with their soft surfaces and long, fascinating written tales of injustice, violence, poverty, love, self-sacrifice, endurance and survival.

. . . The derelict, burned-out shells of tenements in her hometown, New York's Harlem, form the basis of three of her story quilts.

. . . New York's abandoned and half-abandoned buildings are "devastation like you've never seen," but Ms. Ringgold looked at them with the dual vision of a painter and a storyteller.

. . . The first panel of the quilt [20.1] shows the front of an intact building, filled with neatly curtained windows and the horrified faces of the neighbors, peering down at the tragic traffic accident that provides the narrative impetus for the story.

"Ain nobody on this street gonna ever forget that accident. All them cars piled up right out-

side this door? An everybody in 'em dead but Big Al. It wasn't real. They were just going to Coney Island for some corn on the cob," her narrator laments.[1]

The remaining quilts in the three-part *Street Story Quilt* tell of the fall of Big Al into drunkenness and the decline of the building itself—windows bricked up, graffiti and Black Power slogans covering the walls, and finally abandoned ruin. The *Street Story Quilt's* numerous rectangular story blocks, each accompanied by a narrative caption like the one cited above, communicate ideas that could not be told through visual images alone. For Ringgold, the quilts are a "platform for mixing art and ideas so that neither suffers." Critic Lucy Lippard observes that Ringgold's visual imagery has "flair, authenticity, and a clean, sure, ebullient sense of design. . . ." Firmly rooted in Africa's multicultural heritage, the inhabitants "stare straight out at the viewer, resembling African carvings, Ethiopian saint paintings, Egyptian mummy cases." The tie-dyed cloth that simulates the color and texture of the tenement buildings smolders in variations of warm reddish purples and browns. With or without captions, these images would stand as potent art, but the words add another level of meaning to the images. As novelist Alice Walker puts it, the folk language in Ringgold's quilts is "rich and sure." As narratives, the quilts "have life, surprise, heart. . . . One feels the marriage of the stories and the quilts is also true, is inevitable, is justice." In Ringgold's narrative quilts, content and form, story and image, walk hand in hand.

Like Ringgold, Beatriz Mejia-Krumbein (born 1945) is a creator in diverse media who speaks to multicultural and cross-cultural issues. Born and raised in Colombia, South America, and later living in Germany and the United States with her German husband, Krumbein addresses a range of social concerns with her huge handmade books, videos, open-suitcase assemblages, paintings, drawings, and mixed-media works. These concerns include violence against women and children and the cultural displacement and fragmentation experienced by persons torn from their community or country. Her painted quilts objectify the experience of people who are shattered but heroically hold their lives together.

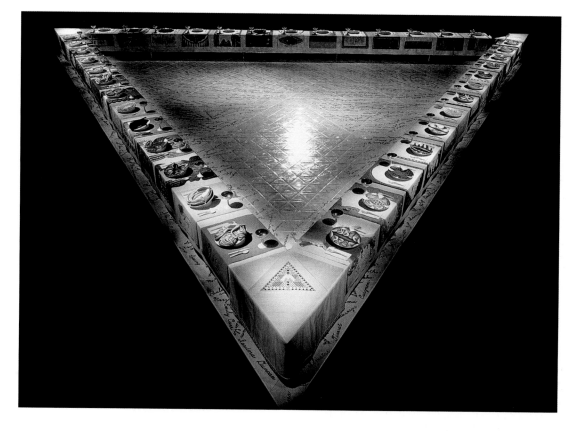

20.3 JUDY CHICAGO. *The Dinner Party.* 1979. Mixed media. 48 × 42 × 3 ft. Collection of the Brooklyn Museum of Art, Gift of the Elizabeth A. Sackler Foundation. © Judy Chicago 1979. Photo: © Donald Woodman.

Each painted face or figure is made up of separate quilt fragments of different shapes, colors, or patterns. *Mute Muse* **(20.2),** executed in 1999, shows a human face, bewildered, looking upward in desperate hope. Strokes of black, gray, and grayish white paint delineate the features and darken the visual and emotional tone of the work. Two swaths of fabric rise up, like arms and hands, to partly cover the mouth and silence it. Returning to Colombia in December 2001 to visit her family, Mejia-Krumbein wrote:

> Life here is difficult. Political tension, and social gap, insecurity and a daily life plagued with terror. . . . *Mute Muse* deals with the limitations of freedom of speech, mental manipulation, and helplessness. The muse will never die but is muted and without audience support. The muse will always be alive and my hope is that this silence could be broken in a music full of solidarity and peace.[2]

The mixed-media quilts of Ringgold and Mejia-Krumbein broke many of modern art's cardinal principles, but in one sense they remained traditional: They were designed to be hung on museum or gallery walls like paintings. Artists like Judy Chicago, in contrast, employ whole rooms—floor, walls, even the ceiling—in museums or galleries for their creations.

Installation Art

The room-size works of Chicago, Jonathan Borofsky (3.16), Robert Gober (8.37), and other artists are called **installations.** These pieces have as broad a range with respect to style, subject matter, and feeling tone as traditional art forms such as painting and sculpture. Some installations are highly abstract, some realistic. Others are expressionistic or surrealistic. Some, like Chicago's *The Dinner Party* **(20.3),** have an enormous historical sweep, while others are more private and present-tense in focus. Art educator Sally Hagaman notes that the massive *Dinner Party,* created between 1973 and 1979, was intended to represent both the oppression and the achievement of women throughout history.

> The room-sized work is composed of an open triangular table, equilateral in structure, that

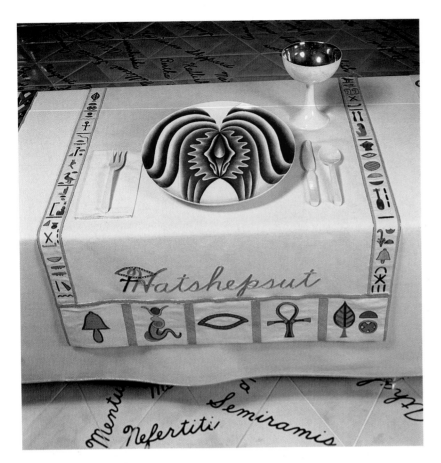

20.4 JUDY CHICAGO. *Hatshepsut*, plate and place setting from *The Dinner Party*. 1979. Multimedia, china painting on porcelain, needlework. © Judy Chicago. Photo: © Donald Woodman.

I recognized that my work could only be accurately understood against the background of a female history, and I wanted to find a way to incorporate that history into my work so that the viewer would be forced to confront my work in the context of other women's work.

—Judy Chicago, artist, 1975

holds place settings [1.10] representing thirty-nine women (artists and others) from myth and history. Each setting at the table has a goblet and large porcelain plate, some with raised and carved areas. These ceramic plates, boldly painted with traditional china-painting technique, symbolize individual women. Each setting rests on an intricately embroidered runner that gives the woman's name and has visual designs expressing her accomplishments. The table rests on a large triangular porcelain floor, embellished with 999 names of women of achievement, thus suggesting that the women at the table were supported by the accomplishments of many others.

One of the thirty-nine women at Chicago's table is Hatshepsut [12.8], one of the four known women pharaohs of ancient Egypt. . . . The Hatshepsut plate [20.4] is set on a runner embroidered with hieroglyphics that roughly symbolize the events of her life. . . . The outermost blue shapes are reminiscent of the ceremonial heavy wig worn by Egyptian pharaohs, male or female. The design of Hatshepsut's plate is a variation of the butterfly image used by Chicago

to symbolize liberation. At the same time, this image visually refers to the female genitals. . . .

The piece was a major undertaking. It involved extensive research in women's history, china painting, needlework, and ceramic techniques in addition to thousands of hours of actual construction time. Chicago used a collaborative approach, engaging some four hundred people (mostly volunteers) in the work's execution. She hoped *The Dinner Party* would be an example of a new art that would express women's experiences, reach a wide audience, and bring new respect for women's artistic achievements. However, the work met with mixed reviews, and was exhibited only rarely, in part because of its large size. (In spite of this, *The Dinner Party* has found its way into many art historical and appreciation texts and ultimately obtained a permanent home in 2002 at the Brooklyn Museum of Art.)[3]

In a 1989 installation piece titled *Initiation*, painter Judy Jashinsky (born 1947) covered the bare walls and floors of several gallery rooms with painted images that simulated the walls and architectural setting of the ancient Villa of the Mysteries in Pompeii, in southern Italy **(20.5)**. Furniture, created by the artist in ancient Greco-Roman style, was placed in the rooms. The result was a total environment, unified by style and subject matter. The centerpiece of Jashinsky's installation was a 9-by-16-foot painting that covered the entire rear wall of the final room **(20.6)**. The viewer, however, did not read this huge image as a painting, that is, as a separate and distinct object, but rather as a continuous part of the architectural interior, an indivisible part of the overall installation. Fooling the eye, the painted image evoked the central room of the ancient Villa of the Mysteries, a sacred place in which individuals were initiated into the religious cult of the Greek god Dionysus. In the room a human drama unfolds. Personages from the present and the recent past have arrived for an important event. Just as in ancient days, an initiation ceremony is taking place. This contemporary initiation involves Jashinsky's own rite of passage as a woman and as an artist. In the center of the illusionistic room, we meet the artist's imaginary daughter (holding a mask of the artist's own face in her hands), the artist's niece (rear left) and several artists who influenced Jashinsky's life. To the right are Jackson Pollock

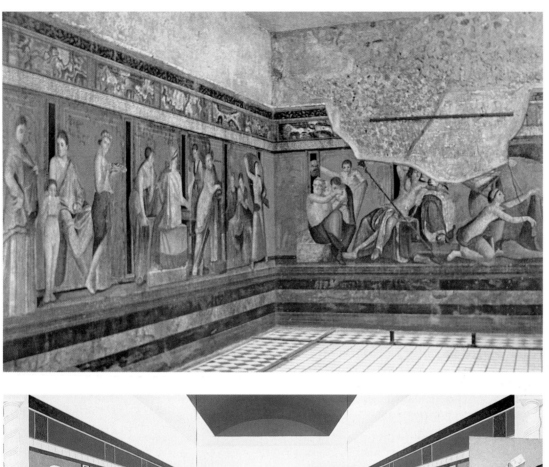

20.5 Villa of the Mysteries. Wall painting. View of corner of room, Pompeii. Ca. 60 B.C.E.

20.6 JUDY JASHINSKY. *Initiation*. 1989. Wall painting frieze. Oil on linen. 9 × 16 ft. Courtesy of the artist.

(18.14), his foot propped up against the wall, and, in the corner, Edvard Munch (17.4), two "bad boys" of the world of modern art. To Jashinsky, they represent her male art teachers but also have "something to do with women trying to understand maleness and sexuality." In the front left corner stands the most prominent figure in her initiation ceremony, Georgia O'Keeffe (Appreciation 36), a woman and artist she greatly admired. What Jashinsky created in her installation was an all-encompassing situation that viewers might totally immerse themselves in, just as the initiate gives herself over completely to her initiation ceremony. (From 1995 to the present, Jashinsky has focused on the Italian baroque painter Artemisia Gentileschi (14.43), creating installations, drawings, manuscript illustrations, large-scale

20.7 TIM DAULTON. *Civilization*. 1989. Wood, styrofoam, paper, and cardboard. 8 × 6 × 42 in., with 20 ft. fabric spread. Courtesy the artist. *Like many installation pieces, this work has remained in storage since its initial exhibition. Only photographs and videotape footage keep it "alive" for the viewer. Knowing the short-lived nature of installation art, do you think the artists work as hard at documenting the pieces as actually creating them?*

paintings, a video, and even a "live" costume ball based on Gentileschi's art and life.)

Confrontational as opposed to ritualistic, *Civilization* **(20.7),** an installation piece by Tim Daulton (born 1953), aggressively challenges viewers as soon as they enter the door. In the darkened gallery space, the viewer is confronted by what Daulton calls a larger-than-life "military toy," a tank whose gun is aimed directly at the viewer's head. Moreover, this tank-toy is alive. Engine noises grumble, and voices come from within. Wheels and treads turn. Lights flash off and on. Tribal peoples are crushed beneath the tread of the monster's forward-moving bulk as noxious waste pours from exhaust pipes, befouling the natural environment. Politicians and corporate executives, far removed from the scenes of their crime, steer the ship of state from its topmost deck.

Beneath the top deck are pictured all the social classes, in descending order of wealth and power. They are the cogs that enable this fortress "civilization" to run smoothly and efficiently. Daulton has presented us with a disturbing vision of society and culture as a vast hierarchical machine run by a military-industrial-political complex. Whether or not we agree with his view of Western civilization, the formal and expressive power of the piece pulls us in. It hits us, visually and intellectually, like a thunderclap. The piece entices us to examine every visual detail and to ponder the numerous critical ideas put forth.

Far more surreal are the works of Sandy Skoglund (born 1946), which reach the viewer primarily through large color photographs of her laboriously developed but short-lived indoor and outdoor installations. (Her *Fox*

20.8 SANDY SKOG-LUND. *Cats in Paris*. 1993. Installation view. Photolithograph. 24¾ × 28¾ in.

Games, on display at the Denver Museum of Art, is one of the very rare installations to find a permanent home.) For her 1993 *Cats in Paris* **(20.8),** Skoglund, a true multimedia artist, sculpted each cat out of clay, arranged the cats and the single human model in the setting, and controlled each minute aspect of the photographic and development process. Although most people will never experience one of the artist's installations "live," her large photographs with their remarkable depth of field pull the viewer into a constructed science fiction–like world of uneasy humor where reality and surreality conjoin.

Conceptual Art

In the late 1960s and early 1970s, various artists sought to move beyond the physical art object and salable artwork commodity altogether. They included the conceptual artists, who valued the artist's creative concepts, ideas, and processes over the final, permanent product

(Interaction Box). Exhibits by conceptualists often consisted of nothing more than the artist's handwritten ideas, typed thoughts, or photographs documenting a project or process. For conceptual artists, the "idea art" of Marcel Duchamp (17.20), which had consistently challenged art establishment boundaries in the twentieth century's first half, was a potent inspiration. Many considered his works the first **conceptual art** pieces.

One artist whose ideas have become the centerpiece of works large and small, both temporary and permanent, is Jenny Holzer (born 1950). Since the late 1970s, Holzer has created pieces based exclusively on text—sayings, statements, pronouncements—arranged for clarity but without particular artistic flair. The words have been typed on paper and xeroxed, pasted on benches, carved into stone slabs, silkscreened on T-shirts, featured on billboards, and programmed as LED (light-emitting diode) signs. In the best Duchampian tradition, her work—with no visual images,

. . . When I think about your art, well naturally one says it's photography, but it isn't photography. . . . It's like installation art. It's like theater. It's like film. It's like painting. It's like pop sculpture. How do you define yourself?
—Robert Rosenblum, art historian, from 1996 interview with artist Sandy Skoglund

CREATING A CONCEPTUAL ARTWORK

Conceptual art has had enormous influence on a wide range of recent art forms, from contemporary painting, sculpture, and photography to performance, installation, and environmental art. Because it is based on ideas, conceptual art frees the artist from dependence on any particular art medium or skill. With no physical or technical restraints, it liberates artists to be fully imaginative. The sky is literally the limit.

Taking advantage of this enormous creative freedom, develop a conceptual artwork cen-

tered on aesthetic, political, social, psychological, and/or cultural ideas. These might take the form of words only or of words and images. Your piece might employ photography, video, drawing, construction, or whatever medium or mixture of media you deem appropriate for conveying your concept or ideas. This exercise should show you how liberating conceptual art is to the creative imagination.

20.9 JENNY HOLZER. *Truisms.* 1977–79. Spectacolor electronic sign. Times Square, New York, 1982. Sponsored by the Public Art Fund, Inc. Courtesy Barbara Gladstone Gallery. *Consisting solely of text and no other imagery, do you consider Holzer's work visual art? If not, how would you classify it?*

After I had written a couple of hundred [Truisms], I had to think about what to do with them. And then I thought that by their very nature, they were public—even though individually they were private attitudes, they were common knowledge— and they should be placed into the public sphere.
—Jenny Holzer, artist, 1986

just thoughts presented in straightforward sentence or paragraph form in diverse media— leads to the question "Is it art?" It has also exasperated certain critics. Robert Hughes has slammed Holzer's work as "failed epigrams that would be unpublishable as poetry but that survived in the art context, their prim didacticism so reminiscent of the virtuous sentiments the daughters of a preelectronic America used to embroider on samplers." Such controversy

notwithstanding, the mainstream art world has embraced Holzer's "Truisms," "Inflammatory Essays," "Laments," and other series of messages, awarding them the highest honors. One of her most impressive works, 535 feet in length, took over the entire core of New York City's Guggenheim Museum (2.14). Holzer's words, in LED sign format, snaked around the inner spiral wall of the museum's ramp for the duration of the exhibit. Messages

included "A SENSE OF TIMING IS THE MARK OF GENIUS," gently poking fun at the enterprising success of some (including herself) at achieving fame in the art world and thereby gaining "genius" status. Other Holzer works **(20.9)** have competed with and even beat outdoor advertising at its own game. Employing huge outdoor LED visuals customarily used by mass-media advertisers and news corporations, Holzer's statements join the artificial environment of information and persuasion while conveying contrary messages such as "PRIVATE PROPERTY CREATED CRIME." Her succinct, polished statements, issued in an authoritative voice, flashed daily before the eyes of thousands of passersby, appropriating the media of mass culture in order to critique it.

Performance Art

Taking their lead from conceptual artworks, the action-oriented happenings, and the action paintings of the abstract expressionists, with their emphases on the work of art as an event or a process, artists began to create an art of staged events or performances. An ephemeral 1975 work by multimedia artist Sandy Skoglund melds conceptual and **performance art.** The idea was to spoof action painting (18.14). The resultant irreverent performance piece, *Percussion for Jelly Beans and Gumdrops with Solo Broom* **(20.10),** involved participants in kicking 25 pounds of gumdrops and 25 pounds of jelly beans across a room and then sweeping the colored candies across the floor "in a parody of abstract expressionism." (Skoglund's later installations (20.8) would incorporate these conceptual and performance art roots.)

With respect to form and content, performance pieces are as individualistic as their creators. Some pieces, like Skoglund's *Percussion for Jelly Beans and Gumdrops with Solo Broom,* tend toward humor and iconoclasm, while others are deadly serious, symbolic, or ritualistic. For instance, in his performance piece *I Like America and America Likes Me* **(20.11),** German artist Joseph Beuys (1921–1986) lived for three days in a gallery space with a live coyote. According to Beuys, the coyote represents North America before damaging European

20.10 SANDY SKOGLUND. *Percussion for Jelly Beans and Gumdrops with Solo Broom.* 1975. Performance.

colonization, when the native peoples lived in respectful harmony with the world of nature. Through his peaceful interaction and his attempt at intimate relationship with the coyote over a three-day period, Beuys felt that he "made contact with the psychological trauma point of the United States' energy constellation: the whole American trauma with the Indian, the Red Man." His "action" was a symbolic attempt to heal wounds across time, to overcome long-term alienation between cultures and species.

Compared to Beuys's ritualistic piece, the multimedia productions **(20.12)** of Laurie Anderson (born 1947) are complicated works. Within a total environment created by slide projections, film images, and theatrical lighting effects, Anderson talks, sings, and plays her violin or keyboard through an elaborate electronic sound system, calling forth an extraordinary range of effects born from a familiarity with both classical and "art rock" music.

20.11 JOSEPH BEUYS. *I Like America and America Likes Me.* 1974. Week-long action with coyote at René Block Gallery, New York. Courtesy Ronald Feldman Fine Arts, New York. Photo: Caroline Tisdale. *Beuys clearly saw himself as a modern-day healer or shaman (11.4). What ancient and contemporary artworks have performed healing functions?*

Her pieces almost invariably require the participation of a large technical crew. At certain concerts and on her recorded albums, musicians and other artists from across the cultural landscape contribute their talents.

Anderson's performance pieces, characterized by potent visual and verbal imagery and musical inventiveness, have been acclaimed in various art world magazines. Music and theater journals also have written about them. Dramatically, Anderson's performance art has expanded beyond the art world and the gallery spaces in which many of her original pieces were performed. In 1983, beginning with *The United States Tour*, she began to stage her pieces in concert halls across North America and Europe. Still earlier, she had recorded songs and albums, with varying degrees of popular success. Her most commercially successful song, "O Superman," reached number 2 on the British pop-singles chart in 1981. Not long afterward, Warner Brothers, a major pop music company, recorded a double album based on *The United States Tour.* Here is Janet Kardon's assessment of *The United States Tour*

and its multisensory assemblage of verbal, musical, and visual images:

> The recurrent themes are the road, flight, a moving flag, symbols of transience that characterize our culture. This ambitious work is an impressive anthology of Anderson's narratives and songs. This musical assemblage includes demonstrations of classical violin virtuosity as well as rock quotations, appropriations from the conventions of the movies, popular music and slang.[4]

Commenting on a 2001 Anderson performance piece that involved a number of performers and focused on the mythical white whale Moby Dick, a student wrote:

> [T]he images behind her were constantly changing on three different screens and various neon colors flashed over the actors. She had many props and she and her crew danced and sang, as the images changed. It felt more like a rock concert to me than a work of art. . . . I felt like I was looking in every direction and trying to absorb so many things at once. I think the competing images and variety of media truly reflect our time period.

20.12 LAURIE ANDERSON. "Let $x = x$" from *United States (Part II)*. 1980. Performance presented by The Kitchen at the Orpheum Theatre, New York. *Like Anderson's* The United States Tour, *rock and pop concerts are multimedia experiences with a strong emphasis on the visual. Do you consider them works of art? Why or why not?*

Along with Laurie Anderson, David Byrne (born 1952) is one of an increasing number of multitalented "crossover" artists working between media and between cultures. An art-school dropout, Byrne was best known in the late 1970s and 1980s as the lead singer-songwriter for the critically acclaimed "new wave" rock group Talking Heads. As a performing artist, Byrne doesn't think twice about weaving together the different arts or crossing over the old boundaries between popular and high culture and between Western and non-Western culture. His performances, like Anderson's, draw strongly from North American Black as well as white culture and take him into almost all the arts, including, in the visual sphere, album cover design, concert lighting and imagery, and film production. Inhabiting a niche between popular and high culture, the Talking Heads' album covers are a match for their intriguing music as works of art. Byrne's cover for *More Songs about Buildings and Food* **(20.13)**, which depicts the band members locked

into and fractured by an imprisoning grid, is an expressionistic portrait of urban unease.

Byrne's most ambitious work of visual art is his 1984 concert film *Stop Making Sense* **(20.14)**, a collaboration with noted movie director Jonathan Demme (born 1944). In the best Anderson performance art tradition, the film blends together diverse cultures and media. In triumphant synthesis, pop music, with its roots in Black soul and rhythm and blues, joins forces with visual imagery and lyrics right out of dada, expressionism, and neo-expressionism. Byrne, a true multimedia artist, made visual-theatrical decisions about lighting effects, costumes, and props and choreographic decisions about the movements of the musicians and the supporting cast. Cinematographically, he contributed substantial input to directorial decisions on camera angles, editing, and the general "look" of the film. In an article in *Artforum* magazine, critic Carter Ratcliff likens Byrne to a contemporary neo-expressionist painter who struggles to find a fit between his

The art that I like the most and the art that I aspire to make helps people live this life as well as possible. . . . For me, at this time, art must address the issues—sensually, emotionally, vividly, spiritually. This means being involved with the aspirations, lies, and dreams of what is snobbishly called low culture.
—Laurie Anderson, artist, 1984

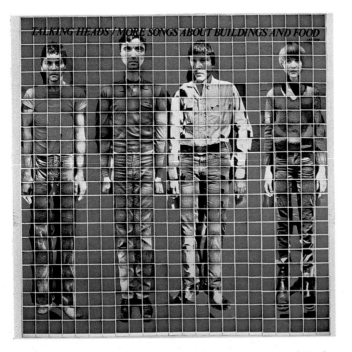

20.13 TALKING HEADS. *More Songs about Buildings and Food.* 1978. David Byrne, designer. © Sire/Warner Brothers Records. *The grid is a compositional form that is continually used in contemporary art (19.11–19.13). Why do you think it is so appealing to artists of our time?*

20.14 JONATHAN DEMME. David Byrne in *Stop Making Sense.* 1984. Island Alive Releasing/Cinecom International Films. *Many contemporary artists explore, take on, or play with different identities or personas in their work. Why is this practice more frequent now than in the past?*

3-D self and the 2-D picture surface. With regard to form and content, Ratcliff observes a direct link between Byrne's nervous, twitching stage presence and the unsettling, alienated figures who inhabit neo-expressionist paintings of the same period. Toward the end of *Stop Making Sense*, the critic notes, "Byrne encases himself in the literal, boxy flatness of a white suit a couple of feet too wide for his frame. Throughout, severe lighting reduces

his face to a play of light and dark planes against a field of darkness." Such distorted, ironic images of the self—Byrne both fits and doesn't fit into his outfit and his public persona—reveal an edgy discomfort with both the outer world and the inner self. The outlandish but deadly serious images, Ratcliff writes, embody existential "confrontations with the terror of the self and its life as a patched-together artifice." Byrne's imagery and music present us with an art that both entertains and unsettles, a multimedia performance art that expresses this single individual's battle to make sense out of a world that often stops making sense.

Other artists who solo as performers and take on various identities and personas before the camera include Bill Viola (born 1951) and Cindy Sherman (born 1954). Viola's video art frequently involves him as protagonist as well as director and set designer. In the previously cited *Crossing* (7.46), Viola is consumed by flames and engulfed by falling water. In her own performance for the camera (7.47), Sherman functions as director, actress, and costume, makeup, set, lighting, and photographic designer. Whether performing roles or acting as themselves, Sherman, Viola, Byrne, and Anderson employ video, film, and photography to make permanent what would otherwise be ephemeral.

BEYOND THE MUSEUM WALLS

Like Byrne and Anderson, who often perform in concert halls, a growing number of artists have moved their work outside museum walls and the constraints of fixed exhibition spaces. City streets, urban walls, and the world of nature have become venues for their art. Social, political, environmental, and spiritual concerns, in addition to aesthetic impulses, have led them into the domains of everyday life. Some works by these artists, like museum pieces, are meant to be permanent, such as murals (1.8, 5.2, 19.21) and sculptures made for specific public places (3.17, 18.21). Many others are short-lived events or experiences that depend on media documentation for broad exposure.

Activist Art

The Shadow Project **(20.15)** is an example of a powerful art event that, aided by media

documentation, has remained powerful over time. On August 6, 1985, citizens in over 200 communities around the world woke to discover gripping human images on the streets and sidewalks of their towns. The images were grim visual reminders of the devastation caused by the dropping of the first atomic bomb on a civilian population, which had taken place on that very day 40 years earlier in Hiroshima, Japan. Silhouettes of actual townspeople had been painted on the streets and sidewalks by over 10,000 volunteers. The silhouettes signified all that would remain of a human being caught near ground zero in a nuclear war. Numerous people from the United States to Canada, from Brazil to Iceland, and from Great Britain to Malaysia experienced the painted human shadows firsthand. Many thousands more experienced the event and the haunting images through mass-media news coverage.

Shadow Project founder Alan Gussow (1931–2000) explained: "By scattering images across the face of the earth, we hope to nourish the collective imagination. It is possible, indeed it is our expectation, that people seeing for themselves what will be left after nuclear war will not only act to preserve their own lives, but to continue all life on earth." Gussow, a highly respected, award-winning painter of realistic landscapes in the 1950s and 1960s, felt it necessary, by 1980, to forgo conventional easel painting in order to deal with his passionate environmental concerns. Through various **activist art** "projects" that coupled art and people (students, political activists, the larger public), he hoped to "stir peoples' imaginations" so that they would care more deeply about nature and the preservation of the planet. From this general impulse the international *Shadow Project* was born.

To put on and record an event like the *Shadow Project* at different times and in diverse places requires that the artist leave the confines of the studio and interact out in the world with volunteer workers, a paid project staff, media people, government officials, and funding agencies. In order to produce such grand-scale images or events, the artist must become a team leader, community organizer, fundraiser, negotiator, and all-purpose troubleshooter.

20.15 ALAN GUSSOW. Poster from *The Shadow Project*. August 6, 1985. Courtesy of the artist. *What other significant activist art projects are you aware of? Still growing in size, the AIDS Memorial Quilt, which covered the entire Washington, D.C. Mall in 1996, has to be the largest and most long-lasting. Can you think of other activist artworks, large or small, global or local?*

Environmental Art

Whereas activist artists such as Alan Gussow have focused their attention on saving humanity and nature, many environmental artists approach the natural and built environment with no set aim of effecting major political or ecological change. Their goals might be social, aesthetic, spiritual, scientific, political, or ecological or various combinations of these. Of all the environmental artists who have brought their work into the mainstream of everyday life, the most famous are probably the husband-and-wife team of Christo and Jeanne-Claude. Both were born on June 13, 1935, in Bulgaria and Morocco, respectively. Since 1964, they have lived in the United States but work worldwide. Along with Robert Smithson (8.47), Nancy Holt (8.43), and others, Christo and Jeanne-Claude are known as pioneers of

environmental art. Driven by a love of clothing the environment, the Christos have wrapped a mile and a half of the Australian coastline in white woven fabric, spanned a mammoth 1,368-foot opening between two mountains in the Rocky Mountains with a 365-foot-high *Valley Curtain* of bright orange nylon, and surrounded eleven islands in Miami's Biscayne Bay with pink fabric. In urban areas, they have completely wrapped an ancient bridge (the Pont Neuf in Paris) and entire modern art museums in Bern, Switzerland, and in Chicago. A current twenty-first-century work in progress, *Over the River,* aims to suspend a fabric covering over Colorado's Arkansas River as the waterway courses through rugged mountain passes. While these projects may take decades to enact, they remain in place only for a matter of weeks or months before they are removed and the site is returned to its original condition.

Of Christo's and Jeanne-Claude's many projects, *Running Fence* **(20.16)** was one of the largest and most complicated in terms of social, political, and artistic considerations. The 1976 press release for the project summarizes the extraordinary amount of effort and resources that went into the creation of *Running Fence:*

> Running Fence, 5.5 meters (18 feet) high, 39.4 kilometers (24.5 miles) long, extending East-West near Freeway 101, north of San Francisco, on the private properties of 59 ranchers, following the rolling hills and dropping down to the Pacific Ocean at Bodega Bay, was completed on September 10th, 1976.
>
> The art project consisted of: 42 months of collaborative efforts, the ranchers' participation, 18 Public Hearings, 3 sessions at the Superior Courts of California, the drafting of a 450-page Environmental Impact Report and the temporary use of the hills, the sky and the ocean.
>
> All expenses for the temporary work of art were paid by Christo and Jeanne-Claude through the sales of studies, preparatory drawings and collages, scale models and original lithographs.
>
> Running Fence was made of 200,000 square meters (240,000 square yards) of heavy woven white nylon fabric, hung from a steel cable strung between 2,050 steel poles (each: 6.4 meters/21 feet long, 8.9 centimeters/3.5 inches in diameter) embedded 91 centimeters (3 feet) into the ground, using no concrete and braced laterally with guy wires (145 kilometers (90 miles) of steel cable) and 14,000 earth anchors. The top and bottom edges of the 2,050 fabric panels were secured to the upper and lower cables by 350,000 hooks.
>
> As it had been agreed with the ranchers and with County, State, and Federal Agencies, the removal of Running Fence started 14 days after its completion and all materials were given to the ranchers.
>
> Running Fence crossed 14 roads and the town of Valley Ford, leaving passage for cars, cattle and wildlife, and was designed to be viewed by following 65 kilometers (40 miles) of public roads, in Sonoma and Marin Counties.[5]

The first question most people ask about enormous projects like *Running Fence* is "Why?" Why did Christo and Jeanne-Claude do it, especially if all their pieces, like *Running Fence,* are to be disassembled in a matter of weeks or months? For one thing, Christo and Jeanne-Claude love the numerous challenges of seeing their complex projects through to completion. They are excited by the process of wrestling with the hundreds of real-life elements—ranchers, government officials, environmentalists, townspeople, financiers, student assistants, and work staff—required for construction of their giant environmental pieces. Just as visual elements such as line, shape, and color make up traditional artworks, human elements—people and social interaction—are key ingredients in any Christo and Jeanne-Claude work. Christo affirms that "people [too] are the elements" of their art though they are not the "subject matter" of the pieces.

What is the subject matter of *Running Fence?* Briefly, the subject of Christo and Jeanne-Claude's work is the social system and the environment within which they work. Their works are images that express our time and place: the complexity of our social system, our technological achievement, the physical qualities of our natural and built environment. Their works grow from and reflect our contemporary reality. They are metaphors of the real life of the places where Christo and Jeanne-Claude decide to work—in the case of the *Running Fence,* contemporary North American and northern California society.

I think all the power and force of art comes from real life, that the work must be so much a part of everyday life that it cannot be separated. It is because my Running Fence *is rooted in everyday life that it gains so much force.*—Christo, environmental artist, 1976

20.16 CHRISTO and JEANNE-CLAUDE. *Running Fence.* 1972–76. Sonoma and Marin counties, CA. Woven nylon fabric, steel cables, and steel poles. 18 ft. high, 24½ miles. © Christo 1976. Photo: Wolfgang Volz.

Specifically, *Running Fence* is rooted in and expresses the life of two counties just north of San Francisco. Sonoma and Marin Counties are comprised of dusty brown fields, sea, sky, cows, sheep, people, homes, and towns. They are also counties that experience urban, suburban, and rural conflict relative to the land. Searching for an idea and an image capable of unifying these diverse elements, Christo and Jeanne-Claude came up with the idea of a fence that would join city, suburb, and rural areas and reflect the counties' linear, horizontal pattern of building and land use. With their project site ever in mind, Christo and Jeanne-Claude carefully chose the formal elements of their fence. The height of 18 feet was chosen because it was the average height of the small houses in the area. They made the fence white to reflect light and to echo the bleached coloring of the surrounding buildings. They used a white, lightweight nylon because it created exciting visual effects with changes in wind, light, and weather. Impressive for its color and light, the fence also made for a fascinating line or shape as it meandered, like an elevated stream, across the rolling contours of the land on its way to the sea. Documented for posterity in photo-

graphs, books, and films and on videotape, *Running Fence* is a remarkable image of our time.

Three other artists who work with the environment are Scott Jost (born 1962), Andy Goldsworthy (born 1956), and Janet Saad-Cook (born 1946). Like Christo and Jeanne-Claude, Jost works with the environment in social, political, and aesthetic ways, but his purpose is also to heal wounded ecosystems, such as that of a polluted stream. His documentary photographs of Blacks Run (7.36), accompanied by text in book and exhibition formats, and his work with a community group to establish a linear-park greenway along the stream combine environmental art with effective ecological activism. Goldsworthy does not aim to heal wounded ecologies but creates his formally beautiful artworks (2.2, 2.3) with native materials—leaves, stones, sticks, ice, snow— in a way that has little or no negative impact on the environment. His mostly ephemeral works are site-specific and vary in location from natural settings to art museums.

Acting out of scientific and cosmological awareness, Saad-Cook uses various materials (plastic films, coated glass, mirrored bronze and stainless steel) to make "sun drawings"

20.17 JANET SAAD-COOK. *Prana Pratishtha*. Sun Drawing. 1998. Installation view. Sunlight, time, steel, bronze, optically coated glass. 16 × 28 × 16½ ft. Collection of Josephine Withers. *When the image of a Hindu deity is completed by an artist, it is purified and its eyes are symbolically "opened" in the rite known as Prana Pratishtha. The artwork then becomes an instrument through which sacred energy flows. Titling the sun drawing* Prana Pratishtha, *Saad-Cook writes, acknowledges the yoga beliefs of the work's owner and recognizes the sun drawing as the "eyes" of her home. How does this additional information affect your appreciation of the work?*

Saad-Cook finds a spiritual connection to the sacred sites of ancient cultures while using the materials of modern science. In the midst of this brilliant and elegant dance of light the viewer experiences the interaction between the sun and the earth and an awareness of a constant cosmological dynamic that is often lost or ignored in our modern world.—M. E. Warlick, art historian

from reflected and refracted sunlight **(20.17)**. By carefully bending, folding, and superimposing the materials, she controls the shapes and colors of a continuously evolving mural of light. As they moved beyond her studio walls, Saad-Cook's sun drawings soon became environmental in the broadest sense. Art historian M. E. Warlick relates that the artist's increasing interest in the yearly cycle of the sun led her to research and visit many sacred sites around the world built by ancient cultures whose members tracked the path of the sun.

In 1983–84, she visited several prehistorical sites of the Anasazi Indians [Appreciation 18] in the American southwest, including those at Chaco Canyon (New Mexico) and Hovenweep (Utah and Colorado). These ancient cultures observed the passage of sunlight on the significant dates of the year, the solstices and the equinoxes. Saad-Cook studied how these ancient astronomers

marked the passage of the sun. Some tribes simply watched the horizon, observing the rising and setting of the sun at different points throughout the year. Others found natural formations in nature, such as rocks over which the sunlight passed. Several of these natural formations are marked with Indian petroglyphs, rock drawings which often symbolize the sun.

In some areas, the Indians built structures with such precise orientation that sunlight enters small windows or openings in a deliberate way on significant solar days. At several of these sites, Saad-Cook set up a number of temporary *Sun Drawing* installations, placing her reflective material within the path of direct sunlight in such a way that light forms were reflected within the Indian structures. In other installations, the *Sun Drawing* passed over their ancient rock petroglyphs. During the summer solstice of 1984, she worked at the Anasazi site of Hovenweep in a ruin called Twin Towers. Attaching her reflective materials along a vertical ledge, she formed a *Sun Drawing* **[20.18]** using the noon sun. This elegant petroglyph of light plunged deep into the three-dimensional circular chamber, with silvery diamond shapes and golden stars connected by arcs of light and shimmering touches of pink, orange, and green hovering along the ancient wall. "I wanted to reach across time," Saad-Cook said, "to connect my art to the beauty they had created, still marking and completing the same cycle and return of the sun."[6]

As the twenty-first century unfolds, Saad-Cook's plan is to develop a global network of sites at which sun drawings would be activated around the world as the earth turns.

Public Art

In contrast to outdoor environmental pieces, performance artworks, installations, and activist events, which tend to be ephemeral, most public paintings, sculptures, and designs outside museum walls are built for permanence. Community-supported murals such as *Ascension* (19.21) and *Community Bridge* (5.2) and public sculptures such as Oldenburg's monumental *Clothespin* (3.17), Newman's *Broken Obelisk* (18.21) for a nondenominational chapel, Calder's giant stabile at a French railway station (8.29), and Liberman's *Iliad* (8.9) in the natural surroundings of a sculpture park are meant to last. So are architectural public spaces such as Moore's *Piazza d'Italia* (10.56), Pepper's

Amphisculpture (8.26), and Athena Tacha's *Victory Plaza* **(20.19),** designed for the American Airlines Center, a sports arena in Dallas, Texas, that opened in 2001.

Inspired primarily by the famous Campidoglio piazza designed by Michelangelo in Rome, Tacha (born 1936) created a linear pavement design from which 137 jets rise in the form of water sculptures. But rather than building on one centralized pattern, Tacha's Web site relates that:

> Victory Plaza has an asymmetrical design with three subtly irregular star-shaped fountains. Lines of force emanate from each star like rays and cross each other, spreading toward the surrounding buildings. The seven-arm stars are twisted clockwise or counterclockwise, like turning pinwheels or spiral galaxies colliding in space, and their "rays" crisscross like the paths of players during a game.
>
> The image of the star has multiple references—to the Lone Star State, to one of American Airlines' logos, to the Dallas Stars, and to all the "stars" of the center's teams. . . .
>
> The fountains are about 50 feet in diameter. Forty-five water jets shoot up from each star, six or seven per arm, forming arcs of water that rise gradually from 3 to 21 feet at the center, echoing the arena's giant arches and converging in a central spectacular splash. Rows of lights under each arm's water jets contribute to enhance the spinning effect at night, and a complex computer program animates the water in a sequence of changing movements.
>
> The jets are regulated by wind level and turned off when the plaza is needed for events. Their heads are set within the pavement to make it fully walkable, and the subtle inclines of the plaza allow drainage of water toward each star center, yet are gentle enough in their ascents and descents for wheel chair accessibility. As a result, the pavement itself appears organic and dynamic, like an actual landscape or a living body—unlike most flat urban concrete expanses.[7]

Aesthetically impressive and user-friendly, Tacha's plaza is a public art success.

Public art can be wide-ranging in style and intent, but it invariably requires that artists balance or integrate their vision with that of the persons who will view or use the work on a regular basis. Both Maya Ying Lin's Vietnam Veterans Memorial in Washington, D.C. **(Appreciation 39),** and the diverse, often unusual public artworks created by Mierle Laderman Ukeles (born 1939) for the New York City Sanitation Department do just that. Both artists were initially somewhat controversial with the public, but they are now very much accepted and deeply appreciated. One Sanitation Department "contextual sculpture" by Ukeles is a garbage truck decorated with mirrors **(20.20)** so people can see who makes the garbage. Driving around New York City, this mobile artwork combines humor with consciousness-raising in a mix of conceptual, performance, installation, activist, and public art. As opposed to artworks that intentionally defy and alienate the public, critic Suzi Gablik writes, Ukeles and the best public artists achieve connection and community: "The way [Ukeles] merges her consciousness with the workers, converses with them, learns from them and

20.18 JANET SAAD-COOK. *Sun Drawing. Twin Towers, Hovenweep.* 1984. Sunlight, iridescent plastic film, metalized polyester, Kapton. Created on site at Hovenweep National Monument, Utah.

20.19 ATHENA TACHA. *Victory Plaza.* American Airlines Center sports arena, Dallas, Texas. 2001. Courtesy of the artist.

becomes one with them" serves to give her interactive art a human and communal fullness that an egocentric art of strictly personal vision lacks. For socially and ecologically conscious critics like Gablik, art must not be shut away and marginalized in elite art world galleries. Rather, it needs to be at the very center of life, actively involved in the healing of a damaged world. This influential critic finds that the public art of Ukeles, Maya Lin, and Allan Gussow offers a new, much needed model for the rejuvenation or "reenchantment" of art in our time.

ART APPRECIATION IN A PERIOD OF PLURALISM

From the mid-twentieth century to the present, art has expanded in every way. In addition to the intercontinental and intercultural nature of so much of our art, we have seen minimalist and maximalist directions—sculptures reduced to all-black cubes (3.4) side by side with environmental and performance pieces that take in the subject matter of the whole world. Following the international triumph of abstract expressionism in the 1950s, we have seen figurative art storm back onto center stage in stunning variety since the 1960s. As we enter the twenty-first century, all possible kinds of artworks and artistic directions—modernism and postmodernism, realism, surrealism, expressionism, formalist abstraction, conceptualism, and their hybrids—seem to exist simultaneously. An all-embracing, nonhierarchical value system—traditionalists would call it anarchic—appears to be in effect. In contrast to periods when a particular style (classicism, romanticism, abstract expressionism) or subject matter (religion, mythology, history) ruled over the rest in hierarchical fashion, a democratic pluralism of subject, style, and purpose seems to have arrived.

In the present, pluralist decades, all art forms, media, mixed media, and new media seem to be valued equally. Painting and sculpture no longer reign as the supreme art forms. Art created from traditional handicrafts might be shown in one museum room, with high-tech

20.20 MIERLE LADERMAN UKELES. *The Social Mirror,* New York. 1983. 20-cubic-yard garbage collection truck fitted in hand-tempered glass mirror with additional strips of mirrored acrylic. Collection of the New York City Department of Sanitation. Courtesy of Ronald Feldman Fine Arts, New York. *Certain critics condemn Ukeles's pieces as more "social work" than art. They claim that the works are less about aesthetic concerns than about advancing a social agenda. What do you think?*

video, computer-generated, or Internet-based works holding sway in another **(Appreciation 40).** Traditional subjects long banished from the halls of modern art—history, religion, mythology, portraiture, genre, landscape, and still life—have returned. Artwork from peoples, groups, and cultures outside the North American–European mainstream is increasingly finding its way into our galleries and museums. The handicrafts and decorative arts and graphic and product design, previously considered "minor" arts, are beginning to be granted more equal status. Sexual barriers are falling as art by women achieves equal recognition. Although art with overtly homosexual or controversial political subject matter tends to be avoided by the art establishment, even that may change. In general, a democratic pluralism reigns.

In such an open-ended, pluralistic art world, fixed rules and governing principles do not exist, at least not for very long. We, the viewers, must set our own standards. If we had

lived in an earlier time, when a clear-cut system of aesthetic values dictated the approved way, art appreciation would be an easy matter. We would feel secure in our responses and comfortable in our judgments. But we don't live in a simple, hierarchical world. Early-twenty-first-century society is ever changing and ever more complex, with an art to match.

As viewers, we are sorely challenged by the new pluralism. With so much and so many types of art before us and so little in the way of fixed standards to guide us, we must largely find our own way. Fortunately, we are not completely without support. The time-tested principles of formalism and contextualism will help us on our journey, as will the bedrock of knowledge we have gained by studying the worlds of art of diverse times and cultures. A growing awareness of the different ways people have seen and represented the world and have responded to art should encourage us to be more open-minded, tolerant, and thoughtful in our processes of appreciation.

Creating Art of Value in Public Places: The Vietnam Veterans Memorial

CORA BETH ABEL

The Vietnam Veterans Memorial (**Fig. A**) changed forever the American notion of a proper commemorative—from a white elevated statue to a black underground abstraction. Known as "the Wall," this artwork was initially so controversial that it prompted the funding of a second memorial nearby, a traditional bronze sculpture of four soldiers. Yet the more abstract work soon won the public's heart. The Wall is one of the most visited sites in the city of Washington. It speaks to a common grief and succeeds dramatically in achieving its purpose—to create a "venue for reconciliation" between opposing factions in an unpopular war.

Great works of public art create memorable spaces—environments that arouse, educate, and inspire. At its best, public art also reaffirms our sense of place, the feeling of being part of a larger community. The Vietnam Veterans Memorial by Maya Ying Lin is an example of great public art that was the culmination of a model process. The public was informed at every step, and qualified jurors made aesthetic decisions. Design criteria included both social and physical requirements: The memorial must be apolitical, reconciliatory, harmonious with the site, and contain nearly sixty thousand names of those missing or killed in the war. Lin understood the power of this last requirement and used it evocatively—the names literally became the memorial.

A jury reviewed over fourteen hundred anonymous submissions, some from eminent architects. Lin, still an undergraduate at Yale, submitted her sketches along with classmates in a seminar on funereal architecture. Lin's proposal was stunningly simple. A black granite wall inscribed with the names of soldiers who died leads viewers into and out from a partially excavated landscape. The granite's highly polished surface reflects both viewer and surrounding scene—grassy field, mourners and tourists, mementos offered along the ground.

Figure A MAYA YING LIN. *Vietnam Veterans Memorial.* 1982. Black granite. 500 ft. The Mall, Washington, D.C.

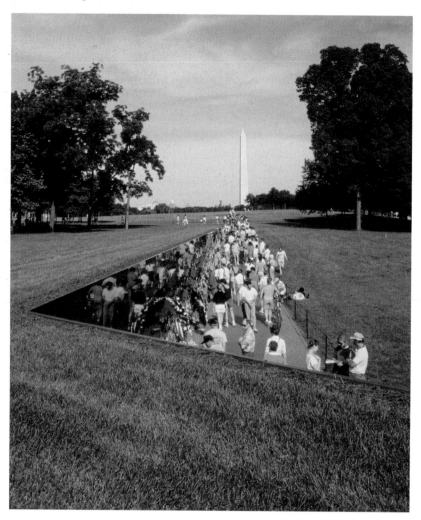

Cora Beth Abel is an artist and a writer on public art. She lives in Cambridge, Massachusetts.

The Wall is composed of two wings: One points to the Washington Monument, the other to the Lincoln Memorial.

As a work of art, the Wall both communicates and catalyzes. People of all ages, regardless of cultural and political differences, connect to its many messages. How and why does this happen? One important key to the Wall's success involves the process of finding a loved one's name. Etched onto vertical panels, names are listed in chronological order by the date of death, beginning with the first soldier who died. People place keepsakes below names of deceased family and friends— flowers, wreaths, books, flags, medals, poems, collages, posters, ribbons, stuffed animals, even pieces of clothing. Lin explained her inspiration that continues to resonate. "I thought about what death is, what a loss is—a sharp pain that lessens with time, but can never quite heal over. A scar. The idea [for the Wall] occurred to me there on the site. Take a knife and cut open the earth, and with time the grass would heal it."

Lin's radical design invited viewers to rethink the meaning of a memorial. Like many artists working in the public realm, she strove to awaken new sensibilities. Yet an artist's desire to challenge perceptions can backfire. In 1981, Richard Serra installed *Tilted Arc* **(Fig. B)** to make New Yorkers more aware of their surroundings. Serra's 12-foot-high curving wall of raw steel forced pedestrians to walk around its 120-foot length in order to cross a busy plaza. New Yorkers rebelled. After eight years of protests and hearings, the art was removed. Serra's intent to goad pedestrians into awareness was realized, but an arrogant disregard for contextual and social connections led to failure.

At first, the Vietnam Veterans Memorial also fueled a divisive emotional debate. Some veterans and politicians saw the artwork as a derogatory black hole or ditch. The unconventional design, the selection of an Asian woman, prejudice against the color black, and distrust of a jury that included no veterans generated animosity. Yet over time the Wall has brought people together. Each year, over four million visitors walk by the Wall. On the memorial's tenth anniversary, the Smithsonian Museum displayed five hundred of the twenty-five thousand objects left at the Wall. In 1998, a Virtual Wall was established (thevirtualwall.org), where over thirty thousand remembrances have been posted. Now, twenty years after its creation, the Wall still inspires a healing yet spirited public discourse about the culture we all share and shape, and that shapes us in return. ▪

Figure B RICHARD SERRA. *Tilted Arc.* 1981. Cor-Ten steel. 12 ft. × 120 ft. × 2½ in. Installed Federal Plaza, New York. Removed 1989.

FRANKLIN FURNACE: *Re-Imaging Performance Art and the Public*

MALAIKA SARCO

Among the most innovative solutions to accommodating the exponential growth of the art world within the physical limits of Manhattan Island is that of a presenting organization known as Franklin Furnace Inc. In 1997 the downtown venue that gave a start to such artists as Karen Finley, Barbara Kruger [7.43] and Coco Fusco went virtual. Franklin Furnace Inc. is now an institution with a mission to "make the world safe for avant-garde art" by promoting preservation of the past, dialogue in the present and creation for the future of performance art.

Anyone with Internet access can learn about the venue's unique history. By visiting www.franklinfurnace.org, visitors can access digital archives, witness or participate in live Webcast performances, and engage in ongoing, critical dialogue about the past, present and future of performance art. The Web site also serves as a networking resource for performance artists, offering information about funding opportunities and links to presenting organizations. Yet most notably, Franklin Furnace actualizes the use of the Internet as a revolutionary new medium in itself.

In the 1990s, a revolution is what the performance art world needed. Performance artists were frequently becoming the main targets of reactionary wrath from conservative groups and opponents of government funding for the arts. In light of this outrage, founding director of Franklin Furnace Martha Wilson glimpsed potential in the World Wide Web as a transcendent performance medium. She saw the Internet as a location of freedom from the militant censorship which had plagued performance art, and as a creative tool capable of rising above the antiquated exhibition paradigms of the physical art world.

In 1995, Wilson chose to "go virtual" with Franklin Furnace, abandoning its physical gallery space in favor of a Web-based institution. In doing so, she made a pioneering step toward identifying cyberspace as a vehicle for discourse, presentation and creation of performance art. Franklin Furnace now utilizes the Internet's capacity for unlimited viewers, open communication and publicly accessible databases to challenge assumptions about the relationship between performer and observer.

Live performances at Franklin Furnace's Web site shift the boundaries of traditional performance art by incorporating elements of interspacial collaboration and audience participation. Artists in different locations, varying parts of a room, or even different countries can create, perform and interact simultaneously through Web technology. Live feed Webcasting transforms video into an immediate performance medium; the camera becomes a portable "eye," exploding the possibilities for broadcast environments.

Moreover, the truly democratic anonymity of cyber communication defies existent power structures within the art world, shifting the acts of observing, responding, and furthering projects to a vast, unseen and diverse public. Many artists capitalize on this interface by integrating forums for audience participation directly into their online performances.

Two such artists are Bosnian and Herzegovinian artist Danica Dakic and Croatian visual artist Sandra Sterle. In November 2001 they incorporated a series of live, online dinner table conversations in the *Go Home Project* **(Fig. A),** presented by Franklin Furnace. The project and its conversations addressed notions of identity, displacement, assimilation and refuge within cultural settings. Virtual

Malaika Sarco is a performance artist and writer who majored in intercultural performance studies at Hollins University. She interned at Franklin Furnace in 2001. For more information on The Go_Home Project, visit http://www.project-go-home.com/gohome/project_gohome.htm.

audience members participated in the dialogue and could interact with the guests present at the physical dinner table by posing questions and offering comments online **(Fig. B).** The conversations were then recorded and posted on the Franklin Furnace Web site, challenging the ephemeral nature of performance with a "living" digital record available to the public.

Initiating programs that make living records and archival resources publicly available is another of Franklin Furnace's projects. In addition to archiving its own rich history that includes such artists as Guillermo Gomez-Peña, Ann Hamilton, Annie Sprinkle and Paul Zaloom, "the Furnace" lends itself to other educational ventures. Currently the organization is collaborating with artists and the online public on a project to document the downtown Manhattan avant-garde art scene of the 1970s, 80s and 90s. The Furnace is also at the forefront of creating archival standards in vocabulary, cataloguing and reproduction rights in providing public online access of temporal and performance art documentation.

As it provides a dynamic site for public appreciation of avant-garde performance art's past, present and future, Franklin Furnace seeks to challenge, educate and innovate through "the convergent art medium" Martha Wilson believes "the twentieth century spent itself looking for." ∎

Figure B DAKIC and STERLE. *Go Home Project*. 2001. Online performance (DinnerWebcast).

APPENDIX 1

Writing About Art

Writing just one or two pages about a building, painting, or graphic design can significantly deepen our appreciation of that work of art. Writing is to the viewer what sketching is to the artist or designer. It gets us to look closely, think seriously, and focus our feelings on the art object. The process of writing can engage the imagination, emotions, memory, and senses and concentrate all these powers of thought and feeling in a singular act of appreciation. Not surprisingly, the result is often an experience that is deeply rewarding.

Here we discuss two approaches to writing about art: the interpretive paper and the research paper. In an interpretive paper, the viewer describes and analyzes the artwork in objective detail and interprets the work from a personal, subjective standpoint. A research paper also includes visual description and analysis, but the writer primarily assembles factual information and expert opinion in order to understand a work as the creation of a particular person, group, society, or culture.

THE INTERPRETIVE PAPER

The First Step: Analytic Description

Probably the easiest way to approach and become involved in a work of art is to describe and analyze it in objective terms, omitting personal opinions, subjective flights of imagination, and rapid-fire emotional responses. The writer strives for an in-depth analytic description of the artwork, that is, a sensitive description of the subject matter (people, animals, natural surroundings, symbols) and formal elements (line, shape, space, color) coupled with a perceptive analysis of the relationships between subject matter and formal elements.

A first analysis of the subjects of Vincent van Gogh's *Night Café* (1.12) describes six persons passing time in a café late at night. The clock at the rear of the room reads 12:15. If we focus on the relationships between these persons, the process of analysis yields a deeper level of understanding. We observe a man in white standing alone behind a billiard table in the right-center section of the room. A long, empty table with a lone bottle and glass is behind him. Hands at his sides, the man looks out at us, expressionless. The darkly clad persons—four men and a woman—drinking at or hunched over the surrounding tables pay no attention to the man in white or to their neighbors. Analytic description reveals that the relationship between these individuals lacks friendliness and ease. As we move to the formal sphere and, in particular, the colors of *The Night Café*, the process of analytic description uncovers potent warm-cool, light-dark, and complementary color relationships—especially bold red-green contrasts—that create a feeling of tension. In *The Night Café*, the formal relationships and subject matter relationships reinforce a tense, uneasy feeling.

An analytic description of Willem de Kooning's nonrepresentational painting *Dark Pond* (18.17) might focus entirely on the formal aspects of the work. There are no recognizable subjects—café inhabitants, chairs, tables, walls—to describe and analyze. Here is a description from Chapter 18:

> The picture surface or ground of *Dark Pond* is entirely black, with white marks, dots, and

Very often it turns out that as I write about something, it gets better. It's not that I'm so enthusiastic that I make it better, but that in writing, because the words are an instrument of thinking, I can often get deeper [into the work of art]. . . .
—Marcia Siegel, critic, 1979

Once you get rid of the normal baggage you carry in looking at art, things happen: you find yourself liking what you hated a while ago.—Chuck Close, artist, 1991

A1

lines of differing length and thickness. Almost every white line interconnects in some way to form an irregular shape—along with a few geometric ones—against the black ground. Although de Kooning has sketchily painted in several of these shapes with white at the picture's upper edge, the others remain white outlines against the black ground.

This passage simultaneously describes and analyzes the relationships between the painting's colors, lines, and shapes (for example, white outlines against a black ground, lines interconnecting to form irregular and geometric shapes). The analytic description of *Dark Pond* then moves to the formal elements of shading, shape, and space and analyzes how these elements are organized on the picture surface.

> Shading is not attempted, and a flat, friezelike effect is produced. Figure-ground distinctions are blurred, although one might perceive the white markings to be up against or slightly raised above the black ground. Given more or less equal emphasis, these many varied shapes interweave to create an "all-over" effect, with no single focal point.

These two passages not only make a "visual inventory" of all the formal aspects of *Dark Pond* but also show how these visual aspects—line, color, shape, space—relate to one another. They show how the painting is organized or composed. A detailed description of the constituent parts of the artwork is accompanied by a summary analysis of the relationships of the parts.

By describing and analyzing a work such as *Dark Pond* in objective terms, we do something the majority of us probably wouldn't do otherwise. We stop to look at a work of art—even one we might not initially understand or like—with an open, focused mind for ten minutes or more. We put aside our personal opinions and value judgments for a brief interval and postpone superficial "I like this" or "I hate this" verdicts that short-circuit serious thinking and feeling. In fact, instant judgments throw up walls to appreciation by stereotyping and oversimplifying. It's like meeting a person for the first time. It's better to observe the person closely and listen carefully to what he or she has to say rather than jumping to snap decisions after one quick glance.

Because they counter our tendency toward instant, sweeping judgments, description and analysis of all we see in an artwork are an excellent initiation into the art appreciation experience, for both beginners and experts. Recall how thoroughly artist Jerry Coulter described and analyzed the line, color, shape, texture, subject matter, and composition of Vincent van Gogh's *Night Café* in Chapter 1. Coulter operates like a visual detective, probing the van Gogh painting for all the facts, clues, and evidence it can reveal. A detective never makes a snap judgment during the initial examination process, and neither should we as viewers of art. The best advice is to proceed slowly, looking closely at every aspect of the work. Our ultimate understanding of the various meanings of a work depends on how carefully we've looked at all its features during this first step of analytic description.

The Second Step: Personal Interpretation

After we take that first detailed look and jot down an in-depth analytic description, we are presented with an exciting challenge. It starts as we develop our own personal responses, understandings, meanings, or explanations of the work, that is, our interpretation. If the analytic description is the soil from which the appreciation grows, then the personal interpretation is the emerging flower. The flowers that blossom will vary widely. The range of interpretations of de Kooning's *Dark Pond* and van Gogh's *Night Café* will necessarily be quite varied, because each viewer brings his or her unique personality, background, purposes, and interests to the piece. In this respect, interpretation is simultaneously a contextualizing and an individualizing experience. When we interpret a work, we bring to it the personal "context" of our ideas, emotions, and knowledge and, in so doing, give individual meaning(s) to the work. We make art works such as *The Night Café* and *Dark Pond* our own. We put our personal stamp on them. No one else's interpretation of these paintings will be exactly the same as ours. Thus interpretation is a highly creative process. The twentieth-century sculptor David Smith said that the artist provides us with the work of art that we, the viewers, creatively "complete" by interpreting it and giving it meaning in our own individual

I sincerely believe that the best criticism [or interpretive writing] is that which is both amusing and poetic: not a cold, mathematical criticism which, on the pretext of explaining everything, has neither love nor hate, and voluntarily strips itself of every shred of temperament. . . . criticism should be partial, passionate, and political.
—Charles Baudelaire, art critic and poet, "What is the Good of Criticism," 1846

way. For example, this interpretation of *Dark Pond* from Chapter 18 endows the painting with subjective meanings:

> De Kooning's line is intense, highly charged, and emotional, much like the pulsating, electrical lines of a rock guitarist. Such lines are not the precise contours of a classicist but rather the passionate outpourings of a romantic. The artist is powerfully involved in the actual physical process of creation. We feel the speed, the force, the gesture of each brushstroke. Every line, shape, and mark is infused with de Kooning's manic excitement, his urgent desire to paint, to get it all said.
>
> It is easy to envision de Kooning struggling, wrestling with the canvas, stepping back, looking with fixed concentration at the evolving work, making sure all is right and in place. Setting passionately back to work, painting over lines and shapes, he ceaselessly destroys hard-won images in order to create an image of ever greater vitality. . . .

During the process of interpretation, viewers can project themselves into the work in large or small ways. The previous interpretation of *Dark Pond* evidences an interest in artistic and musical processes that are improvisational and emotionally expressive. At the same time, it emphasizes and places a high value on the artist as solitary, individualistic creator. Others' interpretations of *Dark Pond*, though based on the same objective visual information, would naturally differ. People with strong interests in politics, sociology, or anthropology probably would not base their interpretations on de Kooning's artistic process or bold expression of emotion. Instead of interpreting *Dark Pond* as the passionate improvisational creation of a romantic individualist, they might find it an unsettling expression of personal disorder, societal disintegration, or political anarchy, and they might make highly convincing cases, based on the visual evidence, to this effect.

Our discussion of the contrasting responses to Jackson Pollock's abstract expressionist painting *Number 1, 1948* (18.15) makes clear how wide-ranging interpretations can be. An American formalist critic interpreted *Number 1, 1948* as a visual first in Western painting, a work in which Pollock's "all-over" approach to composition enabled line and color to function as "wholly autonomous pictorial elements." A psychoanalytic theorist interpreted Pollock's *Number 1, 1948* as a revelation of the artist's mind at the deepest levels, "the unconscious itself." A Marxist art critic from England interpreted the work as an expression of "the disintegration of our culture." (A conservative United States congressman saw the work as "creeping communism.") Finally, a German art historian found the painting deeply American, capturing "an exuberance of the continent, the ocean and the forest, the conceiving of an undiscovered world comparable to the time 300 years ago when pioneers came to this country." Each interpretive response, so remarkably different, nonetheless sheds light on some important aspect of the artwork, ourselves, and our civilization. Exposure to a variety of interpretations helps the viewer realize that other points of view are valid and that his or her interpretation can be challenged, expanded, deepened, and ultimately enriched. In this regard, writing an interpretive paper can be a broadly educational experience, leading to both a deeper appreciation of an artwork and an enlarged understanding of the values and interests that shape our own individual interpretations of art and of the world.

Describing and analyzing a work in objective detail and interpreting it subjectively can be done sequentially, as in our example of the response to de Kooning's *Dark Pond*, or the two steps can be seamlessly interwoven, as in the undergraduate student's interpretive paper excerpted in Chapter 1. Responding to Claude Monet's *On the Cliffs, Dieppe* (1.6), the writer joins subjective, interpretive response with objective, analytic description.

> When my glance fell upon the painting I was suddenly transformed into the mist and coolness and silent secret that is the sea. The ocean is calm; blue and green with touches of pink and purple. The sky is pale, paler than the ocean, and there is a hint of pink and yellow on the horizon. Perhaps in an hour the sky will be ablaze with sunset.
>
> There is a oneness, a unity among sky, rocks, and ocean. There are so many different colors and tiny, graceful brushstrokes that they cannot always be separated or distinguished. The cliffs in the background have almost merged with the ocean. Only at their summit is a contrast between earth and sky discernible.

Interpretations are not so much absolutely right but more or less reasonable, convincing, enlightening, and informative.—Terry Barrett, *Criticizing Art*, 2000

The artist has transported us to a world devoid of people or their influence. All we see is water, earth, and sky. And even these seem to want to merge with each other, share each other's identity, filling the eye of the beholder with the light which suffuses land, sea, and air.

Artist Jerry Coulter does the same as he reacts to the formal elements of van Gogh's *Night Café*. Note how he speaks objectively of the painting's texture and then, almost simultaneously, interprets how the texture makes him feel.

When one looks at the material itself—the way the paint is put on in rough, heavy textures—there's a kind of anxiety in it. There's a scratching, almost flailing in some places as opposed to a fluid, tender touching of brush to canvas. And although there is control, there seems to be a psychotic intensity behind it. It's all put down so excitably, scratched into or thrust onto the picture surface.

THE RESEARCH PAPER

For a research paper on an artwork and its creator, the writer consults books, articles, and the Internet for specific information or seeks expert opinions on the work, the artist, and the artist's society and culture. The writer might interview an artist, designer, craftsperson, psychologist, sociologist, or art historian firsthand. Writing about Vincent van Gogh's *Night Café* (1.12), art historian Werner Haftmann focuses on van Gogh's personal history and the history of the painting itself. He tells us about the artist's relationship to the people pictured in the painting. In effect, Haftmann tells us where, when, how, and why the painting was created. To begin, he introduces us to the artist. We are given facts:

In February, 1886, Vincent van Gogh came to his brother Theo's shop [a Paris art dealership]. Gaunt, awkward, red-headed, highly strung, he took everyone but himself for a genius. Given to dreams of universal brotherhood and love he met with indifference everywhere.

What brought him to painting in the first place was his overflowing love of things and his fellow men. He had been an unsuccessful salesman in an art gallery, and then a lay preacher in the Belgian coal mining area. . . .

After telling us about van Gogh the person, Haftmann speaks of various artworks, including *The Night Café*. He includes the artist's own comments about the work. "In painting the café at Arles at night," Haftmann writes, "Vincent again enhanced and modified the colours in order to show [in the artist's own words] that this is a place where a man can lose his mind and commit crimes . . . an atmosphere of a glowing inferno, pale suffering, the dark powers that rule over a man in his sleep." Haftmann concludes, "Colour became for van Gogh a bridge to the realm where objects are signs, conveying messages from man's inner world."

Haftmann tells his historical story well. Although the research-based style of writing demands factual accuracy, clarity, and logical development, it need not, as Haftmann proves, be dry or ponderous. Haftmann's style is lively and filled with his own humanist values and empathic feelings for van Gogh and his paintings.

Every author's approach to the research paper is unique. Appreciations 29 and 30, in Chapter 15, are both essentially art historical, concentrating on facts and expert opinions and theories about the work, the artist, and his or her times. But the authors of these appreciations marshal facts and learned opinions to different ends; each essay presents a unique purpose and literary approach. Wendy Slatkin's appreciation on Elisabeth Vigée-Lebrun's *Marie Antoinette and Her Children* (Appreciation 30) is primarily descriptive, analytic, and informative. She presents factual information about the artist, her work, and life in late-eighteenth-century France. Slatkin strives for and achieves solid scholarship that tells the story of the artist and the work in a noncontroversial, nonargumentative way. In contrast, Frima Fox Hofrichter, writing about the seventeenth-century Dutch painter Judith Leyster (Appreciation 29), lets her own strong opinions be known. Her paper is a scholarly argument that makes a convincing case for a particular position. Her goal was to prove that Judith Leyster, as a woman artist, represented a common subject of the day (the sexual propositioning of women by men) in a way far different from that of contemporary male painters.

Research and writing in art history—the same holds true for the philosophy and

It is sometimes argued that there is a clear distinction between scholarship (or art historical research) and criticism (or appreciation). . . . But on the whole the best writers on art do both things, and they often do them simultaneously.—Sylvan Barnet, *A Short Guide to Writing About Art*, 1999

sociology of art, and other scholarly areas—are never value-neutral. Even with the same factual materials available to them, art historians might view and interpret the same artists and artworks quite differently. All writers of research papers are committed to their own values and beliefs, however obvious or subtle, conscious or unconscious, and these values and beliefs inevitably enter into their research and writing. All art historians select and organize facts according to their value and belief systems. Recognizing that all art historical research and writing are slanted one way or another in no way diminishes the import of such writing. Art history that is value-based, and therefore diversified in its views of art, is the art history of a democracy. (The art history of a dictatorship, in contrast, is repressively one-sided, allowing for only the one "true," government-sanctioned view of art.) Diversified, value-based art history, along with other scholarly art pursuits, makes for a democratic interchange of competing ideas and information and a subsequent understanding of art that is richer for its multiple views and more truthful for its complexity.

Consider some of the points of view represented in the history-based essays in *Responding to Art*. Appreciations 29–31 and 38 are essays written from a feminist perspective. Appreciation 4, on Matisse's *The Flowing Hair*, is written from a formalist, biographical, and seemingly apolitical perspective that might make these feminist writers cringe. Appreciation 11 provides a politically leftist view of Käthe Kollwitz's *Hamm*, stressing socialist or social democratic themes such as oppression of the working class, especially working-class women. Appreciation 34, on Mexican artist Frida Kahlo, emphasizes the personal over the political, underplaying Kahlo's own outspoken Marxist politics in favor of her personal, physical, and psychological struggles. Clearly, the writer was more concerned with Kahlo's private life than with her public one. In each of these examples, factual information is shaped in accordance with the interests, beliefs, and worldview of the individual writer.

Some critics have asserted that writers of research papers look too much at books and Web sites and not enough at works of art. The best writers of research essays scrutinize the works of art they are studying as closely as the documents they consult. As an integral part of their research, they necessarily engage in probing analytic description. Appreciation 2 is an example of writing that interweaves careful analytic description and scholarly research. Artist Eugene Grigsby's essay on Hale Woodruff's murals *Interchange* and *Dissipation* typifies the mix of sensitive observation and historical scholarship:

> Visually, *Dissipation* gains strength and tension from dynamic diagonals, rippling with rhythmic movements. African masks and sculptures crisscross in and above the hands of the European destroyers. Rich colors animate the patterns of design. Whereas the quiet and composure of *Interchange* evoke calm reflection, the composition and content of *Dissipation* angrily admonish the Europeans for trying to destroy a culture, suggesting that the masks and sculpture of Africa will survive the looting and outlive the flames.

Research-based writing can be as exciting and meaningful as interpretive writing. In addition to presenting factual research, it can shed light on the writer's own thoughts, feelings, values, and beliefs.

Research-based writing requires citations, that is, notes or footnotes that give the sources of specific facts or quotations. The rule for all beginning writers is "When in doubt, cite your sources." In academic contexts, failure to cite sources can even be considered plagiarism, a serious charge. Don't risk plagiarism charges—cite your sources!

A research paper is not merely an elaborately footnoted presentation of what a dozen scholars have already said about a topic; it is a thoughtful evaluation of the available evidence, and so it is, finally, an expression of what the author thinks the evidence adds up to.
—Sylvan Barnet, *A Short Guide to Writing About Art*, 1999

STONE AGE EUROPE, AFRICA, ASIA
ca. 40,000–2000 B.C.E.

Historical Events

ca. 40,000–10,000 B.C.E.
Upper Paleolithic Hunter-Gatherer Society

ca. 10,000–5000 B.C.E.
Mesolithic Transitional Period

ca. 5000–2000 B.C.E.
Neolithic Agricultural Settlement Society

Artistic Events

Paleolithic Cave Paintings and Fertility Figurines

Mesolithic Rock Face Drawings

Neolithic Pottery, Sculptures, Megaliths, Town Planning

ANCIENT NEAR EAST
ca. 4000–400 B.C.E.

Historical Events

ca. 4000–2000 B.C.E.
Development of Cities and Writing

Commercial Economy and Class-Based Society

Artistic Events

Sumerian ziggurat and bull lyre, Akkadian "Sargon" head

Babylonian Stele of Hammurabi, Nebuchadnez-zar's Neo-Babylonian architecture, Persian King Darius's Persepolis Palace

ANCIENT INDIA
2700–185 B.C.E.

Historical Events

ca 2700–1500 B.C.E.
Development of Indus Valley Civilization

ca 320–185 B.C.E.
Emperor Ashoka and Buddhist Mauryan Civilization

Artistic Events

Mohenjo-Daro Priest and Dancer sculptures

Ashokan Column Capital with Buddhist symbols

ANCIENT EGYPT
3000–600 B.C.E.

Historical Events

ca 2700–2190 B.C.E.
Old Kingdom Dynasties

ca 2040–1674 B.C.E.
Middle Kingdom Dynasties

ca 1552–1069 B.C.E.
New Kingdom Dynasties

712–657 B.C.E.
Nubian conquest of Egypt

Artistic Events

Old Kingdom Pyramids at Giza, statue of Mycerinus and Khamerernebty, Scribe, and Potter

Middle Kingdom head of Sesostris, rock-cut tomb paintings

New Kingdom Hatshepsut tomb and statue, Akhenaton relief sculpture, Ramses temples and giant sculptures

Nubian Taharka figurine

ANCIENT MEDITERRANEAN
3000–1000 B.C.E.

Historical Events

ca 3000–1400 B.C.E.
Minoan civilization

ca 1400–1100 B.C.E.
Mycenaean civilization

Artistic Events

Minoan "octopus vase" and "boxing children" wall painting

Mycenaean "Mask of Agamemnon"

ANCIENT CHINA
ca. 1766–256 B.C.E.

Historical Events

ca 1766–1122 B.C.E.
Rule of China's first dynasty, the Shang

ca. 1122–256 B.C.E.
China's second dynasty, the Zhou

Artistic Events

Shang dynasty "four-ram" wine vessel

Writings of Lao Tzu and Confucius in later Zhou era

ANCIENT GREECE
ca. 700–31 B.C.E.

Historical Events

499–478 B.C.E.
Wars between the Greeks and Persians

460–429 B.C.E.
Athens at height of its power

334–323
Alexander the Great conquers Persia and establishes a vast empire

Artistic Events

ca 700–480 B.C.E.
Archaic Period: Kouros and painted pottery of Xekias

ca 480–323 B.C.E.
Classical Period: Parthenon and Doryphoros of Polykleitos

ca 323–31 B.C.E.
Hellenistic Period: Alexander coin, Medici Venus and Laocoön statues

ANCIENT ETRURIA
800–300 B.C.E.

Historical Events

ca 800–500 B.C.E.
Etruscan civilization dominates north-central Italy

ca 500–100 B.C.E.
The Etruscans influence the Romans who gradually conquer and absorb them

Artistic Events

Tomb paintings and funerary sculptures

REPUBLICAN ROME
509 B.C.E.–31 C.E.

Historical Events

The Roman Republic with government by an aristocratic senate and popular assemblies

Artistic Events

Republican public statuary, Aulus Metellus

IMPERIAL ROME
31 B.C.E.–337 C.E.

Historical Events

The Roman Empire with governance by powerful emperors and their families

Artistic Events

Statuary of the emperors, Imperial architecture of the Pantheon, Markets of Trajan, Basilica of Maxentius

Early Christian catacomb art of Imperial Period

BYZANTINE EMPIRE
330–1453

Historical Events

after 330 C.E.
Byzantine Empire emerges from Eastern Roman Empire

1453
Ottoman Turks conquer the final Byzantine stronghold of Constantinople

Artistic Events

Justinian and Theodora mosaics in Ravenna

Hagia Sophia in Constantinople

ANCIENT MEXICO
1200 B.C.E.–750 C.E.

Historical Events

ca 1200–300 B.C.E.
Olmec Civilization

ca 500 B.C.E.–750 C.E.
Teotihuacán Civilization

Artistic Events

Giant Olmec stone heads

Teotihuacán, city and pyramids

ANCIENT NORTH AMERICA
ca. 750 B.C.E.–1550 C.E.

Historical Events

750 B.C.E.–1550 C.E.
Adena, Hopewell, and other Mississippi and Ohio Valley mound-building cultures

100 B.C.E.–1300 C.E.
The Anasazi culture of American Southwest flourishes

Artistic Events

Anasazi "Kayenta Olla" pot

Great Serpent Mound in Ohio

EARLY MEDIEVAL EUROPE
500–1100

Historical Events

771–814
Reign of Charlemagne, King of the Franks and Holy Roman Emperor

Dominance of church and feudal aristocracy and Christian religion

Artistic Events

Carolingian manuscript illuminations, Ottonian bronze doors, Romanesque architecture, Bayeaux Tapestry

ISLAMIC CIVILIZATION
ca. 700–1650

Historical Events

early 600s
Muhammad founds the Muslim religion and Islamic culture

seventh and eighth centuries
Spread of Islam worldwide by conquest and conversion

Artistic Events

Mosques from Europe to Africa and Asia, calligraphy and abstract decoration in Koran, secular texts, and architecture

SUNG AND MING DYNASTY
CHINA ca. 900–1650

Historical Events

907–1279
Sung Dynasty

1368–1644
Ming Dynasty

Artistic Events

Literati paintings of Fan Kwan, Liang K'ai, Mu Ch'i calligraphy

LATE MEDIEVAL EUROPE
1100–1400

Historical Events

1096–1291
The Crusades to the Holy Lands
Rise of towns and commercial economy throughout Europe

Artistic Events

Gothic architecture, sculpture, stained glass, and manuscript illumination, Italian fresco and panel painting

Giotto • di Paolo • Lorenzetti Brothers • Limbourg Brothers

ROYAL PERSIA
1220–1501

Historical Events

The Mongols conquer Iran and Afghanistan in 1220

Rise of Timurid Dynasty; Mongol invasion brings Chinese culture to Central Asia

Artistic Events

Illuminated manuscript "Persian Miniatures" of School of Herat and other royal workshops

THE EARLY RENAISSANCE IN ITALY 1400–1490

Historical Events

1434–1492
Florence at the height of its cultural and political power under the Medici family

Artistic Events

Brunelleschi • Ghiberti • Donatello • Masaccio

Verocchio • Botticelli • Bellini

THE EARLY RENAISSANCE IN NORTHERN EUROPE 1400–1490

Historical Events

1454
Invention of printing press in Germany, beginnings of mass media

Artistic Events

Development of woodblock print and oil painting media

Hubert and Jan van Eyck

THE HIGH RENAISSANCE IN ITALY 1490–1525

Historical Events

1492
The Italian Columbus claims New World for Spain

1503–1513
Papal Rome rises to power under Julius II

1513–1521
Leo X rules papal Rome

Artistic Events

Leonardo • Raphael • Michelangelo • Titian

RENAISSANCE AND REFORMATION IN NORTHERN EUROPE 1490–1525

Historical Events

1517
Protestant Reformation begins

Artistic Events

Dürer • Holbein • Bosch • Bruegel

MEXICO AND PERU ca. 1350–1532 C.E.

Historical Events

mid-thirteenth century
Aztec civilization rises to power; conquered by Spanish Conquistadors in 1521

ca 1438–1532
The Incas of Peru administer a vast empire; conquered by Spanish

Artistic Events

Aztec statues of Mother Goddess and God of Spring

Incan buildings, bridges, and roads

COUNTER-REFORMATION IN ITALY AND SPAIN 1525–1600

Historical Events

1540s
Founding of Jesuits and Inquisition

1550s
Counter-Reformation fully operative

Artistic Events

Mannerism
Michelangelo • Parmigianino • Bronzino • El Greco • Anguissola

WEST AFRICA 1400s–1600s

Historical Events

mid-1400s–mid 1600s
Kingdom of Benin (Dahomey) flourishes

Slave trade with Portugal and European powers

Artistic Events

Bini-Portuguese Oliphant, Benin Memorial Head, Owo Ivory Carving

OTTOMAN EMPIRE ca. 1300–1922

Historical Events

1500s–1600s
The Ottoman Empire, based in Turkey, is at its peak

1520–1566
Süleyman the Great is the most powerful ruler in the world

Artistic Events

Mosques, manuscript illuminations, calligraphy

MOGUL INDIA Sixteenth and Seventeenth Centuries

Historical Events

Mogul Empire blends Indian, Middle Eastern, and Persian cultures

Artistic Events

Illustrated manuscript miniatures, "Darbar of Jahangir"

Taj Mahal mausoleum and gardens

SEVENTEENTH-CENTURY CATHOLIC EUROPE

Historical Events

Papal Italy and Catholic countries of France and Spain at the height of their powers

France and Spain preside over colonial empires

Artistic Events

Baroque
Bernini • Caravaggio • Gentileschi • Rubens • Kondori

Baroque Classicism
Perrault • Poussin • Rigaud

SEVENTEENTH-CENTURY PROTESTANT EUROPE

Historical Events

1609
Dutch Republics gain their independence from Spain

Seventeenth century "Golden Age" of Holland based on international trade and colonization

Artistic Events

Rembrandt • Leyster • Vermeer

EIGHTEENTH-CENTURY FRANCE

Historical Events

1715–1774
Reign of Louis XV

1789
French Revolution

1799
Napoleon's rise to power

Artistic Events

Rococo
Watteau • Boucher • Carriera Chardin • Vigee-Lebrun

Neoclassicism
David • Houdon

EIGHTEENTH-CENTURY ENGLAND

Historical Events

Rise of England as a worldwide power

Artistic Events

Gainsborough • Kauffmann • Zoffany • Sandby

EIGHTEENTH-CENTURY NORTH AMERICA

Historical Events

1776
Declaration of Independence of American colonies from England

Artistic Events

Jefferson • Houdon

EUROPE 1800–1825

Historical Events

1800–1815
Napoleon conquers Spain and most of Europe and North Africa

1815
Defeat of Napoleon at Waterloo

Artistic Events

Romanticism
Goya • Gericault

Classicism
David • Ingres

JAPAN 1800–1850

Historical Events

1793–1853
Gradual breakdown of isolation and centuries-old rule of the shoguns

Artistic Events

Utamaro • Hokusai • Hiroshige

UNITED STATES 1800–1850

Historical Events

Westward expansion

Development of slave states in rural South and free states in industrial north

Artistic Events

Neoclassicism
Jefferson • Leutze

Product Design
Shakers • anonymous crafters

EUROPE 1825–1850

Historical Events

1839
Invention of modern photography

1848
Revolutions throughout Europe

Artistic Events

Romanticism
Delacroix • Turner • Constable

Classicism
Ingres

Realism
Daumier

AFRICA 1800–1900

Historical Events

European countries colonize much of the continent

Indigenous life continues within colonial context

Artistic Events

Kota Reliquary, Kuba Mask, Grebo Mask

vernacular architecture

EUROPE
1850–1875

Historical Events

Industrialization and urbanization

First World's Fairs in England (1851) and France (1855)

Artistic Events

Realism
Courbet • Manet • Nadar

Naturalism
Daubigny • Barbizon School

Academic Art
Cabanel • Gerome

Arts and Crafts Movement
Morris • Webb

Anglo-Japanese Art
Godwin • Whistler

UNITED STATES
1850–1900

Historical Events

1861–1865
The Civil War
Industrialization and urbanization

1890s
Invention of cinematography

Artistic Events

Romanticism
Church • Downing

Naturalism
Homer • Muybridge

Art Nouveau
Tiffany • Bradley

Early Modern Architecture
Sullivan

EUROPE
1875–1900

Historical Events

1875
Democratically elected French Republic
Invention of sequential photography and cinematography

Artistic Events

Impressionism
Monet • Renoir • Morisot
Degas • Cassatt

Post-Impressionism
Gauguin • van Gogh
• Cezanne • Munch

Art Nouveau
Toulouse-Lautrec • Beardsley
• Guimard • Horta

Avant-garde Sculpture
Rodin

Photography and Film
Marey • Lumière Brothers

EUROPE
1900–1920

Historical Events

1914–1918
World War I

1917
Russian Revolution

Artistic Events

Fauvism
Matisse

German Expressonism
Kirchner • Kollwitz • Wiene

Cubism
Picasso • Braque

Futurism
Balla • Boccioni

Der Blaue Reiter
Kandinsky • Klee

Dadaism
Duchamp • Höch •
Hausmann

UNITED STATES
1900–1940

Historical Events

1917
Entry into World War I

1929–40
Great Depression

Artistic Events

Realism
Henri • Sloan • Hopper
• Lange

Regionalism
Wood

Modernism
O'Keeffe • Bearden
• Douglas • Lawrence

Photographic Modernism
Stieglitz • Steichen
• Weston • Bourke-White •
Abbott

Modern Architecture
Wright

Silent Film
Griffiths

EUROPE
1920–1940

Historical Events

1930s
Worldwide depression

1920s and 1930s
Rise of fascism in Germany, Italy, and Spain

Artistic Events

German Expressionism
Beckmann • Murnau

Bauhaus
Gropius • Albers • Breuer

Russian Constructivism
Gabo • Lissitzky

De Stijl
Mondrian

Surrealism
Buñuel • Dalí • Giacometti
• Oppenheim • Magritte
• Masson • Ray • Bayer
• Calder

Modern Architecture
Mies van der Rohe
• Le Corbusier

MEXICO
1900–1940

Historical Events

1911
Mexican Revolution begins for democracy, social justice, and nationhood

1917
Mexican Constitution

Artistic Events

Mexican Mural Movement
Rivera • Siqueiros • Orozco

Surrealism
Kahlo

EUROPE
1940–1960

Historical Events

1939–1945
World War II

1945
Division of Europe into
communist and capitalist
blocs begins

Artistic Events

School of Paris
Picasso • Matisse
• Dubuffet

Modern Architecture
Le Corbusier

UNITED STATES
1940–1960

Historical Events

1941–1945
World War II

Cold War begins in 1946

Artistic Events

Abstract Expressionism
Pollock • Krasner
• de Kooning • Rothko
• Newman • Smith

Post-Painterly Abstraction
Frankenthaler • Louis
• Noland

Neo-Dada
Rauschenberg • Johns

Photographic Modernism
Adams • Siskind

*Modern Architecture and
Design*
Mies van der Rohe • Wright
• Saarinen • Eames • Knoll

Cinema
Welles

NORTH AMERICA
1960–PRESENT

Historical Events

1964–1973
Vietnam War

1990
End of Cold War
Digital Revolution

Artistic Events

Happenings
Kaprow • Oldenburg

Pop Art
Oldenburg • Lichtenstein
• Warhol

Minimal Art
Stella • Judd

Superrealism
Segal • Hanson

Photorealism
Close • Estes

Feminism
Schapiro • Chicago •
Ringgold

Intercultural Expressions
Scholder • Jimenez • Mejia-
Krumbein • Reid • Paul

Neo-Expressionism
Golub • Fischl • Stevens

Conceptual Art
Holzer • Skoglund

Performance Art
Anderson • Byrne • Ukeles

Installation Art
Paik • Chicago • Jashinsky •
Gober • Skoglund
• Holzer • Mesa-Bains

Environmental Art
Smithson • Heizer • Christo •
Tacha • Saad-Cook

Public Art
Lin • Tacha • Pepper • Gus-
sow • Jarrell • Cochrane

Video Art
Paik • Viola

Photographic Post-Modernism
Kruger • Sherman

Digital Image Creation
Brodsky • Cohen • Ratner
(continued)

EUROPE
1960–PRESENT

Historical Events

1980s
Democratization of Eastern
European countries begins

1990
End of Cold War

Artistic Events

Performance
Beuys • Dakic and Sterle

Neo-Expressionism
Kiefer

Cinema
Fellini • Antonioni

NORTH AMERICA
1960–PRESENT *(continued)*

Architectural Modernism
Legoretta • Yamasaki

Architectural Post-Modernism
Venturi • Moore • Gehry
• Erickson

Cinema
Spielberg • Schnabel

AFRICA, ASIA
1960–PRESENT

Historical Events

Internationalization of
economies and cultures

Worldwide multicultural and
intercultural developments

Artistic Events

Drawing and Painting
Nkurumeh • Samba • Uli Art

Sculpture
Munyaradzi • Matamera

Printmaking
Ovissi

Photography
Rai

Cinema
Kurosawa • Guney

Architecture
Olumuyiwa • Pei

Glossary

abstract In artistic circles, a frequently used term denoting a movement away from the **realistic** or **naturalistic** representation of a person or thing; used as a verb ("to abstract"), adjective (an "abstract" work of art), or noun ("an abstract").

abstract expressionism A worldwide art movement, primarily in painting, that originated in the United States after World War II. Employing bold, gestural brushwork or broad fields of color, the abstract expressionists sought to express deeply personal feelings or symbolic thoughts through highly **abstract** or **nonrepresentational** forms.

abstraction The movement away from **realistic** depiction of subjects through simplification, distortion, or stylization. The resulting abstraction might vary in degree from moderate distortions of actual appearances, as in **impressionist** art, to substantial deviations from recognizable objects, as in **cubist** art. Current usage includes **nonrepresentational** art as a form of complete or total abstraction.

acrylic paint A type of quick-drying paint, increasingly popular after 1950, in which the colored pigment is bound together by a synthetic plastic medium.

action painting Within the **abstract expressionist** movement of the 1940s and 1950s, the highly improvisational, spontaneous approach to artistic creation pursued by painters such as Jackson Pollock, Lee Krasner, and Willem de Kooning. The term *action painting* denotes that the work of art arose "in process" (that is, in action) as opposed to being planned beforehand.

activist art Works of art whose primary purpose is to activate social and political change. Such works, in any medium or art form, are often integrated into larger political actions or communal events.

additive Describes processes in sculpture—such as **constructing, assembling, modeling,** and **casting**—in which materials are added and joined together to create the finished form.

aesthetics The philosophical study of the nature of art and beauty. The term might also apply to the philosophy of art or "aesthetic" of an individual, group, or movement.

afterimage A perceptual phenomenon in which a viewer's eyes project a **complementary color's** opposite on any white or gray surface.

all-over composition A composition in which there is an overall and generally equal emphasis on all the different parts or aspects of the work.

analogous colors Those colors adjacent to each other on the **color wheel.** Because of their proximity in **hue,** they readily blend or harmonize.

analytic cubism The stage of cubism, especially as practiced by Pablo Picasso and Georges Braque from approximately 1909 to 1912, wherein objects are geometrized and abstracted from life, taken apart or "analyzed," and then creatively reassembled according to the artist's personal conception.

apse The semicircular or polygonal space generally situated at the east end of a church and housing the choir, sanctuary, and altar.

aquatint An **etching** technique characterized by subtle gradations of **values** from pale gray to deep black and by a pleasing granular appearance.

arcade A series of **arches** raised on columns or piers, or any covered passageway having an arched roof.

arch A curved structure that spans an opening. Arches come in many shapes and variations.

Art Nouveau A European and North American movement in the applied arts at the turn of the twentieth century that rejected the old, traditional styles and emphasized the development of "new" (*nouveau*) functional and decorative artworks. Stylistically, Art Nouveau graphic, product, and architectural design and jewelry and glassware featured sinuous lines and organic shapes abstracted from natural **subjects.**

Arts and Crafts movement A movement in Europe and North America from the last quarter of the nineteenth century to the beginning of the twentieth that sought to raise all product design and

decoration to the level of art. Founded by William Morris and others, it emphasized hand-craftsmanship and well-made, functional, and simply but attractively designed products.

assemblage In sculpture, the combining or assembling of separate pieces of material—wood, metal, stone, and so forth—to create the final work.

asymmetrical balance Nonexact correspondence (or lack of **symmetrical balance**) between the shape, size, and arrangement of parts on either side of a median line or plane in an object or work of art.

atmospheric perspective The illusion of deep space in a painting through the use of increasingly muted colors and less distinct outlines for objects as they move into the distance; also called *aerial perspective.*

avant-garde French for "advanced guard," a term applied to independent artists or groups of artists who are on the cutting edge of the art and culture of their society. The avant-garde arose in mid-nineteenth-century France with Gustave Courbet, Edouard Manet, and the **impressionists** in opposition to traditional mainstream art and culture. It continues to the present day around the world wherever progressive, independent-minded artists challenge the status quo.

balance The sense of equilibrium in an artistic composition between different or opposing forces.

baroque A style of art and architecture especially popular in the Catholic European countries and their colonies in the seventeenth century. Baroque art is characterized by enormous scale, curvilinear movement, dynamic energy, and emotional drama. Due to its original emphasis on religious subjects and the propagation of the Catholic faith, it is often thought of as the style brought into being by the Catholic Counter-Reformation.

baroque classicism A severe, toned-down variant of the exuberant Catholic **baroque** style, especially prevalent in architecture and art created during the reign of the seventeenth-century French king Louis XIV. Buildings in this style employ grandiose scale tempered by a sober **classical** design featuring symmetry and decorative restraint.

Bauhaus A famous school of art and design active in Germany from 1919 to 1933. It sought a union of artists, designers, and craftspersons for the purpose of creating excellent works of design—products, graphics, decorative art, architecture—that might be mass-produced for the good of all persons in society.

binders Substances that hold together the coloring agents or **pigments** in drawing and painting media.

biomorphic Pertaining to shapes derived from biological or natural forms such as flowers, birds, fish, and underwater life; organic forms.

burin A sharply-pointed cutting instrument used to make fine, incised lines in the **engraving** process; also called a **graver.**

calligraphy The art of beautiful handwriting, practiced from ancient times to the present day.

camera obscura From the Italian for "dark" (*obscura*) and "room" (*camera*), a lightproof box with a small opening or lens for projecting an image of an object or a scene onto a surface from which the image can be observed or copied.

carving A sculpting process in which material is removed or cut away from a solid block of material to create the final form.

casting In sculpture and other three-dimensional arts, the process of forming an object by pouring or pressing a molten metal or plastic substance into a mold to harden.

chiaroscuro From the Italian for "light-dark" (*chiaro-oscuro*), the use of light and dark **values** in a drawing, painting, or graphic image to create an illusion of three-dimensional form and spatial depth.

classical Generally describes any style in art that features calm grandeur, emotional restraint, and formal and intellectual clarity. Specifically, *classical* refers to ancient Greek and Roman art and architecture, such as the Parthenon and Pantheon, as prototypical of this style of noble simplicity and visual clarity.

classicism Any style characterized by the aesthetic principles and forms of the **classical** art and architecture of ancient Greece and Rome.

clerestory An upper zone of a wall, usually in a church or cathedral, pierced with windows that admit light to the central part of the structure.

colonnade A series of columns set at regular intervals that support an **entablature** and often one side of a roof.

color field painting The **nonrepresentational** approach to painting within the **abstract expressionist** movement that employs broad bands of flat, luminous color applied on mural-size canvases for the purpose of conveying basic human emotions and universal spiritual states. Exponents of this approach include Marc Rothko, Barnett Newman, and Clyfford Still.

color wheel A circular chart of colors based on the scientific sequence of bands of colored light that pass through a glass spectrum.

columnar orders Various arrangements of columns with **entablatures.** In classical Greek architecture, the three orders were **Doric, Ionic,** and **Corinthian;** the Romans later added Tuscan

Doric and Composite, variants of the original Greek orders (see figure 10.15).

complementary colors The strongly contrasting colors (for example, red and green, yellow and purple) situated directly across from each other on the color wheel.

composition The organization or arrangement of various visual elements and subjects into an artistic whole; also referred to as *design*.

conceptual art Anticipated by the "idea art" of Marcel Duchamp and rising to worldwide prominence by the early 1970s, an art movement that emphasizes the primacy of the artist's ideas and concepts over the finished, physical art object or commodity. Conceptual artworks often take the form of written notes, essays, or photographs documenting the artist's thought processes or creative projects.

construction In sculpture, the combining or assembling of separate pieces of material—wood, metal, stone, and so forth—to create the final work.

constructivism The approach to art developed by Russian avant-garde sculptors, painters, and graphic artists (for example, Naum Gabo, Antoine Pevsner, El Lissitzky) in the late 1910s and early 1920s. These artists worked in a largely **nonrepresentational** style featuring freely arranged geometric forms; often referred to as "Russian constructivism."

content The driving force and reason behind the **form** and **subject matter** of an artwork; the feelings, thoughts, and meanings embodied in the work.

context The physical, social, and cultural background or setting of a work of art.

contextualism An approach to the understanding of art that centers on the study of art "in context," that is, in relation to the rest of life. Contextualism emphasizes the study of everything that surrounds and relates to the work of art: the viewer; the artist; the physical setting of the work; and the art, culture, and society that gave birth to it.

contour line A line that describes the outline, borders, or edges of an object.

cool colors Colors in which blue, green, or purple predominate. These colors tend to have a cooling and soothing effect.

cornice 1. A horizontal molding that projects along the top part of a building or wall. 2. The third or uppermost section of an **entablature.**

cubism Originated by Pablo Picasso, Georges Braque, and others in Paris in the years before World War I, a multifaceted approach to art characterized by flat, loosely geometric forms abstracted from life. Relative to the works of Picasso and Braque, cubist art is usually divided into two major styles or stages: **analytic cubism** (ca. 1909–1912) and **synthetic cubism** (after 1912).

dada The anarchic international movement in art and culture, lasting from approximately 1914 to 1920, that arose largely in response to World War I. Derived from a nonsense word, dada stood for freedom, nonrational creativity, and rebellious nonconformity. Two types of dada artists stand out: those (for example, Marcel Duchamp and Man Ray) who focused on intellectual and aesthetic issues, and those (for example, Hannah Höch and John Heartfield) who emphasized social and political content.

daguerreotype A photograph made on a plate of chemically treated metal or glass, named after Louis Daguerre, the French artist and inventor who developed photography in the 1830s.

De Stijl Dutch for "the style"; a movement in the fine and applied arts that originated in neutral Holland during the period of World War I, led by Theo van Doesburg and Piet Mondrian. It is characterized by dynamically asymmetric compositions created from simple geometric shapes painted in flat colors.

Der Blaue Reiter From the German for "The Blue Rider," a school of artists that rose to prominence in Munich, Germany, before World War I. This **avant-garde** group was committed to highly abstract art expressive of the artist's innermost feelings and spiritual aspirations. Leading members of the group were Wassily Kandinsky, Paul Klee, and Franz Marc.

Die Brücke Founded in Dresden, Germany, in 1905 by Ernst Kirchner and others, a group of artists who saw themselves as a much needed "bridge to the future" in art and culture. Expressing their emotions and inner psychological states through the abstraction of human and landscape subjects, the artists of *Die Brücke* ("The Bridge") were pioneers of the style that came to be associated with **German expressionism.**

dome A roof formed by a series of rounded arches or vaults on a round, square, or many-sided base.

Doric The earliest and simplest **columnar order** developed in ancient Greece. Employed in the Parthenon, it is characterized by sturdy proportions and a minimum of decoration in columns and **entablature.**

drypoint A needle-like tool used to create lines with subtly ragged edges in the **engraving** process; an artwork created by this process.

earthworks Sculptural or architectural creations that employ the earth as a primary building material. Examples are the Native American *Great Serpent Mound* and Smithson's *Spiral Jetty.*

emphasis The principle of **composition** by which certain elements or parts assume more importance than others; also called *focus* or *dominance*.

engraving 1. A **printmaking** process in which a design is cut by a handheld instrument into metal plates or wooden blocks. The cut areas are inked for printing. A dampened paper is then placed on the surface of the plate or block and run through the rollers of a printing press with enough pressure to force the softened paper into the inked areas below the engraved surface of the plate or block. 2. The finished print resulting from the process of engraving.

entablature In classical architecture, the horizontal beam structure supported by columns and divided horizontally into three sections: the architrave (bottom), **frieze** (middle), and **cornice** (top).

environmental art Art whose medium, setting, and/or purpose is based in the natural or built environment. Contemporary environmental art includes the creations of Christo and Jeanne-Claude and the **earthworks** of Robert Smithson. Ancient predecessors of today's environmental artworks include England's Stonehenge and the Native American *Great Serpent Mound*.

ergonomic Describes a **functionalist** approach to product design in which human (or ergonomic) considerations such as comfort, health, and effective operation are the most important criteria for the design process and final product.

etching 1. A **printmaking** process wherein a design is produced by scratching lines on the surface of a metal plate covered with an acid-resistant material. The plate is then placed in acid, which "etches" the lines into the surface of the metal. The lines are inked, and a dampened paper is placed on the surface of the plate and run through the rollers of a printing press with enough pressure to force the softened paper into the inked areas below the surface of the plate. 2. The finished **print** resulting from the process of etching.

expressionism The approach to creating art that focuses on the exaggeration or distortion of natural forms for the purpose of expressing the artist's subjective feelings.

fauvism A style featuring bold distortions of natural shapes and colors that results in brilliantly colored abstractions from life; associated with the early work of Henri Matisse and the group known as the Fauves (French for "wild beasts") around the year 1905.

figure and ground The perceptual tendency to distinguish a visual pattern in terms of a shape-space relationship, with the figure appearing to be in front of and surrounded by the ground (or background). The ground might be perceived as a shape as well.

flying buttress An exterior wall support system, used especially in Gothic cathedrals, consisting of an arch or a half **arch** that transmits the thrust of the building's **vault** or roof from the upper part of the walls to an outer support or buttress.

foreshortening The diminishing or "shortening" of certain aspects of a figure or form as it moves away from the viewer in order to represent it in a proportional spatial relationship.

form The visual or formal qualities of an artwork; specifically the work's elements (line, color, shape, space, texture) and their arrangement or **composition.**

formalism The approach to art that focuses on the sensuous appreciation of the visual or "formal" qualities of an artwork such as its line, shape, color, texture, and **composition.**

formalist abstraction A major current within modern twentieth-century art that primarily emphasizes the formal or "abstract" qualities (for instance, line, shape, color, and composition) of a work of art. Artists committed to formalist abstraction might work in **representational** (Edward Weston, Richard Estes), **abstract** (Aaron Siskind, Georges Braque), or **nonrepresentational** (Piet Mondrian, Frank Stella) styles.

frame construction A building method in which a frame of wood, metal, or another material operates as the skeletal structure that provides the basic support and shape of the final form.

fresco Italian for "fresh" or "cool"; a technique involving the brushing of water-based paints onto wet ("cool," "fresh") plaster. As the plaster dries, the paint becomes a permanent part of the plaster wall or ceiling. Leonardo da Vinci's *Last Supper*, Raphael's *School of Athens* and Michelangelo's Sistine Chapel ceiling are frescoes.

frieze The central section of the **entablature** in the Classical Greek architectural orders; any horizontal decorative band.

functionalist (machine) style A style in product and architectural design that, taking its cue from the beauty and efficiency of machines, pursues the principle "form follows function." Designed primarily with functional or practical concerns in mind, the resulting products and buildings feature simple, streamlined geometric forms and little or no decoration. Arising at the beginning of the twentieth century, this style is usually associated with the **modern** style of design.

futurism A movement in art arising in Italy in the years before World War I. Futurists sought to communicate the dynamism, power, and glory of the new urban industrial "machine" world.

Employing the general forms of **analytic cubism,** futurist painters, sculptors, and photographers imbued their abstractions of city scenes and mechanical experiences with a sense of dynamic movement and energy.

genre The subject area and artistic category focusing on commonplace scenes from everyday life.

geometric Pertaining to shapes that are formed by straight or curved lines that tend to progress regularly according to mathematical laws.

German expressionism The various schools of early twentieth century German painters and sculptors **(Die Brücke, Der Blaue Reiter)** who distorted or abstracted from natural forms for the sake of expressing the artists' intense personal feelings about the world. Germanic artists working in music, literature, theater, and film (*The Cabinet of Dr. Caligari, The Last Laugh*) also adopted this emotionally expressive, psychologically charged approach.

gesture painting Within the **abstract expressionist** movement, the style of painting characterized by bold, hand-driven gestures of the brush or other painting tools. Willem de Kooning, Jackson Pollock, and Lee Krasner are exponents of this general approach.

glaze 1. In oil painting, one or more coats of transparent or semitransparent color laid over a dried layer of paint for the purpose of creating subtle and luminous color effects. 2. In ceramics, glasslike coatings baked directly onto the clay that increase the durability and aesthetic range of pottery and sculpture.

Gothic A style of architecture developed in western Europe between the twelfth and sixteenth centuries. Gothic buildings are characterized by pointed arches, luminous stained glass, and soaring vertical shapes and spaces. The Gothic style is especially evident in the cathedrals of France, England, and Germany, and influenced all the other arts as well.

gouache 1. Opaque watercolor paint. 2. A work of art produced by applying opaque watercolor paints to paper or vellum.

grand manner Art created in the general heroic style of Renaissance masters such as Michelangelo and especially Raphael; art that in subject matter, principles, and techniques follows in the lofty tradition of these grand masters.

graphic art In the centuries following the Renaissance, any form of visual representation, especially two-dimensional media such as drawing, painting, etching, and engraving. In the modern period, the term *graphic art* has come to be specifically associated with the various printmaking arts, such as **etching, engraving,** and **lithography.**

graphic design The systematic organization of visual information, usually encompassing both imagery and text, for the purpose of communication or persuasion. Magazine advertisements and covers, corporate brochures, and publicity posters are examples of graphic design.

happenings Arising worldwide around 1960, a mixed-media environmental art form that features theater-like activities in which persons and/or objects interact in improvisational ways.

hatching In two-dimensional art, the application of tiny lines or strokes ("hatches") in parallel or criss-cross ("cross-hatched") configurations to evoke volumes, textures, and values.

highlight The area of highest reflected light on an object.

history In works of art, the subject area or category constituted by scenes from mythology, religion, and major historical events. The highest ranked category in Western art between ca. 1400 and 1900.

hue The actual color of a thing, identified by a common name such as blue or yellow-orange.

humanism The philosophy or cultural movement that places the highest emphasis on the human individual and his or her interests and accomplishments. The credo of the Greek philosopher Protagoras that "man is the measure of all things" epitomizes this outlook.

hypostyle An architectural design in which the roof of a hall or another large space is supported by rows of columns, giving a forestlike appearance.

iconography The study of an artwork in terms of the meaning of its subjects, symbols, and images, in the context of the contemporary culture.

illuminated manuscript A hand-illustrated (illuminated) manuscript or book with pictures or motifs that relate to the accompanying text. The most famous examples from medieval Europe and Asia feature, in addition to illustrations, exquisite **calligraphy.**

impasto The application of paint to a surface in thick, heavy textures, that is, in a pastelike way.

implied line In a work of art, a line that is not drawn or painted by the artist but rather is the creation of the viewer's own perception.

impressionism Rising to prominence in France in the 1870s, a movement of artists, such as Claude Monet, Pierre-Auguste Renoir, and Berthe Morisot, who painted general, colorful impressions of everyday scenes with the intent of capturing a fleeting moment in time. Employing divided brushstrokes, fuzzy outlines, and brilliant color, the impressionists used a mix of **naturalism** and **abstraction,** and were particularly sensitive to the changing effects of light and atmosphere on their subjects.

installation An art form rising to prominence in the 1970s that features the creation of total environmental works of art installed in entire rooms or other spaces. Installation works can involve a wide range or mixture of media. Judy Chicago's *The Dinner Party* is an example.

intaglio **Printmaking** processes such as **engraving** in which images are incised into a highly polished metal plate using sharp cutting instruments.

intensity The degree of purity or "saturation" of a color.

international style A worldwide, **modern style** of architecture and product design that rose to prominence by the middle of the twentieth century. It embodies the **functionalist** ethic of "form follows function" and is characterized by abstract geometric shapes with little or no decoration and by the absence of reference to regional or traditional styles of the past.

Ionic After the **Doric,** the second **columnar order** to be developed in ancient Greece. Its elegantly detailed elements and columns with scroll-like capitals make the order less heavy than the sturdy Doric but less elaborate than the later **Corinthian** order.

key A term used to describe the prevailing range of color values and **tonal** quality. A painting in a high key is characterized by light or bright colors and one in a low key by dark or subdued colors.

lithography 1. The process of **printmaking** in which a greasy material is used to draw or brush a design onto the surface of a flat stone or metal plate. The surface is chemically treated and dampened so that printer's ink is absorbed only by the greasy areas that make up the design. The surface is then covered with paper, which is rolled through a printing press under great pressure. 2. The finished **print** resulting from the process of lithography.

load-bearing construction The most basic form of architectural construction in which the weight or load of the structure is borne by masses of solid material, usually stone or earth.

local color 1. The color found in a particular locale or setting. 2. The **naturalistic** representation of such colors by an artist.

machine style An artistic style inspired by the **functionalist** aesthetic of machines, especially evident in modern product design and architecture, that emphasizes simple, clear geometric forms with little or no added decoration.

mannerism A movement in art and architecture arising in the first half of the sixteenth century in Italy that emphasized the personal "manner" or style of the artist. In the hands of artists such as Michelangelo, Parmigianino, and Bronzino, these personally distinctive styles are characterized by arbitrary distortions or exaggerations of the rational, classically idealized Renaissance forms of the day.

mass The physical bulk of a **three-dimensional** form or the illusion of such a form on a **two-dimensional** surface.

medium The specific tool and material used by an artist, for example, brush and oil paint, chisel and stone.

mihrab The recess or niche in a mosque oriented to the holy city of Mecca, birthplace of Muhammad.

mimesis From the Greek for "imitation," a striving for realism that dominates much of the art of the Western tradition, both in the ancient Greco-Roman world and in post-Renaissance Europe and North America.

minimalism A movement in art that arose in the 1960s characterized by a reductive focus on the most basic formal elements (color, shape, structure) of a work. The sculpture of Donald Judd and the early paintings and shaped canvases of Frank Stella are examples of the minimalist approach and style.

mobile Developed by Alexander Calder in the 1930s, a type of kinetic sculpture that features moving forms suspended in midair by wires.

modeling In sculpture, the process of manipulating a pliable material such as clay or wax by hand or with shaping and cutting tools.

modern style In art historical terms, those styles of nineteenth- and twentieth-century art, beginning with **romanticism** and culminating with **minimalism,** that emphasize artistic individualism, contemporary subject matter or content, and varying degrees and types of abstraction.

modernism Any style characterized by the aesthetic principles, forms, and subjects of the **modern style** of fine and applied art. Modernist styles tend to reject references to the past and embrace the forms and subjects of the present. In the period from approximately 1860 to 1960, modernism emphasized artistic individualism and varying degrees and types of abstraction.

mosaic The art or technique of creating pictures or designs on the wall or the floor with small pieces of tile, glass, or stone set in a resin or wet plaster grout that then dries to a durable hardness.

multiculturalism A prominent cultural and educational movement begun in the 1980s that emphasizes understanding and respect for cultural diversity in the arts and all areas of life.

naturalism The mid-nineteenth-century style or school of art, anticipated in the painting of John Constable, that emphasizes truth to nature's actual

appearances and a democratic range of subject matter, including scenes of everyday life and commonplace landscape views. Painting outdoors so as to capture with honesty the freshness and light of everyday scenes, Charles-François Daubigny and young future impressionists such as Claude Monet and Pierre-Auguste Renoir worked within the naturalist approach.

negative In photography, the name given to the exposed film in which the light and shade recorded on it are the reverse, in terms of light-dark **values,** of the actual photographed image.

negative space The open area or void surrounding or within a solid, clearly defined **positive shape.** These negative areas often have distinct shapes of the their own and may be called "negative shapes."

neoclassicism Rising to prominence in the second half of the eighteenth and first half of the nineteenth centuries, a style of art and architecture built upon the ideals, forms, subject matter, and symbolism of the **classical** art and architecture of ancient Greece and Rome. Across the arts, the neoclassical ("new classical") style is broadly characterized by heroic grandeur, formal clarity, and emotional restraint.

neo-dada The term applied to the style of art produced by artists working in the general spirit of the anarchic, rebellious **dada** movement of the early twentieth century. Emphasizing freedom, nonrational creativity, and the breaking down of barriers between art and life, the art of Robert Rauschenberg, Jasper Johns, and Allan Kaprow in the 1950s and 1960s was described by certain writers as "neo-dada."

neo-expressionism Rising to prominence in the 1980s, a style of art pioneered by figurative artists in Germany (Anselm Kiefer), Italy, and the United States (Leon Golub). In the service of subjective expression, neo-expressionists ("new expressionists") distort natural form, space, color, and composition in a style reminiscent of early twentieth-century **expressionism.**

new realism A general term applied by various critics to the return around 1960 of full-fledged figurative styles of art (**pop, photo-realism, superrealism**) following more than half a century during which abstract styles of art (**formalist abstraction, surrealism, abstract expressionism,** and their variants) dominated the modern art world.

nonrepresentational Describes imagery that seems to cut all ties with recognizable "real-life" sources; also referred to as *nonobjective.*

oil painting The approach to painting in which oil-based pigments are applied to a flat surface, most often canvas stretched over a wooden frame. More than any other medium prior to photography, oil paint enabled artists to render real-life objects or imaginative subjects in a highly realistic, **three-dimensional** manner.

one-point perspective A geometrical system perfected during the Renaissance by which artists create the illusion of receding space on a **two-dimensional** surface. Figures or objects grow or diminish in size with a mathematical precision according to how near or far from the viewer they are intended to seem. Paintings employing this system of "sight lines," or orthogonals, which recede from the edges of the picture to a single vanishing point within often possess a convincing physical realism and psychological drama. Examples are Leonardo da Vinci's *Last Supper,* Raphael's *School of Athens,* and Jacques-Louis David's *Oath of the Horatii.*

optical color Coloristic effects like **afterimage** and **simultaneous contrast** that are projections of the visual apparatus of the viewer's eyes and mind.

organic Shapes derived from natural forms such as plants and animals. Whether specifically natural in origin or naturelike in a general sense, such shapes tend to be curvilinear and irregular.

overlapping The method of spatial representation in which one figure or form is placed in front of another, partially blocking the view of the forms behind it or in the distance.

pastel 1. A descriptive term for lightened colors or softened **tints.** 2. A colored crayon or chalk that consists of **pigment** and just enough water-based **binder** to hold it together.

pattern An ordered repetition of line, space, shape, or texture on a visual surface.

pediment In classical and neoclassical architecture, the triangular gable end of the roof above the columns and entablature.

pendentive In architecture, one of the triangular pieces of vaulting springing from the corners of the rectangular area, serving to support a rounded or polygonal dome.

performance art Any work of art constituted by the observable activity of the artist. It rose to prominence in the 1970s, a type of art in which the artwork consists of the artist him- or herself engaged in some kind of observable or performing activity. Examples are the artist Joseph Beuys's interactions with a coyote in an art gallery for a limited audience and Laurie Anderson's huge multimedia productions performed in packed concert halls.

perspective The depiction of the illusion of **three-dimensional** space on a flat **two-dimensional** surface; the picturing of objects or figures as they appear to the eye in keeping with a sense of distance and depth. Two types of perspective or

perspectival techniques are **one-point** and **atmospheric** (or aerial) **perspective.**

photolithography 1. A technique for producing an image on a **lithography** stone or plate by photographic means. 2. The finished **print** resulting from the process of photolithography.

photomontage A composite photographic picture made up of different photographic images.

photo-realism A style of **realistic** painting, rising to prominence in the 1970s, based on photographs of a person, object, or scene. In keeping with the photographic way of seeing and picturing, the paintings of photo-realist artists such as Richard Estes and Chuck Close are characterized by extraordinary detail, a tremendously subtle range of values, and objective physical accuracy.

pictorialism A movement in vanguard photography at one with the **symbolist** aesthetics of the late nineteenth century that emphasizes the artistic (pictorial) possibilities of the camera's imagery. Turn-of-the-century photographers such as Alfred Stieglitz, Edward Steichen, and Gertrude Kasebier considered themselves pictorialists and strove for formal beauty, suggestive moods, and poetic truths in their work.

picture plane The **two-dimensional** surface on which a work of art is created.

picturesque In general terms, seeing and representing nature as if it were a pleasing picture; more specifically, the aesthetic movement in England and North America in the late eighteenth and nineteenth centuries that sought to create landscape art and design characterized by charming subjects, playful variety, and pleasing asymmetrical arrangements.

pigments The coloring agents in drawing and painting media.

pilaster In architecture, a rectangular, columnlike projection from the wall. Pilasters form part of the wall and are used for support or decoration.

pop art A style of figurative art rising to prominence in the 1960s whose form and content derive from the imagery of the mass media and the products of consumer society. Claes Oldenburg, Roy Lichtenstein, and Andy Warhol are leading pop artists.

portico A porch or covered walk consisting of a roof supported by columns.

positive shape In **two-** and **three-dimensional** art, a solid or clearly defined shape that stands out in relation to the space (called **negative space**) around or within it.

post-and-lintel A construction system in which horizontal beams or lintels are supported by load-bearing vertical posts or walls.

postimpressionism The movement in art in the last two decades of the nineteenth century that sought to move beyond naturalistic **impressionism** to an art of greater subjective and aesthetic concerns. Among these concerns were the expression of inner emotion, the evocation of **symbolist** feeling and thought, and **formalist abstraction.** Paul Gauguin, Vincent van Gogh, and Paul Cézanne are considered three pioneers of postimpressionism.

postmodernism A movement that arose in the second half of the twentieth century in reaction to **modernism's** rejection of the past and emphasis on artistic individualism and abstraction. Postmodernist artists, architects, and designers value the past (its styles, subjects, and symbols), art that is socially and contextually sensitive, and imagery that is figurative (portraits, still lifes, landscapes) and sometimes narrative.

post-painterly abstraction A style of **formalist abstraction** rising to prominence in the late 1950s and early 1960s and growing from abstract expressionist **color field painting.** Post-painterly abstraction emphasizes flat and luminous color as an end in itself. The colorful "targets" of Kenneth Noland and brilliant "stripes" of Morris Louis are examples of this approach, which rejected the gestural "painterly" brushwork and emotional expressionism of the earlier **abstract expressionist** artists.

potter's wheel A manually propelled or power-driven turntable or "wheel" on which clay pots and other vessels are formed.

primary colors The basic, irreducible colors or hues (red, blue, yellow) that cannot be produced by mixing other colors.

print Any one of multiple impressions made on paper or another material from the same block, stone, screen, plate, or film negative.

printmaking A general term for a number of processes by which **two-dimensional** images are produced in limited editions or sets of identical or nearly identical **prints.**

proportion The comparison of art elements or subjects to one another in terms of their size, quantity, or degree of **emphasis.**

radial balance A type of balance, usually **symmetrical,** in which the constituent parts radiate outward from and are balanced around a common center.

realism In general terms, any artistic style concerned with an accurate portrayal of the external world; more specifically, a style of painting popularized in mid-nineteenth-century France by Gustave Courbet. Realist painters strive for accurate portrayal of a democratic range of contemporary

subjects, including lowly stonebreakers and peasants, in accordance with each artist's point of view.

regionalism A popular school of painters in the 1930s who aspired to a pure and proudly native art, one especially reflective of America's rural regions. Grant Wood's painting *American Gothic* is an example.

reinforced concrete A method of construction that features reinforced or "ferronconcrete" (concrete having a framework of iron or steel embedded in it).

relief Any work in which figures or forms project three-dimensionally from the surface.

relief sculpture A sculpture in which the figures and forms stand out "in relief" from a flat surface.

representational Describes imagery that is based on and "re-presents" recognizable things.

rhythm The ordering of time. In visual terms, the ordering of elements or features in regular or irregular ways.

rococo An eighteenth-century style in art, interior design, and decorative art that grew out of the **baroque** but is more delicate, playful, and intimate; originally called "the style of Louis XV."

romantic Describes any style in art that emphasizes feeling, imagination, and individuality. Formal characteristics of romantic painting include bold brushwork, colorful expression, sensuous textures, and dramatic movement.

romanticism In art historical terms, a movement in the first half of the nineteenth century in Europe and North America that rebelled against the academy and the classical styles of the day. Identified with artists such as Francisco Goya, Théodore Géricault, Eugène Delacroix, and J. M. W. Turner, romanticism valued freedom from authority, emotional inspiration, poetic imagination, and individualistic genius.

rotunda A room or building circular in plan and usually domed.

Salon The most prestigious art exhibition in France from the mid-seventeenth through the nineteenth centuries. Juried and organized by the the Royal Academy, "the Salon" was held annually or biennially. Its name came from the large room or salon in the Louvre palace where the exhibition was first held.

scale The principle of **composition** that refers to **proportional** relationships of size relative to a standard or normal size.

screenprinting Also known as *silkscreen* or *serigraphy,* a printmaking process in which the artist designs and prints his or her own stencils through a screen made of silk or some other open-meshed material.

secondary colors The colors or hues (orange, violet, green) made by mixing a different pair of primary colors; for example, the secondary color orange is made by mixing the primary colors red and yellow.

shade A color darkened by the addition of black, dark gray, or a **complementary color.**

simultaneous contrast A condition basic to **complementary colors** in proximity to each other in which each strongly contrasting **hue** intensifies and complements the other in a way that simultaneously brings out the full brilliance of both.

sketch A quick, fragmentary, or generalized drawing that might generate broad ideas for the final work or product.

social realism A term used in the twentieth century to describe a **realistic** style of art that portrays, often from a leftist political perspective, the life of the common person in society. In the United States, social realism in painting, sculpture, photography, and the graphic arts was the dominant style of the Depression years of the 1930s.

stippling A marking technique that employs an intricate pattern of small dots or circular marks to evoke volumes, textures, and values.

straight photography In general terms, any photographic approach that emphasizes straightforward documentation.

study A detailed drawing or painting that specifically delineates the final work.

style The constant form—manifested in recurring elements, compositional approaches, and content—in an individual's or a group's art. It is common to speak of personal, group, cultural, and period styles.

subject What an artwork depicts, be it a person, place, or thing. Traditional subject areas or categories are landscape, still life, portraiture, **history,** and **genre.**

subjective camera A technique in cinematography whereby the camera films a scene in such a way that the viewer feels as if he or she is looking at the world through the eyes of one of the characters.

Sublime A state of mind, valued by nineteenth-century romantics, wherein nature at its most passionate and powerful is experienced as awesome and terrifying but simultaneously inspiring and exalting. The **romantic** way of seeing and representing nature as Sublime is visualized in J. M. W. Turner's painting *Rain, Steam, and Speed* and in Frederic Edwin Church's painting *Niagara.*

subtractive Describes processes in sculpture, such as **carving,** in which mass is removed from a material (stone, wood, ivory) to create the finished form.

superrealism A style of sculpture beginning around 1970 characterized by extreme fidelity to realistic detail. Duane Hanson sculptures such as *Old Man* and *Dishwasher* are sufficiently lifelike that they are sometimes mistaken for actual people.

support In **two-dimensional** art, the physical surface (paper, canvas, wall) on which one draws, paints, or otherwise creates art.

surrealism The movement in the literary and visual arts from the mid-1920s to the mid-1940s that sought to reveal the contents of the unconscious mind and dream world, joining the conscious and unconscious realms of existence in a superreality or "surreality." In the visual arts, surrealist artists pursued two general stylistic directions, one representational (Salvador Dalí, René Magritte) and the other highly abstract (André Masson).

suspension system A construction system in which a bridge span or a ceiling is suspended from powerful cables or chains, anchored at either end, and supported by vertical towers or other uprights.

symbolism An antinaturalist movement in poetry and the visual arts in the last two decades of the nineteenth century that sought to portray spiritual realities. In painting, artists such as Paul Gauguin pursued a symbolist aesthetic in using line, color, and shape abstractly to suggest or evoke subjective thoughts and feeling states.

symmetrical balance Exact correspondence in shape, size, and arrangement of the parts on both sides of the central axis of an object or work of art.

synthetic cubism The style of **cubism** developed by Pablo Picasso and Georges Braque after 1912 in which the fractured, highly abstract forms of **analytic cubism** are reconstituted into synthetic wholes that are clearly recognizable as figures, still lifes, and so forth. This final stage of cubism features flat, loosely geometric figures against a shallow background.

tempera A type of paint and process of painting, much used in the medieval period and the early Renaissance, in which colored pigments are mixed with water and a **binder** of egg yolk.

tertiary colors Colors created by mixing the adjacent primary and secondary hues on the color wheel; also know as *intermediate colors*. For example, the tertiary hue red-orange is created by mixing the **primary color** red and the adjacent **secondary color** orange.

texture The tactile surface quality of the artwork itself or the simulated surface qualities of objects represented in the work.

texture gradient Relative to **atmospheric perspective**, the progressive loss of textural detail as an object recedes into the distance.

three-dimensional Possessing height, width, and depth.

tint A color lightened by the addition of white, light gray, or another **hue. Pastel** colors are examples of tints.

tone The overall quality of a particular **tint, shade,** or **hue.**

trompe l'oeil French for "fool the eye." Refers to illusionistic effects that are so convincing that the viewer is deceived into believing that painted, sculpted, or projected images are the real thing. Pronounced tromp loy.

two-dimensional Possessing height and width.

unity The organization of all elements or aspects of a work into a single, indivisible whole.

values The range of light to dark in terms of both individual colors and gradations between white and black.

vanishing point The point in the **one-point perspective** system where all the sight lines come together and vanish in infinity. In Leonardo da Vinci's *Last Supper*, the vanishing point is located immediately behind the head of Christ so that the lines of the walls and ceiling all angle in to focus the viewer's attention on the central figure of Jesus.

vault In architecture, an arched roof, ceiling, or other covering of brick or stone.

vehicle In wet media, the liquid material in which the coloring agent or **pigment** is dispersed.

vertical placement An approach to representing space that equates figures or forms lower in a picture with nearness to the viewer and those higher up with distance from the viewer.

volume The physical bulk of a **three-dimensional** form or its representation on a **two-dimensional** surface. Also used in reference to the seeming physical bulk of a **negative space** or shape.

warm colors Those colors in which yellow, orange, or red predominate. These hues tend to make the viewer feel warmer and excite the senses.

washes Broad areas of thin, diluted paint or ink that give a transparent or translucent effect.

woodblock print 1. A process of **printmaking,** one of the oldest, in which lines or shapes are cut into a block of wood so that the design to be printed protrudes from the block. The protruding sections are then inked and pressed onto paper manually or by means of a mechanical press. 2. The **print** that results from the process of woodblock printmaking.

ziggurat In ancient Mesopotamia, a temple mounted on a high, stepped platform where priests might commune with the city's protective god or gods.

Notes

Chapter 1

1. JERRY COULTER. Interview by author, tape recording. Summer 1985.
2. HERSCHEL CHIPP, *Theories of Modern Art.* Berkeley and Los Angeles: University of California Press, 1968, pp. 36–37.
3. Ibid., p. 37.
4. WERNER HAFTMANN, *Painting in the Twentieth Century,* Vol. 1. New York: Praeger, 1960, p. 24.

Chapter 2

1. JOHANNES ITTEN, *The Art of Color.* New York: Reinhold Publishing Company, 1961, p. 60.

Chapter 3

1. RUTH A. APPELHOF, interview in *Miriam Schapiro, a Retrospective: 1953–1980.* Wooster, OH: College of Wooster Press, 1980, p. 48.

Chapter 4

1. JANE AUSTEN, *Northanger Abbey.* New York: New American Library, 1965, p. 93.
2. Ibid., p. 94.

Chapter 7

1. CHARLES BAUDELAIRE, quoted in Aaron Scharf, *Art and Photography.* New York: Penguin, 1974, p. 146.
2. ALFRED STIEGLITZ, quoted in Dorothy Norman, *Alfred Stieglitz: An American Seer.* New York: Random House, 1973, p. 76.
3. SALLY MANN, *Immediate Family.* New York: Aperture, 1992, introduction.
4. LAVELY MILLER. Unpublished essay, 2002.
5. GERALD MAST, *A Short History of the Movies.* Indianapolis: Bobbs-Merrill, 1981, p. 195.
6. *Dorothea Lange: Photographs of a Lifetime.* Millerton, New York: Aperture, Inc., 1982, p. 76.

Chapter 8

1. PETER SELZ and ANTHONY JANSON, *Barbara Chase-Riboud: Sculptor.* New York: Harry N. Abrams, 1999, p. 56.
2. WILLIAM E. HARRIS, "Lost Wax Casting in the Sculpture of Benin." Unpublished essay, 2001.
3. HAROLD J. MCWHINNIE, "The Woodcarving of Sculptor Ralph Baney." Unpublished essay, 2000.

Chapter 9

1. GE BAAS, "Metal Show at Sawhill Gallery: Cool Materials Sizzle." *Daily News-Record,* March 6, 1992, p. 13.
2. SALVATORE SCALORA, "Voodoo Flags of Haiti." Unpublished essay, 1998.

Chapter 10

1. ROBERT BERSSON, *Worlds of Art.* Mountain View, CA.: Mayfield, 1991, pp. 171–73.

Chapter 11

1. Associated Press, "Peruvian President Gets Indian Blessing." News release, July 30, 2001.
2. MARGARET BERGMAN. Unpublished essay, 2000.

Chapter 12

1. JAMES HENRY BREASTED, *A History of Egypt from the Earliest Times to the Persian Conquest.* New York: Scribner's, 1909, p. 231.
2. Virgil. *The Aeneid,* Book II, quoted in H. W. and A. F. Janson, *History of Art.* New York: Harry N. Abrams, 1995, p. 250.
3. H. W. and A. F. JANSON, *History of Art.* New York: Harry N. Abrams, 1995, p. 198.

Chapter 13

1. H. W. JANSON and ANTHONY P. JANSON, *History of Art.* Fifth edition. Englewood Cliffs, NJ: Prentice-Hall/Abrams, 1995, p. 223.
2. KENNETH CLARK, *Landscape into Art.* Boston: Beacon, 1972, p. 13.
3. LAURIE SCHNEIDER ADAMS, *Art Across Time.* Second edition. New York: McGraw-Hill, 2002, p. 403.
4. ESIN ATIL, *The Age of Sultan Sultan Süleyman the Magnificent.* Exhibition brochure, Washington, D.C.: National Gallery of Art, 1987, p. 2.

Chapter 14

1. MARILYN STOKSTAD, *Art History, Volume Two.* New York: Prentice-Hall/Abrams, 1999, pp. 734–35.
2. WILLIAM E. WALLACE, *Michelangelo: The Complete Sculpture, Painting, Architecture.* Hong Kong: Beaux Arts Editions, 1998, p. 155.

Chapter 15

1. LAURIE SCHNEIDER ADAMS, *Art Across Time*. New York: McGraw-Hill, 2002, pp. 715–16.
2. MARY ANN SCOTT, quoted in Robert Bersson, *Worlds of Art*. Mountain View, CA: Mayfield, 1991, pp. 312–13.
3. DENIS DIDEROT, quoted in Lorenz Eitner, *Neoclassicism and Romanticism, 1750–1850*. Engelwood Cliffs, NJ: Prentice-Hall, 1970, p. 58.
4. BILL REID, *Out of the Silence*. New York: Outerbridge & Dienstfrey, 1971, pp. 62–63.
5. Ibid., pp. 86–89.
6. Ibid., pp. 103–4.
7. GLADYS-MARIE FRY, *Stitched from the Soul: Slave Quilts from the Ante-Bellum South*. New York: Dutton Studio Books, 1990, p. 44.

Chapter 16

1. Review of Royal Academy Exhibition. *London Times*, May 8, 1844.
2. LINDA NOCHLIN, *Realism and Tradition in Art, 1848–1900*. Engelwood Cliffs, NJ: Prentice-Hall, 1966, p. 52.
3. ROZSIKA PARKER and GRISELDA POLLOCK, *Old Mistresses: Women, Art, and Ideology*. New York: Pantheon, 1981, p. 37.
4. LINDA NOCHLIN, *Realism and Tradition in Art, 1848–1900*. Engelwood Cliffs, NJ: Prentice-Hall, 1966, pp. 75–76.
5. Ibid., pp. 77.
6. Ibid., pp. 76.
7. WILLIAM C. SEITZ, *Claude Monet*. New York: Harry N. Abrams, 1960, p. 118.
8. WENDY SLATKIN, *Women Artists in History*. Englewood Cliffs, NJ: Prentice-Hall, 1990, p. 116.
9. HERSCHEL CHIPP, *Theories of Modern Art*. Berkeley: University of California Press, 1968, p. 67.
10. Ibid., pp. 67–69.
11. ROBERT BERSSON. *Worlds of Art*. Mountain View, CA.: Mayfield, 1991, pp. 384–85.
12. Ibid., p. 370.

Chapter 17

1. ROBERT HUGHES, *The Shock of the New*. New York: Alfred A. Knopf, 1981, p. 285.
2. HERBERT READ, *A Concise History of Modern Painting*. New York: Praeger, 1966, p. 54.
3. HERSCHEL CHIPP, *Theories of Modern Art*. Berkeley: University of California Press, 1968, p. 206.
4. JOHANNES ITTEN, *The Art of Color*. New York: Reinhold, 1961, p. 44.
5. WILLIAM S. RUBIN, *Dada, Surrealism, and Their Heritage*. New York: Museum of Modern Art, 1967, p. 195.

Chapter 18

1. CHARLES HARRISON and PAUL WOOD, *Art in Theory, 1900–1990*. Cambridge, MA: Blackwell, 1996, p. 419.
2. LLOYD GOODRICH and DORIS BRY, *Georgia O'Keeffe*. New York: Praeger, 1970, pp. 15–16.
3. FRANCIS V. O'CONNOR, *Jackson Pollock*. New York: Museum of Modern Art, 1967, p. 40.
4. ROBERT BERSSON, *Worlds of Art*. Mountain View, CA.: Mayfield, 1991, p. 474.
5. TRICIA LAUGHLIN BLOOM. Unpublished paper, 1999.
6. MAURICE TUCHMAN, *New York School: The First Generation*. Los Angeles: Los Angeles County Museum of Art, 1965, p. 51.
7. JOHN RUSSELL, *The Meanings of Modern Art*. New York: Museum of Modern Art, 1981, p. 390.

Chapter 19

1. LEO STEINBERG, *Other Criteria: Confrontations with Twentieth-Century Art*. London: Oxford University Press, 1972, pp. 12–13.
2. ELLEN H. JOHNSON, ed., *American Artists on Art: From 1940 to 1980*. New York: Harper & Row, 1982, pp. 59–60.
3. MARTIN FRIEDMAN and GRAHAM W. J. BEAL, *George Segal: Sculptures*. Minneapolis: Walker Art Center, 1978, p. 37.
4. MARTIN H. BUSH, *Duane Hanson*. Wichita, KS: Edwin A. Ulrich Museum of Art, 1976, p. 61.
5. ROBERT BERSSON, *Worlds of Art*. Mountain View, CA.: Mayfield, 1991, pp. 548–49.
6. KIM LEVIN, "Morality Tales: Cheri Samba." *The Village Voice*, May 1, 1990, p. 111.

Chapter 20

1. PHYLLIS QUILLEN, "Soft to the Touch, Striking to the Eye, Hard on the Heart: Artist Tells Stories on Quilts." *Daily News-Record*, Harrisonburg, VA, January 19, 1989.
2. BEATRIZ MEJIA-KRUMBEIN. Letter to the author, December 2001.
3. ROBERT BERSSON, *Worlds of Art*. Mountain View, CA: Mayfield, 1991, pp. 534–36.
4. JANET KARDON, *Laurie Anderson: Works from 1969 to 1983*. University of Pennsylvania: Institute of Contemporary Art, 1983, p. 24.
5. PER HOVDENAKK, *Christo: Complete Editions 1964–1982*. New York: New York University Press, 1982, p. 55.
6. ROBERT BERSSON, *Worlds of Art*. Mountain View, CA: Mayfield, 1991, pp. 544–47.
7. ATHENA TACHA. Web site (http://www.oberlin.edu/~atacha/victoryplaza.html), August 29, 2002, p. 1.

INDEX

Note: Page numbers in italics refer to illustrations. Page numbers for the appendix are preceded by an "A," e.g., "A3."

Credits

Abbreviations:
AR = Art Resource, NY
ARS = Artists Rights Society (ARS, NY), New York
G/AR = Giraudon/Art Resource, NY
L/AR = Erich Lessing/Art Resource, NY
N/AR = Nimatallah/Art Resource, NY
RMN/AR = Réunion des Musées Nationaux/Art Resource, NY
S/AR = Scala/Art Resource, NY
V&A/AR = Victoria &Albert Museum, London/Art Resource, NY

p. 1 **Part Opener 1** The Metropolitan Museum of Art, New York. Department of Asian Art: Objects in "The Great Bronze Age of China," a Loan Exhibition from The People's Republic of China.; p.2 **Chapter Opener** The Phillips Collection, Washington. DC; **1.1** Oriental Institute of the University of Chicago. All rights reserved.; **1.2** S/AR; **1.3** Qualcom website; **1.4** © Al Tielemans; **1.5** David Sailors/CORBIS; **1.6** The Phillips Collection, Washington. DC; **1.7** © Peter Reiss; **1.8** Schalkwijk/AR; **1.9** Courtesy Clark Atlanta University Collection of African-American Art. © Estate of Hale Woodruff/Elnora, Inc. Courtesy of Michael Rosenfeld Gallery, New York, NY; **1.10** Collection of The Brooklyn Museum of Art, Gift of The Elizabeth A. Sackler Foundation. © Judy Chicago 1979. Photo: © Donald Woodman; **1.11** © Ernst Reinhold/Artothek; **1.12, 1.13 a-d** Yale University Art Gallery, Bequest of Stephen Carlton Clark, B.A. 1903; **1.14** Amsterdam, Van GoghMuseum (Vincent van GoghFoundation); p.6 **App. 01 Fig. A** Courtesy of the artist; p.7 **App. 01 Fig. B** Anchorage Museum of History and Art. Photo by Steve McCutcheon; p.13 **App. 02 Fig. A, B** Courtesy Clark Atlanta University Collection of African-American Art. © Estate of Hale Woodruff/Elnora, Inc. Courtesy of Michael Rosenfeld Gallery, New York, NY

p. 22 **Chapter Opener 2** Alinari/AR; **2.1** © Hans Hinz/Artothek; **2.2, 2.3** © Andy Goldsworthy; **2.4** © Ellsworth Kelly. Digital Image © The Museum of Modern Art/Licensed by SCALA/AR; **2.5** Freer Gallery of Art, Smithsonian Institution, Washington, DC: Gift of Charles Lang Freer, F1904.248; **2.6** Alinari/AR; **2.7** Courtesy Daitoku-ji, Kyoto; **2.8** © Photothèque R. Magritte – ADAGP/AR/© 2004 C. Herscovici, Brussels/AR; **2.9** Werner Forman/AR; **2.10** Photo courtesy of the artist./© Nancy Holt/Licensed by VAGA, New York, NY; **2.11** Photograph used by permission of The People's Place Quilt Museum, Intercourse, PA. All rights reserved.; **2.12** © 1981 Stiff Records Ltd.; **2.13** Photo courtesy of the artist and Richard Gray Gallery, Chicago; **2.14** © The Solomon R. Guggenheim Foundation, New York. Photograph by David Heald; **2.15** M. C. Escher's Day and Night © 2002 Cordon Art B. V. – Baarn – Holland. All rights reserved.; **2.16** Gift of Edward M. Warburg. Digital Image © The Museum of Modern Art/Licensed by SCALA/AR/© 2004 Estate of Alexander Calder/ARS; **2.17** Francis Barttlett Donation of 1912 and Picture Fund. 14.654. Courtesy of Museum of Fine Arts, Boston. Reproduced with permission. © 2002 Museum of Fine Arts, Boston. All Rights Reserved.; **2.18** Canali Photobank, Italy; **2.21** Courtesy of the artist, © Gene Bodio; **2.22** Ailsa Mellon Bruce Fund. Photograph © 2002 Board of Trustees, National Gallery of Art, Washington. 1967.6.1 a(2326)/PA; **2.23** © AFRICA-MUSEUM TERVUREN, Belgique; **2.24** Photo: Ellen M. Martin; **2.26** Photofest; **2.28** © 1989 Copyright the Estate of Robert Mapplethorpe. Used with permission.; **2.29** Ailsa Mellon Bruce Fund. Photograph © 2002 Board of Trustees, National Gallery of Art, Washington. 1967.6.1 a(2326)/PA; **2.30** © <CRDPHOTO>/CORBIS; **2.33** Yale University Art Gallery, Bequest of Stephen Carlton Clark, B.A. 1903; **2.34** The Metropolitan Museum of Art, New York. Department of Asian Art: Objects in "The Great Bronze Age of China," a Loan Exhibition from The People's Republic of China.; **2.35** Bildarchiv Preussischer Kulturbesitz, Berlin. Photo: Jörg P. Anders; p. 29 **App. 03** Courtesy the Canadian Embassy, Washington, DC; p. 33 **App. 04** Photo Archive Matisse/© 2004 Succession H. Matisse, Paris/ARS

p. 51 **Chapter Opener 3** © The Solomon R. Guggenheim Foundation, New York. Photograph by David Heald; **3.1, 3.2** © Patrick Horst, 2002; **3.3** Apple Records, Inc./Capitol Records, Inc. EMI Records; **3.4** Courtesy Matthew Marks Gallery, New York; **3.5** © Apple Records, Inc./Capitol Records, Inc. EMI Records; **3.6** Courtesy of the Burke Museum of Natural History and Culture, Catalog number 117B, Dance Robe, Clayoquot, late 19th century. Photo Eduardo Calderon; **3.7** Alinari/AR; **3.8** Courtesy of the artist and Bernice Steinbaum Gallery; **3.9** © The British Museum, London; **3.10, 3.11** © The Solomon R. Guggenheim Foundation, New York. Photograph by David Heald; **3.12** Raffaello Bencini, Florence; **3.13** Gift of Steven M. Jacobson and Howard A. Kalka, 1993 (1993.408). Photograph © 1994 The Metropolitan Museum of Art. © Miriam Schapiro; **3.14** AKG, London/Jean-Louis Nou; **3.15** © RMN/AR/© 2004 ARS/ADAGP, Paris; **3.16** Courtesy Paula Cooper Gallery, New York. Photo: eeva-inkeri; **3.17** © 2002 Claes Oldenburg. Photo: Attilio Maranzano; **3.18** © Nicolas Africano; **3.19** © Miriam Schapiro. Photo courtesy of the artist.; **3.20** © Donald Judd Foundation/Art © Donald Judd Foundation/Licensed by VAGA, New York, NY. Photographer: Andrew Moore; **3.21, 3.22** Photo: Molly Chassman; **3.23** © Jose L. Pelaez, Inc./CORBIS; **3.24** © Reuters NewMedia Inc./CORBIS; p.64 **App. 05 Fig. A** Atlantic Records; p.64 **App. 05 Fig. B** © Blue Note/Capitol Records, Inc. EMI Records; p.73 **App. 06 Fig. A** The New York Public Library/AR; p.74 **App. 06 Fig. B** RMN/AR; p.75 **App. 06 Fig. C** L/AR; p.75 **App. 06 Fig. D** G/AR

p. 76 **Chapter Opener 4** AR; **4.1** AKG, London/Erich Lessing; **4.2** S/AR; **4.3** © The National Gallery, London; **4.4** © The Frick Collection, New York; **4.5** Dundee City Council Museum–Dundee Art Galleries and Museums, McManus Galleries; **4.6** © Ron & Linda Card, Cards Unlimited, Inc. Keysville, VA.; **4.7** V&A/AR; **4.8** Courtesy Country Life, Ltd., London; **4.9** Marie Antoinette Evans Fund, 28.849. Courtesy, Museum of Fine Arts, Boston. Reproduced with permission. © 2002 Museum of Fine Arts, Boston. All Rights Reserved.; **4.10** © National Palace Museum, Taipei, Taiwan, Republic of China; **4.11** The Freer Gallery of Art, Smithsonian Institution, Washington, DC.: Gift of Charles Lang Freer, F1898.110; **4.12** Freer Gallery of Art, Smithsonian Institution, Washington, DC.; Gift of the family of Eugene and Agnes E. Meyer, F1974.72; **4.13** The Corcoran Gallery of Art, Washington, DC. Museum Purchase, Gallery Fund; **4.14** Earth Satellite Corporation/Science Photo Library/Photo Researchers; **4.15** Photofest; p. 89 **App. 07** AR; p. 94 **App. 08** © Ansel Adams Publishing Rights Trust/CORBIS

p. 95 **Part Opener 2** Library of Congress, Washington, DC; p.96 **Chapter Opener 5** G/AR; **5.1** Permission of the Buku-Larrnggay Mulka Centre and Yirrkala Community. Photo courtesy of the State Library of South Australia.; **5.2** © 2002 William Cochran; **5.3 a** © Bob Krist/CORBIS; **5.3 b** © Jose Luis Pelaez, Inc./CORBIS; **5.3 c** © Michal Heron/CORBIS; **5.4 Photo Dr. C.** Staewen. 1972 expedition by Dr. C. Staewan to Tibesti sponsored by the Frobenius-Institute at the Johann Wolfgang Goethe-University.; **5.5** © National Portrait Gallery, Smithsonian Institution/AR; **5.6** © 2004 The Saul Steinberg Foundation/ARS; **5.7** M. C. Escher's Drawing Hands © 2002 Cordon Art B. V. – Baarn – Holland. All rights reserved.; **5.8** © Marisol/Licensed by VAGA, New York, NY; **5.9,5.10** Photo: J. P. Langlands; **5.11** Howard University Gallery of Art, Washington DC; **5.12** Photo courtesy of Alitash Kebede Fine Art, Los Angeles. Reproduction permission granted by Randall Galleries, Ltd. on behalf of the artist's estate.; **5.13** © 2002 Barthosa Nkurumeh; **5.14** Photo: Barthosa Mkurumeh; **5.15** H. O. Havemeyer Collection, Bequest of Mrs. H. O. Havemeyer, 1929 (29.100.38). Photograph © 1987 The Metropolitan Museum of Art; **5.17** Freer Gallery of Art, Smithsonian Institution, Washington DC.; Purchase F1932.28; **5.18** © Oronoz; **5.19** National Commission for the Protection of Cultural Properties, Tokyo. (Photo: M. Sakamoro); **5.20** Private Collection/David Findlay, Jr. Fine Art, NYC/Bridgeman Art Library; **5.21** Courtesy of the Robert Miller Gallery, New York/© 2004 The Pollock-Krasner Foundation/ARS; **5.22** The Eli and Edythe L. Broad Collection. Photograph © Douglas M. Parker Studio; **5.23** © Sam Gilliam; **5.24** G/AR; **5.25, 5.26** © The National Gallery, London; **5.27** © Royal Academy of Arts, London, 2000; **5.28** Helen Regenstein Collection, 1966.184. © The Art Institute of Chicago. All Rights Reserved.; **5.29** © The British Museum, London; **5.30** Helen Birch Bartlett Memorial Collection, 1926.224. © The Art Institute of Chicago. All Rights Reserved.; p.119 **App. 09 Fig. A** Photo courtesy of Washington and Lee University; p.120 **App. 09 Fig. B** Courtesy of the artist; p.121 **App. 10 Fig. A** Photo: Diane Elliott; p.122 **App. 10 Fig. B** Courtesy of the artist.